MODERN TIMES, MODERN PLACES

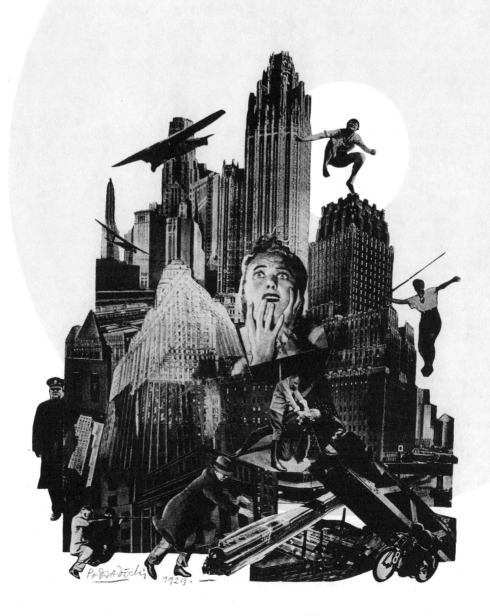

Title-page .
City – Mill of Life, photomontage
by Kazimierz Podsadecki (1929)

British Library Cataloguing-in-Publication Data
A catalogue record for this book is available from the British
Library

ISBN 0-500-01877-4

Printed in Hong Kong by H&Y Printing Limited

CONTENTS

ON BEING A MIDDLE-AGED CHILD
OF OUR TIMES

A century, or a certain decade in it, helps – like a third parent – to write a genetic plot for us. Our obsessions and our mannerisms, the things we dream about and even the way we look, are influenced by the invisible, indefinable spirit of the times we live in. I was born just before the twentieth century reached its half-way mark, and when this book is published I will (if I am lucky, since the date is still some months away) have reached my own half-century. I have lived, like all my contemporaries, through a series of rapid, disorienting changes: the terrified conformity of the 1950s, followed by the shaggy revolt of the 1960s; the materialistic surfeit of the 1980s, then the slow recognition that history did not arrive at a happy ending when the Berlin Wall fell.

Updating our computers every few months and struggling to learn new technological skills, we run as fast as we can in order to stay in the same place. But, while chasing the present, we live in the past as well. Though born in 1948, I felt while growing up that I had inherited the experience of the century's previous decades, through the stories my parents told. Having survived the war and the economic distress which preceded it, they were grateful for the chance of happiness and prosperity which had come to them at last, symbolized by a suburban house and the expectation of life-long employment; they would have preferred to forget the privations of the past, which I of course wanted them to remember. Their narratives made me aware of my own good fortune, and that of my entire generation. I had shoes on my feet, there was always dinner on the table. I was able to finish school, and to go on to university.

I shivered when I imagined the miseries and anxieties of the decades before 1945. One day I listened with stupefaction as a teacher belatedly broke the news of the Holocaust: the sun went out. Yet my curiosity about that earlier world contained an element of rankling envy. I had missed out on an adventure, whose dangers (in comfortable retrospect) I could ignore. That may be why, in this book about the twentieth century, my own half of it is overshadowed by the other half, through which my parents and their parents lived: a period of social collapse, political convulsion and psychological uncertainty, and also – perhaps as a consequence of these upheavals – of audacious creativity, which made the world modern.

At its mid-point, with the war won, the century had supposedly been granted a fresh start. The affluence in which my parents modestly shared, after

childhoods of rural poverty, produced a new world of consumer goods. Our lives were altered by a succession of small miracles, affordable on hire purchase. I remember their arrival at our door, and the pride and wonder they excited: a refrigerator, a washing-machine, a car, finally a television set. People in later generations take these boons for granted, though they rejoice just as naively in their own most recent acquisitions: a Walkman or a portable compact disc player, a mobile telephone, a fax machine, the latest computer software. This, as I now see it, is the happy revolution which my own half-century has lived through. The final third of this book describes the new consumerist culture of surplus and leisure, where individuals – freed for the first time in human history from scarcity, their lives eased by labour-saving devices – can concentrate on the self-cultivation which has come to be known as Personal Growth.

I did my own growing up in Australia. The world in my childhood still had a centre, which was several oceans away. But geographical distance no longer conferred immunity on us, and I often looked up at the bright, smiling sky and imagined mushroom clouds, or speculated about drifting radiation. On Christmas Eve in 1959 I pestered my parents to take me to the film of *On the Beach*, which showed the end of the world happening not far away in Melbourne. It thoroughly depressed us all. During the 1960s there were other adjustments to be made. Australia began to acknowledge its location in Asia, rather than behaving as if it were anchored somewhere just off the Sussex coast – a sign of one of this century's seismic shifts, as power moved inexorably away from Europe. To make these new Asian allegiances official, our government obsequiously trooped into Vietnam behind the Americans. I was conscripted on my birthday in 1968. The British empire saved me from having to fight, and I went to Oxford instead as a Rhodes Scholar. In those days before the advent of the jumbo jet, I travelled to England by ship; the voyage took five dozily stationary weeks. Now, covering the same distance by plane in a little over twenty hours, I occasionally wonder if my boat might have had sails. All of us, if we stay alive for long enough, find that we have receded into history.

I have written this book in the hope of beginning to understand what it has meant to be alive in the twentieth century. There are abundant reasons for assuming that the experience was different from life in previous centuries (and the differences do not only relate to the clothes we wear, or the vehicles we travel in). Of course every previous century has cherished such a belief. We cannot imagine the future; hence our conviction that the present has taken us, like the up-to-date citizens of Kansas City in *Oklahoma!*, as far as we can go. But in the twentieth century humanity did reach a new stage in its development. The very notion of modernity refers to that irrevocable breach with the past.

The physics of Einstein and his successors upset a traditional complacency about time and space, the dimensions of our existence. Freud damaged the upright moral conceit of humanism by demonstrating the intimate collusion of mind and body. No longer able to believe in their own rational sovereignty,

modern men had to contemplate the possibility of their wholesale destruction. Machines killed them off in prodigious quantities during the first of the century's world wars. Then the Nazis industrialized slaughter; even more economically, a bomb devised a method for instantaneously flattening cities and ultimately for terminating life on earth. We now confront the prospect that our species might simply be obsolete, since we have invented a new range of electronic helpers which can outsmart our own befuddled brains. We are also obliged to confront the damage which a century of industrial development has done to our planetary habitat. History has begun to move repentantly into reverse, and men are creeping back underground. As I write this, ecological protesters in Manchester – armed with a digging manual disseminated by the Viet Cong in the 1960s – have tunnelled beneath the proposed site of a new airport runway, sealing themselves in a dormitory of clay. Like the early Christians huddled in their catacombs, they warn of an impending millennium, with seas overflowing and a sky poisoned by our fuels. These are the abiding concerns of our century, which this book attempts to explore: the competition between humanity and inhuman mechanism, or between human values and subhuman behaviour; the choice between the ideal future envisaged by social planners and the atavistic compulsion of our savage past.

What I have written is not quite a cultural history. Certainly it does not set out to enumerate and extol the most significant works of art produced in our century. Rather it is about the ways in which life has changed during the last hundred years, and it looks to art – since artists are the interpreters of their age and also its memorialists – for evidence of those changes. My concern is primarily with high culture, because its artefacts stay around to be investigated. But near the beginning of the book I discuss the way men and women modernized themselves by cutting their hair, and near the end I deal with the intricate ephemera of popular culture in Japan: cigarette advertisements, legends on baseball jackets, the names given to love hotels. The definition of a culture has to include all human activities which are not strictly natural, from cooking food, wearing clothes and having sex for reasons other than procreation to writing poems and building cathedrals. Anthropology becomes increasingly important in my account of the century, because it addresses the fundamental modern question of what a human being is, and points out the shifty relativity of the border between nature and culture.

Emphasizing modernity, I have tried to avoid the abstruse and academic category of the 'post-modern'. The term comes in handy when defining architectural fashions; otherwise I have found limited use for it, since the idea is already latent in modernism. The twentieth century began by insisting on its secession from the past. But it achieved that freedom by anachronistically rearranging the past, like James Joyce in *Ulysses* or Richard Strauss and Hugo von Hofmannsthal in *Der Rosenkavalier* or Pablo Picasso in *Guernica*. By now, modernity may seem elderly or ancient, but those concerted mental and moral

revolutions which occupied the years between the late 1890s and the early 1930s set the agenda for the rest of the century, and instigated arguments which are still continuing. This is the continuous, interconnected story which I have attempted to tell.

Modernity is about the acceleration of time, and also the dispersal of places. The book starts by describing the modern panic about time. It goes on to identify a series of places which are citadels of modern society in its different phases. After Vienna, Moscow, Paris, Berlin and New York, the last in this sequence is a city which allusively jumbles up the others: Tokyo. By the end of the book, the world I describe has effectively made both time and place redundant. The past is available for instant recall in the present, and places no longer stay where they should on the map. In 1988 I remember glancing out of the window of a plane, moments after landing for the first time in Hong Kong. There to greet me, loping across a placard several storeys tall on the side of a building beside the tarmac, was the Marlboro Man: an icon of the wild West, encountered here in what we used to call – in days when empire still insisted on the centrality of Europe – the Far East.

Looking back, the few minutes before that touchdown seem to sum up much of the exhilaration and oddity of life in the twentieth century. The approach to Kai Tak airport is so unnerving that they show you a virtual version of it first, on a videotape inside the plane: technology pre-empts the experience itself. Then the pilot tries to match the simulation, swooping low across the tenements of Kowloon, before making a sharp, steep turn. The runway, a sliver of concrete jutting into the water, appears below. Let down from the sky, the shrieking, rattling tonnage of metal, with a few hundred human lives among its cargo, thuds onto the strip of pavement and just manages to stop a few feet before the runway does. Across the harbour stands a shining Manhattan of glass towers, with a tropical forest growing out of it. Although I could do without that abrupt right turn (which will anyway soon retreat into history, when Hong Kong in the early twenty-first century acquires a new airport), the chance to see such things and to have such improbable experiences is enough to make me a grateful child of our time.

NOTES ON ETIQUETTE,
AND ACKNOWLEDGMENTS

It is difficult, when drawing on such an eclectic range of sources, to be consistent about the language in which titles are cited. With literary works in German, French and Italian, I have given the original title when the work is first mentioned, and from then on have generally used the translated title. Problems arise because the customary translated titles are not always accurate: Thomas Mann's *Der Zauberberg* neatly converts into *The Magic Mountain*, but there are punning implications in Oswald Spengler's *Der Untergang des Abendlandes* which *The Decline of the West* cannot register. Fortunately, not many titles are as runic as Spengler's, and most other non-fictional works – by Sigmund Freud, Émile Durkheim and Primo Levi – are referred to throughout by their translated titles. However, even the translators of Claude Lévi-Strauss's *Tristes Tropiques* and Monique Wittig's *Les Guérillères* leave their titles intact; I have not interfered with Lévi-Strauss's alliteration or with Wittig's pun.

There are other exceptional cases. When discussing Marcel Proust's *À la Recherche du temps perdu*, I have balked at using the translated title, *Remembrance of Things Past*, which irrelevantly invokes Shakespeare and violates Proust's uniquely modern meaning: the element of scientific research vanishes, as does the sense that time itself has been lost. I have tried to manoeuvre around the unfortunate fact that F.W. Murnau's film *Der letzte Mann* was released abroad, presumably for commercial reasons, as *The Last Laugh*. I also prefer the original title of Wim Wenders' *Himmel über Berlin* to the soggy translation, *Wings of Desire*. The film after all is about the sky, and about the possibility of heaven; the German noun covers both realms. Still, I have broken my own rule in the last chapter, which mentions novels written in Russian, Czech, German, Italian, Spanish and French: to spare the reader a babble of different tongues, I have anglicized the titles of all these fictional works.

Sometimes works change their names when migrating between cultures. I have referred to Oscar Wilde's play, which was written in French, as *Salomé*, while calling Strauss's operatic adaptation *Salome*. Discussing the Viennese context of Franz Lehár's operetta, I call it *Die lustige Witwe*, though when I go on to trace the new meanings it acquired in Hollywood adaptations by Erich von Stroheim, Ernst Lubitsch and Curtis Bernhardt, it naturally becomes *The Merry Widow*.

Although most of us read novels like those of Proust, Mann or Robert Musil in translation, we do not watch dubbed versions of foreign films. It there-

fore seems sensible to leave titles like *Un Chien andalou* or *La notte* untranslated, although to apply that rule to films directed by S.M. Eisenstein or Yasujiro Ozu would of course seem pretentious. The titles of operas or songs, usually performed throughout the world in the composer's own language, have also been left in the original – except where the composer happens to be Russian, Hungarian or Czech. The cosmopolitanism of Igor Stravinsky has caused me particular headaches. *Vesna Sviaschennaya* is not quite the same thing as the translated title (supplied by the designer Léon Bakst) *Le Sacre du printemps*. We now habitually refer to Stravinsky's *Svadebka* as *Les Noces* and not *The Wedding:* the ballet's chanted texts are Russian, but the work was first performed in Paris, and at once fell victim to the linguistic imperialism of the host country. With musical works, I have tried to use versions of titles which will be familiar to English and American readers.

Ours has become a century of entrenched intellectual specialisms, and I am only too aware of the squads of highly-qualified commentators on linguistics and psychoanalysis, or totalitarianism and sexual liberation, on whose terrain I have trespassed. Nevertheless I have attempted to make up my own mind about such matters and to give my own account of them, consulting the primary texts to which I refer and from which I quote. My purpose is to connect these different areas of experience and expertise; I would like to believe that each of us can strive towards an overview of the times we have lived through.

At Thames and Hudson, Helen Farr uncomplainingly accommodated my last-minute changes to the text, while Tessa Campbell, trawling for illustrations in the most unexpected places, enabled me to look at the subject with fresh eyes. At Knopf, the intellectual clarity and witty scepticism of my editor Susan Ralston made me think again about large issues and also points of detail; I am grateful to her for setting such high standards.

This is not a book which I would have been reckless enough to propose writing. The suggestion came, more than a decade ago, from Jamie Camplin (who even in the mid-1980s had his far-sighted eye on the millennium). I agreed, and then – after working on the subject for a year – regretted my recklessness and excused myself. Occasionally over the next few years, Jamie reminded me of my broken promise. His gentle prodding kept the idea alive in my head; finally I recognized that it was something which, despite all the risks, I must try to do. Having taken so long to make up my mind, I was lucky that Jamie, almost uniquely in the unsettled world of Anglo-American publishing, had not changed firms or careers. He has a bashful aversion to public expressions of gratitude, and insists that authors, not editors, write books. But sometimes, as I pointed out when persuading him to accept this acknowledgment, they are given the opportunity and also the courage to do so by editors. Whether or not I have been able to write the book Jamie had in mind, I must thank him for his trust, his patience, his advice, and for the invigorating boldness of his original idea.

DOOMSDAY
AND AFTER

We all make vows to ourselves on New Year's Eve. The twentieth century began with the bravest, the most ambitious, perhaps the most foolhardy of such self-improving resolutions: a promise to make the world modern, which meant to create it all over again. Science had unlocked the secrets of life, and technology was beginning to abridge distance. Men were newly endowed with both knowledge of nature and technical control over it. Enthusiasts calculated that, thanks to the forced pace of industrial innovation, the world had changed faster and more completely during the nineteenth century than in all the previous centuries of the Christian era. At the end of the first millennium, a divine curse loured over the cowering, superstitious human race. Since the earth had been allocated a life-span of a thousand years by God, would all life now punctually end? By the time the last century of the second millennium arrived, men had outgrown such credulity. The twentieth century was to be the first in which they freed themselves from the past and its interdictions. Before it began, its plot seemed radiantly clear: in the future, men would replace God.

Things did not quite turn out as planned. Technology shrank the globe, which allowed the world to make war against itself twice in a single generation. Science trespassed on ultimate mysteries, enabling the two global powers which emerged from the conflagration of nations in 1945 to threaten each other, for much of the century's second half, with a terminal storm of fire. When the twentieth century began, there was hopeful, predictive talk of a 'new man', and of course a 'new woman' as well – organisms redesigned according to the most modern principles of ethical uplift and sexual hygiene. The older version of human nature, however, was far from obsolete, and history seemed to demonstrate that man remained a savage. Hence the dismaying affinity between modern times and a more primeval era. Like our fearful, crouching ancestors, entire populations in this century have been terrorized by ogres. An attempt to re-engineer humanity by force began in Russia in 1917; another experiment in visionary politics, uniting metaphysics and murder, began in Germany in 1933. Ideology is

a product of intellectual surplus or excess, generated in societies where theories are churned out in an overworked mental factory: our century is inconceivable without its combative, intolerant, inconclusive mob of isms. The strangest feature of totalitarian politics was its compulsion to rectify human nature and to synthesize disparate human activities, which resulted in regimes thought out in fanatically finicky detail by self-appointed gods. Lenin sermonized outside the Finland Station in St Petersburg, using an armoured car as his pulpit. Hitler devised a 'final solution' to the problem of dissident reality, and viewed his own military catastrophe as the incendiary finale of a Wagnerian opera.

The future, when it arrived, mocked those who believed they had foreseen it. We cannot anticipate our lives, or manipulate the chances which alter the course we devise for ourselves; we have no choice but to live through the portion of history assigned to us. At the end of the century it is easy to identify misjudgments and wrong turnings. Age has a hindsight denied to forward-looking youth. But youth also has a zealous energy which age can only envy. The heroic daring of our century lay in its conviction of absolute, unprecedented novelty. This is what the exhilarating notion of modernity meant: cancelling all the accumulated wisdom of our forebears. Time and space, the antique dimensions of existence, had been killed off by Einstein. He fused them in the relativistic continuum of space-time, which the reckless gang of Italian futurists thought they could experience when they drove their racing-cars. Speed, annihilating distance and duration, reduced space to a volatile blur, and compressed the time it took for wishes to be fulfilled. In a poem written in 1922, Thomas Hardy brooded over the conundrum of Einstein's fourth dimension and bade a sad farewell to time, advising it that 'You are nought / But a thought'. More valiantly eager for the future, the Bauhaus instructor Oskar Schlemmer decreed in 1929 that 'One should act as if the world had just been created'.

A new-born universe called for fresh tenants. Virginia Woolf accordingly reported, as if she were pinpointing an actual, verifiable event, that 'on or about December 1910 human character changed'. Rites of passage made this enigmatic transformation visible. How do human beings usually announce an altered identity? By changing the way they wear their hair. Men who wanted to be ruthlessly modern shaved their skulls, like the Russian revolutionary poet Vladimir Mayakovsky or Johannes Itten, an instructor at the Bauhaus in Weimar. In the hirsute nineteenth century, sages – aspiring to the shagginess of Old Testament prophets – grew beards. For the glowering, bullet-headed Mayakovsky, the cranium was a projectile, made more aerodynamic by being rid of hair. For Itten, shaving announced his priestly dedication to the new world which the designers at the Bauhaus intended to build. He also fashioned a plain monkish smock for himself, with a high collar which did away with the florid neckwear and bemedalled chest favoured by nineteenth-century grandees, and he wore spare, rimless spectacles – a declaration that the eyes themselves are lenses, and might be hardier if they were made of glass in the first place.

Women had their own equivalent to those drastic masculine acts of self-mutilation. In 1920 F. Scott Fitzgerald wrote a story, 'Bernice Bobs Her Hair', about a timid provincial girl for whom bobbing is a transition between two periods of life and two historical epochs. The new style ejects her from Madonna-like girlhood, when she was protectively cocooned in tresses, and announces her sexual maturity. Bernice fearfully acknowledges the revolutionary antecedents of the process. Driving downtown to the mens' barber-shop where the operation will be performed, she suffers 'all the sensations of Marie Antoinette bound for the guillotine in a tumbril'; the barber with his shears is an executioner. The French revolutionaries sliced off the heads of bewigged aristocrats in order to destroy an old world. Bernice, however, has her own hair chopped to fit her for membership of a new society: bobbing conferred erotic allure on girls who were previously dismissed as wallflowers. The bobbed hair of Louise Brooks, in the films she made for G.W. Pabst, *Die Büchse der Pandora* in 1928 and *Das Tagebuch einer Verlorenen* in 1929, signalled availability. On the run from the police in the first film, she disguises herself by waving her hair; when she is sent to a reformatory in the second, the bob is at once undone by the warders, who slick her hair back behind her ears.

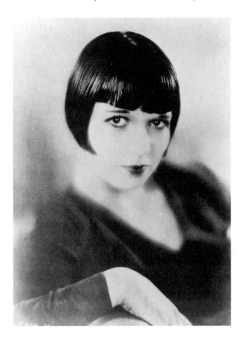

Louise Brooks, bobbed

James Joyce's *Ulysses* in 1922 testified to the change in human character announced by Virginia Woolf. Bodies now did things which, at least according to literature, they had never done before. A man ponders his own bowel movement, relishing its sweet smell. Later in the day he surreptitiously masturbates in a public place and takes part in a pissing contest, proud of the arc his urine describes. A woman has a noisily affirmative orgasm, or perhaps more than one. The same people did not think in paragraphs or logical, completed sentences, like characters in nineteenth-century novels. Their mental life proceeded in associative jerks and spasms; they mixed up shopping lists with sexual fantasies, often forgot verbs and (in the woman's case) scandalously abandoned all punctuation. The modern mind was not a quiet, tidy cubicle for cogitation. It thronged with as many random happenings as a city street; it contained scraps and fragments, dots and dashes, like the incoherent blizzard of marks on a modern canvas which could only be called an 'impression' because it represented nothing recognizable.

The reality men had been taught to recognize – labelled by language and painstakingly reproduced by painting – was a lie, which modernism rejected. Jean Arp, a Dadaist collaborator at the Cabaret Voltaire in Zurich, attempted like Virginia Woolf to identify the moment when the schism occurred. 'Suddenly,' he wrote with the same teasing chronological vagueness, 'in about 1914, "in accordance with the laws of chance", the spirit was transmuted.' After that spiritual change, abstract painting set out on its mission 'to transform the world'. It replaced a deceitful realism with stark, blunt concrete objects, and saved man's soul by grounding him in a nature composed merely of 'lines, surfaces, shapes, and colours'. In 1938 Gertrude Stein explained why Picasso scrambled facial features and transposed limbs, dislocating objects in space and jumbling the temporal sequence of perception like an impish Einstein. The reason she gave was breath-taking in its simplicity. 'The earth', she pointed out, 'is not the same as in the nineteenth century.' She added that of course Picasso, 'being of the twentieth century', understood this.

Between the present and a discarded past lay a chasm; there was no crossing back. To be modern, to acknowledge and to inhabit this new world, was a strict intellectual duty and a bracing imaginative challenge.

There were risks. Existentialism is the philosophy which best suits our times, because it places the individual on a tightrope stretched above vacancy, and turns his negotiation of an average day into a triumph of nerves or guts. We have learned to live existentially, dicing with danger and calculating the likelihood of damage. All progress, ultimately, is harmful, even though the harm may be postponed. A car and a refrigerator are fine things to possess; a pity that the gases they exhale gobble up the ozone layer. Cigarette packets carry health warnings, butter has been demonized, and sex can result – if you are not careful – in death. Air travel is a boon, except when the plane crashes. Drawing on modern probability theory and the science of statistics, an industry has emerged which entices us to gamble with our own mortality: we buy insurance so that we can be financially rewarded if we suffer an accident. Under certain circumstances, death pays a double indemnity. Professional gamblers who guess about the future value of currencies now control the economic and political fate of nations. On one day in September 1992 a speculator allegedly made a profit of a billion pounds by betting against sterling. The century's most nihilistic gambler was Hitler, who balanced the chance of military success against a failure which would entail apocalypse, and took frenetic delight in the catastrophe when it came.

Modernity, which suddenly increased velocity in all areas of human experience, resembled a rollercoaster: a voluntary ride, thrilling because it jested with disaster. The dangers were optional, not predestined. They derived, in a society which had rejected traditional guidance about who we are, from the revelation that identity is tenuous, as mutable as the earth which is forever being eruptively transformed. The American fellow-traveller John Reed remarked that the world

shook as a result of ten heady days in Russia during 1917; for one reason or another, it has shuddered or palpitated throughout the twentieth century.

While we wonder that the twentieth century has managed to reach its end, it is worth recalling that, a hundred years ago, there were doubts about whether it would even have a chance to begin. In 1890 the characters in Oscar Wilde's *The Picture of Dorian Gray* discuss the sexual habits peculiar to this late, worn-out stage of the world's history. Lady Narborough chides the dandified and narcissistic Lord Henry, who seems unconcerned to win the love of women. The vital imperative of the race, which is to breed the future, seems listlessly diminished. Lord Henry listens to her sermon, and murmurs 'Fin de siècle'; she replies even more emphatically 'Fin du globe'. Dorian – who, like the Mona Lisa as described by Wilde's mentor Walter Pater, has already wearily lived through several centuries' worth of self-indulgence and depravity – adds with a languid sigh 'I wish it were fin du globe. Life is a great disappointment.'

The nineteenth century, powered by the internal combustion engine, was a time of hectic, propulsive dynamism. Tennyson imagined history as a railway, on which the great world spun forever down the ringing grooves of change. This faith in illimitable progress brought with it a psychological burden. Could minds and bodies keep up with those indefatigable machines? The White Rabbit in Lewis Carroll's *Alice in Wonderland* lives in terror of being late. Thomas Carlyle called life itself 'a Time-impulse'. But the faster life was lived, the sooner it ended. The engine had to be constantly stoked, fed with fuel; its prodigious output of energy meant that exhaustion and breakdown were frequent. As if in reaction to the force so freakishly expended in manufacturing and engineering, the nineteenth century invented a new ailment, the complaint of an organism whose energy had run out – ennui. For Wilde's aesthetes, boredom is a credential of spiritual superiority. Yawning, they give vent to a mystical otherworldliness. Their predecessor Des Esseintes in J.-K. Huysmans' *À Rebours* organizes his ennui into a regime of ascetic self-denial. After packing his bags for a trip from Paris to London, he imagines the foggy metropolis, decides he has had the experience of being there already, and cannot be bothered to go through with the journey. At its most snobbishly devout, this new vice licensed suicide, as when the hero of Villiers de l'Isle-Adam's *Axël* declares that living is a fate fit only for servants. Boredom – not only a concomitant of satiated wealth and leisure – seems to have been epidemic in Russia. It keeps the apathetic hero of Goncharov's *Oblomov* in bed, provokes the merchant's wife in Leskov's *Lady Macbeth of the Mtsensk District* to commit multiple murders, and reduces Chekhov's Uncle Vanya to clowning despair. The busiest century in the world's history was also the one afflicted by enervation, attracted by sleeping sickness.

Already in 1836 in his *Confession d'un enfant du siècle*, Alfred de Musset identified this as the *mal du siècle*. The hero of his novel, Octave T., suggests several causes for the ailment – it is partly political, a disillusioned response to the failure

of the French Revolution; it is also philosophical, and can be traced back to the cynicism of Voltaire; or it can be seen as a literary fad, imitating Goethe's self-destructively miserable Werther or Byron's heroes, who seek oblivion in debauchery. Musset looked behind him to account for these neurasthenic symptoms, as if hoping to outgrow them, but instead they became more acute. Despite an official ethic of progress and productivity, the secret religion of the nineteenth century enshrined extinction and a joyful nihilism. Romantic hopes for renewal soon ran out. Huysmans' Des Esseintes contemptuously announced that 'The age of nature is past', because sensitive minds were sickened by the lowly monotony of its landscapes, the stupor of its vacant skies. John Ruskin claimed that nature had grown mortally sick, befouled by industry. The material amenities prized by the bourgeoisie were no consolation: poets like Baudelaire, Rimbaud and Verlaine chose indigence and outlawry.

The philosophy of Arthur Schopenhauer proposed that the world – irradiated with glory by the romantic poets, groaning with plenty and possession for the bourgeois novelists – was a mere projection of our self-deceiving will, a fantasy dreamed up by our metaphysical cowardice. A wise man, quietening the will, should choose annihilation. In 1865 the hero of Wagner's opera *Tristan und Isolde* does so in homage to Schopenhauer. Tristan tears the bandages from his wound and ecstatically expires so as not to suffer the happy ending of reunion with Isolde. In 1894 the hero of Gabriele d'Annunzio's *Trionfo della morte* transforms the abstinence of Tristan into a disinterested act of slaughter. Wagner's Isolde expires in a love-death which has no physical cause: it is an act of sublimation, like the levitating of a mystic. When Giorgio in d'Annunzio's novel hears Isolde sing her 'Liebestod' at Bayreuth, he interprets it literally, as the purging and putrefying of a world he despises. The music sounds 'as if all things there were decomposed, exhaling their hidden essences, changing into immaterial symbols'. Before facts can become symbols, the real world must be rid of its materiality. Decomposition must occur: decadence is the romance of decay. Giorgio therefore kills his lover, so that she can become – after her hidden essences are noxiously exhaled – 'an object for thought, a pure ideal'.

If your own life was disappointing, as Dorian Gray moaned, then the logical solution was to end it. This fate was also wished on the world: the *fin de siècle* yearned for the *fin du globe*, waiting with alarm and elation for an imminent cosmic ending. The world which modernism sought to reconstruct had been carelessly condemned to death during the 1890s. Centuries have life cycles. Wordsworth described the French Revolution as a dawn in which it was bliss to be alive and heaven to be young. But the century inaugurated by the events of 1789 stumbled forward into gloom and darkness. By the 1890s, it had aged from dawn to dusk – a twilight of doubt and pessimism which first obscured religious truths and then began to erase the familiar lineaments of the physical world. Heinrich Heine's poem 'Götterdämmerung' imagined the moment when the gods, who supposedly created and should therefore sustain our world, fade into

this twilight. In Heine's poem the mild, benevolent Christian heaven has been invaded by dwarves and ogres, who seek to restore the regime of ancient night. The poet sees a goblin and an angel tussling in the sky, and hears a shriek as the earth succumbs. In Wagner's opera *Götterdämmerung*, the apocalypse occurs on stage. Brünnhilde rides jubilantly onto the funeral pyre which burns the body of Siegfried, who was the last hope for human self-betterment; the flames scorch the sky and consume Valhalla, inhabited by decrepit, demoralized gods; collapsing masonry causes the Rhine to flood, washing away all the wreckage of a failed civilization. Nietzsche, writing *Also sprach Zarathustra* in the early 1880s, indignantly amended Wagner's myth. The pagan gods, Zarathustra says, did not senilely lapse into retirement. They laughed themselves to death when they heard the jealous god of Christianity announce his monopoly and forbid the worship of competitors. Their hilarious outrage revealed that 'There are gods but no God'. Among the many claimants to divinity was man, or rather Nietzsche's superman.

This execution of the gods was the nineteenth century's most splendidly arrogant achievement. The furnaces of industry, those 'dark Satanic mills' of William Blake, humanly harnessed a creative power which used to be a divine prerogative. Visiting the Paris Exposition in 1890, Henry Adams studied the dynamo, a humming, tireless demiurge, and concluded that it was worthier of worship than Christianity's abject Virgin. H.G. Wells regarded the turbines which quietly, cleanly generated electricity at the base of Niagara Falls with the same reverence. The geology of Charles Lyell and the biology of Charles Darwin methodically refuted the biblical account of origins. Wagner's *Der Ring des Nibelungen*, first performed at Bayreuth in 1876, presented a race of fractious, superannuated gods who maintain their power by theft and graft. Liberated from pious fear, man puts an end to their tyranny: Siegfried's sword cleaves through Wotan's ordaining spear in the third opera of the tetralogy. Once the gods had abdicated, the apparatus of morality could be discarded as well. Hence the twilight of the idols described with such satirical glee by Nietzsche in 1888 in his *Götzen-Dämmerung*. Modernity required the revaluation of all inherited values. Christian forgiveness was a code fit only for slaves; Nietzsche, rhetorically hammering the idols into dust, delighted in his own violence, called his book a declaration of war, and recommended battle as a tonic for spirits which had grown feeble and introverted.

The errors castigated by Nietzsche included the very idea of reality. Nineteenth-century moralists liked to repeat that life was real and therefore earnest, that the grave was not its goal. The artists of the period made that reality seem solid by enumerating the world's richly manifold contents – the covetous inventories of household goods in novels by Balzac or Dickens, the census of happy crowds at the seaside or the races in the paintings of W.P. Frith. That confidence soon faltered. Wilde damaged it irreparably with a pun: his nominalistic farce, which disbelieved in everything, maintained that it was more important to

be called Ernest than to be earnest. In the early 1940s, reflecting on the institu-
tionalized absurdity of war, Gertrude Stein returned to the nineteenth-century
refrain and asked 'Is life real is life earnest, no I do not think so, it is certainly not
real'. The war she was suffering through 'is funny it is awful but it does make it all
unreal, really unreal'.

Nietzsche initially ventured to show how what he called 'the "real world"',
the favoured domain of 'the wise, the pious, the virtuous man', was no more than
a myth. He did so by retelling the century's story as a solar cycle, ageing from
sunrise to dusk. His version of morning is not bright with promise, like
Wordsworth's in his commentary on the French Revolution. Nietzsche instead
disgustedly glances at 'The grey of dawn. First yawnings of reason. Cockcrow of
positivism.' Day begins murkily, as reason, already bored, looks out the window.
The rooster heralds the heyday of a philosophy which only believes in what it
can see and own. Such a blithe, brainlessly literal world-view falters before too
long. By the end of the century's long day, the decadent creature Nietzsche calls
'the man of the evening' has retreated into the shade. His instinctual life has
gone to sleep; he dozes in the darkness of Wagner's theatre at Bayreuth, dosing
himself with musical opium as Tristan and Isolde sing their hymn to night. Nietz-
sche sought to position himself at the point in this epochal day when the sun was
at its zenith. In broad daylight, after breakfast, Plato – the philosopher of phan-
tasmal concepts and bodiless ideals – blushes for shame at his own untruthful-
ness. Then comes 'mid-day; moment of the shortest shadow'. In the blaze of
noon, objects shake off the shadows they oppressively trail, and loosen their
anchorage to earth. Heat makes manifest the energy of the seething air; it is a
time when 'all free spirits run riot'. As the sun reaches the top of the sky, Nietz-
sche announces 'We have abolished the real world: what world is left?'

This triumphant cry echoes through the art of modernism, where Nietz-
sche's metaphoric midday also recurs, representing the fierce intensity of a vision
which abstracts the physical world. The impressionist Elstir, the companion of
Proust's youthful holidays at Balbec in *À la Recherche du temps perdu*, prefers to paint
on days when torrid heat, after thirstily drinking up the sea and pulverizing the
cliffs, suffuses the surface of his canvases like 'a gaseous state'. In these boiling
mirages, the only remaining solids – the hull of a boat, for instance – have appar-
ently been precipitated by light itself. Put to flight by brightness, the world whose
material bulk and plenitude consoled the nineteenth century becomes a ghost of
itself. Shade, given a startling prismatic richness by impressionism, usurps sub-
stance, and 'reality concentrated itself in certain dusky and transparent creatures
which, by contrast, gave a more striking, a closer impression of life: the shadows'.
Marcel studies Elstir's landscapes as exercises in reversing Genesis: 'the sunlight
had, so to speak, destroyed reality'.

This was the scenery of Cézanne's Provence, where the pitiless sun X-
rayed nature, disclosing the geometry of cubes, cones and spheres beneath
appearances. The same light caused the façade of Rouen cathedral to waver and

deliquesce in Monet's pictures, and atomized the bodies of the bathers and summer promenaders painted by Seurat, who are seen through a haze of sunspots. Surrealism studied the world unmade by heat. A watch melts in Salvador Dalí's desert, and the cities of Giorgio de Chirico turn into sweltering mirages. Marinetti and the futurists, who shared Nietzsche's love of war, derived the purgative fire from engines or from armaments. They ignited it when they went for joyrides in their fast cars; the barrels of their guns released a shrapnel of jagged, exploding light.

Mahler adapted this narrative of solar celebration in his Third Symphony, which makes audible the panic of revelling nature at noon. After that, the symphony proceeds to Nietzsche's midnight, the corresponding hour of revelation, when Zarathustra – through the voice of a contralto – sings about the consummation of joy in eternity. In *The Waves*, Virginia Woolf followed the sun's transit across the sky. It marks the stages of human life as it rises and declines, but more importantly it reveals the mutability or relativity of physical objects, which change their shape and meaning as light discovers them, explores them, and withdraws from them, consigning them to non-existence. At dawn, light strikes through trees in a garden, '*making one leaf transparent and then another*'. At noon it '*made the hills grey as if shaved and singed in an explosion*'. As afternoon fades, chairs and tables '*wavered and bent in uncertainty and ambiguity*'. In the evening, the same pieces of furniture regain solidity and grow ponderous, '*lengthened, swollen and portentous*'. At night, darkness sucks substance from '*the solidity of the hills*', and the world is once more obliterated, unmade.

This, after Nietzsche's summons, was the dangerous venture undertaken by modernism: a systematic assault on reality, cancelling anything which pretended to be familiar and recognizable, jolting us out of our domesticated timidity. Ever since the beginning of the century, people have grumbled that they do not understand modern art or do not like it. The complaint expresses metaphysical disquiet as much as aesthetic hostility, and it pays an involuntary tribute to that art's most subversive aim, which was to estrange us from our comfortable home-made world of appearances, to free us from facsimiles.

Visually, the revolution – which Nietzsche called 'the great disengagement' – began with the impressionists, who replaced solid, trustworthy objects with fickly subjective perceptions of them. Monet's cathedral, no longer promulgating sacred law, resembles a slice of crumbling cake. The cliffs at Pourville are effaced by rain when he paints them, while his London disappears behind a luminous green and purple smog. In the lily-ponds which Monet designed at Giverny during the 1890s, the world itself was streamily submerged. Nietzsche himself failed to appreciate this misty elision, and in 1888 he scoffed at 'that which one might call *l'impressionisme morale*'. The softening of contours reminded him of Christianity's despicable 'morality of pity'. Because his version of the revolutionary temperament stressed angry virility, he was bound to interpret impressionism as a symptom of '*declining* life'. He disliked the mystique of sensitivity,

and considered it a symptom of weakened will; he therefore dismissed impressionism, which elegiacally blinked at life through a waterfall of tears, as 'one more expression of the physiological overexcitability pertaining to everything *décadent*'. Oswald Spengler, in his meditation on the decline of the West, suggested that the purpose of these paintings was aeration. Greek art was rooted in the ground: Doric columns made sure they had a firm footing. But the art which corresponds to the modern spirit has the impatience of Faust, who spurns the dreary earth and longs to vanish into 'pure and limitless space'. Spengler believed that 'the extreme of this disembodiment of the world in the service of space is impressionism'. The impressionist waits for erosion or dissipation, which in time will wash away the phenomenal world. Nietzsche lacked the patience for these elemental processes. Reality could be more efficiently abolished using heavy-duty weapons, like the hammer he wielded in the foreword to *Götzen-Dämmerung*. Following his example, the futurists deployed their artillery, Wyndham Lewis entitled his magazine of modernist propaganda *BLAST*, and D.H. Lawrence threatened the sedate, good-mannered nineteenth-century novel with two drastic alternatives – surgery or a bomb.

However intemperate his verdict, Nietzsche was right to associate the pictorial technique of the impressionists with a moral attitude and a psychological mood. In 1908, G.K. Chesterton made the same connection in his novel *The Man Who Was Thursday*, an allegory about a gang of political anarchists who turn out to be desperate seekers for an elusive God. Hounded by a diabolical army of fiends, God's police take refuge in a forest. Its 'shattered sunlight and shaken shadows' provide them with camouflage, but this moral chiaroscuro disturbs them. The 'dance of dark and light' between the trees re-creates those conditions of religious doubt and shifty relativity against which they are battling. The flickering alternation of sun and shade induces vertigo, 'recalling the dizziness of a cinematograph': the cinema, for the Catholic dogmatist Chesterton, is a temple of illusion. Driven further into the dark wood, the detectives discover 'what many modern painters had found there'. This, as Chesterton disapprovingly puts it, is 'the thing which the modern people call Impressionism, which is another name for that final scepticism which can find no floor to the universe'. Objective truth had given way to subjective intuition, like the haze of dots through which Seurat saw the figures in his paintings. This pictorial technique caught the fractured, dissociated nature of modern existence. In 1932 the critic Siegfried Kracauer, describing the edgy, nervous stimuli of life in Berlin, said that metropolitan existence was 'not…a line but a series of points'. For Chesterton, to see the world in this way amounted to atheism. The blurred line, broken down into a blitz of dots, announced the erasure of divine purpose. Impressionism, in his reckoning, removed a floor – a foundation of belief – from the universe, but it placed no limits on ceilings. Reporting in 1922 on *What I Saw in America*, he castigated the infidel skyscrapers of New York for trespassing on heaven, and mocked the commercial portents written in light above Broadway, like the fiery prediction of

doom inscribed by a 'huge inhuman finger' in letters of fire on the wall at Belshazzar's feast.

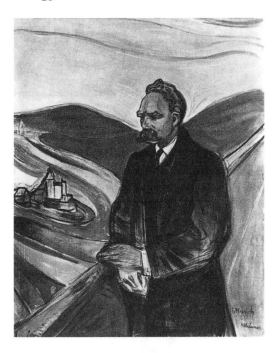

Nietzsche died, insane, in 1900. In 1905–6 Edvard Munch made a painting of him, in which the philosopher confronts the consequences of his 'great disengagement'. He stands, glowering, beside one of the abysses which Zarathustra bestrode. His hand lightly touches a rail, as if to steady him and calm his vertigo. All values have toppled over the edge. The railing which fences off the cavity runs through the painting at a sick diagonal angle; it recalls the bridge on which the skeletal figure stands in Munch's *The Scream* and listens to the anguish of a torn sky and the boiling of an inflamed sea.

Edvard Munch Friedrich Nietzsche *(1905–6)*

Deicide may have been the nineteenth century's loftiest feat, but the victory was equivocal. Man enjoyed the favour of his creator, who singled him out from the animals by conferring the gifts of reason and speech on him. Destroying our own begetter, had we not diminished ourselves? *The Man Who Was Thursday* begins with a bloodshot London sunset, which portends 'the end of the world'. This red-hot light, like the incineration of Valhalla at the end of *Götterdämmerung*, presages the death of God, killed by man's disbelief: as a result, Chesterton comments, 'the very sky seemed small'. The bomb-throwing anarchists derive their policy from Nietzsche, whose admiration for violence they share. Their aim goes far beyond the abolition of government. Ultimately they wish, as one of them fanatically cries, 'to abolish God!' The rule of metaphysical terror does not end there. The dismayed Inspector predicts that 'the human being will soon be extinct. We are the last of mankind.'

After the separate twilights of gods and idols came the twilight of men. In Berlin in 1920, Kurt Pinthus published an expressionist anthology entitled *Menschheitsdämmerung*. The first poem in the volume, Jakob Van Hoddis's 'Weltende', described a jittery urban apocalypse, with the hats of burghers blown away, chronic runny noses, and reports of an impending storm. Among Pinthus's other selections was Georg Heym's 'Umbra Vitae', in which men in the streets stare up at baleful comets, then commit suicide. Around them, nature dies: stagnant seas, trees which never recover from winter, encroaching shadows. Political events in

1931, as the Nazis threatened the Weimar Republic, impelled the graphic satirist George Grosz to notice another twilight: 'dusk', he commented, 'falls on a superannuated liberalism.' Humanistic ideas, he noted, were 'dying out'. Had history moved into reverse, turning the modern world – after its brief atheistic frolic during the 1920s – back into a medieval theocracy? Grosz recalled the grotesquerie of 'those terrible times' as painted by Bosch and Brueghel; their rabid fiends and bastardized mutants thrive again in contemporary Berlin, populated in Grosz's caricatures by slavering, porcine burghers, overripe whores and lecherous psychopaths.

The twentieth century has taken a solemn pride in extending Nietzsche's campaign of sedition. H.G. Wells concluded in 1945 that '*Homo sapiens*, as he has been pleased to call himself, in his present form, is played out', and in 1975 Michel Foucault wrote an unregretful obituary for 'the man of modern humanism', now officially defunct. Nietzsche himself admitted to a fear that evolution might culminate not in the aspiring superman, the disdainful scaler of mountaintops, but in the mean lowland insect called by Zarathustra the Last Man. This democratic being infests a shrivelled world, and extinguishes the stars above it: 'the earth has become small, and on it hops the Last Man, who makes everything small.' The remark looks grimly forward to the political revolutions of 1917 and 1933, which either set free the common man and forbade the extraordinary man his right to life, or conferred power on a race of supermen and rounded up lesser mortals for extermination. Perhaps as well, more sadly, it foresees the damage we have done to a planet which we are so proud of having shrunk to a convenient, serviceable size.

In 1891 Paul Gauguin acted out his own great disengagement, resigning from the French bourgeoisie to resettle in Tahiti. Emigrating to paradise, he predicted that 'a terrible epoch is brewing in Europe for the coming generation'. Such warnings abounded, as if the millennium were concluding a hundred years early. Even when the world continued turning after the last instant of 1899 had ticked away, foreboding persisted. The impresario Sergei Diaghilev made a speech in St Petersburg in 1905, shortly before the massacre of protesters outside the Winter Palace; he spoke of a culture's death, and wondered if there might be a resurrection. The collapse of the global economy in 1929 provoked Georg Fuchs, a Bavarian separatist imprisoned for his treasonous ideas, to declare that 'the world has entered an era of crisis similar to the one experienced by the world of antiquity in the year zero (calculated by the Gregorian calendar)'.

Time ended in year zero, then promptly began again. Christ's incarnation sentenced an old world to death and gave birth to a new one. Did the same apocalyptic rupture separate the nineteenth and twentieth centuries? The Viennese critic Hermann Bahr, an apologist for the Sezession in the visual arts which was Vienna's version of the great disengagement, discerned a torment in the times: 'the cry for salvation is universal; the crucified are everywhere.' This described

the landscape of Golgotha, with a quaking earth and a torn heaven, except that Christ's agony was no longer singular. Bahr asked if a 'great death has come upon the world' to wipe out 'exhausted humanity': he might have been thinking of Des Esseintes and Dorian Gray, pagan decadents for whom life was disappointing. Perhaps, he added, we will all lunge into annihilation, though there was a remote chance that we might 'ascend to the Divine'.

Noting humanity's 'death-throes', Bahr wondered if such anguish might signal 'the beginning, the birth of a new mankind'. Were these 'the avalanches of spring'? This was the challenge the twentieth century issued to itself: to create a renovated humanity, as Christianity had done in year zero. The redemptive miracle now had to be performed without divine assistance; perhaps science could accomplish the feat of deliverance. The Bauhaus designer László Moholy-Nagy called for 'Utopians of genius' to imagine and build a world fit for 'future men'; H.G. Wells believed that salvation would be aeronautic, for the old earth of petty, selfish antagonisms would surely perish now that men in planes could see it from on high, looking beyond borders and barriers to the common concerns of humanity. Ideology promised its own New Testaments. In 1933 André Malraux asked Trotsky if communism could mould a new kind of human being, no longer immured in a jealous, greedy individual identity. 'A new man? Certainly', Trotsky assured him. Seven years later one of Stalin's henchmen drove an ice-pick into his brain. Also in 1933, when the Nazis attained power, the poet Gottfried Benn welcomed the birth of 'a new human type from the inexhaustible womb of race'. The British fascist Oswald Mosley enviously viewed the Italy of Mussolini as the breeding ground for 'a new type of man', as different from earlier political animals as 'men from another planet'.

Georg Kaiser said that his own expressionist dramas functioned as tunnels. Like the narrow channel through which man must pass in order to be born, they were passages where a wrenching, traumatic transformation occurred. The purpose of existence, Kaiser declared in 1922, was to chalk up 'record achievements', and he wished to show individuals whose moral daring caused them to 'vibrate at a speed that makes motion invisible'. Kaiser's new men were moral gymnasts, performing gratuitous acts of sublime selflessness: existential rivals for the racing drivers and pilots who broke successive speed records in the early years of the century. In *Die Koralle* (1917) a billionaire murders his double so that he can die two expiatory deaths – apparently committing remorseful suicide, but surviving in order to be executed for his own murder. In *Gas I* (1918) the billionaire's son exults in the explosion which wrecks his factory, because violence has cleared the way for a new world in which humanity will be freed from toil. In Kaiser's *Der Silbersee* (1933), the libretto for the last opera composed by Kurt Weill before he quit Germany, a policeman and the starving robber he has shot team up as blood-brothers. Their alliance announces what Kaiser called the 'reconditioning of man'; they set out for a heaven of amity and equity, trudging across a silver lake which magically freezes so as to support them.

The sound of dislodged ice for which Bahr listened could soon be heard. Three orchestral songs composed by Paul Hindemith in 1917 marked out the modern itinerary. Hindemith chose poems from an expressionist anthology whose title evoked the judgment day, *Der jüngste Tag*. In the first, 'Meine Nächte sind heiser zerschrien' by Ernst Wilhelm Lotz, the keening voice of the soprano is an open wound. In the second, 'Weltende' by Else Lasker-Schüler, she attributes the world's misery to the death of God. In the third, 'Aufbruch der Jugend' by Lotz, she recovers from her prostration and – hurling forth a fusillade of B flats and high Cs which incites the orchestra to a riotous march – leads the revolt of youth against elderly prohibitions; her troops charge ahead towards a promised land which she identifies with the flaming gardens of summer. But the new season brought with it havoc and destruction. April, as T.S. Eliot insisted, is the cruellest month. Frank Wedekind's play *Frühlings Erwachen* in 1891 had shown adolescents disturbed or maddened by the upsurge of sexuality in their bodies, and Stravinsky's *Le Sacre du printemps* – remembering the earth cracked open to its core by a sudden Russian spring – ends in a slaughter which ensures that the cycle will continue for another year. The Nazis opportunistically adopted this symbolism of violent renewal. Ernst Jünger in 1922, believing that 'new forms need to be filled with blood', rallied the German version of the new man, who was to be a warrior: 'The glowing twilight of a declining age is also a dawn in which one arms oneself for new, for harder battles.' Hitler, manically buoyant in the last months of the war, borrowed Wedekind's title for his effort to halt the Russian advance through Hungary in March 1945, which he called Operation Spring Awakening.

Modern artists, accepting the analogy with year zero, saw themselves as angels of annunciation. The expressionist painter Emil Nolde suffered in 1909 from the cosmic depression analysed by Bahr, aware that 'the earth, this little thing' was a transitory speck in a 'universe of millions of far greater bodies'. He recovered by painting a series of episodes from the life of Christ. This saved him 'from drowning in religion', because the exercise demonstrated that he could found a religion of his own. Pigment was his personal means of vouching for the presence of divinity in nature. Nolde painted 'red-lilac flames above the heads of the disciples, in the holy hour pregnant with joy when they became blessed apostles': the colours he mixed were pentecostal flames.

The task of witnessing to divine revelation now devolved on the painter. Wassily Kandinsky believed that his palette had the power to transfigure a tarnished world. In the nineteenth century, as he argued in 1912, people blindly disavowed the spirit, their eyes closed by a '*black, death-bringing hand*'. His aim was to vanquish this benighted state, training on it '*the white, fertilizing ray*' which 'leads to evolution, to elevation'. Like Christ arising from his tomb on the third day, he intended to defeat death: '*The world resounds. It is a cosmos of spiritually acting beings. So dead matter is living spirit.*' Kandinsky painted radiant apocalypses – a yellow Golgotha, with multiple suns flaring overhead; riders on horses which are blue or

Wassily
Kandinsky
All Saints
(1911)

green, not deathly pale, galloping towards a final revelation. He quoted Christ's welcome to children, 'for theirs is the kingdom of heaven', to justify his own practice of painting childishly, with an infantile delight, and he refused to stand aside 'like the withered tree under which Christ saw the sword': that sword was his weapon against 'the soulless-material nineteenth century'. Another ventriloquistic imitation of Christ occurred in a letter to the composer Arnold Schoenberg, who shared with Kandinsky the mystical task of overthrowing the ancient laws which governed harmony and tone. In 1912 Kandinsky warned his colleague that they should expect to be misunderstood by the infidel and ignorant: 'This is why Christ said, "the rest you cannot grasp today." We stand today on the threshold of the "rest".' On that threshold, Kandinsky and Schoenberg prepared to stage the second coming.

Oskar Kokoschka accounted for the pictorial imagery pressed forth from his psyche – wracked bodies, tortured faces – by blasphemously citing the scriptures. Overhearing the traumas which heaved within, he explained that 'The Word became flesh and dwelt among us'. Events and experiences had buried themselves in his unconsciousness. His mind, he said, was a tomb, but it also took the place of heaven, functioning as a 'HEREAFTER'. Repressed dreams started into life again, like Christ materializing posthumously: 'Whenever two or three are together in My name, I am in their midst.' De Chirico in 1918 made a similar claim for what he called his 'new annunciatory paintings', in which statues move on their pedestals and bizarre auguries streak across the sky. The door of his Paris studio, he said, suddenly gaped open onto the future, with 'the sepulchral

solemnity of the stone rolled away from the empty tomb of the resurrected'. D.H. Lawrence also used the Christian miracle to account for the modern breach with the past. Cézanne, he thought, had struggled against the sexual mortification wished on us by religion, which made us withdraw in loathing from the physical world. His paintings blasphemously reversed Christ's sacrifice, that 'nauseating...crucifixion of the procreative body' which aimed to glorify 'the spirit, the mental consciousness'. Disparaging the sterile mind, Lawrence gave the body a chance of resurrection: the apples Cézanne painted, he said, 'rolled the stone away from the mouth of the tomb'. What emerged was not a pale wraith but a specimen of guiltless, delicious nature. When Cézanne told his female models to be like apples, he brushed away the curse on Eve and the fatal fruit she consumed.

The life of Christ's mother narrated this passage between epochs from another point of view. In 1923 Hindemith composed a song cycle based on the fifteen poems of Rainer Maria Rilke's *Das Marienleben*, which – conservatively reworked between 1936 and 1945, partly orchestrated in 1939 and 1959 – served as a textbook for his evolving theory of musical technique. Rilke's poems, written a decade before Hindemith began work on the songs, reinterpreted devotional vignettes from the life of Mary. If religion was to survive in the twentieth century, it had to transform itself into poetry. Supernatural miracles no longer testified to the existence of God; instead they advertised the improbable imaginative feats of the poet. The mystery of virgin birth, for instance, stimulated Rilke to a defence of symbolism. He explains Mary's purity in a magnificently anachronistic conceit, reorganizing time and space. He suggests that a deer, if it came upon her in the woods, would instantly be made capable of parthenogenesis: without biological coupling, it would be able to conceive that non-existent 'beast of light', the unicorn. For Hindemith, Mary's life was also a pilgrimage between centuries and between the different notions of art which belonged to them. He set the first poems lyrically, transcribing the melody of the angel who announces her destiny; specimens of musical drama followed, as Mary witnesses Christ's intervention at Cana or laments his death. But the final poems about Mary's death and her resurrection and her ascent to heaven demanded, Hindemith said, a style of 'extreme abstraction', in which 'men and their actions no longer play a part'. Earth is the terrain of realism; heaven can only be imagined abstractly. The last image in the cycle is the linen shroud Mary leaves behind when she quits the tomb, its whiteness unobtainable by human bleaching: a perfect blank, the ultimately abstract canvas.

The analogy between the *fin de siècle* and the expiring years before Christianity caused time to stop gave a blasphemous modernity to Oscar Wilde's *Salomé*, written for Sarah Bernhardt (who never performed it) in 1891. Salomé abominably calls for the execution of John the Baptist, who has spurned her; she then makes love to his severed head. The Baptist's function – which he attempts to discharge by preaching to Herod's heedless court – was to proclaim the Messiah's

arrival. Killing the messenger, Wilde toyed with the possibility of rewriting history. What if the pale, meek, self-sacrificing Galilean, blamed by Nietzsche for our lapse into morality, could be prevented from coming, and from expelling the older, more carnal gods? In 1888 in his polemic *Der Antichrist*, Nietzsche took the opportunity to defame the Baptist (rather than Salomé) as a decadent, and claimed that John's 'combination of the sublime, the sick and the childish' would surely have interested Dostoevsky.

Wilde's play vacillates between two world orders: Hellenism, with its unashamed sensuality, and the gospel of Hebraic chastity. In 1881 Jules Massenet based an opera, *Hérodiade*, on Gustave Flaubert's version of the same disturbingly timely story. The Chaldean astrologer Phanuel, who rouses Hérode to rebellion against imperial Rome, predicts a new dispensation –

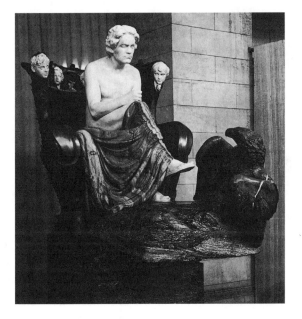

Max Klinger
Beethoven
(1902)

'Bientôt tout changera, les lois et les symboles!' The prophets of modernism seized this chance to change the symbols, and experimentally revised the beginning of the millennium so as to forestall a Christian victory. In 1902 Max Klinger installed his statue of an Olympian Beethoven at the Sezession pavilion in Vienna. On the rear of Beethoven's rocky throne, Christ's crucifixion and the birth of Venus happen side by side. John the Baptist is present, but he points excitedly at the naked, flagrant goddess – as if changing his mind about his rejection of Salome – and ignores the agonized saviour.

Richard Strauss brought Wilde's play forward into the twentieth century by using it as the text for his opera *Salome*, first performed in Dresden in 1905. Strauss derided the forerunner of the new religious dispensation by realizing a prophecy of his own, different from the one the Baptist propounds. His score – volcanically violent, instrumentally as dense as a jungle, with a heckelphone, a wheezing harmonium and an organ added to its already oversized orchestra – made audible what Wagner called 'the music of the future'. That future flirted with a return to the primitive uproar which music originally sought to subdue. Strauss was unafraid of barbaric noise, as in the thudding, screeching discords when Herod's soldiers crush Salome beneath their shields; his vocal writing

pressed song towards gabbling speech in the neurotic patter of Herod and towards shrieking frenzy in the temper tantrums of Herodias. But the sonic future also showed off the technical virtuosity of the orchestra, as if parading new inventions. Strauss found timbres and textures to imitate every poetic image evoked by Wilde's text, from the pallid chastity of the moon to the black caves of grumbling dragons (with which Salome compares the Baptist's eyes).

Wagner, writing about Beethoven's Ninth Symphony in 1870, explicitly proposed his own art as a substitute for the Baptist's annunciation: 'Just as under the world-civilisation of the Romans Christianity emerged, music now emerges amidst the chaos of modern civilisation. Both say to us "Our kingdom is not of this world".' Music assumed the task of transubstantiation, turning material objects like the caves and dragons into impalpable, invisible sound, and inherited the mission of salvation. With cruel irony, the only character in Strauss's *Salome* who cannot master this futuristic idiom is the Baptist himself, despite his constant tirades about the kingdom which is to come. Imprisoned beneath the floorboards for most of the opera, he sings in the schoolmasterish, foursquare manner of a soloist in nineteenth-century oratorio, accompanied by a concert of blatant, officious horns. Executing the Baptist, Strauss silenced the sanctimonious voice of the past and made way for an unhallowed music, truer to the jangling nerves and rampant obsessions of modern characters like his hysterical Herod and fixated Salome.

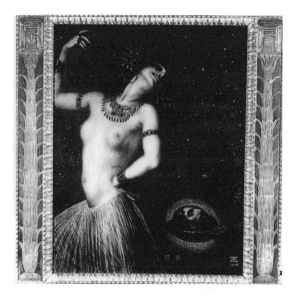

Franz von Stuck
Salome *(1906)*

Because modern painters so impudently used biblical fables to expound their own profane gospel, the story of Salome's dance could be invoked by the poet Guillaume Apollinaire in 1913 to explain the new regime of visual understanding introduced by the cubists. Discussing stylistic uncertainties in the work of Marie Laurencin, an insipid painter who had been his mistress, Apollinaire commented that her art danced like Salomé between Picasso and Henri Rousseau. Their opposed influences presented her with a choice between John the Baptist and her swooning, lecherous stepfather Herod with his collection of baubles. Picasso, claimed Apollinaire, sought to baptize the arts anew, though his purifying medium was light rather than water; Rousseau, with his pictorial

fantasies of naked girls stretched out on sofas in tropical forests and Eiffel Towers going walkabout, could be dismissed as a puerile dotard.

Wilde's *Salomé* turned up again at a moment of historical convulsion, newly adapted to its twentieth-century context. It was performed at the Kamerny Theatre in Moscow during the revolutionary year of 1917. Alexandra Exter's designs cleared away the cobwebbed excess of decoration with which Aubrey Beardsley overlaid the text in his 1893 illustration of the final scene, with Salomé kissing the Baptist's head. Beardsley gave the heroine a gorgon-like coiffure; behind her a black lagoon miasmally bubbled, and flowers of evil flaunted their pistils. Exter, by contrast, constructed a teetering environment for Herod's court, with jagged staircases and jutting platforms on which the characters battled to maintain their balance. Lightning bolts slashed the skycloth. Reconceived in Russia's year zero, *Salomé* became a modular demonstration of a society falling apart.

By 1920 bright, infidel modernity felt confident enough to travesty the fable. Jean Cocteau's farcical pantomime *Le Boeuf sur le toit*, for which Darius Milhaud composed the score and Raoul Dufy designed collapsible cardboard sets, turned Herod's vicious court into an American speakeasy, nonsensically named The Ox on the Roof. The killjoy Baptist is a policeman, who casts a cold eye on the dice-throwing and tango-dancing, and investigates infringements of the Prohibition laws by smelling the breath of the customers. He is soon taken care of, decapitated by the blades of a ceiling fan. A red-headed vamp then performs what Cocteau specified should be 'a caricature of most Salomé dances', using the severed head as a cocktail shaker. The barman, noticing that the policeman has been left with a spout between his shoulders, decants a bottle of gin into his trunk; the dose of illegal liquor startles him back to life. The formula for the miracle of resurrection is alcoholic. God, long dead, can be mocked with impunity.

All the same, the baleful prophecy had not quite exhausted itself. In *Goodbye to Berlin*, Christopher Isherwood describes a parting tour of Berlin's nocturnal dives in the winter of 1932–3, before the accession to power of the Nazis and their closure of the sexual underground. He chooses to visit a cabaret called the Salomé – expensive and depressing, despite an interior décor which apes the apocalypse, with walls of 'inferno-red' plush and 'vast gilded mirrors' catering to the narcissism of the clientele. The customers, like the gaggle of theologians at the court of Herod in Strauss's opera who quarrel about reports of the Messiah's arrival, know that the end is near. At the bar, mannish women and effeminate young men cackle raucously, their guffaws and hoots 'supposed, apparently, to represent the laughter of the damned'. A transvestite Salomé dances: the cabaret turn consists of 'a young man in a spangled crinoline and jewelled breast-caps' who 'painfully but successfully executed three splits'. The next stop on this tour is a communist café in a cellar near the Zoo Station – perhaps the equivalent to the cistern in which Wilde's Herod locks up the noisily sermonizing Baptist. Here the adolescent zealots outline their tactics for 'the coming civil war', describe how they will hurl grenades at the police from roof

tops, and boast of their expertise in making bombs. Meanwhile, Nazis in uniform strut through Nollendorfplatz.

One of the Berlin cabarets, founded in 1929, was called the Katakombe. Dissent, as among the early Christians, hid below street level. At the beginning of the first millennium, a new moral order conducted a subversive campaign against paganism. During the 1930s relations were reversed: the pagan hedonists went into hiding, threatened by two fanatical and stubbornly opposed doctrines of reform. The cabaret in *Goodbye to Berlin* is challenged both by the Communist Party cell and the Nazi barracks. In year zero, inimical gods fought for the allegiance of men. Now the war was between rival ideologies, political religions which concurred only in the fate they decreed for Isherwood's cavorting man in the jewelled brassière, who has managed to split his body down the middle.

Trepidation about the century's end and fear that it meant the end of a world persisted long after modernism had made a new start. In 1918 and 1922 Spengler published the two volumes of *Der Untergang des Abendlandes*. The title literally meant the going-under of the evening land; it was translated as *The Decline of the West*. Almost immediately it became the gospel of modern decadence, and the Berlin cabaret performer Trude Hesterberg claimed to have transcribed it on her body. In one of her acts she played a tattooed lady, whose thighs served as a memorial tablet listing Germany's war heroes; stored in her nooks and crannies, she told her customers, you could also find 'the Decline of the West'. Her body was the most wearily retrospective of history books.

Though Spengler's prognostication of doom made dubious history, it worked as an entrancing, politically convenient myth. He read universal history with a terrifying simplicity. Conventionally, the world's millennial story is divided into three periods – ancient, middle, modern. Spengler treated those three stages as the life cycle of every culture; instead of perceiving an evolution towards freedom and scientific improvement, like the nineteenth century when it celebrated the march of mind, he saw the cycle lapsing, as individual human lives must do, into decay and death. The chronometry of the historian was itself a symptom of the end. Modern man, Spengler pointed out, is an obsessive clock-watcher, mesmerized by that 'dread symbol' of his own mortal brevity. The physics of the Greeks studied a static world; but we are obsessed with dynamics and therefore haunted by abbreviation, so that we compute 'in thousandths of a second'.

The very idea of modernity acknowledged the lateness of the hour. At the end of the Middle Ages, men imagined a Third Reich, a state beyond both ancient and medieval eras which would be 'fulfilment and culmination'. Ever since, as Spengler argued, the notion of 'modern times' – the last term in the series, the epoch of finality – had been 'stretched and stretched again to the elastic limit at which it will bear no more'. We are into overtime; ours is 'a *late* life'. The span of that life remorselessly contracted as Spengler compressed centuries into a single year, situating the contemporary West in the cycle of seasons: 'we

are born as men of the early winter'. Even more alarmingly, the annual cycle imploded into one foreshortened day. Greek culture, sunny and lucid, represented for Spengler 'the scene of the morning', and he called the Ionic column 'the instrument of high noon'. Gothic, in the middle period, favoured mist and fog, dusky half-light. Modern times exhibited what Spengler described as 'the art of the night', longing to be 'back in the darkness of proto-mysticism, in the womb of the mother, in the grave'. The hero of Goethe's *Faust* represents modern scientific man, yet he irrationally visits the Mothers, the Norns who knit human destiny beneath the earth; Wagner's Tristan and Isolde extinguish the torch and commit themselves to night in a double suicide which Spengler saw as 'the death of art' or 'the Last Act of All Cultures'. When night comes, blank inky space expunges matter. The same annihilation occurred in Wagner's covered orchestra-pit at Bayreuth, where (as Spengler said) 'strange surgings' arise from 'dark terrible deeps'. In painting, the nihilistic process was accomplished by the impressionists, whose fuzzy flecks dispersed the material world and scattered it throughout 'bodiless infinity'.

Spengler summed up the nineteenth century as the time of 'the death-struggle'. Musicians, during the anxious transition between centuries, shared his eschatological concern with individual and epochal deaths. If music was the art of the future, perhaps it could foretell the secrets of the grave. Edward Elgar's oratorio *The Dream of Gerontius*, commissioned in 1900, opens with the agitated, querulous hero on his death-bed, confronting 'masterful negation'; between 1904 and 1906 Josef Suk composed his symphony *Asrael*, about the angel who carries away the souls of the dead and his stealthy, implacable summons. Gerontius is received into heaven, but Suk – mourning the sudden deaths of his wife and of his father-in-law Antonín Dvořák – has only the tender vigil of memory to sustain him. Richard Strauss in his tone poem *Tod und Verklärung*, composed in 1888–9, and Mahler in his Second Symphony, subtitled *Auferstehung* and composed between 1888 and 1894, both took the limit of life as an ultimate challenge. Strauss's account of death and eventual transfiguration begins in queasy medical realism. The orchestra transcribes the dying man's stertorous breath and irregular pulse, and the feverish atmosphere of the sickroom. Mahler starts with the last writhings of the Titan to whom his First Symphony paid homage, then advances to the hero's funeral march. Strauss composed an individual's autopsy; Mahler's concern was a collective, communal end, and his procession makes room for 'the great and little ones of the earth – kings and beggars, righteous and godless' in the jostling democracy of judgment day. For Strauss, transfiguration soon follows, in irrepressible C major. Mahler too, after the earth cleaves open to regurgitate its corpses, allows a soprano's voice to float above the mayhem promising the soul's salvation. Both works, as if stretching forward across the gulf between centuries, insist on death's transformation into new life. Modernity announced resurrection, as when de Chirico described the door of the tomb swinging open.

Spengler forbade such optimism: for him the modern world was a ghostly afterlife. Like any ideologue, he was skilled at incorporating contradictory evidence into his system. Scientific theory did not threaten his atavistic world-view, because he could claim that the scientists were also elaborating his doom-laden myth. The quantum physics of Einstein, which studied the energy emitted by atoms, displayed the ancient tendency of human thought to break matter down into its minutest particles. Physics, for Spengler, thus confirmed our tragic plight. In the classical world, the atoms of Democritus buzzed about at random, victims of chance like Oedipus. Modernity imagined the physical world as a field of forces, not an accidental muddle; now the molecule was an aggressor, 'energetically dominating space, overcoming resistances like Macbeth' – but also, like Macbeth, succumbing to exhaustion, undermined by a pathetic sense of solitariness. Spengler had a similar use for the second law of thermodynamics, which governed the loss of heat. Energy drained from machines, which have to be constantly stoked up, and it bled from human bodies, which after a time can no longer fortify themselves; entropy has slowly sentenced the universe to death. The second law of thermodynamics was the threnody of the industrial age, with its voracious combustion engines. For Spengler its moral was also that of the pessimistic primeval saga on which Wagner based his tetralogy: 'What the myth of Götterdämmerung signified of old, the irreligious form of it, the theory of entropy, signifies today.' The world's end, according to Spengler's mystical chemistry, was the 'completion of an inwardly necessary evolution'.

The Nazis venerated Spengler as a sage. *Der Untergang des Abendlandes* became, as the Viennese satirist Karl Kraus remarked in a bilingual pun, a handbook for the 'untergangsters', whose political programme hastened the world's end. Spengler's terminal despair infected Hitler, who rebuilt Berlin – as he explained, anticipating the end – in order to leave impressive ruins behind him. Taking up Spengler's point about the art of the night and its intoxication, Hitler also decreed that Nazi rallies should be held after dark. Heinrich Mann adopted Spengler's chronology with a more bitterly ironic purpose when he remarked in 1931 'It is already evening in Germany, if not midnight'.

Politely disparaging Spengler as a historian, Thomas Mann (Heinrich's brother) called his book a 'highbrow romance'. It was an exercise in the same genre as the scientific romances published by H.G. Wells during the decade which overlapped the *fin de siècle* – *The Time Machine* appeared in 1895, *The War of the Worlds* in 1898, *The First Men in the Moon* in 1901, *In the Days of the Comet* in 1906. Wells's scientists, impelled by the destructive Faustian spirit which Spengler analysed, concoct premature endings. The dotty inventor in *The First Men in the Moon* manufactures a substance which can alter the pressure of air and is capable of asphyxiating the world. 'It would have been the death of all mankind!' he cries, apparently regretting that he has not put it to the test. In another of Wells's early stories, 'The Star', destruction visibly advances across the sky in the form of a new planet, set on a collision course with the earth. This revives the millenarian

panic of the year 1000, when men expected the elderly world to be snuffed out; it also enables Wells to mock the astral announcement of the first millennium, with the star's appearance above Bethlehem. The biblical star was a signal of birth, but the star in Wells's story, a missile purposelessly launched by the universe, warns that 'Man has lived in vain'. Although the earth receives a stay of execution when the death star bumps into the sun, this merely postpones the end. The cataclysm alters earth's climate. Oceans overheat, continents perish of thirst; a thermal doom, as the second law sensibly reckoned, seems certain. *The War of the Worlds* broods, in a teasing phrase, about the 'secular cooling' that will sooner or later kill life on earth. Because the process is further advanced on their planet, the Martians in this story – already in the 'last stage of exhaustion' and coveting the warmth and fertility which earth still enjoys – set out on a colonial expedition. Wells's narrator in *The First Men in the Moon* takes that alienated view of the universe which is a terrifying privilege of the twentieth century. On the moon, he feels himself erased by an indifferent eternity, 'that which was before the beginning and that which triumphs over the end; that enormous void in which all light and life and being is but the thin and vanishing splendour of a falling star, the cold, the stillness, the silence – the infinite and final Night of space'. Man has been expelled from his planetary habitat.

Spengler declared that the West's fate was a decline into senility, a loss of the vital 'desire to be', and refused to imagine a future. Wells, despite his misgivings, strove to represent the new century as a second chance for mankind. *In the Days of the Comet* denounces Christianity as 'rot', but borrows the Christian myth of spiritual renewal to describe a 'Second Advent'. The star of Bethlehem recurs as a comet, a 'white glory in the sky', from which 'the peace that passeth understanding' filters down. A green nitrous fog envelops earth, causing a catalytic change. Men doze off and awake refreshed, redeemed, morally reformed, like 'Adam new made'. Wells calls this revolution 'the Change'; it resembles the New Dawn of harmony proclaimed at the end of the nineteenth century by the bogus theosophical prophet Madame Blavatsky, whose credulous followers included Gauguin and W.B. Yeats. Under the influence of Wells's green vapour a new world is constructed. Its economy is socialist, and its architecture is gleamingly, clinically modern – no more greasy, huddled catacombs and smoking chimneys: instead a blissful consortium of garden suburbs. The blood and mire of the Chicago stockyards magically vanish. New York, 'the high city of clangour and infuriated energy', is toppled. The new American metropoli are given names like Golden City or City of a Thousand Spires or City of the Sunlight Bight, and men weep to enter their gates, 'so fair they are, so gracious and so kind'.

The political philosophers and social engineers of the twentieth century experimented with an approximation of the new world which Wells, in 'sheer ecstasy of triumph and rejoicing', sketched in 1906; it was a future which did not work. Decades of socialist planning failed to bring about the reformation of human nature achieved overnight by the comet's laughing gas. Nor did a glassy,

antiseptic architecture do away with our dark and fetid corners. *The War of the Worlds* has lasted better, with the help of some later emendations. Written in 1898, it describes events that occur after the new century has begun. As a narrative dispatched from the future, it enables Wells to press an alternative definition of modernity, countering Nietzsche's 'great disengagement', or the blazing redemption of reality which Kandinsky described as 'the great abstraction'. 'Early in the twentieth century', reports the narrator, 'came the great disillusionment.' The illusion was man's conviction that he occupied the universe alone, or at least that intelligence guaranteed him 'empire over matter'. This conceit is disproved by the invading Martians, who are minds on stilts, carrying ray guns with which they lay waste to London. They also dismiss the illusions of rationality and civilization. The narrator of the story irritably slaughters a frightened curate, and excuses his crime by arguing that the gibbering man had 'sunk to the level of an animal'. Stampeding hordes reduce society to a pulped, chaotic mass.

No human agency can vanquish the invaders, who are fortuitously halted by bacteria in the earth's atmosphere, 'our microscopic allies'. But although they do not win the war, they manage a moral victory, because they rob men forever of 'that serene confidence in the future which is the most fruitful source of decadence'. For Wells in 1898, decadence did not mean the dandy's experimental perversity. More alarmingly, he saw it as a disease which infected an entire culture, not just its sexual rebels. No longer confined to the social fringes, it was a consequence of the bourgeois belief in progress, which made men think themselves invincible. The twentieth century, Wells here correctly proposed, would cause us to question every article of our faith.

Predictions of the end have obsolescence built in, especially if they are incautious enough to set a date for Armageddon. But during the twentieth century *The War of the Worlds* was updated to incorporate our newest nightmares. The imaginary war between the worlds came down to earth in 1914. Deploring the global conflict in 1916, Wells saw in it a fulfilment of his own prophecy: the angry red planet, named after the god of war, had transformed earthlings into suicidally belligerent Martians, massacring one another in Flanders and the Dardanelles. Even when peace was finally restored, he foresaw in his tract *What is Coming?* that Mars would continue to 'sit like a giant above human affairs', and he transcribed the planet's threatening admonition, delivered in the plain, blunt 'speech of Mars'. If men did not repent and establish the rule of international law, Mars warns that 'I will certainly come down upon you again' to maim and kill the remnants of the race.

In his novel about the planetary feud Wells described 'the beginning of the rout of civilization, of the massacre of mankind', as men were crazed and collectivized by fear. On 30 October 1938 in New York, Orson Welles – playing a Halloween practical joke on his radio audience by broadcasting a dramatized version of *The War of the Worlds* – inadvertently proved the vision true. In Welles's script, the Martians land in New Jersey and advance towards Manhattan. Pro-

grammes of dance music are interrupted by emergency bulletins, with reporters gasping their dread news before they drop beside their microphones. 'This is the end now' cries one, watching the monsters ford the Hudson River like wading skyscrapers. Occasional questing voices wail through the static: 'Isn't there anyone on the air? Isn't there anyone?' In the novel, Wells's narrator meets an artilleryman who intends to become a guerrilla for the sake of the human breed. He will live, he says, in the sewers and railway tunnels of London; he vows to 'keep wild' while hoping not to 'go savage'. The decadent 1890s disparaged nature and thought breeding a lowly business. Wells acclaims the artilleryman as the 'energetic regenerator of his species' – a necessary antidote to Tristan and his kind, for whom eroticism was an induction into death. In this case, the twentieth century complicated Wells's hopeful forecast. The border between wildness and savagery, which preoccupied so many modern artists, was not easy to define; by 1938 the association between brutishness and racial health had become sinister. Orson Welles therefore turned the artilleryman into a fascist, who sees in the collapse of civilization a chance to form a ruling élite of strong men. After they exterminate weaklings with a heat-ray stolen from the Martians, he and his eugenic colleagues will be 'masters of the world'.

On that night in New York, H.G. Wells's future arrived in the present. Listeners who tuned in after Welles's broadcast began assumed that it was describing actual events. The prophecy promptly fulfilled itself, in a brief national nervous breakdown. A medieval millenarian panic had been stirred up in the most modern of cities. Even after the hoax was revealed, Welles and his collaborators were threatened with lynching for having unforgivably exposed the psychological vulnerability of America.

When the atom bomb was detonated, science caught up with the gadgetry of Wells's Martians. Their weapons mystify the narrator of the novel, who can only guess that they must 'generate an intense heat in a chamber of practically absolute non-conductivity' and then aim that killing ray at men 'by means of a polished parabolic mirror of unknown composition'. At Los Alamos, this mumbo-jumbo was corrected by atomic fission. In 1953 *The War of the Worlds* arrived in the nuclear era, when Byron Haskin directed a film version which restaged the terminal combat in Los Angeles. Now the Martians – who resemble metal cobras spitting green fire – simply cause whatever stands in their way to disintegrate. They do so, as a scientist explains, by neutralizing 'the atomic glue that holds matter together. Cut across that magnetic force, and objects simply cease to exist.' After Hiroshima, Wells's uncreating beam of light was only too plausible. The film shows it at work: human bodies dematerialize into mounds of grey ash, tanks into glowing ghosts.

Wells's novel confided the fears of man in the heroic industrial age. Human beings formerly enslaved their dumb inferiors, making horses do their work. Industrial machines, however, were stronger and perhaps smarter than the men who invented and operated them: for how long could their compliance be

relied on? This is one of the most symptomatic modern terrors, acted out by the workers who trudge into the factory's maw in Fritz Lang's *Metropolis*. In 1913 the sculptor Jacob Epstein began to construct his *Rock Drill*, with calipers punishing the earth and boring through its mineral foundations. The drill itself (purchased second-hand by Epstein) was straddled by the twisted plaster torso of its human operator. Epstein, writing in 1940, referred to this visored robot as 'the armed, sinister figure of today and tomorrow. No humanity, only the terrible Franken-stein's monster we have made ourselves into.' Even the Martians in *The War of the Worlds* were not safe from the shaming contrast between organism and engineer-ing. Wells's narrator studies their Handling Machines, which guzzle clay and after a few seconds turn out bars of aluminium. The sight makes him pity the fleshly fragility of the Martians themselves, with their unprotected brains, blob-like faces and sticky tentacles: 'The contrast between the swift and complex movements of those contrivances and the inert, panting clumsiness of their mas-ters was acute, and for days I had to tell myself repeatedly that these latter were indeed the living of the two things.' Appliances, simulating life, actually surpass it. Here is another of the twentieth century's bad dreams: a diabolical man-nequin usurps the heroine's identity in *Metropolis*, and robots gang up on their human exploiters in Karel Čapek's play *R.U.R.*, once more bringing our benighted world to an end.

By 1953, the heavy industry monumentally embodied in the Handling Machines or in Epstein's drill had been replaced by a cleaner, quieter, friendlier but perhaps more insidious technological regime. Machines no longer dwelt in factories. Transistorized and fitted with electronic brains, they had begun to move into our homes. Was this the latest Martian invasion? Haskin's film remade Wells's monsters for a society at the mercy of new technological media. A Martian searching for survivors in a wrecked house wears its metallically-lidded eye on an extendible arm: the creature exactly prefigures Marshall McLuhan's claim, made a decade later, that the media are 'extensions of man', amplifying our senses and prolonging their reach. Television allows our eye to see around the world while we sit comfortably in our living rooms; perhaps it also allows us to be seen and monitored by a brain which may be far away, alert at the end of the cables. As the 'electronic eye' snakes towards him, its iris of red, green and blue spotlights probing for victims, Gene Barry remarks that it is just like a television camera. Politically, too, events had run ahead of Wells's fantasy. To illustrate the world-wide onslaught of the Martians, Haskin used black-and-white newsreels of bomb damage in European cities, with crowds fleeing from air raids. The 'rout of civilization', which Wells saw in the future and hoped by his warnings to avert, had already happened in an uncomfortably recent past.

Wells himself doubted whether the race would long outlive him, and in 1945 he warned that 'the end of everything we call life is close at hand'. Human-ity, he thought, was menaced by a cosmic antagonist, an impersonal destructive energy which would soon flatten 'our doomed formicary'. As he dolefully repeated,

'the human story has already come to an end'. A wit once remarked that God did not die, though Nietzsche did. Wells expired in 1946, soon after publishing these last bleak auguries in *Mind at the End of Its Tether*; the world, however, recuperated. In 1948 André Breton admitted his own earlier 'temptation for *the end of the world*'. In company with his surrealist colleagues, he had imagined apocalypse, like revolution, as a spree of pure, purposeless, thrilling violence. Now, having survived another global war and the dropping of the bomb on Hiroshima and Nagasaki, Breton decided on behalf of his generation that '*we no longer want* the end of the world'. Was it too late for repentance?

THE END OF THE WORLD
IN VIENNA

The end of the world began, by common consent, in Vienna. Karl Kraus called the city a laboratory for the scientific study of apocalypse. Conditions were optimal – an empire which was hardly more than a ceremonial fiction, demolished by a gunshot at Sarajevo in 1914; an architecture of officious, frock-coated façades, valiantly disguising the function of buildings on the Ringstrasse; music which aspired to the condition of confectionery, as in Richard Strauss's waltzing ballet *Schlagobers*, named after Viennese whipped cream; a prevalent sentimentality, given to savouring and deliciously protracting decline; and a Jewish clerisy, excluded from power, which in revenge exposed the discontents suppressed by civilization, released the empty air pent up inside language, and dismantled the melodic scale, defiantly declaring, as Schoenberg put it in his treatise on harmony, that 'eternal laws do not exist for us'.

Kraus himself chronicled the local version of the world's end in his vast, unperformably expansive play, *Die letzten Tage der Menschheit*, a cosmic vaudeville about the last days of mankind. It begins on the Ringstrasse as war is declared in 1914 and ends four years later on that date recurrently commemorated by the twentieth century, the day of judgment. The Grumbler – an alter ego for Kraus, who conducts a dispute with the Optimist throughout the play – accuses Franz Josef, the dodderingly benevolent Habsburg Kaiser, of having signed a paper decreeing 'the death of the world'. Peace, he grumbles, will not conclude the war; its proper end should be a last campaign in which the universe extinguishes our rabid planet. Profiteers, camp-followers and tango-dancing jackals rejoice as the final darkness falls. The jingoistic Siegfried Abendrot – whose given name is that of Wagner's superman and whose surname refers to sunset, when the gods are incinerated against a flaring horizon – proclaims Germany's success in having united militarism and myth. A last frenzy of fire-power is directed at God, who as he expires can be heard from the upper air groaning that he didn't wish things to turn out this way. This line, which concludes the play, is borrowed from Kaiser Wilhelm II, who in 1914 hypocritically lamented the need for war and

assured his German subjects 'Ich habe es nie gewollt'. God serves as a mouthpiece, enabling the commanders of the big battalions to recite their pious lies. Kraus insisted on treating the post-war world as a post-mortem condition. In 1921 he learned that touristic excursions to hell were on offer from a travel agency in Basel. The company advertised reduced-rate autumn trips to Verdun, one of the Great War's most tragic battlefields. A jaunt to the ossuary was thrown in. This, Kraus raged, surely consigned 'the currency stew that calls itself mankind' to 'a place of honour in the cosmic carrion pit'.

Those last days came to pass in a city which, twenty years earlier, had set out to re-create the world. At the end of the nineteenth century Art Nouveau, locally called

Postcard issued to celebrate Emperor Franz Josef's jubilee in 1908

Jugendstil or the young style, brought to Vienna its gospel of renovation. The architect Otto Wagner said in 1895 that Art Nouveau must be more than a renaissance; it had to be a naissance, a completely new beginning. The pavilion designed by Joseph Maria Olbrich for the Sezession was a temple to this creative mystery, with a globe of gilded laurel leaves balanced between the pylons on its roof, like a cranial bubble moulded from the poetic fancies generating below.

The frieze designed by Gustav Klimt in 1902 to surround Klinger's statue of Beethoven mapped the course of spiritual evolution. Inlaid with gold leaf, semiprecious stones and mother-of-pearl, the frieze followed man's evolutionary travails and his arrival at bliss, which occurs in the jubilant choral finale to Beethoven's Ninth Symphony. At the climax, Klimt's knight disarms and, surrounded by angels alighting on earth, embraces a woman who represents his better self, his soul. But the episode cannot manage the transfiguration of reality for which Art Nouveau hoped. The embrace is sealed off inside a bell jar, cocooned and perhaps shameful. The naked, headless man turns away, buried in the woman; she is invisible, except for a tangle of hair and the stiff, shroud-like drapery which she twines around his neck. Klimt quotes Schiller's 'Ode to Joy', set by Beethoven: the chorus appeals to the millions of men on earth and kisses them all – 'Diesen Kuss der ganzen Welt!' Here, however, there are no millions, and the joy of the single man is obtained by sacrifice: why else has he withdrawn his head into his body? From the cavity where his head should have been, coils of fire – the discharge of an encounter which is strictly erotic, not humanitarian – smoke upwards. Beethoven's hearty, gregarious anthem has been replaced once again by the solipsism of Tristan and Isolde. Klimt's lovers renounce the world rather than communing with it.

Gustav Klimt's Beethoven frieze (detail, 1902)

Their guilty rendezvous takes place in a secret garden. Art Nouveau wished to establish heaven on earth; instead it created artificial paradises, fearful in their rank fertility and necessarily set apart from the city – lurking beneath its streets in the grotto-like vegetative tendrils of the Métro entrances designed for Paris by Hector Guimard, or perched on a hill above it like Antoni Gaudí's fanged, rearing reptiles at the Parc Güell in Barcelona. Otto Wagner painted one of these florid, overheated Edens on the front of an apartment block he constructed in 1898–9 on Linke Wienzeile near the Sezession pavilion: a ceramic thicket of majolicas, through which the buttressed heads of lions roar. Wagner intended to depict the life which thrilled through the building, carried along sappy stalks to the pink blooms; but his fable of naissance looks disturbingly like an opium dream.

Even the stark insignia of religion acquired, to the Viennese eye, a seditious erotic meaning. In 1908 the architect Adolf Loos published an article decrying ornament and calling it criminal. He ridiculed the sumptuous, expensive frippery with which the bourgeoisie of the previous century had smothered all surfaces: what were they trying to conceal? To illustrate the absurdity of decoration, he made up a fable about the origins of the crucifix, the ornament which – in the days before skyscrapers – conferred God-fearing respectability on the skyline of a city. The sign of the cross, he said, was the first work of art. It long predated the death of Christ, and had nothing to do with sacrifice and salvation. It was, Loos coolly explained, the crudest of graffiti. A horizontal stroke denotes the female, passively recumbent. The vertical bar represents the man, who penetrates her. Those altars and steeples we look up to are propounding an ancient, obscene message. Yet Loos regarded the draughtmanship of the first dirty-minded

doodler with awe: in creating this sign, he 'experienced the same impulse as Beethoven, was in the same heaven as the one in which Beethoven created the Ninth Symphony'. The crucifix has been inverted. In modern, free-thinking Vienna, it pointed down to the lumbar region and the cellarage of the libido, rather than indicating the sky.

The secret garden depicted by Klimt or by Otto Wagner's tiles was the enclosed preserve of symbolism – a realm of enigmatic correspondences and arcane meanings. The links between earth and heaven had been snapped, or at least hopelessly confused. New omens and auguries, reaching across the gap which divided nature from supernature, had to be identified, and Loos's profane cross was one of them. Symbolism still yearned for the beyond, but could only guess at its whereabouts. In *Die Frau ohne Schatten*, the fourth of the operas on which Strauss collaborated with Hugo von Hofmannsthal, the squeal of fish in the frying-pan voices the plea of unborn children begging for life; in its successor, *Die ägyptische Helena*, an all-knowing mussel sits on a tripod and utters cryptic warnings in a contralto register.

The artists of the *fin de siècle* needed to invent their own symbols: those they inherited had been worn out, or were warped by misuse. Klimt, for instance, often used the figure of Pallas Athene, a patron of the arts and therefore the adopted guardian of the Sezession. In 1898 he painted her in gilded armour which cannot conceal a ripe mouth and a cascade of blonde hair – a high-minded muse, but also an inviting mistress. She appeared on his first Sezession poster, where she leans on her spear and brandishes a shield emblazoned with a satyr's cheeky, goatish face; she watches as Theseus, fighting the artist's battle against stupidity, kills the Minotaur. Then in 1902 Karl Kundmann's statue of Athene, as lumpen a giantess as the Statue of Liberty, sat down outside the par-liament building on the Ringstrasse, where – supplying the Austro-Hungarian empire with another false front – she advertised the Athenian origins of demo-cracy. The myth had been conscripted, corrupted by political opportunism. Kundmann's goddess served as a convenient alibi for the muddling, ineffectual absolutism of the imperial regime. As Robert Musil pointed out, the capital 'made such vigorous use of its liberty that the parliament was mostly kept shut'.

Hence that 'flight into the unpolitical' which the novelist Hermann Broch pointed to as the impulse of Viennese decadence. People in the city, as Musil remarked, adopted liberal attitudes, especially in sexual matters; they consented, however, to being governed by clerics, whose moralizing remonstrances they ignored. A constitution guaranteed equality under the law to all citizens, so long as it was understood that not everyone qualified for citizenship. It was, while it lasted, a convenient arrangement. But one consequence was the disarming of outright libertarians like Athene and freedom-fighters like Theseus. Therefore, when Theseus recurred in 1912 in Strauss's opera *Ariadne auf Naxos*, he was no longer Klimt's muscular monster-slayer. The Ariadne of Hofmannsthal's libretto remembers him only as the lover whose desertion has left her yearning for death.

Symbolism was the idiom of internal withdrawal; its riddling complication protected the unpolitical life from scrutiny. This secession from society occurs at its most outlandish in *Die Frau ohne Schatten,* where Hofmannsthal supplemented geography and waived the rules of biology. The opera takes place in an aerial kingdom afloat somewhere above the South Seas, ruled by a petrified Kaiser and a Kaiserin who has strayed into human form after previous incarnations as a bird and a white gazelle.

Yet this vaguely Asian wonderland is no more fantastical than Hofmannsthal's Vienna. In his librettos, the city is a place of fiction and pretence, an ornamental imposture. *Der Rosenkavalier* is set about 1740 during the reign of Maria Theresa who, after intriguing to attain the throne, centralized state power in the capital, where magnates like Faninal in the opera began to build baroque palaces as declarations of their own importance. What matters in the Vienna of *Rosenkavalier* is the way things look. People are free to behave venally or carnally – Faninal sells his daughter to an ageing rake in order to gain membership of the aristocracy, and the Marschallin philanders with a young lover – so long as they studiously misrepresent their own motives. A mess or a conflict can be explained away as a Viennese masquerade, which is how the Marschallin deters the police officer from investigating the fracas in the sordid inn at the end of the opera. *Arabella,* the last of Hofmannsthal's librettos, is set in 1860, when courtly pomp had become more expensive and appearances were harder to sustain: the heroine's parents, shabby-genteel aristocrats, can only afford to bring up one daughter in Vienna, so they pass off Arabella's sister Zdenka as a boy. The Viennese masquerade has here become psychological. Zdenko secretly loves Arabella's spurned suitor Matteo, and – pretending to be Arabella – invites him to a sexual tryst in a darkened room. Strauss's orchestra riotously transcribes the proceedings, with the curtain modestly lowered. Afterwards Matteo meets Arabella on the stairs and is dumbfounded by her coolness towards him. He sneers at her virtuosity in counterfeiting emotion, and accuses her of acting for acting's sake. Despite his mistake, he has guessed the truth about her. Querulous and reserved, subject to sudden whims and melancholy fits, as unfathomable to herself as she is to anyone else, Arabella lives – as she tells another suitor – in a limbo, waiting for a man who will relieve her from the need to be herself. She may be dressed for the 1860s, but mentally she lives somewhere between 1928, when Hofmannsthal began work on the libretto, and 1932, when Strauss completed the score: she is an elusive, alluring absence. She likes to waltz because while you are in motion you dematerialize. Summarily betrothed to the Slavonian landowner Mandryka, she begins at once to sing with grateful serenity about being buried beside him in the family grave. Death will be a welcome respite from the need to go on pretending that she actually exists.

The city, as tenuous and agnostic as Arabella, relied on its mystique to hold together a makeshift empire of squabbling ethnic groups; like the newly rich Faninal, it claimed legitimacy by citing ancient traditions which had been

improvised yesterday. Hofmannsthal bestowed on it some spurious rituals of his own – the silver rose presented to the betrothed girl, with a drop of Persian attar of roses perfuming its jewelled bud; the cabmen's ball in *Arabella* with its yodelling siren. He even supplemented the local dialect by making up slang for his characters to use. Why not? Hofmannsthal knew that every language is a private idiolect, and that we only communicate by default; in his *Chandos Brief*, published in 1902, he described the loss of faith in words – one of modernism's multiple disengagements – which had caused him to give up poetry. Strauss's score for *Der Rosenkavalier* reveals its own scepticism about the straining charade of baroque Vienna in its anachronistic waltzes. The dance arrives in the city a century too soon: history, like the non-existent custom of the silver rose, is a wishful invention, dreamed up in the present and projected backwards onto the past.

Vienna's modernists struggled to see through what Karl Kraus called 'the fiction of culture' by demolishing the city's pretences. Adolf Loos in 1898 called Vienna a Potemkin village – one of those scenic frauds supposedly erected by Grigori Potemkin, Catherine the Great's lover, during her progress through the Ukraine in 1787. Potemkin promised to colonize the steppes, and squandered fortunes on his failed attempts; so as not to disappoint Catherine, he commissioned fake, flimsy, portable settlements, which she could admire from a distance as she passed. Loos punctured the baroque artifice of Vienna with his utilitarian design for a commercial building on the Michaelerplatz behind the Hofburg, completed in 1911. Confronting a church across the square, flanked by the pompous palaces of the bourgeoisie, the so-called Looshaus – sleekly angular, with slim green columns and windows which lacked eyebrows – provoked a civil war of style. The Kaiser, aware of the affront, had all his curtains drawn, hoping that if he did not see it, it would go away. His subjects daubed it with nicknames

The Looshaus in the Michaelerpla Vienna

like graffiti. They called it, among other things, a marble coal-bin and a cigarette-lighter: to be frankly functional, in this ornamental city, was in itself a disgrace. Indoors, the new building was a temple of modern mobility. The firm of Goldman and Salatsch, which had its showroom on the ground floor, sold outfits to be worn for contemporary diversions like motoring, polo, tennis and skiing.

Musil in 1930, ceremoniously introducing the 'ancient capital and imperial city' in his novel *Der Mann ohne Eigenschaften*, immediately adds that this self-sanctified place has no special significance, and is in fact as bereft of qualities as the apathetic, wayward hero Ulrich, his man without qualities. In common with every other big city, Musil says, Vienna is just an arena of change and chance, discord and dislocation, more like 'a seething, bubbling fluid' than the eternal agglomerations of stone which make up the Hofburg or the Ringstrasse will admit. Nothing can happen here, except – in the twelve months beginning in August 1913, which the novel scrutinizes – the end of the world. The grand thoroughfares have been laid out to accommodate the forward march of history, but instead they are merely conduits for chaos, as whimsical and unpredictable as the weather. *The Man Without Qualities* begins, indeed, with a meteorological report, deciphering isotherms, measuring humidity, taking the city's temperature. Weather is the best evidence of cosmic chaos: it connects the butterfly in China with the American hurricane. Events in the novel, insofar as it has any, are precipitated by an accident, which occurs as unintentionally as the weather. A man is knocked down by a truck with 'too long a braking-distance'. Can you blame a vehicle? Who cares anyway? The man, who may or may not have been killed, is not a character, and the novel immediately wanders away from him.

The pattern of traffic in the streets reflects the arbitrary passage of clouds overhead. Both might be models for the movement of world history, whose only law, as Musil concludes, is 'the fundamental principle of government' in old Vienna – 'namely, that of "muddling through"'. The universe muddles along absent-mindedly, and when a truck collides with a pedestrian or an assassin's bullet with an archduke, the only possible response is a shrug. The worldly wisdom of Vienna devised a sentence which covered all emergencies by impersonalizing the subject and sedatively placing the verb in the passive mood. Musil quotes this useful formula. What people say, when asked to explain how and why the world ended, is 'Es ist passiert': it just sort of, well, happened.

The novel's opening revelation of entropy and instability is ignored by the two strolling citizens Musil describes, who pause near the fallen man and then instantly forget him. Not to believe in the solidity and significance of Vienna would be to doubt their own identities: their proprietorial bearing, like their monogrammed underwear, asserts that 'they were in their proper place in a capital city that was also an imperial residence'. With its twin eagles, the Habsburg empire took out insurance by doubling the Austro-Hungarian ruler's ceremonial title: its abbreviated motto was 'K. und K.', standing for kaiser and king. Musil fused this alliterative tag with the nursery euphemism for excrement, renaming

Austria as Kakania. He sourly compliments Kakania, where hypocrisy is the cement of society, as 'the most progressive state of all', the first to be founded on a modern sense of its own existential levity. Kakania is, he says, 'by now only just, as it were, acquiescing its own existence'.

The same uncertain, slippery tenure of existence overtakes the king and kaiser himself, despite the nodding plumes on his helmet and the self-sacrificing deference of his subjects, in Joseph Roth's great novel *Radetzkymarsch*, published in 1932. The empire's loyalists ceremonially speak of Franz Josef as 'His Majesty', and when not at attention permit themselves to refer to 'the Kaiser'. There is consternation and outrage when an upstart in the novel actually utters his name. Like a god, he must remain sacrosanct, and should be addressed with worshipful indirectness. But of course God had recently died, which reminds Franz Josef – dim-witted, forgetful, with a nose that is liable to run – of his own mortality. He is 'a secular brother of the Pope' and the most apostolic of European monarchs, so the slow death of his regime follows logically once the deity has been unseated.

The decline of Franz Josef, as Roth describes it, summarizes all over again those disengagements which allowed the world to become modern. First the earth was evicted from the cosmic centre, marginalized when Galileo looked through his telescope. Then the all-knowing divine plan was mockingly discarded. Unprotected by god or any imperial deputy, the individual stood alone in empty, friendless space. The delinquent Lieutenant Trotta, another man without qualities, loses his faith in the Kaiser, and promptly tumbles into an abyss. He must now acknowledge that 'the world is only one heavenly body among millions upon millions, that there are countless suns in the Milky Way, each one with its own planets'; individual lives are a flurry of dust. Even Franz Josef lives long enough to outgrow the fantasy of his own divinity. In public, as he proceeds through Vienna, his professional smile is 'like a small sun that he himself had created'. But when he goes to watch military manoeuvres (which he no longer understands) at the south-eastern frontier of the empire, he observes the ethnic discontent which was to lead to the assassination at Sarajevo and prepares himself for catastrophe: 'the huge golden sun of the Habsburgs was setting for him, shattered on the ultimate bottom of the universe, splintering into several tiny solar balls.' The universe, once a unitary force like the family of mankind, is fragmenting. Those minor, breakaway suns want 'to shine as independent stars on independent nations'. The laws of physics pre-ordain the end of the empire: mass explodes outwards, littering space with the particles of our chancy, centreless world. The circular Ringstrasse, excavated at the confident beginning of Franz Josef's reign, could not contain this riot of clashing atoms. In Roth's novel a Jewish holy man enigmatically tells the Kaiser that he will not live to see the end of the world. Franz Josef knows the secret meaning of the prophecy: the world will end very soon after he does. He died at Schönbrunn in 1916, and the monarchy did not long outlive him.

It had no resistance, because it was an empire of illusion. *The Radetzky March* showed that the whole frail structure depended on the image of Franz Josef, mechanically reproduced and bureaucratically disseminated. His portrait hung everywhere, in brothels as well as offices. But his very ubiquity meant that he became invisible, part of the furniture, easy to overlook and no longer especially keen to look back at you, since he had begun to wear 'the indifferent, habitual, and unheeded countenance shown on his stamps and coins'. Conferring value on base metals or personally vouching that a letter would be carried to its addressee, he was a symbol – but no one could remember exactly what it was that he supposedly symbolized.

Vienna still rejoices in its spurious municipal myth. The city takes pride in bedecking itself with what Musil called qualities – creamy charm and waltzing gaiety. But these are psychological equivalents of the dirndl, which is worn by everyone except the peasants whose native attire it supposedly is. In Kraus's view, Kakania gave the rest of the continent a lesson in falsity. Europe, he thought, had become a cheap and nasty variety shop. The states which emerged from that world-ending war covered up their political duplicity and economic distress by selling tawdry souvenirs to tourists – the papier-mâché helmets of London policemen; dwarfed Eiffel Towers; perhaps (for connoisseurs) a silver rose in plastic. In 1926 Kraus suggested a stratagem for ensuring Vienna's prior claim to foreign currency. Viennese tailors should meet American tourists at the railway station in Paris when they got off their boat train. They would be measured on the spot for authentic Austrian folk dress; the final fitting could wait until the customers arrived in Vienna. Culture is merely a costume party, and the purpose of travel is to try on funny hats.

For Musil and Kraus, Vienna was stalled in that neurotic condition of denial which Freud defined as abreaction. Hermann Broch marvelled at the city's capacity for deluding itself: 'Vienna, the capital of a dying monarchy, had every connection with dying but none at all with death.' Its lushly astringent morbidity is summed up by the Marschallin in *Der Rosenkavalier*. In her early thirties, she considers herself superannuated, but of course her self-pity expects to be gallantly contradicted. Haunted by the passage of time, she imagines she can arrest it by stopping all the clocks in her palace. Her awareness of dying forestalls the knowledge of death: she concentrates on the odd facial wrinkle or a stray silver hair, and worries that she may no longer able to allure young men like the rose cavalier Oktavian.

Viennese sentimentality specialized in fond, lingering farewells, postponements of the end. The Marschallin drops a handkerchief during her last exit – a token of her intention to return to collect it and, more than likely, to reclaim the lover she has generously bestowed on a rival. This nostalgia, which relishes decay and regrets only the loss of sexual opportunity, infuriated Broch, for whom death was a serious matter: 'Hitler', he said, 'made death very real.' Broch was imprisoned following Hitler's annexation of Austria in 1938, and in his novel *Der Tod des*

Vergil, completed after his escape to America, he exerted himself to understand the reality of death by studying the last twenty-four hours of the sick, delirious poet's life. Virgil lived and died during an interim between millennia, in the interregnum between classical antiquity and Christianity; this made him, for Broch, a figure of the *fin de siècle*. While the Marschallin upbraids her hairdresser for making her look like an old woman, Broch's Virgil is impatient for a rupture with the past. Poetry itself is an anticipation of departure, which is why Virgil sympathizes with the decision of his hero Aeneas to quit Carthage and give up his beloved Dido. Such brave, wrenching renunciations constitute the wisdom of poetry, 'the strangest of all human occupations' because it is 'the only one dedicated to the knowledge of death'. Accepting the certainty and necessity of oblivion, dismissing the false immortality peddled by art, Virgil even wishes to burn his *Aeneid*.

By contrast with this desolate honesty, the heroines of the operas on which Strauss and Hofmannsthal collaborated are eager to die because they cannot comprehend what death means. Elektra – in the first of the series, adapted from the tragedy of Sophocles – bloodily revels in the idea of death, but is too distracted to notice when she abruptly drops dead. Ariadne comments, as her new lover Bacchus whisks her away, that death is painless, in fact surprisingly pleasurable. For Strauss, the worst ailment induced by those catastrophic times was a case of indigestion. In *Schlagobers*, staged in 1924, a boy celebrates his confirmation by gorging on cakes in a Viennese pastry shop and spends the night nauseously hallucinating about athletic pralines. War breaks out between the rival sweets, but the revolutionary uproar is doused by a flood of soothing, soporific lager.

The confirmation candidate and the confectionery, the first Viennese production of Schlagobers *(1924)*

Between 1909 and 1933 Strauss's six operas set to texts by Hofmannsthal, as Broch said, regaled Vienna with 'a farewell festival, in which the end of a millennium was represented'. To enjoy dying, while contriving not to die, remained the motive of Strauss's music. In 1948, a year before his death, he composed his *Vier letzte Lieder*: songs of almost unbearable beauty – perhaps, given the date, of intolerable beauty. The soprano soars, swoops, hovers, melodically extending words into bridges made from breath and suspending time as she does so. The

first song to be composed (now usually the last of the sequence in performance) set Eichendorff's poem 'Im Abendrot'. The sunset glow after which Karl Kraus named his war-monger now softly suffuses a landscape through which the poet and his companion wander, seeking peace. Unafraid, they nestle in the darkness, which permits them finally to rest. Slowly expending her last long breath, the soprano whispers a tentative query: 'ist dies etwa der Tod?' – can this perhaps be death? By asking the question, Strauss again wilfully prevaricated about the answer. The soprano falls pensively silent, but the orchestra at once replies to her, quietly quoting the motif of transfiguration from *Tod und Verklärung*, which the very young composer had written sixty years earlier. In this recollection of the symphonic poem, death with its bodily qualms is omitted and the spirit's rhapsodic lift-off, signalled in the song by the trilling of two larks, occurs easily and automatically. Vienna, as Broch pointed out, insisted on enjoying the apocalypse.

In 1914 a modern mutation of the *mal du siècle* was identified. The virus was transmitted by a Viennese waltz. Dr Stefan Deliya, a Viennese physician, published a learned diagnosis of the world's obsession with Franz Lehár's operetta *Die lustige Witwe*, which since its first performance in 1905 had been staged throughout Europe and across America. Broch disparaged Viennese operetta as a 'vacuum-product': its vacuous hedonism suited a society which was politically impotent, preoccupied with pleasure while it awaited the end. But in Lehár's music this effortful brightness revealed an undertone of moody lassitude, interpreted by Deliya as a pathological symptom. He worried that the world had succumbed to this mellifluous depression, an incurable sadness which he traced to Balkan or Slavic origins.

Die lustige Witwe had its premiere in the same year as *Salome*. Strauss's heroine sheds her veils in waltz time. For Lehár too, the waltz mimes surrender, with a sly, exactly-timed hesitation – the pretended reluctance required by etiquette – before the rhythm is allowed to take hold. Hanna Glawari, the widow who is merry because rich, comments to Count Danilo that this music in three-quarter time could cause one to forfeit the remaining quarter of one's virtue. The collapse is social as well as moral, even though Lehár's characters blithely refuse to consider the consequences of their patched-up alliances – so similar to the exchanged favours and mutual blackmail which kept the European peace until 1914. *Die lustige Witwe* set the end of the world to music.

Lehár may have begun his career as a bandmaster in the imperial army, but *Die lustige Witwe* unwittingly describes the empire's disintegration – the 'festive apocalypse' of Broch. Its background is the fraying patchwork of quaintly costumed provinces where a temporary European order fell apart in the years before 1914. Musil identified this restive imperial fringe as the incubator of the end. Commenting on the 'national struggles' which paralysed the central government every so often, he complimented the fractious empire on having pioneered that communal breakdown which became an abiding plight in the

twentieth century: 'Every human being's dislike of every other human being's attempts to get on – a dislike in which today we are all agreed – in that country crystallized earlier.' The Austrian example showed that civilization was a repressive cover for lethal instincts, and that the sense of community was grounded not in fellow-feeling but in hostility to some group of excluded others. A pity, Musil sighed a decade after 1914, that this interesting sociological experiment was 'prematurely cut short by a catastrophe'.

Lehár's widow comes from Pontevedro, a jocular garbling of Montenegro, which was already agitating against Austrian rule in 1905. Vienna customarily smiled at the jabbering 'nationalities' of the hinterland, and affected not to know precisely where they all lived. The very idea of a nation horrifies the loyal district captain in Roth's *The Radetzsky March*, because it implies a revolutionary agitation for rights. 'A lot of peoples might exist,' he reasons, 'but no nations.' The desire for self-determination was ridiculed by the Viennese habit of giving the provinces nicknames: who can ever be sure what these silly little countries call themselves? Montenegro first became Pontevedro, then was renamed Marsovia. In Ernst Lubitsch's film of *The Merry Widow*, it huddles in a corner between Hungary and Romania, visible only when a microscope is trained on the map. The spurious realm is supplied with a pidgin language, some second-hand folklore, an army whose marching song is an anthem in praise of women, and a farcical economy. The state is mortgaged to the widow, its richest citizen. But she has decamped to Paris with her millions, which her countrymen fear she will squander on a new French husband, thus bankrupting Pontevedro. The ambassador therefore recruits Danilo, who yawns about the need to serve the fatherland and prefers to disport himself with the cabaret dancers at Maxim's. Danilo is commissioned to salvage the millions by seducing the widow. He negotiates with her while they waltz.

As a diplomat, Danilo accepts his double-dealing mission as another of those cynical arrangements by which a teetering continent was kept in business. The sexual intrigue in *Die lustige Witwe* is consciously modelled on the European balance of power. Danilo likens marriage to the two-way treaties which pretended to keep the peace until 1914, but acknowledges the political realities concealed by those pledges of eternal devotion. Infidelity, he says, turns binary leagues into triangles. When this happens, the whole structure – sexual, social, international – begins to shake. This is why Hanna's decision to purchase any dancing partner who takes her fancy causes such alarm. Danilo accuses her of breaking club rules by adopting a free-trade policy, and goes on to quote Hamlet's criticism of power cemented by treachery: 'Something is rotten in the state of Denmark.' Despite such warnings, the waltz performs its work of persuasion, and Pontevedro is bankrolled for a few more years.

In 1909, after the American success of the operetta, an anonymous novel was published in New York. This version of *The Merry Widow*, 'founded on' Lehár's plot, suggestively filled in the geopolitical background to these deals and

truces. Marsovia, too poor to be independent, relies on the bossy patronage of its neighbour Servia, preferring this to annexation by Austria. France supports the Marsovian cause for its own self-interested reasons: it wants to prevent Austria from gobbling up another bite-sized Balkan kingdom, which would 'destroy the balance of power among the nations'. The widow (here called Sonia not Hanna) edges nearer to Vienna than ever before or since. Shuttling to and fro between Marsovia and Paris, she is courted by the Austrian ambassador to France, who impresses her as 'the image…of the potentate he represented': he has the bushy moustache and military demeanour of Franz Josef, and he proposes that she should entrust her wealth to a new Habsburg husband and settle in Vienna. Her power to repair or ruin a frail European order is drastically underlined. When she refuses to subsidize Marsovia, Danilo denounces her as a rebel. A rival suitor sends him a note defaming Sonia: the novel calls it 'a paper bomb', referring to the method then favoured by anarchists who wanted to speed up the pace of political change. Ironically, the hoard of gold which everyone covets is nowhere to be found. Sonia's funds have been 'abstracted': this tellingly modern word speaks of great and small disengagements, of suddenly rescinded certainties. The gambling son of a banker has looted the vault and lost the cash at Monte Carlo. Sonia's rich husband, an ironmaster, suffers a heart attack and dies in the vault while investigating affairs at the bank. Danilo, apparently resorting to assassination at his fatherland's behest, is rumoured to have murdered him. At last the theft is exposed, undermining a fraudulent civilization: 'The vault was empty. The bank was but a shell.' The novel, in its own daring phrase, rewrites Lehár's frivolous, flirtatious operetta as a 'social tragedy'.

Karl Kraus conceived *The Last Days of Mankind* as an operetta without music, or with music which was second-hand or gruesomely inappropriate. His Vienna is a place of polyphonic noise: the 'Hoch Habsburg' march is churned out by a hurdy-gurdy while drunks slur popular tunes on the Graben and newspaper-sellers scream the latest catastrophic headlines. At a German spa, a councillor of commerce rattles through a ditty about Goethe, Schiller and the munitions industry, each stanza followed by a refrain 'sung by an invisible choir representing the laughter of the world'. On the battlefield, rumbling guns and whistling shells reorchestrate *Die lustige Witwe*. A Prussian colonel ingratiates himself with his Austrian colleagues by asking the band to play something by 'your splendid Lehár, who has brought so much joy to the western front'. The triviality of operetta caustically suited it to this blitzed, bloody theatre. Cynical merriment was the official doctrine of the form, and Kraus blamed the war on the same thoughtlessness. In 1912 he was sourly gratified by a misprint in a Swiss newspaper, which announced a performance of Shakespeare's *König Lehár* – torture, madness, judicial killing and civil strife, all dispatched in irrepressible three-four time.

In 1920 Maurice Ravel's *La Valse* exposed the temporizing, deceptively formal waltz, the instrument of Danilo's diplomacy, as a dance of death. Ravel's choreographic poem begins in outer space, among a nebular fog of shuddering

double basses and snarling bassoons. Scraps of a shredded waltz float past, circulating in purgatory. Then the dance, performed at some grand and otiose imperial occasion, is heard at full volume: furious, joyless, with lurchingly misplaced accents and a whipped, percussive summons to hurry up. The dancers swirl in ever dizzier circles, acting out a frenetic revolution. At last – as the orchestra casts off politeness and is deployed as ordnance, with an uproar resembling that of machine-guns – all fall down. Dancing, like diplomacy, seeks to conduct war by other means, to defuse conflict. And what if the conflicts cannot be harmonized by music and by nimble, side-stepping diplomats? Then, for Ravel's imaginary courtiers as for belligerent tribesmen in their war-paint, the dance itself rehearses the battle, arousing energy and violently discharging it.

More discreetly, Schoenberg in 1925 arranged the *Kaiser-Walzer* by Johann Strauss II for a chamber concert. This is a majestic, martial waltz: a celebration of the pomp which sustains power – or which sustained it in 1889. Schoenberg's version, for a string quartet augmented by piano, flute and clarinet, takes away the officious brass and remains resolutely untriumphal. With hindsight, nothing can be taken for granted. The rhythm is liable to falter, the piano trills uneasily. In the bridge passage before the waltz emerges – that seductive, supposedly reluctant hesitation required by Viennese decorum – Schoenberg takes Strauss on a detour into the twentieth century. The tempo becomes flurried, distracted; wayward chromatic excursions threaten to sabotage the simple-minded tune. There really is a sense, dangerously plausible with only seven players, that the music has lost confidence, that it cannot or will not continue. Then the violins soothingly restore consensus, and the dance, pretending that there is still an emperor and an empire, resumes.

The persistence of *Die lustige Witwe* became a measure of self-deception, a refusal to remember what had happened since 1905. A society which would not learn from history was condemned to repeat it, as if playing Lehár's hit tunes over again. The march from the operetta, whose words concern wooing not fighting, turns up in Erich Maria Remarque's novel *Der Weg zurück*, published in 1930. Remarque's disillusioned German soldiers, on the way back from the trenches in 1918, hear it churned out on an orchestrion – a keyboard which faked orchestral sound – in a rowdy bar. Brawling, they continue an internecine war, now that their only enemies are one another. While the music plays, one of them samples the schnapps, pinches the barmaid's buttocks, and comments 'Good pre-war stuff'. He might be referring to the drink, to the woman's behind – or to Lehár's incorrigible music, so out of tune with a post-war world.

By the time the operetta begins, Hanna has emigrated to Paris. After 1914, when Deliya identified the eastern source of that seditious music, commentators began to suspect that the most interesting part of the story took place back in Pontevedro, while the apocalypse was getting ready to happen. What political shame and economic finagling had Lehár and his librettists concealed? Two post-war revisions of *The Merry Widow* repatriated the characters, implicated

Prince Mirko's
gy in Stroheim's
The Merry
Widow
© *1925 Turner*
tertainment Co.

them in the European calamity, and submitted them to history's verdict on the intervening decades.

In 1925, Erich von Stroheim's film, set in a country which it renamed Monteblanco, pre-empted the operetta's action so as to describe the widowing of the heroine. The husband who buys her is Baron Sadoja, a lame fetishist infatuated by his bride's feet. Fortunately for her, he dies of pre-coital excitement on their wedding night. Mirko, the ambassador who suborns Danilo, becomes the heir to the throne, another representative of depraved, illegitimate authority. He hosts orgies, takes pot-shots at statues, and sadistically torments an old, crippled servant, who assassinates him at his coronation. Stroheim also intended to kill off Danilo in a duel, though the studio overruled him. The operetta was his excuse for the mass execution of a dishonoured ruling class.

More genial but no less subversive, Lubitsch's film in 1934 transformed the operetta into an elegy for a perished culture. The widow's Marsovian home is an Art Deco palace spun from egg whites, with glossy laminated floors; a sculpted warrior with sword erect stands on sentry duty in the entrance hall. Gypsy fiddlers infect Jeanette MacDonald, who plays Hanna, with that exquisite anguish anatomized by Deliya. Her mourning aesthetically contaminates the entire household. In her bedroom she keeps forests of black veils and a troop of sad dummies wearing black underwear. Even her pet Pekinese is black, though she dyes the dog white when she recovers her good humour and migrates to Paris.

At the ragged edge of Europe, the fat, sluggish King Achmed, bedecked with tinny medals and moth-eaten braid, lives off the widow's taxes while wishing

he had married the Sultan's daughter rather his current consort, played by the trashy Una Merkel (who is betraying him with Danilo, Maurice Chevalier). Discovering his cuckoldry, Achmed thinks only of the future's judgment on this squalid, compromise-ridden time: 'This must be kept out of history! You know I have to go down in history as Achmed the Great!' Already, he blubbers, the shepherds are beginning to organize in opposition – one of Lubitsch's best jokes because, after Marx, we all know that revolutions begin among the urban proletariat, which backward Marsovia lacks. Who ever heard of radicalized shepherds? Nevertheless the worst happens, swiftly recapitulating events in Germany and Austria during the 1920s. Danilo is hustled off to a court martial. The widow reacts with silvery volleys of hilarity: merriment or hysteria? She then withdraws her subsidy to the kingdom. Marsovia's economy founders, Achmed falls diplomatically ill, and a peasant woman – cannily operating in a barter economy, where money has no value – sells the newspaper which reports on these disasters for eggs not coins.

Hitler's architect Albert Speer disloyally recalled that his master combined an infatuated devotion to Wagner with a weakness for Viennese operetta, and 'in all seriousness regarded Franz Lehár as one of the greatest composers in the history of music'. *Götterdämmerung* supplied Hitler with his scenario for incinerating the world; perhaps *Die lustige Witwe* had a supplementary use, instructing him in the mercenary bargains and deceit which were necessary to gain control of the world in the first place. He indulged himself by ordering a revival of the operetta in conquered Vienna during 1940. The elderly composer expressed his gratitude for the Führer's patronage in a radio interview, but explained that he did not really keep up with politics. His motto, he said, was 'Immer nur lächeln' – keep smiling. He was quoting Sou-Chong, the Chinese prince in his 1929 operetta *Das Land des Lächelns*. An envoy from the land of smiles, Sou-Chong smiles as a matter of policy, in defiance of true feeling. He smiles despite his confusion when he is captivated by a Viennese aristocrat, whose influence on him he compares with hashish; the same smile remains in place when, after they have married and returned to China, she decides she hates him and leaves for Vienna; he is proud that no one will ever know what is behind his unreadable façade. For Musil – writing in 1919 about the dishonest aristocratic flummery of Viennese manners – this constituted the national style: 'the Austrian countenance smiled because it no longer had any muscles in its face'. Lehár relied on the same ambiguous mask when confronting totalitarian power. In 1940 the only residue of Vienna's happy apocalypse was this fixed grin of compliance.

After the second of the century's world wars, *The Merry Widow* returned to take cheeky stock of the cinders. It was filmed once again in 1952, with Lana Turner as an American widow who has been awarded the costly name of Crystal. Whereas her predecessor in the 1909 novel had to make the final stages of her journey from Paris by steamboat and carriage because 'the locomotive [had] not yet broken into the mountain-locked land of Marsovia', Lana Turner is more

aggressively up-to-date and arrives by train. She confidently carries with her one of the twentieth century's discoveries about the demotic, disrespectful nature of power, prematurely articulated in the same novel: 'a millionaire is often greater than a ruler'. The incompetent Marsovian king who greets Crystal laments that his country has no enemies, only creditors. If he does not pay them, the Austrian emperor has threatened to march in and take over. This was no shuddering re-collection of Hitler's Anschluss in 1938. Rather it blithely, cynically recognized the state of things in 1952, with a pauperized continent permanently indebted to its American saviours, the quaint, grateful province of a new economic empire. Karl Kraus remarked that from 1914 to 1918 'operetta characters enacted the tragedy of mankind'. His adage anticipated the moral history of a century whose most demoralizing insight has been its discovery that evil – bereft of any super-human, satanic aura – is banal. An operetta perhaps deserves to have the last word on the tragic farce of modern times, when Europe, behaving with a reckless folly befitting Ruritania, seemed determined to destroy itself.

INTERROGATING
THE UNIVERSE

The timid Prufrock in T.S. Eliot's poem nervously asks himself whether he dares to disturb the universe, and decides against it. Picasso had no such qualms. According to Apollinaire, he 'aggressively interrogated the universe'. The universe has come to expect such testing inquisitions; it is regularly taken apart and pieced together in a revised form by its human inventors.

This is why the twentieth century continued to commemorate the astronomers Galileo and Kepler, who disputed the orthodox medieval map of the heavenly bodies. Gertrude Stein described Picasso as a latter-day Galileo, engaged in a mortal struggle to 'see what he saw'. Critics demanded that Picasso recant, 'like when they wanted to force Galileo to say that the earth did not turn', but he remained true to his own notion of space. Brecht wrote a tragic drama about Galileo and the church's persecution of scientific truth. In a musical called *The Firebrand of Florence*, performed on Broadway in 1945, Brecht's former collaborator Kurt Weill – now setting a text by Ira Gershwin – made a more impudently comic defence of relativity. The hero is the Renaissance sculptor Cellini, arraigned in a Florentine court for moral lapses and the occasional murder. Cellini pleads his own case by explaining what he calls 'the New Astrology' (rhymed with apology). How can he be blamed for his actions, which have been predetermined by the stars? A man is merely one of those ignited specks thrown arbitrarily through space by God. 'You have to do what you do do', sings Cellini, and gets himself acquitted. Hindemith in his opera *Die Harmonie der Welt* linked Kepler's planetary geometry to his own quest for a harmonic peace on earth. The composer Edgard Varèse preferred the hermetic astronomy of the alchemist Paracelsus, and in his symphonic poem *Arcana* he pondered the eruption of stars and the creation of a solar system. Knots of dense, dissonant, rumbling sound are projected outwards by trombones, sussurophones and a heckelphone, while clarinets shriek and the xylophone scintillates. The arcane suppositions of Paracelsus in the sixteenth century were confirmed by the keening sirens and roaring machines Varèse heard outside his New York window in

1925. The universe, like Broadway, is a wind-tunnel, through which loud projectiles hurl themselves, intent on their own cosmic errands. In 1916 Max Brod, Kafka's friend, published a novel about Tycho Brahe. A colleague of Kepler, Brahe was the industrious cataloguer of new stars. Brod's Kepler is modelled on Einstein, who had worked in Prague between 1910 and 1912. The novel's title was *Tycho Brahes Weg zu Gott*: Tycho Brahe's way to God. But in the sixteenth century, as in the twentieth, the way towards scientific truth – a loftier divinity – led away from the edicts of religion.

Once the astronomers dislodged God as the cosmic motor, Newton the rationalist prepared the earth for human exploitation with his mechanical laws, which presumed the regularity of motion and the fixity of matter. Time flowed always at the same reliable speed; space, by contrast, was immovable. Then, in the twentieth century, the universe suddenly ceased to obey these laws. Time adopted variable, unsychronized tempi, and space too became mobile.

F.T. Marinetti celebrated the change in the physical world's behaviour by declaring, in his First Futurist Manifesto, that 'Time and Space died yesterday'. The manifesto was published in a Paris journal on 20 February 1909: could Marinetti have meant, as if this were the latest news, that the dual demise occurred on the 19th? Or was he joking about the fallacy of Newton's absolute time and the impossibility of fitting intellectual motions – for all the world's great events take place inside someone's head – into its scheme? The chronology trusted by Newton, which in the nineteenth century sustained the efficiency of a clock-watching industrial regime, is a convenient fiction which we agree on in collusion with other people. A calendar is useful for organizing business and setting dates for meetings; its absurdity is shown up as soon as we speculate about exactly when God died, or when the universe began to operate in accordance with the relativity theory. Nevertheless, those changes did take place, and life in the twentieth century is different as a consequence.

The year before Marinetti's manifesto, the same death had been proclaimed in Cologne by the mathematician Hermann Minkowski, Einstein's tutor. Minkowski announced that 'Henceforth space by itself, and time by itself, are doomed to fade away into mere shadows, and only a kind of union of the two will preserve an independent reality.' His imagery derived from the crepuscular *fin de siècle* – doom, fading, shadows. Marinetti, though he thought that he and his futurist colleagues stood like the last men on 'the last promontory of the centuries', stressed the inflamed sunrise of a new creation, not wistful sunset. The manifesto describes a session of nocturnal brain-storming in Milan, after which Marinetti and his gang race to their cars – 'snorting beasts' with 'torrid breasts' – and recklessly drive towards 'the very first dawn'. Daybreak is apocalyptic, as 'the sun's red sword' cleaves 'for the first time through our millennial gloom'. Accelerating their cars, they personally share in the execution of time and space. Speed imperiously orders time to move faster; seen from a moving vehicle, the physical world is swept away in an aerodynamic breeze.

Einstein, less dramatically, considered that his new physics had fused time and space – separate categories in Newton's world, where time mutably travelled through and acted on immutable space – rather than sentencing them to death. Einstein's experiments with velocity were not conducted in fast cars. Instead he studied the performance of metrical rods and clocks, observing that they measured space and told time differently if they were in motion. But his conclusion, as he explained in 1916, was the same as that of the joy-riding Marinetti: 'the world in which we live is a four-dimensional space-time continuum.' He emphasized that this was a world in which we all lived, not some Platonic heaven thought up by physicists; the earth, as Gertrude Stein claimed, truly is different in the twentieth century. Yet we should not be alarmed, like the futurists on their precarious promontory. Einstein demonstrated the ordinariness of the continuum by his humdrum exemplary anecdotes, and pointed out that we cope instinctively with its complex network of spatial and temporal co-ordinates.

His paper on relativity in 1905 disrupted forever the equability of Newton's duration, and it did so by explaining what actually happened when we arranged to meet a train. Railway schedules may optimistically evoke an 'absolute, true, and mathematical time', but in fact they are exercises in what Einstein called simultaneity. When we say that the train will reach the station at seven, we merely mean that its arrival and the arrival of the clock hand at the point which marks the hour are 'simultaneous events'. Einstein's choice of incident was inspired, because railways, extending across continents in the nineteenth century, had given society its first lesson in the relativity of our temporal and spatial arrangements. Until then, each point on the map lived in its private time zone. Towns and villages set their clocks as they pleased; it was only the new ease of communication which obliged them to co-ordinate their time-keeping, agreeing to a standard with capital cities and neighbouring states. The effort of adjustment enabled trains to run on time, yet revealed how arbitrary such protocols were.

T.S. Eliot made simultaneity a defining feature of the modern mind, which is capable of entertaining incompatible ideas and sensations. In 1921 he wrote an essay on the metaphysical poets of the seventeenth century, whom he selected as his own precursors. They possessed, he said, 'a mechanism of sensibility which could devour any kind of experience'. The machine in the head digested disparate experiences – falling in love and reading Spinoza, the sound of a typewriter and the smell of cooking – and formed them into 'new wholes'. A properly trained modern mind could think and feel at the same time, while also registering background noise and analysing odours. Virginia Woolf in 1929 proclaimed that 'life – it is a commonplace – is growing more complex'. Self-consciousness, she argued, had been refined. A contemporary sensibility was 'aware of relations and subtleties which have not yet been explored'. This capacity to juggle relations, to perceive the connection between Spinoza and cooking smells, was a relativistic skill.

In 1903 the sociologist Georg Simmel wrote an essay on 'The Metropolis and Mental Life', an early study of the psychological strains which a modern man endures every day. He emphasized the bombardment of nervous stimuli in the city, that blitz of fractured sensations captured by the flecked paint of the impressionists in Paris and by the jumbled monologues of Virginia Woolf's characters as they walk through London. This chaos is made manageable by a supreme and stringent discipline. To maintain their composure or sanity, city-dwellers grow second skins, affecting a blasé indifference to the uproar. But in their dealings with one another they agree on a common ground, a shared punctiliousness about time. Simmel experimentally imagined the breakdown of this tenuous order: 'If all clocks and watches in Berlin were suddenly to go wrong in different ways, even if only by one hour, all economic life and communication in the city would be disrupted for a long time.' This for Simmel was an unendurable prospect – a scenario for disaster, which the city kept at bay by its 'integration of all activities and mutual relations into a stable and impersonal time schedule'.

Einstein's commentary on the railways demonstrated, however, that this disaster had already happened. Clocks and watches can never be exactly synchronized, and even if they disagree only about fractions of a second, their non-coordination throws all schedules off course and undermines the very notion of stability, permanently disrupting communication in Berlin and everywhere else. As if flouting Simmel's faith in the punctuality which keeps the city going, Einstein took pains to localize his continuum of time and space in Berlin, and thus unwittingly proved the world to be a more relativistic place than Simmel could ever have conceived.

In 1916, illustrating the geometrical calculations required for physically determining distance, Einstein chose 'the place specification "Potsdamer Platz, Berlin"' as 'a point on a rigid body' which might be 'the scene of an event or of the position of an object in space'. The language hints at a learned jest: who would ever have thought of Potsdamer Platz in these diagrammatic terms? The city's body, anything but rigid, consists of flux. Potsdamer Platz in 1916 was a busy commercial crossroads, with neoclassical gates designed by Schinkel confronting a rush of modern traffic too swollen and impatient to pass through them. And who would consider Potsdamer Platz to be the scene of a single event? The city, a functioning chaos, is a scene of noisily simultaneous events, with uncountable human bodies and machines in transit through it. Already in 1905 a Berlin newspaper had kept a vigil in Potsdamer Platz, and in a single hour counted 416 streetcars, 146 buses, 564 carriages, 538 assorted, unclassifiable vehicles, 54 coaches and 138 tricycles battling across it: entropy in action. The first traffic signals in Europe were installed here in 1924, in a vain attempt to restrain the mob of machines.

Despite the alienating effect of his idiom, Einstein's topography serves as a reminder that we think geometrically as we go about our daily business. We triangulate whenever we assess our chances of getting safely across the street (which

in Potsdamer Platz was a notoriously risky undertaking). The irony of Einstein's formulation is that, in the course of the twentieth century, Potsdamer Platz became the setting for so many contradictory events that it lost its identity as an object and disappeared for a time from its allotted position in space.

Throughout the reign of Kaiser Wilhelm II, it was a scene of imperial pomp and affluence. Hotels at its corners – the Palast, the Bellevue – advertised that Potsdamer Platz itself was what travellers came to see: its street-cars and terraced cafés, its decorously parading citizenry. Beyond Schinkel's watch-houses on Leipziger Strasse stood Wertheim's department store, an Aladdin's cave of commodities displayed in a nave of vaulted iron festooned with electrical bulbs. During the Weimar Republic, illicit pleasures trespassed in Potsdamer Platz. The expressionist painter Ernst Ludwig Kirchner in 1914 closed down the Wilhelmine panorama, and concentrated on two prostitutes who pause on a traffic island in the centre of the square. On their plinth, high-heeled and teetering, they impersonate the statues set up for veneration in the imperial city. Feathers, secondary sexual plumage, bristle on their hats. Kirchner's brush sends out jagged discharges of electricity from their bodies: animated by sex, the city has no room for the processional strolling of nineteenth-century burghers. In Kirchner's

Ernst Kirchner
Potsdamer
Platz
(1913–14)

woodcut version, the women are the still point of a frantic maelstrom. All that remains of the square is a series of gouged apertures, like devouring eyes.

Einstein cited Potsdamer Platz as a reliable 'place specification', an anchorage. Yet it soon turned into a playground for the skittish energies liberated by modernism. In 1920 the Dadaist Central Council, in one of its practical jokes against public order, demanded that the government should provide free meals 'for all creative and intellectual men and women on the Potsdamer Platz'. In 1921–2 Moholy-Nagy's film script *Dynamic of the Metropolis* studied Berlin as an arena of contrapuntal motion: traffic patterns, flickering lights. He planned a sequence on Potsdamer Platz, with a long shot of mobilizing police followed by an abrupt cut to a truncheon in close-up, battering the viewer. The square was a field of force, or of violently antagonistic forces: an ideological boxing ring.

This contest of opposed powers reduced Potsdamer Platz to rubble in 1945. Then, before it could be reconstructed, it became a border of contention again, a line of fissure between the eastern and western sectors of Berlin. After 1961 the Wall ran directly through Potsdamer Platz. The populous junction became a mined limbo, across which only the gliding angels of Wim Wenders' film *Himmel über Berlin* – who vault the Wall and wander through no man's land, undetected by the armed sentries – were able to pass. When the Wall fell in 1989 Potsdamer Platz was written onto the maps again. It now belongs, for the time being, to Daimler-Benz and Sony, the corporations which bestride nations and command the world, discounting all ideologies except consumerism.

Relativized by history, Potsdamer Platz became the most modern of places: Einstein was wrong to assume that the body is rigid, the point fixed. He accepted the relativity of his own identity, noting in 1919 – as an example of how his theory worked – that he was called a 'German savant' in Germany and a 'Swiss Jew' in England. If he fell from favour, he added, the two countries would merely need to exchange the labels they attached to him. The issue goes beyond the national stereotypes which his remark so wittily defined. The nineteenth century believed in a responsible, respectable moral agency called 'character'; in place of this, people in modern times possess only a flighty, interchangeable succession of selves, facets which never quite – as in a cubist portrait – add up to a face. But Einstein, like many modernists who repented too late, worried that relativity could be warped into randomness. He fondly teased the notion of a personal creator, to whom he referred as 'the Old One'. All the same, he felt obliged to invoke this superannuated 'Herr Gott' when Max Planck and Werner Heisenberg claimed to have solved the cosmic mystery. Einstein could not accept the indeterminacy of their quantum mechanics. 'I am convinced', he said in rebuttal, 'that He does not play dice.' Yet what is Potsdamer Platz, when we look back through the twentieth century, but a testing ground for chance operations, a board on which the unpredictable dice have been bombs, rockets, land-mines and the bullets of border guards?

The futurists, in their preferred style of exalted rant, called themselves '*the primitives of a completely renovated sensitiveness*', and claimed to possess – thanks to the new physics – a 'renovated consciousness'. It is tempting to dismiss such assertions as bluff. Are the world we live in and the way we live in it really altered by the abstruse formulations of science? Is the human consciousness, with its atavistic freight of urges and obsessions, capable of renovation? Disbelief would be easy, if Proust in the eight vast and minutely elaborated instalments of *À la Recherche du temps perdu*, published between 1913 and 1927, had not demonstrated just how consciousness and conduct changed during the passage between centuries, and related the emotional lives of his characters to the revolution in scientific thought.

Time and the relativity of its workings are Proust's subject. Historical time moves erosively ahead during the decades which the novel covers. The divisions

in French society revealed by the Dreyfus case lead to the collapse of a class accustomed to rule; in the last volume, Paris suffers air raids during the 1914–18 war, and Robert Saint-Loup, a friend of the narrator Marcel (Proust's self-image), is elated by this Wagnerian apocalypse. Saint-Loup compares the bombardiers to Valkyries, the sky-riders who swoop down to scavenge for corpses on the battlefield in the *Ring*. Social disintegration is accompanied by an upheaval in the arts. The characters tire of Wagner and instead patronize Diaghilev's Ballets Russes; belatedly they come to understand Renoir's paintings. Modernism marks a breach as violent as that made by the bombings: Proust compares the change in taste to a geological catastrophe, the symbol of time's cruel irreversibility. But this objective chronicle is also a subjective exercise in memory. Psychological time, unlike that of history, travels backwards – reviving the dead, restoring childhood and its lost paradise.

Musil proudly claimed that the novel had a duty, shared with no other art form, to 'incorporate the intellectual content of an age'. In modern times, science lay at the edge of 'intellectual daring'. This meant, as Musil argued in 1912, that a novelist must seek instruction from Einstein and Minkowski, as well as from their precursor Ernst Mach, who first cast doubt on the Newtonian absolutes of time and space (and whose contribution to relativity is commemorated by the Mach numbers on the Concorde, demonstrating that air speed and the speed of sound are not synchronized). The theories of the physicists were not merely intellectual conundrums. Relativity introduced a new set of practical problems to daily life, as people exerted themselves to cope with the varying tempi of existence. Gertrude Stein realized this when the Germans imposed a curfew during their occupation of France. Before then, she had never worn a watch. Why should she have done so, when every town and city in France was so amply provided with clocks, visible and audible, which summoned the faithful to church? Now she became aware that all those noisy chronometers were telling different stories. In conditions of peace, their disagreements cancelled each other out, because people trundled about their business relativistically: 'when you are going to an appointment sometimes you go quickly because you are late by one clock and then you go slowly because you are early by another clock'. The curfew made punctuality, that most arbitrary and artificial of standards, a matter of life and death. If you were still on the street at six o'clock, you might be shot, or at least locked up. Stein therefore bought herself a Swiss wrist-watch, intended for sporty types with a professional interest in their own acceleration. 'It seems', she reported after a trial period, 'to keep time.'

But did the time it kept correspond to the time of the pulses, or to the more ruminative time of memory? With a punctiliousness which is sometimes maddening, she forced her sentences to register all these uncertainties, rather than efficiently proceeding towards a period. Chronicling the last months of the Second World War, she remarked that 'the long slow days passed away'. Then in the next paragraph she added a disclaimer: 'They did not really pass.' She went

on to explain the reason for her retraction. She had just said to her companion Alice B. Toklas 'Ten days ago we were in Lyon.' Alice however insisted that it was only three. A calendar would not have helped in sorting out the truth, because time's passage is so subjective. Gertrude therefore temporized: 'Well, it seemed like ten, but the days all the same did pass one day at a time.' All she could say for certain was that 'In the afternoons Basket and I always walked.' That, however, is a kind of victory. Routine defeats the passage of time by making it recur. Her poodle Basket was recurrent and thus immortal, because whenever he died she replaced him with another of the same breed, to whom she gave the same name.

Proust explained his own endeavour in 1913 in terms which connected it with the four-dimensional world opened up by the new physics, and also with the experiments of the cubists, who introduced that extra, recessive dimension to their paintings: 'There is a plane geometry and a geometry of space. And for me the novel is not only plane psychology but psychology in space and time.' On a planar surface, only squares and rectangles can be portrayed; Proust, like the painters, wanted to represent cubes or cones, figures you could walk around. A single point of view – like that adopted by the narrators of nineteenth-century novels, who pretended to absolute knowledge – was no longer possible. Musil suggested that souls should be broken down into the elements composing them, which are capable of 'unlimited permutation'. In *The Man Without Qualities* he disparaged the habits of literary narrative, which reduce the hubbub of sensa-tions and happenings to a disciplined sequence – 'as a mathematician would say, a one-dimensional order'. There had to be a way of narrating in space, as well as in cramping, strictly consecutive time.

In 1920 the astronomer A.S. Eddington, whose stellar dynamics con-firmed Einstein's theory of relativity, proposed an archly geometrical definition of a human being. 'An individual', he determined, 'is a four-dimensional object of greatly elongated form; in ordinary language we say that he has considerable extension in time and insignificant extension in space.' The psychological investi-gations of Proust tested that definition, suggesting that the two dimensions over-lapped. Why, since we occupy so much time, should we not claim an equal amount of space, even though the terrain may be mental?

Like Picasso with his permutations of faces, Proust understood that a per-son is 'disseminated over space and time'. This, notoriously, is the case with Mar-cel's elusive mistress Albertine who – as gossip and jealous surmise compound the evidence of her sexual treachery – 'is no longer a woman, but a series of events'. Those events, as unreasonable and discontinuous as the succession of happenings in Potsdamer Platz, shatter the illusion of identity, which depends on singleness and consistency. The spectacle is prismatic. Through her lies and eva-sions, her lesbian adventures and her reported but possibly exaggerated death, Albertine has achieved a dazzling 'multiplication of herself'. Proust also com-pares this to a 'germination': Albertine multiplies without the aid of a male sexual partner. The futurists were thrilled by the same triumph over nature's

procedures for giving birth. Marinetti in 1913 spoke of 'man multiplied by the machine'. Engines enable us to live faster, to cram several existences into a few revved-up decades; we are our own progeny. Marinetti's colleagues Boccioni, Balla and Severini welcomed the way in which modern life, with its bleary, gas-lit nocturnal habits, has 'multiplied our perceptions as colourists', deriding the notion that faces are uniformly pink and forcing us to see them iridescently – 'yellow, red, blue, green, violet'. The Italians viewed multiplicity as an exhilarating, enriching gift. For Proust, the same awareness of infinitude incited derangement. Heisenberg's uncertainty principle – experienced by the mistrustful Marcel as he studies the ambiguities of Albertine – became a psychological ailment.

With promiscuous relativity, Albertine distributes herself around the world. That world, meanwhile, contracts to a single place on the map of Proust's Paris: the Bois de Boulogne, where separate times and spaces are jumbled together in a 'multitude of little worlds'. Exploring this artificial landscape, Marcel finds a plantation of American oaks beside a forest of Scandinavian conifers. A woman in furs, with 'the large, appealing eyes of a dumb animal', emerges from a grove – but she has not grown the pelt herself, and rather than one of our cave-dwelling forebears she is a fashionably clad modern beauty returning from an assignation.

The daylight categories of time and space are also fused when darkness falls. Asleep, we effortlessly voyage between dimensions, entering 'another time: another life'. Our dreams are prehistoric, inhabited by creatures as androgynous as 'our first human ancestors', who commute from one gender to another as they act out their perverse dramas of pursuit and revenge. In *Die Traumdeutung*, the study of dream-interpretation which he published in 1900, Freud discovered inside the mind something like the continuum Einstein described in the physical world. Consciousness may have required renovation, but the subconscious mind, wiser and wilier, had long since dissolved time, space and all other absolutes. Freud accepted Schopenhauer's view that 'our picture of the universe' is imaginary, a design scribbled on an internal canvas. By day, the brain is hard at work forcing fuzzy impressions into a coherent shape. At night, the process continues in a shadow-play, as neural stimuli are given 'forms occupying space and time and obeying the rules of causality'. But space and time are illusions; so, in Freud's phrase, is causality, which was once the steady ground of moral accountability. While we remain awake, our mental life strives to imitate the realistic art of the nineteenth century. Losing consciousness, we instantly convert to surrealism. Proust, however, maintains the vertical order of mental activity which surrealism upended. Albertine climbs from 'the underworld of sleep' up 'the stair of dreams' to arrive at consciousness in Marcel's room at the top of the house.

Proust also arranged the sciences in a traditional ascending order, and drew on every discipline in turn for his research into time and its passage through individual lives and through society. At the basis is physics, concerned with fundamental properties of matter and motion – which for the novelist must include

emotion, because feelings are impulses, forces impelling a body out of its inertia. Perplexed by the restlessness of Albertine, Marcel notes that she is 'not immobile but in motion', and proposes attaching to her (and to other such fluttering fugitives) 'a sign corresponding to what in physics is the sign that indicates velocity'.

In the more degraded and desperate environment of Alfred Döblin's novel *Berlin Alexanderplatz* (1929), such leisurely psychological scrutiny is a luxury the proletarian characters cannot afford. Science served Döblin as a clinically neutral means of transcribing and accounting for violence. Proust's physics studied movements inside the head. Döblin consulted Newton's laws about 'statics, elasticity, shock and resistance', which regulated the blunter, coarser movement of bodies. His protagonist Franz Biberkopf beats to death his girl-friend Ida, with many fractured bones and much spillage of blood. The killing succinctly exemplifies Newton's two rules concerning motion. Bodies seek only to persevere in their state of rest, which was all that the luckless Ida hoped for. But 'change of motion is proportional to the impressed force', and Biberkopf's fist – or his arm, or the whole man and the weighty contents of his skin – thrust her out of her peaceable inertia by belabouring her ribs. Döblin even supplies equations for the force of the blow and the acceleration it induced.

Marcel's research on Albertine, for all its vagueness, appeases his frustration. The autopsy on Ida is more exact but less consoling. Science, in Döblin's anatomy of a crime, teaches us to understand the world without helping us to endure it. Or must we scientifically conclude that the human concerns to which literature caters are themselves a misunderstanding, a myopic and distorted view of the universe with its implacable, morally indifferent motions? Ida's death is no more tragic than that of a fly, or the failure of a light bulb. 'Respiratory impediment' and 'physiological disturbance' occur. A body exchanges its vertical position for a horizontal one. Döblin omits Ida's surname, and says that it hardly matters. Atoms, after all, have no families.

Next after physics on Proust's scale of scientific disciplines comes chemistry. Its speciality is the interaction between substances as they create and destroy bonds; it therefore lends itself to the analysis of fragile, temporary human relationships. Unexpectedly intimidated by Albertine, Marcel reasons that 'the mind is subject to external influences, as plants are, and cells and chemical elements'. Musil struggles to analyse the chemistry of consciousness in *The Man Without Qualities*, remarking that the sexual jealousy of Walter results in a twisted pattern of thinking 'that cannot be formulated in words because the chemical constitution of its obscurity is instantly destroyed when exposed to the light of language'. If consciousness is a stream, perhaps its course should be tracked not in sentences but in equations of state.

Döblin, analysing the alcoholically-saturated brain of the thug Reinhold in *Berlin Alexanderplatz*, tersely reduced violence to a series of chemical reactions. Reinhold's forebrain has been narcotized by liquor. This liberates his middle brain, and the impulse travels down to his boot. He therefore kicks Trude out of

his room. Characters no longer perform deliberate actions, for which they can be held responsible. Reinhold didn't even want to harm Trude. If Biberkopf's killing of Ida was an event in physics, Reinhold's assault on Trude is a chemical reaction. Can the toxins be blamed for working out their destiny? Biberkopf, when released from prison, copulates on the floor with his victim's sister, who witnessed the murder. Moral compunctions are dismissed by a conspiracy of 'the pituitary gland, the thyroid gland, the suprarenal gland, the prostate gland, the seminal vesicle, and the epididymis'. The act itself, grubby and hasty, has its own metaphysical glory, because it briefly extinguishes the universe. The city, the house, the room drop away, and even Biberkopf's body dematerializes. Relieving itself sexually, it testifies to 'the kinetic theory of gases, transformation of heat into energy, electric vibrations'.

Every incident in the *Recherche* confirms the chemical tragedy of entropy, the dissipation of energy as time's arrow – in the great image of Eddington, who was studying stellar movements during the years Proust spent writing his novel – flies towards death. Marcel compares himself with a battery which stores electricity; but batteries leak, vitality wastes, and when the reclusive Bergotte (who has kept his own ancient batteries charged by swathing himself in shawls and tartan plaids, and paying for visits from girls) at last dies, Marcel shudders at the thought of that 'invading chill' of universal annihilation which preoccupied the *fin de siècle*. Despite the blankets and the harlots, Bergotte 'went on growing steadily colder, a tiny planet that offered a prophetic image of the greater, when gradually heat will withdraw from the earth, then life itself'.

A modern sensibility leaps instantly from diurnal details to cosmic laws, from one man's life expectancy to that of the universe. Döblin in *Berlin Alexanderplatz* found himself unable to take for granted the rising of the sun, now that he knew it was as liable to fail as the gas if you don't feed the meter or an alarm clock if you forget to wind it. 'The sun has risen', he announces, but then quizzically adds 'It is not certain what this sun is.' He reports on the humiliating conclusions of the astronomers, who in establishing the centrality of the sun have diminished the earth to a small planet adrift in an infinitesimal system. He wonders why we should bother to rejoice when the sun consents to rise once more, since it is three hundred thousand times larger and more significant than the earth. Its very existence incites a game of multiplication which can only terminate in a row of desolate noughts: 'We are but a zero, nothing at all, just nothing.' Our earth is a nonentity, overlooked – like Döblin's ill-fated characters in metropolitan Berlin – in the mass society of the sky.

God, who assured the earth's eternity, was sentenced to death in the nineteenth century by the sciences of evolution – Lyell's geology and Darwin's biology, which contributed to Proust's account of our life in time. When Swann dates the church at Balbec by pointing to its compromise between Romanesque and Gothic styles, the young Marcel delightedly assigns a region which had been as timeless as 'the great phenomena of geology – and as remote from human

history as the Ocean itself' to its proper place in 'the order of the centuries'. Nearer the end, he is less convinced that the centuries troop past in an orderly formation, signalled by advancing architectural styles. After Albertine's death, he reflects that the successive states of our being are superimposed, as if geologically layered. 'But this superimposition is not unalterable like the stratification of a mountain. Incessant upheavals raise to the surface ancient deposits.' The mind is as turbulent and eruptively unfinished as the earth.

Darwin's investigation of mating plants helped Proust solve another psychological mystery. The novel becomes increasingly preoccupied by the customs of Sodom and Gomorrah: both Albertine and Saint-Loup turn out to be bisexual. To explain this apparent truancy from the biological imperative to breed, Proust invented a science of his own, which he calls 'moral chemistry'. He consults Darwin on the wisdom of the flowers, with their 'different modes of fertilisation'. Darwin had noticed that each plant form possesses both kinds of sexual organs. Why then do they abandon the convenience of unisexual fertilization? Because, as Proust says, this would have resulted in 'the extinction of the vegetable kingdom': self-fertilization produced fewer and feebler offspring, so plants adapted to cross-fertilization. Perhaps the sexual practices of Albertine, Saint-Loup and so many other characters in the novel warn of racial enfeeblement and the West's decline. Or have human beings at last cast off those 'natural restrictions' which constrain the procreating plants? If our first ancestors were androgynous, as Proust remarks in his commentary on the characters in our dreams, then bisexuality may be a paradise which we once lost but have finally – as the end of time loops back to the beginning – regained.

Biology shows how life organizes itself as things grow, die, and – in Proust's version of the science – are resurrected in memory. At its most ambitious, the *Recherche* extends this overview of organic fates into outer space. This is the realm of astrophysics, sublimely distant from the falling apples observed by physics. Marcel tackles the problem of his changed relationship with Saint-Loup by employing a 'three-dimensional psychology'. Studying the way a friendship alters in time, he relates the jostling and manoeuvring within society to the behaviour of heavenly bodies, each of which moves not only on its own axis but also around other bodies.

As time is regained, in the recognitions and reunions of Proust's last volume, the social world dwindles into an estrangingly infinite space. Cliques form and fall apart like stars, in a 'sequence of crystallization followed by dissolution and again by a fresh crystallization'. The war between France and Germany is seen from afar, and likened to the ancient antagonisms of earth: an ocean nibbling a cliff, or glaciers patiently slicing into mountains. The vision is startlingly similar to the Martian view of the earth, described by Wells at the beginning of *The War of the Worlds*. Wells suggests that men complacently bustle about their globe, unaware that they are being studied from above, like 'infusoria under the microscope'. Proust's Parisians persist in their hedonistic round, even though the

Germans are outside the city; blithely unaware of 'cosmic menaces', they refuse to consider that 'if certain moderating and weakening influences should happen to be suspended, the proliferation of infusoria would attain its maximum theoretical rate and after a very few days the organisms that might have been contained in a cubic millimetre would take a leap of many millions of miles and become a mass a million times greater than the sun, having in the process destroyed all our oxygen and all the substances on which we live, so that there would exist neither humanity nor animals on earth'.

Wells's infusoria prove ultimately benign: the Martians are killed off by 'our microscopic allies', bacteria to which they have no resistance. The science of Proust did not permit the fiction of a happy ending. Beyond the epidemic of microbes, he can only look forward to an even fiercer solar catastrophe, 'provoked in the ether by the incessant and frenzied activity which lies behind the apparent immutability of the sun'. Here is the mental malady of the new century, scientifically induced, which begets the complaint of Gottfried Benn in 'Verlorenes Ich': the ego has been lost forever, shattered by stratospheres – as Benn puts it – and martyred to ions, a sacrificial lamb offered up to gamma-rays. Marinetti claimed that science would renovate poetry by augmenting its stock of metaphors. Traditionally, poetic images enforced the dominion of men by '*humanizing* animals, vegetables and minerals'. A skylark is a blithe spirit, daffodils are a golden angelic host, a Grecian urn impersonates an unravished bride. Instead Marinetti proposed that we should '*animalize, vegetize, mineralize, electrify, or liquefy our style*'. Science had withdrawn man's monopoly as 'the centre of universal life'. Why shouldn't the lurid spasms of a light bulb be just as tragic as Hamlet's moonings?

Space, for the futurists, was killed when the X-rays discovered by Wilhelm Conrad Röntgen in 1895 rendered it transparent. Who could any longer accredit 'the opacity of bodies'? Not the physicist Griffin, who in 1897 fiddled with his own refractive index and – without using 'these Röntgen vibrations' – managed to make light pass right through his body. Griffin is the protagonist of Wells's novel *The Invisible Man*; he bandages himself to conceal his insubstantiality, but when he unpeels his camouflage he disintegrates into 'nothingness – no visible thing at all!' The 'whole fabric of a man', Griffin declares, consists of 'transparent, colourless tissue'. We are no more opaque than water. Henri Becquerel, in the year between Röntgen's experiments and Wells's novel, discovered radioactivity, another ray which traversed matter and made light of our materiality. In 1910 Marcel Duchamp painted a portrait of Dr Dumouchel, with radioactive haloes encircling his outstretched hand. Proust likewise referred to 'our intuitive radiography', which pierces 'the tiny particles of epidermis'. Françoise, the maid in the *Recherche*, may be wrong to believe that the X-rays to which her invalid employer is subjected can 'see what is in your heart', but for Marcel radiography gruesomely prints out a negative of life, and transforms a smiling face into a 'rosary of bones'. In Thomas Mann's novel *Der Zauberberg*

(1924), Hans Castorp undergoes an X-ray in the alpine sanatorium for tubercular patients. The medical invention is for him, as for Marcel, a memento mori. The light, piercing the skin of his hand like a sword, allows him to look 'into his own grave'.

He has experienced a negative epiphany, peculiar to modern times: he recognizes the lightness, the unnecessariness, of his own being. This was the mental bequest of the new physics. Heinrich Hertz's experiments with radio waves revealed matter to be permeable. Atoms form no impregnable bulwark; the world is a random cloud of dust. For Döblin, the new-fangled metaphors hailed by Marinetti were

Wilhelm Röntgen's radiograph of a hand (1895)

messengers of disenchantment and disillusion. In *Berlin Alexanderplatz* he wistfully recalls the beacons lit between Troy and Greece to broadcast the homecoming of Agamemnon, and compares them with the modern conveniences awarded to us as a consequence of Hertz's research. Today the hero's return from war would be signalled by telegraph: 'We produce high-frequency alternating currents through transmitters in big stations. We produce electric waves by oscillations of a vibrating coil.' Adding an electron-tube of glass plus a microphone, you have the banal miracle of the wireless. Or perhaps Agamemnon would have telephoned Clytemnestra with the good news. Mythical wonders are now performed automatically, by our technology. Döblin is unimpressed: 'It's hard to get enthusiastic about all this; it functions, and that's all.' Why should we think that electromagnetism is a boon? No matter how his return is announced, Agamemnon will still be murdered in his bath by Clytemnestra when he arrives.

Proust, less fatalistic, hoped that his metaphors might break down barriers between men and a universe of elemental processes in which science has greater expertise than literature. Balancing a rendezvous with Elstir and an introduction to Albertine, Marcel ponders the 'laws as precise as those of hydrostatics' which hold events in their relative positions, as a diver's body is gripped by the weight of water around and above him. Seizing on stray verbal clues in Albertine's speech, he subjects the words to 'appropriate methods of analysis or electrolysis' – as if passing an electric current through water, separating oxygen from hydrogen – so as to isolate the unspoken thoughts which her phrase has molecularly compounded. When he looks at Elstir's portrait of Odette, he likens the painter's genius to 'those extremely high temperatures which have the power to disintegrate combinations of atoms', later recombined 'in a diametrically opposite

order'. Art, like science, works analytically, breaking objects down into their constituent parts. It conducts an inquisition – of a woman's face, or of the universe – which depends on destruction. At its most intrepid, it plots the ultimate attack on matter by splitting an atom.

In the modern world, scientific invention has bestowed a barrage of gadgets on humankind. Some spare us labour, others divert us during the leisure hours we thereby gain; either way, we soon take their magic for granted. For Proust, however, technology altered the way we experience the world, augmenting vision and intensifying emotion. Obsessively cultivating memory, his characters immediately adopt the camera, which alchemically fixes the past on paper. Saint-Loup carries a Kodak, and Bloch's father proudly exhibits his pet stereoscope. The moving images of cinematography have a subtler, stealthier purpose, making pictures of the subconscious mind. Marcel compares his dreams to the flickering of a magic lantern show. Later he likens the black-out in war-time Paris to the conspiratorial twilight of a cinema: in the gloom – as he discovers when he shelters from an air raid in a male bordello – people live out their fantasies, behaving as if they were the shadows freakishly animated by film. The gramophone mechanizes resurrection, restoring voices 'unaltered to life', while the telephone is technology's gift to the lover, compensating for absence by enabling the adored voice to whisper in one's ear. Marcel considers it so miraculous that he treats the operators who connect calls as goddesses, piously placating them for fear that they will declare a number to be engaged; the telephone's purr reminds him of the shepherd's pipe in the last act of Wagner's *Tristan*, which liltingly signals the arrival of Isolde's ship.

The deities of the switchboard, as Marcel says, make sound travel faster than light. This is only one of the accelerations on which modern life has come to rely: the very sense of modernity was created by speed, by the disorienting impatience of technical change. The railway symbolized this unstoppable destiny, steaming into the fourth dimension. In 1895 when the Lumière brothers projected one of their first films, *L'Arrivée d'un train en gare de La Ciotat*, spectators fled from the auditorium, convinced that the locomotive was about to run them down.

Einstein saw the railway, with its variable speeds and its minutely punctilious timetables, as a laboratory for the relativity theory, and he often explained his theories by using anecdotes from a train journey. He pointed out, for instance, that a train moves relative to the embankment, while the embankment also moves relative to the train. Wickedly exemplifying the unreliability of a relativized world, which has bent the rules out of shape, he imagined himself dropping a stone from the window of a moving train. He can see it fall in a straight line, but a passer-by on the embankment who 'observes the misdeed' is sure that it has fallen in a parabolic curve. Can anyone tell the truth, now that nature has begun to play such cheating games? In another impish experiment, he brandished two conceptual lightning bolts and caused them to strike the railway track at points A and B in order to ask whether 'two events which are simultaneous

with reference to the railway embankment are also simultaneous relative to the train?' Given Einstein's own boyish pleasure in the dropped stone and the lightning bolts, it is hard to see why he denied God the right to throw dice.

Einstein's clocks, telling different stories about time as they move through space at variable speeds, could cause headaches. For the tubercular invalids on Mann's magic mountain, relativity is a symptom of their sickness. Down below, time steams onwards, subjugating nature 'by developing roads and telegraphs' and 'minimizing climatic differences'. On the mountain, in perpetual winter, time is suspended. Hans Castorp comes to the sanatorium for a holiday of three weeks, which lengthens imperceptibly into seven years. His vigil also takes away his dominion in space: he used to be a shipping engineer, concerned with international communication and profiting from the shrinkage of the earth. Now, with a thermometer plugged into his mouth, he studies his watch and waits for seven onerous minutes to tick past. Bedridden, he suffers through an inflexible, artificial schedule of visits, dosages and treatments. A day which should consist of twenty-four eventful hours contracts, since activity has been prohibited, into 'the simple sum of nothings'.

Proust – confined to his cork-lined cell, self-sentenced to passivity like Mann's invalids – refused to accept that relativity had deprived life of structure and significance. Time writes off Castorp, who feels he has forfeited his existence in history; Marcel rewrites time, and in doing so regains it. In the last volume of the *Recherche*, the ghoulish salon of the Princesse de Guermantes is transmuted with the flick of a metaphoric wand into one of Einstein's busy, quizzical railway termini. All the novel's surviving characters reconvene at her reception, and Marcel, amazed by the different tempi at which they have aged during his absence from Paris, employs an Einsteinian conceit: 'Time has, it seems, special express trains which bring their passengers swiftly to a premature old age. But on the parallel track trains almost as rapid may be moving in the opposite direction.'

A human being is a time machine, and the separate physical and psychological gears with which we are rigged allow us to travel backwards and forwards simultaneously. As the weary body trudges ahead, the mind nostalgically circles into reverse. Each of us is living proof of the relativity theory.

Racing opposite ways on parallel tracks, those express trains sum up the mystery of subjective time. They also warn of a troubling conflict between historical itineraries. Time in the twentieth century had speeded up, but how could men be sure of the direction in which it was hurtling them? While Marinetti and his followers babbled of humming motors and whirring dynamos, they also hoped that the future might bring back the savage, war-mongering past. That, as the painter Boccioni explained in 1914, was why they called themselves primitives.

In 1895 in *The Time Machine*, H.G. Wells mounted a scientist on an apparatus of nickel and ivory with crystalline handlebars and catapulted him into the year AD 802,701. 'Time', the inventor explains, 'is really only a fourth dimension

of Space.' Therefore why should we not voyage through it at will? His contraption has a lever which can just as easily transport the rider into the past. In 1902 in *Heart of Darkness*, Joseph Conrad sent his ancient mariner Marlow up an African river on a decrepit steamer towards 'the earliest beginnings of the world, when vegetation rioted on the earth and the big trees were kings'.

Wells's Time Traveller gives an oral report on his adventure to a conclave of allegorized social representatives – the Provincial Mayor, the Editor, the Medical Man, the Psychologist – who listen in gathering darkness. Marlow also tells his story aloud in thickening dusk to listeners who are pillars of the society which his narrative condemns: the Director of Companies, the Lawyer, the Accountant. He describes an expedition in the present, derived from Conrad's own experience of the Belgian Congo and its vicious ivory trade in 1890. But the Time Traveller has conflated present, past and future. Displaying successive portraits of a man as he proceeds through life's seven ages, he calls them 'Three-Dimensional representations of his Four-Dimensioned being, which is a fixed and unalterable thing'. Marlow accordingly worries that his journey is taking him into outer space. Trying to imagine Mr Kurtz, the imperial superman who has regressed to brutishness, he compares the effort to a belief that 'there are inhabitants in the planet Mars', which obliges you to form an idea of what they look like. Africa is 'prehistoric earth', but simultaneously 'an earth that wore the aspect of an unknown planet'. Imperialism and science fiction were both terminal symptoms. Spengler thought that the drive to expand was characteristic of doomed civilizations which, incapable of evolving further, could only duplicate themselves by overrunning weaker neighbours; he saw Cecil Rhodes as the first man of the West's last age. As a boy, Marlow searched the map for blank spaces which he might explore. Then Africa changed from 'a white patch for a boy to dream gloriously over' and became 'a place of darkness'. When the empty spaces of our own world have been coloured in by colonists, we must plot the acquisition of worlds elsewhere. Hence Wells's first men in the moon, and hence too the American moon landing in 1969 – that sublimely pointless conquest of a dead, uninhabitable planet; our grandest gesture of abstraction, because it merely gave us a point of vantage from which we could gaze, over a black gulf, at our vulnerable, exhausted earth hanging in suspense.

The Time Traveller begins his story by placing in evidence a cube – the cerebral toy which was the building block of the new physics, of modern art, and of modern architecture: Adolf Loos ordered his students 'to think in three dimensions, to think in the cube', and a journalist visiting the Bauhaus in Dessau in 1927 described Walter Gropius's new glass-walled pavilion as 'a giant light cube'. The body of the cube, as the Time Traveller says, extends 'in *four* directions: it must have Length, Breadth, Thickness, and – Duration', because there can be no such thing as 'an *instantaneous* cube'. Time is the fourth dimension, no different from the three prior spatial planes '*except that our consciousness moves along it*', and the machine simply gives physical impetus to a mental motion.

Marlow adapts this blithe geometrical proof for his own more sombre purposes. The Time Traveller dreams of escaping from space into time; Marlow knows that no such liberation is possible. His auditors, gathered in London at the centre of empire, congratulate themselves on their civilized remoteness from the barbarous 'old times' and from benighted Africa. Marlow's story about the corruption of Kurtz reveals how close the 'beastly, beastly dark' truly is. The cube's duration becomes an aspect of consciousness, where savagery and culture – which we wrongly assign to different epochs in our development – live side by side. Marlow challenges his colleagues to confess their kinship with the ululating natives: 'The mind of man is capable of anything – because everything is in it, all the past as well as all the future.'

The destinations in the two stories – the reformed vegetarian commune of Wells's Eloi; the 'primeval mud' and 'primeval forest' over which Kurtz establishes his obscene tyranny – turn out to be terrifyingly similar, because we carry the past with us into the future. Kurtz's 'The horror! The horror!' is present in Wells's future. The unspeakable act which Kurtz can only paraphrase in his last words is cannibalism. The anaemic, dilettantish Eloi are similarly hunted by the Morlock, a 'bleached, obscene, nocturnal Thing' which (like an albino version of Conrad's darkness) is 'heir to all the ages'. The separate species represent the bifurcation of mankind at the end of the nineteenth century: in *The Time Machine*, a pretty, pampered 'Upper-world', sustained by resentful labourers in the 'Underworld'; in *Heart of Darkness*, Europe preying on Africa. The 'social paradise' of the Eloi suffers from decadence. The year 802,701 is an afterword to 1895: in this 'sunset of mankind' the Time Traveller recognizes the plague of a 'beautiful futility', the lethal languor of Des Esseintes and the dandies. In revenge for their enslavement, the famished Morlocks feed on the Eloi. Wells's disgust was dietary, since he hoped that men would in time give up their 'carnal cravings'. Conrad did not expect us to outgrow the rumoured, gruesomely fascinating rite, which hints at an abiding shame: man's defilement of his own image, the transgression which cries out against our claim to be civilized.

The time-travelling of Kurtz, a high-minded and pious European whose soul is 'satiated with primitive emotions', made him an inescapable symbol of modern man, the mechanical barbarian. In 1925 Eliot used the scornful announcement of his death as an epigraph for 'The Hollow Men'. The effigies in Eliot's poem stood for the shell-shocked, post-mortem state of society after the Great War: Kurtz no longer possessed the energy for diabolical rampages. In 1939, preparing the script for a film which he never made, Orson Welles identified Conrad's character as a Nazi, engrossed in a crusade of extermination; and in 1979 in Francis Coppola's *Apocalypse Now*, he took the blame for the arrogance and impotence of technological America, playing suicidal war-games in Vietnam. At its worst, the twentieth century lunged atavistically backwards like Kurtz, reversing evolution. Science has had a more modest success in putting Wells's time travel to the test. In 1971 a physicist flew an atomic clock around the world

to measure how far time warps in space. The clock returned younger than it was when it set out – though only by 272 nanoseconds.

J.M. Barrie's theatrical fairy-tale *Mary Rose* opened in London in 1920. It appeared to be a whimsical fable about a female Peter Pan, who perpetuates her own childhood by drifting in and out of the material world occupied by the rest of the characters. She vanishes while visiting a magic island in the Outer Hebrides, and remains away for twenty-five years. When she re-emerges from her nether realm she is not a moment older, though everyone else has aged while waiting for her. She is – it turns out – a ghost, unable to rest because she cannot accept the death which occurs when we are expelled from the paradise of youth. Her son, now a grown man, finally persuades his infantile mother to surrender to time, and she floats through an open window into what Barrie's stage direction devoutly calls 'the empyrean'.

Yet this was not the end of her. Barrie's heroine so haunted and perplexed the popular imagination that *Mary Rose* was regularly revived during the next decade: could there have been more to the story than a sentimental longing for the innocent years before puberty? Alfred Hitchcock remembered the play all his life, and in 1964 prepared the script for a film version. The Hollywood studios vetoed the project, which they thought old-fashioned. Hitchcock indignantly retorted that *Mary Rose* was science fiction. The island, he thought, was a laboratory where a person could be 'atomically disembodied', broken down into the atoms of which she is composed, then later reassembled. He predicted that the time would soon come when any of us could go on such astral journeys. A friendly helper would take us apart, or we could do it ourselves. Beamed through time and space, we might re-cohere somewhere else. Mary Rose, it transpired, was a bright and ingeniously modern young woman, who had gone on vacation to the fourth dimension.

Einstein tried to guard against such transformations of physics into fantasy. He did his best to make the extra spatial dimensions opened up by Minkowski a friendly, intelligible environment. He was aware, he said, that 'the non-mathematician is seized by a mysterious shuddering when he hears of "four-dimensional" things, by a feeling not unlike that awakened by thoughts of the occult'; his railway anecdotes were a reassurance that the reality was harmlessly commonplace. But whereas science aims to rationalize the world, art prefers mystery. Poetic metaphors exist to estrange us from nature, comparing familiar things with counterparts which they don't actually resemble. Confronted by the new universe of the physicists, modern artists set out to restore the occult excitement banished by Einstein. Jean Cocteau's *Le Coq et l'Arlequin*, a treatise on modern music published in 1918, began with the pronouncement that 'art is science made flesh'; it consists, in Cocteau's view, of concepts at play. Flesh, however, is a disguise, concealing the busy organs and engines which go about their business inside this decorative envelope.

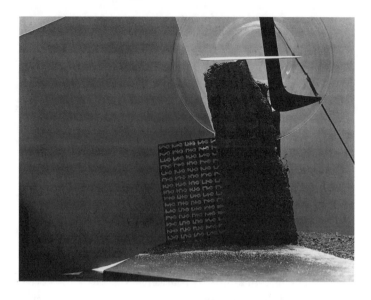

Edward Steichen
Time-Space
Continuum
(1920)

In 1920, the photographer Edward Steichen puzzled over the surreal enigma of the new physics in a still life which he called *Time-Space Continuum*. A glass bubble contains a rudder: it is as if the globe we live on had been rendered transparent, its principle of motion laid bare. Yet the sphere is anchored by a mossy, barnacled stump. This excerpt from the natural world perhaps suggests that we have primitive roots, despite the questions we ask the universe. Discarded, a locksmith's diagrammatic board leans against this assemblage. On it are printed the patterns for keys, like an alphabet which has become unintelligible. Can we really be sure that we know how to decipher the world?

Naum Gabo, in a constructivist manifesto written in Moscow in 1920, challenged art to keep up with the 'penetration into the mysterious laws of the world which started at the dawn of this century'. The futurists thought they had killed off space and time; Gabo on the contrary believed that 'space and time are re-born to us today'. During an entire millennium, sculpture – he argued – remained locked in an Egyptian funerary stasis. Now that space and time had been united, Gabo illustrated their fusion in kinetic sculptures; these showed off their temporal liveliness by performing mobile routines. In Weimar at the Bauhaus in 1929, Oskar Schlemmer called for the investigation of 'space, its laws and its mysteries'. Schlemmer hoped this might lead, after Einstein's reconfiguration of physical nature, to a new design for the human physique, which he tried out in life-drawing classes and extended in his choreographic ventures.

Commenting on Max Ernst's paintings in 1921, André Breton repeated the litany of the modern artistic atheist: 'The belief in an absolute time and space seems about to vanish.' The new physics was thus held responsible for Ernst's mutant ogres and menacing charades. The limp, molten watches in Dalí's paintings mock an outmoded chronometry. Nor do objects stay within their

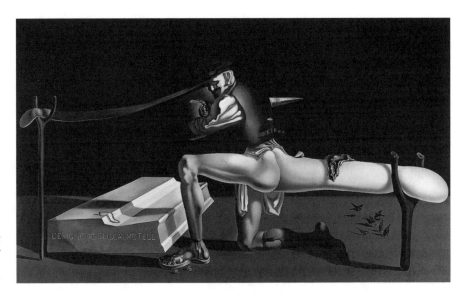

Salvador Dalí
The Enigma of
William Tell
(1933)

spatial boundaries: they sprout extensions, like the elasticized buttock of William Tell in Dalí's 1933 painting, which obtrudes at right angles and has to be supported by a crutch. The surrealists thought that Einstein had played a malign practical joke on nature, tugging it out of shape. The cubists, as Apollinaire said in 1913, marvelled at 'the immensity of space eternalizing itself in all directions at once'. For a surrealist, the immensity was desolate, like Dalí's deserts, and the process of eternalizing into a fourth dimension could leave you with an awkwardly elongated buttock.

Apollinaire invented a verb in honour of the new pictorial geometry. The cubists, as he put it, cubify; they discover in space the dimension of infinity, which formerly belonged to time. But was this plastic eternity something only inert cubic blocks enjoyed? Could human existence be cubed? The futurists believed that technology had given man dominion over space, as if equipping him with the twenty legs of the running horse photographed by Eadweard Muybridge. Wells's Time Traveller noted that duration was one of the cube's dimensions; for the philosopher Henri Bergson, who influenced Proust's theory of how the mind worked, simultaneity meant 'the intersection of time and space', and consciousness itself was the sensation of what Bergson called 'durée'. The thought experiments of modernism therefore played with the notion of life eternalized – a scientifically elasticized longevity.

In 1921 Shaw's metabiological fantasy *Back to Methuselah* previewed the world in AD 31,920. Babies emerge from their eggs already versed in the conundrums of 'space-time and quantity', and the process of ageing is indefinitely protracted to allow for the acquisition of wisdom. 'If you should turn out to be a person of infinite capacity,' says an elder to a new arrival, 'you will no doubt find life infinitely interesting.' Shaw's Ancients, centuries old but mentally undimmed,

look forward to an abstract immortality, a future occupied by an endless philosophy seminar.

The Czech dramatist Karel Čapek immediately contradicted this optimism in *The Makropulos Case*. His heroine Emilia Marty has been alive for 337 years, after testing an elixir prepared in 1585 for Kaiser Rudolf II, the patron of alchemists, astrologers and witch-doctors. She is the eternal woman – goddess, mother and harlot; cynical hag and bright-eyed girl. During her multiple incarnations she has exhausted all possibilities, and now finds existence purgatorially dull. Destroying the formula, she gratefully prepares to die. So much for the delusion of infinity – except that Leoš Janáček, who adapted the play for his opera *Věc Makropulos* in 1926, questioned Čapek's verdict about the necessary brevity of life by invoking his own musical version of the relativity theory. An orchestra puts into practice the simultaneity of Einstein or Virginia Woolf: instrumental groups which are distributed separately in space all play at the same time. In *Věc Makropulos*, those spatial sectors double as time zones. The jagged, jittery figurations of the strings in the prologue evoke the Prague of 1922 – urban agitation, fraught nerves, telephone bells. Then other sounds from a remoter dimension begin to push through this surface of dense modern noise. Drum rolls and trumpet fanfares echo from the court of Rudolf II, as if this ceremonial music were still invisibly preserved in the air of the immemorial city. For Čapek, the endless life which Emilia sought was a fallacy, a bogus nostrum of science. Janáček's score suggested that it might be a reality after all, available to everyone and without the need for alchemical potions. The mind, like the orchestra, contains both past and future.

The most finicky replica of the new universe was a technical diagram for an unworkable machine, supplemented by an instruction manual paginated at random and written in a style which astutely aped the jargon of engineering: the *Large Glass*, also known as *The Bride Stripped Bare by Her Bachelors, Even*, which Duchamp assembled and annotated between 1915 and 1923. Later, with his usual desiccated irony, Duchamp disparaged his own science as mere sophistry. Everyone, he said, prattled in those years about the fourth dimension, though no one had the faintest idea of what or where it was. Despite this disavowal, the *Large Glass* was an attempt at what Eddington – writing in 1927 about Einstein and 'the downfall of classical physics' – called 'world-building'. The bride and her bachelors, trapped for inspection on panes of glass and inside a cobweb of cracks, act out the mystery of time's copulation with space. Or rather they attempt to do so and fail, defaming the laws of physics in an absurdly frustrated attempt at physical intercourse.

The ardent bachelors, their wooing powered by the technological treadmill of a chocolate-grinder, occupy the lower half of the glass panel, walled off in a world defined by linear perspective. They have geometrical bodies – 'rectangle, circle, parallelepiped, symmetrical handle, demi-sphere', as Duchamp pointed out in his box of notes – which means they are imperfect, incomplete.

arcel Duchamp
The Bride
oped Bare by
er Bachelors,
n (The Large
ss) (1915–23)

These hollow men can be identified by the liveries they wear: priest, policeman, undertaker and so on – an entire wardrobe of unavailing social functions. The bride floats free in the upper panel's sky, where she hangs like a fluffy cloud, amorphous and immeasurable. The bachelors mobilize their factory of home-made appliances to send a fertilizing fluid which Duchamp calls 'automobiline, love gasoline' up from their shared testicular chocolate-grinder through pumps, chutes, capillary tubes, magnets and pistons to the languid, lolling bride. In Duchamp's wishful notes, a phosphorescent light flares up as the fuel travels through the contraption. A motor throbs (but only timidly), and artificial sparks are meant to fly. But the efforts of the bachelors, gobbling coal as they try to drive their chariot up a dauntingly steep hill, are wasted. Their seminal gift never reaches its destination. How could the bride ever be possessed by these grinding, grounded suitors, now that reality lies beyond appearance, in the elusive fourth dimension where, as Duchamp claims in the notes, interior and exterior meet?

To explain the machine's notional workings, Duchamp invented his own ludic physics. He promulgated a law of 'oscillating density' (already a property, he declared, of Benedictine bottles, used as ballast by the celibate charioteers). He decreed that the car which transports the bachelors should be built of 'emancipated metal', a material which defied the gravitational mechanics of Newton and his homing apples: 'the *weight* of the metal does not *impede* a horizontal traction'. This wondrous substance, he added, was still 'to be developed'. He also devised a personal unit of measurement to rival the metre, called the 'Standard Stop' even though these stops were hardly standard. By contrast with the metre's officious rigidity, Duchamp cut three threads and let them dangle 'from a height of one metre on to a horizontal plane'. They were at liberty to twist as they pleased on the way down, which of course meant that their lengths would differ. This by no means invalidated them: they represented 'canned chance'. Had not

Einstein warned us to doubt the absolute reliability of the metrical rod? Occasionally the imagery in Duchamp's notes hints at Einstein's conceptual train journeys. The toiling of the bachelors recalls the fanatical but nonsensical punctuality of 'electric clocks in railway stations'. Duchamp, however, went further than Einstein did in his commentary on the subjectivity and mobility of clocks. He took away the clock's authority by shifting it into profile. Looked at sideways, it can no longer tell the time.

Like the bachelors denuding the bride, Duchamp experimented with what he called a 'stripping bare' of language, a nullification of sense. His notes speculate on the 'conditions of a language', and nonchalantly expose the fraudulence of his technical know-how. 'Take a Larousse dictionary,' he recommends, 'and copy all the so-called "abstract" words', then schematize them into signs which will serve as 'the letters of a new alphabet'. You can use those wayward, windblown standard stops as sign-writers. The last word of the painting's title – 'even', or 'même' in French – is an example of language nullified. Duchamp added it belatedly, after the hiatus of the comma, because it signified nothing at all. The adverb is an empty gesture, a shrug of indifference to terminate the phrase. For his first readymades, Duchamp made up titles using filleted words, which reminded him of 'signs from which a letter has fallen off': P.G. ECIDES DEBARRASSE LE. D.SERT.F URNIS ENTS AS HOW. V.R COR.ESPONDS. The gaps ventilate the words, revealing that they are made up of air and emptiness.

The world announced its modernity by inventing languages – revised conventions for representing reality in science, literature, music and the visual arts, which range from mystical equations like Einstein's $E = mc^2$ to numerological rhapsodies like William Carlos Williams's poem about the figure 5 painted on a New York fire engine, from the twelve-tone rows of Schoenberg to the emotionally coded colours of Kandinsky. Duchamp understood that the limiting condition of these brave new jargons and idiolects was their relativity. A language, as Ferdinand de Saussure's treatise on linguistics argued in 1922, consists of signs, whose significance is a fickle matter of interpretation. The words we use have no more intrinsic solidity than the breath which utters them. Written down, they are an arbitrary scribble. Meaning accrues coincidentally, or by accident. With graceful impotence, Duchamp conceded the right of others to attribute meanings to the *Large Glass*, and allowed it to profit from the mishaps it suffered. Forgotten in his studio, it grew a second skin of dust. Man Ray, Duchamp's Dadaist colleague, photographed the filthy, sticky surface, making it look like a lunar waste: the artist was delighted by the effacement of his work. Later, when the glass was splintered while travelling between owners, Duchamp accepted the cracks as a predestined revision of his design.

In 1912 Duchamp painted a *Nude Descending a Staircase*, with the Einsteinian intention of expressing 'time and space through the abstract presentation of motion'. The incorporeal nude, on her way down the staircase, leaves behind only the serial imprint of her swivelling joints and pivoting limbs. There were

many reasons why this image provoked a scandal, but Duchamp liked to think that the main one was its inclusion of mobility. Nudes were supposed to maintain decorum by lying down. It was even better if they fell asleep, because then we could ogle them without being observed. Duchamp's figure refuses to be docile. A breeze has passed through his picture, as if the scent of the body in transit lingered in the air. In the *Large Glass*, by contrast, nothing moves, despite the yearning of all those little, lustful mechanisms for friction and ejaculation. This is the diagram of an oppressive universe where the laws of physics are governmental inflictions. Duchamp's notes speak of a 'regime of gravity' policed by the 'Ministry of Coincidences', and fantasize about a society – like this one, suffocated in its isolation booth of glass – in which 'the individual has to pay for the air he breathes', non-payment being punished by instant asphyxiation.

During the last decades of his life, when he had allegedly abandoned the production of art, Duchamp was often asked what he did instead. How could he justify the space he took up on earth? How did he pass the time? He sometimes answered that his primary occupation was breathing. Given the taxation of air which he shudderingly envisaged, there was a nice, grim truculence to this reply. What does it profit a man to live in a world which proliferates infinitely in all directions, if he still has the same finite number of breaths to draw? Interrogating the new universe, the *Large Glass* finds it as unfit for human habitation as the older version.

Science administered a shock to art at the beginning of the century. For the painter Franz Marc, the new physics confirmed the world's 'mystical infrastructure', persuading him that 'we can see through matter' and provoking him to claim that 'the day is not far off when we shall move through its oscillating mass as we now move through the air'. But Kandinsky, reading Ernest Rutherford's account of atomic structure in 1911, felt reality crumble into granules. He said that 'the discovery hit me with frightful force, as if the end of the world had come. All things became transparent, without strength or certainty.' This resembles Hans Castorp's reaction to the X-ray in *The Magic Mountain*. His envelope of flesh dissipates into mist, and he sees himself as a skeleton. Rutherford had laid bare the morbid molecular scaffolding of nature: the world after all was as shakily mortal as any of its inhabitants. The Dadaist Hugo Ball, delivering a lecture on Kandinsky in 1917, confirmed this sense of flimsiness. 'The electron theory', he claimed, 'brought a strange vibrance into all planes, lines, forms.'

If the particles which made up matter conjoined so chancily, then the architecture of mental confidence – columns, supports, foundations – weakened and collapsed. Kandinsky took his revenge in the volume of illustrated poems, *Klänge* (*Sounds*), which he published in 1913. Here Einstein is pilloried as a stone, 'Ein Stein', which rolls repetitiously downhill until a voice silences the screamed announcement of this feat. Einstein the dissolver of physical substance undergoes the same fate, as his name is split into two syllabic atoms.

The experience of vastation on which Kandinsky reported was set to music by Alban Berg in his *Altenberglieder*, a twelve-minute cycle of five songs composed in 1912, whose texts are messages jotted on postcards by his friend Peter Altenberg. An orchestral prelude consists of unsynchronized chimings, with a glockenspiel attempting to maintain control. It is as if all the world's clocks were relativistically ticking in different tempi. Their disagreements incite a thunderous climax, then lapse into silence. The soprano in the third song looks around the universe, her bleak survey – 'Über die Grenzen des All blicktest du sinnend hinaus' ('You gazed thoughtfully beyond the bounds of the universe') – accompanied by the mournful articulation of a dodecaphonic row: twelve tones which enumerate the building-blocks of matter. But those notes, newly recombined, do not materialize into the familiar world. She no longer thinks, as Altenberg's poem puts it, of house and home. Life and its dreams have lost lustre and value. Arriving at this crisis of recognition, seeing what Kandinsky called the transparency of things, the singer's voice suddenly loses strength and certainty. She hollowly whispers the next phrase, 'plötzlich ist alles aus ---', which announces that suddenly all is over; desolation cannot speak out loud, let alone sing. Then the twelve-tone row sounds again, and she recalls the first line of the poem, describing her continued scrutiny beyond the bounds of space. When she originally sang this line, it was in the past tense: the initial mood was gloomily retrospective. Now, for the repetition, the tense is altered to the present, because there are still no answers to her interrogation of the world, and the effort to understand is newly urgent: 'Über die Grenzen des All blickst du noch sinnend hinaus!' ('Still you gaze thoughtfully beyond the bounds of the universe!'). A brief flurry of vocal ornamentation on the word 'sinnend' characterizes her nervous disquiet. Then she reaches into the air for an abrupt, unanchored climactic note, which more than justifies Altenberg's added exclamation mark. The ground moves beneath her, dislodged by atonality. The high note, which the orchestra does not support, is a precipice.

In the fifth song, an orchestral passacaglia at last supplies the soprano with a foundation, a means of disciplining her frenzy. She wails, pouring out a grief for which there is no motive: a disinterested lament for a world which has been emptied, as she says, of people and settlements, of familiar landmarks. But to confront this white, abstract void brings her peace: 'Hier ist Friede.' The song ends with her decision to ignore the chilling wastes of space and to concentrate instead on one sight in the immediate foreground, even though this may be a spectacle of disintegration. Her cataract of tears dwindles to the dripping of snow as it melts into a pool, dolefully imitated by the orchestra. Altenberg, in some eerie domestic vignettes written in 1896, had been haunted by the same sound when conversation faltered: 'Only the drops of water from the gleaming brass faucet struck the marble basin --- pláp, pláp, pláp.'

The third Altenberg song – in which a huge orchestra plays subdued, hesitant chamber music, falling altogether silent while the soprano breathes

that unspeakable truth – has the infinite littleness of an atomic particle. Berg compressed the metaphysical panic induced by the new physics into ninety seconds. In 1930, Ortega y Gasset reviewed a decade in which Einstein had 'extended the cosmic horizon'. The sky mapped by Newton's physics looked now, in retrospect, like an attic. Milton in *Paradise Lost* referred disparagingly to 'embryo atoms'. Einstein demonstrated that these primal grains of matter were not incomplete and unfinished. Yesterday, as Ortega y Gasset declared, the atom was 'the final limit of the world'. Now it has 'swollen to such an extent that it becomes a planetary system'. But this vast space emerged from Einstein's observation of motions which were incalculably small: the quantum, his new unit of emitted energy, was the tiniest of measures. Although we now pseudo-scientifically refer to quantum leaps, Einstein's quantum was an imperceptible hop.

This altered the scale of nature, closing down the Utopian distances of the nineteenth century – the heaven to which the romantic hero aspired, the retreating frontier of the American west. Hence the modernist cult of brevity. Altenberg in a 1909 essay on 'Kleinigkeiten' or littleness yawned at 'the momentous things in life', which for him had '*no significance at all!*' He preferred to think that 'the *very smallest* thing is *big!*' A person's character cannot be generalized about in the overconfident way of nineteenth-century novelists; it should be glimpsed in stray details – a necktie, a pet dog, a fugitive glance. The postcards Altenberg collected, and on which he wrote the scant, breathy poems set by Berg, were his means of abbreviating distance and imploding the globe. By 1919 he owned ten thousand of these cards, and he was glad that his collection absolved him from having to travel, which had been the weary obligation of the romantic quester. He possessed the world, as he said, 'in extract'. Berg, assembling five of the postcards into a sequence, found a tragedy of lost faith in their cryptic, spasmodically overpunctuated memos.

The abbreviating logic of the quantum was taken to extremes by Schoenberg, who was Berg's teacher, and by his fellow student Anton Webern. In 1928 Schoenberg gave a lecture in Breslau to introduce *Die glückliche Hand*, an opera with a text by Kandinsky. His commentary connected two infinities, the great and the small. The night sky, he said, is for most of us no more than a blank; but even if we are ignorant of astronomy, we know that 'small changes' in stellar patterns represent 'huge movements'. A pinpoint of light has fractionally shifted, and 'worlds may have been destroyed in the process'. We are observing these cosmic traumas across a gulf of unbridgeable space and time: perhaps the upheaval we have just now noticed happened 'two thousand years ago'. From outer space, Schoenberg – exchanging the telescope for a microscope – suddenly turned to a single drop of water. In chemistry, he pointed out, 'one atom of hydrogen more, one less of carbon…changes an *un*interesting substance into a pigment or even an explosive'. Music operates according to the same laws which govern cosmology and chemistry. A tiny change in the combination or succession of tones can

have inordinate consequences. Like a planetary death seen through the telescope or a molecular inflammation seen through the microscope, the effect is 'to burst a form that shortly before was rigid'. Schoenberg achieved such a quantum explosion in his *Three Pieces for Chamber Orchestra*, composed in 1910. The pieces are atonal miniatures, each lasting less than a minute. The first is an invitation to a dance, curtly withdrawn; the waltz stumbles to a halt. The second is a scurrying, shivering nocturne, haunted by shadows, which expires after seven bars. The third sounds a reveille: the orchestra ticks and tinkles like the innards of a clock. Its forty-five seconds are a sample of eternity.

In 1913, when Schoenberg conducted the overwrought, tensely compressed *Altenberglieder* in Berlin, the audience jeered and hooted. A doctor later testified, on behalf of one traumatized listener, that the cycle could cause emotional distress and psychic damage. In a way, he was right. The subject of Altenberg's poems and Berg's songs is the modern mood which the essayist Alfred Polgar in 1926 called 'cosmic uneasiness'. Polgar detected this anxious mental state in the patrons of Viennese cafés, 'peaceless people' who sought to have their anguish allayed, although the therapy they preferred was a drink which stimulated their already fraught nervous systems. Like Ortega y Gasset finding planetary immensities within an atom, Polgar saw the café as a site of breakdown, a place where things fell apart. There is a similarly deathly glance beyond what Berg's soprano calls the bounds of space in an essay Polgar wrote about a performance of *Rigoletto* in the Austrian provinces. The weather is miserable, the public has stayed at home, Verdi's tragedy is a sorry farce. 'In the boxes', Polgar notes, 'the emptiness was afraid of itself.'

Likewise the walls of the café, rendered transparent by the epiphany which Kandinsky described, open onto eternity. 'In this place of loose relationships', according to Polgar, 'the relationship to God and the stars also loosens.' In 1900 Adolf Loos had designed just such an existential establishment in Vienna – the Café Museum, promptly nicknamed the Café Nihilismus. Inside and out, the building annihilated the notion of conviviality which it was supposed to serve. Its windows were blind, refusing to enlighten passers-by in Elisabethstrasse about its function or to return their glances. Indoors, electric lights inside tubes of brass dangled from a plaster vault: a modern galaxy suspended from a white, cheerless sky. The chairs were skeletal, without plush or padding, and mirrors on the wall multiplied emptiness. Modern man no longer possessed the moral security which Kant extolled when he said that he saw the starry heavens above, and felt within himself a force which inclined him to do good. The customer at the Nihilismus or in Polgar's café escapes such 'compulsory relations to the universe', and instead enjoys 'an irresponsible, sensuous, chance relationship to nothingness'. The soprano in the *Altenberglieder*, adrift in the bleak nothingness of a snowstorm, does not share this flighty delight in chance. Polgar, with his cheerful Viennese fatalism, made the best of a philosophical calamity. The café, like the universe, was a field of orbiting, purposeless, caffeine-powered atoms.

Annihilation – in Polgar's assessment of man's new metaphysical status – at least offered a holiday from responsibility, from one's dull attachment to the earth. As the researches of the atomic physicists proceeded, the sensuous vacation relished by Polgar, or by Marc with his dreams of flying free through space, gave way to a moral quandary. In 1950 the hero of Patricia Highsmith's novel *Strangers on a Train* exchanges murders with a chance acquaintance. Guy, an idealistic architect, idly wishes he could be rid of an obnoxious, unfaithful wife; the psychopathic Bruno loathes his father and dreams of killing him. Bruno, believing that they understand each other, strangles Guy's wife, and expects Guy to reciprocate by shooting Bruno's father. At first dismayed and repelled, Guy comes to recognize the deranged Bruno as his other half: an opposite who is resident within himself, altering his identity and his humane values. No one any longer constitutes a single, coherent moral unit. 'The splitting of the atom', Guy reflects, 'was the only true destruction, the breaking of the universal law of oneness.' Science has discovered duality everywhere, which makes all issues ambiguous, all truths reversible. Guy looks at the sun through unkempt, distracted eyebrows, which 'broke the glare into particles', fracturing the visible world. The buildings he constructs seem to vaporize as he thinks about them, since 'matter and energy, the inert and the active, once considered opposites, were now known to be one'. Within the atom, the tiniest of his building blocks, protons and electrons eternally antagonize each other, maintaining 'a balance of positive and negative will'. He therefore commits the crime. If the investigators want to identify the culprit, let them interrogate the universe.

In his treatise on *Harmonielehre*, published in 1911, Schoenberg linked atonality and infinity, and spoke of a fluctuating harmony 'that does not always carry its certificate of domicile and passport'. The expanding universe of the new physics matched the geopolitical world of the twentieth century, with its revised or erased borders and its fleeing populations. Refugees – like Schoenberg himself, forced into exile when the Nazis dismissed him from his teaching post in Berlin – also carry no such secure, stabilizing documentation. But by 1935 Schoenberg had settled in Los Angeles, where he found an equivalent to the vagrant harmony described in his book. Southern California with its contradictory assortment of landscapes was a small world, a contracted version of that infinity which neither begins nor ends at any discernible point. Its topography and its weather, Schoenberg said, were universal. Here you had 'Switzerland, the Riviera, the Vienna woods, the desert, the Salzburg region, Spain, Italy – all together in one place'.

With this witty appraisal of the eclectic west coast, Schoenberg reasserted his faith in what he called 'the unity of musical space'. A fervent mystic, he associated this infinitude with the heaven described in the theology of Swedenborg – a state where 'there is no absolute down, no right or left, forward or backward'. This notion of music as space is strange and paradoxical. Music unfolds through time; being made of air, like heaven, it does not occupy space. On the page of a

score, however, it operates in both dimensions. The bar-lines run horizontally from left to right, and follow the trajectory of time's arrow. But the eye must also read vertically, to gauge harmonics and to separate the overlapping sounds in the orchestra.

Wagner glanced at this mystery in his last opera, *Parsifal*, when Gurnemanz leads the hero out of the forest to the temple where he will witness the communal worship of the Grail. They proceed from one place to the other by walking on the spot, while the painted trees behind them and the sternly marching orchestra in the pit beneath their feet travel on their behalf. The naive Parsifal wonders why he seems to be moving, even though he is standing still. Gurnemanz sagely replies 'zum Raum wird hier zur Zeit': here time is changed into space, or – because Wagner's circular syntax reverses the left-to-right logic of the meaning, putting space first and only then noticing time, which has been transformed into it – vice versa. He is referring to the theatrical trickery of the scene-change, but also to the miraculous powers of music, which can fabricate a forest or a temple out of impalpable air. In an essay written for the Bayreuth Festival programme book in 1975, the anthropologist Claude Lévi-Strauss enigmatically complimented Gurnemanz by remarking that his words are 'probably the most profound definition that anyone has ever offered for myth'. Lévi-Strauss did not explain why he applied them to his own domain: perhaps he meant that myths are stories which travel, migrating between societies, at home everywhere because they dramatize shared human fears and desires. More simply, it might be claimed that Gurnemanz's remark is the earliest and most succinct definition that anyone ever offered for relativity. As Schoenberg understood, music has always worked relativistically, combining duration with simultaneity.

The architect Erich Mendelsohn sought to follow the logic of the new music, which he saw as a response to the atomizing of nature. Music has often been described as invisible architecture, because it deals in blocks of sound and manipulates what Mendelsohn – commenting on Schoenberg in 1942 – called 'structural components'. It was Schoenberg's 'clear recognition of musical material', in Mendelsohn's view, which provoked him to abandon tonality with its deceptive major and minor scales. His 'music without a fixed key' relativized sonic structure.

Schoenberg once ventured to compare himself with Einstein, ironically lamenting his own fate as a dishonoured, unheeded prophet. Compelled to teach composition to ill-prepared Californian students, he remarked that it was like engaging Einstein – by then established as a genius-in-residence at Princeton, where he was often photographed as he scribbled esoteric problems on blackboards, his frizzy hair vouching for the ferment of intellection in his head – to teach mathematics in a high school. Mendelsohn made a similar comparison in his own case, without Schoenberg's woebegone grimace. The economic chaos of Germany in 1923 convinced him that he had a mission to rediscover 'the order of the world' amid 'the wreckage of energy', drawing on the relativity theory to

conjure 'inconceivable space out of light and mass'. After having interrogated the universe, he intended to construct it all over again. 'Seize, hold, construct, and calculate anew the earth!' he admonished his fellow architects.

This was by no means easy. Rutherford's account of atomic structure had shown matter to be volatile, improvised, baseless, compounded of empty space. How could architecture, traditionally proud of its solidity, come to terms with this new truth about the universe? In the buildings which he designed for Berlin during the 1920s, Mendelsohn risked abandoning fixity, in order to illustrate Einstein's theory that 'objects do not exist in space, although they are spatially extensive'. Form for Einstein was not a reliable spatial endowment but a by-product of time. Things, he argued, grew into shape, indefinitely and inconclusively, rather than possessing an authoritative design devised by their creator. Mendelsohn put this principle to the test, experimentally questioning whether it was possible for architecture to extend through space without existing in it. He turned buildings from inert spatial blocks into temporal events. A sketch he made in 1917 for a film studio modelled its banks of windows on the sprockets of film whirring through a projector. The Cinema Universum (now the Schaubühne), which he built between 1926 and 1928 on the Kurfürstendamm, began as a streamlined, navigable disc hurtling across the sky.

In 1941, after reading Sigfried Giedion's study of *Space, Time and Architecture*, Mendelsohn drafted a letter to Einstein querying whether the concept of four-dimensional space-time could be applied to painting (which he called 'art in two dimensions') and architecture ('art in three dimensions'). He had already answered his own question two decades before when he built his Einstein Tower, which stands in the grounds of an astrophysics institute on the Telegrafenberg in Potsdam, just outside Berlin.

The dwarfish tower is placed below the dome housing the institute's giant refractor, which scrutinizes the borderless galactic system and exposes, as Eddington put it, 'the insignificance of our own little world'. Buried in the mound which is the tower's foundation, instruments calculate planetary motions. At its summit, a lidded observatory keeps watch on the sky. Growing upwards, the curved walls bulge and billow, making room for staircases, balconies and windows. Classical mass has buckled in the new conditions of instability described by Einstein. The building is pressed into shape by the combat between internal and external pressures, moulded by the currents of air and time; finally it evolves an eye which can encompass outer space. The white shaft between the machine room underground and the globular look-out is startlingly phallic. The tower is an erector set for the valiant modern intelligence, constructing worlds in a universe where God made the integers and then, abdicating exhausted at the weekend, left everything else to be created by man.

TOUJOURS PLUS VITE

Existe-t-il une automobile dont le moteur donne une puissance de compression bien au-dessus de la moyenne avec de l'essence ordinaire ? OUI — La DE SOTO. Douce et silencieuse, à 100 kms à l'heure ? OUI — La DE SOTO.

Six cylindres à haute turbulence lui permettent de rouler à tout allure — des heures durant — sans effort. Ventilation du cart... refroidissant l'huile et lui conservant ses qual.tés, si loin que vous alli... Graissage à haute pression, préservant le moteur contre les accide... — même si vous ne conduisez pas avec tous les ménagements d... rables. FREINS HYDRAULIQUES à action interne répondant insta... nément à la moindre sollicitation — sûrs, quel que soit le temps. Une telle voiture — rapide — présentant toute sécurité — est-... portée de vos moyens ? OUI. La DE SOTO — Souple, ner... rapide comme un pur sang !

Demandez le catalogue — aujourd'hui-même ! Sept modèles...

DE SOTO '6

TRAINS, CARS, AEROPLANES

As if it were not enough to merge space with time, Einstein went on to couple mass and energy. The inertia of matter, he pointed out, increases with acceleration. According to the thought experiments of Eddington, this meant that velocity could waive biological rules and allow volatile modern man to enjoy something like immortality. A 'fast-moving traveller', Eddington argued, actually lived more slowly than a 'stay-at-home individual', because inertia compensated for his propulsiveness, decelerating both his metabolic processes and 'the watch which ticks in his waistcoat pocket'. Though he may seem to be hastening towards death, in effect he is cannily postponing it. 'If the speed of travel is very great,' Eddington suggested, 'we may find that, whilst the stay-at-home individual has aged 70 years, the traveller has aged 1 year.' The chronometry of consciousness establishes that 'the two men have not *lived* the same time between the two meetings'.

For Eddington, the Bergsonian notion of lived time – time which we personally endure, which flows through our fingers, as the Marschallin sings when she stops the clocks in *Der Rosenkavalier* – was truer to experience than the 'universal time-reckoning' imposed by the Astronomer-Royal from the observatory at Greenwich. This scientific presumption was put into practice by the circumstances of modern life. Suddenly the tempo of existence became faster. The bicycle mobilized the pedestrians of the lower middle class; a witty commentator referred to the 1890s as the 'fin de cycle'. H.G. Wells pedalled ambitiously around London, and a French inventor marketed the Décuplette, a bicycle for ten riders who, when mounted, resembled a scurrying centipede. The surrealist Alfred Jarry made the bicycle a vehicle on which the superman could transcend mortal limits. In Jarry's ribald, fantastic novel *Le Surmâle*, the hero Marceuil pedals his way to victory in a non-stop race over a course of ten thousand miles, easily outstripping a steam train. He then celebrates his success with a bout of equally indefatigable love-making. Duchamp took a more contemplative pleasure in the apparatus. In 1913 he mounted a bicycle wheel upside-down

on a stool and watched it rotate, considering it 'pleasant for the movement it gave'.

Rotation dispenses a keen, alarming modern pleasure in Ethel Lina White's novel *The Wheel Spins*, filmed by Alfred Hitchcock in 1938 as *The Lady Vanishes*. Miss Froy, a genteel English spinster, exclaims 'Isn't all this *fun?*' as she looks out from a train which roars and rattles through the agitated Balkans. Her companion Iris asks the reason for her unmaidenly glee. 'Because it's travel', says Miss Froy, and muses about the marvel: 'We're moving. Everything's moving.' It is perhaps not surprising that Miss Froy vanishes (though she later reappears). Like a rotating wheel or an aeroplane propeller, objects in motion have a tendency to dematerialize. Travellers addicted to motion wanted more than merely to reach their destinations; they demanded the thrill of acceleration. The ocean liners which crossed the Atlantic until the 1950s, competing to set speed records which were rewarded by a blue riband, disappointed their passengers because – in spite of their turbines – they never felt fast enough. Like an aeroplane in unruffled air at its cruise altitude, a liner seems to be running on the spot, and the ocean – like the sky – lacks landmarks against which you can measure your progress. The Cunard company therefore supplied passengers with a sense of furious locomotion by decorating the *Queen Mary* with Art Deco motifs which coupled the latest technology and the hybrid vehicles of ancient myth. An aeroplane darted across one of the veneered walls, accompanied by a winged horse; an express train zoomed in the opposite direction, with a centaur as an outrider. The plane and the train were streamlined, like the liner itself, to ease airflow and maximize speed.

The new tempo extended from transport to the arts. In their psychically automated compositions, André Breton and his surrealist colleague Philippe Soupault valued above all the unthinking haste with which they scribbled, and invented a literary speedometer to calculate how fast they were travelling across the page: they marked their texts with the letter 'v', using several gradations to measure their exact velocity. Music could no longer be permitted to dilate at leisure and luxuriously repeat itself. In 1927 Darius Milhaud composed a trio of accelerated, abbreviated 'opéras-minutes'. He cheated a little, because each of them took seven or eight minutes to perform, but into that niggardly time – catering to a fickle modern attention-span – they managed to cram a speeded-up reprise of three classical myths. Europa was raped, Ariadne abandoned, and Theseus delivered from danger, all at satisfyingly high speed.

Gino Severini, once more paraphrasing Einstein, announced in 1913 that 'speed has given us a new notion of space and time'. The characters in Proust's novel congratulate themselves that theirs is 'an age of speed', and observe the necessity of rapid change in all aspects of existence. Railways have overtaken coaches, just as Wagner has been superseded by Debussy (who will soon be outstripped by a newer favourite). Proust's people assume that history has gained in efficiency, guaranteeing 'the next war could not last longer than a fortnight'.

Saint-Loup laughs that war with Germany will be 'a bigger catastrophe than the Flood and *Götterdämmerung* rolled into one. Only it wouldn't last so long.' Events disproved his calculations. In 1914 people indeed believed that the war could be briskly finished off within a few weeks; by 1918 they realized that it had lasted longer even than Wagner's epochally lengthy opera. An individual can alternate between the conditions of Eddington's two personae, the sedentary man and the gadabout. Thus the sickly Marcel compares his irregular biorhythms to the optional gears of a car, because different days require different metabolic tempi.

Francis Picabia Portrait of an American Girl in a State of Nudity *(1915)*

Ettore Bugatti gave up painting in 1899 to concentrate on the design and manufacture of cars, whose streamlined bodies sculpted the whirlwind. The painter Francis Picabia hurtled around Paris in a succession of luxurious cars, to which he had racing carburettors fitted. He began, docilely enough, with a Ford, advancing to a Citroën, a Rolls-Royce and a Hispano-Suiza. During the First World War, he managed to turn this automotive obsession to good account, and got himself reprieved from the trenches by obtaining a post as a general's chauffeur. The next war was less propitious for him. The rationing of fuel in 1940 obliged him to downgrade from a sleek Nash car to a less greedy Opel. Then, back-pedalling even further, he had to settle for a bicycle. Rather than humanizing machines, Picabia mechanized human beings. His nude portrait of an American girl, made in 1915, was a diagram of a spark plug: a device for generating a brisk and instant erotic fire.

Gertrude Stein acquired wheels in 1917 – wooden ones, fitted to a Ford van shipped from the United States to France for her use. It lumbered about, camouflaged as a supply truck with a red cross on its canvas awning. When the war ended, it was banned from the Bois de Boulogne because it had not been demobilized, and still qualified as a military vehicle. Stein therefore replaced it with a new Ford. Noticing that the dashboard was bare of clock, cigarette lighter and ashtray, she considered the car to be nude, like Picabia's sparky young American who is stripped to her ignition; she therefore named it Godiva. The secretary of an American senator marvelled at Stein's dual accomplishments: she 'made her way through the Paris traffic with the ease and indifference of a chauffeur, and was at the same time a well-known author'. For Stein herself, the two activities overlapped. Her prose, she said, imitated 'the sound of the streets and the movement of the automobiles'. As usual, she did not explain what she meant. Perhaps she attuned the monotone of her long, long sentences to the regular, reliable chugging of the internal combustion engine.

The challenge of living in this recently revved-up universe was not relished by all. The elderly and fussy Henry James, with his obsessively hesitant syntax, was thrown into a disoriented panic when Edith Wharton drove up to his house in Kent in 1912, wanting to carry him off for day trips in her new car. He nicknamed Mrs Wharton the Firebird, after the demonic heroine in Stravinsky's ballet, and called her vehicle the Chariot of Fire. Terrorized after one of their expeditions, he betook himself to bed to recover. In the giddy, nerve-wracking jaunts of the two novelists, the relationship between Eddington's 'stay-at-home individual' and his 'fast-moving traveller' became a war between the generations and the sexes. James saw Mrs Wharton as a peculiarly modern mutant, a woman who was literally 'fast'. That same year the *Titanic* sank on its crossing to New York, its side ripped open by an iceberg. The ship's two thousand passengers were admired for maintaining decorum and observing religious pieties as they waited to drown. The event was an elegy for an onerously stately mode of transportation, and for a top-heavy, decorously ranked society which was also obsolete.

Marcel in *À la Recherche du temps perdu*, younger and worldlier than James, orders a motor car to impress Albertine, and when it charges ahead, covering 'in one bound twenty paces of an excellent horse', he coolly cites the relativity theory to explain the marvel. 'Distances', he comments, 'are only the relation of space to time and vary with that relation.' The car consumes and eliminates the terrain it travels over, destroying Marcel's 'conception…of position in space as the individual mark…of irremovable beauties'. Before he had thought that the beauty spots near Balbec – a secluded house, a particular stand of trees – were isolated and elevated by remoteness. Inaccessibility made them precious, and transformed a trip to see them into a quest. Now they hurtle forward to meet him while he sits still in the car. Cottages run alongside the vehicle as escorts, throwing the contents of their gardens at him as welcoming bouquets.

The car did not travel through a sedate, gravitationally rooted world. It mobilized everything: space, experienced from inside, became a whirligig. Marcel contrasts nineteenth- and twentieth-century modes of entering a town. Whereas you used to arrive at a railway station, placed at a discreet distance from the centre, nowadays you drive directly into the middle of town. The train delivered you to a station which had been prepared as a place of induction, a part standing for the whole whose name it bore. In Paris, two of the termini even helpfully situated you on the earth by taking their names from the points of the compass; in New York, emerging into a marble ballroom, you were assured that this was the ultimate destination – it was called, after all, Grand Central. Riding in a car, you bypass these formal preliminaries, and must do without the uniformed station personnel whose job was to orient you. Information has to be snatched from pedestrians in the streets, who may well not know the way. Even if you can see your goal ahead, you can never be sure of how to approach it, because the rules of circulation do not follow linear perspective. While the car circumnavigates the town, searching for points of entry, the town itself 'darts off

in every direction to escape it'. A castle and its hill dance randomly about, changing places on a horizon which plays hide and seek with the motorist. For express trains, a town was a 'unique point', signalled by its station. For a car, the same town is everywhere and nowhere, a centreless chaos: the spatial equivalent of Eddington's time, with no Greenwich meridian to make sense of it.

The reward for the difficulty of navigation, Marcel decides, is the pleasure we take – as we consult maps and pocket compasses – in personally unriddling the geometry of this relativistic world. Once that pioneering delight wore out, the car forced us to recognize the cubistic mayhem of modern space. Arriving in motorized, structureless California, where perpetual motion in time atones for the incoherence of space, Gertrude Stein in 1935 wittily noted that when you got there you found there was no there there after all. Hitler, organizing the construction of autobahns throughout Germany during the early years of his regime, saw these engineering works as an opportunity to rectify this degenerate contemporary jumble. Of course the highways had a political and military use. They were the routes along which conquest would occur. But, slicing through cities, they also restored to space an integrity and airy freedom which Einstein had taken from it. They carved out the way to a distant horizon, and eased the advance towards it. Hitler was pleased, he said, that 'even in the more thickly populated areas [the autobahns] reproduce the atmosphere of the open spaces'.

Preoccupied by his feats of triangulation on those outings with Albertine, Marcel leaves the driving to his hired chauffeur. The Italian futurists refused to delegate the pleasure of firing their vehicles like bullets from a gun, or using them to batter the obtuse, obstructive material world. Marinetti, on that joy-ride in 1909, shivers at first, aware that his car is a mortuary. He stretches out in it 'like a corpse on its bier'; the steering-wheel bites at his stomach like a guillotine blade.

Giacomo Balla
Speeding
Automobile
(1913)

Cheering up, he makes the car demonstrate its prowess as a killing machine. As he roars through Milan, the city's watchdogs – useless, yapping guardians of spatial boundaries and private property, symbols of the bourgeois dispensation which the futurists condemned – are thrown back against doorsteps or else, if less agile, flattened by his burning tyres like collars beneath an iron. He castigates himself for his squeamishness when he pulls up to avoid two cyclists, but is gratified when the car capsizes and ejects him into a ditch full of effluents from a factory.

Violence is also a means of ignition in Duchamp's *Large Glass*. The notes describe an imaginary waterfall – like Niagara with turbines at the base of the cataract – down which the bachelors plummet in a glider, hoping to generate energy for their expedition to the bride. Because their density was supposed to oscillate, Duchamp allowed them a choice between '3 crashes'. Depending on 'the decelerations or accelerations…the right is chosen rather than the left or alternatively the centre'. Whichever aleatory route they selected, the end would presumably be the same: a clump of concertinaed metal.

The bright young things with their bright young ideas in Evelyn Waugh's novel *Vile Bodies* (1930) live and die futuristically. They rush off to a motor race, where the cars on the track act out the molecular hubbub of nature, 'in perpetual flux; a vortex of combining and disintegrating units'. The timid Miss Runcible, one of Eddington's backward stay-at-homes, accidentally lands in the driver's seat and experiences with a vengeance what the futurists called 'dynamic sensation'. The car veers off across the country. When it finally jerks to a halt, Miss Runcible's poor head won't stop speeding; she is not steadied by the inertia of Eddington's intrepid traveller, whose intellect is braked by 'a slow-moving brain'. She dies in delirium, babbling about the imaginary black tarmac which unrolls before her – in an image brilliantly linking the highway with another modern dispenser of dynamism – 'like a length of cinema film'.

Marinetti's crash confirmed his valour. To anticipate the future was to will your own obsolescence. In the Futurist Manifesto, Marinetti boasted that he and his contemporaries would be slaughtered by 'younger and stronger men' before they reached middle age. He survived, in fact, until 1944, which must have been a disappointment to him, but his colleagues Boccioni and the architect Antonio Sant'Elia were punctually killed in 1916. War after all was 'the world's only hygiene', redefined in a 1915 manifesto as 'Futurism intensified'.

The machines on which we have grown to rely offer us daily reminders of mortality. Our dependence on gadgets has made us into muddling mechanics, since we must be ready to analyse breakdowns and perform emergency repairs. To open up the bonnet of a car – from beneath which steam or acrid smoke may be issuing, or which may disclose clogged arteries and cardiac arrest – is another chilling epiphany unique to modern times. It resembles Castorp's experience with the X-ray, because in examining the car's innards we might just as well be inspecting our own interior. The car, like us, has internal organs, through which fuel is supposed to be pumped. Its cladding of steel is tougher than our skin, and

its capacities exceed ours, which is why we are so anxious to harness it. But that mechanical engine is also chronically liable to develop tics, ailments, fatal diseases. Its life-span is terrifyingly short. It induces all over again the shock of recognition first forced on men in the Renaissance when Leonardo da Vinci sketched embryos in the womb or William Harvey studied the circulation of the blood: the car is an anatomy lesson, and it is never comforting to be shown the evidence of those messy, accident-prone processes which – discreetly unseen and mostly unheard – go on inside us.

In 1966 the Pop artist Claes Oldenburg, acknowledging the automobile as man's double, made a car from canvas stuffed with kapok. He called his playful vehicle the Airflow. Unlike its streamlined prototype by Chrysler, Oldenburg's Airflow was soft and floppy. He wished to disarm the car, to contradict its hard, aggressive surfaces and nullify its capacity for destruction. But he could not help shuddering a little when he thought about the likeness between organism and mechanism, between himself and the engine which guzzled petrol, throbbed and rattled so dangerously, and evacuated fumes of poison. How could he remain unconscious of what happened behind the translucent flesh, or under the locked bonnet? The experience frightened him into going on a diet, which he explained as his chastening, self-mortifying way 'of becoming aware of my body's internal parts'. Henceforth, Oldenburg resolved to drive himself more carefully.

In the fast modern world, sex and velocity became instant allies. A car could be used by teenagers as a mobile bedroom, detached from the parental roof. But the same contraption also functioned as a weapon, a missile. James Rosenquist painted the paradox in 1961 in *I Love You with my Ford*, a huge horizontal triptych, or a triple-decker sandwich of imagery. The top layer is the cold,

James Rosenquist I Love You with my Ford *(1961)*

affectless visage of the Ford: headlights for staring eyes, a mirthlessly grinning radiator, tusks of chrome. Beneath that are the dead faces of two young people, presumably trampled by the car. The bottom tier of the sandwich contains a wriggling mass of spaghetti, like entrails in tomato sauce. A car is a mincer, a device for churning, shredding and pulping human life.

Technology's purpose is to fight and win battles. Science, beautifully resolving both the smallest and largest problems in the universe by splitting the atom, attained its apogee when the bomb fell on Hiroshima. Joining forces, they have created a new kind of society, defined by the novelist J.G. Ballard as a 'technarchy' – a culture geared to hyperactivity and overacceleration, erotically elated by the possibility of its own destruction, which Ballard calls 'autogeddon'. A head-on collision in Ballard's *Crash*, published in 1973, produces an orgasmic fusion of flesh and steel, blood and spilled seminal juices. Technology has deviant ambitions, because it manufactures cars in order to enjoy the suicidal thrill of crashing them. This death-wish licenses any forbidden sexual act, allowing Eros and Thanatos to confess their kinship. Ballard's hero Vaughan, a connoisseur of traffic accidents, copulates with a woman in the back seat of a car while they are driven around the outskirts of an airport. Like a gleaming polished penis, the metal steering column reflects their contortions, and the speedometer on the instrument panel keeps track of their tempo.

Between wars, the car has provided the twentieth century's fast livers with an appropriately existential means of death. Albert Camus, Jackson Pollock and James Dean are among the casualties. But the century's most celebrated public death was not caused by a driver. It occurred in the back seat of an open car, when President Kennedy was shot in Dallas in 1963. The scraps of film which record those few seconds – perpetually replayed in the imagination, obsessively decelerated by investigators so that each frame can be inspected – change the official limousine into a baroque altar on wheels and fix the passengers in a flailing tableau, like martyrs whose agony is sculpted on celluloid. A man's head flicks sideways as his brain is blown away. As the car speeds off, a woman desperately struggles to escape by crawling onto the trunk. Here is one of the primal scenes of modern times, and it hints that we are driving our own recklessly hasty hearses.

Perhaps, despite reports of God's abdication, the sky was inhabited after all.

Riding along the cliffs through jagged rocks which resemble left-overs from some other universe, Marcel in the *Recherche* feels his horse start in fright. He likens himself to a 'young man of the prehistoric age' painted by Elstir, who suddenly encounters a centaur. But instead of a beast from the mythical past, he is confronted by an emissary from the mechanical future. He weeps as he realizes he is about to see his first aeroplane, 'as deeply moved as a Greek upon seeing for the first time a demi-god'. What he experiences is awe, a sense of the numinous; the sensation compensates for Nietzsche's act of deicide. The plane hovers, as if

the pilot were pondering a choice between the four corners of space. He glides above the sea, then demonstrates his contempt for Newtonian gravity by manoeuvring his gilded wings and pointing the plane directly upwards into the sky. Flight in its early days was easily mistaken for a manifestation of the divine. Marinetti in 1916 said that the airman, spiralling 'towards the Void-God', extolled a 'perpendicular mysticism'. Reminded of the swan which carries the Grail knight down from heaven and back in Wagner's *Lohengrin*, Marcel considers 'these 120 horse power machines' to be vehicles for exploring infinitude.

Later, on visits with Albertine to the new aerodromes encircling Paris, Marcel overcomes his sublime exhilaration and begins to understand the influence of aviation on our grounded emotional lives. Albertine is fascinated by flight, and quizzes the mechanics who tinker with the planes. Soon afterwards, she vanishes; then comes a final disappearing act, her death. Baudelaire responded to the atmosphere exhaled by harbour towns, which he called the 'poetry of departures'. Aerodromes brought this exciting instability inland, closer to the centre of the city; by the end of the twentieth century, international airports – where departure and arrival are alike deprived of poetry – transformed the sweet Baudelairean mood into a state of nervous anguish. Cars in the same way soon ceased to be marvels of emancipating metal and instead became boxes puffing poison gas. Technology has a habit of converting its promised heavens into hells.

An aeroplane seen from below for the first time is certainly an annunciation – but of what? The Londoners in Virginia Woolf's *Mrs Dalloway* (1925) gaze at a sky-writing plane which semaphores to them from the beyond. But its smoky letters drift out of shape, as impermanent as Keats's name written on water. The puzzled citizens try to spell out the message, engrossed in the modern guessing game of deciphering symbols. Is it saying Blaxo, or perhaps Kreemo? They collectively decide that it must be touting a brand of toffee. The augury is an advertisement; we have annexed the sky for use as a hoarding. Only one man, glancing up from his garden at Greenwich and remembering Einstein, is prompted to admire man's determination to think himself out of his body.

In Döblin's *Berlin Alexanderplatz*, misery on the ground is contrasted with the circuits performed in the sky above Berlin by the inflatable airship *Graf Zeppelin*, which after crossing the Atlantic in 1928 returns to receive the applause of the citizens. Collating newspaper cuttings, Döblin finds reports of a building which collapsed in Prague, burying its inhabitants in rubble, next to trumpeting editorials about the airship. When the Zeppelin soars above the tenements, dodging rain clouds, people clamber onto rooftops to salute it. The depressed, degraded Biberkopf does not look upwards. Slouching between a soup-kitchen and a flophouse, he gloomily wonders if a sky-pilot might be able to explain why God bothered to create this joyless earth.

In the heroic early days of aviation, some pilots and even a few awe-struck passengers thought they knew the answer, because the machine they rode in

provided a new vision of our world and a refined understanding of its purpose. The aeroplane saw the earth abstractly. The flier Antoine de Saint-Exupéry praised the austerity of its vision. The plane ignored our serpentine, straggling roads, and flattened the bosomy hollows in which we cower; it drew straight lines across the jumbled land. In 1922 Jean Cocteau made his own cool, detached, neoclassical adaptation of *Antigone*. He described his version of Sophocles as an attempt 'to photograph Greece from an aeroplane'. It was this vertical distance from human life with its mazy entanglements which recommended Cocteau to Stravinsky. When they collaborated on the oratorio *Oedipus Rex*, Stravinsky announced his intention

Oskar Barnack
View from
a Zeppelin
(1913)

in the same aeronautical terms, as if he were studying the terrain of our existence from far above. He wanted, he said, to bring out 'the geometry of tragedy, the inevitable crossing of lines'.

Ernest Hemingway, taking off from an aerodrome east of Paris in 1922, looked down as the fields arranged themselves into regularity and commented that he understood for the first time the truth of cubism. Picasso himself had already made the vertical leap of imagination, emblazoning on one of his paintings in 1912 the headline 'Notre Avenir est dans l'Air'. (The picture in question is named after a scallop shell, which is scrambled together with a pipe and a newspaper among the table-top debris of a café. Perhaps there should be a subtitle, declaring that our evolutionary past was in the sea.) At ground level, God creates mess and muddle, as the trudging Biberkopf perceives; from mid-air, God is vindicated as a geometer. During the Renaissance, the formulation of rules for linear perspective imposed order on our cluttered visual field, marshalling objects to recede towards their vanishing point. But that order was fictitious, because there is no point at which objects obediently vanish. Aerial perspective, however, discovered a truth in this illusion. As the plane rises, the world dwindles and finally disappears, until the pilot decides to re-create it by descending. The moving plane is the still point on which all lines converge.

Picasso's pet name for his colleague Braque was 'Wilbourg', in homage to those aeronautical show-offs Orville and Wilbur Wright. Gertrude Stein reported that her own first flight showed her both 'the mingling lines of Picasso'

and 'the simple solutions of Braque'. She responded more ambiguously than Hemingway: she was struck by the way that the view below revised itself from moment to moment. Walking or driving over the ground, we take our bearings from objects which are fixed, even if they happen to be moving towards or away from us at a steady pace. In the air, we have no horizon to aim for, no landmarks – only a blurry sketch of objects seen from unfamiliar angles, all of them in perpetual motion. This, for Stein, evoked the graphic impatience of Picasso, whose 'mingling lines' are forever 'coming and going, developing and destroying themselves'. Picasso's angry revisionism coincides, as a motive of modern times, with the plane's breach of terrestrial bonds. The aerial view, as Stein concludes, reveals how 'everything destroys itself in the twentieth century and nothing continues'.

That vertical perspective was a view from the future, looking back at an earth to which men were no longer tethered. The photographer Berenice Abbott celebrated the evangelical nature of her own art. She called the photographer 'the contemporary being par excellence', because he created the sense of contemporaneity: 'through his eyes, the now becomes past.' Photography, spurning space and outpacing time, naturally took to the air. No sooner had buildings scaled the sky than photographers clambered up them to see how the world looked when the now became past.

Moholy-Nagy favoured the Pont Transbordeur in Marseilles and the Berlin Radio Tower. The bridge and the tower each served him as an 'optical instrument', an apparatus for objectifying. The depthless visual field so far below represented the world before the human eye had begun to sort it out into 'a conceptual image'. In 1925 Aleksandr Rodchenko aimed his camera up the tapering drainpipes and fire-escapes of a house on Myasnicka Street in Moscow; he also photographed the sheer drop from a ledge of the VKHUTEMAS polytechnic. During the 1930s, Berenice Abbott photographed the skyscrapers which were enabling New York to invade heaven. She often had to reassure security guards and janitors that she did not intend to throw herself off the roofs of their buildings. Lewis Hine – whose 'penetrating, eagle-like, agile, but disciplined eye' Abbott praised – swung in a bucket a quarter of a mile above ground while documenting the construction of the Empire State Building, and Margaret Bourke-White set up her studio behind the Chrysler Building's gargoyles, on whose backs she dizzily rode to photograph the city beneath. Later, working for *Life*, Bourke-White became something of a flying ace. The American air force took her along when it bombed the Nazi stronghold of Monte Cassino, and in 1945 she flew over German cities which had been pummelled by planes. She pleaded with pilots to make dare-devil manoeuvres so that she could stare directly into the basilisk face of the Statue of Liberty or photograph the plains of Kansas – unpeopled, a calligraphy of crops – from forty-two thousand feet.

During the Pacific war, Edward Steichen organized a team of Navy photographers, and logged his own experiences aboard the aircraft carrier *USS*

Lexington during combat. His photographs emphasize a grace which overcomes gravity. The plane-spotters on the *Lexington*'s deck jig back and forth balletically as they signal. Once propelled into the air, the pilots are catapulted into the modernist fourth dimension: Steichen imagined them as birdmen, whose bullet-like aerodynamism suggested one of Brancusi's gleaming steel sculptures. Like the anti-aircraft gunners, he found that he needed 'hair-trigger concentration' in order to capture aerial battles. A photographer must keep his head while undergoing a perceptual bombardment: 'you point towards a speck which at first you can hardly see' and 'try with each exposure to anticipate the split second when that moment's aim will be at its peak'. Technical skill depends on that quickwitted anticipation, an aptitude for thinking yourself a fraction of a second into the future.

When war began in 1939, the Royal Air Force recruited the painter Paul Nash as an official artist. He was expected to serve as the laureate of dogfights, celebrating the bravado of British aviators. But he soon warned of a problem. This war would be fought by machines, which reduced men to servile operators. In 1941 Nash painted the Battle of Britain as an exercise in wordlessly decorative sky-writing: all vortical whirls and spirals, a play of intertwined vapour trails above a cubistically flattened landscape. It takes an effort to remind yourself that the loop of black smoke records the track of a downed plane, plummeting into the water. There is no indication of which side the crashing plane belonged to. In this abstract expanse of air, does it really matter?

Nash did his best to make the battle intelligible by characterizing the mechanical combatants. The planes he painted constituted a bestiary. He called the big-snouted Sunderland bomber a 'noble beast', thought that the 'mammalian head' and scything fins of the Wellington made it a killer whale, and saw the long-nosed Blenheim as a shark, ready to gobble up the Luftwaffe's skinny fish. The clumsy, ominous Hampden had to be a pterodactyl, a 'flying lizard'. Once the machines had been turned into sentient creatures, destruction could seem creative after all. Thus Nash described a squadron of planes at night dropping bombs as if they were laying eggs. The metaphors, like the spells of Orpheus, charmed and tamed these fire-breathing furies – until the sceptical modern artist saw through his own sorcery. Nash likened the graceful, manoeuvrable Whitley bomber to a dove, and interpreted its mission redemptively: 'it might be the dove returning to the Ark on Mount Ararat'. Then, acknowledging the self-deception in all his figures of speech, he admitted that 'if it is a dove, it is a dove of death'.

Planes challenge our fondly anthropomorphic wishful thinking. Because they are so far beyond human capacities, we hardly have the right to see them in our own image. Ballard claims that the helicopter in particular spurns our offer of affection. Angrily buzzing, chopping up the sky, the helicopter reveals 'the deep hostility of the mineral world'. Nash called the Wellington bomber 'an avenging angel', but no such supernatural powers can be attributed to the helicopter. In

Ballard's *The Great Atrocity Exhibition*, the tottering gait of a Sikorsky chopper, thrashing the air with its lopsided rotary blades, makes it 'a crippled archangel'. But we continue to animalize these monsters, to whom we daily entrust our lives. We refer to the 747 by a pet name, calling it a jumbo – a fondly overweight elephant, buoyed up like Walt Disney's Dumbo by its flapping, aerodynamic ears. It is a wistfully primitive mental precaution. The machine, we imagine, will be less likely to kill us if we think of it as another living thing, and tame it with our colloquial endearments.

The Russian painter Kazimir Malevich wrote a tract in 1927 on *The Non-Objective World*, praising abstraction for having levered man aloft and established his dominion over the physical world. Malevich called his pictorial ideology suprematism. It combined the arrogance of Zarathustra with the revolutionary tactics of the Bolsheviks. In his account of the victory over reality, 'the familiar recedes even further and further into the background.... The contours of the objective world fade more and more, and so it goes, step by step, until finally the world – "everything we loved and by which we have lived" – becomes lost to sight.' What is this but a description of our view as a plane takes off? Wistfully poetic departures are, however, no longer tolerated. Brisk vertical rupture with those we love and the earth we used to live on counts as a heroic renunciation. In 1912 Marinetti used the aeroplane to assault cubism, with its claustrophobic, onerously solid forms. Flight exposed what Marinetti called 'the horror of the grim cube of my room, closed in on six sides like a coffin'. From further up, it disclosed 'the horror of the earth'.

Casimir Malevich Suprematist Composition: Airplane Flying (1915)

Malevich told his fellow 'art workers' in 1921 that their obligation was to uproot consciousness, to launch it for flight. Again there was messianic talk of a dawning era in which Einstein and Lenin would join forces to dynamize mankind, releasing us into 'a new fourth dimension of motion'. The imperative of the suprematist, in Malevich's manifesto, was to release energy by shattering an 'old organism', whose constituent units could now fly free, expanding 'within new, orbiting, spatial systems'. If this means anything at all, it is suspiciously like a recipe for bomb-making, since violence is a necessary ingredient of the

modernist campaign against reality, and Malevich compared 'the action of atomization' to the detonation of 'a multichambered cartridge'. In 1915 he painted an aeroplane which had been atomized. Disconnected panels of red, yellow, black and blue float on the white ether of the canvas. These angelic wings, not wired together or attached by a motor, are buoyed up by the thermal draughts of consciousness. Like the bird of paradise, this cerebral glider will never touch down for rest or refuelling. Suprematism intended to do away with Newton and his lowly physics. 'In the future,' said Malevich, 'not a single grounded structure will remain on earth. Nothing will be fastened or tied down. This is the true nature of the universe.'

Certainly it was the universe's true nature for the airman. Flying – which enables us to look at the earth's seams and schisms and to study the incursion of oceans – taught Saint-Exupéry that ours is 'a wandering planet'. Malevich admitted that, until the predicted lift-off took place, earthlings did need shelters, but in planning them he prepared them for levitation. The pilot's house which he designed for Leningrad in 1924 was modelled on a plane. The new man, the reformed being of whom the modernists dreamed, made himself manifest as a flier. Saint-Exupéry – who after 1926 flew across the Sahara and throughout South America with the pioneers of air mail – described a ramshackle bus which took him before dawn to the Toulouse airfield as a chrysalis from which he would emerge transfigured, ready to soar into 'interplanetary space'. He believed in the loftiness of the vocation, its almost monastic solitude. In *Vol de nuit* in 1931 he rejects the terrestrial happiness of love, preferring his higher mission.

After his transatlantic flight in 1927, Charles Lindbergh touched down outside Paris in a cruciform white hawk of canvas and silver metal. He was mobbed, as the American expatriate writer Harry Crosby reported, by postulants 'trying to touch the new Christ' whose 'Cross is the Plane'. More soberly, Bertolt Brecht in his text for the cantata *Der Lindberghflug* acclaimed the aviator as a model of heroism for the century which belonged to the common man. Brecht's Lindbergh is no perpendicular mystic; he humbly relies on his machine, recites a shopping list of its contents (electric lamps, matches, sewing kit and a rubber dinghy), and chats matily to the motor as they drone across the ocean together, asking if it is thirsty for oil or benzine. What keeps him going, through fog, snow and exhaustion, is his knowledge that men on the ground want him to succeed, and he perseveres on their behalf.

Lindbergh disavowed the Nietzschean notion of the pilot as a solitary superman, and his humdrum modesty set a precedent for Brecht's artistic colleagues. The cantata was jointly composed by Kurt Weill and Paul Hindemith, who agreed that in a collectivized modern world musicians should also share tasks, working together – like a team of engineers, or the flight crew of an aeroplane – for the good of all. *Der Lindberghflug* accommodates their very different musical interpretations of the subject. Weill wrote a jazzy accompaniment for the airman, who introduces himself by drawling 'Ich bin Amerikaner'. The

singer of the role is allowed one soaring vocal flourish, when he compares his own feat with the trivial thirty kilometres flown by Blériot in 1909: 'Ich überfliege dreitausend' he casually croons, and elongates the phrase as if to span the ocean, displaying his control of breath just as Lindbergh had shown off his control of air currents. Hindemith composed the sections describing the perils of the weather and the temptation of sleep. His textures are contrapuntally thicker and gloomier than Weill's, to suit the meteorological murk; the siren voice of a soprano entices the nodding pilot to close his eyes. Hindemith's Lindbergh suffers fleshly torments and spiritual trials. He is already in the embattled state of Hindemith's St Antony, withstanding the assault of infernal predators in the later symphony and opera *Mathis der Maler*, based on the Isenheim altarpiece painted by Matthias Grünewald. Weill's Lindbergh is a nonchalant populist, jazzily dancing on clouds; Hindemith sees him as a hero of dogged self-reliance, maintaining equilibrium – like Saint Antony, who between 1933 and 1938 supplied the composer with a symbol of opposition to the Nazis – in a state of turbulence.

Brecht derived an artistic and political moral of his own from Lindbergh's flight. The cantata's purpose, he starchily insisted, was to instruct, not to give pleasure. His text offered the listener an apparatus, which should be used as Lindbergh uses his plane. The machine needs to be driven; its power depends on human stamina and vigilance. Because the cantata was intended for performance on the radio, the listener had an additional responsibility. Brecht, like Walter Benjamin in his essay on mechanical reproduction and its desecration of art works, feared that 'the increasing concentration of mechanical means' might turn the user of appliances – a radio, a car, even a plane – into a lazy, passive consumer. Radio demanded, he said, the listener's resistance: he should be redrafted as a producer. We must talk back to the box which is lecturing us, like Lindbergh chatting to his motor. The cantata experimented with this new covenant between man and technology. When it was performed at Baden-Baden in 1929, Brecht set the radio orchestra on one side of the stage and on the other placed a listener, ensconced in an arm-chair, who was required to speak and sing Lindbergh's role. Rather than mutely auditing the news, he participated – like the newly enfranchised proletariat of revolutionary theory – in its making. Brecht's political doctrine caused him to worry about the attractiveness of Lindbergh. Worshipping heroes, we subscribe to a cult of personality which estranges us from the masses. At the beginning of the cantata, Lindbergh says that his name is of no importance. Whenever the work was performed in a concert-hall, Brecht directed that the part of the flier should be sung by a chorus, to prevent any individual from usurping credit for a collective achievement.

Brecht recruited an unwilling Lindbergh for Marxism. Arriving in Paris, he files a report announcing that the human race has at last come of age, casting off its chains. Saint-Exupéry thought differently about the ideology of flight. In *Terre des hommes* – published in 1939, when the European powers were mobilizing their air forces for war – he treated the technical rigour of flying as an end in

itself, a substitute for the philosophies over which the societies he surveyed down below were quarrelling. The opposed political religions had their different recipes for 'the salvation of mankind', but they ignored what Saint-Exupéry considered to be man's abiding need. 'We want', he said, 'to be set free' – freed from fear, and also from the clinging emotional ballast which he called our 'beloved servitudes'. The aeroplane, he thought, supplied this mental and metaphysical freedom. Through danger, it brought man to peace, and reconciled him to death by revealing how brief and chancy his life was – an adventure in a buffeting vacuum. Saint-Exupéry's career in the air was splendidly self-glorifying and ultimately pointless. He mocked the notion that his colleagues in Aéropostale had risked and lost their lives in order to deliver banal commercial mail. His own reconnaissance sortie over Vichy France from Orly to Arras in 1940 – described in *Pilote de guerre* – served no military purpose, and was undertaken as private atonement for his conquered country's shame. Unhappy belonging to any party, despising Gaullists and the Vichy collaborators alike, he joined the Allies because they permitted him to go on flying after the retirement age. Finally in 1944 he disappeared off the French coast, presumably shot down by the Germans.

The aeronautical code, because of its claim to have superseded politics, proved an ambiguous, increasingly sinister gospel. H.G. Wells trusted an élite of fliers with the government of a blitzed world in his film *Things to Come*, released in 1936. Seeing beyond borders, the airman – Wells thought – would surely possess the conscience of an internationalist. Yet the aeroplane had a cruder use, as a dictator's panopticon. Mayakovsky in his epic poem *Vladimir Ilyich Lenin*, written in 1924, imagines his hero in Swiss exile reading newspaper reports of insurrection at home and longing

O,

for an aeroplane

skyward to speed –

The indented lines of verse, like athletes straining on their marks, match Lenin's propulsive impatience. Instead of the plane Mayakovsky makes him wish for, Lenin travelled to the revolution by train, in a German goods wagon. Although Hitler built up his power in cellars and beer halls, Nazi mythology inevitably preferred to see him as descending directly from the sky, striving with storm clouds. In the prologue to Leni Riefenstahl's film *Triumph des Willens*, he arrives by air for the 1934 Party rally on the Zeppelin field, his plane's aquiline shadow swooping over the steeples of Nuremberg.

Lindbergh, the lanky saviour who was worshipped in 1927, gave disastrous advice from his vantage-point above the clouds. Impressed by the strength of the Luftwaffe, he advised that resistance to Hitler was useless. In 1941 the fascist Air Vice-Marshal in Rex Warner's novel *The Aerodrome* preaches a secular sermon which describes the first reptiles clumsily essaying flight and declares that the long travail of physical evolution has concluded with man's storming of the sky. All that remains is 'the transformation of consciousness and will, the escape

from time, the mastery of the self' – the disciplinary correction of human weakness which was practised by Saint-Exupéry at the controls of his plane. Modern wars were won in the air, but they also revealed that a disoriented aerial view of the world could not be trusted. From a vertical distance, the eye is easily duped. Cities at risk from bombers arranged for the pilots to misread their terrain. The Chinese defended Chungking against Japanese raids by camouflaging it. They draped their factories with terraced gardens; chimneys pretended to be trees. In Moscow, the Bolshoi warehouse loaned out tattered operatic sets so that buildings could wear fancy dress. Two-dimensional villages mushroomed in the squares, and rooftops were painted green to simulate open fields.

In the 1960s Lindbergh, by then one of the century's disgraced gods, visited the Tasaday tribe in a Philippine rain forest and repentantly reversed the evolutionary parable of Warner's Air Vice-Marshal. He now believed, he said, that 'the construction of an airplane is simple when compared to the evolutionary achievement of a bird', and he regretted that one drove out the other, because 'few birds exist' in the advanced civilizations which possess aviation industries.

At first, the new aerial perspective offered godly omniscience. Nietzsche's superman, with his head for dizzy heights, bragged that the best route through the mountains was to vault between peaks. The pilot took his advice. Saint-Exupéry reverently treated the planes he flew as analytical instruments. From them he at last recognized 'the true face of the earth', unintelligible to the myopic men who crawled on its crust. Flying towards Punta Arenas in Chile, he understood the precariousness of 'the southernmost town in the world', which made the best of its toehold between volcanic peaks and the polar ice. Those who are anchored to the ground – the cowardly, cringing bourgeois passengers on the Toulouse bus, compared to termites by Saint-Exupéry – delude themselves by thinking of it as fertile and friendly. The airman bracingly takes account of its bleakness, and responds to its challenge. 'Thus', says Saint-Exupéry, 'do we now assess man on a cosmic scale.'

Assessment on a cosmic scale, however, might deprive man of grandeur, and render individual lives insignificant. Even from the Great Wheel in the Prater, Harry Lime in *The Third Man* can disparage people as 'black flies' and ask whether it would really matter 'if one of those dots stopped moving – for ever?' This chilly detachment from common, grounded humanity was responsible for a homicidal modern syndrome, which Christopher Isherwood called 'aviators' caprice'. On his tour of China in 1938, Isherwood clung to the earth in panic during air raids by Japanese planes, remembering all the stories he had heard about this mechanical whimsy. Pilots often decided that they had a personal grudge against one of those bustling, redundant dots, which resembled 'an irritating fly'; they would discharge quantities of ammunition, just to make the dot stop moving.

Not all fliers rejoiced in their motorized divinity. The view from above, so headily extolled by Saint-Exupéry, could be desolate. In 1932 the critic Edmund

Wilson spent two days travelling by plane from New York to Los Angeles, where his wife had died after fracturing her skull in a fall. Stupefied by grief, Wilson passed the trip making notes in a journal. The discipline of observation kept him calm and prevented him from weeping; he placed his trust in the literary edict of his decade, which dealt with problems in society and in the psyche by a new method of detached, painstaking documentation – practised by John Dos Passos in his novels, and governmentally subsidized by the Federal Writers' Project of President Roosevelt's Works Progress Administration. But the outlook, estranged and anaesthetized by Wilson's state of shock, was cheerless, as if the observer were making his own elegiac departure from the earth.

The first mountains crossed after leaving the airport in New Jersey looked, he noted, 'like fairly unimportant creases in the earth'. Fields had apparently been cut from the frayed cloth of billiard tables, the mining towns of Pennsylvania and Ohio were 'a blot, a smudge', and 'ignoble dingy black cars' crawled on the highways 'like bugs'. Cleveland and Detroit were flat cities strewn across a flat, featureless continent, and Chicago amounted to not much more than a rectilinear grid of dwarfed cottages on a filled-in swamp. 'That', Wilson concluded, 'was all American civilization had been.' Around Salt Lake City, he stared at a 'sterile landscape'; traversing the 'vast waste' of Nevada, he picked out more evidence of exhaustion and emotional desiccation in 'the dried-up beds of rivers'. The pain of the spectacle was made more acute because it was so busily denied by the attendants on board. Hostesses distributed good cheer along with the sandwiches and pillows, and indulged in 'a lot of professional smiling'. Wilson was flying over an America sunk, like himself, in depressed inertia. Driving into Los Angeles, he sardonically noticed the roadside restaurants in the Good Humor chain. His personal misery, abetted by a vertical disenchantment, had taught him to mistrust the jollity they purveyed.

In 1955 in *Tristes Tropiques*, his meditation on man's misuse of nature, Claude Lévi-Strauss described a day, a night and a second day spent in mournful invigilation of the earth through the window of a plane flying from Europe across the Arabian desert to India. During the journey, civilization unravelled. Lévi-Strauss was travelling back to the source, towards those towns of the Indus valley where an urban, industrial, bourgeois society began four or five thousand years ago. But the view taught him to doubt the triumphant narrative of culture's advance from east to west. Vertical distance – though he was still low enough to study topography and notice patterns of crop cultivation – exposed the lie: human beings are parasites on a planet which, except in the privileged enclaves of Europe and North America, begrudges them a living.

At first, crossing from the Mediterranean into Egypt, the alienating shock was muffled by a superficial exoticism. Yes, the waters of the Nile really were the greenish colour of eau-de-Nil. Then came the Arabian desert. The sand might pretend to be flesh-coloured, catering to that irrepressible pathetic fallacy by which men colonize the land and make themselves at home by finding reflections

of themselves everywhere. But as the sifting annihilation continued, the passenger in the window seat saw only the evidence of destructiveness. Had the ground been punished by the trampling of a monstrous beast?

Almost mercifully, as the flight tracked towards Karachi, all trace of detail and differentiation was effaced. In 1890 Maurice Denis gave modernism its start by obliterating the subject in painting. Canvases, he said, did not tell stories; they were just coloured surfaces. It was an inflammatory statement then, an act of literal iconoclasm which cleared the way for abstract art. But it fell far short of the purgative disenchantment demanded by a modern man more than fifty years later. The colours projected onto that flat pictorial surface still suffused it with emotion, and thereby humanized it. This, crossing the Middle East, was how Lévi-Strauss unrepentantly viewed the desert, refusing to admit its cruel indifference. He lushly depicted the flesh-tinted sands – 'peach-bloom, mother-of-pearl, the iridescence of raw fish'. When night fell, he was forced to relinquish these hopeful metaphors. Peering down, he reported that 'the desert has become a desert even in relationship to itself'. On his first night flights over Argentina in the 1920s, Saint-Exupéry welcomed darkness and its challenge to his mettle. Adrift among the planets, man could still invent the geometry which he needed as guidance: 'set free by the coming of night, I shall chart my course in the stars.' For Lévi-Strauss, there was no such victory of aspiring, aeronautical mind over supine matter. The plane served as an engine of disillusionment.

After Karachi, the spectacle he described became lunar. Then, tentatively, the signs of a human presence returned. A ragged tapestry of fields announced India, its worn fabric perpetually darned, as if the earth were a threadbare counterpane. These quaint, quizzical divisions again suggested art, 'geographical musings by Paul Klee'. The image is witty and exact, because Klee's infantile scribbles resemble the scratch marks made by a God who has idly doodled the world and populated it with emaciated stick figures. Between Delhi and Calcutta, the land was submerged by floods – another state of elemental nonentity, like the Arabian night. Reconsidering the course he had flown, Lévi-Strauss summed up the ecological plight of the sub-continent, 'caught...between sand without men and men without earth'.

Early enthusiasts for aviation spoke of a 'highway of the air'. Today that highway is as choked, jammed and poisoned as its prototypes on the ground. To keep alive the twentieth century's dream of energetically escaping from mass – summed up in Romain Rolland's command to an aeronaut, who is told to 'Make space retreat' by taking off – we have had to reconstruct a more immaterial version of that highway, which completes the modern elimination of time and space. It compresses the globe into a domestic machine, and then fits the globe into our heads. This route, electronically speedier than ever before, is the information highway. Its magic carpet of data dispenses you from having to travel; it is a virtual autobahn, like the Grand Prix circuits which you tour at unimaginable speed while sitting still in front of a computer monitor.

SCRABBrrRrraaNNG

futurista

GRAAAG

TRAG

tam-tumb-
tumb tumb-tumb-tumb-tumb
-tumb rrrrrraah tatatatata rrrrrraah
tatatatata ṪUUM PAMPAM

Hotcholk
il vostro line
finestre sventrate
Qttrattrok

Pan pilik
Paaak
Piiin̄g

SCH

IIIAAAA

A

OOOO
OO
O

SIMULTANEITA
ESPLOSIONE

min. explosion

ISONZO
campestre intre fresco
notte collettismo battello

SCHI
U

SCHI
UUU

Guerra ai
tedeschi!!
comp. a gru

verdi idraiato

grazie
e ai suoi

ZAUM

'Zaum' is a word which, if it means anything at all, means that words have no necessary, inherent meaning; its coinage sums up the crisis of confidence suffered by language when confronting a modern world which its inherited implements could no longer describe. The Russian futurists made up the word in 1912 to justify their partiality for arbitrary neologisms, unintelligible slogans, fragmented phonemes, a music synthesized from mechanical din. To possess 'zaum' was to bypass reason. Atoms conjoined randomly. As Malevich pointed out in 1921, the perfection of nature lay in 'the blind, absolute freedom of units that exists within her'. Why should letters or syllables not couple with the same automatic promiscuity?

Marcel Duchamp – a virtuoso of nonsensical puns, who called his transvestite *alter ego* Rrose Sélavy – enjoyed the notion that 'words make love'. C'est la vie, as the surname of Rrose asserts (and who is to say that she has no right to customize her given name if she pleases?). André Breton once took up with a dancer at the Folies-Bergères who was famous for her foul mouth. Explaining his infatuation, Breton praised her 'freedom of language'. The surrealists encouraged language to betray itself, in inadvertent, scandalously candid slips of the tongue. Louis Aragon rejoiced when he happened upon a dubious establishment called MAISON ROUGE, whose sign announced its name in red letters. The joke was that, if you looked at the sign from a certain angle, MAISON disappeared and ROUGE could be read as POLICE – a neat subversion of both language and the law.

In humanist fables, language was the divine gift which singled man out from God's lowlier creatures. He alone can speak, while they growl, hiss or miaow; the privilege signified man's capacity for reason, and his entitlement to wield power over lesser species. Even when the religious pedigree faltered, language retained a civilizing mission: its elaborate, beautifully regulated artifice allowed men to domesticate the wilderness of rampant, anonymous objects. This pretension the early twentieth century set out to destroy. Mute reality had been

colonized by language; now things would be emancipated from the language which named and therefore presumed to own them, and man himself would be relieved of his burdensome articulacy. The world was to be read in a newly alienating, disengaged way. 'We pass for poets', Breton declared, 'primarily because we attack language, the worst convention of all.'

That convention was confounded in Zurich in 1916 by the coinage of the word Dada, a verbal alibi for inanity. Tristan Tzara, who founded the movement which the neologism named, insisted that 'DADA DOES NOT MEAN ANYTHING'. Like 'zaum', it was sound not sense: a rudimentary, elementary syllabic stammer. An even purer response was to dispense with utterance altogether, as the silent film did. The Hungarian director Béla Balázs – the librettist of Bartók's opera *Bluebeard's Castle*, and later a colleague of Eisenstein at the State Film Institute in Moscow – acclaimed the early cinema for leading the way backwards. Charlie Chaplin did not need to speak; his bow-legged, lopsided walk was eloquent on his behalf. 'It is the expressive movement, the gesture,' Balázs declared, 'that is the aboriginal mother-tongue of the human race.'

On his first flight in an aeroplane, Marinetti recognized that the old, orderly, Latinate syntax had to be cast off. The plane's whirling propeller dematerialized in motion: could the same thrilling haste be wished onto words, still grounded by plodding grammatical rules? Marinetti argued for 'parolibera' or freewordism, which his followers exemplified in graphic poems about their aeronautical exploits. Gino Cantarelli, describing take-off into the great solar cabaret of the sky, organized his words on the page in flapping, capitalized banners, or printed them in expanding strips as if they were bellowing from the mouth of a megaphone. A single letter, like the central vowel in SPAZIO (denoting space), grew gratuitously tall, measuring vertical distance with its skyscraping peak and marking its triumph with an exultant shout. In one of Paolo Buzzi's aerial poems, the words were coiled into a spiral, to plot the trajectory of a joy-riding plane: why should language accept its horizontal tetherage to the ground? Buzzi attempted a typographic representation of aerial bombardment, using words – jammed into triangular darts, or raining down in a thick shower of screeching vowels – as missiles. Above the damage, elongated question marks hung in the air like drifting plumes of smoke.

The music of the future, Marinetti thought, should be an art of untempered noise; the purpose of language was also to produce shrill, vital, spasmodic sound, not to utter orderly, rational sentences. The Dadaist Kurt Schwitters – whose cumulative masterpiece, his *Merzbau*, was a catacomb of litter, classified in separate cavities and annexes – treasured leavings scavenged from urban gutters, and extended this connoisseurship to rubbishy rejected sounds which aspired to the dignity of neither language nor music: the rumble of engines, the air violently expelled from the human body by a sneeze. During the 1920s in Hanover, Schwitters composed and performed (with no instrument but his own yelping, keening voice and his rhythmically agitated arms) a *Sonata in Primeval Sounds*,

*Kurt Schwitters
citing his poem
'Da steht ein
Mann' in 1923*

which began with a majestic theme transcribed as 'Fümms bö wö tää zää Uu' and climbed to a climactic emission of breath on the vocable 'Ooooooooooooooooo ooooooooooooooooo'. Exiled in London during the 1940s, he orchestrated a symphony which contrapuntally combined the discreet sniffles and eruptive snorts overheard on a bus during the season of colds and influenza:

TSCHIA
HAISCH
HAPPAISCH
HAPPAPEPPAISCH

– and so on, arriving at a stormy final cadence

HAPPAPEPPE TSCHAA!

In 1962 and 1965 the Hungarian composer György Ligeti composed two short music-theatre pieces, *Aventures* and *Nouvelles aventures*, which are operas without words. The singers utter phonemes, not articulate sounds: grunts, growls, squeals, cackles, wails, finally augmented by the crash of broken crockery. These noises are the atomic particles from which a language might be made, but Ligeti's singers do not need to advance to that next, more rational stage. Opera is an arena of instinct and riotous id. Its characters express themselves in spite of words (which usually remain indistinct, obliterated by the orchestra) rather than by means of them; their eloquence is that of a barking dog, a purring cat, or a hungry baby. The meaning of a high C has little to do with the word the composer sets it to. It is a primal cry, of joy or terror depending on the key. To use the distinction introduced by Saussure's structural linguistics, it is a 'signifier' but not a 'signified'; it signifies a certain emotion, though it has no precise and paraphrasable significance. Ligeti's vocalists are happy to unlearn language. Inarticulacy opens their throats and liberates their guttural desires.

The civilizing of mankind, like the education of an individual, began with the learning of language, and graduated through the acquisition of ever more complex words. Modernity sought to undo this progressive history. Art's duty, in the grand humanist tradition, was to narrate and thereby complete the history of civilization. Hence Homer's pedigrees, deciphering the shield of Achilles and the lore inscribed on it, or the series of paintings by Piero di Cosimo which commemorate the human conquest of wild nature. But how could such complacent confidence account for the twentieth century's experience of barbarity? Modern times defiantly reverted to the beginnings of the race, to those mystified,

pre-literate days when, as Malevich said in an essay in 1919, 'man began to cognize the world…by composing signs'.

Cognizing begins, but cognition – a rational understanding which allays terrors by proprietorially assigning names or making captive replicas – is never arrived at. Humanism definitively rationalized the world, and Christianity discerned in every created object an emblem of divine grace. But modernism restored to the sign its baffling, baleful unreadability. Watches melt, giraffes catch fire, women wear several faces simultaneously.

The reforming campaign had an alarming agenda: the sign could no longer be permitted to operate as an individual's signature. In Musil's *The Man Without Qualities*, the assault on human identity entails an attack on writing. The crackpot bureaucrats of the Collateral Campaign wish to enforce the use of shorthand in the empire. They denounce the 'senseless loops' of 'the long-eared or asinine script, as it might be called'. The incidence of one-stroke letters – O, S, I and G – in shop signs is also considered a danger to public health, and Count Leinsdorf proposes legislation compelling shop-owners to use only four-stroke letters – M, E or W, for instance – in their placards. His pastime in the streets is to count the number of strokes in a sign, then to divide the total by the number of letters; an uneven outcome causes him pain. Personal choice is to be overruled so that he can practice his mental arithmetic in peace. The mad Count is in his way an exemplary modernist. He reads the world as an alien, abstractly; his eye refuses the bait of familiarity. Because the qualities which pretend to render each of us unique are an illusion, why should words go on telling their customized lies? If we sign our names with an idiosyncratic flourish, to deter others from usurpation or forgery, we ourselves are committing a fraud. Deconstruction begins in Kakania.

Kandinsky could not accept this as the last word on words. He claimed that 'Modern art can only be born when signs become symbols.' The sign – jolted from the context in which it belongs, read merely as squiggly ornamentation by Musil's reformers – is agnostic, unknowable. De Chirico called his paintings enigmas. Whose body casts that fugitive shadow, imprinted on the scorching piazza? There can be no answer; the sphinx lacks a secret. Or else the sign propounds a meaning which is too rudimentary and self-evident to be trusted. In a 1919 painting by Georges Braque, the contents of a café-bar – chairs, tables, a guitarist, his newspaper and pipe – have been jumbled and merged so that you can no longer tell the difference between the customer's limbs and the arms and legs of the furniture. Nevertheless the sign across the window continues to read CAFÉ-BAR, as if no perceptual revolution had occurred on the premises.

Kandinsky wanted to save these jokily banal or blatant signs from randomness, to re-invest them with authority as symbolic portents. In 1911 he painted a bright, blooming apocalypse. The three riders who announce the end of time gallop towards the new dawn through a landscape whose hills explode into lakes of effusive, contagious colour. In another painting of the same year, he abstracted the evangelists. They are now only lines of forces, like the arcs of

their spears, and the world they arrive to disestablish has already blurred into blue and yellow clouds, with only a few strands of grass left clinging to material form. For Kandinsky, abstraction meant spiritual induction, a transcendence of the real. In 1912 his colleague Franz Marc described in the periodical *Der Blaue Reiter* their common desire 'to create symbols for their era, symbols that belong on the altars of the coming spiritual religions'. Marc's blue horse was one such luminous advent. He miraculously uplifted the beast of burden and made it ready for the theosophical kingdom to come, when 'the technical producer will vanish'.

Georges Braque
Café-Bar
(1919)

Symbols traditionally proclaimed the immanence of heaven. Signs, more troublingly and perhaps more truthfully, tell of our perdition. In 1913 de Chirico described an epiphany experienced at Versailles, a reminder of the superstitious fears which – as a modern man, living in a technically regimented society – he perversely envied. Alone in the geometrical halls of glass, surveying the marble heroes who gesticulated on the terrace, shivering in a wintry sun which poured down '*without love*, like perfect song', he suddenly felt that every window was a watching eye, every statue a rustling, animistic presence. The setting of this vision was wittily apt. The palace with its tamed, trimmed gardens turned back into a haunted, aboriginal forest. In 1902 Hugo von Hofmannsthal evoked a similar landscape when describing the disorientation of his imaginary Elizabethan nobleman Lord Chandos, who has abandoned all literary activity because words and the ideas they refer to have suddenly become self-enclosed, uncommunicative. 'I felt', Chandos testifies, 'like someone locked in a garden surrounded by eyeless statues.' The statues whose eyes have been put out cannot look at you to signal their meaning. They remain unreadable signs, blinded as well as pathetically dumb.

Through the disablement of Chandos, Hofmannsthal communicated his own inability to deal with a modern world which had separated matter from spirit, word from idea. De Chirico had outgrown such qualms. He rejoiced in his panic as 'eternal proof of the irrationality of the universe'. Among the gilded mirrors and strictly disciplined trees of Versailles, he reflected that 'Original man

must have wandered through a world full of uncanny signs. He must have trembled at each step.' Freud promised an end to mystification, assuring his patients that the scientific march of mind, as the nineteenth century confidently called it, was due to conquer that last hold-out of unreason, the human head. In opposition, de Chirico declared himself proud to have inherited from 'prehistoric man' a gift of presentiment. The child – unlettered, instinctual, a prey to metaphysical hysteria – represents the prehistoric sediment in all of us, which is why the Dadaists perhaps took the name of their movement from the infant's first faltering attempt at speech, 'Da-Da'. James Joyce wrote the opening of his autobiographical novel *A Portrait of the Artist as a Young Man* in baby talk, with moocows and a 'nicens little boy'. For one of the narratives in *The Sound and the Fury*, William Faulkner adopted the disorganized world-view and the disjointed syntax of the idiot Benjy, who tells a tale 'signifying nothing'. Alexei Kruchenykh, one of the theorists of 'zaum', dispensed in 1921 with the notion of linguistic correctness and disparaged all standards. He insisted on the value of speech defects – lisps, or the stammering imitated by Dada – because they renovated language, and he prized the inadvertent poetry of misprints. He would surely have approved of the blurting Freudian slip, which demonstrates that language is using us rather than the other way about.

Zealously destructive, Malevich claimed that 'words are only distinguishing signs, and that's all'. In 1915 he made a series of paintings which cleansed those signs of fussy significance. In *Painterly Realism. Boy with Knapsack – Colour Masses in the Fourth Dimension*, the boy is a black rectangle and the knapsack is a smaller rectangle in red, hanging at an angle. *Red Square (Peasant Woman. Suprematism)* is merely a red square in a white border: no peasant woman is present, and neither is the Red Square beneath the Kremlin walls. At its most dogmatic, abstraction planned the purgative destruction of the old, quaint, contemptibly picturesque reality which Malevich mocked in the title *Painterly Realism*. Piet Mondrian envisaged a rectified society – foreseen in his paintings, with their austerely regular grids of stripes – in which there would be no more individuals, only universals.

The reduction of words to signs served the same purpose. It effaced history, abolished precedent, rendered the world unrecognizable and thus immune to cognition. Braque and Picasso included scraps of illegible newsprint and shredded headlines in their collages, while Schwitters scissored the meaningless syllable Merz – the name he applied to the objects stored in his reliquary of rubbish – from an advertisement for the Commerz- und Privat-Bank. Words crave company. They can transmit the proper signals only if arranged into phrases and sentences; a language is an inexhaustible set of combinations and permutations. The modernists atomized this compound. De Chirico praised 'the solitude of signs', exemplified in some landscape paintings by Poussin and Claude from which, he was pleased to report, 'man as a human being is absent'.

Those landscapes could not be anthropomorphized, because the painters had excluded human witnesses; for de Chirico, signs should also remain solitary,

isolated from any system which would confer meaning on them. Words are mere verbiage, a jabbering interference like voices trapped in the limbo of a radio frequency. One of modernism's brave, ruthless projects was a campaign to dehumanize the world, driving out man and demolishing all his works.

The assault began with an inquisition of language, the loftiest of our collective creations and the ground of our community. In 1911 the Viennese philosopher Ludwig Wittgenstein began work on his *Tractatus Logico-Philosophicus*, published in 1921, which opened a fissure between words and the reality they purport to describe.

The world, in Wittgenstein's account of it, consists of 'atomic facts', to which we attach verbal labels. But a word is no more than the picture of a thing. The two can never be matched, because the act of picturing is so subjective. Einstein shared this suspicion of the pictorial faculty. He argued that sensory impressions and the images collected by memory do not qualify as 'thinking'. Thought cannot occur unless 'pictures form series' and 'a certain picture turns up in many such series', which introduces 'an ordering element'. Only then has there been progress beyond what Einstein dismissively termed 'free association or "dreaming"' – the disgraced habits of romantic reverie, earnestly cultivated in the previous century. Modern painters, as if anxious to transform pictorial representation into a course of intellectual research, planned their work in the serial way recommended by Einstein, relying on repetition to emphasize the 'ordering element' – Cézanne's patient scrutiny of Mont Sainte-Victoire; the cafés and still lifes of Picasso and Braque; the suprematist compositions of Malevich between 1915 and 1918, which successively annihilated the subject, finally reaching a state of pure, blinding abstractness in a painting which sets a white square on a white background. Romantic art cultivated the fugitive sketch or the anecdotal moment, like Constable's jotted notations of clouds or Keats's glancing acquaintance with the nightingale. Modernity mistrusted these instantaneous images, and doubted whether images had any value at all. Who can imagine an atomic fact? Who knows what an atom looks like? Does it even matter what name we give it?

Wittgenstein, illustrating the relativity of language, supposed that 'everyone had a box with something in it: we call it a "beetle"'. The rules of the language game debar each player from looking into anyone else's box, which means that our only reference for all those presumed beetles is the specimen in our private box – that is, if our box really does contain a beetle, because we all might just as well be bluffing each other. There is no way of co-ordinating the mental pictures we have separately formed: this is de Chirico's plaintive, ineffectual 'solitude of signs'. Wittgenstein, conceding that all those shuttered cerebral compartments might be empty, concluded that 'one can "divide through" by the thing in the box; it cancels out, whatever it is'. It is another desolating image of divine absenteeism: the tabernacle contains at best (and then only if we are lucky) an insect.

One of the first readymades constructed by Duchamp in 1916, after he moved from Paris to New York, might have been an attempt to play Wittgenstein's sceptical game in three dimensions. He screwed together two brass plates which clenched a ball of string. Later the collector Walter Arensberg, taking possession of this conceptual toy, unscrewed the plates and placed an incognito object – we might playfully call it a 'beetle', since none of us knows what such a creature is – inside the ball of string. When the piece was put together again, it rattled. Duchamp reacted with doleful glee. Arensberg never told him what caused the rattling; nor did he wish to know. 'The noise', he said, 'was a secret for me', and he entitled the readymade '*With Hidden Noise*'. That secret noise is the sound made by modern language-users, immured in the solitary confinement of their separate monologues, like the uncommunicating talkers in Joyce's *Ulysses*, T.S. Eliot's *The Waste Land* or Virginia Woolf's *The Waves*.

Marcel Duchamp Ball of Twine 'With Hidden Noise' *(1916)*

For Hofmannsthal, this loss of linguistic faith was a personal sorrow, for Antonin Artaud a symptom of mental derangement. For Karl Kraus, it constituted a public catastrophe.

At the beginning of the century, Hofmannsthal abruptly stopped writing poetry. He explained the reasons for this renunciation in the letter purportedly written by Lord Chandos, explaining his own abrupt retirement in 1603 to the philosopher and statesman Francis Bacon. The choice of addressee is significant. Bacon's was the most omniscient intellect of his age, and his *Advancement of Learning* defined the procedures for an inductive investigation of nature. It is unsurprising (without being plausible) that partisans should have credited him with the authorship of Shakespeare's plays, because the linguistic originality of Shakespeare – his teeming coinages and prodigal metaphors – made its own contribution to the progress of knowledge. Shakespeare enriched the world by inventing new ways of describing it. His vociferous people, like gods, spawn worlds as they speak. Language supplies them with credentials, and entitles them to power. The rebel Jack Cade in *Henry VI* declares that his mouth will be the parliament of

England. But this voluble delight is unavailable to Chandos, who writes to Bacon what he dare not say out loud.

Through this *alter ego*, Hofmannsthal confided his personal experience of atomization: 'For me, everything disintegrated into parts, those parts again into parts; no longer would anything let itself be encompassed by a single idea.' The analytic method, breaking things down into their constituent parts, was a tool of Baconian science in the sixteenth and seventeenth centuries. Employing it, John Donne wrote a poetic *Anatomie of the World*: the world an-atomized, separated out into atoms. Chandos, obliquely chiding Bacon, laments the destructiveness of such a vision. Robert Musil, more valiant in his response to the challenge of modernity, described that disintegration in 1912 as a strategy of 'mathematical daring'. Even so, as if recognizing the misery of Hofmannsthal's letter-writer, he admitted that this scientific attitude caused people to 'dissolve in futility'. Chandos, like the hero of Musil's novel, is a man who finds himself suddenly bereft of qualities.

When learning advanced as far as Heisenberg's uncertainties and Wittgenstein's cell-like boxes, philosophy reserved one small compensation for the depleted human ego, which had been made to forfeit its sense of priority and privileged separateness. Alfred North Whitehead, Bertrand Russell's collaborator on the *Principia Mathematica*, encouraged men to abandon the conceit of 'independent existence', since 'every entity is only to be understood in terms of the way it is interwoven with the rest of the universe'. That is why the patron in Braque's café-bar is interwoven with his guitar, the table he sits at, the fruit he eats and the patterned tiles on the floor. Cubist paintings were parables about this new 'mode of existence' as Whitehead called it, and our jostling merger with the universe. Wittgenstein in his *Tractatus* put the same perception another way, arguing that no object can be conceived of apart from its context. Each thing must be located within 'the state of things'. We are licensed to exist, in the crowded plenum of modern reality, only insofar as we are connected to other existences, animate or not. Wyndham Lewis, as if surveying one of those cubist table-tops, insisted that 'chairs and tables…are animated into a magnetic restlessness, and exist on the same vital terms as man'. Lewis likened furniture to 'the most sluggish animals'. What difference is there between a sofa and a dog asleep on it? In Lewis's formulation, 'all is alive; and, in that sense, all is mental'.

This was the modern prospect which dismayed and disgusted Chandos. Hofmannsthal's romantic poetry depended, as he said in his verses on evanescence, on a trinitarian unity of three in one, joining self, reality and dream – 'Und Drei sind Eins: ein Mensch, ein Ding, ein Traum.' Now the self, sidelined in impotence, stared in disbelief at a world which had splintered into barbed, hostile bits and pieces. A word, for Hofmannsthal, was an incantation. One of his ballads concludes with a meditation on the word 'Abend', rather than the evening itself. Sadness and deep meaning drip from the word, he says, like thick honey. Merely to utter it is to paraphrase a truth. But for Chandos, words have atomized. Falling

out of the sentences which gave them meaning, they threaten him like de Chirico's invigilating windows and marble sentinels at Versailles. 'Single words floated around me; they congealed into eyes which stared at me and into which I was forced to stare back – whirlpools which give me vertigo and, reeling incessantly, lead into the void.' The nourishing wisdom contained, as in a honeycomb, by the two syllables of 'Abend' gives way to the resonant emptiness of 'zaum'.

Hofmannsthal made this modern epiphany less terrifying by backdating it – to the Renaissance in the Chandos letter, to Greek antiquity in his libretti for Strauss's operas. He admitted that his adaptations of classical myth had a subversive modern purpose, because they all dealt with 'the dissolution of the concept of individuality', that moral vertigo which follows from the loss of faith in language. In *Elektra*, Hofmannsthal's version of the Sophoclean tragedy which was the first of his dramas to be set by Strauss, the heroine talks endlessly of a revenge which she cannot enact. When Orest arrives to perform a deed she can only imagine, she forgets to give him the axe she has kept for the occasion. She repeats the name of their murdered father Agamemnon, and the orchestra takes up her threnody to reveal how the word sings silently inside her head; but the invocation merely confirms her impotence. Even her great cry of recognition, 'Orest!', comes too late. Engrossed in her own dreams, she is the last person to recognize the brother she is dreaming about. Nor does he recognize her. She has to identify herself to him, indignant that her tormentors have taken her name away from her. The heroines of Hofmannsthal's later collaborations with Strauss have an even more insecure tenure of their names and identities. In *Das ägyptische Helena*, Helen of Troy persuades Menelaus that she is not the woman who betrayed him: the Trojan war was fought over a phantom, while she remained in Egypt. In *Ariadne auf Naxos*, Ariadne's grief after her desertion by Theseus ends when she is claimed by a new god, Bacchus. She regards this revival as a death, and believes that she no longer deserves the name which she earned from all those retellings of the mythological tale. Emitting a lyrical last gasp, she asks 'Bleibt nichts von Ariadne als ein Hauch?' – is this all that remains of Ariadne: a breath? But what else remains of language, after the realization of Chandos? Having given up poetry, Hofmannsthal relied on the voluminous orchestra of Strauss to supply a force and conviction which language had forfeited.

Despite Hofmannsthal's renunciation, it was of course still possible to write poetry in this new state of linguistic doubt. Eliot did so in *The Waste Land*, with the editorial help of Ezra Pound, who taught him the value of truncation and disorienting omission. A poem could do without the poet's originating, interpreting voice, chancily piecing itself together – like a city, or a newspaper – from the half-heard, polyphonic chattering of strangers. The Grumbler, Karl Kraus's spokesman in *The Last Days of Mankind*, has a telephone with a party line, and without having to ring the operator he can audit the secret lives of everyone in his Viennese neighbourhood. Whenever he lifts the receiver, he hears commercial intrigues, arrangements for a poker game, and urgent sexual intimacies.

Though he complains of the inconvenience, it allows him to overhear the crossed wires and automatic blather of the collective unconsciousness, like Eliot and Joyce in their urban epics. The unconscious mind, like the city, spends its time recycling events. *The Last Days of Mankind*, between the intermittent dialogues of the Grumbler and his straight man, the Optimist, is made up of quotations. Journalists, incriminating themselves, are made to recite out loud their tub-thumping editorials and dishonestly patriotic dispatches from the front.

Kraus, unlike Hofmannsthal, took sardonic delight in the soiled, second-hand nature of language. A modern poem must be a latter-day creation. Its raw material is the debris of previous literature, because if time is ending, then everything worth saying has been already said. Joyce transposed the *Odyssey* to contemporary Dublin, and Eliot in *The Waste Land* adapted the quest for the Grail to an irredeemable modern London. In 1920 Tristan Tzara printed his personal recipe for making a Dadaist poem:

> Take a newspaper.
> Take a pair of scissors.
> Choose an article as long as you are planning to make your poem.
> Cut out the article.

Next you cut out each word separately, put the words in a bag, shake them up, remove the scraps one by one and transcribe them in that accidental sequence. William S. Burroughs adopted the same method for his cut-up novels during the 1950s, recommending the use of 'scissors or switchblade as preferred'.

Hofmannsthal – who referred, like an incapable Orpheus, to his 'schmale Leier', his thin lyre – could not write poetry of this kind, which is why he gave up the art. In 1923 Antonin Artaud underwent a similar disillusionment. He submitted some poems to *La Nouvelle Revue Française*, whose editor, Jacques Rivière, rejected them for being too quirky and cranky. Artaud pleaded with him, as a matter of mental life and death, to grant the poems the right to exist. He appealed to Rivière's compassion: 'I suffer from a horrible sickness of the mind.' His ailment was that of Hofmannsthal's Chandos, who has lost faith in conceptual thought. Artaud felt that his consciousness disowned him, shaming him by enunciating thoughts which belonged to a mad, unintelligible stranger. His fragmentary writings were an effort to gain possession and control of the antic spirit which inhabited his head. The words, he acknowledged, may have been imperfect, but at least they detained those fugitive thoughts in material form and helped him fend off his suspicion of 'absolute non-existence'. Rivière, using the image of the vortex employed by Chandos, noticed that Artaud's handwriting – 'tormented, wavering, collapsing, as if sucked in…by secret whirlpools' – testified to his distress. Nevertheless, he would not reprieve the poems. Artaud, who felt that 'the poison of being' had deprived him of speech, turned to creative forms which disdained our 'intellectual subjugation to language'. First came the visceral physical stress and strain of his Theatre of Cruelty. The actors chanted, ranted, howled, and used their voices for anything but speech; the aim was to

make the audience scream. Finally, during his years in an asylum, Artaud retreated into the ecstatic unintelligibility of madness.

Karl Kraus, rather than complaining that words had failed him, like Chandos, or confessing that he had failed them, like Artaud, accused language of having betrayed us all. In his judgment, the stealthy doubt which caused Chandos to fall silent and paralysed Artaud was replaced by the blatant noise of language set free, spewed forth by printing presses and belligerent politicians, mimicked by guns. The corruption of words almost caused Kraus to stop using them. He became an angry, fanatical connoisseur of the language misused by others – a collector of quotations like Eliot and Pound, a jesting, grieving anthologist of the verbal waste which congested the world. There was no longer any need for him to write, he sighed: 'I have become a simple newspaper reader.' In February 1915 he reprinted in his satiric periodical *Die Fackel* two parallel columns from the same day's paper. In one, a battalion offers itself to the enemy guns, with limbs blasted off, heads scattered to the winds, hillocks of corpses. In the other, the Kaiser-Wilhelm Café in Vienna celebrates its grand opening – all smarmy cosiness, cheery flowers and glittering chandeliers, with local dignitaries feeding on snacks or lounging at the bar. The two reports collide; the paper makes no attempt to explain or apologize for the fact that carnage and revelry are happening side by side.

Chandos was terrified by the schizoid division between subject and object, which had become separate, competing realities. In the newspaper, schizophrenia is a happy fact of life, a principle of typographical layout. The compartmentalized columns reprinted by Kraus stand for the divided mind of a society whose civilian and military halves cannot acknowledge each other. In 1914, Kraus blamed newspapers for insulating us from the truths they claimed to be reporting: they have 'produced in mankind that degree of unimaginativeness which enables it to wage a war of extermination against itself'. In the Bible, the world begins with the advent of a word. *The Last Days of Mankind* terminates the miracle: 'In the end was the word.' The letter, churned out by a war-mongering press, finally kills the spirit. Nature is massacred to fuel the machines. Among the news items over which the Grumbler broods is an account of an experiment at a paper mill in the Harz mountains, whose owner is anxious to see how long it takes to convert a living organism into a newspaper. He fells three trees in the forest at 7.35 a.m., scales off their bark, pulps them, and delivers them to a printing plant which by 11 a.m. has an edition ready for sale on the streets. In two concurrent scenes, Moritz Benedikt – Kraus's particular bugbear, the editor of the Viennese *Neue Freie Presse* – dictates a bloodthirsty sermon while his enfeebled namesake in the Vatican, Pope Benedict XV, futilely prays for peace. God's self-appointed deputy is now the journalist, not the priest. Benedict XV whimpers about the slaughter, but Moritz Benedikt reasons that it must surely be serving the creator's grand design, because the fish, lobsters and sea-spiders of the Adriatic can feast on the sailors whose ships have been punctured by German torpedoes. Armageddon, when it arrives,

is marked by the publication of an 'Extrablatt', a last and positively final instalment of expiring humanity's chronicle, sold in the darkening street by maenads, who groan and scream their wares. Mankind's agony concludes, in their cries, with the degeneration of language into noise.

For Kraus, paper itself came to symbolize falsity, the forgery of truth. A spoken word may serve as a bond, because it can be verified by looking into the eyes of whoever speaks it. But a word written down is ownerless, unauthenticated, perhaps worth no more than the paper it is scrawled on. In *The Last Days of Mankind* a pastor urges that peace treaties should be considered as mere scraps of paper, to be torn up and thrown into the fire, and a poet proposes that the latest war bonds should be entitled the Truth Issue.

Spengler blamed the same reliance on paper for the modern world's economic fatality. The West began to decline, he thought, when coinage – underpinned by precious metals, and connected to the hard work of unearthing them – was supplanted by paper money, which merely symbolized value rather than incarnating it. The same printing press which manufactured journalistic lies could turn out economic fictions, like the worthless one-thousand-billion-mark note issued by the Reichsbank during Germany's inflation in the 1920s. Money, like language, is a means of exchange whose circulation creates and sustains the sense of community. Unstable currency and flatulent speech are both symptoms of social breakdown. Isherwood, describing Berlin before the Nazi take-over in 1933, remarked that 'the murder reporters and the jazz-writers had inflated the German language beyond recall'. The political invective of the newspapers – Versailles-lackey, Hitler-swamp, Red-pest – had been emptied of meaning by over-use, so vituperation resembled the ceremonious titular courtesy of the Chinese. The Reichsmark had long ago quit the gold standard, and popular songs likewise dealt in a 'miserably devaluated' vocabulary: 'The word *Liebe*, soaring from the Goethe standard, was no longer worth a whore's kiss.'

Isherwood's pun on Goethe and gold, reaching across the disputed national border between languages, hopelessly invoked a classical conscience which upholds truth and guards value. But such standards had been dethroned. Duchamp's so-called 'Standard Stops' even relativized the metre, despite the regulating edicts of the International Bureau of Weights and Measures. If words, as Wittgenstein claimed, can only approximately depict things, how could they be expected to accurately translate feelings? *The Last Days of Mankind* mocks the xenophobic purge of imported words in Germany and Austria at the outset of the war. A sign-painter neatly naturalizes the Café Westminster as the Westmünster; mayonnaise is paraphrased as egg-and-oil dressing, and Hollandaise sauce is stoutly, patriotically translated as Dutch. The establishment stays the same, and so do the dishes on the menu. Words are a fickle, fraudulent shadow-play; things remain incorrigible.

Perhaps language was not God's bequest to us but the devil's, because of its genius for misrepresenting or obscuring the truth. The despair of Chandos

introduces one of the twentieth century's most anguished debates: a prosecution of guilty language, which has compelled literature to examine and condemn itself. Kraus's Grumbler argues that 'no people lives further from its language, and thus from the source of its life, than the Germans'. Aesthetes, he adds, are enraptured by the sound of words (like Hofmannsthal sucking honey from 'Abend'), just as bibliophiles drool over exquisite typography and expensive bindings. This preciosity loves language to death, estranging words from their daily uses. Meanwhile, the actual speech of Germans 'congealed into set phrases and stock terminology', preparing them for surrender to a dictatorship which relied on befuddling jargon and the hypnotized repetition of sacred slogans. In 1933 Kraus analysed Nazi euphemisms, which were a device for thinking the unthinkable and for bureaucratizing obscenity. The concentration camp was described by its proud inventors as an educational institution, even a sanatorium. Yet the perjured words could not help letting slip an illicit truth, like a stifled cry for aid. 'By its very set-up,' Kraus mordantly commented, 'such a camp is better suited to concentration than to diversion.' Nazi neologisms were essential to the policy of extermination: they muffled the violence and anaesthetized the pain (at least for those who were not victims). What better evidence could there be of language's collusion with evil?

Kraus – who died in 1936, before the Nazi annexation of Austria – claimed that there was nothing he could say about Hitler. His refusal was misunderstood, and colleagues charged him with 'Jewish self-hatred'. But politics had forced him into something like the disablement of Hofmannsthal's Chandos. Language, his only means of retaliation, had been co-opted by the enemy. He retreated into the discipline of fastidious proof-reading and insisted, in another literary death-wish, that he would rather his complete works perished than that they should appear with a single comma misplaced. Elsewhere, the reform of language resulted in small, silent, ineffectual gestures. In 1925 at the Bauhaus (or, as it called itself, the bauhaus), typography was redesigned to eliminate capital letters. A uniform lower case looked more democratic, and the designers reasoned that there was no point in writing capitals if we could not speak them. But authority ignored this effort to disarm language; the Nazis summarily closed down the last Bauhaus school in Berlin in 1933.

When, after the War, Germany settled down to forgetting, words once again offered a convenient oblivion. The solemn, officious name given to the camps was contracted, as if diminishing the word erased the thing: the impatient shorthand for

Franz Roh's design for a sanserif alphabe abolishing capi letters (1929)

'Konzentrationslager' became KZ. Literary testimony was struck dumb. The poet Paul Celan – a Romanian Jew whose family perished as part of the 'final solution', and who killed himself in Paris in 1970 – could only paraphrase genocide as 'that which happened'. In 'Todesfuge', his fugue about death, he approached the subject elliptically. The poem contrapuntally interweaves symbols which, in reverence or terror, recoil from naming the events they refer to – black milk of dawn drunk at evening, a grave dug in the clouds, a man with blue eyes and a girl with golden hair. The broken, recurrent, obsessively recombined phrases of 'Todesfuge' still suffer from the dislocation which Chandos lamented. They remain in isolation from each other, or are pieced together in the wrong, illogical order by Celan's fugue. But the gap between words and things, which vexed Wittgenstein, dismayed Hofmannsthal and enraged Kraus, offers to Celan a small mercy. Language erects its own fragile barricade against unspeakable existence.

In 1926 Alfred Polgar wrote an essay explaining why he refused to read novels. The crowding of the planet was partly to blame; so was the rampant monetary inflation. The world suffered, he thought, from hypertrophy, like the exponentiating zeroes added to the German mark. Its cities already bulged with mobs of strangers. Why, given this 'overpopulation of consciousness', should we bother with books about 'people who don't exist and never did'?

Polgar preferred to read grammars, no matter what language they belonged to. He had no interest in studying the habits of reflexive verbs or the quirks of the subjunctive mood; he merely enjoyed the exhibition of a language's form and its functions. Grammars possessed all the sleek, stylish, modernistic virtues, like the cool surfaces and aerodynamic curves of Art Deco ornament: Polgar thought them 'wonderfully fresh, firm, and durable'. They shared the morphological candour of modern buildings which wear their bones outside their flesh or, following the example of the Eiffel Tower, dispense with fleshly cladding altogether. Grammars 'relate to literature like a skeleton to the soft parts of the body.... Here, in grammar, lies disassembled the basic frame of all imaginable structures of thought, with grooves, clamps, cross beams, and bolts. Everything can develop from it. There is no more modern book than a grammar.'

The prime intellectual requirement of modernity was to insist on knowing how things work. The new science of linguistics, deriving from the posthumous publication of Saussure's course in 1922, looked at language as a construction, altered and adjusted by each of its users. After Einstein, physics treated the universe itself as a kit of parts: Eddington in his 1927 lectures announced that, starting from 256 numerical coefficients, 'we are going to build a World'. In 1975 Pierre Boulez paid tribute to Anton Webern, whose atonal harmonies 'established a grammatic base' for a new kind of music.

But grammars, in spite of Polgar's witty prejudice, never superseded other modern books, for the simple reason that the novels he refused to read engaged

in their own grammatical scrutiny of the language they employed. To be truly modern, literature had to push language to its limits, to risk its disassembly into the tenuous gadgets itemized by Polgar. The director Sergei Mikhailovich Eisenstein saw the visual narrative of cinematic montage, which sliced up scenes into a rhythmic assembly of glimpses, as an attack on the dreary continuity and completeness of the sentence. A sequence like the massacre on the Odessa Steps in Eisenstein's *Battleship Potemkin* was for him the equivalent of 'passionate disconnected speech. Nothing but nouns. Or nothing but verbs.' Joyce, having exhausted every available English prose style in *Ulysses*, went on to invent an altogether new language – a punning Esperanto, as international as music – for *Finnegans Wake*. Hermann Broch in *The Death of Virgil* finally allows the delirious poet to overhear 'the word beyond speech' which he has tracked through so many circuitous sentences. But this privilege is reserved for those who are quitting life, and resists translation into our mortal language: Broch leaves it, in the novel's last sentence, 'incomprehensible and unutterable'. He praised Joyce for abandoning 'the entire petrified language system', and his highest compliment to 'the double novel *Ulysses* and *Finnegans Wake*' was to call the compound 'a nonnovel'. Joyce, he thought, had given up the realistic depiction of life in order to define a 'new idea of the human essence', which required 'the purest abstract spirit, hardly suggestible in concrete terms'. He approvingly likened Joyce's characters to the robotic or spherical figures in constructivist paintings, or to Picasso's distorted faces, and suggested that 'whoever could not endure such dehumanisation' had 'recoiled from the unconditionality of the new'.

Broch had no patience with the lowly communicative errands performed by language. For him its true task was 'to make cognitive units audible and visible' by bringing subject and object – which in the real, imperfect world are separated by time – together within the spatial frame of a sentence. Austerely dehumanized, it aspired to the condition of algebra. Yet, leaving Virgil's revelation unwritten, Broch was obliged to admit that what he called 'supratemporality' may be more accurately served by numbers than by words.

Proust suffered from his own version of this linguistic agnosticism. He expended many more than a million words on the quest for lost time, only to conclude that language can never adequately account for the sensations compressed into a single moment. The *Recherche* becomes ever more insecure about its own medium: such self-conscious scruples are a defining attribute of the modern mind. Marcel at first derides the malapropisms of the countrified maid Françoise, then remorsefully recognizes that her blunders are atavistic survivals, like specimens in a zoo. She gives voice to 'the genius of language in a living state': the subjective, vocal 'parole' which, in Saussure's linguistics, takes confident command of the systematic, impersonal 'langue'. For the theorists, her errors would qualify as authentic 'speech acts'. They also remind Marcel of the relativity and inefficiency of all tongues, since the French words whose pronunciation snobs correct are 'only blunders made by the Gallic lips which mis-

pronounced Latin or Saxon, our language being merely a defective pronunciation of several others'.

Joyce's response to the same perception was to write those several other languages simultaneously, as he did in *Finnegans Wake*. His playful etymologies reunify languages which had split into mutual incomprehension; the myths he retells vouch for the universality of human experience and reunite the family of man. For Proust, the lexicon proves to be an instrument of subversion. Rather than convening community, it exposes the sham of a society obsessed with lineage and pedigree. An etymological study of place-names is enough to undermine the ruling class, which bases its entitlement to power on an ancestral relation to the land. The names of both M. de Chevregny and Mgr. de Cabrières, for instance, signify 'a place where goats assemble'.

As the novel proceeds, Marcel grows to mistrust the words he is voluminously piling up. Ambiguity, the verbal equivalent of that suspected infidelity which tortures him during his affair with Albertine, invades the plainest of statements. In Venice after Albertine's death, he receives a garbled telegram in which she apparently reports that she is no longer dead and wants to marry him after all. Later, recovering from the shock, he recognizes that the message had been sent by Gilberte, whose mannered orthography confused the Italian postal clerks. The message corrupted during transmission illustrates the unreliability of writing: in signing her name, Gilberte with her affected dots and dashes has counterfeited her identity. The experience of deciphering Albertine's lies prompts Marcel to retreat from his own art. He unlearns language: 'I had in the course of my life developed in the opposite direction to those races which make use of phonetic writing only after regarding the letters of the alphabet as a set of symbols.' He knows that symbolism is an artifice, a set of substitutions, and he prefers the infant's phonetic babbling. Thus he ignores whatever Albertine explicitly says, paying attention instead to stray inflections, bemused silences, or embarrassed flushes. Near the end, he complains that the art of memory – accounting for the significance of stray, insistent images retrieved from the past – involves the decipherment of a dead language, which no one any longer speaks and which has left no texts to help us. The cloud or the church spire or the taste of the madeleine cake are like 'those hieroglyphic characters which at first one might suppose to represent only material objects'. An aside, like the confession of Chandos, betrays his own Herculean fatigue. The difficulty of interpreting this 'magical scrawl' explains, he says, why so many writers give up writing.

The sonata and septet composed by Vinteuil tease Marcel with an alternative to fumbling, inarticulate literature. Music, he believes, eavesdrops on paradise, dispensing with verbal intermediaries, and he wonders how much more refined and harmonious our lives would be if 'the invention of language, the formation of words, the analysis of ideas' had never happened; our spirits might then have conversed by singing. Vinteuil's legatees salvage the mystical formulae of the septet from 'papers more illegible than strips of papyrus, dotted with a

cuneiform script': cuneiform, whose wedge-shaped inscriptions were decoded only in the eighteenth century, was, as D.W. Griffith claims in the Babylonian episode of his film *Intolerance*, the universal idiom of the ancient world.

Hofmannsthal also pined for a means of expression beyond language – 'a magical mode, as is the case with love'. Before the disillusioned Chandos letter, he often challenged language to match the emotional eloquence of music. His poem 'Erlebnis' ('Experience') describes a valley at dusk which brims with mournful melody: the sound, Hofmannsthal guesses, of death. But the lyrical failure to which Chandos testifies led Hofmannsthal towards the partnership with Strauss, in which the poet's function was to provide cues for music to be written by someone else. During their collaboration on the ballet *Josephslegende* in 1912, he explained his notion of the visionary shepherd boy to the worldly Strauss. Joseph, defending himself against the carnal wiles of Potiphar's wife, longs to 'capture a piece of heaven and tear it to his heart'. This, he implies, should also be the proper ambition of music; language no longer presumes to reach so high. It is sadly ironic that Hofmannsthal should have been describing not an opera libretto, where his words could at least battle against their inundation by Strauss's orchestra, but the synopsis he prepared for a ballet – a self-cancelling silent poem.

Wittgenstein in the *Tractatus* gruffly declared that thought must not trespass beyond the bounds of the available vocabulary: 'Wovon man nicht reden kann, darüber muss man schweigen.' If we lack the means to talk about something, we should stay silent. But even if we possess the words, how far can we trust them? They are never more than a crude semaphore. Modern painting shared this disbelief. A picture is also a language of signs, a system of conventional associations which does not necessarily depict reality.

Words irrepressibly chatter on the surface of Picasso's earliest cubist experiments in 1912–13. Often they are labels on bottles of Suze and Vieux Marc, Bass and Hennessy. Most of these paintings are set in cafés; by contrast with the atomic limbo of the Viennese coffee-house, the Parisian café – convivial and congested, dense with verbal and visual noise – is a laboratory for cubism, demonstrating the merger of man with all other people and with inanimate objects, breaking down the privacy of consciousness which those Viennese coffee-drinkers anxiously guard. The words Picasso paints, accordingly, are not any single individual's speech acts. They are common property, part of the verbal environment which permeates our heads: brand names, advertisements, graffiti. Language is no longer a human monopoly, and can be generated by machines. A typewriter busily clacks away in the orchestra during Erik Satie's ballet *Parade*, designed in 1917 by Picasso for Diaghilev's company; in *Ulysses* Joyce situates the Homeric lair of Aeolus, the god of the winds, in a newspaper office, where the press, stamping type on the batches of paper, seems 'almost human', as if 'doing its level best to speak'.

The cubist mind is cluttered, like the consciousness of Bloom as he walks through Dublin in *Ulysses*, with roaring sounds, hastily-scanned signs, suggestive smells; it struggles to balance the external bombardment of sensations and its own unvoiced, overheard, internal commentary. This, for Joyce's admirer and imitator Döblin, disproved the notion of our independent existence, already assailed by Whitehead. Döblin described language as a grand, impersonal collective, a mass society: 'One believes one is speaking, and one is being spoken; one believes one is writing, and one is being written.' Less comically buoyant than Joyce, Döblin feared the individual's annihilation. The fate of Biberkopf in *Berlin Alexanderplatz* is spoken or written by Berlin, dictated by the economic and social conditions of the city.

Newspaper reports and summarized statistics crowd into Döblin's novel, devaluing the hero's tragedy. Picasso also recycled his raw material, using cardboard or tatty floral wallpaper as the ground for many of those early paintings, but he did so with no intention of cheapening his own images. The borrowed materials rescued him from the romantic cult of the white, fresh page or the unstained canvas. The artist originates nothing; the world is already made, as yesterday's newspapers testify, and we can only rearrange it. Sometimes the figures in this series, like the *Man with a Hat* or *Man with a Violin*, have faces and limbs of pasted newsprint. Picasso did not mean to suggest, like Karl Kraus disgustedly assembling quotations, that we are second-hand creatures, absorbing the prejudices fed to us by the press. Kraus was horrified to think that a tree in which birds sang could, a few hours after being felled and pulped, be used to disseminate lies on street corners. More happily, the paper glued into Picasso's paintings recalls shared origins: for the cubists, a joyously chaotic urban pantheism took the place of religion. Why should bodies not be made of newsprint, since paper like flesh is organic matter? Nor is the mind determined by the press, as Kraus believed. Unsynchronized with the world outside, it concentrates on its own momentous trivia. The headline which trumpets 'LA BATAILLE S'EST ENGAGÉ' in Picasso's *Guitar, Sheet Music and Wine Glass* goes unheeded. In Avignon during the months after the declaration of war in 1914, Picasso worked on a still life which brandishes a bunch of tricolours above a chopped-up patriotic slogan, 'VIVE LA'. Though the flags know which side they are on, you can fill in the rest of the phrase however you wish. The mind has its own definition of history, and the 1914–18 war primarily interested Picasso as a continuation of cubism by other means. Walking on the Boulevard Raspail in Paris with Gertrude Stein, he pointed out an army truck painted in camouflage patterns and remarked that he might have invented it himself.

The truck, hoping to disappear into the landscape, had learned from cubism the wisdom of being 'interwoven with the rest of the universe'. Camouflage is the art of misrepresentation, which is why Picasso saw in it an analogy to his own creative workings. His charcoal sketch *Bottle on a Table* was made on a sheet torn from the financial news; he turned the page upside-down and pasted a

strip of blank paper over some of the columns with their irrelevant numerical ledgers, announcing his disrespect for words and figures. Before cubism could read the world in a new way, that world had to be rendered illegible.

Music, which uses the alphabet to transcribe the scale, confirmed the retreat of language from referentiality. For Stravinsky, the primary unit of language was not the word but the syllable, and in setting literary texts he overrode verbal meanings and instead chose, as he put it, to 'syllabize' or 'syllabify'. A syllable solidified and regulated tone, offering the musician a gobbet of 'purely phonetic material', a sonic cell like the scraps of folk melody which are endlessly repeated in *Le Sacre du printemps*. When other syllables were added, a word emerged, whose discursive meaning was of no interest at all to Stravinsky. He proved his point in 1933 when setting André Gide's text for the narrated ballet *Perséphone*. Every time the heroine's name recurred, Stravinsky made sure that it was differently inflected or accented by the musical line. To jerk, jar and syncopate her name was to question her identity. He defended this mannerism by arguing that the church encouraged composers of religious music to syllabify liturgical texts, so as to discourage them from 'falling into sentimentalism, and consequently into individualism'.

Prokofiev experimented with the same atomizing of identity when he disemvowelled his own name. He brusquely signed himself P-R-K-F-V, encoding his identity in what Eisenstein called a 'harsh tap-dance of consonants'. Vowels were liquid, lyrical, and therefore could be dispensed with; consonants functioned as building blocks, set in place with a percussive clatter. It would have been even more modern to replace a name with a number. Eisenstein found himself memorizing the telephone number at Prokofiev's new flat because of the emphatic '*intentional crescendo*' with which the composer pronounced it.

Between 1923 and 1925 Alban Berg worked on a Chamber Concerto for presentation to Schoenberg on his fiftieth birthday. The piece begins with a dedicatory motto consisting of a triad or, as Berg more devoutly put it, a 'trinity' of names. In German musical notation the opening bars salute the master and his two pupils: *Arnol*D S*CH*oen*BE*r*G*, *A*nton W*EBE*rn, *A*l*BA*n *BE*r*G*. The piano slowly, tenderly touches in the notes which correspond to the name of Schoenberg, the violin incisively sketches Webern, the horn adds Berg himself in a deferential undertone. Thematic scraps from this passage are intertwined throughout, like the lives of the three embattled allies and conspirators. Although the concerto begins by spelling out those compressed words, the language it speaks remains secret, reserved to initiates; it has been composed in cipher. The sign becomes a symbol by obscuring the significance it possesses in the external world, where it serves as a pointer, a caption or a label like those on Picasso's bottles. Only after taking these precautions can it hint at more arcane meanings. What's in a name? Not, surely, a person's identity.

Schoenberg himself insisted that music should abstract itself from the visible reality which words transliterate. The prophet in his opera *Moses und Aron*,

which he worked on between 1930 and 1932 but left incomplete when he died in 1951, calls the God whose commands are uttered through the burning bush 'unsichtbarer und unvorstellbarer': unseeable, unrepresentable. Moses reproves the efforts of his brother Aron to supply the people with an image or an idol to assist their worship, and shatters the golden calf in an iconoclastic fury. Invisibility, the attribute of God, is also the mystical province of music. Yet music betrays Moses, lapsing back into the sensual, material world. A skittering, errant, entrancing flute accompanies the descants of Aron the publicist; during the orgy around the golden calf, the orchestra gives vent to a percussive riot. While Aron mellifluously sings, Moses the stammerer struggles to speak, unable to make his tongue articulate his revelation in words. For the chorus of fickle believers and revellers, language regresses to a babble of sounds which are no longer human: a muttering rumble of disaffection during the absence of Moses on the mountain, a sibilant hiss when Aron transforms his brother's staff into a snake.

In despair, Moses renounces speech. Schoenberg likewise, after preparing the text of the opera's third act, left the music for it uncomposed. Silence was the ultimate abstraction. Kandinsky encouraged Schoenberg's identification with the prophet in a letter written to him in 1912, sympathizing with his difficulty in communicating his abstruse theory of composition: 'This is the reason the Ten Commandments were also given only one-sidedly.' The benighted idolaters, preferring golden calves, deserve no more. Perhaps Moses should have kept the decalogue to himself?

During the decade in which Schoenberg agonizingly delayed completion of his opera, Freud was speculating about the figure of Moses, and anxiously debating whether he dared to make his conclusions public. He began the study which became *Moses and Monotheism* in Vienna in 1934, but decided to keep the text secret, fearing the hostility of the politically powerful Catholic Church: his book treated religion as a collective neurosis and explained away the cults of Moses the liberator and Christ the redeemer as a reflex of guilt for a slain, primal father. He made revisions and additions, but only published the work in 1939, after his arrival in London as a refugee. By then, his book about the mythical deliverer had assumed a new obligation, which was to explain the continued persecution of the Jews.

The purpose of *Moses and Monotheism* apparently contradicts that of *Moses und Aron*. Having quit Germany in 1933, Schoenberg reaffirmed his Jewish faith. His opera is a religious testament, as well as a tribute to the religiosity of music. Freud, however, acknowledged that his own aim was an act of deicide. His sceptical account of Moses, scrutinizing the Bible as 'a pious piece of imaginative fiction', deprived the Jewish people 'of the man whom they take pride in as the greatest of their sons'. He demythologized Moses, but compensated by making him a figure whose baleful prohibitions mark a stage in what he called 'Menschwerdung', the gradual advance of the human race towards maturity. But in the process, the ancient prophet became a modern artist, engaged like

Schoenberg in a revolutionary disengagement from reality.

For Schoenberg, the speech defect from which Moses allegedly suffered is the proud evidence of his integrity, which makes him refuse to collude with the glib verbalizing or vocalizing of Aron. Freud diagnosed the problem differently. At first he seized on it as evidence for his seditious claim that Moses was an Egyptian. If so, he must have spoken 'another language', and would have needed an interpreter in order to communicate with the folk he had chosen as his own. Later he hinted at another explanation. Perhaps the defect lay not in Moses, but in language itself; possibly it offered a clue to the linguistic reform which accompanied the establishment of monotheism.

Although Freud declined to believe in the legends about the exodus of the Jews from their bondage in Egypt, he did think of Moses as a liberator. In declaring God to be single and indivisible, and in refusing to countenance images of this withdrawn, inconceivable creator, Moses mentally rescued the race from the haunted, infantile credulity of a 'barbarous polytheism'. Formerly there were gods everywhere, like bogies ready to pounce. Now there would be one God only, who was nowhere at all. Schoenberg's Moses meditates on this immaterial idea as he listens to the admonitions of the burning bush at the beginning of the opera. This contribution of Freud's Moses to the march of mind was announced by a rejection of 'hieroglyphic picture-writing'. Hieroglyphs were the rudimentary contrivance of primitive man: a sign depicts the object it stands for. But as children are gradually weaned from recognizing a picture of a pet animal to accepting the written word 'cat' as a substitute for the furry thing itself, so the human race – as the triumphant adventure of 'Menschwerdung' began – must have been roused to advance beyond baby talk. Freud therefore boldly guessed that the Israelite scribes employed by Moses 'may have had some share in the invention of the first alphabet'. By banning the visual representation of God, Moses impelled our ancestors to exchange signs for symbols, and made it possible for us not merely to imagine but to conceptualize. Once we stopped childishly picturing God as a bearded, scowling grandfather, we could eventually learn to replace him with one of Einstein's formulae, or with the dodecaphonic series of notes which for Schoenberg were the hidden constituents of matter.

Moses und Aron ends as the prophet groaningly laments the inadequacy of his language: 'O Wort, du Wort, das mir fehlt!' After this comes the uncomposed third act. *Moses and Monotheism* concludes with a defiant victory, emphasizing instead of the 'word I lack' the words we can all do without. This was the abiding intellectual gift of Moses to his people. His monotheism, driving out pictures, established the 'omnipotence of thoughts'. By this Freud referred to a proud belief in our psychokinetic powers, provoked, he supposed, by 'the development of speech'. In more primitive times, the mind expressed its omnipotence through magic (which includes 'the magic of words': the notion that to confer them on objects gives us power over the things named). As man, oriented by Moses, strode further down 'the path to hominization', magic was superseded by technology.

Freud made Moses responsible for opening up 'the new realm of intellectuality', lifting us above 'the lower psychical activity which had direct perceptions by the sense-organs as its content'. Moses was not a stammerer after all. He spoke a newly austere and complex language, unreadable by those who thought of written words as puerile cartoons.

His was a feat, as Freud put it, of 'sublime abstraction'. Moses may or may not have set his people free from their Egyptian slavery by leading them through a sea which whimsically parted in the middle. He did, however, liberate the mind from its bondage to the lowly reality portrayed by pictures and named by words. Cézanne, whose destination was a 'promised land' attainable only through the abstraction of the visible world, likened himself in 1903 to Moses, and wondered whether he would arrive at the visionary goal: 'Shall I be like the great Hebrew leader, or shall I be able to enter?' Hofmannsthal's Chandos tells Bacon that he will write no more books, 'because the language in which I might be able not only to write but to think is neither Latin nor English, neither Italian nor Spanish'. He hopelessly seeks 'a language none of whose words is known to me, a language in which inanimate things speak to me'. But the defeated silence into which Chandos retreats is not our only option. The speech defect of Moses may have been a blessing. What we cannot talk about, we can describe in music, or in mathematical equations.

METAMORPHOSES

When human character changed in December 1910, the human body promptly underwent alterations of its own. Modern painters turned their models inside-out, exposing their viscerae. They carved faces down the middle, or abolished the pulpy, vulnerable physique and replaced it with a machine. If the earth was not the same in the twentieth century, then it must be peopled by redesigned beings. In 1920 Karel Čapek imagined a laboratory for the manufacture of humanoids. *R.U.R.*, his play about robots, lists the necessary equipment and ingredients – a kneading trough and pestle for whipping up the spermatic paste, vats for preparing the various organs, and a spinning mill for weaving nerves, veins and digestive tubes.

The humanists saw man as a replica of divinity. Leonardo da Vinci's Vitruvian figure stretched his limbs like the points of a compass to take the measure of a universe over which he ruled. Such an alliance between physical perfection and geometrical regularity could not be sustained in the twentieth century. Apollinaire, analysing cubist painting in 1913, quoted a parable by Nietzsche to warn of the hybridized, variant creatures modernism would manufacture. Nietzsche makes Ariadne ask her lover Dionysus why he pulls her ears. The witty god replies that he likes them, and wishes they were even longer. Tugging on her lobes, he argues for the reinvention of her body, uttering – in the view of Apollinaire – a 'condemnation of all Greek art' with its 'merely human conception of beauty'. Greek art, like Leonardo's classical nude locked inside his global circle, worked with only three dimensions. Relativity has endowed us with a fourth, and Dionysus, as Apollinaire interpreted his foreplay, had begun to experiment with this new plasticity. His caresses prophetically envisaged the bodies moulded into new shapes by modern artists. Picasso's Gertrude Stein has an African mask for a face, and Dalí's waxen, malleable Gala wears fried eggs on her bare shoulders or a dress inlaid with aborted foetuses. The figures in Paul Klee's paintings are frail stick-insects. In the caricatures of George Grosz, respectable citizens metamorphose into swine.

*close-up from
W. Pabst's
Die freudlose
Gasse (1925)*

Abstraction entailed a programme of physiognomic reform. The architect Friedrich Kiesler, criticizing the visual surfeit of realism and the groaning ornateness of nineteenth-century design, remarked that the modernists felt the need to put art on a diet; the rectangular style of Fernand Léger – whose nudes consist of body parts slotted together like machinery, interlocked in the service of a social function – imposed this stringent regime. So did fashion. W. Somerset Maugham approvingly describes a sleek, icy British diplomat in one of the spy stories which he published after the First World War: the man is tall and thin, 'with exactly the figure to show off modern clothes'. In revolutionary Russia, citizens of irregular, baggily bourgeois shape were made to fit the standardized mould. During the 1920s the clothes designer Natalia Lamanova economized on fabric and in the process modified the Russian physique, emphasizing a rectangular cut in her tunics and Tolstoyesque peasant blouses – four-square, functional, uniform in every sense. At the Bauhaus in Weimar, Oskar Schlemmer, choreographing a geometrical dance which he called *The Triadic Ballet*, organized living bodies into diagrams of spatial law. Like Cézanne with his cones, spheres and cylinders, Schlemmer treated his dancers as abstract puppets. The head for him was an egg, the torso a vase, and the arms and legs were clubs. Posture and gesture spoke a language of symbols. The fingers of a hand made up a star, and the intersection of backbone and shoulders formed a crucifix. 'Result: *dematerialization*', as Schlemmer proudly reported in 1924. These mobile, musical axioms looked to Schlemmer like a new race of Vitruvian men and women, 'wondrous figures' personifying 'the loftiest concepts' and 'capable also of embodying symbolically a new faith'.

A young man in Noël Coward's play *Easy Virtue*, first performed in 1926, is taken aback when his female companion refers to the force of sexual desire: 'The way you modern young girls talk – it's shocking, that's what it is!' She tells him to 'move with the times', and adds that there is nothing new in such frankness.

Oskar Schlemmer's The Triadic Ballet *at the Bauhaus, photographed 1926*

'Being modern', she explains, 'only means twisting things into different shapes.' The same rule applied both to personal conduct and to art. Like Dionysus twisting Ariadne's ears into a different shape, Picasso boasted about his 'gift of metamorphosis', which he employed against a world where bodies had hardened into separateness, drifted into estrangement. The result was not starkly volumetric, as in the Bauhaus ballet; nor did it look chastely angular, like the tail-coat of Somerset Maugham's ambassador or those simplified Soviet costumes. Picasso created a continuum of ardent flesh, a sensual equivalent to the table-top democracy of objects in his cubist cafés. In his paintings concerned with desire and its satiation – *The Embrace* in 1925, or the studies of copulation he made in 1933 – orifices migrate around the body or between the glued bodies of lovers, augmenting the inlets for pleasure. Why should we condemn such polymorphousness for being perverse? In *The Swimmer* (1929), an elemental reunion occurs. The woman's body splits apart, and – at the small cost of her head, which has disappeared into one of her flippers – she regains the fluency and formless ease we lost when we clambered onto dry land. Picasso enjoyed the thought that he was assisting nature, whose constant work is recycling. In 1942 he rearranged some spare parts of a butchered bicycle into a bull's head. The handle bars served as horns, the saddle contributed the face. Pleased as he was with his impromptu sculpture, he still looked forward to a time when it would be thrown on the junk heap. There perhaps someone would discover it, see its metaphoric possibilities, and turn it back into a bicycle. Then, Picasso smiled, 'a double metamorphosis would have been achieved'.

In 1916 Franz Kafka documented the unhappier case history of a man who has been metamorphosed. Gregor Samsa wakes up one morning to find himself transformed into an overgrown insect. Kafka's story, one of the recurring modern nightmares, is about the insecurity of our privileged status in the world, which depends on biological accident. When Gregor mutates to another species, his family feels absolved from having to treat him humanely. Civilization has won no permanent victory over savagery; moral bonds can easily be revoked. The furniture is removed from his room, despite its 'good influence…on his state of mind'. Is there more to our self-congratulating culture than a lumber-room of fixtures and fittings? Man initially distanced himself from the animals by standing upright, walking on two legs rather than four. Then, to celebrate his triumph, he sat down on a chair, rather than squatting on the ground. If you take away the chair, or the desk it is drawn up to, you can topple this fragile hierarchy. Helen Schlegel, in E.M. Forster's *Howards End*, imagines the removal vans and overstocked warehouses after Doomsday. Amused by the disparity between our temporariness and the permanence of furniture, she foresees that 'in the end the world will be a desert of chairs and sofas…rolling through infinity with no one to sit upon them'.

The practice of metamorphosis analytically dismantled human beings. Character was traditionally the novel's prize exhibit: novelists of the nineteenth

century cherished individuality – the criminal geniuses of Balzac, the gro-
tesques of Dickens – like a protected species at the zoo. Forster attempted to
prop up this cult of the idiosyncratic being in the lectures he published in 1927
on *Aspects of the Novel*, which famously differentiated 'flat' characters from
'round' ones. Flat characters stay stereotypically on the page, while round ones
acquire profiles and contradictory aspects, inviting the reader to walk around
them. Forster's terminology suggests the three-dimensional subjects of cubism,
which effectively sabotages his argument. To circumnavigate someone is to
realize that their facets don't add up, just as to reflect on your profile or the
back of your head is to recognize that you don't know yourself. In *Jacob's Room*
Virginia Woolf glances at a specimen of cubistic window-dressing in a West
End clothes shop. 'The parts of a woman were shown separate'; the woman
herself, however, is not there. A disembodied hand grips a skirt, though the
pole-shaped body cannot wear it. The figure has many hats, but no head. At
least she possesses feet, 'pointed gold, or patent leather slashed with scarlet'.
Ulrich in *The Man Without Qualities* is studied in the round, over the course of
an immensely long and meticulously inquisitive novel. That is how Musil can be
so sure that he is not a character.

Ulrich himself passes the time which the novel takes to get him nowhere
reflecting on the automatism of the body, the waywardness of the mind, and
their refusal to make common cause. Ideas spiral inside his head as chancily and
transiently as fireworks, spreading out from a centre they do not possess, demon-
strating 'an incoherency that is characteristic of the present era and constitutes
its peculiar arithmetic'. Yes, the brain – like the earth – is different in the twenti-
eth century, because the activity which we like to call thinking proves to be scatty
and inconsequential. None of us, when left alone, whispers Shakespearean
monologues. And what tenuous wiring connects the cloudy head to our twitching
physical extremities? Among many other metamorphoses, Ulrich has a vision of
dismemberment. When he meets the political hostess Diotima, he clasps her
hand a little longer than is polite, so that it seems to come off in his own hand.
He stares at it, marvelling at its pudginess, its lack of weight, and the inconsistent
duties it is called on to perform. 'A fundamentally pretty shameless organ', as
promiscuously nosy as the snout of a dog, it still plants itself on the heart to attest
fidelity, or formally pledges friendship to a stranger by exchanging sweat. Ulrich's
reverie resembles the existential qualms of Roquentin in Sartre's novel *La Nausée*
(1938). Roquentin recurrently sees the world as a jelly – squelchy, shuddering,
unstable. He is nauseated, and longs for the defunct Newtonian cosmos in which
objects were solid and obeyed mechanical laws. Ulrich, a more accommodating
Viennese sensualist, 'could not quite resist Diotima's beauty', despite the ficti-
tious nature of her hand. A fluid universe is a comfortable enough place to live
in, because the only imperative is to stay afloat.

Involved in a street brawl, Ulrich marvels at the unconsciousness of his
nervous and muscular response. The imperial bureaucracy of Kakania, whose

innocuous employee he is, has its own official notion of him – 'this whole and chief person as identified and defined by civil law'. Society could not exist unless it tagged citizens with identities and classified them as responsible moral agents. How else would it know who to prosecute when they commit crimes against it? Yet these legal devices deny the moral autonomy they supposedly wish on us. When Ulrich is arrested after another dispute in the street with a labourer who curses the Kaiser, he feels the doleful, pedantic rituals of the law taking him apart. The police report mechanistically robs his name ('those two words that are conceptually the poorest, but emotionally the richest in the language') of its precious aura, and reduces his face to a sketchy set of categories, turning him back into a flat character.

He experiences 'the statistical disenchantment of his person', which is one of the twentieth century's depressing epiphanies. Ours is the age in which the overabundance of human beings first forced governments to think of people numerically, issuing them with passports, identity cards, tax codes, driving licences. In modern times, the individual consists of the complementary sets of numbers which refer to him. This was another of the contemporary nightmares invented by Kafka, whose Joseph K. in *Der Prozess* and *Das Schloss* struggles against a bureaucracy which accuses him of obscure irregularities. He needs a license to exist. During the desperate emigrations of the 1930s, qualification for visas or travel permits became a matter of life or death. In Brecht's *Flüchtlings-gespräche* – a dialogue between German exiles stalled in the railway station at Elsinore, where they are hoping to cross between Denmark and Sweden – one of the characters, Kalle, remarks that a passport is the noblest part of a man (which is how humanists once described the soul). Ziffel replies that a man is merely the material vehicle of his passport.

Despite the droning legal inquiry at the police station about who did what to whom, Ulrich's sensations tell him that a person does not perform pondered, rational actions. Rather we are 'swept along…like Europa on the bull's back'. It is a disturbing simile. The bull was a disguise of Ovid's metamorphosing Jove; he changed shape in order to abduct nymphs like Europa, who came to personify the European continent. Musil's novel, which he began to write during the 1920s, breaks off just as Europe – still powerless to stop the belligerent, rampaging force which propels it, like Ulrich unable to rein in his own body – takes up arms in 1914. At the last soirée given by Diotima before war breaks out, the squabbling guests agree in absolving individuals and societies of blame for the collective rush towards destruction: surely no one would argue that Europa wanted to be raped. A Marxist at the party insists that 'a person's economic foundations entirely determine his ideological superstructure', while a Freudian answers back that 'the ideological superstructure is entirely a product of the instinctual foundations'. Ulrich sums up the evening as 'a demonstration of infinite chaos'.

That chaos is elemental. Ulrich, scribbling down formulae and symbols which transcribe 'an equation of state of water', meditates on man's liquefaction.

We are mostly composed of water. A human being is a neural soup with some gobbets of matter adrift in it. But even that chemical condition is somehow too palpable to be true, and Ulrich goes on to imagine the water evaporating, blowing away. Is it not akin, after all, to air? Metamorphosis breaks down the body so as to disperse it on the wind.

In *Petersburg*, the novel of revolutionary patricide on which he worked between 1913 and 1916, Andrei Bely made the same declaration, and in doing so jettisoned all the pre-revolutionary novels which had denied this breezy modern truth. The student terrorist Nikolai Apollonovich stands on a bridge over the Neva and considers his metaphysical position. He has been ordered to kill his own father, but he doubts that the universe will notice the abomination. 'People as such', he decides, 'do not exist.'

While Gregor in 'Metamorphosis' tragically lapses from humanity, the comedy of Kafka's 'Investigations of a Dog', first published in 1931, exposes the boastfulness which sustains that favoured human condition. Since everything is relative, our apparent dominion could well be an error of perspective. The smug canine who narrates the story cares only for his own kind. 'What is there actually', he asks, 'except our own species? To whom else can one appeal in the wide and empty world?'

Science fiction, throughout the century, has answered that question in ways which would please neither the dog nor his equally complacent human masters. Our world may be wide, but it is not empty. If cubic space proliferates in all directions, we must be prepared to conceive of worlds elsewhere, alternatives to the one we inhabit. Our self-image, no longer guaranteed by a deity who copied his own features, is at best provisional. In Arthur C. Clarke's novel *2001*, published in 1968 to coincide with Stanley Kubrick's film, scientists speculate about extra-terrestrial life, and are forced to concede the relativity of our own species. Some xenophobes insist that the inhabitants of other planets must be humanoid, give or take a few fingers and some oddities of pigmentation. Their anthropomorphism is mocked by the biologists, 'true products of the Space Age'. They deny that the human prototype has any sanctity. It is indeed 'a bizarre piece of improvisation', cobbled together by chance and a long series of evolutionary choices. Over the course of its development, organs have been reassigned to new purposes, or left – like the appendix – dangling in redundancy. It should not surprise us if extra-terrestrials possess an even more scrambled organism.

The Martians of H.G. Wells, the anaemic Eloi and gross, furry Morlocks described by his Time Traveller, and the hybrids of man and beast created by the mad vivisector in his *Island of Dr Moreau*, were among the first laboratory specimens of mutation and metamorphosis. The hero of *The First Men in the Moon* apologizes for the 'incurable anthropomorphism' which makes him shudder at the blue-skinned, tentacular Selenite. Science fiction aimed to cure this anthropomorphism, and so did abstract art. Because the creature has no nose or ears,

because its eyes are displaced and its neck is jointed, Wells's character in looking at it suffers 'an absolute, an overwhelming, shock. It seemed as though it wasn't a face, as though it must needs be a mask, a horror, a deformity, that would presently be disavowed or explained.' Might this not have been the reaction of an unprepared observer confronted by the squatting figure in Picasso's *Demoiselles d'Avignon*, painted in 1907? Her nose might be a gash, a cavity bisecting her face. Her eyes are unaligned, and of discordant colours. Her mouth is a puncture mark, and she wears her single ear on her cheek. But she should not be accused of monstrosity. Hers is the human form relativized, seen from several angles simultaneously. The painting supplied the disavowal or explanation which the Wellsian narrator looks for in vain. Why do we arrogantly assume that all living things must have the same organs as ourselves, set in a corresponding pattern? Why do we even imagine that the view we have of ourselves in the mirror is the authorized version?

Proust's Albertine is a moral and psychological puzzle, but also a graphic conundrum, because – like the Selenite whose face is not organized to be looked at frontally, or like the ochre-red, totemic woman in Picasso's painting – she multiplies before Marcel's eyes. Like Picasso, Marcel acknowledges his own metamorphic power. Desire imperiously works on the plastic substance of the adored body. 'We are sculptors', he says. He watches Albertine as she sleeps, and reports that she creates a fresh self each time she moves her head. Seen in full face she is 'the other woman'. Lying beside her, he looks at her in profile and her identity changes. When the infinity of her possible facets is narrowed down, turning the cubist portrait back into a realistic replica, she is demystified and impoverished. Marcel reports that 'she acquired an almost beggarly air from having (in place of the ten, the score that I recalled in turn without being able to fix any of them in my memory) but a single nose'.

Wells's extra-terrestrials are saved from this anti-climax. On the moon, there is no bodily prototype, and therefore no norm. One of the creatures encountered by the scientist Cavor has a jutting forearm, another is 'all leg', some have brain cases like distended bladders, and others are pin-headed, with blobby bodies. The Grand Lunar, possessing an omnific mind, does without the skull we are obliged to wear. Because his intelligence is unlimited, why should it be clamped inside a box of bone? Cavor makes no judgment on these variations: nothing inhuman is alien to him. The Martian invaders in *The War of the Worlds* at first incite 'disgust and dread' because they lack nostrils, chins and brow ridges, while they have too many twitching feelers; their skin is oily, fungoid. Yet Wells's narrator, overcoming his nausea, later admits that they may have made practical improvements to the human apparatus. 'They were heads, merely heads. Entrails they had none.' So how do they fuel themselves? They extract blood from other living creatures and – circumventing the tangled, knotted, sluggish plumbing which occupies so much space inside us – inject it directly into their veins. Not a pretty sight, but what a time-saver! Nor do they ever get liverish.

Spared the pangs of indigestion, they are 'lifted above all these organic fluctuations of mood' which besiege human beings. We can only bow down to our evolutionary betters.

A green gas wafting down from an asteroid in *In the Days of the Comet* miraculously socializes the earth. The great disengagement and the great disillusionment are alike banished by what Wells now calls 'the Great Revival', instantly abolishing capitalist greed and disseminating a gospel of free love. As a new world dawns, the uplifted spirit requires the mortification of outmoded flesh. Men and women, ignoring the selfishness which motivated the old economy and the old marital monopolies, 'denied the bodies that God had given them, as once the Upper Nile savages struck out their canine teeth because these made them look like the beasts'. The hero Willie converts Nettie to sexual communism by arguing that the body should be reformed, purged of remnants which belong to our 'lowliest ancestry', like our inward ears, our fishy teeth, and the bones left over by 'marsupial forebears'. The mind performs this drastic surgery. Like the tribesmen pulling their own teeth, we must, Willie says, overcome the animal instinct which persuades us that we deserve only a single biological partner. Evolution is both a moral and a physiological adventure.

Shaw's *Back to Methuselah* considered redesign of the body as a stage on the way towards renouncing it. The futuristic She-Ancient is able to sprout extra appendages at will, and the Newly Born begs her to grow multiple arms and legs just for fun, like a circus freak. This playful plasticity, which is the energy of modern art, did not amuse Shaw: Ecrasia points out that an artist may be able to create masterpieces, but he can't improve the shape of his own nose. Cosmetic surgery, Shaw jokes, would be more of a boon to mankind than artistic creativity. He little imagined that American aesthetic medicine would one day put his whimsy to the test. Meanwhile, the He-Ancient dismisses Ecrasia's complaint. Such physical adjustments, he says, are trivial, because a superman 'can alter the shape of his own soul'. He is vague about the gymnastic exercises which may be required.

Surrealism had its origins in a similar morphological jest. Apollinaire coined the word in 1917 to describe the antics of the ballet *Parade*, and then explained its meaning in the preface to his play *Les mamelles de Tirésias*. The androgynous Greek seer Tiresias narrates Eliot's *The Waste Land*: possessing two complementary sets of sexual organs, he has retired from the stale, sterile coupling which preoccupies the poem's characters. Apollinaire's Tirésias – who begins as Thérèse, but deflates and detaches her breasts after her conversion to feminism – is caught in the act of commuting between genders. For political reasons Thérèse declines to breed. Her husband has to replenish the race on his own, which proves unexpectedly easy: he single-handedly spawns more than forty thousand babies in one day. Evidence, possibly (even though biological details are missing), for Proust's theory that we were once all ambisexual? For Apollinaire, the husband's feat resembled the metabiological breakthrough

which the He-Ancient hopes for. It was an unleashing of zany creativity, a re-engineering of the species. In his preface, Apollinaire explained the husband's fertility by arguing that 'When man tried to imitate walking he created the wheel, which does not resemble a leg. He thus performed an act of surrealism without realizing it.' The invention of the wheel, overcoming bodily limits, began the long travail of human progress. Surrealism, which transcends the real, did so by similarly illogical leaps of faith.

Man's 'final structure', as Wells suggested in *The War of the Worlds*, may be 'not unlike the actual Martian condition'. If evolution continues, we may end as a brain with several pairs of hands attached. All other flailing limbs and messy, suppurating organs will in time become obsolete and drop away. That prophecy, bizarre when Wells made it, was promptly fulfilled. The conquering monsters in the fantasy anticipate the amplified powers of modern man, described by Freud as a 'prosthetic god': a mutant creature, promoted to a state of almost supernatural leisure by technological appliances which abolish bodily labour.

Metamorphosis is the gift of a god. In Genesis, the creator imposed a form on heaven and earth, dividing the waters from the dry land. Classical mythology, less concerned about maintaining separate categories and policing borders, delighted in the fickle, irresponsible changing of shapes. The gods of Ovid transform themselves into bulls or bears or swans in order to prey upon human beauties.

The early twentieth century, convinced that it was remaking heaven and earth, inevitably recalled and imitated those first creative feats. G.K. Chesterton hints at the connection in *The Man Who Was Thursday*. The detectives, who believe they are hunting a criminal anarchist, turn out to be seekers after faith, and the goal of their quest is the elusive, shape-changing deity to whom they give the code name Sunday. They all know him, but none of them can describe what he looks like. Because he is a creative force, he exists in a state of ferment. Infinitely potentiating in all directions at once – like space in Apollinaire's phrase – he cannot be realistically pictured. When they compare notes, the disciples find that his face falls apart, and can be rearranged as disturbingly as the countenances of Wells's Martians and moon calves, or violently juggled like the features of Picasso's models. One of them complains that Sunday's face is 'so big, that one couldn't focus it or make it a face at all. The eye was so far away from the nose, that it wasn't an eye. The mouth was so much by itself, that one had to think of it by itself.'

The malleability of the face provokes a 'doubt whether there are faces'. Is identity no more than 'a combination in perspective'? These are the perceptual uncertainties experienced by Hofmannsthal's Lord Chandos, but for Chesterton they defer to a higher certainty. The Professor decides not to worry that Sunday's face has dissolved into its separate constituents. Staring at a colleague, he remarks 'I do not believe that you really have a face. I have not faith enough to believe in matter.' Sunday has been abstracted, and abstraction is the only honest

response to the unknowability of God, or the incomprehensibility of the physical world. Objects are not concrete. Matter itself is fluctuant, ventilated, made up – as the new physics pointed out – of emptiness. Sunday, insubstantial but omnipresent, is said to resemble 'shapeless protoplasm', the streamy continuity of interwoven entities described by Whitehead. Everyone compares him to something different, but their metaphors agree in evoking 'the universe itself'. To envisage Sunday is to 'think of the whole world'.

Modern painting began with the imperious refabrication of the world, which is why the painters themselves claimed an affinity with God. In 1904 Cézanne declared that by resolving nature into a geometrical assemblage we could come to comprehend 'the spectacle that the *Pater Omnipotens Aeterne Deus* spreads out before our eyes'. Rainer Maria Rilke revered Cézanne as God's personal confidant, like the biblical prophet. 'Not since Moses', he said about a painting of Mont Sainte-Victoire, 'has anyone seen a mountain so greatly.'

In 1907 Rilke made devout, repeated visits to a Cézanne exhibition at the Grand Palais in Paris. Mesmerized by the paintings, he pondered the improbability of matter, the issue debated by the would-be worshippers in the novel which Chesterton published the next year. Sunday's followers make disbelief in matter a credential of faith. For Rilke, Cézanne's paintings represented the last stand of a material world whose contents were being bled of substance and integrity by human interference and technical innovation. D.H. Lawrence identified Cézanne's apples as the fruit of Eden, deprived of their curse and made freely available. Rilke, however, said that apples when painted by Cézanne 'cease to be edible altogether'. For good or ill, they were just objects, stubbornly there. This, against all the odds, was their victory, like that of the mountain: 'to achieve the conviction and substantiality of things, a reality intensified and potentiated to the point of indestructibility'. They resisted the dematerialization which frightens Chandos; things had been saved from the devious magic which renders them transparent, turning them into symbols or signs. That was why Rilke specified that the apples were not edible. To eat them is another way of destroying them.

Yet despite Rilke's conviction and his fidelity, he implied that reality was in need of substantiation, and in his comments on the way Cézanne's images were made – their animated planes, which denied the existence of line and contour; the hypnotism of colour, an optical illusion – he could not help admitting that these were replicas, replacements, an artificial means of detaining fugitive nature in a still life. There was an almost Proustian urgency to his quest, culminating in a denial of time when Rilke describes himself standing for two hours in front of paintings which were themselves obligingly immobile. But once the vigil ends, he must slip back into time and succumb to its drifting entropy.

In a letter to his wife, Rilke reported that Cézanne's paintings were no longer to be seen; they were due to be ousted 'by an exhibition of automobiles which will stand there, long and dumb, each one with its own *idée fixe* of velocity'. The joke was painfully wry. Velocity, the opposite of fixity, was hardly the proper

subject for an *idée fixe*; the cars, uselessly and stupidly stalled, mocked the medita-tive stasis of the paintings. Modern times had resumed. Ahead lay futuristic America – the realm of the ersatz, an Eden carpeted with Astroturf. As Rilke put it in a letter to the young poet Witold van Hulewicz, people now craved 'empty things from America, semblances of things, shadows of life'. The objects he treas-ured, to which he addressed his 'Dinggegedichte', a poetry of and about things, were doomed: plastic flowers, after all, do last longer. 'Perhaps', Rilke suggested, 'we are the last to have known these things.' Abstraction announced the loss of a grounded, aged, authentic being. In a future which became the present only too soon, mountains can be flattened to construct airport runways, and if you should fancy an apple you can swallow a flavoured vitamin pill.

The expanding space described by Apollinaire relativized or atomized objects, bending them out of shape. Rilke emphasized the indestructibility of Cézanne's apples; as it developed, modern painting made a cult of destructibil-ity. Picasso liked to apply pressure, to discover the fault lines in a face, as he squeezed tears from the subjects in his series of *Weeping Women*. Dalí more pas-sively waited for organisms to putrefy, and watched them revert to shapelessness like the protoplasmic face of Chesterton's Sunday. Dionysus tweaks the ear of Ariadne, but the bodies Dalí painted grow their own extensions like William Tell's flaccid buttock. Picasso's *Guernica* is a torture-chamber of brutalized form. In Dalí's painting about the same Spanish conflict, *Premonition of Civil War*, a rabid giant tears himself limb from limb. The German expressionists subjected matter to similar metamorphoses. The world blows itself apart in what Ludwig Meidner called his apocalyptic landscapes; Grosz and Otto Dix painted grue-some episodes of sexual carnage.

Rilke venerated Cézanne because his art came to the aid of imperilled nature. Apollinaire, in his essays on the cubist painters in 1913, saw the 'social function of great poets and artists' differently. Their duty was to renew, literally to revise, the appearance of nature. Reality is boring, and we turn to art to be saved from its monotony. As Nietzsche put it, we are given art so that we might not perish from the truth. The order we discern in the world was for Apollinaire 'an effect of art'. Without that deceit, 'there would be no seasons, no civilization, no thought, no humanity,…and the impotent void would reign everywhere'. It is an astonishing argument, which takes for granted the desperation and bad faith of the modern mood: the debility of Chandos, or the confusion of Chesterton's questers who find, in the impressionistic chiaroscuro of the forest, that there is no floor to the universe. Perhaps the braver option would be to confront the truth, and to perish? Art no longer extols an order which God imprinted on creation. The artist merely pretends that such order exists. He concedes our abject reliance on it, even though he perpetually destroys it. Hence Picasso's sublime arrogance in questioning the universe and reordering it, as Apollinaire says, 'in accordance with his personal requirements'; hence too the serene stubbornness of the old man in 'The Blue Guitar', Wallace Stevens's poetic meditation on a

1903 painting by Picasso. People complain to the guitarist, 'You do not play things as they are.' He calmly replies 'Things as they are / Are changed upon the blue guitar.'

In 1895 the dramatist August Strindberg found this desire to outdo God in the paintings of Gauguin. Picasso improbably coloured a guitar blue. Gauguin – in the blasphemous fury of his Polynesian landscapes, with their torrid skies – preferred 'to see the heavens red rather than blue with the crowd'. The Viennese critic Hermann Bahr, writing in the same year as Strindberg, wondered at the effrontery of a Sezession painter who specialized in red trees. Bahr decided that 'red trees may be painted', but asked 'should they be painted?' They flouted appearances, in order to provoke a violent nervous protest in the beholder. Bahr thought that Ludwig von Hofmann's red trees were the semaphore of an isolated soul, whose inner world had cancelled out external reality: a token of maladjustment. The red sky of Gauguin was more flagrant and rebellious, less pitiably autistic. As Strindberg understood, Gauguin painted 'a sky which no God could inhabit', just as he planted in his humid, newly-created jungles 'trees such as no botanist could ever discover'.

The painters in their own way rehearsed or re-enacted that deicide which brought the modern world into being. Strindberg acidly described Gauguin as 'a sort of Titan who, jealous of the Creator, makes in his own leisure hours his own little creation'. The myth he alluded to contradicts the Christian version of our beginnings. Rather than being a monopoly of God, creation comes from impiety and insurrection. The Titan is Prometheus, who challenged Zeus by fashioning the race of men from the clay. Such creativity is incendiary: Prometheus stole fire from heaven in order to supply his inanimate pets with a vital spark. Like Gauguin in Strindberg's description, or like any modern artist, he 'abjures and defies'.

The Promethean myth, as a vindication of modern vision, recurred in Apollinaire's defence of 'the new school of painting…known as Cubism'. His introductory essay concludes by asserting 'I love the art of today because above all else I love the light, for man loves light more than anything; it was he who invented fire.' He was of course, with teasing effrontery, changing the story. The gift of Prometheus is forgotten. Fire, in this version, is not stolen from Zeus and donated to man; human beings themselves invent it. Apollinaire went on immediately to nominate Picasso, the artist who most recklessly flaunted this creative power, as the legatee of Prometheus: 'If we were alert, all the gods would reawaken.' The early twentieth century's new schools of painting, like its new political philosophies, campaigned for a renovated heaven (red or blue depending on choice, or shedding green gas if you subscribed to H.G. Wells's fantasy) and for an earth stocked with improved inhabitants. As Musil world-wearily commented in 1922, 'Every new "ism" that arrives is hailed as the forerunner of a new humanity, and the end of every academic year rings in a new epoch!'

The futurists shared Apollinaire's delight in the brazen Promethean fire, and in their manifesto proclaimed themselves 'Lords of Light'. Picasso, as Apol-

linaire said, dared to stare into the sun, ignoring another pious taboo: 'He accustomed himself to the immense light of depths.' The futurists bragged that they drank from the molten fountains of the sun. But the light they worshipped was not spoken into existence by God; it crackled directly from the mains, electrically generated. The 1910 Manifesto replaced the maudlin tragic hero – man, according to classical literature, at his noblest – with the flashy agonies of a light bulb, shrieking its grief in spasms of colour.

In 1908 Stravinsky composed an orchestral fantasy called *Feu d'artifice*, four irregular minutes in which pentatonic and octatonic scales clash, erupt and fizz in trajectories of invisible light. The pyrotechnics were a display of mental fireworks, showing off Stravinsky's technical skill. In 1917 the piece was choreographed for Diaghilev's Ballets Russes, with a design by the futurist painter Balla. The set consisted of jagged cut-outs and gyring Catherine wheels, and its jarring planes and gyrating circles – cubism electrified – were operated by an electric motor. The world briefly exploded into life and spontaneously combusted: a miniature modern Genesis, a pendant to Stravinsky's other dramatization of origins, when the springtime earth splits open like a body in parturition.

Strindberg compared the recalcitrant Gauguin to a savage in wilful retreat from civilization, or to a child as yet ignorant of civilized manners who 'takes his toys to pieces so as to make others from them'. His characterization raised the most troubling aspect of modernism: the link between artistic innovation and social or psychological regression. What provoked this disengagement from appearances? Was it a godly freedom like that which Apollinaire attributed to Picasso, or the destructive tantrum of which Strindberg accused Gauguin?

The art historian Wilhelm Worringer proposed a disturbing answer in two studies which, under cover of their concern with the early history of perception, referred to convulsions in the contemporary world-view: *Abstraction and Empathy* (1907) and *Form in Gothic* (1912). For Worringer, the 'tendency to abstraction' was a psychological puzzle, the symptom of a flaw in culture. He contrasted abstract art, motivated by 'a feeling of separation from outside nature', with the happy empathetic adjustment of man to the external world which underlay realism. Abstraction, he suggested, was the reflex of primal, abiding terrors. Modern artists shared the mental condition of our earliest forebears.

Worringer believed that primitive man must have been overcome by the 'chaotic confusion' of impressions in a world to which he had just awakened. He surely recoiled in dread, huddling in his cave, and this 'space-shyness', as the philosopher T.E. Hulme called it, presumably led to a haunted dualism. Man and the world were enemies, God and the world were strangers. Our speech, art and religion all derive from primitive man's 'endeavour to recast the incomprehensible relativity of the phenomenal world into constant absolute values'. Worringer's allusion to relativity brought this ancient dread up to date: Einstein had mystified the world all over again. Worringer's analysis also glanced at Freud and

his diagnosis of the discontents which unsettle civilization. He argued that man's gradual adjustment to the outer world healed a breach within the mind, compelling instinct to give way to reason. The relativistic bombardment of things going bump in the night therefore 'resolved itself into an ordered arrangement of significant events' and 'chaos became cosmos'.

The power to design abstractions was the earliest evidence of this struggle for 'mental mastery', an initial sign that the traumatized patient might be curable. Primitive man calmed his 'metaphysical anxiety' by drawing a straight line, which appealed to him because it did not exist in nature. Its rigidity, stiffened like a body taut with fear, was 'abstract and alien to life'. This is why Duchamp's Standard Stops, those floppy, flexible substitutes for the metre, were so wickedly subversive: they make us think about where we would be without the straight line, that supreme fiction which gave us the power to rule space. Modern novelists, confusing chronology like Joseph Conrad in *The Secret Agent* or Andrei Bely in *Petersburg*, revoke our painfully-acquired confidence that life consists of significant events in ordered arrangements.

As an account of our tribal infancy, Worringer's theory can be no more than guesswork. But as an oblique explanation of modernism, it is startlingly accurate. In 1919 Piet Mondrian virtually paraphrased Worringer when claiming that his own colour-flecked, rhythmically syncopated grids – diagrams of a theosophical heaven, no longer painted an angry red like Gauguin's godless sky – aimed to represent 'the absolute…in the relativity of time and space'. For Mondrian, such art triumphantly concluded the growth towards mental mastery whose earliest stages Worringer tried to imagine. 'The cultivated man of today', Mondrian said in his contribution to the journal *De Stijl*, 'is gradually turning away from natural things, and his life is becoming more and more abstract'. To illustrate his point, he banned flowers from his Paris studio, though he kept a single artificial tulip in a vase, having painted one of its petals white: he disliked the colour green, and the idea of greenness.

Once the primitive phase had passed, humanity arrived, in Worringer's wishful history, at the confidence of classical man, who saw himself as the measure of all things. But did classical humanism go too far when it 'assimilated the world to [man's] finite humanity'? Worringer criticized such 'anthropocentric arrogance'. The return of abstract art promised an epilogue to humanism, as our 'changed consciousness' transformed the mess of nature into something like the supernatural diagram of Mondrian's *Broadway Boogie-Woogie*, which looks at New York from above as a heavenly city, whose rectilinear plan makes manifest 'the purest expression of universality'. Yet modern art also demonstrated another response, which moved backwards rather than ahead. The security of the classical world-view was easily unlearned. Worringer acknowledged an undertow of fear which had never been exorcised, and valued this primitive consciousness because it retained a capacity for awe. For classical man, he said, 'life becomes more beautiful, more joyful, but it loses in depth, in grandeur, in force'.

Realism sought to pacify the indistinct menace described by Worringer, just as science aimed to rationalize the world. The twentieth century began with the disarming confession that progress after all had not been made. The end of every afternoon is a reminder that we are still cowering cave-dwellers. We only maintain our good cheer with the aid of electric light.

In *The War of the Worlds* Wells's narrator creeps through depopulated London, flinching from 'the windows in the white houses [which] were like the eye-sockets of skulls', and shudders when he senses that 'Night, the Mother of Fear and Mystery, was coming upon me'. Eliot in *The Waste Land* discovered 'fear in a handful of dust', a desolating memento of death. The phrase so disturbed Evelyn Waugh that he borrowed it for the title of his novel *A Handful of Dust*, in which the lives of his self-indulgent socialites collapse into ashen futility or outright terror. The tribal ruler in Waugh's tragic farce *Black Mischief* quakes at the onset of 'Night and the fear of darkness'. Disabled by his Western education, he is the victim of a double dread, combining 'the inherited terror of the jungle' with 'the acquired loneliness of civilization'. His ancestors, Waugh unashamedly contends, overcame their fear by merging in a huddle, 'abandoning…all the baggage of Individuality'. That relapse is not available to the isolated Seth, who cannot 'expand to meet the onset of fear'. In 1932, the year of Waugh's novel, Paul Klee made a wry, uncomfortable joke about the emotional link between primitive and modern man in his painting *Mask of Fear*. It borrows the form of a tribal mask, worn to ward off menacing spirits. The ancient defence has been adapted into something like an armoured vehicle, with an antenna and a chimney spout poking through its second skin. The mask effaces individuality: two pairs of feet, fashionably shod, poke through the bottom, rapidly trotting towards cover. Yet how secure is it? Although it fortifies the face, the mask looks eggshell-thin. Dalí in 1931 extolled 'the new surrealist *fear*', which he derived from the superstitions of childhood. The infant sees demons everywhere. Inanimate objects in the nursery loom, rear, cast spooky shadows; surrealism pays frightened homage to 'the haunting notion of the metamorphoses'. Dalí adopted a 'paranoid-critical method', which listened to the promptings of nocturnal fantasy and discredited 'the world of reality'. In his paintings a naked woman writhes in agony as a series of drawers slice open her torso, a telephone's black mouthpiece weeps a gluey tear, and a grand piano is sodomized by a death's-head.

Paul Klee
Mask of Fear
(1932)

Dalí was unembarrassed by the charge of lunacy. Surrealist experiment, he said, entailed the 'simulations of mental diseases'. The panic of primitive man, modernized as nervous frenzy, also returned in expressionism. This revulsion from nature first appeared in the work of Egon Schiele, Klimt's pupil in Vienna, who died in the 1918 influenza epidemic at the age of 28. Klimt and Schiele both painted Friederike Beer. For Klimt she was a mannequin, the wriggling patterns of her gown merging with the Chinese screen behind her, her face a perfect circle of well-fed, rouged contentment. In Schiele's version she is gaunt and harrowed, sprawling on the floor in a dress of savage arrows which looks like a strait-jacket, mockingly adorned with little wooden dolls. Schiele made his last portrait of Klimt in the mortuary, after the undertakers had shaved his corpse. 'I found Klimt', he reported, 'very changed.' Yet all his portraits recognize death's encroachment inside us: the skull's obtrusion through the skin, the body's slow betrayal of the mind which pretends to own it. Expressionism is about a truth within, which presses to be externalized; it forces mortality to the surface. The flesh for Schiele is an open wound, and the distresses and agonies we think we conceal beneath our clothes gape and babble like mouths all over us. A girl's raised skirts reveal her genitals as a blood-coloured gash. Schiele's own navel is a crimson question-mark on a slab of sallow skin. Far above it, his eyes widen in surprise at the oddity of this snapped life-line, another blocked point of entry to the interior.

Schiele's self-portraits confronted the enemies within, buried selves which inhabit us like viruses and periodically take over, distorting our faces and wracking our limbs. Looking in the mirror, he confirmed the relativizing of identity on which Musil commented in 1921. Musil believed that the disquiet of modern existence and the nightmare of the 1914–18 war had left human beings ethically unbalanced, 'almost formless, unexpectedly malleable, capable of anything', vacillating at whim between good and evil. Schiele painted himself as a skeletal

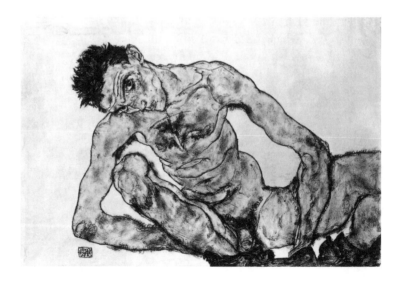

Egon Schiele
Self-Portrait
Squatting
(1916)

anchorite, and as a malevolent criminal; as a lyric poet, playing on the lyre of his own twisted spine, and as a pugilist livid with bruises; as a prisoner in a scarlet tunic of shame, and as Saint Sebastian pricked by critical barbs; as a pouting aesthete, and as a grimacing hairy ape.

Waugh described individuality as burdensome luggage, which we dump in an emergency. For Schiele, individuality served only as a wardrobe of possible disguises, tried on in turn and impatiently discarded, because none of these costumes can shape or define the moral amoeba inside them. Formlessness fascinated and disgusted Dalí, governing his dietary fads. He began his autobiography by announcing – as if it were the most telling clue to his character – that he detested spinach 'because of its utterly amorphous character'. He preferred to eat 'things with well-defined shapes that the intelligence can grasp', and especially enjoyed crustaceans. 'The very opposite of spinach', he said, 'is armour.'

'How', as Tristan Tzara demanded in his 1918 manifesto, 'can anyone hope to order the chaos which constitutes that infinite, formless variation – man?' That false hope, clearly, had to be abandoned. The honest response was to relish disorder, to delight in the variability which disconcerted Musil or the viscosity which appalled Sartre's Roquentin. Rilke's *Das Marienleben* in 1912 ends with the contemplation of the Virgin's 'reinen Leiche', more radiant than the sun itself, wrapped in dazzling white linen: an immaculate corpse, unravished by death. The surrealists, connoisseurs of what Breton called 'convulsive beauty', were less likely to overlook the evidence of physical decomposition. Hence their cult of 'exquisite corpses'. This was their name for a favourite parlour game, which involved making collaborative collages on folded paper. One such monster – jointly produced by Man Ray, Yves Tanguy, Joan Miró and Max Morise in 1928 – showed Siamese twins whose heads fuse in a passionate kiss while their lower extremities go about their separate business, the woman's hand discharging a pistol into the flesh they share while the man's arm abruptly concludes in a spluttering stick of dynamite. Expressionism favoured less exquisite cadavers. Käthe Kollwitz's lithographic sequence *Der Tod*, made in 1934–5, showed death claiming victims by seductive entreaty, rape or robbery. Kollwitz's handiwork makes an annihilating contribution of its own – lines which seek out the brittle bones of the emaciated figures, inky pools in which bodies are blurred and identities blotted out.

In 1929 Alfred Döblin wrote an introduction to August Sander's photographic index of contemporary German faces, *Antlitz der Zeit*. Sander's portraits of grizzled peasants, stout burghers, stiff patricians and wild-eyed artists prompted Döblin to revive the medieval academic debate between nominalists and realists, and to ask 'Is the Individual Real?' Nominalists, he explained, trust in the profusion of phenomena, the quirks of individual existence. But for realists, local peculiarities, which Musil called 'qualities', should be overlooked: only universals existed. Döblin himself agreed with this view, although his universals were unlike the 'universality, harmony and unity' which Mondrian in 1919

hailed as 'inherent characteristics of the mind'. Döblin's universals – which collectivize the faces of the people Sander photographed, showing them to be creatures who borrow identity from the class they belong to or the mass they are merged with, like Biberkopf in *Berlin Alexanderplatz* – were the lowest common denominators of experience, forces which limit the individual's desire for autonomy. Social caste was one of these levellers; death, for Döblin as for Kollwitz, was another. He compared Sander's living people with a volume of death masks, and noticed how the withdrawal of life from these plaster facsimiles 'has erased all individual presence'.

Unlike corpses, Sander's bustling Germans still enjoy the illusion of uniqueness – until you notice their professional uniforms and the shared traits which show individuals held hostage by the family or the group, dying into solidarity: the funereal Sunday best of the peasants, and the starched, militaristic stiffness of the sports teams; the menacing huddle of a workers' council, and a line-up of schoolboys in spiked helmets, waving banners on the Kaiser's birthday. Soon there will be no more need for any of them to trudge off to the fields or march to their offices. They will alike be lost in what Döblin – in a phrase which conjures up the frigid, alien settings of Wells's science fiction – called 'the great monotonous moonscape of death'. Expressionism grimly foresaw the end: what were Tzara's infinite, formless variations but a recipe for entropy and inevitable decay?

The camera had other alarming revelations to make. Hermann Broch suggested that the spirit of modernity first asserted itself in the visual arts because 'the hand that draws' seems to do so automatically, with an 'unburdened unconsciousness', and it can afford to be more 'furiously future-minded' than the hand holding a pen. Maybe so – but the graphic results were also liable to be contested. When Gertrude Stein saw Picasso's portrait of her, in which her head was flattened into a hieratic mask, she said she didn't look like that. She would, Picasso rejoined: he had painted what lay under the skin, the genetic identity which would emerge in time. At least Stein could dispute the resemblance. With the camera, there was no right of appeal. Its verdicts on faces, no matter how surreal, possessed an unimpeachable verisimilitude.

This is why the close-ups of the silent cinema had such hallucinatory power. The Dadaist Hugo Ball – who ran the Cabaret Voltaire in Zurich in 1916, reciting nonsense verses while dressed as a column of tubular cardboard – justified his gibberish and his architectural costume by claiming that the pictorial arts had banished the human figure. 'The human countenance', he added, 'has become ugly and outworn.' But although the painters might have declared our tired, conventional, drearily symmetrical physiognomy to be obsolete, a newer art sought its rehabilitation. Fritz Lang in 1926 claimed that film had provoked a *'rediscovery of the human face'*, which was newly exposed 'in its tragic as well as grotesque, threatening as well as blessed expression'. (As if for purposes of research, Lang during the 1920s in Berlin collected decapitated heads, souvenirs of Polynesian religious rites, with nacreous gobbets representing the last tears

shed by these sacrificial victims.) On screen we could watch what he called 'the expressionistic representation of thought processes', transforming or deforming the face. When the Corsican upstart dreams of victory in Abel Gance's *Napoléon*, his beaky, aquiline features are suddenly fused with those of his pet eagle. Close-ups of the fat, gloating bosses in Eisenstein's *Strike* are intercut with shots of snorting hogs. More startlingly, at the end of G.W. Pabst's *Diary of a Lost Girl* the hypocritical pharmacist who has seduced Louise Brooks seems to mutate between species before our eyes. When he is spurned, his hand grips into a rapacious claw, and his face is twisted into a hyena-like snarl as he spits out a curse. Beatitude, included in Lang's list, is observed less often than grotesquerie. One of the rare cases is the blissfully abstracted face of Rosa Falconetti as the tortured saint in Carl Theodor Dreyer's *La Passion de Jeanne d'Arc*. Transfiguration allows Jeanne to vacate her face: her eyes roll towards heaven and her flesh is unpeeled by flames. Meanwhile the gargoyle visages of her persecutors – pudgy, weathered, warty, congesting the frame in close-up – manacle them to the bodily world she has quit. Gloria Swanson had a point when, harking back to the days of silent film in *Sunset Boulevard*, she cried 'We had faces then!' Never, thanks to D.W. Griffith's invention of the close-up, had the face been studied so minutely, or so prodigiously enlarged.

In the twentieth century, faces became more expressive – sometimes violently, eruptively so. The surrealists maligned the bland beauty of classical art. Duchamp in 1919 fixed a moustache to the Mona Lisa, and in a caption smirked about her sexual appetite. Her serenity disguised a dirty secret. The expressionist face, less covert, blurted out its ulterior motives: what it ex-pressed, or pressed forth, was a scream.

The scream, as a considered response to existence, was a novelty of modern times. The German philosopher Lessing, in his eighteenth-century treatise on aesthetics, *Laokoön*, declared it improper in the visual arts, because it 'distorts the face in a repulsive manner'. Laokoön, the Trojan priest devoured by a serpent, should merely sigh as the monster gobbles him up. The Dadaist Jean Arp had no patience with the stoical imperturbability of classical sculpture, and proposed that Laokoön and his writhing sons should be allowed 'to relieve themselves after thousands of years struggling with the good sausage Python'; he also recommended an enema to relax the Venus de Milo. Edvard Munch in 1893 ignored the ban on screaming as a pictorial subject, and supplied the new century with one of its icons. The scream in Munch's painting does not issue only from the human figure, a disquieting compound of foetus and cadaver. The face with its open mouth is a funnel for nature's more impersonal anguish, voiced by the turbulent water and the inflamed sky. A scream qualified as political protest and social criticism. Karl Kraus contrasted the different styles of oppression in Berlin and Vienna by citing the scream as an inalienable right: the only freedom of speech which mattered in the twentieth century. In Prussia, he argued, they let you move, though your mouth was gagged. Back home in Austria, they locked

you in solitary confinement, but at least you were able to scream. Screaming also served as a necessary vent for emotional distress. Artaud – for whom theatre was a salutary unleashing of the irrational – complained that 'in Europe no one knows how to scream any more', and ridiculed French actors whose atrophied throats, used only for talking, were 'no longer organs' but lifeless abstractions. He admired Chinese acupuncture, which curatively pricked the body's multiple pressure points, and thought that there should be a similar therapy for the soul, to be achieved by primal screams.

The scream challenged music to press beyond the bounds of tonality, which acknowledged only sounds which could be tuned, purged of discord. Schoenberg defined art as 'the cry of despair of those who experience the destiny of mankind'. That cry, shrilly or gutturally voiced, resounds through modern music. The nameless Woman in Schoenberg's monodrama *Erwartung* screams for help when she discovers the body of her lover; Klytämnestra in Strauss's *Elektra* delivers two cries of echoing, haunting horror, left without notation in the score, as her son kills her. In *Lulu*, Berg's opera based on the play by Wedekind, the Painter responds to Schön's disclosure of Lulu's infidelity by saying 'Oh, wenn ich schreien könnte!' – if only I could scream. But he cannot, and instead he emits a choked groan offstage as he slices his throat open, painting the room with the expression of his fury and remorse. The opera concludes with the dying scream of Lulu, again offstage. These are sounds so terrible that they can only be heard, not seen.

The contemptuous moralist who slaughters Lulu is Jack the Ripper. Lulu herself acknowledges the psychopath as a righteous judge and a cleanly incisive deliverer. Although she brings Jack home as a customer, she begs him to make love to her, and even pays him for the favour. As an expert on the bodily interior, Jack the Ripper counts as an honorary expressionist. Moosbrugger, the psychopathic killer of prostitutes in *The Man Without Qualities*, is also an artist by other means. He leads a quiet and diligent life as a carpenter except that, every once in a while, a craving 'turned his personality inside-out'. When this happens, he turns his victims inside-out. The most recent has had her throat cut, her breasts sliced off and her heart pierced, with an additional wound unzipping her from the navel to the sacrum. The world has performed a similar surgery on his head, exposing the fantasies which rage inside it: 'The open sky sometimes peered right into his skull.' All the same, his state of moral disintegration is no different from that of the cultivated, law-abiding Ulrich. Moosbrugger feels himself to be unstable, like a house agitated by a seismic rift; he wonders how his own body – by contrast with those of the carved-up women – manages to hold together.

In 1907 the painter Oskar Kokoschka wrote a play about the sex war, *Mörder, Hoffnung der Frauen*. Murder is supposedly the only hope women have against the brutality of men, although in the play the Man, despite the scars of a coital battle, slaughters the Woman and her ladies in waiting. Kokoschka designed a poster which represents intercourse as a mutual massacre. A skeletal

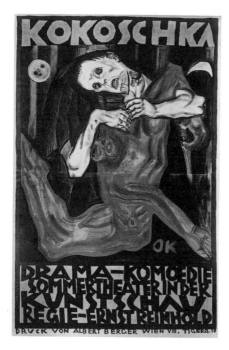

Oskar Kokoschka's 1908 poster for Mörder, Hoffnung der Frauen

woman, her throat sliced open by a black wound, grapples with a flayed, bleeding man, whose head is misplaced and whose agonized hands form into screaming mouths. Kokoschka's water-colours depict scenes of carnage, with stained paint seeping into the paper like fluid shed by the fighting bodies. A dog in one design laps at a pool of crimson. In the ink drawings he contributed to the periodical *Der Sturm*, men and women pick at each others' scabs. Even the calligraphy is cruel: the incisions of Kokoschka's pen scratch tattoos on the skin. The Man in *Mörder, Hoffnung der Frauen* brands the Woman with a fiery hieroglyph; she responds by gouging a hole in his side with a knife.

These monsters, like Conrad's Kurtz, introduce the shadowy underside of modern experience. They link civilization and savagery, and implicate art in the most repellent crimes it is possible to imagine. Max Nordau in *Entartung* – a bilious study of degeneracy, published in 1892, which accused Verlaine of mongolism, called Mallarmé a certifiable lunatic, and supplied the Nazis with excuses for persecuting the artists who offended them – described Wagner as a sadist, who was only kept from committing sex-murders because he sublimated his vicious urges through music. The argument is foul, yet Nordau's identification between creativity and crime was taken up by artists who shared none of his political assumptions. *World of the Bourgeoisie*, a lithograph made by George Grosz in 1918, exposed the city's sexual abattoir. A meek burgher sits down to a meal which consists of a naked woman's hind quarters, the buttocks seared by a lash. The diner has not done his own carving. A gory knife lies on the table, its handle pointing towards a sketch of Grosz himself in profile. In 1920 Otto Dix in *The Sex-Murderer: Self-Portrait* painted an even more flagrant confession. Ferally leering as he brandishes his blade, dressed for the occasion in a suit which resembles a tiger skin, Dix slices up a female victim, hurling her arms and legs – on which his own bloody hands have left an exclamatory signature – around the room. Wounds gush like ornamental fountains. The woman's head, torn off and thrown aside, still manages to scream as a single eye stares at her own amateurishly butchered remains.

For Wedekind and Berg, Jack the Ripper offered redemption. In a society held together by graft, deceit and sanitized cannibalism, a knife can cleave through the lies. Grosz and Dix in their self-portraits pleaded proudly guilty to

an extra charge. If the modern artist was a vivisector, surgically redesigning the human form like Wells's Dr Moreau, should he not also admit an affinity with the killer?

Before the modern painter could begin to look at the world, he had to equip himself with fresh eyes. The painter Maurice Denis disliked the impressionists because they succumbed to the jittery, fatigued 'optical sensations' of the contemporary city-dweller. Cézanne, looking beyond this blinking, flickering barrage of momentary sights, said 'One

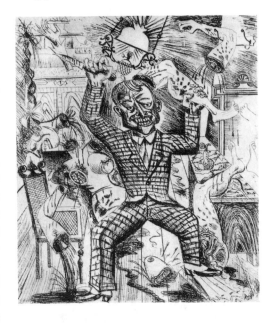

*Otto Dix
The Sex-
Murderer
(Self-Portrait)
(1920)*

must make an optic, one must see nature as no one has seen it before'.

The camera manufactured just such an apparatus, and reinvented reality instead of merely photographing it. In 1928 Albert Renger-Patzsch published an album entitled *Die Welt ist Schön*, in which the camera disproved traditional notions of the world's beauty by equating organism and machine. On the book's embossed cover, an agave plant and an electric pylon stood together, equated in size, aesthetic quality and structural clarity. Gertrude Stein justified Picasso's shattered forms and the hasty crudity of his line by implying that these were the first drafts of Prometheus, whose messy creatures were tentatively modelled from the clay of a river bed. 'He who created a thing', she said, 'is forced to make it ugly.' For Renger-Patzsch, beauty, like ugliness, was the prerogative of the sovereign human creator. It did not inherently belong to the world; the artist found it there, in dishonoured or disregarded objects – fishing-nets, factory chimneys, kitchen utensils. Another German photographer, Kurt Blossfeldt, published his *Urformen der Kunst* in 1928: his gigantic close-ups of plants discerned in their stems and leaves the primal forms of art and architecture. A fern, for instance, is a crosier staff; a ramifying shoot of Indian balsam looks like chain mail or a linked metal fence. Karl Nierendorf, in his preface to Blossfeldt's book, might have been recalling Worringer's claim that abstraction is the best evidence of our evolutionary capacity. Scrutinizing vegetation, Blossfeldt's camera reminded Nierendorf that 'what elevates man above other creatures is his ability to change through his own mental efforts'. Nature is abandoned to 'the eternal monotony of regeneration and decline'; numbingly repetitious, as Apollinaire remarked, it threatens to bore us to death. Art, however, is an 'inconceivable supplementary creation', answering to the need 'for permanence, for eternity'.

Proust in his essay *Contre Sainte-Beuve* defined style as 'the transformation that the writer's mind imposes on reality'. Commenting on the paintings of Elstir in the *Recherche*, Marcel claims that an artist's vision can alter the appearance of the visible world as irrevocably as a geological catastrophe. Here again was the grandest and also the most dangerous aim of modernism: renovation of the earth. The danger lay in the possible link between metamorphosis and distortion or deformity. Musil in *The Man Without Qualities* saw a troubling analogy between abstraction and insanity. The crazily enthusiastic Clarisse – a believer in hetero-dox religions, who is sure she can save Moosbrugger's soul by playing the piano to him – has a 'way of thinking' which reminds Ulrich of 'those modern paint-ings that were done in unmixed pure colours, harshly and formally unwieldy'. Like Bahr with the red trees, he has to admit that what is unrealistic can also be 'astonishingly true'.

Émile Zola called art 'nature seen through a temperament'. For Dalí this served as a definition of paranoia, with its justified warping of reality. Freud in *The Psychopathology of Everyday Life* acknowledged how difficult it was to avoid the refracting gaze of neurosis: 'Only for the rarest and best adjusted mind does it seem possible to preserve the picture of external reality, as it is perceived, against the distortion to which it is normally subjected in its passage through the psychi-cal individuality of the percipient.' External reality had not recovered from the assaults made by Einstein's relativity and Heisenberg's uncertainty; should it per-haps be written off as a shaky projection of our more or less pathological dreams? Dalí made several portraits of Freud in 1938, depicting the analyst as a sorcerer tormented by his own spells. One version turns his bald cranium into a planet spinning out of control; in another, based on the grotesque heads doodled by Leonardo, Freud's brain is occupied by coiled, secretive snail shells, and his profile distends and buckles into that of a leering maniac. While Picasso ques-tioned the universe, Dalí conducted his own 'inquisitorial process of matter', which concluded in the antic mimicry of madness.

In 1937 in Munich, Hitler opened an exhibition of approved German art, and harangued painters who 'on principle saw meadows blue, skies green, clouds sulphur yellow'. The new optic Cézanne called for in 1904 was now condemned as 'a gruesome malfunctioning of the eyes'. Hitler archly wondered whether such 'eyesight-deformation' could be the product of mechanical failure or of inheritance. In the first case, he prescribed spectacles; in the second, sterilization. A holy war soon began, proclaiming its mission to save the world from mod-ernism and to testify that the earth was still the same. In the last, losing year of that war, Richard Strauss composed *Metamorphosen*, a threnody for string orches-tra which sweetly grieved over the prostrate cities of the Reich. The work of metamorphosis, formerly the privilege of gods, had been achieved by bombers.

THE ADVENTURES
OF MERCURY

Creativity presupposes a beginning. It is life's renewal, a fresh start. But the early twentieth century thought of itself as an end, an epilogue to history. In modern times, matter was atomized, and men were reduced to accidental conglomerations of atoms. Did the creative impulse now express itself in acts of analytical destruction? Picasso, specializing in metamorphosis, showed things in the process of falling apart – psychologically in *Les Demoiselles d'Avignon*, where the up-to-date bordello girls change into primitive witches, venereal ogres; physically in *Guernica*, where bombs turn the Spanish town into a charnel.

Indefatigable, agitated by what Duchamp called in his own case 'a mania for change', still iconoclastic in his old age, Picasso came to represent both the valour and the frenzy of modernity, its merger of creativity and destruction. He exhibited the mixed motives of the artist, who is, according to Freud, an assassin in fantasy; he symbolized the heresy of art itself, which defies the creative monopoly of God. Once in the late 1940s, in his studio at Vallauris in the Alpes-Maritimes, he snatched a squelching vase from the potter's wheel, twisted it in his fists, then massaged it into the shape of a dove, risking its decomposition as the clay bulged and thinned. 'You see,' he said, 'to make a dove, you begin by wringing its neck!' The novelist Patrick White, grateful that he was set free from naturalism by the Picassos he saw in London in 1936, recalled that epiphany with unease. He spoke of 'the terrors of abstract painting', which commanded him to abandon his literary models and jump into empty space. Picasso's work explains why abstraction can and perhaps should be terrifying.

The *Demoiselles*, painted in 1907, is a work of desecration. The standing women with their upraised arms once might have been chaste caryatids supporting a temple; Picasso also quotes from El Greco's *Apocalypse of St John*, making bodies twist and curl like licking flames and disclosing a patch of incinerated sky. But the temple here is an Avignon brothel, and the saint's vision of last things arrives through the experience of sex, with its ashen after-taste of death. The painting ravages the bodies it represents. The soft, obliging contours of bought

*scene from
enri-Georges
ouzot's
e Mystère
casso (1955)*

flesh become angular and abrasive. Noses are flattened against faces and sharpened like weapons, breasts could cut you. Cézanne's cones and cylinders were the demonstration of God's workmanship. The bodies of Picasso's whores are also made up of geometrical building blocks, slotted hurriedly together with the joints left on show, but they do not proclaim the serene science of the maker. The painter, who is their prospective customer, does his own dismembering in advance. Through the drapery, which mocks the coyness of classical statuary, protrude legs whose owners seem to have misplaced them. A hand thrust into the air – for what reason? to draw open the curtain on some voyeuristic tableau? to pull the sky down? – floats free of the figure from whose head it sprouts. The disjointed forms assault our illusions about space: cubism here creates a sense of dislocation. Inside or out, back or front – none of the conventional categories which we employ when colonizing the world and making it habitable have any meaning here. The squatting figure on the right surely has her back turned, yet she has revolved her head through a full circle to confront us. What has become of the second leg of the woman on the left? By contrast with its plump partner, it looks like a jagged, rudimentary column. Perhaps those are the folds of the clothes she is discarding, or perhaps they anatomize the bones and sinews beneath the skin.

As well as confounding our trust in space, the *Demoiselles* leaves us disoriented in time. A painting is meant to be a frozen moment, stilling life like the fruit laid out on the table. Here the brothel girls obligingly hold their poses while the client makes his choice. Yet into this timeless frame Picasso compresses a long history, which runs swiftly backwards towards the abyss, as twentieth-century time tends to do. Epochs overlap. The painting recognizes and challenges all of its precursors – Cézanne's monumental, mountainous female bathers, the cool

odalisques of Ingres, the Venus de Milo (who had been threatened with an enema by the Dadaists) – but goes on to disrupt the notion of art and its history institutionalized by the museum. The central figures belong to the classical tradition of idealized nudes, which they burlesque. The women flanking them, however, originate elsewhere. Their heads are African tribal masks, elongated by the contours of the tree from which they were carved,

Pablo Picasso
Les Demoise
d'Avignon
(1907)

striated in ritualistic patterns or coloured with ochre, their eyes or noses gouged out of the wood or scorched into it. This primitive presence makes the painting abruptly recede in time. A modern scene of sexual commerce becomes an ancient ceremony of exorcism. The purpose of those masks is to outface spirits, to deflect primordial terrors which still haunt us.

While working on the *Demoiselles*, Picasso visited an ethnographic exhibition at the Palais de Trocadéro in Paris. He promptly incorporated a reference to African sculpture into the picture, overpainting the modern faces of those two figures. He added the masks for the same reason which caused the Africans to wear masks in the first place: the concealment of a fear which is still helplessly confessed in that graphic grimace. The tribal carvings allowed Picasso to rediscover an older and more potent explanation for art. The masks, he said, had a 'sacred purpose', perhaps more authentic than the devotional sentiments of Western religious art; battling to maintain an equilibrium between shrinking men and a hostile world, they demonstrated that 'painting isn't an aesthetic operation, it's a form of magic'. Picasso had a healthily superstitious respect for the primitive figurines he collected, and balked at accepting a New Guinea totem – hideously tinted, its limbs rickety, its feathered head leering – which Matisse offered to him. The fashioning of images is a device of witchcraft. Picasso, frightened by the manikin, believed that Matisse wanted to be rid of it because he shared this terror and wished to pass on the dangerous task of adjuring it.

The ancient thaumaturgy which such qualms invoke was backed up by modern psychiatry. The *Demoiselles*, inadvertently confiding those sexual anxieties which Picasso the libertine officially disclaimed, confirms Freud's theory that art masks truths we cannot bear to tell ourselves. Truth, Picasso once indignantly told an interviewer, could not possibly exist, and he cited his own paintings as proof. He exemplified the point by stubbornly denying that he had repainted the heads in the *Demoiselles*. As a child, his son Paulo heard him constantly repeating a phrase which might qualify as a litany for our relativistic times: 'The truth is a lie.' His fascination with masks – those worn by the Avignon whores, or the ten-foot-tall body sculptures into which he inserted the French and American Managers in the ballet *Parade* – admits the deceptiveness of the painted image, just as his frantic erasures and messy inkings-out in *Le Mystère Picasso*, the film directed by Henri-Georges Clouzot in 1955, incite suspicions about what he wants us not to see.

The *Demoiselles* attempted to exorcise a private trauma; *Guernica* applied the same cathartic technique for casting out demons to a public calamity. The German air force, doing a favour to General Franco, bombed the Basque town late in April 1937. Picasso began his mural within days; by midsummer it was installed in the Spanish pavilion at the International Exposition in Paris. The immediacy of response was journalistic, as was the choice of an official venue for the work's publication. Picasso hinted at the alliance with newsprint by confining himself to monochrome. *Guernica* restricts itself to the stark extremes of black

Pablo Picasso
Guernica
(1937)

and white, with grey as a soiled compromise between them. The gored horse
has been stippled all over with what might be finicky, bristling hairs. Seen from a
distance, as the painting's size demands, these marks blur into columns of print:
the story of Guernica is written on the bodies of the victims. *Guernica* is what
the nineteenth century called a history painting, the representation of a world-
altering event – except that the incident in question, rather than being retrieved
from a sedate, remote past when Caesar crossed the Rubicon or Washington
crossed the Delaware, is as freshly offensive as yesterday's headlines; and the pro-
tagonists are not transfixed for posterity in noble attitudes, as the decorum of
history painting required, but caught in a terminal panic, running for cover,
writhing in anguish, screaming at the sky.

As with the *Demoiselles*, space in *Guernica* recedes into a dizzy temporal
depth. The painting begins on 26 April 1937, but runs backwards through history,
uncovering antecedents for the outrage. Its lamenting female chorus alludes to
Greek tragedy, as does the architectural setting – a flat, forbidding wall, like the
gates of a palace or a city, with windows through which a witnessing head can
stretch to report on the obscenities within. Tragedy means the song of a slaugh-
tered goat. Picasso respects the etymology by extending the agony throughout
nature. The painting's antagonists are animals: the bull, with ears as barbed as its
horns and a tail flicking to celebrate its triumph, and the gashed, collapsing horse.

This might have also been an air raid on Golgotha. The sprawling soldier
is Christ toppled from his cross. A woman cradling her dead child would qualify
as a Pietà if only she were more piously resigned: instead she keens hysterically. A
light bulb glares above the tangled bodies like the sun which God irately switched
off when his son expired. Among the sources of *Guernica* are a series of blotched,
brutal ink sketches which Picasso made in 1932, adapting Matthias Grünewald's
sixteenth-century painting of the crucifixion. In the absence of religious faith,
Picasso's style does the work of excruciation. One revision of Grünewald makes
the nailed Christ throw back his head and open his mouth to roar; in another,
his hands have become scratching claws, and the ink blots are a geyser of dried

Pablo Picasso
Crucifixion
(1932), from
he Grünewald
series

blood. A third surreally imagines how the scene would look if decomposition had been allowed to occur. Not sealed in the tomb, Christ's carcass has been left to rot, like the skeletal bishops in *L'Age d'or*, the film on which Dalí and Buñuel collaborated in 1930; his rib-cage hangs on a hook. Other versions confer levity and grace on Grünewald's agonized figures by relieving them of their humanity. Picasso tries looking at them as a linear pattern, or as vegetation. Twice he redraws them metamorphically, as polyps or whimsical sea creatures who frolic in a strange submarine ballet. Freed from the body, they need no longer feel pain. To be abstracted counts as a salving ascent to heaven.

In the year when Picasso made these revisions of Grünewald, Hindemith began composing his opera about the painter, *Mathis der Maler*, first performed in Zürich in 1938. The example of Grünewald helped Picasso to see the incident at Guernica as a crucifixion. For Hindemith too, Grünewald's prematurely expressionist paintings – made, as he said, in 'uncertainty and despair…on the threshold of the modern era' – served as an allegory about his own beleaguered conscience during the Third Reich. At work on the painting in Hindemith's opera, Mathis imagines himself as Saint Antony from his own painting, assailed by tempters in the wilderness. Should the artist, in a time of ideological war, be bribed into acquiescence, or take up arms? Ought he to resign from practising that art in impotent protest, as Mathis does? At the end of the bad dream, Mathis is absolved from responsibility for the historical crisis. His ecclesiastical patron appears in the guise of Saint Paul and orders him to resume painting, reassuring him that he possesses a talent which is 'übermenschlich', or supermanlike. This is not the summons to an atheistic revolt like that of Picasso, whose disregard for created nature made Apollinaire declare that 'Avant tout, les artistes sont les hommes qui veulent devenir inhumains'. Hindemith's Saint Paul uses the word coined by Nietzsche, but reconciles it to orthodoxy by telling Mathis that he owes his gift to God. Apollinaire's adjective more dangerously recognized that the superman may be inhuman – cruelly enjoying his power of will, like Picasso redesigning the world.

Emerging from the nightmare in *Mathis der Maler*, Paul and Antony sing a grateful 'Alleluia!' Grünewald pointed Hindemith towards the quietism of internal exile, followed in 1938 by emigration, first to Switzerland and later to the United States. Music, being otherworldly, is safe from terrestrial convulsions: the opera begins with a concert of angels, transcribing another panel from the Isenheim altar. Picasso's study of Grünewald prompted a different response to the emergencies of the decade. The crucifixion, like the raid on Guernica, was a massacre of the innocents. God can no longer be trusted to defend us. The function of painting, Picasso indignantly argued, was not to decorate apartments: it must be employed as an instrument of war. In 1944, accordingly, he joined the Communist Party, though his new faith soon enough faltered, disillusioned. In 1953 he made a rapid, more or less realistic obituary sketch of Stalin, showing his head as an egg with a walrus moustache affixed, and some avuncular worry lines rubbed in. The Party's hardliners condemned his work for its deviant fantasy. Ideology had no use for imagination.

Guernica in any case has outlived its polemical purpose. It now looks like Picasso's authoritative report on our morphological plight, locked up inside bodies – wrenched and wracked by his own art – which have been expressly invented to feel pain. Apollinaire said that Picasso studied objects like a surgeon dissecting a cadaver. Here the objects, unlike the table-top impedimenta of the cubist café, are human subjects, and they remain alive during the operation. *Guernica* picks out the soft, sensitive extremities which are of interest to torturers: the sole of a foot and the palm of a hand, both scored with stigmata, anchor the composition in its bottom corners. Nipples seem to be squeamishly detachable, mouths are megaphones for broadcasting agony. But it is the eyes which give the painting its unbearable emotional power. The bull's are fixed, unfeeling, while those of the horse have contracted into an unbelieving stare. One of the dead soldier's eyes has twisted askew in its socket, as if falling out. Those of the dead child are blank, lacking pupils: they were never given the chance to see. Three of the women have eyes squeezed at the corners into the shape of tears. Why are we given eyes, if not to weep with? The bloodshot filament of the light bulb in the black sky might be the eye of God – except that, as the painting makes clear, he is either blind or dead.

At the Bauhaus, Moholy-Nagy decreed that the visual arts should concern themselves with 'the hygiene of the optical'. They must cleanse sight, rendering the eye vitreous. The surrealist joker Man Ray photographed a woman whose eye has squeezed out a glass tear. Picasso would have had no patience with Man Ray's jest, or with Moholy-Nagy's programme of reform. His paintings, compassionately bearing witness, testified instead to the pain of the optical.

To look, as modern physics explained, is to alter what you look at. Picasso's imperious way of seeing put Heisenberg's principle into practice. His art created uncertainty.

The critic André Salmon referred enigmatically in 1912 to the 'Trismegistusian harlequins' Picasso had painted between 1901 and 1905: those sad, emaciated clowns, expelled from the Italian comedy in which they once performed, now living on the city's margins with their dogs and their querulous babies. Salmon borrowed the phrase from a poem by Apollinaire referring to the Greek god Hermes Trismegistus, whose honorific title announced that he was trebly great, licensed as priest, king and philosopher to preside over the realms of religion, law and art. The harlequins are the god's derelict offspring, punished for their freakish talents by social exclusion. Perhaps they were also cryptic symbols for Picasso's supernatural or inhuman gifts. Hermes founded the hermetic science of alchemy, which sought – like cubism – to unveil nature's secrets, and when the physicist Ernest Rutherford was ennobled in 1931 he chose an image of Hermes Trismegistus for his baronial crest. His own experiments brought alchemy up to date, treating radioactivity as a transmutation between atoms.

Picasso flirtatiously adopted the god's identity in *Les Aventures de Mercure*, a ballet he designed in 1924 to a score by Erik Satie. Roman mythology twinned Hermes with Mercury, a worldlier god with more interest in merchandise than magic. Mercury, a liquid metal, is a tricksy substance, named by alchemists after the quicksilver planet. It can dissolve gold by forming an alloy with it, and is liable to poison the brains of those who work with it: Lewis Carroll's mad hatter was deranged by mercury, which hat-makers used for imparting a sheen to felt. Mercury also came to the rescue of sufferers from syphilis. The life-saving refrain of the medical team in Ernest Hemingway's novel *A Farewell to Arms* (1929) – men who spend their days patching up the casualties of the Italian battlefield and their nights risking fatal infection in the local brothels – is 'We put our faith in mercury'. Syphilis was the abiding terror of the early twentieth century, a disease which spread along the fault line of society because, like Picasso's *Demoiselles*, it revealed the existence of a sexual underground. Stefan Zweig called prostitution the 'dark subterranean vault over which rose the gorgeous structure of middle-class society'. The descent into this hidden realm with its deadly risks had a brave, revolutionary allure. The brothel, for Hemingway's characters as for Picasso, was an existential arena like the bullring; and the pathology of syphilis worked like a parody of modern art with its ruthless metamorphoses, disfiguring the body and twisting the mind into fantasies of megalomaniac exaltation.

The mischievous episodes of *Mercure*, accompanied with jaunty triviality by Satie, might be a dramatization of Picasso's alarmingly mercurial creative nature. The work's subtitle was 'poses plastiques'. Ballet, by mobilizing images, enabled Picasso to paint in time as well as space, combining 'plasticity and mime' – as Apollinaire said of *Parade* – to signal 'the advent of a more complete art'. Choreography granted the wish of Duchamp, who in 1912 had scandalously painted a nude descending a staircase: it allowed painting to walk out of its frame. Mercury's poses correspond to Picasso's shrewd impostures. The three

scenes of the ballet display the god's triple functions, less high-minded than those of Hermes. He appears first as the fertilizer, killing Apollo and then reviving him. Picasso, who obsessively drew or painted artists ogling nubile women, envied this capacity to give life (and to revoke it): art is the male's effort to compete with the generative female. In the finale Mercury shows himself as the magus. He invents the alphabet, whose letters dance a celebratory polka. That feat probably meant less to Picasso than Mercury's alliance in this scene with Chaos, the force which helps Pluto to spirit Proserpine away to the underworld. Apollinaire, in his account of Picasso as the century's 'new man', said that he imposed an order on the incoherent universe for his own personal convenience. A merely personal order is what others might call anarchy.

For Picasso, the crucial scene was perhaps the middle one, in which Mercury the wily robber steals jewels from the Graces while they bathe. Modernism, bored with the romantic cult of originality, treated theft as the artist's impudent prerogative. T.S. Eliot justified the recourse to quotations in his own poetry by shrugging that minor poets borrow, while great poets steal. In *Journal d'un voleur*, an autobiographical novel about his criminal career, Jean Genet linked robbery and artistry by remarking 'I have been told that among the ancients Mercury was the god of thieves'. Picasso insisted that he would rather copy others than repeat himself; among his previous ballet designs was *Pulcinella* in 1920, which had a pastiched score by Stravinsky, who boasted that he composed Pergolesi's music better than Pergolesi himself had been able to do.

Picasso shared this aptitude for impersonation. Dressed for a society party in the 1920s, having abandoned his uniform of proletarian denim, he was overheard murmuring 'Monsieur Ingres' to his reflection in a mirror. Such cheeky appropriations, like the larceny of Mercury, covered Picasso's competitiveness. The dog in Kafka's story complains that, as history plods onwards, each generation inherits more wisdom which it must take care to forget. Picasso coped with the modern predicament of belatedness by remembering everything, but in an impishly redesigned form. Thus he systematically worked through the entire history of art, enlisting his predecessors as precursors of his own coming.

The motive of Picasso's earliest adaptations was sacrilege. When his friend Carlos Casagemas committed suicide in 1901, Picasso first made a portrait of the corpse – its flesh a morbid green, a bullet hole in the temple – and then dispatched his friend to heaven in an infidel parody of El Greco, with Toulouse-Lautrec cabaret girls, naked except for their stockings, romping expectantly on the clouds: Casagemas had killed himself for love, which Picasso made sure he would enjoy without complications in the afterlife. In 1931 he purged David of his chilly classicism in *Woman with Stiletto*. David's Marat, drained of blood, has hardened to a marble effigy in his cold tub; Picasso instead painted Charlotte Corday on the rampage, with electrified hair and a shark's grinning mouth, her body ballooning to fill up the bathroom. She has not only stabbed but flayed Marat, and all that remains of him is a blank page of crinkled parchment,

surmounted by a pimply head. Blood lushly carpets the floor. David painted a principled assassination, Picasso a lusty murder.

Later – in serial versions of *Les Femmes d'Alger* by Delacroix made in 1955, of *Las Meniñas* by Velázquez in 1957, and of Manet's *Le Déjeuner sur l'herbe* in 1960–70 – the impulse of appropriation seems more affectionate. Picasso loved these paintings so intensely that he was unable to tolerate the thought he had not painted them himself. He therefore did so, and with his usual superlativeness made fourteen variants of the Delacroix, forty-four of the Velázquez, and twenty-seven of the Manet (with an additional eighteen maquettes for sculptures developed from the lunching figures).

The Delacroix sequence began with a portrait of Jacqueline Roque, the last of his wives. Picasso dressed her up in a Turkish harem costume borrowed from Delacroix, then progressively undressed her. He disrupted the lazy, lounging still-ness of the original in a rough-and-tumble of spilled, cavorting bodies, legs raised in the air, with a mirror to multiply pleasure; the coffee-pot bounces towards the ceiling, clearing the floor for sexual gymnastics. Although Jacqueline remains rec-ognizably herself, abstraction overtakes the other figures, which lose their heads (they are optional in an orgy) and handily wear their breasts and buttocks on the same side. Picasso's method can be seductive as well as surgically dissective, and cubist fragmentation allows him to take possession of these bodies piecemeal.

Despite his intention to pay homage, he could not help outdoing *Las Meniñas*, at least in one respect. The viewpoint of Velázquez, who painted him-self standing guard at the canvas, is fixed, and a network of sight-lines – tran-scribing the trajectory of power at court – connects him with the king and queen who, reflected in a mirror, supervise his portrait session with their daughter. The painter depends on them as patrons; they depend on him as their official image-maker. Perspective, ensuring that everyone knows their place, gives *Las Meniñas* its tension and fraught self-control. Picasso ignores these protocols. Cubism allows him to walk around in the room, and sets free his inquisitive gaze. The Infanta did not want to pose for Velázquez, which is why the meniñas have to cosset and cajole her. Picasso turns her whichever way he pleases, and in a sepa-rate study peers at her in profile and full face at once. His largest version of *Las Meniñas* is almost the same size as the enormous original – not so tall, but signifi-cantly wider. The composition of Velázquez, summarizing a political hierarchy, extends upwards; Picasso elongates the room sideways, and cubism with its impertinent ocular democracy invades the court.

Manet's sedate outdoor lunch, as Picasso went to work on it, cast off its inhi-bitions, and gained a supplementary population of bulging nudes, rolling on the grass in rubbery, serpentine postures. Eventually these figures stepped out of the painting and took on a bodily third dimension. The studies of Manet led to the sculptures Picasso designed for the Moderna Museet in Stockholm, where the concrete monoliths now picnic in perpetuity on a lawn above the harbour. Art, as cubism always intended, has expanded into life.

Explaining Picasso has been one of our century's most fervent intellectual endeavours. The hope is that, in accounting for him, we might resolve the problems of the new physics and the old metaphysics, as well as clearing up the psychoanalytical puzzle of aggression and vindictiveness which made him, when he strangled that imaginary dove, identify creativity with killing. So far disappointed, the quest remains urgent, because this is an art which, like the Avignon brothel, compounds ancient dreads and contemporary doubts. 'Picasso', as Michel Leiris remarked in 1937, 'sends us our death notice: everything we love is going to die'. Leiris wrote this after seeing *Guernica*, but his baleful comment was more than a premonition of general war. It referred to the manifold instabilities of our modernized world, and blamed Picasso for much of the mental damage. In 1991 – when modern history seemed to have come to an end, with the fortuitous collapse of communism – a character in Milan Kundera's novel *Immortality* made Picasso share responsibility for 'that European perversion called history', with its fanatical craving for progress (or at least change) at any cost. Beethoven wanted to hustle or bully the world into perfection. So did Stalin. Now that the dialectic has worked itself out, Kundera's Paul concludes that we are better off without both visionary artists and prophetic despots. Europe, he points out, has got through the last half century without destroying itself in another war. It is no coincidence that, during the same quiet, happy, mediocre time, 'no new Picasso has appeared, either'. Another character in the same novel borrows two of Picasso's favourite motifs in order to sum up modernity's brutal assault on a visible world which men once loved and reverently protected. 'Reality', he says, has been 'magnificently violated like a woman raped by a faun.' (Stravinsky was unapologetic about the creative violence to which he subjected Pergolesi in *Pulcinella*, and said that 'rape may be justified by the creation of a child'.) Kundera's spokesman adds that, at best, reality puts up a valiant, losing fight against Picasso, 'like a bull with a toreador'.

In this inquest on Picasso, Rainer Maria Rilke stands alone in valiantly arguing that his work expressed a desire for faith, rather than a quizzical nihilism. After long meditation on *Les Saltimbanques*, painted by Picasso in 1905, Rilke proposed an interpretation of the picture in his Fifth Elegy, written in 1921–2. The poem begins by asking who they are, this crew of rootless circus performers (including a Trismegistusian harlequin), fugitives pausing in an indistinct desert during some bereft migration. Rilke is touched by their precariousness and existential pathos. But when he imagines them in the ring, they reacquire sublimity. Impelled by the force of dissatisfied, striving will, they soar through the air without the support of a safety net and miraculously rebound onto a scrap of carpet adrift in space; he compares the glorious 'salto mortale' of the jumpers with the rapture of lovers, who in their own way joyously taunt and defeat death. They earn the coins tossed at them by the spectators, he concludes, because their skill has shown us how we can overcome our mortality. Acrobats have been transformed into angels.

Picasso's downcast fliers do not seem to share Rilke's worshipful exhilaration. Other writers reacted more ambiguously, and asked if Picasso's researches into form and volume were not recklessly playing dice with the universe. Hence Gertrude Stein's comparison with Galileo (except that, as she added in her 1938 essay, Picasso refused to recant by disowning the evidence of his eyes).

Pablo Picasso *Les Saltim-* *anques 1905)*

The poet Paul Éluard remarked in 1941 that 'More and more, Picasso paints like God, or like the devil'. Could objects so angrily dismantled ever be put back together? Was it still possible to conceive of a rational maker? Did matter owe whatever shape it temporarily possessed to chaos and convulsion? Picasso's art addressed such testing questions to the state of things – poking a sword into the void, as Éluard said in a poem about him – but felt no obligation to propose answers. In 1956 Francis Poulenc composed a song cycle, *Le Travail du peintre*, based on Éluard's poems characterizing modern painters. A flighty waltz accompanies Chagall's fairy familiars, and the evocation of Klee has an eerie playfulness; but the Picasso poem which begins the sequence is set by Poulenc with heroic sternness. Its lofty declamation matches the severity of an artist who scrutinizes the world he has wrenched awry with 'a fixed eye / like a blind man, like a madman'. The poem and the song explain why André Salmon in 1912 paid awestruck tribute to Picasso's 'tragic curiosity'.

Tragic, or merely foolhardy? Oskar Schlemmer doubted Picasso's mental health, and suspected him of passing on his ailment to the rest of us. In 1913, Schlemmer brilliantly nicknamed him 'the Hamlet of painting'. They shared the antic disposition, the questioning irreverence, the metamorphic facility; both of them were 'experimental to the point of madness' – or perhaps beyond it. Picasso showed Method actors how to twist their bodies into abstruse shapes. James Dean's favourite party turn was to wear his glasses askew, which made him appear to have three eyes. 'I'm a Picasso', he would explain. In 1921, while Rilke was writing the elegy in which the stunts of the acrobats displayed the operation of religious grace, Schlemmer likened Picasso to 'the tightrope walker (the comedian who courts danger)': he risks his life for the sake of excitement, not so he can vault into heaven. By 1932, in the decade belonging to dictators,

Picasso had become 'this artistic Napoleon'. At the same time, Schlemmer in another antagonistic simile called him 'the Kreuger of painting' – a reference to Ivar Kreuger, the Swedish monopolist known as the 'match king', who had recently shot himself in Paris after his frauds and double-dealings were exposed. The ingenuity, in Schlemmer's view, concealed emptiness.

A virtuosity like Picasso's inevitably courts the accusation of charlatanism. It comes as a relief to be told that there is nothing there: sooner this than the involuntary state of possession which genius entails. Picasso challenged incredulity by outrageously comparing himself to a God in whom no one, Picasso himself included, any longer believed. Like God, he said, he had no style. God had made guitars, harlequins and doves without consulting a prototype; he created things which did not previously exist, and so did Picasso. God also reserved the right to do a botched job. 'I keep making mistakes,' Picasso told Jean Cocteau, 'like God.' In the absence of other pretenders, he was compelled to go on playing the role. For the photographer Gjon Mili in 1949 he made a series of 'space drawings' with a flash-light: designs scribbled on the air, which existed only inside the camera. The session allowed him to re-enact Genesis, as he put into practice God's initiating utterance 'Let there be light'.

Clouzot's *Le Mystère Picasso* served the same purpose of mystification. In the film Picasso – at first invisible, doodling on a blank, transparent screen – tries out the imported American novelty of a felt pen instead of a brush, and uses it to write the world into being. He begins with a black and white sketch, followed by the advent of colour as a blue sky floods the page. A jungle of decorative scribble congests the screen. Then the film is reversed, the vegetative complications clear away, and we are left with the first tentative shoot from which life began. The world makes and unmakes itself before our eyes.

But Picasso is driven to tease and if possible affront Clouzot's reverence, exposing the cruelty of his imagination. In a bullfight scene, the bull tosses a picador, who lands – after a quick cut – in a sudden puddle of blood. Then, during another nervously jumpy cut, Picasso adds the burning orange sand of the arena; next the spectators, whose faces are skulls; lastly the striped rib cage of the bull, as if it were already a skeleton. Near the end of the film, Picasso like Wells's Dr Moreau stocks his newly imagined world with a zoo of hybrids. He draws a cactus, turns it into a fish and then a rooster. Clouzot, as if appalled by this metamorphic obsession, hurries him up by warning that the film will soon run out. Picasso, preoccupied by the concoction of monsters, grafts a human face onto the bird's plumage. Clouzot shouts that there are only forty-five seconds left. 'I've got time', says Picasso, and with eight seconds still to go he blackens the face, obliterates the bird, and reveals in its place a devil.

Man Ray declared that to create is divine, whereas to reproduce is human. While Picasso anachronistically exhibited the prerogative of the gods, the artists who followed him accepted their own lesser humanity. Creation makes something from nothing; reproduction plays with pre-existing ingredients, and in

y Lichtenstein
me d'Alger
(1963)

the twentieth century its toil has been eased by machinery. Hence the Picasso paintings reproduced by the Pop artist Roy Lichtenstein during the 1960s. 'I'm trying to make a commercialized Picasso', Lichtenstein explained. Granular dots like news-print show through the surface of his 1963 painting *Femme d'Alger*: newspapers or postcards make multiple copies of an image, and Pop artists had outgrown the sense of shame – the fear of lost individuality – which once attached to mechanical reproduction.

The women in Picasso's original, *Les femmes d'Alger*, alluded to the lazy, sultry Algerians painted by Delacroix; they also recalled a remoter African ancestry, and one of them has a displaced tribal mask for a face, worn lower down to protect her belly. Reproduced by Lichtenstein, Picasso's subject has forfeited this matriarchal power. Angular zones of flat, bright colour reduce the woman's body to two dimensions, and control her cubist tendency to pluralize and proliferate. She has become decorative: she stays on the wall, or disappears into it.

In 1964, Andy Warhol caught sight of Picasso's daughter Paloma in Paris. He was excited by this glancing contact: 'Picasso was the artist I admired most in all of history, because he was so prolific.' His remark measured the distance between modern times and post-modernity, between creation and reproduction (or simulation). When Picasso died in 1973, Warhol took note of a magazine's assessment that he had painted four thousand masterpieces. 'Gee,' he reflected, 'I could do that in a day.' The feat would be easy, because the four thousand masterpieces would all be the same painting. On second thoughts, Warhol calculated that it might take him a little longer to equal Picasso's output – approximately eight months.

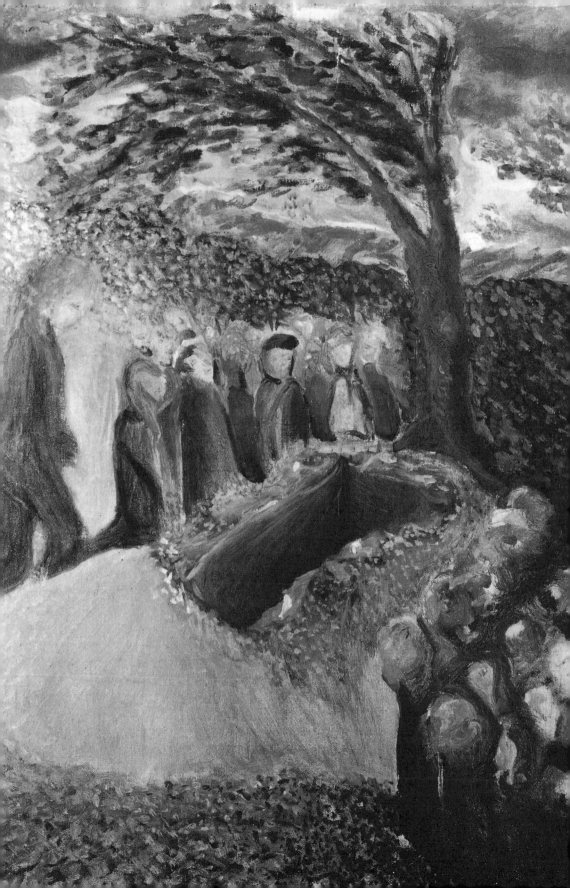

RETUNING THE SKY

Music descends from the sky, or perhaps props it up. Mythology defined music as a gift of the gods, the sign of a mystical accord and evidence of universal order: the spheres allegedly sang as they went about their serene business of revolving. Once God had died, where was music supposed to come from? In 1912, recommending himself to the pianist Ricardo Viñes, Satie refused to call himself a musician. His compositions, he said, were mere 'phonometry'; he should be considered a humble 'acoustic worker'. Iwan Goll described the vicissitudes of a contemporary metropolitan Orpheus in a poem written in 1918. Kurt Weill used Goll's text for his 1925 cantata *Der neue Orpheus*, and sarcastically mimicked the music which the divine singer must churn out to scratch a living: Orpheus gives piano lessons to beginners, bangs a drum at the circus, and plays maudlin hymns on an organ. The new physics upset the system of checks and balances which maintained the harmony of the spheres, each contributing its own note to the scale. What sound now filtered down from outer space? In *Der neue Orpheus*, the sky creaks tunelessly: the world's axis has grown rusty. When Niels Bohr defined the laws which accounted for the spectrum of atoms and their electronic orbits, Einstein commended his theory as 'the highest form of musicality in the sphere of thought'. But that music was silent.

In his First Cantata, composed in 1938–9, Webern bewailed this destitution. Singing a poem by Hildegard Jone, the chorus laments that, when the strings once blessed by Apollo sound, no one now remembers the Graces, those harmonizing intermediaries between earth and heaven; a soprano shyly reaches for a high note and pays wistful homage to a perfection which used to be 'die Gabe des Höchsten', the gift of the Highest. Bereft of the traditional consolations which convinced them that theirs was a religious calling, modern musicians had to invent the art all over again. The effort, risky and sceptical, can be overheard at the beginning of Berg's *Altenberglieder*. The first song begins with a disorganized sonic mayhem, as half a dozen jarring, jangling ostinati ring out together. The disorder recalls the rumbling upheavals in the choral movement of

Beethoven's Ninth Symphony, sorted out by the authoritative entry of the bass. No such easy assumption of command was possible for Berg. When, after a congested and disorienting minute, the simultaneous scales and sighing figurations talk themselves to a loud, abrupt dead end, the soprano is unsure whether her voice can restore order.

Before she utters a word, she is allowed two tentative rehearsals, demonstrating the mysterious nativity of musical sound inside the body. First, almost inaudible, she pensively hums a note with her mouth closed. Humming is a hermetic practice. We do it to dispel an oppressive silence, or to paraphrase some private memory; it is like a secret, unshared smile. Then the singer ventures another, more exclamatory note, also wordless, but this time with her lips parted. Now she feels confident enough to release a sound, previously sealed within, into the external world. Berg's annotation in the score instructs that the note should be lightly exhaled, 'like a breath', and it serves as a prelude to the first word she pronounces, which floats out to hang like an arc in the air.

That word, significantly, is 'Seele', meaning soul. The singer goes on to declare that, just as nature is refreshed and made more radiant by snowstorms, so there are convulsions inside us which, when they pass, leave us with a profounder understanding of ourselves and the world. Ambiguities crowd into the initial word, and complicate the negotiation between noise and music, inarticulate sound and language, which occurs during the prelude. Although 'Seele' denotes soul, what precisely is that? Is the spirit anything more than the air which Berg tells the singer to expel in his annotation? Breath, we know, is a vital sign. Can we be so sure about the moral or spiritual force which quits the body, supposedly in quest of salvation, when we die? That first word begs a multitude of questions about biology, religion and music's relation to them. Song is one of the ways in which the body exercises its organs and exhibits emotion; do we still dare believe, in addition, that it testifies to the presence of a divinity inside us?

Freud, analysing the human advance towards intellectuality in *Moses and Monotheism*, paused to speculate about the notion of 'Seele', which – along with the connected idea of 'Geist', the ghostly concept of spirit – signalled a victory for emerging civilization. Mental adulthood means the capacity to deal with abstractions: forces whose existence we cannot doubt, even though they remain as invisible as wind, ungraspable by our senses. Ancient man thought of these disembodied energies as gods. At their most dangerous, they might be evil emanations, transmitted like curses, fended off by masks or sacred body paint. These were the powers which Picasso, as a twentieth-century savage, attributed to the African or Polynesian statuettes he collected. Modern man, educated by the new physics, is more likely to think of the forces which Freud calls 'geistige' (intellectual? spiritual? both? – all our uncertainties are compressed into the word) as radio waves, X-rays or gamma rays, effects of electromagnetism: light on its inconceivable errands. Superstition, however, is the beginning of science. Freud points out that 'the movement of the air...provided the prototype of intellectuality',

because intellect or 'Geist' took its name from an animating breath of wind –
'"animus", "spiritus" and the Hebrew "ruach (breath)"'. Having arrived at this
idea, men proceeded to 'the discovery of the mind (Seele)' and of 'the intellec-
tual (geistigen) principle in individual human beings'. We still say that a dying
man gives up the ghost or, in Freud's German version of the phrase, that he
breathes out his 'Seele'. The opening of the *Altenberglieder* summarizes this dis-
covery of the mind, which is also the discovery of music.

The First Symphony of Aleksandr Scriabin in 1900 concluded with a
vocal homage to its own art, extolled as a priestly vocation. The singers promise
wonders. They believe that music, as well as imparting visions of enchantment
and teaching new modes of thought, can cure the sick and embolden the spirit to
perform heroic exploits. A chorus, representing all the peoples of the world, is
assembled in praise of this international, all-purpose remedy. Mahler's Eighth
Symphony – first performed in 1910, three years before Schoenberg conducted
the *Altenberglieder* in Vienna – began with a massed, multitudinous choral appeal
to the unseen source of life and music, invoking the spirit singled out by Freud:
'Veni, creator spiritus.'

Berg's solitary soprano can produce no such prophetic whirlwind of
sound. The air made vibrant when she vocalizes and the blizzards or thundery
showers she goes on to sing about make manifest – inside and out, in little and at
large – the force invoked by Scriabin and Mahler and analysed by Freud; but the
breath which swells from her is soon withdrawn, and the whimsical, transient
weather rages for a few seconds in the orchestra and then abates. It is as if Berg
has moved beyond those symphonic anthems which restore faith in the old musi-
cal covenant, to the more quizzical and disconsolate level of mental development
which Freud defines at the end of his commentary on 'Seele'. Once man recog-
nized the existence of spirits, he distributed them throughout nature. They
lurked everywhere: this was the religion called animism, which saw the world as
literally soulful ('beseelt'), crowded with souls. But the abstracting process had
further to go. 'Science,' Freud concluded, 'which came so much later, had plenty
to do in divesting part of the world of its soul once more.' The task of demystify-
ing, he added, was still not complete. His own practice of psychiatry made its
contribution: his clinical purpose was to cast out demons, banishing bad dreams
by interpreting them. The mind, like the world as seen by science, is a piece of
machinery.

Already, within the aphoristic span of Berg's first song, that fall has
occurred. The soul, reverently named when the singer makes the word 'Seele'
shine out, has a minute later changed back from spirit to empty air. The rage
which stirred up the snowstorm – like Freud's God in *Moses and Monotheism*, who
is 'the greatest and mightiest, although he is invisible like a gale of wind or like
the soul' – dwindles to a hollow murmur. The song concludes by describing the
soul and nature enveloped alike in cloud, overlaid by what Altenberg calls a
murky breath, 'ein trüber Hauch'. This might be the vapour of condensed air

you breathe out on a cold day: a wintry negation of the glad opening. On such days your lungs hurt, and in speaking you conjure up a ghost.

Every phrase in the poems is ambiguous, which enables Altenberg's words to tell their own teasing, lateral tales. There may be a kinship between 'Hauch' and 'ruach', the Hebrew word for breath in Freud's series of names for the unnameable. 'Hauch' is also a crucial word for Klytämnestra in the *Elektra* of Strauss and Hofmannsthal, given its first performance in 1909. Deranged by guilt for her murder of Agamemnon, she begs her daughter to prescribe some remedy for her tormenting dreams. She is making a coded appeal for therapy, although Elektra, the unmerciful analyst, gloats that the cure must be Klytämnestra's own sacrificial death. All she wants, Klytämnestra says, is a single, life-saving word, which is very little to ask: 'Wenn auch ein Wort nichts weiter ist! Was ist denn ein Hauch?'

What indeed is a breath? When sung, in Strauss's operatic setting of Hofmannsthal's play, it is worth many words. The singer must make 'Hauch', elongated as she holds her breath, sound like a smothered eruption; her enunciation of it should anticipate her last breath, the guttural death rattle later heard offstage when her son Orest kills her. After this hollow whisper, she goes on to tell Elektra about her nightmares. She is ravaged by a dread for which no name has been invented: 'ein Etwas hin über mich. Es ist kein Wort..., nichts ist es' – a something crawls over me, not a word, a nothing. Words, reduced to the expiring breath which she lets go in declaiming 'Hauch', have failed her. Her terror is wordless; she can only call it nothingness, nullity, non-being. But Strauss's orchestra gives a face and a form to this unseen, indescribable thing which has unsettled Klytämnestra's mind. As she sings, a bass tuba stalks her, moving with stealthy deliberation as if it dragged a heavy body, slurring and growling malevolently. A player in the pit lends his breath to the instrument and manufactures a monster.

Kandinsky, a friend and supporter of Schoenberg, believed that music and painting were natural allies, linked by the physical affinity between 'the vibrations of the air (sound) and of light (colour)'. Music causes the air to tingle or quake, stirred by Freud's gale or Altenberg's storms; a painter's colours, according to Kandinsky, also bounced off the canvas, beaming radiantly or radioactively through space. This faith in the vibrancy of colour prompted Kandinsky – in a treatise written in 1910, called *On the Spiritual in Art* – to orchestrate the spectrum. Red, he thought, made a noise like a drumbeat, yellow evoked the trumpet, blue was best transcribed by the flute, and orange tolled with the orotundity of a church clock. The natural world is a sensorium, a sounding-board for cosmic energies. Kandinsky thought that the human body shared this receptivity: 'men of sensitivity are like good, much-played violins which vibrate at each touch of the bow'. Musicians are experts at the arousal of emotion; Kandinsky claimed the same power for painters, and argued that the soul could be played upon by colour as well as by the violinist's bow. Hence his image of the reverberant palette. 'Colour', he said, 'is the keyboard, the eyes are

the hammers, the soul is the piano with many strings.' The painter should be a pianist – choosing tones like notes, with a view to inducing a sympathetic unison 'in the soul'. Kandinsky's treatise recommended chromotherapy: he thought that coloured light could be healthful, healing, just as music had charms to soothe distress. He did not consider the obverse of this programme for salvation. The vibrancy which cures can also kill; modern music chooses disturbance more often than pacification. Klytämnestra – with her untuned consciousness, her flailing quest for appropriate words, her lapse from melody into gasps, groans, hysterical laughter when she is told Orest has died and anguished screams when he reappears to slay her – is a test case: a woman driven to dementia by sounds in her head.

Her private trauma becomes, in the *Altenberglieder*, a metaphysical disquiet which afflicts us all. Unlike language, music is not embarrassed by the need to explicate mysteries, and Berg's first song has an orchestral epilogue which eavesdrops on the attempt of mind or spirit or music to understand and possibly harness the invisible, unintelligible wind. Although the beginning of the song subdues chaos, the end cannot prevent it from returning; the singer's initial release of breath, as she meditates on the idea of 'Seele' and finally gains the confidence to utter it, is revoked in a strange, haunting inhalation. Her last words are followed by a mournful descending scale, like a ladder let down into a void; after this a distracted whirring and tinkling, as of objects still faintly agitated after the animating breeze has withdrawn; at last a shivering, slithering chord on the muted violins, a wheezing exhalation by the harmonium, and a distant rumble on the low strings – perhaps the echo of some astral convulsion. If the chiming, discordant prelude announces the birth of music and of a world whose motions it sustains, then here, only three minutes later, music is engulfed again by silence while the world implodes. The soul, so recently invented, has already been extinguished.

Because the songs could not stave off chaos, the attempt had to be made again, with tragic inconclusiveness, in the *Three Orchestral Pieces* which Berg composed between 1913 and 1915. The so-called 'pieces' consist of a 'Präludium', in which music once more emerges from a remote percussive clangour, only to be concussed by a thudding blow; 'Reigen', a round-dance which accelerates the Viennese waltz until, overwound, it veers out of control; and 'Marsch', a trampling parade of hardware. These were the relics of a symphony Berg was unable to complete: the ordaining, harmonizing structure had lost its power.

A symphony sets itself problems which, by taking its time, it duly resolves. Mahler's last exercises in the form, before his death in 1911, test the limits of sonority and the capacity of music to contain and tame disorder. In his Sixth Symphony the orderly routine of development is stunned by the terminal bludgeoning of a hammer, which strikes again in Berg's *Three Orchestral Pieces*. In the unfinished Tenth Symphony an excruciating dissonance causes the ground to quake and the strings to shriek in alarm. Schoenberg defended his own atonality

as 'the liberation of dissonance'. For Mahler, dissonance meant not freedom but doom. In the Ninth Symphony, Berg heard 'die Todesahnung', an announcement of imminent death – Mahler's own, and perhaps that of music as classical and romantic composers had understood it. The opening movement suffers recurrent upheavals, distraught breakdowns after which the orchestra regroups its forces and limps haltingly on. In the last movement, the taut, tenuous strings describe a life which hangs by a thread. This is one of those Viennese farewells ironically analysed by Hermann Broch, but rid of the smiling, manipulative self-pity in which the operatic heroines of Strauss and Hofmannsthal indulge: the Marschallin in *Der Rosenkavalier* sagely nods 'Ja, ja' as she renounces her young lover, though she is not ready to accept sexual relegation; Ariadne pretends to believe that sex with Bacchus delivers death and transfiguration. The agony in Mahler is unfeigned, as is the courage – in the episodes of serenity recalled by the Ninth Symphony, or the solemn chorale in the last movement – required for such resignation. The finale is invaded by pauses, contemplative rests which are almost more eloquent than the music they interrupt. By the end, the surrender to silence is so imperceptible, like a gradient of shelving land which drops below the water-line, that it should be difficult to identify the moment when the music stops. And how, after this quietus, could music presume to start up again?

Schoenberg, after attending Mahler's funeral in Vienna, commemorated him in the last of his *Six Little Piano Pieces* – nine bars only, barely a minute in duration; a funeral march which has been stalled, paralysed by the loss of its regular rhythmic tread, ventilated by silence. In an angry, heartbroken memorial essay published in 1912, Schoenberg hailed Mahler as a saint, and lamented that his 'complete goodness and greatness' had suffered martyrdom at the hands of malicious critics and meddling bureaucrats. The turn of the century could not forget an earlier millennial crisis and its religious warfare, and Schoenberg boldly cast Mahler the rejected saviour as the murdered Christ, made to suffer self-doubt during his vigil in the garden. 'Not once was the cup allowed to pass away from him', he said. 'He had to swallow even this most bitter one: the loss, if only temporarily, of his faith in his work.' The same analogy is implicit in Schoenberg's oil painting of the scene at Mahler's grave. A spring gale agitates the trees: Freud's 'anima', invisibly attesting to God's outrage. On either side are ranked the meagre band of mourners, like apostles. A nimbus hangs over some of their heads. The grave itself, dug into a bare hillock, is a terrifying empty oblong, the entrance to nowhere. But because no coffin is visible and the orifice has not yet been choked with earth, the way is left open for resurrection. Perhaps this hole is the source of that eruptive energy which shakes the trees and hustles storm clouds across the sky.

Schoenberg's obituary returned to the conundrum of the 'Seele', which preoccupies Berg in the first Altenberg song. 'Here', he said of Mahler, 'is someone believing, in his immortal works, in an eternal soul. I do not know whether our soul is immortal, but I believe it.' He added, anticipating Freud's point about

Moses and his sponsorship of mind, that 'the highest men' – prophets like Mahler, or like his own operatic Moses – will stubbornly persist in believing that the immortal soul exists 'until the power of this belief has endowed humanity with one'. In a coda, he rallied his fellow disciples, disseminators of the gospel, and brandished a sword in defence of the faith: 'Meanwhile, we have immortal works. And we shall know how to guard them.'

For Schoenberg, Mahler's music proved the soul's existence. Schoenberg fervently believed in a variety of heterodox gods – the free-lance angels of Swedenborg, Madame Blavatsky's New Dawn, the occult arithmetic of mystical numbers (especially twelve, sanctified by the dodecaphonic row). His oratorio *Die Jakobsleiter* dramatized man's vertical struggle towards divinity as a quest for higher sonic frequencies, inaudible to earthbound men. The angel Gabriel, who grades the questers in order of spiritual merit, says in the oratorio that the 'One Much Higher' is a remote harmonic overtone, shimmering far above the fundamental note. The soprano aria *Herzgewächse*, which Schoenberg completed late in the year of Mahler's death, points in the same direction. The text is a symbolist poem by Maurice Maeterlinck, about the blossoms spontaneously grown by the heart: a bouquet of twining, writhing carnal plants with a lily – pale, ill, lunar, pointing towards the crystalline blue sky – at its centre. Schoenberg chose the accompanying instruments for their religious pedigree: a celeste (which sings of eternity at the end of Mahler's *Das Lied von der Erde*), a harp and a harmonium. The vocal line performs high-flying feats. The soprano is asked to reach a sustained F an octave above the stave on the first syllable of her final phrase, which describes the lily's 'mystiches Gebet', its mystical prayer. To sing the note at all is to reach dizzy heights, overcoming the doubts which afflict the singer of the *Altenberglieder*. In *Die Jakobsleiter*, the ladder Jacob saw in his dream is for Schoenberg a musical scale, surmounted by a vertiginous coloratura soprano who – marking out the ceiling of the universe in a wordless rhapsody – sings the part of the Soul.

Berg, partitioning the inheritance of Mahler's 'immortal works', appraised them differently, without Schoenberg's priestly certainty. He heard the Ninth Symphony in 1912, after Mahler's death, and was moved by its struggle against extinction, which ends in resigned despair. Mahler's thoughts, Berg said, remain on 'the beyond', but he breathes an increasingly rarefied air, like the thin atmosphere of the high mountains, which cannot nourish him. Instead of oxygen, he inhales what Berg calls 'Äther'; unconsciousness claims him. This annihilating ether has replaced the interplanetary air which buoys up the singer of Stefan George's poem in Schoenberg's Second String Quartet and wafts her to such blissful vocal altitudes. The divine, inspiring breath released by the soprano at the start of the *Altenberglieder* is stifled. This pained, desperate musical respiration was a medical symptom. Berg suffered all his life from asthma, which he self-scourgingly thought had psychological causes, and he joked to Schoenberg that the last of the *Three Orchestral Pieces* was 'the march of an asthmatic'.

He worked on this movement during the months between the assassination at Sarajevo and the outbreak of war, for which he was conscripted, medically disqualified, then recruited a second time and grudgingly declared fit for service. At the same time he discovered Georg Büchner's play *Woyzeck*, about a soldier brutalized and degraded by military authority. After the war he adapted it as the text for his opera *Wozzeck*, first performed in 1925. Berg's experience in the army – 'in chains, sick, captive, resigned, in fact humiliated' as he said after demobilization in 1918 – helped him to comprehend Wozzeck's misery and his murderous rage. Wozzeck repeatedly laments his own fate and that of those who, like him, are misused, betrayed, acted upon. 'Wir arme Leute', he sings – we poor (wretched, as well as impoverished) folk. He tells the officer who jeers at him that if he and the cohorts of his fellow victims ever got to heaven, they'd be put to work making the thunder. Berg's orchestra at once fulfils his gloomy prophecy. After Wozzeck's death, his verbal motto is trumpeted forth in a symphonic interlude which, if played with proper force and intensity, should shake the earth's foundations: it is a secular Dies Irae, anticipating the day of wrath when society's outcasts will be vindicated.

The oppression of which Wozzeck helplessly complains is already audible in the orchestral march composed in 1914. The clangour of cymbals prepares for the scene in the opera when Marie watches the soldiers on parade; the strutting Drum-Major, who – wanting to procreate a line of little, high-stepping drum-majors – casually seduces her and later beats up Wozzeck, is already on the rampage here. When the hammer-blow from Mahler's Sixth Symphony resounds in the *Three Orchestral Pieces*, it represents the battering mechanism of history, which has no use for human individuality and drills men into uniformity so as to more efficiently slaughter them. Hence what Theodor Adorno called the 'over-contrapuntalization' of Berg's march: the music engages in a compulsive, relentless mobilization. 'Reigen', placed second in the running order, was composed after 'Marsch', and may have a comment of its own to make about the society – 'nauseating' as Berg called it in a letter to Schoenberg from Vienna in 1915, expressing his disgust at the local diet of 'operettas and farces' – which had produced the catastrophe it now merrily ignored. The title suggests the sexual carousel of Arthur Schnitzler's play *Reigen*, a farce about the eternal round of copulation, written in Vienna in 1897 but – because it exposed the private parts of bourgeois civilization – not licensed for performance until 1920. Berg's round-dance is a joyless waltz, kept going through a kaleidoscope of frantic, haunted, belligerent moods by the circular, pointless automatism of its rhythm. Is this the way of life which the armies, marching to their rendezvous with the hammer, were supposed to defend?

Recomposing Mahler during this advance towards disaster, Berg aggrandized or collectivized an individual tragedy. The fatal injuries, personal and professional, which in Schoenberg's view constituted Mahler's martyrdom and sainthood, were superseded in the *Three Orchestral Pieces* by the tragedy of a

continent and of all its poor folk. Music, no longer upholding the sky, may have forfeited its special relationship with God, whose voice it once was. But it could still, in God's absence, concoct the thunder.

During a congested, cacophonous ensemble in the middle of *Salome*, Herod and his queen argue with the schismatic sects at their court while the Baptist howls imprecations from his cistern. Everyone has a different opinion about the Messiah, and the contradictory ideas which Strauss yokes together are often in clashing keys. Herodias, enraged by the prophet's slander and the theological quibbling of the Jews, shrieks a demand for silence. The orchestra promptly obeys. There is a second or so of peace, then the Baptist returns to his harangue. When he resumes singing, time itself starts up again after the full stop of Christ's incarnation. His first words announce that the day has come, and the Lord's feet can be heard treading on the mountains. That moment of silence represented Strauss's arrival at what, for him, was a terminus of polytonal uproar. The pause marked an urgent re-assessment: was it still possible to believe, with a fervour like the Baptist's, in tonality?

Music made itself modern by undergoing a specialized and stringent version of Nietzsche's 'great disengagement'. In Schoenberg's *Die glückliche Hand* – a psychodrama, composed between 1910 and 1913, about the artist (owner of the happy hand, which can fashion jewels), his private demons and his elusive muse – the protagonist's choral conscience chides him: 'Can you not renounce?' What Schoenberg renounced was melody. He disengaged music from its traditional duty to harmonize discords. He did so sacrificially, aware of the cost. 'The Supreme Commander', he said in 1948, had ordered him to travel this 'harder road'. Gabriel in *Die Jakobsleiter* orders a monk whose faith has faltered 'Go, spread the word, and suffer: be a prophet and a martyr.' Schoenberg, like Mahler, set himself to follow this punitive course, taking pride in public rejection. Late in life he was asked by a person to whom he had been introduced if he was Arnold Schoenberg the composer. He replied, 'Yes. Someone had to be.' The remark wryly affected penitence, but also proudly intimated that he had no choice. Lacking a mentor like Gabriel, he nominated himself for the role of Messiah.

The calling, with all its attendant risks, was a sacred one. In 1928 Schoenberg described talent as 'a guardian angel': an indwelling sense of vocation. To liberate dissonance – which to most of his early auditors meant unleashing bedlam – was for Schoenberg a mission of deliverance. He shared Kandinsky's view of the spiritual life as a matter of vibration, like a receptivity to radio waves. Clearing the air for sounds and combinations of notes censored by conventional tonality would therefore make it possible for us to hear the singing spheres or tune in to heaven. This is why the vocal type Schoenberg favoured was that of a high soprano. The heroine's stratospheric coloratura in Berg's opera *Lulu* reveals her amoral flightiness; for Schoenberg – in *Herzgewächse*, in the Soul's cadenzas at the end of *Die Jakobsleiter*, and in the Second String Quartet – the same range

testifies that the singer is a visionary, rather than an air-headed escapee from responsibility.

The poem by George set in the quartet is called 'Entrückung', which means transport – more specifically, space travel. Schoenberg was sure, when he completed the quartet in 1908, that 'the departure from earth to another planet' would in due course occur: the poem, he said, 'foretold sensations, which perhaps soon will be affirmed'. While waiting for aviation to catch up with art, the opening of the fourth movement ventured to anticipate how it would feel to be 'relieved from gravitation'. Take-off, without the blasting combustion of rockets, is mimed in a rush of upward scales, followed by a cradling arrival at orbit. Far above earth, the traveller floats through 'thinner and thinner air' – a zone of refinement, not the suffocation which overtakes Mahler in Berg's commentary on his Ninth Symphony. Here, according to Schoenberg, 'all the troubles of life on earth' could be forgotten.

In 1946, after his resettlement in Los Angeles, Schoenberg personally experienced this rite of passage without needing to leave the ground, and transcribed its purgative stations in his String Trio. He died, then returned to life. A dose of benzedrine which had been administered to relieve his asthma provoked a heart attack. He was injected with a pain-killer, but lost consciousness: 'my heartbeat and pulse stopped.' A needle aimed directly into his stalled heart saved him. During a long recovery, he counted 'about 160 penicillin injections'. The trio, like a cardiograph or an encephalogram, records what happened to him on this disputed frontier between life and death. Its literalness may alarm the squeamish: the stabbing strings recall the punctures made by those jabbed hypodermics. But after the initial spasm of panic and some swooning glissandos which accompany collapse, there are interludes of aerated serenity, even a lilting waltz, and the conclusion reviews the calamity through an anaesthetized haze, as if the body which has broken down belonged to someone else. Death, the greatest of disengagements, is a mystery which music knows how to elucidate.

Schoenberg renounced tonality (a stage on the path towards revelation) during his work on the vast oratorio *Gurrelieder*, which occupied him from 1900 to 1911. The stylistic change which overtakes *Gurrelieder* towards the end announces a series of conversions. It begins in an opulent aphrodisiac night, like that which envelops Wagner's Tristan and Isolde, during a passionate encounter between Waldemar and his lover Tove; it ends – after Tove's death and Waldemar's own progress beyond vengeful despair, as their tragedy is absorbed by mercifully forgetful, eternally repetitious nature – with a radiant dawn. It begins as a duet between two operatically self-obsessed individuals; it ends, in a series of roof-raising choruses, with the celebration of a collective life. Developing, it grows to incorporate all people, all living creatures, all life whether embodied or not: peasants and simpletons, wood doves and eels, the fluttering rampancy of the summer wind and the sprouting fertility of the fields. The abandonment of tonality is its gesture of inclusion. Waldemar and Tove, as Wagnerian aristocrats,

are confined to the lofty, arduous medium of song. But their social inferiors, the wise survivors who adopt nature's protective camouflage, enjoy the liberty of Schoenberg's 'Sprechstimme': music acknowledges the eloquence of the prosaic speaking voice. In the Second String Quartet a drifting, anchorless atonality offers to chart the frigid spaces between the stars. In the pantheistic *Gurrelieder* – where Tove's theme is posthumously disseminated throughout the orchestra, like her body consumed by the earth, while a Speaker excitedly numbers the swarming insects of summer – the new musical language lays claim to a lowlier but richer realm. Atonality suited heaven because, as Schoenberg said, it refused to discriminate between up and down, right and left; the same impartiality enabled it to represent life on our populous, uproarious earth.

Gurrelieder ends with the summer wind wildly disconcerting nature, jumbling separate existences into a happy chaos. In 1904, just before he became Schoenberg's pupil, Webern composed an orchestral idyll called *Im Sommerwind*, a large and lush romantic homage to the landscape of the Carinthian Alps. Skittering breezes carry snatches of alphorns, bird-song and village dances; beneath this elemental agitation, the sight of the mountains induces a solemnly mighty meditation on their maker. When he adopted Schoenberg's method, Webern renounced this cloudy, gusty romantic rhetoric. His new works were epigrams, not panoramas. His *Six Pieces for Orchestra*, composed in 1909, are as dense as they are brief. The third module – eleven bars which last less than a minute, a series of muffled fanfares and elegiac chimings – is so soft and stealthy as to be scarcely audible: it purposefully tests our capacity to listen.

Sound blows through the romantic orchestra as negligently as the summer wind. Sounds in the work of the new, modernized Webern are still fugitive, because music is the art which most poignantly reminds us of our imprisonment in time; but before they elapse, these tiny disruptions of the air are analysed, as if in a wind tunnel. This practice of atomization put nature under the microscope. *Im Sommerwind* recorded what a mountain looked like or what it made Webern feel like when he looked at it – activities befuddled by the self-dramatizing subjectivity of the romantics, for whom landscapes were interior monologues. The later Webern, with his sonic axioms, removed himself from the scenery and made the mountain comprehensible by breaking it down into particles. His spare combinations of notes were molecules clustered around a nucleus: the building blocks of matter. While Schoenberg directed music towards outer space, Webern – like the crystallographer Max von Laue, who in 1912 found a way of photographing the heart of stone by beaming X-rays into it – concentrated on inner spaces. Crystals forced the twentieth century to give up a fuzzy romantic view of nature as an organism, by exposing its subtle symmetrical structure. There may be a clue to this notion of music as crystallized sound in *Die Jakobsleiter*. Gabriel's musical ladder, with the spiritual overtone vibrating at a higher frequency than the ground-tone, doubles as a scale of geological evolution. He tells the man who is struggling that he has further to go, 'wie der helle

Bergkristall, / fremder sind, als Kohle dem Diamenten!' – as the brilliant rock crystal is still more distant from diamond, which lies ahead of it, than from carbon, its murky, unrefined source.

The mountain, for Schoenberg's prophet in *Moses und Aron*, is a vantage point, a place for receiving instructions from the sky. Climbing it is his proof of spiritual prowess; to come down from it, when Moses interrupts the orgy around the golden calf, entails disillusion. Webern was an enthusiastic climber of Tyrolean mountains, who told Berg that the exertion entailed a 'search for the highest'. But rather than sublime altitudes, he climbed in search of dwarfed alpine plants, carrying a botanical lexicon in order to understand 'the deep, unfathomable, inexhaustible meaning in…these manifestations of nature'. At the summit, he found these small, precious organisms which were, in the phrase used by the photographer Blossfeldt, the 'ur-forms' of art; like crystals, they constituted patterns of growth, frozen for observation. For Webern, a mountain miraculously constructed itself by piling up such infinitesimal, impeccably regular grains. As if miniaturizing his mountains, he achieved a contraction of what Schoenberg called 'musical space'. Strauss's *Eine Alpensinfonie* in 1915, scored for an orchestra which produces deafening avalanches of sound, took almost an hour to describe a self-glorifying victory over a Bavarian peak. Webern in 1929–30 compressed his memory of climbing the Dachstein in Styria into three-and-a-half minutes. The mountain, bulky for Strauss, became transparent: the instrumentalists in Webern's quartet – violin, clarinet, tenor saxophone and piano – convey the cool clarity of the air high up, not the obtuse geological weight below.

Space narrowed even further in Webern's chamber music. His *Five Movements for String Quartet*, composed soon after the death of his mother, alternate between violent outrage and prostrated misery; the chamber this music is played in might be Vienna as Karl Kraus defined it, the isolation cell in which you were permitted to scream. Webern's compression of space can induce claustrophobia. More hearteningly, he also experimented with the detention of time. One of his songs sets a poem by Kraus which begins 'Wie wird mir zeitlos'. The soprano steps out of time on a lawn in a park. A butterfly pauses indefinitely on a stone; no ageing is permitted. The moment – like one of the miniature, portentous instants examined in the *Six Pieces for Orchestra* – will last forever. Webern's sacred songs impel a high soprano to make unprepared assaults on notes which properly belong to a flute. In a poem about the crucifixion, the first syllable of the word 'Himmelreich' (heavenly kingdom) requires a leap as abrupt as that on 'mystisches' in Schoenberg's *Herzgewächse*. The daunting feat underlines the meaning the subject had for Webern. Christ's incarnation, which concluded an old calendar and began a new one, was the descent of eternity into time. Music must perform a complementary deed of valour: Webern set it to rescue us from the tragedy of duration, ascending – as the voice vaults up an octave – from time into eternity.

Berg's verdict on the disengagement from tonality was more sombre. In his music it marked a breach, a necessary but wounding loss of innocence; a fall, rather than the sudden, ecstatic levitation in Webern's song. Hence his choice of operatic protagonists – the downtrodden Wozzeck, the degraded Lulu. Berg, without the benefit of Schoenberg's mysticism, came to sympathize with the decadent religion of Baudelaire, for whom the way to illumination lay through a systematic derangement of the senses; in 1929 he set three poems about the consolations of liquor from *Les Fleurs du mal* in his jazzily maudlin concert aria *Der Wein*. Near the end of the fourth movement of his *Lyric Suite for String Quartet*, completed in 1926, Berg directed that sound should dwindle into 'the wholly spiritual, soulful, unearthly'. He was not relying on the existence of the 'other planet' in Schoenberg's quartet. The effect is of enervation, asphyxiation: the quartet is about the denial of love, which prompts a craving for death.

Schoenberg, looking back in 1949, still considered the grim and sordid fate of Wozzeck 'forbidding to music', whose rightful province was otherworldly. But Berg's operas are about people whose indeterminacy matches the ungrounded, restless chromaticism of his musical language. Wozzeck the nonentity lacks what his social betters think of as character, while Lulu the celebrity adopts and discards characters like costumes or husbands, and conducts her sex life according to the serial policy enshrined by Schoenberg's methods of composition. Harmonies remain unresolved, and so do human fates. The bastard child of Wozzeck and Marie, laconically told of their deaths in the last scene, goes on indifferently playing.

A letter from Alban Berg to his wife in 1914, musically notating his love for her

The advance into atonality, which gives Berg's music its harrowing expressiveness, counted for him as a rite of passage. He marked the transition by ritualistically re-creating his early songs. He first set Theodor Storm's amorous lullaby 'Schliesse mir die Augen beide' (Close both my eyes) in 1907; he recomposed it using the twelve-tone regime in 1925. The early version is emotionally soothing, blandly repetitive: another specimen of late-romantic narcosis. The second attempt has a startling intensity. The voice veers upwards in sudden, distracted climaxes; the piano, operating independently, is preoccupied with engineering a return to the implied tonality from which the singer diverges. It may be significant that Berg addressed the first,

conventional version to his wife Helene, and the second to his mistress Hanna Fuchs, who happened to be someone else's wife. The secret is cryptically spelled out by the tone-row, which extends from H (German musical notation for B) to F. But while sending this forbidden message, the dodecaphonic system introduces a residual self-control: although the voice in the second song seems to be free-associating, scandalously liberated, its erotic impulse is bounded by a strict and arbitrary method.

Between 1905 and 1908 Berg composed a group of seven songs with piano accompaniment; he returned to them in 1928 to prepare an orchestral version. Again the revision introduced a troubling complexity to situations which were once blithely unselfconscious. Heard with the piano, the *Sieben frühe Lieder* are the outpourings of an ingenuous romantic. The singer proceeds from an assignation at dusk to post-coital repose by the fireside, concluding with a hymn to summer days of fruition. Music comes easily to her, like the leaves to a tree. A nightingale's song causes roses to bloom; the night resounds, as if singing, when the lovers meet; a summer wind like Webern's dispels all words but makes the meadows sing. The vibrancy in which Schoenberg and Kandinsky delighted is here a state of sexual arousal, shared by the landscape. Despite her nocturnal escapades, the heroine remains a believer. At night, she says, God personally weaves wreaths of stars with his beatified hand, and hangs them above her 'Wander- und Wunderland', the wonderland through which she entrancedly wanders.

The orchestra, when Berg added it after the composition of *Wozzeck*, comments on the singer's trusting rapture with sad, anxious hindsight. Because her vocal line stays the same, she can pretend not to hear the devious, disruptive whispers of the musicians massed behind her. Her first song, 'Nacht', now becomes an exercise in what Mahler thought of as 'Nachtmusik' – spectral, sinister, with a warning growl of brass as she ventures into the woods, followed by muffled crashes and rumblings. The end, harmonically unresolved, questions the outcome of the rendezvous. Cocooned in naiveté, the singer is without knowing it almost in the position of Schoenberg's expectant heroine in the monodrama *Erwartung*, who gropes through the clutching trees at night towards the body of a lover whom she may have killed. Pangs of dread stir in the orchestral commentary on the fourth song, when Rilke's poem describes the soul being carried off to the depths of night; in the fifth song, the soprano relishes timelessness – the idyll by the fire, with the minutes passing gently – but time continues to tick after her voice falls silent, and the brief epilogue, like a trail of ellipses, begs leave to doubt whether her contentment should be the last word on the matter. The atonal orchestra suffers from doubts which the radiantly happy singer declines to share.

The first of Schoenberg's *Five Orchestral Pieces*, composed in 1909 just before *Erwartung*, was given the title 'Vorgefühle' (Premonitions). He applied this clue to its meaning reluctantly, afraid that it might betray the psychological confidentiality of music: it is an art which 'can tell all,…even the things one doesn't admit to oneself', precisely because it does not use words. But he hoped the caption

would be unspecific enough to give little away, and added a nonchalant waiver – 'Premonitions (everyone has those)'. The terse, jangled, jittery movement does not get the chance to reveal what has provoked its forebodings. Is it afraid of its own shadow? Conveniently, it has a technical alibi: its scuttling panic derives from the superimposition of double and triple metres. Schoenberg called the fourth movement 'Peripetie', borrowing the term from Aristotle's formal anatomy of tragic drama: the peripety was a sudden alteration of fate or fortune which precipitated a play's climax. Once more, the details of the tragic confrontation which the music alludes to are omitted. A showdown is certainly taking place in this episode, which is successively tense, wary, hostile, relieved and traumatized – but between whom, and about what?

This is the logic of expressionism, applying pressure to elicit emotions which seem inordinate because they have no obvious cause. In art as in life, expressionism was about an inability to hold the balance between the psychological interior and the social exterior. In 1903 Max Steinitzer astutely called Mahler 'the incarnation of Man as Expression, among many for whom only Man as Form exists'. He was

A silhouette of Gustav Mahler conducting, by Schliessmann

referring to Mahler's youthful intolerance of cant, his too-piercing gaze, his ruthless disregard of good manners. Formal man wears a polite mask. Expressive or expressionist man allows his feeling to show in his face, even if his rage or passion are inordinate, unwarranted by the social occasion which has prompted them. Portraits by expressionist painters – for instance Richard Gerstl, the lover of Schoenberg's first wife, who killed himself when the affair ended – show the process at work. Gerstl's reproachful, obsessively fixated eyes burn holes in the facial mask, directly transmitting improper thoughts. Mahler the conductor, who did not sedately beat time like his predecessors but invited the music to take over and electrify his body, served as an icon of expressionist man, neglecting all considerations of form. His wild, high-strung contortions on the podium, much mocked by caricaturists, made him look (in Romain Rolland's phrase) like 'an epileptic cat'.

Schoenberg's most audacious exercise in composing a drama for absent, enigmatic antagonists was his accompaniment for an imaginary film sequence, *Begleitungsmusik zu einer Lichtspielszene* (1929–30). Otto Klemperer, who conducted the first performance, proposed commissioning Moholy-Nagy to produce a film for the score to accompany. He accepted that the film (which in any case was never made) would have to be abstract: Schoenberg's story – the narrative of a phantasmal emergency – must remain untold. In the last movement of the *Lyric Suite*, Berg first supplied a narrative, then suppressed it. Originally the moribund finale set another sonnet from *Les Fleurs du mal* – hardly a love poem, more an

admission of aching need, envying the state of extinction. Berg prudently revoked the words, which made too desperate an appeal to Hanna Fuchs, and left the movement – not deciphered until 1977 – with no evident cause for its grief. As it ends, the quartet's four dispirited members one by one stop playing. Since Berg saw to it that Baudelaire's poem could not be used in a diagnosis, it is as if they had committed suicide without leaving notes behind.

Such music aspires to the condition of neurosis, which could be defined as an emotion unwarranted by external reality. T.S. Eliot, psychologically disassembling a tragedy as Schoenberg had done in 'Peripetie', argued in 1919 that Hamlet was a sick man because his moping inertia lacks an 'objective correlative': it is disproportionate to the facts of the case. (His problem, Eliot argued with assistance from Freud, was not that he disliked the idea of killing his stepfather; actually he wanted to make love to his mother.) Berg invoked the notion of a motiveless malaise in explaining the fifth movement of the *Lyric Suite*, which is meant to be played 'deliriously'. The manic, exacerbated tempo, he told Hanna, 'can only be understood by one who has a foreboding of the terrors and sufferings to follow'.

Berg conceded that his own compositions were 'records of a nervous state'. In 1913, after his own breach with the dissonant anxiety of *Salome* and *Elektra*, Strauss pretended to pity Schoenberg, and said that only a psychiatrist could help him now. His bewilderment revealed how morale was damaged when the sky lost its capacity to carry a tune. Hindemith's opera *Sancta Susanna* in 1921 analysed religion as a symptom of sexual hysteria: the inflamed Susanna uses a crucifix as a masturbatory aid. During the heroine's first, uneasy dialogue with one of her superiors in the convent, a high-pitched drone – a mockery of devotional Muzak – sounds from the organ, continuing so long that it seems to ring in our own ears, literally invading the body and irritating the brain.

The premonitions in the *Five Orchestral Pieces* – spurious enough at the time, since Schoenberg's titles were an afterthought – turned out to be justified. Music was about to undergo the most drastic of disengagements: a nervous breakdown.

It all derived from a single, worryingly unorthodox chord. Wagner's *Tristan und Isolde* began with a fraught disharmony, which represents the frustrated desire of the lovers. The dissonance is only resolved, after many hours, in the last bar of the opera, when consummation mystically occurs for the dying Isolde.

Thomas Mann in 1930 referred to 'the noble malady of the *Tristan* music'. By then, with the Weimar Republic in disarray, Wagner had begun to take the blame for all the woes – political as well as artistic – of the twentieth century, and his reputation has never quite recovered from Hitler's enthusiastic patronage of the Bayreuth festival. For Mann this music, which he so much admired, incubated an ailment. It warned of social collapse, which preceded and predestined the modern nervous breakdown. Mann's abiding subject was the internal frailties

of the bourgeoisie, the class which apparently typified the solid, material triumphalism of the nineteenth century, during which it inherited the world; he diagnosed its illness musically.

Wagner's operas epitomized that bourgeois world with its plush and its pomp, its fondness for the invention of ancient, legitimizing traditions, its suppression of economic realities – the dwarfish miners in *Der Ring des Nibelungen* toil underground – and its worship of women as symbols of redemption, whose high-mindedness rescues men from a society where wealth, like the gold in the *Ring*, must be obtained by theft. But the comforts of the burghers were insecure, and Wagner warned that they would soon be revoked: hence the curse on the Nibelungen ring. The tetralogy imagined in advance the way this world might end, which is why *Götterdämmerung* could be absorbed into Hitler's nihilistic gameplan. Perhaps the surfeited dynasts – Wotan and his fellow gods in the *Ring*, or the mercantile clan in Mann's *Buddenbrooks* – secretly longed for their own overthrow. Their wish, if that's what it was, began to come true in 1914.

This, as Mann understood it, was the premonition voiced from the darkness of the covered Bayreuth orchestra-pit by the *Tristan* chord. Why else did Gustav von Aschenbach stay behind, beyond the season's end and against medical advice, to die – like Wagner – in Venice? The luxurious death-wish in the first bars of *Tristan* made audible all the discontents of a civilization unsatisfied by its own success, which looked either to modernism or to war and revolution as its means of suicidal release. A character in Mann's story 'Tristan', published in 1902, interprets the *fin de siècle* as a self-induced, psychosomatic disease: 'it not infrequently happens that a race with sober, practical bourgeois traditions will towards the end of its days flare up in some form of art.'

The aesthetic flare-up had sickly consequences. Mann's 'Tristan' transfers Wagner's *Tristan* to a sanatorium, where one of the patients dies as a result of her addiction to this febrile music. Another story, 'Der Volsungsblut' in 1905, removed from Wagner the camouflage of myth. Siegmund and Sieglinde – the brother and sister whose incest in *Die Walküre* begets the liberator Siegfried – are not shaggy-pelted primitives but bored, pampered children of the industrial bourgeoisie, who imitate the forbidden sexual act of their namesakes after seeing the opera. Wagner's characters are outcasts, clinging together as they evade the hunters. The Siegmund and Sieglinde of Mann, with their 'spoilt and costly well-being', have no such desperate excuse, and no such heroic vitality. 'Like self-centred invalids, consoling themselves for the loss of hope', they revel in a feebleness which is the prerogative of those whose needs and wants have been catered to by technology. Their prototypes in the opera flee through a storm, while Mann's characters, riding to the theatre in their carriage, are 'wafted on the wings of ease'. Innocent as animals, Wagner's siblings do not know that incest is against the rules. For Mann's pair, its appeal lies precisely in that prohibition. Like dissonance, it is tempting because it is disallowed – and has not their affluent society told them that their every wish will be fulfilled?

The irresolute *Tristan* chord hesitated on the edge of a precipice. In 1947 in Mann's novel *Doktor Faustus*, an account of music's complicity in German fascism, the teacher Kretschmar borrows from another of Wagner's fables to explain the perils of the art he both reveres and dreads. In *Parsifal*, the gullible hero is set upon by the sorceress Kundry, who seeks to attain salvation by corrupting him. She is, Kretschmar proposes, engaged in music's seditious, infectious work. The art ought to be as unsensuous as mathematics, which it so closely resembles (and that ascetic intellectual play with numbers was revived by the modernists: Berg organized the *Lyric Suite* in multiples of twenty-three bars, while Schoenberg made such a fetish of the number twelve that he deducted a vowel from the name of Aaron so that *Moses und Aron* would have twelve letters in its title as well as twelve notes in its tonal row). But, as Kretschmar laments, music refuses to confine itself to mental arithmetic. It craves a more sensuous life. He personifies the art as 'a Kundry, who…flings soft arms of lust round the neck of the fool'. He mistrusts opera because of its aphrodisiac plots, and even calls orchestral music a Venusberg of bewitching delights, like that in which Wagner's Tannhäuser wallows; the only instrument he approves of is the drily didactic piano.

Marx denounced religion as an opiate. Mann charges music, and especially that of Wagner, with the same narcotic power. In *The Man Without Qualities*, the highly-strung Clarisse has a fixation on the sex-killer Moosbrugger. Walter sees in this a specimen of 'that hankering for the problematic and morbid' which is the fatal motive of modernity, and he connects 'the small nostalgic compact we make with death when we listen to *Tristan* and the secret fascination that most sexual crimes have for us even though we don't yield to it'. Is music merely a scapegoat? Not entirely: it does dangerously exemplify the irrational, by which modern times have been so perturbed.

Nineteenth-century progress was supposed to render unreason obsolete. In 1864 the essayist Walter Bagehot argued with supreme fatuity that the Victorian railway network had done away with the eccentricity of the characters in Sterne's novel *Tristram Shandy*. Such cranks, he thought, could not exist 'now, when London ideas shoot out every morning, and carry on the wings of the railway a uniform creed to each cranny of the kingdom'. Alas, trains did not make people more sensible. Nor has television, which beams a uniform creed to each corner of the globe, managed that feat.

The twentieth century first confronted irrationality inside the mind, where Freud investigated the freakish persistence of 'the uncanny'. Then came the social inquest. Could there be rational explanations for the muddled apocalypse of 1914, or for Hitler's demand in 1945 – while Albert Speer planned a last concert in bombed Berlin, with Wilhelm Furtwängler conducting Brünnhilde's immolation from *Götterdämmerung* – that Germany itself should be destroyed, so as to deprive the victors of industrial assets? Whether or not its guilt can be proved, music cannot escape suspicion, if only because its area of operation lies outside the bounds of reason.

Certainly the change in its language, instigated by the *Tristan* chord, came accompanied by alarming symptoms. Atonality is the idiom of Freudian derangement for Klytämnestra in *Elektra* or for the nameless woman in *Erwartung*; and both of them owe their mental distress to Wagner. The tuba which terrorizes Klytämnestra jeers at her by distorting *Tristan*, recalling nights of love in the dark garden while she suffers from guilt-stricken insomnia. Her bad dream, Strauss later conceded, was his furthest venture into 'psychic polyphony'. After that, rationality counselled retreat to more temperate harmonies. The singer in *Erwartung* quotes Kundry when she finds the dead body. Her scream for help, 'Hilfe!', lunges between its two syllables through the sheer drop of an octave, as Kundry does in telling Parsifal that she laughed at Christ on the way to Calvary. Kundry is at least reprieved, allowed to expiate her crime by serving the Grail knights and to die in their temple. For Schoenberg's woman there is no help. At the end she remains in the tangled wood with the cadaver, still searching for a way out.

The *Tristan* chord was treated with almost clinical caution by modern composers. It had set them free from tonality. But it had also burdened them with its legacy, like the ring which taints whoever handles it until Brünnhilde returns it to the cleansing Rhine. A disabling indebtedness to the past is the most modern of diseases: psychoanalysts call it the Oedipus complex, literary critics know it as 'the anxiety of influence'. Because the chord is the motto of an obsession, to quote it is to declare one's own neurosis. It inevitably occurs in the hopelessly depressed finale to Berg's *Lyric Suite*; it had already been used by Alexander Zemlinsky, Schoenberg's tutor and brother-in-law, at the beginning of a song, 'Entbietung', composed in 1900–1, in which a frenzied lover begs a woman to twine blood-red poppies in her hair – though in the song the drooping chord soon recovers from its low spirits, and a climax, which the opera delays for hours and then grants only posthumously, arrives two minutes later.

Bright, young modernity sought to exorcise the malevolent chord by mockery. Strauss incongruously quoted it in his absurdly difficult, brashly exhibitionistic *Burleske* for piano and orchestra, composed in 1885. The piece exists to demonstrate virtuosity, and the passing extract from *Tristan* in the soloist's long cadenza – a blinking pause among cascades of prestidigitation – measures the distance between the rude health of the twenty-one-year-old Strauss and the debility of Wagner. Debussy allowed the chord a consciously inept, fun-killing walk-on in the piano suite *Children's Corner*, composed between 1906 and 1908. The quotation intrudes in 'Golliwogg's Cake-Walk', as if tripping up the doll; then the dance resumes, and jazz banishes romantic melancholy. Hindemith quoted the *Tristan* chord in his suite of piano pieces *In einer Nacht*, on which he worked from 1917 to 1919. The motto, repeated automatically until all emotional content drains from it, is now just one more of the random sounds nature makes at night, like branches rhythmically scratching at the walls: Hindemith subtitled the section in which it occurs 'Fantastic Duet of Two Trees Outside the Window'.

To deride Wagner was a credential of contemporaneity. In 1921 Jean Cocteau defended the buffoonery of his musical play *Les mariés de la Tour Eiffel* by declaring it an antidote to the false sublimity of the nineteenth century, medicine for 'notre époque…encore amoureuse de Wagner': the nervous breakdown was not compulsory. In his collaborations with composers – Satie for the vaudeville *Parade*; Poulenc for Apollinaire's *Les mamelles de Tirésias*; Satie, Poulenc and four of their colleagues for *Les mariés de la Tour Eiffel* – Cocteau said he wanted music to walk on, not to swim in. The turbulent Wagnerian orchestra, which represents a river in *Das Rheingold* or a storm at sea in *Der Fliegende Holländer*, is like an ocean bottled in the pit. You can swim in it, or possibly drown. Cocteau preferred to put boards over this restive element: Satie's score for *Parade* is as down-to-earth as a city street. Hindemith also dispensed with the oceanic unconsciousness of Wagner, which swells beneath the stage. In the early 1920s he made a joky arrangement of the *Fliegende Holländer* overture, with its ferocious nautical weather, as played – he specified – by a bad orchestra at seven in the morning beside a village well. The resulting fiasco was transcribed as a party piece for Hindemith's own string quartet. Acidly untuned, the storm disintegrates into a squall, and the shallow well stands in for the ocean. The Wagnerian hysteria promptly wanders off into a waltz: the tottering players feel safer on banal dry land.

Hindemith coped more brutally with the Wagnerian legacy in his opera *Das Nusch-Nuschi*, which caused a scandal in 1921 because of a single disrespectful quote from *Tristan*. In this lewd oriental farce, the Nusch-Nuschi is a nut-crushing monster, ridden by the Burmese deity who sponsors sexual desire. On a tropically sultry night, four of the emperor's wives abscond from the harem to pleasure themselves with a noble libertine. The emperor, discovering his cuckoldry, sings King Marke's sorrowful rebuke when he finds Tristan with Isolde, though in this context the citation sounds more fatuous than dignified. He then orders the castration of the wrong man, but the executioner's work has already been done by the Nusch-Nuschi, which specializes in squashing testicles. Hindemith's wicked quote serves to emasculate Wagner as well.

Das Nusch-Nuschi dismisses Wagner's agonized erotic postponements. The conclusion, after much laughter, is a return to carnal revels. Hindemith's ribaldry fell in with another modernist assault on Wagner and the morality of the nineteenth century. *Tristan* relaxed dissonance, but stopped short of liberating it. Modern times advanced into a happy anarchy, in both musical language and personal behaviour. In a 1914 manifesto, Marinetti linked the mysticism of *Parsifal* with the current fad of tango-dancing, and argued that both should be banned. Their crime, in his view, was their cowardly chastity. The virginal Parsifal spurns Kundry when she offers herself, and Marinetti thought that tango-dancers were no more enterprising. 'To possess a woman', he pointed out, 'is not to rub up against her, but to penetrate her!'

The surrealists accordingly debauched Wagner. *L'Age d'or*, the giddily blasphemous film on which Dalí and Buñuel collaborated, concludes with the hero

and heroine muckily coupling in the dirt at an open-air concert, while the orchestra plays Isolde's more refined Liebestod. Dalí drew Tristan and Isolde cannibalistically feasting on each other during intercourse, while in his own sexual career he profited from their talent for psychological torture. In his autobiography he describes a five-year romance which – exercising 'all my sentimental perversity' – he refused to consummate. Tristan and Isolde are kept apart by social prohibitions; in Dalí's case, denial was a weapon used against the woman, an attempt (for her own good, of course) to drive her mad. He had a similar illicit use for *Parsifal*, which he proposed to 'consider...impartially from the socio-political point of view'. Wagner's patron was an insane would-be absolutist, Ludwig II of Bavaria. Dalí took this to mean that the artist's every whim must be indulged. Play-acting the pure fool, he gave the code name of Parsifal to his surrealist stunts, which included a love-feast very unlike the communion in the Grail temple. Dalí gorged on chicken, champagne and anything else he could 'possess in the sacred tabernacle of the palate', after which, in a delicious Proustian resurrection, he regurgitated the lot. His vomit – comprising rabbit, armpits, clams and bile, among other substances – poured out according to the Christian principle that the last shall be first.

The most surreally deformed adaptation of Wagner comes in Tod Browning's 1932 film *Freaks*, which concerns amorous intrigues among a team of fairground monsters. The trapeze dancer Cleopatra, in league with the weight-lifter Hercules, marries Hans the midget, then poisons him to gain control of his inheritance. While Hans lies on a sickbed in his circus wagon, another dwarf plays on his flute the keening melody piped by the shepherd during Tristan's delirium. Unlike Tristan, Hans recuperates, and the little people – stunted, limbless, cone-headed, crawling through the mud in an invincible lynch-mob – team

up against their superhuman oppressors. They murder the strong man with the Olympian nickname, and ground the queen of the air: Cleopatra ends on show as a human chicken, flapping her feathery wings in vain and cackling despite her inability to lay an egg. The sky has been emptied of high fliers.

Near the end of Strauss's *Elektra*, Orest goes into the house to kill his mother. Elektra waits, barely controlling a panic which surges in the orchestra. Then she remembers that she has not given him the axe Klytämnestra used to slay their father, which she has kept for this occasion.

She cries out in fury 'Es sind keine Götter im Himmel!' – there are no gods in heaven. It is a self-lacerating complaint. Who, after all, sent the gods packing? Modern times began with their abdication, and music, which always claimed to derive from heaven, took the initiative in pulling heaven down.

In classical myth, Orpheus received the gift of music from the sun-god Apollo. Romanticism chose another source for the art. Isolde welcomes Tristan to their rendezvous in the garden by extinguishing her torch, and their love duet is a hymn to sheltering, obscuring darkness. Tristan kills himself, as he says, so as not to suffer the return of daylight. Turning away from reason and radiance, music now belonged to the night. In 1908 Mahler's Seventh Symphony included two sections of 'Nachtmusik'. The first of these nocturnes is disturbed by distant, menacing military fanfares, among the lulling bells of drowsy cattle. In the second, a mandolin sings a serenade. Night is the region of fear and also of desire.

Schoenberg's *Verklärte Nacht* describes a night which has been transfigured. This string sextet, composed in 1899, took as its source a poem of erotic confession and forgiveness by Richard Dehmel. A man and woman are walking through a wintry wood, accompanied by the supervising moon. The woman tells her companion she is carrying a child which is not his. He gravely pardons her, accepts the child as his own, and puts his arm (according to Dehmel) around her hefty hips. Their breaths, like the soul condensing in the *Altenberglieder*, merge in the cold air; the moon irradiates the night. Although the work has symphonic ambitions, Schoenberg composed it for a sextet because of the poem's intimacy: without words, the strings duplicate every nervous hesitation and reversal of mood in the exchange, and the chromatic shifts and key changes in the score act out a moral and emotional struggle.

The night is no longer merely a cover for adultery or an invitation to voluptuous, mystical death, as in *Tristan*. Its transfiguration involves what Nietzsche called the transvaluation of values, unlearning inherited morality. The moon by the end of *Verklärte Nacht* is brighter and even warmer than the sun which it replaces, because like an X-ray it has pierced the outer defences of these people and set them free. A music society in Vienna refused to perform the sextet because of a single, unlawful dissonance. Was this an objection to Schoenberg's musical speech, or to what his characters – in their candid disregard for bourgeois protocols of sexual ownership and pedigree – were silently saying? New styles in music helped to prompt the modern change in human character and conduct.

A decade later, in *Erwartung*, the situation had changed. The man, who has deserted the woman, lies dead in the nocturnal wood; she has probably killed him, although in her distraction she cannot admit it. Night, the time of Freudian dreaming, is here a landscape of indistinct paranoia, and the moonlight which sheds splendour in *Verklärte Nacht* now turns bodies into spectres. Schoenberg obtained the jotted, fragmentary text from the medical student Marie Pappenheim:

it might be the record of an unsuccessful psychoanalysis, in which the hallucinating patient is not rescued from her private darkness. The unconscious mind free-associates at will, strays backwards, revolves in circles; a musical monologue can only capture this jumpy, inconsequential process by casting off the restraints of tonality, which sought to package thought in conclusive sentences.

These contrasted nocturnes point to one of the crucial choices Schoenberg had to make on his 'harder road'. The moon in *Verklärte Nacht* is a searchlight, ruthlessly honest, tender despite its clarity. In *Erwartung*, the moon supplies deceptive lighting effects for the woman's lunacy. Even the cinema, in Schoenberg's *Begleitungsmusik*, is called a 'light-play': a flickering lunar phantasmagoria. The single, shocking dissonance in the sextet aimed to loosen rigid codes of right and wrong. But did the complete, liberated dissonance of the monodrama involve a surrender to insanity? In the 1920s Schoenberg found a means of ordering this fearful freedom through the dodecaphonic system. Meanwhile, in 1912, he temporized between flexing the rules and overthrowing them altogether, and relied on irony to keep his options open. This is how he came to choose a freakish clown as the hero of his cabaret song cycle *Pierrot Lunaire*.

Innovations in art are attuned to changes in the way people behave, the way society works, the way the universe is construed: that is what modernity was all about. So Schoenberg's adoption of the pierrot – a colleague of Picasso's harlequin from the Italian *commedia dell'arte* troupe, now operating under the protection of the moon – brought to the surface a series of revolutions which connected sexual manners with planetary motions. Isolde quenches the beacon, preferring instinct to the light of reason. By the end of the nineteenth century, the moon had replaced the sun in the religion of the decadents. In 1885 Jules Laforgue – the poet of dandyism and dissipation, admired by T.S. Eliot – wrote *L'imitation de Notre-Dame de la Lune*, which scornfully rejected the healthy sun (hated in particular, Laforgue added, by pierrots, because it threatened their white skin) and worshipped the soulful, anaemic moon.

The moon stalks through Wilde's *Salomé*, where it goads the characters to play metaphoric games. Needing to borrow its light, the moon is nothing in itself; its nonentity means that it can be compared with anything else in the universe. Salomé compares it to a piece of money or a silver flower. She is sure that the moon must be a virgin, while Herod imagines the moon reeling drunkenly, 'looking for lovers'. Herodias, tiring of this quest for resemblances, says 'No; the moon is like the moon, that is all'. Though the rejoinder is flat-minded, in a way she is right. The moon can be compared with so many dissimilar things because it is unknowable, meaningless; John the Baptist, who worships 'a God that you cannot see', is probably a fraud. This agnostic conclusion was disputed, with equally jarring consequences for the modern world, by Wells's science fiction. 'I thought the moon was a dead world', remembers one of the lunar explorers in *The First Men in the Moon*. He comes to appreciate his error. The heavens are indeed populated, though not by gods.

Albert Giraud

PIERROT
LUNAIRE

1893
DER VERLAG DEUTSCHER PHANTASTEN
BERLIN

The lovelorn, pallid comedian Pierrot belongs beneath the moon. He is lunar in complexion and lunatic by temperament, estranged from the daylight world. The costume advertises social marginality. In one of the songs Schoenberg wrote for a Berlin cabaret in 1901, the promiscuous Gigerlette entertains her male customers while dressed as a blossom-white Pierrette. Pierrot is the first of Lulu's incarnations in Berg's opera: she wears the costume to have her portrait painted, bucolically accessorizing it with a shepherd's crook. Jack the Ripper, before killing her at the end of the opera, bays at the moon. His too is a lunar profession, like that of the prostitute. In 1908 Ravel composed a set of piano pieces called *Gaspard de la Nuit*, describing the murderous escapades of a sleep-walker like Schoenberg's Pierrot.

Albert Giraud title-page to Pierrot Lunai 1893

Picasso's harlequins were social renegades, reminders of the artist's exclusion. Schoenberg's Pierrot is no starved outcast, with only a rug (as Rilke said of the saltimbanques) for existential anchorage; he is a psychotic zany who has chosen to live on the lawless fringes of society, which is why he is at home in the cabaret. The painter George Grosz, writing from a mental asylum in 1917, assumed the persona of Pierrot the sex criminal, asking where his nights had gone, wildly cataloguing his ravaged women, and grieving over friends felled in the war: 'end of the witches' sabbath, of the most gruesome castration, of slaughter, cadaver upon cadaver, already green rotting corpses glow among the rank and file!' With these reveries as evidence, the therapist Magnus Hirschfeld had Grosz declared too mad for military service. In the poems by Albert Giraud which Schoenberg set, Pierrot is equally frenetic. He robs graves, blasphemously commandeers an altar to celebrate a black mass, drills a hole in the bald skull of a colleague and sucks the brains out through his pipe. But his rampages are discounted as pranks, scenarios which may or may not have been acted out in reality. The character attracted Schoenberg as an imp of liberated dissonance. The performer of *Pierrot Lunaire* is set free to veer between speech and song, merely glancing at the prescribed pitch.

In *Pierrot Lunaire*, madness expresses itself in the irresponsible, uncensored whimsies of the unconscious mind. While the woman in *Erwartung* absorbs reality into her obsessive dream, possibly killing the man who deserts her so that she can keep him forever, Pierrot has abandoned the effort of control. His mind disintegrates into snatches of song and motiveless tantrums, whipped up to conceal

his disabling misery. *Erwartung* ends with an enraptured love-death. The woman recalls the man's kiss, and her ferment of congested, contradictory thoughts overflows into the orchestra, where all the instruments race up and down the chromatic scale at uncoordinated speeds. By contrast with this babbling of simultaneous voices, the improvised, kaleidoscopic existence of Pierrot requires different combinations of soloists from a chamber ensemble for each song: a flute when the moon falls ill; a mournful bass clarinet, with some shuddering aid from the viola, the cello and a skeletal piano, for an imagined beheading. The woman in *Erwartung* settles down into maniacal certainty, while Pierrot remains febrilely unstable, ironically enjoying the privileges of the insane.

The second movement of Berg's Chamber Concerto is a palindrome. Repetition backwards begins as the piano plays a low C sharp twelve times. Midnight chimes, as in Nietzsche's *Zarathustra*: the time of regression and reversal. *Pierrot Lunaire* is also psychological night music. The most unsettling of the poems, 'Die Nacht', describes nightfall as a plague of flapping wings, which thicken to kill off the sun. At dusk, monsters clamber down from the sky onto earth, where they take up residence in the human heart. This is a very different landscape from the one Schoenberg envisaged in his quartet, where the singer navigates through shining ether. The new music, setting out for heaven, arrived in the underworld instead. Hence the angry or penitent withdrawal of faith in his own art by the later Schoenberg. The exodus led by Moses never reached its goal. Song, the facile gift of Aron the huckster, was not so much renounced as bitterly refused. The *Ode to Napoleon Buonaparte*, a satire by Byron which Schoenberg set in 1942 as an assault on the European dictators, must be declaimed with scorn, spat out. The denial is even more stringent in *A Survivor from Warsaw*, a harrowing account of the Polish ghetto composed in 1947. The reciter moans in pain, roars in outrage, or (when he lends his voice to the Nazi guards) barks. The only singing is done by the condemned Jews, dragged from their hiding places in the sewers and rounded up for the gas chamber. Herded, beaten, while a trumpet mocks them with a reveille, they burst into a hymn. The reciter calls this 'the old prayer they had neglected for so many years – the forgotten creed!' Their triumphant choral shout is one of the astounding moments in the music of our unharmonious times. It repairs the covenant – but for only a minute, on the way to extermination.

Schoenberg's universe was constructed like Jacob's ladder. Music enables man to struggle up towards the altitude where the trilling, aerial soul disports itself; if the quest fails he falls back, like Moses returning from the summit, into disenchanted speech. Hindemith's *Die Harmonie der Welt*, in which Kepler listens to the music of the spheres, made the same attempt to keep the cosmos in tune. But that effort had long been doomed by science, which demonstrated that the universe was not constructed for man's glorification. The sky at night reveals to us our solitude and our estrangement from a world which is, like us, a temporary accident.

There was, however, another kind of night music, another way of listening to the sounds which reverberate in the empty spaces of a modern world. As a young man in the Hungarian countryside, Béla Bartók taught himself the names of the constellations and the stars by sitting outside all night, with a lantern and a candle to help him consult a map of the sky. It was hard work, he admitted, because the wind kept blowing his candle out. In 1907, aged twenty-six, he wrote a letter to a friend in which he summarized his own passage through all the great modern disengagements. God, he decided, had not created man; it was man who could not abide life without the fiction of a creator. Bartók the atheist railed against the teaching of metaphysical lies, and thought it would be better to be taught nothing at all. He could accept the gods of Greece, who had fleshly frailties like human beings. But Judaism involved the worship of a deity who was inconceivable – a proof of mental eminence for Freud and Schoenberg; for Bartók, as for the Roman soldiers in Wilde's *Salomé*, the beginning of obscurantism and mental enslavement.

Having disposed of supernature, he then turned to 'the origin and existence of the world', and with the pitiless zeal of youth derided our fond efforts to make ourselves at home in it: 'The world is infinite in space and time. A finite brain can never conquer the infinite.' He admitted that we might be able to traverse a few light years in planetary space, or to analyse the chemical composition of stars, but – unlike Schoenberg envisaging a voyage to other planets – these for Bartók were niggardly achievements. Our faith in the immortal soul, expounded by Schoenberg's swooping coloratura, seemed to him mere conceit. What we call the soul can be analytically broken down into 'the functioning of the brain and the nervous centres'; it was not man's exclusive prerogative, and existed as well (until death definitively snuffed it out) in snakes and worms – 'and why not also amoeba, infusoria, microbes and bacilli?' Infusoria, as in Wells's *The War of the Worlds*, demonstrate the absurdity of our notion that the universe is our personal playground. Bartók's letter concluded by restating the cosmic shock which underlay the idea of modernity: 'Terrestrial life one day began, and one day will end. Our astronomers can already calculate when this will take place – millions of years ahead, but tragic anyhow for us men.'

The night music of Mahler, whether ghostly or amorous, always presupposed a sleepless human listener. Bartók, in response to the vastation described in his letter, composed night music which the universe, cleared of human inhabitants, might be humming to itself. His earliest exercise in the form was in 1926, in the fourth movement of his piano suite *Out of Doors*. It begins with a tinkling which might be tintinnitis – or are these the imperceptible flickering of stars? Then come a series of plinks like water drops. Musical sentences have atomized: the intervals between the sounds may or may not make up phrases. Gradually the darkness is populated with leaps and friskings, the trajectories of unseen creatures. The end trickles or evaporates – like life on earth – into silence. Bartók's final specimen of night music was the third movement of his long violin sonata,

composed in 1944, a year before his death in American exile. It has passages of near inaudibility, when the soloist resorts to sonic camouflage. The violin faintly whistles or chuckles, or tingles like a cicada. Music, being invisible, blinds us like night. Bartók returned the world to its beginnings, when matter was without form and void and we could not separate individual existences by identifying the sound they made; and he reminded us that the world every evening punctually reverts to that primal state.

Bartók's was a universe both infinitely large and infinitely small, comprehensible only through the alienating eye of the telescope or the microscope. He stared up at the galaxies, but also studied protozoa. In 1911, at work in Switzerland with his librettist Béla Balázs on the opera *Bluebeard's Castle*, he fished for water insects in a scummy pond and roamed through the night to capture glowworms. Between 1926 and 1937 he assembled a cellular anthology of brief piano pieces which he called *Mikrokosmos*; the collection pays homage to lowlier life forms and the bodily music they emit – the exploratory whirr of 'Buzzing', like a night noise overheard, or 'From the Diary of a Fly', in which the insect sketches vagrant droning patterns in the air. Within a few seconds, these studies administer the same jolt to our anthropocentric complacency which Kafka achieved by casually remarking that Gregor Samsa woke up one morning to find himself metamorphosed into a beetle.

Leoš Janáček shared Bartók's respect for the music made by species other than our own, and proposed some shaming comparisons between their creativity and ours. In 1922 he attended a concert given by a thrush in his garden. Its repertory, even more compressed than Webern's crystals or particles of sound, astonished him: it sang forty-four different melodies – each lasting less than a second, with pauses for thought between them – within two minutes. Human beings can utter six syllables a second. The little brain of the thrush, Janáček calculated, could cram three or four melodic scraps into the same time-span; its articulation left something to be desired, but it always sang in tune.

The name of Janáček's boozy, sausage-eating anti-hero in *The Excursions of Mr Brouček* means 'beetle': he is man reduced, by his lowly cravings, to equality with the insects. The opera *The Cunning Little Vixen*, first performed in 1924, concerns the life, loves and chicken-killing sprees of a fox. Many composers have imitated larks or nightingales; Janáček earnestly notated the musical conversation of his pet dogs, trained his hens to bid him good night before they roosted, and admired the intellection of bees, whose sustained single note as they foraged between flowers seemed to be evidence of 'a sharp mind, and a consciousness full of impressions'. On a visit to Venice in 1925 Janáček heard a mosquito which was homing in to sting him as a gypsy violinist, aiming its 'bloodthirsty nocturne' in his ear. His menagerie upset the hierarchy of creatures maintained by humanism. Men supposedly belonged at the summit, set apart by the privileges of speech and song; they alone can apprehend – though with their intellects not their ears – the polyphony of the planets, which the astronomy of Kepler called

'musica humana'. But life on earth, for Janáček, was as democratic as the orchestra. Shot by the hunter, his vixen is a tragic heroine – though not for long, because the irrepressible biological comedy of nature soon generates another vixen to take her place. *The Cunning Little Vixen* ends in an upsurge of pantheistic jubilation, provoked by the gurgling cry of a frog.

For Olivier Messiaen, it was birdsong which restored the harmony between heaven and earth. In his *Quatuor pour la fin du temps*, composed in 1940 in a German prison camp, an ecstatic choir of birds at dawn announces apocalypse, gathering up a sullied human world into eternity; and

Josef Čapek's design for the hen in The Cunning Litt Vixen *(1924*

in his opera *Saint François d'Assise*, first performed in 1983, darkness brightens as the nightingale sings and the saint who preached to the birds dies in a sunrise of illumination. The evangelizing birds showed Messiaen a way of overcoming the local limits of human speech. His visionary tour of America, *Des canyons aux étoiles*, includes a virtuoso exhibition of mimicry for the mocking-bird, known in French as 'le moqueur polyglotte': it is proficient in all languages. Bird-song enabled Messiaen to rid music of the neurotic uncertainties made audible in the *Tristan* chord. His song cycle *Harawi, Chant d'amour et de mort*, composed in 1945, rediscovered Isolde in the Peruvian jungle. The heroine Piroutcha sings in an invented language – the onomatopoeia of bliss, like the chattering of a bird: 'Mapa nama lila, mika, pampahika.' Death when it comes to her involves no wrenching breach in consciousness, as for Wagner's delirious Tristan. Nor does it require the effort of sublimation or self-willed levitation made by Isolde. Piroutcha is absorbed into a cosmos which, as she looks up from her unlettered wilderness at the stars, she describes in impeccably modern terms: a dance of atoms, electrons and spiralling nebulae.

In Strauss's *Ariadne auf Naxos*, the youthful and idealistic Composer rhetorically demands 'Was ist den Musik?' He answers himself at once, declaring music to be a holy art. The trouble is that no one agrees with him. His opera about Ariadne has been butchered at the behest of a philistine patron, but the hired performers go through their paces all the same. Music, however sacred its sources, is for them a trade, as it was for the hard-headed, mercenary Strauss.

The Composer's question is one of those fundamental interrogations which modern artists felt obliged to make: a return to first principles. The Dadaist Richard Huelsenbeck denied in 1920 that music was superior to noise.

The orderly succession of tones gave way to a chaos of simultaneous sounds – 'crashing, screeching, steam whistles', all the detritus of the overloaded urban air – which the Dadaists called 'bruitism'. Bartók allowed the hysteria of motorized traffic to invade the score for his ballet *The Miraculous Mandarin*, completed in 1919. Woodwinds, characterizing the streets outside the brothel where the mandarin is murdered, play chords as startling and intemperate as car horns. In 1927 Janáček noted down the sounds which assaulted him in a Prague street. Trams rattled, cars yelped, a coach bumped along, the hooves of horses rang on the cobbles: all the noises Janáček transcribed came from modes of transport, since sound is motion. No hierarchical grading, like that of an orchestral score, was possible. The ear is undiscriminating, and Janáček represented the uproar in a circular diagram, more democratic than the seating plan of the traditional orchestra.

Schoenberg persisted in the ancient belief that music was holy. Hindemith too, in the treatise on composition which he began to publish in 1937, pointed to a mysterious affinity between tonality and galactic order, with the solar key of C installed at the centre of a planetary system. Otherwise, responses to the Composer's query were bewilderingly unsure. How could music claim to be holy when, in *Götterdämmerung*, it had sentenced the gods to death? Perhaps, as Mann suggested of *Tristan* and its progeny, music was an illness, no less deadly for being noble and soulful. The nationalist composer Hans Pfitzner was sure that it constituted a social menace, and railed against 'the international-atonal movement' as 'the artistic parallel of the Bolshevism which is menacing political Europe'. He blamed the threat on 'a minority', meaning the Jews. Hindemith in defence of his art tried to present it as a social amenity. Modern music had a reputation for inciting riots, like those at the first performances of the *Altenberglieder* or *Le Sacre du printemps*. Healing this anti-social affray, Hindemith composed music which bonded performers and consolidated communities – an exercise in town-building, *Wir bauen eine Stadt*, for Berlin schoolchildren in 1930; a symphonic celebration of industrial Pittsburgh in 1958. Janáček released music from these civic duties, claiming that its laws 'exist in all living beings', whether human or not. At the opening of the Brno conservatory in 1919, he called for composers who, like the robins in his garden, could 'fill the skies with explosions of sound': he did so himself in 1926 in his *Sinfonietta*, with its memory of a military band brassily upbraiding the sky above Brno.

All the same, Janáček's summons to fill the skies took for granted that those skies were empty. Nor could nature's home-grown lyricists be relied on. Cocteau, disparaging the romantic faith in instinct and inspiration in *Le Coq et l'Arlequin*, announced that in his opinion 'the nightingale sings badly'. Bartók's night music imagined what sounds might be made by a modern, dehumanized universe: the repercussions of convulsions as remote from us in time as in space, ricocheting through vacancy.

ARMS AND MANKIND

The universe faced a further gruelling interrogation in 1918. Kaiser Wilhelm II had said that he did not want a war. How then did it manage to happen, and why – after Saint Loup in Proust's novel prophesied that machines would abbreviate the coming conflict – did it drag on for four years, stalled in the squelching mire of the trenches? How was it possible for a gunshot in Sarajevo to multiply itself until an entire generation had been slaughtered? Could it be that civilization, which regressed so promptly to murderous barbarity, was no more than a pious lie? The war which convulsed the world between 1914 and 1918 marked a breach in consciousness, like the fall of man. It brutally and irrevocably modernized mankind, and set the agenda for the rest of the century. The peace treaty forced Germany to pay reparations to France; Hitler purged this national shame in 1939. The Austro-Hungarian empire disappeared discreetly enough, only to be reconstituted after the next war when Stalin took possession of Franz Josef's outlying provinces. Set free after 1989, the 'nationalities' – as Viennese courtiers used to call them – now quarrel with one another, not with an imperial centre. The century has been one long war, with occasional exhausted intermissions; its subsequent history is the unfinished business of 1918.

The disillusioned veterans who return to a bankrupt Germany in Remarque's novel *Der Weg zurück* cannot forgive the Kaiser for ordering them to fight and then absconding to Switzerland, where he waited out the inevitable revolution at home. His betrayal reminds them of God's desertion. The hero's mother is prompted to ask the universe those ancient questions about origins and purposes. She wants to know 'what mankind is up to that such a thing could happen, and how it all came about'. She looks back from the other side of a mental gulf, from east of Eden: 'We had a very different notion of what manner of thing life was, before, if you remember.' The motto of military remembrance, at cenotaphs all over the one-time British empire on the anniversary of the armistice, is 'Lest we forget'. But who can remember what the innocent world was like before what Karl Kraus called those last days of mankind? Remarque argued in his

earlier novel *Im Westen nichts Neues*, published in 1929, that all those who took part in the war were destroyed by it, even if they saved their lives. The soldiers who came home, on whichever side, were troubled ghosts, or corpses marching towards a last judgment. We are all, as inheritors of their doubt and despair, the walking wounded.

During 1915 and 1916 Mayakovsky wrote a tirade called *War and the World*, about the earth minced and churned into gore. Epic poets traditionally sing in praise of arms and the man. Mayakovsky, disgusted to find himself versifying carnage, atones with an act of voluntary self-mutilation. This thing in his hand, he explains, is not a lyre. The poet has torn out his heart, and plucks at his own aorta. A swaggering exaggeration? Not altogether. Remarque reported having seen a soldier on the battlefield bite the artery in his arm with his clenched teeth for two hours, to keep himself from bleeding to death.

The Way Back includes a post-mortem parade of mutilees, ranked according to the organs or limbs they have lost: faces from which the eyes have been gouged out; bodies which end in rigid, clanking prostheses or do not end at all, like a stout, stalwart man cut off at the hips. Their shell-shocked companions, quaking inside a private nightmare, are like souls who suffer purgatory there on the streets of the embarrassed city. The hero, going back to his peace-time job as a teacher, feels himself to be a fraud. Standing in front of his class, he wonders whether he should break the news to them: 'Should I tell you that all learning, all culture, all science is nothing but hideous mockery, so long as mankind makes war in the name of God and humanity with gas, iron, explosive and fire?' Perhaps, staying true to modernity, he ought to give his pupils lessons in tossing grenades or aiming bayonets. Should he describe how brains look when hurled about by gunfire, or the way the intestines unravel from a gutted torso?

For Remarque's characters, the war consists of atrocious scenes like these: images which no one before the war dared to imagine, stories which no one after the war dared to tell. Later wars added to the archive of obscenity: women and children bombed in Spain, the bulldozed cadavers of Belsen, the cunning chemicals which barbecued human beings in Vietnam, a lake of bloated corpses in Rwanda. By now we are case-hardened; one way of coping with life in the twentieth century is to grow a tougher skin, which is why we so admire the terse, hard-boiled heroes of Hemingway or Dashiell Hammett or Raymond Chandler. But in 1918 the shock was too recent, the lapse too sudden, to be dealt with in this way.

Kandinsky, responding to Rutherford's account of atomic structure in 1911, thought that 'the end of the world had come'. The new physics deprived nature, as Kandinsky said, of its 'strength and certainty'; the war completed this metaphysical assault. Those who survived reflected on it as an apocalyptic combat – not a battle of Britons against Prussians, but of men against mankind and its delinquent creator. The Bauhaus theatre director Erwin Piscator, quoting Remarque's comment about the generation which died whether or not it escaped

Trench warfare in the Somme in 1916

the grenades, declared that the war put an end forever to talk about 'the greatness of man' and 'the eternity of divine order'. Since such talk had been the official, self-congratulating anthem of the West ever since classical Greece or the Italian Renaissance, it was a startlingly abrupt termination.

War has sometimes been recommended as a necessary control on numbers, now that medicine and the humanitarian conscience have lengthened life. But need the numbers culled have been quite so extravagant? Two million were slaughtered around Verdun and on the Somme in 1916, with a grand total of eight-and-a-half million dead by 1918 – though these figures were superseded by the fifteen million lives lost between 1939 and 1945, when the world tried to wipe itself out all over again. With so many individuals killed, it was as if the whole notion of individuality had been liquidated. In their 1918 manifesto, the Dutch founders of *De Stijl* pointed to the breach between 'an old and a new consciousness of time. The old is connected with the individual. The new is connected with the universal.' The war was the individual's suicidal rebellion against the universe, and those egomaniac nationalities deserved to be expunged. Theo van Doesburg considered the collective slaughter a merciful release. In 1921 his third *De Stijl* manifesto took stock after the Russian Revolution: 'Europe is lost. Concentration and property, spiritual and material individualism, were the basis of old Europe.' The universal order to which van Doesburg looked forward was not socialism but an 'internationale of the spirit' – a cool, clean, theosophical heaven, ruled at right angles, which never existed anywhere outside Mondrian's paintings.

In 1929 in *A Farewell to Arms*, drawing on his experience as a volunteer ambulance-driver on the Italian front, Hemingway made a list of honorific words, the proud pillars of moral tradition, which would never recover from their disgrace: 'sacred, glorious, and sacrifice and the expression in vain'. The

wounded narrator Frederick Henry is visited in hospital by a gung-ho Italian colleague, who wonders what medal he will qualify for and asks 'Did you do any heroic act?' Henry indignantly denies it. 'I was blown up', he explains, 'while we were eating cheese.' In response to the war, Hemingway developed a style of studied avoidance. *A Farewell to Arms* begins by refusing to commit itself, prevaricating about time and space: 'In the late summer of that year we lived in a house in a village that looked across the river and the plain to the mountains.' Which year, and which mountains? Is this the loyal soldier's refusal to impart information which might have a military significance, or just the weariness of a man who no longer cares where he lives and has lost count of how many years the war has been going on? The next sentence studies the pebbles in the bed of the nameless river. Objects looked at so closely soothe and steady the mind, helping it to meditatively clear itself. Besides which, the pebbles are not involved in the war. Eventually, in the third sentence, Hemingway mentions the presence of troops in the vicinity. But rather than noticing what uniform they wear or where they are heading, he blandly comments on the dust they raise in the dry summer heat. At the end of the first chapter he is specific about the situation – although, cautiously or despairingly, he relies on understatement. A very small man who might be 'the King', invisible in a speeding car, passes the house. Whose king? Does it matter? He is on his way 'to see how things were going, and things went very badly'.

The chapter concludes with an aside about the cholera epidemic that winter: 'in the end only seven thousand died of it in the army'. Only! This, however, is the negligent arithmetic of a war which killed millions, and Hemingway's sentence can be read on an upbeat note of victory or as a morose and stoical dying fall. The numbers defeated the protocols of commemoration. During the war Maurice Ravel composed a suite of antique dances, *Le Tombeau de Couperin*, paying homage in each section to a friend killed in battle. The decision to remember the dead is noble and dutiful but also futile: who, confronting the parade of crosses in the cemeteries of Flanders or Normandy, can resuscitate all those vanished strangers? Ravel, according to his friend Roland-Manuel, felt that 'flowers left on graves are sad, not in themselves, but because they are meaningless to the passers-by'. We are called on not to forget. But even seven thousand – a niggardly total, given the necrology of modern times – is too large a number for us to remember, and Hemingway, unlike Ravel with his individual dedications, names no names. Frederick Henry remarks of a friend killed beside him 'He looked very dead'. That sentence captures the emotional and linguistic bafflement which the war inflicted. It may sound laconic; actually it is flustered, even sentimentally excessive. The verb is awkwardly aware of the fact that we can only look at death, not experience it. The adjective tries to modify a condition which is immitigable. Is being dead a matter of degree? Henry recovers his composure by going on to make a statement which asks less of words and causes him less psychological strain. 'It was raining', he adds.

The war, doing Wittgenstein's work for him, gave language a dressing-down. A jittery terseness – the equivalent of Hemingway's understatements – overtook the war poetry of August Stramm, the expressionist from Westphalia who was killed on the Russian front in 1915. Single words are grudgingly released, as if through gritted teeth. They remain disconnected, because how can syntax presume to restore logic to a confused and untrustworthy world? Stramm's account of a patrol begins by tensely glancing sideways at things to be afraid of:

> The stones enemies
> Window grins deceit
> Branches strangle.

Stramm's poem about a war grave refuses to indulge in eloquent gestures of grief, and merely notes the impertinence of the flowers deposited there. Frederick Henry recoils in embarrassment from flushed patriotic adjectives, and declares that military reality has left words like 'honour' or 'courage' sounding obscene. The duplicity of politicians showed up abstract nouns as gas-bags. Only concrete substantives can be trusted – 'the names of rivers, the numbers of regiments and the dates'. The futurists, splintering syntax in their earliest manifestos, intolerantly ordered the destruction of adjectives. Nothing was necessary, they thought, but verbs with their vapour trails of energy. But war, while confirming the shame of adjectives, taught Stramm and Hemingway to treat verbs with care: the actions those busy words described were more than likely making a deadly assault.

The change in human nature did not occur, effortlessly and overnight, in December 1910. It was tortuously drawn out over four years, between 1914 and 1918. Nor did human beings decide to change, as if whimsically adopting a new fashion. The change was involuntary, brought about by a series of bombardments. Piscator said that the war had killed off the notion of bourgeois individualism, the ideology which linked Kantian man, carrying a moral imperative within his breast, to the romantic solitaries and materialistic go-getters of the nineteenth century. The communal latrines at the front convinced Remarque that the individual's prissy privacies had gone for good. Twenty men sat side by side in a long, intent line, supervised as they voided their bowels. This was part of that 'renunciation of personality' which the army required of recruits, who were taught to behave like automata: a useful induction into the nature of modern life.

War, conscripting entire societies and executing them wholesale, revealed our fate to be collective. Lenin welcomed war in 1914 as the signal of 'a violent historical crisis, the beginning of a new epoch'. The crisis revealed that ideas and engines, ends and means, were out of synch. A British commander took note of the same rupture, remarking that the war was fought with nineteenth-century ideals and twentieth-century machines. No one realized in advance that notions of military etiquette had been rendered obsolete by weapons of mass destruction. Poison gas did not mind whether those who breathed it were soldiers or

civilians, which instantly made the protocols of international law irrelevant. In the past, societies handed over their disagreements to a particular chivalrous caste: wars were conducted like duels on a somewhat larger scale. Technology changed all that. Gas and then bombs made it possible to conceive of a new objective. Rather than inflicting casualties on the members of an army, why not altogether annihilate the society with which you had picked a quarrel? Knopf-macher in Joseph Roth's *The Radetzsky March* protests against the antiquated fad of duelling: 'This *is* the twentieth century!… We've got the gramophone, you can telephone someone hundreds of miles away, and Blériot and others are already flying through the air!' His mistake was to imagine that technological innovation would make men wiser, rather than enabling them to be more efficiently vicious. After 1914 war took to the air, which hugely aggrandized the scale of destruction.

Piscator at least believed that revolution, managing the masses as a theatre director choreographed crowds, could atone for the marauding individualism which had caused the war; by the time he died in 1966, this new god had also failed. Robert Musil's conclusions were less naive. He had no faith in the political doctrines which outlawed individualism. Rather he thought that the individual, after living through the war which begins as *The Man Without Qualities* ends, had become a stranger to himself, bemused by his own actions and aghast at his incomprehension of his own species. 'What we have experienced since 1914', Musil wrote in 1921, 'will have taught most people that, ethically speaking, the human being is…capable of anything: good and evil range equally widely in him.' In 1923 his accusation was even more direct: 'The last nine years have taught all of us, I believe, what excesses of cruelty and trespass not only secret neuropaths but also good, ordinary people are capable of.' Language, entrusted with maintaining our faith in rationality, was among the casualties. After his demobilization in 1918, Musil remembered the writing of the pre-war years: 'an explosive poetry of ideas' in which 'blown-off bits of philosophical thinking' were 'festooned with scraps of emotional flesh that had been torn away with them'. This describes the carnage of the battle-field. Rather than airily lifting off, as the futurist cult of the 'parola libera' wished, language took a direct hit, and spattered the bleeding wreckage all around. Moos-brugger was quaintly antique even before Musil started his novel. In the trenches, every soldier learned to be a serial killer.

The war domesticated horror, liter-ally brought it home. After a few more wars, horror became trite, like the painless Pop catastrophes of Andy Warhol – a

Andy Warhol
129 Die in Je
(Plane Crash
(1962)

painting, for instance, which copies a newspaper headline excitedly blaring '129 DIE IN JET!', while a weather report in the corner of the front page keeps smiling: 'Fair with little change in temperature.' Roth, looking back to the unfallen world before 1914 in *The Radetzsky March*, was amazed to remember an era when 'it was not yet a matter of indifference whether a person lived or died'. Once upon a time, individuals left an empty space behind them. The vacancy was preserved, commemorated. The trenches in Flanders or the beach at Gallipoli administered a lesson in the individual's dispensability. When one contingent was gunned down, another was immediately sent out to fall on the bodies of the forerunners. The generals on all sides assumed that there were plenty more queuing up for the privilege. What was a man, after all, but a corpse in waiting? Hitler shrugged at the human cost of his megalomaniac schemes. That, he said, was what young men were for. Their purpose, as well as their duty, was to die. George Grosz and Wieland Herzfelde mocked modern painters for their infatuation with cool geometrical cubes, or – in the case of the expressionists – with the aspiring vertical lines of Gothic architecture. The most authentically contemporary artists, according to the Dadaists, were the field commanders of 1914–18, who 'painted in blood'.

In 1932 Louis-Ferdinand Céline in his autobiographical novel *Voyage au bout de la nuit* likened the generals under whom he suffered during the war to priests performing a primitive rite, greedy for sacrificial blood. The Aztecs, he recalls, disembowelled eight thousand eager believers a week. Their pumping hearts were torn from their chests to feed the sun god, or perhaps to buy rain from the angry sky. Céline commented that 'such things are hard to believe until you get involved in a war'. On the battlefield the despicable General Céladon des Entrayes, sending Céline out to confront the German artillery with his sabre, had re-established this holy carnage. Unmerited promotion had made him 'an abominably exigent little sun-god' and allowed him to indulge 'the Aztecs' contempt for other peoples' bodies'. The rival gods Quetzalcóatl and Tezcatlipoca, like French and German war-lords, were engaged in perpetual combat, and had already churned up the world four times; its life could only be prolonged by transfusions of blood. Their brutal cults seemed like a commentary on current events, which is why – from Strindberg to D.H. Lawrence – modern writers were fascinated by ancient Mexico.

Dying soldiers in Remarque's novels are resented if they linger too long in much-needed hospital beds: death is a production-line, and these malingerers are not working hard enough on their own demise. Even a coffin is a temporary shelter, from which the occupant is liable to be ejected. When a shell hits a cemetery, men tug bodies from the boxes to make hiding places for themselves or stretchers for their fellows. To the poet Blaise Cendrars, who went into battle with the French Foreign Legion, the bundled cadavers after a German attack were ignoble, like the squalid refuse collected by rag-pickers; the cavities left by shells, choked with bodies, resembled affluent garbage bins. Cendrars saw human limbs

flying ownerless through the air. These might have included his own right arm, amputated in 1915. The numbers on the billowing casualty lists numbed the mind; death was devalued by its extreme popularity. Novelists began to execute characters without ceremony, sometimes inside negligent parentheses. Virginia Woolf in *To the Lighthouse* explains a distant thud which reverberates across the water: '[A shell exploded. Twenty or thirty young men were blown up in France, among them Andrew Ramsay, whose death, mercifully, was instantaneous.]'

When Kokoschka completed *Mörder, Hoffnung der Frauen* in 1907, his play about sexual warfare could only have been read as a private psychological confession. Man – as Otto Weininger prescribed in his fanatical diatribe on gender, *Geschlecht und Charakter* – is the idealist, aspiring to the sky; woman wants to embed him in the murky earth. The nameless Man in Kokoschka's play makes conquistadorial love to the Woman, then priapically mounts a tower. Spent and discarded, she kills herself. Hindemith read the play in 1917 and set it to music in 1919. By then, Kokoschka's pre-war Man, who rides on, armoured and bandaged after previous carnal duels, had become a post-war survivor, a lethal, emotionally hollowed automaton. The Wagnerian fanfares of Hindemith's score now bitterly mock a disgraced romantic chivalry. The soldiers copulate on the ground with the Woman's attendants; the uprisen Man dismissively massacres them all, as if swatting midges. It no longer mattered what Kokoschka's obscure, deranged play meant, because its action was no longer confined to the mind. By 1919 it seemed simply true: an instance of those acts of cruelty and trespass which the war, redefining human nature, had licensed men to perform.

The sculptor Bruno Elkan persuaded Hindemith that, after the war, art must abandon 'all remembrance of reality'. Stark abstraction was a means of protest. 'We fly with hair standing upright', Elkan said, 'from our terrible reality.' This is how the Man in *Mörder, Hoffnung der Frauen* behaves, as he strides away from the citadel he has incinerated. The war, belatedly vindicating Kokoschka, had made a neurotic nightmare look realistic. Hemingway alludes to the problem in *A Farewell to Arms* when a priest, after a season of military reverses, enigmatically comments 'Many people have realized the war this summer. Officers whom I thought could never realize it realize it now.' The priest speaks Italian, which Hemingway translates, but the unidiomatic, repetitious outcome exactly catches the attitude of sick disbelief. To realize the war, to understand what it really meant, was to jettison your faith in a world which you once thought of as real.

A polluted, intolerable reality was replaced by the warped imaginings of the surrealists. Kokoschka himself, gunned down by the Russians in August 1915 with his flailing horse on top of him, described the experience as a demented, disorienting joke. 'I had', he noted with amazement, 'a tiny round hole in my head.' Perhaps that was why the sun and the moon were improbably shining at the same time. But what explained the recalcitrance of the leg in the cavalry boot which led a life of its own, too far off even though it was supposed to belong to him? In 1942 André Breton declared that surrealism was 'a function of war'. At their cabaret in

Zurich during 1916, the Dadaists Richard Huelsenbeck and Tristan Tzara illustrated his point by wittily denying it. Tzara in one of their nonsensical double-acts peddled his *Dada Revue*, reciting its price and publication details while assuring potential customers that it was 'entirely unrelated to the war'. He added a disbelieving snigger of bad faith: 'hi hi hi hi'. How could Dada, even in neutral Switzerland, not be related to a war which had institutionalized absurdity?

A Latin tag, which schoolboys probably once regarded as a piece of proverbial wisdom, preaches that it is sweet and decorous to die for your country. Virgil in the *Aeneid* treated war as an arena of moral and spiritual valour. Even Christians think of themselves as soldiers, marching – as the hymn puts it – on to war. The association between battle and virtue has always been one of civilization's compulsory refrains. Besides which, as Thomas Mann regretfully conceded in 1922, 'War is romantic'. While he adhered to the new German republic which had emerged from military defeat and the Kaiser's departure, Mann took care to insist 'I am no pacifist'. It pained him to renounce the 'mystic and poetic' allure of war. Modern times, bidding a remorseful farewell to arms, had to unlearn centuries of pious training.

When the war came, Lytton Strachey registered his conscientious objection to military service, taking along an inflatable rubber pillow to the tribunal which heard his case: carefully positioning himself on the chair, he explained to the scowling judges that he was a martyr to piles. E.M. Forster in 1939 famously rearranged the moral priorities of the citizen, and declared that if required to choose between betraying his country and betraying his friend, he hoped that he would have the guts to betray his country. The specification about needing guts was important. Its coarseness opened wounds: the spilled intestines described by Remarque, the eviscerations over which Céline's general presided. But guts are also the physical basis of courage, and Forster's phrase presents betrayal as an act of bravery, not cowardice.

The moral history of the twentieth century would be more palatable if everyone had been as exquisitely scrupulous as Strachey or Forster. But there was another view of the matter, a sinister restatement of the traditional bond between war and virtue. If 1914 disclosed a disparity between antique ideals and up-to-date machinery, perhaps the machines were right to trample those ideals. Was not the war a vindication of modernity, violently completing the abstraction of the world? Marinetti, excited by the acceleration of social and cultural change which occurs in wartime, called Italy's colonial campaign in Ethiopia 'the finest futuristic poem which has yet appeared'. The beauty of war, in Marinetti's view, was that it superseded timorous, skulking nature. The costumes and hardware it doled out to combatants made heroes of them, regardless of how they performed in battle. Man became superhuman, his face rendered impervious by a gas mask, his voice boosted by 'terrifying megaphones', his defiant words seconded by flame throwers.

War had brought to pass what Marinetti called the 'dreamt-of metalliza-tion of the human body'. As in the scientific romances of Wells, evolution reached its triumphant climax as the pulpy organism changed to a gleaming, insentient machine. The epilogue to Wells's *In the Days of the Comet* compliments the astral beacon in a phrase which now sounds chilling: 'In a manner it had dehumanised the world'. In Wells's view, this was no bad thing, because it got rid of atavistic quirks and ineradicable foibles – the world's 'spites, its intense jeal-ousies, its inconsistencies, its humour'. The last item in the list of vices is signifi-cant. A brave new world will outlaw jokes, which as Freud understood are the pockets of resistance for neurotic, inconsistent human nature. After the war, met-allization became an aspect of revolutionary demeanour. Lenin told the operatic bass Feodor Chaliapin that he was a dangerous man, because his singing melted the heart and weakened a Bolshevik's ruthless mettle. Chaliapin, taking the hint, emigrated to Paris in 1921 and never returned to Russia.

The body can be seen metallizing itself in *Triumph of the Will*, Leni Riefen-stahl's film of the Nuremberg rally in 1934. After their roll-call, the worker bands stand to attention, holding upright not guns but spades. The camera moves past them, reviewing them like a general inspecting an honour guard. One by one their faces – scarcely individualized because they have been pre-selected for their Aryan features, and in any case the experience is about submergence in a mass – slide behind the spades as the camera tracks down the line. Flesh gives way to fortifying metal. The mythology of fascism took over the vision of an abstracted, automated future, and turned it into a prescription for running society like an industrial installation. Military necessity, commandeering obedience, was essen-tial to morale. Marinetti's 1909 manifesto called war 'the world's only hygiene'. This may have been bravado or hyperbole; Hitler believed it, and in addition thought of genocide as a sanitary policy.

Marinetti insisted on judging warfare according to aesthetic criteria. Gun-fire and cannonades constituted music; because art aimed to stimulate all the senses simultaneously, the 'stench of putrefaction' made its own contribution to the synaesthetic symphony. The paintings of Gino Severini in 1914 and 1915 treated battle as a mechanical game. The weapons are merely disporting them-selves. A child calls his finger a gun, aims it at you, makes a noise, and insists – since you have agreed to play the game – that you fall down. A cannon painted by Severini mouths silent, harmless words: BBOUMM it belches. Another slo-gan, 'Anéantissement' or annihilation, speeds through the smoky chaos like a dart, but annihilates no one. The futurists sought to liberate language. Here it is set free to pick quarrels and exchange insults. Verbal artillery is discharged down long metal barrels with what another inscription, perhaps imitating the stammer of a machine-gun, calls PRECISISION; it describes an exact, graceful trajectory in its 'courbe graduelle vers la terre'. Blood and agony are replaced by immuniz-ing, euphemistic words. In a corner, Severini discreetly refers to a 'pénétration désagréable' and allows a hurt Frenchman, who does appear in the painting, to

cry out 'Oh là là! ça sent mauvais'. This is a war of words, so why not let them get on with it?

No wonder Hemingway thought the war unspeakable, because the language which offered to give an account of it had given up, or died of shame. Remarque in *All Quiet on the Western Front* describes some of the noises which Severini's headlines muffle – the screams of wounded horses, like 'the moaning of the world,…[of] martyred creation', a sound so appalling that the soldiers risk sniper fire and struggle through the mud and darkness to shoot them. On another occasion, the bodies of the dead left unburied in summer swell up and start to vocalize as they decay: the distended stomachs hiss and throb as putrefying gases percolate inside.

But what did a metallized body have to fear? In Severini's painting of an armoured train, the men who crouch over their rifles wear angular blue capes and peaked hats which harden them into geometrical constructions: cones surmounted by triangles. Arcs of light crackle from their guns, and a tank puffs out a cloud of white steam. The machines produce a shimmering, iridescent weather. Severini discounts the possibility of casualties. The only red is symbolic, belonging to the picture's sign-language: the insignia of the Red Cross, or a slice of French tricolour. As with the blue cubic soldiers, costume is a cladding of steel: the starched white uniform of a nurse looks like a carved, uncompassionate iceberg. Since war is fun, Severini assumes that its victims will be made fighting fit once more by a laugh. A banner headline prescribes the remedy he thinks appropriate, 'LE FIGARO JOURNAL AMUSANT'. The only evidence that the train has a cargo of butchered men is the fist, probably clenched in pain, of a figure lying in the bed beside which the icicle in the Red Cross uniform impassively sits. Severini does not allow him a face: the stiff French flag eliminates it. The futurists had the good grace to suffer for their insane principles. Marinetti and Luigi Russolo were wounded in action; the architect Sant'Elia was killed, and Boccioni died after tumbling from his horse during manoeuvres.

In 1918 Blaise Cendrars published a prose poem, 'J'ai tué', which concludes with an account of his first kill, when he virtually severed the head of a German soldier with his knife. The transaction is surgically disinterested. The battlefield might be a factory in which Cendrars anonymously toils, making his small contribution to the grand, concerted enterprise. He describes Germans being processed like beasts in an abattoir, cut up as cleanly and quickly as possible. The general in command – no savage executioner, like the Aztec ogre in Céline's novel – supervises the affray as if he were working out a mathematical proof, and consults his table of logarithms. Cendrars does not protest at being moved around as part of the equation. He knew he was taking part in an abstract war, whose design was only comprehensible from a distance, and he allowed himself to be abstracted – treated as part of an apparatus which could not pause to explain its intentions. Gertrude Stein, as teasing as ever, remarked that 'the composition of this war, 1914–18, was not the composition of all previous wars'.

In the past there was 'one man at the centre' directing multitudes at the margin. Now the composition 'had neither a beginning nor an end' and 'one corner was as important as another corner, in fact' – as Stein, having proved her point, sums up – 'the composition of cubism.' The general in Cendrars' account does not occupy the centre. He too, checking his calculus and determining probabilities, is relegated to a corner, constrained by chances he cannot control. All concerned must trust the machine they are serving. Cendrars – like a Picasso sitter who did not expect his portrait to be a likeness – willingly surrendered personality, rather than claiming, as Remarque did, that his personality has been stamped out.

Deafened and stunned by the barrage, Cendrars enters a state of bliss, and begins to hear the remorselessly regular thud of the guns as 'music of the spheres'. He is soothed by his absorption into this grand, mechanistic enterprise, which mobilizes 'water, air, fire, electricity, radiography, acoustics, ballistics, mathematics, metallurgy, fashion, art, superstition, the lamp, voyages, the table, the family, universal history'. The cool blade in his hand instructs him to turn his body into an extended weapon. He has withstood bombs, cannons, gas and mines. Now he is challenged by 'my own kind, a monkey'. Leaping out of the trench, he makes short work of the Boche, and congratulates himself on his agility, his nervous control and his 'sense of reality'. He, a poet, has killed. But though he is proud of the act, he does not reckon it to be a heroic achievement. Like the knife, he is a glorified utensil, an apparatus performing its function and sharpening its skills. Dehumanization is a safely, comfortably impervious state. Before the war Cendrars bought himself a film projector and used it to calm his nerves. The clattering motor, the jerky images and the automatic laughter of the viewers supplanted the worrisome life inside his head. 'I do not dream', he reported. 'No metaphysics.' He recommended the result, as restorative as a course in hydrotherapy. 'The machine', he insisted, 'does everything.' That remark introduces a modern epiphany: Andy Warhol too envied machines, and wished he could be one. For the man who wanted to be a mechamorph, war could only seem idyllic, even if it cost him the odd limb.

Fernand Léger illustrated 'J'ai tué' with some diagrams of volumetric pipes, rivets and robots on the march, their skulls metallized by tin helmets. Léger once remarked that despite his time as a soldier – conscripted in 1914, he served as a sapper and was gassed at Verdun in 1916 – he had never painted cannons. The reason, he said, was that he had them behind his eyes. The weapons were no longer there to be looked at; they had provided him with a new way of seeing. What he saw, with this militarized gaze, was a world which belonged to machinery. Human beings served the gadgets, and sometimes nourished them: what else did it mean to be cannon fodder? In 1923 Léger designed a laboratory for Marcel L'Herbier's film *L'Inhumaine*, the set for a Frankensteinian demonstration of scientific power. In this cathedral of technology, the altar has been replaced by a turbine, and the votive chapels house gadgets which perform irreligious miracles: the prime exhibit is a television transmitter. The ultimate marvel

occurs when the scientist Norsen resuscitates his dead mistress Claire, reviving her corpse with a zigzagging electrical current. Coldly selfish in her previous life, she awakens to a humane capacity for love. The film's sentimental critique of inhumanity did not interest Léger; for him the laboratory, like the war, served not to cure inhumanity but to transform human beings into supermen. Ideally, Norsen's experiment on Claire would have worked even better in reverse, changing the soft and yielding woman back into a steely sexual automaton.

Writing to Cendrars from the front, Léger emphasized the teeming productivity of the battlefield, its efficient requisitioning and distribution of commodities: 'again and again fresh armies of workmen. Mountains of pure raw material, of manufactured objects.... American motors, Malaysian daggers, English jam,…German chemicals.' Military strategy had managed a grand feat of industrial organization, splicing and welding, hammering and screwing these polyglot goods together so that 'everything bears the stamp of a tremendous unity'. A society made ready for war – rallied as a team of mutually interdependent, slotted and lubricated parts – had been initiated into modernity. It had also, if you bring to bear a hindsight not available to Léger, been prepared for totalitarian rule. Niels Bohr remarked in 1939 that, in order to produce an atomic bomb from the separation of uranium isotopes, it would be necessary to turn an entire country into a factory; during the Manhattan Project, this is exactly what occurred in the United States. War is the highest, most productive stage of capitalism.

Gertrude Stein likened the war to a cubist composition because she viewed its chaos as a quirk of design, a jarring after-shock of relativity. Like cubism, the war redesigned the human body. But the process was not quite the sleek, precise technical improvement admiringly depicted by Severini or Cendrars. Remarque's novels are more specific about the metamorphoses. Soldiers whose feet have been shot off hop towards shell-holes on splintered stumps. One man turns up to have his wounds dressed, clasping his spilled intestines with his hands. One casualty is 'light to carry, because almost half of him was missing'. A stretcher-bearer has been minced: he could be scraped up with a spoon and buried in a tin can. Another veteran has one eye interred beneath scar tissue, while its partner is made of dull glass. A patch conceals the cavity where his nose was. His mouth, sliced in half, has grown back together askew. Through bracketed prosthetic teeth, he struggles to enunciate the name by which, when his body was whole and recognizable, his friends used to know him. Is a man still a man when all that remains of his flattened face is 'a black, oblique hole with a ring of teeth marking the mouth'? These physiognomic revisions astound the onlookers. 'I never saw the like of that before', someone comments when the bag is removed from the black, flat remnant of a head. 'However did it happen?' One of Céline's characters, entrenched beside the Meuse, watches a man dematerialize. A shell blasts his companion's face, and all that remains of him is a fart, a small gust of putrid air. The bomb blast at Hiroshima in 1945 perfected this analytic

decomposition of mankind. Near the epicentre, people boiled. Their insides turned to steam within a single, blinding second. Evaporation and charring reduced their density; a whole city vanished in the hot wind.

During the last decade of the nineteenth century, apocalypse seemed a salutary prospect. The poet Rupert Brooke, eagerly enlisting in 1914, greeted war as the merited condemnation of 'a world grown old and cold and weary', and thought that battle would be like a refreshing bathe: he and his fellow recruits were 'swimmers into cleanness leaping'. A year later he died in the Aegean, not all that cleanly. He was finished off by a case of blood-poisoning on his way to Gallipoli. Living through the end of the world, for those who witnessed more of the war than Brooke, banished all thoughts of transfiguration. Armageddon was obscene: nature's self-crucifixion. One of Stramm's poems described a poplar hanging itself, and the novelist Henri Barbusse compared a wounded man standing upright on a hillock to 'a screaming tree'. In Remarque's shelled graveyard, corpses blown from their coffins are killed all over again, as if one death were not enough.

In its revulsion from the war of 1914–18, the twentieth century reconsidered the nature of heroism and defined a morality appropriate to modern times. One of its defining figures is the so-called 'good soldier' Švejk (better known as Schweik), created by the novelist Jaroslav Hašek. Hašek himself was an inverse idealist: a deserter from the imperial Austrian army, who joined the Russians in 1918 and fought to free his Czech homeland. Schweik, aware that the enemy is the politicians and generals on the home team, concentrates on saving his own skin, which may be the better part of valour; he was later adopted by Brecht, who saw him through a second world war. Survival, once only the coward's concern, takes courage: hence

Illustration (1911) by José Lada for The Good Soldier Schweik

Brecht's Mother Courage, selling her wares and selling off her children in a permanently ravaged Europe. This is why Humphrey Bogart's Rick in *Casablanca* – brooding at the bar, amused by the squabbling of spies and partisans – became such an exemplary figure. Rick is the disengaged, unenlisted man, cynically neutral in self-imposed exile. He does not betray his country, and must have served it in the past, because he claims to be on the German blacklist, their 'roll of honour' for immediate execution; the betrayal which wounds him, however, is that of his friend – or rather his lover, who did not keep her appointment to flee

from Paris with him as the Nazis took over. If he falls from grace by committing a patriotic act at the end of the film, he only does so, as the wry Vichy policeman comments, out of sentimentality. Supposedly he leaves Casablanca for the Free French garrison in Brazzaville. It remains to be seen, as he drifts off into the fog, whether he will join up. He has already explained to Ingrid Bergman's Ilsa that it would make no difference to 'this crazy world': why should he bother contributing to the 'hill of beans'? He long ago lost his illusions about placing arms in the service of ideals. For him, the only available heroic act is one of renunciation, which is why he gives up his seat on the plane to Lisbon and, along with it, his chance of happiness.

By 1943, when *Casablanca* was released, its romantic misery coincided with the mood of the times. The century's wars had been fought against humanity. Political idealism could never again be trusted. But perhaps it was still possible, as Bogart's sacrifice stoically demonstrated, to be an idealist in personal relationships.

The war was being impatiently imagined long before it broke out in 1914. These dreams were what made it inevitable – even though it served no purpose and, in the absence of a political reckoning, had to be fought all over again two decades later. War released the energies which the new physics had shown to be caged inside matter; it freed belligerent human instincts, caged by flimsy civilization. Modern times arrived at self-recognition during those years of pointless killing. The mechanical iteration of guns, shells and bombs contrived the optional, avoidable apocalypse which, in Spengler's view, the modern world longed for.

Explosions were the symbol of this war, and of the psychological, social and physical tensions that provoked it. The expressionist Ludwig Meidner began to paint the war in 1912–13. His pictures are about gratuitous explosions, unleashing again the violence which first created the world: they are studies of destruction as a creative fiat. In them, imagination obsessively rehearses a scenario which culture and conscience attempt to suppress. What is the stick man in *Figure in a Nocturnal Street* running away from? A sunburst at the end of the street announces the advent of light, which here means the world's end, not its beginning. Perspective no longer beautifully regulates space. The vanishing point of the vista is where the flash occurs, and it causes the street to implode. Houses bend and buckle. The figure runs so as not to be consumed by the vacuum. A street, Meidner argued, cannot be represented by sedate, sedentary 'tonal values'; it is created by 'a bombardment', and its volatile, disjected fragments consist of 'whizzing rows of windows, screeching lights between vehicles of all kinds and a thousand jumping spheres, scraps of human beings, advertising signs and shapeless colours'. The spheres in a modern metropolis do not revolve in tuneful consonance. They have jumped, as Meidner noticed, out of their rightful orbits.

One of the many paintings which Meidner called *Apocalyptic Landscape* anticipates what a blitzed city will look like, with toppling façades and panicked

crowds. In 1913 no such calamity had ever occurred, and there are no war-planes above Meidner's city, no guns visible on the outskirts. The sky itself has decided to dispense death. Irate planets discharge waterfalls of fire – luridly beautiful, like rainbows which no longer signal peace between men and the irate heavens. Or perhaps the buildings below have spontaneously chosen to blow apart, to show off the restiveness of those atoms locked up in bricks and mortar. A tower in the fore-ground flares up, like a head which can no longer dampen down its incandescing thoughts. In *Burning City* the bombardiers can be seen at work, crouching beneath a parapet and exulting in the scorched ruins beyond. Scars shaped like an asterisk mark places where they have scored a hit: those yellow stars are the emblems of cosmic catastrophe, of some giddy revelry in the universe which settled, solid human cities deny at their peril. 'Are not our big-city landscapes', Meidner asked, 'all battlefields filled with mathematical shapes? What triangles, quadrilaterals, polygons and circles rush out at us in the streets! Many-pointed shapes stab at us.' To the modern eye, every sight-line is a firing line.

Meidner thought that his 'visions of mass graves' were worthy of a Hebraic prophet. The spectacle of cratered land and hysterical mobs seemed to him more religious than military. 'The spirit is everything', he said; 'I can do without nature.' If nature, stubbornly continuing to exist, stifled the wild, ardent spirit, then it deserved to be destroyed. The mad terrorist in Fritz Lang's film *Das Testament des Dr Mabuse* – made in 1932, as a coded commentary on Nazi tactics – scribbles his last will in an asylum. Lang's camera looks over Mabuse's shoulder as he plans an explosion at a chemical factory, one of the nihilistic pranks by which he intends to destabilize society. The word he writes is 'Attentate'. Inscrib-ing it in angular Gothic script, Mabuse's hand bears down on the cross bars of those four Ts. Suddenly the word looks like a diagram of Golgotha, with four tilted crosses rearing against the sky. Mabuse's writing, like Meidner's paintings, contrives to crucify the world.

The plume of steam from a train in Meidner's *Burning City* flaunts another uncomfortable truth. Heavy industry, which built these monumental human shelters, gambles with destruction by playing games with fire. The train is kept in motion by a furnace, stoked with fuel. If there were no chimney through which it could let off steam, it too would blow up. In Lang's *Metropolis*, a worker struggles to control a pressure-gauge, arms outstretched on the face of a clock, pinned on a cross for the duration of his shift; when he gives up in exhaustion, the machine erupts, tossing bodies through the air. Every engine, every factory incubates explosions, only just averted. Perhaps it is a shame that so much seething, thrilling energy should be meekly pacified. To dehumanize the world, as Wells implied in his story of the comet, would clear away our fussy, timid, civilized con-cerns and acknowledge that nature is a playground of impersonal force and ele-mental combat.

Georg Kaiser, in the two parts of his expressionist drama *Gas*, first per-formed in 1918 and 1920, staged judgment days like the flaming denunciations

which descend on Meidner's cities. In *Gas I* a factory explodes, with smashed windows and tumbling chimneys. The Billionaire's Son, proprietor of the gas works, pleads with his employees not to bother about reconstruction. His speech is one of the moral explosions, blasts of unmotivated will, which expressionist drama required of its characters; like soldiers going over the top, they must be prepared to sacrifice themselves for an idea. The tycoon asks the victims 'What was there so terrible about the explosion?' It merely formalized a fragmentation which already existed. The people it blew up were not whole to begin with. They were mutilees, functioning either as hand or foot or eye, according to their allotted task on the production line – as if the limbs and organs subtracted from Remarque's parading veterans in *The Way Back* had been recycled, profitably put to work.

Explosions, in this bracing modern view, were scathingly truthful: like all analytical procedures, they took apart things which only pretended to cohere. Duchamp's *Nude Descending a Staircase* was jeered at in 1912 as 'an explosion in a shingle factory'. The slur was unjust but not imperceptive: Duchamp aimed to show that a body is made of moving parts, insecurely fastened by sinews, articulated by joints, and when it moves (especially if you jolt downstairs, with no clothes on to cover up the evidence of shock and dislocation) the whole apparatus – like a tall building or a suspension bridge, which flex and sway so as not to collapse – risks coming apart. A roof made of shingles is no sturdier than a nude made of brittle, abrasive, separable bones. William S. Burroughs pointed out that the magnified images of pictorial modernism were the debris of an explosion, scattered by 'seismic upheavals in the human mind'. Seurat saw the world fragmented into dots, Picasso wracked faces into abrasive, colliding facets. To look at things this way, Burroughs said, involved 'literally *blowing up* the image', and since a person is 'made of image', required to fit the prototype of a human being, this meant that people were being split apart, as if by the detonation of a shell or a grenade.

After the industrial accident in *Gas I*, Kaiser ends *Gas II* with an even bigger bang. Wartime bombardment shatters a concrete bunker, and humanity receives the incontrovertible order to exterminate itself. The critic Kurt Pinthus in 1918 recommended drama as the most passionate of forms, best suited to expressionism, because in a play 'Man explodes in front of Man'. Character, in Pinthus's description, is an incendiary device with a built-in timer. The person on stage is tested, provoked, tormented, until finally, as when the pressure-gauge lunges out of control in *Metropolis*, the dial reaches zero. That is when Ibsen's Hedda Gabler shoots herself, despite the fact that 'people don't do such things'. Expressionist plays inexorably moved towards moments of psychological detonation. In 1924 Moholy-Nagy praised Stramm for the 'explosive activism' of his drama. He dispensed with tiresome, painstaking narrative, and relied instead on 'the impetus of human sources of energy, that is, the "passions"'. Passion is a psychological fuse. The Man in *Mörder, Hoffnung der Frauen* loses his patience with the Woman and strikes her dead; the novice in Stramm's *Sancta Susanna* loses her

self-control, strips herself naked, pulls the loin-cloth from the crucified figure above the altar, and consummates her bridal union with Christ. These characters resemble the veterans in *The Way Back*. They look peaceful enough, Remarque says. But like the French fields in which they fought, they contain buried explosives. Disillusion has turned them into walking land-mines.

The bomber, like his close colleague the aviator, is one of the twentieth century's symbolic protagonists. Bombs – whether planted in garbage bins on busy streets, in railway carriages, in cars parked in skyscraper basements or tucked away in the baggage compartments of aeroplanes – have given modern life a new kind of terror. Nothing and no one can be trusted. The most innocent, innocuous containers may be ticking towards eruption. The men who detonate such weapons resemble bombs: they are the carriers of inflammable ideas. Often they do not mind dying when the countdown concludes, which makes them virtually invincible. Their presence among us is one of the legacies of the war, which left society permanently militarized, on guard against enemies within.

They predate the war of course, although this, like the premature blitzes of Meidner, merely demonstrates that the assassination in Sarajevo was the war's excuse, not its cause. War legitimized the innate self-destructiveness of civilization. Perhaps, in a universe of clashing atoms, it obediently exemplified a law of physics. This is Joseph Conrad's suggestion in *The Secret Agent*, the novel he published in 1907 about an anarchist plot to blow up the Greenwich Observatory. Verloc suborns Stevie, his wife's young brother, to carry the bomb; it goes off before it should, and the policemen have 'to gather [Stevie] up with the shovel'. Mrs Verloc, when she hears of the accident, imagines 'bits of brotherly flesh and bone' bestrewing the park while Stevie's head, having bounced off his shoulders, hangs suspended and then fades 'like the last star of a pyrotechnic display'. She kills her husband with a carving knife to avenge the boy. Conrad describes the murder as if it were a second explosion – a seismic upheaval in the cramped suburban room.

A bomb works, according to a process which physics clarifies, by maddening the air. Mrs Verloc's mental agitation likewise stirs up a whirlwind in the parlour. When Verloc speaks, 'the waves of air of the proper length, propagated in accordance with correct mathematical formulas, flowed around all the inanimate things in the room'. Air pummels Mrs Verloc's head as if smiting a rock; its pressure causes her ideas to widen. The parlour begins to pitch and tilt, behaving 'as though it were at sea in a tempest'. The knife arrives in Verloc's chest before Conrad ever specifically says that his wife has aimed it. He might have been killed by the unhinged energies of that madcap room, with its seasick floor and cyclonic air currents. 'Hazard', Conrad remarks of the deep, unimpeded incision, again begging the question of how the knife got to be where it is, 'has such accuracies.' Ours is a hazardous universe, forever firing missiles at us. We are like soldiers dodging a barrage in no man's land. If, having run the gauntlet, we find we are still alive, it must be because of the universe's temporary oversight.

Mrs Verloc's rage and grief draw on reserves of energy stored during our collective, uncivilized past. The modern woman regresses, acting with 'the simple ferocity of the age of caverns, and the unbalanced nervous fury of the age of bar-rooms'. For the anarchists in Chesterton's *The Man Who Was Thursday*, explosion is a more cerebral reaction, precisely timed and calibrated, not a sudden visceral outburst. Chesterton's plotters are experts: one of them 'organised the great dynamite coup of Brighton'. They prefer Verloc's bombs to the domestic utensil his wife grabs in her distress. Their weapon of choice is dynamite, invented and named by Alfred Nobel (who later endowed a prize for peace). A knife may be used for conducting a personal quarrel, but dynamite by its very nature generalizes and aggrandizes the dispute. It works by expanding: 'it only destroys because it broadens'. Dynamite, like the dynamos worshipped by Henry Adams and H.G. Wells, showed off the nineteenth century's unbridled dynamism.

The Secretary in Chesterton's fable thinks of his own brain as a bomb, and smites his skull to let out the resentment and rebellion which boil inside: 'A man's brain must expand, and it breaks up the universe.' Hence the choice of target in *The Secret Agent*. Blowing up the Observatory would achieve no political or military advantage; its aim is to disrupt the artifice of universal order, a system of time-keeping arbitrarily governed by the meridian buried on the hill. Nietzsche said that he philosophized with a hammer, using ideas as cudgels. The philosophical bombers of Chesterton, carrying on Nietzsche's campaign against God, pass beyond such bludgeoning crudity and adopt cleverer armaments. One of them has logically proved 'that the destructive principle in the universe was God; hence he insisted on the need for a furious and incessant energy, rending all things in pieces. Energy, he said, was the All.' And energy, of course, slumbers inside the bomb or the stick of dynamite, awaiting ignition. This incendiary motive reappears in the palette of the painters known as 'fauves', or savages, with their acid greens, scorching yellows and charred blues. 'We treated colour', explained André Derain on behalf of his colleagues Matisse and Vlaminck, 'like sticks of dynamite, exploding them to produce light.' Cocteau – discussing Stravinsky's *Le Sacre du printemps* as a piece of fauvist music, violently brilliant – called the score 'indispensable dynamite'.

Andrei Bely's novel *Petersburg*, published in 1916, rehearsed two revolutions in its story about a time bomb secreted in a sardine can. The novel anticipates the political explosion which occurred in St Petersburg a year later, when the cruiser *Aurora* fired its signal of blanks at the Winter Palace. But it also deals with a psychological revolt which, as the motor of modern times, was already under way. The young dissident Nikolai Apollonovich – the last of those rankling idealists who brood on the social margins in Russian novels of the nineteenth century, a rebel finally enlisted by a cause – is ordered by his radical cronies to kill an enemy. It so happens that the bomb's target is his father, the patrician senator Apollon Apollonovich. For Picasso, the Oedipal fantasy analysed by Freud was a

cruel, simple law of creative progress. In art, as he liked to repeat, one must kill one's father. This Freudian law also held good in revolutionary politics. A battalion of Red Guards performed the *Oedipus Rex* of Sophocles in the streets of Moscow on May Day in 1920, with crowds of onlookers swelling the chorus and sharing responsibility for the king's expulsion. Oedipal rebellion gained an extra impetus from the war of 1914–18, when biological priorities were reversed. Fathers or doddering grandfathers on the general staff sent a generation of sons out to be killed in the trenches.

Nikolai sets off his bomb in a city dreamed up in tribute to classicism and rationality, those shaky pillars of civilization. Peter the Great laid out its obsessively regular vistas on a foundation of bogs and marshes. The very improbability of his frigid Venice, and the sacrifice of those enslaved armies who built it, asserted the primacy of will, which holds the world together and overrules the baseness of nature. Apollon the imperial bureaucrat, with his faith in codification and his strictly numbered bookcases, follows the precepts of Peter the Great by revering 'the plane geometry of the state'. St Petersburg is a diagram of Utopia, legislated into being with the slide rule and the knout. Its abstractness and its right angles exclude the realistic mess and crooked corners of humanity. Apollon hates the islands in the Neva, swarming with discontented artisans, and thinks these blobs should be riveted into submission by iron bridges, or punctured by the arrows of avenues.

He is a totalitarian cubist. As he travels down the Nevsky Prospect in a cubic carriage with quadrangular walls, he passes his idle time in fantasies about pyramids, triangles, parallelepipeds and trapezoids. For him, these are the oppressively heavy building blocks of power, not – as the same shapes seemed to Cézanne – the mental aids used by God when he experimentally fabricated our earth. Bely's novel makes it clear why Stalin had to move his capital further east. How could the revolutionary redesign of society be accomplished in a city designed to exemplify different ideological principles? St Petersburg, like Plato's republic, was the headquarters of a tyrant who claimed to be reasonable. Landlocked Moscow, overlooked by its hilltop fortress, with its ancient credulity – the poet Marina Tsvetayeva, thinking of its churches, called it 'my city of bells' – was easier to transform into the centre of a regime pledged to doctrinal orthodoxy and sustained by secrecy, invisibility and nocturnal arrests.

The bomb planted by Nikolai in *Petersburg* is the pure, gratuitous expression of modernity: the analytical disbanding of man and matter. It will dissolve his father into molecules, meat, his sweaty carnal constituents, an atomic shambles. But the very idea of it also dismantles Nikolai. Because he questions everything, his thinking has already ejected him from himself. The ceiling lifts off his head, and he has the sensation that a breeze has blown him through the breach, 'into darkness, above his own head (which looked like the planet *earth*), and – he flew apart into sparks'. The bomb, which works by the deadly expansion of gases, teaches him the volatility of being. He asks his father what 'I am' means.

His father replies 'A zero'. When Nikolai demands what zero is, Apollon answers 'A bomb'. Nikolai understands 'that he himself was a bomb. And he burst with a boom.'

War and revolution demonstrated that this man-made thunder had irrecoverably altered the world and our way of seeing it. Eisenstein trained as an engineer before he became a film director, and after being conscripted in 1917 he was sent to the army's School for Ensigns. There he prepared for battle by making a study of land-mines. The experience taught him, he later claimed, how to piece together a cinematic montage.

In *The Battleship Potemkin*, the episode in which the soldiers shoot down demonstrators on the Odessa Steps is narrated in quick, abrupt cuts, as staccato in their rhythm as rifle fire – jittery alternations between long shots of the flailing crowd and close-ups of terrified faces, angular views of tramping boots and a runaway pram. The emotional effect is explosive, and the operation of land-mines taught Eisenstein how to engineer it. A mine blows up when 'an increasing force compresses' and 'the containing frame bursts'. Eisenstein drastically increased the force of his images by compressing them in time, chopping each one back to a few elliptical frames. This burst the border which contains the image and pacifies it. Film is a moving picture: why should movement not be accelerated until the object flies off the wall or breaks through the screen? When the soldiers fire their first volley into the crowd, Eisenstein re-creates the panic and disbelief of the victims by 'the shaking of a single head in three sizes'. The close-ups make it look as if the head itself, another containing frame which fails under extreme pressure, were about to burst. Studying mines, Eisenstein was especially fascinated by the trajectory of detonator capsules. When hurled out-wards by the blast, they made visible the waves of turbulence which agitate the air. He followed the same rule in assembling his shredded images: 'the shock scatters myriad fragments'.

His observation could be extended to cover the physics of modernity, and its metaphysics as well. Hugo Ball, in a lecture on Kandinsky which he delivered in Zurich in 1917 at the Galerie Dada, surveyed a world which disintegrated when man killed God, and remarked 'I am dynamite'. The personal integer had erupted. After that change in human nature announced by Virginia Woolf, man had to give up the notion that he was a unified, coherent construction. The mind, like Nikolai's sardine can in *Petersburg*, can barely hold the lid down on its caged spells. And the uncoordinated body goes about its maimed, awkward business independently, which is why the gait of Charlie Chaplin seemed so characteristic of modernity. In 1928 the Belgian poet Henri Michaux, taking for granted the irreparable rupture between soul and body, thought and feeling, said of Chaplin 'We no longer have emotions. But we still move'.

Those expanding gases remind Nikolai of the distempered stomach from which his family suffers. Will the rumbling acids, he wonders, burst the belly which contains them? He computes the explosion arithmetically. When the

bomb goes off, it will multiply a single unit to infinity. But that infinity consists of debris, a diaspora of butchered bits – splinters of furniture, scraps of flesh, slush which was once a brain, all scattered to the winds within a hundredth of a second. The 'sphericality' of the seething gases terrifies Nikolai. 'There is no horror in the numeral one. The numeral one is a nonentity, a one and nothing more! But one plus thirty zeroes will make the hideous monstrosity of a quintillion.' So the ten-times table, if you go on reciting it for long enough, will arrive at numbers too large for the mind to conceive of, and return you to an imploded zero.

The bomb mimes both destruction and creation, and discloses the similarity between them. That is why it terrifies and fascinates us in equal parts. This is the way the world ends. But it may be also the way the world began. In 1927 the cosmologist Georges Lemaître first suggested that we inhabit an expanding universe whose dilation – as it proceeds irresistibly towards complete breakdown – was set off by some primal explosion of matter. That event abridges and annihilates galactic time. It may have occurred ten billion years ago, but its fall-out is still with us, perpetuated in the electromagnetic rays which beam from quasars.

Verloc in *The Secret Agent* conspired to blow up the meridian. Nikolai in *Petersburg* ultimately aims his bomb at the planet which, in Roman mythology, was responsible for universal time-keeping. He thinks of his father as Saturn, who is the god Chronos: 'The circle of time had come full turn.' In 1916 this cosmic convulsion could take place only in Nikolai's vengeful fantasy. The history of modern times went on expanding the mental reach of these explosions until, at least potentially, they could break up the universe, as Chesterton's anarchist wishes, and bring back the chaotic moment when time started. By 1945 bombs were capable of instantly flattening cities. A decade later they had acquired the power to hold the earth itself hostage. These were devices expressly concocted to fulfil the wishes of Faustian man – the modernist usurper who is Spengler's hero and villain, a creature who glories in his own power by ordering the world to disembody itself. Elias Canetti pointed out in the 1960s that any fanatic – Saddam Hussein with his store of nerve gas is the most topical, followed by whoever buys the Soviet nuclear arsenal – could now outdo the plagues of retribution visited on infidel countries in the Old Testament: 'Man has stolen his own God.' We know what form an act of God takes in the twentieth century. It billows upwards in the shape of a malevolent mushroom.

The wars which have raged throughout our century, more or less without interruption, sum up the paradox of modern times: the connection between scientific progress and moral regression, between technology and cruelty. Machines were meant to project men into a future of ease and forbearance. Instead, at Verdun or on the Somme, at Auschwitz or above Hiroshima, they invented new ways of killing, and brought back the past at its most brutish.

Freud and Einstein, two of the century's sages, exchanged opinions in 1932 about this tragic flaw in civilization. Einstein, denying knowledge of 'the

dark places of human will and feeling', sought Freud's advice about controlling 'man's mental evolution' so as to repress 'the psychoses of hate and destructiveness'. Freud was prepared for the enquiry. In an essay written in 1915, he recalled a conversation with a poet he met during a summer holiday in 1913. The poet could not enjoy the scenery of the Dolomites, because he knew it would decay. Freud tried at the time to argue him out of his fatuous melancholy. Looking back, he recognized that the poet was right after all: 'A year later the war broke out and robbed the world of its beauties.' It ravaged the landscape, but even more damagingly assaulted our pride in the conquests of civilization and science, and 'let loose the evil spirits within us'. The barbarism of the great civilized nations demonstrated that 'the primitive mind' still slumbers in all of us, awaiting its opportunity to run riot. Freud, who refused to consider his work a branch of medicine, had no easy answers for Einstein.

His reply hinted at Einstein's naive lack of self-awareness in asking the question. How could war be cured if it catered to a need of human nature? And was not this abiding aggressiveness as much a part of Einstein's physics as of Freud's own science of mind? Freud pointed to the parallel between the colliding polarities of their thought: the psychic combat of Love and Hate, the physical law of attraction and repulsion. Bodies draw closer together, impelled by eroticism or by the earth's magnetic field. But they also struggle to preserve their autonomy, and will unthinkingly eliminate any object which trespasses in their terrain. Wary about graduating from psychology or physics to 'ethical judgements of good and evil', Freud admitted that a scientist might reject his theories as 'a kind of mythology'. Then, having tempted Einstein to make this disclaimer, he cunningly outwitted him: 'Cannot the same be said today of your own physics?' They were both myth-makers, and they made complementary myths. Each of them in his own way recognized that conflict is the very principle of existence.

Their grand modern fictions were invented out of nothing, like the world whose genesis they sought to imagine, and they concluded by envisaging a catastrophic return to nothing. Freud noted the class wars and murderous purges in Russia as a clinical symptom: Europe was waging war against itself, determined to destroy its own culture. Einstein, when he wrote to President Roosevelt in 1939 to warn that the Germans were requisitioning uranium from mines in Czechoslovakia, had conceived the possibility of an atomic bomb. Both of them, as concerned citizens and men of conscience, reacted against the amoralism of their own theories. Freud worried about the anarchy and irreverence of dreams, just as Einstein indignantly denied that God plays dice. But to analyse is to atomize, to break down; thinking is destructive.

At the end of his letter to Einstein, Freud dangerously entertained an unthinkable thought, which mocked earnest efforts to keep the peace. The civilizing process, he speculated, 'may perhaps be leading towards the extinction of the human race', because it inhibits sexuality. The dandies of the 1890s, despising the insipidity of nature, thought that living should be left to the servants. The

victory of intellect over instinct safeguards culture for a while, but in the long run it foredooms the race. Einstein's world-view was shadowed by entropy, the waste of vital heat which leads towards universal death. Freud here revealed his own equivalent: an enfeebling decadence, defined by Nietzsche in *Twilight of the Idols* as 'a symptom of *declining* life'. By 1933, after resettling in Princeton, Einstein found himself closer to Freud's point of view. In a letter he complained about the cheery conformism of American society. Was this the price to be paid for survival? 'The tragic irony', he said, 'is that the very quality which is the source of the unique charm and value of European civilization – that of the self-assertion of the individual and of the various nationality groups – may lead to discord and decay.' The choice was hard: between boring blandness and perpetual strife. As the Germans marched into Paris in 1940, Gertrude Stein reflected on the 'eternal fascination' of war, which turned life into the semblance of a novel. War, she thought, 'is a thing based on real life but invented, it is a dream made real'. For an artist, this is a dangerously thrilling proposition. She candidly admits that civilization, whether at war or not, nurtures a death-wish.

Certainly in 1918, when casualties were tallied, it seemed as if the human race had only just avoided extinction. A shell ripped through Apollinaire's helmet in 1916, and shrapnel penetrated his skull; they trepanned him. He died just before the armistice, having written *Les mamelles de Tirésias* in 1917. The play recalls his metaphysical despair at the front, on a night when he thought that the German guns had put out the stars, and it pleads with the French to learn the lesson of the war. A stage manager urges the public to rekindle those lights in the sky and to guard the fire of life on earth by making children. During the war Strauss and Hofmannsthal worked on their higher-minded biological parable *Die Frau ohne Schatten*, which the composer called a 'child of pain'; the opera, completed in 1917 but not performed until 1919, concludes with two married couples singing the praises of procreation, while a choir of importunate embryos begs for the right to be born. Despite these massed inducements to renew the world, *A Farewell to Arms* considers the sad reality of a single case. Frederick Henry's child is stillborn, and its mother dies of a haemorrhage. He leaves the hospital and walks away in the rain, unable to forgive the universe for its blunders.

The surreal buffoonery of *Les mamelles de Tirésias* makes up for the defects of nature: the play, according to the manager, snubs both time and space, and creates its own proper, private universe, where Thérèse's husband can reproduce with no help from her. Yet such a lucky escape from the apocalypse could happen only in a farce. Freud returned to the subject of our modern power over time and space in his essay on *Civilization and its Discontents*, published in 1930. Science in the twentieth century has indeed subdued the forces of nature. The surreal miracle cited by Freud is the telephone, which permits him to speak to a child living far away, or instantly reassures him that a friend has safely reached the end of a long journey. Yet do such benefits truly contribute to 'the economics of our happiness'?

Technology only pretends to reunite those whom it has already sundered: 'if there had been no railway to conquer distances, my child would never have left his native town and I should need no telephone to hear his voice'. Apollinaire in his biological anthem invokes the 'new fire' of sexual love, a torch which re-ignites the stars. Freud, however, understood the dangers of fire, so calamitously unleashed in the explosions painted by Meidner; it must be repressed, even though to do so contradicts our instincts. 'Primal man', Freud conjectured, liked \to put out fire by urinating on it. Flame is phallic, and it dared our ancestors to advertise their own potency. A wilier individual who renounced the urge could steal the fire, as Prometheus does in the legend, and use it for his own purposes: then civilization began. But beneath the insecure floor, the fantasy of arson still rages. Men will always enjoy setting fires, just as they will not be dissuaded from fighting battles. Love is no cure for war, as Apollinaire believed. War, in Freud's reckoning, generates its own erotic heat; sex and death are allies, not enemies.

Near the end of the interval between world wars, Walter Benjamin contributed another disturbing insight to this analysis of our belligerence. In 1936 his essay on 'The Work of Art in the Age of Mechanical Reproduction' reconsidered the direction in which technical progress was tending. A technological society, he argued, is always ready and eager for war. Why have these machines been invented? Certainly not to allow Freud the wistful pleasure of conversing with an absent child. Machines, so much smarter than we are, want to show off the energy they have in store; they delight in violence, which is their revenge on the humans who presume to harness them. We are defenceless because machines have conditioned us to regard ourselves as inferior versions of themselves. This is the baleful effect of those modern arts made possible by mechanical reproduction, photography and film. Benjamin claimed that 'mankind, which in Homer's time was an object of contemplation for the Olympian gods, now is one for itself. Its self-alienation has reached such a degree that it can experience its own destruction as an aesthetic pleasure of the first order.'

This looks far into the future – towards the end of the world as imagined by Hitler, who dreamed of watching skyscrapers melt when New York was bombed, and beyond this to the different apocalypse of Vietnam, where napalm spectacularly flayed the jungle and a Vietcong captive had his brains blown out on the television news; to Ronald Reagan's fantasy of ballistic fireworks among the stars, and then to the Gulf War, replayed on the news like a video game. Kaiser Wilhelm may not have wanted a war, even though he started one. Everyone else in 1914 did, and many of us, in some unreformed recess of ourselves, still do.

THE DNIEPER POWER STATION—A MAGNIFICIENT MONUMENT TO LENIN,
AN EMBODIMENT OF THE LENINIST ELECTRIFICATION SCHEME

THE BEGINNING OF THE
WORLD IN MOSCOW
AND PETROGRAD

A revolution is more than the abrupt overturning of a political regime; it attempts to reconstruct the world. Its boldest aim is the abolition of politics and the erasure of history. It dismisses the weary, cynical reliance on compromise and the conservative homage to precedent, placing its trust in a purgative destruction. All revolutions think millennially, and imitate the dramaturgy of the apocalypse.

Time stops when the first uprising occurs. The past officially ceases to exist. In Russia in 1913 Mayakovsky called for a secession which he called 'the great break-up': his violent, vengeful paraphrase of Nietzsche's great disengagement, the mental revolution which created the consciousness of modernity. Mayakovsky demanded that Pushkin, Tolstoy and Dostoevsky be thrown overboard from 'the ship of history'. The punishment, of course, was merely symbolic. The Nazis, more literal-minded, made funeral pyres for infidel books.

After this spasm of coerced forgetfulness, time can be permitted to start again, so long as it begins from year zero. Now it tabulates events according to a revised calendar. There are new anniversaries to celebrate, sacred moments when eternity intersects with time. Russia in the first years of the Revolution staged demotic festivals each October. In 1918 the painter Natan Altman redesigned the gaping square behind the Winter Palace in Petrograd (as St Petersburg was patriotically renamed during the war; its new identity lasted until 1924, when it became Leningrad). On three sides the perimeter was marked by architectural façades; Altman closed off the fourth side, which opens into Nevsky Prospect, with a screen of unseasonal, artificial trees, turning the celebration into a rite of spring. Nazi Germany had its seasonal rites, concentrated – as a pagan affront to Christianity, which placed the annunciation in mid-winter – during the summer. Hitler religiously attended the Wagner festival at Bayreuth, and Himmler commemorated the solstice in an alfresco temple of standing stones in the forest at Sachsenhain. Having abolished the recent past with its enlightened liberalism, they invented a primeval history to replace it. Hitler applauded the

savagery of Wagner's Siegfried, who keeps a bear as a pet and contributes to racial purity by gleefully slaughtering a dwarf. Himmler organized his own neolithic theatre, using slaves as scene-shifters: the thousands of boulders at Sachsenhain, which pretended to remember ancient Germany, were dragged into position in 1935.

To compute time, in the brave new world, becomes a heroic task. The Nazis took their seizure of power in 1933 to be the inauguration of a new millennium, and began tabulating the achievements of a Thousand Year Reich. During the same decade, Soviet economic policy organized time into a succession of Five Year Plans, pre-emptive assaults on the future. Such impatience is an apocalyptic symptom. Revolutions, which work by speeding up time, know they will arrive at an end prematurely. Theirs is a Faustian bargain with history: a period of racy exhilaration, followed by disintegration, when time will resume its slow, accustomed pace. Nazi chronology maintained a fatalistic countdown. The Reich would not last forever, only for a thousand years. Hitler rebuilt Berlin because he foresaw a time when the city would be in ruins, and he wanted the archaeological remains to look grandiose.

Amazed and increasingly alarmed, Boris Pasternak described revolutionary Russia as a society firing itself into the future. He called it 'our unprecedented and unbelievable state, rushing headlong towards the ages'. An analogy with space travel is legitimate: the Bolshevik Revolution was a mental adventure, attempting – as if with the aid of the propulsive force which freed Wells's explorers from gravity in *The First Men in the Moon* or *Things to Come* – to think beyond the limits of known reality. Nor was the American sympathizer John Reed exaggerating when he said that the ten days in October 1917 had shaken the world. A revolution works like an explosion, inducing a chaos which its scientific managers fancy they can control and direct. The 'great break-up' envisaged by Mayakovsky began as an aesthetic programme, attacking received notions of beauty. The Russian experiment went on to break up a society and its economy, then ventured to amend the country's landscape and even to rejig human nature.

Lenin declared that communism would be attained by combining the Soviet administrative system with electrification. He saw his industrial policies as a therapeutic shock: the electrocution of a feudally inert empire, to be carried out by councils of workers. Stalin promised to attend to the requisite psychological changes, and told Gorky that Bolsheviks must be 'engineers of souls'. That spiritual engineering was mostly performed by Stalin's henchmen in labour camps and in the torture-chambers of the Lubyanka prison in Moscow; and the ailing nuclear reactor at Chernobyl, which contaminated half a continent, is an apt monument to Lenin's faith in the dynamo. But should technical deficiencies, or the creed's eventual perversion in a police state, impugn the hopes of those first days? The Russian Revolution summed up the spirit of the twentieth century – in its reckless anticipation of the future and its belief that technology would deliver a perfect world; in its overreaching hubris and its tragic relapse to earth.

Before those days which shook the world, the Revolution rehearsed a cosmological convulsion.

In 1913, the musical play *Victory over the Sun* was staged at Luna Park in St Petersburg. The text, in a language made up for the occasion, was by Kruchenykh, the theorist of 'zaum'; Malevich did the designs. The promoters described it as a 'cubofuturist' work. Malevich's costumes excised the plump contours of the human body. The characters wore razory cubist triangles, painted in clashing tones – midnight black, fierce solar yellow – to suggest the collision of elemental energies invoked by the Italian futurists. The cubism of Cézanne was grounded, solid, which is why Rilke thought of his paintings as a safeguard for imperilled reality. Futurism, in Malevich's union of the two styles, ignited those cones and cylinders and hurled them into the sky – literally so, because the play concerned a planetary kidnapping, carried out by Strongmen of the Futurity who reach up and capture the sun, holding it prisoner.

One of Malevich's sets was a perspective box, like a window or a picture-frame, inside which a diagonal line separated two equal triangles of black and white: the blank moon and the coagulated void beyond it? the uniforms of two intergalactic armies? The box, whatever its precise meaning, was a device for telescoping the universe, bringing future time and remote space into view. Because of Kruchenykh's home-made language, no one who saw the play was quite sure whether a victory over the sun was meant to be good or bad. The futurist supermen imitate the rebellion of Prometheus, who stole divine fire for the benefit of mankind, but they also recall the fate of Icarus, whose waxen wings melted when he flew too near the sun: their victory causes a plane to crash. The play's contradictions can be forgiven, since it was allegorically interpreting events which did not occur until 1917. The sun, around which the earth rotates, is presumably the motor of revolution. The strongmen – like Canetti's terrorists impersonating God as they throw their bombs, or perhaps like Lenin with his worship of electricity – stage a metaphysical *putsch*. Taking command of historical development and revising the laws of physics, they harness the means of both production and destruction.

The poet Benedikt Livshits thought that Malevich's settings announced 'the Luciferan futility of the world'. Malevich cited the atomic theory as justification for his fragmented forms. 'All matter disintegrates', he pointed out. Revolution shatters the false order of external nature and lays bare a mob of jostling molecules. Why should it apologize for its destructiveness? Things can only be analysed if they are broken up, broken down, atomized. Lucifer, seen as the guardian angel of the proceedings by Livshits, was born of light: the brightest seraph and the first to fall, another symbol of fatal aspiration. Although serfs and wage-slaves may have hoped for material gains, what poets expected from the revolution was the thrill of annihilation. André Breton's surrealist colleagues disapproved when he became a member of the French Communist Party. Breton explained his motives: he joined up, he said, because the communists had vowed

to demolish all ancient buildings. That, for him, was enough for a political programme. In 1920 George Grosz and the collagist John Heartfield announced that 'the cleaning of a gun by a Red soldier is of greater significance than the entire metaphysical output of all the painters'. They were delighted by the thought of 'bullets whistling through the galleries and palaces', puncturing 'the masterpieces of Rubens'. The revolution's fellow-travelling visionaries welcomed the political movement as an epidemic of destruction, or an incitement to nihilism.

The director Vsevelod Meyerhold saw his theatre as an arena in which 'the new man' – that revolutionized being whom the early twentieth century tried so hard to engender – could demonstrate his freedom. In 1920 he proposed erecting an outdoor trapeze for acrobats whose bodies would 'express the very essence of our revolutionary theatre and remind us that we are enjoying the struggle we are engaged in'. The revolution's composers translated that struggle into a sonic bacchanal. Aleksandr Mosolov's orchestral fragment *Zavod* made music from the noise of industrialization in an iron-foundry: striding, stamping mechanical rhythms, with battered sheets of metal to announce the white-hot emergence of steel from the smelter, like a man-made sun. In 1929 Shostakovich accompanied Mayakovsky's play *The Bed-Bug* with some brassy, blaring marches puffed out by fire-brigade bands. *The Nose*, Shostakovich's opera based on Gogol's subversive farce about a misbehaving, ownerless organ, contained an interlude for percussion which traced music back to the childish, defiant pleasure in making noise as loudly and as antisocially as possible: rhythms are banged or battered out on drums, bells, rattles, cymbals, triangles – anything that can be beaten or shaken, clicked or clacked, any means of raising a joyous, impenitent alarm. His next opera, *Lady Macbeth of Mtsensk*, completed in 1932, treated the Shakespearean killers to music suitable for an anarchic comedy. It contains slapstick orchestral chases for the muddling police, and an uproarious instrumental transcription of sex which reaches its climax when the snorting horn deflates, losing its erection. To emancipate dissonance, for Shostakovich, was to unleash a riot.

Cacophony suited the ribald license of carnival, the revolutionary season extolled by the literary critic Mikhail Bakhtin, who found this mood of anarchy and ferment prefigured in the work of Rabelais. The commissar Lunacharsky, planning May Day demonstrations in 1920, recommended that the propagandist skits performed outdoors should be 'imbued with uncontrollable, uninhibited laughter', and the poet Aleksandr Blok thrilled to the tumult of revolution, arguing that 'the roaring noise is an expression of its sublimity'. This contagious frenzy was soon reined in. A party hack judged the brazen tumult of Shostakovich's score for *The Bed-Bug* incompatible with 'the development of our socialist society according to Marxist precepts'. After *Pravda* denounced *Lady Macbeth of Mtsensk* as pornography, Shostakovich wrote no more operas.

The poet Marina Tsvetayeva, remembering her dead colleague Max Voloshin in 1932, paid tribute to mysticism, not activism. Instead of 'political

convictions', Voloshin, she said, occupied himself with 'myth-making and, in the last years of his life and lyre, the creation of a world – the creating of the world anew'. Although Tsvetayeva sympathized with the White Russians, her elegy for Voloshin recalls the proper agenda of revolution in holy Russia, with its promise to re-create the world. Even Lunacharsky described the first social disturbances as a 'divine dance', a lava-like eruption of purifying violence. Stalin took care to eliminate such inordinate dreamers. The secret police murdered Meyerhold. Driven into exile, impoverished and desperate, Tsvetayeva hanged herself. Shostakovich stayed alive, but in a state of permanent nervous collapse. Their crimes? They remembered that revolution in the beginning – or before the beginning, at the time of *Victory over the Sun* – had jubilantly freed men from the dictatorship of reality. Reaching up, you could pluck down the sun.

The same cosmic upheaval, concluding in another victory of the sun and a new revolutionary dawn, was choreographed by Sergei Prokofiev in his ballet *Ala et Lolly*. When Diaghilev rejected the score, Prokofiev reworked it in his *Scythian Suite*, performed in 1916 in Petrograd. Primeval Russian myths here allude to the travails of contemporary politics. Ala, the daughter of Veless the sun god, is to be abducted by his nocturnal enemy Tchoujbog. Lolly rescues her, and the sun routs the demons. Although these are characters dredged up from the Scythian past, Prokofiev composed for them a music of the Bolshevik future. Astral events are described with mechanically propulsive rhythms, poundingly regular and indefatigable: the universe is a factory, the sun its self-vitalizing dynamo, and the revolution intended to harness this creative force.

The sequel to these preliminary assaults on outer space came in Mayakovsky's *Mystery-Bouffe*, written to commemorate the first anniversary of the Bolshevik take-over. The hyphen in the title splices together a medieval mystery play and an opera buffa, solemn biblical lore and irreverent satire. The revolution brings about a deluge like Noah's flood, which spares the unclean proletarians. Evacuated in the ark, they are visited by Christ: Mayakovsky played the role himself in Meyerhold's production. The saviour strolls across frothing water in the vicinity of Ararat and updates the sermon he once delivered on another mount. Now, instead of counselling meekness and the patient expectation of heaven, he goads his grubby followers to reward themselves on earth. They promptly maraud through the underground dungeons, which religion invented in order to frighten men into piety. Hell's boiling cauldrons do not dismay them, since they spend their working lives among industrial furnaces. They thrust their way into heaven, where cowering angels milk the clouds and feed them an insubstantial meal. The proletarians decide that they prefer Petrograd to this dreary idyll, but before leaving they grab God's thunderbolts, now deployed in the Russian campaign of electrification. They tramp back to their commune with its fuming chimneys and bountiful crops: this is their kingdom come, an earth 'washed by revolution and dried in the heat of new suns'. They plait sunbeams into dazzling brooms with which they clear away the debris of

history, and they pave their streets with stars. Mayakovsky spoke of himself as 'a cloud in trousers', a volatile spirit materializing on level ground: mystery clad in buffoonery. His definition also hinted at the messianic promise of communism, which planned to regain paradise within five years and fuelled the effort by nationalizing the sun.

After this solar revolution, there were subterranean convulsions to organize. Ancestral Russia was docilely content to cultivate the earth's surface; the new industrial economy hauled up riches from beneath it. The sickle was supplanted by the hammer, or by the electric drill. In 1923 Mayakovsky wrote an ode saluting the workers who extracted the first ore at Kursk. Famished industry, Mayakovsky said, cries out for sustenance: 'Where are the rails?' Communism could not be constructed without iron. But the world's deposits – quitting Pennsylvania, seceding from Norway, disowning the Germans and the French – have porously made their way to the Ukraine, where they wait like bottled genies to be set free by the local workers. Each straining toiler deserves a monument; the poem is a collective tribute, assuring the miners of Kursk that tractors in the future will rumblingly voice their praises, and their names will be written across the horizon by the smoke from factory chimneys.

Mayakovsky's epic of engineering allies creativity with industrial productivity. At the end of the poem he defers to the tractor as a louder and more diligent cheer-leader, an 'electrolecturer'. *The General Line*, the film about collective farming which Eisenstein completed in 1929, concludes with an exuberant, effortless athletic display by tractors. First the peasant Marfa, a pioneer of industrial agriculture, yokes all the antiquated, creaking farm carts to a single tractor and takes them on a joy ride over bumpy terrain where horses could never have plodded. Then the farm acquires a battalion of tractors which team up to plough a circular furrow, whirling around the field in a silent waltz. 'Two, ten, a hundred tractors!' Eisenstein enthused. 'What are all the Songs of Roland compared with this epic inspiration?' Roland the knight relied on his horse for the accomplishment of chivalric deeds; the commune performs its miracles with the aid of mechanized horsepower.

Political doctrine and economic duty obliged artists in the new society to reconsider their purposes and methods; both Mayakovsky and Eisenstein had discovered the lyricism of the machine. In Shostakovich's Second Symphony, first performed in 1927, a shrill factory whistle rallied the chorus to an anthem celebrating Lenin and labour. If tractors could utter onomatopoeic lectures or perform laps of honour, sirens should be permitted to sing. Steam-heating pipes in Moscow hooted out a birthday greeting on the Revolution's sixth anniversary in 1923. The regime approved of ballet because dancers were muscular workers, industriously trained according to the Soviet discipline of biomechanics. Prokofiev in *The Stone Flower* – his last ballet, posthumously staged in 1954 – composed a mineralogical saga set in the Urals. The stone cutter Danila, identified in the orchestra by a chiming hammer, searches for rock to carve. The guardian

goddess of the Copper Mountain, sternly costumed in malachite, spirits him away and petrifies him so that he cannot reclaim his humanity. But the anguish of his young bride causes his exoskeleton of stone to melt, and the sorcery is defeated. A sweetly romantic outcome, but also an ideological blessing: human will has subdued obdurate nature and expropriated its buried treasure.

In 1930 Margaret Bourke-White visited the Soviet Union to document the programme of industrialization. She photographed a Moscow textile factory, a steel mill at Stalingrad, the hydroelectric dam at Dnieperstroi, and the canal connecting the Ukraine with the Black Sea ports. Her photographs extolled the heroism of these grand constructive feats. In a tractor factory she recruited a young worker in a peasant's smock and knee boots, with tousled fair hair and a handsome scowl, and posed him leaning against the new, gleaming, riveted wheels. The engineer in her photograph personifies the engine, storing all its latent force in his body. A half-finished bridge at Dnieperstroi is a valiant mental proposition, its span – which still juts over empty space – determined to refute the burdensome law of gravity. Locomotive cranes swinging through the air are ladders up which men clamber to the heaven despoiled of secrets in Mayakovsky's *Mystery-Bouffe*. Braced and buttressed to withstand floods, the dam is a rebuke to the intemperance and wastefulness of nature. Bourke-White herself, climbing on scaffolds at the dam or negotiating cross-beams above the inferno in the steel works, exhibited her own daredevil courage in overcoming the technical difficulties of the assignment.

What Bourke-White called 'the new industrial spirit' seemed to her truly spiritual, a cult. She saw the Russians as 'religious fanatics worshipping before a new shrine', and photographed them at their devotions. A woman kneels before a pile of cement bricks, her rude personal altar. A textile worker bends over her bobbins, watching as the threads web the air into tight, tense bridges – a light-weight female equivalent to the roads driven across turbulent rivers at Dnieperstroi. Bolting down a generator shell or assembling a turbine, men are preparing tabernacles for a god they themselves have created.

Writing about her tour, Bourke-White drew, as Blok had done, on the rhetoric of literary sublimity. She marvelled at the five thousand metres of concrete daily poured at Dnieperstroi, or rhapsodized over torrents which would be made to discharge an electric current. These were the high mountains and stormy, surging oceans of a modern romantic, who is delighted to be diminished by the gigantism of the universe. But her excited metaphors warned of a new and dismaying stage in the Revolution's development. On the scaffolding above the dam, she looked down on 'figures like gnats raising structural work...and always on the horizon the ceaseless motion of cranes weaving restlessly back and forth like antennae of beetle hordes marching upon their prey'. Men as expendable insects, machines as predators: Bourke-White had adopted the despot's-eye view. Slave labourers built those dams and canals; the agricultural reforms of the 1930s were carried through with no pause to count the millions of lost

human lives. The Strongman of the Futurity, when he finally loomed into view, was Stalin. The radiant, rejoicing commune in *Mystery-Bouffe* or the rebuilt Kiev of *The General Line*, a playground of flimsy Meccano, are unveiled as promised lands which are ours for the wishing. But to reconstruct the world required copious slaughter, and the future turned out to be a lumbering totalitarian state, whose only efficient enterprise was that run by the KGB.

Arriving in Moscow from Berlin in 1926, Walter Benjamin commented on the absence of cafés. On his first trip to Russia in 1928, the architect Le Corbusier also noted the lack of an amenity which Parisians relied on. 'There are no cafés in Moscow', he said. 'Impossible to get a drink.' It was a warning sign: it served notice that all available space in the city had been apportioned according to a political theory which did not allow for idling and the observation of passers-by, those refined pleasures of the *flâneur* refreshing himself at a café table in Berlin or Paris. As Le Corbusier added, perhaps with a shiver, 'The people take things seriously'. In Moscow no one was permitted, like the customers of the Café Nihilismus in Vienna, to spend time in the contemplation of emptiness and atomic disconnection. Le Corbusier came to Moscow to work on his design for Centrosoyuz, the head office of the consumer co-operatives. The commission itself should have explained to him the absence of cafés. Random conviviality – or the refined and alienated pleasure of solitude, enjoyed by Polgar in his Viennese café – had been replaced by co-ordinated effort. The Soviet political economy had altered the relationship between public and private realms.

In the West, houses were castles, resorts of impregnable individuality, strong-boxes like the mind. Outside them was an area of chance and lawlessness: the streets, used only for swift transit between one domestic refuge and another. The bourgeois home was sanctified by its soothing décor and its accumulation of keepsakes, set in opposition to the bleak, unloved utility of the workplace. Russia reversed these priorities. The private realm contracted to a niggardly minimum. The law allowed each citizen, as Benjamin pointed out, a mere fifteen square metres of living space. The home, no longer a family's exclusive domain, was collectivized. Constructivist social reformers, legislating against individuality, even proposed doing away with separate rooms. Children were separated from their parents, herded together and sorted out by age; the communal area

A factory crèche in the 1930s: 'children enjoy salt-water bath

was subdivided into zones given over to nutrition, sanitation, and sexual activity. Visiting flats which housed eight or more families, Benjamin had the sensation of stepping into a small town, or sometimes an army camp, with residents bivouacking in the hall. He did not necessarily disapprove of this experiment in eroding the nucleus of social and emotional life. He liked the bare walls, stripped of the trophies shown off in Western parlours, and considered the weekly habit of rearranging the few sticks of furniture which remained to be good mental housekeeping – a reminder of our temporariness; also 'a radical means of expelling "cosiness"', along with the morbid sentimentality which pervaded the bourgeois interior. Soviet citizens did their living at work, and came home only to sleep. In this dispensation they had no time for dilettantish relaxation, nor any space set apart for it. 'Free trade and the free intellect have been abolished', Benjamin remarked, accepting without regret that if you wanted to be rid of *laissez-faire* economics you must resign yourself to mental regimentation. 'The cafés are therefore deprived of their public.'

When their factories or offices closed, people went to workers' clubs, which organized their leisure. Le Corbusier described a typical example, containing a gymnasium, a library and a cinema: facilities for both physical and intellectual recreation, to be used in the compulsory company of one's fellows. Bourke-White photographed the entrance to a Moscow workers' club, with two members posed on the spiralling staircase. A young man is on his way up; on the landing is a grizzled, bearded elder on his way down. The photograph is another heroic allegory of the new world. The young man does not bumptiously bustle past the old one like a competitive Westerner. He pauses on his step, and lowers his head in respect. The old man raises one of his hands in a blessing which is comradely, not priestly. The club is a secular church; its stairs lead not to heaven but into the equally blissful economic future.

The same strict reorganization of society inevitably threatened the churches, since prayer is the ultimate withdrawal from communal engagement, a wishful preparation for death. Mayakovsky, temporizing in his *Mystery-Bouffe*, tried to preserve Christ by converting him to socialism and identifying him only as 'an ordinary man'. Blok in his poem 'The Twelve', written during the first revolutionary winter, placed a bloody banner in Christ's hand and set him at the head of the victorious Red Army. These new allegiances did not protect him for long, and Christ became an official enemy of the people. The Soviet regime tore down more than fifty thousand churches. Such iconoclasm could be considered avant-garde politics. In 1930 André Breton remarked that 'modern poetry is essentially atheist', explaining that its single sacred task was 'to dechristianize the world'. Stalin and Khrushchev carried out this modernist purge with a vengeance.

Throughout the revolutionary decades there were periodic plans to demolish St Basil's Cathedral, whose nine multicoloured domes – pineapples, mushrooms, big tops, purple turbans – anomalously sprout below the Kremlin.

On his way to an interview with Lenin in 1920, H.G. Wells noted without regret that the 'absurd cathedral of St Basil' had been damaged during street fighting, just as George Orwell later lamented that the Spanish republicans did not manage to blow up Gaudí's Sagrada Familia in Barcelona. Walter Benjamin was pleased to find that at least the inside of St Basil's had been 'not just emptied but eviscerated like a shot deer'. A nasty metaphor: junking the icons of an alternative religion is equated with scraping out offal. Stalin, irritated that the cathedral blocked the traffic of tanks and missiles which trundled into Red Square on May Day, proposed replacing it with a pantheon in honour of Bolshevik heroes. The cathedral was saved when an architect chained himself to its fence in protest, before being transferred around the corner to the Lubyanka. Finally Red Square obtained its own legitimate place of worship: the squat mausoleum in whose basement pilgrims once filed past the carrot-coloured corpse of Lenin. The Church of Christ the Saviour, a white chimera which occupied a peak on the other side of the Kremlin, was not reprieved. Stalin condemned it in 1931. Demolition proved difficult: the sturdy walls withstood all battering rams, and had to be dynamited. It was to be replaced by an elephantine Palace of Soviets, never completed because the bedrock could not support a skyscraper. The shell was stripped of its steel in 1941 to make armaments. A hole in the ground remained, put to use as an open-air swimming pool. Revolutions proceed in cycles or repetitious circles. When communism fell apart, Leningrad went back to its baptismal name of St Petersburg, no longer embarrassed to be commemorating a Tsar and a saint; and on its reconsecrated hilltop the Church of Christ the Saviour is currently being rebuilt.

Le Corbusier, asked to advise on a civic plan for Moscow, recommended the wholesale demolition of the straggling, villagey conurbation, sparing only the Kremlin, Red Square and the Bolshoi. Revolutions demand clean slates, empty spaces. But the streets, once cleared of their obstructive history, could not be abandoned to contingency, so avidly pursued by the Western *flâneur* who has nowhere to go and nothing to do. By contrast with the mute, secretive façades built by Adolf Loos in Vienna, walls were papered with slogans, and posters delivered lectures. Sometimes the walls acquired weapons as well as hectoring voices. In 1926, when *The Battleship Potemkin* was shown at the Metropole cinema in Moscow, a mock-up of the rebel ship was fitted onto the side of the Metropole Hotel. Masts with victorious pennants obscured the florally ornate Art Nouveau building; from a turret, the ship's guns poked out above the pavement. Mayakovsky famously claimed that for revolutionary artists 'the streets are our brushes, the squares our palettes'. In 1933 the designers Vladimir and Georgii Stenberg painted Red Square red with billowing fabric and floodlights. At last it earned its name. Beauty and redness are synonymous in Old Slavonic, and the square was called 'krasny' because it was beautiful, not on account of its colour. The decorative scheme of the Stenbergs brought the etymology into line with the chromatic preferences of the regime.

In a totalitarian society, every act is political. Reality qualifies as art, and the street is a theatre: hence the Soviet fondness for popular festivities. Hordes of flag-waving workers in 1920 re-enacted the invasion of the Winter Palace. During the 1930s participation was discouraged. The mob, bullied into acquiescence, stood behind barricades in Red Square on Sports Day to watch athletes exhibit a physical elation and flexibility which were no longer – as in the heyday of Meyerhold's trapeze – available to all. Later still, the free-for-all carnival described by Bakhtin was militarized. On May Day Stalin and his successors stood on Lenin's grave to review goose-stepping troops.

The theory of how a new society should be run at first idealistically challenged reality and then, during Stalin's enforced collectivization, stamped it out. Revolution entailed the shattering of all customary forms. In a 1922 constructivist manifesto Alexei Gan described the aim of both architecture and social engineering, which was 'to find the communist expression of material structures'. The dialectic strained human nature, and severely tested the laws of physics. Erich Mendelsohn, who made several trips to Russia in 1925–6, noted the impracticality of Soviet building projects, more concerned with doctrinal correctness than with stability. One such folly was an unbuildable design by Ivan Leonidov for the Lenin Institute in Moscow: a balloon beside a slim, teetering chimney. The sphere was a global auditorium, meant to maintain its balance while holding four thousand people. The pillar symbolized a stack of books, rising high enough to accommodate a library of twelve million volumes. Both structures – as if at risk of gliding into space, despite their groaning weight – were fastened to the ground with mooring ropes. Mendelsohn contrasted this dotty amateurism with the more superficial whimsies of American architecture, setting Leonidov's project against a Gothic warehouse in Los Angeles with a shrubbery of radio antennae on its roof. American architects raised the structure first and added the technological symbols afterwards, like the lightning bolts which crackled on top of the RCA Victor Building in New York. In Russia, as Mendelsohn put it, 'technique is primary, the building itself only a secondary attribute'.

Perhaps the utopian notion of society as an engine, all its parts happily cooperating, was best realized in the theatre. Constructivist set-designers specialized in scale models of communities or cities, guaranteed not to break down before the end of the performance. Lyubov Popova designed *The Magnanimous Cuckold* in 1922 for Meyerhold's company. Fernand Crommelynck's play is about a pathologically jealous husband who tests his wife's fidelity by offering her to his friends, goading her to confirm his suspicions. In revolutionary Russia, which had dispensed with privacy and the sexual monopoly of bourgeois marriage, Crommelynck's maniacal hero seemed genuinely magnanimous, donating his wife to the common good. The farce was now a fable about social lubrication. Popova illustrated this new and unexpected moral in a kinetic set which represented a windmill in cross-section, with grinding wheels and revolving sails, steep

ladders, pulleys and delivery chutes: it made visible the motor of desire, but also displayed the economy in farcically furious, hyperefficient action. Actors scrambled over the bare frame, scampered along catwalks and slid down ramps, exemplifying the socialist transformation of work into fun.

Meyerhold, in a lecture on biomechanics during the run of the production, claimed to have reconciled theatrical technique and 'the industrial situation'. In Russia, by contrast with the sweated, slave-driving toil of capitalism, 'labour is no longer regarded as a curse but as a joyful, vital necessity'. What difference was there, after all, between acting and factory work, between games in Popova's constructivist playground and milling flour to feed the masses? The question had better remain rhetorical. Meanwhile in 1923 Aleksandr Vesnin built an even more spectacular set for *The Man Who Was Thursday*, adapted from Chesterton's novel by the Kamerny Theatre in Moscow. Popova's gymnasium of scaffolding here became a labyrinth, a tiered and treacherous metropolitan prison. Onto the stage Vesnin crammed lift-shafts and escalators, cranes and derricks. Advertisements perambulated through the streets on sandwich-boards, or rotated in the sky. Chesterton's anarchists no longer pursued God; in this version they aimed their bombs at top-hatted capitalists, seeking to liberate the downcast, trudging workers who could be seen thanklessly operating the gadgetry. On occasion this futuristic scenery made its way out of the stage door, to be set up in the streets as a prototype for the city. In 1932 a monstrous ball-bearing, inscribed with political slogans, was positioned in a park opposite the Bolshoi. In photographs of the display, the dwarfed theatre – with Apollo in his chariot driving a team of horses above the portico – was framed inside the ball bearing: a confrontation between mythology and engineering, the god and the machine.

Despite such menacing challenges, Moscow remained its unreconstructed self during the Revolution's first decade. Le Corbusier, with his abstract fondness for rectangles, joked that its layout derived from donkey tracks. Benjamin considered its atmosphere Asiatic, dominated by the cluster of cathedrals within the walled seclusion of the Kremlin, or perhaps – apart from the snow and ice – chaotically Mediterranean. By contrast with the empty, melancholy thoroughfares of Berlin, Moscow streets (and, even more so, Moscow buses) were a hubbub of amiable pushing and shoving. Trade, as in Naples, was carried on in the open air. Grandmothers selling food, clothes and knick-knacks spread the contents of their apartments over the pavement. Seventy years later they are still there, though more dispirited and with fewer wares. Nowadays they hold up a bunch of withered carrots, a bruised banana or a darned cardigan; sometimes they augment their pensions by peddling prescription drugs. Benjamin's analogy with the south is confirmed, at the end of the century, by the Moldavian gypsies who beg in underpasses, pinching their fair-haired babies – kidnapped, the Russians believe – to make them cry.

Stalin made Moscow conform to the spatial edicts of totalitarianism. The public arena was no longer a place of spontaneous convergence and solidarity, as

it had been during the first revolutionary festivals. Outdoors, you were kept under observation. Stalin encircled Moscow with a ring of baleful Gothic sky-scrapers, more or less interchangeable: hotels with horns, office blocks with antlers. Wherever you stood in this teeming panopticon, one of these watch-towers – the Foreign Ministry, the Leningrad Hotel, the University on Lenin Hills – had you in its sights. Other buildings served to embody the overbearing massiveness of the state. The Moscow Hotel, for instance, completed in 1936 just below the Kremlin, looks like a platoon of bulbous muscle-men standing on one another's shoulders. Stalin, it is said, absent-mindedly approved two alternative designs for the façade. The architect, not daring to point out the mistake, built both, one on top of the other. The wandering paths of Le Corbusier's donkeys gave way to boulevards so wide you could scarcely see across them, with fast lanes reserved for the cars of political functionaries; to discourage *flânerie*, you could only cross these empty avenues every few blocks, and had to do so through pedestrian tunnels. Everywhere you followed disciplinary marks on the ground. In Red Square the troops still do as they were once told and erect barricades around Lenin's tomb, to control the queuing of crowds which no longer come.

The domain of privacy contracted even further. Walls, having acquired voices from the political posters glued to them, now grew ears. Personal conver-sations were confined to the bathroom, after all the taps had been turned on. Home offered no protection. Citizens of whom the regime disapproved slept uneasily, expecting a midnight knock on the door. The music of Shostakovich characterized the epidemic of dread in this terrorized society: the hysterical whirlwind of the scherzo in his Tenth Symphony, or the miasma of rumour and suspicion which stealthily thickens in his setting of Yevgeny Yevtushenko's poem 'Fears' in his Thirteenth Symphony, *Babi-Yar*.

The sinister consummation of Stalin's urban vision lay underground, in the resplendent catacomb of the Moscow Metro, gradually opened after 1935. Far below the earth, escalators as deep as mine-shafts admitted you to halls of red granite and majolica, of polychrome glass and gem-crusted mosaics, lit by chandeliers. The station at Komsomol Square is a pavilion of rococo marzipan, Culture Park pretends to be a Greek temple, and Metro Mayakovskaya com-memorates the poet in an Art Deco arcade of sleek dove-grey lavatorial marble and stainless steel. Russia reversed the invidious Western contrast between private affluence and public squalor. Here, although homes may have been like cattle-pens fragrant with the smell of boiled cabbage, the railway stations resembled museums. These were palaces for the people – who were, however, not permitted to live in them, only to pass through at speed.

Many stations, like the one at the Arbat, were built on the sites of demol-ished churches, and the excavations seemed to delve into gloomy crypts. The sta-tion at Revolution Square, between the Kremlin and the Bolshoi, is especially funereal, with bronze statues bowed beneath the weight of the arches like Michelangelo's mournful sculptures on the Medici tombs in Florence. These

crouched figures, who clutch guard-dogs or shoulder rifles, are engaged in defending the fatherland; the concourse of another station is protected by the glowering partisans who expelled the Nazis from Byelorussia in 1944. Recessive and cavernous, the Metro was planned for secondary duty as a network of air raid shelters: a bunker, or perhaps a burial chamber, for the entire city. The refugees could gaze up at an alternative sky. At Mayakovskaya, lunettes in the vault showed fighter planes soaring above the Kremlin and parachutists free-falling; on the ceiling of the tunnels in the station at Novokuznetskaya, golden Soviet girls and boys ran races, picked fruit, twined wreaths and generally relished life in a socialist Eden.

One of the oddest, maddest relics of Soviet decoration is a linen oblong from the 1930s which celebrates the Metro in a crazy quilt of red stitching. The station picked out by the needle consists of columns alternately patterned with squares and zigzags, arranged in a drastically foreshortened perspective which hurtles you towards its vanishing point on an express train. Above the arches and the latticed pediment is clamped the initial M, magnetized to the roof by two flat, heavy cross-bars like the feet of a robot. Red snakes undulate around flagpoles. The border is like a barbed-wire fence of red lozenges. This piece of cloth was intended for use as a pillowcase. Ideology, not content with regulating social and economic life, stretched upwards to disestablish heaven. Then, in the building of the Metro, it invaded the innards of the earth. Not even sleep, if you laid your head down on this politicized pillowslip, guaranteed you a brief immunity. Totalitarianism is about the ubiquity of politics, the omnipresence of power; it works by directing your dreams.

Pledged to create a new man, communism reformed human nature and even tinkered with physiology. Among the faulty mechanisms which the constructivists set out to reconstruct was the human body. Meyerhold's system of biomechanical training adapted the time-saving exercises of the American factory to the theatre, insisting that ballet dancers and labourers in a foundry both needed to possess rhythm and to understand the laws of balance. Toil could be equated with play, and sport was the continuation of work by other means.

Aleksandr Rodchenko sketched some experimental models of the new body – a weight-lifting champion in 1919 for instance, whose physique is formed of the same adamantine substance as his bar-bells. His bent head and swollen muscles, the joints of his hips and the sockets of his buckling knees all duplicate the black, solid balls of iron he is lifting. Rodchenko's athlete is no narcissist, like a stockbroker at the gym in the 1980s striving to achieve a purely personal best. He is preparing his body for its role as a constructor. The biomechanical miming of Meyerhold developed into a cult of robotics. Some advertisements for state enterprises designed by Rodchenko in 1924 and 1925 replaced the outmoded body with a cybernaut. One of these mutants sells watches, and like a time-and-motion expert recommends the virtue of punctuality. He has stopwatches

biomechanical work-out, drawn by V.V. Lutse in 1922

instead of hands, and a clock where his head should be. Another dial, presumably with an alarm which sounds at mealtimes, ticks in his stomach. In a poster for the state publications office, Gosizdat, Rodchenko built a body out of books. Its backbone is a stitched spine, and its upraised hands are two more volumes, generously hurled into the air. Meyerhold's actors wore overalls, not fancy dress, and Varvara Stepanova designed a similar uniform for Rodchenko, leather-lined at stress points, with so many square pockets for pens and slide rules and spectacles and note pads that he resembled a filing cabinet on legs.

Tsvetayeva identified Mayakovsky as the new man in person, 'the first man of a new world, the *first of those to come*', and Rodchenko's photographic portraits in 1924 made him an icon of Bolshevism. His head is shaven, as belligerent as a fist, warning of his disdain for aesthetes with long hair. He glares at the camera with unfeigned menace: he saw himself, he once said, as a literary boxer, and Tsvetayeva called him a gladiator. Leaning forward on his chair, he seems to be straddling the seat of a motorcycle, the snorting, bellicose chariot which will carry him into the future. His jacket pocket contains his pens, the tools of his trade. In one of his poems he declares 'I feel Soviet / like a factory'. The cigarette which juts from his lip or smoulders in his hand is his personal factory chimney, fuel for his creative engine. 'This face', as Tsvetayeva commented, 'is the very imprint of the proletariat'; it should have been used on money or postage stamps. Rodchenko universalized it, as if it were indeed a face on every banknote in circulation. In his photomontages for the autobiographical poem *For This*, Mayakovsky balances on the girders of a bridge or prepares to glide off the dome of a cathedral; in a design for the cover of *A Conversation with the Agent of the Masses about Poetry* – a collection of correspondence between Mayakovsky the literary worker and a tax inspector – his cranium bubbles out into the globe with all its continents on show, orbited by buzzing planes which stand for his aerodynamic thoughts. It is not surprising that Tsvetayeva likened 'the physics of Mayakovsky's poems' to 'the face of Sunday in *The Man Who Was Thursday* – too large to be thought'. Chesterton's unimaginable Sunday, as she knew, is God. A book cover by the designer Kamensky, for a biography published in 1931 after Mayakovsky's death, tattoos the numerals 1917 on his skull, and gives him one far-seeing eye which burns red like a beacon. The sculptor Chaikov carved that same ferocious head from a boulder of black granite in 1940. The man whom

Tsvetayeva called 'a live monument' was by now the very stuff of which mountains are made.

The new man saw himself as a new kind of artist. In a society which disallowed private property, Mayakovsky could no longer insist on the solitude and exclusiveness of his genius, as the romantic poets did. When he published *Mystery-Bouffe*, he invited readers and performers to alter and improve the text as they saw fit, making it a genuinely collective creation. He claimed that the brawling slang of his diction had given civil rights to the rugged language of the streets: it was as if he had freed the serfs all over again. His essay 'How Are Verses to be Made?' applied the ideology of constructivism to poetry, and demonstrated that the business of 'word-manufacturing' required no flighty visits from the muse. A poem is not prompted from within, nurtured by dreams; it exists in response to a social demand – in Mayakovsky's case, the need of the proletariat to be exhorted, directed, sometimes congratulated: 'On the march, about turn!' The poet is an artisan who contributes in his own way to the building of a new society. Mayakovsky called rhyme a species of cement which binds lines together, and likened rhythm, 'the basic force and the basic energy of poetry', to electricity, the voltage on which Lenin relied to construct communism. As an industrial chore, poetry depends on the supply of raw materials and the proper tools. Mayakovsky therefore spelled out the equipment needed for his productive task: those pens and pencils which bristle in his pocket in the Rodchenko portraits, a desk with a typewriter on it, a room large enough for pacing in, and a bicycle outside the door for visits to the editorial office. He also required a pipe and cigarettes, because the brain like any other furnace needs to be stoked with fuel. His cheeky humour, however, hinted at a likely breach with this stern gospel. He recommended that the poet's kit should include 'a suit for visiting the doss-house' and 'an umbrella for writing in the rain'. Perhaps the artist is more at home on the social margins.

Mayakovsky's poetry inclined, he said, to 'the shout instead of the lilt, the thunder of the drum instead of the lullaby'. His predecessors chased phantasmal symbols; he was more concerned with compressed, peremptory slogans, which could be chanted by crowds of protesters:

> Eat your pineapples,
> Gobble your grouse,
> It's all up with you, bourgeois louse!

Being, as Tsvetayeva said, 'the world's first ever poet of the masses', Mayakovsky spoke to and on behalf of multitudes. One poem, entitled '150,000,000', convened the entire population of the Soviet Union as its potential audience. Whenever he could, he declaimed his verses to the crowds, copying the attitudes of Lenin outside the Finland Station (though without an armoured car for a rostrum). Visiting revolutionary Mexico in 1925, he was taken to a rowdy banquet by Diego Rivera. His hosts fell into an ideological squabble, which they conducted with fists, chairs, broken bottles and pistols. Mayakovsky silenced the

affray by calling for attention and reciting his poem 'Left'. Orpheus, as Rivera remarked, had once more soothed the insurgent beasts.

This was poetry as a public-address system, not a pining monologue. In 1925, in one of Rodchenko's posters for Gosizdat, a female worker wearing a head-scarf opens her mouth, showing off a semicircle of impeccable

Aleksandr Rodchenko's poster for the state publishing house

Soviet teeth. She smiles as widely as she can, cups her hand to funnel the sound, and screeches 'BOOKS'. The cry explodes from her lips in strident capitals, red on black, shaped like a megaphone. Print no longer silences a writer's voice, making him plaintively mime to readers he will never meet; here publication proceeds by word of mouth. Anton Lavinsky's poster for *The Battleship Potemkin* converted the megaphone into a gun barrel. The ship's guns zoom off the flat surface, broadcasting news of the naval mutiny. Between them Lavinsky placed a sailor, who like Rodchenko's woman raises his hand to form an acoustic trumpet and purses his lips, as if to release a deafening whistle which we cannot hear. Eisenstein's film may be silent, but its shouted prophecy resounds through the world. The constructivist El Lissitzky applauded the poster as a new Soviet art form, which had overcome the lonely introversion of the book. Single pages escaped from their compressed, crowded prison of bindings; enlarged a hundred times, they could be pasted on the walls. In revolutionary Russia, journalism recovered its voice. Bands of actors, known as living newspapers, toured the country reciting headlines and acting out current events out for the benefit of the illiterate.

In Western cities, as the sociologist Georg Simmel pointed out at the beginning of the century, the *flâneur* was an inveterate window-shopper. He flirted with the stimuli of commercial displays, browsing but seldom buying. The Soviet citizen was allowed no such dilettantish leisure. Every poster pointed an admonishing finger and roared a command. Mayakovsky, who thought up catch-phrases about hygiene at work and happily undertook commissions for advertising jingles, believed that the writer's task included 'calling people to obey slogans'. The state department store Mosselprom even painted his commendations and inducements across its brick frontage. With a mastery of the double standard which a copywriter on Madison Avenue might envy, Mayakovsky composed slogans for placards about the dangers of smoking – a house incinerated by a stray pipe, a worker who concentrates on breathing out smoke rings and

damages his electric drill – while also singing the praises of the national brand:

Chevronets cigarettes are good for taste
Strong as our exchange rate
Nowhere else but at Mosselprom!

Bolshevism ironically pioneered the art of hidden persuasion, that siren song of consumer capitalism, just as, in its scientific approach to propaganda, it first understood the insidious power of publicity. In 1919 the Third International, or Comintern, was founded, charged with promoting communist dogma outside Russia. A newspaper kiosk designed by Rodchenko illustrated the work of propagation: the box selling papers sprouted upper tiers, with a cantilevered deck for orators, a rigging of flags and banners, and masts like antennae. Vladimir Tatlin's projected tower, meant to be erected on the Field of Mars in Petrograd as a monument to the Third International, equipped the humble kiosk both to commandeer the air and encircle the earth. The tower was to consist of three vertically stacked chambers: a cube to house the legislature, a pyramid for executive offices, and a cylinder containing a bureau of information and propaganda. All levels would rotate, though at different speeds: revolution expects that everything should revolve. The cube was meant to turn once a year, as steady and implacable as the great globe itself; the pyramid had only a month to complete its circuit, while the cylinder, giddily elated, would wheel round on its axis every day. An elevator would have sped a third of a mile to the summit, where telegraph posts and a radio station were set to electrify and indoctrinate the sky. (Later a battery of electronic eyes and ears for espionage would surely have been added.) Tatlin's decision that propaganda should have its headquarters in that whirligig penthouse revealed the aspirations of the new state, committed to promulgating a universal faith. The tower failed to get off the ground, at least in the Soviet Union. It was Western television transmitters, beaming episodes of *Dallas* and Coca-Cola commercials through the undefended air above the Iron Curtain in the 1980s, which won the doctrinal war.

Mayakovsky designed political cartoons which were stencilled for distribution by the Russian Telegraph Agency, and in 1928 Rodchenko photographed the industrial dissemination of the word in his documentary study of newspapers. Truth – incised on the metal of the elegantly curved, shining stereotype plates – goes forth and multiplies. As the stereotypes revolve, they give birth to an infinitude of identical offspring, piled up in the photograph *Freshly Printed Lines* and counted, as if they were his progeny, by the newspaper vendor who will spread them through the world.

Could the new man be propagated in bulk by the same clean, efficient methods? In due course the Soviet regime turned out so many exemplary bodies that Rodchenko no longer needed to imagine how they might look, as in his sketch of the weight-lifter: he could simply photograph them, which he did in his documentation of Soviet acrobats and gymnasts. A diver in his photograph *The Plunge*, taken in 1932, curls himself into a cannon-ball, fired into the future by his

own volition. Rodchenko catches him among the clouds, with no water in view – more a flier than a swimmer. By 1936, when Rodchenko photographed the Sports Day gymkhana in Red Square, the body's liberty, energy and swallow-like grace had been curtailed. Slotted into assemblages, it has become the instrument of a superior social will. Women, posing inflexibly on a conical frame, compose a pyramid, and seven immobile men are pinioned to the spokes of a huge wheel, which trundles along towards a destination they did not decide on. The men smile gamely, but the juggernaut into which they are braced might have been dreamed up by a torturer.

This was the summer of the Berlin Olympiad, in which the world limbered up for another war; also in 1936, Benjamin warned about the body's fate in an age of mechanical reproduction. His essay argued that the modern, technological arts of photography and film are the enemies of human individuality, since they ignore the singleness which – like a halo – vouches for a person's value; Benjamin warned of impending political consequences. He looked with disquiet at the parades and rallies which the camera specialized in recording – the painfully abstracted bodies photographed on Sports Day by Rodchenko; Leni Riefenstahl's marching Nazis on the Zeppelin field in Nuremberg, or her saluting athletes at the stadium in Berlin. In such spectacles, he said, 'the masses are brought face to face with themselves'. The result of this encounter is not recognition but alienation, not sympathy but hostility. The camera, Benjamin believed, overlooks emotional quiddities, and instead merely counts heads. It cannot see beneath the skin, and is therefore insensitive to pain.

During his visit to Moscow in 1928, he had commented admiringly on the Soviet citizen's 'unconditional readiness for mobilization'. The rearranged furniture in those communal flats testified to a desire for improvement. Everything should change, or revolve. This experimentation extended from economics to sexual morals. Workers were brusquely transferred to new towns or new functions. The feminist Alexandra Kollontai preached the ideological merit of promiscuity. Propaganda grew wheels. In Petrograd pianos expropriated from bourgeois parlours bumped through the streets on the back of lorries to dispense musical uplift; trains painted with slogans toured the hinterland, disgorging teams of activists at every stop; Rodchenko designed an open-air mobile cinema which could be fitted into a truck and driven around the farms.

The guns poking into the street in the posters for Eisenstein's *Battleship Potemkin* were playful toy pistols, and the film itself ends with the flagship's crew refusing to fire on the mutineers. But the dictators co-opted the aesthetics of the machine age. Mussolini realized that ideas needed to be backed up by ammunition: he called propaganda 'my best weapon'. Hitler too understood the strategic importance of mobility: the future, he predicted in *Mein Kampf*, would bring about 'the general motorizing of the world'. A motorized world, as he well understood, was already a militarized one: the new autobahns would carry his troops into the countries he wished to annex. Benjamin quoted Marinetti's hymn

to the beauty of war, which 'initiates the dreamt-of metallization of the human body'. By 1936, the prophecy had been fulfilled in the impervious person of Josef Dzhugashvili, who nicknamed himself Stalin, which meant 'man of steel'. The age of mechanical reproduction was not quite the eugenic paradise foreseen by Rodchenko in his photographs of the newspaper industry.

Benjamin struggled to appease his own political conscience by separating the right and left wings of totalitarianism. He did so in a neatly reversible paradox. Fascism, he argued, is politics aestheticized; 'communism responds by politicizing art'. The first is the greater of the evils, because the masses are given shows, not rights. Communism at least redistributes property and re-allocates power. In the process perhaps it twists art into propaganda, but that for Benjamin was a minor crime. The argument was specious, and events soon disproved it. In the summer of 1939, Hitler dispatched his foreign minister Ribbentrop to Moscow to sign a non-aggression pact with Stalin. Scoundrels do not bother to keep their word, and in 1941 Hitler invaded Russia, a miscalculation which probably cost him the war. But however cynical it may have been, the 1939 treaty established a truth which Benjamin in 1936 could not accept. Neither regime was any better than the other. Despite their mutual abuse, they were twin despotisms, equally obsessed with maintaining and if possible augmenting power. The different ideas which that power was meant to serve – the tribe as opposed to the economic collective; the rites of sun worship versus the generation of hydroelectric energy; Hitler as painted by Hubert Lanzinger in archaic armour on a war horse, set against Lenin on his tank outside the Finland Station – were pretexts.

Any moral gap which might have existed between left and right, revolutionary populism and dictatorship, quickly closed after Lenin's death in 1924. Mayakovsky's memorial poem about him, though duly mournful, pleaded against a posthumous personality cult, because to deify Lenin would be to deny his ordinariness. Mayakovsky noted that he wore jackets of average size, and could walk through a door without stooping. He was effective because anonymous: in the months after his return from exile he directed operations while remaining hidden, and preserved his incognito with theatrical wigs and false identities. Emerging to take charge of the October coup, he travelled to Bolshevik headquarters by tram, and was at first refused entry by the sentries. His own doctrine emphasized the feebleness of the individual, whose shortcomings had to be supplemented by organization. One man, as Mayakovsky put it, cannot lift up a single tree, let alone build a house ten storeys tall. The poem concluded by accepting Lenin's expendability.

The embalming of his body announced the different intention of Stalin's state. From the pyramids of the pharaohs to the pickled effigy of Chairman Mao in Tiananmen Square, totalitarianism has always made a fetish of death. Rigor mortis is a condition of ultimate stability, saved from further organic change by the taxidermist's fluids (though even these were unreliable, and Lenin's corpse often had to be taken away for re-irrigation). Despite its professed atheism, the

Boris Iofan's
sign (1933–7)
for the Palace
of Soviets

Soviet regime appreciated the usefulness of religious superstition. God, who can listen to unvoiced thoughts as well as to private conversations, is the most invincible of secret policemen. In Eisenstein's *October*, made in 1927, Lenin was resurrected. Eisenstein hired a proletarian lookalike to impersonate him, but the film's stagy tableaux – the arrival at the Finland Station, the announcement of victory at the Smolny – concentrate on the devout, enraptured faces of his followers, staring at what they know to be a miracle.

The secular saviour served as an alter ego for Stalin, who in official paintings of the 1930s was often aligned with a statue or bust of his predecessor. Condemned to symbolize the state, Lenin became ever more monolithic. In 1924 El Lissitzky designed an aerial tribune with a speaker's box in which he set a figurine of Lenin, bravely leaning out into empty space. Here was the revolutionary doctrine of constructivism at its most ingenious: an industrial crane adapted to transport ideas, not girders. In the next decade, the more ponderous architects favoured by Stalin set another version of Lenin on top of the Palace of Soviets, where his statue, massively planted on a pillar, was meant to replace the golden domes and crucifixes of the felled cathedral. Two hundred feet tall and plated in chromium, this Lenin would have harangued the skyline with an upraised arm. In models of the building he resembles an angry, brideless groom on the upper tier of a wedding cake, sentenced to a lonely Siberia of icing.

In the last days of the Soviet Union, the desecration of monuments became a popular sport: a return, perhaps, to Bakhtin's theory of revolution as rampage. When the Russian crowds pulled down those statues of Lenin, they were taking part all over again in the gleeful revolt which created the modern world. Men once more killed the god who oppressed them.

In the event, the sky proved unattainable.

Soviet architects fantasized throughout the 1920s about constructing a society which would no longer be anchored to earth, enslaved to material needs. An aerial railway strode above the streets in Leonidov's plan for the Lenin Institute. Lissitzky designed a series of platforms on stilts to be erected along a Moscow thoroughfare. These were his reproof to the American skyscraper, which piled up floors like stacked pancakes and segregated inhabitants inside their boxes. American skyscrapers taper off into useless spires; Lissitzky's columns were to support – somehow or other – a flat, wide living area, a commune in the clouds. Rodchenko thought that evolution meant striving upwards, and sketched 'top elevations' for the new city, networks of pylons and antennae, suspension bridges and landing stages for planes. Most outlandish of all, Georgii Krutikov designed a cosmic city which would orbit the earth, with apartment towers balanced like trapeze performers on tripods whose only foundation was a bubble of ether. These futures never left the drawing board.

El Lissitzky's Wolkenbügel *a platform to support a tower in the clouds (1924)*

At the end of the 1920s Mayakovsky foresaw a more plausible Soviet future in two satirical plays which were disliked by his orthodox colleagues and censured by the cultural commissars. *The Bed-Bug* imagines Russian life fifty years ahead, and *The Bath-House* makes an educated guess about society a century hence. In *The Bed-Bug* the alcoholic lout Prisypkin apparently dies in a fire, but is cryogenically preserved when water from the fire hoses freezes. After he has undergone ten five-year periods of progressive reconstruction, the Institute for Human Resurrection votes in 1979 to defrost him. A bed-bug which he has incubated during his half-century on ice also scuttles back to life. Prisypkin and the insect dislike the abstemious future, and Soviet science fails to cure their mutual addiction to vodka. Both are eventually transferred to the zoo. Man, like the microbe, is incapable of regeneration. In *The Bath-House*, a wild-eyed scientist reinvents that most modern of vehicles, the time machine, and adjusts its levers to project him into the year 2030. Before that jaunt begins, the machine has more immediate uses: you can switch verbose hacks at Communist Party congresses onto fast forward, and spare yourself from having to live through their sermons. But the bureaucrats who have taken over the Soviet state will allow no such short cuts, and

disparage visionary impatience: 'We don't need day-dreamers. Socialism is about accounting.'

Mayakovsky's joke about the optimistic prophecies of science fiction was just. H.G. Wells claimed to have seen the future in Russia, and proudly announced that it worked. Mayakovsky knew better and, disillusioned, he shot himself in 1930, leaving a note in which he made arrangements for the payment of his taxes. Tsvetayeva saw his action as his unforgiving verdict on himself. For twelve years, she said, the citizen had exterminated the poet. At last, in revenge, the poet executed the citizen. She judged his record as a believer too harshly. Rather than betraying his own genius, Mayakovsky was betrayed by a revolution which, rapidly completing its historical cycle, soon restored the autocratic past. Among Stalin's chosen avatars was Tsar Ivan II, familiarly known as the Terrible.

At the end of 1917 Kafka made an enigmatic allusion to events in Russia, pointing out that there is no such thing as a 'decisive moment in human development'. Any and every moment promises to be decisive, though the promise is always broken. Nevertheless Kafka sagely approved of the compulsion to deny history. 'The revolutionary movements of intellect/spirit that declare everything which happened before them to be null and void are in the right,' he said. In Russia cities were renamed, cathedrals demolished, Tolstoy thrown overboard, obstructive kulaks murdered, disgraced politicians declared to be non-persons who might never have existed. Kafka ironically smiled on such amnesia. The truth, he explained, is that 'nothing has yet happened'. The counter-revolution in Russia at the end of the 1980s was another decisive moment, and it promptly nullified and voided the preceding seven decades. For a short while we thought that history with its vexatious, unsatisfied dialectic had ended. Then, almost immediately, history resumed.

THE NEW HUMAN BEINGS

The new man, ideologically fostered, was meant to be the ideal citizen of modern times. But he had rivals: when Tod Browning's *Freaks*, with its menagerie of mutants, opened in 1932, a newspaper advertisement in New York announced 'A Horde of Caricatures of Creation!' and gravely warned 'adults not in normal health' to stay away from the film. Hermann Bahr in 1891 foresaw the arrival of futuristic creatures whom he called 'the new human beings'. These were not supermen who had outgrown our cowardly natures, like Nietzsche's Zarathustra, or evolved an alternative to our clumsy bodies, like Wells's Martians. Nor were they the teeming, identical labourers of the Soviet system, reprieved – as Piscator thought – from the curse of bourgeois individualism. They remained desperately human, imprisoned in idiosyncrasy. These were the subjects of Freud's case histories: the so-called 'Rat Man' with his fantasies of anal rape by rodents; the jurist Schreber, who believed himself to be God's wife; the girl 'belonging to a family of good standing' who had become infatuated with an older woman and hurled herself onto a suburban railway line when her father disapproved.

Bahr had his own definition of these new human beings: 'They are nerves.' The twentieth century came to classify them as neurotics. Stalin promised to be an engineer of souls; but this notion of the spirit as an engine had its risks. Modern technology learned how to reinforce building materials, enabling them to cope with undue stress. What happened when people were wired to the same dangerous degree of tension, forced to absorb pressure like the twisted cables of a suspension bridge or the thin spinal column of a skyscraper? Our appliances – those artificial limbs which, as Freud said, have turned us into gods – depend on the crackling generation of energy. But the mind and body are less able to bear such voltage.

For Bahr, nervousness constituted 'the release of the modern'. A jangled static electricity overflowed from a mind which, as Simmel said in describing the sensory blitz of the city, had been poked and prodded by too many stimuli.

eonard Baskin
ormented
Ian (1956)

Elsewhere Bahr described this psychological frenzy as the 'third phase of the modern'. His phrase, like the third kingdom of Spengler and Hitler, had an apocalyptic ring; the idea of modernity, as Spengler was to point out, implied our arrival at the end of time. The three ages into which Bahr divided man's were the classical, the romantic and the modern. Each era had its own psychological temper. Classicism revered reason, romanticism stood in awe of passion, but 'when modernism says "man", it means the nerves'. Bahr summed up the mood of the new human beings as 'a mysticism of the nerves', or 'the virtuosity of nervousness'.

Otto Dix
Ich Dix bin ◀
A und das O◀
(1919)

He did not pause to explain how men came to acquire these 'new feelers', tentacles adapted to the connoisseurship of recondite and perhaps perverse sensations. To write the history of mental events is no easy matter. Nevertheless, developments after 1891 proved the truth of his assertion. The decadents of the nineteenth century's last decade were virtuosi of the nerves, recharting the border between pleasure and pain, instinct and censorious reality, as Wilde's Salomé does when she kisses the Baptist's severed head. 'The content of the new idealism', Bahr enigmatically declared, 'is nerves, nerves, nerves – and costume.' The comment fits the lunar figure of Pierrot, whose woeful face and spectral smock are belied by his violent, impudent antics. Novelists soon began to explore what Bahr called the 'self-consciousness of the unconscious': the scrutiny of conscience in Henry James, Proust's retrieval of vanishing sensations.

Antonin Artaud – a martyr to overtaxed modern nerves, who spent nine years in a succession of insane asylums – thought that the writer's vocation was to be a 'nerve meter', an instrument like a cardiograph or a seismograph for recording the spasmodic passage of 'nerve waves'. He claimed in 1925 that there was an 'infinite musicality' in these tides of anguish, like the inaudible cries which plants are supposed to emit when we cut them or pull them up by the roots. Kandinsky, discussing the psychological impact of colour in 1911, assumed that all artists were new human beings, creatures of preternatural sensitivity who wore their souls just beneath their skin. This precious suggestibility shaded into obsessiveness and hallucination: Kandinsky mentioned a case

reported by a Dresden doctor, whose 'exceptionally sensitive' patient could not eat a certain sauce without seeing and tasting the colour blue.

Strauss, employing what he called his 'Nervenkontrapunktik' in *Salome*, identified counterpoint with jangled neurosis. In 1928 Schoenberg argued that the evolution of modern musical language followed changes in the human nervous system. The sense of hearing had become more delicate and refined. Recognizing this new 'finesse of the ear', composers could write more sparely than ever before, abandoning romantic bombast and listening instead to the vibrancy of empty air: the introverted humming of Berg's soprano in the *Altenberglieder*, or Webern's fugitive, peripheral sounds in the *Five Movements*. As for Kandinsky, the nerves in Schoenberg's theory were genuinely mystical – attuned to mysteries, as if able to overhear the singing spheres. More crazily and capriciously, Hindemith used the word coined by Bahr, 'Nervosität', as the title for one of the brief, flurried sections in his piano suite *In einer Nacht*: less than a minute of stifled panic, in which the soloist's fingers seem to transcribe a trapped, pacing movement to and fro in a closed room.

At the beginning of the new century, Bahr's praise of nervosity marked a change in the tempo of existence, an escape from the sluggish past. Adolf Loos lived in the United States between 1893 and 1896, working at odd jobs. The experience made him proselytize, when he returned to Vienna, for what he called the 'Nervenleben' of the Americans. These were men with 'modern nerves' – quick-witted, briskly efficient, rigorously scheduled, doing everything on the double. The projection speed of silent films artificially accelerated movement: early audiences in Europe wondered if all Americans rotated down the street at Chaplin's jittery, skittish pace, and if cars really drove so terrifyingly fast as those used by the Keystone Kops. Soon enough this nervy impatience crossed to the statelier, more ceremonious continent. In 1900 Otto Julius Bierbaum edited *Deutsche Chansons*, a populist anthology of poems suitable for music, from which Schoenberg took the texts for the Berlin cabaret songs he composed the next year. The cheeky verses dispense with the preliminaries of courtship, and have no time for the postponements to which desire is subjected by Wagner's Tristan and Isolde. Bierbaum explained that man in the modern city possessed 'Varieténerven' – quickly surfeited, hungry for change, insisting on immediate gratification; life was a variety show.

Those vaudeville nerves required a swift succession of excitements. Carl Ludwig Schleich, a doctor interested in the phenomenon of cocaine addiction, commented in 1921 on the 'mobility mania' of modern times. This agitation resembled the state of religious expectancy which the Baptist sings about in *Salome*; men craved ecstasy, most speedily available in chemical form. Opium was the drug of choice in the romantic nineteenth century: its pleasure lay in stupor. The modern toxin, cocaine, delivered ferocious intensity rather than dreamy prostration. Looking through the skin, Schleich did not see the skeleton morosely studied by the hero of *The Magic Mountain*. Instead he imagined a network of

twitching, questing fibres, eager for happiness: he likened the ganglia of the new human beings to the quivering wings and antennae of butterflies, perpetually 'in search of blood and stimuli'.

The sensual ideal of the romantics was repose inside the body, where they felt luxuriously embedded: hence the 'drowsy numbness' of Keats as he listens to the nightingale. Modern man, with those avid ganglia, lived nearer to the surface, awake to every sensation which teased the flesh, nerves cued for instant response. This is how Brecht's colleague Marieluise Fleisser accounted for the cult of sports during the 1920s. She considered athletes to be supreme specimens of modernity because they fine-tuned the organism, using it as an engine, not a comfortable divan: 'The neural pathways by which will is translated into physical movement are trained until they react to the slightest impulse.' Tendons, muscles and nerves unleash force in sudden, explosive spurts. In top form, the body is 'like the flash of lightning attracted by a rod'. Fleisser might be describing Frankenstein's monster who, with spark plugs screwed into his temples, was galvanized back into life by the energy of the storm. Yet the monster, like a battery, is charged with an energy which he expends in acts of violence. Were the nerves really an instrument for a virtuoso to play upon, like Paganini with his violin, and could their agitation truly be called a mystical state? Two years after Bahr's 1891 essay, Freud and the hypnotist Joseph Breuer began to publish their *Studies on Hysteria*, which diagnosed a representative sample of the new human beings, their anonymity scrupulously guarded – Elisabeth von R., psychosomatically crippled by her forbidden love for her brother-in-law, or Emmy von N. with her convulsive tics, stammers, cramps and her self-mortifying anorexia.

Treating such cases, Freud and Breuer at first assumed they were tinkering with a 'psychical mechanism'. They sought to trace the neural route by which the patient translated emotional guilt into a physical affliction: the body expressed what the mind too strenuously denied. Breuer explained cerebral workings by using analogies from the latest technologies. He likened the 'tonic excitation' of the nerves to a telephone line which transmits 'a constant flow of galvanic current', or to 'a widely ramified electrical system for lighting and the transmission of motor power'. These were audaciously modern analogies. Even more daringly, the sociologist Émile Durkheim in 1912 described religion as 'a sort of mystic mechanics', and argued that rites of consecration were a technology of the spirit, asking to be charged by supernatural energy 'just as today a body is put into contact with a source of heat or electricity to warm or electrize it'. Breuer's notion of the brain as a dynamo had to concede the danger of electrical faults, and the contraption's liability to break down. If the nerves were overburdened with crackling current, Breuer argued, there would be sparks or the smell of burning: frazzled filaments, scorched insulation, short circuits – in sum, hysteria, or what the Italian futurists described as the anguish of the expiring light bulb.

Freud spoke of his psychiatric mission as if it were the equivalent to Lenin's schemes for the extension of hydroelectric power. 'Where id was, there

ego shall be': obscure, deviant instinct would be banished by luminous reason. But it was no easier to keep the current circulating in a single human head than to electrify the Soviet Union; and perhaps, despite Freud's profession of faith, the way of the nerves led down into darkness rather than up towards the light. He was prepared for attacks on the scientific pretensions of psychoanalysis. He considered himself an artist, and called his case studies short stories, conceding that they apparently lacked 'the serious stamp of science'. There was a touching poignancy and frustration in this remark. Novelists can accompany characters to the end of their lives; the short story releases them into a future of which the writer must remain ignorant, over which he has no control. After curing the hysterical cripple Elisabeth von R., Freud got himself invited to a ball which she was due to attend. He watched her dance gaily, forgetfully, past him. 'Since then,' he added, 'by her own inclination, she has married someone unknown to me.'

Marx ordered his disciples to 'transform the world'. Rimbaud's romantic commandment was to 'change life'. Inheriting both agendas, the twentieth century has struggled to synchronize them. Can revolt occur inside the head, as well as on the streets? Is revolution a psychological idea, or only a political one? Freud's thought turned reality upside-down, but he observed the consequences with remorse and dread. Revolutions always go further than their instigators intend. Freud regarded *Moses and Monotheism* as an exercise in historical romance. His study surmised that Moses was an Egyptian, murdered by the Jews who then guiltily mythologized him. He hoped that his conjectures would be found 'worthy of belief', or at least of that suspended disbelief accorded to works of art. In fact his purpose was to attack the slavishness of belief by secularizing Old Testament miracles. He finished the book as he left Vienna in 1938 for exile in London, and remarked with grim jocularity on his bad timing: just when the Jews were being despoiled of worldly goods and civic rights, he had taken away the most venerable of their ancestors.

As a boy, Freud's heroes were Hannibal, Brutus and Cromwell – the invader who almost trampled the citadel of civilization; the assassin of a tyrant; the soldier who executed a king, and in doing so served notice to God, by whose divine right earthly monarchs claimed to rule. His fantasies about Hannibal were a scenario of personal revenge, an attack on Rome whose universal church propped up the Austro-Hungarian empire and sanctified its anti-Semitism. In *Civilization and its Discontents*, he took a leisurely poetic pleasure in elaborating an image of Rome in ruins, torched by vandals or quietly mouldering. Though his purpose was to illustrate the archaeology of the mind, the metaphor betrayed a more secret aim, the enactment of a private dream: Freud imagined the holy city ravaged, as if by the mental plagues of 'trauma and inflammation'.

Unable to ride his conquistadorial elephants over the Alps like Hannibal, Freud contented himself with subtler subversions of authority. In an anecdote from *The Interpretation of Dreams*, published in 1900, he remembers that he defied

obnoxious railway officials – who kowtowed to imperial grandees while refusing him equal privileges – by humming the aria from Mozart's *Le nozze di Figaro* in which the disgruntled hero threatens the predatory Count. Having boarded the train, Freud secured the compartment he had paid for, despite the queue-jumping of idle aristocrats, but he still had no access to a lavatory. When his complaints were ignored, he sarcastically proposed cutting a hole through the floor of the carriage to accommodate bodily functions. That night, the daylight episode was re-enacted and wildly fantasticated. Waking up to urinate, Freud emerged from a 'revolutionary phantasy' which had whisked him back to 1848, the year of popular revolt throughout Europe. The need for the urinal led to infantile recollections of bed-wetting, and the 'scenes of micturition' prompted Freud to explain that this was the primal, wordless way in which the body expressed contempt or, like a dog demarcating its terrain, asserted ownership. These transactions – psychological and political, not merely sanitary – were unspeakable during the nineteenth century. Freud's suggestion of the hole in the floor, dispensing with the polite plumbing and closeted water of bourgeois Europe, sums up the rude shock of his ideas, which undermined the decorous concealments of society.

In 1901, in *The Psychopathology of Everyday Life*, he went on to demonstrate that the anxious artifice of reality was a minefield of hidden meanings and ambiguous menace. Slips of the tongue, for instance, let loose sedition. Freud later added to the book an example from a speech made in 1907 by the German Chancellor, manifesting support for Kaiser Wilhelm II. The Chancellor meant to declare that it would be 'unfair and unjust to speak of a coterie of irresponsible advisers round our Kaiser'. Instead, tripped up by the row of double negatives, he said it would be unfair to speak of responsible advisers, and unwittingly blabbed out a truth.

Freud the revolutionary was wary of the ego's self-deceiving desire to award itself a crown. He referred satirically to 'His Majesty the Ego, the hero of every day-dream and every story', and in his 1919 study of *The 'Uncanny'* he unmasked this illegitimate upstart in stories about ghostly doubles. Man the incorrigible narcissist promotes himself to immortality by his wishful thinking. It was all very well for the enlightened ego to crush the id. But the ego, like Caesar imagining himself to be a god, schemes to attain absolute power and to assure its permanence, which is why Freud saw it as his duty to impersonate Brutus. A truth-teller accompanied Roman emperors during their triumphs, whispering a reminder of their mortality. The 'death instinct' invoked by Freud was a similar remonstrance to doomed Tsars and Kaisers, and to the dreams of glory and perpetuation nurtured by every ego. The double, as he points out in discussing Egyptian funerary replicas, begins as our insurance against having to die; but when its spell weakens, it becomes – like Freud himself – 'the uncanny harbinger of death'.

In his assault on the potentates whose downfall announced the onset of modern times, Freud took over and extended the 'great disengagement' pro-

claimed by Nietzsche. At night, as he implied in *The Interpretation of Dreams*, every man is a superman, enjoying the orgiastic liberties of Zarathustra. Nietzsche sought to overturn Christianity by the transvaluation of its values, replacing lamb-like meekness with a reverence for force. Though we may flinch from such brazenness, Freud challenged us to deny that the same insurgency does not flare up within each of us under cover of dark. Using Nietzsche's slogan, he claimed that 'a complete "transvaluation of all psychic values" takes place between the material of the dream-thoughts and the dream'.

Sigmund Freud
Salvador Dalí
(1938)

Nietzsche released the superman from moral accountability, placing him 'beyond good and evil'. The dreamer benefited from the same amoralism, which was described by Freud even more flagrantly than it was by Nietzsche. Dreams, as Freud coolly puts it, expose us as 'ethical and moral imbeciles'. The jeering atheism of Nietzsche's *The Anti-Christ* protested too much, because the battle against divinity had already been won, overnight and without effort. Freud called dreams 'the blessed fulfillers of wishes'. That is what gods were supposed to be: why else did we invent them, if not to grant our prayerful requests for success in war or gifts at Christmas? If we can gratify our own wishes, the gods and even God himself are obsolete.

The very act of interpreting dreams was for Freud an attainment of superlative, transcendent power. Hence the zest with which he discussed wet dreams, consulting Otto Rank's table of correspondences which indefinitely multiplied sexual meanings: 'Water = urine = semen = amniotic fluid'. This was Nietzsche's 'joyous science' with a vengeance. The practice of interpretation involved quoting scripture with the devil's proficiency; Freud made possible the modern art of literary criticism, which specializes in transvaluing the literal values of the texts it deciphers. Thus he placed in evidence one of his own dreams, warning with an unregretful smirk that every reader would be disgusted by it. He is astride an open-air cesspit, clogged with fresh faeces. He urinates on the seat which perches above the pit, and washes it clean; the stream even swills away the caked filth. He feels – a reproof to his dainty or hypocritical readers – 'no disgust'. On the contrary, the experience leaves him with a proud flush of accomplishment. Interpretation desecrates the lofty and sublimates the lowly. All

meanings are reversible. 'Even the museum of human excrement', he says, 'could be given an interpretation to rejoice my heart.' Explaining the dream, he recalled the labour of Hercules in the Augean stables, and accorded himself, as a cleanser of the soiled mind, the heroic role: 'This Hercules was I.' Again he drew on Nietzsche. He wittily likened himself to Gargantua, 'Rabelais' superman', who climbs onto Notre Dame and showers Paris with his built-in hose. Freud is a Zarathustra whose genius is physiological: 'I was the superman.'

Freud admired and emulated Brutus, but only because he was aware of his own innate Caesarism. Unravelling his obsession with railway urinals, he candidly admitted the urge to megalomania which made him plot revenge. In the episode at the outdoor privy, he took the stream of his urine to be 'an unmistakeable sign of greatness'. Like a tragic hero, Freud was tugged between opposing truths. We wish to live forever, yet know we must die. Though we ought to shun death, we actually yearn for it: what else is our 'wish to sleep'? The mysticism of the nerves here lapses back into the empowering darkness where Wagner's Tristan and Isolde crave extinction; Freud beautifully illustrates this retreat from daylight reality by quoting Romeo and Juliet, who quarrel about whether the bird they hear is the nightingale or the lark – an excuse for prolonging the night, or a summons to parting at dawn. Dreams tell their beguiling stories, he suggested, in order to prevent us from waking up. They are *the GUARDIANS of sleep and not its disturbers*. Elucidation operates like an alarm clock: it enforces the stern regime of the superego. But id takes over again at nightfall. No matter how much we congratulate ourselves on our rationality, the dream (as Freud argued, once more quoting Nietzsche) preserves a 'primeval relic of humanity', an 'archaic heritage' we will never outgrow.

The contradictions between mind and body or modernity and primitivism, between the will to power and the wish to sleep, are insoluble. Here lies the rift in Freud's thought, which makes it – whatever its scientific veracity or medical value – so powerful as testimony about the nature of human beings, new or old.

One of the generous projects of modern times was the ambition to equate art with life. Braque and Picasso incorporated souvenirs of reality in their collages. For Bartók and Janáček the sounds made by insects and animals qualified as music. Soviet Russia intended to disestablish art by making society beautiful, turning work into play. Freud contributed to this democratic opening-out of creativity: the dream, which disclosed our secret life as supermen, also revealed that we are all artists. Daytime thought, Freud said, trades in concepts. Dreams perform no such dreary 'ideational work'; they are made from 'involuntary ideas'. When reason's control is relaxed, imagination takes over. Anna O. – a patient of Breuer's, whose neurosis disordered her speech – referred to her daydreams as a 'private theatre'. Another hysteric, the poet Cäcilie M., fell victim to her own talent for what Freud called 'symbolization'. Words had the power to hurt her: a slighting remark or a friend's treachery caused actual physical pains.

Breuer, studying these 'hypnagogic hallucinations', remarked that artists worked by self-hypnosis, sedating the meddlesome conscious mind.

Freud specified that dreams 'think predominantly in visual images'. The dreamer is a painter first, only secondarily a writer. Hermann Broch claimed that modernist innovations began in the visual arts and passed belatedly to literature, because the doodling hand is less inhibited, less liable to take dictation from reality, than the hand which forms words. Language for Anna O. and Cäcilie M. was an affliction. It promised to rationalize their fantasies; they baffled it by making it incoherent. Obsessions articulate themselves, Freud said, in texts which look truncated or distorted, 'like a mutilated telegraph message'. Marcel receives such a telegram in Proust's novel, apparently sent from beyond the grave by Albertine – or transmitted by his own wishful fantasy; Freud would have known how to crack the code. Therapeutic relief depends on the transition from the automatic writing of dreams to conscious, responsible speech: the 'psychical process', as Freud and Breuer insisted, must in the end be 'given verbal utterance'. They compared 'the symptomatology of hysteria with a pictographic script', which is decipherable once you have discovered some bilingual inscriptions. Speech and writing are acts of exorcism. As id yields to ego, visual riddles succumb to verbal explanation. The picture retrieved from the memory starts to fragment when the patients describe it: they are *getting rid of it by turning it into words*.

Our dreams evaporate if we try to relate them. The artist therefore refuses the proffered cure, in order to maintain his compact with unconsciousness. What for Freud and Breuer in 1895 were 'pathological states' promptly turned into symptoms of modernist vision. Anna O., for instance, suffered from a squint, diagnosed by Breuer as an 'affection of the obliquus'. She complained that the walls of the room were tumbling in on her. This is exactly how the expressionists saw the city: the façades of tenements converge at sickly angles in Döblin's *Berlin Alexanderplatz*, and in Meidner's paintings the same Berlin buildings tremble and totter. The 'functional disorganization of her speech', as Breuer called it, also promoted Anna O. to the avant-garde. In her distress she gave up conjugating verbs and relied on infinitives. She also forgot about both definite and indefinite articles. Writing, she used a private jargon which merged the vocabularies of four or five languages. Yet the same tics can be found in the poems of August Stramm, who dispensed with connectives because experience itself is incoherent, or in *Finnegans Wake*. Verbal condensation, achieved by Joyce's polylingual puns, was for Freud the native idiom of dreams.

In a relativistic universe, there are no rules to be broken, and therefore no grounds for the accusation of abnormality. As inadvertent poets, we are at our most creative when we misuse words – or when, through slips of the tongue, we permit them to use us. Freud's investigation of verbal humour in *Jokes and their Relation to the Unconscious*, published in 1905, showed up the irrationality of language, its aggressiveness and its freedom from shame. Jokes, like dreams, hold nothing sacred. Heine compared Catholic priests to employees in a wholesale

business and Protestant clerics to retail merchants; Freud quoted the jest with feigned reluctance, aware that 'among my readers there would probably be a few' – but only a few! – 'who felt respect not only for religion but for its governors and assistants'. That unrepentant apology was one of his own most dangerous jokes. Humour gives offence while defying the victim to take it: a laugh is an insincere retraction.

For the vitalist Henri Bergson, who published an essay on *Le Rire* in 1900, laughter served the purposes of progress. 'Life', Bergson thought, 'presents itself…as evolution in time and complexity in space', so that anything which contradicted these laws – repetition, interference – was funny. The physics of Einstein disrupted this cosmic complacency: time did not only move optimistically ahead, and space could implode as well as expand. Nevertheless, for Bergson the mission of laughter was to dispose of obstacles which block the 'élan vital'. He thought that a man who fell over in the street was ridiculous because he succumbed to 'mechanical inelasticity', losing the 'adaptability and living pliableness of a human being'. Comedy makes sure that mankind remains upright. Freudian jokes, however, were regressive, harking back to fixed and incurable obsessions. The new human being was not the flexible figure imagined by Bergson: we are tripped up by impediments within, like Elisabeth von R. whose mental torment incapacitated her body, so that 'every fresh theme which had a pathogenic effect had cathected a new region in the legs'. Bergson compared man's advance towards social peace with the process of planetary cooling, in which a 'solid crust covers the fiery mass of seething metals'. Explosions belong to the remote past; any pressures left over can be harmlessly vented by comedy. But volcanoes remain active, and Freudian laughter was just such an explosion.

Language no longer tempered this violence. Words abandoned their single-minded fidelity to the things they named, and gave up their classical task of identifying man as a rational creature. Freud was a connoisseur of their treachery. A young woman in one of his anecdotes orders herself to forget the title of the novel *Ben Hur* because to utter it would be to say 'bin Hure' – I'm a whore. The treason within that unspoken pun was the more alarming because the book, recounting the life of Christ, had pretensions to sanctity. In another case, a female stammerer hesitates over 'condolence' for fear of saying 'condom'. She saves herself from voicing it, but her stumbling gives away its presence in her mind. In *The Psychopathology of Everyday Life*, a young colleague with whom Freud has been discussing the plight of the Jews cannot find the word he needs to complete a quotation from Virgil. Freud himself supplies the missing word, 'aliquis', then investigates the reason why it went into hiding. The result is an etymological detective story, a chase which exhilaratingly takes in Christian saints and their relics as well as Jewish ritual sacrifices. Finally Freud discovers that 'aliquis', an innocuous Latin pronoun, has by a chain of associations reminded the young man of liquefying blood. Here is the secret: his memory of the line from Virgil was paralysed by fear, because he was nervously waiting to hear whether a certain

woman had menstruated. If the blood does not flow, he tells Freud, it could be awkward for them both. Words, riotously atheistic or ribald, also declaim a protest from which their users would timidly shirk. Freud thought that slips of the tongue were endemic in war, when truth is officially debarred – hence his admiration for the mother who, in reply to a question about her son's regiment of Mortars, said he was with the 42nd Murderers.

Reality itself, under Freud's tutelage, became a minefield of symbols. A character in Hitchcock's Freudian detective story *Spellbound* scrapes some lines on the table-cloth with a fork, causing Gregory Peck to have a dizzy fit. Sinister or devious or obscene meanings could take up residence in the most humdrum places – slithering into the cigars Freud smoked, invading a woman's dressing table. In one of Freud's case histories, a man whose wife has rationed her sexual favours absent-mindedly uses her powder-puff while shaving. His wife tells him off, but gets her pronouns mixed up and complains that he is powdering her with his puff. Nevertheless she means what she says. To powder, as Freud's colleague Otto Rank explained in deciphering the anecdote, was a Viennese colloquialism for copulating. 'A powder-puff', he added, 'is an obvious phallic symbol.' Though that equation seems far from obvious, it could be taken as a tribute to the ingenuity and versatility of the procedure which Freud called symbolization. Henceforth the phallus, a master of disguise, could be found anywhere – in the gear sticks of cars, the nose cones of rockets, and at the tip of every skyscraper which claimed to be the tallest in the world; in the braying horns of Strauss's *Rosenkavalier* prelude, the bananas worn as a skimpy skirt by Josephine Baker, the cuts of bleeding meat with which Dalí bedecked the naked shoulders of his wife Gala, and the pronged flowers photographed by Robert Mapplethorpe.

Revolutionary Russia identified beauty with utility. This was the point of Lissitzky's crane, Rodchenko's pylons, and the working mill in Meyerhold's *Magnanimous Cuckold*. Freud too found art in everyday life, but in his view beauty meant perversity. A sexual spell charged utensils and accessories with magic, invested them with the power to perform as fetishes in some occult erotic cere- mony. Eroticism adhered to that powder-puff, just as it guiltily tainted the money which the 'Rat Man' ironed, hoping to cleanse the infectious paper of bacteria. Following Freud, the surrealists invented a new art form: the flagrant object, dis- covered indecently exposing itself in bourgeois society. Duchamp exhibited a polished porcelain urinal which might have served as a baptismal font, and chose a chocolate grinder to symbolize – as Freud would have said – the toiling sexual- ity of his bachelors. Dalí designed a telephone with a lobster reposed in its cra- dle. The cold shell of the crustacean was his antidote to the disgusting humidity of the hand set, its apertures permanently sweaty after being pressed against human mouths and ears. Sometimes it was necessary to customize these objects, cancelling the usefulness which the Russian constructivists esteemed. Man Ray in 1921 fitted a row of nails to the underside of an iron, which changed it from a domestic appliance to an item in a torturer's kit. Meret Oppenheim in 1936

swathed a tea cup in fur – impractical to drink from, but an adroit allusion to cunnilingus. Because hair is a badge of sexuality, the surrealists perversely added it where it did not belong while removing it from areas in which it grew naturally. André Breton, in a discussion about depilating private parts, exclaimed in 1928 'It's a scandal that there are still unshaven sexes!' In a totalitarian regime, as Benjamin argued, art and life are forcibly politicized. In a society which subscribes to Freud's theory, art and life submit to a corresponding fate: both are eroticized.

In anatomizing the mind, Freud characterized the historical predicament of modern times.

An atavistic past lives on inside us. Infancy, for Freud, was our personal retraversal of prehistory, an apprenticeship in savagery which we are lucky enough to outgrow. Even in later life, dreams return us to our 'phylogenetic childhood'. The unconscious mind is liable to remember things it has no record of knowing: 'the dream's superior knowledge' allows it to 'command memories which are inaccessible in waking life'. Freud diagnosed this preternaturally long memory as the source of our problems. *Studies on Hysteria* proclaimed that '*hysterics suffer mainly from reminiscences*'.

Because we remember too much of the past, dreaming our way back to the terrified early years of the race, to forget is a self-protective necessity. Selective memory loss, as in the case of the young man who could not complete the quote from Virgil, was a recurrent plot in Freud's work. Amnesia supplied an antidote to that twentieth-century complaint which he called hypermnesia. This was one of his symbolic fictions, closer to myth than to scientific observation: a parable about the retentiveness of consciousness in a century burdened by the past it has inherited, from which it tried in vain to disengage itself by brightly announcing that the earth was different and human nature had undergone a fundamental change. A convenient forgetfulness served as the lever for unlocking disturbed minds in that cycle of Freudian films which indoctrinated America during the 1940s. Gregory Peck in *Spellbound* imagines he has murdered his employer, which blocks his memory of having caused his brother's death in an accident when they were boys. Michael Redgrave in Fritz Lang's *Secret Beyond the Door* wants to murder his wife, who compels him to remember the origins of his misogynistic rage: his mother once denied him a bed-time kiss. Ginger Rogers in *Lady in the Dark*, her therapy assisted by some Kurt Weill songs, is cured of her bossy masculinity when she dredges up an equally trivial incident of parental rejection.

Like all dreamers, Freud did his thinking in images, or rather – since a pipe is never just a pipe – in metaphors. Emotional cathexes, he thought, could migrate from one person to another, who is chosen as a surrogate. The same process, which he called transference, creates metaphors, where an image serves as a surrogate for some quite different idea. This was the case with the reverie from *Civilization and its Discontents* in which Rome is imagined to be 'not a human

habitation but a psychical entity': a hypermnesic city where nothing has been lost, so that the palaces of the emperors still rise beside medieval battlements, and temples built to Jupiter nudge Catholic basilicas, just as in the mind savagery overlaps with the manners and morals of civilization.

Having indulged his 'phantasy' at length, Freud apologetically curtailed it, 'for it leads to things that are unimaginable and even absurd'. Perhaps, writing the essay in 1929 between world wars, he did not dare to continue imagining this immortal, indefatigable Rome. Quite apart from his own desire to play Hannibal, he knew that he was reconstructing a civilization which the unredeemed modern mind had vowed to destroy. Like Freud, Buñuel and Dalí in *L'Age d'or* traced civilization to its origins in the murky sediment of the mind. In their film, Rome is founded all over again in 1930, on the site where some Majorcan bishops have ossified. Dignitaries foregather to consecrate the place, and its prototype is remembered with aerial snapshots of the Forum and the Vatican. But the ceremony is interrupted by a man and a woman, enjoying avid sex in the squelching mud. Are they, rather than the officious clerics and politicians, the city's true founders? After the next war, Broch added a footnote to Freud's image in *The Death of Virgil*, published in 1945. Broch quotes a passage from Virgil's epic poem in which Aeneas comes to a Rome which is older than any of the archaeological layers uncovered by Freud. He arrives at a humble encampment, with cattle pastured in a field which would become the Forum. Broch's hero remembers what predates the foundation of Rome, and can anticipate what will come after it – shattered statues, and an ocean of flame which leaves behind, as in Dresden or Berlin, only powdery walls and resilient weeds.

Freud had no interest in that skyscraping conquest of the air which was the official, optimistic course of the twentieth century. His own investigations led downwards, to the basements where guilty secrets were buried. During their voyage to America in 1909, Jung described one of his dreams to Freud. He was exploring a tiered building, descending through architectural styles. The ages did not coexist, as in Freud's Rome; pressed on top of each other, they had to be unpeeled. Jung began in a rococo salon on an upper floor. At ground level the rooms were shadowy, musty, medieval. The cellar looked Roman. Below that was a cave roughly hollowed from the bedrock: a charnel house strewn with shards of pots, bones and disintegrating skulls, 'like remains of a primitive culture'. Freud read this dream as a diagram of the many-storeyed, multicameral mind. But the head is a haunted house, and he guessed that one of the skulls must be his own: in the dream, Jung had wishfully murdered him. Freud's image of Rome treated the unconscious as an archive where our personal and collective past is stored. Jung's domestic museum emphasizes the grimier function of the unconscious as a hiding place. At his most confident and enlightened, Freud used a metaphor which evoked the civil engineering of the Romans, driving straight lines across uncharted terrain: dreams, he said, were 'the royal road to the unconscious'. In Jung's case, the passage is by way of the back stairs.

Freud's subterranean scavenging earned him, as he said, the disapproval of 'strict science', and made him 'a partisan of antiquity and superstition'. As well as brooding on the superimposed settlements which have all been called Rome, he was obsessed by Pompeii, preserved beneath its smothering counterpane of ash. Bergson thought that volcanoes had quietly become extinct as humanity matured; Freud understood their intermittent violence, and knew that they had their reasons. Vesuvius buried Pompeii as a neurotic conceals an incriminating secret, to protect it from inspection by the rational daylight. In 1907 he wrote an essay on the necrophiliac delusions in Wilhelm Jensen's *Gradiva*, the story of an archaeologist who becomes infatuated by a Roman relief of a young woman. (Freud himself, happy to share the hallucination, owned a plaster copy of the carving.) Jensen's hero dreams that Gradiva died in Pompeii when Vesuvius erupted. He visits the excavated city, and is convinced that he has found her there alive. Events proceed according to the deductive logic of the Freudian detective story: instead of a reborn Gradiva he has met his former girlfriend Zoe, rejected when he buried all erotic longing to devote himself to science; she helps him to dig up the past.

The archaeologist disturbs tombs in order to safeguard their contents, but the analyst disinters those repressed memories so that the patient can watch them crumble to dust in the fresh air. Conscious thoughts are soon eroded; what is unconscious remains immutable. While treating the 'Rat Man', Freud directed his attention to the collection of antique statuettes in his consulting room. Burial, Freud said, ensured the preservation of his keepsakes, and 'the destruction of Pompeii was only beginning now that it had been dug up'. It was an extraordinary statement, reversing the apparent truth in order to be more intimately, deeply truthful about his own mixed motives. The work of archaeology is surely not destructive. In saying that it was, Freud hinted at the risks of analysis, and conceded the mind's need to stand guard over its own sealed, sleeping tomb.

Freud adored those antiques which he showed off to the 'Rat Man'. He bargained for them in Vienna, and hunted for acquisitions on holiday; he fussily rearranged them, fretted until the Nazis permitted them to join him in exile, and died in their company in the study of

Max Pollack's etching of Freud in his study, surrounded by his familiars

A dream of
ves: a drawing
Freud's patient,
1e 'Wolf Man'
(1910–12)

his London house. They still occupy that shrine-like room, swarming over his desk and cluttering the sideboards – Egyptian sphinxes and scarabs; birds with human heads and gloating, lecherous baboons; a capering Eros and an ancient Chinese sage of white jade.

Reflecting on the war in 1915, Freud commented that every civilized man is the convener and curator of a personal museum, arranging his own Parnassus or School of Athens. To collect imposes a regimental order on randomness. A collection is also a small personal investment in immortality. Freud was reverentially tender in his dealings with his miniature deities and totemic animals. He explained in *The Psychopathology of Everyday Life* that 'the anatomical integrity of [his] nerve-muscle' guarded him against hasty movements which might harm them: 'It is very rare for me to break anything…. I cannot…recall any object in my house that I have ever broken.' Having made this disclaimer, he at once went on to describe a positive riot of domestic vandalism – a marble ink-stand negligently knocked to the floor, a silver-handled stick broken during a game with his children, a glazed Egyptian figure crushed, a marble Venus dislodged from its bracket and shattered when he flung his slipper at the wall. He analysed the breakages as sacrificial acts. He threw that slipper to celebrate his daughter's recovery from illness, and did not mind when it destroyed his Venus: the figurine would serve as an offering of thanks.

This episode of 'wild conduct', as he called it, showed how easily a civilized man could revert to savage mayhem, refusing to count the cost. The learned analyst, a truant to his own rationality, assumed that his daughter's recovery must have been due to divine intervention. In older cultures, men made grateful sacrifices to the gods on such occasions. But Freud, despite his sympathy with myth and pagan superstition, was a modern man, a rebellious atheist. Knocking Venus from her perch, it was the goddess herself whom he sacrificed.

Freud agreed with Jung that our myth-making powers have not perished, because they are still on show in the reckless fantasies of neurotics, unbeholden to reality. His patients were metaphysicians. In their dreams they omnipotently

wielded 'the forces that construct religions', and in doing so revealed that religion is never more than a construction of the wishful, vengeful mind, transferring to the sky our tormented family romance. Senätspresident Dr Schreber of Dresden exalted his father into God. He proved his piety by fancying that he had grown female genitals, and felt the presence inside himself of a male embryo. Freud detected a blasphemous motive in these devout hallucinations. Schreber was rebuking both God and his father for their aloofness, reminding them that they had been begotten in his dreams. The 'Wolf Man' saw himself as Christ, whose birthday he shared. This meant that his father must be God. But he still had grounds for mutiny. His own father loved him, whereas God sentenced his son to death and ordered Abraham to slaughter Isaac. The 'Wolf Man', an anal erotic, therefore equated God with shit. The 'Rat Man', enjoying sex for the first time, thought 'One might murder one's father for this!' Unthinkable, or at least unspeakable, but nonetheless true: discovering his virility, a man inherits the world, and rudely dispossesses his elders. Freud believed that civilization advanced from matriarchy to patriarchy, from the rule of the senses to the more abstract dominion of the mind. He has been castigated for this by feminists, even though he saw the advance as temporary, soon revoked: the father will be slain by his son, the infant Oedipus whose wishes, 'repugnant to morality', have been instilled in him by nature. The theory was another of Freud's fictions about history, a typically modern attempt to explain why human beings – who repeat the same sagas of aggression in every generation – have made such small progress since time began, and why revolutions always go round in circles.

We perpetually retell these legendary stories because we cannot outgrow them. For Freud, this explained the abiding power of classical tragedies. Agamemnon on his return from Troy sacrificed his daughter Iphigenia to gain a favourable wind for the Greek fleet. When he returned home, his wife Klytemnestra killed him for murdering their child. Their daughter Electra, like a female Oedipus, obsessively lamented the loss of her father and fantasized about her mother's death. Eventually her brother Orestes returned to slay Klytemnestra. He was then pursued by the Furies. The story goes on forever, because the same conflicts seethe in every modern family, even if its members do not act on their impulses.

Aristotle, borrowing a medical term, thought that witnessing these actions had a 'cathartic' effect on audiences: pity and terror left them feeling purged. Freud and Breuer gave the word back its medical meaning by arguing that a patient who has suffered an injury can only be relieved by cathartically reacting to the offence. 'By "reaction"', they explained, 'we here understand the whole class of voluntary and involuntary reflexes – from tears to acts of revenge.' It is a startling remark. Sometimes to cry will do the trick. On other occasions, as in Agamemnon's family, it may be necessary to kill. The shock derives from the implied dismissal of Christianity, which emphasized the obligation to forgive. Breuer thought that 'the instinct of revenge,...so powerful in the natural man'

had been 'disguised rather than suppressed by civilization'; this meant that Christian morality and the civilized rule of law were alike fraudulent. The source, as for so many modern assaults on our complacency, was Nietzsche, who in *Twilight of the Idols* praised the 'intoxication of power' which thrills through an outburst of connubial scolding. All complaints, Nietzsche approvingly noted, contain 'a small dose of *revenge*'. Society goes to work like an animal-tamer, humiliating the savage creature by making it domestic and tractable: 'Man is finished when he becomes altruistic.'

Proving Freud's point about the contemporaneity of classical tragedy, in 1901 Hofmannsthal began work on an adaptation of Sophocles' *Electra*. Strauss used Hofmannsthal's version as a libretto, and *Elektra*, their first collaboration, had its premiere in Dresden in 1909. The opera, which psychoanalyses the myth, is an unabashed vindication of revenge; and its distraught sopranos transform hysteria – that traditionally female ailment, supposedly incited by uterine disorders – into ecstatic song. Hofmannsthal knew *Studies on Hysteria*, but his play has no faith in therapies of alleviation. Klytämnestra comes to Elektra to have her dreams interpreted. The diagnosis outrages the analyst's professional oath: Elektra prescribes the axe, and rejoices when she hears her mother's death rattle. Perhaps she is purged after Orest performs the reflex action of revenge on her behalf, but the cure turns out to be fatal, since she abruptly drops dead. If there is any catharsis, it comes from the lyrical hysteria of Strauss's three protagonists – Elektra, celebrating matricide with a jubilant high C and a frenzied waltz; her sister Chrysothemis, who wails for sexual satisfaction and sobs in frustration; the moaning, keening Klytämnestra, whose account of her bad dreams is Strauss's most daring venture into orchestral dissonance. In his case history of Elisabeth von R., Freud mentions two patients who might have been candidates for casting in the opera. Rosalia H. is a singer who suffers from constricted vocal cords, 'cathected with residues of innervations' left over from a miserable childhood. Another young woman, also the victim of distress in her family, has 'contracture of the masseters': she will not open her mouth wide enough to make an operatic career. Freud unlocked their voices, and reported that the second patient 'has sung in public' since being hypnotized by him. The best cure for hysteria is to give in to it by singing opera. The unholy uproar of Strauss's orchestra, as Elektra cavorts and calls on Orest to strike again, administers its own kind of catharsis. It recalls Nietzsche's commentary on 'the psychology of the orgy' in *Twilight of the Idols*, 'an overflowing feeling of life and energy within which even pain acts as a stimulus'. This rampancy provided him 'with the key to the concept of the *tragic* feeling, which was misunderstood...by Aristotle'. The error of Aristotle was his notion that the experience is good for us, because it restores moral equilibrium. For Freud and Breuer or Strauss and Hofmannsthal, tragedy had no such healing outcome.

Freud planned his intellectual quest as an allegorical journey, a brave venture into dubious and perhaps inimical terrain. He likened *The Interpretation of*

Dreams to 'an imaginary walk', and in a letter to Wilhelm Fliess he explained the varying landscapes through which the exposition passed. In the scholarly preamble, he fumbles through 'the dark wood of the authorities (who cannot see the trees)': the sages he cites are blind, and their texts obfuscate the issue rather than letting in the light. After that comes 'a cavernous defile through which I lead my readers': his analysis of his own specimen dream, rationalized despite its surreal absurdities. Having found, like a wily Hannibal, this passage through the mountains, he reaches a lucid plateau, 'the high ground and the open prospect'. Here Freud paraphrased the visionary finale of Goethe's *Faust*, with prophets and angels hovering in mid-air while they consider their verdict on the hero's soul. In the play, gazing into an illimitable space which can accommodate all aspirations, Doctor Marianus says 'Here is the prospect free, / Spirit-uplifting'. The allusion marked the magnitude of Freud's aim. By interpreting dreams, he intended to redeem mankind.

But his metaphors always speak with a double tongue, and the image betrays a rankling uncertainty. Emerging onto the plateau, Freud thought he could clearly discern the route ahead, and in the letter to Fliess he asked himself which direction he should choose. Was he being too confident? In Maurice Maeterlinck's play *Pelléas et Mélisande*, first performed in 1892, Golaud, following a trail of blood, finds Mélisande whimpering in the forest at dusk. She relies on him to guide her safely home, but he too, he admits, is lost. The protagonist of Schoenberg's *Erwartung* remains in the thicket, trapped by her mania. Near the end of his book, Freud brought back the image of the landscape, and in doing so revised the vista which exhilarates Doctor Marianus. 'It must be clearly understood', he warned, 'that the easy and agreeable portion of our journey lies behind us.' Until now, he explained, he had been climbing towards the light. From here onwards, scrutinizing mental processes, he would go down paths which were bound to end in obscurity, returning him to the dark wood.

The new human beings were unashamed tenants of their own bodies. Virginia Woolf thought that the modern spirit arrived in Bloomsbury when Lytton Strachey with pretended prissiness asked her sister Vanessa about a white spot on her dress: was it semen? Josephine Baker added a new area to the human anatomy, and made that contraband precinct an erotic zone. Jiggling and wiggling inside her belt of bananas during performances of the *Revue Nègre* in Paris and Berlin in 1925 and 1926, she demonstrated a self-evident truth, hitherto overlooked: 'The rear end exists.'

Despite his tragic misgivings, Freud's clinical anecdotes helped along this emancipation of the body – for instance in the case of the young man who dreamed that he flew through the air at the opera, reached into his mouth and extracted two of his teeth. Another short and foolish story? Not after Freud interpreted it. The young man was homosexual, and felt attracted to his companion at the performance. The opera they were attending happened to be *Fidelio*, an

inappropriate hymn to married love; but this was the clue which enabled Freud, in a Sherlock Holmes-like feat of deduction, to explain that flight across the theatre. Beethoven's libretto borrowed a line from Schiller's 'Ode to Joy', which led Freud to speculate about another phrase from the poem set by Beethoven in his Ninth Symphony: a reference to the thrill of befriending your fellow man, which Schiller calls a 'grosse Wurf' – a great throw, as in a winning throw of the dice. So this must have been why the young man hurled himself through the air, into the arms of a would-be lover. As for the dental extractions, they were transposed upwards from below the waist. After an earlier rejection, the patient had masturbated twice to calm himself. The playful heterogeneity of this explanation suggests a surrealist collage. In his analysis, Freud combined the loud, comradely humanitarianism of Schiller and Beethoven with a love which still only spoke its name in riddles, and scandalously fused a night at the opera with a visit to the dentist.

The young man's trajectory through the air, hardly correct bourgeois comportment, thrillingly advertised the volatility of desire. Freud begrudged himself such escapades. In a dream of his own, he described feeling transfixed by shame, as if his feet were glued to the stairs. Interpreting the scene, he confessed some of his bad habits. In Vienna he divided his life between two apartments in the same building on Berggasse: he worked on one floor, and lived on another. Although he could only move between floors by using the public staircase, he treated this as an extension of his private domain, and sometimes undressed on the way up or down. This was his first offence against homely propriety; the second, which accounts for the imaginary glue, he had the decency to commit in a patient's house. He used to visit this old woman twice a day to inject her with morphia. He always scrupulously cleansed his syringes, and elsewhere in *The Interpretation of Dreams* he brags that 'in two years I had not caused a single infiltration'. He took fewer sanitary precautions when hurrying up to his patient's apartment. He often felt the need to clear his throat, and the concierge provided no spittoon; Freud, just to spite her, made a practice of spitting on the stairs. Hence the pool of incriminating glue. It is a fairly disgusting story, and Freud did not spare himself in examining its causes and consequences. He was addicted to cigars, which is why he needed to spit: 'Pharyngitis as well as heart trouble are both regarded as punishment for the vice of smoking.' He fell ill with cancer in 1923, and died of it in 1939. Deciphering his dream, he moralized the disease which killed him.

These scruples define a fault line in Freud's thinking, which corresponds to the breach he saw in civilization itself. *Studies on Hysteria* counted among its subjects 'people of the clearest intellect, strongest will, greatest character and highest critical power'; hysteria had transformed these solid citizens into lunatics. We cannot dissociate ourselves from them, because we are all, in our dream life, insane. Yet although Freud acknowledged Nietzsche's contempt for law-abiding, God-fearing virtue, he could not bring himself to share it – except in stray acts

(instantly regretted and atoned for) of domestic anarchism or untidiness. His worries insinuated themselves in the 'two pieces of consolation' he offered to Elisabeth von R. The first, inevitably, was that 'we are not responsible for our feelings'. This has become the litany of all those who nowadays blame junk food or alcohol or depression or 'black rage' or some other spurious syndrome for the crimes they commit. What Freud called a vice must now be euphemized as a drinking problem or an eating disorder. Today, when smokers sue tobacco companies for addicting them to nicotine, psychology has become a school of moral irresponsibility. Despite the awe with which he regarded the liberated antics of his dreamers, this was not the path Freud chose when considering his options on that sunny plateau, and the noble severity of his second consolation to Elisabeth von R. would find no favour in our psychobabbling age. He hoped to reassure her by pointing out that her ailments constituted her judgment on herself. They were a self-administered punishment for her unlicensed affection: 'the fact that she had fallen ill in these circumstances was sufficient evidence of her moral character'.

The contradiction which Freud could not resolve left his theories open to misinterpretation in two equally invidious ways. If we are insane by nature, why not surrender to our fantasies? In Freud's name though not with his blessing, the surrealists plotted a revolution of purposeless violence, an upsurge of jesting terrorism. Their practical jokes disrupted the respectful, solicitous contract which maintains society. Jean Cocteau's cronies telephoned his mother in the small hours to falsely inform her of her son's death in a horrific accident. André Breton stole the wallet of an impecunious waiter, and congratulated himself because the deed was so gratuitous. To act without self-censorship or concern for harm done to others constituted what Breton called 'lyrical behaviour'. The consummate surrealist prank, he thought, would be to rush down to the street and discharge a pistol into the crowd. The recent fashion for drive-by killings in American cities might have pleased him. As Breton reconceived it, the aim of psychoanalysis was to achieve 'the expulsion of man from himself'. Sometimes, when the demons have been uncaged, it is other people who have been expelled from their skins, whether they wished it or not.

Psychoanalysis, for Freud, was not meant to justify creative psychosis. But neither did it claim to dose our discontents with aspirin, as the therapeutic culture of America required: this was the second misreading of the gospel. On his way to New York with Jung, Freud remarked that they were importing the plague. The puritanism of their hosts supplied an effective remedy. Freud's disciple Ernest Jones, who infected Hamlet with the Oedipus complex in a celebrated critical essay, reported on an incident during an American lecture in these days of innocent immunity. A patriotic lady upbraided Jones, charging that Freud's filthy theories referred only to Austrian dreams: 'he had no business to speak of the dreams of Americans.... She was certain that all her dreams were strictly altruistic.' This society, constitutionally high-minded, rejected Freud's notion of the

death instinct and his vision of a civilization eroded by internal antagonisms. Later, when therapy became as popular as a patent medicine during the 1950s, it administered doses of conformity, unkinking heads as if nipping and tucking double chins.

Surreal savagery or meek adjustment to society: was this the choice which new human beings had to make? Freud sympathized with neither option. Tragedy is a clash between two imperatives, which have equal shares of the truth; the tragedies of Aeschylus, Sophocles and Shakespeare were the models for Freud's account of our predicament. He diagnosed the ailments of the twentieth century but, as he sadly admitted to Einstein, could prescribe no cure.

Exposition des
Arts Décoratifs

VESSELS AND VOIDS

Space and time, according to the Futurist Manifesto, perished in 1909. This sudden convulsion in the world's physical arrangements set the modern agenda, with its quest for new ways of representing experience. Hence the jumbled time-schemes of literary narrative, or the convergence of spatial planes in cubist painting. The new physics presented a greater challenge to architecture. The futurists thought that 'the opacity of bodies' had been disproved by X-rays. De Chirico in 1919 made the same point: the second sight of X-ray vision knew how to penetrate 'bodies that exist within matter' which remained invisible to the sun, and therefore demonstrated 'the metaphysical aspect of things'. These were the beautiful, insubstantial myths of modernity, which architects had somehow to put into practice. If 'space no longer exists', as the futurists declared, buildings were surely illusions. Matter had lost its bulk and opacity. By what means could a structure be made to stand upright? Whatever the conceptual strain, the challenge had to be confronted: architecture, after all, is the memorial any period in history leaves to itself – time made manifest as space.

Sigfried Giedion in 1941 looked back at the efforts of modern architecture to incorporate a newly unstable world-view. Giedion acknowledged that the building blocks deployed by architects had become suddenly unreliable, fickly relative. Space, in the geometry of Euclid, receded in strictly linear perspective, like the formal gardens of Versailles. Einstein showed the falsity of this layout: the classical vista depended on a fixed, autocratic point of view, fancifully exempted from the mobility and many-sidedness of everything in the universe. In fact, static points in space were events in time. Another manifesto issued by the futurists in 1912 pointed out that 'objects in motion multiply and distort themselves – just as do vibrations, which indeed they are – in passing through space'. A building does not settle comfortably in space, but travels by at speed. It is never still, because it alters as you walk around or through it. The philosopher Martin Heidegger chose to illustrate the tenuousness of being by a reference to buildings, apparently the most tangible and solid of things. We assume that

*ne Eiffel
wer, electrified
the Art Déco
ibition in
'25*

a building *is* – that it possesses a being. But where does that being reside? Not necessarily inside it. Is it a sum total of architectural details? Perhaps, Heidegger concluded, the being of a building is as subjective and indefinable as the smell which it exudes.

Such notions may be theoretically correct, but do they translate into bricks and mortar? In 1914 Antonio Sant'Elia's project for the Città Nuova experimented with mobilizing the structures he sketched. The tower blocks in his new city were to have exterior elevators. Modern buildings from the first eagerly gratified what Freud would have called the 'flying dreams' of their tenants. When not

Sant'Elia's des‌ for a station surmounted by an airport (1913–14)

allowing citizens to levitate, the masonry in Sant'Elia's imaginary city stood back to admire bodies which were more mobile. Three tiers of traffic circulated, with pedestrians, street-cars, automobiles busily scuttling on different levels; at the hub, Sant'Elia planned to build an airport on top of a railway station. His grandest design was for a powerhouse, the dynamo which would keep this collective body in motion. In his sketch, the romantic landscape is mechanized, thanks to a thundery sky and the diagonal abyss of the water chutes.

Mies van der Rohe in 1924 made a proud, stubborn disclaimer on behalf of modern architects: 'We will build no cathedrals.' They were forbidden to do so by what Mies called 'the will of the age', since buildings are the 'pure carriers' of that imperious force. A painting by the expressionist Kirchner might have been an illustration of Mies's dogma. In 1914 Kirchner painted the railway bridge across the Rhine at Cologne. Telescoping perspective, he made the light, tall, narrow iron arcs of the bridge soar exuberantly from the interior of Cologne Cathedral, like flying buttresses which have cast off their job of anchorage. The bridge extends the nave into the open air; engineering supersedes the obscurantism of religion. The prime mover in the new world foreseen by Mies was a turbine, not a deity. Sant'Elia's fantasies anticipated Dnieperstroi, or the Hoover Dam on the Colorado River. Even a power-station, for all its bulk, is just an apparatus which water passes through at torrential speed. The Città Nuova likewise existed to facilitate transit, and Sant'Elia happily accepted its transitoriness. A modern city, he thought, should not outlive its builders: 'the fundamental characteristics of Futurist architecture will be impermanence and transience.

THINGS WILL ENDURE LESS THAN US'. Sant'Elia himself was killed in 1916, and his capital of velocity remained unrealized.

Those who followed him agreed that modern structures ought to share the fragility of their human makers. Mies contrasted the obtuse bulk of Roman aqueducts with the levity and grace of cranes or electric pylons. The twined cables which hold up the Brooklyn Bridge are, he noted, as delicate as spiders' webs. Of course these confections of iron and steel can lift weights and support loads, but they do so by flexing, by absorbing shock and releasing stress. The new building materials of the twentieth century – ferroconcrete, or skeletal steel rods – had the fraught, resilient intensity which Bahr identified in his new human beings. The age, according to Giedion, sought to impart the highest tension to people and to things, relying (like Breuer with his image of cerebral electricity) on their capacity to manage the pressure. Robert Maillart built a pavilion for a cement company in Switzerland in 1939, its barrel vault as thin as an eggshell, and Alvar Aalto made furniture from equally flimsy sheets of plywood, elasticized by chemical alteration. Vladimir Tatlin designed a chair from a single tube of metal, bent into shape and cradling a moulded seat: bristling with tension, it looks like a briefly stationary bicycle.

Giedion considered Maillart's warehouses to be models of the way a modern building should behave. Doing without beams, Maillart engaged in a precarious balancing act. The concrete slabs of his floors were not inert, but co-operated at every point in holding up the structure. This for Giedion was the equivalent of a collage by Picasso or Braque. In those paintings, the surface – like Maillart's slabs – did the work and constituted the interest, rather than being the means of access to some remoter and more enigmatic realm. Maurice Denis in 1890 had made modern painting possible by astutely observing that a picture, before being a war-horse or a naked woman, was a flat surface on which colours are set down in a certain order. Nor, it might be added, is a building primarily the house of God or a temple to democracy or a place for storing money. It is a series of surfaces arranged in three dimensions and engineered to stand up; the colours are optional. Its meaning lies in the ingenuity with which it juggles opposing forces. The more improbable it looks, the better. What, after all, does our earth have to stand on? Giedion found an image of this cosmic conundrum – the dislocating legacy of the new physics – in a factory built by Walter Gropius in Cologne in 1914, which had a spiral staircase seen through glass walls. It represented movement equivocally poised in space, with no visible means of support. Fallingwater, the house which Frank Lloyd Wright constructed above a cascade in rural Pennsylvania in 1935–6, sent its cantilevered concrete slabs jutting out across the ravine (they soon cracked), and unfurled a flight of stairs into the stream.

Architects learned to enjoy this unfounded, floating universe, and became expert at playing its relativistic games. Le Corbusier called his Villa Cook, designed in 1926, 'la vrai maison cubique'. Giedion delighted in Le Corbusier's

Frank Lloyd Wright's Fallingwater *at Bear Run, Pennsylvania*

houses, as multifaceted as cubes and capable, like the faces in Picasso's cubist portraits, of disclosing new sides on request. Every spatial relationship was optional. The roof, being flat, might serve as an extra floor. Walls were elided, replaced by partitions between rooms which could be raised or lowered at will. Staircases, preservers of social hierarchy in older dwellings, gave way to ramps, gliding imperceptibly from one level to another. Picture windows admitted the outdoors. Le Corbusier himself jeered that traditional houses were all the off-spring of the mud hut. His own ventilated, variable structures were made of air, specimens of 'construction spirituelle'. The Villa Savoye, built between 1929 and 1931, seemed to hover. It resembled a white, rectangular cloud, apparently supported by nothing more than a row of thin struts. Home in the nineteenth century was a castellated retreat, defensive to the point of paranoia: the suburban villa of the clerk Wemmick in Dickens's *Great Expectations* even has a drawbridge, to signal its unbreachable privacy. Removing all barriers, Le Corbusier introduced to architecture Whitehead's perception that there was no such thing as an 'independent existence' in modern physical reality.

Gottfried Benn took the new physics personally. Space and time, as he claimed in his poem 'Verlorenes Ich', once held man together. What happened when they unravelled? The world had been thought to bits, and so had the ego, now merely a stray particle in a windily infinite field. In 1932 Benn found evidence for this psychological disintegration in architecture. Space had undergone a 'displacement from inside to outside'; its new dynamic expressiveness – the tensile agitation of iron and steel, the cantilevered risks it took – was a last gesture of despair and defiance. In the heyday of Kantian man, categorically sure of his own rectitude, objects in space possessed the same integrity as individuals.

Modern man had lost this confidence, and therefore could not bestow it on the structures he created. 'Spatial feeling' was now 'projected, extruded, metallically realized'. A building was a 'discharge mechanism', a means of expending surplus energy, a dramatization of death. 'The final stage' had to be near: at the time he wrote this essay on spatial nihilism, Benn sympathized with the twilit Wagnerian cosmology of the Nazis.

His rhetoric is cloudy and his political conclusions are suspect, but Benn's assertions fit many buildings which are animated by a modern spirit. Architects, he thought, rely on metal to realize a titanic projection of will. Hence the hubris of the skyscraper: the upper floors of the John Hancock Building in Chicago ricochet in the gales which blow in from Lake Michigan, so that coffee cups dance across office desks during stormy weather. Frank Lloyd Wright removed barriers between structure and nature at Fallingwater; the Hancock Building and its neighbour the Sears Tower fortify structure for a terminal battle against nature. Wright's Prairie houses merged with the terrain in which they were set, illustrating the continuum of space where all things happen simultaneously. Those heaven-storming skyscrapers make a related point about the way in which the earth is different in the twentieth century: they prove the redundancy of what Benn called 'the deistic epoch'.

Thrusting outwards or upwards, such buildings display 'the mind's formal and constructive powers'. But these illimitable, overreaching powers expire as they are expressed, because the centre is empty, a column of air. Among the wonders of the post-modern world there is one which, despite the very down-to-earth business transacted in it, perhaps fits Benn's bizarre view that architecture has learned how to flirt with annihilation: Norman Foster's headquarters for the Hongkong and Shanghai Banking Corporation, built during the 1980s. Unconcerned by its looming height, it is scarcely planted on the ground, and bestrides the street on slim legs. In any case, where on the teeming, exiguous earth of Hong Kong, constantly augmented by reclamation from

Norman Foster's Hongkong and Shanghai Bank (left) and I.M. Pei's Bank of China (right)

the sea, could it find a toehold? Its weight is carried by masts, from which its dozens of office floors are suspended. The maintenance cranes on the roof suggest that it was actually built from the top downwards, like a rope-ladder unfurling from the sky. Diagonal girders on the outside recall Mies's image of the spider's web, but this levity is deceptive: the glass walls are braced against battery by typhoons. It shamelessly contrasts the constructive powers of the mind with the ruder, wilder arrangements of nature, in the jungly mountain which rears behind it and the harbour – a chaotic watery street – which opens up in front. The apparent impossibility of the thing is its proudest boast, and its boldest technical feat is the vacuum inside it, where an atrium rises to the roof, cross-sectioning the floors of workers.

Perhaps it is a monument to the immateriality of the money which built it – to the airiness of the notional wealth which flows in and out through fibre-optic cables and spills from computer screens in rows of digits. The executives who commissioned Foster told him they wanted a building which looked like a bank. But what does a bank look like? Not, in the days of electronic money, like a strongbox. The building symbolizes money, which is itself a symbol – but of what? Wealth is no longer dug from the earth. The terrain Foster's building stands on is valuable, but not because there are precious minerals in it. Money now means mobility, and is itself in perpetual motion, circumnavigating the earth in seconds. Foster's bank, appropriately, resembles a spaceship, resting on its pad between flights; and next to it is an even more audacious neighbour, the Bank of China designed by I.M. Pei, whose glass walls – an aquarium for passing clouds, once again questioning the relation between inside and outside – execute several hair-raising turns on the way up and conclude in a needle aimed at the sky. Pei's building presumably also contains some abstract hoard of money, but that function hardly seems relevant when you look at it. Its purpose goes well beyond the conservation and multiplication of assets. It advertises the daring of Spengler's modern, Faustian man and his head for heights. In Benn's terms, it pushes 'the spirit of construction...to the limits of immateriality' and asks what will come 'after nihilism', when the sky has been punctured by that needle.

The challenge to the sky began in 1889 when Eiffel completed his tower, an ornamental flagpole for the Exposition Universelle which celebrated the centenary of the French Revolution. The fair announced the modern contraction of the globe. A commentator remarked that while Jules Verne had dreamed of travelling round the world in eighty days, here it could be done in a single day as you strolled from a gallery of industrial machines to an African village, from Aztec pyramids to the pagodas of Angkor Wat. The journey took you backwards through time: the architect Charles Garnier mounted an exhibition of human housing, setting troglodytic caves against the glazed, metallic labyrinth of the Grand Palais. A ride up the Eiffel Tower took you in a different temporal direction – into the future. This was as far above the earth as anyone had ever

climbed; with Paris flattened and eerily quietened far below, it was like looking back at the world from outer space.

The tower demonstrated the prowess of the new technology, inaugurating a second iron age. No building made of stone could have reached so high. But its garishness caused offence, and it was tolerated only because, like all the tepees and pagodas on the fairground below, it was due to be demolished when the Exposition closed. It survived by accident, because a use was found for it. Eiffel's whimsical Babel became a site for conducting experiments in optics, aerodynamics and meteorology, and in 1907 it began to serve as a radio transmitter, beaming broadcasts overseas. Thus it contributed to the construction of a new scientific worldview, creating both an intellectual context and a justification for itself. Marc Chagall painted it in 1911, rearing beyond soiled tenements and the railway viaduct of the Pont de Passy. Its radiance tears the sky like a frayed cloth: an alternative sunrise emanates from it, as it proclaims its own gospel of electric light.

Blaise Cendrars said that the tower was at first literally inconceivable. Like the cube over which Wells's characters puzzle in *The Time Machine*, it created a plastic puzzle. You could walk around it, as if around a statue. But you could also see through it (as well as riding up it). During all these perambulations, it was constantly changing, reversing relations between inside and outside. It had no plumb line. Nor was there a definitive way to look it, or a mandatory place to look at it from. 'Under the laws of realism it crumbled,' Cendrars commented, 'and the laws of Italian perspective could not catch it.' Here was the relativity theory built in iron, or the uncertainty principle absorbed in a merry, maddening dance. 'There are no columns and supports, no foundations any more': this was how Hugo Ball, in his 1917 lecture on Kandinsky, defined the spirit of the age, though he might have been describing the effrontery of the tower. To walk down the spiral stairs, Giedion added, gave 'the moving spectator a glimpse into four-dimensional experience'. The tower turned into a paradigm for modern architecture: 'scaffold and skeleton of the future' as the expressionist Theodor Däubler called it in 1916. It belonged to the future because it so unashamedly showed off its skeleton, wearing its innards – the iron bars which braced it, the wheels and pulleys of its elevators, those coiling stairs – on the exterior. Adolf Loos thought that buildings should confront the street with a blank face, the circumspect mask worn by the city-dweller. The Eiffel Tower, disdaining artifice and concealment, appeared on the street naked.

It caused a scandal in 1889 because it looked like nothing on earth. Hence the need to invent a meaning for it. Baudelaire, atheistically revising Genesis, announced that in the beginning the imagination created analogy and metaphor, shattering the world in order to put it together in a multitude of new ways. The tower might have been a kit of parts especially invented for this cosmic game. The novelist Huysmans saw it as a cathedral of capitalism, but thought that Eiffel had failed to give it a properly devilish ferocity. Throughout its life it has been a gift to cartoonists because, possessing no identity of its own,

it can be turned into whatever you wish – most often, since it bestrides Paris, into an elegant female leg, its girders a tight fish-net stocking. The tower universalized itself after the Exposition Universelle. In 1919 Cendrars wrote a poem locating likenesses of it everywhere. A palm tree in Asia and a giraffe in Africa cause him nostalgic twinges, while at the North Pole the aurora borealis imitates the tower's festive fireworks.

The tower, so manifestly improbable, became for the surrealists a place where anything could happen. In 1921 Jean Cocteau wrote *Les mariés de la Tour Eiffel*, a combination of classical tragedy and surreal farce, performed by the Ballets Suédois with a collective score by the composers known as Les Six. During a wedding party on the tower's first platform, a cyclist pedals by, looking for the road to Chatou, a lion (not a birdie) jumps from a camera, and a hunter takes aim at an ostrich which, when it flutters to ground, proves to be a telegram. The tower by now had an aerial, and Cocteau personified it as 'a beautiful young woman in mittens, whose sole former employment was that of reigning over Paris and who today is simply the telegraph lady' – a working girl who relays messages and knows all the local gossip, not some high-society hostess superintending the city.

The tower's transparency was a reminder that matter consists of vacancy, and its metaphoric versatility showed up the same airy emptiness in the words we apply to things. This suited it to the form of the calligramme – a poem printed in the form of a pictograph, with the words aligned on the page to make up a diagram of the object itself. In 1918 Apollinaire published a 'Composition en forme de Tour Eiffel', in which the tower broadcasts a tiered message to the world and, claiming to be the eloquent voice of Paris, hurls a curse at the Germans. White paper, seen through the intricate grid of letters, is the sky on which the tower imprints itself. Eiffel's structure thus lent its patronage to the twentieth century's deconstruction of language: the calligramme robs words of density, and allows you to see through them. The Nazis, during their occupation of Paris, symbolically conquered the tower by hanging a V above the first platform. The tower itself is an inverted V; the Nazi letter, standing the right way up, vengefully turned the tower on its head. V of course meant 'victoire', addressing the abased French in their own language. Below the platform the conquerors slung a banner in German: 'DEUTSCHLAND SIEGT AUF ALLEN FRONTEN'. At the liberation, in another cartoon, the tower reassumed female form, stuck a tricolour in its cap, and vaulted across the rooftops to embrace General de Gaulle. All these allegiances were temporary and opportunistic. In Baudelaire's universe of correspondences, an object can symbolize anything at all, or everything in turn.

The tower's aeration prompted Moholy-Nagy to classify it in 1928 as sculpture, not architecture. He called it 'a broken-through, completely perforated "block"'. Welded and riveted together by force, the tower was clearly an assemblage. It therefore begged to be disassembled, playfully appealing to the nihilism which Benn found to be characteristic of twentieth-century structures.

This made it a precious conceptual tool for painters, who modernized vision by breaking reality down into its constituent atoms. Georges Seurat painted the tower before its completion in 1888: his flecked, luminous dots, separately applied, exactly match the additive procedures by which it was engineered. Breaking off before the top, it gently decomposes, merged with the swimming molecules by which Seurat represents the sky. As he saw, the tower cannot be separated from the elements in which it lives and which live inside it. As a lattice, it scatters light; as a transmitter, it animates the air. Contrariwise, energy from outside shudders through it and makes it shiver as you stand on it.

The painter Robert Delaunay specialized in dislocating the tower, knocking it down or uprooting it in a series of views made after 1910. Sometimes it folds up like a concertina and tumbles onto the grey, huddled Paris roofs; on another occasion it begins to gyrate in the sky; it subsequently takes flight, and swoops above the city's neoclassical porticoes. Delaunay's style was called 'simultaneist': a variant of cubism, with its study of converging angles. The label suited his favourite subject, because the tower too, with its overlapping points of view, was a simultaneous phenomenon. It reminded Rodchenko, on his visit to Paris in 1925, that the responsibility of a modern artist was 'to show the world from different points,…to look from all sides'. Seeing it from a distance, Rodchenko thought the tower banal: a stupid figurine, done to death by its reproduction on postcards. Then, travelling past on a bus, he saw it from beneath, and was exhilarated by the staccato succession of iron bars. At last it gave him a sense of 'mass and construction'. Photographically, he considered 'the most interesting modern shots' to be those taken from above, below, or diagonally. The tower, which posed in all of these dizzy positions, acted out Rodchenko's admonition: 'We must revolutionise our way of seeing.'

Delaunay's multiple versions enforced the lesson about variability and relativity, as did the lithographer Henri Rivière in his book *Les trente-six vues de la Tour Eiffel*, published in 1902. Rivière's thirty-six studies – taking the tower from its beginnings, as workers assemble its stumpy legs, to its eruption in fireworks on Bastille Day, and looking at it from every corner of the city – paid homage to Hokusai's thirty-six views of Mount Fuji, but in doing so he acknowledged the difference between the sacred mountain and this tenuous manufactured monolith. The modern city lacks supernatural presences. In most of Rivière's scenes, the tower is a faint, distant, irrelevant smudge on a wintry horizon. Do the people who inhabit these innocuous, downtrodden industrial suburbs even live in Paris? Everyone in Japan reveres Fuji, but cats chasing each other across the slates or a disconsolate beggar on a bench ignore the landmark behind them. The last image in Rivière's sequence is of a painter at work on the tower – an artisan, not an artist, clinging to the girders half-way to the summit above the featureless, slate-coloured ocean of Paris, intent on his infinitesimal job of touching it up. The tower was projected into the air by imagination; it takes endless reimagining to keep it there.

Apollinaire cited the tower as a byword for abstraction. Why should art have to represent reality? The Eiffel Tower, he pointed out, became useful only late in its career, when it sought employment as a telegraph lady; its construction was 'désintéressée' – disinterested, purposeless. René Clair jokily abstracted it from the real world below in his film *Paris qui dort*, made in 1923. A crackpot scientist immobilizes Paris with a magic ray; only the caretaker in his cabin on top of the tower and the passengers on a plane coming in to land at Le Bourget escape its effects. Awake in a sleeping city, the dilettantes take up residence on the tower. They loll on the edge of its platforms, tossing jewels over into empty space or making paper darts from money. It is their iron Olympus, an eyrie for idle, self-indulgent, ennui-ridden gods.

In the same year Mayakovsky had a chat with the Eiffel Tower, persuading it to hurl such parasites overboard. He arranged a secret rendezvous with the tower in the Place de la Concorde; it took advantage of thick fog to slink across the river. He whispered sedition in its radio ear, regretted that so fine a specimen of engineering had wasted away in 'Apollinaire moods', and warned that, as soon as it rusted, it would be sent to the scrap heap in Montmartre. Instead he invited it to escape this fate by emigrating to Moscow. Delaunay said that the tower 'communicates...with the whole world', transmitting time signals and radio waves from the pin-point of its omniscient head; Gino Severini in his Futurist painting 'Paris Métro-Ferris Wheel-Eiffel Tower' had dynamized it by association with the shuttling rains and the rotating wheel; Mayakovsky challenged it to march across Europe with its powerful paws, browbeating the sky with slogans in Morse code as it went. He also hoped it would help foment a revolution in Paris. The Métro, he reported, had already joined the cause, and its tracks would be torn up to bludgeon opponents. His poem ends with a promise to arrange a visa for the Eiffel Tower.

Russia needed this fellow-traveller, because Tatlin's tower, designed in 1919, had not been built. Tatlin set out to surpass Eiffel: his tower would have been taller, with radio transmitters and cinematic projectors growing from the top level. (It was left to American skyscrapers to go a stage further: the spire of the Empire State Building had a mooring post for Zeppelins.) Whereas the Eiffel Tower relied on painters like Delaunay to jolt it into action, Tatlin – with his cube, pyramid and cylinder rotating at different, syncopated speeds – dreamed of actually mobilizing his monument to dramatize the will of history.

This remained the grand fantasy of modern architects, synchronizing their structures with a universe which had lost its fixity and anchorage. The earth was different: it could not be relied on. Frank Lloyd Wright's Imperial Hotel in Tokyo, completed in 1922 and demolished in 1968, withstood earthquakes by balancing itself on a liquid sub-soil, not digging through it. Expansion joints allowed its separate sections to respond to pressure by sliding apart, slotting together again when the vibration relented, like the segments of an aeroplane buffeted in flight. The articulated parts floated on an underground lake, poised

on central poles sunk into the marsh. The whole elaborate complex was a feat of juggling. Krutikov sketched his cities in orbit; the cross-section of an ocean liner made Le Corbusier dream of a navigable city. More pragmatically, Le Corbusier compared his prototype for cheap, mass-produced housing with Henry Ford's Model T, which had bestowed mobility on the working man. A box with factory windows stood on tiptoe, allowing vehicles to circulate around the ground floor. Le Corbusier called the scheme '"Citrohan" (to avoid saying Citroën)...a house like a car'. Richard Neutra, an apprentice of Mendelsohn and Wright, kept up the analogy in his steel-framed, glass-walled Lovell Health House, built in Los Angeles in 1929. He illuminated the staircase with headlights from a Model T Ford, as if bringing the highway indoors.

Great buildings are microcosms, models of the way society works. Van Gogh in 1888 referred to the 'obeliscal' communities of the past, architecturally sturdy and coherent: individuals were stones, brought together for the common good. Tatlin also used geometrical metaphors in explaining how his Monument to the Third International mapped out the future. The three levels were encircled and unified by a spiral, which for Tatlin was 'the most effective symbol of the modern spirit of the age'. The triangle, ideally equilibrated, expressed the order of the Renaissance (like van Gogh's obelisk). For the bourgeois society of the nineteenth century, 'the dynamic line...was the horizontal', which took possession of the land. But modernity, set free from material want, springs into the air, lifted up by the energy which the spiral stores in its coils. Tatlin had understood the meaning of those curling stairs inside the Eiffel Tower. Once again, the structural fantasy was realized elsewhere, by the ebullient spiral of Wright's Guggenheim Museum in New York. Van Gogh, surveying the rubble left behind by *laissez-faire*, hoped that socialism would rebuild the obelisk. Not, however, in ponderous stone: as Tatlin said, the lighter, freer constituents of modern architecture were iron and glass, both born from fire.

The dream of a transmigrating tower came true, but with a difference. In 1958 the remains of the shoguns, Japan's feudal rulers, were evicted from their mausoleum in Shiba Park to make way for the Tokyo Tower – a facsimile of Eiffel's original, though of course a few feet taller, and painted a garish red. It treads on this venerable ground because its spire is a television transmitter, and Shiba is the best place in Tokyo for propagating electric waves. Fuji can be seen from the platform, whenever the smog clears. Rather than emigrating to Russia, as Mayakovsky proposed, the Eiffel Tower chose exile in the capital of the postmodern world, a city confected from quotations. Here it can reminisce with other uprooted monuments about the Europe they have lost: on a side street behind the Tokyo Tower stands the Volga restaurant, which wears St Basil's cathedral on its roof.

The Guggenheim Museum is an upside-down ziggurat, nicknamed by Wright, who spelled the word backwards, a taruggiz. Exploring it you start, according to

the same logic, at the top. Dispensed from having to climb stairs, you are wafted to the roof by an elevator, and slither back down on a ramp which curls around the walls. It takes some self-control to concentrate on the paintings, because a gulf yawns on the other side of the low parapet. The building has an empty centre; it roofs over the void.

This evacuation of architecture is a bold and dangerous modern ambition. Solidity mattered only so long as the bedrock remained secure. But the consciousness which called itself modern took pride in coping with a congenital instability. The romantic poet Giacomo Leopardi thought that the noblest talent of human nature was our capacity 'to imagine the infinite number of worlds' and to be exhilarated by the prospect of our own littleness. Aware of the nothingness beyond the horizon, we have the strength 'to suffer the want and the void'. George Grosz declared on behalf of his Dada colleagues 'We were complete, pure nihilists, and our symbol was the vacuum, the void'. Schoenberg in 1911, in his treatise on harmony, claimed a similar mental valour for his music. His researches disrupted the old order of tuned spheres; atonality vagrantly explored a universe which was no longer finite. He banned the use of harmony as metaphysical glue, like 'cement or bricks of a building', as he put it in a letter to the composer Ferruccio Busoni. Art, if it was to keep faith with 'the eternal', could not 'shy away from the vacuum'.

This cosmic frisson is built into the architecture of our century. Wright was fond of Lao-tzu's maxim that 'The reality of a vessel is the void within it', and he exemplified the adage at the Guggenheim. Le Corbusier defined the modern virtues as 'emptiness, cleanliness, absence'. Loos applied the same law to interior decoration, decreeing that rooms must be planned centrifugally. Furniture, Loos proposed, should be confined to the corners, and placed straight against the walls, not at an angle: 'the centre is empty, a space for movement'. This was his reproof to the *horror vacui* of the nineteenth century, which cluttered all available surfaces and choked space with gewgaws and keepsakes. Bourgeois décor – stuffily overelaborate, gravitationally loaded like the weighted hoops of a crinoline – created a society in which movement was difficult. Clearing the floor, Loos prepared for a society intent on perpetual motion. The ramp which slid through Le Corbusier's Villa Savoye was more like a highway than a staircase. Nineteenth-century interiors were treasuries, fiercely retentive. A modern house was meant to be a transit lounge: you pass through at speed, so there must be no obstacles to trip you up, and certainly no sentimental trophies to deter you from leaving. Even rooms set aside for rest became sites of furious energy. The Bauhaus designer Marcel Breuer installed climbing rungs, a punching bag and a basket-ball hoop in the bedroom of Erwin Piscator's Berlin apartment.

Loos borrowed the centrifugal layout of furniture from Japanese houses, just as Wright learned about internal emptiness from a Chinese sage. In 1923 Boris Arvatov designed his own utopia, which also deferred to Eastern influences: an aerial city of glass and asbestos, poised on springs. It relied on asbestos

to reduce weight. Now we know, of course, that asbestos causes cancer; nothing could more succinctly sum up our loss of faith in the future envisioned by the modernists. Arvatov wanted his structure to rotate, like a paper-walled Japanese house which can be swivelled on its axis. Unfurnished rooms in flimsy dwellings: the example of Japan taught architects to renounce the traditional values of their trade with its dogged dependence on stone and brick and its desire to erect monuments which would stand for a thousand years. The Japanese house with its variable modules and its short life-span was, as the architect Richard Rogers has said, modern a millennium ago.

In 1925 Antonin Artaud addressed an open letter to Buddhists, 'who are not in the flesh', begging them to overturn a nation of iron and industrious wheels, in which the brains of men could not see beyond 'an activity of roofs, a blossoming of façades'. Artaud prayed that these mystical intercessors would put an end to the insanity of Western technological progress: 'come, tear down our houses.... Design us new houses.' Visiting New York in 1929, the French essayist Paul Morand reacted as if that revolution had already occurred. He marvelled at the transition from gravity to weightlessness, from dreams of immortality to a careless evanescence, and the glazed skyscrapers prompted him to remark that 'the voids have definitely mastered the solids'. Whether he knew it or not, Morand was paraphrasing one of the laws of modern architecture, propounded by Gropius, who claimed that glass would become ever more important as a structural element, thanks to 'the growing preponderance of voids over solids'.

Alfred Stieglitz caught the city during a building boom in 1910, and showed it in the process of voiding itself. His photograph *Old and New New York* contrasts a row of squat brownstone villas, relics of the past, with a blueprint for the future rearing above them: a skyscraper whose floors as yet contain nothing but air, with cranes hauling it further upwards. To the modern eye, this was a building's ideal state. Unfinished, with its engineering exposed, it had not yet been filled and fussily domesticated by human tenants. The philosopher T.E. Hulme in 1914 praised 'the superb steel structures which form the skeletons of modern buildings', and lamented their 'gradual envelopment in a parasitic covering of stone' as 'one of the daily tragedies to be witnessed in London streets'. In 1919 in his tract on *Alpine Architecture* Bruno Taut – another utopian projector, who fantasized about houses of crystal glinting on mountain peaks – called for an 'architecture of scaffolds, of space opened up to the cosmos'. Much later, architects contrived to save buildings from disappearing behind that thick integument of stone which disgusted Hulme. The scaffolding could stay in place, worn as an exoskeleton. The Centre Pompidou in Paris, designed by Richard Rogers and Renzo Piano during the 1970s, refused to conceal its intestines – its supportive girders, its coloured ducts for wiring, plumbing and ventilation, and its outside escalator like a transparent caterpillar.

The emblem of the new architecture – and of the new spatial mentality which accompanied it – was the pagoda, an orientalized Eiffel Tower. Maggie

Verver in Henry James's novel *The Golden Bowl* (1904) meditates on an imaginary pagoda plated with porcelain and bedecked with bells. The metaphor, like the quizzical cube in *The Time Machine*, serves to illustrate the multiple facets of the situation in which she finds herself: her new husband has resumed an affair with a woman who is now Maggie's stepmother. The pagoda fits the ambiguous, endlessly recessive case because its space, 'sometimes...ample and sometimes narrow', alters as she walks around it, sampling 'apertures and outlooks' which all offer different views. Although you can see straight through it, the pagoda has no obvious doors giving you access, so that it remains 'impenetrable and inscrutable'. The image was taken over by Virginia Woolf in *Night and Day* (1919), where the structure represents a teetering mental folly: a character has built 'one of those piles of thought, as ramshackle and fantastic as a Chinese pagoda'.

The novelists of the early twentieth century revealed the holes in consciousness – its false starts and lapses, its deviations from logic, its helpless subjectivity. Hence the aptness of the pagoda, the cathedral of a religion which accepts vacuity; its five storeys symbolize the mystical nothingness of life. All things in the world, according to Zen numerology, are combinations of five – the senses, or the elements (earth, air, fire and water, with the addition of ether) – so the pagoda with its ghostly transparency reminds us that everything, including our own bodies, is insubstantial, fated to moulder and evaporate. This is why the crazed acolyte in Yukio Mishima's *The Temple of the Golden Pavilion* (1956) burns down the shrine of Kinkaku-ji in Kyoto, an act of arson which in fact occurred a few years before Mishima wrote his novel. The temple, soon reconstructed as an exact replica of itself, is as illusory as a mirage. Mirrored in its pool, it defies you to distinguish the reality from the reflection. And it is as empty as those rooms which Loos designed according to Japanese principles: Zen temples contain no sacred, precious relics. To destroy it, for the priest in the novel, is to release it from the prison of materiality. Its unbelievable perfection, he decides, is 'a beauty *which did not exist*,...an adumbration of nothingness'. Fire, reducing the golden walls to air, returns the building to the nonentity from which we all came.

Modern architects had already made such nihilism a structural method. Wright, explaining his design for the National Life Insurance Company in Chicago, remarked that 'the exterior walls, as such, disappear.... The walls themselves cease to exist as either weight or thickness'; a curtain of glass with copper mullions was to replace them. This would have been a thirty-one-storey pagoda, its floors growing from a central trunk. It is amusing to think of life expectancies being anxiously and profitably calculated inside a structure which, as an adapted pagoda, advertised the worthlessness of life itself. The tower, however, was never built, but between 1949 and 1956 Wright did construct pagodas for S.C. Johnson & Son and the H.C. Price Company – in Racine, Wisconsin, a column with a hollow core, glowing inside its membrane of glass like a habitable, many-tiered cloud; and in Bartlesville, Oklahoma, a slim, quivering arrow, its balconies protruding like the pagoda's overhanging ledges.

Le Corbusier's
Maison
Citrohan
(1920)

Wright also applied Lao-tzu's principle in the Prairie houses which he designed for the suburbs of Chicago and points further west. The long, low sweep of their jutting decks and flat platform roofs extended towards a borderless horizon. Inside, the floor plan abolished the cellular divisions of the bourgeois household to create one 'big room', as free as the plains or the sky. Pioneers had very recently pitched tents on this land, or impromptu cabins which they abandoned when they moved on. Wright's dwellings paid tribute to that questing spirit, mistrustful of roots and foundations. Designing a resort at Ocatilla in Arizona, he camped in the desert with his team of helpers during the winter in 1927, their ephemeral sheds guarded by bristling cacti. A house, for him, was not a bunker. It enclosed space, but did so only provisionally. At its centre, like a beacon lighted inside a circle of wagons, was the fireplace; its flames with their restless, entrancingly random energy demonstrated that life means motion or circulation. The architecture of the past worshipped permanence, and therefore consecrated death. Loos commented that if, during a walk in the woods, we happen upon 'a tumulus six feet long by three feet wide, shaped by the spade into a pyramid', we reverently tell ourselves 'Someone is buried here. This is architecture.' Wright – like Sant'Elia in his call for short-term cities – rejected this solemn memorial function. For him, architecture announced that someone was living here, rather than marking a grave.

The void within the vessel enabled it to embrace a landscape, like those Prairie houses incorporating the outdoors. Further west, architecture gallantly sustained a battle with nature which it was bound to lose. Wright's compound for A.M. Johnson in Death Valley, crouched on the edge of a canyon, followed the topography of the desert, levelled and abraded by erosion. In the Los Angeles suburb of Los Feliz, he designed assemblages of concrete blocks for Charles E. Ennis and Alice Barnsdall, like Mayan temples crumbling in a tropical thicket. Across the ocean, inside the same ring of fire which agitates the earth around the margins of the Pacific, his Imperial Hotel in Tokyo prepared to sit out earthquakes.

More recently, Tadao Ando has designed buildings which defer to nature or disappear into it. His Sumiyoshi Row House in Osaka, with its courtyard open to the bitter or sultry Japanese weather, devotes a third of its tiny space to a void. The materials of architecture, Ando points out, are not confined to stone and wood. The elements also contribute to a building, which must make room for

them. The Church of the Light in Osaka, completed in 1989, has a cross behind the altar formed by unglazed slits in the wall, allowing light and wind to penetrate its defences. Insulation seems improper, a metaphysical lapse: Ando's thin walls apologize for their own substantiality, aspiring, as he says, to the state which Zen Buddhism calls 'mu', or nothingness. These vessels serenely wait for the moment when, sooner or later, the void decides to swallow them.

The constructive techniques of architecture mimic current hypotheses about the way the world itself has been put together; and because they design spaces for people to use, architects also fabricate ideal societies. 'New styles of architecture', as W.H. Auden put it, signify 'a change of heart', and the new architectural materials of the twentieth century ordained changes in the way we live. Sant'Elia listed the 'surrogates for wood, stone and brick' approved for use by futurist architects – 'reinforced concrete, iron, glass, cardboard, fibre' – and praised their 'elasticity and lightness'. Wright, piling up Mesoamerican blocks in Los Feliz, extolled concrete as 'a plastic material'. The workshop at the Bauhaus made chairs and tables from plywood, valued for its pliability. 'To build', Gropius decreed, 'is to shape the patterns of life', and modern life demanded a setting which was flexible, adaptable, free.

Like Le Corbusier sneering at the mud hut, Paul Scheerbart, in a treatise on the use of glass published in 1914, dismissed 'brick architecture and wooden furniture'. We live, he lamented, in closed rooms. Glass walls promised to banish this spatial dread, the ailment of the cowering nineteenth-century bourgeois like Dickens's Wemmick. They let in the healthful light; according to the messianic predictions of Bruno Taut, they made the house 'a vessel for the divine' or 'a salutation of the stars'. Schoenberg, commemorating his friend Loos's sixtieth birthday in 1930, paid him the highest of compliments by declaring that his interiors treated space three-dimensionally, seeing every object 'from all sides simultaneously, ... as though it were made of glass'. This was the visual skill first put into practice by the cubist painters. Schoenberg viewed it, more exaltedly, as a prophetic talent, a capacity to look beyond obstructions and to foresee the future. He likened Loos's modelling to that of Michelangelo, who carved his statue of Moses – that icon, for Schoenberg as for Freud, of mental omnipotence – from a single hillock of marble, as if the stone had been transparent. Hofmannsthal's *Arabella*, the last of his opera libretti for Strauss, may be set in 1860, but one of its most striking and self-consciously modern images locates it in the 1920s, when it was written. Adelaide tells the fortune-teller she has engaged 'You see through men as through glass', crediting her with the gift of vision extolled by Schoenberg, Scheerbart and Taut.

Mies van der Rohe built a pavilion for Germany at the Barcelona Exhibition in 1929 with glass walls held in place by chromium bars, and designed an office tower for Berlin which had a steel spine and a skin of glass, enabling it – as he said – to commune with 'universal space'. The tower's angular peak, like a

vitreous alp, evoked Taut's fantasy of a crystalline house perched in the mountains. Mies, however, moved Taut's tabernacle of silence to the uproarious vicinity of Friedrichstrasse Station. Glass never had a chance to cleanse and sanctify the city: the tower was not built. In his scheme for the League of Nations at Geneva in 1927, Le Corbusier designed an assembly hall in glass, the model for a newly co-operative globe. When his project was rejected, Le Corbusier adapted it for Centrosoyuz in Moscow; there he was once again frustrated, this time by Stalin's conservative bureaucracy. Nevertheless, when the Soviet regime attempted to reform itself in the late 1980s, the idealistic metaphor of glass had a comeback: Gorbachev called his new policy of openness 'glasnost'. After Germany's reunification, Norman Foster was engaged to redesign the cratered, scowling Prussian pile of the Reichstag in Berlin, in preparation for the government's return from Bonn at the end of the century. He employed the same symbolic materials, setting a dome of steel and glass above the debating chamber, with a twisted cone of mirrors to refract the sun.

Oskar Schlemmer in 1922 recorded a waking dream of 'a perfected glass culture', with factories as brightly glorified as cathedrals irradiated by their rose windows. 'I have seen the future', he reported. At Dessau, Gropius built a house for that future, its glass-curtained walls exposing the artisans busily at work or contentedly at play. The new human beings who worked at the Bauhaus were exponents of a doctrine which they described as 'New Living'. Their apartments were clean, well-lighted places, their bare walls kept clinically, calmingly bare. They did not rely on possessions to tether them to earth. Furniture was minimal, and designed so that it could be packed away; equipped with collapsible battens, tables and chairs perched on the floor like birds alighting briefly on a branch, rather than putting down roots like a tree.

Marcel Breuer's armchairs of tubular steel with canvas upholstery were, in his view, 'necessary instruments of contemporary life'. Tensile and springy, slit to increase mobility, they shared the nervous, shock-absorbing tautness which Benn saw as the 'spatial feeling' of modern man. Like small domestic Eiffel Towers, they also asked how much stress a structure could bear. Would the aluminium brackets, tightly stretching the canvas, cause it to rip apart? Breuer scoffed at drowsy, overstuffed sofas. If a house by Le Corbusier was a machine for living in, then his chairs were machines for sitting on – until, ricocheting from the sprung seat, you leapt back into action. Of course people had to rest, but Breuer hoped that this design fault in the human anatomy would soon be overcome: 'Every day we are getting better. In the end we will sit on resilient air columns.' A film-strip of his chair designs in 1926 imagined how this evolution might occur. The cantilevered seat suspends the sitter in a steel frame, which the body never touches. Then the chair dematerializes, and the sitter, legs crossed, hovers in mid-air, riding thermal gusts like a glider. While mankind awaited this Martian future, Breuer designed folding chairs for use on boats, terraces, playing fields, summer houses and outdoor cafés. All the hopes of modernism – its plan to

*Chairs by Ma[rcel]
Breuer, designe[d]
in 1925*

liberate humanity from repression with the aid of what Breuer called 'healthy body culture' – travelled in those deck-chairs. Auden announced the official defeat of the revolution when he observed, in his poem '1929', that 'The chairs are being brought in from the garden.' The good weather is over; in sanatoriums, Auden added, the patients are 'less certain of cure'.

A new life required new clothes, as well as new spaces to live in. The relation between architecture and costume preoccupied Loos. His Haus am Michaelerplatz lodged the firm of Goldman & Salatsch, which sold the wares of English tailors. Loos admired the discreet anonymity of English clothes. His buildings presented a blankly undecorated face to the street; likewise, in a city of disconnected individuals, 'modern man', he argued, 'uses his clothing as a mask. So monstrously powerful is his individuality that it can no longer allow itself to be expressed through clothing.' His logic was startling, and had its own neurotic modernity: the uniform buttons up wildness. Because we are so violently differ-ent from one another inside ourselves, we try to keep the peace by looking the same on the outside. The utilitarianism of English clothes, like the Haus am Michaelerplatz confronting the Hofburg, mocked the ceremonial flummery of Viennese court costume. Loos reported for duty during the war in a uniform which Goldman & Salatsch had customized for him: his collar was open, not reg-imentally stiff, and he wore leggings instead of heavy boots. The response was a threatened court martial. But, as Oskar Kokoschka pointed out, the boots rejected by Loos cost Austria-Hungary the war, because they afflicted the im-perial army with sweaty feet.

As well as the sleek Norfolk jackets and sober frock coats of Edwardian England, Loos commended American work clothes, and in 1908 prophesied that the future belonged to the man in overalls. The modern world, as it turned out, was proletarianized by the firm of Levi Strauss, which began making jeans for Californian gold-miners. Levi Strauss, before importing denim, used tent canvas, held in place by rust-proof copper rivets: the same principle, and the same materi-als, as in Breuer's chairs. The individuality which Loos thought so 'monstrously

powerful' had come close, as Theo van Doesburg claimed, to destroying the world; such egomania had to be exterminated, and the uniformity of a new dress-code cancelled it out. Russian-style smocks were customary at the Bauhaus. On outings, members dressed alike in blue mechanics' overalls. The women of course wore trousers. Schlemmer in 1925 reported on a personal initiation into modernity. For a visit to Paul Klee, he put on a pair of white linen trousers, held up by a narrow belt, also white. He added white shoes, and a shirt which he called 'idealistic': the linen flag of an unbesmirched world. The costume 'has transformed me completely. The open collar is a blessing! I never want to wear a stiff collar again.'

Not all bodily reforms were so welcome. At the Bauhaus, the counter-revolution began in the cafeteria. Johannes Itten, who ran the school in Weimar before it moved to Dessau in 1925, wanted to introduce a vegetarian Mazdaznan diet. Itten insisted that 'the thought processes and emotions must be controlled'. Schlemmer doubted that rectitude would be guaranteed by a pure stomach, and wondered whether the Dutch – represented in the twentieth century by van Doesburg and the angular, abstemious Mondrian, who wanted to separate art from the material world – had not produced greater painters in earlier, more car-nivorous centuries. Itten's attempt to enforce asceticism at the Bauhaus failed, and in 1923 Moholy-Nagy replaced him.

Breuer's chairs may be good for our posture, but they are not very comfortable. We eat for comfort as much as for sustenance, not to raise our consciousnesses. Humanity is perhaps not ready to be rehoused in paradise: this has been one of our century's most disillusioning discoveries. Modern men have found it hard to live with or live up to the architecture of modern times. Architects, in retaliation, tend to maintain that inhabitants get in the way. Neutra evicted the tenants before he would allow his California houses to be photographed; people messed up the geometry of his shining cubicles. Walter Benjamin said in 1930 that 'to live in a glass house is a revolutionary virtue par excellence'. In Mexico City the radical muralist Diego Rivera occupied a pair of sun-bleached white boxes, half made of glass and set one on top of another, linked by an outside staircase which – showing off its fearless, cool-headed modernity – had no banister. Otherwise, few home-owners aspired to posses this revolutionary virtue. The critic Rudolf Arnheim, praising the 'architectural honesty' of Gropius's Bauhaus in 1927, remarked that when you looked through those candid windows you could see people 'relaxing in private'. It did not occur to him to reflect that, if you could see them, they were not in private. And how could they relax while being watched?

A nude stood in a bathing pool inside Mies's Barcelona pavilion. She was made of marble, and impervious to shame. Le Corbusier, more aggressively, placed a bidet in a corner of the bedroom in his Paris apartment, and hung a biomorphic painting of a garden by Léger on the wall above it. Duchamp had exhibited a urinal as a work of art; Le Corbusier's interior décor suggested that

sanitary routines could profitably be combined with the appreciation of art. The transparent life made visible domestic areas which were traditionally out of bounds. In 1912 Loos incited another Viennese fuss with his design for the Scheu House: an arrangement of cubes with two flat roofs, which formed terraces leading directly outdoors from the bedrooms on the first and second floors. Neighbours complained, saying that there should be laws against this lowering of the division between public and private realms. Loos was told that the house with its white, blazing blocks might have felt at home in Algiers, but did not belong in Vienna. The criticism, despite its coded racism, might have been taken as a compliment. Le Corbusier rallied architects to turn from the misty, befuddled north with its gloomy cathedrals towards the Mediterranean. Adhering to the solar religion of the 1920s, he called on the sun to burn away the sickly, cowardly evasions of Christianity – to 'empty, cleanse and purify,...to strip a block of stone until it has no moral value left except that of its very proportions'.

The surrealists, who turned their sexual flagrancy into a revolutionary virtue, adopted the glass house as a symbolic domicile. In 1928 André Breton published *Nadja*, his memoir of an affair with a girl of the streets, a demented seer who wandered into his life and then wandered out of it, isolated in her mania. His erotic confession entitled Breton to claim that he lived in 'a house of glass, where at night I sleep on a glass bed surrounded by glass curtains'. Though this was merely a metaphoric dwelling, the surrealists, with their questionnaires about sexual preferences and peccadilloes and their practice of wife-swapping, behaved as if they inhabited a glass house. The poet Paul Éluard complaisantly surrendered his wife Gala to Max Ernst, with whom she had taken up, because he said he loved Ernst more than he did her. The sacrifice was not great, because after marrying his next wife, Nusch, Éluard continued to have sex with Gala, who subsequently married Dalí. 'I pride myself', said Breton, speaking for them all, 'on living my life in broad daylight'. Le Corbusier in 1930 defined a house as a body X-rayed by the sun. Its girders were a skeleton of steel; its ramps and sloping floors served as muscles, permitting motion; plumbing and ventilation ducts were its veins and bowels, charged with the business of circulation.

Such feckless transparency was not tolerated for long. The dream of a vitrified world – wiped clean, shiningly new – abruptly ended when Hitler reviewed plans for the stadium in which the 1936 Berlin Olympiad was to be staged. Otto March, according to Albert Speer, 'had designed a concrete structure with glass partition walls'. Hitler furiously vetoed the plan, and ordered the cancellation of the games. The Olympiad had to be officially opened by the head of state, and he vowed 'never [to] set foot inside a modern glass box like that'.

A fit of despotic pique? Not entirely. The Nazis, with their aesthetic politics, were pledged to exterminate modernism. Hitler fancied himself as an amateur architect, and he knew that buildings contain theorems about the function and purpose of society. A sun-worshipper like Le Corbusier would have seen the games as a festival of bodily freedom. For Hitler, athletic displays were a military

drill, mobilizing the populace and co-ordinating its energies for the greater glory of the state. His Reich had no place for glass walls, because power depended on opacity. Whereas architectural modernists praised elasticity and lightness, Hitler wanted buildings which were impregnably tough and stalwart. As Ortega y Gasset said, commenting on Spengler's analogy between distended, declining Rome and the overcrowded modern world, 'The epoch of the masses is the epoch of the colossal.' Besides, a stadium is a useful amenity for a totalitarian regime. In Chile, the dictator Pinochet converted a sporting arena into a prison camp, where dissidents were held while they waited to be shot. Here is another reason for banning glass: bullets shatter it.

The obsequious Speer saved the situation by altering March's plan. He removed the offensive partitions, and showed 'how the steel skeleton already built could be clad in natural stone and have more massive cornices added'. Appeased by those bullish cornices, Hitler permitted the Olympiad to take place. The solids, on this occasion, had well and truly triumphed over the voids.

The void praised by Wright and Gropius was serenely complete in itself; it did not want to be filled, which is why Loos insisted on pushing furniture into the corner and why Neutra expelled his clients from their houses. In 1996 Rafael Viñoly's International Forum opened up a canyon in the middle of cluttered, claustrophobic Tokyo. Somewhere out of sight there are offices, concert-halls and meeting rooms, but the public space itself is a dazzling vacancy, like a gouged-out, skeletal battleship. The building's sublime feat is to contain so much emptiness. But when does emptiness become hollowness, achingly aware of something which is missing?

Hollow space, a void without positive value, is an idea which perturbed modern culture, confounding the idealism of architects. In 1925 T.S. Eliot summed up his generation – bereft of faith, paralysed by indecision – in 'The Hollow Men'. Walter Benjamin in 1930 discovered the same windy frailty in language. He assailed the militaristic rhetoric of Ernst Jünger, who had twisted Germany's defeat in 1918 into a spiritual victory. 'What does it mean to win or lose a war?' Benjamin asked. 'How striking the double meaning is in both words!' Jünger's manipulations revealed the 'peculiar hollow space, the sounding board in these words'. In 1935 the Marxist philosopher Ernst Bloch published a sequence of essays, *Heritage of Our Times*, in which the vacuum is an omnipresent sign of political convulsion and social collapse. 'Holes and hollow spaces', Bloch warned, were opening up everywhere, as if the ground had suddenly caved in. One of his meditations, entitled 'The Void', is a prose poem about the failure of domestic architecture at a time when no doors were proof against a knock before dawn, and no windows safe from the sound of breaking glass. The house dissolves. Why should it offer protection, if there is only a hollow man at home? 'The empty ego forms no shell any more to hide the one inside.' The sleek, functional interiors admired by Loos were for Bloch reminders of instability, expendability:

'the furniture vanishes,…goes to the wall'. Le Corbusier designed rooms like this, as in his modular cabin beside the sea in the south of France. In 1936 Neutra built a plywood house which could be readily transported across the city or country; it is now parked, for the time being, at an address in the Los Angeles suburb of Westwood.

Bloch ignored the up-to-date virtues of compactness and convenience. He saw only lives hurriedly packed into a suitcase and hustled off to prison or across the border. He was alarmed by the habit of streamlining, so popular in the 1930s, when aerodynamic curves were applied to objects – bathroom fittings, a skyscraper like the Chrysler Building in New York, with its gargoyles made from automobile radiators and hub caps, or the Maison Citrohan – which had no capacity to travel anywhere, whether by land, sea or air. 'The house as ship denies the space in which it stands,' Bloch declared, 'since ships would like to vanish.' Everything in the modern interior of 'The Void' is an appliance, switched on and abruptly switched off. People, in the new German state from which Bloch had fled in 1933, are treated in the same way, used up and then discarded. Outside, the streets are pitted by rankling memories. Old buildings are torn down and new ones replace them, erasing the past – but 'a hole still remains…. The space remains open for what is missing.' The map of Berlin today is full of such emptiness: the place where Hitler's bunker was, unmarked so as to discourage pilgrimages, or the hollow swathe of terrain marked by the invisible, pulverized Wall.

Architecture at its most rudimentary provides shelter for individuals. This is the shell Bloch spoke of; Le Corbusier cited 'la coquille de l'escargot' – the shell which is the snail's exoskeleton – as a perfectly functional dwelling. More ambitiously, architecture bestows the conviction of permanence on entire societies. A civilization can be equated with its monuments. Yet during our century that equation fell apart. The monuments were no longer made to last; nor, apparently, was civilization.

Scaffolding, when the Eiffel Tower was built, announced the brave new modern world – open and honest, strong because supple and flexible. Later, as both architecture and civilization lost their confidence, the image became ambiguous, or even sinister. In *The Revolt of the Masses*, warning against the totalitarian state's encroachments on the lives of its citizens, Ortega y Gasset used an architectural fable: 'The skeleton eats up the flesh around it. The scaffolding becomes the owner and tenant of the house.' Primo Levi modified the metaphor when describing the private rituals on which he relied to maintain self-respect and sanity in a Nazi concentration camp. He always scrupulously washed himself. The purpose of the exercise was 'to save the skeleton, the scaffolding, the form of civilization'. The cladding of stone has been stripped from the building; flesh has wasted away. We are reduced to the girders beneath, and they are precarious.

Kurt Schwitters began assembling a hollow column of bric-à-brac in Hanover during the 1920s. His *Merzbau* was a reliquary for refuse (including,

Kurt Schwitters
Merzbau
(1923)

in one of the annexed caves, a jar of urine, displayed so that the light turned its contents to gold). By 1936 it had swollen to occupy the entire floor area of his studio, and breached the ceiling as it grew upwards. Schwitters planned a dozen such megaliths, which would stand, he said, as 'gigantic forms in space'. He underestimated: in the last few decades they have sprouted all over the globe. The architect Rem Koolhaas recently described a Generic City, pre-packaged and standardized, which can now be found in Singapore and Houston, Beijing and Melbourne, with skyscrapers 'based on the Chinese pagoda *and/or* a Tuscan hilltown'. The specimens are interchangeable. There will always be a Hilton, and more than likely a Daimaru. English of a kind will be spoken, Calvin Klein and Levi Strauss will be worn. Golden arches will beckon us to our meals. Orientation is easy. We know where we are, because we are nowhere at all. Such cities resemble airports. We aim to get through them as quickly as possible, consuming as we go. Here, Koolhaas remarks, is 'Schwitters' *Merzbau* at the scale of the city: the Generic City is a *Merzcity*'.

In 1927, Brecht concluded his volume of *Devotions* with an attack on the ancient notion of an eternal city, phrased as a mockery of ecclesiastical consolations. 'Of these cities,' he said, referring to the asphalt wilderness of Berlin or his imaginary Mahagonny, 'there will remain what passed through them – the wind!' Twenty years later, when he returned from California, he found that the prophecy had been only too promptly and exactly fulfilled. Berlin was a pile of rubble and ash somewhere near Potsdam. Buildings in ruins are the testimonials of modern times: the Kaiser-Wilhelm-Gedächtniskirche in Berlin, like a limbless veteran out of place beside the smart, rich Kurfürstendamm, or the Atomic Dome in Hiroshima with its hollowed head and tortured metal frame. Failing other, more violent means of destruction, we take a grim pleasure in watching or imagining demolition. H.G. Wells laughed at our 'concrete cavern systems for refuge' in *The Shape of Things to Come*, his history of the future, and derided the skyscrapers of the twentieth century as crouching midgets. He happily reported that the Empire State Building was finally torn down in the year 2106.

Among the most eloquent buildings of our century are some which were never built, like Tatlin's tower or Scheerbart's spars of crystal. If they were built, they look as if they very nearly might not have been, since – like the Guggenheim Museum – their existence seems to contravene the laws of physics. Sometimes bombs have unbuilt them, which is what happened to the *Merzbau* during the war. They happily confess their own provisionality. When Kisho Kurokawa built his Nagakin Capsule Tower in Ginza in 1972, he jauntily emphasized its temporariness. The portholed concrete cartons, meant as offices and living quarters, looked as if they had been hastily and shakily piled up, but that was Kurokawa's point. 'A capsule', he argued, 'is a dwelling of *Homo movens*.' City-dwellers had broken their connections with the land; this rootlessness called for 'an age of moving architecture'. Today, shoddy but immobile, the Capsule Tower has acquired a prophetic force. Here was a preview of those dwellings which typify the late twentieth-century city: the disposable homes of the homeless, cobbled together from paper, plastic and canvas.

Wim Wenders' film *The State of Things*, made in 1982, concludes with a sequence containing an allegorical quarrel about architecture between the producer and director of an unfinished film. The producer, after running off with the funds, remonstrates with the director, who has turned the film into a diary of how the actors and technicians occupy time while they wait for filming to resume. 'You can't make a film without a story', the producer says. 'It's like building a house without walls.' The director is unrepentant, prepared, like a modern architect, to challenge gravity: 'Why do you need walls? The space *between* people can carry the load.' The exchange takes place at night, while they ride backwards and forwards along Sunset Boulevard – through a slide area where the land is buttressed against slippage; beneath outsize advertising billboards, our culture's ephemeral monuments, replaced every month or so; past buildings like the Chateau Marmont, a castellated Norman hotel which resembles a movie set forgotten by the wreckers. To clinch the commentary on architecture's place in the current state of things, they are travelling inside a mobile home.

But the struggle to assert our constructive power continues. On Lindenstrasse in Berlin, not far from the site of Checkpoint Charlie, stands a canting cliff of zinc. This is the Jewish Museum, designed by Daniel Libeskind. Its walls, tugged out of shape, zigzag to form a tormented star of David. Windows are slashed in its sides like scars, painful incisions made by memory. The patterned striations track the movements of Berliners who once crossed this plot of land on their way between home and work. Libeskind reconstructed their daily itineraries from antique phone books and street maps, then superimposed the routes on his building's façades in an 'invisible matrix or anamnesis of related connections'. Below the grey walls, an uprooted garden dramatizes the Jewish trauma of enforced migration. Trees, coffined inside stone columns, struggle to push their leaves and branches into the air. The garden's cobbled floor rises at a steeply raked angle. Your feet fret to maintain their balance, while you squeeze through

crevices between the trapped trees. A building about displacement inevitably upsets your equilibrium.

You enter the museum on an underground ramp, feeling the leaden tug of gravity. A steep staircase challenges you to climb it, then confronts you at the top with a dead end. Beams punch their way in from outside. You cross sudden gulfs on narrow bridges, sharing the sense of rupture experienced by Jewish Berliners who fled abroad or were sent off to be killed. Unconsecutive and uncomfortable, baffling and daunting, the building compels you to live through that violent breach with the past which made Schoenberg leave *Moses und Aron* unfinished: Libeskind sought, he has explained, 'to complete the Act III libretto in architectural form'. Schoenberg's opera has to stop because Moses cannot utter – let alone sing – the word he needs. Libeskind's building likewise arrives at an abrupt, silent terminus. The museum displays mementoes of the city's exterminated Jewish population: the bed linen, garden furniture, and toys they left behind, confident that they would return to reclaim them; the register of their signatures, attesting to identities they forfeited when the concentration camps translated them into numbers. But, more hauntingly, it contains their absence. It is a place of resonant, echoing emptiness, punctuated by tall, hollow, unheated chambers that Libeskind calls 'apocalyptic voids'. The door of the final void, devoted to the nihilistic notion of the Holocaust, thuds shut with dread finality. A faint, reflected light shines unreachably far above. The traffic murmurs outside, enjoying its freedom. The acoustics prepare a trap: your slightest murmur is amplified in the vault, and you soon learn to lower your voice.

Libeskind describes his design as 'a tectonic intervention in Berlin'. His phrase alludes to the tectonic plates which shift and scrape beneath continents; when the tension becomes intolerable, they knock cities over. Only in the twentieth century would an architect – heroically bending, breaking and disrupting space to dramatize the tragedy of modern times – dare to compare his building with an earthquake.

THE MYSTERIES
OF PARIS

Modern times promised, as periods of revolution usually do, the establishment of heaven on earth. Creativity would cease to be the eccentric prerogative of individuals, with society itself revealed as a work of art. Sant'Elia called for ivory towers to be toppled, and argued that grain silos and railway stations should be recognized as works of architecture, not meanly functional engineering. Satie added a clacking typewriter to the orchestra, classifying it – since it made a noise – as a musical instrument; Antheil incorporated wailing sirens and whirring electric fans. Joyce in *Ulysses* transcribed the incoherent uproar of the street – 'Hooray! Ay! Whrrwhee!' – which is solemnly blessed by Stephen, who calls it the voice of God. Eliot's *The Waste Land* anthologized shoddy popular songs and gossip overheard in bars. Tristan Tzara, admiring a palimpsest of shredded posters, claimed that poetry 'in its habitual form, the poem' had been superseded by the arbitrary, ravaged insignia on the city's walls. The surrealists liked to repeat Lautréamont's commandment that poetry should be made by everyone. In this way they hoped to bring together Marx and Freud, combining social liberation with psychological revolt. Breton in 1933 proclaimed 'the equality of all normal human beings before the subliminal message', and Paul Éluard argued in 1937 that 'surrealism labours to demonstrate that thought is common to all'. If Freudian dreams could be extended into daylight, social prohibitions would be overthrown and sanity exposed as an oppressive fiction.

The hated bourgeoisie relied on realism to take inventory of a world which consisted only of goods, possessions. Breton derided reality as a 'miserable mental expedient', which surrealism undermined by showing up its spooky strangeness. A shoeshine parlour patronized by Louis Aragon became a temple to 'the very spirit of modernism', and a place where miracles were manufactured. For sixty centimes, you could come out wearing the sun on your feet. Aragon admitted that the polishing of shoes was 'a minor art', but insisted all the same, repeating himself as industriously as the bootblack's brush, that it was 'art art art'. Likewise Breton regarded the inspired babbling of his mistress Nadja as

*James Abbe
Backstage at
the Folies-
Bergère (1924)*

extemporized poetry. Transcription was irrelevant because, as Breton said in 1933, 'all is written on the blank page'. Nadja's fits, frenzies and hallucinations marked her out as a seer. After its own heterodox fashion, surrealism was a religious revival. Science and technology had deconsecrated the world. The surrealists sought to restore the sense of mystery. The sociologist Émile Durkheim – writing in 1912 about religion as a social fixative, a foundation of community, not the revelation of some disembodied truth – remarked that 'in the present day as in the past, we see society constantly creating sacred things out of ordinary ones'. This was the enterprise of the surrealists. The sacred things they created, like Man Ray's spiked iron or Meret Oppenheim's shaggy cup, were fetishes: a fetish is a magician's implement, an object charged with powers which may be occult or perhaps (like the footwear of Mae Murray in Erich von Stroheim's film of *The Merry Widow,* which overexcites her elderly husband on their wedding night) more blatantly erotic.

Surrealism proposed the re-enchantment of reality. In 1935 Breton gave a speech in Prague, which he complimented as 'the magic capital of old Europe'. Prague was the headquarters of alchemists and cabbalistic philosophers in the seventeenth century, when the Emperor Rudolf II welcomed Kepler and Tycho Brahe to his court. In the twentieth century, Karel Čapek imagined and named the robot there, while Kafka saw the frowning castle on its peak as an emblem of supernatural menace. Encouraged by this setting to play the magus, Breton announced that he was unveiling 'the world of new shadows, known as surrealism'. Shadows were permitted to warp or transfigure the substance of things. The Tour Saint-Jacques, for instance, was a favoured fetish of the Parisian surrealists. It is indeed an enigmatic, sinister object, with its vertical menagerie of rearing monsters and chivalric warriors, on guard against aerial assault. Breton first likened it to a sunflower, then later with beguiling vagueness called it 'a monument to the unrevealed' – a symbol symbolizing only its own insoluble mystery.

Aragon called in 1930 for a reawakening of the marvellous, 'the *clinical* image of human liberty'. With a self-consciously scandalous paradox, he blamed religion, during 'the centuries tyrannized by hell and the cross', for turning the world to dreary prose. But now, Aragon said, the imps and bogies could leave the dark Gothic forest where they hid from the censors, and sit unashamedly beside us at a café table. Why not? The cup on the table may have grown hair, and the sugar cubes might be made of marble, like those placed by Duchamp in his ready-made bird-cage. Cafés after all are sites sacred to visionary intoxication, places where men go, as Breton said, to drink 'watery spirits'.

Conjuring up those spirits, the surrealists were engaged in a holy war against cubism. Aragon in his phantasmal guide-book *Le paysan de Paris*, published in 1926, complained that 'wherever the marvellous is dispossessed, the abstract moves in'. In his role of a metropolitan peasant, the relic of a more superstitious, numinous age, Aragon sought out the lairs where marvels, expelled from the newly sleek, mechanized city, had taken refuge: curiosity shops in

decrepit arcades, or a suburban park at midnight. The cubists, by contrast, inhabited a Paris composed of straight lines and right angles, which permitted no detours or digressions. Cocteau remarked in 1916 that 'the cubist code forbade any journey other than the one on the Nord–Sud from the Place des Abbesses to the Boulevard Raspail.' He was referring to the Métro which linked Montmartre and Montparnasse; he predicted that Picasso would not stray off this strict map by travelling to Rome, where Diaghilev wanted him to paint the sets for *Parade*, the ballet with the score by Satie which included a typewriter in the percussion section. (Picasso, venturing beyond the confines of cubism, contradicted Cocteau by making the journey.)

Abstraction, for the surrealists, was as invidious as realism, and as much of a metaphysical fraud. Realism reduced the world to commodities, tagged with prices, intended merely for use. But an abstracted world was equally desolate: a pile of angular building blocks like Cézanne's mountains, an assemblage of chimneys and pylons, pulleys and conveyor belts, like the cities painted by Léger, an uninhabitable rectangular grid like Mondrian's diagrams of heaven. Breton took his friend Philippe Soupault on a pilgrimage to the museum of Gustave Moreau's paintings in the Rue de La Rochefoucauld. In this obscure and retrograde junkyard, where unicorns and centaurs romped while Salomé discarded her veils and angels pelted the Vatican with flowers, the chimerae painted by Moreau showed them how 'to free ourselves from the tyranny of cubism'.

The final victory of abstraction, as Freud claimed in his essay on Moses, was to abolish God, who became an invisible idea, a concept rather than a presence. The surrealists disputed this view of mental evolution. Soupault – who teamed up with Breton for the first experiment in writing automatically, taking dictation from their pooled unconsciousness – praised surrealism for its 'demonstration of freedom', and said that it marked 'an "era" in the history of the human mind'. But his view of that mental history contradicted Freud's. In psychoanalysis, the id surrenders to the ego's tutelage, and the ego in its turn learns to respect the moral imperatives of the superego. Surrealism, subverting reason and flouting morality, licenses the ribald id.

The inconceivable God worshipped by Moses proved, for Freud, the primacy of human intelligence, which is able to see beyond facts. To the surrealists, this view of things was arrogant and potentially fatal, because it overlooked the garden of wonders and oddities which passes for reality. Aragon sneered at Christ, who pretended to reign in a kingdom not of this world. 'The kingdom of vision', Aragon insisted in 1925, 'is of this world.' Surrealism prepared a second coming for that neglected world, split apart by a new way of seeing: 'Take note of the era to come!… Follow the rising plume of smoke, the whiplash of the apparition in the midst of the bourgeois universe. A lightning flash is smouldering beneath the bowler hats. Devilry really is in the air.' The imagery of apocalypse corresponds to Jakob Van Hoddis's poem 'Weltende', published in 1920, in which the world's end begins when bad weather blows away the hats of the staid

burghers. In Germany an era of disintegration and social collapse did follow; the devilry of the surrealists was more harmless, a state of joking topsy-turvydom. A single image, Aragon claimed, could 'annihilate the entire universe'. Unlike Berg's soprano in the *Altenberglieder*, who fearfully whispers that everything has suddenly ended, Aragon assumed that the universe did not mind being playfully annihilated. It was never real, so how could it object to being surrealized?

Breton in *Nadja* confessed himself helpless to withstand 'the fury of symbols,…the demon of analogy'. That demon was the cause of Nadja's madness. Aragon, however, conducted the quest for spirits and symbols as assiduously as a detective. In *Le paysan de Paris* he worked his way through the quaint, recondite alcoves of the Passage de l'Opéra – the shoeshine parlour, the philatelist, the handkerchief shop – because these were recesses of fantasy, in retreat from the bright modern daylight of the boulevard; at the Parc des Buttes-Chaumont he deciphered a column inscribed with dull municipal statistics as earnestly as if it concealed some arcane lore in an incomprehensible 'cuneiform darkness'. Surrealism offered a technique, like a Geiger counter or a metal-detector, for intuiting and expounding mysteries. Rather than waiting for inspiration to visit him, Aragon saw it as 'a faculty to be exercised' during his perambulations through Paris. Mysticism was a drug, available to all and guaranteed to work instantaneously.

In place of the discredited Christ, the surrealists had their own prophet – that divine reprobate and revolutionary atheist, the Marquis de Sade. The sexual excesses of Sade were his challenge to a doting God. He brutally flogged a servant girl on Easter Day, an allusion to the scourging of Christ: could God be shocked into retaliating? No lightning bolt struck him down; the id had nothing to fear from the deified superego. Buñuel and Dalí compounded the blasphemy in *L'Age d'or*. They enlisted Christ in the secret society of debauchees who arrange the protracted orgy in Sade's *Les 120 journées de Sodome*. At the end of the film our supposed redeemer is the last to stagger from the locked and bolted retreat. Despite his exhaustion, he briefly returns to gratify himself once more with one of the trussed-up slaves, who can be heard responding with a screech of pleasure, pain or both. By 1937, in a lecture delivered by Éluard at a surrealist exhibition in London, Sade himself had become a saviour, as well as an exemplary democrat. Sade wanted, Éluard said, 'to restore to civilized man the power of his primitive instincts,…to liberate the erotic imagination', because 'he believed that only in this way could true equality be born'. As so often throughout the twentieth century, civilization envies savagery.

Breton tried to convince his surrealist colleagues and their sexual partners to join him in an orgy at a deserted mansion. Lacking the energy for Sade's systematic marathon of 120 days, he planned to cram the revels into a long weekend. Even so, he could not assemble a quorum. The project was meant to realize an imaginative wish. Breton craved an equivalent to the Gothic castle which, as well as supplying the privacy required by Sade's libertines, served as a

*Man Ray
Imaginary
Portrait of
.A.F. de Sade
(1938),
verlapping with
the Bastille
where Sade was
imprisoned)*

playground for exploratory fantasy. The modern world had only its factories – clean, well-lighted, humming with dynamism. It also needed darker, dustier, idler spaces, which the imagination could roam through and get lost in.

Since castles were unavailable, the surrealists set about transforming Paris into a labyrinth of Gothic mystery. The second automatic sentence scribbled down by Soupault in 1919 was 'We run through cities without sound, and the enchanted signs no longer touch us'. Soupault hoped to learn, or perhaps remember, the enchanted language of those signs. He wrote the sentence blindly, which was a precondition of surrealist vision.

As she trails along the boulevards or across the bridges with Breton, the babbling Nadja, blessed or cursed by second sight, surrealizes Paris. She points out things which are not there: a mob of ghosts in the Place Dauphine; subterranean channels; a hand with no body belonging to it, flaring above the Seine. Everything, like the Tour Saint-Jacques, testifies to the unrevealed. *Nadja* begins in Breton's lodging, the Hôtel des Grands Hommes near the Panthéon (from which it grandiosely takes its name). Great men, paralysed on columns, balefully keep watch through the city; Breton's narrative is nervously pantheistic. He confides that the statue of Étienne Dolet in the Place Maubert always causes him an 'intolerable malaise'. He does not explain why, but the sensation is an augury. Dolet was a Renaissance humanist burned at the stake for denying the immortality of the soul. Breton's unease refutes Dolet's atheism: a soul adheres after all to the wintry, wizened figure on the pedestal.

Modern times began when the free-thinkers executed God. But there was an immediate reaction – a pursuit of what T.S. Eliot in 1934 called 'strange gods', in which the surrealists fervently joined. Seen through Nadja's eyes, Paris is a city stalked by invisible spirits. She belongs in their company, and when she disappears into the asylum Breton makes no attempt to locate her: it is her privilege to dematerialize. He is at the mercy of this unreliable, incoherent genie. Aragon's

quest in *Le paysan de Paris* was less troubled and frustrated, because he did not personify the deity. In his city, spirits inhabit places, though they shun the consecrated ground of cathedrals: 'the spirit of religions, coming down to dwell in the dust, has abandoned the sacred places'. Instead its catacomb is the Passage de l'Opéra, where – among starveling shops and a tawdry theatre, between a bathhouse and a brothel – 'a profound religion is very gradually taking place'.

Aragon admitted that urban sites were 'not yet inhabited by a divinity'; he aimed to make the shrines ready, and to preside over the installation. He chose this nondescript arcade as the place where revelation would occur precisely because it was so introverted and backward-looking, set apart from the sanitary, modernized Paris made possible by Haussmann's boulevards. Surrealism germinates in secrecy, under cover of darkness – like mould, like the dust on Duchamp's *Large Glass*, or like pubic hair. The arcade is an erotic zone, an orifice admitting Aragon to the city's interior. Leaving the street, he finds himself in a jungle, or perhaps at the bottom of the sea: the shop windows contain the 'fauna of human fantasies', choked with 'marine vegetation'. In the gloom, he watches darkness weave its 'thick tresses' into plaits. Aragon peers into the establishment of a ladies' hairdresser, likening the curled strands to serpents uncoiling in hidden grottoes, longing to decipher those tangles which, fresh from the pillow, must still contain the twisted, knotted remnants of recent dreams.

The mysteries in *Nadja* concern the city's past and the spectral ancestors who haunt the Panthéon. Aragon suffered from a different mystical seizure, which he called 'the vertigo of the modern'. Exploring Paris, he set out to discover 'the face of the infinite beneath the concrete forms' as he walked 'the length of the earth's avenues'. The urban stroller could no longer be sure of the ground beneath his feet, and saw cracks surreally widening into ravines. Charles in T.S. Eliot's play *The Family Reunion*, losing his faith in a reality which supposedly paves over the gulf, feels as if the earth had split 'right to the centre, as I was about to cross Pall Mall'. In his poem 'As I Walked Out One Evening', W.H. Auden finds the same entry to eternity gaping inside the kitchen cupboard: 'the crack in the tea-cup opens / A lane to the land of the dead'. Vertigo is the sense of dizziness felt by those who see abysses beneath them. Aragon – allowing analogies to multiply, and describing his visit to a prostitute on an upper floor of the arcade as a 'venture by my own self, the man jumping into the sea, the renunciation of all masquerade' – persuades himself to fall without fear into that inviting emptiness.

There was a sad epilogue to Aragon's excavation of the Passage de l'Opéra, that receptacle of dreams and below-the-counter desires. Walter Benjamin, during his decade of exile in Paris, worked on a study of the arcade as a social and economic novelty. In 1935 he wrote an overview of his planned *Passagen-arbeit*, entitled 'Paris – the Capital of the Nineteenth Century'. This essay completed the topography of the surrealist city, and elegiacally explained why Paris remained the capital of a defunct century, unable to cope (in Benjamin's view) with the exigencies of the present. Benjamin saw the arcades as a

dead end. Built of iron and lighted by gas, they showed off the new industrial technology, which might have been used to reconstruct society. But the Paris of the Second Empire suppressed innovation, and kept its citizens quiet by giving them things to buy: the arcades became, as Benjamin notes in disillusionment, 'centres of the luxury-goods trade'. When the socialist Fourier tried to imagine a more equitable regime, he simply extended them into the future. Fourier's phalanstery – a commune of interdependent men, modelled on the military phalanx – was for Benjamin nothing more than 'a city of arcades'. Like the Musée Moreau with its unicorns, these alcoves were a resting place for discredited dreams.

The revolution failed to occur – or perhaps was foiled by the surrealists, who stirred up revolt inside the mind not on the streets – and Benjamin, despite the years spent classifying quotations, never finished his study of the arcades. A disenchanted surrealist, he understood the aptness of his personal failure. Surrealism collects fragments of reality; its quest cannot be completed before the collector has trudged to the ends of all the earth's avenues, picking up everything which catches his eye. Aragon, inspecting the stamp shop in the Passage de l'Opéra, calls the philatelist's obsession 'a most strange goddess, a slightly foolish fairy': a muse as dangerous as the unhinged Nadja. Breton frequented the flea market at Saint-Ouen, where he searched for things which had been damaged, rendered useless, like the trophy he describes in *Nadja*, a cylinder inscribed with unintelligible lines and legends. Collecting was the only way to comprehend the surreal city. Apprenticed to randomness, shunted off to the margins, the artist became a rag-picker. Baudelaire compared the poet to a *clochard* indexing the city's refuse, curatorially presiding over 'the archives of debauchery', and Cocteau saw Picasso as a scavenger, who foraged on scrap-heaps and in gutters for the materials of his collages. Aragon reported on Picasso's indignation in 1920 when, after he used a dirty shirt in a painting, visitors pityingly brought him swatches of expensive fabric. He refused, because only 'the true waste products of human life – poor, soiled, and scorned' qualified as the stuff of art.

Benjamin in 1931, paying tribute to the photographer Eugène Atget and his exhaustive documentation of Paris, said that Atget 'looked for what was unremarked, forgotten, cast adrift': musty racks of second-hand clothes, battered pots and pans, the stagnant industrial canals of the Basin de la Villette and the cabins of the real rag-pickers at the Porte d'Ivry. It was neither necessary nor possible to collect all this fetishized refuse. Impressions, souvenirs or visual anecdotes would do. Playing the role of a circus barker for surrealism, Aragon attracted customers for this 'new vice' by crying 'Walk up, walk up, this is the entrance to the realms of the instantaneous, the world of the snapshot'. The camera, like a quick-acting hallucinogen, demonstrated the oddity or derangement of everyday things. It was a machine for surrealizing reality. Man, as Éluard said, 'will need merely to close his eyes for the gates of the marvellous to open'. The camera's shutter was such a gate, flicking open to capture an unregarded marvel and seal it in darkness.

Breton illustrated *Nadja* with photographs of its settings by Jacques-André Boiffard, and some scraps of the heroine's visionary doodling. There is no portrait of Nadja herself, only a close-up strip, repeated four times, of her mesmeric eyes, wide open as if photographing us as we look at her. Boiffard's photographs of places have a studied blandness, which after a while becomes a means of mystification. Any object, looked at for long enough, will turn into something strange, terrifying, unreal. Is the gigantic Mazda bulb, irately discharging bolts of brightness on a billboard in one of Boiffard's snapshots, any less weird than the fiery hand which Nadja claims to see above the Seine? Benjamin – preoccupied by the calamity of mechanical reproduction, for which he held the camera responsible – said that Atget's urban scenes 'pump the aura out of reality'. But an aura, being a spirit like Nadja herself, is meant to be invisible, and Boiffard's photographs testify that there may be more to these locations than the eye can see.

Breton, for instance, referred to the whimsical itinerary of his afternoon walks, on one of which he happened to encounter Nadja. He always wandered in the same area, but insisted that there was no 'pole of attraction' in his chosen area of Paris, 'neither in space nor in time. No: not even the very beautiful and very pointless Porte Saint-Denis.' Boiffard photographed this triumphal arch, with some indifferent passers-by to emphasize its pointlessness. It seems to have dropped directly from the sky; it has no roots in the modern city. Yet nothing in *Nadja* is accidental – or rather, all of its coincidences, like the light in a window which goes on precisely when Nadja says it will, are the working-out of some pre-destined plot. Benjamin's 1935 essay explained why the Porte Saint-Denis deserved to be a landmark on the surrealist map of Paris. Describing the consumerist delights of the arcades, he quotes a remark by Balzac about the grand epic poem of display which extended 'from the Madeleine to the Porte Saint-Denis'. Breton's steps, not at all pointless, took him to and fro along the Boulevard Bonne-Nouvelle: every day he patrolled the border of the area demarcated by Balzac, the wonderland of bewitching 'nouveautés'.

The arch may be drab and degraded in Boiffard's photograph, but paroxysms lurk inside the stone. In 1927, the year before Breton published *Nadja*, Max Ernst painted a *Vision Provoked by the Nocturnal Aspect of the Porte Saint-Denis*. Here the arch retains the aura which photography steals

Max Ernst's nocturnal visio of the Porte Saint-Denis (1927)

from it. Ernst gives it a grainy, scratchy, wooden texture, like floorboards with paint applied to them. A gateway to the psychological cellarage, it resembles a floor pushed upright, displaced by some incubus tearing its way out of its prison beneath the streets. The pompous monument is now gnarled and contorted, a petrified jungle. Howling faces hide in it, and it ends in pinnacles like hair electrified by fright. By day in the photograph, the Porte Saint-Denis pretends to belong in reality. After dark in the painting, it shows itself to be surreal.

Night surrealized the city; the surrealists were intrepid noctambules. In 1937 Breton's *L'Amour fou* described a walk at midnight from Montmartre to the Quartier Latin, taken with the woman he currently loved. On this occasion the illustrations were by the Hungarian photographer Brassaï who, following Breton's path, revealed a city irradiated by romance: the Tour Saint-Jacques is an inflamed penis, and the flowers in the market at Les Halles voluptuously bloom without needing any stimulus from the sun. The surrealists venerated *Tristan und Isolde*, Wagner's hymn to a mad love. It provides the soundtrack for a bout of sexual exhibitionism in *L'Age d'or*, and in Buñuel's *Abismos de Pasión* – his Mexican adaptation of *Wuthering Heights*, released in 1953 – the score recurs to accompany the necrophiliac wedding night of Heathcliff and Cathy in the crypt. Brassaï photographed a poster for the opera on a boulevard kiosk, which looms through the foggy night like a minaret; a passer-by pauses to consult it, or to say a licentious prayer.

The surrealists, however, dismissed the high-minded abstinence of *Tristan*, in which the lovers prefer death to sexual satisfaction. For them, the opera was about carnal freedom, and they saw Paris as a kingdom of nocturnal pleasure, a playground for fantasies censored during the day. Brassaï roamed through the lower depths. He explored the Bassin de la Villette, an industrial precinct abandoned by everyone but thugs and tarts, visited the brothels near Les Halles (an area known as 'the Belly of Paris' which, as he commented, also catered to 'the lower parts of the body'), and even spied on homosexual liaisons in public urinals. His photographs made visible a world which had previously camouflaged itself in an inscrutable darkness.

The earliest photographs were called sun pictures, and the images trapped by the camera were known as halos or halations. But the values of black and white are reversible, as a photographic negative reveals. Light, in Man Ray's photographic solarizations, banishes dark. But Brassaï's *Paris de Nuit*, a tour of the surreal city published in 1933, depicts a metaphysical battle between white and black which has a very different outcome. The two zones – reason and the irrational, reality and what Paul Morand, in his introduction to the book, calls 'l'irréel' – divide Brassaï's photographs in half. *Môme Bijou*, the ancient, raddled courtesan photographed in a Montmartre bar with her sparklers still bravely scintillating, maintains the appearance of respectability above the horizontal line described by the table-top. Down below she discloses the truth: tatty stockings, dirty legs which sprawl apart (by contrast with those elaborately posed hands).

We are all centaurs – beasts below the belt. Elsewhere the contested border between white and black is vertical. Brassaï photographed two ruffians from the gang of Grand Albert in the Quartier Italie. Here the underworld does not lurk beneath the waist or under the streets. The nether region has risen up to build an impenetrable wall, a hiding-place of dense black. The young toughs peep around this barrier. Assailed by the law, they can easily scuttle back behind it. The nether region is extending its dominion. No longer content to be half of life, as night is, or a third, like sleep, it occupies three-fifths of the photographic plane, and the boy near the centre could well be sliding it even further across, using it as a screen of self-obliteration.

Brassaï happily demonized the darkness of Paris, invoking both Sade and Céline to justify his rambles. He admitted being 'drawn by the beauty of evil', and felt impelled to undertake a personal 'voyage to the end of the night'. The cheaper brothels, foul with smoke and sweat, offered him a brief 'descent into hell'. The infernal overlapped with the excremental, and he likened the cesspool cleaners, wading through ordure on their night-time rounds, to 'anonymous black-hooded and booted devils'. Demolishing all pious prohibitions, night supplied the ultimate excitement craved by Sade: sacrilege. With its coloured windows, Suzy's house of pleasure in the Quartier Latin looked 'like a chapel lit up for midnight mass'; at the Acropolis – a brothel near the Opéra, where you could cruise around the earth while making love, progressing through a series of rooms furnished in Chinese, Persian or Turkish styles – Brassaï found a Gothic theatre of excruciation like those described by Sade and envied by Breton. The establishment's amenities included the torture chamber of a medieval castle, equipped with a crucifix. The willing martyr was fastened in place with handcuffs and manacles, rather than having nails driven through his or her flesh. Despite this clemency, the cross here had an extra feature not imagined on Calvary. By operating a crank, the beam to which the legs were strapped could be split apart as far up as the crotch. 'Beyond a certain angle,' Brassaï reported, 'screams of pain and supplication would fill the room.'

Aragon, for whom night was a 'décor of desires', sought similar transgressive pleasures in the open air. In 1924 he took Breton and Marcel Noll on an outing after dinner to Buttes-Chaumont which, as an alternative to Brassaï's red-light district, for him contained 'the collective unconsciousness of the city'. This park featured on the itinerary of an excursion to Paris which the Dadaists planned in 1920. Their prospectus offered to remedy the incompetence of official tour guides by taking visitors to selected spots 'which really have no reason for existing'. Buttes-Chaumont was well chosen: it is as cryptic and macabre as the Tour Saint-Jacques. On a cliff beyond Montmartre, reality – with some help from the landscape gardeners – turns surreal. The park has an alpine peak built of brick and clad with a skin of porous stone. The mountain is hollowed out with tunnels, so that people can crawl through it and peer out of crevices, like weevils in cheese or thoughts burrowing in the cerebral cortex. A waterfall courses

through a high-roofed cavern, with stalactites squeezed from a pastry-cook's funnel.

A classical temple perches on the little alp, beside a romantic bridge springily suspended over an artificial chasm. This might have been constructed to illustrate Breton's description of surrealism as a 'tiny footbridge over the abyss, which cannot be edged with guard-rails'. Before the grilles and protective fences were put in, the bridge was a favoured location for suicide. This, for Aragon and his companions, was the park's most alluring mystery. *Le paysan de Paris* argues that night, being a human invention, is subject to the vagaries of fashion. Night at Buttes-Chaumont is not the frightful state described by Worringer in his account of primitive man, terrorized by howling wolves, infested by flapping bats. The modern night is a time of revelry, personified by Aragon as a woman with tattoos on her body, who curls her hair with sparks and leads men enjoyably astray. Her most irresistible proposal, in the dark of this public garden, is an invitation to death, not sex. The victims of the suspension bridge, Aragon says, included many who had no thought of killing themselves, only to find – when they peered down into the surreal chasm – that they were 'tempted by the abyss'.

Such aerial views were characteristic of modernism, with its ambition to revise space. The Pont Transbordeur, a ferry-bridge in Marseilles which Sigfried Giedion commended for its 'airy sensitivity', was a favoured vantage point, and photographers like Moholy-Nagy and Germaine Krull looked down from the span at the ships passing beneath. But all they had in mind was a safe optical experiment, demonstrating how the eye telescopes perspective and cancels out distance. Aragon moved much closer to the edge. For him, the only use of such a bridge was that you could throw yourself off it, succumbing to 'the vertigo of the modern'. The secret at the centre of the park is our self-destructiveness, which the surrealists laughingly encouraged. Benjamin called suicide '*the* achievement of modernism in the realm of the passions': the only creditable reaction, as Tristan and Isolde realized, to a world which is absurd.

In his *Passagen-arbeit*, Benjamin quotes a nineteenth-century gazette which assessed the arcade as 'a city, indeed a world, in miniature'. The same might be said of Brassaï's global brothel. The description also fits Aragon's park. Its monuments and geographical markers, like the column of local statistics, try to anchor it in reality. But at its heart is the black, forgetful gulf, with that tremulous bridge conveniently stretched across it. Summing up surrealism in 1929, Benjamin called the Paris of Breton, Aragon and their colleagues 'a "little universe"'. The phrase, echoed by the essay on the arcades, is more than a cliché, and Benjamin went on to give his reasons for using it. Surrealist Paris is a compressed world because 'in the larger one, the cosmos, things look no different. There, too, are crossroads where ghostly signals flash from the traffic, and inconceivable analogies and connections between events are the order of the day.' Surrealism is no less crazed than the dream which we mistake for reality. Even by day, are we not sleep-walking through a phantasmal landscape like that of Buttes-Chaumont,

stumbling perilously close to the precipice? The universe, in Apollinaire's comment on Picasso, patiently abides interrogation. The surrealists lacked the scientific rigour and disinterested curiosity of the cubists. Their universe impatiently awaits the image which, as Aragon said, will cause its annihilation.

For all their posturing effrontery, the surrealists lived up to the ambition of modernism, which promised a festive transformation of life. If revolution faltered, there was always carnival, with its temporary respite from reality.

Brassaï likened the Bal des Quatz'Arts, with its giant frolicking phalluses and near-naked dancers, to 'a Roman Saturnalia, where every licence was permitted'. The motto of Itten's Bauhaus equated work with play; although Schlemmer fondly recalled 'our exuberant parties', the reality was chaster than the transvestite balls photographed by Brassaï. Holidays were secularized. Christmas was commemorated with a love-feast celebrating solidarity, at which Gropius served food to his disciples. Other festivals dedicated to lanterns and kites turned childhood games into constructive exercises for grown-ups. At the Cabaret Voltaire in Zürich, the revels were not quite so seemly. Dada Night in 1916 advertised a virtuoso turn by Tzara, who intended to urinate in different colours and took noisy offence when the exhibition was not allowed. Instead poems were shouted, chairs uprooted, windows smashed. 'Effect atrocious', as Tzara gloated. An event was hardly modern unless it caused a scandal. Evelyn Waugh catalogued the movable feasts of young, fashionable London during the 1920s in *Vile Bodies*. The characters rotate between parties set in Greece or the Wild West, in Russia or at the circus; they are alternately required to come dressed as someone else, or to turn up undressed. Dalí, both a self-promoter and an impresario for surrealism, made such occasions a regular feature of the New York social calendar. In 1935 he staged a 'dream betrayal' of the city. Guests were invited to wear their dreams. Gala came in a sheath of transparent red cellophane, accessorized with a foetus and a lobster. Dalí swathed his own head in yards of hospital gauze, and applied some cosmetic blood stains. His shirt – a portable glass house – was a shop window, opening into an ulterior realm: it displayed, inside his ventilated chest, a brassiere.

In a less playful mood, the surrealists relied on obscenity as a revolutionary affront. The hero of Georges Bataille's novel *Histoire de l'oeil*, published in 1928, jeers that the universe only 'seems decent because decent people have de-sexed eyes'. He and his partner exhaust the repertory of sexual acts, availing themselves of every orifice and all the body's fluids. Their purpose, like that of Sade, is metaphysical sedition. Seceding from 'the real world, the one made up solely of dressed people', they transform a 'personal hallucination' into 'the total nightmare of human society', more virulent than Dalí's dreamy charade at the expensive East Side restaurant. Reality consisted of people with clothes on; the surrealists forcibly disrobed them, and showed society to be no more than a hypocritical façade.

This flagrancy introduced one of the twentieth century's most cherished projects: the attempt to radicalize sex. A popular song of the 1960s suggested 'Let's all do it in the road', expecting that public copulation would overthrow the state. Indoors, sex became a laboratory for existential research, a form of psychological surgery. In an apartment stripped of furniture, as bleakly uninhabitable as the world itself, the couple in Bernardo Bertolucci's film *Last Tango in Paris* (1972) work through the closed set of coital options, and discover that the body's cavities are voids, vacuums, places where death hides. The same experiment, in Nagisa Oshima's *In the Realm of the Senses* (1976), ends in castration.

Long before this desperate terminus, the parties, orgies and riots of the surrealists proclaimed the amoral playfulness of modern life. Marinetti's term for this antic frenzy, coined in 1913, was 'fisicofollia' – the joyous madness of the body. He found the spirit of modernity on show in the variety theatre, which ignored the emotional subtleties of classical drama and instead exalted 'life in the open air'. Hamlet with his tedious crises of conscience was ousted by teams of clowns and tumblers; sickly psychology gave way to physiological delight. Schlemmer traced the same change from mental pain to bodily pleasure in a genealogy of the theatre which he published in 1924. Wagner, sanctimoniously staging a Mass in his last opera, *Parsifal*, had consecrated the theatre. Since then, his temple had been rowdily transformed into a cabaret, a music-hall, a circus arena or a bullring.

These makeshift theatres – choked with fumes or strewn with sawdust, loud with the cries of spectators who had come to see blood – became the proving-grounds of modern valour, cheerfully democratic fields of battle. The surrealists patronized the seasonal *fêtes foraines*, which trundled rude and garish side-shows around the Paris suburbs; they especially enjoyed the Guignol, in which Punch and Judy belaboured each other with sticks. They were also addicted to the Cirque Médrano. In 1915 Cocteau recruited its clowns for a planned production of *A Midsummer Night's Dream*; Satie wrote some snatches of musical accompaniment, which he called 'grimaces'. His orchestra pulls invisible faces, behaving as cheekily as a music-hall band: horns heckle the actors, and the brass breaks wind. Léger praised the circus for releasing artists from the static rectangle of the canvas, and for bending, flexing and bouncing the block-like forms of cubism. The arena, 'a whirlpool of masses', was for him an enchanted circle. 'The stiff dry angle', he said, 'does not fit in. The round is free, it has neither beginning nor end.' Tzara, excited by the same wild gyrations, vowed that Dada would make 'the fecund wheel of the world circus' rotate in the imagination of every individual.

This glorification of the low, rough theatre, the place where modernity showed off its 'fisicofollia', had its monument in Cocteau's *Parade*, performed by the Ballets Russes in 1917 with the sets, costumes and curtain which Picasso went to Rome to paint and the score by Satie with the obbligato typewriter. Cocteau called it a 'ballet réaliste', although Apollinaire, inventing the superlative for the

occasion, praised its 'sur-réalisme'. It was realistic because it enfranchised the random, rowdy street and its noises: clattering machinery, whirring wheels, the odd pistol shot. It was surrealistic because it reversed reality. The ballet is about its own muddled, improvised making, and its failure to take place. It sees through theatrical illusions, or behind them. In 1932 Brassaï photographed the frantic scene-shifters and dishevelled fan-dancers in the wings at Folies-Bergère, commenting that 'the magic of a great music-hall is not what appears on the stage.... The magic – full of surprises, full of the unexpected – occurs backstage.' Picasso's curtain also looked through the pretences, showing the comedians, their pets and a visiting toreador backstage at dinner.

The parade is a sampling of music-hall or circus acts performed in the street to drum up custom. In Cocteau's scenario, barkers tout the particular specimens of 'fisicofollia' they manage – a Chinese conjurer, a revved-up American moppet who speeds through the multiple perils of Pauline, and a pair of acrobats. The manager of the acrobats advertises his clients in terms befitting an evangelist. 'THE MODERN MAN', he cries, 'is entering our world.' The two modern men make their entry leaping and turning cartwheels, in costumes on which waves break and stars burst: the lithe, restless embodiments of an expanding universe. But who exactly was this elusive, ubiquitous creature, the modern man, and would the world allow him to modernize it? The vaudeville ends, as Cocteau pointed out, in tragedy. The show does not go on because, after the free preview, no one will pay to see it. Exhibiting their skills, the performers hint at the technical mysteries of modern art, misunderstood and reviled by the crowd. Picasso himself, the creator of those 'Trismegistusian harlequins', possessed talents at least as occult as those of the Chinese magician.

Pablo Picasso
overture curtain
for Parade
(1917)

On the curtain Picasso painted a pair of harlequins. The figure in blue was modelled on Cocteau, his red colleague on Léonide Massine, who choreographed *Parade* and danced the role of the conjurer. The harlequins here suggest both the lonely vulnerability of the artist and the fraudulence of the society which rejects him. Though he may be scavenging for pennies in an indigent theatrical troupe, inside his camouflage the harlequin is a god. He is a descendant of Hermes, Picasso's tricksy self-image. Bacchus is also among his ancestors, and, in the *Ariadne auf Naxos* of Strauss and Hofmannsthal, Harlekin's wooing of Zerbinetta anticipates the arrival of Bacchus to re-awaken Ariadne. The harlequin's costume alludes to both of these divine forebears. In the *commedia dell'arte* he still carries the mercurial wand of Hermes; the leopard-skin of Bacchus, changing its spots, turns into the harlequin's chequered tunic. Picasso's harlequins are emotionally ambiguous – sometimes sturdy, rebellious outcasts, on other occasions moony and morbid. One of them, painted in 1916, is swarthy and muscular, holding his guitar like a cocked gun; the nose in his grim, stubborn face has been broken by cubist dislocation. An earlier specimen, dating from 1901, pines at a café table, against a frieze of flowers recalling the nature from which he has been exiled.

While working on *Parade*, Picasso painted a harlequin who has both faces at once. One of his profiles is sharp, beakily impertinent; the other turns aside to scream in terror. What provokes this anguish? The harlequin, a professional illusionist, is undeceived by the costume drama which we call reality. Hugo Ball, Tzara's co-conspirator, in 1916 defined Dada as 'a harlequinade made of nothingness,…a play with shabby debris, an execution of postured morality'. He insisted, despite this jesting nihilism, that 'all higher questions are involved'. These phrases aptly characterize *Parade*, which negates itself by vivaciously introducing a show on which the curtain never rises. In 1926 Evelyn Waugh extended the corrosive metaphor beyond the theatre, calling contemporary society a 'bodiless harlequinade'. The manic performers in the parade may be concealing depression; they soon slump into exhaustion. Is the American girl, who capers so fanatically in her sailor suit, a specimen of happy 'fisicofollia' or an overwound automaton? Waugh returned to the subject of the harlequinade in a 1937 essay which meditates about clowns, contortionists, mannequins and their eerie fascination. Like Kafka's beetle, these freakish beings act out the predicament of modern man, in danger of forfeiting his humanity. For Rodchenko, who subscribed to a revolutionary notion of the body as an apparatus, there had been no reason to regret this loss. In 1920 he praised the circus for its mechanistic rigidity: the movements of clowns or acrobats, like those of machines, bracingly lack 'a psychological connotation', and have 'nothing to do with any aesthetic intent'. Waugh wrote much later, at a time when entire European populations had been mobilized into compliant masses, triggered by their controllers into shouting slogans or starting wars; the spectacle had come to seem sinister. He remarked on the ventriloquist's 'unnatural rigidity of expression' and the dummy's 'unnatural mobility', and saw 'in their endless losing battle of wits with the robot a symbol of our age'.

Rodchenko was wrong to assume that the acrobat is insentient: he is fighting for his life. Hemingway admired the bullfight's unforgiving moments of truth, and the singer Lotte Lenya, an acrobat in her childhood, found the same existential bravery in the circus. 'You cannot cheat or lie when you are on a tightrope', she said. The villain in Hitchcock's 1930 thriller *Murder*, who does a circus act in spangled drag, fails Lenya's severe test. He lies about his sexual tastes, and about his racial origins: the film quaintly exposes him as a 'half-caste', and he commits suicide by leaping from the high wire. Cocteau in his synopsis of *Parade* called the circus an 'accidental art' – an art by accident, or the art of accidents? Waugh specified that he loved acrobats, 'particularly when things go wrong'. We pay our money in the hope that the lion will, just this once, turn on its tamer.

Aragon saw vertigo as a condition of modernity; confronting this mental challenge, an artist required a trapezist's head for heights, and success was a reward for risk. Mayakovsky, playing the bolshevized Christ in his own *Mystery-Bouffe* in 1918, scrambled up a fire-escape behind the proscenium, then hurled himself into empty space, where he dangled with the support of a leather harness: a delevitation directly from heaven. Meyerhold, in his 1921 production of the piece, cast a circus clown as the devil, and had him perform tricks on the rope he used to escape from hell. In other cases the risks were merely stylistic. Stravinsky's *Mavra*, performed by the Ballets Russes in 1922, juggled opera and cabaret, Tchaikovsky and ragtime, Russian folklore and the rigid closure of neoclassicism. Cocteau likened its balancing act to a clown who plays the mandolin while perched on a teetering skyscraper of chairs. This feat of equilibration took place, he added, 'on the edge of the void'. Clowns are free spirits, marginal and disrespectful, inane and perhaps (like Schoenberg's Pierrot) insane. Their flimsy dress became daringly modish in the 1920s, influencing the fad for pyjamas: the revue which Léonide Massine choreographed in London in 1925 concluded with *Pyjama Jazz*, using night-clothes from Selfridge's. But clowns are also notoriously doleful, with smiles painted onto their ghostly faces, which is why Beckett chose them to represent modern man at the end of his tether in *Waiting for Godot*. Jaunty and dejected, *Parade* sums up the success and failure of the surrealist campaign to tease or subvert reality.

In 1929 Buñuel introduced a series of avant-garde films in Madrid. Among them was René Clair's *Entr'acte*, used five years earlier as an interlude in *Relâche*, a ballet designed by Picabia with a score by Satie. It was commissioned by the Ballets Suédois, Diaghilev's competitors, in the hope of outdoing *Parade*. 'Relâche' is a theatre's cancellation sign, and when customers arrived for the opening at the Théâtre des Champs-Elysées, they found it had been postponed: they were offered 'relâche' instead of *Relâche*, just as *Parade* touted a show which was called off for lack of interest. The creators, yawning with the ennui of bored gods, had attempted their own version of Genesis. Picabia said that he, Satie and Clair had made up *Relâche* 'un peu comme Dieu créa la vie' – in other words, to kill time, and perhaps with a certain disdainful curiosity about what might

Relâche
(1924), with
Marcel Duchamp
as Adam in Eden

happen when some human figurines (thirty men in tights, and a woman who strolled onstage from the audience and removed her evening dress) were granted free will. This was creativity automated.

Clair's film begins on the roof of the theatre, where Duchamp and Man Ray amuse themselves with a game of chess (the hobby for which Duchamp soon afterwards abandoned art). Their board, thanks to a cinematic dissolve, is the Place de la Concorde. The circulating cars serve as obliging pawns; the city is their playing field, their circus ring. A cannon roams about unsupervised, poking its barrel at the skyline. Somehow or other Jean Börlin is shot, and plummets to the street. (Börlin, the dancer whose illness caused the 'relâche', was another impish harlequin: his repertory included *Arlequin*, danced to music by Chopin, in which he mimicked Nijinsky's harlequinade in *Carnaval*, set to Schumann.) His funeral procession is led by a tardy camel, while the mourners skip along behind. The coffin, bored by the pace, hops off the hearse and goes for a ride on its own. It rejects burial in favour of a furious aerial circuit on a rollercoaster. Finally it bumps to a halt in a field, its lid pops open, and out leaps Börlin, miraculously resurrected. He waves a magical wand – the harlequin's implement – and with it causes himself to disappear.

In *Entr'acte*, surrealism once more declared war on Paris, bourgeois propriety, and the universe's supposedly irrevocable laws. Nevertheless, the more society was shocked and jarred, the more unfeelingly immune it became. During the twentieth century we have developed a prodigious resistance to scandal, even to horror. The world may be ending, but business continues as usual. The Madrid socialites to whom Buñuel presented Clair's film were so snootily blasé that he thought of organizing a menstruation contest to loosen them up. It remains unclear how the competition would have worked. Remembering the incident decades later, Buñuel merely added – unnecessarily, but with evident relief – that 'like so many other surrealist acts, this one never happened'. Revolution had to be postponed; an ingrained reality was not easy to dislodge.

THE END OF THE WORLD IN BERLIN

Nadja considered the streets of Paris, as Breton observed, 'the only region of valid experience' – the surreal territory craved by a free spirit. In Berlin or Vienna, the streets were less welcoming to the *flâneur*. Alfred Polgar commented in 1918 on the political posters which papered Vienna's walls after the collapse of the Austro-Hungarian Empire. In strident typographic trumpet-blasts, the buildings shouted injunctions or imprecations or calls to arms. The new republic had 'transformed the street into a vertically spread newspaper'. To understand the city's mood, Polgar recommended reading the Herrengasse each day, even if you got your feet cold while tramping up and down. He noted that the people who came to study the posters or listen to their lectures were themselves posters, eloquent in their abject silence. Downcast and famished, their bodies broadcast messages to the new state: 'exhortation, warning, entreaty, death threat'.

When Kaiser Wilhelm II made his getaway in 1918, and Germany too proclaimed itself a republic, Paul Cassirer – a publisher, art dealer and patron of the expressionists – hoped that the workers' revolution would construct a shining, transparent Berlin, 'a star made out of diamonds'. This glass asteroid, like so many of modernism's ideal futures, remained a dream. It was Berlin's fate to be the twentieth century's dystopia: a city of expressionist anguish, just as Paris was the capital of erotic licence for the surrealists. The Berlin streets were no adventurous field of experience. They served as an incriminating byword for the contagion of modernity. The unlamented Kaiser railed against 'gutter art' and vetoed an award to Käthe Kollwitz, whose woodcuts – expressionistically scratched into the surface, making images by the same abrasive process which etches lines of worry and despair on human faces – documented the miseries of the war and mourned the failure of the Spartacist rebellion in 1919. The Nazis employed a variant of the Kaiser's slur, condemning the 'asphalt music' of Kurt Weill. The composer took the attack as a compliment: he was proud that he had managed, in the trudging, tramping marches of his *Berliner Requiem* or the opera *Mahagonny*, to absorb the atmosphere of those downtrodden pavements.

In 1925 G.W. Pabst directed a film – made in Berlin but set in Vienna – which connected the economic and social plight of the two cities. The title, *Die freudlose Gasse*, has no patience with the *flâneur*'s strolling connoisseurship: the street is joyless. The film begins with a miserable slow-motion parade of bowed figures, like the crippled march-past which Polgar watched on the Herrengasse. A veteran of the war limps along, still wearing his military boots although one of them contains a wooden leg. Whores sidle by. Everyone bends beneath an imagined weight. Then all turn the corner, and are effaced by darkness. Later Pabst reviews another dejected line-up. This time the figures are stationary, propped against a wall as they keep an all-night vigil outside the butcher's shop, hoping for a share of some frozen Argentinian meat. Since they are too weary to move, the camera tracks down their bleak, pinched, surly faces. Lighting is supplied by the headlights of a car, raking them as it glides by to stop at a brothel further down the street.

A republic is about public things, deeds performed in public. But in the Herrengasse or in Melchiorgasse, which is Pabst's joyless street, the communal space had become a last resort of the indigent; bourgeois society, evicted from the security and sanctity of the home, was turned out of doors. The next stage in the process of breakdown followed very soon. In Berlin in 1933 when the Nazis took over, Ernst Bloch described their thunderous processions, their rabble-rousing songs, and the banners they flaunted as they strutted down Unter den Linden, and remarked 'they stole the street'.

This militarization of the street inevitably entailed the closure of the arcades, those recesses treasured by the amateurish surreal wanderer. In 1930 Siegfried Kracauer drew baleful conclusions from the defacement of the Linden-passage, an arcade which formerly ran between Friedrichstrasse and Unter den Linden. This arcade catered to the covert desires of the upright bourgeoisie. One of its shops discreetly traded in pornographic images, the stuff of dreams; in a twilight zone beneath its murky glass roof it harboured obsessions – philately, for instance. Tunnelling between two thoroughfares, it kept its distance from their pomp and bustle. Kracauer admired this independence: the Lindenpassage withdrew from the bourgeois domain in order to 'protest against the façade culture outside'. He suspected that this sly, marginal liberty would soon be disallowed by the law. Benjamin, in his essay on Paris arcades, pointed out that iron and glass – the materials of the Lindenpassage – were at first not considered respectable, and were therefore used only in buildings which served 'transitory purposes': arcades, railway stations, sheds at industrial expositions. You pass through such structures on your way somewhere else; it is as if the buildings, like passengers in transit, were themselves fugitives. The Lindenpassage was redundant because, as Kracauer pointed out, Berlin itself and the rest of Germany were engaged in a convulsive rite of passage – a compulsory transition to a future which he foresaw with dread.

Another modern epiphany followed logically from the death of God and the demise of time and space. After matter had wasted away, atomized by the physicists, money – which underpinned reality for the materialistic nineteenth century – fell fatally ill.

Until 1914, one dollar was worth just over four German marks. By 1919, when Germany began to manufacture money to pay off its war debts, a dollar could be exchanged for seventy-five marks. Then a zany multiplication game began. In October 1923 a dollar was worth four hundred and forty million marks. A month later it fetched four trillion, should anyone have wanted to buy such a flotilla of worthless paper. The currency was churned out by presses which usually printed newspapers (an equally disposable item), and it shared their life-expectancy. Cups of coffee in the Weimar Republic tended to treble in price while you were drinking them. Bavarians, who preferred to barter agricultural produce, sneered at money as 'Jew-confetti from Berlin'.

Spengler published his *Decline of the West* between 1918 and 1922, when the hyperinflation was accelerating. In the book, he argued that the major event of modern times was 'the abstraction of property through paper currency'. The change occurred during the eighteenth century, when economic activity became dislocated from its effects and its proper, palpable fruits. This destroyed the kinship of men with nature, and snapped the moral bond between action and consequences. Work originally bought man a loaf of bread, his share in the bounty of the soil. Later in history he learned to accept a lump of gold hewn from the ground as a substitute. Later still, he was asked to take a piece of paper with a value inscribed on it instead of the gold: a substitute for a substitute.

A note issued by a bank is a form of credit, which therefore raises the vexing question of credibility. On fifty- and one-hundred-dollar bills, the legend 'IN GOD WE TRUST' hovers above the United States Capitol and Independence Hall like smoky sky-writing, drifting towards dissipation. Why should we trust the greenback, if the greenback so credulously trusts that has-been, God? The evil geniuses of the German inflation were financial atheists, men who knew how to make money precisely because they did not believe in it. A stock-exchange wizard infects society with a mania for gambling in Fritz Lang's 1922 film *Dr Mabuse der Spieler*. In *Die freudlose Gasse*, a bloated speculator, aware that Vienna needs coal in winter, notices that one mine has the monopoly. He starts rumours of a strike, which lowers the value of the mine's shares. He gobbles them up cheaply, and feasts on the ruin of countless lives.

The calamity, in Spengler's view, derived from abstraction: the same disengagement from reality which, according to the enemies of modernism, had overtaken the arts. As always, dangerous political assumptions impinge here; but they should not detract from Spengler's crucial and frightening insight. Money is a fable, a fabulation, a story we tell ourselves, hoping to believe it. All that sustains it is faith. Our economy, and the social network of exchanges and contracts it nurtures, depends on a convention which can be altered or revoked at will.

Modern times began by disrupting all such agreements. To change the rules of musical harmony – even though these too were never more than a fiction, like all laws – threatened social concord and mental composure. The human face, like all supposed norms, was shown to have only a relative validity. Picasso and H.G. Wells, for their own different reasons, rearranged it: the result was terrifying. Literature began to acknowledge the gulf between words and things, which changed realism into mere representation. Wittgenstein's linguistics demonstrated the artifice and instability of meanings and therefore of values; so did the German inflation.

In Berlin during 1925–6 Walter Benjamin abstracted bank notes from a function they were no longer able to perform, and rendered them absurd. He did so simply by describing them. Since they had lost their purchasing power, perhaps they might have some ornamental, aesthetic merit instead? What he saw astonished him. Capitalism relied on a team of fictitious, incompetent bodyguards – 'the innocent cupids frolicking about numbers, the goddesses holding tablets of the law, the stalwart heroes sheathing their swords before monetary units'.

The economic catastrophe introduced everyone, whether they liked art or not, to the mental rigours of modernism. Spengler cautioned that money should not be confused with the 'value-tokens' we use for our shopping: 'like number and law', it is '*a category of thought*'. Having been conceptualized, money was set free to do unthinkable things. The Dadaists mocked the pharaonic presumption that funds stashed in a vault can count as a life yet to be lived, a pension plan for immortals. They set up a savings bank of their own, which insured the investor against inflation by paying out interest in the afterlife. 'Every hundred-mark bill', their prospectus vowed, 'multiplies according to the law of cellular division, 1327-fold a minute.' They had it on good authority that 'even the ancient Egyptians fed their dead with dada'. In 1919 Duchamp paid his New York dentist with a handwritten cheque drawn on The Teeth's Loan & Trust Company Consolidated, and in 1924, having devised a technique for winning at roulette, he raised funds for a trial run at Monte Carlo by selling trumpery bonds. These certificates were decorated with Man Ray's photograph of Duchamp impersonating Pan, the god of panic; Rrose Sélavy, Duchamp's transvestite second self, was promoted to treasurer and added her validating autograph.

Seen from Berlin, such jests looked less amusing. In Fritz Lang's 1933 sequel to his earlier film about the inflation, *Das Testament des Dr Mabuse*, the terrorist decorates the pages of his plan to destabilize the currency with doodles. But are those looping strings of zeroes the free-associations of a crazed mind or a record of economic actuality? Benjamin reckoned that there must be an equation between life, time and money. If millions of monetary units are worthless, then the millions of minutes which make up a life are also robbed of significance. Döblin interrupts the narrative of *Berlin Alexanderplatz* to tally the thousands of hogs, calves and oxen killed at the Berlin slaughterhouse, with the proviso that 'there is no reason why we should concern ourselves with them'. The numbers he

gives are an index of this unconcern. Statistics are dismissive, replacing lives with numbers. A money economy, as the sociologist Simmel predicted in 1903, would ignore all but 'numerical designations, reducing qualitative to quantitative values'. The astronomer Eddington made a similar point when explaining the new physics. Its laws, he said, went about their implacable business somewhere behind the world of appearances; they were as disconnected from what we took to be reality as a telephone number is from the personality of the subscriber to whom it has been assigned. The number, in Eddington's estimation, was realer and truer than the name in the telephone directory – another modern epiphany, like Brecht's comment that a man is merely the extension of his passport.

Spengler claimed that values, once detached or abstracted from the land in which they once had roots, were 'made fluid'. Currency wants to be current, to flow, to metamorphose into goods which will soon, thanks to the vagaries of desire, be exchanged for other, newer, glossier commodities. 'Money', Spengler observed, 'aims at mobilising *all* things.' The diarist Hermann Keyserling commented in 1920 on the spendthrift mood of liquidation in society, which he likened to 'the *carpe diem* of late antiquity'. Keyserling saw the popularity of the cinema as a symptom of this longing to be swept up and swept away. Moving pictures switched off 'the activation of the self', and lured viewers into a 'three-dimensional force field'. People gladly paid for the privilege of seeing reality replaced by a phantasmagoria.

The worst effect of the inflation, more calamitous than economic sabotage, was its devaluation of the individual. In 1928 Döblin remarked on the eclipse of heroism in Joyce's *Ulysses*, his model for *Berlin Alexanderplatz*. The modern world, he said, contained no isolated events, and no individual persons to whom they happened; people had been merged and massed, and their lives were ruled by 'the factors of state, parties and the economic system'. This is emphatically untrue of Joyce's Dublin, where characters are still free to follow their personal trails through the city and to pursue their private quests – Stephen's for a father, Bloom's for a son. Döblin's comment referred to the apathetic determinism induced by Berlin.

People were among the things impatiently mobilized by money – tolerated while their liquidity lasted, thrown away when they had been sucked dry. The lesson of personal expendability, also enforced by the casualty figures on the Somme, became a rite of passage into the modern world. The inflation merely speeded up a process whose inevitability Simmel had noted in his *Philosophy of Money*, published in 1900. Once the industrial economy became highly specialized, it ceased to distinguish between the persons it required to carry out its tasks; they were anonymous and interchangeable, like cannon fodder. When the lowest common denominator was reached, people became food, good only for conversion into fuel. In an early poem by Brecht, 'O Falladah, Die Du Hangest!', a Berlin cart-horse posthumously narrates its own cautionary tale. Weak and weary, it has dragged its cart into Frankfurterallee when suddenly it collapses.

The driver rushes to the telephone. In his absence, people congregate to hack the meat from the horse's bones, even though it hasn't finished dying. A while ago, the horse remembers, they were feeding it treats, and berating the driver if he treated it unkindly. What made them change? Watch out – it warns – or they'll start eating you. In *Die freudlose Gasse*, the twin despots of the Viennese neighbourhood are the swinish butcher and the procuress. Marlene Dietrich barters sex for a cut of beef. Greta Garbo, as a prim typist, is treated in the same way by her boss, who thrusts a wad of money into her skirt.

Simmel summed up the economy's indifference to human welfare in a quietly chilling image: 'the personality which merely performs a function or occupies a position is as irrelevant as that of the occupant of a hotel room'. Despite the effusive welcome you receive when you check in, the room itself tells you the bleak truth. Someone of whom all trace has been cleared away was here yesterday. Someone else will sleep in this bed tomorrow, when you have checked out. The revolving doors of the hotel lobby in F.W. Murnau's 1924 film *Der letzte Mann*, or the glass doors which vacantly, forgetfully swing elsewhere in the hotel throughout the film, repeat the nonchalant shrug described by Simmel. Like the wheels on the gaming tables in Lang's films about Mabuse, those windy doors breathe a litany about the rotating brevity of lives. In their cycle, inflation soon leads to deflation. As Döblin conceded in his inventory of slain cattle, our supply of tender feelings has been overtaxed. Is a banker's leap from a Wall Street window-ledge any more tragic than the fall of a share in the market? For the painter Meidner, the topography of the city, like a disposal chute, served to make such eliminations easy. 'Monstrous buildings', he said in his survey of Berlin, 'sag and shake out a suicide or two.' Or three, or a hundred: the total, as Döblin sighed, hardly matters.

People pass through the hotel, like the animals through Döblin's abattoir. This transience makes both places chillingly modern. In 1929 Vicki Baum published her best-selling novel *Grand Hotel*, set in Berlin. The revolving door of Baum's hotel impatiently conducts guests in and out. One loses his fortune and is hauled off to prison, while an employee learns that his wife has had a child. But these small tragedies and comedies are just inconsequential extracts from the stream of phenomena, and the cleaners – sweeping the lounge with damp sawdust or changing the bed linen upstairs – soon wipe out all memory of them. The hotel is abuzz with such happenings; all the same, the refrain of those who keep a vigil in the lobby is 'Nothing happens.' Whatever occurs between a guest's arrival and departure, Baum says, is 'nothing complete in itself'. These are merely quantum agitations: the new physics warned that story-telling, with its faith in the existence of individuals, recites lies about the true state of the world. The hotel lobby is a more reliable witness. The war-wounded Dr Otternschlag morosely studies it through a glass eye, and reflects that 'The earth is an extinct planet – no warmth left in it.' At the end of the novel, the front door, going round in a circle, equates beginnings and ends in order to cancel both out as it 'turns and turns – and swings…and swings…and swings…'. The thief Baron Gaigern, soon

to be murdered, explains the moral of the revolving door to the dying accountant Kringelein. The door's perpetual circuits make it look crazed, and the provincial Kringelein, unused to such modern novelties, gets stuck in it. Gaigern tells him the secret: 'The revolving door must remain open.' You must be sure that the exit is clear; he means that 'you must be able to die when it suits you'.

Learning from the door, the hotel's guests carry their chosen means of extinction with them. Otternschlag has his phial of morphine, and the ballerina Grusinskaya keeps a supply of veronal. Garbo played the suicidal Grusinskaya when the novel was filmed in 1932; aptly enough, it was in the hotel – a catacomb of separate solitudes – that she spoke the line which became her signature, asking to be left alone. Walter Ruttmann's documentary film *Berlin: die Sinfonie der Grossstadt* in 1927 emphasized the cruel dismissiveness of doors like the one in the lobby in *Grand Hotel* when a late-afternoon storm swirls through the city. Revolving doors whirl, as if powered by those furious gusts. A switchback railway careers up and down stilted mountains in a fun-fair. And a mad-eyed woman climbs over the parapet of a bridge, then jumps to her death in the canal.

Preparing a study of the detective story earlier in the 1920s, Siegfried Kracauer paid particular attention to the hotel lobbies in which episodes from so many of these novels were set. Detective stories are fables about guilt in a modern world from which God has abdicated. Divine laws have lost their validity, and social jurisdiction has broken down; the detective conducts the quest for an answer on his own, piecing together fragmentary clues. Kracauer found this metaphysical and moral collapse on view in the hotel. God once built a house for the community of believers; the hotel, by contrast, is 'a negative church', where no one belongs and in which no one believes. This is its convenience. It is a place where modern men can enjoy the benefits of nonentity or annihilation, vanishing into 'an undetermined void'. So far as the hotel is concerned, they are 'marionettes,…not human beings'. How many of the so-called 'guests' (one of the euphemisms which hint at the institution's fraudulence) have registered using fake names, or in the company of temporary spouses? The detective – inconspicuous in a corner of the lobby, pretending to wait for someone while looking over the top of his newspaper – can watch society falling apart into the sum total of its pretences, just as the universe decomposes into 'the doubly unreal mixture of undifferentiated atoms'.

Emil Jannings as Murnau's 'last man' is forced through this destructive cycle, as if trapped inside the hotel's dizzily revolving doors. Losing his job as a commissionaire, he lapses from pomp to squalor: he is banished underground, demoted to an attendant in the lavatory. When a customer hands him a bank note as a tip, he drops it – how many million notional marks? – in the soap dish. The currency is as soiled and disposable as the towels on which his clients wipe their hands. His apparently happy ending (responsible for the film's inappropriate English title, *The Last Laugh*) does not reprieve him. He inherits the fortune of an eccentric millionaire who dies in the lavatory. But he disburses the money in

gluttonous meals, carriage rides, cigars and tips. He has no choice but to spend it before he himself is spent.

In 1930, six years after *Der letzte Mann*, Jannings suffered devaluation all over again in Josef von Sternberg's *The Blue Angel*. Here he played a fussy, dictatorial schoolmaster whose infatuation with the singer Lola costs him his social standing, his self-respect, and even – when he impersonates a cockerel in the cabaret, flapping his wings as a conjurer smashes eggs on his venerable head – his humanity. Sternberg's source was a novel published in 1905 by Heinrich Mann, *Professor Unrat*, which mocked the sanctimonious propriety of Kaiser Wilhelm's Germany. Mann's novel made clear its verdict on the paternalistic empire in a subtitle which referred to the professor's moral collapse as 'the end of a tyrant'. But Sternberg shifted Mann's story forward in time, and made it a chronicle of disintegration during the 1920s: a parable, like the commissionaire's demotion, of mankind falling through the floor. *The Blue Angel* confirms the account of modernity in *The Decline of the West*, where what Spengler called 'Kultur' surrenders to the modish vice which goes by the name of 'Zivilisation'. The teacher has a duty to maintain culture, the bookish patriarchy of the past. But Dietrich's Lola prides herself on being civilized – worldly-wise, free from the nuisance of morality. She is a pianola frantically pedalled by men, and asks them only to indulge her with an occasional pianissimo. Jannings marks the stages of his decline by ripping pages from a wall calendar. He tears off and discards the years between 1925 and 1929: an avalanche of lost time which, like currency then in circulation, is worth less than the paper it's printed on.

Someone had to be blamed for this devaluation of men and their money. The Jews, with their showers of confetti, became the official scapegoats; but women – temptations to that spendthrift liquidation decried by Keyserling,

The Blue Angel *(1930)* Emil Jannings Marlene Dietr and Rosa Vale

synonyms for conspicuous consumption – could also be burdened with the guilt. Lola, who is called Rosa in Mann's novel, was given a new pedigree by Sternberg. He made her a namesake of Lulu, the fatal woman in Wedekind's tragedies of sexual morality, *Erdgeist* and *Die Büchse der Pandora*. Wedekind's titles reveal how the stigma is imposed. Lulu begins as an innocent earth spirit, but is charged with corruption by the bourgeois hypocrites who choose, of their own free will, to be infatuated by her; she becomes Pandora, carrying evil and original sin in her box. Jack the Ripper, knifing her in a London slum, cleanses the world of her taint.

Wedekind worked on the plays throughout the 1890s, which made his Lulu a contemporary of Wilde's Salomé. Both were the hedonistic evangelists of a new century, killed by men who fear them. Pabst filmed *Pandora's Box* in 1928 with Louise Brooks, and Berg's opera *Lulu* was left incomplete when he died in 1935. Their adaptations removed Lulu from the *fin de siècle*. Pabst bobbed her hair; Berg wrote ragtimes and jazzy waltzes to accompany her act as a cabaret dancer. As Spengler would have said, they mobilized her, involving her in the contemporary calamity. Flitting between husbands and protectors, changing names and identities as often as she undresses, the Lulu of Pabst and Berg came to represent, like paper money, the flux and agitation of modernity.

The third act of Berg's opera places her at the centre of a financial panic. In a Paris casino, fates are decided by the whimsy of a wheel, like the rotation of those Berlin hotel doors. Reckless investors, governed by the fatalism of the economic mood, trust their gains to a chimerical enterprise, a cable-car which is to be built to the summit of the Jungfrau mountain. A Jungfrau is a virgin; the untrodden solitude of the peak is to be breached by technology. Civilization – confirming the distorted morality which Wedekind condemns – is the justified rape of nature, rendering the earth fertile and profitable. But the scheme misfires, and the shares plummet. Lulu, herself shared out between men, is rapidly off-loaded, and escapes before she can be sold into sexual slavery in Cairo.

Pabst omits this episode, and instead enlists Lulu as the heroine of an impromptu revolution – perhaps a nubile and cheeky descendant of Rosa Luxemburg, who was murdered by Freikorps volunteers after the Spartacist uprising in Berlin in 1919. In the film, Lulu is put on trial for shooting one of her husbands, the financier Dr Schön. But how can justice operate in conditions of social breakdown? Aren't all laws an ineffectual bulwark against the anarchy of nature and the compulsiveness of desire? The defence lawyer ogles his client, who in turn makes eyes at the judge. When she is sentenced to five years' imprisonment, her supporters create a riot by setting off a fire alarm and are able to smuggle her to freedom. In Berg's opera, as in Wedekind's play, she is saved by a single act of sacrifice: the lesbian Geschwitz, voluntarily infecting herself, takes Lulu's place in the prison hospital where she lies ill with typhus. Pabst, however, foments a popular uprising, like the demonstration by the beggars which breaks into the royal procession through London in the *Dreigroschenoper* of Brecht and Weill (which Pabst himself filmed in 1931).

Lulu owns to no parentage, and in Berg's opera she calls herself a 'Wunderkind', a prodigy who emerged from nowhere: she has no roots – according to the values upheld by Spengler – in any land. Stranded in the last days of the Weimar Republic, she is a candidate for persecution as a racial outsider, the carrier of an imported evil. Pabst's film begins in a sleekly modern apartment, rented for Lulu by her current keeper. It is impersonal, temporary, its very up-to-dateness suggesting the swift turnover of a hotel room, with Art Deco light fixtures and throw-pillows on the floor. Yet there is one item which must be Lulu's own, a single token of anchorage and origins: a Jewish menorah.

Later, having perhaps quietly undergone conversion to Christianity, she kills Schön beneath an emaciated Gothic carving of a figure at prayer which occupies a niche in their bedroom. Her own death in London occurs at Christmas, with the Salvation Army chanting hymns. Her elderly hanger-on Schigolch – a former lover, or perhaps her father, or possibly both – urges her onto the streets as a prostitute, because he wants to sample Christmas pudding. The Ripper carries a sprig of mistletoe and a candle in his pocket. When Lulu finds these, he lights the candle as if preparing for a ritual, and holds the mistletoe above her head like a crown of thorns. Then he stabs and slashes her. Is he punishing her for his own sacrilegious parody of Christian sacrifice? Does he imagine he is avenging Christ's murder by the Jews? In Wedekind's plays, Lulu is menaced only by the moralists. Three decades later, she found herself to be a casualty in a new outbreak of religious warfare. Schoenberg detected anti-Semitism in Berg's libretto, where the cynical banker who profits from the Jungfrau catastrophe is slurred as a 'Saujud' or piggish Jew; this was his reason for refusing in 1936 to orchestrate the opera's third act.

Mack the Knife, the urban pirate in *The Threepenny Opera*, might have been a fitting colleague for Jack the Ripper. Heroes supposedly embody the values a community holds dear. What ideal figures are dreamed up by a society in collapse? One of these is a criminal who first flouts the law, then causes it to cave in. Mack, betrayed by his accomplices, is reprieved on the scaffold when Queen Victoria intervenes to pardon him. This may be mercy, but it could also be her terrified appeasement of revolutionary unrest. Or does she recognize Mack the exploiter as her natural ally? The other anti-hero is a psychotic killer, who merges with the Salvation Army on its march and thinks of himself as a deliverer. Mack's knife is an instrument of social criticism, separating men from their cashboxes; Jack uses his to practise a messy moral surgery, and after he slaughters Lulu and Geschwitz he complains – as if scrubbing down after an operation – that such slatterns never have enough clean towels.

Mack leaves corpses in the gutter, like refuse. Jack, more precise and purgative, cuts out the offending parts of his female victims, desexing them to make them fit for heaven. Mack's crimes are casual: lives have less value than money, and can be nonchalantly discarded. Jack is an obsessive technician, a eugenicist who identifies evil and kills in order to cure it. The Victorian London

which they both inhabit is of course Berlin, where inflation had made individuals disposable and called into question the fellow-feeling on which a community depends.

In 1928 in *Das Berliner Requiem*, Weill and Brecht sought to dramatize the emotions of the big-city dweller in confronting death. Human nature is different in the metropolis, where – armour-clad, defended by the psychological withdrawal which Simmel defined – you can afford to ignore the bell which tolls for your neighbour. A requiem for the citizens of Berlin therefore negates its own consoling function. Earthly justice is unavailing or corrupt, as Mack's reprieve advertises, and religion has no reassurance to offer. Brecht's poetry blackly extinguishes hope, praising darkness ('Lobet die Nacht') not the celestial light which glimmers in the official text of the Mass. Weill's orchestra comfortlessly omits the strings, which play on the emotions and delude the spirit. The *Requiem* is scored for a harsh, gruff wind band and peremptory percussion; a cheap, wheezing organ of the kind favoured in funeral parlours accompanies the reciter's sarcastic sermon.

Death, whether that of a cart-horse in the Frankfurter Allee or a political martyr in the Landwehr Canal, is a brutal cancellation. You are spent, like money; you can circulate no longer (though if you're edible you have a brief afterlife). Two of the songs recall Rosa Luxemburg, dumped from the Liechtenstein Bridge into the canal after being killed, but their epitaph for her is terse and impatient. The drowned girl herself – as her body putrefies in the water – discovers the futility of sacrifice, because death, the organism's consumption by nature, is never a victory.

The only mercy is oblivion, and funeral rites are organized to ensure that we forget, not to aid remembrance. The soldiers in the *Requiem* erect a monument to their fallen colleague because its weight will seal his grave, and stop him from rising up to denounce them for having killed him. Jimmy Mahoney in *Aufstieg und Fall der Stadt Mahagonny*, the opera by Weill and Brecht which was first performed in 1930, is executed for being bankrupt. A man without money has forfeited the right to life; the chorus, chanting a substitute for a requiem after the sentence is carried out, shrugs that nothing can be done to help a dead man.

The German inflation and the ensuing world-wide slump administered a moral shock, like the atomic theory which left Kandinsky 'without strength or certainty'. The memory persists. The return of inflation to Europe and America in the 1970s prompted the swift demolition of welfare by right-wing politicians: compassion is costly. The favoured economist of those years, Milton Friedman – who argued that inflation could be suppressed by controlling the supply of money, which meant placing limits on government spending – blithely declared that 'currency is a fiction'. Margaret Thatcher dismissed as equally fictional the network of associations and obligations which are formalized by economic exchange, announcing that 'There is no such thing as society'. It was a perception worthy of Mack the Knife, who graduates from thug to financier after realizing

that to own a bank is a more cost-efficient form of theft than robbing one. A society did once exist; what Thatcher meant, with a grin of self-congratulation, was that it can easily be destroyed.

To demonstrate her thesis, the scenario of the 1920s returned in Russia during the early 1990s. First the squabbling, nocturnal food queues, then the line-up of elderly traders displaying a battered can of Coca-Cola or a pickled herring or a pair of darned socks. In hotel lobbies, prostitutes each morning presented crisp pairs of hundred-dollar bills at the exchange desk, cashing in the reward for their hard night's work. The streets, meanwhile, were abandoned to the gangsters.

Sometimes it seemed, in addition, as if there was no such thing as the city.

Spengler argued that the vista of a world-city lies at the end of every culture's evolution. Its arrogant skyline closed off the view, and its artificially civilized manners rendered nature sterile. 'The stone Colossus, "Cosmopolis"' for him symbolized paralysis, decline and death. A desert of brick and asphalt, it was preparing for its imminent future as a ruin, when it would shelter 'a small population of fellaheen', huddling among the tumuli 'as the men of the Stone Age sheltered in caves and pile-dwellings'. Spengler wrote this in the early 1920s, thinking of classical Rome, the city imaginatively reconstructed by Freud, or of the crumbling Mayan pyramids, reclaimed by the jungle, which excited the surrealists in Mexico; but he had prematurely described Berlin in 1945, with streets blocked by damaged tanks, women conducting archaeological digs in the rubble, and the woods of the Tiergarten a levelled waste, all the trees chopped down for fuel.

Berlin had a short career as the kind of city Spengler thought of as 'abstract' – the willed creation of a being he called 'brain-man', whose life is 'land-alien'. At Hitler's behest, Speer began the grandiose reconstruction which was to turn it into a petrified citadel with the new name of Germania. Speer went to work on a city which seemed uniquely unstable: capital of all the modernist vices. While Paris provided the surrealists with an open-air museum of curios, the social and architectural reality of Berlin matched the explosively jittery mood of expressionism.

Expressionist bodies, releasing their anguish in a scream, could not contain the disruptive energy inside them; the expressionist city likewise tore itself apart – perhaps retributively, delighting in a destruction which presaged revolution, or perhaps to create a more metaphysical upheaval, because the fixity of buildings and the finality of street plans had paved over the chaos of nature. In his novel, Döblin points to a building site on Alexanderplatz, 'emptied, evacuated, and eviscerated'. Here, where a department store once conducted business, the city had gouged out a voluntary wound, attempting suicide as a reminder that Berlin would share the doom of Rome, Babylon and Nineveh, consigned to dust by Spengler. The process continues. The commissars of East Berlin turned Alexanderplatz into a blotchy concrete waste, with an arid, rusty fountain and a

global clock telling the time in exotic longitudes which the citizens of the German Democratic Republic were not at liberty to visit. After the reunification of Germany, the planners proposed razing Alexanderplatz all over again to build a ring of skyscrapers around its margins. The result, they fancied, would look like Bernini's Piazza Navona in Rome.

The surrealist city catered to solitary pleasure-seekers, like the *flâneur* sampling the quaint wonders of the arcades. For the expressionists, the city was a collective nightmare, a place of psychological condensation where men went to pool their fantasies and lose themselves in a wild rampage. The poet Georg Heym described the 'Korybanten-Tanz' or bacchic uproar of the millions marauding through the streets, burning incense to Baal, the city's deity, and Georg Trakl analysed 'der Wahsinn der grossen Stadt', the madness of the metropolis. In Heym's poem, Baal thrusts a butcher's fist into the darkness and shakes down a storm of fire; Trakl senses a holy wrath, which punishes the city with pestilence. The bad weather in Van Hoddis's 'Weltende' is equally eschatological. A screeching wind plucks slates off roofs. Swollen tides hop on shore, bursting through bloated dams ('dicke Dämme', thick as the waists of burghers). Trains spontaneously leap to their deaths from railway bridges. Everyone, in preparation for the end, has a runny nose.

The surrealists seduced reality, persuading it – like Breton when he likened the Tour Saint-Jacques to a sunflower – to melt into something dreamy and desirable. The expressionist city resisted such enchantments, and was immune to the sorcery which enabled Nadja to telepathically switch on the light in the red window. It could only express itself in violence, first stealing energy from the inhabitants it fed on – Spengler's 'amorphous and dispirited masses' – and then using that accumulated force against them. Döblin introduces *Berlin Alexanderplatz* by warning that Biberkopf, after being discharged from prison, will struggle to make his way in the world, before being crushed by some vast, anonymous assailant, a power which 'torpedoes him with huge and monstrous savagery'. That implacable opponent was the city, a cosmic malignancy which must now take the place of a vindictive, irresponsible God.

On Biberkopf's first journey back by streetcar from the prison at Tegel, the city pounces. Is the conductor who demands his fare a policeman in a different uniform? Expressionism here is a reflex of persecution mania. Döblin attributes motion to objects which should be rooted to the earth, sedately fixed on the map; they hurl themselves through the air like missiles. 'Busy streets sprung up', or 'house front after house front raced along without end'. Biberkopf is scarcely animate, while dead things prod, push and threaten. He is aghast at the wax dummies gruesomely imitating flesh in a department store window, but when he looks back at the street he can no longer tell the difference. The strolling, smoking people become as rigid as the lamps at the corners, as white as the houses. How can they move, or simulate laughter? He recoils from the city: 'It – did – not – live!'

Spengler's stone colossus had become a double or 'Doppelgänger', like the mannequin of clay in Paul Wegener's 1920 film *Der Golem*. The golem was a body with no soul, invented by a rabbi in sixteenth-century Prague to defend the imperilled Jewish community; it returned in modern times as a killing-machine, a concrete giant which tramples men like Döblin's city. Lang's nubile robot in *Metropolis* was a female variant. Too ladylike to be a mass-murderer, she instigates mayhem by her own demagogic methods, inflaming a cabaret audience with her abandoned dance or inciting factory workers to rebel. Doubles like these acted out the fears of a society which had lost control of its own destiny. Human beings, to survive for this long, had learned (as Simmel suggested in his study of the metropolis) to impersonate automata. The city, like the currency, was a multiplication table of meaningless numbers. People could only await an end which they seemed powerless to avert. Or should the end be anticipated by a 'final solution' – the technological war of humanity against itself?

On the street-car, Biberkopf's head threatens to burst because he cannot separate himself from the rushing, roaring phenomena of the city. Kracauer, studying the demeanour of passengers on public transport in Berlin, noticed something even more worrying. Simmel pointed out the new psychological predicament introduced by mass transit: now strangers were compelled to confront each other for long periods, and they coped with this unwelcome intimacy by iron-clad indifference. Kracauer observed that this cool oversight had been extended from other passengers to the city itself. On bus journeys into the suburbs, he felt he might have been travelling through a foreign country – a place he did not know, and which he was absolved from having to care about. He was mystified by these 'constantly new people with unknown aims', intersecting 'like the linear maze of a pattern sheet'. Kracauer's sense of disconnection troubled him. A community had splintered into a crowd. If other people were so unknowable, they might be his enemies. The streets he moved through at speed had become a power vacuum. He no longer felt that the city belonged to him, or he to it. Who then would claim ownership, and by what belligerent means?

The emptiness of the streets showed them to be inhospitable, and warned that they might be dangerous. The estrangement of outer space had arrived in the centre of Berlin. Pondering the relation between individuals and masses in a 1922 essay, Kracauer struggled to connect his social observations with the laws promulgated by the new physics. What motivates groups, and generates their ideas? He proposed an analogy with 'the law of inertia in mechanics', then worried about applying it to society, because the physical law was 'valid only in a Galilean space – that is, in a space that is empty, containing no masses'.

Kracauer's science was shaky: the space he referred to was mapped by Newton, not Galileo. Nevertheless his idea is poetically suggestive, and it evokes the urban mood of the time. Emptiness is a notion unique to modern times, beyond the comprehension of earlier cosmologists. At the end of the nineteenth century, physicists dreamed up a bath of ether, inside which they thought the

universe must go about its business. It could not be seen, but it had to be there: they could not conceive of empty space. Experiments which studied the propagation of light, and led to the formulation of the relativity theory, revealed the truth. Sound is a vibration, and can only be transmitted by matter. But light, travelling in temporal waves, dispenses with matter. This put an end to the ethereal ocean: the universe after all was a large and empty room. Kracauer's sociological speculations brought that vacancy down to ground. He saw it in the Berlin streets, and

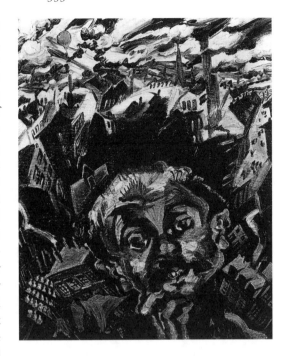

Ludwig Meidner
I and the City
(1913)

found it in his archetypal hotel lobby, which 'signifies only its own emptiness' and is populated by the 'emptied-out individuals' who appear in detective stories – people bereft of qualities, expressly constructed as accessories to some imagined crime.

In Ibiza during 1932, Walter Benjamin attempted to chart the Berlin of his childhood, lost to him in exile. He remembered his early explorations of the city as a series of tentative, terrified ventures to the edge of a precipice. Taken to the zoo by his nursemaids, he encountered for the first time a street which had not been tamed, domesticated, made habitable: Schillstrasse, forlorn between the shops, perilous at the crossings. He recalled being trapped on another occasion by a sudden, freakish flood on Kurfürstenstrasse. Approaching adulthood, he saw the whores on duty in tenement doors as the guardians of a psychological barrier. They patrol 'the edge of a void', and 'beyond this frontier lies nothingness'. The women of the streets, like the vagabonds who inherit those streets between midnight and dawn, function as the city's map-makers. They know exactly where the world ends – the border where you can slip out of your social class; the gap through which you can drop out of society altogether.

An urban view, for the expressionists, was the scene of a future accident. 'It sometimes seems to me', Kracauer remarked in his commentary on the eerie, alien suburbs, 'as if an explosive has been planted in every possible hiding place. At the very next moment, it will blow up.' Any street corner could be the setting for a brawl, which might incite a riot, or serve as the excuse for a *putsch*. There was no need for a reason: violence crackled in the air. Ernst Bloch defined

expressionism as 'image-explosion', tearing up the pictorial surface to let out a seething, searing energy. Artists in Berlin, like street-fighters, rehearsed the collapse of society; more literally than Aragon ever intended, they experimented with the annihilation of the universe.

In Meidner's sketches of Berlin, apocalypse visits the most placid outlying areas of the city. Meidner drew the Wannsee-Bahnhof in 1913. Light pelts from the sky in black, scratchy bolts like bursting shells, and the street tilts at a sick angle. A mob – refugees from the pastoral idyll to which the lake is devoted – pours into the station's gullet, anxious for extinction. Reality itself is threatened with derailment. In a Wilmersdorf street, telephone lines flap free above the buildings like deranged hair, and arc lamps stare down with sore eyes. Pedestrians hasten to quit the scene. An angry, skidding tyre carries a car away, just in time. Another of Meidner's sketches, which includes a self-portrait, restages Munch's *Scream* on a Berlin railway bridge. The buildings shudder and reel, and clouds rain shrapnel. The artist, scurrying for cover, raises a protective hand above his head: the sky is falling. Munch said he heard a scream 'piercing nature' – ripping it open, along the fault lines of those scorching clouds or the blue-black vortex in the water, to reveal the emptiness behind. In his painting the landscape presses in on the distraught figure, squeezing his body and reducing his head to a skull. The blue circle of his open mouth is the nothingness into which the world will vanish. Meidner's scene is starker, without the hallucinatory colours of Munch: black ink stabbing white paper, leaving blots like dried blood. It describes a different catastrophe. Nature has been superseded, except for those turbulent clouds (which could have billowed from some detonation). Houses here do the screaming, and a lamp jumps off its pedestal in alarm. The world does not cave in on the figure of Meidner, as it does in Munch's *Scream*. Instead it flies outwards, tipping off the edges of the paper, since there is no centre to hold it in place.

Like the clay statue when it comes to life, the architecture of Berlin seemed freakishly liable to rise up in rebellion against those who made it and relied on it to shelter them. Biberkopf in *Berlin Alexanderplatz* sees the roofs of houses sliding off and soaring away. The sky is no longer a protective canopy; why should we place any trust in ceilings? When the demoted Jannings walks miserably home in *Der letzte Mann*, the walls of the buildings he passes elastically stretch on tiptoe to peer down and mock his distress. A tenement courtyard turns into a carousel, performing a mad dance of sardonic glee around him.

Isherwood in *Mr Norris Changes Trains* took a gloomier, more Gothic view of the Berlin tenements with their deep central shafts. Looking up the sooty walls with their diseased plaster towards a dim scrap of sky, he likens a courtyard to 'a coffin standing on end'. He is himself inside the coffin, which has its head on the earth: a ghoulish illusion suggested by the buckled house-fronts, leaning towards each other as if eager to close the aperture above them. Baulks reach across the gap to prevent the buildings from meeting. Isherwood seems to be buried alive.

Because no sun ever leaks down this far, the courtyard also resembles a mountain gorge at twilight. This is the haunted landscape of Murnau's *Nosferatu*, stalked by vampires. Just as Döblin's hero sees the golem modelling clothes in a shop window, so Isherwood's narrator, visiting an innocuous slum, finds himself lost in the Carpathians. Modernized in a hurry, Berlin still atavistically preserved the superstitious ancestry of mankind. Helicopters buzz between skyscrapers in Lang's *Metropolis*, and cars shuttle along aerial highways. But, further down, a sorcerer has his den in a rustic cabin, and gargoyles grimace on a Gothic cathedral. A mechanical civilization rested on a primitive subsoil. Walking downstairs to a cabaret in a cellar, you could regress several thousand years.

This superimposition of epochs made the city feel infirm, insecure. The streets were a no man's land, and the people who walked in them, having – like Biberkopf – learned the lesson of their own insignificance, were not individuals, just animate statistics. The buildings, so liable to rear up derisively or to lose their heads, merely pretended to be solid, like the tattered city painted on a theatrical backcloth, which any wind can ripple. Bloch called Berlin 'perennially new, …built hollow' after bourgeois culture caved in.

Rilke in the tenth of his *Duino Elegies* imagined an expressionist capital named 'Leid-Stadt', the city of pain, where noisy silence pours into the mould of emptiness and creates an exploding monument. This is how Bloch saw Berlin: its mortar, he said, was not allowed to harden before the economic speculators and political fanatics resumed the process of demolition and reconstruction. Cracks had already opened in its bright new frontage. These fissures were the arcades which fascinated Benjamin and Kracauer, disposal areas – in Bloch's view – for the treasures of the disinherited middle class, hollow spaces choked with domestic ruins and degraded household gods. This was a more tragic version of Breton's account of the Paris flea-market in *Nadja*. For Bloch, all those bizarre trinkets had a history. Added together, they told a story of disaster and diaspora. The surrealists, as Bloch put it, plugged the gaps in the world with 'rotting substances, dream substances'; they swept the refuse of society into the convenient hold-all of the arcade, and constructed cathedrals (like the floral Tour Saint-Jacques of Breton, or Ernst's lunar Porte Saint-Denis) to the new religion of relativism.

From Bloch's vantage-point in Berlin, the enjoyment of pointlessness and the connoisseurship of decay no longer seemed a proper response to the emergency. He called surrealism 'an aesthetically isolated dynamite'; the expressionists refused to muffle the explosion or to render it powerless and merely playful with the help of art. Isherwood described the months of anarchic civil war before the Nazis, having stolen the streets, stole the state. 'Hate exploded suddenly,…out of nowhere' in dance halls or swimming baths. Anything which fell to hand qualified as a weapon – 'spiked rings, beer-mugs, chair-legs, or leaded clubs'. Every surface, as expressionism required, was torn. 'Bullets slashed the advertisements on the poster-columns, rebounded from the iron roofs of latrines.'

This violence, like the sudden nightmarish fluency of the Kurfürsten-strasse in Benjamin's memoir, dramatized the speed of change and disintegration in society. Within fifteen seconds, Isherwood calculated, a young man could be knocked down, robbed, beaten, stripped and left bleeding by his attackers, who would have vanished before the time was up. The flood in the street abruptly washed away the past, erased records, which is why Benjamin felt impelled to salvage the city he remembered. Kracauer in 1932 acknowledged the impossibility of the attempt, describing the Kurfürstendamm as a 'street without memory', a conduit for 'empty flowing time, in which nothing is allowed to last'. Behind the ravaged, glossily updated façades, there were glimpses of marble staircases, still intact although obsolete – relics of the hierarchical world before the war, or before the deluge.

The hedonistic tempo of Berlin, which Kracauer called its 'complete presentness', turned the city into a visual flux, a place which in the literal, elemental sense seemed dissolute. Ruttmann gave his film a grandiose subtitle, *The Symphony of a Great City*; but in it Berlin dissolves. Perpetually in motion, it ceases to be visible. No landmarks – anchors in the eddying of human and mechanical traffic – ever appear: no Brandenburg Gate or Gedächtniskirche. The millions of people who live there are also washed away, carried off in crowds.

This flickering agitation and rapid forgetfulness made Berlin cinematographic. The camera, effortlessly traversing space and abridging time, even outstrips the express train which charges in from the country to arrive at the Anhalter Bahnhof at five in the morning during Ruttmann's opening sequence. Film, compounding the miracles of the new physics, can relativize time at will, speeding it up or reversing it, as Ruttmann goes on to do: the end of the working day in his *Berlin* is the beginning run back to front, and factory doors which we saw slide open now swing shut. Benjamin's memoir recalled the more sedate and stable era when railway stations were still, like the Brandenburg Gate, ceremonial points of entry to the city. But in Ruttmann's film the Anhalter Bahnhof is one more landmark which remains unseen. The camera had no patience with a pile of immobile bricks; it was too busy enjoying its own new-found power, as volatile as light. Now, Benjamin claimed in his 1932 essay, 'only film commands optical approaches to the essence of the city, such as conducting the motorist into the new centre'.

Film, which would not stay still for long enough to look at a monument, also elided human faces. Ruttmann's *Berlin* testifies, like Döblin's novel, to the dismaying modern conviction of the individual's redundancy. The train arrives in a vacated, possibly devastated city. Paper strewn in gutters and a trickle of effluent through the sewers are the only hints of a human presence. The first people to appear in the film are made of wax: dummies preening in a shop window, like those which alarm Biberkopf. Before dawn there are no citizens; then, as the day begins, there are too many – an innumerable army of workers, squeezing onto trains. Individuality is a privilege of the plutocrat. Long after the mobs have made

their way to their factories or offices, Ruttmann shows the bosses strolling out of their villas. Their chauffeurs bow; they ride into the city in solitary splendour.

The economic machine has no use for humanity. Hands are all it needs; it can afford to lop off heads. Ruttmann shows telephone receivers being picked up and slammed down, but cuts out the bodies of those who handle the instruments. Stories are told by physical extremities alone, since people consist merely of feelers. Night in Berlin is narrated in visual shorthand. A male hand casually touches a bare female arm, and two pairs of legs climb into a taxi. The next image is an electric sign, HOTEL. Nothing more needs to be said, or shown: the head, after all, is disengaged during sex.

Twice in Ruttmann's *Berlin* the hurtling, flooding city disintegrates. It swoons, or perhaps is knocked out; its working rhythm is punctuated by regular breakdowns. In the morning, ownerless hands remove the cover from a typewriter. The machine's brand-name, alarmingly, is TORPEDO. Next a row of typewriters appears: the secretarial pool is a munitions factory. A battery of fingers begin to pound the keyboards. The jumbled alphabet swims in and out of focus, then starts to swirl, gyrating as crazily as Dr Mabuse's wheels of fortune. A black-out follows: time for lunch. The film concludes with another fainting fit. Nocturnal galaxies flare in Berlin's West End. The lighted façade of the Café Zoo begins drunkenly spinning. Objects in motion disappear, like the propellers of planes, and the building revolves until it is ejected from its own skin. Ruttmann cuts to a Catherine-wheel rotating in the sky, which giddily exhausts itself and is blotted out by blackness. That is the end of the film, and of Berlin: an expressionist explosion, as Paul Cassirer's diamantine star combusts.

Cities which served as the headquarters of empire were for Spengler 'petrifacts'. In his mythology, they replaced the maternal, nurturing earth with a dead body, stiffened by the rigor mortis of concrete. The grid of rectangular blocks symbolized 'soullessness'. Spengler foretold the commanding role of the next cosmopolis, which assumed power after Europe's two self-destructive wars: the rise of New York, he suggested, was 'the most pregnant event of the nineteenth century'. Here, across an ocean, was the ordained terminus of the West. Its profane, blazing pinnacles, seen in 1924 from a ship docked at a pier on the Hudson River, gave Fritz Lang a preview of the future, and provoked the reverie of *Metropolis*. Isherwood, sailing into New York with Auden in 1939, described the city in imagery which connected the different auguries of Spengler and Freud. As their ship slid past, he called the Statue of Liberty 'the giantess' and saw her torch as a club. The looming, bludgeoning woman had undergone the Spenglerian fate of petrifaction, which in *The Decline of the West* signals 'the end of organic growth'. Over the way, the towers of lower Manhattan warned of another authoritarian terror: the skyscrapers, Isherwood said, were 'father fixations'.

In Paris, the surrealists saw the circus, the music-hall and the brothel as resorts of freedom, playgrounds for the follies and frolics of the body. Cocteau insisted that

the music-hall and the circus should not be confused with art. Instead, he said, they offered excitement and danger, as did machines and animals. The same institutions recurred in expressionist Berlin, but here they possessed a different and more corrosive meaning. Wedekind's *Erdgeist* and Berg's *Lulu* begin with a parade outside the circus tent, which likens society to a menagerie. The heroine is shown off as the Animal Tamer's prize snake. Nature, amoral and unashamed, has filled Lulu with self-protective venom. The ringmaster advises her against pretending to be harmless, and in doing so he dismisses Nietzsche's complaint in *Twilight of the Idols* that civilization, like an animal-tamer, humbles and makes servile the beast in us. The circus is no longer marginal, as it was in the Paris of the surrealists: it challenges society, and threatens to overthrow it by releasing the beasts from their cages.

The houses of pleasure which Brassaï and Aragon patronized in Paris were infernos for atheists, who – enjoying a season in hell, or participating in a mock-up of the crucifixion – could enjoy a brief holiday from morality. In *Das Tagebuch einer Verlorenen*, Pabst went further, commending the brothel as a more moral place than the society it secretly serves. Louise Brooks as Thymian, disgracing her family when she becomes pregnant, is sent to a militarized reformatory for lost girls. She escapes after fomenting a revolt against the sadistic warders. The cosy, grand-matronly madam who takes her in is no ogre. Pearls repose on her ample bosom, a handbag swings from her pendulous arm. She smiles benignly as she pairs off her girls with the customers, her eyes glistening behind her pince-nez. What has she to be ashamed of? She permits nature, persecuted and repressed by the reformers, to express itself. In the novel by Margaret Böhme which Pabst adapted, Thymian spends her hours of repose between clients reading Nietzsche.

The Berlin cabarets, explicitly invoking Nietzsche as their founder, encouraged the uprising of rude, savage nature against anaemic society. Otto Julius Bierbaum in 1897 described the cabaret as a place of naked joy and blasphemous wit, where acrobats swung through a godless sky – an arena in which the Nietzschean superman sang and danced. In 1900 Ernst von Wolzogen called his theatre an 'Überbrettl'. A 'brettl' is a pocket stage; the superlative prefix, imitating Nietzsche's 'Übermensch', promised both transcendence and subversion. Kurt Hiller, opening the Neopathetische Cabaret in 1910 as an expressionist locale, explained that its spirit was a new and superlative form of pathos – not gravity and grief but the ribald, volcanic laughter of Pan. Between 1921 and 1923, a cabaret called the Wilde Bühne took over the cellar of the Theater des Westens, near the Zoo Station. Brecht sang (or balefully croaked and acidly snarled) his ballads here. The name reversed the enfeebling work of Wedekind's Animal Tamer: this was a wild or untamed stage, a jungle beneath the downtrodden asphalt.

The Nietzschean elation soon wore out. In 1928 the secret agents in Lang's film *Spione* spend an evening at the Café Danielli, where the floor show is a brutal boxing-match. After the knock-out, a violinist strikes up, and dancers

invade the sweaty, blood-stained ring. Among the customers is the paralysed Haghi, a financial demon like Mabuse. He is bound to his wheel-chair, with a uniformed nurse in starchy attendance at his dinner table. The cabaret has lost its charmed liberty: in the boxing-match it is invaded by the power struggle which convulses the city, and the presence of Haghi's nurse hints that it is also an incubator for social maladies.

Was the cabaret perhaps a lair for the subhuman, rather than the super-man's native abode? Jannings as the stiff-backed pedant in *The Blue Angel* spends his time bemusedly playing with a golliwog doll on Dietrich's bed, and during his rampage in the cabaret crows like a berserk rooster. For Louise Brooks, in the films she made with Pabst, sex meant salvation. Marlene Dietrich, the opposing Berlin archetype, deploys sex as perdition.

Dietrich returned to the cabaret in her fifth film with Sternberg, *Blonde Venus*, released in 1932. Here she outdoes Lulu's impersonation of the serpent. A gorilla marauds onto the stage, flicking its clawed paws at the audience. Then it slithers out of its own skin. The grimacing head-piece comes off to reveal a blonde, frizzed Dietrich, throatily singing 'Hot Voodoo'. But this face is another disguise. Inside the ape is the love goddess; inside profane Venus is a faithful wife and devoted mother. Dietrich vamps in the cabaret to pay for an operation which her baby needs. In Hollywood, if not in Berlin, redemption was compulsory. All the same, Dietrich was merely play-acting the maternal role, and could easily remove that disguise. After *The Blue Angel*, Sternberg put her through a succession of metamorphoses. She played a spy with serial identities in *Dishonoured*. In *Shanghai Express*, she steamed implacably through a revolution, flaunting the plumage of a black swan. As a harlot in *The Scarlet Empress*, she was raised to supreme power by another revolution. In *The Devil is a Woman*, she hunted men through the giddy chaos – a revolution with a predetermined life-span – of carnival in Seville. Though the costumes changed, her face remained immune to emotion, set in stone like one of those 'petrifacts' which for Spengler represented the fatal falsity of civilization. As played by Dietrich, even a hairy ape was artificial.

Berlin, in Bloch's view, hid social decay behind 'rigid façades'. Dietrich's maquillage served the same purpose; so did the specifically modern art of mont-age. Picasso glued rags, papers, scraps of cloth together in his collages. The cabinets of curiosities in Aragon's arcade or Breton's flea-market also made a serendipitous virtue of randomness. Montage in Ruttmann's *Berlin*, collating scraps of film and forcing them into intimacy, evoked the collisions and frictions of the city, where violence always awaits its chance. Two telephone receivers are angrily banged back onto their cradles; a pair of chained dogs snarl and grapple in the street. The technique has the irresponsibility of the *agent provocateur*, because who is to say how deliberate the connections are? Ruttmann shows a dusky, bewildered foreigner in Asian clothes wandering between the street-cars in a Berlin street. Immediately afterwards, a train steams past a placard advertising soap. A racial slur, or not? Coincidence is the mystery of the metropolis.

Bloch observed that montage 'improvises with the cracked content' of a frac-
tured society, filling in its hollow spaces with whatever comes to hand. The world
is assumed to be fundamentally and irreparably incoherent; it can therefore be
pieced together however you please. Montage, in Bloch's phrase, crystallizes
chaos. It is at home in the ruins.

The shows performed in the cabaret were organized according to the
same opportunistic method. Revue seemed to Bloch 'one of the most open
and unintentionally honest forms of the present', because its haphazard succes-
sion of skits and whirligig transformations acknowledged that 'reality itself is
full of interruptions'. Like a kaleidoscope, it made decorative patterns out of
accidental, fragmentary encounters. Lulu has a brief career as a revue dancer in
Pabst's film of *Pandora's Box*, and – enraged to see Schön in the audience with his
fiancée – she struts off and, when he rushes to her, alternately harangues and
entreats him until he breaks off his engagement. The episode demonstrates the
new art of montage at its most flurried and hysterical, as Pabst intercuts the
squabble with the technical mayhem of the scene-change. Brassaï the surrealist,
snooping backstage at the Folies-Bergère, discovered nothing worse than a cheer-
ful, impudent state of undress. When Pabst looks behind the scenic screens, he
finds emotional breakdown and social upheaval occurring in the wings.

Pabst here dissects chaos, as Eisenstein did on the Odessa Steps, analysing
sound, fury and terrified flux. Whether the subject was a theatrical tantrum or a
massacre, montage specialized in depicting life as a battle. It reduced matter to its
raw state: a bombardment of separate atoms, propelled through the air like bul-
lets. The revue was a mutation of the military review, an inspection parade. The
soldiers laid down their arms, changed their sex, and became a high-kicking cho-
rus line. But by the late 1920s in Berlin, the revue had been militarized all over
again, its dancers tyrannically drilled into precision. Kracauer called the chorus in
a show like Lulu's a 'machinery of girls'. Below sixteen brave, fixed smiles, thirty-
two shapely legs operated as one. Had the false Maria from *Metropolis* artificially
reproduced herself, in order to gyrate in company with a row of clones?

The spectacle reminded Kracauer of pistons being put through their
paces in a factory, and called up unsettling memories of the alliance between
industry and war. A mechanical civilization is happiest and most profitable when
fuelling society for a fight; in battle, men must behave like machines. The new
dances which were popular in the 1920s called for bodies which could be
instantly switched into high gear. The circling grace and languid surrender of
the Viennese waltz gave way to the Charleston, for which you needed locomotive
legs and an inhuman talent for contortion. Tap-dancing imitated the indefati-
gable rat-tat-tat of a machine-gun.

In 1912 the cabaret performer Egon Friedell described Berlin itself as 'a
wonderful modern machine hall, a giant electric motor', busily working to fabri-
cate pleasure. It did not worry Friedell that the mighty metropolitan gadget as yet
possessed 'no soul'. He trusted that it would acquire one in time. Instead the war

began, and machines got down to the business of efficiently killing off mankind, for which they had been trained. Afterwards, the revues continued the battle between men and machinery. Their frenetic animation seemed sinister to Kracauer, because it contrasted with the idleness or exhaustion of the audience. Leisure, like the work from which it supposedly offered relief, had been industrialized; enjoyment was automated. Brecht's *Mahagonny* sentences its citizens to indulgence as if to hard labour. First they eat, then they have sex, after that they box. Whatever else they might be doing, they must conscientiously keep boozing. Each of these activities is deadly – Schmidt's gluttony kills him – and in Weill's score they are all accompanied by the same grimly regular, joylessly upbeat choral refrain. The city exists to deprive men of their money. Conspicuously consuming, they are liquidating themselves.

The role of Leocadia Begbick, the owner of the clip-joint in *Mahagonny*, was sung in the first production by Trude Hesterberg, who also happened to be Heinrich Mann's candidate for the part of Lola in *The Blue Angel*. A decade earlier Hesterberg had been the proprietor of the Wilde Bühne, where – as she proudly recalled – Brecht's recitation of his ballads provoked 'a bona fide theatre riot'. By the time she appeared in the opera, the situation had altered. The establishment run by Widow Begbick is no Nietzschean game-preserve, a safe haven for moral and political outlaws. She trades in vice because it is good business; her values are impeccably bourgeois, since for her the worst crime (punishable by death) is to evade payment for your pleasure. The cabaret and the brothel, annexed by society, had become as oppressive as the prison and the execution chamber.

The ideological war which began with scuffles and brawls on street corners in the late 1920s was fought for seventy years. The partitioning of Germany and the division of Berlin lowered the temperature of the conflict, and replaced fisticuffs and gunfire with an exchange of images. Along the Kurfürstendamm, vitrines on the pavement exhibited, as if in glass cases at a museum, the trophies of consumer capitalism – Louis Vuitton luggage, tropical holidays, Turkish rugs. On the other side of the city, megalithic ancestors stood guard. A square, stolid Lenin carved from red Ukrainian granite clenched his fist in a square named after him. In Treptower Park, above the communal grave of Red Army troops killed while liberating the city, Mother Russia grieved on her pedestal and a giant Soviet soldier belaboured a swastika. Between these antagonistic worlds ran the Wall, which was actually a pair of walls, with a ploughed, mined wasteland running between them. Spengler might have recognized the Wall, dwarfish and shoddy though it was, as one of his petrifacts: a funereal terminus, a declaration that the dialectic of history had reached a stalemate. In 1975 György Ligeti summed up the frustrating paradox of the city in a proposed dictionary definition of 'Berlin (West): A surrealist cage; those inside it are free'.

The city's reality had certainly become surreal, but the internees within the cage continued to behave expressionistically. During the Cold War the right

to self-expression was enlisted as a political virtue. In 1946 the critic Robert Coates described the painters of the so-called New York School as abstract expressionists. Jackson Pollock hurled paint at canvases while dancing around them; Mark Rothko covered the available area with swathes of colour, using the canvas as a meditative pool. The picture plane, for Pollock, Rothko and their colleagues, was a field of experience like Nadja's streets, an arena in which they energetically exercised their freedom or demonstrated their serene self-absorption.

In Berlin, such expressionism had no need to be abstract. The inhabitants of the cage, like stir-crazy prisoners, were natural extremists. Working in Kreuzberg, a district grazed by the Wall, the painters Salomé (christened, more innocuously, Wolfgang Cilarz) and Rainer Fetting revived the revelry and defiant perversity of Weimar Berlin, with its untamed stages. Salomé in 1979 painted a cabaret where acrobatic pierrots couple with men in leather. For Fetting in a 1981 panorama, a male shower-room is a dungeon of erotic delight. In a self-portrait, Salomé, with his head shaved and his face rouged, wears high-heeled shoes and silk stockings. He has barbed wire twined around his legs: a prickly cage which transforms pain into pleasure.

The Wall itself, decorated and defaced, became a shared canvas for the immured occupants of West Berlin. Benjamin, during his childhood explorations, often felt he had reached the limits of safety, beyond which lay the unknown. A doorway blocked by a prostitute was just such a barrier, terrifying and tempting. He had to imagine these perimeters; the Wall constructed his nightmare in reinforced concrete, and marked the precipice with a sign near Checkpoint Charlie which warned in three languages 'YOU ARE LEAVING THE AMERICAN SECTOR'. Anger and frustration vented themselves on the Wall. A number of West Berliners killed themselves by ramming their cars into the barricade at high speed. Would-be émigrés from the East jumped over, and were usually gunned down.

Fetting in 1978 painted van Gogh painting the Wall: under his hand the soiled surface takes on the radiance of a sunflower. The abstract expressionists were praised for their physical vigour and mental valour, the credentials of liberty. Those who painted slogans, cartoons, graffiti, tropical landscapes and lurid apocalypses on the Wall qualified for the same accolade. They had to work surreptitiously, often at night; the rough, rocky texture deterred them. If they possessed unusual skill and bravado, they managed to sign their names at the rolled summit, designed to prevent people from climbing over. Some of them, like libertarian gymnasts, left upside-down signatures at the top, as if they had painted while suspended feet first from the sky.

Modernism began, it has been said, when Maurice Denis decreed that a painting was first and foremost a flat surface. The expressionists, however, could never accept the impenetrable plane. They blew the surface up, as Bloch noted, or gouged it out like Kollwitz in her wood-cuts. The Wall's painters circumvented the surface in a different way. They made it fancifully transparent. Some-

Rainer Fetting
Van Gogh
and Wall V
(1978)

times they painted holes in the Wall, or zip-fasteners opening onto freedom. On one section they lowered it so that Humpty Dumpty could vault over, undetected by the armed guards. Where it obstructed the view, they filled in what was missing. In Kreuzberg the spire of a church poked up on the other side between blocks of communal housing; its lower portions were restored in a *trompe l'oeil*. The Wall, breaching the modernist edict of Denis, functioned as a picture window, a view of elsewhere. Looking through it – or walking through the gaps in it after 1989 – was a means of transit from the modern world with its revolutionary schisms to a future we can only think of as somehow post-modern: an outlook as blurred and doubtful as the exit from the Lindenpassage.

The crossing-point between west and east at Kochstrasse is occupied now by a business centre, which offers dry-cleaning, dog-sitting and supervised workouts, along with Internet access. A shopping mall has opened on Friedrichstrasse, replacing the missile-pitted tenements which used to lead from the sentry box at Checkpoint Charlie to the windy desolation of Unter den Linden. The development, tackily opulent, calls itself the Friedrichstadt Passagen, although its arcades, with marbled lozenges underfoot and a glazed cobweb overhead, do not resemble the 'passagen' explored by Benjamin and Kracauer, those anti-social catacombs sacred to reverie. Gucci and Reebok display their wares, while a series of posters revises the history of Berlin in the 1920s, when it was supposedly the capital of 'Glanz und Glamour'. The posters choose to remember only the fashions – cloche hats, waistlines below the hips, natty English tweeds for men – and the heedless dances. In the atrium of the Friedrichstadt Passagen stands a column assembled from the junked, compressed fenders of automobiles: debris redefined as décor. Further along the block, Planet Hollywood has landed beside the baroque churches of the Gendarmenmarkt, complete with palm trees and inflatable super-heroes. Capitalism certainly won the ideological war, but it is hard to accord any moral victory to handbags, sneakers and tropical cocktails.

THE EARLY PEOPLE

Modern times began with a hasty retreat from modernity. Picasso superimposed African masks on contemporary faces, and Freud re-read Greek myths as a guide to the psychic disorders which continue to plague us. In *The Man Without Qualities*, fashionable Vienna is obsessed with the killer Moosbrugger. The case, as Musil remarks, demonstrates the yearning of civilized life for barbarism. Umberto Boccioni in 1914 thrilled to 'a *barbaric* element in modern life in which we find inspiration'. His futurist colleagues called themselves the primitives of a new sensibility, and defensively added 'You think us mad'. This remains the paradox of our century, and its most vexing problem – the desire to relinquish the arduous gains of culture and the bequests of science; the appeal of regression.

In 1953 Walter Gropius, reviewing the last half-century of technological innovation, claimed that those few decades had brought about a profounder change in the conditions of human life than all the previous Christian centuries combined. Gropius concluded that science was moving too fast for us: 'the means outgrew man'. He believed that eventually we would catch up, though the evidence suggests otherwise. Perhaps the fault lies with the impatient, predatory means, not with backward man. We are now aware that progress has vandalized the earth, perhaps irreparably.

According to Spengler's logic, nostalgia for the primitive was the death-wish of the exhausted, overextended West. But it could also be seen as a guilty expression of atonement. Technical change proceeded at an irresistible pace, eager for conquest and spoiling for war, which brought all its machinery out to play. Machineless men were disparaged as barbarians, fit only for enslavement or (as in *Heart of Darkness*) extermination. Of course the exploiters claimed to have a civilizing mission. But, as the painter Emil Nolde charged in 1912, Europe expropriated land and annihilated native races to impose a culture which was 'over-refined, pale and decadent'. Perhaps the secret mission of science was to eradicate nature. Visiting the South Pacific in 1914, Nolde admired the way

(left margin) wo figure dies by rnand Léger tail, 1923) Milhaud's Création monde

that 'primitive men live in nature', and called them 'the only real human beings left'. Europeans seemed to him to be 'malformed puppets, artificial and full of conceit'.

Art made amends by sympathizing with the victims, and by challenging the values of an iniquitous civilization. The circus folk of Picasso supplied modern artists with a self-image; so did the 'Naturvölker' of Nolde. The clown and the acrobat were mendicants, outcasts from bourgeois society. The savage blithely predated that society, and thus questioned its legitimacy. Franz Marc believed that tribal people, not yet estranged from nature by machinery, could show modern men how to resolve 'the problem of religiosity'. Science had done away with sanctity. Art's purpose was to restore the sense of awe and wonder, recalling that early stage in mental evolution when 'mystery awoke in men's souls, and with it the primordial elements of art'.

Those primordial elements, for tribal as for modern men, were abstract. Marc marvelled at the 'sheer will to abstraction' in the earliest artifacts made by mankind. He argued that 'our European desire for abstract form is nothing other than the highly conscious, action-hungry determination to overcome sentimentality', whereas 'those early people loved abstraction before they had encountered sentimentality'. In the nineteenth century, sentimentality forcibly humanized the world. A realistic, representational art was a means of asserting ownership, and sentimentality mistily sanctified the appropriation. Romantic poets treated landscape as a sensorium, vibrating in tune with human feelings, and Victorian painters gave dogs the soulful, weepy eyes of men. Abstraction bracingly pointed out that the world is unknowable, alarming. Baudelaire defined genius as childhood regained at will. Marc formulated the idea in extremer terms: artistic vision was savagery regained.

That recovery began, ironically enough, with an event which was intended to confirm the technical pre-eminence of Europe: the 1889 Exposition Universelle in Paris, presided over by the Eiffel Tower. The fair undermined its official purpose by exhibiting an array of alternative cultures. Gauguin, two years before his departure for Tahiti, frequented the Javanese village and ogled the adolescent temple dancers. In the same bamboo settlement, Debussy heard the tinkling percussion of the gamelan, which generated an infinitude of irregular, patterned sound from the five notes of the pentatonic scale.

This shifting, rippling tonal surface showed Debussy a way of circumventing the influence of Wagner and his enervated chromaticism. The piano imitates the gamelan in 'Pagodes', from the collection *Éstampes* composed in 1903. (There are no pagodas in Java, so the piece derives from an association of ideas.) The keys are not hammered; a breeze seems to be wispily passing through the instrument, as if through the ventilated pagoda. The sonority of the gamelan recurs in 'Cloches à travers les feuilles' and 'Et la lune descend sur le temple qui fut' from the second set of *Images* in 1907, and in 'Canope', an evocation of Egyptian funerary urns from the second volume of *Préludes*. The scenario in each case

concerns culture's reclamation by nature: leaves disperse or diffuse the message of the bells, the moon haunts a defunct temple, and a body gently sifts into dust.

Museums which had been founded to show off colonial spoils became, like the Paris fair, sites of seditious revelation. In 1903 at the Anthropological-Ethnographic Museum in Dresden, Kirchner studied roof beams from Oceania, carved with tableaux representing the sexual customs of the islanders. In 1907 Picasso was mesmerized by the African masks in the ethnographic collection at the Trocadéro. Matisse preferred the gallery of Islamic ceramics in the Louvre, and in 1910 made a pilgrimage to Munich for an exhibition of Islamic art. In 1916 Blaise Cendrars wrote 'Les grands fétiches', a poem saluting some priapic African sculptures in the British Museum. By 1924 Fritz Lang had assembled his own small museum of totems and fetishes, which he installed in his Berlin apartment. Noh masks from Japan cohabited with Siamese temple flags and Polynesian shrunken heads on Lang's bookshelves, though his furniture was sleekly modern. He organized an itinerary which summarized man's cultural evolution. Visitors were conducted through the library, where 'winged monsters of the South Seas' leered and grimaced; when they arrived in Lang's office, the smile of a bulbous wooden Buddha consoled them and cast out their atavistic fears.

Ethnic pedigrees were coveted and cultivated. Gauguin insisted proudly on his Peruvian birth. Strindberg, encouraged by his example, renounced Nordic puritanism and called himself an honorary Aztec, a believer in the cult of human sacrifice. 'My God', he declared, 'is that Vitsliputsli who in the sun devours the hearts of men.' Kandinsky fancied that his great-grandmother belonged to Mongolian royalty, and Klee believed that his mother, though born in Switzerland, had North African ancestors. Picasso was amused by the rumour that he too had black blood. He elected his own ancestor, and sometimes signed himself 'Paul' in homage to Gauguin.

Marc called the members of the Blaue Reiter group 'Wilden', wild creatures. Nolde thought that the artist must be 'divine and bestial, a child and a giant', and in 1921 he painted a menagerie of perverse animals, as unashamed as children or artists: a leopard flecked with gold spots, its fangs glistening and its claws shining, its breasts swollen; a blue-whiskered wolf which rears on its hind legs in a mating display. Marc, explaining the circulation of blood (the throb of a Nietzschean life-force) in the bodies of the horses he painted, said in 1912 that what he aimed for was 'the animalization of the experience of art'. Janáček earnestly set music to study the way other creatures communicate, and learned to imitate the speech of his farmyard hens. He found nothing unseemly in his conversations with them. We use baby language, he pointed out, when talking to infants; it is only proper and polite to adopt an animal voice when addressing other species.

We are now embarrassed by this paternalism, which treats savages, babies, birds and beasts interchangeably. But no insult was intended. The purpose, on the contrary, was reverential. Derain told Maurice Vlaminck that he intended to

study the art of children because they alone saw things truly, and Klee's friend August Macke in his essay on masks praised children as creators faithful to 'the mystery of their senses, more so than the imitators of Greek form'. Nevertheless, the early people were dealt with as if they were little people, needing firm guidance. Cio-Cio-San in Puccini's *Madama Butterfly* begs her piratical American husband to love her as if she were a baby, and tells him that the Japanese are small people, accustomed to little things. Their transistorized size made them – at least in 1904, when the opera was first performed – natural victims. Ravel also associated the gamelan with fairy tales, linking the exotic with the infantile. In 'Laideronnette impératrice des pagodes', from the suite *Ma mère l'Oye* which he composed between 1908 and 1910, the Chinese dancers are as jerky as puppets, their miniaturized bodies jangling as if they had bells attached to their joints. Debussy in 1919 remarked on the facile talent of the Javanese, whom he called 'charmants petits peuples', and supposed that they absorbed music instinctively from the rhythm of the sea. He did not mean to condescend. In fact he considered that Europeans were the unskilled infants, and said that the gamelan orchestra made the learned counterpoint of Palestrina sound like child's play.

Gauguin, the first evacuee from civilization, deserted Paris for Tahiti. There he lived, he reported, like 'a savage, a wolf in the woods without a collar'. Van Gogh meanwhile cursed 'decrepit Europe', and predicted that the future of art lay elsewhere. His choice, by contrast with Gauguin's Polynesia, was Japan. He did not need to travel there, because he saw Arles as 'a Japanese dream'. Like a scene from the floating world of the prints he collected, the town swam in a mirage of colour, surrounded by fields of yellow and purple flowers.

It was apt that two painters should have taken the lead. The West betrayed its debility by the pallor on which Nolde remarked; W.B. Yeats dismissed Christ, the source of this moral anaemia, as the 'pale Galilean'. Strindberg praised Gauguin's impiety in depicting a heaven which was red, not blue. Nolde, who travelled to New Guinea by way of Siberia and China in 1913–14, painted a tropical holocaust, with a scarlet sun in an incinerated sky above a boiling sea. In 1914 Klee travelled to Tunisia with Macke. The colour of North Africa took possession of him, and – as he wrote in his diary – made him a painter. His version of the mosque at Hammamet is made up of red and crimson pools, with dotted greenery and a flight of asterisks which have taken wing from a tiled wall. No perspective organizes the sweltering haze; line, which means rectitude and regulation, has been blotted out. In 1920 Matisse designed an imaginary China for the Ballets Russes production of Stravinsky's *Le Chant du rossignol*. The backdrop was turquoise, and Death wore red. Matisse conceived the costumes 'as moving colours'. Tahiti, which he visited in 1930, was for him an aquarium of liquefied colour: jade lagoons, pastel coral, blue fish. In 1953, the year before his death, he completed *Souvenir d'Océanie*, cutting and pasting oblongs of paper – green and blue, yellow and orange and red. The design abstracted his memories, translating them into solid blocks of luminous emotion.

All these journeys entailed rejections of the West and its feeble creed. Gauguin resuscitated Christ and his mother by transposing them to Tahiti, and giving them an ecumenical honour guard of angels copied from a frieze on a Buddhist temple. Nolde, aware that religion was an alibi for imperial profiteering, represented the confrontation more starkly and sarcastically. His 1912 painting *The Missionary* arranges a tableau of ethnographic exhibits from three separate countries. A Korean idol is cast as the Christian missionary. He wears the correct funereal costume, but the disguise has not tamed the savage in him. He leers wolfishly and bares razory teeth. His eyes protrude, which is not surprising since he has a stake drilled through his skull. A Nigerian figure of a woman kneels to receive his blessing. Inanimate, she has been manoeuvred into it. She has not yet learned the Christian virtue of physical self-disgust and her suppliant posture presses forward her bare, conical breasts, beneath which she holds a pot for libations. On the wall hangs a Sudanese tribal mask, whose face has blanched with shame or horror at the transaction.

The painters sought to extend the spectrum: Matisse travelled to Morocco or Tahiti to see a different light. But this aesthetic quest had other implications. Race is colour-coded. These journeys, and the evidence on display in ethnographic museums, obliged the modern world to recognize the relativity of what Europeans considered to be civilization. Peter Altenberg befriended the villagers who had been imported to stock an Ashanti encampment at the Vienna Zoo, and proposed celebrating his sixtieth birthday in 1919 by performing 'solo Ashanti dances to wholly *primitive, enchanting* rhythms'. In D.H. Lawrence's *Women in Love*, the protuberant buttocks of a West African carving boast of its 'purely sensual, purely unspiritual knowledge', lost to sterilized Europe. Orson Welles directed *Macbeth* in Harlem in 1936; Mary McCarthy, after seeing the production, found it 'significant that our white culture has had to draw so heavily on the negro for the revivification of its classics'. Shakespeare, suffering from the anaemia diagnosed by Nolde, was revivified by a blood transfusion. Welles's production, set in Haiti, required the slaughter of a dozen goats, which lent their hides to the 'devil drums' of the witch doctors.

Carl Van Vechten's novel *Nigger Heaven*, published in 1929, described the renaissance of negritude in New York – in part a mere *risqué* vogue, in part a more genuinely risky modern exercise in cultural apostasy. The place referred to in the title was not the abode of the blessed. It alluded to the cheapest seats in the theatre, the gallery on high which was all that blacks could afford; it was also a metaphor for Harlem, which looks down from its hill at the lowlands of Manhattan. But Van Vechten took up the religious hint, and used it for his own sacrilegious purposes. Drunk, doped and sexually aroused, two of the characters ask their driver to take them to hell. He knows the address, and delivers them to the Black Mass, a cabaret where the floor show consists of 'evil rites', which turn out be orgies of self-mutilation. The jazz band snorts and vomits throughout the 'barbaric ceremony', while 'demoniac saxophones wailed like souls burning in

an endless torment'. Van Vechten gleefully corrupts a term from the mysticism of Kandinsky, who fused the arts by equating colour and sound, tint and clang: he describes the 'depraved clang-tints of this perverted Dies Irae'. Harlem is a jazzy inferno, where white society goes to experience its own perdition.

The novel's heroine is the overeducated librarian Mary, one of the upwardly mobile 'New Negroes'. Organizing an exhibition of African sculptures, she is intimidated by their crudity and violence, just as she envies the abandon of a black man at a cabaret, 'dancing with that exotic Negro sense of rhythm which made time a thing in space'. Like the statuettes, he is primitive and modern at once. Doing the Lindy Hop, he speeds through a demonstration of the relativity theory. Mary has forfeited the savagery which is her birthright, a prerogative 'that all the civilized races were struggling to get back to'. This, she ruefully reflects, 'explained the art of a Picasso or a Stravinsky'. Whatever the exaggeration, she has summed up one aspect of the modern agenda: a headlong, reckless regression.

Modernism, aware that it was creating the world anew, irresistibly speculated about origins, and brought up to date the myths which account for the earth's creation and the creativity of men.

According to Christian lore, the logos, or logic, makes sense of a chaos which is without form and void. When God utters a word which means light, light itself promptly shines and routs the darkness. This verbal theology lost its authority in modern times. Eliot's hollow men chant a jingle about the way the world ends and replace the originating bang with a sorry whimper, while Joyce in the punning language he invented for *Finnegans Wake* revoked the power of words to regulate chaos. The word, spoken with an Irish brogue, becomes indistinguishable from the void: 'In the buginning is the woid, in the muddle is the sound-dance and thereinoften you're in the unbewised again.' The middle degenerates once more into muddle, which God in Genesis supposedly banished forever.

Yet there is hope in the next of Joyce's multiple puns. The sentence is mispronounced as a dance of sound, or perhaps – like some tribal rite – a dance in honour of the sun. The world does not answer to a linguistic model of order, in which subjects depart in quest of objects and then, having attained them, reach a full stop: arbitrary atoms do not behave in accordance with some divine proposition. The dance, however, invokes an older and more reliable notion of origins. Before the powers which determine our lives can be represented, they must be conjured up. The graphic arts make images of them, but the dancer experiences them more immediately, as they manifest themselves inside him, agitating his body.

The Balinese theatre persuaded Antonin Artaud that dance was the most primal of all arts, 'a state prior to language, able to select its own language – music, gestures, movements and words'. Rather than saying or making things, it

used the body as a mute, mobile hieroglyph. In 1921 the journalist Hans Siemsen welcomed jazz as a solvent of haughty Prussian uprightness, and declared that if the Kaiser had been able to dance, the German apocalypse need never have occurred.

According to the early people, the world was wordlessly danced into existence, and it is sustained by dancing. Darius Milhaud dramatized the process in his *La Création du monde*, performed in Paris by the Ballets Suédois in 1923. Milhaud's orchestra was a Harlem jazz band; the first voice heard – that of a loving, grieving god – belonged to the saxophone. This version of the creation took place in an Africa designed by Léger, who turned the dancers into vaingloriously crested birds, agile hopping monkeys and reptiles with scissory beaks. Above an earth of ochre, the three deities in charge of manufacturing the species stood guard, like giant robots or fuming factory chimneys. In the modern understanding, the primitive and the industrial are inevitable allies, and their affinity sums up the twentieth century's predicament: they disclose what the world was like before and after humanization. Is there any difference between a nature dominated by gods and a nature churned up and sucked dry by machines?

A man and a woman are finally manufactured, almost as an afterthought, at the end of *La Création du monde*. But the earth is not, as in Genesis, their personal inheritance, a park they own and cultivate like Eden. In Africa, men have not abstracted themselves from nature and established dominion over it. This was the cautionary difference between romantic ballet and primitive or modern dance. The ballerina strives to free herself from gravity, giving the impression that she weightlessly floats in the air. The tribal dancer is tethered to the earth, on which he drums – entreating or admonishing, beating out numerical spells – with percussive feet. The critic André Levinson described a flamenco dancer he saw in Paris during the 1920s as 'a living xylophone'. This brutal, bruising anchorage to the ground turned Nijinsky's production of *Le Sacre du printemps* into a painful initiatic rite: he left the stage after rehearsals with bleeding feet.

Matisse's great panels *La Musique* and *La Danse*, painted in 1909–10 and now in the Hermitage, derived both arts from primitive sources, and proposed an account of creation which defied religious edicts. The musicians float, untethered, between a green earth and a blue sky. Their bodies are red: music is flame. The violinist stands, his colleague squats. The flute player's legs sprawl apart. The singers foetally curl; they wear mask-like faces, neither individualized nor expressive. Only the black gap of the open mouth emits sound. As when the soprano hums in the *Altenberglieder*, music arises inside the body, rather than being handed down from on high. In the dance panel, the five circling figures have grown hair and acquired sex organs, but their heads are bowed, bent into their trunks. They are agitated by a force which starts from the solar plexus, flinging their limbs outwards in contrary directions, almost dislocating them. The circle is incomplete because two of the hands do not quite meet, or have come unstuck in their excitement. The animating hand-clasp on the Sistine Chapel ceiling can no

Henri Matisse
La Danse
(1909–10)

longer be trusted: energy does not flow from a god to inert man, but is passed in a current between human bodies. Hence the tribal reliance on dance, which creates and sustains a community.

Nolde speculated along parallel lines, although the making of the world – in his expressionistic view – was a more eruptive affair. Instead of hoping for the arrival of Nietzsche's 'Übermensch', he looked back to what he called the 'Urmenschen' as prototypes. Primitive people, he said, 'create with the material in their hands, between their fingers, giving expression to their delight in forming images'. Modelling clay, they mould 'Urnatur', the primal soil. Or, like the dancer, they create with their own bodies.

First Nolde sketched the ungainly dancers at cafés and cabarets in Berlin, who – stiff-backed, holding one another at arm's length – cannot cast off their social training. Then in 1913 he made a lithograph of a tribal Salome, naked except for a transparent skirt. Her dance dispenses with a partner. Rather than miming courtship and politely stifling desire in a set of pre-ordained movements, she whirls herself into a frenzy. The flame of a brazier leaps, sharing the excitement she unleashes. Another painting, *Candle Dancers*, makes the same association between dance and fire, the element which both creates and destroys. Dance ignites the body, makes it molten. Candles on the floor drip puddles of wax, as their flames scorch the legs and skirts of the crazed, flushed women. The carpet is a flood of lava. Before the world can be remade, it has to be melted down, shaken free of its material prison. The dance, in its suicidal fury, returns the body to the state of formlessness which prevailed before God in Genesis confined earth and water, fire and air to their separate provinces.

For Picasso too, dance was a dangerous and agonizing ritual. *La Danse*, which he painted in 1925, arranges its three figures in a replica of the crucifixion. The woman at the centre has her hands flung outwards, as if fastened by nails, and her legs are crossed like those of the pinioned Christ. Her partners tug at one another's hands, elongating limbs which have been pulled from their sockets. The man has a black, sinister profile, and his female accomplice wears a skull with two rows of jabbing teeth and plays a guitar whose cavity has been carved in her own chest. One of her breasts has come unstuck, and her sex organs have gravitated downwards; all her force collects in her feet, which are larger than her head – blunt instruments like mallets, designed to bang on the floor and awaken whatever god lies asleep beneath it. The central figure might be the sacrificial victim in *Le Sacre du printemps*, sanctified by the dance of death which her priestly tormenters choreograph.

'L'Élue', the chosen one in Stravinsky's ballet, abides by the dancer's contract with the earth: she dies so as to ensure its renewal in the spring. The figure of the dancer reintroduced such ancient transactions to the modern world. Deprived of words, with only a body to use as tribute or as a bribe, the dancer reminds us that we are embedded in nature and exist only so long as we retain its favour.

Jean Börlin, in the roles he danced for the Ballets Suédois, happily absconded from humanity on stage. In *Sculpture nègre*, performed in 1920 to a score by Francis Poulenc, he turned to wood. He covered his face with a grainy mask and wore a tunic with the texture of bark, from which fronds of dry grass grew. The next year in *L'Homme et son désir*, a creation myth devised by Paul Claudel with music by Milhaud, he struggled a little further up the evolutionary scale. Playing embryonic man, he was given a slick outer skin of yellow grease, like birth-slime. Nijinsky danced regressive charades of his own for the Ballets Russes. The first of these was his performance as the slave in *Schéhérazade*, who instigates an orgy in the Sultan's harem and is post-coitally massacred. Black-skinned, Nijinsky wore gold pantaloons and festooned his torso with jewels. Two years later, in 1912, he played the lustful, scandalously barefoot goat-god in *L'Après-midi d'un faune*, who pursues a nymph but fetishistically makes do with her scarf. Gauguin in 1901 had disparaged the insipid Arcady in the paintings of Puvis de Chavannes by calling him 'a Greek', and claimed that 'the great error was the Greek'. Nijinsky set out to rescue Greece from neoclassicism, just as Hofmannsthal had done in *Elektra*, with its vendettas, its maniacal dances, and its procession of human and animal sacrifices. Mallarmé's satyr, in the eclogue written in 1865, was a less rapacious creature: an idealist like all romantic poets, whose reach, when he grabs air and seizes only the scarf, exceeds his grasp. Nijinsky thought this pastoral too tame, and also considered Debussy's *Prélude à l'après-midi d'un faune*, completed in 1894, soft-edged and wan.

During the same period in which Nijinsky was planning the ballet, the tubercular patients in *The Magic Mountain* happen to hear the *Prélude* which

Debussy composed for Mallarmé's poem. A session of gramophone records has been arranged for them, meant as musical therapy; instead the music confirms that the whole world is expiring. The *Prélude* is seditious, not soothing, and it annihilates time with its dreamy languor. Just before the declaration of war in 1914, Mann's protagonist Hans Castorp overhears a contemporary death-wish in Debussy's music: 'the very apotheosis of rebuff to the Western world and that world's insensate ardour for the "deed".' Nijinsky took a different, but equally extreme, view. He modernized Mallarmé and Debussy by primitivizing them, transposing the poem's action – as the ballerina Tamara Karsavina said – to 'the stone age of prehistoric tribes'. The result dismayed the composer.

During preparations for the *Faune*, the designer Léon Bakst arranged a rendezvous with Nijinsky at the Louvre, to look at Greek vases. Nijinsky did not turn up at the appointed place; Bakst found him studying the Egyptian collection instead. Egyptian art, according to the criteria of contemporary taste, was considered primitive, because abstract and geometrical; African artifacts like those Picasso saw at the Trocadéro, much lower down the hierarchy of civilized esteem, were called savage. Although Nijinsky animated the figures painted on Greek vases, arranging friezes of dancers with their hands and feet turned outwards, the movements also looked angular and Egyptian. This primitivism made his work modern: Diaghilev referred to the 'cubist choreography' of the *Faune*. To dance in one of Nijinsky's ballets entailed suffering through the

Nijinsky as the faun, surrounde[d] by cubist nymp[hs]

morphological torment which bodies undergo in paintings by Picasso like *La Danse*. Karsavina, rehearsing *Jeux*, grumbled that Nijinsky made her keep her head screwed to one side and her hands curled inwards as if she had been 'maimed from birth'.

As the faun, Nijinsky might have been acting out Franz Marc's demand for the animalization of art. Kokoschka, admiring his musculature, wondered whether he might not be a hybrid creature – animal (or rampant child) and god combined. He had, Kokoschka thought, the thighs of a centaur, not a man. He sported horns and a tail, and used wax to make his ears taper until, as his wife Romola remembered, they looked like those of a horse. Make-up gave his

mouth, she added approvingly, 'a bestial line', slack and languid. Cocteau called him 'this little monkey'.

Nijinsky reserved his most inflammatory gesture for the last bars of the score when the faun, stretched out on the stolen veil, deliciously shuddered and allowed himself – in a discreet pelvic thrust – a self-induced orgasm. Classical nymphs made a habit of metamorphosing to escape from their lecherous pursuers – Echo into air, Syrinx into a reed. Pan's father Hermes, sympathizing with his frustration, supplied a second-best by showing him how to masturbate. Was Nijinsky alluding to this divine gift, and its bonus to humankind? Duchamp in his *Large Glass* made similar claims on behalf of auto-eroticism. The rotation of the bachelor machine, frantically grinding away although the bride remains out of reach, represented (as Duchamp explained) 'a kind of narcissism,...a kind of onanism'.

Nijinsky spent his short career commuting between prehistory and the future. He could simultaneously impersonate a vegetable and a spirit: in *Le Spectre de la rose* he played the ghost of a flower. *Jeux* was his 'plastic apologia' for the new man – the Nietzschean athlete liberated from taboos, whose body exists to afford him pleasure. The score by Debussy describes a bout of sexual experimentation after a tennis match. The ballet opened in 1913, two weeks before the primitive cataclysm of *Le Sacre du printemps*. Diaghilev, to underline its futurism, proposed a programme note announcing that it was set in 1930.

Like a shaman, Nijinsky gave house-room inside himself to the demons of the age, its replacements for the human being. His performances asked whether we are beasts like the faun, or automata like the doll in Stravinsky's *Pétrouchka*. The demons, once installed, proved hard to expel. In 1919, at a last private recital in St Moritz, he danced his own narrative of the war, which he accused his audience of having failed to prevent. On a cruciform velvet carpet, he multiplied his body until, as his wife said, he had filled the room 'with horror-stricken suffering humanity'. He was then declared insane, and spent twenty years in sanatoria before another war broke out and he was interned for military, not medical, reasons. The madman is one who tells us truths we would rather not hear.

Hugo Ball remarked in 1917 that 'our age has found its strongest artistic types in Picasso the faun and Kandinsky the monk'. Those antithetical types, the savage and the priest, confronted each other within Nijinsky; acting out the intolerable strains which a man must cope with in modern times, he danced in the vain hope of resolving the contradiction between them.

The surrealists in 1929 published a map of the globe as they saw it, elasticizing and relativizing geography. A different earth had to be freshly charted. Countries too flat-mindedly real for the surrealist taste shrank into insignificance. In the Pacific, the Australian continent dwindled, while New Guinea, officially placed on the map by Nolde's expedition, stretched self-importantly across the ocean. The Great Lakes overflowed, depriving the United States of most of its territory.

*A surrealized
world, from*
Variétés
(1929)

Labrador and Alaska distended to fill up the gap: what made them surreal, pre-
sumably, was their emptiness. Mexico – 'the surrealist place par excellence', as
André Breton declared – dilated on its peninsula, dwarfing sub-equatorial South
America. Apollinaire in 1908 fancied that the paintings of Douanier Rousseau
recalled an 'Aztec landscape', though he imprecisely extended the dominion of
the Aztecs as far south as Brazil, adding that Rousseau depicted the jungles
where mangoes and pineapples grow.

Surrealism was about the upsurgence of irrationality, breaking through
the tame decorum of civilization. Mexico's enigmatic jumping beans rehearsed
this rebellion. A surrealist hanger-on brought some of these to Paris in 1934, and
staged a performance on a café table; Breton furiously objected when a sceptical
rationalist proposed cutting them open to see what made them jump. On a some-
what grander scale, Mexican volcanoes displayed the same disruptive outbreak
of energy. Breton visited the crater of Popocatépetl with the exiled Trotsky in
1938, and also made a point of climbing the sacrificial pyramid of Xochicalco.
The surrealists admired Pancho Villa, the cattle-rustling guerrilla who began to
organize a campaign for land redistribution in 1910. But Vitsliputsli, Strind-
berg's savage god, was as important to them as Villa (who resigned from his revo-
lutionary career in 1920, accepting the bribe of a large hacienda).

Artaud, who travelled to Mexico in 1936, saw it as the site chosen for 'a
new concept of Revolution, and also a new concept of Man'. He specified that
this would be a revolution conducted according to surrealist principles, not
Marxist dogma. He planned to inaugurate the Theatre of Cruelty with a drama
of his own on the conquest of Mexico. Rather than rebuking European colonial-
ism, he wanted to contrast Christianity with 'far older religions', which had
their basis in bloodshed and were still alive to 'the hidden magic of the earth'.
Glancing around the world as if consulting the global map of the surrealists, he

dismissed the countries which currently monopolized power. Europe was dere-
lict, and the United States had only magnified its vices; China and Japan were at
loggerheads. Only Mexico offered hope for the future, because it was still rooted
in a primordial past: it 'had not changed fundamentally', Artaud believed, 'since
the age of Montezuma'. Nor did the revolution which he envisaged intend to
bring about political and economic change. He saw it as a revival of 'pre-Cortés
civilisation'. Agrarian reform mattered less than the extermination of individual
consciousness, which was hardly part of the Marxist agenda. Artaud argued for a
return to the solar cult. Perhaps sacrificial victims would be less readily available
in the twentieth century; the theatre, however, staged the rite of disembowelling
by other means. This is why Artaud emphasized the danger of performance: it
must leave us feeling that we have been eviscerated.

Eisenstein spent the years from 1930 to 1932 working on a film about
Mexico, financed by the novelist Upton Sinclair. The project collapsed when Sin-
clair's money and patience ran out; the existing footage was pieced together and
released in 1939 as *Que Viva México!* Despite his disappointments, Eisenstein's
Mexican sojourn induced a profound change in his view of the world. It freed
him from Soviet materialism, with its faith in the revolutionary force of electric-
ity. The social convulsions of Mexico had not replaced gods with dynamos. A
profounder upheaval brought the gods back, and compelled Eisenstein to
acknowledge their power.

In Chichén Itzá he was taken on a nocturnal tour of the Mayan museum.
Just as he and the curator entered the hall where the stone effigies of copulating
monsters were kept, the lights failed. Darkness brought about an instant regres-
sion. The granite faces leered in the brief flicker of matches. Eisenstein, freed
from all inhibitions in the camouflaging dark, groped his way down their protu-
berant bellies to find their sexual organs. Then the sudden return of the electric-
ity ejected him into the twentieth century, with its shame and shiftiness, its
ignorance of both divinity and carnality.

He referred to that fumbling trip around the museum as his 'pilgrimage
to the gods', implicitly comparing it with the journeys of expiation in *Que Viva
México!*, where pilgrims crawl or hobble across rocky ground towards a remote
shrine, or take up the burden of the cross in Easter pageants. The official atheism
of Soviet ideology came to seem paltry and superficial. Mexico, as the poet
Octavio Paz pointed out, demonstrated the kinship between religion and revolu-
tion. Both were modes of apocalypse, promulgating a vision of man's purpose in
the world and of his ultimate destination: 'religions are…based on the revelation
of a deity; revolutions, on the revelation of an idea. Hence revolutions are disin-
carnate religions, the skeleton or the ghost of a religion.'

Que Viva México! made the skeleton or ghost incarnate again, in the subver-
sive riot which Mexicans call the Day of the Dead. At the Feast of All Souls in
late October, people dress up as ghouls and cavort through the streets. Eisenstein
filmed picnics in graveyards, and alluded to copulation among the tombstones;

he showed a child eagerly biting into a skull made of sugar. Here was a case of social hierarchy overturned by the spirit of carnival, so brutally censured in the puritanical Russia of Stalin. The impish, jigging skeletons reconciled Eisenstein to 'the eternal circle'. That was another way of defining revolution, with its repetitious cycles. It departed from Soviet orthodoxy, which saw revolution as a way of gaining control over time – industrially harnessing it, parcelling it out in pre-ordained Five- and Ten-Year Plans. Instead the Mexican fiesta, celebrating the passage from life to death and back again, encouraged surrender to time. The earth rotates through the seasons according to a one-year plan, which is always the same. Mesoamerican history, as Paz says, did away with linear and successive time and with the tempo of economic productivity and propagation extolled in Eisenstein's *General Line*. Before Cortés and his buccaneers arrived from Cuba in 1519, the local culture consisted of 'an immense and dramatic ritual ceremony', endlessly repeated in those acts of sacrifice which kept the sun alive. The subject of that ceremony, according to Paz, was 'the myth of origin: creation/destruction: creation/destruction…'. The two conditions were mutually dependent, perhaps indistinguishable, and their loving antagonism would go on forever. Mexicans, Eisenstein commented, were wise enough to enjoy the eternal circle. This helped him to comprehend and perhaps to bear the reversals of fortune – veering between exhilaration and despair, official approval and capricious disgrace – which beset him at home between 1917 and his death in 1948. Mexico is still governed (though that is hardly the word) by the National Revolutionary Party, formed in 1929 to unite squabbling factions; in 1946 it was renamed the Party of the Institutional Revolution. Permanently unstable, the country has institutionalized the state of revolutionary unrest.

Eisenstein so admired the carnal sacraments of Mexico that he even recorded without disapproval Villa's habit of hanging prisoners naked because he enjoyed watching their 'last physiological reactions'. The ejaculations of corpses announced that the cycle was beginning all over again. Eisenstein derived the same erotic pleasure from the spectacle of death in *Que Viva México!* when three peasant boys are punished by the landowners for their attempt at insurrection. Stripped and trussed, they stand on a hillock beneath the sun in the attitudes of Michelangelo's sculpted slaves, stoically passive but also elegant. Their physical beauty is a mute expression of scorn: is this why their tormenters hate them? Like a trio of baroque Saint Sebastians, they await a martyrdom whose pains they are prepared to relish, because their suffering will glorify them. One of their cowboy captors lolls on his saddle; in a close-up, Eisenstein lingers on his polished, pointed boot and its spurs, as spiky as cacti. The boys dig pits, and are buried in them standing up. Only their heads protrude, still cocked at angles of defiance. Then the cowboys ride their horses across this dusty Golgotha, battering the exposed skulls. It is a perverse crucifixion, with a characteristically Mexican amendment: the bodies are not suspended in the air, but pressed into the ground, which they will fertilize.

Another episode of *Que Viva México!* concerns the bullfight, which Eisenstein saw as a version of the same barbarous religious ceremony. In the *corrida* he filmed, the matador slickly dispatches the bull; Eisenstein's sketches designed another outcome, with the matador crucified on the bull's horns. The fight itself became a contest between phallic equals – the man armed with a sword, the beast with its horns – rather than the exertion of superior human will which Hemingway applauded. One of Eisenstein's drawings, an exercise in Picassoesque pornography, emphasizes the sexual organs of the rampant bull, gratified as the vanquishing man plunges in his blade. In a later sketch the bull slumps to the sand. A tree sprouts from his forehead; the limp matador is nailed to its cross-bars, his hands extended, while the tail of the beast arches the air. On location in Mérida, Eisenstein had himself photographed girlishly kicking up his heels as a matador pricked him from behind with a pair of spears wrapped in flowers. Once more life and death, sex and cruelty literally interpenetrate.

Visiting a garrison at Acapulco, Eisenstein looked down from the ramparts in the moonlight at a courtyard in which a platoon of soldiers stretched out with their women, enjoying rest and recuperation. The prostrate bodies looked at first like corpses after a battle, 'cast in silver'. Then he noticed that they were writhing in unison. The floor was actually 'a vast cornfield', with insemination in progress. Artaud wondered about the 'physical source' of Mexico's revolutionary energy. Eisenstein had already answered that query: the source was sexuality – or, beyond that, the restive volcanic pangs of the regurgitating earth.

Que Viva México! begins by surveying the baleful faces sculpted on Mayan temples in Teotihuacán or Yucatán. These beaked, predatory creatures merge humanity with the birds and reptiles. Quetzalcóatl, the plumed serpent, has a head like a brick oven: vacant, staring eyes and a greedy oblong mouth. But, just as the skeletons are clad once more in skin on the Day of the Dead, so these monolithic profiles change from stone to flesh. Standing contemporary Mexicans next to the sculptures, Eisenstein demonstrated that this 'immobile eternity' also existed here and now. The primordial shapes seemed modern to him, and the Mexican faces he filmed were constructed according to the geometry of cubism – complete circles, offset by the 'rectilinear silhouette' of the white tunic which the *peónes* wore or by the conical shaft of their sombreros. A parting incised through black, thick, wiry Mexican hair reminded Eisenstein of 'a ravine'. These physiognomic traits linked human beings with the characteristic forms of the landscape, like the swivelling curves, abrupt angles and needling points of the cactus. This culture remembered its origins, when men were roughly shaped from the same burning clay which sustains the plants. Time did not unravel horizontally; it was layered vertically. Eisenstein compared the juxtaposition of ancient and modern, Aztec and Hispanic, with the stripes of the *serape*, the blanket which transformed the bodies of his Mexicans into cubistic pillars.

The same revelation of a new order in nature, absorbing time into space, came to Milhaud and Claudel in Brazil, where they planned *L'Homme et son désir*

during Sunday outings to the resort of Petropolis above Rio de Janeiro in 1917 and 1918. Claudel's preferred title was *L'Homme et la forêt*: the 'poème plastique' is about man before individuation occurred, still enmeshed in an undergrowth of dreams and cravings. Milhaud, listening to the Brazilian rain forests, attempted to transcribe the first pulsings of life. The percussion throbs irregularly, underscored by the strokes of a hammer on wood. Leaves rustle, invisible creatures scuttle, and voices intone cries which remain inarticulate. The jungle at night is an orchestra of swarming, unsynchronized, unattributable sounds. Audrey Parr designed a set which was layered like the stripes of the *serape*: it had four tiers, carpeted in purple, green and blue to suggest the fuzzy strata of tropical vegetation. The dancers, singers and instrumentalists occupying the four levels functioned independently of each other. This was the amiable swampy chaos of nature, before humanity took control.

Because Mexico had ignored the linear progress of history, Eisenstein could connect his own modern, mechanical art form with the superstitious imagery of the earliest people, who exorcised their fears by drawing the monsters which persecuted them. He felt an affinity with the revolutionary muralists, Diego Rivera and José Clemente Orozco. They wrote graphic slogans on the walls of public buildings, just as Eisenstein's images were painted on walls by a beam of light. From Belshazzar's feast to the latest urban graffiti, writing on a wall has always seemed mysteriously prophetic, as if the stones themselves were crying out against the city. Eisenstein, accepting the Mexican alliance between

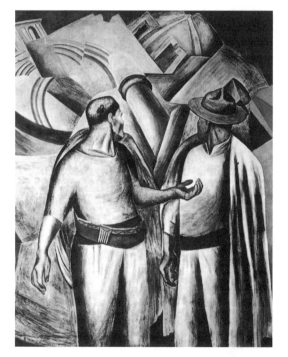

religion and revolution, was happy to design sacrilegious last judgments, as he did in the episodes with the martyred *peónes* or the dancing skeletons. The Catholic missionaries in Mexico co-opted pagan cults, changing the name of the god who was worshipped; Eisenstein and the muralists similarly commandeered the traditional tableaux of Catholicism.

In his mural at the Ministry of Public Education in Mexico City, Rivera showed a miner being frisked as he leaves the shaft at the end of his day's work. Raising his arms, the man is a candidate for crucifixion. In the

José Clemente Orozco Destruction of the Old Order (detail, 1926–7) at the National Preparatory College

National College of Agriculture at Chapingo, in an amphitheatre which had been a chapel, he painted the entombment of Villa's ally Zapata, and in doing so reconsecrated the place. Zapata lies in an open grave, wrapped in a red blanket. He does not vanish from his tomb on the third day like Christ, but other resurrections are possible: the roots of the corn reach down into his grave, and the plants flourish by feeding on him. Orozco painted a socialist day of judgment at the National Preparatory College in Mexico City, with a ferocious, bearded deity who reduces the world to a junk-heap of incoherent symbols – swastikas and dented helmets, strips of bleeding flesh and the bleached carcasses of beasts. In Guadalajara, he set a seething inferno in the cupola of a building, transferring the inferno from beneath the floorboards and placing it at the summit of the sky, where heaven should have been.

Buildings, battered by those imprecations from above and below, lost their solidity and security. The white incandescent light from the projector, when it conjured up images like the massacre in *The Battleship Potemkin* or the heads trampled by the horses in *Que Viva México!*, likewise attempted to set fire to the screen. In the cinema, a primitive terror and panic could be re-created. Eisenstein wanted spectators to feel that the gunfire in *Potemkin* was about to puncture the screen. Thinking of his own images and of Orozco's, he asked whether a wall across which these incendiary dramas were emblazoned could 'still be a wall?' He hoped not: the revolutionary intends to knock down walls, and that can be done with a brush, a ray of light, or an aerosol can of spray paint.

Thanks to Villa and Zapata, Breton associated Mexico with 'the struggle for liberation'. Later the southern extremities of the continent became a region below the threshold of consciousness, where the means of psychic rather than political revolution grew wild in the jungle. In 1949 William S. Burroughs left Texas, where he had improbably set up as a farmer, and moved to Mexico City. He was supposedly studying pre-Columbian civilization. He conducted his research with chemical assistance: he believed that in his drug-dreams he re-experienced 'the mass migrations of the Mayans' inside his head. He ventured into Panama and Ecuador during 1951, and in 1953 trailed through Colombia and Peru. In Bogotá, he was sarcastically delighted when the locals mistook him for a cruising American capitalist – either 'a representative of the Texas Oil Company travelling incognito' or an emissary of Squibb Pharmaceuticals. Actually he was searching for *peyote*, *yagé* and other mind-blowing potions; he also planned treasure-hunts for lost cities and hoards of Inca gold. (Later he transferred his quest to another continent with a reputation for irrationality, spending time in North Africa. He called Tangier 'the prognostic pulse of the world, a frontier between dream and reality'.)

The surrealist world-map squeezed Western Europe onto its beaches, though extra room was found for the Austro-Hungarian empire, already long defunct. Paris of course kept its place, but was balanced by Constantinople as a reminder that our culture has travelled to us from the east. The most generous

allotment of land, top-heavily overshadowing the rest of the globe, went to a country which like Mexico had suddenly risen into view, graduating from feudal prehistory to revolutionary modernity: Russia.

As emissaries from this world beyond the Western pale, the Ballets Russes purveyed exoticism of every variety – Arabian in *Schéhérazade*, Chinese in Stravinsky's opera *Le Rossignol*, Hindu in the ballet *Le Dieu bleu*, as well as Russian folklore. The primitive and the modern once more met and merged, eliding the long history between them. For Natalia Goncharova, who became a designer for the Diaghilev company, primordial Russia had pioneered abstraction. In 1912 in Moscow she described the crude stone idols of the Scythians and the painted wooden dolls sold at fairs – figures like the jerkily articulated Pétrouchka, with his body of sawdust and plaster – as cubist works.

Her partner Mikhail Larionov also found the future in the past, and in 1913 argued that the source of futurism lay in ancient Assyria and Babylon, with 'the cult of the goddess Astarte and the teaching of Zarathustra'. Astarte's religion of fertility and the Zoroastrian belief in annealing fire lead – over the course of a millennium, by a very indirect route – to Marinetti's declaration that we are born from electricity, and can see our life-span foreshortened when a light bulb expires. Larionov elaborated this personal myth when he designed *Le Soleil de nuit* for the Ballets Russes in 1915. Massine, with a scorching aureole on his head and another fiery planet grinning like a Halloween pumpkin on his orange blouse, played the midnight sun, unquenchable in a blue-black sky.

The Ballets Russes brought baleful auguries with them. In their earliest Paris seasons they performed extracts from Borodin's opera *Prince Igor*, left unfinished when he died in 1887. The opera's incompleteness is ironically apt, because the work itself concerns unfinished historical business: Igor sets out from Novgorod to fight a tribe of Polovtsian Tatars, but is captured by them. There is no national victory; culture fails to defend its border against barbarism. In 1909 the Ballets Russes presented the Polovtsian dances from the opera, in which the Khan deploys his slave girls to weaken the captive Igor's patriotic loyalty. The ballet was revived in 1913 on the same bill as *Le Sacre du printemps*, which took an even more pessimistic view of the relation between civilization and wildness. The affinity was enforced because the two works shared the same designer. Nikolai Roerich's Polovtsian camp was a desert waste, with crouching huts, a smoking fire, and listless flags drooping in the sullen air: a temporary resting place for men who have not yet sunk roots into the earth, or taught nature to do their bidding. Stravinsky later remarked on Roerich's 'Polovtsian-type backdrops' for *Le Sacre*. In 1942 Roerich returned to the opera's subject during the so-called Great Patriotic War against Hitler. In his painting *Prince Igor's Campaign*, the defensive army marches out of Novgorod beneath a sulphurous sky, its shields blood-red, its flags scything the sky. Luckily the story had a different ending this time, and the Red Army drove back the invading hordes – who came (since the twentieth century had transvalued all values) from the civilized west, not the east.

The Polovtsian camp, designed by Nikolai Roerich for the Ballets Russes

In 1918 Aleksandr Blok wrote a sequel to his poem 'The Twelve', in which he had converted Christ to Bolshevism and conscripted the apostles as Red Guards. 'The Scythians' proposed Pan-mongolism as a universal creed, the rightful heir to Christianity, and threatened a holy war. The return of these marauding nomads from Russia's Asiatic fringes, here and in Prokofiev's *Scythian Suite*, was a symptom of political disturbance. In the nineteenth century, Scythia represented heathenism at its most fiendish. A crusader in Walter Scott's novel *Count Robert of Paris* encounters a pack of Scythians in Constantinople. Disgusted by their flattened nostrils, stupid eyes and sinewy limbs, he suspects that they share the deformities of the demons they worship. But Blok honours his Scythians as a race of new and ruthless evangelists. Like the Polovtsians in *Prince Igor*, they are devotees of sensual violence: 'The Twelve' makes the connection explicit by borrowing epic similes from *The Song of Igor's Campaign*, the twelfth-century poem which was the source for Borodin's opera. The Scythians know how to tame slave girls, as if saddling horses and digging in the spurs; they clear a field for sword-play beside the Ural mountains, and draw up their war chariots. They want to interbreed peacefully with Europe, which their blood, they believe, will re-invigorate. But if they are rebuffed, they will conquer, pillage and impose their religion by force.

Larionov illustrated Blok's poems in 1920, and in doing so pointed out the continuity between primitivism and modernity in Russia. His Bolshevik soldiers in 'The Twelve' have cubist bodies, as aggressively angular as the re-engineered figures of Léger. Two of them are wrapped in the same greatcoat, solidifying to form a bulwark: the revolution manufactures such men on a factory production

line. But when Blok's marauders menace the West, the centuries instantly recede. In Larionov's design, the Scythian who utters the threat has a pair of superimposed visages. At first he looks grizzled and almost genial, puffing on his pipe. But this face is detachable, and what emerges from behind it is an ogre. His mouth extends from ear to ear, and is open – but not to smile: it reveals a row of teeth like square tombstones. He has the 'unintellectual eyes' described by Scott's crusader. Lacking pupils, they can return no gaze, and give no signal of reciprocal feeling. His nose has been flattened in combat, and the fringe of hair marks his low forehead with a pattern of axe wounds. The outer identity peels off like loose skin; under it is this implacable helmet. The Scythian wears his mask beneath the skin, not on top of it. It is his atavistic will, pressing through to the surface.

During his visit to Moscow, Walter Benjamin was startled to see some African sculptures pulling faces at him from the wall of a peasants' club. When he looked more closely, he discovered that the objects were gas-masks. It was an impeccably modern error or perhaps a conscious metaphoric substitution, mistaking the technological for the primitive. Both items, after all, serve the same purpose. The tribal fetishes deflect spells, the gas-masks keep out malignant chemicals. When David Alfaro Siqueiros painted a mural denouncing the bourgeoisie for the Electrical Workers Union in Mexico City in 1939, he clamped iron helmets and the rubbery visors of gas-masks on the oppressors' heads. This was his collective portrait of a class which he considered unwilling and perhaps unworthy to wear a human face.

The confrontation with tribal masks – or with that underlying face which the Scythian has scarified in preparation for war – shook complacent assumptions about human character. Is the face, which we think of as an inalienable personal possession, an overrated asset? Lawrence calls the countenance of the totemic African statue in *Women in Love* 'void', a blank, 'abstracted in utter physical stress…, abstracted almost into meaninglessness by the weight of sensation beneath'. A face is a membrane stretched tight, tense to the point of breaking, over emotions which seethe beneath it. This 'savage woman' has valiantly hardened her skin into a shield. Western culture has masks of its own: society teaches us to transform the face into a facsimile. We think we can hide behind the face by freezing it, making it inexpressive. Hence, according to Simmel's essay on metropolitan psychology, the self-protectively blasé manner of the city-dweller. Our social masks are faces which have been neutralized, rendered uniformly pallid like the ghostly make-up of a clown. Agathe, Ulrich's sister in *The Man Without Qualities*, disparages her lovers and reflects that 'she might just as easily take an African tribe's ceremonial masks seriously as the erotic masquerading adopted by European men'.

Agathe has, however, confused two very different cultures. The Viennese masquerade tells a lie, while the masked African ceremony lays bare the truth. The gap is defined by the mask paintings of Nolde, made as a tribute to the Belgian fantasist James Ensor, whom he met in 1911. Ensor painted the false faces of carnival – part-time Pierrots and would-be ghouls, whose costumes are discarded

once the season of revelry is over. His masks were the armoury of social pretence and moral hypocrisy, worn by the crowd which, in Ensor's greatest painting, welcomes Christ into Brussels to be crucified. Nolde intermingled the disguises Ensor found in Ostend curio shops with the less frivolous masks which glared at him in anthropological museums. He made these tribal exhibits look like severed heads, painting them in yellow, green and crimson, the colours of putrefaction. Strung up to dry, their lank hair streaming, they are still twisted by the expressions of dread or devilish glee they wore when they died. A death mask is a face which can no longer be used as camouflage.

The mask in tribal rituals, no matter how distorted, is the real identity, not the flimsy screen affected by Agathe's wooers. It augments and aggrandizes the single, paltry being: Léger constructed body-masks for *La Création du monde*, turning the dancers into giants. Like the dance, the mask announces that supernatural powers have taken possession of the body. Its lurid features, as August Macke said, belong to 'the invisible god'. It overrides individuality, and ignores the fragile prerogatives of a middle-class society – the private self, the unrepeatable fingerprint, the locked and bolted suburban villa – which had been swept away by the political and economic traumas of the early twentieth century. The carved or painted face expresses primal emotions, which course between human beings and fuse us with one another. Constantin Brancusi in 1914 represented the anguish of birth in a bronze which he called *The First Cry*. The polished ball is embryonic, having had no time to grow facial features. But a ridge arching across it serves as a mouth, and silently vents the cry of protest which is our common, instinctive reaction to the world we have entered.

A modern man, once his mask is removed, may well have no face beneath it. The characters in Magritte's paintings wear question marks or standardized pudenda or shiny green apples on their shoulders. Sometimes their heads are swaddled in mummy-cloths; often they have no heads at all. In tribal society, the masked man was united with the gods, or with the elements which they personified. In modern times, man is overwhelmed by his membership of the mass. Whether tragic or comic, the mask's generic reaction suits everyone, since we have been reduced to anonymity or nonentity. In Magritte's painting *Golconde*, a rain of respectable bowler-hatted clones descend from the sky into an equally drab and faceless city. The person, in the clan or the metropolis, is merely a conduit for larger forces. The composer Leverkühn in Thomas Mann's novel *Doktor Faustus* struggles to make sense of Germany's moral collapse, which allowed the Nazis to seize power in 1933. He concludes that 'the antithesis of bourgeois culture is not barbarism, but collectivism'. When Larionov's Scythian reveals his ancient, savage face, this dialectic breaks down: the two options which Leverkühn wants to keep separate are one and the same.

At the Trocadéro, Picasso had to content himself with effigies: the rigid, incised faces of sculptures from the Congo or the Ivory Coast, one of which he set on his

own shoulders in a 1907 self-portrait. In 1925 Africa itself arrived in Europe, impersonated by Josephine Baker in the *Revue nègre*. The routine which made her notorious was a 'danse sauvage'. Wearing sprigs of feathers, she coupled with a male colleague, also in tribal undress, while jungle drums thundered. The setting for this jazzy orgy – as for Nijinsky's production of *Le Sacre du printemps*, *Relâche*, and so many other modernist acts of desecration – was the Apollonian temple of the Théâtre des Champs-Elysées, on whose ceiling Maurice Denis had painted a classical landscape inhabited by chaste pastel nymphs. A wealthy patron who later attended *Les mariés de la Tour Eiffel* at the Champs-Elysées innocently admitted to Cocteau that she always sat as high in the theatre as she could. It was a positive advantage if she had only a partial view of the stage; she could concentrate on the serene antiquity of the ceiling.

André Levinson, amazed by Josephine Baker's 'simian suppleness', watched as she regressed through the centuries, rejoining 'our common animal ancestors'. In 1910 the Viennese essayist Felix Salten had been affronted by 'the bold lewdness of wriggling, contorting Negroes', and said that their cakewalk unmasked modern man as 'a mating monkey in a tail-coat'. Did a dance have the power to reverse all the effortful victories of civilization? Levinson knew that Josephine Baker had come from the wilderness by way of industrial America. She belonged, he thought, to the urban jungle described by Upton Sinclair in his novel about the Chicago stockyards; she was an artificial primitive, served up for a commercial market. Her dances, 'ancient observances dedicated to Priapus and Hecate', once had a ceremonial function. They began in 'the primeval forest' as 'rhythmic orgies induced by a panic terror of the demons who inhabit the night'. Like Picasso's African masks, they deflected evil or neurotic dread. But in the modern city, electricity had exorcised darkness by flicking a switch; the combat with spirits could therefore be restaged as a salacious travesty.

Josephine Baker cavorting in a cage, drawn by Paul Colin (c. 1927)

Despite this accusation of falsity, Baker became an icon – or perhaps, since icons are pictures of sanctity, a profane fetish. She was photographed preening with a leopard. Alexander Calder in 1926 twined a likeness of her vibrant body from wire. Her limbs were filaments of copper, her breasts and stomach concentric twists of metal. In his mobile – a sculpture rescued from the

immobility of stone – Calder suspended her from the ceiling. She danced in the air, exhibiting the perpetual motion which for Calder characterized the behaviour of circus animals. Matisse in 1952 sculpted her with his scissors. He cut the separate bits of her from black paper – muscular legs, a global abdomen, a minute head, and arms which ricochet through space, flapping as if they were wings – and glued them to an acreage of canvas, where she germinates like a black blossom in a pantheistic field of flowers.

From Baker, popular music inherited a mission to redefine the boundary between civilization and wildness. It has provided each new generation with its own heathen idols: Elvis Presley and his rotating hips; the Rolling Stones, whose record-covers featured a lapping tongue, or a denim-clad crotch with a built-in zip begging to be unfastened; Madonna, the specialist in kinky outrage. Dances are a society's subconsciousness, and the paroxysms of the Charleston announced a change in the tempo of life and the temperature of dreams.

Jazz, whether its sources were American or African, served the same purpose for modern composers as Japanese prints had done for van Gogh, Gauguin and the impressionists. It demonstrated that the accustomed idioms of sound and sight were no more than local conventions. The earth became different when it was heard and seen differently. Arriving from another, unknown culture, jazz overthrew the sacred inevitability of tradition. Instead of dutifully following one another in time, musicians worked side by side in space, even if they were continents apart. Respect for chronology implies a confidence in evolution. From Haydn by way of Beethoven to Brahms, the orchestra evolved like a grand, ingenious machine. Wagner aimed to compose 'the music of the future'; Strauss therefore had to claim that his own music was even more futuristic, more minutely adept at translating sound into sight. Wagner set thunderstorms or orgasms to music. Strauss, wanting to do better, transcribed a baby's bath-time in his *Sinfonia Domestica*, and when Mandryka in *Arabella* remembers having his ribs crushed by an angry bear, the orchestra promptly re-enacts the mauling. Jazz put an end to this competition with the past. The nineteenth century's faith in progress was replaced by the twentieth century's awareness of simultaneity.

Debussy, in the 'Golliwogg's Cake-Walk', used jazz to tease Germanic tradition. The strutting, prancing dance step is wrong-footed by the quotation of the opening bars from *Tristan und Isolde*. The doll falters, but recovers to end with an emphatic battery, as if stamping on this morbid chromaticism. Général Lavine, the music-hall freak commemorated in the second volume of Debussy's *Préludes* in 1913, also does a cakewalk. Lavine like the golliwog proposes an alternative to the long-suffering soulfulness of German music: his speciality was playing the piano with his toes. Stravinsky in 1918 composed a bouncy ragtime in his *L'Histoire du soldat*. The dance enables the fiddling soldier to awaken a princess from her enchanted sleep; Stravinsky himself was grateful to jazz because it freed him from the ancestral tradition of Russian folklore. The therapeutic concert begins with a drowsy tango, works up to a friskier waltz, and reaches its climax

with the riotous ragtime, during which the comatose princess throws herself into the soldier's arms. This was Stravinsky's joke about the healing powers of music: jazz with its rude health revives a body prostrated by the psychological maladies of romanticism.

Engineering a clash between jazz and the Russian tradition, Stravinsky adopted it as a sign of his own deracination. The tribal nostalgia of black music did not interest him and, proud of his own cosmopolitanism, he refused to share its threnody for an enforced emigration. Of course the West's discovery of imaginative worlds elsewhere happened as a consequence of empire-building. The impressionists acquired their Hokusai and Hiroshige prints because Commodore Perry's gunboats had breached the insularity of Japan, opening it as a market for trade. The Paris Exposition in 1889 invidiously contrasted industrial Europe with those makeshift imported villages with their huts of mud and grass. The Pacific expedition in 1914, which took Nolde along for the ride, was organized by the Imperial Colonial Office. Its professed aim was medical – to investigate the declining birth-rate in New Guinea. Its motives, however, were hardly humanitarian. By refusing to breed, the indigenous people had deprived the German colonists of cheap labour. The artists undid the work of the imperialists, and chose to be colonized by the cultures which their governments – compelling the natives to wear trousers and believe in Jesus – had subjugated. But they seldom relinquished their comfortable assumption of primacy, which is why the composers felt no shame about filching jazz from those to whom it belonged.

High society annexed wildness. Man Ray photographed Saint-Exupéry's wife in 1937 wearing a beaded head-dress from the Congo; the socialite Nancy Cunard accessorized her outfits with a succession of black lovers. In Paris, Gertrude Stein reported on the chic augmentation of her circle: 'Carl Van Vechten sent us quantities of negroes.' Imported in bulk, these tropical delicacies lost their novelty. Fashion enfeebled the carnality of jazz. The voodoo forfeits its power in Poulenc's flirtatious masquerade *Les Biches,* performed by the Ballets Russes in 1924. Predatory aristocratic ladies stalk a group of dandified men, who appear to prefer one another. A ragtime awakens the comatose princess in *L'Histoire du soldat,* but in *Les Biches* a rag-mazurka fails to spice up desire in the languid males.

Only Ravel, in his three *Chansons madécasses,* worried about the connection between music and the politics of negritude. The two outer songs of the group, composed in 1925–6 to eighteenth-century poems by a Creole who lived in India and had never visited Madagascar, are sultry idylls; but in the middle one, when the colonial invader takes advantage of this voluptuous stupor, the blacks fight back and spill a pleasing amount of the enemy's blood. Before the singer's warning about the white man, Ravel added a repeated cry of 'Aoua!', which begins as a call to arms and resounds at intervals to renew the spell – a vocal flourish like the screech of a peacock, with the flute keening and the piano banging out a dissonant chord. The shriek is Schoenbergian, as is the murderous plot of the song:

Ravel's singer is a solar version of Pierrot Lunaire, wearing a black face, not a white one.

For Stravinsky, black and white denoted the keys on a piano, not the colour of skins. The title of his *Ebony Concerto*, composed in 1945, teasingly introduces a racial reference which the music ignores. Ebony does not even define a mood: a dirge recurs, as if from a New Orleans jazz funeral, but its grave pace is soon dispelled – a brusque denial that music has any emotional content. Stravinsky was delighted by the determinism of the pianola, which plodded about its business as implacably and inexpressively as a musical sewing-machine; for the same reason he enjoyed the formality of jazz, and the capacity of those who play it to fabricate patterns. Even so, he left them no margin for improvisation. The

Pablo Picasso's cover design (1919) for Ragtime

Ebony Concerto is so complex and rhythmically inflexible that the clarinettist Woody Herman and his band, for whom it was written, needed to engage a conductor to guide them through the first performance at Carnegie Hall.

The internationalism of jazz and its formulaic structure made it – in Stravinsky's view – an abstract art, as remote from representation as the rectilinear universe of *De Stijl*. Mondrian, not coincidentally, was a devotee of the boogie-woogie, with its nimble bodily geometry. In 1918 Stravinsky composed a *Ragtime* for eleven instruments. He worked on a cimbalon, a Hungarian variant of the balalaika, because its sonority reminded him of the kind of piano (like Dietrich's pianola, which she naughtily describes in *The Blue Angel*) heard in a bordello. Despite this allusion to the brothel, his *Ragtime* had no intention of slumming, like the 'gutter music' of the Weimar Republic. In Weill's *Mahagonny* a deluded pianist rumbles through a sentimental rhapsody, indulging in drastic spasms of rubato and torrential cadenzas. One of the maudlin patrons in Begbick's saloon murmurs 'Das ist die ewige Kunst' – That's what I call eternal art. Stravinsky excludes such vengeful parody. The pianola or the brothel piano were interchangeable with the harpsichord which he revived in his opera *The Rake's Progress*; at least they avoided the romantic error of attaching the keyboard to the heart-strings. When the score of *Ragtime* was published, Picasso drew an illustration for the cover which paid its own tribute to the abstractness of the music. A violinist and a banjo player collaborate. The segregation between high and low art has broken down, because the two figures are

umbilically linked by the design. Picasso, like a jazz musician generating endless riffs, created them both from one continuous, looping line which begins and ends nowhere, merging the musicians with their instruments and with one another: a graphic maze as pure and purposeless as Stravinsky's technical bravura.

Jazz led Stravinsky sideways, enabling him to exchange Russia for an imaginary America, the elective homeland of rootless or uprooted modernity. It also conducted him backwards. Rather than fretting like Wagner to anticipate the future, Stravinsky re-invented the past. Jazz eased his migration to the eighteenth century, as he turned against the tawdry confessions of romanticism and instead exemplified the classical virtues of proficiency, punctuality and discipline: the *Ebony Concerto* is the kind of jazz which Bach might have composed.

Back in the twentieth century, jazz remained an audible symptom of convulsions which Stravinsky, who scorned Bolshevism, chose to overlook. Hindemith included a series of joyless dances in his piano suite *1922*. His shimmy cannot manage the required delirium, the Boston is more listless and hesitant than a waltz should be, and a ragtime overcompensates by its mechanical rigour, like Kracauer's chorus girls kicking their industrialized legs. Hedonism, in the Weimar Republic, was hard work. The suite is introduced by a march (society mobilizes, while the dance blithely continues), and interrupted by a stalled, meditative nocturne or 'Nachtstück', which recalls a peaceful darkness abolished by the electrified brilliance of the city. Jazz contributes to the rumbling disquiet in Ravel's Piano Concerto in D, composed in 1929–30 for the left hand of Paul Wittgenstein, who had lost his right arm in the war. This is nervous music, disturbed by an ominous tapping, the muted alarms of sirens and a belligerent march. The end comes abruptly, like a gunshot.

Ernst Křenek dealt with this confrontation of cultures in his opera *Jonny spielt auf*, first performed in 1927. The Jonny who strikes up is a black jazz fiddler from America, who invades Europe and vandalizes its proprieties. His rival, the classical composer Max, broodingly traverses a glacier which for him – like the crystals of Webern – represents the fixity of artistic form, remote from the wayward mobility of Jonny and his agitated music. Jonny's band plays in the lobby of a hotel: he is at home in what Kracauer saw as its shuttling atomic

Hans Reinmer *
Jonny spielt
auf at Hambur
in 1927

chaos. He speaks a slangy Esperanto, mashing together several languages, just as he commutes between the fiddle, the saxophone, the banjo and the trombone. Sabotaging high culture, he assaults an operatic soprano in a hotel corridor. When she rebuffs him, he steals the prize violin from a touring virtuoso, and leaves a banjo in its place.

His practical joke recalls the devil's confiscation of the soldier's fiddle in *L'Histoire du soldat*. In romantic music the violin, given to plaintive sentimental wheedling, speaks for the soul. The sleazy Daniello, the virtuoso in *Jonny spielt auf*, uses it for seduction. In 1927 Ravel taught the instrument new tricks in his Violin Sonata, employing it as tool or a gadget, the technological extension of the arm which plays it, rather than allowing it to sing sweet nothings. The second movement of the sonata is a jazzy 'Blues' in which the violin is plucked or strummed like a banjo, not elegantly bowed; it competes with the piano in percussive force. The soprano's manager in Křenek's opera understands that music is a business, the production of sound for profit, and he berates the 'foolish sentimentality' of her erotic liaisons with Max and Daniello: she will upset her nerves and make herself hoarse. The vocal cords, though made of gristle and embedded in a human body, should be as resistant to feeling as the terse strings of the banjo.

After the devil taught his caustic lesson to the soldier, Stravinsky himself renounced strings in his next compositions. In 1920 he composed a stiffly funereal elegy for Debussy which he entitled *Symphonies of Wind Instruments*, and for his ballet *Les Noces*, he decided that the voices should be accompanied by a contingent of pianos, kettledrum, bells and xylophone, explaining that 'the sustained, that is to say "soufflé" elements (the elements produced by the breath, as the "wind" in an instrument ensemble)…would be best supported by an ensemble consisting exclusively of percussion'. In *Le Sacre du printemps*, the bassoon and the tubas broadcast commandments from the remote past in blasts of chilling sound. Stravinsky liked wind instruments because they were incapable of sloppy romantic effusiveness; for the same reason he used Latin in his oratorio *Oedipus Rex* – a petrified language, 'not dead' (as he put it) 'but turned to stone'. Ernst Bloch denounced this neoclassicism as reactionary and inhuman, and commented sarcastically on Stravinsky's stringless orchestra: 'Things that are hollow are good for blowing through.'

In *Jonny spielt auf*, the violinist pays the death penalty for purveying retrograde sentimentality. He fails to retrieve his violin from Jonny, who has modernized its repertory. Stranded by history, he is pushed under a train, which steams on towards Amsterdam, where it is due to connect with a ship bound for America. Jonny rallies the refugees from a defunct continent. Max, now converted to modernity, catches the train when Jonny hijacks a police car which he drives off at reckless speed, having knocked out the guardians of the law. He explains his expropriation of Daniello's instrument by declaring that the old world has grown too weary to enjoy its own creations, and has therefore succumbed to America, which conquers elderly Europe through the dance. The transfer of power between

the continents is first solemnized by a liturgical brass chorale, then repeated – as the train leaves for the future – in a jazzy riot, with sirens shouting the praises of unbridled noise.

In 1929 Paul Morand published *Black Magic*, a collection of stories about negritude and revolution. One of them predicts an uprising in Haiti, occupied by the Americans, and charts its farcical course through the 1930s. Morand's hero Occide is radicalized by the study of witchcraft. He learns occult Hebraic formulae which can conjure up the apocalypse, 'for voodoo is a brother to the Kabbala'; the clairvoyant who initiates him into the mysteries advises that 'the knell of the Western world has been tolled'. This alliance between black magic and Marxism is more than a little fanciful. In 1946 Breton happened to be in Haiti when the promised revolt occurred. He volunteered to deliver an inspiring address to the masses. The local consul, to preserve diplomatic protocols, packed him off to watch a voodoo ceremony instead: sorcery was entertainment for tourists, not a rehearsal of retribution. Occide in Morand's story completes his political education after a visit from a Russian propaganda ship, which displays a banner announcing that 'the poor are the Negroes of Europe'; he installs a Soviet republic, gives Port-au-Prince the new name of Octobreville, and issues a uniform of moujik blouses and red arm-bands to the witch-doctors. Beyond the example of Russia, he looks back to a more primitive source – 'the old Communism of Africa, that of the bare body'. The United States soon loses patience with the experiment, and sends the Marines back in.

Křenek's Jonny makes no secret of his own ideological programme which, like Occide's regime, entails both a political reckoning and a spiritual renewal. Taking up the violin, he brags that he intends to play it like old King David plucking his harp, and will sing hymns to Jehovah, the creator of black men. The Nazis targeted Křenek's hero as a cultural Bolshevik and, acting on his own cheeky simile, branded him with a Star of David: in 1938 an image of Jonny the black Jew, a composite racial enemy, advertised their exhibition of *Entartete Musik* – music they considered to be degenerate – in Düsseldorf. At the same time, Křenek followed the characters in his opera to the United States. He might have asked himself on the way who the true barbarians were: the imps of id like Jonny and Josephine Baker, nostalgic for the Swanee River, or the upright Germans with their symphonies, their cathedrals and their death camps?

At first, individuals like Gauguin sailed off in quest of barbarism, which, as he told Strindberg in 1895, 'is for me a rejuvenation'. Then barbarism came to visit, packaged as entertainment by the Ballets Russes or the *Revue nègre*. The masks meanwhile stayed in the museums, safely dead and uncontagious. Finally, to consummate the union between primitivism and modernity, an entire country – citing the most abstruse philosophical pretexts, and enlisting the aid of the latest technology – put itself through what Thomas Mann in *Doktor Faustus* called a 'deliberate rebarbarization'.

In 1930 Mann contributed an essay to the *Berliner Tageblatt* in which he traced popular support for the Nazis back to 'Europe's psychology of the unconscious'. His argument had a Spenglerian pessimism, which made it a symptom of the very problem it attempted to diagnose. Modern times began when the French Revolution inaugurated 'the bourgeois epoch' with its liberal virtues – freedom, fraternity, a belief in unstoppable progress. Once economic disaster submerged the middle class, the blessings of that revolution were revoked. A character in *The Magic Mountain* mentions the sinking of the *Titanic* as an example of how rapidly people who are buoyed up by their mechanical comforts and their confidence in a mechanistic world can be 'flung...back upon primitive conditions and fears'. Imperilled, a society degenerates into a scrambling mob. Respect for the rights of others is a luxury which the drowning man cannot afford. Fear simplifies his ideas: the need to save your own life makes life itself the supreme imperative.

Hence the treason of modern philosophers, who, as Mann charged, exalt 'the powers of the unconscious, the dynamic, the darkly creative'. D.H. Lawrence thought he had found the world's 'oldest religion' in Mexico, and praised its life-giving sacrificial rites. Mann, lamenting the worship of 'the Mother-Chthonic', whose tabernacle is 'the holy procreative underworld', shook his head over the return of Larionov's favourite goddess. Mankind had spent centuries struggling free from 'the service of Moloch, Baal, and Astarte', deities devoted to sexual excess. The abstract god of Freud's Moses was the next best thing to no god at all. Why should these hard-won mental benefits be so recklessly discarded?

Mann tactfully avoided naming names in his newspaper article; in *Doktor Faustus* he singled out the sociologist Georges Sorel, who in 1908 developed Bergson's vitalism into a cult of violence. Sorel thought that a mass society was bound to dispense with cumbersome parliamentary democracy. Why go to the trouble of counting votes, now that the individual is officially extinct? The secret ballot, the decision painstakingly arrived at in a curtained booth, could be replaced by the concerted chanting of a crowd, repeating slogans 'like primitive battle-cries'. For Sorel, political action depended on the exploitation of communal energies. Mobs could be goaded into those acts of supposedly spontaneous violence which the Nazis organized: bonfires of books, the shattered glass of Jewish windows. Reasoned argument would be wasted on the crowd, which – as Mann says, paraphrasing Sorel – understands only 'fables, insane visions, chimeras'.

Sorel's most potent myth was that of a general strike which, he predicted, would magically cause the state to wither away. Again the primitive and the modern collude: to paralyse industry was like casting a maleficent spell. Put to the test, the sorcery failed: the British general strike in 1926 foundered after nine days. Myth, however, is not obliged to tell the truth. For the demagogue, it is a fiction (or more than one, like Hitler's trumped-up coupling of nationalism and socialism) which the masses can be made to believe. Mann in his newspaper

essay notices the same 'fanatical cult-barbarism' in popular culture, which sets up entertainers or sports stars as seasonal gods, to be worshipped by the mob.

The savages – in Mann's analysis of this 'proletarian eschatology' – invade from the social underground, rather than crossing the eastern frontier like Blok's Scythians, or the plague in *Death in Venice* which has spread from the mephitic delta of the Ganges across China and Persia towards the Mediterranean. *Doktor Faustus*, published in 1947 after the prophecies of his 1930 essay had come true, attempted a more personally painful inquisition. It was easy for Mann to deplore the vulgar irrationality of Nazi myth-making. The pimp Horst Wessel, killed in a brawl between thugs, was promptly canonized. He became a martyr, a brown-shirted Christ, and non-believers who did not jump to their feet for his tawdry anthem were persecuted. How could Mann the patrician not deride such coarse opportunism? But in the novel he forced himself to confront the complicity of his own high culture.

Germany has always taken pride in being the home-ground of philosophy and music; yet both of these lofty mental disciplines made a pact with savagery. Martin Heidegger, installed as rector of Freiburg University in 1933, looked forward to 'a complete revolution of German existence' under the Nazis. Richard Strauss, the official music director of the Reich, assumed that his art conferred immunity. When the American army arrived at Garmisch-Partenkirchen in 1945, he saved his house from being requisitioned by introducing himself as the composer of *Salome* and *Der Rosenkavalier*. He prudently refrained from mentioning *Elektra*, which so excitingly and disturbingly manifested what Mann called the 'epileptic ecstasy' of the German mood. The GIs spared him, vaguely fancying that the world was indebted to him for the *Blue Danube Waltz*.

Mann's version of Faust, the composer Leverkühn, invigorates himself by making a bargain with the devil, who thrives in an age which has killed off God. His demon is a prostitute who infects him with a venereal disease, and makes him – at the eventual cost of his life – a great artist. Strauss serves as a convenient excuse for this apostasy. Leverkühn attends the first performance of *Salome* in Dresden; in May 1906 he travels to hear the composer conduct his opera in Graz, using the trip as a pretext for a detour to visit the woman 'whose mark he bore'. He pretends to dislike the opera, which only interests him technically; in fact he is participating in its plot, secretly sharing in the heroine's act of sacrilege. Germany fulfils its 'historical destiny' through a similar alliance with 'daemonic powers'. The student Deutschlin scoffs at the revolutionary youth of Russia, who have 'profundity but no form'. The barbarism of the Bolsheviks was crude, rampant, bear-like; the Nazis devised a barbarism better suited to the German character – high-minded, proud of its garbled derivation from Nietzsche, Spengler and Heidegger, rigorously efficient.

Mann credited Leverkühn (to the extreme annoyance of Schoenberg, then living, like Mann, in California) with the invention of the dodecaphonic system. Schoenberg was right to take offence. Though Leverkühn in the novel

promotes his twelve-tone row as a model of planetary order and cosmic regularity, the narrator Zeitblom describes the procedure as a mad and dangerous game, 'incomprehensibly and vaguely daemonic'. Surrendering to its arbitrary operations, Leverkühn reminds him of a man who finds auguries in a roll of the dice or in the succession of fortune-telling cards. During his work on the novel, Mann befriended Theodor Adorno, Walter Benjamin's cousin, who was his neighbour in Los Angeles; he consulted the manuscript of Adorno's *Philosophy of Modern Music*, which was published the year after *Doktor Faustus*, and made use of its ideas. Adorno's study likened the twelve-tone composer to a gambler, waiting to see what number would turn up, and deplored the superstitiousness of the method. Music used to be 'the enemy of fate': Orpheus sang to challenge the cruel gods, and persuaded them to alter their sentence. In Schoenberg's schematic rows – or perhaps, more justly, in those of Leverkühn – music finally succumbs to fatalism.

The history of the art is rewritten in *Doktor Faustus* by the jesting nihilist Breisacher. He maintains that music, rather than accompanying the forward march of civilization, is 'the achievement of barbarism', because polyphony developed in the raw, coarse north, particularly in 'savage Britain'. Zeitblom takes this argument as a warning of 'the new world of anti-humanity' and its revival of the 'dark era' of theocratic battles. Adorno, looking back on a half-century in which music had failed to save civilization, suggested that it had always been eager to give in. Schoenberg did not emancipate dissonance; it could already be heard, suffering under 'the taboo of order', in Bach and Mozart. The tension within dissonance prompted Adorno to account for it as one of Freud's festering discontents: it voices desire, and complains about denial.

All these pent-up, anarchic yearnings are gratified in Leverkühn's *Apocalypsis*, a cantata which terminates the history of music while describing the end of the world. The old harmonic regime is here diabolically upset. Tonality in the *Apocalypsis*, rather than representing spiritual grace, is synonymous with earth-bound banality, and dissonance expresses 'everything lofty, solemn, pious'. Like Mahler in his choral symphonies, Leverkühn writes hymns to be sung by harried, multitudinous humanity; like Berg in the *Lyric Suite*, he traces music back to its origins in 'mere noise'. But unlike Berg and Mahler, he permits no redemption – neither for the mass, as in Mahler's transfiguring finales, nor for the individual, as when the dying Geschwitz calls Lulu an angel; not even for nature, which serenely renews itself in *Das Lied von der Erde*. The brass in the *Apocalypsis*, blaring at intervals with gulfs of silence between them, opens up an abyss. Glissandi on the trombones – an indecent sound, a relic of savagery which in Zeitblom's judgment should be banned or at least rationed – unleash howling panic when the avenging angels slaughter mankind. In his 1930 essay Mann called expressionist art a 'shriek of the soul', recoiling from an intolerable reality. In the novel, that metaphorical terror is collectively voiced by Leverkühn's chorus, 'frightfully shrieking' when the sky darkens and doomsday arrives.

Although the *Apocalypsis* is made to bear the burden of Germany's crimes against culture and humanity, the musical work it most resembles is *Le Sacre du printemps*. It is as if Leverkühn had transposed Stravinsky's prehistory to the end of time, and incorporated into his score the hysteria which broke out in the audience when *Le Sacre* was first performed in 1913. Adorno's book assailed the authoritarianism of Stravinsky, also a recent emigrant to California: the cultural combats of Europe in the 1930s raged on, unappeased by the end of the war, in the western suburbs of Los Angeles. Adorno compared Stravinsky to 'le Sage', the wise elder who presides over the ritual slaying in *Le Sacre*, and sarcastically likened them both to the showman manipulating his puppets in *Pétrouchka*. The composer is an 'all-mighty magician', a dictator who can order marionettes to come alive and a living woman to dance herself to death. Zeitblom accuses Leverkühn of coveting the occult powers of a medicine-man, the priestly wizard charged with managing celestial affairs in the barbarous infancy of culture.

Doktor Faustus was Mann's small act of sabotage. Zeitblom writes the novel during the last months of the war, and although his sons – fervent believers in Hitler the thaumaturge – are fighting in the Wehrmacht, he hopes for Germany's defeat. While waiting for that, he enjoys his own ironic revenge on Leverkühn. The terrifying music exists only in his verbal description. The notes, translated into words, are silenced. He has averted the apocalypse.

When the Nazis came to power, Otto Dix, the caricaturist of the swinish Berlin bourgeoisie, prudently moved to the Bodensee on the Swiss border. There he concentrated on painting landscapes, which were safely neutral: the change in genre, he commented, was 'tantamount to emigration'. Nolde's myth of 'Urnatur' was captured by the nationalists, who redefined the tribe as the Hitlerian 'Volk'. In doing so, they perverted primitivism. Picasso at the Trocadéro or Klee in Tunisia had learned to recognize the marginality of Europe, soon to lose its self-appointed role as global potentate. On its eastern fringe, the West did not decline; it simply dissolved, its claim to cultural dominion discounted by musical evidence.

In 1926 Janáček composed his *Glagolitic Mass*, which challenged the hegemony of Roman religion and German music. He dispensed with Latin, the language of an ecclesiastical empire, and instead used the *Glagolica*, a testament of the Byzantine missionaries who converted the Slavs to Christianity in the ninth century; he replaced the solemnity of the Masses composed by Bach and Beethoven with a shout of exultancy – the pantheistic jubilee of the earth itself, celebrated in the open-air cathedral of a pine forest. Studying Magyar folk music during the same year, Bartók speculated about the origins of the pentatonic scale. It could not possibly derive from the Germans (to whom Bartók referred, with diplomatic obliquity, as 'our neighbours'). He believed that he had identified 'the remnants of an old musical folk-culture brought from Asia by the first Magyars' and found analogies in the music of the Kirgizes and Tatars. The nomads

of Kirgizia on the Chinese border had been overrun by Russia during the nineteenth century, and were eventually awarded their own Soviet Socialist Republic to walk up and down in; but Bartók's reference to the Tatars recalls their warning in *Prince Igor* that there are limits to such imperial conglomerations.

With the five steps of the pentatonic scale, Bartók constructed an imaginary bridge between continents, extending potentially as far as Java. In 1923 he composed a *Dance Suite* to celebrate the union of Buda and Pest, joined across the Danube fifty years earlier. Again folk music sponsors fraternity. The riotous elation of Hungary (with snorting glissandi on the trombones, which Zeitblom would have disallowed) gives way to the capering rhythms of Romania, then to a quiet, lilting Arab sorcery. The fifth dance in the suite, Bartók proudly commented, was too primitive to possess national characteristics: it is the sound of the peasantry anywhere, thumping a tattoo on the ground. His *Allegro Barbaro* for the piano, composed in 1911, also attempted to capture the demotic energy which first gave rise to music. Barbarism here does not mean to threaten, despite the harsh dissonance and stubborn repetitiousness of the piece. Like the pumping of blood, its rhythmic aggression is a rudely healthy vital sign. Visiting Berlin, Bartók admitted the temptation to emigrate westwards. He was called home, he said, by the folk-songs of Hungary; they fastened him to his native ground.

The defenders of fascism in *Doktor Faustus* see in modern history the working out of an inexorable dialectic. Atomization, they proclaim, leads towards collectivization. Individuals, no longer sustained by bourgeois society with its hallowed privacy, are reduced to specks, like the 'atomized sounds' which Adorno heard in Schoenberg. Interchangeable, they disappear into the mass, which can be ordered about and manipulated as if it were a solitary, impotent person. Freedom is replaced by the dictatorship of a single party.

The ethnomusicology of Bartók challenged this deterministic German myth. Why should the atom not be a doughty, autonomous individual? Cities render people uniform and treat them as herds; elsewhere they coexist without being collectivized. The melodic scraps or metrical gestures of Bartók's *Mikrokosmos*, many only twenty seconds long, are a seed-bed of diversity, from which an entire world might proliferate. Much of the material filed away in this encyclopaedia for the piano consists of songs or dances from Hungary, Bulgaria, Transylvania and Yugoslavia: the germs or genes of national identity, a unique signature inscribed in music. This is a more benign myth than Spengler's. So much the worse that events in the region which for Bartók was the bridge between west and east have disproved it. The fate of Yugoslavia in the 1990s suggests that the dialectic might be doubling back on itself: when the collective state fails, the atoms are set free to kill each other.

Bartók worked intrepidly in the field, recording folk-songs on expeditions through Turkey and studying bagpipe music during visits to Scotland. In 1913 he learned Arabic to assist his research, and was delighted to discover a common linguistic ancestry which linked Hungarian and Turkish. He attempted to realize

the humane hope of modern times: a world reduced to microcosmic size by the ease of communication should have been able to free itself from the curse of Babel. Music escaped this malediction, and film, so long as it remained silent, spoke a language which all nations understood. Maria in *Metropolis* tells the workers about the tower of Babel, toppled by God who punished men for their presumption by confusing their tongues. She predicts the same downfall for the industrial city; the curse promptly overtook film when sound and images were synchronized in 1927. Still Joyce's polyglot puns in *Finnegans Wake* erased the borders between tribes and their incompatible dialects. Even the polytonality of Stravinsky experimented with a babble of simultaneous musics, like the overlapping tunes played in competition at the St Petersburg fair in *Pétrouchka*: a man with a hurdy-gurdy churns out a Russian song, while one of his competitors plays a Swiss melody. The fair, like the *fêtes foraines* of surrealist Paris, is itself a primitive relic, the refuge of nomads who seasonally pitch their camp in the city before moving on. Painting internationalized words by abstracting them from meaning. Klee was enchanted by Arab calligraphy, and thought that its whirls and tendrils were beautiful because he did not know what they meant. Tunisia liberated colour; its decorative alphabet also liberated line, forming signs which – to Klee at least – signified nothing. Huelsenbeck explained the etymology of Dada by saying that 'the child's first sound expresses the primitiveness, the beginning at zero, the new in our art'.

It was a short step from baby talk to the babble of the early people. In 1917 Poulenc composed a *Rapsodie nègre*. Accompanied by buzzing strings and a clattering piano, the singer chants verses in a language which Poulenc called 'pseudo-Malagasy'. Despite the invocation of Africa, the most frequent word is 'Honoloulou', while the poet, a friend of Poulenc's, marsupially signed himself Makoko Kangourou: dreams slither across geographical boundaries. Finally words and even music are abandoned. The cheeky finale consists of animal noises – a cow-like repetition of the syllable 'Mou', concluding with a gruff canine bark. At the Cabaret Voltaire, Huelsenbeck chanted poems in African languages which he made up for the occasion, while the audience ritualistically grunted and thumped their table tops. Nonsense, for the Dadaists, was the Esperanto of the unconscious mind.

When separate worlds first collided, commerce devised a compromise between their different languages. At the ports where they met, Chinese and European traders transacted business in a hybrid tongue. Foreign words were slotted into home-grown sentences. Pantomime sorted out problems of comprehension, since the dancing, gesticulating body speaks clearly enough without words. Pidgin became the language of homeless modernity, a readily convertible currency like jazz, which Yehudi Menuhin defined as an 'African-American-European synthesis'. The bar girls in *Mahagonny* speak German, but use English to serenade the moon of Alabama. Křenek's Jonny converses in a slangy creole, slithering between English and German, and the touring virtuoso Daniello,

whose features are vaguely Levantine, slides into French when intent on seduction. Poetry may be untranslatable, but popular songs never need translation, no matter in what country they are heard. Languages continue to interbreed, with Franglais spoken in Paris and Japlish in Tokyo.

Words, however, have proved to be more adaptable than those who use them. Satellites beaming signals instantaneously through the air have shrunk the earth. On the ground, still scarred by border wars, this makes little difference. H.G. Wells fantasized about a global intelligence which would one day learn to see across frontiers and beyond horizons; our only hope, he thought, was a world government administered by that universal mind. Today anyone with access to the Internet can consult humanity's collective electronic brain, but the notion that political solutions are dictated by technology now seems at best quaint, at worst sinister. We have learned to be pluralists, and no longer patronizingly speak of a clash between civilization and barbarism. But we are not much nearer to understanding each other, even though our rainbow skins may be clad alike in the united colours of Benetton.

SPRING,
SACRED AND PROFANE

The musical work which ritually acts out the primitive nature of modern life was known to its composer as *Vesna Sviaschennaya*, meaning holy spring. Bakst made the French translation, *Le Sacre du printemps*, about which Stravinsky had his doubts. The next translation, into English, involved another loss. Rendered as *The Rite of Spring*, the title forfeits its allusions to sacredness and sacrifice. Stravinsky's Russian phrase had an even wider range of reference, because it corresponded exactly to the slogan with which the Secessionists in 1898 introduced their programme of artistic reform in Vienna. They called their journal *Ver Sacrum*; the title was a motto of modernist renewal.

Stravinsky started from his recollections of sudden seasonal change in Russia, where spring seems to arrive in an hour, splitting open the body of the frozen earth. Roerich, who designed the first production, invented an ancient Slavic rite for the music to accompany: tribal elders select a young woman who sacrifices herself to guarantee nature's renewal. The mechanical propulsion of the orchestra hardly matched the hazy picturesqueness of the settings – a verdant grove carpeted with yellow flowers – or the quaint ethnographic kitsch of the costumes. But this contradiction gave the work its dual, quizzical identity, at once modern and primitive. At the end of time, we imagine the beginning. The score, resonating throughout the century, soon grew beyond Roerich's custom-made folklore. *Le Sacre du printemps* has become a parable for modern times – an account of convulsive, instantaneous change and its mortal costs.

While working on *Le Sacre*, Stravinsky also composed the rite of another spring. The first and second of his *Three Japanese Lyrics* are about the ice-floes and sprouting flowers which announce rebirth, and the third welcomes the cherry-blossom. The savagery of ancient Russia defers in these songs to a more fragile culture. The eruptive orchestra is replaced by a chamber group, which represents the awakening of nature in a web of agitated flight-paths: chirping flutes, winds which hum like insects, plucked strings, a cascading piano, and the whining, droning sonority of a high soprano.

The heroine in the ballet remains mute. In the *Japanese Lyrics* she is allowed to sing, and her response to the season is momentary rapture. Instead of Russia's perpetual, churning cycles, the lyrics – which last for only a minute each – single out precious, unrepeatable instants, ephemeral like the blossom. There is no room here for the earth to quake and gape open. Stravinsky adopted the severe economy of means which he admired in Japanese prints. The soprano cannot tell if the white dots in her garden are flowers or flakes of snow, and she mistakes the cherry-blossom for a cloud draped across the land; the shifting tonality of the songs compounds these visual puzzles, as does Stravinsky's arbitrary accentuation of the words. He called the lyrics an exercise in 'two-dimensional music'. They chasten spring, summarizing its abundance as a haiku does in its abbreviations, refusing (as if contritely, in a retraction of *Le Sacre*) to renounce control. In Russia, there is a cataclysm; in Japan, a petal falls.

The myth, like one of Sorel's political fictions, rallied the new century. In Wedekind's *Spring Awakening* the wintry, desiccated elders try to retard the season of juvenile sexuality. The play has a forerunner of Stravinsky's sacrificial virgin: the pregnant fourteen-year-old Wendla, who thinks she has dropsy and is killed by a brutal abortionist, after which her death is officially attributed to anaemia. When Melchior fantasizes about copulation, his outraged teachers berate him for disregarding 'mankind's sense of shame when confronted with the moral order of the universe'. That order is upheld when the boy blows out his contaminated brains. Spring for Wedekind was a rebellion against the inflictions of sacredness. The morality and theology of the nineteenth century, as Nietzsche pointed out, were arbitrary regimes whose purpose was to hinder or defame natural energies. Man, born sensually free, was everywhere in chains.

Spring in Germany was therefore an occasion for rampant irrationality. In 1906 Strauss composed a song called 'Frühlingsfeier', based on a poem by Heine; the title means the rite of spring. He orchestrated it in 1933 and his score described the season as a Dionysian killing spree. A horde of women, goaded by the new life which thrills inside them, hunt the vegetation god Adonis, who must die and be reborn to fertilize the earth. They find him covered with blood, and the soprano both sobs and exults, while the volcanic orchestra fumes. In 1937 Carl Orff's *Carmina Burana* made the political agenda of the season more explicit. The chorus which chants about the delights of spring is the reborn collective, to which individuals must sacrifice themselves. A soprano succumbs to her lover in a slithering vocal diminuendo, and a roasted swan sings deliciously while turning on its spit. These episodes of jubilation are countered by the sombre address to Fortune which begins the work and ends it: in the new pagan culture of Nazi Germany, the body supplies pleasure and imposes power for a while, but must finally be relegated to oblivion.

Russia advertised its Revolution as a political response to the earth's urgent germination of new life. Oskar Schlemmer reported in January 1919 on a premature seasonal revolution in Moscow. Kandinsky and his colleagues, using

house-fronts as canvases, had conjured up 'an artificial spring…with giant sun-flowers, flower-beds in a potpourri of colour, silver trees'. Stravinsky dissociated himself from this liberating version of spring. In his Harvard lectures during 1939–40, he protested that he had been enlisted as a musical revolutionary against his own will. Rejecting Bolshevism, he forswore the instinctive tumult of spring, when, as he said, the 'life-sap' rises and intoxicates us; he therefore revised Nietzsche's fable about the birth of music, and told his Harvard audience that Dionysus must be subjugated because 'Apollo demands it'. The neoclassical Stravinsky did not even mind if a dictator demanded it. Later in the lectures he mentioned Stalin's prohibition of Shostakovich's *Lady Macbeth of Mtsensk*, with its carnal flagrancy and its antisocial uproar. *Pravda* attacked the score for being pornographic (just as *Le Sacre du printemps*, when Eugene Goossens conducted it at a New York concert in 1926, was denounced by the president of the orchestra as 'obscene music'). More in sorrow than in anger, Stravinsky remarked that the condemnation of Shostakovich may have been 'perhaps not altogether wrong'.

Such a judgment explains why Adorno should have called Stravinsky a reactionary, not a harbinger of fertile summer but 'the herald of the Iron Age'. Yet Stravinsky – who instigated a revolution in art, whether reluctantly or not, and then after that cycle had worked itself out set about inciting another revolution, which looked like a counter-revolutionary betrayal – possibly understood the process better than Adorno the Marxist. The century's first revolution welcomed the future and hastened its arrival. Its second revolution restored the past. That was a logical sequel, because revolution, completing its circuit, rapidly returns to the place where it began. The left has no monopoly of change: there are right-wing revolutionaries as well. *Le Sacre du printemps*, ambiguous and therefore uncannily prophetic, sounded radical in 1913, but by 1933 it had come to seem conservative, in subject if not in musical substance.

April, as T.S. Eliot pointed out in his own maimed rite of spring, is cruel. Though *Ver Sacrum* may have looked forward to regeneration without misgivings, *Vesna Sviaschennaya* was from the first more aware that sanctity is an idea painfully evolved by men, rather than a blessing which nature confers along with the crocuses and daffodils. Sacredness therefore requires a sacrifice. *Le Sacre du printemps* concludes, like a tragedy, in death.

In 1912, while Stravinsky was completing the score, Durkheim published his study of the social origins of religion. He began by admitting the oddity of his apparently retrograde research. Why should we have to consult 'the very beginnings of history' in order to understand humanity at present? The reason is that, in our social behaviour, 'we still have the mentality of primitives'. Lévi-Strauss, during an anthropological expedition to Brazil, heard what seemed to be a quote from *Le Sacre* in the middle of the Amazon. Attending the sacred ceremonies of the Nambikwara tribe, he admired the nasal-toned pipes which they played while supervising the transit of souls. The 'chromatic effects and rhythmic variations'

of their tunes recalled 'certain passages of the *Sacre*, especially the woodwind modulations in the section entitled "Action rituelle des ancêtres"'. The ballet is not confined to Roerich's notion of the Stone Age; it can take place in any primitive society, or in 1913 and any subsequent year. Its primitivism is what made it modern, and ensured that it has retained its troubling contemporariness. Durkheim might have been describing the action of the *Sacre* when he observed that we live in fear of society, which harshly punishes dissidence. Civilization, as Freud maintained, is an institutionalized and oppressive conscience, whose burden afflicts us with our psychological discontents. Durkheim studied the same onerous compromise. Society must secure our obedience; it does so by inventing the bogy-man, using religion to terrorize us. We are all self-elected sacrificial victims. We volunteer gladly, because society promises us a reward: the comfort and security of membership, obtained when we give up our singleness. Sacrifice, which creates kinship, is the ritual in which the social contract is signed.

Durkheim looked for his evidence to the actual Stone Age of the Australian aborigines. Commenting on the sacrificial banquets and the totemic feasts of the Alatunja tribe, he said that the essence of these ceremonies was 'no longer the act of renunciation which the word sacrifice ordinarily expresses'; they were acts of 'alimentary communion'. Stravinsky's Élue offers herself as food and fuel for the earth, which consumes her on our behalf. She has been cannibalized – as we all are, in one way or another – by the collective. Durkheim's analysis of primitive folkways agreed with Simmel's account of the nervy stratagems evolved by modern man to cope with life in the big city. Their sociology introduced a new and implicitly pessimistic view of our predicament, which overturned the nineteenth century's faith in the benevolence of nature and the autonomy of the individual. Stravinsky dramatized the same idea in a different and more aggressively immediate form. Ethnology goes on adding footnotes to his fable, and in 1997 an Australian aboriginal dance group collaborated on a production of the ballet at the Sydney Opera House.

Igor Stravinsky composing Le Sacre, *by Jean Cocteau (1913)*

A year after the first performance of the *Sacre*, war began – and Stravinsky seemed to have supplied its sound-track. The photographer Jacques Lartigue, when he first heard the score, recalled the roar of planes revving up for take-off at the airfield of Issy-les-Moulineaux. The painter Jacques-Émile Blanche remembered the score during the air raids on Paris: its rhythms suggested the thudding regularity of bombardment. Stravinsky acclimatized those implacable

rhythms to the next war in his *Symphony in Three Movements*, composed between 1942 and 1945, which alludes to newsreel images of the fighting. The timpani perform a rumba, suggested to him by the striding agility of 'war machines'. Of course, with the advent of industrialized killing, the sacramental overtones of the ballet's title had to be expunged. In *A Farewell to Arms*, Hemingway's hero reflects on the decimation of our vocabulary by the 1914–18 war, when young men were harangued about the privilege of sacrifice. He mentions this word in a glossary of patriotic humbug, and gives it his own disillusioned definition: 'sacrifices were like the stockyards at Chicago if nothing was done with the meat except bury it'.

The word may have been declared unfit for further use, but the practice survived in a world which claimed to be modern and humane. Stravinsky's lethal rite was a reminder of psychological secrets shared between primitive society and modern times. In an essay written during 1905–6, Freud attempted to explain the pleasure we take in watching people suffer on stage. Our unsavoury emotions, he thought, derived from drama's origins in sacrificial rites, although slaughtered goats have since been replaced by human scapegoats like Oedipus or Lear. Yet why should we sadistically relish the spectacle of torment, and why should they afford the heroes such 'masochistic satisfaction'?

The letting of blood, Freud suggested, forestalls a 'rebellion against the divine regulation of the universe, which is responsible for the existence of suffering'. It is god we want to punish; we kill a human deputy instead. Sacrifice, like a show trial or a public execution, discourages revolution. Stravinsky restaged this ceremony in later works. The devil outwits his victims in *L'Histoire du soldat* and *The Rake's Progress*, and the incestuous couple efficiently carry out society's sentence on themselves in *Oedipus Rex*. It would be hypocritical to weep over the anguish of these dupes, just as we cannot pretend – after Freud's analysis of our motives – not to be gratified when the dancer collapses in *Le Sacre du printemps*. We have signed the warrant, and gloat as it is carried out. The jarring bitonality of the *Sacre* recurs in Puccini's *Turandot*, left incomplete when he died in 1924. The most insistent references to Stravinsky come when the Mandarin announces the next in a long series of beheadings, and the Peking mob rejoices to hear the news. Stravinsky's rites are always accomplished with orderly, punctual protocol. The chorus in *Oedipus Rex* gently blesses the blinded Oedipus as it ushers him into exile. Puccini's crowd is more bloodthirsty, and its enthusiasm for ceremonial murder retrieves the *Sacre* from prehistory and introduces it to the 1920s, a time of collective panic when politicians were learning to mobilize the force of mass hysteria.

The surrealists, taking the myth literally, flirted with a revival of sacrifice, which they believed would restore sanctity to a world deserted by god. Modernity had made a habit of massacre, as Hemingway recognized when tallying casualties in *A Farewell to Arms*. A massacre does not pause to acknowledge the separate identities of its victims, whereas sacrifice – according to the insane logic of

Georges Bataille – mystically ennobles its chosen ones, rather than reducing them to statistics. Massacre is an industrial operation, churning out corpses to win wars. Sacrifice, in Bataille's view, was sublimely useless, like the romantic suicides of Werther or Axël or the love-death of Isolde. Squandering life, it mocked the costive accumulations of the capitalist. During the 1930s, Bataille schemed to establish a solar religion like that of the Aztecs, whose observances were to be celebrated on the Place de la Concorde, which had been the site of the guillotine. He formed a secret society called Acéphale: the title was his homage to the guillotine's clean and merciful removal of the head, where man's reasoning powers were lodged. He even boasted that he had secured legal approval for the execution of volunteers.

The idea of the sacred is so incompatible with man's actual nature that it implies a contemptuous curse on humanity. That, Bataille argued in 1951, is why we make war – to achieve our own extinction. Those homicidal orgies on the Place de la Concorde would have 'pantomimed the destruction of the universe'. More soberly, Octavio Paz in 1950 in an essay on Mexico's annual Day of the Dead contrasted the collective slaughter of the Aztecs with the sedated, euphemized way of dying in the modern world, and wondered whether there had been any progress. The Aztecs sacrificed their victims in the interest of 'cosmic health'. The results were palpable. The sun has not yet gone out; spring has so far always returned. Christ sacrificed himself to buy for us an afterlife which remains an empty promise. We still hope that science will save us from having to die in order to find out whether Christianity has cheated us. While research continues, we dismiss death as a design fault which will soon be overcome, and apply cosmetics to corpses. We have lost the Aztec sense of incorporation in nature. Death, which we refuse to consider as a personal fate, resorts to more impersonal methods of asserting itself. 'The century of health, hygiene and contraceptives, miracle drugs and synthetic foods, is also' – Paz points out – 'the century of the concentration camp and the police state, Hiroshima and the murder story.'

There were many reasons why *Le Sacre du printemps* should have caused a riot in 1913. The scandal was a tribute to its assault on complacent received ideas – about music and ballet, but also about society, religion, the sinister compact between them, and the multiple ways in which the earth was different in the twentieth century. The fogies who whistled and hooted merely proved its case about the frailty of culture and the barbarism of man. The painter Valentine Gross said that the theatre shook, as if suffering an earthquake. At the second performance, Gertrude Stein and Alice B. Toklas enjoyed the dancing, but did not hear a note of the score: the music had been entirely superseded by the audience's bawling and squabbling. Cocteau recalled that the public imitated animal cries and bayed for blood. The work was promptly nicknamed *Le Massacre du printemps*.

Avant-gardists live by provocation, and are always gratified by a fuss. It became a point of pride to outdo this uproar, while jocularly massacring the language with puns which invoked the original disturbance. George Antheil's

Ballet mécanique added an aeroplane propeller (actually an electric fan wearing camouflage) to its battery of cacophones. When Antheil's work was performed in 1924, Aaron Copland reported that it 'outsacked the *Sacre* with the aid of a Pleyela automatic piano'. Cocteau's first title for *Les mariés de la Tour Eiffel* was *La Noce massacrée*, which had the advantage of doubling the word-play. As well as committing its own sacrilege, his farcical hybrid of tragedy and cabaret urbanized the rustic Russian nuptials of Stravinsky's ballet *Les Noces*. These frivolities demonstrate how quickly the bourgeoisie learned to tolerate avant-garde teasing, and suggest how skilled the modernists of Paris became in obtaining publicity for their outrages. But the fury provoked by the *Sacre* was not spurious. Debussy called the score 'extraordinarily savage'. Of course the sanctimonious New Yorker who fumed about 'obscene music' was talking nonsense. Music, which uses neither words nor images, is strictly incapable of obscenity. Yet the comment is comprehensible. Stravinsky's deviation from harmonic rules was violent and impenitent enough to be considered a breach of etiquette, even an offence against public decency. In 1920 the American critic Deems Taylor called the *Sacre* mere 'imitations of noises', not music at all.

The score has been tamed by its admission to the canon of classics; shock is a more appropriate reaction to it than respect. Debussy told Stravinsky that he had extended the range of what was permitted in 'the empire of sound'. In fact Stravinsky had, perhaps impermissibly, gone further than that. The *Sacre* denies that sound is an empire – orderly, regulated, imposing civilized values by force on recalcitrant nature. The bassoon, howling mournfully in the first bars, does not paraphrase a soulful human emotion. It utters a primal cry, like the spasms fixed on the faces of tribal masks. The wind instruments shrill and jeer in the passage which follows, chuckling and chattering simultaneously, beyond imperial control. They have to be subdued by a bludgeoning, when the remorseless thud of 'Les Augures printaniers' starts up. Once that rhythm begins, bolstered by eruptions of brass, it strides to the foreground, rejecting its discreet traditional role as a time-keeper. But for all its brutal insistence, it has no urge to advance. Whereas the music of the nineteenth century offered modulation, development and resolution, the *Sacre* remains static. Time, as in dance, becomes space. The only movements are circular, as befits a revolution: the 'Rondes printanières' or the slow, cumbrous, heaving 'Cercles mystérieux' of the acolytes. At the end there is no release, only an abrupt hammering termination like a loss of consciousness, as the chosen dancer collapses. Despite her death, there has been no progress. Sacrifice is an annual obligation. Ritual constructs the world and perpetuates it, but only for a fixed time.

Nijinsky's choreography offered its own affront. Cocteau said that modern composers should not bother plumbing mystical profundities, and called for music you could walk on, not swim in. Romantic ballet angelically spurned gravity; Nijinsky made his dancers – who are supposed, according to the scenario of the *Sacre*, to be adoring the earth – pound on the floor with flattened feet,

Design by
Nikolai Roerich
in 1945 for a
new production of
Le Sacre du
printemps

rather than using it as a spring-board for soaring upwards. Artaud, writing in the 1930s about the 'bestiality and animalism' of theatrical rituals in Bali, said that the feet of the dancers battered the ground as if determined to make it split open. This was exactly the image of spring in Russia which had first suggested the *Sacre*. Artaud compared theatrical performance to surgery carried out with no anaesthetic, or to rites of human sacrifice. Pain and bloodshed, he thought, were essential to the process; only with their aid could the myth tell its story about 'the slaughter of essences that came with creation'.

The critic Jacques Rivière called the 1913 *Sacre* 'a biological ballet', and added that, predating primitivism, it exhibited 'the dance before man'. But it was also the dance after man, a mechanized ballet performed by automata. Nijinsky cramped and wracked his dancers, emphasizing angularity, not ethereal grace. Their arms stuck out in profile, while their elbows seemed to be glued to their waists. Their feet were skewed inwards. Lacking the flexibility of living creatures, these were bodies re-engineered to suit the demands of the machine age. Whether seen as atavistic or industrial, Nijinsky's *Sacre* was a calculated insult to humanist self-conceit.

Stravinsky may have been disconcerted by the choreography, but he too was attracted by the idea of the world before or after man. The characters of his early stage works include a living firebird and a clockwork nightingale. He even wrote a symphonic poem – the *Scherzo fantastique*, first performed in 1909 – about insects. This busy, buzzing piece took its plot from Maurice Maeterlinck's *La Vie des abeilles*, published in 1901. Maeterlinck's study of the hive enabled Stravinsky to pay a competitive compliment to his master Rimsky-Korsakov: the flight of Rimsky's bumble-bee grows into a humming swarm. But the *Scherzo* also anticipates the *Sacre*. The society of the bees has its unforgiving rules, and its requirement of sacrifice. The queen coolly kills off the male when he has outlived his sexual usefulness. At the onset of winter, Maeterlinck remarks, 'the great festivals, the great dramas, are over' – at least until next spring, when the ritual of wooing and slaying must be performed all over again.

The happy sacrifice was repeated in *Les Noces*, where the bride and groom are immolated together while the society of on-lookers, well-wishers and drunken in-laws gossips and rejoices. The newly-weds are ritualistically prepared for the ceremony. Friends of the groom curl his locks with olive oil, and attendants braid the bride's hair while she squeals in

A rehearsal of the first scene from Bronislava Nijinska's Les Noces *(1923)*

pain. In Bronislava Nijinska's choreography for the first production in 1923, those plaits extended into a looped umbilical rope which twined around the bride's attendants and fastened them inside its web. Marriage confirms society's ownership of individuals, rather than their private romantic isolation. Their personal desires are irrelevant, since marriage is a biological factory which ensures the future of the race. Chimes and bells briskly organize time, and a chorus issues bossy instructions. Invisible voices pre-empt the emotions of the bridal pair, singing their dialogue for them and sending deputies on ahead to warm the marriage bed. Stravinsky likened these stray, disconnected scraps of conversation to the polyphony of the streets in *Ulysses*, where individuals emerge only fitfully from the mass and soon recede into it again, and Nijinska efficiently collectivized the bodies of the dancers. The women bent at back-breaking angles to construct a pyramid of horizontalized heads on which the bride supported herself. The men leaned on one another's shoulders, forming a phalanx which advanced across the stage like a centipede performing eurhythmics.

Maeterlinck treated the beehive as an archetype of the human city, although he believed that the insects had organizational talents which other species could only envy. He considered the honeycomb to be 'the most perfect creation of the logic of life'. What delighted him most of all was its 'hexagonal cell': the comb is a model prison. In 1929 Ortega y Gasset revived the example of the bees in his Spenglerian polemic *The Revolt of the Masses*. Once more, the end recalled an imaginary beginning: confronted by the disintegration of European societies, Ortega brooded about the origins of this expiring culture and found a premonition in 'the sufferings and death of the Graeco-Roman world'. He likened the Greek and Latin *polis*, the ideal unit of political society, to a beehive, and paid tribute to the achievement of the 'hive-building swarms' which put an end to the solitary wanderings of prehistoric man. But prehistory had returned in the twentieth century: the nomads – the Polovtsians of *Prince Igor*, or Blok's

Scythians – again threatened the city and menaced the accomplishments of civilization. The masses, whose advent Ortega called a 'vertical invasion of the barbarians', could not be housed in the *polis*. Overflowing, they roved rootlessly across the earth. Nowadays, in Ortega's view, they did not commit acts of vandalism like Attila; they vulgarized the world instead. Debussy told his colleague André Caplet, with a hint of disapproval, that *Le Sacre du printemps* was 'primitive with every modern convenience', and Ortega witheringly described Americans as 'a primitive people camouflaged behind the latest inventions'.

Ortega's reflections on the novelty of the city in the ancient world had a baleful relevance to the 1930s. The city did not begin, he argued, as a huddle of 'habitable dwellings'. Its purpose was to make room for public functions, rather than to shelter individuals. Its arrival was therefore announced by the marking out of an empty space – a square or forum set apart from the open country. He made a daringly modern claim for this innovation, which 'signifies nothing less than the invention of a new kind of space, much more new than the space of Einstein'. Despite Ortega's enthusiasm, that empty space was uncomfortable. Kracauer or Polgar, in their own parables about social breakdown, redefined it as the hotel lobby or the café – limbos for the transient citizens of modern times. An empty space closer to Ortega's specifications was built outside Rome by the fascists, with muscle-bound statues encircling a stadium which seated a mass of twenty thousand; on the way in, the believers contemplated Mussolini's name carved on a gigantic granite boulder. At the Foro Mussolini, the bloated Roman forum replaced the democratic Greek *polis*.

Although Maeterlinck lamented 'the absence of pity' among the bees and their 'almost monstrous sacrifice of the individual to society', his qualms were soon disallowed. Why should human beings not be exhorted to build their own cellular prison? It did not matter if, to achieve the feat, they had to be treated like insects, or slaves. There were now so many men in the world that collective measures seemed inevitable. In 1936 – when revolutionary movements were proclaiming the elimination of the selfish, wasteful bourgeois individual as one of the century's grandiose achievements – Karel Čapek reconsidered the nature of the beehive in his science-fiction fable *War with the Newts*. The mating dance of the totalitarian newts helps to explain the self-destructiveness of Čapek's human contemporaries, rushing to join political movements which relieved them from the need to function as autonomous beings. The male newts impregnate the water, into which the females eject their eggs. The transaction remains impersonal, 'free from erotic illusion', and their festivities instil a collective identity. 'Real animal communities', Čapek proposes, 'are found only where the life and development of a species is not based on the sexual pair: with bees, ants and termites. The community of the bees might be expressed as: I, the Maternal Hive. The community of the newts can be expressed quite differently: We, the Male Principle.' Stalin's Russia and Hitler's Germany both experimented with something like this collective paternity, shattering the nucleus of the family and setting up the dictator as a collective parent.

Schoenberg remembered Maeterlinck's bees in 1942, at an even more demoralized moment in human history. He had received a commission for a piece of chamber music, and decided that he must choose a subject dealing with tyranny and the causes of the war. He was unable to account for German adhesion to a philosophy which declared the individual to be valueless and exalted instead 'the totality of the community'. His former compatriots were behaving like ants, or bees; the Führer, Schoenberg wittily suggested, was their queen. They had consented to the annihilation of their privacy and singleness, because they believed that their only purpose was 'to keep the race alive'. He linked the futile killing of the drones and of the queen's multitudinous offspring to 'the sacrifices of the German *Herrenvolk*'; he did not yet know about the sacrifices which other races had to make so the Germans could enjoy 'world domination'. When he consulted *La Vie des abeilles*, he was offended by Maeterlinck's poetic justification of the hive, which is forgiven its cruelties because its regime is orderly and beautiful. Rejecting Maeterlinck, Schoenberg chose to set Byron's vitriolic *Ode to Napoleon Buonaparte* instead.

In the twentieth century, ritual murders – rather than placating jealous, hungry gods – lay a bait in the hope that the derelict gods will be lured out of retirement. Any deity will do in an emergency, or any human impostor with a taste for blood. In 1933, the year Hitler set himself up as an idol to be worshipped by the German masses, Schoenberg explained the episode of the golden calf in *Moses und Aron* as 'a sacrifice made by the masses, trying to break loose from a *soulless* belief'. The myth – whether set at the base of the biblical Mount of Revelation or in pagan Russia, in Mexico before Columbus or in a backyard apiary – remains an invaluable guide to modern history. The Aztec sacrifices admired by Strindberg, Bataille and D.H. Lawrence keep us cautiously aware, as Octavio Paz has said, of nature's 'radical inhumanity'. The gods shed blood to create the world. Men, alive on sufferance, have a debt to pay, and must donate their own blood to feed their hungry makers or to stoke up the sun. Put in less superstitious terms, that is the most wrenching of the twentieth century's disengagements. The world was not custom-made for us; we are in it on sufferance, and have lost the control which we once thought was ours. In the *Sacre*, a single victim sufficed to restore the balance. A generation later, humanity itself appeared to be committing suicide.

Cocteau called the ballet a prehistoric pastoral. Yet if its subject was indeed the world before man's arrival, it needed to be backdated even further. This happened in Walt Disney's *Fantasia*, released in 1940, which trimmed down Stravinsky's score and rearranged its sections to accompany – in the solemn words of the film's narrator – 'a coldly accurate realization of what scientists believe went on in the first few billion years of life on earth'. Disney's cartoon about evolutionary travails shows fish wading out of the deep onto dry land, but stops short before the emergence of *homo sapiens*. There were prudent reasons for this fade-out, which replaces Stravinsky's thundery consummation: Disney had

been warned that the film might be boycotted by Christian fundamentalists, still determined to scourge Darwin as a heretic.

But the absence of man gives this version of the *Sacre* an alarming grimness, and makes it indeed more modern than Stravinsky can have intended. (The composer later denounced the film, as he had reviled Nijinsky's choreography.) *Fantasia* begins with the world – our 'lonely, tormented planet', as the narrator calls it – seen from outer space, revolving in a vacuum. There is nothing primitive about this view: it is the alienating vantage-point of contemporary science, which has revealed to us the puniness of our position in the universe. In the water, life wriggles into being like the doodles of an abstract artist. The first marine blobs and versatile amoebae might have been drawn by Klee. At once the rudimentary creatures begin gobbling each other up. Durkheim's 'alimentary communion' is here an uglier and more urgent business, unblessed by any sacrament; it is also surely truer to the precarious, competitive strife of prehistory than Stravinsky's anthropomorphized ritual. Roerich's backgrounds for the ballet were lushly green. In *Fantasia*, the rite is red – the colour of lava gushing from the molten earth, of a scorching sun which desiccates the land and kills off the dinosaurs, and of blood.

Instead of a human sacrifice, Disney's climax is the battle between two gigantic scaly lizards with hungry mouths which flare like furnaces. The tyrannosaurus, a carnivore which had mastered the art of walking on its hind legs, batters the lazy vegetarian stegosaurus to death. But all victories on our beleaguered earth are short-lived: the dinosaurs in the next sequence expire in a drought, littering the desert with their bones. Stravinsky's myth of fertile spring seems comfortable by contrast with this torrid summer – relieved only when the earth cracks open once more, releasing a tidal wave and engendering life all over again.

There is no inevitable, triumphant ascent of man. The film's reminder that the dinosaurs became extinct introduces a terrifying modern remonstrance. This after all is one of the unsolved mysteries of evolutionary history; it haunts the twentieth century, because our recent record makes us suspect that the same thing might happen to our own supercilious species. Arthur C. Clarke's *2001* imagines a voyage to earth by galactic creatures who 'had not been men – or even remotely human'. When they arrived, the dinosaurs had already perished; taking stock of the species that remained, the visitors began to alter the ecosystem through some adroit genetic tinkering. Do we owe our dominance to their partiality? If so, we can hardly expect to retain it forever. In Lawrence's *Women in Love*, Birkin writes off humanity as 'a dead letter' and is anxious for 'a new embodiment'. He is perversely heartened by the nemesis of the dinosaurs: 'If only man was swept off the face of the earth, creation would go on so marvellously, with a new start, non-human. Man is one of the mistakes of creation – like the ichthyosauri.' *Fantasia* corrects that mistake after the event, by indefinitely delaying man's appearance. Birkin's theoretical ranting seemed only too plausible in 1942, when Schoenberg pondered the self-destructiveness of the bees.

Perhaps, he suggested, the Nazis saw themselves as 'successors of mankind'. After all, as Schoenberg reflected, the giants, dragons and dinosaurs had all 'destroyed themselves and their world'. We have no permanent entitlement. As the *Fantasia* sequence ends, the earth turns ownerlessly in space, waiting to see which species will take out the next short-term lease.

Disney made prompt amends for this alarming scenario. The *Sacre* is followed by Beethoven's *Pastoral Symphony*, set in a pastel-coloured classical paradise. Some modern icons are sentimentalized and made harmless: among the livestock in Arcadia are a pack of blue horses, more innocently frisky than Franz Marc's animals, and a flock of pink fauns with fluttering tails, cuter than Nijinsky. The episode is a rite of autumn, with a gluttonous Dionysus presiding over the harvest. Beethoven's orchestral storm quickly blows over, and an avuncular Jupiter, tired of playing practical jokes with lightning-bolts, dozes off on the downy clouds. The sun is no longer the death star which parches the earth in the previous segment; silhouetted against it, Apollo can be seen driving his chariot. The gods have been improbably restored to heaven.

A myth seeks to universalize itself, and the *Sacre* is omnipresent in time and space. A Stravinskyan reveille on the brass introduces spring in *Tapiola*, Sibelius's symphonic poem about the Finnish forests and their legendary population of demons and ogres, though it sounds more like a last judgment than a nativity. This landscape – with its filtered gloom, its storms of ice and howling winds – will not be pacified by a single sacrifice. Nevertheless, when the battery of the weather abates, *Tapiola* ends in a sudden, fortuitous modulation to the major key, as if nature had changed its mind and decided to allow us house-room. The brevity of this accord, and its belatedness, warn that we should never again presume to be in control.

Sibelius remarked that he believed in civilization – but he had his own wintry, stoical reason for doing so: 'Look at the great nations of Europe and what they have endured. No savage could have stood so much.' Civilization no longer congratulates itself on a victory over barbarism; at best it can only wonder at its capacity for endurance. The world, as the *Sacre* demonstrated, predated man, and will still be turning when he has danced himself to death.

The guilty disavowal of modernism began with an inquest on spring. Was it a holy time of renewal after all? Could the wreckage it left behind be blamed on the exuberance of nature? In *The Magic Mountain*, Hans Castorp questions the fiction of chronology, which arbitrarily divides up duration and decides that the start of a season or a century must be occasions for rejoicing and for making resolutions. He sees the segmentation of the year as a practical joke. Spring, he quite logically insists, actually starts at the beginning of winter, because that is when the days slowly lengthen. In fact we are being 'led about in a circle', encouraged to fix our eyes 'on something that turns out to be a moving point. A moving point in a circle.' This is another way of expressing that axiom of

political disillusion which taunts us as we reconsider our century with all its promised and postponed futures. A revolution goes round in a circle; reactionary retreat is part of the process. Castorp describes midsummer madness as a recognition of time's absurdity. Primitive people celebrated the solstice with revels and public abandon. We call the same rites summer holidays, costuming ourselves in lurid shirts and worshipping the sun. The 'tragic joy' of the season pays tribute, Castorp believes, 'to the madness of the circle, to an eternity without duration, in which everything recurs – in sheer despair'. If time, modern or ancient, is simply a repetitive cycle, then our only remedy is to arrest it: to reject futures which always turn out to be the past in disguise. If nothing ever changes, modernity need never have happened.

Hofmannsthal, extracting his own version of *Elektra* from Aeschylus's trilogy about the blood-feud in the house of Atreus, prevented the tragedy from reaching a satisfactory resolution. In the last instalment of the original *Oresteia*, Athena spares Orestes, calls off the Furies who persecute him, and founds a city named after herself, where justice can be socially administered, not entrusted to avengers. Such appeasement was irrelevant to Hofmannsthal: modern men longed for release from the constraints of civilization, and had no interest in recalling the covenant which founded it. When the revenge is accomplished, Hofmannsthal's Elektra, like Stravinsky's sacrificial virgin, collapses during her victory dance. But after civilization had actually, rather than wishfully, torn itself apart, that experimentation with the apocalypse seemed unpardonable. Paul Claudel therefore made his own translation of the *Oresteia*, ensuring that it reached its conciliatory conclusion. The Furies, commanded to be merciful, turn into the kindly ones, 'les Bienveillantes', and the Athenians vote to acquit Orestes. Between 1917 and 1922 Milhaud composed a score for Claudel's *Les Euménides*, which ends with 'the progressive advent of light and joy', democratically celebrated by fishmongers and vegetable sellers around the Piraeus harbour while the 'immense Latin sky' canopies their heads. Neoclassicism attempted to patch up the universe which had been damaged, perhaps beyond repair, by those reckless modern interrogations. When Strauss returned to Greek mythology in later operas – *Ariadne auf Naxos*, *Die ägyptische Helena*, *Daphne* – he emphasized the exploratory loves of the Olympian gods, not the divine frenzy which turns Elektra into a maenad.

Like Stravinsky, who indignantly denied that he was ever a revolutionary, Hindemith repudiated his own youthful modernism. A point of no return, like the pause in *Elektra*, arrives half-way through his miniature opera *Hin und zurück*, first performed in 1927. At this impasse, Hindemith stops time, then turns it back on itself. The piece begins with a sneeze, followed – just before the crucial mid-point – by a gunshot, when a cuckolded husband kills his unfaithful wife: two irrevocable acts, expenditures of energy which can never be recalled. But Hindemith grants music a magical power to change the course of time's arrow. After the hiatus, the dead woman is brought back to life, and the music and words

repeat themselves in reverse order, punctually arriving at a happy ending which is signalled by a repetition of the sneeze.

This miracle is a cheeky conjuring feat; a decade later, when he published his treatise on musical composition, Hindemith had come to believe that music actually possessed the power to decelerate time's rush towards destruction and to undo the entropic decline of history. He reasserted the architectural function of tonality, destroyed by Schoenberg. In the treatise he suggested that, for Pythagoras and the Greek inventors of music, tonal intervals evoked 'the first days of creation and of the world: mysterious as Number, of the same stuff as the basic concepts of time and space'. The overtone series made up the very 'building stones of the universe,...so that measure, music and the cosmos inseparably merged'. That universe had been rescued – or so Hindemith piously hoped – from Hans Castorp's suspicion that time and space were leading us round in giddy circles. The return to musical orthodoxy implied a recovery of religious faith. *Nobilissima Visione*, Hindemith's 1938 ballet about Saint Francis of Assisi, ends with a passacaglia praising creation: the strict formal procedures of music extol the orderliness of God's handiwork.

Stravinsky in 1934 described his own harmonizing mission in similar terms. 'The phenomenon of music', he argued, 'is given to us with the sole purpose of establishing an order in things.' It enabled man – who is rendered helpless by 'the imperfection of his nature' – to make peace with time, the dimension of existence which mocks his pretensions and soon relegates him to oblivion. We are time's victims, impatiently hustled from the past into the future, denied the chance 'to give substance, and therefore stability, to the category of the present'. Music offers us salvation. Compelling us to concentrate on each separate instant, it makes the moment audible, and reconciles us to the gradual, irresistible process of change. Stravinsky's heroes are tragic fools whose overreaching impatience – the motive, as Spengler saw it, of modern, Faustian man, who is doomed when he sits still – causes them to misunderstand time. The soldier in *L'Histoire du soldat* forfeits his right to the present: the three days specified in his contract with the devil are sneakily elongated to three years, so that his village neighbours forget who he is and his fiancée marries someone else. Oedipus, consulting the oracle, receives a prediction about something that has already happened. Tom Rakewell in *The Rake's Progress* buys a future of instantly gratified wishes at the cost of his soul. There is a political moral in Stravinsky's account of his own art, and in these cautionary downfalls. Because music shows us how to detain and relish the present, we are less likely to be misled by the blandishments of the revolutionaries – or, in *L'Histoire du soldat* and *The Rake's Progress*, the devils – who promise us the future. Hindemith thought that music might buttress the tottering universe; Stravinsky, more pragmatic and more sceptical, wished merely that it might stabilize an infirm society.

Although Stravinsky called music 'the sole domain in which man realizes the present', his own music increasingly concentrated on realizing the past. He

jauntily exhumed Pergolesi's tunes in *Pulcinella*, and chose Latin for *Oedipus Rex* because it was a language fixed in rigor mortis. His ballet *Perséphone*, composed in 1933–4, celebrated the rite of spring once more, in the doleful awareness that renewal is temporary. Perséphone, the goddess of spring, knows it to be a tragic season. Nature is annually reborn; human beings are permitted only one circuit. Rather than surrendering to crazed exhilaration like the heroine of the *Sacre*, she commiserates with the multitudes imprisoned beneath the burgeoning, indifferently fertile earth. She therefore divides her year between the shining fields and the dim, wintry underworld. Her decision rebukes the modernists for ignoring our benighted ancestors. Neoclassicism, rather than denying the past, defers to its authority, and fondly looks forward to joining the ranks of the dead. As a character in Jean Giraudoux's play *Intermezzo* puts it, 'When my turn comes, I shall make a perfect ghost'. Lawrence passed his own judgment on this classical necrophilia in *Women in Love*. The bloodless rationalist Gerald Crich freezes to death, fading into the 'glamorous whiteness' of the mortifying ice.

Satie in *Socrate* – a recitation coolly narrating the suicide of the philosopher, first performed in 1918 – sought to whiten music, to rid it of murky emotion just as his exemplary death transforms Socrates into a bleached, imperturbable statue. Stravinsky longed to compose what he called a 'white ballet', which would be 'the perfect expression of the Apollonian principle', with sylphs or animated statues as its dancers. Apollo himself is the protagonist in Stravinsky's ballet *Apollon musagète*, and he rigidly upholds the classical virtues of restraint and composure. The expressive fury which was the prerogative of modern man – Hermann Bahr's 'single scream of distress' – is now disallowed. Apollo gives a mask to Polyhymnia, the muse of mime. Its purpose is to anaesthetize the face, to nullify feeling, rather than to voice the anguish or terror which are painted on Picasso's African masks; when Polyhymnia discards it in order to speak, Apollo dismisses her. He chooses Terpsichore as his partner, because the muse of dance remains obligingly silent.

In André Gide's narration for *Perséphone*, the shades insist that they are not unhappy. Perpetually beginning again the pursuits broken off when they died, they move in that pointless circle which for Castorp was the shape of time. But they do not protest against the strict choreography of eternity. They have no emotions left to express; they are serene because they have outgrown hope. This was perhaps why the classical gods made a comeback in the two decades between world wars. Once the Christian God had been expelled, these were the only plausible deities. Goaded by vices which they shared with their human subjects, they made no pretence to moral superiority. They also inhabited a world which was finite, and therefore capable of being destroyed; the theories of modern science and the events of modern history confirmed that warning.

Classical stories had a doomed determinism. However often they had been told, however ingeniously they might have been adapted, their outcome was mandatory. In 1929 the title of Giraudoux's play *Amphitryon 38* wittily

acknowledged the lateness of the day and the world-weariness of the archetypes, who have already performed this comedy of sexual permutation at least thirty-seven times before. The myths, like the oracle in *Oedipus Rex*, described fates which were inescapable. In 1935 in Giraudoux's *La guerre de Troie n'aura pas lieu*, negotiators bargained and intrigued to forestall the Trojan war, which had not yet taken place and did not need to – except that, because the myth foreknows everything, it inevitably did.

Durkheim in his sociology of religion lamented the exhaustion of the gods. The present, he said in 1912, was a time of moral mediocrity; he wondered when and how society would regain its mythopoeic powers and enjoy another period of 'creative effervescence' like that of the tribal cultures he studied. It happened soon enough. Fascism was atavistic politics, and Hitler modelled himself on Wagner's Wotan, who looks ahead with elation to the imminent end of the world. Resistance required the support of another pantheon. During the German occupation of France, Simone Weil found a guide to current calamities in the *Iliad*, 'the poem of force' which exposed the playful malice of the gods; in 1943 Sartre's *Les Mouches* represented the invaders as a plague of parasitical flies, feeding on the blood of Orestes.

After the war, the myth-making was done by popular culture, which draws from the pool of our collective, secretly collusive fantasies. On holiday in Greece in 1952, Cocteau praised the Olympian gods, whom he called 'the living paintings of a *ceiling*'. Heaven had become a decorated dome, with fluffy artificial clouds. Anyone was eligible for immortalization – a dictator's consort, festooned with jewels for her visits to the slums, or a thief and murderer who cheekily described himself as a holy sinner. Cocteau nominated Hubris, 'the personification of Excess and Insolence', as 'the reigning goddess of 1952', and remarked in August that 'Eva Perón's canonisation by the Pope and Genet's by Sartre (another pope) are the two mystical events of this summer'. A god for Cocteau was a 'monstre sacré': a monster sanctified by the stylish extravagance of his or her behaviour.

By the time Cocteau noticed these latest promotions, the Olympians had migrated. Cecil Beaton, visiting Hollywood during the 1930s, observed with relish that 'Apollos and Venuses are everywhere. It is as if the whole race of gods had come to California.' This, in fact, was the wishful premise of two Hollywood musicals. In *Down to Earth* (1947) Rita Hayworth as Terpsichore delevitates in a huff to protest against a Broadway show which travesties the muses as jiving 'hot goddesses'. Eventually she begs permission to stay on earth, because 'people have more fun' and Coca-Cola is not available on Parnassus. In *One Touch of Venus* (1948) Ava Gardner steps down from her pedestal in an art gallery and falls in love with a lowly department-store window dresser. Summoned back to the skies, she leaves behind a living replica of herself, happy to work as a sales assistant. This Venus has admirably democratic motives; more often, Hollywood selected a shop assistant or an usherette or a girl at a soda-fountain and, after a change of

name and a cosmetic make-over, turned her into a love goddess. Film-makers magnified and mystified ordinary faces, projecting them onto a screen as large as the sky. What was this if not the creation of deities? In 1956 Jean Renoir's *Eléna et les hommes* presented Ingrid Bergman as another incarnation of Venus. Cocteau remarked that Marlene Dietrich stepped 'straight into myth,...fully armed from head to foot', riding astride the chair which she mounts in *The Blue Angel*, and Greta Garbo made herself mythical simply by the way she imperiously displaced air as she strode through the lobby at the end of *Grand Hotel*.

An age without gods cannot help being idolatrous. The mass media, as Cocteau pointed out, therefore manufacture 'instant myths' for our consumption, 'inventing people who already exist and endowing them with an imaginary life': a grab-bag of film stars and supermodels, murderers and property developers, corrupt politicians and disgraced television evangelists. Durkheim argued that 'there are rites without gods, and even rites from which gods are derived'. In 1912 this was a shocking, atheistic idea. At the end of the twentieth century, we take it for granted: those rites are known as publicity, and the beings they conjure out of nowhere are celebrities. 'Gods', as Elizabeth Taylor shrills in *Cleopatra*, attacking the democratic scruples of the Roman senate, 'are not elected!' God may or may not have created woman, but Roger Vadim invented Brigitte Bardot. Cocteau dreamed up a heavenly provenance for the designer Christian Dior. His surname, Cocteau insisted, amalgamated god and gold, 'dieu' and 'or'.

The short life and abrupt death of Diana, Princess of Wales is a parable of the process. She began with the advantage of aristocratic birth, to which she added a royal title; but she exchanged these guaranteed prerogatives for the more volatile, fickle fame bestowed by tabloid newspapers and glossy magazines. She enticed and allured the photographers who pursued her, and whispered her secrets to journalists. Using these intermediaries, she spurned the class society to which her status had assigned her, and appealed directly to the anonymous masses. It was a dangerous bargain. She replaced the deference and respect she could have enjoyed if she had remained regally inaccessible with an adulation which cherished her for her flaws and her traumas – her bulimia, her suicide attempts, her bad choice of lovers. The contract required her public destruction, and the paparazzi were present to photograph her body in the mangled car. Mobs deposited flowers, teddy bears and amateurish poems outside the gates of Kensington Palace, and applauded her coffin, as if she had died to entertain them. Like the revisions of myth by Sartre or Giraudoux, Diana's story ironically altered a Greek precedent. As her brother remarked at her funeral, 'a girl given the name of the ancient goddess of hunting was the most hunted person of the modern age'.

The myth still demands sacrifice. Idols are discarded when they lose their looks or their bankability, but Diana's self-destructiveness ensured that she avoided this relegation. She died young, and was instantly immortalized. The facts ceased to matter. The socialite killed in a limo with a playboy, after shopping

for jewellery and Parisian real estate, turned into 'the people's princess', mourned by what her brother called a 'constituency of the rejected'. On Olympus, she became interchangeable with her fellow deities, and Elton John altered a dirge he had written about Marilyn Monroe to fit her, prophesying that Diana's 'footsteps will always fall here along England's greenest hills'.

In exceptional cases, resurrection is possible. The supermarket tabloids have exhumed Elvis Presley, and kept him alive with sightings at Burger King and testimony from posthumous girl friends. He has wandered back to the beginning of time, and projected himself into outer space. One tabloid published a photograph of a caveman reconstructed by scientists, who turns out to be a 'prehistoric Presley' with brilliantined hair and a costume of pelts, not sequins. Another claimed that Russian explorers had found a statue of him on Mars, booming 'All Shook Up'; the extra-terrestrials worshipped him as a deity. The myth of vernal renewal which inaugurated our century now seems tired and elderly. But mythology itself retains its power over us, and its most blatant fictions tell the truth about our desires and about needs which, for want of a better word, we have to call spiritual.

THE NEW INHUMANITY

Modern times, accepting the prospectus of technical innovation, presented human beings with an ultimatum: change, or trudge off to extinction like the dinosaurs. Did character voluntarily alter on that spurious date in December 1910, or was it being fractured, relativized, like the faces of Picasso's subjects? The hero of Virginia Woolf's novel *Jacob's Room* is a modern man, consisting of facets or fractional viewpoints, parts which no longer constitute a whole. When he dies, prematurely and pointlessly, in a war which seemed to Mondrian to be the death sentence of individuality itself, all that remains of him is the objects in his room and a pair of empty boots. The loss, factored into the cosmic total, is perhaps not great. Mondrian himself observed that 'in the great epochs of style, the "person" disappeared'.

The fabled human spirit dwindled to a ghost, a breath of wind. The rest of man, the bodily kit, hardly qualified as an efficient machine. The futurists Balla and Depero announced in 1915 the advent of a 'metallic animal', a new creature which could speak, shout and dance automatically. They promised to construct millions of these in preparation for 'the vastest war'. The wars between flabby earthlings and steely Martians or cerebral moon-men in Wells's science fiction dramatized this evolutionary panic. The world we had made no longer reflected our own image, or suited our dimensions. A skyscraper, as Musil pointed out, is a good deal taller than a man on horseback. Ulrich in *The Man Without Qualities* abandons the cavalry for a more contemporary profession. He enrols in a civil engineering course, but the whirring turbines and busy pistons reinforce his sense of estrangement and convince him that our soft, misty, moralized universe, which supposedly vibrates in unison with human feeling, is a lie. The engineer sees the truth: 'the world is simply ridiculous if one looks at it from the technical point of view.'

Considered as technology, the human being is also a botched job. Freud and Breuer, investigating hysteria, detected faults in our wiring. Wells planned a radical overhaul. He conceded that we could not do without a brain and a pair of

hands, but thought that the rest – all those looped tubes and messy pipes, those embarrassing extremities with their inconvenient appetites – might well be jettisoned. With these adjustments, men could perhaps catch up with their machines. From here, an argument begins which has continued throughout the twentieth century. How protective should we feel about our flawed, middling humanity? Should we not recognize that our current design is a compromise, and accept its obsolescence? Léger was pleased to have scrapped the old model in his designs for *La Création du monde*, which encased the dancers in abstract armour. 'Man', Léger announced, 'becomes a mechanism like everything else; instead of being the end, as he formerly was, he is now the means.' In 1923 this counted as an achievement – an advance beyond humanism and smug anthropomorphic sentiment. It is a measure of the moral history of our century that Léger's proclamation now sounds more like a threat than a promise.

The constructivist El Lissitzky rallied the artists of revolutionary Russia to take up the ruler and compass, emulating engineers. For their first project, they redesigned humanity. In 1920–1 Lissitzky sketched a prototype for an improved species. His 'New Man' is a geometer, with legs and arms extended like the points of two intersecting compasses, which enable him to bestride the earth. A man, aided by those calipers, is a constructive force; Lissitzky's model has already reconstructed his soft, padded, lazy body, reducing it to efficient

El Lissitzky
New Man
(1920–1)

angles. His brain is ideologically programmed: his eyes are stars, the symbols of ignition and electrification in the Soviet Union, one black and the other red. Lissitzky's colleague Toporkov encouraged Russian workers 'to regard the machine not statically, but dynamically'. A machine, after all, has moving parts; it is alive – more indefatigably so, perhaps, than its human operator. Toporkov approved of drivers who gave their steam-engines nicknames, since man's comradely friendship with the machine would increase production.

Moholy-Nagy, writing about 'Constructivism and the Proletariat' in 1922, implied that engineering had replaced the inspiriting creative force personified by God in Genesis. The machine, he claimed, had disturbed forever the peasant's mental sloth. Once switched on, it awoke the proletariat to the recognition that

'This is our century – technology, machine, socialism'. That mental enlighten-
ment occurred because the man who operates a machine spends his day contem-
plating a demiurge. The dairy farmers in Eisenstein's *The General Line* worship
their centrifuge, and gape at the cosmological wonders it performs, spraying the
sky with creamy galaxies as it churns their butter. They witness the remaking of
the milky way.

But the god who inhabited the machine was not necessarily benign; he
might turn out to be as jealous and vindictive as the one who persecuted man
from his superior vantage point in heaven, or as hungry as those primitive gods
who lived in the earth. Toporkov believed that machines could be befriended. Yet
since they possess a power surpassing that of men, why should they acquiesce
in servitude? Once again, as so often in the twentieth century, the encounter
between the past and the future, between our old, irrational human nature and
what Musil called the psycho-technical skills of the new world, created a prob-
lem. Men were less ready to be motorized than Lissitzky and Moholy-Nagy
hoped.

Wells recognized the contradiction in his story 'Lord of the Dynamos',
written in 1894. In south London, the turbines which keep the electric railway in
business are overseen by an engineer who 'doubted the existence of the deity, but
accepted Carnot's cycle'. (Carnot was the French physicist who first recognized
the motive force of heat, and showed how it might be mechanically harnessed.)
For the atheistic engineer, the dynamo has replaced God; but for his Asian assis-
tant Azuma-zi – nicknamed Pooh-Bah by his boss, who accuses him of possess-
ing a 'nigger mind' and an appearance 'beyond ethnology' – the dynamo is a
god, serener and more potent 'than the Buddhas he had seen at Rangoon, and
yet not motionless, but living!' Lost in London where 'the people...hid their
gods' and homesick for his native idols, Azuma-zi touches the spinning coils ten-
derly. Eventually, to demonstrate his piety, he feeds the engineer into this maw,
then electrocutes himself when another live offering, the so-called 'scientific
manager', fights him off. This brings to an end 'the Worship of the Dynamo
Deity, perhaps the most short-lived of all religions'..But despite its brevity, Wells
notes that it has accumulated the credentials proper to a religion, 'a Martyrdom
and a Human Sacrifice'.

Of course the cult was not so short-lived, and the sacrifices never stopped
accumulating. The victim in Kafka's story about the penal settlement is punc-
tured, mashed and mutilated by a writing machine which tattoos the moral com-
mandment he has broken into his body. More whimsically, during the 1930s the
cartoonist Rube Goldberg dreamed up a series of gimcrack contraptions which
circuitously torment their users. A home tooth-puller, for instance, allowed you
to be your own dentist. Anaesthetics were disallowed: the patient in Goldberg's
drawing, having tied himself down, tickles a bird which mixes a cocktail which
makes a squirrel drunk which causes a gramophone record to play which annoys
a dwarf, whose rising temperature then lights the fuse of a cannon which fires a

ball which yanks a string – thus, at long last, ripping a tooth from the mad profes-sor's mouth. Goldberg laughed at the futility of machines, but the elaborate chain reactions he set up showed how our ingenuity, escaping from control, can return to torture us. Perhaps the machines which we yoked into service were all the time driving us, pressing us beyond our capacities and negligently discarding us when we broke down.

In 1810, the year before he committed suicide, the dramatist Heinrich von Kleist wrote a brief essay on marionettes, which described puppets performing a bur-lesque in the market-place. Hofmannsthal in 1922 acclaimed Kleist's parable as the profoundest philosophic commentary on man's nature since Plato. The over-statement was intentional, and it served to emphasize Kleist's treason against a long tradition of humanist reverence. Plato established the classical image of man, recognizing the antagonism between soul and body but treating the soul as the body's better half, its noble and eternal component. Kleist's study of the marionettes enabled him to take that image apart. Soul and body remain mis-matched, but for Kleist the soul was an intruder, afflicting the body with self-awareness.

The damage to human self-esteem between 1810 and 1922 confirmed Kleist's parable. The secular religions named after Marx and Freud assume that our behaviour is determined, prompted by economic interest or sexual compul-sion. In modern times, man is at best a mannequin. The hero of Wells's *In The Days of the Comet* looked back in 1906 at his narrow-minded, vindictive temper before the comet reformed the world and made men altruistic. He imagines his unreconstructed self as a 'little dark creature…about an inch high', and goes on to dismiss 'all that previous life of ours', when the puppets were jerkily animated by greed or lust, as 'an ill-lit marionette show'. Dalí in 1931 described the surreal-ists as 'highly developed automatic puppets, such as men now risk becoming'. Since the body was an apparatus going through predetermined motions, why shouldn't the imagination be allowed the same liberty? Therefore the surrealists, collaborating on those nonsensical collective creations which they called their 'exquisite corpses', wrote or painted according to the blissful automatic whim of the unconscious mind.

Kleist's essay transcribes a conversation with a dancer who, having seen the marionettes gyrate through their skits, declares that he prefers them to his flesh-and-blood colleagues. They do not aspire to think, and are incapable of feeling; their limbs are 'lifeless, pure pendulums', automatically obeying gravity. They are spared the curse of consciousness, which has lamed and disabled us ever since Adam and Eve ate the apple. 'Grace', Kleist's friend tells him, 'is purest when there is either no consciousness or an infinite consciousness: either the puppet or the god.' Kleist wonders if we could regain paradise by eating the forbidden fruit a second time. His friend solemnly advises that this would be 'the final chapter in the history of the world'.

By 1922 that final chapter had apparently been written. Kleist's essay accordingly became, in ways he could never have anticipated, a treatise on the predicament of modern man – economically besieged and spiritually deflated, warned by the moralists of collectivism that his individuality was a relic of the selfish past, wanting (as Mondrian said in 1919) to 'turn away from natural things' towards an existence that was 'becoming more and more abstract', yet still vexed by an inconvenient, querulous soul.

This was a crucial and extraordinary moment in the psychological history of mankind. Humanity itself, like the universe, underwent interrogation; men pronounced a sentence of death on their own inferior species. Because the theatre is a laboratory in which we examine our own nature and test its limits, the inquisition began there. In 1907 the director and designer Edward Gordon Craig elaborated a theory of acting which contained a prescription for the new kind of being. 'The actor must go,' Craig decreed, 'and in his place comes the inanimate figure.' Adding a superlative prefix in homage to Nietzsche, he called this creature the Über-marionette, and supplied a definition using oddly industrial imagery. His 'divine puppet' was 'the actor plus fire, minus egoism: the fire of the gods and demons, without the smoke and steam of mortality'. The smoke and steam were the huffing and puffing of personal emotion; Craig wanted instead a body which – like the face when covered by a tribal mask – could depict emotions belonging to no one in particular. In 1905 he commissioned Isadora Duncan to find him some wooden dolls with articulated limbs in Brussels. He preferred bodies which no longer seemed mortal, clothed 'with a death-like beauty'. Artaud, who took up this necrophiliac notion, explained it a little more lucidly in his theory of the actor 'as a Double, as the Ka of Egyptian mummies, as a perpetual spectre'.

Craig and Artaud developed a modern fantasy, dreamed up at a time when men had the scientific means to make themselves redundant. The Über-marionette and the Double were technological incubi, dead things which had been rigged to simulate life. The 'higher, controlled life', as Artaud called it, of 'the stiff, stilted artist' was an experiment in robotics. The inventor Rotwang in Lang's *Metropolis* creates a mechanical plaything, a woman with glazed, bloodless skin and crystalline bones, whose face is as yet, according to Thea von Harbou's script, a lump of inchoate matter. One of his nicknames for her is Futura; another – because she can simulate the chastity of a Gothic madonna or the wiles of an Asian dancer – is Parody. In *2001*, Arthur C. Clarke paraphrases Kleist's formulation when he describes the symbiosis between man and machine. People are now kept alive, Clarke points out, with the aid of artificial organs. Soon the brain might be replaced by an electronic intelligence. After that, mind would be free to cast off its partnership with matter. The robot is a stage on the advance towards 'something which, long ago, men had called "spirit"'. Then, looking further ahead, Clarke virtually (and no doubt inadvertently) quotes from Kleist: 'if there was anything beyond *that*, its name could only be God'.

Fritz Lang's Metropolis *(1926): Rotwang (Rudolf Klein-Rogge) with Maria (Brigitte Helm) and her robotic double*

This last evolutionary push began when Isadora Duncan discovered her solar plexus, the engine from which all movement derived. In her dances she was like a self-manipulating marionette: she stimulated that vital centre with its network of nerves as the puppeteer does by pulling on the wire or thread, and made her limbs respond to these internal commands. It was as if her body thought for itself, without needing to translate messages relayed from the brain. The critic Arthur Symons described the dancer in 1898 as an icon of modern liberation. He called the dance 'life, animal life, having its own way passionately'. Isadora performed barefoot, and in loose Grecian tunics; she helped to release women from their stifling enclosure in nineteenth-century clothes. But Symons emphasized the intellectuality of the art, as well as its instinctive wantonness: 'the abstract thinker, to whom the question of practical morality is indifferent, has always loved dancing, as naturally as the moralist has hated it'.

Dance is abstract because it treats the body as pure form. It is a mode of thought because it uses that body as the soft, raw material for sketching geometrical theorems. It taught the new woman and her male partner a revolutionary lesson – how to use the body as a vehicle, rather than suffering it as an encumbrance. Peter Altenberg became infatuated with the dancer Grete Wiesenthal, and in 1915 wrote to her with earnest recommendations about a proper diet and efficient purgatives, recommending menthol rubs and arm exercises to be performed while she listened to a military band: 'Forward! Get a move on! Precise! Like the clatter of machine guns, rat-ta-tat!' This romance of locomotion had its dangers, and it proved fatal to Isadora. She favoured long scarves – free-flapping pennants, tokens of aerodynamism. In 1927 one of these twined around the wheel of an open car in which she was riding, and strangled her.

Loïe Fuller, Isadora's precursor, devised dances in which, with the aid of fluttering veils and flickering artificial light, she seemed to dematerialize. 'Yes', as

the She-Ancient sagely nods in Shaw's *Back to Methuselah*, awaiting the next stage of evolution, 'this body is the last doll to be discarded' – a toy we play games with, to be thrown away when we learn how to live cerebrally. Fuller called herself 'an instrument of light', and consulted scientists who might help her to transmit herself through the air like electricity. She questioned Edison about phosphorescence, studied the researches of the Curies into radium, made experiments of her own with fluorescent salts, and called one of her routines 'La Danse ultra violette'. The Italian futurists paid tribute to her 'Danse serpentine': Balla sculpted in tensile, jangling wire the lines of force which her body left behind, and Severini painted her as an aeroplane propeller, rotating so fast that it becomes invisible while stirring up a vortex of turbulence. Along with the pseudo-science, there was a visionary ambition in Fuller's antics. An industrial society employs the body as an internal combustion engine, a biomechanism. Why not drive it as hard and fast as possible, goading it to match the speed of thought? The new physics supposedly abolished space; there ought to be a way out of that spatial prison we carry around with us, our physique.

In Soviet Russia, the divine puppet became a piece of ideological gadgetry, preternaturally efficient and productive. Theorists of 'industrial gesticulation' adopted a choreographic approach to the industrial assembly line, studying the kinetic skills of workers and quantifying the energy consumed by the repetitive movements they performed. A troupe of gymnasts called the Blue Blouses proselytized in factories, using their bodies as a collective Meccano. In a lecture on biomechanics delivered in 1922, Meyerhold insisted that actors should learn from blacksmiths, cobblers and foundry-workers how to train reflexes, conserve force and – like Kleist's marionettes – keep the centre of gravity correctly positioned. Meyerhold envisaged a 'new man who is capable of any form of labour', and declared that in the regained paradise of Russia there was no longer a difference between organism and engineering, or labour and leisure: 'a skilled worker at work invariably reminds one of a dancer.'

The Bauhaus had its own techniques for arriving at Utopia. As in Russia, the purpose was to augment and if possible surpass humanity by constructing the divine puppet. Mondrian believed that his pictorial style, which he called abstract plasticism, satisfied our deep longing to outgrow the quarrelsome, wasteful disparities of individual existence. 'Man adheres', he thought, 'only to what is universal'; his angular polychrome grids were maps of a heaven and earth laid out at orderly right angles. The theatrical experiments of Schlemmer put this mysticism to the test, playfully trying out ways in which the individual might be universalized. Opening out the flat surfaces of Mondrian, allowing the rectangles to clad themselves in flesh, Schlemmer advanced to what he called 'the fully plastic art of the human body'.

The theatre's purpose was to transfigure the body, and Schlemmer's diagrams illustrating man's manoeuvrability in space signalled a drastic refiguration of the human image. Schlemmer conceded that a man was 'a being of flesh and

blood, mind and emotion'. But, more importantly, a man was also 'a remarkably well-functioning apparatus of joints'. He could be simplified into cubic blocks, and turned into architecture on legs. Or you could inspect the functions of those slotted parts, fitting together in greased sockets and made flexible by muscles. Looked at in this way, a man was a larger replica of the jointed dolls for children manufactured in the Bauhaus workshops. If you watched the body's swivelling motions, another aspect of its identity became clear: it was a technical appliance. By cataloguing our vocabulary of gestures, Schlemmer reached the frontier where physical limits were metaphysically overcome. Loïe Fuller achieved that result with breezy veils and vaporous tricks of light; Schlemmer less excitably pointed out that the body is a cryptic set of symbols. The hand spreads its fingers into a star, the shoulders and backbone form a crucifix, our folded arms write an alpha sign. We conceal mysteries inside ourselves; in expressing them – by moving any of our limbs, or by dancing – we mime our escape from 'physical bondage'. Schlemmer welcomed any invention which amplified the body and extended its capacities. As props he employed medical prostheses and the protective gear of deep-sea divers. Like Cocteau, who cast a pair of loudspeakers as a Greek chorus in *Les mariés de la Tour Eiffel*, he thought that the megaphone could make a man monumental. Technology was the evolutionary ladder which enabled the puppet to attain the powers of a god.

Bauhaus dances showed the world in the process of being abstracted. For the *Mechanical Ballet* in 1923, volunteers disappeared inside portable constructions of cardboard, wire, canvas and wood, performing a geometrical playlet in which squares, circles and triangles cavorted together: the building blocks of a potential universe, rearranged inside the brain of some cogitating creator. Schlemmer's *The Triadic Ballet* put a set of figurines – adapted to resemble the basic forms of ball, cube and pyramid – through their paces. The dancers wore bulky padding to make their bodies globular, or stiff papier-mâché painted like metal to turn them into machines. Choreography was for Schlemmer an exercise in thinking cubically. He had to combine the plane geometry of the floor, ruled into squares like a chess board, with the solid geometry of the bodies moving across it. He did so by juggling height, depth and breadth, which are the triple aspects of space; he learned about such triangulations, he explained, while using aerial photographs to make maps during the war. This apprenticeship in the surveying unit taught him, incidentally, about another spatial quirk which made the earth different in the twentieth century: its so-called surface, he discovered, was no such thing. A surface is a byword for superficiality. Like the ridges and crenellations and bumpy planes of a collage by Picasso or Braque, the terrain which Schlemmer had to flatten onto his charts always jutted into a third dimension.

The triad possessed a mystical significance for him. The number three advanced beyond the solipsism of the romantics, who divided the world into single entities, minds on desert islands, and saw love, like that of Wagner's Tristan and Isolde, as a frustrated attempt to make one plus one add up to two. Three

jumped to the next stage: 'egotistic one and dualistic contrast are transcended, giving way to the collective'. That, reduced to simple arithmetic, was the formula for creating the post-war world. It had also been the logic of the new physics. Einstein was grateful to science, he said, because it freed him from the illusoriness of 'I' and 'we', allowing him to concentrate on what he called the 'it' – the impersonal laws which governed nature.

Hindemith's musical score for *The Triadic Ballet* contained its own premonition of this future, when human beings, whose competing wills had caused the damage, would have merged with the mass or adhered to the universal: it was entrusted to a player-piano, because the mechanical instrument would not stray off into 'spiritual and dramatic exuberance'. The dancers were like dolls; the tunes to which they moved were churned out by a music-box. Schlemmer wished that people could be tempered and co-ordinated like the piano's wires, drilled into acquiescence. He admitted in 1926 that the ballet should really have been performed by puppets, moved on strings like the piano's keys, or by remote-controlled automata like the overwound doll Olympia in E.T.A. Hoffmann's story; he would then have attained the 'infinite consciousness' which Kleist looked forward to in his essay on the marionettes. He later collaborated with the conductor Hermann Scherchen on a version of Stravinsky's *Les Noces* which banished people and their bothersome emotions. Now the marriage was to be a union of disembodied shapes and lights, performed by 'continuous colour projections'. Schlemmer was glad to be spared 'the complications of pantomime performed by human actors'.

In 1930 he returned in his diary to 'the issue of the figural', by which he meant the human being's stubborn refusal, both in art and life, to wither away. He pleaded that the most heroic images of man were 'doll-like', and pointed to the statuary of Egypt and Greece or the impassive monoliths in Seurat's paintings. Why should men refuse to be 'purified in the crucible of abstraction'? In the end, they would have no choice. The world could only be modernized if the human race accepted its own imminent extinction. 'The way to style', Schlemmer insisted, 'leads via the doll!'

Salome and Elektra in Strauss's operas had already set out on Schlemmer's way to the future, which actually travelled back to the past. Although they spend most of their time singing, they reveal themselves most intimately when they fall silent and allow their bodies to speak. Salome seduces Herod by removing her veils, Elektra dances herself to death in a sated frenzy. Both of them return the theatre to its primitive source – a dumb show which, as Arthur Symons said, 'apes the primal forces of nature, and is inarticulate, as they are'. Hermann Broch analysed this development in his study of Hofmannsthal, and deplored its assault on human faculties which we had acquired after such long effort. He noted the decline from the grand operas of Wagner, so noisily vocal, to the wordless theatre of modernism, represented by *Le Sacre du printemps* or the *Josephslegende* of Strauss and Hofmannsthal. He understood why works like these had to do without

language. They dealt with primitive human feelings, which are expressed by the whole body and not spoken by the loquacious, civilized head; they must therefore be populated by 'mutely gesticulating figures, ultimately marionettes'.

Broch added that with the advent of Isadora, 'modern ballet was born, a sibling to modern painting'. In partnership, these twin arts conspired to do away with language, man's supreme creation and the signature of his rationality. Hofmannsthal in his Chandos letter lamented the failure of words, and suggested that humanity might never recover from the recognition that they were empty air; but modernists quite happily renounced the power of speech, and considered themselves better off. Schlemmer approved of the embargo. In ballet, he said, the performers must be 'masked, and – especially important – silent'. Christmas festivities at the Bauhaus in 1927 included a Silent Night, which imposed the carol's title as a commandment. No one was allowed to speak, although in an emergency party-goers could purchase cards with inscriptions on them. There were economic penalties for complex statements: these written words cost a pfennig each. The WoPo or Word Police patrolled the room to ensure that no one broke the rules.

Sometimes the marionettes were animals unable to speak, like Nijinsky's faun. But they could equally well be machines, which had no need of language because they communicated by discharging electricity. The Bauhaus designer Kurt Schmidt painted a man struggling with the control panel of a monstrous engine. A factory worker in Lang's *Metropolis* loses his grip on the dials, and the apparatus explodes. Schmidt depicts a happier outcome: the worker remains seated, but spark-plugs and pistons dance around him, possessing a fizzy dynamism he cannot share. Léger, prosecuting his campaign to mechanize men, designed *Skating Rink* for the Ballets Suédois in 1923. The subject was the gyration of life itself, a rotating sexual chase performed by massed teams of men and women. Skates, like the megaphones of Cocteau and Schlemmer, were technological aids, enabling the meagre body to surpass itself: a modern equivalent to the elevated buskins of the actors in Greek tragedy. Jean Börlin played a madman, dressed by Léger in a rectangular jacket with a block-like top hat and trousers which had one leg striped, the other chequered: a figure composed of squares and straight lines, estranged from the whirling circuitry of the rink; an individual with the bars of his mental prison imprinted on his costume, baffled in his efforts to join the collective fray. *Crescendo*, choreographed by Massine in London in 1925, also summed up modernity as a geometrical dance – the treadmill of pleasure, fuelled by cocktails, jazz and the jarring conjugations of sex. A programme note explained that the purpose was to exhibit 'the angular tendencies of the time'. Ballet possessed an undeniable expertise on such matters, because in a society run by machines 'man becomes a puppet'.

In 1922 Schlemmer constructed a *Figural Cabinet* stocked with such mechamorphs. Bodies made of nickel with brass knobs pranced around, trying on heads for size. Light bulbs ignited inside their eyes, and their emotions could

be gauged by reading the barometers they wore. These cybernauts were operated by a crackpot technician called Spalanzani: Schlemmer borrowed the name from one of Hoffmann's characters, the supposed father of the clockwork girl Olympia. While the figures paraded, Spalanzani talked on the telephone, pondered 'the function of the functional' and – when the mechanism of the puppet show had a fit – blew his troublesome brains out. Despite this calamity, Schlemmer hailed the 'abstract spaces of the future', inhabited by 'figures in outline, not differentiated individuals'. He longed, he said, for 'translucency'. As it happens, this was already within the power of another Hoffmann demon, Dapertutto, who dispenses with his rivals by causing the light to pass through their bodies. Yesterday's black magic is tomorrow's technology.

But would men really be happier as marionettes? If so, why was a marionette like Stravinsky's Pétrouchka – stranded between wood and flesh, as his screeching bitonal cry and epileptic jerks announce – so keen to become a man? Pétrouchka has somehow grown a human heart, and languishes for love of the ballerina with whom he performs at the fair. Their colleague the blackamoor, invulnerable because he has no feelings, batters him and throws his limp body away. Pétrouchka, however, retains one privilege of the inanimate: since he was never alive, he cannot be killed, and he resurrects himself to jeer at his handler. Bartók extended this existential riddle in his ballet *The Wooden Prince*, first performed in Budapest in 1917. The prince fails to impress the princess; she falls in love instead with a stick figure he hastily improvises, even though its dancing is ungainly, accompanied in Bartók's score by a clatter of percussion and much wooden rattling, and its stiff limbs are soon out of joint. Meanwhile a fairy consoles the prince by granting him enchanted dreams. Soul and body, art and reality remain maladjusted. Stravinsky's pierrot and Bartók's scarecrow both suffer from that 'spiritual dislocation' which for Symons was the puppet's abiding ailment; pathetically aspiring to humanity or awkwardly aping it, they disassemble modern man. Technology encourages us to overreach ourselves, and therefore merely increases our discontent. We can neither return to the doll's unconsciousness nor advance to the infinite unconsciousness of the god.

The problem is briskly resolved for the manipulated hero in Stravinsky's *L'Histoire du soldat*. A soldier renounces his humanity when inducted into the army. He is drilled to assume a rigid posture, giving up the elastic liberty of the human being. His body angularly struts like clockwork. He becomes, as Canetti put it in *Crowds and Power*, a 'stereometric figure'; it was stereometry – the geometry of solid figures – which revealed to Schlemmer in *The Triadic Ballet* 'the basic laws of the human body' and enabled him to construct forms 'appropriate to our times'. A common soldier in Berg's *Wozzeck* is a tragic hero because the barked orders and institutional brutality do not succeed in mechanizing him. He loves, suffers, hallucinates, and grapples with the conundrums of the universe. But Stravinsky's soldier, comically duped by the devil, has no private life to sacrifice. Ernst Bloch saw him as a projection of the composer's own 'musical inhumanity';

his demeanour was determined by what Adorno called the 'animalized insensitivity' of Stravinsky's relentless, motorized music. The same protocol benumbs the tragedy in his *Oedipus Rex*. A narrator anticipates events so as to pre-empt our spontaneous reaction to them; masks, like military uniform, muffle emotion. What is a tragedy after all but the operation – rigorous and surgically exact, indifferent to individual pain – of an infernal machine?

Stravinsky took a sardonic pleasure in dehumanizing the performance of music. He was enthusiastic about the pianola, and wished to mechanize the cimbalon in *Ragtime*, accepting a live player only as a last resort. Piano rolls, like gramophone records, allowed him to control time: he wanted to determine the tempi of his works for future players. Though he condemned the liberties of instrumental virtuosi, he approved of Arthur Rubinstein because he had 'strong, agile, clever fingers'. He added that 'fingers are not to be despised; they are great inspirers'. They also advertised the fact that playing music was manual labour, not soulful effusion. Antheil, who gained fame as a keyboard virtuoso, said that the pianist's fingers were 'both his ammunition and his machine guns', which must be 'tempered into steel'. Relishing the hostility which his own mechanistic compositions incited, Antheil wore a gun when performing: a thirty-two calibre revolver, snugly ensconced in a silken holster underneath his arm. He claimed that once, in Budapest, when an audience was more than usually obstreperous, he took the gun out and laid it on top of the piano. A respectful silence ensued. Dissatisfied audiences in Wild West saloons sometimes shot the pianist; Antheil was the first pianist who threatened to reverse the practice.

Antheil boasted that he drove the piano 'at about a hundred miles a minute'. He could only maintain this speed if he sweated, since he needed to be 'well oiled like an engine'. Stravinsky recommended that his *Concertino* should spin along as unstoppably as a sewing-machine. On a more grandiose scale, Arthur Honegger in his symphonic poem *Pacific 231*, composed in 1923, described the fire-breathing metabolism and rhythmic equanimity of a locomotive hauling three hundred tons at a speed of 120 kilometres an hour. Cocteau saw Stravinsky – installed in a studio equipped with pianos, drums, metronomes and a battery of other gadgets for producing noise – as a pilot snugly housed in his cockpit. His instruments terrifyingly proclaimed his inhumanity. They resembled, according to Cocteau, the tentacles of an insect, its size multiplied a thousand times by cinematography as it was photographed in the act of coupling.

Technology at the end of the twentieth century is able to congratulate itself on two supernatural achievements, which unfortunately cancel each other out. Life can be engineered, with appliances performing domestic chores and standing in for workers on the industrial assembly line; biotechnology feeds us with new, improved versions of the fruit and vegetables first planted in Eden. But life can also, thanks to the technology of destruction, be comprehensively annihilated. Is the machine our humble servant, or our hypocritical enemy? Gods in

the classical theatre travelled in machines. Have they now become machines, expressly designed to cause pain? Art plays games as a way of allaying fears and learning to cope with a hostile reality; the dolls and puppets of the modernists were mental utensils, helping them to answer these terrifying questions about man, god, nature and the changed relation between them.

In 1913 in Munich Rilke saw an exhibition of Lotte Pritzel's emaciated wax dolls, immobilized as they performed ecstatic dances. These dolls, he commented, would have been wasted on children; but because adults too are still 'beginners in the world', we have not outgrown the need for such dummies. They are our desolate educators. By their refusal to reciprocate our tenderness, they force us to recognize the division between the conscious subject and the inert object, between life and death. Like Artaud in his essay on theatrical doubles, Rilke was reminded of Ka, the Egyptian spirit which allegedly survives physical death: children feed their dolls, bribing them to betray some sign of life, just as the Egyptians left provisions in their tombs for Ka. Artaud's actor makes the Ka visible. The dolls are less co-operative. Their eyes remain beady, and their dinners go undigested. They are heart-breaking things, which lack even the second-hand anima of the marionette. When children throw them away or crack open their pretty skulls, their tantrums express a legitimate rage – a complaint against the world's obtuseness and the unbridgeable isolation of souls.

After the end of his affair with Alma Mahler, Oskar Kokoschka asked Lotte Pritzel to supply him with a life-size souvenir: an Alma who would be his inalienable plaything. Pritzel refused the commission, and the doll was eventually made in Stuttgart by Hermine Moos. Kokoschka besieged her with instructions, ordering her to stuff Alma with horsehair – properly disinfected – from a gutted sofa. Her pulpier regions were to be filled with down, and her rump and breasts had to be made from squeezable wads of cotton wool. Kokoschka consulted a chemist about the skin, to see if an epidermis of silk could be treated so that it clung to the cotton wool. For flesh tones, Moos was told to use powder, fruit juice and gold dust. He begged her not to deter his questing fingers: 'Please permit my sense of touch to take pleasure in those places where layers of fat or muscle suddenly give way to a sinewy covering of skin, e.g., on the shin-bone, the patella, the ends of the shoulder-blades, collar-bone and arm.' Although, like Schlemmer, he emphasized the importance of the joints and wanted the arms and legs to swing naturally, he insisted that the doll must be supine, permanently compliant: '*The figure must not stand!*'

There was more to the episode than a desperate fetishism. It turned, like all these experiments with marionettes and mannequins, into an inquisition of what it meant to be human at a time when humanity seemed residual, soon to be outgrown like a childhood toy. The doll demonstrated how easy it was to fake life, given the proper ingredients. The creator also reserved to himself the supreme analytic pleasure of destruction. When the doll was delivered to Kokoschka in Dresden in 1919, he painted it, exercised it in his carriage, took it to the theatre,

and treated it to meals in restaurants. Eventually it was decapitated at a drunken party. The police came to call after they received reports of a headless corpse thrown from the window. Watching as it was hauled away with the rubbish, Kokoschka wistfully interred his 'dream of Eurydice's return' and remarked that 'the doll was an image of a spent love that no Pygmalion could bring to life'. The real analogy was not with the sculptor Pygmalion, whose sculpture of Galatea fulfils his ardent wish by learning to breathe, but with Hoffmann's magician Coppelius, who fabricates Olympia, fits her with glass eyes, rigs her body to flirt and flutter, and then – like the sex-killers painted by Otto Dix, in a vengeful demonstration of mastery – dismembers her.

Left over from the early nineteenth century, Hoffmann's fantasies acquired an unexpected and alarming modernity, because they dramatized these psychological and technological nightmares. Schlemmer impersonated Spalanzani, while Meyerhold adopted the pseudonym of Doctor Dapertutto, which enabled him to warn of the freakish supernatural powers unleashed in the theatre. Freud analysed Olympia the automaton, and inevitably described her as a product of the castration complex. Offenbach's opera *Les contes d'Hoffmann* – which makes Hoffmann the neurotic victim of his own creativity, infatuated with the inorganic nightingale Olympia and persecuted by evil geniuses like Dapertutto – returned

to popularity. Moholy-Nagy in 1929 designed a production of the work for the Kroll Opera in Berlin: near-naked girls disported themselves on swings during the barcarole in the Venetian episode, and the house in Munich where the sorcerer Doctor Miracle operates was decorated with clinically white, efficiently streamlined Bauhaus furniture.

In 1932 the surrealist Hans Bellmer saw Max Reinhardt's production of *Les contes d'Hoffmann* at the Grosses Schauspielhaus in Berlin. He soon began constructing his own female doll, which he obsessively photographed for the rest of the decade, curled in tousled bed sheets, strung from a tree in the woods, or hurled like refuse into a stair-well. During those same years, a series of Hollywood films brought up to date Mary Shelley's 'modern Prometheus', permitting Frankenstein to invent life by butchering corpses and attaching electrodes to the effigy which he sutures

Hans Bellmer
Doll *(1934)*

together. Bellmer's methods were Frankensteinian in their violence. His father mistook wood for flesh, and wondered why Hans was collecting limbs left over from surgery. Bellmer disdained the tenderness of Kokoschka with his soft, cosseting cotton wool and slippery silk, and used a drill to excavate the doll's nostrils: it had to suffer in order to breathe. His plaything underwent multiple amputations and perverse transplants. It mislaid its head, had a leg torn from its socket or an extra pair grafted on. A body is a kit of parts, and any arrangement – including the symmetry of Vitruvian man – must be considered provisional. For his own deviant reasons, Bellmer justified these sadistic dislocations by telling the critic Peter Webb that they resembled linguistic experiments. Lexical and syntactic rules had lost their power, once the twentieth century recognized that words were signs ineffectually pointing to absent things, keener to conceal meanings than to reveal them; Bellmer therefore treated the doll, he said, as 'a plastic anagram,…like a sentence that invites us to rearrange it'.

Kokoschka took no such liberties. He behaved chivalrously towards his effigy of Alma, and respected its right to ignore his devotion: the woman, according to the code of courtly love, must be haughtily indifferent. Bellmer, however, wrenched his doll out of shape, and ravaged its internal secrets. He installed a museum of kitschy feminine trinkets in its stomach. Viewing was through the navel; to switch on the torch which the doll had swallowed, you pressed its nipple. The body's apertures were peep-holes, providing access to a forbidden knowledge.

These games dangerously investigated the relation between biology and engineering, and formulated a new and defiantly modern approach to eroticism. If living, as Axël said in the novel by Villiers de l'Isle-Adam, could be left to the servants, then the reproduction of life must also be a menial chore. Freud endowed the sexual instinct with a more metaphysical ambition, and described a combat between Eros and Thanatos. Bataille, to whose authority in these matters Bellmer deferred, amended the theory: sex and death were not enemies but illicit collaborators. Sexual entry, like a surgical probe, was a means of research; its purpose was to confront mortality, as if tunnelling into the grave to scrutinize its mysteries. This is why Bellmer carved those lighted cavities inside the doll, and subjected it to such polymorphous agonies on the operating table. His was the infinite consciousness of Kleist's god, ruthlessly twisting the splintered limbs and vivisecting the plastery flesh of a mannequin which represented unconscious, outmoded humanity.

Knowledge, in Bataille's account of modern eroticism, makes love to death. With the same intrepid contempt for taboos, twentieth-century science despoiled God of his most exclusive power, the capacity to invent life. Since the process had always been officially unthinkable, there was no word for its product. Karel Čapek coined one in 1920 in *R.U.R.*: robot, derived from the Czech verb 'robotiti', which means to labour or to perform drudgery.

Work, as the Bible maintains, is a punishment for the original sin of our parents in Eden. If we could manufacture a race of servants who were not alive and who therefore never tired or fretted for their liberty, then we would escape from the curse laid on our species and guarantee ourselves eternal leisure. That is what we expect from our technology. Čapek's play suggested that our motives might be more dubious, and saw the outcome less optimistically. In revising the conditions imposed on our existence and goading science to surpass biology, are we happily committing collective suicide? Rossum's Universal Robots, like the slaves and the proletarians before them, rise up against their human masters and kill them all.

R.U.R. *at the Théâtre des Champs-Elysée in 1924*

Čapek's prognosis was immediately answered by Shaw in *Back to Methuselah.* In Čapek's factory, machines bring human history to a sudden end, after which two mechanical specimens, deputizing for Adam and Eve, go off to engender a new race. Shaw, whose pentateuch keeps that history going until at least the year AD 31,920, placed his trust in endlessness: the indefinite gaseous expansion of human hope, sustained by what Shaw called his 'genuinely scientific religion'. This was metabiology, otherwise known as creative evolution, and it assumed that, given infinite time, men would outgrow the defects of human nature and the flawed design of the human body. Learning to incorporate the superior intelligence of machines, they would at last be indistinguishable from gods. Shaw, warping Čapek's coinage, defined a robot as a being who was denied the luxury of original sin: it had no imperfections to overcome, and therefore could not take part in the evolutionary adventure. Adam and Eve make a ghostly return in 31,920 to contemplate the fortunate effects of the fall, from which the play began. Even the serpent and Cain, who boasts that by killing his brother he became the first Darwinian, are gratified.

When *Back to Methuselah* concludes, the race has advanced beyond dolls, surpassing the dead end of anthropomorphism. Pygmalion – already disparaged by Kokoschka, and mocked by Shaw himself when Henry Higgins tries to speed up evolution by teaching Eliza Doolittle upper-class vowels – sculpts two automata, who promptly turn on him and are soon sentenced to death. Because humanity is at best an experimental model, art makes a mistake in imitating it; all

moulds, including those which decree what our bodies look like, must be broken. The Ancients serenely wait for the day 'when there will be no more people, only thought'. It did not occur to Shaw in 1921 that nature might not be equally patient. There is an additional reason why the earth is different in the twentieth century: we have noticed that it is dying.

Before the robots kill him, Domin in *R.U.R.* commemorates 'today, the last day of civilisation' and longs for 'another hundred years for the future of mankind'. No postponement is permitted. The robots unplug the electricity, and Hallemeier cries out '*The end*'. In 1922 Čapek's next play, *The Makropulos Case*, permitted humanity the extra lease of life which Shaw asked for in *Methuselah*, and suggested that it would make no difference. The revolutionary socialist Vítek sets out the curriculum of a life extended to three centuries – fifty years allowed for childhood and education, another fifty for exploration, then a hundred years of effort for the benefit of others, followed by a further hundred of smiling retirement as an ancient wiseacre. But his assumption that we would at length achieve perfection is refuted by the appearance of Elina Makropulos, who with the help of an alchemist's potion has survived to the age of 337. Despite having cheated mortality, she is weary and disgusted, and finally, rather than dosing herself once more with the elixir, chooses the mercy of an end. Though we may think we have exceeded nature or surpassed it, in fact we have betrayed it. Kristina, offered the secret formula by the shrivelling Elina, repentantly burns it, just as Helena in *R.U.R.* destroys the chemical recipe for constructing artificial life.

In 1936 Čapek published his science-fiction fable *War with the Newts*, which tried out another hypothetical apocalypse. Men have colonized the marine salamanders as slave labourers and used them to fill in the oceans. The Salamander Syndicate aims to reverse Genesis, abolishing all that unprofitable liquid and rebuilding Atlantis. Japan, Čapek reports, has constructed a terrace to close the gaps in its archipelago, with an artificial volcano erected on the platform as a reminder of sacred, obsolete Fuji; Germany, always in need of extra room, is scheming to develop a continent of reinforced concrete in the Sargasso Sea. The newts rebel, gnawing away at the coastlines to protect their watery habitat, and cause a terminal flood: 'Oceans covered everything once, and they'll do so again. This is the end of the world.' They offer men a knock-down deal on their life-rafts: 'Sell your continents while there is time! You may sell them in their entirety, or in lots of individual countries.'

The end of the world – as Čapek saw it from land-locked Bohemia, at the eroded, embattled centre of Europe – was already under way in 1936. His newts, tunnelling up from below with their pneumatic drills, hastily rewrote the map like Hitler erasing borders. In 1945 the victors completed the process, carving up what was left of the globe between themselves. Since then, the political fable has developed a new ecological plausibility. Land continues its imperial assault on water, with floating airports in Hong Kong and Osaka and oil-rigs like cities on stilts in the North Sea. The oceans will have their revenge when the polar ice-caps

melt. All of Čapek's plots express the same eschatological fear. Our arrival at technical mastery of the world is not a joyous conclusion to history but a symptom of the end. Human primacy depends on the pillaging of nature and the subjugation or slaughter of other species. Mankind's obituary may well be written by those expropriated creatures, when they re-inherit the earth – by Maeterlinck's bees or Kafka's beetle; by Čapek's newts, or the sex-mad butterflies, parasitical flies and militarized ants which overrun his *Insect Play*; perhaps by the birds which dive-bomb California in Hitchcock's film. After escaping from Germany, the painter Max Beckmann looked back over his shoulder at its collectivized society in 1938 and commented that the official Nazi policy was 'to lower...the way of living of mankind to the level of termites'. This – expressed with reference to a range of other, more slavish species – is one of the eerie novelties of twentieth-century vision, as unsettling as the view of the earth from an aeroplane or a spaceship: we are capable of imagining the world as if our own kind no longer existed in it.

The paradox of the divine puppet proved difficult to sustain. Alfred Polgar read a report in 1936 about the enforced closure of the Neapolitan marionette theatre. The puppets, condemned for behaving 'like ghosts', had not adapted to 'the new age' and were denied a place in the reformed Italy of Mussolini. Polgar found a morbid logic in this absurd ban, and commented that 'where people are themselves marionettes and only as such have a right to life, real marionettes have to act like ghosts and, moreover, like mocking ghosts'. Could he have been thinking of the resurrected Pétrouchka, laughing from the rooftops?

Karel Čapek died in Prague in 1938. His brother Josef, a painter who collaborated with him on the plays, was interned after the German invasion of Czechoslovakia, and died in Belsen in 1945. Primo Levi, deported to Auschwitz late in the war, described the concentration camps as a demonic marionette theatre. Prisoners walked with the shuffling gait of 'puppets with jointless bones'; deprived of possessions and of affection, they were 'miserable and sordid puppets', hollowed out like Eliot's men of straw. The Nazis consciously educated their prisoners in this view of themselves, and reinforced the lesson with blows. At Vilna in Lithuania, Jews were dragooned in 1943 to dig up twenty-four thousand corpses from mass graves so that the evidence of genocide could be burned. Many of them uncovered their wives and children, hurled into the pit. After incineration, they had to pulverize the larger bones, which would not burn. They were denied the use of tools, made to pick up and carry all those decayed and discarded human beings with their hands. They were also denied the use of appropriate words. If they referred to the 'bodies' of their twenty-four thousand fellows, or called them 'victims', they were beaten by the supervising guards. The approved German word, drummed into them with rifle-butts, was 'Figuren' – puppets, marionettes, humanoid things which might just as well have been made of wood.

The modernist puppet rejoiced in its freedom from distracting human emotion. The puppets of Auschwitz or Vilna, however, had been robbed of the

right to feel, or to consider themselves human. The brutality of the Nazis exter-minated the spirit. They reversed the Promethean science of the modernists, who – altering the body, questioning the value of individuality, taking away extraneous qualities – sought to redefine humanity. Nazi technology aimed instead to achieve what Levi called the 'demolition of a man'. He was astonished by his own survival, physically at least. The human race, having forfeited forever its sense of prerogative and entitlement, took longer to recover.

THE CHAPLINIAD

Modern man is an archetype, conveniently faceless. If we gave him individual features, what would he look like? One of Rodchenko's Soviet athletes, or perhaps one of those wracked, neurotic new human beings painted by Egon Schiele? Actually, the representative modern man could be recognized from his feet – or at least from his shoes. In Walter Ruttmann's film about Berlin, two boots, awkwardly over-large and with gaping soles, waddle into close-up on a cinema screen. There was no need to show the rest of the body. By 1927 the tramp would have been recognized everywhere in the world from that evidence alone. Charlie Chaplin, in the century which allegedly belonged to the common man, was the common man in person.

In 1921 the Dadaist Iwan Goll published a poetic homage to Chaplin, variously entitled in different editions *La Chaplinade* or *La Chapliniade*. Either way, the title was ironically apt, turning Chaplin (who detested horses, which he considered to be cantankerous and half-witted) into a chivalrous hero of romance, prancing through a cavalcade, or else into an epic warrior of the sidewalks, whose mishaps constituted a modern, mock-heroic version of the *Iliad*. A title-card at the beginning of Chaplin's *The Great Dictator* remarks, with grim understatement, that between our century's two world wars 'humanity was kicked around somewhat'. Chaplin's comedy is about the damage suffered by humanity in modern times.

The tramp, much admired by Robert Musil, was a man whose qualities did not fit him. His shoes and trousers were too large, his jacket uncomfortably small. The bowler hat belonged to a *petit-bourgeois* employee, although the tramp had no job to go to. The irrepressibly jaunty cane suggested a leisured stroller, as if Baudelaire's *flâneur* had fallen through the floor, and now trailed along muddy, dusty suburban streets or hobbled down a featureless open road. Despite his downcast circumstances, his table manners had a feminine daintiness, even if he happened to be eating one of his own shoes. Like the dandies of the 1890s, he vacillated between the sexes, and challenged the toughs and braggarts of the slum with his winsome androgyny.

The second-hand persona and the scavenged garments imply disintegration: what is society but a costumed pretence? In one of Chaplin's early films, the tramp bluffs his way into a fancy-dress ball. He nonchalantly mingles with knights in armour and rococo courtesans, who all assume that he is one of them, dressed up for the evening in shreds and patches. He reacts with instinctive terror to the sight of a policeman, his natural enemy. But the policeman immediately puts on a carnival mask: even the law is an imposture.

In his autobiography, Chaplin acknowledged the kinship between his chosen persona and Picasso's clowns and acrobats, those marginal figures who announced the collapse of nineteenth-century society and the creation of twentieth-century art. Remembering his impoverished early years with his mother in south London, he remarked bitterly that 'Picasso had a blue period. We had a grey one, in which we lived on parochial charity, soup tickets and relief parcels.' In *The Circus*, the tramp strays into the ring and turns out – simply by being himself, and reeling through the usual daily series of mishaps – to be funnier than the clowns; he is ordered onto the high wire, and manages to keep his balance even when his safety harness fails. But there is no chance that he might become one of Rilke's high-flying angels. When the circus moves on, he stays behind in the waste ground at the edge of town, sitting on an empty box inside a circle traced in the dirt which was once the ring. He folds up a paper star, then struts off towards a fading horizon. Membership, even of this nomadic alternative society, is not a possibility. In *The Kid* a policeman scoops him up from the gutter and delivers him by the scruff of the neck to the doorstep of a mansion. He is welcomed inside by the single mother of the orphan he has fostered, but the happy ending which the film proposes is unimaginable: since he has so tenderly mothered Jackie Coogan, listening to his prayers and kissing him goodnight, how long will the biological parent tolerate him as her rival? In *City Lights* he is adopted by a drunken millionaire whose life he has saved, but ejected from the house when his patron sobers up.

Chaplin was one of Franz Marc's 'early people' – a psychological exile who looked at society from below or from outside, and who saw the world aboriginally, as a place not yet quite ready for human habitation. In London he belonged to the underclass, in America (where his refusal to become a citizen fuelled the campaign against him during the Cold War as a menace to public morals and political order) he was an unassimilated immigrant. Eisenstein described him as a would-be primitive. Gauguin had been able to escape to Tahiti, but today – as Eisenstein noted in 1945 – there are no such refuges left. Every wilderness has an airport and a luxury hotel. So Chaplin's response was evolutionary flight: he recoiled into the regained paradise of childhood. But his retreat was never as sentimentally self-deluding as Eisenstein claimed. In his films, the city itself is a jungle, not a private island. The streets are ruled by bullies, looming ogres, bands of sarcastic urchins. Civilization is the preserve of the rich, with their polished cars, their locked houses and their omnipresent police force. Public

The Idle Class
(1921)

space is comfortless, the last resort of those who have no private recess to shelter them. Many of Chaplin's early films were made in parks, which for him were synonymous with loneliness and abject displacement. You only go to a park, he said, if you are unhappy; you only sit on a bench if you have nothing better to do.

In *His Prehistoric Past*, the tramp dozes off on one such park bench. Sleep is another form of internal exile for the poor, a precious vacation from reality. His dream transports him back several millennia. Now he wears a shaggy pelt, although he has kept his bowler hat; but the same irate monster – played by Mack Swain, his permanent nemesis – threatens him, and a policeman soon shakes him awake and hauls him back to an even ruder reality. Parks are the city's lacunae, its oblivious deserts. The tramp is a native of such extremities – the embankment in *City Lights*, where you can either sleep or commit suicide, or the no man's land between opposed armies in *Shoulder Arms*. At the end of *The Pilgrim* he is abandoned on the frontier between Texas and Mexico, which is an arbitrary line traced in the dust. The border, however, allows no escape. In Texas he is a wanted man, and, although a generous or perhaps exhausted sheriff escorts him this far and then thrusts him across into Mexico, he is at once caught in crossfire between bandits who spring up from behind the cactus bushes. He traipses back to the American side, but remembers his criminal record and cautiously waddles into the distance with one foot on either side, forever marginal.

Chaplin worked in a new art, when conditions were still rough and ready, in a city which was also bravely improvising on hostile terrain. His early films give peripheral· glimpses of a makeshift society, still as temporary as a tribal settlement. He shuddered when he first saw the Sennett studios in Los Angeles, situated in a suburb with the overconfident name of Edendale. Lumber yards abutted on derelict farms, with shops in huts which did not look as if they expected to be doing business for long; the area could not decide 'whether to be a humble residential district or a semi-industrial one'. The pathos of such

Californian places is that whatever decision society makes can soon by vetoed by nature – by mud slides, earthquakes, or encroaching sand. The holly wood after which Hollywood was named is long gone, and it is impossible to be there without imagining a time when Hollywood itself – already a notional place, because no film-making happens in the city of that name – will have been erased, like the eroded sign on its hills which once said HOLLYWOODLAND. Chaplin, feeling vindictive after his exclusion from the United States in 1952, imagined Hollywood being swallowed up by 'the prehistoric tar pits of Wilshire Boulevard'.

He was often mystified by the compliments of his modernist admirers, and blinked when Gertrude Stein told him that films should dispense with plots. What she wanted, she said, was to see him 'just walking up the street and turning a corner, then another corner, and another'. In a way she was right: her high tolerance for boredom was the other side of his manic inventiveness. She serenely contemplated emptiness; he filled it up. The vistas of early Los Angeles through which the tramp perambulates have exactly the contingency and dreary consecutiveness desired by Stein. Chaplin's films candidly reveal the city's mazy lack of a centre, its disorienting sprawl. A society has unpacked itself hurriedly from the moving van, which perhaps – stranded between the desert and the ocean – came to the wrong address. The roads have not been sealed; the trees have not grown, and neither has any communal spirit, which is why people throw stones or pick fights, or why their cars splash you with mud.

Making films in those years resembled camping out. The flimsy stages, like those in the theatre, lacked a fourth wall. They also lacked a roof, to take advantage of the California sun. This exposure is responsible for some startling shocks: literal ventilations of the illusion, like the alienation effects of Brecht. In *The Kid*, the mother arrives at the police station to claim her abandoned child. Though she is indoors, the feathers on her hat flap as if in a gale – presumably because a gale was actually blowing through the boxy set. In *The Idle Class*, when Chaplin is titivating in a hotel room, the cloth on his dressing table rides up and down, caught in the same furious gusts. This is a society which has not had time to make itself weatherproof.

Amenities are lacking, and so are human faculties which we usually take for granted. Chaplin systematically withdrew the powers and privileges to which a civilized man feels entitled. The early history of film coincided not only with the civic beginnings of Los Angeles; it seemed to replay the infancy of mankind. Chaplin frustrated the development of speech, the first signal of advance beyond a primitive mental state. Even after films learned to talk in 1927, he stubbornly continued miming, and lamed language by distorting it into nonsense.

In 1931 the pompous municipal speech at the unveiling of the statue in *City Lights* is transcribed by the snorting, farting musical score. As the singing waiter in *Modern Times*, made in 1936, Chaplin diverges from his text and makes up meaningless rhymes: who cares what an operatic aria is saying? In 1940 Hynkel in *The Great Dictator* rants unintelligibly, with occasional references to

sauerkraut and Wiener schnitzel, interrupted by coughing fits. Hitler's harangues were also arias, meant to induce hysteria, not to diffuse enlightenment. A high-speed typist startles Hynkel by taking down his diatribe even faster than he can gabble it out, her keys clattering away. Since he is talking gibberish, the machine can be left to write whatever it pleases. Chaplin mistrusted sound because it threatened his universality: Meyerhold warned in 1936 that Russian peasants would cease to feel an affinity with the tramp if he insisted on addressing them as an Englishman. But there were more complex reasons for his resistance to technological innovation in a medium which had been made possible by technology. His practical jokes reveal a quizzical modern awareness that language impedes communication. He once attended a Hollywood dinner for the ballerina Anna Pavlova. Having suffered through a verbose eulogy in Russian, when his turn to speak arrived he paid tribute to her in a lingo which he claimed was Chinese.

What Chaplin wanted to show was a period in our psychological history before speech became unthinkingly available to us. He returns to the arduous invention of language, and emphasizes its ingenuity in helping us to overcome a handicap or manoeuvre an exit from difficulty. In *The Circus* he passes food up to a colleague on the trapeze. He misses his aim, and it slops back to ground, splashing over one of the acrobats. Chaplin excuses himself by acting out an elaborate alibi. With a motion of his hands he invents a passing bird, which has dropped this wet tribute. We learn to talk – he suggests – in order to talk our way out of things. He expertly revealed the body's capacity, even when it remains silent, for telling lies about its actual motives. In *The Kid* Jackie Coogan's hand, preparing to throw a stone through a window, grazes the sleeve of a policeman who has come up behind him. He at once begins playing with the missile, tossing it about harmlessly while looking for a chance to run away. Chaplin in *The Adventurer* is similarly caught out. Lying on top of a cliff, he fights off the police who are pursuing him by hurling rocks down at them. Then he notices a boot which has suddenly planted itself in the ground beside his head: it belongs to another policeman. His response is a brilliant physiognomic lie. He quickly covers it up with dirt and sand. If he cannot see it, how can it exist?

Reducing a man's qualities to tattered lendings like the tramp's costume, Chaplin rejoiced in taking away physical skills which are the body's own laboriously home-grown machinery. In *The Idle Class* he is trapped in a phone booth without his trousers. He escapes by wishfully amputating his own legs, and scuttles through a gaggle of censorious matrons under cover of his shirt tails: he has no need for trousers, because he ends at the waist. Chaplin's gags demonstrated that a man can survive without a tongue or legs.

Sometimes survival is easier if the mind or the memory are removed, leaving only a well-oiled, obedient automaton. The Jewish barber in *The Great Dictator* spends the years between world wars in hospital, suffering from amnesia. When he returns to the ghetto, his affectlessness proves psychologically helpful. He slips back into the repetitive motions of his previous life, only slightly puzzled by the

decades of dust and cobwebs in his shop. He is taken aback by the anti-Semitic graffiti painted on his window, but wipes off the mess without thinking further. Told to hail Hynkel by the storm-troopers, he shrugs that he has never heard of the man. But when they insist, he consents: 'Oh, all right.' This is how men behave in a totalitarian society, or in any mass society which takes no account of individuals. They try not to notice, or train themselves to be less sensitive. Anonymity is the safest camouflage. In *Shoulder Arms* Chaplin gets through a battle by pretending to be a hollow tree, its lopped, butchered branches testifying to man's war against nature. To cope with the world, he allowed the tramp only the talents and the tactics of the early people: native wit, and a gift for evasion. Chaplin resented technology because it speeded up evolution and dispensed too easily with difficulties. Given a gadget, he could be counted on to destroy it. In *The Pawnshop*, he eavesdrops on the vital signs of an alarm clock with a stethoscope. After a punctilious examination, he decides to perform surgery, and makes an incision with a can-opener. The operation naturally kills the patient.

Although film may be able to do without sound, it cannot exist without sight. Yet Chaplin flirted with that disability too. His chosen persona was that of the man who is overlooked; although his popularity soon made him the most recognizable figure in the world, the character he played is disregarded by everyone, insignificant even in his own estimation. In *City Lights* the blind flower-seller recovers her vision thanks to his charity. But once she is able to see, he becomes invisible to her – just one more passer-by, absorbed into the crowd of lookalikes. At the end of *The Circus* he altruistically erases himself. He arranges a marriage between the girl he dotes on and his rival, showers them with rice, and encourages them to forget that he ever existed.

The tramp's self-sacrificing meekness gave him a religious aura. Chaplin's fellow director Jean Renoir called him 'the god of non-violence', and volunteered to serve as his apostle. When the dramatist Clifford Odets offered to introduce him to Chaplin, Renoir felt like 'a devout Christian [invited] to meet God in person'. The twentieth century, as the introduction to *The Great Dictator* announced, experimentally diminished or even dismantled humanity. Christ's detractors nailed to the cross a slogan declaring 'Ecce Homo': behold the man. The title of Primo Levi's memoir, *If This Be a Man*, implies that, after Auschwitz, we can no longer be sure what a man is. Certainly it is no longer conceivable that God should permit his only-begotten son to live and die as one of us. Nietzsche, espousing the anti-Christ, claimed that human beings did not need to be redeemed in this way. Chaplin's victimized and sweetly beatified tramp brought Christ back. The humblest of men restored the lustre of humanity. Eisenstein compared the tramp with Parsifal, the pure fool who inherits Christ's Grail in Wagner's last opera, and called him the incarnation of 'Christ's simple man'. Hart Crane's poem 'Chaplinesque', vaguely recalling *The Kid*, admired the same radiant goodness, which transforms comedy into communion: 'the moon in lonely alleys' makes 'a grail of laughter of an empty ash can'.

Eisenstein described the factory in *Modern Times* as a 'motorised Golgotha'. In *Limelight* Chaplin played a dying comedian called Calvero; the film, as Cocteau noted, was 'the calvary of a clown'. Chaplin's sense of his own sanctity and martyrdom increased as he was persecuted for his socialist sympathies, and for alleged sexual infractions. He told Winston Churchill (according to Orson Welles) that he intended to star in a biopic about Christ, prompting Churchill to ask if he had cleared the rights. Chaplin also wanted to collaborate with Stravinsky on a surrealist film about a decadent night-club which presented the crucifixion as its floor show. Blood would have dripped onto one of the dancers, prompting her to complain about the mess. Stravinsky thought the idea sacrilegious, which was probably the point of it. The project gave warning of Chaplin's messianic ambition. He came to feel that he had been elected to a mission, entrusted with a responsibility to rescue humanity.

On the soundtrack of *The Great Dictator* he twice used the prelude to *Lohengrin*, in which Wagner's high, shimmering strings narrate the descent of grace to earth as the Grail knight Lohengrin, Parsifal's son, wafts down from the sky to perform miracles. At the end Paulette Goddard listens in exile to a radio broadcast by the Jewish barber, who has assumed the identity of Hynkel. The barber, disarming the dictator's regime, calls for peace on earth and goodwill between men. His voice, transmitted directly from heaven, tells her to look up at the sun, and promises that mankind is 'flying into the rainbow, the hope, the future'. The *Lohengrin* prelude makes that assurance audible. But if the music brings this consolation with it, why did Chaplin use the same excerpt from Wagner in an earlier scene, when Hynkel does his crazed, conquering dance with the weightless globe? The coincidence suggests that the two characters Chaplin plays in the film may be secretly similar, despite their racial enmity. The dictator is a little man magnified by technology, which gives him global power. When Chaplin first saw photographs of Hitler, he described him as 'a bad imitation of me', and threatened to sue for plagiarism of his moustache. Another of his unrealized projects was a film about Napoleon, whom he idolized. Comedy is aggression by other means.

Laughter has no conscience, and shows no mercy. In *The Great Dictator* Chaplin dangerously mocks Hynkel's Jewish victims, who are being recruited for an assassination plot by a renegade fascist. The ancient Aryan tribes, they are told, performed rites of human sacrifice, picking out the victim by lot at a feast. The ghetto elders organize a midnight supper to choose the saboteur who must die while blowing up Hynkel's palace. The lucky man will find a coin hidden in the pudding he eats. Paulette Goddard, however, overhears this plan, and puts a coin in every pudding. They all chew nervously, gag when their teeth strike metal, and either swallow the evidence or surreptitiously slip the coins onto someone else's plate. Chaplin himself gobbles down half a dozen. When he hiccups, they clink inside him, as farcically as the swallowed whistle which chirrups throughout an operatic recital in *City Lights*; eventually he coughs them all up.

Despite the brilliance with which the scene is directed and performed, this anatomy of shifty cowardice hardly supports the barber's final appeal to 'universal brotherhood'.

The girl Chaplin rescues from the streets in *Monsieur Verdoux* expresses the world's gratitude to him: 'I was beginning to lose faith, then this happens and I want to believe all over again.' Her devout little prayer to her personal comforter, who has fed her and sent her home without expecting sex, is mordantly ironic. The murderer Verdoux was intending to try out a new poison on her; he only spares her life because – when she tells him that she would have killed to protect her invalid husband – he recognizes her as an amoral equal, impelled like him to renounce the categories of good and evil. Chaplin's gradual exposure of his own darker side – which led to his ostracism from public favour after he released *Monsieur Verdoux* in 1947 – forced the twentieth century to recognize once again the falsity of its hopes for redemption and renewal. The common man had incubated a monster.

Meeting Chaplin in 1926, Aldous Huxley went for a walk with him on the beach at Malibu. They ignored the frolicking female bathers, because they were engrossed – as fellow 'theologians of art' – in discussing 'the way of cinematographic salvation'. The world certainly expected Chaplin to salvage it. The Berlin critic Hans Siemsen described him in 1922 as the loftiest kind of human being, a 'Weltverbesserer' or world-betterer. Blaise Cendrars in 1924 credited Chaplin with winning the war for France, remembering how morale was kept up by soldiers who returned from leave with accounts of his latest films and spread a life-saving hilarity through the trenches. In 1929 Marc Chagall made a portrait of him in which the tramp has stepped out of his gaping shoes to reveal chicken feet; his face has drifted away from its anchorage on his shoulders, and under his arm he carries, along with his cane, an angel's wing – hence the avian extremities and the detachable human face.

Marc Chagall À Charlot Chaplin *(1929)*

To his consternation, Chaplin found himself being transformed into a mythic figure, and lost control of the character he had invented. The choreographers of the Ballets Russes – for whom the dancer was the emblem of modern man, celebrating the freedom of the body – saw the tramp's perambulations through the city as an

impromptu ballet. Massine imitated his twitchy locomotive quirks, and gave the American Girl in *Parade* a Chaplinesque routine to perform. Nijinsky visited Chaplin on the set of *The Cure* in 1916, and Chaplin went to see him backstage before a performance of *L'Après-midi d'un faune*. There was an immediate sympathy between their adopted personae: the primordial unsocialized creature played by Nijinsky in the Debussy ballet, and Chaplin's social outcast. In 1919 in *Sunnyside*, he allowed the tramp to gambol through an abbreviated version of the faun's afternoon. Chaplin here is an abused, incompetent farm hand, tossed by a steer he is riding. Concussed, he dreams himself back into Arcady and cavorts with three wood nymphs. But unlike Nijinsky he is tethered to reality, dragged down by his social circumstances and those heavy shoes; he tumbles bruisingly back to earth. In 1925, after photographing Isadora and Thérèse Duncan as blurry volatile sprites on the Acropolis, Edward Steichen made a portrait of Chaplin for *Vanity Fair*. He saw in him, Steichen said, a 'dancing faun', and posed him rakishly, leaning on his cane with his hat doffed and a cheeky leer in his face, with shadows distorting his ruffled hair into a hint of horns. When he reissued his silent film *Shoulder Arms*, Chaplin added a spoken introduction which justified its lack of speech by calling it a pantomime, or a 'comic ballet'.

He initiated a romance between low and high culture, between American populism and the European avant-garde, which has continued throughout the century. Cocteau saluted him as 'le profond Chaplin', and in the preface to *Les mariés de la Tour Eiffel* ranked him with Shakespeare and Molière; Eisenstein enrolled him in the company of Aristophanes, Erasmus, Rabelais, Swift and Voltaire – tribunes of satire, immemorially battling against darkness. As the century begot new political and moral terrors, Chaplin was assigned to exorcise them. On an outing to the beach at Santa Monica, Chaplin handed to Eisenstein a German expressionist book in which the figure of Charlie apparently presided over a cosmic catastrophe. He begged Eisenstein to read it for him, and tell him what it meant. Cocteau in 1953 told him 'you are the surveyor of Kafka's Castle'. It was a lot to live up to.

The periodical *Disque vert* proclaimed in 1924 'Charlie est dadaïste'. The reason given was the impulsive arbitrariness of his behaviour. Proust and Freud, the editorial declared, had written dissertations on the subconscious mind; Chaplin made its perverse whimsies visible in action. Hence his association with the manic, murderous frenzy of Milhaud's ballet *Le Boeuf sur le toit*. Milhaud adapted the score for piano and violin, called this setting *Cinéma-fantaisie*, and recommended that it 'could well illustrate a Charlie Chaplin movie'. In 1920 the Paris newspapers announced that Chaplin would appear at a Dada demonstration to be held at the Grand Palais. He did not show up, probably because he was never invited. The myth had dispensed with the man, and flourished in his absence.

Since he belonged to the world, his identity could be counterfeited at will. The improvident father in Evelyn Waugh's *Vile Bodies* blithely hands his daughter's suitor a cheque for £1,000, having signed Charlie Chaplin's name on it.

Or he could be taken apart. When Léger saw his first Chaplin film in Montparnasse, he called the tramp an 'objet vivant': a piece of sculpture in motion, not a human being. Assuming him to be a puppet, Léger designed a 'Charlot cubiste' composed of wooden blocks, angled so that he could acquiescently lift his hat and twirl his stick. In the film Léger made in 1924 to accompany Antheil's *Ballet mécanique*, this marionette with the jigging, dangling arms and legs flew apart as it turned somersaults in time to the music. A myth is a piece of bricolage, tenuously stuck together; analysing it, you inevitably break it down into its component parts.

Chaplin himself admitted how easy it was to manufacture Charlot. In a caricature now in the collection of the Cinémathèque française, he reduced his persona to the abstract essentials. A slanting diagonal line and a small black oblong give you the essential information: they stand for the dapper, tilted brim of the tramp's bowler hat and the exiguous strip of his moustache. He added a spiral to signify a tuft of hair, and two arcs to represent a single eye. This was the sketch of a face in visual Esperanto. A few quick signals, internationally comprehensible, conjured up the tramp. Léger constructed his illustrations to Goll's *Chaplinade* from a similar shorthand. Here the body of Charlot resembles a guitar from the collages of Picasso and Braque, and his hair is a right-angled flight of stairs. Puns allow him to skip effortlessly across borders, like films before the addition of sound. Léger stamped the legend CHARLOTTENBURG across one of the illustrations. Charlot, a world citizen, is presumably resident in that district of Berlin. He could be matched and mated with other archetypes. A Léger cartoon in 1933 posed his cubist Charlot between photographs of the Mona Lisa and the Venus de Milo, reporting that Leonardo's eternal woman was 'amoureuse de Charlot'. The tramp had spurned her, and her response was to commit suicide. All the earth's dignitaries were expected at the funeral. Chaplin had become the first of the twentieth century's custom-made gods: a global celebrity, whose image had a career all of its own, rendering the man himself redundant.

At the Bauhaus, they saw him differently, as an icon of man's merger with the machine. Schlemmer said that Chaplin 'performs wonders when he equates complete inhumanity with artistic perfection'. The reverse is the case: his routines dramatized the struggle of frail, imperfect man against the machine, and if he could not outwit it, he playfully wrecked it. But his own motives no longer mattered. If the Ballets Russes had etherealized Chaplin, the Bauhaus sternly intellectualized him. T. Lux Feininger made a photographic self-portrait in 1928–9 in which he dressed himself as the tramp. His version of the costume, however, looked severe not shabby: the black coat was a monastic uniform, and he wore a high, stiff, impeccably clean collar. Feininger replaced Chaplin's usual battered bowler hat with a straw boater, and this change marked another revision of the persona he had appropriated. The tramp's bowler hat was absurd because its gentility hardly suited a vagabond. The boater is more appropriate for the healthy, athletic outdoor life extolled by the Bauhaus – a luxury the tramp could never have afforded.

In 1928 Moholy-Nagy paid tribute to Chaplin in a photomontage which he later entitled *City Lights*. The tramp here ogles two chubby female bathers, perched above him at the end of a perspective which illustrates how the eye sends out diverging lines of force to encompass space. Sight endows the little man with a power of connoisseurship and control which he never possessed in his films. The women balance on the edge of the perspective, as if debating the plunge at the end of a diving board; the beam which Chaplin projects is their only means of support. One of Moholy-Nagy's preliminary titles was 'Da stehst du machtlos vis à vis': there you stand powerless face to face. But the visual diagram refutes this sad erotic frustration. The dark bar of the perspective which Moholy-Nagy traced on the photographic surface follows the gaze connecting Chaplin with the girls. To look at the world, according to Bauhaus aesthetics, was to commandeer it. Chaplin, who remains plaintively invisible to the flower-seller in *City Lights*, is here equipped with the sovereign power of sight, which Moholy-Nagy called 'the dynamic of the optical'. In 1921–2 Moholy-Nagy planned a film of his own, *Dynamic of the Metropolis*. Like Ruttmann's study of Berlin, it was absolved from having to tell a story or possess a moral: its effect was intended to be 'visual, *purely* visual', revealing a city composed of light in transit, electrically mobilizing objects and sparking desires. This was a jazzily elated, ignited view of the metropolis which the tramp could never have shared.

In Russia, the tramp was inevitably required to join forces with the Revolution. Lenin singled out Chaplin as 'the only man in the world I want to meet'. His American career was ruined by post-war accusations of fellow-travelling; still he was never more than a sentimental socialist, and in *Modern Times* he is only caught up in a political demonstration by farcical accident. Meyerhold, however, assumed that his mishaps with cops amounted to a denunciation of 'the police state', and praised his acrobatic stunts for connecting industry and the theatre, labour and art. 'Observe', Meyerhold ordered, 'how Chaplin deploys his body in space to maximum effect; study, as we do, the movements of gymnasts and blacksmiths.'

Chaplin himself was less enthusiastic about industrial calisthenics. In *Modern Times* he sabotages the factory, and in *Monsieur Verdoux* the hero morosely recalls the drudgery of his life as a bank clerk – 'A monotonous rhythm, day in and day out'. The conscription of Chaplin to Soviet orthodoxy was undermined by his refusal to allow his films to be distributed in the Soviet Union during the 1930s, because he was never properly reimbursed. Grumbling that Henry Ford received hard currency for his tractors, he argued 'My pictures must be worth at least as much as several tractors'. On one occasion he almost relented after being offered some of the Tsar's armchairs in lieu of payment. Meyerhold's 'citizen-poet' was an astute businessman; as a Hollywood star, he also belonged to a royal family which has outlasted all of the century's revolutions.

Although Chaplin's politics could not be reconciled with those of his Soviet admirers, his comedy proved useful as a means of impudent resistance to

authority, cultural as well as political. In 1931 the director Grigori Kozintsev published a manifesto on behalf of his actors, who practised what they called 'eccentricism': they cultivated biomechanical nimbleness, not emotional sensitivity, and Kozintsev expressed their disdain for high, soulful culture by saying 'We prefer the arse of Charlie Chaplin to the hands of Eleonora Duse!' During his youth, Shostakovich worked as a cinema pianist in Leningrad, often accompanying Chaplin's films, for which he retained a life-long affection. On New Year's Day in 1967, at a party attended by Benjamin Britten in Shostakovich's *dacha* outside Moscow, the special treat was a showing of *The Gold Rush*. Shostakovich's music was often called Chaplinesque, a coded term which hinted at its political irresponsibility. The farcical incompetence of the authorities in *Lady Macbeth of Mtsensk* owes much to the Keystone Kops with their calamity-ridden, unavailing pursuits: silent films allowed Shostakovich to protest wordlessly against a regime in which the administration of justice was a brutal, capricious farce. His First Symphony, completed in 1925, has episodes of high-speed clowning, which sag into morbid despondency. Shostakovich – overtaken by nervous tics and apologetic fidgets as he waited for the moment when Stalin would decide to have him purged – saw the tramp as a tragically demoralized figure, who manages to survive by humbling himself.

Brecht considered *The Gold Rush* to be a prototype for his own epic theatre, more concerned with physical antics than with subjective empathy, but found Chaplin ideologically soft. A film, Brecht insisted, was no more than a few miles of celluloid circulating through a tin box. The crudity of the mechanism ought to alienate our emotions, warning us that we are looking at black and white shadows, not people who beseech our sympathy. Chaplin's need to be loved by his audience interfered with this neutral, didactic detachment: Brecht particularly loathed 'the famous close-up of the doggy look which concludes *City Lights*'. He also had his doubts about the doctrinal soundness of Chaplin's skits. Farce for him was not saturnalian, a jesting riot like the Chaplinesque chases composed by Shostakovich. On the contrary, it bossily mechanized life. One of the escapees from the Third Reich in Brecht's *Flüchtlingsgespräche* remembers a sketch in which Chaplin stuffed a suitcase with clothes, locked it, then noticed the arms and legs of his pyjamas were sticking out. He promptly took a pair of scissors and sliced them off. The moral, overshadowed by the memory of Nazi repression, is that too much tidiness is a bad thing. Eisenstein in 1937 criticized gags like this for their individualist illogic. He was prepared to laugh when Chaplin delicately manicured his nails with gigantic guillotine-bladed clippers meant for slicing up wall-paper. Nevertheless the routine was 'individual and illogical'. Chaplin, Eisenstein complained, persisted in infantile pranks. Was he not aware that, in the century of socialism, society had at last become adult?

His political incorrectness lay in what Brecht starchily called his 'vertrackte Dialektik': his distorted logic. Adorno in 1932 observed that Brecht had made good this deficiency in the figure of Jimmy Mahoney, the protagonist of

the opera *Aufstieg und Fall der Stadt Mahagonny*, who squanders his earnings from the gold rush and is executed when his money runs out. Jimmy, Adorno said, was 'a subject without subjectivity, a dialectical Chaplin'. The lack of subjectivity was an ideological bonus: Jimmy did not cravenly appeal for sympathy, like the tramp in the final close-up of *City Lights*, and Brecht's gags contained a stauncher criticism of social abuses than Chaplin ever managed.

In *The Gold Rush*, the starving tramp is reduced to eating his shoes. He does so with lip-licking relish, carving the leather tenderly, sucking in the laces like strands of spaghetti, and offering his companion in the snow-bound cabin a bent nail as if it were a wishbone. However funny this may be, Adorno considered it a good deal less politically instructive than Jimmy Mahoney's desire to eat his hat. Chaplin incidentally had anticipated the idea: in *The Pilgrim*, a hat left on the kitchen table is mistaken for a pudding, and coated with custard, cream and currants; it proves fairly indigestible. But Jimmy's hat is conceptual. He proposes eating it as a protest against anarchy, which by permitting every kind of indulgence renders pleasure banal and boring. It is a blasphemous thought: a man who is tired of Mahagonny's consumerist delights deserves to die.

Hunger was no longer a sufficient excuse for eating your hat or your shoes. You needed to cite a dialectical motive as well, and be able to prove that the act entailed a radical critique of the productive power. Revolutions never take long to surpass the intentions of their instigators, who find themselves dismissed as reactionaries. European adherents to the doctrine which Meyerhold called Chaplinism often found Chaplin himself to be a half-hearted Chaplinist.

Einstein visited Los Angeles to lecture in 1926, and had dinner with Chaplin. His wife told a well-rehearsed story about how the professor had announced that he was brooding over a big idea, retired upstairs for a fortnight, and eventually came down (like Moses from the mountain) with some pieces of paper on which he had scribbled the theory of relativity. Chaplin politely asked Einstein whether his account of time and space rebutted Newtonian mechanics. Einstein replied that he had merely extended Newton's ideas. They seem not to have had much more to say to each other on the matter. But in 1929 the essayist Waldo Frank described Chaplin as an embodiment of Einstein's atomic physics, calling the tramp 'the atom of himself' and likening him to 'an atom that must journey alone through the world'.

Chaplin's routines acted out some of the ideas about nature which Einstein formulated. Relativity for the tramp is a practical joke played on us by the physical world, which seems determined to be a hindrance. In *Modern Times*, threatened by robbers in the department store, he tries to escape down the up escalator on roller skates. The means of acceleration cancel each other, and despite his flailing arms he runs on the spot. As the title of that film implies, Chaplin was uncomfortable about the behaviour of time in modern life. His first, hostile impression of America when he arrived in New York was its 'slick tempo'.

While his Russian admirers saw the tramp's gait as a lesson in the way an industrial economy altered time and motion, Chaplin himself flinched from the ritualized haste of shoe-shine boys, bartenders or soda jerks, whose jobs turned them into high-speed robots.

The technological impatience of modernity – the cult which Musil called accelerism – alarmed Chaplin. Explaining his dislike of Mack Sennett's motorized farces, he said 'I hated chase. It dissipates one's personality.' He was paraphrasing that fatal second law of thermodynamics which underlay the despair of Spengler. Chase dissipates energy, and therefore unmakes the man who has so carefully assembled a personality for himself. It threatens him with loss of his hat, his cane and his stoical composure. Monsieur Verdoux, Chaplin's wise and almost mystically serene serial killer, sighs from his domestic retirement about 'this monoxide world of speed and confusion'.

This meant that Chaplin had an ambiguous attitude towards the tempo of film, which quickens life to match the speed of projection. In 1957 Paul Morand succinctly defined film as 'un art de vitesse', obedient to 'le dieu de l'ère nouvelle'. Louis Aragon commented on the dervish-like agitation of Pearl White in her silent films, and remarked that she frenetically sped through life because that was the way a modern young person behaved: 'elle agit pour agir'. For Chaplin, that was not a sufficient reason for action. He understood, as he put it, that 'time-saving in films is still the basic virtue. Both Eisenstein and Griffith knew it. Quick cutting and dissolving from one scene to another are the dynamics of film technique.' Montage enabled the director to abbreviate both time and space. Chaplin, however, chose not to make use of those technical powers.

Modern Times was his protest, like Dalí's molten watch, against the dictatorial punctuality of modern time. Working as a night watchman in the department store, he leaves Paulette Goddard at rest in the bed department, a timeless zone, and trudges off to punch his time clock. Restored to his job at the mill, he places the mechanic's fob watch under a compressor, which descends to flatten it. 'My family heirloom ruined!' wails the owner. His comic inventions assert time's subjectivity: he reserves the right to take his own good time. In *The Pawnshop* he dismantles the clock, plays an endlessly resourceful series of games with its parts, douses them with oil, and pours them into the owner's hat rather than cramming them back inside their metal case. Because the tramp is going nowhere, he occupies himself in whiling time away; his great triumph is to make it stop.

The constitution of physical space also seemed manifestly absurd to Chaplin. Commenting on his first stage role as a child actor, he said that 'only mechanics bothered me'. When he had to make tea on stage, he could never remember whether to put the tea or the hot water in the pot first. The mechanistic drill of cause and effect continued to bother him. Why does gravity persecute us, forcing us to expend so much energy just in maintaining equilibrium? In *The Gold Rush*, the unmoored cabin sits poised on the edge of the abyss, balanced on a fulcrum. Inside, while it rocks precariously, Chaplin has to rush back and forth

Modern Times
(1936)

to keep it balanced. The sequence is hilarious to the point of exhaustion, and the exhaustion is mental because, like Einstein's laws, it forces us to contemplate the mad whimsicality of nature's arrangements. In *The Great Dictator* the barber finds himself flying upside-down in an open plane. He observes with wonderment the way objects flout gravity. A fob watch leaves his pocket and suspends itself in the air, as if its anchoring chain were a pedestal. When he uncaps his canteen, a spout of water flies upwards like a fountain. One of Hynkel's charmed despotic powers is his apparent immunity to gravity. Before his dance with the globe, he shins up the curtains, capering in mid-air.

Chaplin's single sets represented his notion of space as a prison: a place, like Sartre's hell, from which there is no exit. Again he denied himself those dynamics which are the cinema's special liberties. Film enabled directors to open out what Meyerhold called the 'detested rectangle' of the stage, with its immutable proscenium. But Chaplin made comedies about bodies trapped, as we all are, in boxes. *The Gold Rush* asks how you can survive while snow-bound in a single room. What do you eat – the dog? your shoes? your room-mate? In *The Pilgrim*, Chaplin plays a convict on the lam disguised in the stolen clothes of a priest. He keeps on imagining he is still in jail, which, one way or another, he is. When buying a train ticket, he grips the grille like the bars of a cell; in church, he sees the twelve choir members in their stalls as a jury, and when given the Bible he raises his hand to swear an oath. The most cramping prison of all is a parlour, with its penitential gentility.

Time, when the tramp is under attack, camouflages itself as space, in a baffled trial of Einstein's theory which had equated the two dimensions. In

Shoulder Arms, Chaplin wills himself to become a tree, in *The Circus* he hides from
the police by stiffly impersonating a puppet, in *City Lights* he goes to sleep in the
rigid embrace of a statue. But space offers no safe haven, because the tree starts
to walk, the puppet flexes, the statue wakes up. The temporal continuum must be
resumed. Although Chaplin battles valiantly against them, both time and space
are immutable. He refuses the quick cuts of montage; the conditions of physical
existence are only waived, as Freud pointed out, in dreams, which is why the
tramp spends so much time unconscious – relishing a heaven where even dogs
have wings in *The Kid*, romping through a more pagan paradise in *Sunnyside*.

Chaplin's comedy sympathized with our physical predicament, doomed
to exist in these contrary, warping dimensions. It also acknowledged the social
and political nature of our suffering, in a society run at the behest of machines.
The Dadaist Hans Richter, writing in the late 1930s, praised Chaplin for his
technological acting, which demonstrated that the body consists of 'levers,
weights and pivots (like the camera)'. Yet, far from seeking to arrive at 'harmony
with the apparatus', Chaplin was protesting against it, attempting to rescue the
human being from reduction to an apparatchik.

This is the subject of *Modern Times*. The factory appraises men as produc-
tive gadgets, and experiments with ways of increasing their productivity. Hence
the feeding-machine, which usurps bodily functions and economically abridges
lunch-hours. The principle is that of the harrow in Kafka's story about the penal
settlement, as Chaplin discovers when the sweetcorn which he is being force-fed
goes berserk. His automated meal merely fattens him for the cannibalistic
machine. A fan belt sucks him in like a tongue, and he circulates through a gullet
of grinding cogs. Regurgitated, he scampers after a secretary, again like Nijin-
sky's faun – but this charge of erotic energy is not his own, and has come from
the electricity inside the machine. Later he goes on a rampage at the controls,
causing the turbines to seethe, crackle and combust: both he and they suffer a
nervous breakdown.

He has been maddened by the repetitions of the assembly line. He spends
his day there tightening nuts, always with the same quick, mannered motion. But
when he stops working, he can't get rid of this mechanical jerk, and continues to
brandish a non-existent spanner. This is one of Chaplin's funniest and most
alarming jokes; it is also a parable about the fate of the body in the twentieth
century, and the drastic new theory of comedy devised to account for it. Henri
Bergson thought that comedy derived from 'raideur', rigidity. A man slipping on
a banana-skin has lost his proud uprightness, and is now no more than a dead
weight, toppled by gravity. But the banana-skin was accidental: what happens
when rigidity becomes compulsory, enforced by social and economic decrees?
Bergson considered repetition ludicrous, because 'what is living should never
…be repeated exactly the same'. Yet the conditions of factory work legislate
against unsynchronized individual quirks, and the workers are prevented from
laughing at their own reduction to gadgets. Such regimentation leads logically to

the prison camp in *The Great Dictator*, where the inept, shuffling barber spends the day learning to goose-step. Here indeed is Bergson's 'mécanisation de la vie', coinciding with that metallization of the world which Hitler promised.

Eisenstein called *Modern Times* a contemporary tragedy. The tragedy was that modern times were no longer funny. *The Great Dictator* tried to mock Hitler, as if he were one of the street-corner toughs to whom the tramp administers a sneaky, surreptitious kick. Chaplin deployed the cheeky arsenal of comedy, calling Hynkel the Fooey not the Führer, tripping him up as he strides downstairs, tricking him with an overdose of hot English mustard. Freud in his study of jokes paid tribute to Bergson's 'discovery of psychical automatism'. Chaplin shared this perception, which is why he derided the attitudinizing of Hitler when he first saw photographs of him: 'the salute with the hand thrown back over the shoulder, the palm upward, made me want to put a tray of dirty dishes on it'. This was a brilliant joke, but a helpless, self-defeating one. To caricature Hitler as a waiter did not diminish or disarm him. Comedy appeals to a shared admission of human frailty and irregularity; it has no power over those who have forsworn humanity. Machines lack a sense of humour. When the jokes rebounded, Chaplin put his trust in a sentimental miracle. The barber assumes the dictator's identity and converts him to pacifism. In his final sermon he chides mankind for its petty quarrels, assuring his followers that there is no need for hatred because the earth is rich and can support us all. Such benedictions have no power to banish scarcity. Nor does the barber succeed in cajoling machines to grow souls as a supplement to their motors. 'The aeroplane', he says, 'cries out for the goodness in men.' On the contrary, the aeroplane cannot tell the difference between good

The Great
Dictator
(1940)

and evil, and sees men as specks of dust, or as targets. In the Abyssinian war of 1935–6, Mussolini's son bombed some Galla tribesmen, and reported on the mission with an anaesthetized detachment which he had learned from the machine he piloted: 'I dropped an aerial torpedo right in the centre, and the group opened up just like a flowering rose.'

The gospel was ineffectual and also perhaps dishonest. Chaplin's double role in *The Great Dictator* hints that the demagogue is resident within the little man, whose grudges he articulates. The docile, sweet-natured barber may have been a mask worn by the despot, just as Hitler allegedly adopted Chaplin's moustache as an endearing camouflage. Comedy is ruthless. An inventor invites Hynkel to test a new and impermeable bullet-proof vest which he is wearing. Hynkel shoots him, and the inventor drops dead. The incident is funny because – like the nonchalant Hynkel, who shrugs – we do not care. In *The Idle Class*, there is a chilling moment when Chaplin reveals the nullified face of the comedian, who counterfeits emotions and sports a painted smile. The dissolute husband opens a letter from his wife, who announces that she is moving out until he gives up liquor. He turns away, his shoulders heaving, his body quaking. But he is not hiding his face in order to sob. When he turns back towards us, we see the reason for the agitation. He is vigorously shaking a cocktail for himself; his face remains frozen, indifferent.

This anticipates the moral shock of *Monsieur Verdoux*, when Chaplin looked back impassively at the world and warned that he no longer felt disposed to ransom it. Here there was no double role to serve as a diversion or an extenuation: Chaplin, refusing to be likeable, played a murderer whose crimes simply carried out official capitalist policies, profiting – on a modest scale, because Verdoux does not kill enough people to be acclaimed as a national hero – from the modern massacre of humanity. Nor was sentimentality allowed to make special pleas on his behalf. Verdoux likes kittens, and delicately spares a caterpillar which gets in the way of his shears as he clips roses; he is less concerned about his latest wife, whose remains are being smokily puffed out by his backyard incinerator.

Monsieur Verdoux reconsidered the historical convulsions which Chaplin treated in *The Great Dictator*. Verdoux loses his job at the bank in 1930. Having been declared expendable by society, he sets up in business on his own, liquidating rich women. By the time he is executed in 1937, newspaper headlines report on economic collapse, social upheaval and military adventures: NAZIS BOMB SPANISH LOYALISTS. The hungry girl on whom he chooses not to try out his poison acquires a munitions manufacturer as her protector. It is an even better proposition than murder, and enjoys official approval. 'It'll be paying big dividends soon', she prophesies. Hitler and Mussolini even have walk-ons, though now they play themselves in newsreel footage: in 1947 Chaplin recognized that his teasing of Adenoid Hynkel and Benzino Napaloni had missed the mark. Caricature is now inappropriate, because the film can discern no moral difference between the two sides in the conflict, which means that the victors have no reason

to feel superior. Accepting the sentence of death with his usual glazed neutrality, Verdoux refuses to affect penitence. 'As for being a mass killer,' he politely enquires, 'does not society encourage it?'

During a panic on the stock market, Verdoux telephones his brokers (who are busy committing suicide) and orders them to sell. It's too late, he is told: 'you were wiped out hours ago'. They might be advising him of his own death, since a man with no financial assets has no right to life. In fact Chaplin comports himself throughout the film like a wistful, white-faced ghost. Before his wedding to the last of his wives, he is asked how he feels. His reply is curious. He chooses his words carefully, and repeats them: 'Very abstract. Very abstract.' This is his considered verdict on the dehumanizing tendency of modern times in politics and warfare, in art and in personal conduct. Why pretend that you are an individual, when society considers you to be a number, or perhaps a zero? Why bother about your emotions as a sentient subject or your duties as a moral agent when such unquantifiable concerns have been declared obsolete? In 1930, day-dreaming about the film in which he hoped to play Christ, Chaplin absolved Pilate of responsibility for the crucifixion. While Pilate was deliberating on the case, 'some idiot in the crowd' – Chaplin surmised – yelled out that suggestion. 'Mass psychology had triumphed', he concluded.

The world did not forgive Chaplin for telling it these truths. His doting American public turned against him, and paranoia – after his return to Europe – now goaded him to believe in the healing powers which admirers once attributed to him. In *Limelight*, released in 1952, Calvero cures a young dancer's paralysis with his inspirational lectures. Discovering that her problem is psychological, he murmurs 'Ah, Doctor Freud': a remarkably prescient comment for the drunk and debilitated clown to make, especially since the film is set in 1914! Then in 1957, when he made *A King in New York*, Chaplin punished unworthy America by refusing to save its soul. The king he plays, deposed by war-mongers, brings to New York a prescription for the peaceful use of atomic energy, which will establish Utopia. Dismayed by America's commercial hucksterism and political intolerance, he takes the secret back to Europe. Another god had failed – or abdicated in disgust.

THE AGE OF LIGHT

Chaplin, representing modern man, made himself manifest in an art specially adapted to the nature of modernity. Film seemed to have combined and superseded all the other arts. In 1914 George Bernard Shaw described it – with a woebegone grimace, since he remained a faithful legatee of the Gutenberg era – as an invention which would eventually prove more significant than that of print. Silent film claimed indeed to have rescued us from the babble of divergent tongues, institutionalized by the printing press. Abel Gance's *Napoléon* likens a besieged town to the tower of Babel: trapped deputations chatter in English, Spanish and Italian, while Napoléon himself, certain of success, remains calmly silent. In *Intolerance*, D.W. Griffith condemns 'the greatest treason in history' when the priests of Bel, conspiring against Babylon, cause the loss of cuneiform, a universal written language. Film, for Griffith, was its retrieval, dealing in images not words.

This creed was promulgated by the oracular critic Vachel Lindsay in 1915. Like Griffith, Lindsay described film as an arcane art: using technology to satisfy primitive 'spirit-hungers', it conjured up a picture-alphabet of speaking looks and mute rhetoric, destined to be read by the new social class of urban cave-men. Rather than cuneiform, Lindsay's analogy for this occult idiom was the hieroglyphics of the Egyptians. He likened the reels of film to the 'mighty judgement roll' encoded by scribes in the Book of the Dead, and thought that films, like those papyrus inscriptions, might be able to narrate our passage through the hereafter. The habit of movie-going turned Americans into contemporaries of the ancient, yearningly superstitious Egyptians: 'here is a nation, America, going for dreams into caves as shadowy as the tomb of Queen Thi.' The camera performed miracles, making visible 'the unseen powers of the air'. A god who had been officially declared defunct glimmered into a second incarnation on celluloid in Cecil B. De Mille's *King of Kings*. Although the priests in *Intolerance* betrayed mankind, the cinema replaced these disgraced spiritual leaders with a new élite of grand viziers. Lindsay called film-makers 'prophet-wizards',

free-lance adventurers in 'the soul-world' who were able to make thoughts materialize as pictures. 'Transubstantiation must begin', he ordered. Thanks to these technological magicians, both men and machines would once more be able to see visions.

These mystical transports were meant to be seen and not heard; in those early days, silence was one of film's spiritual credentials, not a technical deficiency. In Carl Theodor Dreyer's *La Passion de Jeanne d'Arc*, the tortured saint is shown a forged letter from the king. 'I cannot read', she indignantly replies. Her denial is mute: it is a silent film. Neither can she write, and an inquisitor guides her hand when she is coerced into signing the bogus confession. Grace, like film, is beyond verbiage. In Eisenstein's *The General Line*, writing is the parasitical occupation of bureaucrats, the enemies of action. They spend their time sharpening pencils, messily splashing their pens in ink-wells. The potentate who turns down the dairy co-op's request for a tractor signs his letter with vainglorious floridity, and solemnly affixes an official stamp. Paper, which betrays Dreyer's Jeanne d'Arc, obstructs the peasants. Eisenstein's silent films were unable to record what the people in them said. But for this very reason, they could tell the people who saw them what to think and say. Intertitles, like the living newspapers of the early Soviet era, served as a communal bulletin board, dictating messages in loud capital letters. As the farmers in *The General Line* watch their gleaming separator transform milk into butter, the titles blurt out their dumbfounded reaction:

<div align="center">

IT'S THICKENING

OR

IS IT?

</div>

When the miracle occurs, the titles rally a rejoicing chorus:

<div align="center">

IT'S THICKENED!

THICKENED!!

</div>

A fountain of milk spurts up, followed by a parade of numerals – 29 38 43 50 – as farmers flock to join the co-op. The concerted speech of the titles bolsters and amplifies the impotent individual voice.

Microphones threatened the silent understanding extolled by Griffith in Babylon and embodied by Dreyer's saint. Sound introduced a disputatious jabbering into paradise. In Christopher Isherwood's novel *Prater Violet*, a director based on Berthold Viertel denounces mike-shadow as 'the Original Sin of the Talking Pictures'. The microphone itself sometimes sneaked into the visual field and hovered there, as Isherwood put it, as balefully as the raven in Poe's poem.

Film, speeding through the projector at the rate of twenty-four frames a second, flickered like the sanctifying flames of Dreyer's pyre, or accelerated to match the pace of Soviet progress. Blaise Cendrars in 1917 rousingly argued in his *L'ABC du cinéma* that war, revolution and the relativity theory had altered the human spirit. These combined convulsions had given birth to a new race of men whose language, Cendrars prophesied, would be the cinema. Their minds already resembled a film. Henri Bergson in 1911 explained his notion of creative

evolution by pointing out that reality is not stable: it exists in flux, a condition of transience and perhaps of transit. In 1944 Gertrude Stein reflected on the jittery mood in provincial France, as the villagers waited for the Allies to reach Paris. 'Everyone is waiting', she wrote, 'they say it goes so fast it makes them feel as if they were at a cinema'. Anticipation resembled a film when speeded up.

Consciousness adopted the same brisk and variable cinematic tempo. 'The mechanism of our usual awareness', Bergson claimed, 'is in its nature cine-matographic.' Hence the impatient impressionism of a mind walking down the street of a modern city, assailed – in Virginia Woolf's phrase – by 'innumerable atoms'. Thought does not proceed logically or consequentially; it jumps, frisks and strays, like images on a reel of film. 'I am like a film-strip', George Grosz remarked. He wondered who was cranking the handle, making him incons-equentially notice the objects which hurtled across his field of vision. The novelist Lawrence Durrell in his *Alexandria Quartet* questioned whether identity was any-thing more than a cinematic illusion. Do people exist continuously and consis-tently, or do they merely give the appearance of it by repeating themselves, like 'the temporal flicker of old silent film'?

The director in *Prater Violet* defines the new art by recalling the shuttling of celluloid on the projector's wheel. He likens film to a time-bomb, unstoppably counting down to an explosion: 'Once it is ignited and set in motion it revolves with an enormous dynamism.' It rushes ahead at its own pace, never going back to apologize or explain, forcing you to keep up. It is as if the Prater wheel which grinds through its circuit so slowly in *The Third Man* had run out of control, or spun itself into a frenzy like the psychotic carousel in Hitchcock's *Strangers on a Train*. The director Howard Hawks preferred subjects which emphasized action: the dare-devilry of fliers in *The Dawn Patrol* or *Ceiling Zero*, the furious pursuit of a story by fast-talking journalists in *His Girl Friday*, the capture of a marauding rhino in *Hatari!* These sequences conveyed the urgency of modern life, and in doing so propounded the credo of cinema. As Hawks said, 'To stay alive or die: that is our greatest drama.' But what if you happened not to be a sporty existen-tialist, elated by risk like Hawks and his hunting buddy Hemingway? In Yukio Mishima's novel *Forbidden Colours*, Nobutaka and Yuichi go to see a film. Their purpose is 'to kill time'; instead they see a reminder that time will kill them. The film is a Western, featuring the usual inane shoot-outs and pointless chases through a prickly desert beneath 'tragic clouds'. The tragedy is epistemological. 'With mouths slightly open, the two men looked aghast at this world of undeni-able action.' They have stopped moving in order to watch. The filmed reality meanwhile speeds headlong towards disintegration.

If modern men thought cinematically, as Bergson argued, then what they thought about was also cinematically disjunct. Ludwig Meidner, advising painters in 1914 on how they should deal with the metropolis, said that a street is not composed of 'tonal values': we see it as spasmodic flashes, mobilized by light which 'hacks things to pieces'. That is how film worked, breaking the world down

into frames which no longer had any necessary connection and could be spliced together in any order which pleased the free-associating mind. The Soviet director Lev Kuleshov remarked that 'The cinema consists of fragments and the assembly of those fragments…which in reality are distinct'. Its natural state, like that of the mind, is chaotic. In 1923 Ronald Firbank published a comic novel called *The Flower Beneath the Foot*, suggested by an Algerian sojourn during which he had seen Theda Bara vamping on film as Cleopatra. In the North African state of Pisuerga, Laura Lita Carmen Étoile de Nazianai is a maid of honour, charged with reading to the queen. Her employer wonders at her pace, and asks where she learned to read so fast. Laura replies 'On the screens at Cinemas'. The queen is scandalized. Film, however, taught a new kind of literacy, and did so very quickly. It dispensed with alphabets and spelling bees, and catered to the darting promiscuity of the eyes. It administered lessons in reading faces, rather than simply listening to the words (mostly false) which issued from their mouths.

We have grown accustomed to this blitz of images, which dance both in front of the eyes and behind them. Earlier in the century it seemed distinctly alarming: another portent of the overnight change in human character. Thomas Mann's tubercular patients in *The Magic Mountain* are disconcerted by their visit to the Bioscope. They feel themselves cast adrift in time and space. An exotic historical melodrama on the screen is accompanied by a tawdry, choppy piano accompaniment in the pit. Is the live pianist giving orders to the dead shadows, which move when he bangs the keys? And how is it that the 'actual tempo' of his playing can overlap with the film's dressed-up past? Watching a newsreel, they are exhaustingly hustled across the continents, as if by a whirlwind: 'space was annihilated'. The frenetic rhythm of the projection broke down the familiar world into 'millions of pictures, each with the shortest possible period of focus'.

These mind-bending conundrums warned them that the earth was now a different place. Film, matching the jerky, nervous movement of consciousness, also duplicated the infirm, unfounded structure of nature. It shows Mann's characters 'life chopped into small sections': it works, that is, by atomizing. The new physics had demonstrated the infinite divisibility of matter, proving that there is no such thing as an a-tom, a particle which cannot be broken down into something smaller. Béla Balázs analysed the way that the Soviet documentary filmmaker Dziga Vertov edited his work by referring to the 'molecules of life' – snapshots of people at home, in the streets, at work – which he scrambled and later spliced together, as if forming shaky aggregates like H_2O or CO_2, or organizing musical notes into a dodecaphonic row.

This was a uniquely modern mode of vision. It assumed the inherent disorder of things, and saw order as a human pretence. That assiduous but makeshift fiction was the technique which film-makers called montage; the equivalent habit of the cubists was collage. Both practices testified to what Balázs in his discussion of cinematic editing called 'the power of the scissors'. Tristan Tzara's recipe for making a Dada poem relied on the same utensil, as did Ezra

Pound's ruthless editing of Eliot's *The Waste Land*: Pound excised links and causal connections between the episodes, leaving quotes and anecdotes and urban snapshots to confront each other. Karl Kraus, who announced in February 1915 that he had become 'a simple newspaper reader', used scissors and paste to demonstrate the schizophrenia of contemporary history. He excerpted in his magazine *Der Fackel* two parallel columns from the same day's paper. One described a battalion gloriously shredded by enemy guns, with limbs blasted off, heads mislaid, corpses stockpiled; the other commemorated the grand opening of the Kaiser Wilhelm Café in Vienna, all smarmy cosiness, cheery flowers and scintillating chandeliers, with local dignitaries gorging on snacks or slumping at the bar. Editorial comment was irrelevant. Juxtaposing the columns, Kraus permitted them to incriminate each other.

A sliced, sutured world seemed somehow cleaner. Its edges were clear, even if jagged. It recognized that all structures were provisional, but knew that nature could not be relied on to hold things together. The film editor in *Prater Violet* brandishes the scissors at Isherwood and sneers about the sloppy, shapeless organic form favoured by nineteenth-century romantics: 'We need technicians. Thank God I'm a cutter.... I don't treat film as if it were a bit of my intestine.' Ortega y Gasset had conservative qualms about this modern world-view, exemplified alike by physics and films. In 1931 he objected that 'physics, which began by being *mechanics* and then became *dynamics*, tends in Einstein to be converted into mere *cinematics*'. Relativity theory, he thought, had suppressed causality; now nature unreeled in a purposeless flurry, at whimsically inconsistent tempi. Another painful reminder of our estrangement emerged from the disjunctions of cinematic editing. The gigantic close-ups of Hollywood cinematography worried Renoir because – like the interior monologues of modern novelists – they were technical symptoms of a contemporary mental ailment, 'the isolation of the individual'. Two people exchanging intimate endearments in a love scene actually have to be placed far apart. The camera, determining the best angles and switching its point of view from one to the other, insists on their alienation.

A cameraman in *Medium Cool*, Haskell Wexler's semi-documentary film about the 1968 riots in Chicago, argues that film inevitably prefers dynamics to statics, and is thus predisposed towards violence. Nobody, he points out, wants to look at someone who is sitting down. A battle is much more cinematic than a peace conference. Film can do no more than watch how people behave. They have to move, because they are in a motion picture; their motives for doing so are anyone's guess. In Antonioni's *La notte*, two married people wake up one morning and find, to their own surprise and dismay, that they are no longer in love. Antonioni, asked to account for the lapse, blamed the universe: 'We live in an age where nothing is stable any more. Even physics has become metaphysical.' Or, to take up Ortega's point, it had become cinematic. Jeanne Moreau in *La notte* goes for a protracted, purposeless walk through Milan. Nothing of significance happens; only in a film could the random episode be so compelling and revealing.

The camera has captured the haphazard zigzagging of a molecule or particle. Through the lens, Moreau's itinerary looks like a case study of Brownian motion – the account of how dust particles behaved, agitated and pointless, which Einstein absorbed into his kinetic theory of matter. She arrives eventually at the periphery, where the city relapses into the country. It is as if she has ventured to the edge of the known universe. Looking across the border, she sees nature in its original chaotic, unconstructed state.

With less anxiety, Jean-Luc Godard and the film-makers of the French *nouvelle vague* used a jerky hand-held camera and quick editorial cuts to create a modish sense of what existence actually felt like: its levity and tenuousness, its uneven tempo and its uncontrollable flux. The picaresque adventures of Jean-Paul Belmondo in Godard's *Pierrot le fou* recapitulate the undirected walk of Moreau in *La notte*. 'The important thing', Godard emphasized, 'is to be aware that one exists.' We survive by forgetting this. The visual shocks of film oblige us to become self-conscious about our chancy relation to an equally fortuitous world.

The cinema, for good or ill, was a model of the new world described by science. Eisenstein in 1929 quoted Einstein's defensive comment about occult terrors of 'four-dimensional space-time', and proposed the cinema as the medium in which men could learn how to feel at home in this renovated universe. Soon, he predicted, film-makers would announce their arrival at a fifth dimension. The critic André Levinson remarked in the same year that the crank used by camera-men and projectionists was 'the greatest philosophical surprise since Kant', because it compelled 'the two categories in terms of which we consider the universe' to change places. Space became time when the static frames of film began to move; the fluid motion of time, projected onto a screen, now occupied space. Abel Gance welcomed the fusion of time and space as a sign of mental supremacy. He wished to fill 'every fraction of a second' in his films with 'that strange sensation of four-dimensional omnipresence cancelling time and space'. The conqueror enjoys this omniscience in Gance's *Napoléon*, thanks to a triptych of overlapping screens which gives him the capacity to see around corners.

Buñuel translated the quirks of physics into a charter of surreal liberties. In film, he said, 'time and space become flexible, contracting or expanding at

The conquest of Italy in Abel Gance's Napoléon *(1927)*

will'. At the beginning of *L'Age d'or*, some Majorcan bishops who celebrate Mass on a rocky shore suddenly crumble into dressed-up skeletons: a visual curse hastens the long-drawn-out process of decay. In *Un Chien andalou*, on which Buñuel and Dalí collaborated in 1928, ants crawling across a man's hand dissolve into the thicket of hair in a woman's arm-pit, then into a spindly sea-urchin. Next the infested hand, now amputated, turns up on its own in the street. The ants and the pubic hair are symptoms of sexual disgust. The sea-urchin defends itself by bristling, but its show of aggression is too weak. The chopped-off hand testifies that a castration has taken place. Objects lose their singularity in space, but editing creates magical, devious affinities between these unlike things. Camera angles made it possible to subject matter to a testing, torturing inquisition. Early filmgoers often recoiled from close-ups of a face, as if they were looking at a severed head. Buñuel liked zoom shots, because they suggested that the objects which the camera moved in on were distending, and might possibly explode.

Film-making is discontinuous. A story, atomized into separate scenes, is never photographed consecutively, and adjoining locations can be on different continents. Montage covers up the cracks. These working habits, adopted for industrial convenience, unconsciously imitate the jumbled chronology of modern literary narrative and the dismantled, rearranged facets of modern painting. Film can elide time, and abridge space. In Stanley Kubrick's *2001: A Space Odyssey*, one of our simian ancestors, battering an animal carcass in a torrid prehistoric waste, hurls a bone into the air; a jump-cut instantly transforms the weapon, across the gulf of a few million years, into an orbiting spaceship, ethereally gliding to the sound of a Johann Strauss waltz. At the end of the film, the astronaut played by Keir Dullea speeds through the ages of man, his face desiccating and cracking as we watch. Then time goes into reverse and he is reborn, sent back to earth as a child destined to toil through the same odyssey all over again. Geography is equally mutable. Michael Powell and Emeric Pressburger mocked up the Himalayas in suburban London for *Black Narcissus*. Editorial scissors have long legs. In Orson Welles's *Othello*, Iago walks out of a church on the Venetian lagoon and directly into a cistern situated in Morocco. The Hollywood studios maintained their own global villages – those back-lots where Fifth Avenue abutted on Montmartre or a dusty Western town with its saloons and hitching-posts had a patch of Tarzan's jungle in its backyard.

Film required a new mental elasticity of its viewers, who had to keep up as it sprinted backwards and forwards in time and vaulted through space. When *Intolerance* was first shown in Russia in 1921, people were puzzled by its alternation between different stories, set in Babylon, Jerusalem, sixteenth-century France and contemporary America; some audiences heckled the projectionist, believing he had muddled up the reels. The film was their crash course in thinking and seeing relativistically.

Aragon, admiring the antics of Pearl White, observed that 'with the cinema, speed made its appearance in life'. It was a symptom of the acceleration

which had overtaken modern existence. Paul Claudel in 1928 pointed out that 'the car and the cinema are similar in principle'. In a car, we charge through motionless nature; trees and buildings are cyclonically uprooted and discarded as we whirl past. In the cinema, we sit still and watch as those volatile objects have their revenge, bearing down on us like the train in that early film by the Lumière brothers which sent viewers fleeing in panic as it pulled into the station. The propulsiveness of the medium recommended it to Lenin, who said for the Bolsheviks 'film is the most important art', and Stalin in 1927 welcomed it as 'the greatest medium of mass agitation'. The agitprop trains Lenin dispatched across the country were themselves moving pictures, the carriages painted with revolutionary caricatures. The addition of motion to pictures allowed the director Jean Renoir to enjoy a small Oedipal victory over his father. In his early film *Partie de campagne* he posed the picnicking characters in tableaux modelled on Auguste Renoir's paintings; then – gleefully pushing a swing, or hurling open a window to watch the wind as it playfully bent the trees – he brought them to life. Vincente Minnelli mobilized an entire gallery of paintings in the final ballet of *An American in Paris*, which proceeds from Dufy's Place de la Concorde to the Pont Neuf as painted by Renoir, wandering on through Utrillo's Montmartre to reach a street carnival which might have been painted by Douanier Rousseau. In all cases, the pictures exuberantly dance out of their frames.

In a film, immobility is either a joke or a curse. In René Clair's *Paris qui dort*, a ray-gun stalls the city in its tracks like a still photograph. A man about to jump into the Seine brandishes a suicide note blaming the hectic pace of metropolitan life for his distraction. Yet he has been frozen on the brink, suffering paralysis – a fate worse than the haste which has deranged him. To pull the plug is a last judgment: it stops the film, and all other machines. In Robert Wise's science-fiction parable *The Day the Earth Stood Still*, an alien sage descends in a spaceship to warn mankind against its self-destructive ways, and switches off every engine in the world as a demonstration of his power.

Because the cinema is about mobility, it soon invented its own indigenous, indispensable narrative form: the chase. Chases allowed the cinema to devise a syntax for itself. What other medium could give people so much space to race through, or could cross-cut so rapidly between unsynchronized tempi? The chase is also the motor of historical progress. In *The General Line*, a tractor frolics away with a cavalcade of captive wagons attached to it; the kulaks, rendered obsolete by technology, ludicrously pursue it on horseback. In Griffith's *The Birth of a Nation* the Ku Klux Klan gallops to rescue sweet Lillian Gish from an enforced match with a mulatto lecher; *Intolerance* concludes with two parallel chases – a chariot pursued by foot soldiers in Babylon and a locomotive tracked by a racing-car in America, one on its way to save a city, the other to halt an execution.

We go on compulsively watching – as Hitchcock proved in *North by Northwest*, where the chase proceeds by car, train, crop-dusting plane and (failing all

else) on foot – whether or not we know who the pursuers are or what they want from the man they are hounding; it does not matter if the destination of all concerned is a non-existent point on the compass. The nonsensical story of Hitchcock's thriller is an exercise in that 'lyricism of chance' which for Aragon was the surreal charm of the cinema. All we require is that the bright, hyper-active shadows should not stop running. Logically enough, now that the defunct studios have turned their back-lots into amusement parks, films are extended into roller-coaster rides. At Universal Studios in Los Angeles, you can travel through Steven Spielberg's *Jurassic Park* and joust with audio-animatronic dinosaurs from the safety of a carriage which is a cinema-seat on wheels. The experience sums up the peculiar contradictions of life in the twentieth century: prehistory can be revisited, thanks to the latest technology.

'I am in constant movement' said Dziga Vertov, speaking on behalf of the cinematic eye. He enumerated the acrobatic feats which the machine had taught him to perform: 'I approach and draw away from objects, I crawl under them.' The camera could roll over on its back like a happy dog, or soar aloft in an aeroplane. Since Vertov's time, it has developed even more outlandish skills. The Steadicam, strapped to the operator's body, is effectively weightless, suspended groundlessly in space like the notional observer envisaged by Einstein; its invention during the 1970s permitted Kubrick to circle deliriously around the corridors of the deserted hotel in *The Shining*, or to follow Jack Nicholson through the foggy involutions of the maze. Why stop there? In Andrei Tarkovsky's *Andrei Rublev*, the peasant Efim takes off from a belfry in an improvised balloon and goes for a meandering visionary flight across the steppes. The cinema enables us to abstract ourselves from the earth on which men in earlier centuries were grounded. With its aid, as Claudel predicted, we can 'take a walk in the cosmos'.

A character in Wells's *In the Days of the Comet*, remarking on the sudden transformation of a modernized world, refers to 'the great age of Reason and Light that has come', sponsored by the comet's advent. Man Ray in 1934 called modern times 'the age of light', a period of solar health and sensual freedom. Buildings lost their inhibitions and exposed their insides to the invigorating air, like the De La Warr Pavilion which Erich Mendelsohn and Serge Chermayeff constructed at Bexhill-on-Sea in 1935. D.H. Lawrence made propaganda for paganism in a story called 'Sun', about a woman whose neurotic ailments are cauterized by sunbathing. During her visit to Russia in 1930, Margaret Bourke-White toured a rest home for locomotive workers on the Black Sea, and noted that the regime was 'hygiene mad', promoting the virtues of vitamins and sun-baths. In 1932 Niels Bohr, addressing a medical conference in Copenhagen on the therapeutic powers of light, paid homage to 'this beautiful branch of science' and gratefully acknowledged light as the scientist's 'principal tool of observation'. The physics of Bohr even managed to incorporate the health-giving physicality of Lawrence's sun: he defined light as the 'transmission of energy between material

bodies'. Mikhail Larionov, an exponent of 'luchizm' or rayism, also set out to paint the light given off by objects, which he described – more spiritually than carnally – as their aura or halo.

The enlightened gospel of the day was proclaimed by the camera. Images captured on film, Man Ray thought, were 'oxidized residues, fixed by light and chemical elements, of living organisms'. They possessed a surrogate immortality, since they continued to transmit a light which once beamed from the thing photographed; they were 'the undisturbed ashes of an object consumed by flames'. An athletic male nude photographed by Man Ray

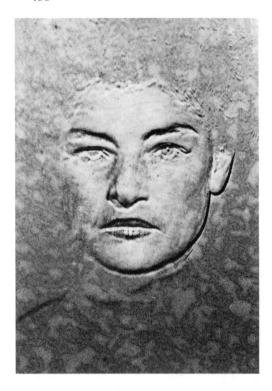

Man Ray's solarized Portrait of Ju[l] *(1954)*

shows what he meant. The technique which he called solarization inflames the man's body. But a light this bright must conceal a corresponding darkness. While we watch, the figure goes into shadow, succumbing to eclipse; the living organism scorches, leaving an ashen deposit behind. Sunbathing at Carmel in 1924, the photographer Edward Weston overexposed himself as if his skin were film: 'What a glorious sensation! – the sun penetrates right through me…until every pore is open and every nerve tingles with joy.' Tanning is a process of photographic development, a lesson in the photosensitivity of the epidermis. Duchamp described the longed-for, unattainable orgasm of the bride in his *Large Glass* as the halation of desire. Pleasure irradiates her, he said, and induces a 'cinematic blossoming'.

As a photographer, Bourke-White was a functionary of light, which made her, as she thought, an emissary of enlightenment. In Russia, she imitated the swift, imperious operation of electricity, the force which was meant to modernize the country. Her interpreter remarked that 'when she works, she is the lightning'. When Bourke-White photographed the steel works at Stalingrad, the light she ordained – which flooded the cavernous factory at the flick of a switch – competed with the combustible glare from the furnace. In managing this experiment, she upheld the camera as an evolutionary challenge to the human eye. That dim organ could not read 'the long light range' between the metal's 'living whiteness' and black, clotted shadow. Her own scientific placement of her lamps, and her

expert funnelling-down of tonal values, looked ahead to a future when men would have overcome their bodily limitations.

Light, like the sun in D.H. Lawrence's story, had a redemptive power. A photographer could now make decisions which used to be a divine prerogative, choosing to reward some unregarded person with an aureole. The miracle extended even to kitchen utensils. 'Take an aluminium saucepan', Léger suggested in 1926. 'Let shafts of light play upon it from all angles – penetrating and transforming it. Present it on screen in a close-up – it will interest the public.' Photography made the earth in the twentieth century look different, by taking pictures of things which had never been so reverently or radiantly observed before. A polished pepper photographed by Edward Weston resembles a precious gemstone, and a wash-basin, with a cheap metal pan propped up behind the pipes, might be a shrine. Léger considered that 'light animates the most inanimate object and gives it cinematographic value'. In 1929 Fritz Lang made a film about space travel, *Die Frau im Mond*. The expedition goes to the moon, but the scientist who pilots the rocket takes his surname from a more incendiary star: Lang called him Helius.

When film acquired the capacity to render the world in colour, it was as if God's initial commandment in Genesis had been brought up to date, improved with the aid of chemistry. In Michael Powell's *A Matter of Life and Death*, released in 1946, Marius Goring plays a dandified spirit-messenger who descends from a black-and-white heaven to the polychrome earth, where he has to claim the body of a pilot killed during a wartime battle over the English Channel. As he steps down from one realm to the other, the colourless rose in his button hole suddenly blushes pink and the ring on his finger turns scarlet. He admires a lush lilac-bush and murmurs, with a rueful glance towards his home above the clouds, 'One is so starved for Technicolor up there!' It was no longer enough to say 'Let there be light'. All the colours of the rainbow must shimmer into view. In a colour film, even black and white had their values enhanced. Antonioni ordered the designer of *Blow-Up* to paint whole tracts of London black, 'to neutralise and emphasise certain shapes'. In the Woolwich park where David Hemmings unwittingly photographs the corpse, a blank and abstract vista was constructed beyond the trees (which themselves are so acidly green that their foliage might have been hand-painted). Prevented by a municipal rule from whitewashing a row of houses, Antonioni built an alternative street and painted it blazing white. This is the radiant void, beginning where the congested, fertile enclave of our human world runs out. The grass in the park, left to its own natural devices, dissatisfied Antonioni, who had it spray-painted a more hallucinatory shade of green. Filming the industrial waste of *Il deserto rosso*, he tinted a forest grey to make it look like cement. (Unfortunately nature outwitted him: it rained, and the paint drained off.)

Mysticism – in an opportunistic match which sums up the misguided confidence of modern times – was precariously underpinned by science. Larionov

attentively followed Madame Curie's experiments with radium and ultraviolet rays, which gave credence to his so-called 'doctrine of luminosity'. After Einstein, when time and space had lost their absoluteness and matter had dissolved into fragile atoms, light became the fluid substance of nature. Objects from now on existed only insofar as they reflected light. The brightness generated by nature itself gave to artists, as Moholy-Nagy proposed in 1923, 'a new plastic medium'. Photographers or film-makers created with light, as painters had done with pigment; and their creations made visible and intelligible the mysterious transactions analysed by the new physics.

Moholy-Nagy considered himself to be a 'Lichtner', a manipulator of light. He illustrated 'the morphosis of light' by making camera-less photographs, which he called photograms: objects exposed on X-ray plates produced spectral images, like Man Ray's 'oxidized residues'. Thought, in Moholy-Nagy's definition, was the 'functional result of cosmos-body interaction'. Photograms were luminous ideas, emanations of consciousness which showed 'the immanent mind seeking light'. In 1931 Moholy-Nagy designed a title page for the journal *Foto-Qualität*, on which a ghostly hand from one of his photograms has a small camera superimposed

László Moholy-Nagy Foto-Qualität *(1931)*

on its open palm. The hand has grown an eye; the body is no longer the brittle skeleton which dismayed Hans Castorp when he saw his X-ray. The way a photographic negative turned black into white was for Moholy-Nagy an 'optical miracle'. Superimposition, or the dissolve by which scenes in a film melt into each other, seemed to him a kind of 'irradiation' – a discharge of radioactivity, imparting enlightenment rather than causing cancer.

Gance thought that film should implant 'a sun in every image'. The bulb in the projector functions like a sun, quickening still frames to life when the motor starts to run. Sometimes the light can be blank and pure, like the Platonic realm of ideas. In *Napoléon*, the snowball fight fades out into featureless white, thanks to an iris of almost transparent ivory which Gance fitted over the lens. The puritanical Ingmar Bergman recalls a childhood experiment, when he dipped a roll of film in a soda bath which ate through the emulsion. The result was invisible cinema, suitable for strict iconoclasts – 'white, innocent, transparent.

Pictureless'. Griffith, not afflicted by these doctrinal scruples, redeemed the cinema from its dependence on electricity by making it a pious homage to the sun, the radiant source of life. He subtitled *Intolerance* 'A Sun-play of the Ages', and insisted on using available light when filming it. He shot the fall of Babylon at dawn, and lit Lillian Gish, as the mother eternally rocking her cradle, with a thin diagonal shaft focused through a hole drilled in the studio ceiling, as if she were under God's personal superintendence. Gance's Napoléon orates to the setting sun, or dodges lightning bolts in a battle; no wonder Robespierre wears dark glasses.

But if the sun was one of photography's divinities, another was the being described by Weston as 'Lady Moon' – the sun's ghostly negation, a source of undead, purloined light. It shines on a graveyard in Ansel Adams's photograph of moonrise at Hernandez in New Mexico, taken in 1941 without an exposure meter, since Adams, as he said, arcanely 'knew the luminance of the moon – 250 c/ft^2'. Weston, following the Manichean dictates of his art, divided nature between 'logic and common sense' and night with its dark, poetic hours of superstition. In 1945 Bourke-White called her aerial documentation of bombed Germany a 'moon's-eye view': lunar not solar, because this levelled, featureless world was a photographic negative of reality.

For Cocteau, this was the eerie, nocturnal benefaction of the cinema, which bathed objects and organisms in a chilly silver radiance. 'A sort of moonlight sculpts a telephone, a revolver, a hand of cards, an automobile', Cocteau said in 1919. He nervously wondered at 'an alabaster race of beings…glowing from within'. Were they radioactive? In *Le Sang d'un poète*, which he directed in

Conrad Veidt as Cesare in Das Kabinett des Dr Caligari *(1919)*

1930, a mouth suddenly materializes on the open palm of the poet's hand, then fades in the white glare of the phosphorescent flesh. Duchamp's film *Anémic Cinéma*, made between 1924 and 1926, summed up the spooky, bloodless nature of the medium in an anagram. Robert Wiene in *Das Kabinett des Dr Caligari* kept his characters immured inside their delusions by using painted rather than natural light. The sunlight streaming into those crooked rooms or the puddles of brilliance beneath street lamps in the warped, rickety town square were painted onto the sets. Caligari's cabinet is hermetically sealed against the outdoors, against nature and sanity; the asylum is run by a lunatic. Wiene, contradicting Griffith's optimism, recalls the devious ambivalence of the art. Film writes with light, but its scripture is only legible in darkness.

The religious wars in *Intolerance* are disputes about holy light. Belshazzar expels Cyrus with a fire-spouting engine of war, and when the Huguenots retire on the night before the St Bartholomew's Day massacre, a title card reads 'Candles out – fading lights'. The special effects mystically challenge our sense of reality. Heaven glimmers above the battlefield, on which hostilities are suspended; prison walls become transparent, then disappear into the air. We are asked to believe what we see. Surely it is not possible to photograph something which does not exist? This celebration of light extends throughout the history of the cinema; it is perhaps the twentieth century's most plaintive attempt to unify religion and science. Fire transfigures the saint in *La Passion de Jeanne d'Arc*; her face is solarized as she burns, just as the sinister doctor in Dreyer's *Vampyr* is blotted out by a hail of whiteness, buried alive in the flour ground by the mills of God. In Murnau's version of *Faust*, the blaze of purging fire on the funeral pyre of Margarethe irradiates the sky when she forgives Faust. An angel routs the devil by pointing to a word pentecostally inscribed on the clouds in letters of pulsing flame – LIEBE, or love. In Murnau's *Sunrise*, night is the realm of delusion. The vamp tempts the young farmer by moonlight, but flees back to the electrical glare of the city at dawn, when he recovers the wife he had given up for dead. Sunrise – the time of exorcism in Murnau's *Nosferatu*, where daylight causes the vampire to crumble into dust – here brings resurrection.

The cinema exists to dazzle us, persuading us to worship its man-made suns. Kubrick realigns the planets in *2001*, announcing the sun's advent with the fanfare which hails the superman in Strauss's *Also sprach Zarathustra*. When the door of the spaceship opens in Spielberg's *Close Encounters of the Third Kind*, light floods out like a blinding revelation. The neon galaxies in Coppola's *One from the Heart* turn Las Vegas into the New Jerusalem, where a million fuzzily tropical neon suns never need to set. A firework display above the French Riviera in Hitchcock's *To Catch a Thief* stands in for what must have been an extremely lurid sexual encounter. In *Rashomon*, staring up from the vantage-point of the woman who is being raped, Kurosawa aimed his camera directly at the sun, which no film-maker had ever previously dared to do. Its light had always been glimpsed indirectly, and there was a superstition that its rays, if not filtered, would sear the

film in the camera. Kurosawa makes it a literally stunning moment: the scorching, omniscient glare blots out the consciousness of the woman who looks into it.

The final trilogy directed by Krzysztof Kieślowski, *Trois Couleurs*, contemplates the spectrum of signals transmitted by the striped French tricolour – blue for liberty, white for equality, red for fraternity. The stories told by the three separate tone-poems explore the emotional and moral wavelengths of colour. The mood of *Bleu* is melancholy. For the bereft widow, liberty means that life should henceforth leave her alone. When she recovers, blue refers to the tidal ocean of common feeling in which we are all afloat. Equality in *Blanc* offers men a cleansed slate. That whiteness at first looks as bleak as the snow which covers Poland, and, like the snow, it soon becomes dirty. But it can also be white-hot: the heroine's orgasmic shout is illustrated by a blanked-out, glowing screen. Red denotes consanguinity, the blood which unites us. The characters in *Rouge* are bound together by telephone-lines, and Kieślowski's camera follows their voices through the cables as if tracking the movement of corpuscles along the veins of a sprawling, many-headed body. Peter Greenaway's *The Pillow Book*, released in 1996, begins with a fable about the creation – of man, of pictures which miraculously move, and of colour. A Japanese father paints a calligraphic greeting on his daughter's face for her birthday. He tells her that God, sculpting the first humans out of clay, coloured in their eyes, their mouths, their sexual organs. Finally, admiring his handiwork, he allowed them to move. The episode is filmed in soft, grainy black and white. Then the child looks at herself in a magic mirror, and the letters inscribed on her face blush red. Growing up, she treats the skin of her lovers as manuscript, painting poems about desire on their scalps, their eyelids, and the inside of their legs. Japanese brushwork closes the gap between words and things, the rift which modern linguistic theories turn into an unbridgeable abyss. The pictograph for rain should look watery, that for smoke should drift and disperse on the paper. Similarly film, whose language is light, speaks in colours, rather than – like literature – relying on signs or symbols which refer to invisible objects, absent bodies.

Though it began with the heliocentric anthems of Griffith, film recoiled during the 1940s into a haunted darkness: hence the brooding fatalism of *film noir*, where shadows rear into substance like the unseen predators stalking Simone Simon through New York in Jacques Tourneur's *Cat People*. Light dwindles to a speck, always in danger of being extinguished by the surrounding gloom. At the end of Fritz Lang's wartime thriller *The Ministry of Fear*, a brother and sister involved in an espionage plot grapple for a gun. She seizes it; he turns off the light and makes his escape in pitch darkness. A door opens briefly into the lighted hall. His voice as he vanishes says 'You wouldn't shoot your brother'. The screen blackens again as the door slams. Then a pin-prick of light is drilled through the darkness. That hole marks the passage of a bullet. For a second the bright dot is blotted out, as the brother's body tumbles to the floor. These are the psychological mysteries of chiaroscuro; perhaps the heroine would have shrunk

from fratricide if the lights had stayed on. No matter how faint and narrow the ray, it can still make possible the commission and the detection of a crime. In Hitchcock's *Rear Window*, Raymond Burr thinks he can retreat into invisibility by turning off the lights in the Greenwich Village apartment where he has murdered and carved up his wife. James Stewart, the professional photographer keeping watch with his cameras from across the courtyard, detects a tell-tale sign of life. It is the glowing tip of Burr's cigarette, picked out by Stewart's infra-red eyes. Film may not have succeeded in its mission of enlightenment, but it has taught us how to see in the dark.

The metaphysics of the medium depend on this variable balance between light and dark. Akira Kurosawa found an explanation for his psychological conflict with his older brother in the same technical dichotomy. Heigo bullied Akira during their childhood; brilliantly successful at school, he dropped out, took odd jobs (including one as a narrator who interpreted silent films out loud), then abruptly killed himself. Akira came to understand that Heigo was his doomed double, sacrificed in order to free his own sunny disposition: 'I...think of my brother as a negative strip of film that led to my own development as a positive image.' The doctor in Powell's *A Matter of Life and Death* rigs up a *camera obscura* in an outhouse. With a lens wedged in the skylight, he beams a panorama of the village onto the bare surface of a table. But immediately he opens the shuttered window, the slate is wiped clean. His shadows are killed off by the sun. There is a nocturnal underside to Man Ray's proclamation about the solar spirit of modernity. Film reduces the world of flesh and blood to a flickering mirage. It takes the material universe of the nineteenth-century realists and reveals all those supposedly solid objects to be made of grey, unevenly luminous granules. When Hemmings in *Blow-Up* enlarges his innocuous photograph, he finds a dead body in the shrubbery. He should not have been surprised. The process of enlargement, which Antonioni follows with such morbid fascination as Hemmings works in his dark-room, shows nature decomposing. Colour fades from the park. The trees are a blurry, random configuration of white dots, eclipsed by black. Of course there is a corpse in the vicinity. As seen by the cruelly truthful eye of film, everything that exists is a spectre: a briefly animated shadow.

Léger advised all those who wished to qualify as citizens of the modern world to make an immediate appointment with the oculist. 'Have your eyes, your spectacles, remade', he commanded. 'Cinema is about to begin.'

Technology promised to augment our imperfect bodily capacities. The telephone, for instance, extended the reach of our ear; photography, as Moholy-Nagy claimed, offers 'a basic enrichment of our optic organ'. In 1936 he listed the varieties of photographic vision, which cumulatively accounted for a 'psychological transformation of our eyesight'. The camera allowed us to see in ways inconceivable before – quickly thanks to snapshots, or slowly thanks to time exposures; we can penetrate solid objects with radiography, or fuse them in the

form of photomontage. The photographer in *Blow-Up* discovers that his camera has seen things which his eyes have overlooked. The sound technician in Brian de Palma's *Blow Out* likewise learns that his tape recorder, which has eavesdropped on a political assassination, is acuter than his ears. Blaise Cendrars remarked in 1919 that the cinema had bestowed on man 'an eye more marvellous than the multifaceted eye of the fly'. This, in the anti-humanistic twentieth century, could be considered an evolutionary advance. The screen, Cendrars pointed out, contained and compressed 'a hundred worlds, a thousand movements, a million dramas'. It did come to manage at least three, projected simultaneously, when Cinerama was invented in the 1960s; and after that, a fully circular screen was installed at Disneyland in California, requiring eleven cameras to fabricate an image which extends through 360 degrees.

Human eyes grow tired, and lower their shades; they go out of focus, or develop cataracts. The camera reinvented that feeble organ, and transformed the process of seeing or conducting surveillance into a scientific discipline. A sequence in Léger's film for Antheil's *Ballet mécanique* examined the eye of the model Kiki, looked at upside-down: the camera can expertly illustrate cubism's multiplication of visual facets. The transparency of film suited it to the analysis of society. In Eisenstein's *Strike*, made in 1924, workers sharing their grudges are posed in silhouette against the glass wall of the factory, with outlined wheels turning behind them like the innards of a movie camera. Another scene frames reflections upside-down in a puddle, just as images are inverted in a camera's view-finder. The workers scuttle backwards into view to confer, standing on their heads like the reflected chimneys. They then disperse, as if the film were being rewound.

Inversion and reversal are technical tricks of the trade; they are also experiments in the dialectical manipulation of nature. In *October*, made by Eisenstein in 1927 to mark the tenth anniversary of the Revolution, a statue of Tsar Alexander III is tugged from its pedestal three times. On each occasion it stubbornly jumps upright, only to be pulled down again. Three separate Cyrillic title-cards cheer 'УРА!' Repetition of this unrepeatable victory makes it possible to relish the moment, and also teaches a useful lesson: practice makes perfect. A more sadly improbable nostalgia caused G.W. Pabst to reverse the footage at the end of his *Don Quichotte*. The film was made in France during 1933, the year of the Nazi book-burnings on Unter den Linden in Berlin, and it ends with the incineration of Quixote's library. The religious censors heap onto a pyre the romances from which he derived his ideals. As they burn, he too expires. But then Pabst turns time back on itself, and the black, crinkled pages slowly grow smooth and white again. German political history, however, was not so easily unwritten.

The camera's challenge to the eye brought up again that rivalry between humanity and mechanism which is the most disturbing motif of modernity. An informer in *Strike*, whose supercilious, leathery-lidded eye is seen in a gigantic

close-up, betrays one of the agitators to the police by photographing him with a spy camera hidden in his pocket-watch. In Offenbach's *Les contes d'Hoffmann*, which Moholy-Nagy designed for the Kroll Opera, the quack Coppélius supplies the puppet Olympia with enamel eyes. 'Aimez-vous l'optique?' he asks Hoffmann, showing off his wares. Hoffmann accepts the magic spectacles touted by Coppélius, which make the automaton look as if she is alive. Moholy-Nagy in 1933, as if adding a footnote to the opera, quoted a scientist who dismissed the human eye as a clumsy piece of work, and listed the superior skills of the camera. The scenario for his film *Dynamic of the Metropolis* concentrated on experiences which the cowardly eye avoided, and demonstrated that they held no terrors for the camera. One episode was to be shot from beneath a train, another in a carriage plummeting down the steepest slope of a switchback railway. All of us, Moholy-Nagy commented, would close our eyes under such circumstances, and wish we were somewhere else. The camera, he smugly added, goes on filming.

The camera had its own way of seeing the world, which did not necessarily agree with the priorities of the human eye. It saw things piecemeal, or atomically; and it also ignored the usual discriminations between great and small, high and low, animate and inanimate. Léger recommended the photographic study of a pipe, a chair, an eye or a typewriter, all in isolation from each other. 'Before the invention of the moving picture,' he argued, 'no one knew the possibilities latent in a foot – a hand – a hat.' He listed those items separately – jumbling them with furniture and machinery – because the logic of his 'new realism' defined the human being as an assemblage of bits and pieces like any other mechanism. Making the customary modern call for 'new men', Léger announced that 'we are in an epoch of specialization – of specialties'. Some men, as the social fable of Lang's *Metropolis* suggests, are economically interchangeable with their hands, others with their heads; each of us is overdeveloped in one way and retarded in others.

Such an appraisal of people suited the specializing, dissociated eye of the camera. Alfred Stieglitz, photographically documenting his lover Georgia O'Keeffe, divided her up into zones and appendages, characteristic gestures and glances: hands, furry pudenda, soulfully averted eyes. In film, one part of a person can stand for the whole. Barbara Stanwyck's braceleted ankle in Billy Wilder's *Double Indemnity* tells us all we need to know about her, and in Frank Tashlin's *The Girl Can't Help It* Jayne Mansfield is equated with her breasts, or with the milk bottles – spouting like geysers in the hands of a delivery man as she wiggles past – which symbolize them. More tenderly, Griffith in *Intolerance* focused on the hands of Mae Marsh, wringing each other as she clasps them in her lap during the trial. A close-up of Robert Mitchum's hands in Charles Laughton's *The Night of the Hunter* gives away truths which his sly face conceals: he has inscribed the words LOVE and HATE on the fingers. The musical *Easy to Love*, choreographed by Busby Berkeley, contains a sequence narrated by three pairs of feet. Esther Williams, who has gone home and kicked off her shoes, is invited out by the crooner Tony Martin. She resists his entreaties on the

telephone, while we watch her feet sliding back into those white high heels. Next we see a pair of long, bare legs, which can't belong to Williams because they end in black high heels, interlacing with a man's legs on a dance floor. Then the legs of Williams, identified by her white heels, appear in the background, tapping and jigging enthusiastically under a table. A complex story can be told by concentrating on the characters' extremities.

Balázs in 1923 said that because of the cinema 'man has again become visible'. But so had everything else, and if visibility was the criterion of significance, man no longer enjoyed pre-eminence in the world. In those early films, man was visible but inaudible. The disability had important consequences. Speech, as a unique human talent, justifies our sense of hierarchy. To take away the privilege of language restores democracy to the phenomenal world, creating a state something like the overlapping, interdependent clutter of objects on a cubist café table. 'In the shared silence', Balázs remarked, 'inanimate things become almost homogeneous with people, and gain thereby in vitality and significance.' Robert Musil in 1925 likened this cinematic atmosphere to the totemism of primitive peoples, who see a tree or a stone as the residences of a spirit. Artaud in a 1927 essay agreed: film concentrates on 'the epidermis of reality', and thus 'discovers the original order of things'.

This order has no need of nomenclature. The cinema's silence seemed more like a blessing than a technical defect. In the letter which Hofmannsthal wrote for Chandos, the disillusioned poet vows to renounce the use of Latin and English. Instead he wishes to learn 'a language of which I don't know a single word, a language in which dumb things speak'. He was alive too early; that language, unavailable in the Renaissance, is the cinema. Dumb things speak, for instance, in *Dial M for Murder*. Hitchcock made the film in stereoscopic 3-D so as to give those obtuse objects voices. At first it is disconcerting to see so many vases, lamps and ornaments jutting towards us, upstaging the loquacious actors. Then we realize that this is a story whose outcome is determined, despite all the chatter, by implements, utensils – a latchkey poking out from under the stair carpet, or the blade of the scissors which Grace Kelly drives into the back of the man who is trying to strangle her. Andy Warhol once said that 'the best atmosphere I can think of is film, because it's three-dimensional physically and two-dimensional emotionally'. For Hitchcock too, the nature of film (and the deficiency which Warhol prized) corresponded exactly to the human predicament. Watching *Dial M for Murder* through those polarized dark glasses, we are made to share the insight of the photographer in Julio Cortázar's story 'Blow-Up', which was the source for Antonioni's film: through the lens of his camera, he comes to understand 'things in their true stupidity'. In *Il deserto rosso*, Antonioni emphasized this blunt, brutish world of mechanical objects by using a telephoto lens, which cancelled the roomy recession of perspective and made those things – the grey pipes of a refinery, a ship's rusty bulwark – collide with human beings rather than serving as a backdrop for them.

Film has its own version of the existential nausea which afflicts Roquentin in Sartre's novel. Objects we think of as tame because tiny can swell to inordinate size; body parts can detach themselves. Howard Hawks took the world apart in his comedy *Bringing Up Baby*: a dog absconds with a paleontologist's prize bone, and the brontosaurus whose skeleton he has pieced together collapses into rubble. When the poor farmer pleads for a horse to pull her plough in *The General Line*, Eisenstein shows the landowner's gross, bloated ear in close-up. Even so, it remains deaf to her plea. The title card has to shout on her behalf: 'NO HORSE!' The syllable the landowner mouths in reply does not need to be voiced, or translated. In David Lynch's *Blue Velvet*, a human ear turns up in the grass, still trailing some strands of hair, but mottled by decay and housing a colony of insects. It has been sawn off, according to the forensic examiner, by a pair of scissors: further testimony to the power of that humble tool, which as Balázs said permits film to cut up and then recompose the world.

The human image underwent new and dislocating changes when the format of the screen changed during the 1950s. Jean-Luc Godard made *Le Mépris* in CinemaScope. Fritz Lang, playing himself in this film-within-a-film, complains about the horizontally stretched ratio. CinemaScope, he declares, is no good for filming people; it should be reserved for snakes and funerals. This attack on the anamorphic lens is wryly confirmed by Godard, who uses its unwieldiness to measure the distance between people. The camera has to pan back and forth between Michel Piccoli and Brigitte Bardot as they quarrel about the state of their marriage. Swivelling, its gaze slowly travels each time across a lamp on the table between them. Piccoli plays with the switch, flicking it on and off, even though it is bright Mediterranean day outside the window. The lamp is one of those dumb, obstructive objects which the camera cannot help noticing; it also stands for the limitations of film, since its light cannot elucidate the problems of Godard's characters. On a trip to the cinema, they disagree about the motives of the characters in the inset film which Lang is supposedly directing. Once more, CinemaScope obliges the camera to criss-cross an empty aisle, because the pairs of entrenched disputants are seated on either side of it, Bardot next to Lang while Piccoli sides with Jack Palance, the crass producer. Each traversal of the gulf makes it wider. The format is ample – but what it contains (like matter, as the new physics demonstrated) is emptiness.

Vertov, welcoming the inhumanity of the medium, proudly declared 'I am the Cine-Eye. I am the mechanical eye.' He believed that his kino-eye was better adapted for 'research into the chaos of visual phenomena filling the universe' than its lazy human predecessor. The posters designed by Rodchenko for Vertov's film *Camera Eye* in 1924 set an unblinking, glassy eye inside a series of oval or trapezoidal geometric frames, which cordoned it off from nature. Vertov's camera executed daredevil stunts, dodging in front of speeding trains, scrambling along girders or up factory chimneys. As well as intrepidly enjoying such risks, it could perform ocular tricks, feats of visual conjuring. In *Man with a Movie Camera*,

Aleksandre Rodchenko's poster for Dziga Vertov's Kino Glaz (Camera Eye) (1924)

made by Vertov in 1929, the portico of the Bolshoi Theatre suddenly splits in half like an amoeba reproducing itself; the sections of the façade, jolted out of their dull architectural inertia, perform a gyrating dance. The camera, an eye with no human body ponderously attached to it, is more manoeuvrable than a person. In his film of Schnitzler's *La Ronde*, Max Ophuls sent the camera waltzing in elegant, exploratory circles, as if gliding through a courtship ritual. In *Citizen Kane*, the camera retreats vertically from a reminiscing woman, moves through a skylight and withdraws into the wet, oblivious night. Mounted on a tentacular crane at the beginning of Welles's *Touch of Evil*, it criss-crosses two squalid border towns, skipping between Mexico and the United States without the permission of immigration officers; the take – long in time as well as in spatial reach – concludes only because the camera's eye blinks, temporarily blinded when the car it has been following explodes.

Despite his head for heights and his acrobatic ingenuity, Vertov in his persona of 'I, apparatus' claimed no special heroism for himself. His camera, a mass-produced artifact, loyally celebrated the toil of the industrial production line, and lent a hand to the workers by increasing the speed of projection: its magic boosted Soviet productivity, demonstrating how easy it was to increase the output of images. The apparatus did not succumb to exhaustion like the mechanics it photographed. It was also innocent of the prurience of human observers. Taking no liberties, it studied people who did not know that they were being watched as they slept on park benches, sunned themselves at the beach, or washed and got dressed.

The camera, as personified by Vertov, resembled an exemplary Soviet citizen, indefatigable and contentedly anonymous. Moholy-Nagy thought that film would promote 'the hygiene of the optical', a cleansing and rectification of vision. At the Bauhaus, Herbert Bayer photographed a case of glass eyes – cool and clear, not repellently viscous and palpitating like their flesh-and-blood

equivalents. Along with this task of moral sanitation, the camera undertook a campaign of political restitution. In 1928 an advertisement for Albert Renger-Patzsch's volume of photographs *Die Welt ist Schön* made a startling and touching claim: 'The enjoyment of looking has been reawakened in our impoverished Germany,…an enjoyment that can be shared by…poor or rich alike.'

To look cost no money. To take a photograph was almost as cheap. Brecht and Weill wrote an opera for beggars – an opera about them, but also one which (because it cost precisely threepence) they could afford to attend. Photography in the same way democratized vision. Things photographed were stripped of singularity and exclusiveness, forcibly removed from the art market with its precious connoisseurship, its social snobbery and its exalted price tags. Walter Pater claimed in 1873 that the Mona Lisa was a 'symbol of the modern idea' because she enjoyed a vampirish 'perpetual life'. Photography proved his point. Sold as a postcard, the Mona Lisa now exists in millions of faithful copies; we can all enjoy her company at home, without having to elbow our way through crowds of tourists to catch a glimpse of her behind a layer of bullet-proof glass. The camera enabled everyone to make images, and – by photographing loved ones, family celebrations, holiday landscapes – to play at being an artist. Skill and talent were not required. The camera, cured of snooty aesthetic pretensions, did not mind who looked through its alternative eye, and was equally impartial about what it looked at. It vindicated the drab, random visual congestion of the world, which painting would have sorted and sifted into order. Following Vertov into the streets, King Vidor filmed *The Crowd* in New York in 1928, allowing his movie camera to travel in the back of a truck, from where it peered out at the traffic through a peep-hole, or camouflaging it behind a bulwark of crates on a corner; Vidor himself lounged nearby, mumbling directions to the camera man. Film had a special aptitude for immersion in what Vachel Lindsay rapturously called 'the sea of humanity [which] is dramatically blood-brother to the Pacific, Atlantic, or Mediterranean'. Hence the screen's distension to contain rampaging armies in Vidor's *The Big Parade*, or the metropolitan hordes of *The Crowd*.

Like all other individuals in the Manhattan streets, Vidor's camera had been effaced by the mass. Yet every image it caught served as a testimonial, witnessing to the existence of some nameless, unregarded person. Sartre was impressed by the opening of *The Crowd*, when the camera slides up the façade of a skyscraper, chooses a window to look through, enters the room, slides down the long columns of lookalike clerks at their identical desks, and singles one of them out from the crowd, looking at his face in close-up and telling his story. The character begins to live when denominated by the camera. 'This', Sartre said of that long, levitating camera movement, which scales the outside wall and then explores the room on unseen rails, 'is the sport of a god.'

As the advertisement for *Die Welt ist Schön* declared, the new art offered a benison in a time of economic distress, when individuals had begun to feel that they were mere statistics. In 1936 the Farm Security Administration, established

by Roosevelt's New Deal, sent James Agee and the photographer Walker Evans to investigate the plight of sharecroppers in Alabama. They called their report on agricultural poverty *Let Us Now Praise Famous Men*, although its purpose was to praise the stoicism of men, women and children whose lives disperse like dust. Agee commented that 'if I could do it, I'd do no writing at all here. It would be photographs'. The photographs Evans took are a series of mute memorials, compassionate obituaries – weathered faces, prematurely old, and emaciated bodies; huts shoddily carpentered from planks; a pair of ownerless shoes, and a grave freshly dug in the eroded soil. The camera uncovered evidence of social malaise and prepared a case for the prosecution. The demonstrators brutalized by police during protests against the Vietnam war at the Democratic Party convention in Chicago in 1968 chanted a reminder to Mayor Daley's henchmen: 'The whole world is watching.' It was watching on television; the camera had become the conscience of mankind.

Although Vertov emphasized the intrepidity and bravado of the new mechanical eye, D.W. Griffith made the camera's eye sentient and even sentimental, endowing it with emotion. Griffith punctuated sequences by opening and closing the camera's diaphragm. During one of the Civil War battles in *The Birth of a Nation*, the iris opens on a small group of figures: a bereft mother is comforting her children on top of a hill. As the aperture continues to widen, the rest of the scene gradually comes into view. Off to the side and far below, an army files endlessly through a long valley. The travelling gaze has discovered the reason for the destitution of the woman's family. Several times during this sequence, the iris blinks shut, like a tired or depressed eye which is unable to go on looking at conflict or carnage. But sleep is restorative: after these elegiac lapses, the iris always reawakens, aware of its responsibility to go on testifying to the iniquities of war. The camera functions as a recording angel, overburdened by the sum of human crimes and follies. In 1919 Cendrars wrote a screenplay for the apocalypse, which he entitled *La Fin du Monde – filmée par l'Ange N. D.* Cendrars cast the angel of Notre Dame as his cosmic cinematographer; the film (which remained unmade, thus allowing the world a further lease of life) was to end with the camera's eye slowly closing, obliterating all of existence in one long, cleansing blink.

Cendrars conferred omniscience on the camera. Men in simpler days fancied that they were under observation by God, who looked down from a point of vantage above the clouds. In modern times there is a less fanciful equivalent: cameras in buses or lifts or poised on top of buildings keep watch on us, breaching our privacy in order to ensure public safety. When we sit in the cinema, imagining ourselves to be invisible in the darkness, are we being studied from behind the screen?

Orson Welles drew on these paranoid suspicions in the script for his adaptation of Conrad's *Heart of Darkness*, which he worked on in Hollywood during 1939. (The studio cancelled the project; Welles made *Citizen Kane* instead.) The film was to begin with a black screen. Conrad's darkness is African, equatorial,

the symbol of indwelling evil; film generates its phantasmal play of light out of darkness, which subliminally blots out the image after each frame has been projected. Since there was nothing to look at on the screen, Welles's voice invited us to close our eyes, warning that we must open them whenever commanded to do so. He then ordered us to imagine ourselves as a canary in a cage. The screen promptly showed just that, with Welles's mouth murmuring through the bars. The next image was a gun, shooting us in close-up. The screen blacked out again. At last Welles explained his game: his camera was conducting an inquisition of the darkness inside our heads, like an encephalogram. 'You're not going to see this picture', he told the audience. 'This picture is going to see you.' The screen filled with a human eye, planetary in its dimensions, buoyed up among floating clouds. Then we were to see ourselves, the audience in the cinema: each seat contained a camera, staring back at the screen. Another eye appeared, with a sign for a mathematical equation attached to it and a capital letter bobbing in the vicinity. The eye, as in Vertov's manifesto, equalled I. But whereas Vertov claimed documentary veracity for the camera, Welles warned of its unreliable subjectivity. It saw things relativistically; cameras, as if demonstrating Heisenberg's uncertainty principle, change the nature of what they photograph. Welles was to play both the narrator Marlow and the mad, murderous Kurtz in his version of the novel: could the viewpoint of either character be trusted? Having proved its point, the eye in Welles's prologue tricksily winked.

Despite its flippant conclusion, Welles's introductory essay on the character of the camera had an unsettling moral. In 1903 a bandit fired his gun directly into the camera in Edwin S. Porter's Western *The Great Train Robbery*, as if intending to kill off the audience. Hitchcock took the practical joke further in his film about wartime espionage, *Saboteur*. The spies are pursued through the auditorium of Radio City Music Hall during the screening of a film. Their exchange of gunfire does not alarm the audience, because the characters in the film are also shooting at each other. Suddenly a man, intercepting one of the stray bullets, slumps forward in his seat, dead. Were those silver spectres on the screen real after all, and could their bullets ricochet into the third dimension? In Hitchcock's *Spellbound*, Leo G. Carroll as a crazed psychiatrist turns on himself the gun with which he has been menacing Ingrid Bergman. The barrel, distended in close-up, swivels towards us. Ours is the head it aims at; after it fires, Hitchcock inserted into this black and white film a single red frame – the gun's ballistic flash, or perhaps the eruption of blood inside the brain, blotting out consciousness. Michael Powell's *Peeping Tom*, made in 1959, deals with a psychopathic photographer who can only satisfy himself sexually through the lens. As he photographs the women he desires, an erectile blade slides out of the camera to pierce their throats.

These are fables about the violence and the perversity of the new art. Isn't photography an invasion, an attack? Buñuel, in a lecture delivered in Mexico in 1953, called film 'a magnificent and dangerous weapon if it is wielded by a free mind'. The power of this weapon went well beyond that of the gun in *Spellbound*

or the stiletto in *Peeping Tom,* both of which are wielded by madmen with free minds; Buñuel likened the brilliance it detonated to a nuclear blast, claiming that 'the screen's white eyelid would have only to reflect the light peculiar to it and we could blow up the universe'.

As a surrealist, Buñuel delighted in the destructive potential of film. To blow up the universe – for doctrinaire modernists in politics, science and art – was the only legitimate aim of action or of thought. 'Sometimes', Buñuel remarked with the same cheerful amorality, 'watching a movie is a bit like being raped.' He meant that the viewer's head is forcibly filled by someone else's fantasy. Such violations occur in Kurosawa's *Rashomon,* where the truth of the violation and murder in the forest are never ascertained, and in Godard's *Weekend,* in which a young woman is casually raped by a vagabond. These offences correspond to the cinema's burgling of our unconscious minds. This is also what Ingmar Bergman implied by the title of his 1968 film *The Shame.* Liv Ullmann is sexually suborned by her husband's best friend; she surrenders to ensure that she and her husband will outlive the war. She is shamed by the choice she makes, which estranges her from herself, making her realize that she never knew what she was capable of. She feels, she says, that she is in a dream – except that the dream belongs to someone else. That is the sensation, alluring or alarming, which we pay for with the price of a movie ticket. In Berlin during 1920, posters bullied passers-by into seeing *Caligari,* as if subjecting them to a hypnotic spell like that which the doctor casts on his sleep-walking accomplice Cesare. Sometimes the posters gave the citizens orders ('You must see *Caligari*') or brusquely interrogated them ('Have you seen *Caligari?*'). But the most insidious and effective of the publicity slogans promised nothing less than the abrogation of personal identity: 'You must become Caligari.'

This psychological assault happens through the eyes: hence that savage initiation (another metaphor, like rape, for the way that film makes its incision in our brains) which begins *Un Chien andalou.* A man sharpens his razor, gazing

Eye surgery in Un Chien andalou *(1928)*

balefully out the window. A sharp, narrow cloud cuts across the sky towards the moon, and bisects it. The man takes the razor, prises open the eye of a woman who sits in the room beside him, and slashes the blade across her eyeball. Its jellies spurt through the gash. Buñuel himself played the man with the razor.

As a film director, he was using the blade to make the woman see, not to destroy her sight. Film carves a vent through which we look into the subconscious mind.

This incident, unwatchably gruesome, was Buñuel's tersest parable about the way cinema works – puncturing the eye to gain access to our dreams. It had its predecessors. In *Voyage dans la lune*, the fantasy directed by Georges Méliès in 1902, a space gun fired from earth pokes through the eye of the cheesy-faced man in the moon. Less jokily, at the end of the massacre on the Odessa Steps in Eisenstein's *Battleship Potemkin*, an old woman rears up in agony, one lens of her spectacles shattered, the eye beneath it split by the sword of a Cossack. In *Caligari*, the somnambulist Cesare is roused from a sleep which has lasted twenty-three years. His eyes, sealed beneath heavy lids, sunk in puddles of shadow, stir and flutter, then gape wide like open wounds. Erich von Stroheim in *Greed* photographed the mental perturbation of a woman who is sexually attacked while etherized in a dental chair: the camera studies her silently babbling mouth and her fluttering eyelids, screens on which her drugged brain has projected images of desire and fear. The eye is supposed to be the noblest of our sense organs, a prerogative of our uprightness. Animals, closer to the earth, decipher their environment through their noses; with our heads in the sky, we supervise nature. In the cinema, a beam of light broadens out from the cinema projector to fill the screen. Striking through darkness like a blade, it symbolizes the eye's supremacy. Film takes a dangerous delight in challenging the organ from which it derives and to which it is addressed. It exposes the eye's vulnerability, looking back at it in order to look through it.

Long after *Un Chien andalou*, the cinema continued to paraphrase Buñuel's ruthless optics. Dalí, engaged by Hitchcock to design the tormented dream of Gregory Peck in *Spellbound*, included a man with a pair of outsize scissors who cuts up the eyes which curtain the walls of a gambling den. Hitchcock himself set

Salvador Dalí's design for the dream in Spellbound *(1945)*

the camera to scrutinize the eye, whose imperceptible flickerings give away our guilt. The camera reviews a crowded hotel ballroom in *Young and Innocent*, then implacably closes in on a single figure, narrowing its distance until it fills the screen with his eye, which shiftily twitches: this is the killer. At the beginning of *Vertigo*, the camera fastens on the eye of Kim Novak, which distends in terror. But it cannot photograph the secrets she conceals behind her eye, and the film's credit titles translate those psychological qualms into abstract spirals which twist through her pupil. The bathroom murder in *Psycho* concludes with a close-up of Janet Leigh's staring, sightless eye and a shot of blood and water circling down the plug hole. Things seen by the eye – including the face of the person with the knife, obscured from us by the shower curtain – are written on water. Film incriminatingly fixes those transient impressions.

In Dreyer's *Vampyr*, made in 1931, the eyes of a corpse remain open, and the body is not permitted the mercy of blindness after death. Though the coffin lid is screwed down, a glass pane is inserted into it, through which the undead occupant observes his own funeral. Cocteau had a similar belief in the supernatural power of cinematic vision. He surrealistically praised film for its ability to show 'the optical illusions of unreality with the rigour of realism', and illustrated the point in his *Testament d'Orphée* by painting eyes on the closed lids of the dead poet. In Sam Fuller's great Western *Forty Guns*, the eye indulges in a bout of deadly erotic target practice. Gene Barry flirts with the female gunsmith who is making him a new rifle; trying out the armament while she takes his measurements, he aims it at her while the camera adopts the viewpoint of the eager bullet, framing her down the elongated phallic barrel.

Isherwood, studying Berlin through his window in 1930, called himself 'a camera with its shutter open'. This mechanical invigilation had its dangers; it could be a punishment, compelling us to look at things – like the razor biting into the eyeball – which our bodies cry out against. In Stanley Kubrick's *A Clockwork Orange*, the young thug played by Malcolm McDowell is reformed by being made to watch pornographic films. Prevented from blinking, he is exposed to scenes of rape and battery until they sicken him. The scene was as much of an ordeal for the actor as for the character. Kubrick strapped McDowell into a chair, braced his head and neck, had his eyelids pulled open, administered drops to distend the pupils and artificial tears to moisten them. At the end of the day McDowell, counting himself lucky not to have been blinded, went to the hospital with scratched retinas. In Suzuki Seijun's *Branded to Kill* – a film about Tokyo gangsters, made in 1967 – one of the hit-man's targets is an oculist. He is seen at work in his office, brusquely plucking out an eye in close-up. The empty socket pulses needily. Then the oculist slams the eye back into its hole with his fist. It is, we realize with relief, made of glass – a plaything, like a child's marble. Immediately after replacing the eye, the oculist is shot dead by a bullet travelling up the water pipes into his consulting-room sink, which he is bending over. In the heyday of Pop Art, violence had become harmless fun, and Buñuel's trauma turned into a

stunt. Arnold Schwarzenegger, as the lethal cyborg in James Cameron's 1984 film *The Terminator*, plucks out one of his own eyes when it is damaged in a gun battle. The operation is painless, like the surgery he performs on the cables of his injured arm with a screw-driver: Schwarzenegger, who has engines where his organs should be, does not share our human squeamishness. Nor does he bother to put back the squashed eye, since he does not use it for seeing with. Behind it is the aperture for the camera installed in his head, which sends out a scorching ray of infra-red light. Not wanting to show passers-by a disconcertingly asymmetrical face, he adopts the disguise most favoured by cinematic celebrities – a pair of dark glasses.

Although Moholy-Nagy trusted in 'the health of the visible', other modern artists blamed the eye for its misleading account of a world in which nothing was quite as it appeared to be. Magritte in 1928 painted the eye as a deceptive mirror, containing a trompe-l'oeil sky; in a 1926 painting a slug-like eye, torn from the body which housed it and flecked with blood, dragging a snaky tail behind it, crawls through a landscape of pyramids. Visual appraisals are false because they are detached or 'cool', as Marshall McLuhan claimed: focus depends on distance. We do not look at a cubist painting from a single, studious position outside it; we are meant to be surrounded by it, immersed in it, having abandoned the eye's distinction between I and not I, subject and object. Apollinaire called cubism 'this cinematic art', because it revealed 'plastic truth' in all its aspects. Oedipus, the classical hero afflicted by a modern psychological ailment, only began to see once he put a spike through his ignorant eyes.

Bataille in his *Histoire de l'oeil* attempted to modernize the disgraced sense of sight by emphasizing the fleshliness of the organ, its prying obscenity and its usefulness as a sex aid. The camera neutralized the business of seeing: Isherwood, mentally photographing his Berlin neighbours, feels 'quite passive, recording, not thinking'. Bataille made amends for this sterile detachment by dirtying the eye. In his novel the eyes of the dead Marcelle are pissed on until they close, and the eye of a garrotted priest is tugged from its socket and has its ligaments severed so that Simone (who also pleasures herself with eggs, and gobbles the testicles of a bull which has gouged out a toreador's eye) can insert it into her vagina. That, for Bataille, was where eyes should be lodged – between the legs, not in the head. They are vehicles of lustful imagination, not devices for taking snapshots and cataloguing phenomena. 'To others', he comments, 'the universe seems decent only because decent people have gelded eyes.'

Buñuel celebrated the indecency of film by calling it an instrument custom-made for 'expressing the world of dreams'. A film is a reverie, the indulgence of an alternative life like Catherine Deneuve's sojourn in the brothel in *Belle de Jour*. In Richard Wright's novel *Native Son*, the young black hero Bigger Thomas goes to the movies in the Chicago slums. While society in the streets outside denies his wish for a better life, 'in a movie he could dream without effort', needing only to

'lean back in a seat and keep his eyes open'. The last word registers a surprise: this is a dreaming you do without closing your eyes.

The technical tricks of the medium – dissolves or fade-outs, for instance – imitate the elusiveness of those tantalizing nocturnal stories which disintegrate when we try to remember them. When Léger saw *Entr'acte*, René Clair's inter- mission feature for the ballet *Relâche*, he took it to be an evolutionary summons. 'We begin', he said, 'to use our eyes for the things that really count' – that is, for seeing through reality; for recording dreams. Picabia, who devised the ballet's nonsensical plot, called it a film which captured 'the non-material events which take place inside our head'. Why should film, with its supernatural capabilities, bother to recount what everyone could look at with their dim, unreliable eyes? Duchamp, who has a walk-on part in *Entr'acte*, derided painting as 'retinal': a banal inventory of things seen. The camera's special province lay elsewhere; it photographed the invisible.

In 1918 Mayakovsky wrote the scenario for *Fettered by Film*, in which he played a painter who can no longer practice his art because the world he should be depicting has lost its solidity: people have suddenly become transparent. The painter takes refuge in the cinema, where a ballet-dancer steps down from the screen to console him. He kidnaps her, rolling her up in a poster on which her image is printed. But she is homesick for her unearthly Platonic habitat, and hurls herself at white surfaces which remind her of the screen – a wall of ceramic tiles, a linen table-cloth. In *Spellbound*, Gregory Peck is equally traumatized by the sight of fresh snow. 'That's the white he's afraid of', remarks his analyst, Ingrid Bergman. Eventually Mayakovsky's ballerina dematerializes into a coil of cellu- loid. The painter desperately tries to discover which train will take him to the land where such inconstant angels dwell. He has fallen victim to the filmgoer's ailment of nympholepsy, an infatuation with luminous shadows. The medium painfully reminds modern man of his atheistic dilemma. 'There is nothing there', Peter Greenaway has said of film. 'It's totally non-existent.'

Film allowed mental images to escape from their asylum and wander the streets. Caligari's cabinet was the cinema itself: a recess of trance and trauma, the lair of creatures who commute between life and death like Cesare. Paul Wegener's *Golem* in 1920 flirted with the occultism of the medium. The golem is a clay giant, animated by a cabbalistic password; the cinema's ghosts return to life inside the machine. The rabbi in Wegener's film regales the court at Prague with an anachronistic magic lantern show. But the fantasy proves to be uncon- tainable: it will not remain on its flat screen, or – like the golem – stay safely dead. One of the visionary patriarchs is enraged when the courtiers mock him. He strides forward, acquires a third dimension, and shakes the palace to its founda- tions. Following from the marvels displayed by Wegener's wizard, the grandest aim of the film-maker has been to conjure up a spectacle which might expand to take over the world. At the end of Gance's *Napoléon*, converging armies march across the Alps on three screens which dissolve into a flaunting tricolour, the

banner of a revolutionary apocalypse, 'inundating, enflaming and transfiguring, all at one and the same time'. De Mille caused the Red Sea to part in *The Ten Commandments*, and Spielberg in *Close Encounters of the Third Kind* called down from the sky a spaceship which resembles an inverted airborne Manhattan. Miracles are now available to order, and can be called up by computers in the special-effects laboratories of the company which George Lucas calls Industrial Light and Magic.

The special gift of film is to show us what we cannot see. Characters in Cocteau's *Orphée* fall down dead, then bounce instantaneously upright, revived by simply winding the footage backwards; they walk into the underworld through a mirror which shatters as they pass and then gathers up its shards and makes itself whole again. Such resurrections occur throughout Cocteau's version of *La Belle et la Bête*, made in 1946. A necklace discarded by Belle turns into dry, bedraggled hair. Dropping to the ground, it mutates again into a string of shining pearls. Tears congeal as diamonds. Cocteau paid tribute to the sacred doctrine of the medium, which Dalí called 'phoenixology'. Miraculous in itself, film suits stories about characters who are incapable of dying – the fairy tale of Beauty and the Beast; the myth of Orpheus; the legend of Tristan and Isolde, who are granted a posthumous erotic reunion in *L'Éternel retour*, written by Cocteau for the director Jean Delannoy.

Because film captures light, which it traps inside the dark-room of the camera, it inevitably waylays spectres, figments of the spectrum. We know these spirits must exist, because they have left a silvery trace of themselves on celluloid. This is the testimony of *Vampyr*, a poem about the phantasmagoric properties of light. The hero stares in amazement at the midnight sun; he escapes through a milkily opalescent forest, his body almost annihilated by the overexposure of the film. When light leaked back into the camera, Dreyer was grateful for the technical mishap: the blur looked like ectoplasm. The simplest cinematic tricks prove the proximity of the supernatural. Earth leaps up of its own volition onto a gravedigger's spade. Double exposure enables the hero's soul to slip out of his body and wander through the fields. Shadows dance in agitated circles even though there are no bodies to cast them. A series of dissolves enables us to watch dissolution occur, as the vampire's preserved body instantly rots, turning into a skeleton. At the beginning of *Vampyr*, the haunted protagonist is described as one of those whose 'imagination is so developed that their vision reaches beyond that of most men': a seer, or perhaps – since the new art endowed everyone with that visionary power – a filmgoer. Kenneth Anger has called films a trap set to catch 'an astral body'. Spirits are snared in mid-flight, like the gauzy imps in Max Reinhardt's 1935 version of *A Midsummer Night's Dream* (in which the young Anger played the Indian prince stolen by Oberon); their feet and wings adhere to chemically coated celluloid. The astral bodies in Anger's own films are erotic phantoms – a sailor whose ejaculation is a Roman candle in *Fireworks*, a satyr in black leather astride his motorcycle in *Scorpio Rising*.

In *Ordet*, made in 1954, Dreyer audaciously staged a miracle. A woman dies in childbirth, but is revived during her funeral. A holy fool, who believes himself to be Christ, compels her to rise from her coffin. He worships light as the medium through which grace makes itself manifest: the reflected beams of a car's head-lamps, raking the walls of the house in which the woman dies, are to him a signal of the saviour's presence. Having asserted his belief in the possibility of resurrection, Dreyer indignantly denied that his mysticism was a retreat from the atomic age. In his view, Einstein's relativity had demonstrated that beyond the three-dimensional world which our senses apprehend lies the fourth dimension of time; beyond that, Dreyer thought, lay a fifth dimension – the realm of 'the psychic, proving that it is possible to live events that have not yet happened'. The hero's 'strange adventure' in *Vampyr* exemplifies Einstein's equation, $E = mc^2$. Mass when mobilized releases energy, which is spirit. 'The new science', Dreyer concluded, 'brings us towards a more intimate explanation of the divine power.'

Or of the demonic power. With the wicked relish of the romantic satanist, Kenneth Anger declares that 'I have always considered movies evil', because they traffic with the spirits of the air. In 1933 in *Das Testament des Dr Mabuse*, Fritz Lang adapted the cinema's shadow-play to account for the hypnotic politics of fascism. The psychiatrist Baum is invaded by the spirit of his patient Mabuse, whose mad tirades paraphrase Hitler. Lang ascribes the rise of Nazism to a contagious insanity, and shows how the infection passes from one mind to another. Baum, reading the dead Mabuse's testament, looks up and sees its author sitting opposite him, whispering his seditious counsels and schemes for state terrorism. Then the spirit walks out of Mabuse's ghostly body, crosses the room, stands behind Baum, crouches down and fuses with him. With the help of double exposure, Baum has become the post-mortem extension of Mabuse. His study is decorated with African masks, whose purpose was to render the face impenetrable. The camera knows how to pierce such defences: when Baum opens his terrified eyes, it drills through the skull of the babbling revenant Mabuse to examine his crinkled cerebral cortex. Film can lay bare the brain.

Elias Canetti, discussing mass dementia and the psychology of fascism, likened crowd behaviour to the hallucinations of alcoholics, which have, as he put it, a 'cinematic character'. A man suffering from delirium tremens looks at a reality which has apparently been altered by trick photography, with objects warping or madly merging. These 'aborted monstrosities' reminded Canetti of Saint Antony's temptations in Grünewald's Isenheim altar-piece – the painting which Hindemith and Picasso read as an allegory of ideological derangement in the 1930s. But the temptations of the saint, so long as they are merely painted, can remain imaginary. The camera gives these delusions a more terrifying veracity. In Michael Powell's *The Small Back Room*, a bomb-disposal expert who has lost his foot in a blast confronts the tempting whisky-bottle which would dull his pain. A ticking clock hammers his brain, its internal mechanism grinding him down like an instrument of torture; the bottle on the table swells to the size of a cudgel,

then takes over the room and squeezes him into a corner. In Billy Wilder's *The Lost Weekend*, another alcoholic staggers up Third Avenue in New York. Hiding the camera in laundry vans or piles of cartons, Wilder's second unit merely photographed what was there – the rattling trellis of the elevated railway tracks, the grimly barricaded pawnshops, the accusing clock-faces. But the documented sights look bleary, swimming in an unbearable glare, as if the camera saw them through aching, unfocussed eyes. Film found it dangerously easy to re-imagine the world through the eyes of a madman.

David Farrar in The Small Back Room *(1949)*

Rather than bringing to birth the new humanity predicted by Cendrars, the cinema in its competition with biology begot a series of technological nightmares – Wegener's rampant golem, the false metallic Maria in Lang's *Metropolis*, or the monster pieced together from corpses and jolted into action by lightning-bolts in James Whale's *Frankenstein*. More benignly, it added to nature's store of creatures a mouse dressed in shorts, a scatter-brained duck, an elephant with aerodynamic ears. Eisenstein in 1941 praised Walt Disney's cartoons for restoring to film an 'absolute freedom from all categories, all conventions'. Disney did not photograph what already existed; his animators created life first and photographed it afterwards. Chaplin's dejected comedies were, as Eisenstein put it, a modern *Paradise Lost*, lamenting our expulsion from the happy garden of childhood and our abandonment in the downtrodden, inimical city. Disney supplied the necessary sequel, a *Paradise Regained* which was attainable without 'the necessity of another primal extinction'. The cartoons, capriciously redesigning reality, offered relief from an industrial regime in which nature had been 'completely enslaved'.

The same freedom is the boon of the great production numbers in American musicals, where the song is often merely an excuse for erotic day-dreaming and graphic doodling, as riotous as any of Buñuel's surreal fantasies. Busby Berkeley constructed ceremonial arches of plump female thighs, through which his camera appreciatively panned in *Gold-diggers of 1937*. He filled a tank with the same agile limbs in *Footlight Parade*, split apart at the groin as they splash in a watery orgy. In *The Gang's All Here* he choreographed a ballet of ripe bananas, salaciously inclining their pointy tips to greet Carmen Miranda. Musicals waive

the cumbersome laws of physics. Girls dance on the wings of a fleet of planes which bounce above Copacabana in *Flying Down to Rio*, and Fred Astaire cavorts upside-down on the ceiling in *Royal Wedding*. Budgets allowed for a reconstruction of the world. In *Top Hat*, the Venetian Lido was built indoors as a pristine acreage of laminated white, with streamlined bridges for Astaire and Ginger Rogers to dance across and inky water – dyed black to make those smooth piazzas look more brilliant – coursing through the canals.

Cendrars, visiting Hollywood in 1936, was enraptured by a sequence from *The Great Ziegfeld* in which Dennis Morgan sings 'A Pretty Girl Is Like a Melody' as he strolls down a revolving mountain peak whose ledges throng with dancers. The figures – men in top hats with jaunty canes, women whose filmy dresses flutter in a soft breeze – endlessly proliferate, as if the white tower, serenely spiralling as it recedes into the upper air, were an assembly line on which life itself was manufactured. Or could it have been Jacob's visionary ladder, connecting earth and heaven once more and repairing the discordance which separated modern man from God? The set appeared to be 'drawn into the slow rotating movement of the constellations'; the song, echoing 'the faraway music of the spheres', filtered down 'like a sweet murmur, from the breathtaking depths of the sky'. Eisenstein was right to call cinema 'the great consoler' – a dream which sustains us while we wait for that promised, postponed new world. Happy the century that can afford to construct such fantasies.

All the same, ours has hardly been an age of light. Moholy-Nagy thought that art, by its 'education of man's subconscious', would prepare for revolution. His creative use of the camera tried to make amends for the iniquities of capitalism, which had turned machines against men. In 1935, engaged as a designer for the film of H.G. Wells's *Things to Come*, he constructed his ideal future in miniature: spotless, smokeless industrial idyll made from glass and flexible, transparent plastic, where walls had been abolished in order to admit 'man's natural life force, light'.

But technology unfortunately lacks a conscience. Listing the possible artistic manifestations of light in 1932, Moholy-Nagy suggested an arrangement of 'searchlights directed at the sky at night'. The same idea occurred to Albert Speer, who put it into practice above the Zeppelin field at Nuremberg during Nazi party rallies, constructing a cathedral whose pillars were the beams of 130 anti-aircraft lights (the bulk of Germany's strategic reserve, commandeered from Göring at Hitler's behest). As for what Moholy-Nagy called the 'morphosis of light', its most spectacular demonstration happened at Hiroshima in 1945. The bomb-blast littered the city with photograms – shadowy outlines of victims, imprinted on the sides of buildings by the radioactive glare.

Moholy-Nagy referred serenely to 'the optical culture of our age' and praised its hygienic virtue. He can hardly be blamed for not anticipating the corruption of that culture. In 1928, as the advertisement for Renger-Patzsch's *Die*

Welt ist Schön pointed out, sight was a novelty. The world seemed to be full of things which had never been properly looked at: Weston's unexpectedly noble and classical vegetables, the quaint vernacular architecture in Walker Evans's book of *American Photographs*, Renger-Patzsch's own close-ups of plants or machines. Since then, everything has been well and truly seen. Photography aims to conduct a census of the visible. William Eggleston in his book *The Democratic Forest* extends the art's franchise to dejected palms in Miami, supermarket shelves in Washington, a bus-stop in Dallas. All subjects are welcome; there can be no grounds for refusal. Sight is permissive, indiscriminate. As the photographer Robert Frank has noted, 'You can photograph anything now'. And anything, once it has been photographed, can claim to be beautiful – Irving Penn's cigarette-butts trampled in the gutter, Tokyo's grunge and sleaze recorded by Nobuyoshi Araki, or the severed heads and circus freaks of Joel Peter Witkin.

Today we are importuned by images on all sides. There is now too much to look at, so that taking a photograph – as harried tourists know – is a quick, convenient substitute for seeing. The veracity of the image cannot be trusted. Television seamlessly merges fact and fiction, news and docudrama. When the World Trade Center in Manhattan was bombed in 1991, the American networks which reported on the incident immediately turned it into a disaster movie, belonging to the tradition of *Towering Inferno* and *Die Hard*: a local channel called its extended news broadcast *Terror at the Towers*. When a fire-bomber attacked a New York subway train, there was a sequel. Reporters entitled this new outrage *Terror on the Tracks*. Anyone who possesses a video camera can – like the impotent hero of Stephen Soderbergh's *sex, lies and videotape* – transform their own life into a home movie. Adept at seeing things superficially and telling lies about them, the camera has entered into an alliance with commerce. On television, advertisements for cars take over the crags and monoliths of Monument Valley where John Ford made his finest Westerns, and fast-food restaurant chains imitate the folksy conviviality of Frank Capra's comedies; a Calvin Klein perfume was recently touted with the help of some commercials which looked like the surreal fables of Cocteau. The image, valued by Moholy-Nagy as an emanation from a mind in quest of enlightenment, is now a false face, a glossily cosmetic fiction. Disgraced politicians and fading celebrities put their trust in image make-overs.

William Hurt in Wim Wenders' *Until the End of the World* suffers from sick eyes, inflamed and exhausted by the glut of images on a congested, expiring earth. In 1983, Wenders bumped into his colleague Werner Herzog at the top of the Tokyo Tower. Herzog was searching for things to look at, but had come to the wrong place: Tokyo, separated from the observer behind thick glass and belittled by vertical distance, is smudged and erased beneath a cloud of pollution. The best reason for making the trip to the summit is to avoid seeing the tower itself. Gloomily studying the non-existent view in Wenders' film *Tokyo-Ga*, Herzog remarks 'The simple truth is that there aren't any images around now.... There's hardly anything left. You have to really look.' Herzog wants, he tells Wenders, to

climb a mountain, or perhaps hitch-hike to Mars or Saturn on the next rocket. There he might be able to find things which have not gone stale from being looked at and photographed a million times before. The disillusioned director in Wenders' *Lisbon Story* abandons work on his movie, sickened by the mercantile shame of his own calling. He lives in a wrecked car on a plot of vacant ground in the slums, among tattered posters of political candidates whose careers depend on the untruthful images they sell to the voters; he deposits video cassettes in litter bins, since imagery, like garbage, is a disease of affluence. Still, unable to cure himself of the cinematic habit, he wears a video camera slung over his back as he wanders through the city. It films what happens behind him, making its own choices about what to see. The images it captures may be blurred, unintelligible or unwatchably tedious. But at least they do not constitute a slick, pretty sales pitch.

'That's what life is,' remarked William S. Burroughs in 1983 – 'a film.' The comment qualifies as another modern epiphany. In his novel *The Place of Dead Roads*, Burroughs added a proviso: '*All pictures are faked.*' Pictures, that is, which have been painted, and are fake because they deny our temporality and our temporariness. But pictures which move have a unique capacity to show us what time looks like as it passes. They can make visible the lapsing of life itself, in human bodies and on the earth. Antonioni's *L'eclisse* ends at an urban crossroads, the setting for a rendezvous between the lovers Alain Delon and Monica Vitti which does not take place. But although the characters fail to keep their promise, the camera maintains its vigil and studies the busy errands of molecules. A bus arrives, containing neither Delon nor Vitti. An anonymous man gets off, holding open an evening paper with a headline about the instability of the atomic age. The unbuilt building on the corner shivers inside its shroud of tarpaulin. Water trickles into a gutter and drains away. The sky darkens: a slow, protracted eclipse, erasing everything. Then an alternative sun, unwatchably bright, glares to signal that the film is over. It might be only a street lamp, or it could be the silent flash of a bomb, irradiating the world and extinguishing it.

At end of *The Passenger*, as Jack Nicholson prepares to die, Antonioni's camera escapes from the fetid hotel room, magically squeezing through a barred window like a soul exhaled by the body, travels back and forth on a lost, wayward circuit of the dusty square, and continues to move until, beyond a white wall, it locates a bright, watery horizon: the border to an undiscovered, invisible country. It then wheels back to cast a retrospective glance at the world it has left behind, represented by the transitory hotel, a place of passage, peering through the same window to wonder at the slumped, useless body which Nicholson has meanwhile quit. The camera has taken us, as Claudel hoped it would, on a tour of the cosmos.

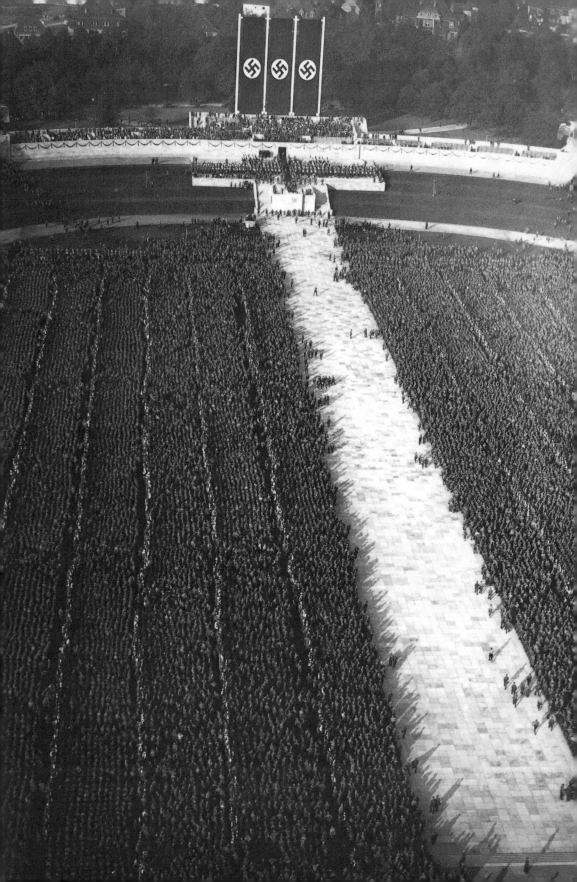

POWER AND DARKNESS

The twentieth century hesitated between beginning the world all over again and ending it. Perhaps one was not possible without the other. Time, rendered flexible by relativity, could move in either direction, or in both simultaneously – forward to the sleek, technological future, back to a vitally barbaric past. When the two itineraries overlapped, they produced the century's most grotesque, sinister and vicious social experiment: the Third Reich.

Hitler retribalized Germany, turning it back into a primitive society of peasants and warriors. To achieve this regressive aim, however, he used the methods of modern engineering. The state he created, with its autobahns to expedite troop movements and its abattoirs and gas ovens, was ferociously efficient; but while carrying through this enforced modernization, he denounced and persecuted the infidel spirit of modernity. He ridiculed modern architects as vandals, accused modern painters of possessing diseased eyes, and reviled the atonal din of modern music. The culprits were hounded into exile, or rounded up for killing. The mixed motives of the century hypocritically or schizophrenically battled it out in Hitler.

Among the birthday presents he received in 1939 was a collection of manuscript scores by Wagner. They seem to have perished with him in his bunker six years later: he could not be separated from them, because those operatic myths – Rienzi saving Rome by dissolving the corrupt Senate, Lohengrin or Parsifal revising Christian gospel, Siegfried forging his sword – supplied him with the script for his political actions. The collection of manuscripts included an orchestral sketch for *Götterdämmerung*. The donation was made by a consortium of German industrialists, who knew that the world's end would be good for business. Apocalypse was a precondition of Hitler's revolution, and in this respect he was an unwitting avatar of modernity. He began from that awareness of rupture which set the new century adrift. God had expired, and man – at least in his bourgeois incarnation – was moribund, demoralized by military defeat and panic-stricken by the economic catastrophe which followed from it. Hitler made

Nazi Party rally at Nuremberg, with a few ornamental stragglers

the schism official, declaring that 'the Age of Reason is finished'. His own state-craft, accordingly, was irrational to the point of self-destruction. Did he want to annex the world, or to annihilate it? His street-corner thugs and bureaucratic murderers were kept busy, since the task he set them – which began with the funeral pyre of books on Unter den Linden and ended in the slaughterhouses of Auschwitz – was nothing less than to torch the West's accumulated wisdom and eliminate all those who cherished its values.

Leni Riefenstahl's 1936 film *Triumph of the Will*, recording Hitler's descent on Nuremberg as an airborne redeemer, described 1918 as the year of Germany's Passion. The terms of the Versailles peace treaty were, in this view, a national crucifixion. Hitler's advent, like that of Christ, marked a breach between eras. The Third Reich even erased the calendar to make way for him: a line was drawn under the total of 1933 years in the Christian dispensation, and number-ing began again from zero. Promising that his state would inaugurate a new mil-lennium, Hitler deliberately invoked the convulsive beginnings of that world order which he had vowed to destroy. In Broch's *Death of Virgil*, the poet senses a subterranean turbulence, a sign of 'the coming overthrow of the creation'. He warns Augustus that they live in the anxious interregnum between epochs. Though the Augustan peace promises a golden age, Virgil believes that a differ-ent saviour will take over from the emperor and bring about 'the divine renewal of the world'. Augustus is ready for the challenge. He promises that, should another Spartacus arise to challenge the state, he and his entire host will be nailed to crosses like the rebel slaves.

Augustus threatens Christianity before the event, hoping to forestall the arrival of the new millennium and its peaceable, forgiving ethics. Hitler, near the end of a second millennium, rejected Christian morality. The swastika – a *Hakenkreuz* or hooked cross, its hacked angles alluding to the pagan cult of sun worship – replaced the crucifix. It saddened Hitler that the invading Arabs had lost the Battle of Tours in the eighth century. Their messianic militarism, he fan-cied, might have become the European creed. But God's death during the nine-teenth century liberated what Nietzsche called 'the manly instincts that delight in war and victory', and gave Hitler his chance to accomplish a cultural conquest which had eluded the Arabs. A photomontage by the exiled satirist John Heart-field (formerly Herzfeld) showed an obese Göring pluckily taking part in the 1936 Olympics. Wearing a horned helmet, his arms and legs dislocated to form a swastika, he aims his javelin at a pinioned, emaciated Christ on the cross.

When Broch's Virgil condemns the mob which gloats over sacrifices in the arena, Augustus boasts, as Hitler was to do, of turning 'brutalization into disci-pline, unbridled cruelty into games' in order to instil a 'necessary hardness' in his subjects. Fascism admired and mimicked the authoritarianism of imperial Rome: its token was the fasces – a bundle of rods embellished with an axe blade, symbolizing consular power. That power, which apportioned life or death to millions of people, claimed to derive its rights directly from the blood and soil

of Germany. But in fact its pretence of legitimacy, like that of paper money, depended on symbols, solemn fictions. Albert Speer, justifying the expenditure of resources on ceremonies like the Nuremberg rallies or the 1936 Berlin Olympics, said that there were 'representational reasons' for such bullying pomp. What is power after all – like the world itself, according to the metaphysics of Schopenhauer – but a representation, an illusion, a show of force meant to compel belief and submission? The Nazis relied on theatrical props and dusty heraldic devices to prop up their regime. They undertook a frantic, frustrated quest for the earliest manuscript of *Germania*, in which Tacitus supposedly vouched for the ethnic autonomy of the race; they coveted a holy lance in the Vienna Treasury, envying its sacred pedigree – after stabbing the side of the crucified Christ, it had supposedly been passed on by way of the apostles to Charlemagne and then, when the Holy Roman Empire collapsed, to the Habsburgs. They had their own obscene sacraments. Brotherhood was enforced by touching the flag bloodied by the so-called martyrs killed during the failed *putsch* of 1923. Temples for the coffins of these sanctified hoodlums were constructed on the Königsplatz in Munich, and consecrated at night in 1935.

Though the Nazis hoped to ground their faith by purloining relics and faking genealogies, their superstitions revealed an instability which their edicts attempted to suppress. This morbidity overshadows *Olympiad*, Riefenstahl's documentary film of the 1936 Olympic games in Berlin. The carnival of bodily vigour looks gloomy and funereal. The prelude, meant to recall the naked eurhythmics of the Greeks, takes place on a cold northern beach, under a frowning sky. Three women dance or pray to the sun in the prelude. Their bodies overlap, yearning for unison. Interwoven, they possess a forest of waving arms, formed into a Gothic arch. When they raise their hands they sketch a steeple. The frolicking Naiads were Riefenstahl's homage to the painter Arnold Böcklin, whose *Isle of the Dead* was one of her stylistic reference points. It did not seem odd to her that the setting for this festival of health should resemble Böcklin's pallid, rigidly symmetrical mortuary among its stiff pines. Athletes, in her estimation, had volunteered to suffer agony; their exertions, like all heroic action, were a rehearsal for death. In editing her record of the diving contest, she reversed the footage so that the divers seem to be soaring upwards, like souls freed from their entombment in the body. Fired into the pool, they are immersed once more in a primal source, absorbed as if by Wagner's Rhine or the oceanic unconsciousness of Jung. The figures line up on the board, awaiting their turn to launch themselves into the abyss; the camera admires them from below, as they stand outlined against a sombre sunset. One after the other they execute a leap which, with its virtuoso flourishes and optional gyrations, expresses their indifference to living. It is more like watching a kamikaze raid than a sporting competition.

The endless circuits of the track at the Olympic games had their source in Greek mythology. They duplicated the daily errands of the sun, driving its chariot around the sky. The races run on earth, like the dances in *Le Sacre du printemps*,

ensured that the universal order was maintained. But Riefenstahl's *Olympiad*, rather than upholding the regime of light, ends in darkness. Instead of a closing ceremony, she photographs Speer's chilly cenotaph of electric beams. A doleful bell clangs, and as the searchlights converge, the score quotes from the Grail music in Wagner's *Parsifal* – not, in this context, a symbol of accord between man and God, but a warning, like those torches raking the sky, that man had penetrated God's domain.

The struggle, after which Hitler named his self-aggrandizing memoir *Mein Kampf*, was unremitting; the will tirelessly urged itself on, determined to triumph. Being picks up speed as those bodies hurtle to the edge of the diving-board in *Olympiad* and ricochet into the air. Then, however, a dead weight hits the water. An undertow of fatalism tugged at both the physical exploits of the Nazis and their metaphysical conjectures. Did they ever believe they could replace a culture which over more than two thousand years had painstakingly assembled an amalgam of classical ethics and Christian virtue? The SS leader Himmler consulted astrologers; other cosmologists held in esteem by the high command undermined the achievements of the Reich by predicting imminent doom with the coming of another ice age. Perhaps catastrophe was a more heroic outcome than survival. Nietzsche in *Götzen-Dämmerung* said that only 'shopkeepers, Christians, cows, women, Englishmen and other democrats' had the ambition to be happy. Superior spirits on the contrary desired a glorious death. If defeat was certain, gratification lay in ensuring that millions of underlings – and maybe even the world itself – shared that fate.

Their regime was initiated by acts of destruction. The Reichstag burned in 1933, and in 1938 synagogues and Jewish businesses were vandalized on Kristallnacht. Fire warned of an elemental rampage; the sound of broken glass demonstrated the fragility of civilization. This atavistic terror licensed the brutish appetite for revenge which, as Josef Breuer believed, our social morality should keep under control. Yet the violence of the Nazis also harnessed collective energies as turbines do, and showed that a crowd incited to fury has the same superhuman force as a machine. Primitivism was the alibi for a ruthless technological modernity.

The Nazis relied on myths to cover this contradiction, and to conceal the truth from themselves. One of their ugliest fantasies was that of the blood-bath. In Fritz Lang's film *Siegfrieds Tod*, the Wagnerian hero is drenched by the blood of the dragon he has killed. The shower makes him invincible: blood has given him a 'necessary hardness'. But one spot on his back remains unanointed, because a leaf clings to it while he is bathing. Kriemhild, wanting revenge, marks the spot which a blade can pierce by sewing a cross onto his tunic. Hagen aims his spear at the target, and kills Siegfried. Nature – in the form of the fluttering, wayward leaf – is the hero's enemy, laming him. He must shed his own soft humanity. The crucifix stitched by Kriemhild signifies weakness. Myths like this were jerry-built fictions, a convenient camouflage for power. The hero's legendary blood-bath

had already been analysed by Freud in his *Interpretation of Dreams*, where the episode is rationalized: for him, indeed, it showed the tactics which reason could sneakily use in revenging itself on a crazed irrationality. How does an analyst penetrate the demented narrative of a dream? Freud explained that linguistic slippages are a reliable way in. There is always, he said, a 'weak spot in the dream's disguise'. He likened this spot to the patch on Siegfried's back, not washed by the dragon's unholy blood. In Freud's version of the parable, the analyst ironically takes the role of the deadly, vanquishing Hagen, whose blood will not flow when Siegfried and Gunther wound

George Grosz
Siegfried Hitler
(1922–3)

themselves to sing their oath of blood-brotherhood in *Götterdämmerung*, and who stabs Siegfried in the back. No spells or magic runes can protect modern man against Freud's piercing insight. There may be no such thing as a hero, but the regime which accredited such myths managed to transform reality into a twelve-year nightmare.

The blind spot of the Nazis – as damaging to them as the patch on Siegfried's back, not toughened by blood – was their indignant denial of modernity. Speer, imprisoned in Spandau, learned that a Russian tank now stood in Wannsee to commemorate the Red Army's victory over Berlin. He winced, and noted in his diary that the rams and sphinxes of the Egyptians were more appropriate as ceremonial icons. 'Technology', Speer insisted, 'is always opposed to mythology.' That was why he resisted Hitler's scheme for a boulevard with weapons seized from the Reich's enemies displayed on pedestals. He thought that you could exhibit Goethe's pen in a museum, but not Hemingway's typewriter, and – still dreaming of armaments in his prison cell – he maintained the distinction between heroic combat and mechanical warfare: 'Achilles' sword is not a rifle and Hagen's spear not a flame-thrower.' The Marxist literary critic Georg Lukács had a better understanding of the relation between heroism and technology. He argued that the shield of Achilles in the *Iliad* was a true emblem of epic, because its decorations narrated the work which went into making the hero's weapons, rather than merely describing what they looked like. The shield qualified as a piece of machinery, just as much as Hemingway's typewriter. It also advertised the true nature of society, which is itself a complex economic mechanism, not the pristine tribe of Nazi theories.

Speer bragged about his hostility to modernity, and thought that his own muscle-bound architectural schemes were 'a last attempt to defend style against

industrial form'. But the despotism of the Reich depended on technical resources, which is why radio sets were issued free to all households, attuning every mind in the land to that of the Führer. Karl Kraus remarked that the war of 1914 showed up the illogical 'coexistence of thrones and telephones'. The ease of communication doomed monarchy, whose mystique depends on incommunicability, on an absence like that of God. The Japanese heard their emperor's voice for the first time in 1945 when he announced the country's surrender after the bombing of Nagasaki. Unaccustomed to being addressed by a descendant of the sun, they expected that he would command them to atone for the national shame by committing suicide. Demi-gods may not broadcast on the radio, but dictators do.

For Kraus, the Nazi take-over in 1933 revealed the 'coexistence of electrical technology and myth' – in other words, the synergism of the modern and the primitive. The Russian Revolution, by contrast, valued the written word and strove to enfranchise the masses by making them literate. The savage deputation

from the Asiatic provinces in Eisenstein's *October* is won over by the dissemination of Bolshevik leaflets, which promise bread, land and peace. In Germany it was more important to hear Hitler speak than to read *Mein Kampf*. Hermann Otto Hoyer painted the nativity of Nazism in a Munich beer-hall, where Hitler lectured his first group of acolytes. Co-opting the Christian mythology of genesis, Hoyer called the picture *In the Beginning Was the Word*. That beatific word had to be spoken, not read. Words on the page remain silent, but spoken words have the power to mesmerize. Speer noted that Hitler mistrusted books, which were a

Grigory Shegal Leader, Teache Friend (Stalin at the Presidium of the Second Congress of Collective Far and Shock Workers, February 193 (1936–7)

resort of anti-social privacy. He preferred the collective experience of the theatre, where a crowd, under the spell of the show, is transformed into a congregation.

Written words are fixed, or have meanings which can be verified in a dictionary. The word when spoken can be conjured with. The philosopher Martin Heidegger called Socrates the greatest of philosophers, for the simple reason that he wrote nothing down: his seminars must have been an exercise in sorcery, like Hitler's ranting broadcasts. Heidegger's own philosophy relied on the same

malleability – a fatal talent of the German language, in which it is so easy to cut words up into their constituents and splice them back together in new ways. Inside his name, Heidegger excavated the words for heath and acre. This justified his primitivist notion of himself as a wood-cutter, who toiled to clear paths through a lexical forest. Were these fanciful etymologies a pedigree, a legitimizing provenance like that for which the Vienna lance supposedly vouched, or did they reduce language to a shadow-play? The Nazis followed strict 'language rules', a coded speech which took care to empty words of meaning. This euphemistic jargon ensured that they did not tell, and eventually could not recognize, the truth. After the war it proved difficult to establish which members of the high command knew about the industrial arrangements for mass murder, because no one had ever referred to the matter directly. They spoke only of a 'Final Solution', abstracted from the reality of cattle-trucks and incinerators. Thumbscrews and spikes were applied to the conspirators who attempted to assassinate Hitler in 1944. The procedure was known as 'intensified interrogation'.

Heidegger denounced the nihilistic legacy of reason, which had given Western man control over nature while estranging him from reality or the bedrock of his own being. But in this precise sense the Nazis – despite the enthusiasm for their revolution which Heidegger expressed in 1933, during his inaugural address at Freiburg University – were practising nihilists. Hence their reliance on machinery to do their killing. Technology offered insulation, detachment; it broke the link between their loftily expressed ideas and the appalling reality, and introduced a species of moral remote control. First you classified your enemies as subhuman; then when you murdered them you could describe the process as sanitation. The Nazis represented themselves as a force of folksy, ancestral nature, making war on the superficiality of culture. The opposite was the case: as engineers of death, they advanced culture's technical campaign against nature, which it seeks to supplant or to eliminate. In their specifications for the trucks in which consignments of Jews were gassed with exhaust fumes, they referred to the human cargo as items being processed, and fussed over the redistribution of the vehicle's load when panic – as the poison filtered in – caused the dozens of trapped victims to rush for the rear doors. Might the gas-wagon lose its balance? Superintendents at Treblinka boasted of their productivity, and said that the concentration camp was working at 'full capacity'. They meant that the crematoria burned twenty-four hours a day, labouring mightily to reduce the inhabitants of the Warsaw ghetto to ashes. At Auschwitz there was general contentment when the gas Zyklon B boosted efficiency. Now people could be killed in lots of three thousand, and in only a few minutes. Of course this industrial view of cadavers as product, with hair cut off and gold teeth removed to be lucratively recycled, could not altogether conceal the obscenity of the operation. Treblinka reeked of decay, with extra bodies left to rot in cesspits. The ground above the mass graves heaved like an ocean, made turbulent by those tiered, fermenting corpses covered by only a thin shroud of sandy soil.

The terminology of the Nazis combined sacramental appeals to a higher power with an acutely modern technical canniness. Hitler used the word 'Gleichschaltung', which means synchronization or streamlining, to denote an enforced co-operation. It was a useful coinage, because it covered the suppression of dissent; he took it from manuals describing electrical circuitry. On trial at Nuremberg for war crimes, Albert Speer adroitly transferred the blame by pointing out that the telephone had abridged the chain of military command. How could he have known about the slave labourers worked to death in the factories for which he was responsible? Orders, he claimed in self-defence, were transmitted directly down the wire from the highest to the lowest levels, where 'they were carried out uncritically'; intermediaries like himself had been excluded. Stalin's secret police devised a technology for destroying the morale of prisoners. Those accused of imaginary ideological crimes were processed through a so-called 'conveyor'. Guards working in shifts interrogated prisoners around the clock. The suspects were weakened by starvation and the denial of sleep, and beaten for good measure. Within a week, most of them readily confessed to any infraction their accusers cared to invent. At Auschwitz, totalitarianism industrialized death; in the basement of the Lubyanka in Moscow, it set up a factory which manufactured guilt.

Despite Hitler's fulminations against the avant-garde, his doctrine made surreptitious thefts from modernism. His contempt for squeamish humanism derived its force from a garbled version of the notion – held in common by philosophers, novelists and even cubist painters – that individuals or independent existences were obsolete in the twentieth century. The Nazis formally decreed the death of the individual. Robert Ley, who preached the gospel of 'Kraft Durch Freude', mistrusted solitaries, and arranged sessions of drilled and mandatory leisure for the eugenic members of the Party. Induction into its ranks was a rite of passage involving the glad sacrifice of an irrelevant individuality. Uniforms were crucial, because they created uniformity. This was one of Hitler's aesthetic scruples: long before the war began, he outfitted civilian members of his entourage – his doctor and photographer, for instance – in military kit, because otherwise they spoiled the pleasingly faceless effect. Speer, serving as his architect, was likewise hustled into costume.

The logic of this demand was enunciated by Yukio Mishima, who fastidiously designed uniforms for his own fascist corps, the Shield Society, which he founded in 1968. Mishima was masochistically grateful to military discipline, because its barked orders put an end to the querulousness of the intellect. At the same time it braced the body into shape. The soldier, in Mishima's definition, was 'individuality...pared down by a uniform'. The regulation clothes, he rejoiced to discover, refused to fit skinny bodies or to accommodate sagging bellies; they called the wearer to order. In *Triumph of the Will*, Riefenstahl surveys a parade of helmeted SS men, doubly dehumanized. Their helmets turn the skull into a cudgel; and Riefenstahl – avoiding the evidence of individual faces, though they are

overshadowed by the metal brim and equalized by the baleful, implacable expression they share – chooses to photograph them from behind.

The individual's demise supposedly occurred when the ranked classes of nineteenth-century society – segregated inside their villas or cottages, separated by custom and culture – subsided into an undifferentiated mass. The crowd is one of the new phenomena which define the temper of modern times. Initially it is terrifying, because it obliterates your own frail, single being. Hitler aimed to make that extinction a source of comfort. In *Triumph of the Will*, 52,000 labourers with shouldered spades chant a litany, proudly declaring that they too qualify as soldiers. They recite only the regions they come from, since they have grown from their native soil: do trees have proper names? Hitler, addressing them, vows that no one will be permitted to join the German community without passing through the same initiation into manual labour, which levels distinctions. Minds may possess a residual individuality. Bodies, however, are all the same – and if there are unfortunate variants, these are best dealt with by a policy which the Nazis, euphemizing again, called euthanasia. At the rally filmed by Riefenstahl, the youth leader Baldur von Schirach remarks that all his cohorts have been refashioned in the Führer's image, as facsimiles of him, because he embodies the highest selflessness. Rudolf Hess's concluding address propounds this truth as a mathematical equation. One equals all: Hitler is the Party, and Germany is Hitler.

The theory had to overlook the fact that individuals did still unregenerately exist. A seditious jingle which circulated in the Third Reich defined the German ideal – as blonde as the swarthy Hitler, as tall as the runtish Goebbels, as lean as the porcine Göring, as chaste as the rapacious Röhm (the SA leader, murdered on Hitler's orders in 1934, who recruited sexual partners from the ranks of his young followers). The irregular bodies of the Party functionaries irritated Speer when he choreographed the first Nuremberg rally. They could not form a straight line; their bellies ballooned when they stood to attention. Speer suggested that they should march up to Hitler in darkness, with spotlights on the banners far above them. Darkness, in this case, was a kind of mercy-killing.

Organized into multitudes by a leader who represented their collective existence, people now existed only as part of a design. The mass, as Kracauer noted in his summary of fascist aesthetics, serves as an ornament. Lang's films of the Nibelungen saga show this decorative enslavement at work. The dwarfs chained to Alberich's hoard have petrified. Kriemhild crosses the river by walking on a human pontoon: soldiers up to their necks in the stream make a path for her with their shields. Hagen in *Kriemhilds Rache* forms a bodily roof, raising his shield to protect Gunther from falling timbers as the Gibichung hall burns. At Nuremberg, Riefenstahl photographed pine forests made of men. In a travelling shot, filmed from a car circling the arena, the saluting troops merge into a palisade of outstretched limbs. The right and left wings of fascism joined in celebrating the individual's obsolescence. In Treptower Park in Berlin, where the

Russians built a monument to their liberation of the city in 1945, a frieze shows a phalanx of twenty-one Red Army soldiers with bayonets fixed. Their uniforms and weapons are identical, but so are their dogged, jutting profiles. They recede into the distance, and the line presumably continues beyond the vanishing-point. Above them floats the disembodied head of Lenin: rather than aspiring to personal identity, their devoutest aim is to resemble him.

Arno Breker sculpted muscular guardians for the courtyard of Hitler's Chancellery, as alike as pin-ups from a physique magazine or an underwear advertisement, their bronze skin permanently tanned. The entrance was flanked by twin giants representing Party and Army. They possessed the same bodies, because the ideas they stood for could be equated: their brows were furrowed by duty, they wore their pectorals like breast plates, and their genitals compactly packaged the racial treasury. They even adopted the same stance, with one leg striding forward into action. They were differentiated only by a single accessory, and a symbolic gesture. Party held up a torch, Army a sword. Party opened his hand, fanning the air into a cyclone, imitating the semaphore of an orator. Army clenched his hand into a fist. Breker specialized in designing the Reich's version of the new man. The figure in the statue he called *Vocation* has a long, prehensile neck, like an elevator raising his head of oiled, blonde, wavy hair to a pinnacle from which the future is visible. But his eyes are empty, refusing empathy. This marble archetype takes on flesh at the beginning of Riefenstahl's *Olympiad*, when a straining Greek statue comes alive – thanks to superimposition – as the German decathlon champion. Speer believed that Nazi statuary would restore the human figure to cities 'whose human quality was being threatened by the onrush of technology'. Once again the blind spot in the myth prevented him from seeing that figures like these were automata, not human beings. Ferdinand Staeger's painting *Political Front* showed columned troops by moonlight at the 1936 Nuremberg rally, tapering towards a vanishing-point on the remote horizon. An alley of raised bayonets symbolizes the interchangeability of these cloned men.

Nature was too quirky and capricious to be trusted; hence the genetic engineering of Nazi doctors like Josef Mengele. Hitler saw breeding as a matter of increasing the gross national product: he spoke of a 'systematic population policy' which would turn out a hundred million extra Germans to settle the new Asiatic provinces of the empire. Because the comradely cults of Party and Army made the family redundant, the contribution of women to this process seemed doubtful. In *Triumph of the Will* they remain out of sight, except for a few grizzled peasants and mothers pressing babies towards Hitler to receive his benediction. Riefenstahl concentrates instead on homoerotic horseplay in the camps: romps in the showers, some sweaty wrestling, and a few sweet vignettes of Hitler's honorary offspring combing one another's hair. At Hitler's court, Eva Braun was officially invisible. In the early years of their association, Speer concealed his own marriage from Hitler, as if it constituted a demerit. He later claimed, with his usual ingenuity, that this reticence was his protest against the Führer's

unchivalrous treatment of Eva Braun. The commandant's wife in Strauss's opera *Friedenstag* – first performed in 1938, and set on the day when the fratricidal Thirty Years' War between Germans ended in 1648 – tries to gain herself a place in the new order by begging her husband to recognize her as a fellow-warrior. Her bridal song, she proudly cries, was the discharge of guns. Kriemhild in Lang's films of the *Nibelungenlied* does not, like Wagner's Brünnhilde, offer to redeem the world through love. She joins forces with Attila to sack Rome, but later spurns the Hun as a milksop. He hesitates when she makes plans for the massacre of the Gibichungs, and would rather dote on their child. Kriemhild is disgusted: paternal sentiment hardly becomes a warrior.

Industrially pre-empting nature, the Third Reich offered its citizens the bliss of extinction. Before she became Hitler's personal mythologist, Riefenstahl acted in a series of alpine extravaganzas directed by Arnold Fancke. She climbed sheer cliffs in quest of a mystical blue light, vaulted across chasms on her skis, or performed aeronautical manoeuvres around Greenland icebergs. The mountainous settings exploited that perilous excitement which the romantics called sublimity: the thrill of risking yourself against the indomitable might of landscape. Exhilaration is proportional to the likelihood of death. Always there is the chance of a fall, the revelation of emptiness beneath. In 1933 Riefenstahl published a book about her exploits in these mountain films, *Kampf in Schnee und Eis*; her title invoked Hitler's memoir of his own self-aggrandizing struggle. The book includes a photograph of the glacier on Mont Blanc. The fissured pinnacles of ice crack apart like a jigsaw puzzle, with serrated edges and deadly gaps between the pieces. In 1933 this terrain served as an allegory of the world far below these icy heights, where a society had only recently fallen through the floor. Riefenstahl accordingly re-created the topography of Fancke's films at Nuremberg. She made narrow mountain passes from the stonily erect bodies of the soldiers; her glacial pinnacles were Speer's vertical beams of light, and the Führer's rostrum hovered in mid-air like an eagle's nest.

Beyond the fantasy of military conquest lay the higher gratification of ultimate defeat, which meant absorption into the vaster power of nature. The romantics, scaling peaks or withstanding storms, were engaged in a solitary combat; Hitler transformed this into a communal agon – an invitation to mass suicide. Railing against flabby Christianity, he envied the Shintoism of the Japanese, 'who regard sacrifice for the fatherland as the highest good'. Politicians generally promise happiness and pathetically trust in its permanence; but at Nuremberg Hitler roused the young Party members with an astonishing admission of nihilism. He encouraged them to steel themselves through privations, because whatever he and his colleagues might achieve today or tomorrow, they will all inevitably pass away. When nothing remained of him, Hitler told this next generation, they must hold in their hands the flag he tore from nothing. Here, rewritten as propaganda, was the drama enacted by Heidegger's metaphysics: Being wrestles free from Nothingness, and attempts to plant itself in a native soil,

to defend the eugenic legacy of blood; eventually Nothingness must reclaim it. The party's rhetoricians loved to invoke the ennobling anguish of that end. Hess at Nuremberg pointed out to Hitler the protective barricade of Party flags, then went on – in a peroration which any other political movement would have considered blasphemous – to prophesy that only when those banners have frayed will the meaning of his reign be truly revealed.

In *Mein Kampf* Hitler anticipated the time when Berlin, after its thousand years of glory had ended, would share the fate of mouldering Rome. Its memorials, he decided, must not be Jewish warehouses and international hotels; on its central boulevard, striding across the city on a route cleared by demolition, the history of the world would be recapitulated and concluded in a synopsis of architectural styles. For Hitler's residence, Speer chose Pompeian motifs – a piquant reference to the dead city under its counterpane of volcanic ash. Göring's office was to be grossly baroque, like an overgrown Pitti Palace on an even more self-important scale. The City Hall evoked the chivalric castles of the Middle Ages. The Ringstrasse in Vienna, laid out in the 1860s, had attempted a similar review of the past, with a Grecian parliament, a Gothic City Hall, a Renaissance design for the University and a baroque palace to house the Burg-

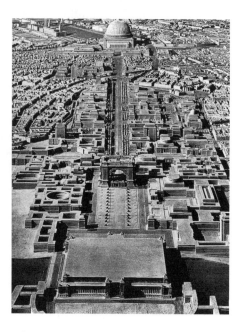

Albert Speer's design for Germania

theater. But there the plot was confidently evolutionary, demonstrating how the past had ushered in the happy, lavish present. Speer's buildings, uprooted from their native landscapes, remained as the solitary specimens of derelict cultures, like the remnants of endangered species rounded up in a zoo.

The new capital which Hitler called Germania was designed with a view to its eventual ruination. Speer presented him with a Piranesian sketch of the Zeppelin Field at Nuremberg, its toppled pillars reclaimed by nature. The courtiers were aghast that he had dared to imagine the regime's downfall. Hitler, however, was delighted. His obsession with immortality implied a contempt for our current mortal existence. Being, in Heidegger's terms, is homesick for Nothingness. Hitler amused himself by designing his own mausoleum, and Speer's fondest wish was that his own buildings might have a stoically protracted, elegantly anguished death. He disdained steel and reinforced concrete – the materials which modernized architecture by rendering structure elastic –

because they did not weather well, and would look undignified when they decomposed. The ruins of Berlin were not quite what Speer had in mind, and they arrived sooner rather than later: the flimsy wall of the Anhalter Bahnhof, with a grassy waste where the railway tracks used to be; the underground cells of the SS prison excavated beside the Martin Gropius Bau; or Tacheles, a wrecked department store behind Unter den Linden, which used to bulge with the goods and chattels essential to bourgeois life and is occupied now by tribes of strung-out, noctambulant artists, with a downed helicopter, an overturned bus and a smattering of spent torpedoes in its back-yard.

While they awaited their own overthrow, Speer's buildings had a morbid function to perform. Their purpose, like the sublime thunderclaps of romantic nature, was to intimidate and belittle insignificant man. Inside Hitler's Chancellery, diplomats had to trek the length of three city blocks down otiose corridors and through yawning galleries before, exhausted, they arrived in the Führer's presence. The floors on the way were kept permanently slippery with polish, providing visitors with an extra ordeal. The Olympic stadium was a starkly simple device for containment and control. Its oval shape resembles the vice-like bandage clamped around the head of Breker's *Wounded Soldier*, so tight that it compels him to grimace in pain. A society could be crammed onto the stadium's cliffs, all present and correct for inspection by the Führer. The acoustics of the place are alarming. The height of its walls make a megaphone of it, and if you happen to be nearby during a football match, you can hear it directing howls of outrage or shrieks of glee at the sky.

Speer explained the psychological calculation behind megalomaniac spaces like the domed assembly hall he designed for the new Berlin, meant to hold 180,000 believers. A room this size would remind the individual that he existed now only as a speck; trooping through the door, he would undergo atomization. The hall was an auditorium for the afterlife, like Valhalla, to which the Valkyries carry off warriors whose cadavers they select from the field of battle. The Nazis, desperate for some mythological guarantee of their primacy, believed that the Aryan tribes had descended from the race of giants, and they dispatched scientists to hunt for the fossilized remains of these ancestors in Tibet. Breker's statuary reconstructed them, and so in its wishful way did Speer's dome: perhaps all those thousands of small men, merged or pulped and responding as one, added up to a single giant. This exponentiation of numbers was one of those epiphanies which defined modern experience. Crowds swelled to fill up a new kind of city which Germans called the 'Millionenstadt'; currency during the 1920s extended into a vapour trail of noughts. Hitler played his own sublime games of multiplication. In 1942 he tallied the numbers which would be added to the Aryan stock of the Reich by annexing the Nordic populations of Scandinavia and the Balkans. The preliminary total was 127,000,000, though this – he insisted – would be boosted by a baby boom after the war. Likewise the Berlin assembly hall had, as Speer conceded, 'inflationary dimensions'. Its internal

volume, he reckoned, would be able to contain sixteen basilicas the size of St Peter's in Rome. Inside it the United States Capitol in Washington would dwindle to an egg-cup.

These were fantasies best indulged with scale models, and Germania remained a miniature toytown, shown off to visitors in a playroom at the Chancellery. Grandiosity and bombast inflate reality, but they are made of wind. Sooner or later the giant shrivels into an insect. All those noughts did not confer value on the German mark; rather they drained worth from it, like air escaping from a balloon. Hitler planned to endow Munich with the largest opera-house in the world, seating five thousand spectators. It did not occur to him that the music would be inaudible inside such a hangar, or that in the assembly hall he would dwindle, in Speer's phrase, to 'an optical zero'. Technology has since learned how to resolve this deflationary problem: the walls of video screens used at political rallies and stadium concerts transform the tiny body of the speaker or singer into an electronic giant. The crowd, however multitudinous it might be, is still kept in awe by this looming phantom.

If the world did not consent to its renewal, Hitler determined to destroy it. When he celebrated his pact with Stalin at Obersalzberg in August 1939, the elements colluded. The northern lights flared, and the Untersberg seemed to be burning. The scene looked to Speer like a setting for the last act of *Götterdämmerung*, in which Brünnhilde's funeral pyre incinerates Valhalla. Hitler, eager for the violence ahead, said to one of his adjutants that the sky appeared to be bleeding. He did not, according to Speer, understand nuclear physics, and had only a fuzzy notion about the bomb his scientists were attempting to construct. But he relished the Faustian gamble of the enterprise. Speer heard him grumbling about 'the possibility that the earth under his rule might be transformed into a glowing star'. Even so, Hitler – a pyromaniac who detested snow, and entertained enraptured reveries of Manhattan in flames – found that prospect to be a laughing matter. He 'joked that the scientists in their unworldly urge to lay bare all the secrets under heaven might some day set fire to the globe'.

After the fall of France, one of his cherished ambitions came true. He made a day-trip to Paris: his only visit there, and his last excursion beyond the borders of the Reich. The conqueror's itinerary was that of the galloping tourist. He dashed between the Eiffel Tower, the Palais Garnier and Montmartre, then flew back to Berlin. The local population was prudently kept out of sight. For those few hours, he was absolute ruler of a vacant city. Then in August 1944, as the Allies closed in, he ordered the German commander General von Choltitz to destroy Paris. Choltitz procrastinated, and before Hitler – who might have dispatched the Luftwaffe – learned of his underling's reluctance, de Gaulle had arrived. Paris survived, as the world has, by chance. In March 1945, when military defeat was certain, Hitler followed the suicidal decision of Brünnhilde, who exultantly rides her horse into the flames. He ordered that Germany should predecease him. Demolition squads of Gauleiters were sent out to spoil the enemy's

victory by reducing the country to rubble. They industriously blew up bridges and railways, sank ships to block rivers and canals, ripped apart telephone and telegraph networks and scrapped radio transmitters. To prevent easy recuperation, stores of spare parts and switching diagrams for the communications system were junked.

When supplies of explosives and ammunition ran out, arson was recommended. Dismantlement, in this punctilious agenda for destroying the world, came as a last resort. This was Hitler's final demonstration of technology's power over nature, its capacity to accelerate history or to terminate it. Within a few weeks, the earth was left scorched, ready – once it cooled – for human beings to begin the long task of creating civilization all over again.

If fascism, as Walter Benjamin claimed, is politics aestheticized, then we have no alternative but to consider Hitler as an artist – and to ask what this tells us about the purposes and the value of art.

An aesthetic politics deploys power to impose a personal fantasy. Politicians are usually content to manage or to adjust reality, leaving the invention of alternative worlds to the professional dreamers. But the dictator imagines the state; the people who live in it are characters he has created, elements in a design over which he retains total control. Artists, accustomed to sovereignty in their own small worlds, warmed to the notion of a visionary despotism. The dramatist Pirandello saluted Mussolini as 'one of the few people who know that reality exists only in man's power to create it...through the activity of the mind'. Ezra Pound praised Il Duce as an 'artifex', and rejoiced in his 'passion for construction'.

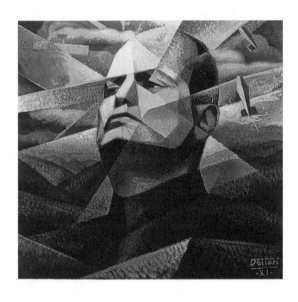

Gerardo Dottori
Il Duce *(1933)*

He also deferred to 'the essential fairness of Hitler's war aims'. Cocteau, ever ready to astonish, paid tribute to the genius of Stalin, calling him in 1951 the only great politician of his time and approving of his brisk way with opponents: he 'refuses all dialogue because he knows that a conversation with fools always degenerates into a dispute'. In his novel *Pompes funèbres*, set during the Nazi occupation of Paris, Jean Genet rhapsodized about Hitler as a 'master magician' whose atrocities constituted 'the most prodigious flowering of nightmares' ever

generated by an individual. Officiating at a black mass in Nuremberg, Hitler – Genet felt – 'was representing me'. Freud thought artists were afflicted by a sense of impotence and unworthiness, which made them rely on imagination to satisfy the desires which reality had frustrated. Are they all, in that case, would-be tyrants?

Hitler, a painter without talent and an architect without professional training, treated the map as his personal drawing board. Once Poland had been cleared of its obnoxious inhabitants and the empty spaces of Russia colonized, he decreed that the Black Sea would become a German holiday resort. In 1942 he planned even further-flung excursions around the edge of the globe. He intended to thrust south of the Caucasus, encourage insurrections against the British in Iran and Iraq, and requisition the oil wells of the Persian Gulf. Meanwhile, a few more élite divisions would be pushing through Afghanistan into India. This was the scenario of a fanatical, vindictive dream. Unlike most artists, Hitler had an army, an air force, an industrial establishment and a corps of executioners to help him carry it out. Busily conquering the world, he retained the finicky habits of a dilettante. He fretted about the design and lighting of Wagner's operas at Bayreuth, and bemoaned the shortage of tenors able to sing Siegfried as if this were some moral deficiency in the nation, a sad comment on German virility. Victories in battle were not complete unless underscored, when they were announced on the radio, by suitable orchestral fanfares. Hitler chose the soundtrack personally: snatches of Liszt's *Préludes*, appropriately turgid, were used during the Russian campaign.

In 1938, choreographing a march-past of storm troopers, Hitler remarked 'We must bring the masses illusions. They need illusions, not only in the cinema and the theatre.' Sometimes the aesthetic illusions were simply lies. Riefenstahl, dissatisfied by her documentation, needed to do retakes of the Nuremberg congress. Speer hastily confected a backdrop, and Hess and the others worked themselves into a factitious passion for the camera's benefit, addressing their remarks to the place where the absent Führer would have sat. Was the oratory cynically turned on for effect, or had the performers in this charade persuaded themselves to believe their own fictions? When it came to the test, fidelity to the aesthetic design or delusion mattered more to them than the meagre prosecution of political or military advantage. Hitler would not be dissuaded from constructing the assembly hall in Berlin, even though he was warned that the elephantine dome would poke through the clouds to beckon enemy bombers. At the desperate end of the war, Goebbels withdrew troops from battle so they could be used as extras in Veit Harlan's film *Kolberg*, about the mobilization of Prussia against Napoleon in 1813. He even ordered the munitions factories to manufacture dummy bullets for the actors to fire, and rallied the recruits to his fantasy by predicting that in a century's time another film would surely be made about their sufferings in 1944. Defeat and death, in this reckoning, would be amply compensated for by a walk-on role in the film of the apocalypse.

Dalí's infatuation with Hitler, which disgusted his radical cronies like Breton, was undoubtedly perverse: he liked to imagine the way the Führer's plump back was deliciously constricted by the rigid straps of his uniform, and enjoyed casting him in the submissive female role because of his soft white skin. But Dalí also understood the self-destructiveness of Hitler's irrational policies. Evil is a determined repudiation of natural law, a war conducted against reality. Dalí called Hitler 'the great masochist', and suspected that he had incited a world war 'solely for the pleasure of losing and burying himself beneath the rubble of an empire'. This lethal, surrealistic folly was 'the gratuitous action *par excellence*', and it made Hitler 'a truly modern hero!'

The surrealists were well placed to sympathize with his appeal. As Buñuel pointed out, they saw themselves as revolutionaries, devoted to an assault on middle-class society and its meek pieties. They despised the law-abiding methods of politics, though usually they preferred fomenting scandals to using guns. Engaged in 1939 to design a window for Bonwit Teller on Fifth Avenue in New York, Dalí disgusted shoppers by displaying cobwebbed mannequins speckled with blood; the mouldy bathtub they lolled in quit its moorings, crashed through the plate glass, and swamped the sidewalk. The long-suffering bourgeoisie had once again been shocked out of its smugness. Dalí's jests, like his promise to consume the corpse of his wife Gala if she died before him, were ventures beyond the moral perimeter. Buñuel – who considered his own 'destructive impulse' to be stronger than his 'creative urge' – said he thought it more enjoyable to burn down a museum (which is more or less what the Nazis did, incinerating books they disapproved of and ejecting art which they considered degenerate from public collections) than to inaugurate a new hospital. Once you have set yourself free from inhibitions, anything is possible: might it have been amusing to burn down the hospital as well? What Buñuel called the 'aggressive morality' of the surrealists 'exalted mystification, black humour, the insult, and the call of the abyss'. So, less wittily, did the brown-shirted Nazi cohorts.

The scenario concluded – as it did for Hitler, regaling himself in the Chancellery by watching newsreels of blitzed London – with a satisfactory cataclysm. Playful gangs of terrorists scamper through Buñuel's film *Cet obscur objet du désir*, randomly blowing up bankers and kidnapping prelates. They are rebels whose cause is nonsensical or even non-existent, as obscure in its motives as Fernando Rey's obsessive passion for his Spanish servant. Eventually Rey, the object of his desire, and all the objects of consumerist desire on show in a Paris arcade are blown away in a final, whimsical blast of fire. Just before the bomb detonates, Buñuel's soundtrack recalls the incendiary, addictive romanticism of Wagner: their voices materializing out of nowhere in the shopping arcade, Siegmund and Sieglinde sing their incestuous duet from *Die Walküre*. Wagner wrote music to accompany the world's end. In the 1970s Buñuel dreamed of 'a cosmic catastrophe that would wipe out two billion of us'. He declared that the extinction of humanity would be no great loss, and considered it neat and seemly that we

should not outlast the millennium. Buñuel's frivolous terrorists blow up their targets as a child might smash a toy. Perhaps they have a grievance against the world; probably they are merely curious to discover how it works. Like the nuclear scientists whose research intrigued and puzzled Hitler, they are experimenting with their own divine capacity for destruction. What they practice is the politics of perversity, whose tactics suit the prerogatives of the twentieth century – its dismissal of God, its questioning of inherited laws, its bold analytical scrutiny of nature.

In the secret history of modern times, the domain of fascism extends beyond politics. By calling Hitler a masochist, Dalí associated him with the namesake of a complementary 'ism', the Marquis de Sade. Genet fantasized about Hitler as a masterful, lethal sadist, who commanded a battalion of taut buttocks and consummated his love for his soldiers by sending them out to die for him. The eighteenth century considered Sade insane and locked him up in the Bastille (from which the mob released him during the French Revolution). During the prim nineteenth century he remained, as Henry James said, 'all but unnameable'. The twentieth century has recognized him as a sovereign immoralist, a liberator as well as a libertine. Apollinaire described Sade as 'the freest spirit that ever existed', and Buñuel valued his proposals for the 'sweeping annihilation of culture'. The characters in *L'Age d'or* enjoy the liberty which nihilism confers. The hero, interrupted while copulating in the mud, kicks a dog to vent his annoyance, and later batters a blind man in the street. Another character impetuously shoots his Mongoloid son, who disturbs him as he rolls a cigarette. A collective manifesto on the film – signed, among others, by Aragon, Breton, Dalí, Éluard and Tzara – denounced 'moral myths as the residue of primitive taboos' and commended violence for destroying the artifice of manners and Christian compunction. Because the year was 1930, the surrealists inevitably glanced at current economic contributions to their annihilating campaign. The frenzy of love, represented by the man and woman noisily grappling in the mire, is the only experience which remains authentic, untainted; it relieves the 'bankruptcy of feelings' which derives from the failure of capitalism. In an unholy merger of sadism and socialism, the surrealists justified the obscene revels in the castle by claiming that the obscenities of the divine Marquis predicted the 'decomposition of class society'.

Sade wrote his digest of sodomite revels in 1785, but the manuscript stayed underground until it was rediscovered in Germany and published in 1904. This gave it an honorary modernity, allowing Buñuel and Dalí to conclude their film in the castle where Sade's aristocrats hold their scatological rites. *Les 120 journées de Sodome* can be read anachronistically as a parable about the collusion between power, art and evil in the twentieth century. Pier Paolo Pasolini employed it as a clinical commentary on fascism in *Salò o le centoventi giornate di Sodoma* – his last film, released in 1975 after he had been beaten to death by a hustler he picked up in the Roman slums.

Salò was the enclave in northern Italy to which Mussolini's supporters retreated in 1943, accompanied by a gang of thugs recruited from reformatories. In Pasolini's version it is a totalitarian version of Sodom: the fascists are absolute rulers in a kingdom of forbidden acts. The environment is impeccably aesthetic, the most self-admiringly civilized of concentration camps, with a Léger design on the walls of the villa, music by Orff on the radio, and aphrodisiac readings from Boccaccio before bedtime. Sade's revellers, in Pasolini's adaptation, are four pillars of society, official guarantors of probity: a duke, a banker, a judge and a monsignor. Having rounded up at gunpoint an assortment of nubile victims, they set about degrading, torturing and finally killing them. Their sexual entertainments are proudly, wastefully gratuitous. Physical pleasure is beneath their dignity; a more intense delight derives from ordering others to have sex, especially if they are disinclined to do so. The most refined and recondite tableaux are those which mock nature. Georges Bataille, sharing the surrealist enthusiasm for Sade, based a new and morally disconcerting definition of humanity on exploits like these. For Bataille, eroticism – not reason, as humanists had always argued – elevates man above the animal state, because erotic play is useless, fantastical, aestheticized, and can flourish only if biological imperatives are ignored. It inverts the productive utilitarian drill of sex, as the Nazi doctors inverted the healing aims of medicine. Of course not everyone can enjoy these exalted human prerogatives; they depend on accomplices, like the dog-collared slaves in *Salò*, who are classified as beasts.

Following a trail which led from Sade to Nietzsche and on to Heidegger, Pasolini treated fascism as the apogee of civilization, the ordained climax of modern history, the ultimate proof of our escape from submission to God. Its dominion did not stop short with military defeat in 1945. Pasolini believed that society had learned how to make Hitler's brutality look benign. Human beings remain commodities, pieces of meat: the overlords of Salò select their male victims by appraising the size of their genitals. People are permitted to live because the market requires customers to gobble up whatever it excretes. Pasolini explained the coprophiliac diet of chocolate mousse in *Salò* as a critique of consumerism and the way it force-feeds us.

The German painter Anselm Kiefer began his career in the 1960s with his self-styled 'attempts to become a fascist'. Travelling in France and Italy, he photographed himself beside monuments or on beaches, his arm stiffly raised in a Nazi salute. The purpose was exorcism. Kiefer, imitating a shaman, invited the demon to take up residence in his body and jolt his arm into the air. His photographs demonstrated the folly and impotence of the gesture, deriding puffed-up authority. The Third Reich was a mythopoeic regime, so the surest way to cast off its spell was therefore to reclaim its fictions and retell the stories which bolstered its power. Kiefer and the film-maker Hans-Jürgen Syberberg have both gone back to Wagner, who served as Hitler's alibi. In 1975 Kiefer painted a landscape of furrowed ground under snow, which he called *Siegfried vergisst Brünhilde*.

This was his oblique commentary on *Götterdämmerung*, in which Siegfried forgets Brünnhilde. She sends him down from their mountain top to resume his career as a slayer of dragons, and he promptly forsakes the memory of love for the pursuit of power. But in Kiefer's painting there are no figures: the earth has forgotten both Siegfried and Brünnhilde, just as it will soon forget the melted snow. In another of Kiefer's illustrations for the *Ring*, Brünnhilde's searing funeral pyre burns down to charred sticks and dim embers. History's ruins are here an ignoble mess. In the film of *Parsifal* which Syberberg directed in 1982, the route to the Grail temple leads through a rocky gorge, decorated with Nazi banners. Syberberg's set is a bleached mountain range, with abrupt peaks and cavernous gaps, which – when the camera pulls back far enough for us to see it in perspective – proves to be the aquiline death mask of Wagner. At the end of the opera, the temple is trapped inside a glass ball, in turn contained within the empty eye-socket of a skull. The skeleton's head still wears a crown: has the history of modern times been a nightmare left over from the nineteenth century?

The fetishes and fixations of the Nazis retained their aesthetic appeal for Mishima in post-war Japan; they regulated his attack on the profane, mercantile modernity of his country, and directed him towards his sacrificial suicide in 1970. He was ashamed of having survived the war, and fancied that this was because he lacked 'the muscles indispensable for a romantic death'. He therefore set about an arduous course of physical training. Political and aesthetic ambitions overlapped. The body, primed for combat, was a portable arsenal, advertising the ferocity of Mishima's band of latter-day samurai, who set out to overturn the democracy imposed by the American army of occupation. In its place they intended to establish a regime which Mishima, a year before his death, chillingly defined as an 'aesthetic terrorism'. To qualify for membership of that ruthlessly beautiful, rigidly perfect society, Mishima moulded himself into a 'fluid sculpture'. Like a Pygmalion in reverse, he wished to transform flesh into unfeeling stone; he gladly accepted the consequence of such perfection, which was death. Sooner extinction than entropy, the loss of honour and muscle tone. He argued that the greatest statues, like the bronze charioteer of Delphi (or – perhaps more appropriately – like the aggrieved soldiers and excruciated athletes of Arno Breker), implied 'the swift approach of the spectre of death just on the other side of the victor'.

In 1960 Mishima wrote a story called 'Patriotism', about a young lieutenant who commits hara-kiri in sympathy with some colleagues disgraced by the failure of their military coup. The code of conduct which he follows is inimitably Japanese; onto it Mishima grafts the lore of German romanticism, which recurs in Nazi ceremonial and in Hitler's rhetoric. Before the lieutenant slices open his stomach, he and his young wife make love. She, after impassively witnessing his death, has been granted permission to cut her own throat. Their sexual rapture, made keener by the proximity of death, is likened to those mountain sports which were the favourite pastime of Zarathustra and Riefenstahl. The lieutenant

and his wife attain dizzy heights, from which they plunge into abysses, then 'climb again in a single breathless movement to the very summit'. He is commended for his military stamina, as he pants 'like the regimental standard-bearer on a route march'. In 1965 the story was filmed. Mishima volunteered to play the lieutenant, with his cap tugged down over his brow: the uniform curtly cancelled individuality. He actually drew blood when scratching the sword across his skin, as if in a trial run for what he called the 'private play of our own' enacted at a Tokyo military base five years later – another attempted coup, after which Mishima slit his abdomen and waited for a comrade to behead him. For the film's soundtrack he chose Isolde's Liebestod from *Tristan und Isolde*. No matter that the lieutenant slumps in a pool of his own butchered entrails, while Isolde floats away into painless, spontaneous bliss. The lieutenant has convinced himself that his bedroom is a battlefield, 'the front line of the spirit', and music solemnizes this union of militarism and mysticism.

The year before the film was made, the Olympic games had at last been staged in Tokyo. They were due to be held there in 1940, although the war caused their cancellation. (Hitler consented to this choice of venue, but warned that they would then come home permanently to his own capital.) In 1964 the occasion was Japan's opportunity to disown the feudal past which Mishima sought to revive, and to gain admission to the modern world. The filmed record therefore took care to demythologize the event. Kon Ichikawa's *Tokyo Olympiad* is a masterpiece of bright, zany, happy-go-lucky Pop Art; it might be a parody of Riefenstahl's *Olympiad*, and it ends with a splashy firework display, not the erection of Speer's cold, chimerical temple. Germany had appropriated Greek mythology, as if annexing another country. When the Olympic flame is kindled in Riefenstahl's film, the score teasingly quotes from the music which describes the magic fire lit by Loge at Wotan's command in *Die Walküre*. The torch's progress towards Berlin – speeding past Constantinople, Bucharest and Vienna – is like a return journey on the autobahn, demonstrating

'workers' sports association' in 1930, whose members sing as they march

how the continent is manacled by new lines of force. Ichikawa, disavowing imperial pretensions, emphasizes the smiling consent of witnesses on the streets as the torch trundles down through Asia. Japan was content to be colonized by the games. As planes loaded with athletes touch down, the commentary in Ichikawa's film excitedly notes that there had never before been so many foreigners on Japanese soil.

Tokyo Olympiad generously dispensed with the dream of physical perfection, which is also a prescription for psychological sameness. Irregularity makes us human, and the bond we share is strengthened by errors and mishaps, the evidence of our pardonable frailty. Ichikawa's camera lingers on accident and uncoordination, the comedy of chaos which Nazi stagecraft debarred. At the opening of the games, a flock of lazy pigeons will not quit the arena when told to do so, and a flustered steward dashes at them to frighten them into the air. Then it rains, and the crowd cringes under dripping umbrellas while the course is mopped up. A spectator is distracted by a coughing fit; children by the roadside smirk at the waddling gait and wiggling bottoms of contestants in the men's fifty-kilometre walking race. This awkwardness is wished on them by the definition of the event: one foot may leave the ground only after the other has returned there. Riefenstahl's athletes exhibit the strain and stress of romantic heroes, sublimely overtaxing themselves. Ichikawa sees the walking race as a Chaplinesque farce, played out – since the weather is a constant reminder that reality ignores our controlling will – on a puddled track. The statues, released from their rigor mortis, are permitted to have private lives. During the hop, skip and jump event, the commentator introduces Joseph Schmidt, 'a motor mechanic back in Poland', while a runner in the marathon is identified as 'Ronald Clark – he is an accountant in a printing company in Melbourne'. It is a relief to learn that the death of the individual was misreported.

Yet the reprieve was brief. Fascism, regimenting its subjects and discarding those who did not fit the approved design, had its own dogmatic notion of how the twentieth century's new man should look, and what his racial provenance should be. Hence its mutation into what has been called body fascism: the tyranny of beauty or of bulk, sponsored by companies which goad us to buy their gym equipment and leisure wear so we can have bodies like those in the advertisements. Before the 1984 Olympics in Los Angeles, Andy Warhol's magazine *Interview* published a portrait gallery of American athletes by the photographer Bruce Weber. The first spread shows a gymnast whose arm salutes at a tactless right angle, and a tableau of divers playfully trampling each other evokes the sporty enjoyments of Riefenstahl's young Nazis in their camp at Nuremberg. The swimmer Steve Lundquist, crew-cut, has a head which might have been sculpted by Breker, and a corresponding physique. Everyone displays the same codified body: the only difference between the athletes and the models in the interleaved advertisements for designers like Perry Ellis is that the latter wear slightly more clothes. That regulation body defines a cultural type. Lundquist,

who admits to liking motorcycles, coyly denies that he is the personification of the All-American Boy. No such disclaimer is permitted to the former sculling champion Jack Kelly, Grace's brother, interviewed beside an old photograph of himself with his sisters, who constitute an impeccable WASP gene pool – 'all vigorous, smiling, healthy and attractive; a picture of the idealized American family incarnate.' This racial archetype is available for purchase in any clothes shop: Kelly is said to be indistinguishable from 'the square-jawed model in an Arrow Shirt ad' from the 1950s. Warhol signed an introductory editorial, which adapted the deathly motto of the Roman glad-

Beauty, strength and body fascism: a young Dutch navigator is voted Playboy of the Year on the Côte d'Azur in 1972

iators as they entered the arena. Looking forward to seeing the games on television, he said 'We who are about to watch salute *you*'. The gladiators died to entertain the Romans; Warhol, reversing the salute, implied that the spectators were already dead – doomed to the second-hand, vicarious life of those who watch television – and celebrated the athletes as symbols of arrogant, brainless health.

Syberberg insisted on the recognition of a spirit which he called 'Hitler-in-us'. The dictator was himself dictated to – programmed by the romantic culture from which he emerged, manipulated by 'this century of technology and mass movements'. This is why, in Syberberg's 1977 fantasia *Hitler, A Film from Germany*, he has so many doubles: toys, dummies, effigies, marionettes. Like a dream, Hitler spoke for the somnolent, irrational imagination; like a robot, he performed tasks too foul for a human being to undertake. Was he the spirit of modern times in person? Discussing sex, its theatre of power and its dramas of transgression, Michel Foucault challenged us to acknowledge 'the fascism in us all'. We now know, for good and ill, what man is capable of, and must listen with bowed heads to the case for the prosecution.

AMERIQUES, AMERIKA

While one world ended in Europe, another began in America. The old continent exists in a condition of permanent antagonism, its quarrels unresolved despite incessant wars. The battle lines overlap: the hostility between France and Germany; the West's superstitious fear of the East, where Blok's Scythians press against the border. When these ancient hatreds are appeased in one place, they migrate elsewhere, with Bosnia as an action replay of the century's previous history. Although Europe is at present pondering a federal future, the nations which propose to unite still contain factions ardently devoted to disintegration: neo-Nazis, Basque separatists, Irish republicans, and skinheads who enjoy roughing up immigrants. America was invented in order to save divisive, oppressive Europe from itself: a conscience in exile across the ocean. But Utopias have to be positioned somewhere off the map, beyond the margin of reality, and the new continent was too large and loud, too ideologically confident and economically prosperous, to remain marginal. Le Corbusier, studying the New York skyline from a liner in 1935, admired its white cathedrals, cleansed of the old world's ordure. The city's tall buildings were emblems of unashamed power, which enabled America literally to save Europe by its intervention in both of this century's world wars. Those rescue missions made good its claim to moral supremacy, and the haven for refugees became the official guardian of civilization. When he got ashore, Le Corbusier said of New Yorkers 'They are gods.'

In 1938 Thomas Mann, announcing his intention to settle in the United States, predicted that 'for the duration of the present European dark age the centre of Western culture will shift to America'. André Maurois, back in France after his wartime exile in 1946, wrote an essay for the *Reader's Digest* paying tribute to the country which had sheltered him. Other Europeans sniffed at the blandness and superficiality of the waste spaces between the two coasts; Maurois pointed out that they had reason to be thankful for the like-minded predictability of Americans, who ate the same food and shared the same values no matter what region they lived in. Sooner this homogeneity than the crazy quilt of disputed

*he cubical city:
bert Gleizes
n Brooklyn
ridge (detail,
917)*

territories, jabbering languages and ancient feuds which made up the map of Europe.

But time never stops, and in history there are no happy endings. After 1945 America's role of custodian changed into that of an imperial policeman; its crusade failed in Vietnam. Meanwhile the country had experienced its own dark age, and the centre of Western culture moved on – perhaps back to Europe, perhaps further west to Japan. Possibly the very idea of a centre disappeared from view. On an earth where space was first abbreviated by travel and then eliminated by the electronic transit of information, the centre is everywhere and therefore nowhere at all.

Before this geographical implosion, the notion of an offshore or eccentric centre entranced the modern mind. Breton in his surrealist manifesto praised the insanity of Columbus, who sailed over the edge of certainty into the unknown. Blaise Cendrars, returning to Europe from São Paulo in 1924, allied himself with Columbus (even though they travelled in different directions). He wanted to improvise his own version of the 'Baudelairean prayer' which Columbus confided to his log-book – a plea to be forgiven for daily lying to his shipmates about their position, so they could not find their way home. Brecht, allowing himself to feel clement for once towards the country in which he found refuge from Hitler, wrote a poem about a democratic judge in Los Angeles who had to rule on applications for American citizenship. Confronted by an Italian restaurant owner, the judge asked him to recite the eighth amendment to the constitution. The candidate replied '1492', and was not admitted. Every three months he returned to try again, but to all queries – about Civil War generals, or the length of presidential terms – he serenely gave the same answer, '1492'. Finally the judge, relenting, asked him when America was discovered. This time the answer was correct, and the Italian gained his toe-hold in paradise.

Despite his inability to learn the language, he had claimed a share in the national myth by memorizing that sacred date. It is surreally apt that he gave the right answer by mistake. Columbus himself discovered America accidentally, on his way somewhere else. He too, like the shipmates he misled, was lost. The continent he strayed into was an ulterior realm, a hemispherical libido: 'the huge, indeterminate area', as Breton defined it, 'over which the protectorate of reason does not extend'. The composer Edgard Varèse moved to America in 1915, and felt that he was living outside the protectorate of sonic reason, surrounded by indeterminate, intemperate sounds – angry car horns, the alarmist sirens of police cars and fire-engines, hammers and electric drills, the clattering elevated railway. Those raw, untuned noises penetrated his room in downtown Manhattan and found their way into a long orchestral poem which he called *Amériques*, given its first performance in 1926. Varèse cautioned that the work did not simply transcribe what he heard in the city. Its title, he said, symbolized discoveries of every kind, referring to 'new worlds on earth, in the sky or in the minds of men' – the multiple epiphanies of modernity. After sedate Europe, the uproar of New

York seemed somehow cosmologi-
cal. With its thundery ructions and
eruptions, *Amériques* sounds as if the
big bang were still happening on
West 14th Street.

In 1492 America announced
the existence of a world elsewhere,
remote in space, occupying its own
time zone. It was a jolting encounter,
a shock to European self-possession.
As Lévi-Strauss reflected in *Tristes
Tropiques*, after the landfall made by
Columbus 'a human community
which believed itself to be complete'
had to confront an unrecognizable
mirror-image of itself. The sight was
unacceptable. The Spanish colonists
decided that America was populated
by heathens, savages; they must be
annihilated. Every subsequent Euro-
pean rediscovery of America has provoked the same self-reassessment, and has
been tempted to respond with the same angry denial. But during the twentieth
century Europe gradually lost the bigoted conviction of its own superiority.
Confronting America now entails the admission that Europe is incomplete,
laggard. To cross the ocean has become a latter-day version of the classical
Grand Tour through the stately patrimony of Italy and Greece. With its sky-
scrapers and films, its fast cars and faster food, America was the native soil of
modernity. Everyone who lives in the twentieth century is an ersatz citizen.
Membership can now be obtained without passing through the golden door
superciliously overlooked by the Statue of Liberty. Jeans and T-shirts, hamburgers
and pop songs are the necessary credentials, and they are available everywhere
on the centreless earth.

As an idea, America was always a universal possession. George Grosz
designed in 1917 a lithograph which he called *Memory of New York*. He was
remembering a place he had never been to, except in his sleep, but he did so
accurately enough by mixing and matching slogans – HOTEL, EXPRESS,
PEPPERMINT, COMPANY, DANZING (a spelling error you might easily find
in New York, with its slangs and lingoes and customized jargons) – which peep
through a geometrical jungle of windows and railway tracks. Darius Milhaud
collected Argentinian tangos and Brazilian sambas during his residence in South
America; Cocteau, in his scenario for *Le Boeuf sur le toit*, expatriated them to a bar
in Harlem during Prohibition. Neither Milhaud nor Cocteau had been to New
York in 1920. The same was true of Léger, who designed the ballet. But they did

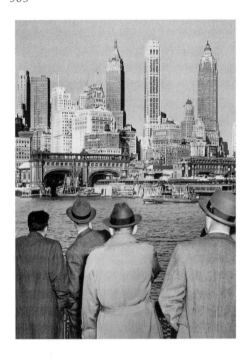

*Arriving in the
future: downtown
Manhattan and
South Ferry*

not feel themselves at a loss. America was synonymous with freedom, a state of anarchic licence: were they not therefore free to imagine it? Misinformation could be liberating, because it cleared an open space for the fantasy. During his European boyhood, the hero of Vladimir Nabokov's *Lolita* pored over a map which generously assigned the Appalachian mountains a swathe of land extending from Alabama to New Brunswick. He happily pictured the entire eastern third of the country as 'a gigantic Switzerland or even Tibet, all mountain'.

In a 1926 poem Hermann Hesse lamented the plight of European intellectuals, dismayed by their exclusion from social esteem and political influence. He imagined an alternative existence for himself, a more engaged and vital life, which necessarily had to be transferred to America, and specifically to Harlem, which in those years was more like the Quartier Latin than a ghetto: he wished he could strum the banjo or blow the saxophone in a jazz band. Cramped within borders of barbed wire, the European imagination envied America its frontier and the openness of its space. In a poem written in Berlin in 1917, Grosz wondered how it would feel to stride out of your cabin each morning and fire off your pistols to awaken the world. 'Oh!! Colorado! Freedom!!!' he sighed. At this time, the outer limits of Berlin, undergoing rapid development by speculators, were marked WW on the map: the city had its own Wild West. Breton's friend Jacques Vaché dreamed of the American West as a surreal zone of lawlessness. In 1918 he announced his intention of going off to be a trapper or prospector or miner, and described how he would swagger into the Arizona Bar with his spoils. He died soon afterwards of an overdose – another mode of migration: Svidrigaylov in Dostoevsky's *Crime and Punishment* announces that he is going to America (meaning extinction) just before he blows his brains out.

To invoke America and its stock company of fabled characters, relishing their freedom in the open air, was a remedy for Europe's neurotic ailments. In 1922 Cendrars attacked the nocturnal hysteria of Wiene's *Caligari*, and added to his review a motto gesturing towards a breezier realm: 'Hurray for the cowboys!' But the myth was available to all subscribers, and proved dangerously adaptable. Hitler admired the stoicism and tactical cunning of the Indian brave Winnetou in the cowboy novels of Karl May, another expert on America who had never been across the ocean.

The hungry fantasy acquired the few facts about America it needed from films. Grosz or Vaché, like Cocteau with his Chaplinesque farce, were daydreaming themselves into the movies. There was an analogy between what they thought of as the social and psychological nature of America – airy, antic, unencumbered – and the hallucinatory look of life in the cinema. As Georg Lukács pointed out in 1913 in his essay on 'Die Welt als "Kino"', things when filmed lost bulk and presence. No longer securely aligned by perspective, they seemed to jerk and shudder. Lukács could only account for the cinema's appeal by assuming that people wanted to live like this, 'without fate, without causes, without motives'; they longed for a reprieve from predestining reality. Film, like

George Grosz
Memory of
New York
(1917)

Grosz

Aus Nr. 376

America or like those other planets whose air breathes into Schoenberg's second quartet, seraphically lightened being. Hence the gymnastic high-jinks of the Jeune Fille Americaine in *Parade*, who whirled through a digest of cliff-hanging escapades from a Pearl White serial, or the career of the bemused Swedish immigrant in Cole Porter's *Within the Quota* (performed by the Ballets Suédois in 1923), who pranced off the boat and, after some misadventures with a Coloured Gentleman, a Jazz-Baby and a Cowboy, fortuitously eloped to Hollywood with Mary Pickford, the Sweetheart of the World.

These characters had projected themselves into what Lukács called 'a strange abyss', a busy vacuum. They had no particular reason for their agitation. However, as Niels Bohr pointed out, the very concept of purpose had been discarded by the new physics. Things did not decide to move, like Aristotle's stone which fell to the earth because it wanted to go home. According to the laws of mechanics, as summarized by Bohr in 1957, 'the course of events is explained as automatic consequences of given initial conditions'. This description of atomic motion could be applied both to those dots of light which flicker on a cinema screen, and to the agitation which seemed to be characteristic of modern American life. The Jeune Fille Americaine emits quanta of ebullient energy. She acts that way automatically, as a consequence of two initial conditions: she is American, and she has stepped out a film. Gertrude Stein, in a lecture delivered on her return home during 1934 and 1935, offered a similar definition of 'the American thing', which sounds clumsy but is in fact very precise. The national thing in question was 'a space of time', like Einstein's equation of mass with energy. Stein viewed the entire American land-mass as a container for motion: 'Think of anything, of cowboys, of movies, of detective stories, of anybody who...is an American and you will realize that it is something strictly American to conceive a space that is filled with moving.' That space – a frame for mobility, which overflows its edges – might double as a cinema screen.

Between 1911 and 1914 Kafka, who never travelled further from Prague than France and northern Italy, wrote a novel about a country which was to him

a blank. It was published posthumously in 1927, and given the title *Amerika*. He did not need to know the place he was writing about. Even for his hero Karl Rossmann, America remains the undiscovered country, a state of non-existence. Kafka's brave conceit was to take an America which he refused to imagine and declare it to be vacuously unimaginable – just as resistant to human occupancy as the rest of the world.

Karl does not even want to get off the ship. After his first sight of the Statue of Liberty – whose torch has been replaced by a sword – he retreats to the engine room and considers applying for a job as a stoker, which would at least ensure his return passage to Europe. Standing on a hill which exists on no map, he looks down at the harbour and at the bridge linking Brooklyn and Manhattan. The two cities 'seemed to stand there empty and purposeless. As for the houses, it was scarcely possible to distinguish the large ones from the small.' When he sights a ship, it proves to be elusive, like the idea of America: 'one could not follow it for long; it escaped one's eyes and was no more to be found'. His companions, who have learned to pretend that there is such a thing as reality, can distinguish and name the squares and gardens. Karl is stubbornly unable or unwilling to see anything.

Kafka refused to accredit the myth of American freedom. How could the new country be any different from the labyrinthine prison of Europe? It allowed him no scope for the vagrant, delighted free-association of Cocteau or Grosz. Arriving in New York, Karl undergoes inspection by a gigantic apparatus whose business, like that of the castle which overshadows Prague, is surveillance and inquisition: the skyscrapers 'stared at [him] with their hundred thousand eyes'. Similarly the noisy dormitory at the Hotel Occidental is not a place of rest and privacy but a panopticon. A piece of office furniture resembles a penitentiary: the paranoid Karl studies 'an American writing-desk of superior construction', with enough compartments for the President to file away all his state documents – those paper recipes for gaining and maintaining power. Perhaps all the President's subjects could be housed there too, kept in the solitary confinement of their own cubicles. This is a society where the lights are never turned out, where people are denied the luxury of invisibility. Even outside in the streets, you are inside an obscurely dictatorial scheme whose purpose – in a novel which Kafka did not complete – remains unknowable. The streets themselves, so long and straight, look to Karl as if they are fleeing into the distance, trying to escape from America.

Brecht appointed himself an expert on America long before he took refuge there, after an early term of exile in Scandinavia, in 1941. His collaborations with Weill – the opera *Aufstieg und Fall der Stadt Mahagonny*, first performed in 1930, and the opera-ballet *Die sieben Todsünden*, given its premiere in Paris in 1933, after he and Weill had both quit Germany – were set in a sketchily imagined, groundless America. Brecht thought he had good reason for his geographical howlers: this, he considered, was a society without roots, where space was

notional. Travelling west, Brecht likened Texas and Arizona to Siberia seen from a train window. Deserts of dust, not ice, the states were versions of nowhere. The site of Mahagonny is determined arbitrarily. The founders are on the run, like Kafka's New York street. When their truck breaks down, they decide they had better build their dream-city in this precise spot. That random place wanders all over the map. The suckers who come to Mahagonny to be ripped off include lumberjacks and trappers, who step over the border from Alaska and suddenly find themselves in a desert by the sea. The saloon girls serenade the moon of Alabama, but when there is a hurricane warning Mahagonny trembles because the nearby city of Pensacola (which is in Florida) has been wiped out.

All American cities, wherever they happen to be stationed, were for Brecht variants of Mahagonny. The land served only to be exploited, as he recognized when he saw oil rigs industriously boring into California beaches. Once the soil had been exhausted, the profiteers would simply relocate. America was a mercenary mirage, which could be envisioned or instituted anywhere. Cendrars had his own generic version of Mahagonny, which he called Ville-Champignon – a mushroom city, as opposed to Brecht's 'Netzenstadt', the city of traps and nets. On his travels, Cendrars saw towns in the West which had sprouted overnight like fungi of steel and reinforced concrete. Speculators designed maps for these imaginary places, giving honorific names to avenues which were still merely hopeful trails through the mud. American settlements do not grow; they are invented, conjured out of nowhere like America itself. Settlers, for the time being, are an optional extra.

In *Die sieben Todsünden*, the sisters from Louisiana undertake a tour of self-enrichment, gold-digging successively in Memphis, Los Angeles, Philadelphia, Boston, Baltimore and San Francisco as they work their way through the seven deadly sins which are, for the bourgeoisie, cardinal virtues. There is no logic to their route, and no particular reason for targeting any of the cities (except Los Angeles, where they hope to be talent-spotted for the movies); they are mobile for the sake of mobility, kept going by restless, rapacious desire. Brecht, who spent the last years of the war in Los Angeles, wondered at the entropic agitation of its freeways – all those cars, 'Lighter than their own shadows, faster than / Mad thoughts', full of happy motorists who had come from nowhere and were going back there at high speed. California houses, he thought, were not dwellings but extensions of the garage. Some Americans, to the astonishment of European observers, lived in mobile homes, stationed temporarily in trailer parks. Others occupied houses which could be conveniently motorized. Jean Renoir, resident in California after 1941, gaped at the sight of feudal manors or Spanish haciendas which had been neatly sectioned and winched onto trucks for transportation to a new plot of land. Despite the folderol of their external decor, these houses looked to Renoir like 'huge match-boxes'. But their flimsiness made them resilient. During an earthquake, they shuddered a little, then regained their composure.

In New York during the nineteenth century, a certain date in early spring was set aside as moving day. People often changed house without needing to: you got the first month's rent for free. This itchy stampede was a local pastime, and it became a characteristic trait of modernity. During the first decades of the twentieth century, the sacrosanct notions of society and civilization faltered in Europe. America at least told the truth about itself: what kept it in business was greed. It pursued happiness without ever arriving, because you can never have too much money. Therefore all associations were contingent; the builders of skyscrapers expected them to be demolished when their rentable life-span was used up. After the stock-market crash of 1929, Brecht wrote a poem prematurely gloating over the fall of New York, as expendable as Mahagonny. The spirit of turbulence and temporariness even infected America's weather, with its manic-depressive extremes. Paul Claudel wondered whether the succession of blizzards and tornadoes – to which we can now add earthquakes, plus the odd fit of bad temper from a supposedly extinct volcano – were not fiendish experiments, like the factitious storms with which aircraft are assailed in flight simulators. Perhaps God's intention in sending them was to test the limits of the 'huge Void' which he may or may not have created.

Claudel, afraid of this mental gulf, complained in 1951 about 'the strange feeling of *unreality*' endemic in America. That, however, was the country's ambivalent attraction. It encouraged the optimist to sustain hope, because it solemnly vowed to make dreams come true; it allowed the cynic to rake through the wreckage of broken promises and lost illusions. Either way, it was not such a bad bargain. Who, in modern times, would prefer reality?

In Europe, revolutions set out to revise human nature by force. In America, the new man already existed, at large in a brave and briskly renovated world.

New York when first seen from an arriving ocean liner resembles the geometrical structures of abstract art. The painter Francis Picabia saluted it in 1913 as a cubist city. Camus, entering the harbour in 1946, faced up to the monoliths which represented economic might and remarked that 'the heart trembles in front of so much admirable inhumanity'. Moving closer, you noticed people who apparently belonged to an improved and more prodigiously efficient species than their European forebears. Heidegger in 1939 denounced the idea of America with its 'dreary technological frenzy' and its 'unrestricted organization of the common man'. He never went there (or anywhere else except France and Greece), but observation confirmed this imaginary vista. Léger, visiting New York in 1931, thrilled to the city's perpetual motion. Le Corbusier admired the same scarcely human dynamism, its piston-driven rhythms regulated by jazz: he likened the trumpeter in a Harlem night club to a turbine, and compared tap-dancers to sewing-machines. The great mechanism had to let off steam, so Léger was not surprised to see clouds of vapour gushing from manholes in the street. A young New Yorker he met obeyed the same metabolic laws, very different from

those which governed physical existence in France. She smoked conscientiously throughout their meal together. Cigarettes, she told him, cranked up your nerves while subduing the appetite, and ensured that the body – which must always be ready for action – did not get fat. Auden, settling in New York in 1939, enthusiastically adopted what he called 'the chemical life', keeping the brain stimulated with amphetamines, switching it off at night with sleeping pills. A pharmacy was a service station for engines of flesh and blood.

If the new man could be seen walking on Broadway, perhaps it was American clothes which had made him. Rupert Brooke in 1913 praised the informality of the local attire – dungarees, open collars, rolled-up sleeves – which freed the body from cramped European rules about posture and propriety. During winter in the cubist city, people were cubed. Brecht observed that overcoats with padded shoulders made their owners look bulky, angular, sculptural. He thought that the men who wore the overcoats were intent on developing faces to match them: they chewed gum because the habit was supposed to push the jawbone forward. If you consumed enough, you might grow a granite chin like that of Dick Tracy.

Bodies in America behaved differently. The movies showed off new styles of locomotion, never seen before. James Cagney twirled and pirouetted while concussing opponents; John Wayne loped, swaying slightly like tall timber in a gale; James Dean had the elastic limbs of a cat. For Brecht, this casual grace revealed power limbering up. He noted the way in which Americans, lacking the manual loquacity of Europeans, applied brakes to their gestures. Again his point is best illustrated from films: the stubborn inarticulacy of Gary Cooper, or the premeditated stammering of James Stewart. While Le Corbusier saw the whole country performing in overdrive, Brecht studied the deliberate, lazily elegant slow motion of an American getting up from a chair. The action reminded him of 'a whole state turning over'. This was a race of taciturn giants, accustomed to dominance.

Arnold Bennett reported on another odd modern trait. Americans, he noticed, lived on the telephone. That was how they chose to communicate, even if they lived next door or could see one another across a Greenwich Village courtyard. Machines mediated their relationships. Without its prostheses, the body is an abject thing: in contemporary Los Angeles, walking is reserved for the indigent, who do not own cars. To be a pedestrian is to announce your disenfranchisement, and to invite attention from the police. Apollinaire, explaining how Thérèse came to change sex, said that the invention of the wheel was a surreal act. Now we all have wheels underneath us, we can experiment with other surreal mutations of the body. The purpose of the right leg is to press down on the accelerator. Has the left leg become vestigial, now that cars are automatic and do not require us to change gear?

The fascination of America lay in the advance warning it gave of these changes in physical reality. Simone de Beauvoir, touring the country in 1948, found the topography of San Francisco 'shocking in its obstinate abstraction –

deliriously geometric'. European cities which occupy hilly terrain above a harbour, like Lisbon or Marseilles, send their streets curling around the heights, with pauses for lookouts across the water. But in San Francisco the grid of the street plan rules the bumpy or plummeting land in straight lines. The layout is Platonic, and it refuses to acknowledge the irregularity of the hills on which it is incised. The cable cars, negotiating slopes too steep to drive or even walk on, impressed de Beauvoir as evidence of the city's 'abstract urbanism'. The effort of maintaining this geometrical delirium is audible beneath the streets: the fraught cables whirr and groan, hauling the cars and holding the sandy hills together.

Those clattering subterranean wires alerted de Beauvoir to 'the triumph of abstraction' in America. Its people, she thought, lived in an 'abstract climate', which made them exemplary citizens of the modern world. Despite their reputation for materialism, Americans recoiled from the physical world. They bought their food in cans, stored it in frigidaires, and heated it in electric cookers; they typed their most intimately personal letters. Air had to be 'conditioned' before they deemed it breathable, and the body's sexual self-expression was inhibited by 'hygienic practices' (of which de Beauvoir, as a proudly unhygienic European, disapproved). Money here had lost its grubby concreteness. For Americans it symbolized loftier values, the 'pseudo-realities' which the society idolized – success, moral eminence. De Beauvoir found the same abstractness in the synthetic jazz dispensed by jukeboxes, which she called 'noise and rhythm, nothing more'. Having rescinded and forgotten the past, these people lived in a perpetual present. Yet what value could the present moment have if it lacked a before and an after? It was a vacancy, which must be filled with distracting sound.

At the Chicago stockyards, cowboys rounded up the compliant hogs or steers and herded them into what de Beauvoir described as a 'concentration camp' of corrals. Her phrase implicitly accused America of fascism, since it had set out to mechanize mankind. The animals trotted to their doom, and within hours had been reified as sliced hams or roast beef. 'The triumph of man over nature was now complete', said de Beauvoir, trying not to smell the seething blood. Though she viewed the stockyards as America's Auschwitz, she was comforted by her trip through those cemeteries which seemed to occupy so much of Queens, across the East River from Manhattan. After all, she concluded as she surveyed the encampments of mortal, unmechanical people, 'in America man is still human.'

Other transplanted observers pointed to the continuing battle against nature's built-in limits, to which ancient Europe had long ago resigned itself. Cendrars in New York watched crates of loam being hoisted above the streets and planted in the sky. Defying nature, a garden eventually bloomed on top of a skyscraper. The soil which nourished the rhododendrons and camellias was money. In California, Brecht performed a similar illicit miracle, sprinkling his garden with expensive water stolen from thirsty states beyond the mountains. He noticed how ravenously the dry earth of this cultivated desert drank it up. His

efforts created a facsimile of nature, as illusory as the aerial shrubbery described by Cendrars – oversized flowers without a smell, fruit with no taste. Nature, both on the New York roof-terrace and in the Santa Monica yard, had been usurped by culture. The same victory permitted American houses to enjoy their own optional internal climates: tropical heat in the winter, and an arctic chill in the sweltering summer.

In the cubist city, people lived geometrically. The New Yorkers in Stephen Sondheim's musical *Company* buzz around their unattached friend Bobby, who seems emotionally neutral, sexually neutered, and copes with the city by retreating into glazed autonomy. No one knows who Bobby is; they can only hazard guesses about what he might be like. Among their scatter-shot metaphors, one is brilliantly exact, linking him with a New York landmark, a symbol of the city's abstraction and of what Camus called its heroic inhumanity. Bobby reminds me, someone says, of the Seagram Building – the stark, featureless skyscraper by Mies van der Rohe on Park Avenue, which stands back from the street inside its shield of bronze. It is often said that people grow to resemble the dogs they keep. Do they also develop resemblances to buildings in the cities where they live?

The Cubical City, a novel published in 1926 by the *New Yorker* columnist Janet Flanner, studied the relation between New York's architecture and its uprooted human users. Cubing, as capitalist America understands, is a form of multiplication. American cities cube themselves by buying and selling 'space in air', rising high while they spread laterally, with 'elevators to the sun and street cars to all outlying suburbs'. Those elevators, now taken for granted everywhere in the world, were one of the inventions which defined the modernity of America. Karl in Kafka's novel gets a job as a lift-boy at the Hotel Occidental – a uniquely American occupation. During the 1920s the press magnate William Randolph Hearst ransacked Europe to outfit his plutocratic folly at San Simeon on the California coast. He installed an Italian Renaissance ceiling in his dining room, and slept (after updating the mattress) in a bed once occupied by Cardinal Richelieu; but he was especially proud of an elevator which in its earlier life on the other side of the ocean had served as a confessional box in a church. Briskly secularized, mobilized by pulleys, it now flaunted America's freedom from gravity, conscience, and the onus of the past. To the radical composer Hanns Eisler, lifts also exemplified the fatal flaw of the American social and economic system. In exile from the Third Reich, he arrived in New York in 1938 during a strike by the city's elevator operators. He noted with a smirk that a technological culture needed slaves to work its machines. Even for local users, these mobile cabins seemed odd; new modes of transport create new psychological moods. Janet Flanner's heroine Delia retires, like most New Yorkers, into an isolation chamber. She resembles 'a figure in a cube of glass', as if permanently sealed in one of those hydraulic boxes.

Delia's father, a property developer in the Midwest, gloats over the 'cubic glory' of buildings: their quota of rentable space, measured in cubic feet. But can the human being's emotional capacities keep up with this bounding multiplication

game? The elevator shafts mount towards a defunct God. They take you so high that all your illusions are punctured. From the top floor of a skyscraper, the stars are no longer glorious, and become 'mere points of antique gaseous light'. People in this environment lose their humane softness. The face of Delia's sister Nancy is white, like china when baked. Delia herself possesses an 'architectural mouth', and she views her wrist-watch (another modern novelty, clamping the awareness of time to one of the body's most vulnerable spots, where it ticks faster than a pulse) as a kindred spirit, imagining its 'minute mechanisms fitted like heart and liver behind platinum' and admiring its 'little intelligent face'.

Apartment-dwelling enforced this emotional redefinition of people. The cubical city begrudged people space, and forced them to reconsider priorities. They lived to work; apartment blocks were merely dormitories. Blaise Cendrars observed that the demarcation between private and public realms, so sacred to bourgeois Europe, had been reversed. The home was no longer a temple to family values, a museum of personal trophies, a buffer against the rude, impersonal world outside. The 'milliardaire', Cendrars claimed, felt at home only in the office, with twelve jangling telephones and five radios. Apartments, cubing the available area, transferred industrial ingenuity to a domestic setting: another idiosyncratic piece of American furniture was the bed which folded away into the wall each morning. Even that low-rent New York institution, the railroad flat, revealed something about the values of these remorselessly modern people, who were happy to live – or at least to sleep – in rooms which resembled the carriages of trains. Janet Flanner summed up the economy of the apartment, and noted one of its disadvantages – 'Three rooms, kitchen and bath: all modern comforts except that of privacy. Where in the compressed pyramidal dwellings of New York did rent-payers go when their hearts were breaking?' The answer has by now become clear. If you want privacy, you go down to the street, and disappear into the uncaring crowd.

At first this utilitarian simplification of life alarmed Europeans, who remembered the protective comforts of the old bourgeois world. This is why the motels of middle America so fascinated Nabokov. Those Swiss chalets, Spanish haciendas and half-timbered Tudor cottages pretended to rusticity, yet they were conveniences for people in transit on the highway, like the fugitive Humbert in *Lolita*. Hitchcock in *Psycho*, also seeing the motel as no American ever would, felt their latent terror. A motel has a shorter memory than the Berlin hotels which alarmed Kracauer; it erases all record of you as soon as the sheets are changed (or the blood mopped from the bathroom floor and the car with the body inside it fed to the greedy swamp). But surely there are traces of those who have passed through? The Gothic mansion on the hill in *Psycho*, preserving the past with the help of taxidermy, represents the secret life of those minimal sheds with their scrubbed white tiles.

Isherwood in his novel *A Single Man* advanced beyond Nabokov's amusement and Hitchcock's dread, praising the motel for its monastic austerity. He

took it as further evidence that Americans had abstracted themselves from mat-erial things. Their spiritual vocation – which was served even by their economic endeavours – left them no time for European enjoyments. All they needed was a capsule, like a vitamin pill or a car or a rocket: a motor for the spirit, which you either inserted into the body or inserted the body into. This gave the motel a high-minded beauty, like the cell of an anchorite. Isherwood's hero explains that 'an American motel-room isn't *a* room in *an* hotel, it's *the* Room, definitely, period' – an overnight staging-post, to be used while we cool our heels on earth. In 1947 Claes Oldenburg was enchanted by a motel at Malibu in which, as he later claimed, each room was upholstered in the fur of a different wild beast. You could choose to sleep (or to make adulterous love) in the lairs of a leopard, a tiger, or a zebra. This was not quite the Platonic idea of a room extolled by Isherwood, but Oldenburg's motel, jokily savage, also refused to subscribe to European notions of civilization, partitioned off from the wilderness.

The breach with the older way of living was absolute, like a time-warp or a case of incurable jet lag. Kafka imagined that the first days of a European in America must amount to a kind of rebirth. He assumed that, before the renais-sance can occur, there must be a death. The identity you arrived with might be denied entry: harassed officials at Ellis Island would often assign new names, anglicized and therefore easier to spell, to immigrants from Eastern Europe. Céline in his novel *Voyage au bout de la nuit* sees America as the other world, not the new world: a post-mortem place. The new country reminds Céline's hero Ferdi-nand Bardamu of his 'individual nullity'. He is not ungrateful for its callous indif-ference to him: exile, or life in any foreign country, involves the 'inexorable perception of existence as it really is'. Not everyone derived such morbid plea-sure from lost status and a cancelled past. Brecht constantly grumbled because in America he had to spell a name which was famous elsewhere. But Isherwood and Aldous Huxley, moving to Los Angeles, both understood that their journey was like that of Svidrigaylov. As well as a new life, America offered them an afterlife, an acquaintance – at this frayed terminus of the West – with last things.

Isherwood made his home in the canyon above the slide area of Santa Monica, where he could anticipate the coast's reclamation by the ocean and dream, after his conversion to Vedanta, of the body's crumbling into a mystical flux. Huxley moved to the Hollywood hills, with the light-show of the city below him and the searing desert with its hallucinogenic cacti behind him. There he hovered between illusion and enlightenment. When his house at the edge of Griffith Park was burned down by a brush fire in 1961, incinerating his archives, he told a friend that the disaster made him feel 'extraordinarily clean!' Isherwood admired his calm, 'worthy of an Asian philosopher'. America is ever ready to work its miracle of nullification.

One of Huxley's favourite outings in Los Angeles was to Redondo Beach, where a sewage pipe, often glutted with condoms, spilled the city's excreta into the ocean. This for him was another scene of extraordinary cleanliness: the

detritus of human life is voided at last, washed away. Céline's hero sees the entire country, from sea to shining sea, as an extension of that duct. America in *Voyage au bout de la nuit* gobbles down the immigrant, mashes him up with others of his kind, draws off the nutriments it can use, and then, having conducted him through its tunnelled underworld, ejects whatever is left of him. Bardamu first dreams of going there in France, while he is amorously nuzzling the rear end of an American nurse called Lola. He therefore considers the journey as a 'profound and mystically anatomical adventure'. So it proves to be: he first communes with America in a foul cloaca beneath City Hall in New York, where the cubicles have no doors because nullities do not require privacy; and he feels he has been consumed by the country's gullet when he goes to work on the assembly line in the Ford factory at Detroit.

Nabokov's *Lolita* describes its own mystically anatomical voyage. Here the European infatuation with America is personified in Humbert's craving for the pubescent, precocious heroine. America offers Europe a second chance, the solution to a continent's mid-life crisis: why not represent the rebirth as an older man's pursuit of a dangerously juvenile woman? Humbert's nympholepsy is a love-affair with America's bizarre novelty, its rowdy, appetizing vulgarity, and its colloquial language. Nabokov wrote a first version of the novel in Europe, and then after moving to America in 1940 he began to acclimatize his fable and accumulate a continental variety of settings for it. Abducting Lolita, Humbert takes her on a zigzagging trip through the Midwest. Their itinerary is the narrative of a seduction. He wants to venture into every recess of the land, feeling his way back to the pagan paradise secreted there, reclaiming his connection with the innocent, shameless infancy of the race.

The seducer, obtaining pleasure for himself, in return bestows education. America like Lolita is a child; its wilderness, as Humbert says, is lyric, epic or tragic but 'never Arcadian'. He seeks to repair that deficiency, smuggling into the raw and unrefined country the gods of Arcady, who undergo new incarnations here. He refers to thunderstorms on the prairies as 'Jovean fireworks', and calls the investigator who tracks him a 'Proteus of the highway'. As he drives, Humbert wishfully cultivates the land, pointing out 'Claude Lorrain clouds' or 'a stern El Greco horizon'. Industry is read, or purposefully misread, as mythology: he marvels to see Pegasus – the flying red horse, the company logo of Caltex – take flight over a gas station.

America had already hallowed its own terrain by sentimentally or sacredly invoking places on the other continent, and Humbert, pointedly introducing 'a town named New Orleans', relishes the implausibility of these transplantations. In 1931 the conservative French critic Georges Duhamel, rabidly denouncing the cultural menace of America, attacked such illegitimate offspring. A Catholic graveyard in New Orleans with French epitaphs on the tombstones was for Duhamel 'the burial-place of a race and a civilization'. Humbert is kinder, and thus more perceptive. To call a city New Orleans or New York was a poetic act.

Those names are metaphors. The word means a carrier; metaphors transport the conviction of likeness between unlike objects or disparate continents, erecting fragile bridges of affinity. One of Nabokov's transplanted gods recurs in a comment by the film director Eric Rohmer in *Cahiers du cinéma* in 1955. 'America', he said, 'is protean: one moment astonishingly familiar, the next incomprehensibly opaque to our European eyes.' Like Nabokov, Rohmer wrote at a time when there was a delicate, unsteady balance between knowledge and mystified ignorance. During the 1930s America was completely foreign, so that Brecht could jumble up its geography with impunity. By the 1960s it was omnipresent. Everyone in the world, thanks to television and popular music, lived there. The pivot between familiarity and incomprehensibility, clarity and opacity, is where metaphor inserts itself.

Love, however, seldom sees clearly. Humbert's view of America is an infatuated misinterpretation. Lolita, who dotes on juke-boxes and candy-bars, is actually 'a disgustingly conventional little girl', not the sprite imagined by Humbert. When he learns the country's language, it becomes banal. He finds himself in the sadly demystified state of G.K. Chesterton, who on his visit to New York in 1922 wished that he did not understand English: then the neon advertising signs above Times Square, abstract and unintelligible, would have been a 'garden of wonders'. Having forfeited the sense of estrangement and enchantment, the best Humbert can hope for is an inadvertent pun which, with the sly logic of the Freudian slip, will mystify America all over again. In an Appalachian town, on a drably ordinary main street, he catches the language dreamily babbling: 'a garage said in its sleep – genuflexion lubricity; and corrected itself to Gulflex Lubrication'. His poetic unconsciousness – his learnedly dirty European mind – has made America briefly mis-speak itself.

While Humbert brought with him in his baggage the lubricious gods of Ovid, the actor Charles Laughton transplanted other mementoes, tenderly raising zinnias, anemones and roses, which fraternized with the cacti in his garden perched above the coastal highway between Santa Monica and Pacific Palisades. His motive, like Humbert's, was consecration. Brecht, who finally overcame his nostalgia for the Berlin asphalt just before returning there, in 1944 wrote his most beautiful California poem about Laughton's improbable garden. It was hard, he found, to remain detached while tending your own patch of American earth. Watering his own plants in a 1942 poem, Brecht was surprised to find himself taking the chore seriously. He noticed how careful he was to distribute the water evenly and to irrigate the soil even where no grass grew. He assumed, suppressing deeper feelings, that his political conscience guided the hose: no part of the garden must be denied the means of life. In his account of Laughton's garden, he allowed himself to relax.

The house Laughton occupied on Corona del Mar had been a Spanish mission, and his garden carried on the missionary enterprise. In his poem about the fall of New York, Brecht deplored the forgetfulness of new arrivals, who –

anxious to acclimatize, which means to be bastardized – cast off profound national traits as if they were bad habits. The garden made him reconsider this judgment. He was amazed by the feats of Laughton's fuchsias. These immigrants had put down roots, and now bloomed in lusciously un-European hues. But the enterprise, like all previous attempts to colonize or convert America, remained precarious. While Brecht was writing the poem, California trembled, impetuously revising its own map, and Laughton's rose bushes slid down the cliff into the ocean.

Though Europeans liked to smile at infantile America, secretly they found some of its enjoyments irresistible: ice cream, for instance. Grosz, who made it to New York in 1932, saw the city's cool, tiled, gleaming ice-cream parlours as tabernacles, the visible (and edible) sign of America's secession from the grim, dark European past. Kurt Weill included an ecstatic sextet on the subject in his opera *Street Scene*, first performed in 1947. Lippo Fiorentino relieves the swampy summer heat of a Manhattan tenement by distributing cones to his neighbours; he rhapsodizes about the delights available at the soda-fountain, his wife contributes a flurry of delirious coloratura on her chosen flavour, vanilla, and another enthusiast shouts 'Hallelujah and Hosanna!' This is not necessarily a parody. Ice cream is one of the good things in life, and a culture which overthrew European decorum by permitting adults to consume it in the street could not be so very wrongheaded.

What the arriving Europeans could not forgive was America's innocence, its lack of an incriminating, imprisoning history. If this was paradise – a renewal of the world, or a heaven where ice cream replaced ambrosia – then their responsibility seemed clear. They must bring about a fall. These latter-day pilgrims brought the knowledge of evil with them. Like Humbert, their intention was to debauch a minor.

Cendrars, watching some rich vacationers get off the train in Tampa, teased this pastel Eden where the houses were 'too white' and the sky 'too blue'. Los Angeles reminded Man Ray of the radiant climate in the south of France. But, when he moved there in 1943, he made immediate plans to darken the blithe sunshine. With Buñuel, he prepared the scenario for a film to be set in a sewer beside the freeway; the studios were not tempted by the proposal. Hanns Eisler, who arrived on the west coast in 1942, described the California climate as an 'appalling idyll'. He detested the year-round spring, which made him melancholy, and complained that the ocean interfered with his concentration. The proper response to this classical landscape, he told Brecht, was to write elegies: complaints about having to live in Arcadia, with a plea for repatriation to the mortal, fallen world. This he did in his *Hollywooder Liederbuch*, setting many of Brecht's sarcastic lyrics about Los Angeles. Brecht too found eternal life tedious. Sick of the evergreens in his garden, he travelled to the Hollywood hills in order to see trees which had died for the duration of the winter. Human corpses were

not allowed to behave in such an unseemly way: Brecht noted that the dead wore cosmetics, their faces fixed in a permanent rictus of delight. The city's eponymous angels were everywhere, though somewhat exhausted from wishing one another a nice day and flashing their dental work. Los Angeles, as Brecht recognized, was a neat and economical solution to the problem of the afterlife. The same place doubled as heaven and hell – a paradise for those who could afford the admission price, an inferno for everyone else. Both Brecht and Eisler assuaged their homesickness by returning to the newly-constituted East Germany after the war, staying just ahead of deportation orders.

Camus came to America after his years in the French Resistance, during which he wrote *Le mythe de Sisyphe*, his account of humanity's endless, pointless, existential trials. He walked down Broadway, bemused by the local deities: towering above him, a GI fifty feet tall puffed out rings of real smoke as he savoured his Camel cigarette. Camus, looking around, was sure that the spirit of tragedy must exist here, as in beleaguered Europe – but for the moment he could not tell where it was hiding. Later he decided that the indomitable upbeat manner of Americans must be one of its symptoms: 'In this country where *everything* is done to prove that life isn't tragic, they feel that something is missing. This great effort is pathetic.' Sartre agreed, calling Americans a 'people who are tragic for fear of being so'. In 1946 Maurois shook his head over an American mining strike, which had halted industrial production at a time of widespread famine. This, he thought, was 'a tragic situation', simply because Americans could not see it that way. 'They have the invincible optimism of happy peoples, and cannot believe that all will not turn out all right in the end.' As he finished his teaching stint in Kansas City and prepared to return to France, he took dejected inventory of the bombs, rockets and microbes which men in the last few years had invented as instruments of their own destruction. He concluded, reasonably enough, that 'humanity is going through a crisis which may end in annihilation'. Still, the news of imminent apocalypse had not reached Kansas City.

Soon after his arrival in New York, Auden wrote the text for *Paul Bunyan*, an operetta composed by Benjamin Britten which had its first performance at Columbia University in 1941. Auden annexed American folklore, and used it to unsettle what he saw as the complacency of his adopted country. Bunyan was a mythical lumberjack, a giant who single-handedly levelled forests and made the American wilderness habitable. Auden interpreted him as a totem of industry, driven to uproot nature. But Paul Bunyan's work is not merely rapacious, like that of the trappers and gold-diggers in *Mahagonny*. He clears the way for a society devoted to the exercise of human freedom. Auden called America the 'fully alienated land', and despite the ambiguities of the phrase – it was an alien's description of a country whose immigration officials still classify foreigners as aliens, as if they were trespassers from another planet – he meant it as a compliment. The alienated land is also the abstracted land, forcibly modernized. Rodchenko, with his austere modern taste, confirmed Auden's call for an

unvegetated new world; he had little time for trees. On a walk near his summer home, Rodchenko deplored the chaos and clutter of nature, and thought nothing worthy of being photographed: 'only these pine trees are passable – tall, naked, almost telephone poles'. The best a tree could hope for after the revolution was to be chopped down, given a severe hair cut, and set up again to support electric wires.

Alienation became a sociological and psychiatric buzz word in the 1950s, a summary for all the disaffections of the age. In Auden's view, it was simply the modern fate, which America had embraced. People in New York lived, he presciently said, as everyone would soon be obliged to live – emotionally isolated, though physically crowded together; disconnected from the earth. Paul Bunyan, chopping down trees, cut through the dense lumber of the past. He opened up a vacant space where people could do exactly as they pleased. The Sheep Meadow in Central Park, with its notable absence of sheep, is one such place, and Washington Square is another, like the beach at Venice in Los Angeles, the streets of Haight-Ashbury and the Castro Valley in San Francisco, or the People's Park across the bay in Berkeley. These are arenas of proud, unafraid exhibitionism, where man, as Walter Benjamin put it, becomes an object of contemplation to himself – showing off his muscles, doing stand-up comedy routines, selling poetry or drugs, giving attitude. Men go to America to escape from God, from all the prohibitions of history. Therefore, once the deified Bunyan has cleared the timber, his offstage voice announces his retirement. What America needs, he says, is rebels and dissidents, nay-sayers and show-offs who will take over the clearing in the forest. He calls for 'disturbers of public order' and 'energetic madmen': an influx of refugee aliens, ready to civilize the wilderness by depraving and corrupting it. Mahagonny, after all, was not such a bad place. It might be seen as Europe's gift to America, a follow-up to the Statue of Liberty.

Among those alien visionaries who sought refuge in America were filmmakers like Fritz Lang, Billy Wilder and Robert Siodmak. Their vision of the country was extraneous, sceptically foreign, so that the name given to the genre they helped to form remains untranslatable: *film noir*, with its pessimism and its optical distortions carried over from German expressionism.

Wilder's *Double Indemnity*, released in 1944, looks at the balmy suburbs of Los Angeles, invisible to Americans because so familiar, and finds them both strange and sinister. In Glendale, the fiendish Barbara Stanwyck lives in a Spanish villa with a garden of honeysuckle bushes: evil does not only reside in mean streets. Fred MacMurray, as the insurance salesman she suborns, spends his life travelling from door to door enticing people to make bets about their own mortality. His job sums up the bedevilled mobility of this new city, made restless by psychological disquiet. He stops at a drive-in restaurant for a beer, to cut through the sour taste of Stanwyck's iced tea; he spends afternoons at a bowling-alley, rolling a few lines to forget her. Both locations, noticed as if for the first time by Wilder, seem quirky, perverse. In this culture, refreshment and amusement are

Salvador Dalí
Gangsterism
and Goofy
Visions of
New York
(1935)

catered for by places of transit. California had filled up rapidly during the previous decade, first with refugees from the Dust Bowl, later with employees of wartime industry. MacMurray comments 'I thought all Californians were from Iowa'. Arriving recently, people had walked out of their previous lives; the lack of a past which can be consulted makes everyone a suspect. Innocent places, like the motels to which Humbert takes Lolita, become guilty by association. MacMurray and Stanwyck plot the murder of her husband at a supermarket called Jerry's in Los Feliz, among stacks of baby-food. The market, with its standardized products, displays the affluent fruits of American conformity: an apt cover for this treacherous subversion. Aldous Huxley, high on mescaline, liked to roam through the aisles of a Los Angeles establishment called the World's Largest Drugstore, savouring the freakish ugliness of its cut-rate wares.

Sunset Boulevard, directed by Wilder in 1950, adopts Brecht's vision of a heaven which doubles as hell, and observes this society from underneath. It begins on the kerb where the street name is inscribed, among tendrils of grass and smeared oil stains; then the camera tilts up over the gutter and across the slick, pock-marked street, chasing the homicide squad on its way to the scene of the crime. William Holden's body, stretched out on the surface of the swimming pool, is also studied from below. He hangs there – mouth open and eyes idiotically gaping, surprised by death – while the flash bulbs of the police explode behind and above him. The pool, no longer cleansing or refreshing, becomes a grave, like the shower in *Psycho*; later in the film it is seen drained, and squealing mice scurry through its jungle of weeds.

In *Shadow of a Doubt*, made in 1943, Hitchcock imported evil to a small town, the crucible of American values. Santa Rosa, luxuriating in the California sun, is idyllically average. The detectives investigating Joseph Cotten, who has fled west from Philadelphia, explain their intrusion by saying that they need to question a typical American family for the National Public Survey. Cotten's law-abiding relatives believe it is their patriotic duty to co-operate: this blissful

portion of the land is not yet alienated. Hitchcock glances coldly at the earnest communal effort to sustain a national idea. In the library where Teresa Wright goes at night to read the newspaper article about her uncle's career as a murderer, a poster on the wall behind her pleads BUY A STAKE IN AMERICA. Cotten has ripped the incriminating page out of the family's copy while making a house from the paper. This trick is his demonstration that everything is flimsy. You can commit murder in the suburbs without using a weapon. Cotten unerringly discovers the fatal flaws in the house: a loose step on the back stairs; a garage door which is liable to jam while the car is breathing out poison. He kills to express his contempt for a hypocritical society, and his greatest blasphemy is his disdainful casualness about cash, which he leaves littered on the floor. After Cotten's lecture to the women's club, the bank manager remarks 'We don't get many American speakers. It seems like foreigners make the best talkers.' His nihilism and the fury of his invective make him an honorary alien, unfit for this devout, docile paradise.

Cotten plays a fallen angel, lucid like Lucifer, a terrorist whose violence is principled and selfless. He murders rich widows to punish them for their avarice, but he has no use for their money and gives away most of it in charitable donations. Seen from Europe, such a character had a unique integrity. Sartre, for instance, admired American tough guys, the writers of those hard-boiled thrillers which appeared in translation as the 'Série noire'. In 1946 he praised their 'barbaric brutality' for revealing the truly 'tragic, cruel, and sublime' face of America. Camus in his novel *La Chute*, published in 1956, commented that 'every intelligent man…dreams of being a gangster, and of ruling over society by force alone'. His only objection to thrillers was that they made that feat seem too easy. Reflecting on totalitarianism and the war it provoked, Camus remarked that most would-be thugs nowadays turned to politics, and hastened to join whichever party promised to be cruellest: in contemporary society, ideology satisfies our 'sweet dreams of oppression'. Maurois, preparing to teach Tolstoy to his students in Kansas City, envied the simpler and perhaps more honest response of 'the "post-Christian" novelist (Hemingway)' to spiritual qualms. After Hitler, Tolstoy's belief in a superintending God had to be abandoned. The tough guys showed how a form of grace might be salvaged from the wreckage of faith. They derived a moral style from whatever they happened to like doing: boozing, fornicating, or fighting bulls. For Joseph Cotten in *Shadow of a Doubt*, to kill a rich, fat, lazy widow presumably counted as a moral act.

The *Cahiers du cinéma* critics deciphered the industrial products of Hollywood as secret allegories, ministering to godforsaken modernity. Of course adjustments had to be made. Jacques Rivette for instance tortuously argued that violence in the thriller existed only to create a void, an interval during which the hero could take stock of himself and his capacity for good and evil. Perhaps this is what William Holden was doing while suspended in Gloria Swanson's pool, or when stretched out on a slab in the morgue (which is how Wilder wanted *Sunset Boulevard* to begin). The all-purpose embodiment of this existential valour was

Humphrey Bogart, who played Hemingway's Harry Morgan in *To Have and Have Not*, Hammett's Sam Spade in *The Maltese Falcon*, and Chandler's Philip Marlowe in *The Big Sleep*. André Bazin, writing about the death of Bogart in 1957, cerebrally disarmed the tough guy. As handled by Bogart, Bazin claimed, the revolver became 'an almost intellectual weapon'. That 'almost' is breath-taking in its audacity, metaphorically vaulting across the gap between continents. By stealth, the feisty American detective was transformed into a brooding European artist. In Wim Wenders' *Hammett*, Sam Spade vanishes back into the ailing, enfeebled novelist who invented him. When Dashiell Hammett's apartment is ransacked, Frederick Forrest rescues his precious Underwood, and checks that it still works. A typewriter is the only intellectual weapon he needs.

Bohemian rebels like Vaché in Paris and Grosz in Berlin envied the lawlessness of the West, beyond the social pale. But in America the Western told a different story. Like the tree-felling exploits of Paul Bunyan, it was about the domestication of wildness – fertilizing the plains, laying railway tracks, massacring natives. The Western convened and consolidated society, as at the dance in John Ford's *My Darling Clementine*. Its violence had a higher purpose, defending pastoral peace and quiet. Hence the emblematic figure of the sheriff, like Gary Cooper in *High Noon*, or the chivalric saviour who providentially appears and then disappears when his task is done, like Alan Ladd in *Shane*. In Europe, this agrarian optimism could only seem glib and false. The hero of Graham Greene's *The Third Man* writes Western novelettes. Arriving in post-war Vienna, he finds that his crusading fables about the frontier do not match the complex iniquity of this old, self-destructive civilization.

The refugees who travelled in the opposite direction altered the ingenuous Western myth. In 1939 Marlene Dietrich appeared in *Destry Rides Again*, helping her lover to cheat at cards and entertaining the rowdy populace of Bottleneck in the Last Chance Saloon. This is a West which has registered the effects of the European diaspora. Dietrich's leering song about the boys in the backroom was written for her by Friedrich Holländer (anglicized in exile as Frederick Hollander), who composed Lola's repertory of cabaret turns in *The Blue Angel*. Another deracinated recent arrival is played by Mischa Auer, as a Russian whose name is Boris Stavogrin although everyone calls him Callahan. When Dietrich wins his pants in a game of cards, he refuses to remove them, reminding her that 'I've met every king in Europe'. Dietrich's own provenance is fudged: her character is called Frenchy, because she comes from New Orleans.

Dietrich resisted Hitler's appeals for her to return to Germany, and spent the war gamely singing to and fraternizing with American troops. All the same, she never seemed at home in the indigenous form of the Western. In 1952 she made an incongruous appearance in *Rancho Notorious*, directed by Fritz Lang. Her character here is called Altar, long since profaned. 'What's that in there?' demands Arthur Kennedy, pointing to her frilly boudoir. 'A bedroom, or a morgue?' Despite her change of continent, the fatal woman behaves like an

older and even more perverse Lola. Since this is a cowboy film, she climbs onto a man's back and whips him across the floor of a saloon, goading him along with a hat pin stuck in his rump. She lethargically drones and drawls her songs, clenching a cigarette in her mouth. Scarcely drawing breath, she douses the cigarette in a glass of beer and punches a patron who has molested her. Her boss fires her for surliness. 'I'm sick of smiling', she says, preferring to sneer. From the dance-hall she graduates to the notorious ranch, which resembles the thieves' co-operative in Brecht's *Dreigroschenoper*. She provides a hideout for bandits, and skims off ten per cent of their takings in return.

Lang's observation of Western society is correspondingly Brechtian. The American 1870s are the German 1930s in fancy dress. In the town of Gunsight, a Law and Order Party has jailed the crooked local politicians. Like Macheath in the *Dreigroschenoper*, they are royally treated. Whisky is delivered to their cells, and the sheriff thoughtfully includes a file in one of the bottles to ease their escape. Kennedy is imprisoned for the venial offence of trying to buy a drink on election day. Noting his psychopathic rage, the sheriff comments that they need a padded cell for him. He chooses to be locked up with the gunslinger Mel Ferrer, rather than with the politicians: sooner an outlaw than those licensed, respectable thieves. *Rancho Notorious* swiftly and abruptly brought the bad news about lust, greed and official complicity to innocent America. At the beginning a girl opens the dark safe of an assayer. A robber's hands tighten on a wire screen, and he swallows. A scream is heard. Then the rapist gallops away, and his companion shoots at a child. Kennedy stands over the corpse of his bride-to-be. 'I don't know how to tell you this,' says the doctor, 'but she wasn't spared anything.'

The French critics had turned the thriller into a parable of morality coping with the failure of divine law. The Western likewise was made to take account of a tragic history which America was founded to deny. Akira Kurosawa studied what he called 'the grammar of the Western', then applied that grammar to his own language. In 1961 Kurosawa remade *Shane* as *Yojimbo*, changing a gunman to a samurai and backdating the nineteenth-century West to medieval Japan, where bandits marauded and warlords feuded with no central power to regulate them. In 1964 Sergio Leone took *Yojimbo* as the pretext for the first in his great sequence of European Westerns, *A Fistful of Dollars*. A loop extended around the globe from America to Japan and on to Italy (also roping in Spain, where Leone made his film). The grammar remained the same, but now it generated new and unexpected sentences. Leone mistrusted John Ford's homely, pacified West. 'We Romans', he remarked, 'have a strong sense of the fragility of empires.'

American Westerns hope for the end of history: a time when, as the song in *Oklahoma!* says, the farmer and the cow-hand will be friends. Leone took a longer view, adopting the European perspective which extends backwards from the present to the ruined Roman forum, the image of oblivion which haunted both Freud and Hitler. His Westerns foresee interminable conflict, a lethal, self-cancelling scramble for spoils. Where the frontier does succumb to civilization –

as at the end of *Once Upon a Time in the West*, with Claudia Cardinale earthily catering to crowds of workers in a town which sprouts beside the railway – the fatalistic Leone cannot hide his disappointment. To him this means that epic has been emasculated. It announces, as he has said, 'the birth of matriarchy and the beginning of a world without balls': a virtual paraphrase of Sartre's admiration for America's barbarism and brutality.

In Leone's *Once Upon a Time in America*, released in 1984, the upwardly mobile thug played by James Woods obtains a jewelled papal throne for the gang's headquarters. Robert de Niro, when Woods shows off the throne, asks accusingly 'What are you doing with it?' Woods replies 'I'm sitting on it'. He also uses it as a prop for his foot while he shines his shoes. Civilization has once more made the crossing from Europe. To Leone, this signifies America's lapse from lawless freedom – on the frontier, or on the unpaved, unpoliced New York streets and the slum rooftops where the boys in *Once Upon A Time in America* form their gang – to the rule of a corrupt legality. America's manifest destiny was to save Europe from its civilized, declining doom. Instead it has developed its own replica of Europe's punitive institutions and organizations. But two passages of comic bravura in Leone's film rejoice in what might have been, if the frontier had never been closed down. As a practical joke on an Irish police chief, whose wife has finally succeeded in bearing him a son after a series of daughters, Woods and de Niro mix up the babies in the maternity ward. The cop, peering proudly beneath his child's nappy, is aghast to discover the wrong sexual organs. The switching of cribs is a high-speed farce, accompanied by an ebullient Rossini crescendo. Woods accounts for this exhilaration by defending the blameless American justice of the operation. 'It's better than fate', he says. 'You give some the good life, and give it to others up the ass.' But you do so randomly, not as directed by inheritance. The scrambling of lives is his means of affirmative action, a reproof to European determinism.

Later the gang encounters Tuesday Weld, who in a previous sequence had been raped by de Niro during a hold-up. She cannot be sure which of the men she has – as she delicately puts it – met before, because their faces were all covered by handkerchiefs. They line up for an identification parade. 'Let's see how good a memory you've got for faces', says Woods. They all then take out their penises. Weld chooses Woods rather than de Niro as her assailant. 'We've been hanging out together so long', Woods explains, 'we're beginning to look like one another.' The device matches the interference with names and numbers in the maternity ward. Faces are a prerogative of the individual, and thus best kept covered; genitals are democratically interchangeable.

Floorboards, as in the town beside the railway line in *Once Upon a Time in the West*, cover up the vacuum. In his 1966 Western *The Good, the Bad and the Ugly*, Leone reversed this mitigating process, and turned a story about profiteering during the American Civil War into a reflection on European history in the twentieth century. The costume drama happily admits its own contemporariness.

It looks at the past back-to-front, so that Eli Wallach, playing 'il brutto', introduces himself to a soldier as Abe Lincoln's grandfather. His comment mocks the rear-view vision of the old Hollywood epics, in which characters tended to chirpily announce that they were going off to fight in the Hundred Years' War: they knew in advance that it would last a hundred years, because they had read about it in their history books. But the joke also points out Leone's anachronistic rewriting of American history.

At a railway station in *The Good, the Bad and the Ugly*, the photographer Mathew Brady, the actual memorialist of the war, is seen posing a cheerful tier of men in blue. 'Hold it! Don't move! Don't breathe!' Brady commands. His camera stills life – kills it, holds it hostage in the past. Leone's pictures move, and in doing so they bring the past alive in the twentieth century. The armies occupy sandbagged trenches, from which they squabble over a militarily worthless bridge. The scene belongs on the Somme in 1916; as satisfied by bloodshed as a Great War general, Clint Eastwood comments 'I've never seen so many men wasted so badly. It looks like it's gonna be a good long battle.' The blitzed town where the gunfight takes place – all dust, rubble, tatterdemalion fugitives and blasted trees – is Ypres, or perhaps Dresden at the end of the next war. The prisoner-of-war camp in which Wallach is tortured while a band plays and a model choir warbles alludes to the Nazis' showplace of Theresienstadt, a concentration camp which masqueraded as an artists' colony.

The European present is written over the American past, smearing and smudging it. The credit titles of *The Good, the Bad and the Ugly* jumble up photographic reportage from the 1850s with the artistic fads of a century later. Gobbets of paint explode across the screen from guns or cannons, flushing the faces of Eastwood and his colleagues. This is the bravado of the action painters, whose aesthetic weapon was pigment. An amoeboid blob of colour, spattered as if by Jackson Pollock, is scraped away to the sound of gunfire, revealing a grainily monochrome Brady print buried underneath. Modernity overpaints history; Europe messily effaces America, where good and evil once fought it out in stark, simple black-and-white. *Once Upon A Time in America* concludes with a long close-up of de Niro. He has taken refuge in an opium den, where he consoles himself for the loss of hope. As the drug goes to work, his face suddenly twists into a stupefied, humourless grin, which freezes into a mask. America is literally a pipe dream.

In 1950 the photographer Robert Frank left Zurich to live in America. 'How', he asked himself ruefully, 'can one be Swiss?' He spent 1955 criss-crossing the United States, photographing cafeterias and flophouses, shoe-shiners at work in public lavatories and the abraded faces of retirees, with a glimpse of the deadening assembly line in Detroit where Céline suffered. In the South a sheriff asked him what his business was. 'I'm looking', he replied. He was given an hour to get out of town. In Arkansas he spent three days in gaol for the same offence of observation. To look – or at least to see what he did – was an un-American activity.

When Frank's book *The Americans* was published in 1959, his friend Jack Kerouac wrote a preface praising 'the EVERYTHING-ness and American-ness of these pictures!' All the same, the book was condemned for being 'anti-American'.

The country, as Frank saw it, was on the run. Hell's Angels in leather scowlingly bestride their bikes at a rally in upstate New York. Boys at the Motorama in Los Angeles try out cars they will drive when they grow up. A drive-in movie in Detroit, the automotive city, makes official that affinity between the car and the cinema which Claudel pointed out. Modernity means speed, but where are all these vehicles going? They travel towards dissolution, like nature according to the laws of the new physics. Roadside crosses in Idaho mark a crash on the highway. Witnesses in Idaho stand guard over some blanketed corpses after another accident. In an overgrown Venice backyard, a car's corpse rusts and rots.

Leone's film laughs at Mathew Brady for seeing the Civil War so simply, as a conflict between black and white. Frank, however, argued that black and white were the proper constituents of photography because they represent the moods of despair and hope between which the human condition – according to the jiving existentialism of the Beat generation – shuttled. In *The Americans*, he brought the highs and lows jarringly together. A black nurse in Charleston holds up a baby so white that it looks like an albino. The Stars and Stripes, draped across many of the photographs, illustrates the national mood of schizophrenia with its bands of inky black and glaring white. On a highway in New Mexico, the two dispensations unheedingly pass one another by. An infinite white line down the centre of the road glows as it recedes into the distance, remembering the luminous hope it offered to the cross-country migrants of the 1930s on their way to California. But while that tapering strip unravels in one direction, a car heads towards Frank on the other lane, black and menacing in the emptiness. The onward trek of hope is contradicted by the futile return journey of despair.

Siegfried Kracauer spoke of film's noble task, which was 'the redemption of physical reality'. Frank also hoped that his photographs might contain 'the knowledge of where God is'. Yet in the downtrodden America of his book, God, though often invoked, is hard to locate. The decals on a slickly lacquered car, as black as a hearse, announce that CHRIST DIED FOR OUR SINS and CHRIST CAME TO SAVE SINNERS. Its number plate remembers another saviour, identifying Illinois as LAND OF LINCOLN. Meanwhile, the polished trunk and windows reflect Chicago's spindly fire-escapes: who will redeem this reality? In Los Angeles, opposite a gas station and a shed advertising LUBRICA-TION (which might have momentarily titillated Nabokov's Humbert), a statue of Saint Francis lifts his crucifix towards the hazy outline of City Hall. His benediction wilts in the smog. In Santa Fe, another line of petrol-pumps stands to attention in the desert, looking oddly anthropomorphic. With their hoses looped at rest, they are soldiers shouldering arms. Above them a neon sign, switched off

in the ruthless sunlight, broadcasts its urgent message to the stark, empty land: SAVE. But it is advertising economy, not salvation.

That double-take introduces a newly alienated way of looking at America. The home-grown vision of Walker Evans, in the great book of *American Photographs* which he published in 1938, trusted and relished the country's vernacular, hand-written language – the scrawl on a peeled sign saying GAS, a lunch wagon boasting GOOD FOOD. Once upon a time, words kept their promises. The food then probably was good, and the gas at least did not pretend that it could save your soul. In *The Americans*, the waitress at a diner in Hollywood stands in front of a battery of cheer-leading placards which insist that the jumbo hot dogs are BIGGER & BETTER THAN EVER!! and the beef burgers have ABSOLUTELY NO FILLERS. Her basilisk face with its pursed, painted lips defies you to believe what you read. Nor does she second the greeting of Santa Claus, who beams behind her head and wishes customers a Merry Christmas. The modern viewpoint is defined by its optical atheism. The appearance of a thing no longer constitutes its reality: the constituents of matter, after all, are invisible. And words, as Hofmannsthal's Chandos found, have no reality at all, even if printed in loud block capitals with double exclamation marks to stress their strenuous sincerity.

On the east coast, New York provided a heroic image of the modern world with its superhuman machines, its galvanic energy and its brazen atheism. Hart Crane called the Brooklyn Bridge both 'harp and altar' and thought that its cables soared upwards, tugging down to earth the 'heaven of the Jews'. Man had outdone his maker. When Radio City Music Hall at Rockefeller Center opened in 1932, someone called it the kind of place God would have built – if he'd had the money. The west coast presented a second frontier, a modernity without heroism. The desert flowered, but with the aid of costly, stolen water. People lived in their cars, which was like life on a treadmill. The most celebrated local industry manufactured lies.

Isherwood called California 'a tragic country – like Palestine, like every promised land'; tragic because its promises are always broken. This breach is implicit in the signs photographed by Frank, with their reminders that language no longer has any compact with truth. You save money by buying discounted gas, but may well lose your life in a road accident as a result. Such alienation effects are inescapable in the American West, where entire cities – by contrast with the cubical granite of New York – are made from signs: the neon mirage of Las Vegas, the procession of billboards along Sunset Strip. At the beginning of *Zabriskie Point* in 1969, Antonioni saw Los Angeles as a montage, a palimpsest of scenic flats. A bucolic mural turns out to be painted on the side of a meat-packing warehouse: the grazing cattle it displays have already been slaughtered. A billboard offers aerial escape, advertising flights back to New York. Signs silently jabber: SAFEWAY, CAR WASH, GUNS, MORTUARY, SMOG INSPECTION STATION. The city, with its junkyards, telephone poles, coagulated traffic and dusty dejected palms, consists of random visual noise. The

modern eye is prepared for such lexical snares. In *Paris, Texas*, written by Sam
Shepard and directed by Wim Wenders in 1984, Dean Stockwell plays Walt,
whose job is to make those roadside billboards which reassure drivers that their
dream lies ahead. Billboards trumpet the shame of language, its market of false-
hoods (in which Brecht, seeking work from the Hollywood studios, said he had to
sell his wares); Walt's brother Travis, played by Harry Dean Stanton, therefore
stubbornly refuses to speak, and goes off like a grizzled hermit to wander
through the desert.

In his native land, Travis experiences that dislocation which for Céline
was the stranger's lot in America. After he finally consents to utter a few words,
he says that on his wanderings he was 'lost in a deep, vast country where nobody
knew him. Somewhere without language or streets.' Foreigners felt that sense of
nullity at once, because the language, or at least the idiom, was strange to them.
Travis makes himself feel it too, by unlearning language: hence his muteness.
Streets humanize space, giving it names, making it speak. *Paris, Texas* strays
between the San Fernando Valley with its razored hills, straggling grasses and
tract homes like cardboard cartons, and the mushrooming towers of Houston,
still uninhabited; this is landscape which has nothing to say, whether streets have
been ruled across it or not. The brothers ask the name of a town they drift into
while crossing the Mojave Desert. It does not have one.

As the world grew smaller, its separate cultures hybridized. After 1945
Western Europe was enrolled in the American empire, and – as *The Good, the Bad
and the Ugly* demonstrates – it adopted American history as it own. Germany was
eager for Americanization, keen to forget its own pre-war history. Wenders, born
in Düsseldorf in 1945, grew up listening to American music and watching Ameri-
can films, the citizen (like Grosz or Hesse before him) of an imaginary country an
ocean away. In *Kings of the Road*, released in 1976, he transferred the American
genre of the road movie to Europe. But just as the Western lost its confidence on
a continent where there were no frontiers left to conquer, so the road movie, rely-
ing on limitless space, reached a dead end. The journey up and down a divided
Germany in *Kings of the Road* keeps on arriving at barbed wire and mined ditches –
a border which cannot be crossed.

A madman on a bridge above the freeway in *Paris, Texas* gives warning of
the apocalypse, and warns 'There will be no safety zone'. So much for SAFE-
WAY, the supermarket chain whose loudly capitalized sign Antonioni took note
of in *Zabriskie Point*. Wenders, fluent in English but reserving the alien's right to
misunderstand, has searched throughout the West for insignificant signs, legends
and hoardings which – exposing the false consciousness of language – signal to
him something they never intended. While location-scouting for *Paris, Texas* he
visited a small town in New Mexico, and photographed a bisected store-front
on an empty sidewalk in the grilling sun. The shop sign enigmatically says
ODS, with incised emphatic shadows under the letters. In the window below, a
few dummies model antiquated frocks, said to be for the ENTIRE FAMILY.

Wenders chose those words for the photograph's title. Is this then the entire family of the town, made of wax and lacking heads? In Houston, he photographed one of the skyscrapers erected overnight during the oil glut. Two men are stranded on an upper tier; the ground floor is empty except for some tropical plants. Outside on the street, a traffic sign barks commands at invisible cars. NO PARKING ANY TIME, it remonstrates. Some arrows point out possible turns, one of which is marked ONLY. This last word supplied Wenders with his title. Having removed it from its context and cancelled its function, he encouraged it to start singing: he called the photograph *'Only' (the lonely)*. In El Paso he discovered one of his heroes, gone to ground in the desert. Above a white box under the burning blue sky, a chef holds up a frosted birthday cake with an inlaid heart to advertise HAMMETT BAKERY. Wenders, pretending to stumble over the word, entitled the photograph *Ham...burger*. In Glendale he came upon a rundown outlet which sells BRIK-ART, an ornamental lining for fireplaces or kitchens. A sign announces in an oxidized sunburst 'It looks so real!' The photograph's title is a hollow echo, omitting the exclamation: *So real*.

That might serve as a motto for the new, demythologized West. Whereas the New York of Mondrian or Camus was proudly abstract in its cancellation of nature, this second frontier is furnished with simulacrae, replicas of things which were real in some previous life. In Las Vegas, an Egyptian pyramid, a palace vaguely belonging to Caesar and a turreted castle which might have housed King Arthur's knights grow side by side, like a colony of genetically-boosted, air-conditioned fungi. In Glendale, the Forest Lawn cemetery resurrects Leonardo's *Last Supper* in fervent stained glass. The Forest Lawn brochure takes pride in the 'safe and beautiful setting' of its mausoleum, where 'this celebrated work defies the ages' – rescued from the putrefying egg tempera of the convent refectory in Milan, and from the bombs which damaged it during World War II. In Malibu, the Getty Museum occupies a Pompeian villa which, safe and beautiful and eternally peaceful like the mortuary, apparently survived the eruption of Vesuvius. Among so many artistic replicas, it is not surprising to find replicants at large – unfeeling mimicries of human beings, like the one Harrison Ford fights off in Ridley Scott's film *Blade Runner*, set in a futuristic Los Angeles which is drawing nearer by the minute.

The intellectual fashion has moved beyond deploring the unreality of America, as Claudel did. The post-modern option is to celebrate it: 'So real.' Umberto Eco enjoys what he calls the country's hyper-reality. The surrealists subverted or undermined a world which the nineteenth century thought of as real and earnest: Dalí, venturing into the New York subway, reported that the trains ran on tracks made from the entrails of cattle, and also likened the skyline to a 'Gothic Roquefort cheese', infested by weevils. But the post-modern vision confronts reality with an exact duplicate of itself, rather than a surreal distortion.

The hyper-real is reality hyped, inflated, larger and glossier than the real thing, like the unfragrant flowers in Brecht's garden or the *Last Supper* in stained

glass, like the robotized bodies of Rutger Hauer as the replicant in *Blade Runner* or Arnold Schwarzenegger in *The Terminator*. To hype means to inject a stimulus artificially, as if with a hypodermic needle. That is the predominant activity in American commerce and its offshoot, politics. To be hyper means to possess a crazily intense form of high spirits, a happiness which verges on insanity. That is the prevailing mood of people in American television sitcoms, egged on by the taped hilarity of an invisible audience. Post-modern America has a prodigious skill at play-acting. It must live up to the expectations of the rest of the world; even more importantly, it must keep faith with its own sacred illusions. The country's official philosophy stipulates that reality is flexible. Your dream will come true if you wish hard enough. You can be whatever you want to be. The critic Jean Baudrillard – observing the pumped, buffed, waxed bodies some Americans now wear, after hours of expensive anguish at the gym – suspects them of being a new race: no longer quite human, since humanity means imperfection.

Once upon a time, the West looked surreal. Antonioni's characters druggily imagine an orgy on the sand of Death Valley in *Zabriskie Point*, with inhibitions burned away by the heat. Messiaen in *Des canyons aux étoiles*, composed between 1971 and 1974, located his own flamboyantly Catholic version of the heavenly city among the landscapes of Mormon Utah – the thrusting buttresses of Cedar Breaks, where the creator is made manifest by horn calls and clashes of cymbals; Bryce Canyon with its red and orange pillars of rock, their striations described in musical scales which climb from excitement to ecstasy; Zion Park, its cavity filled by the xylophone with choiring birds, Messiaen's feathered angels. Like Kafka (though unironically), Messiaen thought of America as an afterlife: the Utah canyons, he said, resembled 'landscapes…we'll probably see after our death, if we have the chance to visit other planets'.

The hyper-real West has no such supernatural allure. The great exhibit of the region is the Grand Canyon – as hollow as the sky, with rainbows, sunsets and other special effects painted onto its sides. From *Stagecoach* to *The Searchers*, the crags and columns of Monument Valley were emblems of heroic solitude in John Ford's Westerns. Now those spaces seem merely empty, bereft. Baudrillard defines Monument Valley as a linguistic vacuum, with its 'blocks of language suddenly rising high, then subjected to a pitiless erosion'. The post-modern cowboy is not taciturn, with the tight-lipped stoicism of Gary Cooper or John Wayne. Like Travis in *Paris, Texas*, he suffers from aphasia.

On a post-modern map, the world terminates somewhere in the vicinity of Mulholland Drive, which roams along the top of the Hollywood hills. Mulholland Drive is less a place than a time-space, which is how it appears in David Hockney's huge painting of a drive along it. Beyond it, behind the barricade of mountains, is a caustic waste of sand. The desert, as Isherwood said – remembering his journey across it by bus on the way to Los Angeles in 1939 – 'relentlessly reminds the traveller of his human condition and the circumstances of his tenure upon the earth'. Ahead lies another indistinct nowhere: the earth is

rubbed out by smog before it can reach the ocean. San Francisco has its Golden Gate, which yokes the headlands together: an arch to ritualize exit and re-entry. The Los Angeles littoral stages no such ceremony. All it can manage is the sad, unsteady Santa Monica pier, which for Baudrillard, who might be walking the plank on a pirate ship, leads straight to the unfathomable depths of language, as treacherous as a continental shelf. 'The Western World', he says, 'ends on a shoreline devoid of all signification.'

David Hockney
Mulholland
Drive: The
Road to the
Studio *(1980)*

As an elegy for California, the United States, and the European civilization which has its furthest outpost or its last stand here, that is overstated and under-observant. No, this section of the coast is crowded with significances. The sainted Monica, whoever she was, contributes a blessing. The memory at least of Laughton's missionary garden above the highway survives, as does the vision of the developer who reconstructed a would-be Venice here in 1904, with a piazza of flaky plaster and cottages not palaces democratically laid out along trickling canals. The problem is that the buildings are all sand-castles, and the writing is inscribed on water. A post-modern world must learn how to live with insignificance.

All the same, Wenders has used the topography of this last fragile frontier to rewrite the covenant – revoked by modernity – between earth and heaven, man and nature. His 1997 film *The End of Violence* takes as its twin poles the observatory which overlooks Los Angeles from Griffith Park and the dilapidated Santa Monica pier. Inside the observatory, a NASA scientist who was trained to look up from earth at the sky now reverses his viewpoint, scanning a wall of video screens on which the city is kept under surveillance from the air. Criminals can be identified and eliminated by a supervising strike force; these armed angels promise to put an end to violence (and also to our autonomy and freedom). Like Mendelsohn's Einstein Tower in Potsdam, the observatory warns of the dangers inherent in our interrogation of the universe. Once we scrutinize the sky through our telescopes, we assume the prerogatives of the gods we have unseated, and can turn vindictively against our own lowly kind.

But the Santa Monica pier, on which the film concludes, offers a final hope to the woebegone human species. The plot's survivors, seceding from the mainland, gather there for a showdown. The camera takes stock of the scattered protagonists, plus an anonymous Californian crowd of joggers, sun-worshippers, philosophers and children flying balloons. Then it lifts off, floating upwards. At first the angle is ominous, because of the earlier aerial reprisals: has the pier, with the human cargo on its creaking planks, become a target? But as the viewpoint drifts higher, bouncing on empty air, we see that there is nothing to fear. The flying camera sweeps around in an exhilarating arc, surveying the beach from Santa Monica to Venice, with Los Angeles hazily shimmering beyond. Then it banks, swivels and gazes across the peaceful Pacific, yearning – as the sun sinks, on its way to enlighten a part of the world we cannot see – for a remoter horizon. Leaning on the pier's rails, the narrator looks towards China, and hopes that someone there is looking back. Where the West runs out, in the sifting declension of those Santa Monica cliffs, the East begins.

THE END OF THE WORLD IN HIROSHIMA

The world ended at Hiroshima in the early morning of 6 August 1945. A light blotted out the sun and tore the protective membrane of the sky; through the scar, a storm of energy escaped, knocking the city to its knees and vaporizing or scorching its citizens. A hundred thousand people died. Those who survived the day waited for radiation sickness and cancer to consume their bodies. In the Peace Museum, you can see a charred wrist-watch, removed from one of the victims. The hands on its dial are arrested at 8.15 a.m. – the moment when time stopped; perhaps the beginning of another year zero, because from now on the earth was a different place.

The blast surrealized the world. Beside the T-shaped bridge which was the bomber's target a hall built for industrial exhibitions still stands. The girders which once held up its dome are a crown of thorns. A skeleton of calipers rusts among the scattered masonry. For as long as reality could be relied on, things, whether animate or not, occupied the portion of space allotted to them, obeyed the behest of gravity, retained identity and definition. In Hiroshima, the laws of physics were revoked in an instant. The city turned to a molten waste, and human bodies twisted into deformity like the melted, dented bottles picked out of the rubble. Our subjective life may be airy and unrooted, but we have always taken comfort from solid objects, like Samuel Johnson kicking a stone to refute the notion that nature is illusory. On that morning in 1945 such bluff confidence became untenable, and all the modern convulsions within consciousness – the doubts implicit in relativity theory, the experimental metamorphoses of reality, the contemplation of voids or vacuums – erupted into the world outside. Matter itself destabilized, things behaved antically. Shards of glass punctured the walls of buildings, as if brick were soft and porous like flesh. On a bridge near the spot where the bomb fell, a concrete slab heaved upwards, then crashed down into the river below without sinking: it ricocheted. The tower of a temple leaped into the air and fell back. At the same moment, a small rock – another infinitesimal particle with a life of its own – jumped onto the pediment. When the tower settled

Souvenir of a person vapourized by the bomb (1945). He was sitting on the steps of the Sumitomo Bank, waiting for the doors to open; the flash of light – 5000°C – bleached the stone, but left the darker imprint of his body

*The Industrial
Exhibition Hall
(1945), now
known as the
Atomic Dome*

back into place at the end of its brief vertical adventure, it sat askew, levered out of plumb by the rock.

It is hardly possible to walk around the site without recalling the icons of modern art and their wracked inquisition of reality: the limp, waxen watch in Dalí's *The Persistence of Memory*, warning that the motor of the universe can run down, or the light bulb like a flaring eye which hangs above the butchered town in *Guernica*. The age of light ended at Hiroshima. The atomic bomb solarized everything within range. President Truman, when he announced its detonation, said that it harnessed the elemental forces of the universe, drawing from the same source which gave the sun its power. In fact it superannuated the sun: at ignition, it was ten times brighter. The glare penetrated sealed laboratories in the city and developed the film stored there. It saw through things, transforming them into photographic negatives of themselves. Thermal rays imprinted the shadow of a circular iron ladder on the outside of a gas tank, and on Yorozuyo Bridge they scorched the asphalt, leaving bleached white lines where the ramparts blocked them. The stitching of a woman's kimono was incised across her skin like a spontaneous tattoo. The bomb took a flash photograph of a person who happened to be sitting on the steps of the Sumitomo Bank at 8.15. The body evaporated, but a circular blob of darkness clung to the stone as a memento. When the volcano erupted at Pompeii, the cooling lava calcified the citizens and turned their corpses into rough, immortal sculptures. In Hiroshima, people left only elegiac shadows behind. Afterwards a black rain fell, compounded of mud and radioactive soot.

This was the physical shock, which jolted the earth awry. A moral aftershock ensued, coinciding with the entry of Allied troops into the German concentration camps. Between them, Auschwitz and Hiroshima have been the

subjects of distraught debate ever since. The camps, cities of death, revealed what men were capable of doing to one another. The dead city provided further evidence of that, but disclosed something else as well, which may have been more catastrophic: it revealed what men were capable of doing to mankind and to the planet we live on. Which was worse, the extermination of single races or the potential to wipe out all life on earth? Probably the former, if only because the latter has not yet happened. The inquest was doubly dismaying because neither Auschwitz nor Hiroshima could be written off as aberrations or lapses. Both were, in different ways, the logical outcome of modernity and its technological victory over nature. The Nazis had their respectable cultural forefathers and learned apologists, from Nietzsche to Spengler, Heidegger and Gottfried Benn. J. Robert Oppenheimer, the physicist in charge of the laboratory at Los Alamos in the New Mexico desert where the bomb was made, had an even more venerable patron. He was often likened to Prometheus. The development of civilization, according to the myth, began when Prometheus stole fire from the Olympian gods, and used it to quicken the manikin he had sculpted from clay; that development reached its conclusion when men, assuming the privileges of divinity, bombarded their own earth with fire.

In 1944, while work on Oppenheimer's Manhattan Project proceeded, Niels Bohr arrived in Washington from Europe. He warned that the plan to release nuclear energy through a bomb constituted 'a far deeper interference with the natural course of events than anything ever before attempted'. Man, possessing what Wells in *The War of the Worlds* called 'empire over matter', no longer lived as part of nature. Abstracted from his current world, he could sentence it to death and then set off in quest of an alternative residence in the stratosphere.

An innocent equation contained the formula which made it possible to end the world. Experiments during the 1930s tested Einstein's assertion that $E = mc^2$. The Austrian physicist Otto Frisch explained 'the secret of nuclear (often called "atomic") fission'. Protons come together to form heavier nuclei, but in doing so they actually lose mass, which sets energy free. The escape is inordinate, because 'the factor c^2 (speed of light multiplied by mass) is very large'. Frisch illustrated the transaction with an image which surrealized reality: 'the mass of a paper-clip is equivalent to the entire energy a small town uses during a day'. This was one of those modern revelations which has caused the ground to shudder beneath our feet; to think about the statement induces the mental panic which Sartre called nausea. Being is volatile, wasteful. The town, populated by a consortium of airheaded molecules, exists to consume and exhale energy. The other item in Frisch's fable recognizes the terrifying, impacted density of things, a quality like the viscosity which perturbs Roquentin in Sartre's novel. That inert paper-clip on the desk, waiting to perform its slavish function, is an explosive device.

When they measured the energy of particles released from split nuclei, the experimentalists found that there was a surplus. Any one of the newly-formed

neutrons might induce another nuclear fission. 'By assembling enough pure uranium,' Frisch speculated, 'one might…liberate nuclear energy on a scale that really mattered!' The initial decision was a human responsibility, a moral act. After that, the neutrons took over. The bomb was nothing more than their chain reaction, exponentially continuing beyond human control. The enjoyment of Promethean power was brief. Almost at once human beings remembered their impotence. We are held hostage by physical forces which do not recognize our sovereign rights. The paper-clip might be a Molotov cocktail. Technology meanwhile developed in accordance with a chain reaction of its own. Any industrial production line must soon declare its own wares obsolete, so the customers will be forced to buy replacements. Nuclear fission gave way to thermonuclear fusion, which endowed the hydrogen bomb, first tested in 1952 in the Marshall Islands, with new and improved destructive powers.

The disappearance of mass liberated energy, including the energy of formerly unthinkable ideas. Once they became thinkable, those ideas needed names, which meant the coinage of new words or the revision of old ones. The term 'fission', which refers to the splitting of the atom, is one of the twentieth century's subtlest and most devious neologisms. Borrowed from biology, it referred at first to the way live cells divide in order to reproduce themselves: bacteria are fissiparous. But the split which the physicists engineered was not a contrivance of nature or a means of regeneration. Perhaps the etymology salved the conscience of science. Nevertheless, the fiction contained a truth. To set off the bomb returned the universe to the moment when it first exploded into life. At that instant, was there any difference between creation and destruction?

The 1950s enlarged our common store of bad dreams, secretly transmitted from head to head in our shared darkness. Creatures surfaced from black lagoons, or rose through the polar ice, disturbed by experimental bomb tests. They romped across the continents, wrecking the Eiffel Tower or the Empire State Building, wrapping their rubbery limbs around the Golden Gate Bridge and buckling it. Another repellent organism, with a skin of shivering tripe, staged its last stand in Westminster Abbey. Other blasts dislodged the earth's axis, and sent it spinning out of control. Mutations occurred overnight in our own species. Had your neighbour, who seemed so well-adjusted to life in the suburbs, actually been bred in a pod, with green sap in his veins? Might the head next to yours on the pillow belong to a Martian? One popular nightmare of the period imagined what it would be like to wake up as the last man on earth. You could wander through a windy, deserted Manhattan, where all the items in all the shops were yours for free. Under other circumstances, this might have been a gloating reverie of enrichment; but unlimited credit somehow did not make up for the extinction of all human life except your own.

Films functioned as a collective unconsciousness, deriving their scenarios from fears which were only too plausible. In Nicholas Ray's *Rebel Without a Cause*,

teenagers are taken from their school to Griffith Park above Los Angeles to be given a demonstration of how the world will end. A meteor approaches, the polar ice melts, the oceans boil. A lecturer authoritatively predicts that he and his young audience will be 'destroyed as we began, in a burst of gas and fire'. The existence of the bomb forced everyone to speculate about the life-span of the earth. President Kennedy encouraged the construction of fall-out shelters in public buildings, and Americans learned about the drill of civil defence. During his stand-off with Khrushchev over the Cuban missile bases in October 1962, the world waited to see whether it would be permitted to survive until the weekend.

That game of bluff was an existential trial, an exercise in living dangerously (and, had the outcome been different, in dying gracefully). It revealed how tempting the bomb was, despite its supposed value as a deterrent. During Dwight D. Eisenhower's presidency, the sedative slogan 'Atoms for Peace' was printed on uncountable numbers of postage stamps, as if relying on repetition to blunt the contradiction. Why construct the bomb, if not to use it? For scientists, it was the supreme challenge. National budgets were devoted to its manufacture, and industrial corporations invested in the prospect of war. The politicians however maintained that the whole operation was about keeping the peace. The idea of the bomb was an impossible, self-denying paradox: so much destructive force, generated in order to be kept permanently in reserve; a weapon meant to serve as a merely symbolic token.

The paradox, as the myth-makers recognized, was that of the hidden god, whose face cannot be looked at. Yet curiosity and the defiance of taboo are the motive forces of human development, the sponsors of civilization. Who, having been warned against doing something, will not instantly disobey? This is the way the bomb is imagined in Robert Aldrich's film *Kiss Me Deadly*, made in 1955 and loosely based on a novel by Mickey Spillane. Doomsday here is portable, and can be crammed into a briefcase which is left for safe-keeping in a locker at a Los Angeles gym. In Spillane's novel, the case contains dollar bills. But when the private eye Mike Hammer pries the container open in the film, he glimpses a furnace of radioactivity (which merely sears the hairs on his wrist); he snaps it shut. The film cannot end without granting us a proper look at this Promethean ferment. The case is stolen from the malevolent doctor who wants to sell its secrets by a young woman; like Eve she finds the prospect of forbidden knowledge irresistible. The doctor tries to frighten her with mythological embargoes. Barking, as he says, like the hell-hound Cerberus, he utters the doomy words 'Los Alamos' and 'Manhattan Project', and reminds her about the fate of Pandora and Lot's wife. She ignores him; she too is an intrepid experimentalist, like the physicists who first interrogated the universe. She tears the case open, shrieking in joy and then in anguish as the light flays her. The scene takes place in a cantilevered beach house somewhere between Santa Monica and Malibu – the fringe which Baudrillard later identified as the terminus of tired European civilization. The cottage rocks on its stilts and flies apart, breathing a fireball into the night sky.

Antonioni's *Zabriskie Point* concludes in the desert where Oppenheimer's team made the atomic bomb. The cops have killed the hero, to punish him for his joy-ride in a psychedelic plane; the heroine takes her imaginary revenge on the house of a real-estate developer, a token villain who represents the conspiracy of capital against rebellious youth. She stares at the house, and as she does so it blows up. This is the apocalypse of commodities: an atomic diaspora of wire, cloth, shredded paper, and glass shrapnel from television tubes. Freezers erupt, regurgitating the food in them. Prominent among the fall-out is a loaf of Wonder Bread, the ultimate symbol of suburban anaemia and of technological interference with nature, since it looks and tastes like toilet-tissue. All these consumer items dance in the air to the metallized fury of Pink Floyd. The young woman here does not need to open any prohibited box, or even to secrete dynamite in the cliff. The explosion happens gratuitously, set off by telepathy. The bomb is an idea, and to think of it is tantamount to pressing a trigger (which is why the pious vows of politicians never to use it seemed so hypocritical).

The more occult and occluded the idea became, as the missiles accumulated in their silos like a crop of grain, the more attractive it grew to be. It was hardly feasible to invite press coverage when the first bombs were dropped on Hiroshima and Nagasaki, so in 1946 the United States provided an overdue photo-opportunity by exploding a spare at Bikini atoll. Since eroticism is a field of force, a discharge of energy, the bomb became sexy by association: the first two-piece bathing costume for women made its appearance later that year, and co-opted the name of the test site when the model who wore it claimed that her navel would set off as many shock waves as the atomic blast. In the slang of the 1950s a desirable woman was a bombshell (preferably blonde). The bomb's combustible secret, slumbering under cover, acquired an extra allure, officially off-limits but frequently visited in fantasy. All this followed logically from the appropriation of the biological term fission, yoking together creativity and death. Allen Ginsberg turned the metallic phallus on its owner, and told America 'Go fuck yourself with your atomic bomb', while William S. Burroughs gleefully fantasized about a prim, white-uniformed nurse arriving in J. Edgar Hoover's office at the FBI to administer high colonic irrigation: she then inserted a time bomb in his fundament.

The culture of the 1960s extolled an infectious, electrified energy. Art was rescued from its inertia: when Robert Rauschenberg exhibited a series of plain white canvases, John Cage called them 'airports', which in those blither days was the most lyrical of compliments. The unpainted rectangles, in Cage's view, were places of transit for 'lights, shadows and particles'. The bomb, lurking just beyond the edge of apprehension, could also be admired for its avant-garde conceptual engineering. In 1967 the critic Harold Rosenberg called it a masterpiece of kinetic sculpture. There was a proviso, not unacceptable to a public which had sat through the four minutes and thirty-three seconds of silence composed for the piano by Cage and given its first non-performance in 1952. The bomb, as

Rosenberg cautioned, could 'never be exhibited in its working state', and had to remain 'invisible, a presence of pure energy that cannot be endured'. Is that not the definition of divinity, from which men must avert their eyes? In Ted Post's film *Beyond the Planet of the Apes*, children in an apocalyptic future worship a nuclear missile. They adapt a nursery rhyme for the purpose, finding substitutes for roses and posies:

> Ring-a ring o' neutrons,
> A pocketful full of positrons,
> A fission! A fission!
> We all fall down.

Although the god must remain in hiding, obscuring the ultimate mystery, there were rehearsals of that angry force. In 1960 a so-called 'meta-matic' contraption, soldered together from junked technology gathered on rubbish-dumps,

A preliminary sketch (1960) by Jean Tinguely for Homage to New York

destroyed itself in the garden of the Museum of Modern Art. Jean Tinguely called it his *Homage to New York*: a kinetic sculpture modelled on the frenzied kinesis of the city, where everyone in the streets is a bomb waiting to go off. He assembled it in a geodesic dome on the premises, left behind by Buckminster Fuller. Inside this lightweight hemisphere of polygons, Tinguely plotted planetary sabotage. His ingredients included a child's pram and chamber pot, as if the intention had been to retraverse the history of human development. An Addressograph machine amused itself by making a noise, since there was no more addressing to do now that the world had ended; its artificial hands banged on cans and rang a bell. A weather balloon ponderously inflated, sampling the poisoned air, while a money-thrower contributed by Rauschenberg hurled silver dollars to the winds: at Doomsday, currency reverts to valueless tin. The whole apparatus puffed out acrid smoke and gave off a satisfying stench.

On the night, everything went wrong – but who dares to script the apocalypse? A roll of paper fed through back to front; the fire extinguishers did not work on cue, which permitted an alarming blaze; the pram detached itself and ran away of its own accord. Tinguely was undismayed by these mishaps, and took pride in his work's self-immolation. Art traditionally craved permanence, and conferred immortality on its maker. The rules changed when the universe itself become mortal, and the earth seemed to be in terminal danger. The suicide

of the meta-matic, which fizzled into a heap of scrap, seemed to Tinguely's technical assistant Billy Klüver a case of 'good machine behaviour'. Machines are conduits for an energy which is greater than they are; their destiny, like that of bombs, is to explode. In 1965 New York itself blew a fuse when a power blackout threw the city into darkness. It turned out to be a happy apocalypse, an orgiastic Armageddon. 'It was', joked Warhol, 'the biggest, most Pop happening of the sixties.'

Once the unthinkable became thinkable, the next step was to make it laughable. The laughter was desperate, but also giddily carefree. The bomb, invented by man to bring about his own annihilation, was patently absurd, against reason. It had indeed, as Bohr advised, changed the natural order of events, and its existence insidiously mocked all previous sanctities. Joseph Heller's novel *Catch-22*, published in 1961, projected this contemporary awareness backwards in time to a hilariously demoralized corps of American bomber pilots stationed in Italy at the end of the war against Hitler. God, no longer hidden, is derelict of duty: the squadron commander, a Major with the supernumerary surname of Major, is only in when he is out. A black marketeer among the American officers sentences his own men to death by trading their parachutes in Alexandria, where he has got a good deal on silk. Heller's hero Yossarian, ordered to raid the city of Ferrara, disregards the order and jettisons his bombs in the sea. He is nevertheless awarded a medal for killing fish. It cannot be pinned on him, because – refusing to wear his uniform in protest at official insanity – he is naked. The nonsensicality of the episode does not impugn its realism. In Vietnam, Marines with less cultural conscience than Yossarian and more concern for cost-efficiency often went fishing with dynamite rather than the old, outmoded, time-wasting rod and line.

During the 1960s the end was so physically immediate, so readily imaginable, that New Yorkers knew exactly where to locate ground zero: Russia had aimed its missiles at the intersection of Canal Street and Broadway, on the periphery of Chinatown. Claes Oldenburg suggested that a communal tombstone should be prematurely erected at the spot. He proposed a concrete slab, so heavy that it would decline through the asphalt like a pat of butter melting over a baked potato: a monumental piece of comfort food, softening the tragedy for popular consumption. James Rosenquist, who served his apprenticeship as a

James Rosenquist
F-111
(1964–5)

painter by working on commercial billboards, remembered discussing the down-town target with some fellow workers on a hoarding above Times Square. They congratulated themselves on their immunity, a mile north of the target. 'The old timers would say, "Well, I'm not worried. At least we'll have a nice view right up here against the wall."'

In 1964–5 Rosenquist painted a billboard jocularly advertising the bomb, a sectional mural which runs for eighty-six feet around all four walls of a gallery. It is called *F-111*, after the fighter plane then being used to blitz Vietnam; the spindle of gun-metal streaks across the canvas, exiting in a burst of fire. On this metal projectile Rosenquist superimposed a slide-show of images referring to the affluent America whose way of life was allegedly at risk in Vietnam – hurdles for athletes, goads to competitiveness; a little girl, far too young to be a customer at the beauty shop, who cutely preens under a hair-dryer; a slice of synthetic, un-nutritious cake, and a can of spaghetti swarming like worms. The Vietnam war had no discernible military objective, which is what made it so lethally foolish. President Johnson, however, insisted that the Asian hordes had to be kept at bay because they wanted what Americans had – for instance, hair-dryers and canned spaghetti. It was a war devoted to the propagation of imagery. Mary McCarthy, visiting Vietnam in 1967, watched the world being Americanized by force. She described Saigon as a stewing Los Angeles, and noted the 'indestructible mass-production garbage' bequeathed by the invaders. Shanties near American bases qualified as 'a form of Pop Art', having been assembled from discarded cans: the outside walls displayed the flattened insignia of Coca-Cola or Campbell's soup. The troops, generating tumuli of rubbish, left behind what McCarthy called 'the faecal matter of our civilization'. Making its own donation, the undercarriage of Rosenquist's F-111 is about to excrete a scarlet missile.

Rosenberg described the bomb as a secret and sacrosanct masterpiece, kept under wraps. Rosenquist's point, as his painting extended across the Ameri-can horizon, was the opposite: the bomb is everywhere visible. We do not notice it because we are looking at its by-products all the time. Rather than being reserved for the *cognoscenti*, those fearless questioners who dare to open the box, it has become a victim of its own popularity, rendered banal – like the imagery of Pop Art – by overexposure. The bomb for Rosenquist was not the inspiration of a Promethean or Faustian genius. His painting sees it as the collaborative feat

of a mass society, like the supermarket's processed food. His commentary on *F-111* emphasized that a bomb is manufactured by 'masses of people', marshalled by corporations which operate by 'massing them', urged on by 'the heavy ideas of mass media'. People do the work because they have cars to run (among the impasto of images on the plane's wing is the tread of a winterized tyre, the rubber trenched and furrowed) and little girls who need cake and permanent waves; everyone subsidizes it through their taxes, so it is a consumer durable owned by all. Governments indulge us by declaring wars. How else would we be able to play with our shared toys?

For Rosenquist, the act of painting was like piloting the plane itself. He explained the convergence of images whose common denominator is the weapon – or the militarized economy which makes it – by describing the trajectory of an aircraft coming in to land. Before you reach the airport, lateral straying from your flight path is allowed: hence the apparently irrelevant glimpses of suburbia. The closer you get, the more precisely aligned you need to be. Yes, the cake after all does have a connection with the F-111: the little conquistadorial flags planted in its icing, as if left behind on the surface of the moon, stand for 'protein and iron and riboflavin – food energy'. A cake is a capsule of energy, a bomb which explodes to life inside you; and the hole gouged in its soggy centre, recalling the mould it was baked in, looked to Rosenquist like 'some kind of huge abyss', a site for underground experiments. Understanding *F-111* entails lining up these distracted objects until, like ammunition, they all fire at the same point. When the great engine hovers above the landing strip, the pilot must be exactly on track.

Near the end of the painted narrative, an atomic bomb goes off, with a beach umbrella as an ineffectual shield against fallout. On one side of the explosion is the hair-dryer, which might be a steel nose-cone, ineffectually armouring the little girl's head. On the other side is a deep-sea diver, around whose helmet air-bubbles boil into a mushroom cloud. He disappears behind the froth; it is as if his head had blown up, unable to contain the destructive idea which the human brain has concocted. The composition ends in the lake of spaghetti: the maggoty mess of a solarized world?

Burroughs suggested that there was a 'difference between the air before August 6, 1945, and after that date'. The difference was 'a certain security', the currently untenable assumption that 'no one is going to explode the atoms you are made of'. Marguerite Duras' script for the film *Hiroshima mon amour*, directed by Alain Resnais in 1959, begins with recollected glimpses of the bomb and its billowing cloud, superimposed on the straining bodies of a French woman and a Japanese man. The shots of Bikini atoll were cut from the finished film, but Duras expected them to be subliminally present, like repressed memories, and she specified that the sweat on the shoulders of the couple should seem to be dewy atomic fallout. Death is the subtext of love, and the insecurity bequeathed by the bomb comes between the man and the woman. Perhaps it is the reason for

their approximation: they are voluntarily exploding the atoms they are made of, unravelling their lives in the course of a chance sexual encounter. Such psychological trials rehearse themselves compulsively in the imagination of people living in a nuclear age. The heroine of Sylvia Plath's novel *The Bell Jar*, published in 1962, wonders 'what it would be like, being burned alive all along your nerves'. She is referring to the anguish of Julius and Ethel Rosenberg, executed in the electric chair for passing information to the Soviet Union; she might just as well have been empathizing with the incinerated citizens of Hiroshima.

Rosenquist confirmed that, after the bomb, nature was different. Technology, as well as speeding up the accomplishment of physical tasks, had produced an 'extreme acceleration of feelings'. History now moved too fast, abbreviating or eliminating the time needed to make decisions and ponder consequences. He compared this to the pace of traffic. In the nineteenth century, someone watching life pass by on horseback along Sixth Avenue would see 'a pulsing, muscular motion', as rhythmically regular and steady as music. Now all you are aware of is 'just a glimmer, a flash of static movement'. The cars, like the F-111 with its flaming exhaust, have shot past before you can properly register them. The sedentary brain cannot match such speed. Even physical sensations had been altered by the new state of things. In the first panels of *F-111* the plane's cockpit is overlaid with a pattern like a chain-link fence. The allusion is to wallpaper. The atmosphere, as Rosenquist intuited, had become opaque, suffocating, toxic: 'you walk outside of your apartment into what used to be open air and all of a sudden feel that it has become solid with radioactivity and other undesirable elements.' The physicists needed heavy water – weighted with extra hydrogen isotopes – to operate the nuclear reactors which processed uranium for the bomb. Why shouldn't the air be heavy too, hurtful to breathe? Oxygen in *F-111* looks like barbed wire, and the minty, bristling lawn behind the hair-dryer is surely Astroturf.

The hero of our century's adolescence makes a belated, elegiac appearance in Rosenquist's guide to the painting. He addressed it, he said, to 'the new man, the new person', who is baffled by 'the change of nature in relation to the new look of the landscape' and estranged from an older morality by corporate ethics – a distorted survivor in a world which apparently has no further use for nature or for humanity. Yet *F-111*, as chirpy as its Day-Glo colours, refuses to mourn. It is after all an idyll, surveying a peaceable kingdom of cake and cosmetics where bombs (dropped to preserve that soothing peace) are luxurious accessories like cars and hair-dryers. In 1941 Margaret Bourke-White, on assignment for *Life*, kept a vigil during the German bombardment of Moscow. She thrilled to the 'unearthly beauty' of the nocturnal air raids, 'a man-made spectacle' which equalled nature's stormy exhibitions of force. Armed with 'enormous brushes dipped in radium paint', the Luftwaffe and the Russian anti-aircraft gunners executed 'abstract designs with the sky as their vast canvas'. This boldly gestural art equated paint with light and both with death. To watch a battle as a performance, to praise violence for its flair, was a uniquely modern way of seeing

things, the result of a fellow-feeling with technology. Bourke-White had thought herself out of the human being's threatened, cowering skin and adopted the machine's point of view. Rosenquist – more aware of his transgression or treason, yet determined to be honest – regards the explosion in *F-111* with the same aesthetic partiality. He painted it in bright red and yellow and wanted it to look beautiful, 'something like a cherry blossom'.

But the image can only do its palliative work if you refuse to think too deeply about it. Christa Wolf's novel *Störfall: Nachrichten eines Tages*, which takes place in April 1986 soon after the nuclear reactor caught fire at Chernobyl, begins by noticing that on the day in question, the cherry trees in her garden in East Germany were in blossom. The sight frightens her, rather than giving her joy: the flowers seen to have exploded, as if impelled by the same combustible urge that caused the disaster in Russia. The narrator of *Accident: The News of a Day* learns later in the year that the fruit is contaminated. For similar reasons, she looks askance at mushrooms. Whether edible or not, they tactlessly allude to the cloud named after them.

Pop Art cultivated a bright, brash superficiality, ignoring such mementoes of death. That, as the subtitle of Kubrick's *Dr Strangelove* counselled in 1963, was one way you could stop worrying and learn to love the bomb. Christa Wolf's novel concludes by testifying to the pain with which we contemplate our exit from the earth; the frightening thing about Kubrick's film is that it does indeed pacify our fears by regarding the planet as if – like one of Walter Benjamin's Olympians, looking down on the farcical agitations of men – we were not residents with a life interest in it. The pilotless fighter planes with which *Dr Strangelove* begins have already expatriated themselves: they belong to Strategic Air Command, which keeps them permanently in flight, always prepared for combat. They conduct all their vital functions in mid-air, and during the film's credits they refuel in flight, perhaps copulating at the same time when their cables embrace. The machines have their own timetable for the end of the world, and once the war game begins it must be played through to its conclusion. Human beings are spectators, and of course victims; no initiative of theirs can alter the outcome. This induces a chilled calm. Kubrick's actors are specimens of the new, post-human man – anonymous spare parts in the machine. James Earl Jones serenely decodes his orders in the bomber, indifferent to the approach of death. Even when maniacal, like Sterling Hayden as the general who instigates Doomsday, the characters in the film are self-containedly so. Their degree-zero insentience is matched by the tracts of frozen Russia which the bomber crosses on its way to the target. Rosenquist's glossy, acidly brilliant paint allows the explosion to be radiant, as florid as blossom; Kubrick, filming in black and white, keeps the tonal range subdued, bleeding colour from his mortified world, making all its surfaces look glacial or metallic.

When the end comes in *Dr Strangelove*, it is multiplied for safety's sake, just in case one Doomsday device had not managed to sanitize the planet. In a world

where there is no one left alive to watch his film, Kubrick permits the primal scene, the sight forbidden to humanity on pain of death – a flash, soundlessly followed by that thick, fuming pillar of air – to repeat itself indefinitely. Shock causes a stunned paralysis of feeling. Repetition, the mechanistic procedure favoured by Pop Art during the 1960s, achieved the same anaesthetizing result. Warhol in 1963 nonchalantly explained his crashed planes and wrecked cars by saying 'when you see a gruesome picture over and over again, it doesn't really have any effect'. A coolly affectless lack of effect, an almost other-worldly apathy – this was how he wanted his pictures of carnage to be received (or not received, since the spectator's blasé eye should not blink). The Vietnam war introduced bombs, defoliated landscapes, self-immolated monks and piles of tagged corpses into American homes each evening on the television news. After a while, the viewers switched off. How could the human race respond to the prospect of extermination? Maybe the idea, stupefying us, precluded any response at all. In that case the appropriate stance, which Freud would have called an abreaction, was that so creepily cultivated by Warhol with his silver wig, his grey face and his uninflected voice: numbness.

The same malady overtakes the GI Slopthrop in Thomas Pynchon's 1973 novel *Gravity's Rainbow*, an exploration – as ambitious and intelligent as Proust's *Recherche* or Mann's *Magic Mountain* – of the changed way men live in a universe which has incubated the means of its own destruction. Slopthrop, known as Rocketman, has an eerie affinity with the V-2 bombs rained on London by the Luftwaffe. They land in areas of the city where he has previously had sex, and he is therefore sent off to discover their secret, which involves a scrutiny of his own internal workings. On his quest he feels himself undergoing the mechanical plight of disassembly, and begins to suffer from 'numbness'. The contagious ailment of the early twentieth century was the very opposite: a jangled mysticism of the nerves, as Hermann Bahr described it; the vital ferment of Adolf Loos's 'Nervenleben', supplemented by Josef Breuer's jolts of psychic electricity. The post-modern demeanour, by contrast, has an almost post-mortem passivity. Warhol, gunned down by an angry feminist in 1968, died briefly on the operating table. He recuperated, but afterwards insisted on behaving like one of the undead, a famished noctambulant vampire. Might mankind too, as *Dr Strangelove* suspects, be already extinct? A ship in *Gravity's Rainbow* is named after Anubis, the Egyptian god of what Pynchon calls 'the Deathkingdom', and one of Slopthrop's ancestors has written a treatise on unsaved, unremembered souls, known as 'the preterite': people whom life has passed by or who have passed out of it, Eliot's hollow men. In 1987 Burroughs likened his novel *The Western Lands* to those funerary papyri which make up the Egyptian Book of the Dead; the narrative begins with Oppenheimer contentedly contemplating a film of Hiroshima in ruins.

This shared death sentence accounts for the spectral atmosphere of Antonioni's *Blow-Up*, made in 1966. Despite its jaunty hedonism, London in the film

is a city of the dead. A troupe of mimes, their faces painted funereally white, imitate life rather than living it. The emaciated Mod mannequins photographed by David Hemmings look like effigies. Dejected down-and-outs, men whose existence is preterite, hobble from a shelter into a squally, unhopeful dawn. In an antique shop, a grizzled man mounts guard over the damaged, dishonoured idols of the past. As Hemmings drives through Westminster, he casually passes an explanation for this terminal mood: a band of demonstrators against American nuclear bases crosses the road, carrying scribbled sketches of the mushroom cloud, or placards which silently chant NO NO NO. One woman, breaking ranks, leaves her sign in the back of his open car. It tells the occupying Americans to GO AWAY, but promptly goes away itself, flapping off in the wind when Hemmings speeds up. The title of the film initially refers to the photographic blow-up which suggests that Hemmings has unknowingly witnessed a murder; but that usage is a metaphor, derived from the explosion which the peace marchers want to prevent. There is an analogy between the two activities. In the darkroom, Hemmings inspects the granules of matter, enlarging those grey particles until he discovers – or possibly invents – a crime; in their laboratories, the nuclear physicists unearthed the apocalypse within a single, invisible atom.

Gravity's Rainbow speculates about the cosmological upsets provoked by this murderous technology. It begins with a V-2 screaming across the sky above London, a savage advent which recalls the appearance of that new, ministering star in year zero of the Christian era; it ends with a rocket launch, its countdown recalling the first catastrophic moment of biblical creation, when 'God sent out a pulse of energy into the void'. In a combustible world, man feels himself to be precarious, alive on sufferance, liable to be snuffed out by an uncreating 'Word spoken with no warning into your ear, and then silence forever'. When the bumbling doodle-bugs arrived above London, buzzing like outboard motors, potential victims had time to speculate about their statistical chances of survival. So long as the chugging remained audible, you were safe; if the motor switched off, the buzz-bomb was falling on you. But the V-2s travelled faster than the speed of sound, which disrupted the orderly sequence of cause and effect: they could kill you before you realized what had happened. Slopthrop, terrified by this demonstration of contingency, recognizes that a human being is merely a projectile dispatched on a short voyage through space, at the mercy of specks of dust or electrical shocks which can cause the mechanism to fall apart.

This is the gospel of the rockets: they point to life's proper destination, which is a return to dead matter. As fire-breathing machines, they specialize in 'the impersonation of life', and show that 'The real movement is not from death to any rebirth. It is from death to death-transfigured'. These words are uttered in *Gravity's Rainbow* by Walther Rathenau, who actually advised the German war ministry in 1914–15, oversaw post-war reconstruction in 1921, and in 1922 was assassinated by fanatical nationalists. Pynchon brings him back in a seance, when he indiscreetly betrays his foreknowledge of 'the new cosmic bombs' and

The damaged reactor at Chernobyl (1986)

describes the industrial city as a necropolis, moribund despite its busy productivity, the capital of 'Death the impersonator'.

Here, in a newly paranoid form, is one of the twentieth century's most terrifying imaginative scenarios. We treat our machines as drudges. Could they, like the homicidal computer in *2001*, be meditating revenge? In the film version of Nevil Shute's novel *On the Beach*, released in 1959, the crew of an American nuclear submarine awaiting the end of the world in Australia sail back to the United States, where the entire population has already succumbed to radiation. They are puzzled by an insistent transmission in Morse code, sent out from somewhere near San Diego. That meaningless, insistent signal, tapping at random and sometimes forming words by default, is their only hope: might there be a survivor, perhaps unskilled in telegraphy? They eventually track down the source. It comes from an office at a power-station, whose generators were not shut down by the last man alive. The telegraph key is being rattled by a Coca-Cola bottle, held in the grip of a window blind and agitated without purpose when the wind blows. Shaw's prediction needs amending. In the future there may be no more people, but Coke bottles are indestructible. Machines, needing exercise, will happily make do with inanimate playmates.

As their liberation continues, the machines no longer rely on war as a pretext. The reactor at Chernobyl decided, against all the odds, to catch fire. Sooner or later meltdown – avoided at Three Mile Island in Pennsylvania in 1979, and also at Chernobyl – may occur somewhere else, and the chain reaction will be able to proceed unimpeded, burrowing through the core of the earth and emerging on the other side. What we call an accident might be a rebellion. The plane-crashes which are never explained look increasingly like spasms of mechanical hysteria, pummelling human bodies with unbearable g forces until their spines snap, shredding them and riotously hurling their possessions through the air.

In *The Western Lands* Burroughs alarmingly proposed that 'the ultrasecret and supersensitive function of the atom bomb' was to slaughter souls – meaning (presumably) to nullify the very idea of life. 'If human and animal souls are seen as electromagnetic force fields, such fields could be totally disrupted by a nuclear explosion.' Some souls inconveniently survived the blast in 1945; hence the need for the hydrogen bomb, 'a Super Soul-Killer' which promised 'what the Egyptians called the Second and Final Death'. The experiment completes that usurpation of nature which began with the industrial revolution, when 'a standardized human product overthrows himself and replaces his own kind with machines (they are so much more efficient)'. Burroughs acknowledged this doom as a personal inheritance: his grandfather invented the adding machine, the earliest computer – a brain smarter and quicker than the human brain which made it. The industrial economy devised a disease in its own image, and sent it out into the world to speed up the elimination of the human species. Cancer with its 'explosive replication of cells' manufactures 'identical replicas on an assembly line', like the 'auto parts, tin cans, bottles and printed words' automatically multiplied by Pop Art; it sets up its own chain reaction, as unstoppable as 'an atom bomb that has already been detonated'. While waiting for the fall-out to reach her, the woman in Christa Wolf's *Accident* also waits for news from the hospital where brain surgeons are operating on her brother. She, like Burroughs, cannot help thinking of cancer as a conspiracy of the *Zeitgeist* against the human spirit: all those billions of dull, sated cells, stupefied by affluence, amuse themselves – since they must have an occupation – by constructing tumours.

Burroughs visited blame for the calamity on Einstein, who 'wrote matter into energy' and calculated that light travels at 186,000 miles a second. This, according to the calculations of Burroughs, must mean that light is leaving the planet at that rate, running out, leaking away. Again there is a conspiratorial link between the bomb, which outshone the sun, and the theft of light by photographers like Hemmings in *Blow-Up*, who trap it in a dark box. The eruptive briefcase in *Kiss Me Deadly* might be a camera: the association is possible because, as Burroughs reasons, photography has monopolized and hoarded light, robbed us of a natural resource. 'A photo has no light of its own, but it takes light to be seen. Every time anyone takes a picture, there is that much less light in circulation.' To take a photograph is to steal a soul; the camera therefore joins in the deadly work of the bomb. Burroughs accused film of leeching vitality from the world, vampirishly feeding on bodies and imbibing their dreams: 'Hollywood has filmed the species right down to the bone. There is not a dream of man that Hollywood hasn't cooked down to a hideous travesty.'

These are fanciful superstitions; but when the human mind must suddenly reckon with new realities, fiction has its uses. The most disconcerting image of the century was that man-made sun above Hiroshima. How can we come to terms with it, except by telling stories? The futurists saw the snapped filaments of a burned-out electric lamp as a symbol of modernity, tragically excitable and

overheated; in *Gravity's Rainbow,* Pynchon recites a fable about Byron the immortal light bulb, who defied statistics by not expiring when he was supposed to, and received a threatening visit from the police who investigate Incandescent Anomalies. Byron had incendiary intentions, and planned to recruit all the world's other menial light bulbs for an uprising against their human owners. Beneath the bomber's wing in *F-111* nestle three candy-coloured light bulbs. One of them has cracked, shattering like a vitreous eggshell and allowing light or life to drain from it. The bulbs, as decorative as Easter eggs, disarmingly anticipate the vanishing point towards which the plane and all the trophies in orbit around it are heading: 'some blinding light,' as Rosenquist put it, 'like a bug hitting a light bulb'.

What will happen when the end comes, if it does? Art can only tell us what it might be like – which counts as information, and therefore as assurance. It might, for instance, be like crashing through the membrane of a movie screen, tearing a way into the silvery, metallic source of light – Pynchon's 'Deathkingdom' – on the other side. At the end of the world, Pynchon invites the spectators, dazzled by the light show which has split the sky, to join him in admitting that we've 'always been at the movies (haven't we?)'. Life already looks like a speeded-up cinematic simulation of itself: it is logical to envisage the afterlife of the race as a moving picture, populated by animated spectres. Describing the rocket tests filmed by the Nazis, Pynchon comments on the German attraction to 'the rapid flashing of successive stills to counterfeit movement'. The rocket showed how this technique could be 'extended past images on film, to human lives': it kills by violent dislocation, jolting and jerking bodies through space as if they were mechanically accelerated images in a film. The Nazi scientist Pökler in *Gravity's Rainbow* is infatuated by Rudolf Klein-Rogge, the actor who in three of Fritz Lang's films played the composite villains of modern times: Attila, the primitive marauder in *Kriemhilds Rache*; Mabuse, who does Attila's work of vandalism more deftly, destabilizing middle-class society by inciting financial panic; and Rothwang, the inventor in *Metropolis*, who has begun to construct automata for the post-human future. Klein-Rogge's roles are linked by their deathliness. The characters all wish to 'move beyond life, toward the inorganic' – which is also the destination of film, and of the V-2s. The actor himself, with his stiff limbs and staring eyes, has apparently renounced organic life, and resembles an unhinged robot. Listing the seven Egyptian souls, Burroughs calls the first of them 'my Director', an invisible but all-powerful *auteur* who 'directs the film of your life from conception to death'. Film unwinds at a predetermined speed, programmed in advance like an explosive. But despite this irrevocable count-down, it also offers hope. It can be played backwards, and the spectacle of divers jumping out of the water (as they do in Riefenstahl's *Olympiad*) or of mushroom clouds quietly subsiding, compressing themselves and burying their fulmination underground, suggests another mind-bending interference with the natural course of events. 'Nothing can really stop the Abreaction of the Lord of the

Night,' Pynchon comments, 'unless the Blitz stops, rockets dismantle, the entire film runs backward: faired skin back to sheet steel back to pigs to white incandescence to ore, to Earth.' Perhaps the universe is happening back-to-front, reverting to its point of origin. If so, there is a chance of escape from the random madness of war, when a meteor can plunge down on you at any moment.

Slopthrop, however, suffers the fate of an obsolete, rusty machine. He is 'broken down', the parts of him 'scattered'. Burroughs predicted that the same would happen to us all. 'The human mould is broken', he declared; our species, outsmarted by its own technology, is 'caught in a biologic dead end and inexorably headed for extinction.' He detected everywhere – in the regimented niceness of the suburbs, and in the buttoned-down discipline of corporate employees – signs which pointed to the death of the quirky, spontaneous individual. For Burroughs, people so grimly compliant were in effect dead, 'telepathy-controlled zombies'. He believed that the Pentagon had synthesized chemicals to induce obedience, including 'an anti-dream drug that will excise the myth- and art-creating faculties'. Yet his own vivid fantasias testify that these sedatives have so far not worked.

Despite the ghoulish glee with which Burroughs pronounced our death sentence, Pynchon's novel reprieves the world by recalling a moment of creative rapture: an artificial genesis, the result of a poetic reverie. Between 1854 and 1862 the chemist August Kekulé (another character, like Rathenau, borrowed from history by Pynchon) had a vision first of linking up long chains of carbon atoms into polymers, and then of designing benzene rings which resembled 'the Great Serpent holding its own tail in its mouth' – except that the serpent, the emblem of chemistry, traditionally stood for the closure and autonomy of the physical world, whereas Kekulé had found a way to break into that cycle and fancifully reconstruct it. His conjectures led to the creation of the dye industry and were to contribute indirectly to the technology of the bomb. But they were prompted by dreams, which might have made him – if he had taken a different path – an artist. The activity of polymerizing freed chemistry from its subservience to nature. It also showed how an artist could choose to outdo reality. Pynchon calls Kekulé's research the 'last permutation of useful magic,…still finding new molecular pieces, combining and recombining them into new synthetics'. Plastic is one name for the substance which eventually resulted; another is mythology – a fiction which defies, transcends and yet reveals the structure of reality.

Christa Wolf's narrator in *Accident* condemns the dispassionate, obsessive brains which have concocted the idea of nuclear power. Then she has to admit that the same science has made possible the medical technology which saves her brother's brain. Our defences lie there, in the cerebral cortex exposed by the surgeons. Anxiously accompanying the operation in her own mind, she pictures the frontal lobes where our centres of association and the very faculty of consciousness are lodged.

Our associative powers help us to restore balance and integrity to the world, obliging the anomalies and unthinkable ideas of science to take account of nature and imperilled humanity, which they have overlooked. Making metaphors, such as those which liken the bomb to a mushroom or a cherry tree in bloom, is an example of what Pynchon calls plasticity. That is why artists have been so determined to imagine what we will, if we are fortunate, never have to see. To bear witness is a small victory; to insist on responding salvages the notion of responsibility. The second half of the twentieth century, managing to recover from the moral shocks of Hiroshima and Auschwitz, has shown how redoubtable we are, as hardy as the reborn plants in the spring garden of *Accident*. A character in *Gravity's Rainbow* looks up into the darkness above wrecked Berlin after 1945. No stars are visible. But in their absence, the sky can be rearranged. 'It is possible', Pynchon comments with indefatigable bravado, 'to make your own constellations.'

AMERICAN INFINITIES

Until 1941, America managed to resist the destructive dialectic of European history. Gertrude Stein, looking back across the ocean from her home in France, suggested in 1940 that 'Americans think the world is flat because of their continent'. Once America intervened in the war, first in the Pacific after the Japanese attack on Pearl Harbor and later in Europe, a return to unspoiled isolation was impossible. The anxious peace of 1945 left the United States as the custodian of a divided continent. After a new war in Korea, the self-sufficient republic became an imperial potentate, heavy-handedly extending its protection to countries menaced by the rival empires of Russia or China. For almost three decades, until the flustered retreat from Vietnam, this was the contentious moral drama which preoccupied the world. Had America betrayed its founding principles when it set up as a global policeman? At home, was the society quietly experiencing the same collapse into authoritarianism which had wrecked Europe? The American theologian Reinhold Niebuhr wondered in 1943 'how history is to overcome the tragic consequences of its false eternals'. God had long since been routed, and no value dared to proclaim itself true and eternal.

The fall into history, with its tragic choices between freedom and political engagement, was abrupt and bewildering. America had been unmarked – at least according to its national myth – by the inbred antagonisms of Europe. Stieglitz thought of the country as pristine, like the world at creation. In 1923 he took a photograph which he called *Spiritual America*: it showed a detail of a white horse's flank, braced by the harness which connects it to a plough. The task of cultivation, discerning and honouring the spirit in nature, could begin all over again on this fresh terrain. Stieglitz called the gallery high above Madison Avenue which he directed between 1929 and 1946 An American Place and considered it, like its namesake, to be a sanctuary or a sanctum. After he had taken down a show, he surveyed the clean, well-lighted place, and saw in those empty walls an image preferable to any which paintings or photographs could superimpose on them. This was what infinitude looked like to Americans: the board

Dennis Hopper as Billy the Kid and Peter Fonda as Captain America in Easy Rider *1969)*

fence thirty yards long and nine feet high which has to be whitewashed at the beginning of Mark Twain's *Tom Sawyer*, or the dazing, blinding immensity of the white whale in Melville's *Moby Dick*.

After a blizzard in 1923 Stieglitz wrote to Sherwood Anderson from his country home at Lake George about this limitless and bleachedly, blessedly abstract America, calling it 'White – White – White – so clean'. He did not mind when people gave up visiting his Manhattan eyrie. 'The Place never had a *cleaner* feeling', he said in 1942. 'A deep religious feeling one might say.' Georgia O'Keeffe, discovered by Stieglitz, also expounded what Edmund Wilson in 1920 called America's 'white consciousness', painting lilies with bristling sex organs, the sun-baked cubes of the Ranchos Church in Taos, New Mexico, or depicting bones bleached and purified in the desert. Dissidents of course could claim in retaliation that America was a whited sepulchre, and the country's cult of whiteness looks different to the black agitator

Georgia O'Keeffe
Ranchos
Church No. I
(1929)

in Ralph Ellison's novel *Invisible Man*. Sent to work in a paint factory, he is given a lecture on the virtues of Optic White, specially developed for coating national monuments. His boss suggests an experiment to demonstrate the paint's purity: if you applied it to a chunk of coal, 'you'd have to crack it open with a sledge hammer to prove it wasn't white clear through!' Ellison's persecuted hero prefers the camouflage of blackness, and makes himself invisible by hiding from his pursuers in a coal hole.

Edward Weston found his equivalent to Stieglitz's ideal, snow-laundered landscape in 'the white silent level' of the desert around El Paso, where 'the sky is white, there is no horizon, all is a shroud of white'. In 1925 Weston photographed a toilet bowl, its scrubbed enamel gleaming, and in 1930 made a similar study of a bedpan. He likened the 'chaste convolutions' of the toilet to the *Victory of Samothrace*, and suggested that the 'stately aloof' bedpan 'might easily be called "The Princess" or "The Bird"!' Why should these polished receptacles be thought unworthy? During the 1960s the Pop artist Claes Oldenburg constructed life-sized toilets from white vinyl. But they were soft machines, and their floppy impracticality mocked the human bodies which made them necessary. Weston, treating the toilet as an altar, did not intend to be ironic. The installation

was, he said, a 'useful and elegant accessory to modern hygienic life'. The prospectus of a New Jersey company which manufactured 'sanitary pottery' declared in 1915 that 'the great contribution of America to Art is the pure white American bathroom'. By no means its greatest contribution, but all the same a not inconsiderable one.

Ansel Adams made a connected and equally startling claim in 1950 when introducing his scenes of Yosemite under snow, the icy peak of Mount Rainier, or a frozen lake in the Sierra Nevada. He argued that the national parks in which he had taken the photographs were 'America's unique contribution to the democratic idea'. The parks set aside a series of Edens, a solitary habitat fit for the American Adam. Those white mountains suggested an answer to Niebuhr's query about 'false eternals'. For Adams they represented 'intangible values', and were precious because they could not be used for 'profit or material advantage'. In the West, America turned into an open-air cathedral. The east coast too had its less grandiose natural shrines, commemorated in the music of Charles Ives. In the first movement of Ives's piano sonata, the idyllic setting of Concord, Massachusetts, recalls Emerson with his belief in 'the infinitude of the private man'; in *Three Places in New England*, a pantheistic hymn of praise wafts breezily over the Housatonic River at Stockbridge.

Throughout the 1930s America offered shelter to refugees from Europe. During the 1940s, boldly affronting its mission in history, it became aware of a new obligation: to take over, care for and cure European culture (or what remained of it). In 1943 an exhibition of paintings by Mark Rothko and Adolph Gottlieb advertised America's readiness 'to salvage and develop…Western creative capacity', and in 1948 Barnett Newman announced that 'here in America, some of us, free from the weight of European culture' were engaged in 'reasserting man's natural desire for the exalted', ill-served by the European modernists with their campaign 'to destroy beauty'. By 1959 Clyfford Still could confidently denounce 'Western European decadence'.

Earlier in the century, jazz had been the official image of American freedom: sensual, flexible, improvising itself into existence. Now the chosen form in which America testified to its eminence was painting. A culture is its icons; the shattered European tradition consisted of cathedrals (many of them bombed) and paintings (mostly removed from public galleries and secreted in mine shafts for the duration of the war). Art's highest aim was to build a habitation for God, and to make images which, like Michelangelo's account of creation in the Sistine Chapel, gave the deity a face. Newman and his colleagues inherited this priestly task, although they interpreted it in their own way. Rather than merely housing or representing God, they knew they had to reconceive him. Hence their abstract glimpses of cosmic beginnings. In Newman's *Genesis – The Break*, a hovering circle introduces the idea of order to a void and unformed earth. Gottlieb's *Thrust* in 1959 imagined the same moment more convulsively: a dark planet is moulded from a chaotic Rorschach blot of pigment.

God could no longer be given human features. But he might be envisaged indirectly, through those western landscapes which looked like his most recent handiwork, with chasms, canyons and broken pinnacles of rock under the eye of a blindingly truthful sun. Newman's *Cathedra*, of 1951, is a field of blue: it represents the roofless cathedral of the sky, interrupted by two vertical stripes which might be supports for an unseen celestial throne. Newman invoked the precedent of the Kwakiutl Indians from the Northwest, in whose art an abstract shape was 'a living thing,...a carrier of awesome feelings'. Jackson Pollock, stretching his canvases on the floor, compared his procedure to 'the Indian sand painters of the West'.

A myth of cosmic origins obsessed these painters, because they too were engaged in designing a new world. This had always been an American enterprise: the country was founded to protest against the injustice of the fall. But the return to first principles and to the rites which initiated life on earth acquired a new urgency in the late 1940s, when Americans surveyed the detritus of European history. Hence the revised pedigree for the human race proposed by Barnett Newman in 1947. 'The first man', he said, 'was an artist.' Visual assertion, drawing on a cave wall or scribbling on the sand, came long before verbal testimony – which is why the painters claimed primacy for their own art. Speech and writing require the prior existence of a society, because there has to be agreement about what words mean. After the experience of modern times, this could no longer be taken for granted. In any case, words had contributed to the political disaster by so subtly and palatably masking truth.

Developing his own narrative of our beginnings, Newman added that 'the aesthetic act always precedes the social one'. This was the stark moral prospect of the post-war world, as described by the French existentialists. All absolutes were in disgrace or disrepair. Man, condemned to absurdity by his foreknowledge of death, had to recover a reason for his life by making cool-headed choices and devising his own moral code. Those choices were his own gratuitous actions, irrational or even suicidal, and they constrained no one but himself. Hemingway's Robert Jordan chooses death at the end of *For Whom the Bell Tolls* and, 'holding onto himself very carefully and delicately to keep his hands steady', desperately hopes that it will be stylish and stoical. What action could be more gratuitous than the aesthetic one of staining a canvas? In deciding to make your mark on the world, you were endeavouring to create yourself. Rothko in 1947 summarized the long artistic tradition which modernism had terminated by remembering a 'single human figure – alone in a moment of utter immobility': Leonardo's Vitruvian man perhaps, his limbs like compass points pinioned inside a circle. The problem, for Rothko, was how to endow that figure with freedom, to make it move. It 'could not raise its limbs in a single gesture that might indicate its concern with the fact of mortality'. Paralysed, it was denied the chance to grapple against what Heidegger called 'das Nichts', translated by Sartre as 'le Néant'. Hence the agile bravura of the painters. Pollock walked around his prone canvases, dribbling paint onto them or hurling it at them. William S.

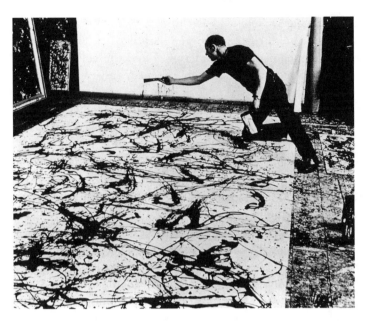

Jackson Pollock painting No. 32 in 1950, photographed by Rudolph Burckhardt

Burroughs worked out an even more volatile technique. He shot at the paintings he made in the 1980s with his arsenal of guns, splintering wood like bone and splashing colour like gore. He valued the messy randomness of the result, which, he thought, disrupted the predictability of a 'pre-recorded' universe.

These acts were voluntary inspirations. Their spontaneity condemned the automatic acquiescence of a collective morality, which had corrupted Germany and Russia before the war. Of course such procedures, whether in life or art, were dangerous. Gottlieb and Rothko in their 1943 statement called painting an adventure into the unknown (the white nowhere of the unpainted canvas), reserved for 'those willing to take the risks'. Failure was likely; yet the daring and candour of the act gave it a certain nobility. Gambling with his self-possession, the artist became a tragic hero.

The ideologies which generated the war, preparing for their different versions of heaven on earth, officially banished tragedy. André Malraux challenged this mandatory optimism at a conference of Soviet intellectuals during the 1930s. How, he asked, could the revolutionary gospel explain the accidental death of a man run over by a tram? His hosts assured him that such mishaps were rare in Russia, and would certainly become rarer. If one unfortunate man were to die that way, the commissars would ensure that safety was improved in the future; and anyway the victim, a happy martyr, had sacrificed himself for the communal good. Such hypocritical blather did not survive the tally of those millions massacred by Stalin. After the war a theory of tragedy, examining the fatal flaw in the constitution of the universe, replaced discredited theologies. Rothko adopted Nietzsche's explanation of tragedy as a geyser of Dionysian violence, and in 1943 illustrated the omen of the eagle from the *Agamemnon* of Aeschylus.

In the play, two eagles devour a pregnant hare; Rothko painted the aerial car-nage, suspending the birds and their prey between a frieze of classical masks – faces transfixed by the contemplation of suffering – and the columns of an uprooted temple. The incident was for him a fable about creativity and the self-rending it entails. He jokingly compared his later paintings to 'trunk murders'. The frames, with lakes of maroon coagulating inside them, were like the mur-derer's bleeding suitcase; it was as if they contained the butchered remnants of human beings, mutilated, ground up or liquefied by abstraction.

Harold Rosenberg in 1952 described Rothko and his colleagues as 'action painters', because of their obsession with what Newman called the 'aesthetic act'. He reprinted his apologia in *The Tradition of the New*; this collection of essays also included a study of character in tragic drama, which implicitly paid tribute to the valour and recklessness of the painters. Rosenberg valued drama because it upset a received, codified morality. Society classifies us as logical, accountable beings. It issues us with driving licences and expects us to behave responsibly; the law presumes to pass authoritative judgment on our deeds. For Rosenberg, this diagram of the human being was a bureaucratic fiction. Drama demonstrates what it is really like to be an individual. Characters like Hamlet describe the view from within. They are inside themselves, as Pollock said that he wanted to 'be *in* the painting'. Their immersion means that they have no notion of how they look from the outside, no interest in the appraisals of what Rosenberg dismissively calls 'social legality'. They cannot be sure who they are, because identity frac-tures into a repertory of neurotically warring selves. This theory of dramatic psychology matched the way Rothko explained his compulsion to paint vast murals. Small pictures, he said in 1951, miniaturize the world. A large picture denies you this reductive distance, because 'you are in it. It isn't something you command'. Nor, as Hamlet discovers, can you command yourself. Change, Rosenberg concluded, demands drastic remedies: 'the dissolution of identity'. The outcome may possibly be rebirth. First, however, you were obliged to die. For that risk too, Rothko volunteered.

The mystique of gratuitous action was an inquest on the collectivism of the 1930s. It also took note of current changes in American society. Perhaps there was no need to exterminate the individual, as Hitler and Stalin wished. Under corporate capitalism, the individual had quietly withered away, disap-pearing into his business suit. In 1950 David Riesman analysed the malady of 'other-direction' in *The Lonely Crowd*, a sociological study which argued that Americans had lost control of their own lives. Affluence kept people compliant. James Dean's father in Nicholas Ray's film *Rebel Without a Cause* wears an apron as he cheerily performs his household chores, bemused by his son's rankling dis-content. While the families in the television sitcoms enjoyed the good life, punc-tually resolving all problems before the end of each half-hour episode, the retired general who occupied the White House avuncularly presided over industrial preparations for another world war.

In 1959 the sociologist C. Wright Mills reconsidered Spengler's prophecy and corrected his schedule of historical eras. Mills announced that 'we are at the ending of The Modern Age', which was in the process of reluctantly giving way to 'a post-modern period'. He likened this interregnum to the transition from the Roman empire to those 'centuries of Oriental ascendancy, which Westerners provincially call The Dark Ages'. Spengler introduced modernity as a Third Reich. Mills, neatly avoiding the sinister resonance of the noun, called the new era 'the Fourth Epoch'. Its characteristics, however, were those which commentators had detected in Europe during the 1930s: 'the ideological mark of The Fourth Epoch – that which sets it off from The Modern Age – is that the ideas of freedom and of reason have become moot'. Of course men were free, but only to choose whether they preferred Coke or Pepsi. They lived in a society which had been rationalized by technology, yet perhaps the machines were madly stockpiling the means of global destruction. America, having routed fascism, was now accused of being benignly fascist, seducing its citizens with goodies and gadgets rather than regimenting them. The enemy had no monopoly in the abuse of power. Sylvia Plath's poem 'Daddy', written in 1962, excoriated her dead father for war crimes committed inside the family, but confessed that 'Every woman adores a Fascist'. No home was without its resident 'authoritarian personality', the character-type on which Adorno in 1950 blamed the collapse of bourgeois society. Like Rothko in 1947, Mills addressed 'the cultural problem of individuality' by contrasting the legions of tamed or brutalized white-collar employees with 'the ideal of the Renaissance Man'. That ideal no longer matched social reality. Mills, reviving another venerable modern fear, pointed to 'the ascendancy among us of The Cheerful Robot'.

In the absence of creeds, how could a man reclaim his freedom and live – in the jargon of the day – authentically, as the author of himself? Americans sought to recover power and autonomy through physical action. Existentialism, as they understood it, was a kind of spiritual athletics. It began with the cult of the bullfight popularized by Hemingway. The matador Romero in Hemingway's *The Sun Also Rises* lives dangerously, and has his moment of truth when he faces the horns. But the Pamplona fiesta is followed by the Tour de France, billed in the novel as the 'greatest sporting event in the world' – though congested, without risk, catering to lazy fellow-travellers. A team-manager for the bicycle race comments smugly on 'the number of motor-cars that now followed the riders from town to town'. In the automotive 1950s the car earned back its reputation for heroic daring, so long as it was driven recklessly enough. In *Rebel Without a Cause* the drivers on the chicken run race their cars towards a cliff which plunges into the Pacific, stopping as close to the drop as they can. The boy who challenges James Dean points down at the foaming gulf: 'This is the edge, boy. This is the end.' Dean brakes just in time; his rival soars through the air and plummets onto the rocks. But who has won? It's the other boy who takes that leap of faith into the unknown commended by the existentialists. Dean soon made amends,

dying in September 1955 on the way to a weekend of races when his Porsche sports car collided with a milder-mannered Ford sedan, a vehicle symbolizing the timid velocity of the suburbs.

The balancing act was precarious. Could such foolhardy games really disrupt the docile habits and conventions of society, and – like the gunshots of Burroughs – puncture the fatalistic plot of the universe? The equation required some hefty hyperbole. Clyfford Still, whose abstract and untitled canvases sought to dramatize cosmic convulsions, maintained in 1948 that 'a single stroke of paint…could restore to man the freedom lost in twenty centuries of…subjugation'. W.H. Auden placed a similar burden on a soprano's top note. Between 1947 and 1951 he worked on the libretto for Stravinsky's opera *The Rake's Progress*, in which the libertine Tom Rakewell gratuitously marries a bearded lady, flaunting his indifference to the automatism of desire. For Auden, the improbable exaltation of opera enlisted it in the same battle against twenty centuries of subjugation (or at least against the collectivizing tendencies of the previous half-century). The heroine's aria in *The Rake's Progress* concludes with a strenuous, brilliant high C. That note carried the same metaphysical load as Newman's 'aesthetic act' or Still's grandiloquent brush stroke. 'Every high C accurately struck', Auden argued, 'demolishes the theory that we are the irresponsible puppets of fate or chance.'

Rothko, brooding about tragedy, saw even his abstract paintings as 'dramas', and in 1947 called the shapes in them 'performers'. Those purple blotches, yellow stripes and plain black rectangles were engaged in life-and-death struggles. Their blurry edges represented identity dissolving, to be painfully re-formed. Rothko personified the indistinct oblongs as 'a group of actors who are able to move dramatically without embarrassment and execute gestures without shame': multicoloured, mobile Vitruvian men. In fact just such a group of actors, dedicated to the same demonstration of human freedom, had been formed in New York in the very year when Rothko made this statement. Elia Kazan and Lee Strasberg opened their Actors' Studio in 1947, teaching what came to be known as the Method. Their style of acting was raw and visceral; it drew on turbulent personal emotion rather than relying on fancy elocution and theatrical pretence. It sought what Rothko, discussing his own art, called 'the secret of direct access to the wild terror and suffering which lay at the bottom of human existence'. The Method encouraged actors to improvise, like Still or Pollock with their gestural spontaneity. This too was how the forms in Rothko's pictures emerged. 'Neither the actions nor the actors can be anticipated', he said, 'or described in advance. They begin as an unknown adventure in an unknown space.' The mannerisms of the Method actor were another way of subverting life's predestined script. Marlon Brando ostentatiously mumbled, slurred and hesitated, refusing to learn lines and recite them to order.

Kazan's graduates embodied the 'homme révolté' described in 1951 by Albert Camus, the rebel standing truculent guard over the integrity of his being.

Brando played a bike-riding outlaw in *The Wild One*, a union member who breaks ranks in *On the Waterfront*, and a mystical vagabond, clad now in snake-skin, not the motorcyclist's leather, in *The Fugitive Kind*. Fantasizing about a film of his novel *On the Road*, Jack Kerouac wishfully cast Brando as the babbling visionary Dean Moriarty. James Dean – directed by Kazan in his first film, *East of Eden* – studied the existential prototype even more conscientiously. He liked to be photographed with a cigarette suspended from the corner of his mouth: the disdainful pose was borrowed from a photograph of Camus on a book jacket. It remained unclear what kind of revolution these youthful dissidents had in mind. The bikers in *The Wild One*, playfully looting a shop, say they are 'storming the Bastille', though they liberate no prisoners and rectify no social abuses. Someone asks Brando what he is rebelling against. 'Whatta ya got?' he snarls: whatever it is, he's against it. In *Rebel Without a Cause*, Dean's revolt is a symptom of neurosis, not a political protest.

A contradiction threatened this view of drama as a proving-ground for authenticity, like the arena where the bullfighter confronts death. Action, as Rothko or Newman understood, is not quite the same thing as acting. The deaths in tragedy after all are simulated. Method actors insisted on their own veracity by masochistically choosing to suffer: the scenes in which Brando is beaten up in *The Wild One* and *On the Waterfront* are almost unwatchably realistic. Rothko went further. He compared his paintings to skins torn from his agonized body. They testified to his misery, and in 1970 he authenticated the emotion congealed in those crimson and acid yellow rectangles by committing suicide. This was designed as an exemplary end, a last, desolate lesson in autonomy. Slashing his wrists over a sink, Rothko proudly stood up to die, like the hero of George Chapman's seventeenth-century tragedy *Bussy d'Ambois*.

Analysing the predicament of Sisyphus, who is sentenced by the Judges of the Dead to roll a stone inconclusively uphill in Tartarus, Camus identified suicide as the only serious philosophical problem. Anyone who persisted in remaining alive must have a very good reason for doing so. For artists, suicide became a credential, almost a character reference. In 1963 Sylvia Plath kneeled on her kitchen floor and placed her head in the gas oven; in 1971 Diane Arbus, the photographer of dwarfs and transvestites, carnival freaks and handicapped children, opened her veins in the bath-tub. The people in Arbus's portraits protest against their own embodiment by mutilating themselves. Snakes twine across the skin of a tattooed monster at the carnival, and a skull is incised on his forehead. A naked man impersonates a woman by squeezing his genitals between his legs. Death saved Arbus from the accusation of prurience, because it established her kinship with her subjects: in examining their physical and psychological disfigurements, she had apparently driven herself to despair.

Rothko, pondering the disablement of his own abstract forms in 1947, conceded that 'without monsters and gods, art cannot enact our drama'. Gods have been at a premium during the twentieth century. Monsters are more readily

available, and the photographs of Arbus singled some of them out for awed inspection. Her freaks were visitors from another world, supernatural portents – an albino sword-swallower with a jewelled hilt of steel poking out of her throat; a mother whose baby is a pet monkey; a woman who turns herself into a witch by placing a beaked bird mask on her face. Looking at faces in the street, Arbus saw scars, open wounds, flaws or fissures which represented the tragic breach between inside and outside, spirit and flesh. In 1963 she photographed a nudist camp in New Jersey, patronized by middle-aged suburban couples whose sagging bodies squelchily adhered to the plastic furniture in their cabins. Barnett Newman described art as man's protest against expulsion from Eden, and hoped that in contemporary America it might be possible to usher Adam back into the garden. At the nudist camp, with its murky lake, its litter and its noxious plumbing, Arbus found that this dream had come true. God had forgiven Adam and Eve, and decided not to evict them after all. But his mercy concealed a curse. Arbus imagined him saying to them 'Stay in the Garden. Get civilized. Procreate. Muck it up.'

In Texas while making his last film, *Giant*, James Dean arranged his feline, versatile limbs into an impromptu crucifixion. He wrapped his arms around a pole which he slung behind his shoulders, and relaxed his lower body as if it were suspended from that cross-beam. Elizabeth Taylor knelt at his feet like the mother of God. Their poses had no justification in the plot: Dean plays a disaffected and vindictive ranch hand, and Taylor, though maternally fond of him, hardly worships him. But the tableau hints at an unappeasable yearning to rehabilitate the spirit. Can there be a religious art in a world bereft of God? Barnett Newman translated existential issues into tones, 'the hard, black chaos that is death, or the greyer, softer chaos that is tragedy'. But do abstract shapes or featureless fields of colour qualify as icons, aids to spiritual understanding? After

The Rothko Chapel in Houston (1965–7)

Rothko's death, a sequence of his paintings was installed in Houston in a non-denominational chapel. This room, where nothing but the whisper of the air-conditioning intrudes on a meditative silence, has the venerable calm of Stieglitz's gallery, except that An American Place was a haven of uninscribed whiteness, whereas the panels in the Rothko Chapel resemble dried blood. All figures have been effaced by the thick, dense layers of paint, but the arrangement hints at the scene more brazenly impersonated by Dean and Taylor. In the central triptych, the middle panel is elevated, preserving a hierarchy. Though Christ was crucified between two thieves, his cross rose higher than theirs. God is present here – or at least the very emptiness beseeches his presence. But, perhaps wisely, he does not show his face.

The original title of Spengler's book described the declining West as the 'Abendland': the land of evening, lapsing into twilight. In America, the sun had not yet been used up. Driving through Mexico in *On the Road*, Dean Moriarty – Kerouac's tribute to his charismatic buddy Neal Cassady – rejoices in what he calls 'this morning world', whose history lies ahead of it, not ominously behind. His companion Sal Paradise, who is Kerouac's own *alter ego*, admires the trusting innocence of the Indians who watch as they speed down the highway. They have been spared the knowledge which jars the world in the second half of the century, never having heard of the bomb which 'could crack all our roads and bridges'.

Kerouac and his cronies in the Beat generation often consulted Spengler's narrative of the last things, and with a radiant innocence of their own they turned it into a source of optimism and encouragement. They were eager for apocalypse, which for them did not meant a lapse into demonism and mental dissonance like the symphony in Mann's *Doktor Faustus*. A band plays mambo for Moriarty and Paradise in a Mexican bordello, with mad drums beating out African rhythms which are the pulsation of life itself and trumpets splitting the sky 'like the sounds you expect to hear on the last day of the world and the Second Coming'. Sal values the Mexicans because, living close to the earth 'where it all began and where Adam was suckled', they are prepared for the moment 'when destruction comes to the world of "history" and the Apocalypse of the Fellahin returns once more as so many times before'. Staggering into a bar in Denver during his first cross-country jaunt in 1947, Sal describes himself as a 'Prophet who has walked across the land' – or rather hitch-hiked. On his way, he wonders at the gusty plains, the sheer mountains, the sulphurous desert and the uproarious cities, seeing the continent as if it were freshly created. The purpose of his journey is 'to bring the dark Word'. But this is a prophet who contents himself, after traversing wild America, with a gasped exclamation: 'the only Word I had was "Wow!"'

By the 1930s, romanticism in Europe was under suspicion, accused of sponsoring the return to political barbarism. In America, cordoned off from this

history by the Atlantic, romantic dreams admitted no such guilt. Kerouac and his friends saw the country as the last resort of the Faustian spirit, which Spengler identified as the fatal, exhausting motive force of progress. Here lay the 'infinite spaces' which Goethe's Faust aspired to experience and conquer, mapped by Route 66, the highway which transports Sal from the east coast to the west. Hastening through Louisiana with Dean on another of these frantic trips, he feels 'the too-huge world vaulting us'. Goethe's Faust is condemned when he pauses to look behind him and contemplate what he has achieved. Whenever geography presents Dean and Sal with a terminus, they ricochet in the opposite direction, desperate to remain on the go. 'We lean forward', Sal comments, 'to the next crazy venture beneath the skies.' Having reached San Francisco, they immediately start to long for New York, and shuttle back in reverse order across the desert, mountains and prairies. When they arrive in New York, they pause briefly before tramping the length of Long Island, until they find 'there was no more land, just the Atlantic Ocean, and we could only go so far'.

Even the sprawling United States proved to be finite, abruptly curtailed by its two oceans. Sal's imagination therefore yearns southwards, and he plans a circular tour of the world's 'equatorial belly', travelling along a subconscious belt which extends (he believes) from Malaya to India to Morocco to Mexico and on to Polynesia and Siam, negotiating the curve of the globe to touch southern Spain. This is the fluid highway which unites all the earth's 'basic primitive, wailing humanity'. Kerouac vowed to rescue Goethe's hero from the death which finally overtakes him when his venturesome eagerness slackens: one of his schemes – unrealized when he died in 1969, his health wrecked by a transcendental diet of drink and drugs – was to add a third part to *Faust*. His would have been an automotive Faust, fuelled for the road with caffeine, liquor, uppers soaked in Coca-Cola and hallucinogenic *peyotl*. An extra psychic impetus was available with the aid of an orgone box. This 'mystical outhouse', like the carport and the fallout shelter, was a novel annex to suburban houses in the 1950s. Old Bull Lee, modelled by Kerouac on Burroughs, has an orgone accumulator in his Texas backyard. These sheds were patented by the psychoanalyst Wilhelm Reich, who believed that people sickened for the lack of orgones, which were – in Kerouac's solemn definition – 'vibratory atmospheric atoms of the life-principle'. Reich claimed that orgone energy was 'demonstrable visually, thermically, electroscopically and by means of Geiger-Müller counters', and believed it to be responsible both for the flaring of the northern lights and the blue flush of frogs when sexually excited. He was sure that it had 'a parasympatheticotonic effect', polishing off cancer cells. This vital force could be conveniently stored for home consumption in Reich's therapeutic boxes; Old Bull therefore repairs to his garden, removes his clothes, and settles down inside the accumulator to top up his deficient supply of bions, like a car having its battery recharged.

Kerouac viewed cars as vehicles aimed at infinitude. In *On the Road*, Dean grabs the wheel of his rickety Hudson and twists the ignition key as if goading all

those metaphorical horses beneath the bonnet with his spurs. Driving is his art, and he possesses the daredevil proficiency of the virtuoso. He turns off the motor and rolls 'on pure momentum' down the hairpin bends from the mountains into the San Joaquin Valley. He is elated by the noise of the cars in Mexico City – mufflers are unheard-of; the horn is played like a musical instrument – and the belligerence of their drivers. 'This is traffic I've always dreamed of!' he shouts. 'Everybody *goes!*'

Here once more was the streamlined dream of modernity: the world motorized. In *The Wild One* a doddery dishwasher, eventually killed by a runaway cycle, grumbles about the invasion and thinks that everyone these days has been overstimulated by gobbling vitamin pills. The gang members, descending from their mounts, amuse themselves by bouncing along the dusty street on pogo sticks. The old man may be right. On the wall of the soda fountain rowdily patronized by the bikers hangs a sign suggesting DRINK PEPTO!, which will kick you into overdrive for only ten cents. Even parking cars, which ought to be a safe and stationary business, when practised by Kerouac's Dean is as aerodynamic as pole-vaulting. He zooms backwards into tight corners at forty miles an hour, slams on the emergency brake with such force that the car shakes, then – without cooling his slick heels on the ground – hurls himself free of it on his way to deposit the keys, pick up a ticket, and throw himself on board another chromium missile. With his whirligig routines, Dean performs what Sal calls 'our one and noble function': the imperative of their existence is '*move*. And we moved!' America itself disappears in a blur as they roar across it at ninety miles an hour. The country, which burns up the collective energy of all those who live in it, becomes the smoke from an exhaust pipe.

Sal acknowledges that Dean is a con-man, but cannot blame him for his confidence trickery. He cons people 'because he wanted so much to live', and a single life was too meagre for his purposes: he therefore invents others. The ambition to go everywhere is complemented by the desire to encompass all American lives. Kerouac worked on the railroad in Chicago, unloaded crates of cantaloups in Denver, fire-watched in a forest below the Canadian border, and planned the acquisition of a stock ranch in California. He saw himself as a one-man Babel, a confluence of all the country's garrulous lingoes. His projects included books written in the dialects of blacks, bums and hip musicians, with additional volumes using the specialized speech of Canucks, Chicanos and Indians. These were his techniques for self-augmentation, like exercises with a chest-expander. The European atheism about language, which prompted Hofmannsthal's Ariadne to reduce a word to an expiring breath, had been banished. Ginsberg called his collection of poetry *Howl*; Kerouac likened his own art to that of a saxophonist, and said that 'the requirements for prose & verse are the same, i.e. *blow*'.

Like the painters, Kerouac saw art as a mode of action. He sought relief from the silence of composition by noisily typing and retyping his manuscripts.

He took pride in the physical exertion of this sedentary work, and sweated his way through several T-shirts a day while writing *On the Road*. As if driving, he totted up mileage: near the end of November 1948 he counted 32,500 words drummed out on the keyboard since he began three weeks earlier. He had no patience with the laggard productivity of his friend John Clellon Holmes. 'Great God,' he blustered, 'learn to type a thousand words a minute, buy two tape recorders'. That, after all, was the purpose of technology: it enabled the finite, flagging body to accomplish superhuman feats. The analogy between Kerouac's long, enraptured, associative sentences and the unfurling highways they extolled was enforced when – distracted by the need to place new pages in the typewriter, which was like having to slow down for petrol every few minutes – he made himself a scroll almost as long as the billowing ribbon of Route 66. He pasted together ten twelve-foot sheets of paper and rigged them to roll through the machine without interruption as he battered the keys. Robert Rauschenberg performed a similar stunt in 1953, gluing twenty sheets of paper together end to end, then coating the sidewalk on Fulton Street in downtown Manhattan with black ink. John Cage drove a car through the puddle of wet ink and along the paper. The result, entitled *Automobile Tire Print*, is twenty-two feet long: another abbreviated extract from the tapering horizontal latitude of America.

Robert Rauschenberg Automobile Tire Print *(1953)*

Kerouac's characters took to the road because they were restless, rootless. Motion is a Faustian imperative, the vocation of what Ginsberg called 'an American Man, one striving heroic soul'. But there are other reasons for travelling: to evangelize, for instance – to spread a new faith. Hence the journey from Los Angeles to New Orleans in Dennis Hopper's film *Easy Rider*, released in 1969. The characters here are gentle, disarmed crusaders, who set out to find remedies for the discontent of the 1950s. Hopper is Billy the Kid, attired in cowboy suede with flapping fringes and a necklace of native amulets, while Peter Fonda plays Captain America, with the Stars and Stripes brightly emblazoned on his leather jacket and crash helmet: cowboy and astronaut, the range-rider and the explorer of uncharted psychic spaces. Their costumes do not travesty authority, like the decommissioned military garb sold off to London hippies in Carnaby Street; instead they dress in fond, loyal homage to national archetypes. Dean and Sal watch the diorama of open space reel past, not bothering themselves with conditions on the ground. Perhaps they assume that the bomb which Kerouac's Mexicans do not know about will do the work of reform; their concern is to live while they can. The easy riders travel more slowly and ruminatively, and are more concerned with the society they see along the roadside.

For that reason, they do not drive cars. They have keener consciences than Sal and Dean: the car for them has become an obnoxious, poisonous trophy of the industrial economy. They travel on motorcycles, though these are not the threatening machines ridden by Brando's pack in *The Wild One*. Hopper resembles a trick cyclist in a circus, performing acrobatics on the seat or looping around Fonda in playful arabesques. The bike is not a capsule, enclosed in paranoia; it allows the easy riders to feel the wind on their faces and to smell the earth. They repair a tyre in a barn while a farmer changes his horse's iron shoe: there is a harmless bucolic continuity between the two modes of transport. The choice of vehicle was a crucial concern for the pilgrims of the 1960s. Ginsberg in 1965 cashed in a Guggenheim grant to buy a Volkswagen camper van, inside which he could both sleep and write; he drove it from San Francisco to Oregon, and used it as his base camp for hikes and mountaineering expeditions in the national parks. Ken Kesey – who wrote *One Flew Over the Cuckoo's Nest*, another of the decade's parables about the hedonistic spirit of rebellion, and also opened a psychedelic discotheque in San Francisco – cruised the country in a futuristic bus, with electronic aids to ecstasy installed. He called this horizontal spacecraft 'Further'.

Along the road in *Easy Rider* America's manifest destiny goes into reverse. History is unwritten, and the country returns to its agrarian sources. Fonda admires the way that campers in a commune support themselves by fertilizing the stony, sandy ground. He and Hopper contribute to this subsistence economy by growing a crop of their own. This is their hair, much derided by the yokels who pester them. Adherents to modernism cut their hair off: Mayakovsky's shaven scalp, the androgynous bob of Louise Brooks. During the 1960s the order was countermanded: hair now had to be grown again, as the unruly body's protest against social protocol.

At this distance, *Easy Rider* reveals the pathos and even the muddled hypocrisy of the attempt to reform and redeem America. Jack Nicholson – a drunken lawyer adopted by Hopper and Fonda, who teach him how to smoke marijuana – rhapsodizes beside the campfire about the Venutians, who have (he believes) infiltrated America from their outpost in space ever since scientists in 1946 began bouncing radar off the moon. The aliens, according to Nicholson, have much to teach earthlings. 'Their society is more evolved. Thanks to their technology, they can feed, clothe, house and transport themselves without effort.' This is the happy state sponsored by the comet in H.G. Wells's novel; men are still waiting to be saved from themselves by some supernatural advent. Nicholson explains with inimitable stoned sagacity that the Venutians 'don't have no wars, no leaders, and no monetary system'. The easy riders also wave such iniquities away in a sweet-smelling grassy haze. Yet they secretly rely on the monetary system they despise: their cross-country spree has been subsidized by a cocaine deal, and they store the proceeds inside a plastic pipe, banked in the fuel tank of Fonda's bike. This hiding place concedes the contradiction which compromises their radical integrity. Mobility after all requires money.

Relying on wishful faith rather than concerted action, the 1960s confused revolution with a religious revival. Eating with the farmer and his Chicano brood, Hopper and Fonda listen to an elaborate, earnest grace (during which Hopper even consents to take off his cowboy hat). They join in the solemn prayer of the hippies, who ask that the seed they have planted may grow. Communes, like the Mass, are about the experience of communion: marijuana butts, ritualistically shared, replace the usual wafer. In New Orleans during Mardi Gras they repair with two prostitutes to an overgrown graveyard in the French Quarter, take some pills, and guiltlessly couple among the tombs.

The jargon of the previous decade made explicit the link between mendicancy and mysticism. The word 'beat' meant many things. It referred to the pulsation of jazz, but it also acknowledged dereliction and fatigue, the price of social exclusion and endless Faustian striving. Sal looks tenderly at Dean's dented cardboard suitcase, with dirty clothes spilling out of it and rope to hold it shut. Like Don Quixote's battered horse Rosinante, it is a perquisite of downcast nobility and a tribute to undaunted wandering. Sal calls it 'the beatest suitcase in the USA'. But destitution is traditionally a badge of sanctity. Suffering beatified the beatniks, and since San Francisco was the city to which they made their pilgrimages they were known as Franciscans, as if they belonged to the holy order which practised a devout poverty. Hopper and Fonda are suddenly, pointlessly martyred at the end of *Easy Rider*, gunned down by rednecks driving a truck. As Fonda's bike explodes, the camera suddenly lunges into the air, jolted by the blast. Then it floats free of the turbulence, and looks out across pasture and a curling river towards green mountains. America is large enough to absorb a single tragedy, or even these twinned deaths. The camera tilts upwards, and takes the easy riders with it: a romantic sublimation, impossible in any other culture.

As this aerial epilogue hints, freedom – for Americans – has always lain off the map. Huck Finn, contemptuous of society and its entanglements, lights out for another unsettled territory at the end of the novel. The Freemen in 1995 went to ground in Montana, insisting that their portion of the wilderness was beyond the jurisdiction of the federal government. But the supply of available limbos has inevitably dwindled. During the nineteenth century, the epic exploit which preoccupied the United States was the conquering advance from east to west, solidified by the laying of railway tracks. In the twentieth century, the land mass has railroads, highways and air routes inscribed all over it. Travel, becoming too easy, loses its ability to guarantee you escape. There is nowhere you can safely arrive, confident that you have outstripped civilization. The only remedy is to stay in your car. America has become a race-track: the circuits around it continue at unabated speed, although the force which motivates the motors is dully automatic, dispirited.

Unless, that is, the very abundance of cars overloads the whole system and calls a halt to motion. The traffic jam is an inimitably modern event, which shows how our perpetual motion cancels itself out; in Jean-Luc Godard's

Weekend it marks the onset of apocalypse. In Bob Rafelson's *Five Easy Pieces*, released in 1970, Jack Nicholson finds himself unable to move on a choked Texas freeway. The drivers behind him blow their horns, blaming him for the obstruction. He rants at them in reply. Then he notices a means of escape. On the back of a stalled truck, which is carting someone's household effects to a new location, he spots a piano. He climbs up, finds himself a chair, and begins to play a classical concerto, eloquently hammering the keys while the tuneless horns continue to honk. When the traffic unjams, he does not return to his own car. He rides off in whatever direction the truck decides to take him, afloat on the music. The romantic rebel can simply eject himself from society, choosing to inhabit a private dream.

That option soon became untenable. In 1970 – with Richard M. Nixon installed in the White House, the war in Vietnam continuing, and hippies grieving over another failed revolution – Monte Hellman directed *Two-Lane Blacktop*, about a half-hearted, spasmodic, inconclusive race from California to Washington, D.C., between a battered 1955 Chevrolet and a sleek yellow 1970 Pontiac. Two bedraggled youths, played by members of a rock band, drive the Chevrolet: they might be latter-day versions of Dean Moriarty and Sal Paradise, drifting morosely, glad of the race because it gives them – for the time being – a goal. The Pontiac belongs to an enigmatic entrepreneur played by Warren Oates, who changes his life story to suit the part of the country he is travelling through or the expectations of whichever hitch-hiker he has most recently picked up. Leaving California, he claims to have been testing jets in Bakersfield. Crossing Arizona, he says he won his car shooting craps in Las Vegas. In Arkansas, he tries to endear himself to an old lady by telling her he has bought his mother a house in Florida and is driving down to fix it up for her. These are the versatile reveries of the con-man, which Sal admired in Dean. But the passengers in *Two-Lane Blacktop* are less credulous. 'I'm jest goin' to the graveyard', the old lady repeats. A frizzed hippie, still wearing the satin regalia which was Sergeant Pepper's uniform, promptly regrets having accepted the offer of a ride and orders Oates to stop the car: 'I want to get off this machine.' The America which rushes past outside the windows has been made redundant, because its landscapes can be duplicated inside the car. Oates, showing off his tape deck, offers one of the hitch-hikers a choice of cassettes: 'What kinda sounds you like? Rock, soul, hillbilly, Western?' The passenger, bored by this surfeit, shrugs that he pays no mind to such things.

'Well, here we are on the road', says Oates, brightly reviving the chivalric zest of Kerouac's novel. 'Yeah, that's where we are all right', one of the Chevrolet drivers glumly replies, taking the fact to be self-evident and banal. Enraged by the dilatoriness and dilettantism of his young competitors, Oates wonders if they understand what a car is. He defines it for their benefit: 'That's a thing you get in and go from one place to another. It takes', he shouts, 'a shorter time!' For the boys in the Chevy, motion consists of running on the spot, since – having thrown

overboard the hopes of the previous decade – they know they are going nowhere. In a café by the roadside in Arkansas, a girl who has drifted into company with them drearily amuses herself by playing the pin-ball machine. As she does, she sings the Rolling Stones song which was an anthem of the orgiastic 1960s: 'I can't get no satisfaction – 'cos I tried – and I tried – and I tried – and I tried....' She turns it into a dirge, bled of Mick Jagger's yelping ecstasy. The repetitions are those of a stuck record, or a stalled car. Having commuted between the Chevy and the Pontiac, in Tennessee she transfers to a motorcycle driven by a shy, slouching boy with whom she has not exchanged a single word. He is not a wild one, and his bike has no fiendish sexual allure: it is just another mode of transport, which will take her somewhere else.

The girl in *The Wild One* ingenuously asks Brando where he is going when he leaves town. 'Oh man,' he sighs, 'we just *go*.' He spits out the verb with the sputtering impatience of a motor cycle revving up. 'You don't go any special place, that's cornball style.' But travel without a destination is entropy; it mimics the expiry of the universe. 'Thing is,' says Oates in *Two-Lane Blacktop*, 'you got to keep movin''; like Kerouac, he proposes digressions to Canada or Mexico. Later he briefly discloses the panic which keeps him in motion. 'We'll build a house', he promises the girl (who is unattracted by the prospect of domesticity). ''Cos if I'm not grounded soon, I'm gonna go into orbit.' The moon landing, another very brief stopover, occurred in 1969. By then the interstellar spaces were as busy as interstate highways, with satellites shuttling in orbit – symptoms of our refusal to live on the lowly earth. The mantra in the diners where Hopper and Fonda grab a meal is 'Come again now', though those who say it know that the transients will never pass that way again. For all these Faustian seekers, the ideal destination was still the condition of whiteness: the unwritten page, the unpainted canvas, the opportunity to begin America all over again. Driving north along the Pacific coast in *Five Easy Pieces*, Nicholson picks up a furious, fanatical woman who is disgusted by a society which mass-produces garbage. She is on her way to Alaska. She has seen a picture of it, and reports that 'Alaska's very clean and appeared to look very white to me'. That, Nicholson wittily growls, was before the great thaw.

Ortega y Gasset in 1931 analysed the disillusionment which he considered to be a prevalent modern mood. He called it finitism, and attributed it to Einstein, whose world-view was 'curved, and therefore closed', containing no room for utopian infinities. We live, Ortega concluded, in 'a truncated universe'. For much of our century, America exempted itself from that fate. 'America does not know that the world is round,' concluded Gertrude Stein in 1940, 'because there is no threat of war.' The white line on the centre of the highway tapered towards its vanishing point, then continued beyond the horizon. But that open road eventually closed down. In 1963 Andy Warhol drove from New York to Los Angeles with some friends, remaining studiously unmoved by the view from the car. The radio played at full volume throughout the trip, both to keep awake whoever was driving and to provide some respite from the landscape outside the

windows. Warhol later complained about the choice of music available from local stations. 'There were long stretches', he yawned, 'when there was lots and lots of Country and Western' – almost as dull as the countryside of the West itself. Dreaming of his destination, he had his own version of that white and mystical place which for Stieglitz symbolized America. He longed, as he said, to go to 'vacant, vacuous Hollywood', and had already imagined it: 'Plastic, white on white'.

Dean and Sal in Kerouac's novel make a detour through Washington in 1949 on the day of Harry S. Truman's swearing-in. They stay only long enough to laugh at the bellicose hardware lined up on Pennsylvania Avenue for the inaugural parade, then zoom away. Washington is also the finishing-line agreed for the race in *Two-Lane Blacktop*, but the cars never get that far, and the competitors have no chance to mock the lumbering heavy-duty apparatus of government. Hellman's film literally burns up somewhere in Tennessee. As the Chevy starts its engine to begin the last, weary sector of the trip, the screen begins to sear, curl and blacken. The film running through the projector has apparently caught fire, like a tyre worn out by long abrasion on the highway, and there is no other reel to replace it. All supplies are limited – of celluloid, rubber and macadam; of energy and hope.

Nevertheless, between 1984 and 1996 the singer Art Garfunkel walked across America. His refusal to drive announced his resignation from society. The self-denial was temporary: whenever he got tired, he flew back to New York and resumed his trek later at the point where he had given up (which is why the crossing took him twelve years). He followed a more northerly route than Kerouac, skirting overpopulated California. After the plains of Nebraska, he crossed the Rocky Mountains near Spokane, and chose as his destination the mouth of the Columbia River, between the states of Washington and Oregon. Highway patrols, trained to treat pedestrians as renegades, often stopped him for questioning; he told the cops that his journey was 'a spiritual exercise in refreshment'. The source still exists, though now – as Garfunkel acknowledged by heading for the far north-western corner of the country, where America ran out of Americans – it lies further afield; and you must earn its blessing by arriving footsore.

IMPORTANT INSTALLATION
INSTRUCTIONS:

WARNING!
KEEP HANDS OFF FACE AT ALL TIMES.
WEAR SAFE GLOVES WHEN HANDLING.
HOLD BY HANDLES OR METAL ONLY.

SELF PORTRAIT

SEASON 87/88

SEASON 87/88

 SAMSUNG

 Thirten

FRUIT OF THE LOOM

 ANGELICA

Marlboro
LIGHTS

CalArts

 RENAULT

 BODY GLOVE

US Sprint

EXTRA-STRENGTH
TYLENOL

NEW YORK CITY
Ⓜ
TRANSIT

GREENPEACE

USAA

CLOSE·UP

NIKE

TV
GUIDE

Manhattan Cable TV

GUSANO
ROJO
Mezcal

Con
Edison

TROJAN

 The **VOICE**

Gillette
Atra Plus

INTEGRAL YOGA
NATURAL FOODS

CITIBANK Ⓒ

BLUE ROCK
MOUNTAIN SPRING
WATER

SURFER
MAGAZINE

THE BEST IN SENSORY AND INTELLECTUAL EXPERIENCES

C U L T U R E L U X

ADMASS

The social and political predicaments of modern times matched the way the new physics described the constitution of nature. Atoms hardly qualified as individuals. People began to complain, as Mann put it when accounting for fascism in *Doktor Faustus*, of being 'atomized'. This meant that they were 'reduced to one uniform level,…out of touch' with each other and with their shared destiny. Those atoms congealed into a mass, inert until a new kind of politician learned how to manipulate it. In the mechanics of Newton, mass was steady, gravitationally grounded, able to withstand acceleration. But Einstein's formula equated mass with energy. The collective bulk, no matter how large or small, could be annihilated by fusion or fission, made to release the force which it harboured. That is how the sun, the stars and nuclear weapons operate; it is also how Hitler, Mussolini or Mao Zedong worked on the crowds they mobilized.

Hugo Ball, in his 1917 lecture on Kandinsky and the modern spirit, sketched in advance the plot of the ensuing decades. 'A thousand-year-old culture disintegrates', he said. 'There are no columns and supports, no foundations any more – they have all been blown up.' He blamed the electron theory for first confounding our sense of physical solidity. After that we had to acknowledge our own personal instability. The mind gave up its sovereignty over the body's self-willed antics, or even – as the mayhem of the Freudian dream demonstrated – over itself. Each of us was hostage to what Ball called 'the randomness of nature'. Then, merged with our squabbling fellows, we were cast adrift in a third destructive element, 'the mass culture of the modern megalopolis'. Such communities had never existed before, and they broke the rules of community by ignoring the private desires of those who lived in them. 'Individual life died out', Ball reported, joining in the pessimistic refrain of the early twentieth century; machines assumed control.

A consumer's autobiography: Tormented Self-Portrait *by Ashley Bickerton (1988)*

This was a contagious nightmare, which only slightly distorted the social reality. After atomization came an enforced collectivization. Cities now contained millions of inhabitants, yet together – because of their dependence on the

'turbines, boiler-houses, iron hammers, electricity' listed by Ball – these multitudes were as bereft of power as the isolated individual had been. The recalcitrant American journalist Hunter S. Thompson unavailingly protested against the reduction of places and people to undifferentiated numbers, which he saw as a warning of incipient fascism. In 1963 he wrote from Colorado to the Postmaster General in Washington, attacking the 'stupid, vicious "Zip code" system', which he called 'government harassment'. In 1965 he campaigned against 'the dehumanization of phone numbers', another baleful symptom of the new society. His exchange in San Francisco had converted from letters to numbers, and he had been assigned a 'seven-digit number that neither man nor beast could ever get straight in his head'. Fascism had devised a new kind of state to suit a society whose members were an undifferentiated mass, rather than belonging to distinct castes and classes. It claimed to be restoring power to the people: the power, that is, to cheer, salute, obey. In the corporate state, humanity, as Walter Benjamin pointed out, was asked to contemplate itself. The people had been incorporated, the mass personified by a demagogue who undertook to make decisions for them. A glib dialectic transformed freedom into enslavement. Goebbels, haranguing the German theatrical profession in the year of the Nazi take-over, gave this tendency of modern times the force of an official diktat. 'Individualism', he decreed, 'will be smashed.' Henceforth the people were forbidden to consider themselves as persons: they existed only as members of the 'Volk'.

The Nazis derived a political science from these new social conditions. Concentration camps were treated by the Gestapo as clinics, experimental installations where the individual was psychologically eroded. Work, as the inscription above the gate of Auschwitz piously attested, makes you free. But the regime inside the gate reversed the rule. Meaningless work makes you a slave, and additionally deprives you of any sense that your skills or your very existence have value. During his internment at Dachau, the psychoanalyst Bruno Bettelheim noted the topsy-turvydom of the camp's economy. Plumbers did duty as barbers, or vice versa. The reallocation of trades was grotesquely impractical, yet that was its point: men were given back-breaking lessons in their own irrelevance. The guards dreamed up futile Sisyphean jobs for their charges, making them stagger from one end of the grounds to the other with useless boulders, which then had to be carried back to the starting point. The obligatory salute and the barked greeting 'Heil Hitler!' had a similarly regimental function. The aim was less to hail Hitler than to make the body behave like clockwork.

Albert Speer thrilled to the 'mass exultation' incited by Hitler. The swimming faces which surrounded the Führer's car looked, as Speer said, ecstatic; the crowds were animated by a 'surge of rejoicing'. Energy burgeoned within the mass and expressed itself in a devout frenzy. Religion, in the aftermath of God, can be redefined as an infectious hysteria. Speer noted that Hitler did not exert himself to prompt 'the worship of the masses'. The excitement was 'called forth…solely by the effect of [his] presence'. A real presence, like deity taking on

flesh? Hitler himself, more cynically astute than those who believed in him, understood how this credulity could be engineered, and knew that the technology of mass communication had replaced electoral consent as the politician's power base. In *Mein Kampf* he argued that 'all great, world-shaking events have been brought about not by written matter but by the spoken word'. The writer remains invisible, silent, estranged from the equally isolated reader. The speaker (with some extra help from microphones and radio transmitters) retains the bard's aptitude for crowd control, a 'psychological instinct for mass effect and mass influence'. Analysing his own craft, Hitler candidly admitted his contempt for those who were taken in by it. Writing could be dispensed with because 'the mass of people…is lazy'. They prefer slogans, catch-phrases. He looked forward to the enhanced manipulative potential of film, since the spectator 'needs to use his brains even less'.

Like a Hollywood casting agency, the Third Reich's Propaganda Ministry specialized in convoking tame, well-rehearsed masses to order. The bureaucrats could supply crowds tailor-made for any political occasion, from a studiously informal troupe of school children to the tens of thousands required to furnish the most grandiose rallies. The art overlapped with that of film, where crowds are known as extras – superfluous people, the dressing for outsized sets. In 1948 the critic Lotte Eisner commented on the balefully choreographed 'mass movements' in Lang's *Metropolis*. The crowd of subterranean toilers coalesces, as she said, into 'a dark, compact, amorphous mass', and the funereal tread of the enslaved workers seemed to anticipate the way Hitler compelled his subjects to 'march…towards the charnel-house'. The first film directed by Lang after his escape to the United States showed the mass in a less somnolently suicidal mood: in *Fury*, released in 1936, rioters set fire to the gaol in which Spencer Tracy is being held for a crime he did not commit. The pyromaniac spree demonstrates what happens when the individual is cancelled out. A mass degenerates into a mob, whose members, as Lang remarked, 'have no personal conscience any more'.

To be absolved of moral qualms might seem, for as long as the fit lasted, a psychological benefit. The totalitarian state required a more permanent sacrifice from its citizens: the surrender of autonomy, symbolized by its invasion of domestic spaces. Conversations in Soviet Russia were said to be secure only if conducted in bathrooms, with all the taps noisily running to baffle the electronic ears implanted in walls, beneath tables, and (of course) in telephone receivers.

The first men to call themselves modern recognized that they were engaged in a struggle for survival, as they fought against obliteration by the crowd. The totalitarian state made this mental battle even more desperate. The behaviour of Shostakovich during the Stalinist terror is a case-study of the ego's stratagems, using subterfuge to protect its right to life and to self-expression. The regime, insisting on its monopoly of all activities, demanded that composers write homilies to the new Soviet man. Optimism was compulsory, and

Shostakovich suffered periodic denunciations for his recusancy and was required, like Galileo, to make shamefaced recantations. In 1936 Stalin condemned *Lady Macbeth of Mtsensk* for its cacophony. In 1948 Andrei Zhdanov, in charge of 'musical activism', berated his Eighth Symphony for its 'unhealthy individualism'. Khrushchev ridiculed him in 1962 for composing decadent jazz and causing belly-ache. Throughout these decades, Shostakovich scrupulously carried a briefcase containing fresh underwear and a toothbrush, in preparation for his arrest. Sometimes he spent the night on the landing outside his flat, so that his family would not be disturbed when the music critics of the KGB came up in the lift to remove him. Even when not in immediate danger, he obsessively tidied away the traces of his delinquency. After listening to the BBC, he always returned the dial to the wave-length of Radio Moscow, in case someone happened to check.

It was his good fortune that music, using notes, not words, can evade interrogation about its doctrinal sympathies. He supplied his symphonies with secret plots, revealed to colleagues whom he trusted. He alerted the conductor Kurt Sanderling to the caricatures he had smuggled into the Eighth Symphony, composed in 1943: a capering piccolo supposedly described a soldier on a weekend's leave, liberated from the war effort, while the pompous bassoon accompanied a Party apparatchik during an official trip abroad. His Tenth Symphony was composed in 1953, the year of Stalin's death. Shostakovich alleged that its scherzo portrayed the dictator: the strings foment a cyclone of furious, pointless activity, while the drums bludgeon everyone into line and the brass puffs out sycophantic fanfares. The movement has a crazed levity, because despots can indulge their most trivial or lethal whims, and its end is shockingly peremptory. The terror of such a society is its arbitrariness. Nothing can ever be foreseen, since the rulers are beyond reason; you should always be ready for departure. The novelist Milan Kundera, who suffered similar persecution in Czechoslovakia, might have been thinking of Shostakovich's scherzo when he remarked on the ghastly infantile playfulness of totalitarianism, which 'deprives people of memory and thus retools them into a nation of children'. Kundera called the Stalinist terror a time of 'lyrical delirium'. That is precisely what Shostakovich composed.

Katerina in *Lady Macbeth of Mtsensk* whispers her curses on the rapacious father-in-law whom she later poisons, and converses with her lover Sergei in muttered asides. Shostakovich adopted the same seditious methods. The ego, writing in cipher, stubbornly testified to its survival. After Zhdanov's 1948 decree censured subjectivism, Shostakovich took to reiterating his own name: the Tenth Symphony and the Eighth String Quartet, composed in 1960, rebelliously spell out his initials, D-E flat-C-B (the key transcribed as H in German musical notation). The quartet, safe in the absence of an incriminating voice, quotes one of Katerina's laments from the opera. Gestures like this belatedly turned Shostakovich's heroine into a wishful projection of himself. Katerina murders the men who oppress her, and remains unrepentant: she is a Lady Macbeth who has no guilt-stricken sleepwalking scene. Shostakovich later claimed that, in

certain circumstances, it was justifiable to kill one's tormentors; the deed could be called an execution. His irony flirted with moral anarchy. When his second wife, a Komsomol hardliner, nagged him about the children she had inherited from his first marriage, he coolly suggested slaughtering them. In Nikolai Leskov's original story Katerina does just that, to express her contempt for society and its inflictions (although in the opera she stops short of infanticide).

All the same, despite this vengeful dissent, Shostakovich slowly turned into the Macbeth who is omitted from his opera – a man mined by remorse and self-hatred, terrorized as much from within as from without. He preserved his rebellious identity in music, but at the cost of apparent compromise with the regime. He joined in the campaigns against the dissidence of Andrei Sakharov and Alexander Solzhenitsyn. Lending his name to official denunciations, he explained that he would sign anything, 'even if they hand it to me upside-down'. This may have been his coded sneer at a world where everything, truth included, was already upside-down. His irony exerted itself to cover the gap between acts and motives, words and meanings. In a letter he slavishly referred to the 'Great Commander, comrade Stalin'. The censor would be appeased, and the reader could supply the quotation marks and the sarcastic tone of voice. When his own turn to be expelled from favour arrived, he upbraided a colleague who refused to follow orders by slandering him: 'I am most displeased by your behaviour. You had no right to act like that.' He meant that the loyal friend should have remembered his own family and complied in order to protect his wife and children. Perhaps he also meant that he did not deserve to be rescued. At a meeting of the Supreme Soviet, he was seen vociferously applauding a speech in which a jealous rival slurred him. Onlookers thought he had not noticed – or had he?

Characteristically he relished a gimmick added to his surreal farce *The Nose* at its revival in 1971, a few years before his death. The director inserted an epilogue in which the singer whose nose has strayed from home attacked the opera – a relic of the early alliance between revolution and the theatrical avant-garde – and declared it unworthy of the socialist fatherland. Shostakovich suggested that the singer should seek him out in the audience and harangue him personally. Exile was not an option for him. To stay alive, he had to rely on the ambiguous and self-mortifying techniques of silence and cunning.

Einstein, having escaped to America, reflected in 1939 on his apartness in Princeton: 'Perhaps, some day, solitude will come to be properly recognized and appreciated as the teacher of personality. The Orientals have long known this. The individual who has experienced solitude will not easily become a victim of mass suggestion.' He did not mind that American society sidelined intellectuals. At least, by taking no notice of him, it exempted him from incorporation into the mass. Yet for how long? Freed from Dachau by his family, Bruno Bettelheim resettled in America. In 1964 he made his first visit to Israel. His hosts marched him through a rigorous schedule; with a glance back over his shoulder to

Chicago, he reported that Israel was 'a totalitarian society populated by basically lovely people, but totalitarian nevertheless'.

America, having won the war, proceeded to create its own glossier and more amiable version of the regimes it had defeated: a soft totalitarianism. When she visited Los Angeles during her lecture tour in 1948, Simone de Beauvoir met the gossip columnist Elsa Maxwell. It was a piquant encounter between the radical feminist and the reactionary, satin-swathed beldame, who were electrified by a mutual antipathy. Maxwell had devoted some recent columns to French intellectual life, but when de Beauvoir questioned her on the subject, she indignantly denied having read any of the books she mentioned. 'In America', she informed the astonished de Beauvoir, 'no one needs to read, for no one thinks.' Her columns, she said, were meant as a substitute for thought, since her own prejudices engendered an instant consensus. She warned that thinking led to anarchism, and praised President Truman for his cheery brainlessness. When de Beauvoir insisted that the atom bomb and the Nazi death camps had to be thought about, Maxwell chuckled heartily and asserted her own eternal optimism. 'I love life,' she admonished de Beauvoir; 'life is marvellous.' Was a society in which opinion-makers like Maxwell discouraged thought any better than those run by despots and censors who forbade citizens to think?

Throughout the 1950s sociologists worried about America's malaise. Erich Fromm detected a psychological instability in democracy. Freedom terrified those who possessed it, and they shed their mental burden by conforming. In Germany or Russia they joined political parties; in the American suburbs, they paid their dues to the country club or attended meetings of the PTA. The atom bomb was partly to blame for this panicked timidity. Had it not been created by 'the teamwork of huge corporations of scientists and technicians'? No one remembered, as William H. Whyte complained in 1956, that it all derived from 'what an eccentric old man with a head of white hair did back in his study forty years ago'. Despite their 'public worship of individualism', Whyte claimed that Americans had become a nation of compliant 'organization men'. Arthur Miller diagnosed the national failing in *Death of a Salesman*: Willy Loman, who ingratiates for a living, is pathetically eager to be 'well-liked' by his fellows. C. Wright Mills argued that 'the classic community of publics is being transformed into a society of masses', and warned about the encroachment of totalitarianism at home. A public consisted of individuals, each of whom made rational choices; a mass was a herd, its pooled emotions aroused by the media. Although Mills denounced the 'political alienation and spiritual homelessness' of the society, in America the individual at least died a glutted, luxurious death, having been redefined as a consumer. David Riesman pointed out that, for other-directed men, 'people and friendships are...the greatest of all consumables'; the peer-group, with its compulsory niceness, 'is engaged in *consuming itself*'.

In 1957 in a study of advertising as a means of mind-control, Vance Packard breathtakingly remarked that 'Americans have become the most manip-

ulated people outside the Iron Curtain'. Ministries of propaganda were replaced by advertising agencies. Demagogues and despots gave way to celebrities as the incarnations of communal desire, but the epidemic hysteria looked and sounded the same. Bobbysoxers mobbed Frank Sinatra at the Paramount Theatre in New York during the 1940s; Beatlemania was the ailment of the 1960s. The scope available to the private life contracted, though not because of scrutiny by the secret police. Now the mass media enforced what Gore Vidal has defined as the rule of 'total publicity'.

The KGB bugged hotel bedrooms and eavesdropped on telephone calls. Tabloid newspapers have enthusiastically taken up these techniques, while paparazzi crawl through bushes or dangle from trees in order to document indiscretions. The celebrity enters into a bargain with the gossip columnists and candid cameramen: to be totally publicized means that you must, when the media decide that you are obsolete, be defamed in full view of the public. Kenneth Anger's second volume of scandalous anecdotes, *Hollywood Babylon II*, published in 1984, had a snapshot of Elizabeth Taylor on its cover. Bundled into the back of a car, she is bulbously fat and blowsy, with ratty hair – a goddess gloatingly degraded. A decade later, telephone lines set up by British tabloids enabled you to listen to surreptitious tapes on which members of the royal family arranged adulterous liaisons or chatted with soothsayers. The guillotine was no longer necessary. Trial and summary execution took place in this electronic forum; anyone could join the jury for the price of a premium-rate phone call.

In 1955 J.B. Priestley, imitating the catchy slogans by which the copywriters infiltrated our memory and programmed our cravings, coined a neologism for this novel kind of society, which had been invented in America but was promptly imitated around the world. He named it 'admass'. John Kenneth Galbraith in 1958 described the American prototype as 'the affluent society'. The world had at last overcome scarcity. For the first time in human history, there were enough material goods to satiate us all. But productivity and profitability could only be maintained if people hungrily consumed. Advertisers, charged with making sure that the process continued without interruption, magically transformed luxuries into necessities, and endowed the items for sale with allure or aura – that magic, chimerical halo which had actually been banished, as Benjamin thought, when mass production made the very notion of individuality obsolete. Elias Canetti called consumerism the last of the universal religions. Its ambitions are as messianic as any of its predecessors': it lays claim to every individual soul, since the world is full of potential customers for its burgeoning goods.

By stealth, another profound change in human nature took place during the 1950s. Gertrude Stein, describing her adopted country in 1940, remarked on the notorious reluctance of the French to spend money. They preferred to save. For them, this amounted to a historical mission: their duty was to conserve the past and donate it to the future. Her point applied to most other cultures at that time. Throughout history, the common experience of men had been subsistence.

The peasant enticed the means of life from the niggardly earth; if he was lucky, there might be a small surplus to be traded. Yet in America, yearningly eyed by rationed Europe after the war, excess became the natural state of things. Such an economy required spendthrift habits to fuel it. President Eisenhower made consumption a duty, and in 1958 admonished Americans with the punning slogan 'You Auto Buy'. Andy Warhol shopped patriotically. In 1975 he tabulated the results of an expedition to Macy's in New York. He set out to buy thirty identical pairs of jockey shorts, though he was ashamed to admit that he had ended up with only fifteen; he compensated by buying eight pairs of lookalike black socks. 'Buying', Warhol sagely commented, 'is much more American than thinking.' He added that the mentality of Europeans and Orientals favoured trading – barter, exchange, all the wily arts of the merchant. But Americans, he claimed, would 'rather throw out than sell'. Affluence means that obsolescence is built-in; the state of plenty is assessed by what you can afford to discard.

Warhol with his multiple sets of underwear served as the apologist for superfluity. In *Nova Express*, published in 1964, Burroughs adopted Dostoevsky's motto 'Everything is permitted'. Its corollary was another relativistic proposition, which held that 'Nothing is true'. This served to license indulgences more enterprising than Warhol's lust for socks and jockey shorts; the only commandment which retained its force was the exhortation to consume. In his diary Warhol described Liza Minnelli bursting into the house of the designer Halston and breathlessly demanding 'Give me every drug you've got'. But was the permissiveness which Burroughs celebrated a new form of repression? The imagination after all had to be content with the mass-produced wares in Macy's, or with whatever chemicals Halston's dealer had in stock. Desires were titillated only because the market could sell satisfaction.

The shopping list could of course be extended to include human bodies, as well as the socks and underpants they wore. People were also tagged as commodities, ripe for consumption. In 1975 Pier Paolo Pasolini made a quixotic call for the abolition of television, responsible for what he called the 'mercificazione' of everything and everyone in the world. The films turned out by Warhol in the studio which he called The Factory during the 1960s took a more relaxed view of this mercantilized society. Items are eroticized when put on sale: it is not jeans you buy, but the sculpted buttocks which model them in the advertisements. Warhol's blissful pornotopia is a supermarket of sex, where a beer bottle can be requisitioned (as one is by the transvestite Holly Woodlawn in *Trash*) for use as a dildo. *Blow-Job* documents a lengthy act of fellatio. A team of volunteers toils away beneath the camera's sight line, vying to feed on a young man whose vaguely enraptured face alone registers their progress. After half an hour, he lights up a cigarette, to signal that the transaction has been successfully completed. In *My Hustler*, three ageing connoisseurs appraise Paul America, lolling on the beach at Fire Island. The commodified body in *Flesh* belongs to Joe Dallesandro, who in the sequel *Trash* has given up sex in favour of heroin, because no

inconvenient orgasm curtails the trip. The male hustler was one of the new cultural heroes invented by the 1960s: man redefined as his own stock in trade – no longer an economic producer, now a consumer item. He inherited the styles and the garments of earlier American archetypes. John Rechy's novel *City of Night* celebrated the outlawry of the hustler, and the hero of John Schlesinger's film *Midnight Cowboy* (for which Warhol hired out some of his self-styled superstars, who appear at a druggy party) locates a seedy, lawless frontier on 42nd Street in Manhattan.

This recognition of a profession which had never before been visible aligned sex with all other exchanges in an economy whose stated purpose was to supply pleasure. Warhol in 1975 put it with his usual drawling candour. 'What [Americans] really like to do', he said, 'is buy – people, money, countries.' The remark covered all areas of the national existence, from sexual intercourse to presidential politics, taking in imperial expeditions along the way. The war in Vietnam was an exercise in buying love, an advertising campaign with military back-up. Mary McCarthy, visiting Hanoi in 1968, understood that this was a new kind of military enterprise. No strategic interest was being defended here; America merely sought another market to consume its goods, ranging from helicopters and poison gases to soft drinks and hamburgers. McCarthy equated the bombs dropped on North Vietnam with 'the candy hurled at children in the South by friendly GIs': both were donations made by plentiful America – its surplus, descending from the sky like manna or napalm.

The political system had altered to accommodate this new reality. The dispute in Indochina was supposedly about the right of political self-determination. But elections, whether in Vietnam or Washington, had become an adjunct of showbiz, which is in its turn a branch of other, more serious and lucrative businesses. Voters might fancy they were making free choices, but their roles had been pre-ordained by pollsters, newscasters and the advertising agencies which supplied the candidates with their sales pitches. McCarthy wondered whether 'the purpose of having elections [was] not simply to market TV time, convention hall space, hotel suites, campaign buttons, and so on'. In 1968 this counted as an incendiary suggestion; by now it seems self-evident. Ronald Reagan's serenely vapid performance as Celebrity-in-Chief made official a change in the nature of the office he held. Decision-making has been adjusted to suit the timetable of television news broadcasts. Rather than ideas or arguments, politicians emit those choice gobbets of verbiage which the media classify as 'sound-bites'. Consumerism invades that phrase too: a sound-bite is a snack-sized piece of noise; fast food for the ear, which bypasses the brain.

Like 1917 or 1933, 1968 was a revolutionary year – except that the enchantments of admass ensured that, once the crowds had been dispersed, business promptly resumed as usual. Vietnam taught McCarthy that revolution had become impossible. It must be powered by the zealotry of denial, and the affluent economy had bribed potential enemies in advance. Blacks rioting in the

ghettos, as McCarthy noted in 1968, looted television sets. They wanted to be plugged into society, not to overthrow it. By 1992, when Los Angeles burned after the policemen who beat the black motorist Rodney King were acquitted, every house in the ghetto had a television set. Other, more sumptuary needs had to be satisfied. David Hockney saw a woman run out of a looted shop carrying the grand total of six ginger wigs. From now on, she too could conspicuously consume.

Candy bars succeeded where bombs had failed. After the ignominious withdrawal from Vietnam, another empire peaceably annexed the remainder of the globe. The golden arches of McDonald's have become the logo of an ecumenical church. Food marches in the vanguard, because the American economy treats whatever it manufactures as ersatz food, expelled soon after it is consumed and therefore needing to be consumed all over again. Like the bodies for which they are destined, these products are democratic levellers. Warhol once said that it did not matter if you happened to be Elizabeth Taylor or the President of the United States, because the Coke you drank was the same as the one available from a vending machine in the ghetto. At a trade fair in Moscow in 1959, Vice-President Nixon displayed to an unconvinced Khrushchev the superior amenities of the American kitchen, bathroom and laundry. He might have proved his case if he had offered Khrushchev a meal, rather than singing the praises of washing-machines. Soon after the 1989 massacre in Beijing, a branch of Kentucky Fried Chicken opened at the southern edge of Tiananmen Square, occupying a many-storeyed pagoda and guarded by a cut-out of Colonel Sanders, whose ruddy features had been given a subtly Oriental cast. On a side street in Kyoto the same totem announces the same product, though here the colonel has exchanged his white suit for samurai attire, with a bristling head-dress and a sheathed sword. During the mid-1990s in Moscow, it was sadly fashionable for people to drink their tea from dented, discoloured Styrofoam cups: souvenirs of an outing to McDonald's, which was the poor man's equivalent of a trip abroad. The American way of life has turned out to be a franchise operation.

As the liberating American armies made their way across France in 1944, Gertrude Stein reflected on her country's bequest to the modern world. America, she pointed out, had arrived in the twentieth century a few decades before the other continents. Indeed it had virtually patented the notion of modernity. It did so by pioneering the notion of mass production. This is the procedure which Benjamin called mechanical reproduction; Stein herself described it as 'series manufacture'. It announced the forthcoming century of the common man, newly reprieved from indigence and scarcity. 'The twentieth century', Stein argued, 'is a century that found out that the cheapest articles should be made of the very best material...otherwise you could not turn them out fast enough,...because cheap material could not stand the strain.' This marked a breach with the treasures and trophies of the bourgeois household, intended for

the delectation of the few, top-heavy with ornament as if to boast of their cost and rarity: 'the nineteenth century believed that the best material should be only used in expensive objects'. America made appliances which everyone could afford, and turned the ownership of those appliances into a ticket of admission to the modern world: light bulbs, Model T Fords, washing-machines, television sets. Americans themselves were made according to the same industrial method-ology, as Stein recognized when she greeted and congratulated and fed GIs from Kansas and Nebraska and Colorado in 1944. There were so many of them, all different and yet – more importantly – all the same.

By conferring the benefits of affluence on every member of the popula-tion, America created the notion of a popular culture. It toppled the barriers between art and ordinary life, and put into practice a revolution which all the modernists had hoped for. Francis Picabia thought that 'art is, and can only be, the expression of contemporary life'. Georg Lukács saw the promiscuous eye of the movie camera as a test case of this democratic vision. Through the undiscrim-inating lens, 'everything is true and real, everything is equally true and real'. This is why Mahler, who thought that music must 'embrace the cosmos', refused to exclude sounds once considered cheap. Hence his symphonic quotations from blaring military bands and plodding country dances. Satie in 1920 composed music which aspired to the condition of Muzak: 'musique d'ameublement', to be played while the furniture was moved around during the interval of a play, meant to be repeated until the sounds disappeared into the wallpaper. Klee praised the messy daubs of children as painting of genius, and Kurt Schwitters in his *Merzbau* adopted crate-lids and playing-cards as pictorial surfaces and pram-wheels, wire netting, string and cotton as sculptural ingredients. Adolf Loos, admiring the sleek modernity of cigarette-cases, umbrellas and spectacles, announced in 1908 that 'there is no doubt that the products of our culture have nothing to do with art'. At the Bauhaus, Moholy-Nagy propounded the belief that 'everyone is talented'. The only requirement was a sturdy physique: 'any healthy man can become a musician, painter, sculptor, or architect, just as when he speaks, he is a "speaker".'

Yet although they wanted to discard or dishonour the art of the past, the European modernists never managed to unlearn their own education. Like Picasso impersonating a *clochard*, they were consciously slumming. Satie's wry comments on the tedium of his own scene-changing music disclose his distance from the 'ordinary life' which Cocteau saw as the stuff of modern art. 'The public worships boredom', Satie argued, because it is 'deep and mysterious.' Sedative repetitions induced a trance-like state, enabling Satie, as he said, to mes-merize his listeners. Here was a new version of the spell cast by Orpheus, the first classical musician. Satie's irony allowed him to tease the standards of the past without altogether rejecting them. By contrast, when Warhol claimed that he liked boring things, he was in deadly earnest. He proved his good faith by choos-ing to be bored and boring. He made a film about a man asleep for six uneventful hours, looping the footage because even he became stupefied by his vigil behind

the camera, and another in which the Empire State Building stands there being its inert, implacable self in the distance for eight hours (with a momentary epiphany towards the end, when the sky darkens and the skyscraper's lights go on: a hard-earned instant of bliss, which – like the young man's eventual orgasm in *Blow-Job* – scarcely seems worth the effort).

Warhol patiently schooled himself to demonstrate the truth of Satie's whimsy about a deep and mysterious tedium. Boredom enabled him to resign from the chore of being himself; the death of the individual occurs when you become aware of your subjection to time, which creeps along at its mechanically regular pace, indifferent to personal life-plans. The experience is not maddening. It does not induce the revulsion which Sartre's hero felt in *La Nausée* when he noticed the sluggishness of the dragging seconds. It is a comfort, a mercy, almost an out-of-body experience: looking back at your stalled self, you see that its restless anxieties do not matter. Why should they, when there are so many uncountable, mass-produced others in the same predicament?

In 1975, in *From A to B and Back Again*, Warhol transcribed a telephone conversation with one of his interchangeable hangers-on, whom he referred to collectively as Bs. Eating toast and watching television, he listens to this particular B's minute, punctilious narrative while she cleans out her closet. B recites a summary of the television programme which A himself is also watching: 'I wasn't bored because I had forgotten it already.' She overflows with consumer lore, knows all about the best abrasive cleaners, and disapproves of Brillo scouring pads – stockpiled by Warhol, who in 1964 silk-screened pyramids of Brillo cartons – because they contain no soap; she can tell you why Hoover vacuum cleaners are better than those made by Singer; she recommends cleaning typewriters with Q-tip cotton wands, which most people reserve for clearing wax out of their ears. Her puritanical drill counts as art: she is imposing the fiction of order on messy, contingent life. Though intent on her commentary, Warhol does not mind when they are cut off by an impatient switchboard-operator, as the interruption allows him to go to the bathroom. Since his solution to the problem of our existence in time is perfect passivity, he of course does not call her back. Nevertheless it annoys him that she takes twenty minutes to call him. When he grumbles, she rightfully rages 'A, I'm not thinking about time, I'm thinking about DETAIL!' Exactly: absorption in detail achieves the annihilation of time. What matters, as the clowns in Beckett's *Waiting for Godot* know, is to keep busy by doing nothing. B's domestic minutiae resemble a photograph blown up, or a television image inspected too closely, so that what looked like a picture falls apart into bustling amoeboid dots. These are the nano-seconds which make up a life, or the specks and sand-grains and bits of fluff which cohere (or so we pretend) into matter – all different yet all alike, manufactured in an infinitesimal series like Warhol's entourage of anonymous, faceless Bs.

While waiting to be called back, he toys with the notion of telephoning one of this B's namesakes, 'to kill time'. Any B would do. The product, like the

multiple Coke bottles or Campbell's soup cans which Warhol silk-screened, is guaranteed to be uniform. Warhol's social alphabet resembled the numerical systems of those tribes which classify phenomena by distinguishing single from double, while categorizing everything else as 'many'. There was only one A, Warhol himself; Bs are many, multiple. The double, necessary for love, is eliminated from the series. Duplication has traditionally been a terrifying notion: hence the stalking *Doppelgänger*, who usurps one's precious right to be unique. Warhol exorcised that ancient fear. We are all off-prints, turned out by a stereotype machine or a photocopier. He even did away with his own singularity, licensing stand-ins to impersonate him at parties (all they had to do was wear silver wigs, look bored, and say nothing) or leaving assistants to direct his films, complete his paintings, write his books.

In the course of her vendetta against germs and grime, the house-cleaning B flushes her watercolours down the toilet and drains her dyes in the bath-tub. 'No more painting', she cries in iconoclastic zeal, 'NO MORE ART!' She is paraphrasing Adolf Loos. 'All that arty stuff', which she took up in the first place as therapy, can be dispensed with. Why should we uphold a hierarchy of activities, which maintains that writing a book is art, while cleaning the keys of the typewriter you write it on is not? Art consists of uselessly specialized skills, and depends on talents which are undemocratically distributed. But culture is our shared creation, and any activity we perform – dressing, cooking, cleaning the house – deserves credit for the contribution it makes. After 1917, art in Russia was ordered to wither away, along with the state: life, the Bolsheviks promised, would be such an adventure that no one would want to escape into fantasy. B, as indomitably cheery and fanatically spick and span as the housewives in advertisements from the 1950s, goes about her domestic tasks in the same spirit. Who needs painting, when you can admire the spin cycle while your clothes are drying at the laundromat? 'You get incredible patterns', she tells Warhol. She likens these to the strobing, vortical stripes painted by Kenneth Noland – except that the dryer's fortuitous designs are cheaper, more variable, and also (because they deny the privileges and pretensions of authorship) more American.

Warhol made a similar deadpan joke about Rothko, Pollock and their view of art as a solitary vocation, ennobled by suffering. He too would have been an abstract expressionist, he said, if only he'd known how easy it was: all you had to do was splash paint around. He was disqualified by his lack of angst. In 1960 Claes Oldenburg mocked *The Subterraneans*, which he described as 'this bad Kerouac book' – bad because its fugitive, transcendental romance of the open road now seemed merely self-indulgent. Oldenburg defined himself as one of those 'WHO DO NOT WISH TO ESCAPE'.

Immured in America, Oldenburg and other like-minded detainees adopted their own dissident policy: 'we thus become clowns or wits or wise men.' Their conceptual jests aimed to redefine culture. John Cage, who enjoyed the randomly tuned barrage of the New York streets, defined music as 'anything a

man "makes"'. His quote marks registered a doubt about the god-like conceit of creativity. Can a man make anything at all? Do we not merely copy what already exists? Cage thought that 'theatre takes place all the time wherever one is, and art simply facilitates persuading one this is the case'. At Black Mountain College in North Carolina in 1952 he propped himself on a ladder and recited an anthology of sacred texts, ranging from Zen Buddhist tracts to the Declaration of Independence. Meanwhile Merce Cunningham danced a duet with a dog, which revised his choreography to suit itself, and Robert Rauschenberg superintended the musical score by playing records at the wrong speed. Rauschenberg explained his own activities by saying that he acted in the space between life and art. He painted, but he also scavenged for urban flotsam, which was ready-made art. In 1953 he rubbed out a drawing by Willem de Kooning. It took him a month to wipe out all traces of the sketch; he expended forty erasers in the process. Having finished the job, he presented the spoiled page as a new work of art, created – although that was hardly the word – by himself. It was a complex, quizzical joke. Oldenburg remarked in 1967 that drawing was a magician's trick: it conjured objects out of nothing. The artist who managed such wonders could equally well make things revert to nothingness again: 'Hitler, he erased half of Europe, but the world is *not* a drawing.' We suffer in modern times from 'flagging belief in Reality', and Oldenburg warned that 'art as life is murder'.

Better to copy than to create, because creativity hints at the converse activity of destruction. The serial manufacture of copies also aligned art with the productive zeal of industry. Roy Lichtenstein worked his way through the icons of modernism, reproducing them in a bright, brisk shorthand. His Pop facsimiles questioned the sorcery of those painters who had altered and abstracted visible reality. He made five studies of Rouen Cathedral, based on the series by Monet. The impressionist cathedral had melted in the light: the observed object capitulated to the subjective observer. But Lichtenstein's cathedral is no vague, shimmering apparition; it consists of a dotted grid, colour-coordinated to match the times of day – mild yellow, torrid red, nocturnal blue. Since Gothic cathedrals were collective endeavours, Lichtenstein left most of the series to be completed by his assistants. In 1973 he painted a version of *Horse and Rider* by the futurist Carlo Carrà. The futurist horse, a prototype of the racing-car, vanished into a windy smudge as it gathered speed. The same finicky dots which stabilized Rouen Cathedral stop Lichtenstein's horse in its tracks. Its planes are made sharply distinct: it has two heads, three sets of legs at front and back, and the rider possesses four jerky heads – this is how the illusion of movement can be contrived in a static painting. The future, which now belongs to the past, has lost its frenetic urgency. In 1977 Lichtenstein turned his attention to surrealism. He painted a girl weeping – but the tear she sheds is crystalline, and even its inky shadow is solid; she has been saved from the liquid decay which Dalí wished on the world.

Lichtenstein's atomic specks reduce a painting to a diagram. Like the dots on the matrix board which spell out news headlines and advertisements above

Times Square, they can be programmed to say anything you like. Oldenburg pointed out that American painters usually painted houses or advertising billboards. Rauschenberg, as if coating a house, produced a series of canvases which were entirely white, and Jasper Johns investigated the unconscious artistry of signs, turning the flag which symbolizes America back into décor, design. Oldenburg improvised flags from driftwood gathered on the beach, or cooked them up from muslin soaked in plaster, laying on paint in garish candy colours so that they looked like ravaged birthday cakes. These solemnly playful experiments questioned both the nature of art and that of the United States, a nation convened around the veneration of symbols which sometimes forgets – since, as the anthem insists, 'Our flag was still there' – that those symbols are fictitious and thus mutable.

There was no longer a need to renew the world, which had been the modern mission; instead segments of reality could be preserved in all their pristine anarchy. Rauschenberg maintained that 'Times Square is America's greatest work of art'. A California chauvinist might have responded that the billboards towering above Sunset Boulevard were America's greatest art gallery. The city had its own scenery, alternately arid and tropical. Oldenburg likened Manhattan streets to desolate plains or torrential rivers, and saw the shops as tangled, teeming forests. Advertisements grew into a matted foliage of 'creeping and crawling dreams'. In a church on Washington Square Oldenburg exhibited a mural made from dirt and refuse, and he sold his own frivolous merchandise – yesterday's archaeological relics, including 7-Up signs and calcified pies made of gooey plaster – in a

Joni Mabe
Traveling
Panoramic
Encyclopedia
of Everything
Elvis *(1993)*

studio which he called The Store. With these environments, New York acquired its own unkempt equivalents to the national parks cordoned off by American romantics.

On his first journey across the country, Warhol reported that America became more Pop the further west you went. Travelling along the same road, Robert Venturi in 1972 challenged his fellow architects to learn from the florid casinos and uproarious neon signs of Las Vegas. What architecture could learn was that buildings, as Venturi put it, were never more than decorated sheds, boxes with attitude. Lichtenstein desanctified Rouen Cathedral by applying to it the graphic conventions of the comic strip; Venturi brought about the same confrontation between high and low by defining Amiens Cathedral as 'a billboard with a building behind it' and invidiously contrasting it with the Golden Nugget casino in Las Vegas. The cathedral's billboard was its sculpted portico, which had votive niches to house the saints. But this advertisement for the afterlife paled when set against the electric firmament outside the gambling hall, with a strobing clump of gold as its lodestone. The shed had disappeared behind its spangled, celestial décor. Tracing embellishments of its façade, Venturi reported that 'by the 1960s, [the Golden Nugget] was all sign; there was hardly any building visible'. Through the incandescent door, there lay only the dream of enrichment, and after that the desert.

When the Pop vision reached the coast, it found an entire city of freestanding signs which had no intention of meaning what they said. In 1966 Ed Ruscha painted the HOLLYWOOD sign, sweeping across the hilltops and elasticizing the horizon like a CinemaScope lens. Behind it burns a shameless sunset, crimson and orange, painted on a sky-cloth inside a studio. But the letters of the sign are blotched, and Ruscha takes care to show the metal struts which hold them up. At the same time, Ruscha assembled a photographic dossier of Los Angeles parking lots. He photographed them from the air, and made sure that they were empty: this is a mass society from which the mass has gone missing, a motorized culture in a condition of serene and eerie stasis. With the people and their vehicles cleared away, Ruscha could study the language of signs, so valiantly determined to make the world intelligible and so plaintively incapable of succeeding. The tiered gulf of Dodgers Stadium, vacated, stands like an extinct volcano in a wilderness ruled at finicky right angles, with positions for tens of thousands of non-existent cars; the address of this unearthly place is a suburb called Elysian Park. Another would-be heaven imprints itself on the ground at Century City, a development just outside Beverly Hills, constructed on the ruins of the Twentieth Century Fox backlot. Ruscha looks down at one more depopulated grid, a parking lot on the Avenue of the Stars. The stars, however, do not shine in this merciless daylight, and the oblong of asphalt with its geometrical markings might be a glimpse of deep space, inky and alien. The aerial perspective sees through all illusions, and shows what the sheds look like without their decoration. Ruscha's vertical angle eliminates façades and exposes the rooftop

tangle of ducts and pipes which they were meant to conceal. One photograph hovers above a vacant parking lot in Van Nuys, with arrows pointing in all directions around an oasis of sheds and shrubs. According to the title, this is the Church of Christ at 14655 Sherman Way, but, without a billboard, the church remains unidentifiable. In which of those sheds does God reside when he visits the San Fernando Valley?

The banal Elysium of the Los Angeles suburbs suited the world-view of Pop. Museums, which André Breton wanted to demolish, could be safely excluded from your itinerary; the average house on a side-street was now a cornucopia of art. In 1956 a collage by Richard Hamilton ingenuously asked *Just what is it that makes today's homes so different, so appealing?* Hamilton happened to be English, but when societies began to enjoy affluence, they became outposts of America, and his domestic haven was pieced together from transatlantic sources. He created nothing, simply cutting objects out of magazines and brochures and gluing them into place. Homes in the affluent society are convocations of goods. Equipped with a technological wish-list, we go shopping for the life we have seen portrayed in advertisements.

Richard Hamilton's consuming couple at home

The home assembled by Hamilton is occupied by a posturing muscle-man, who grips a Tootsie popsicle at groin level as if it were a dumb-bell. On the lolly's wrapping, the word POP made its debut in a work of art. The body-builder's other half, naked except for a modish lamp-shade on her head and some metallic cones which armour-plate her nipples, preens on the sofa. Beside her on the coffee table is a tin of ham. She is meat; he too exists, as his thrusting popsicle proclaims, to consume and to be consumed. Their state of undress should not be surprising. Their home is so different and so appealing because it is a playground, like the beach. In fact their black-and-white rug is a blown-up extract from Weegee's photograph of the beach at Coney Island on a July afternoon in 1940, sweatily congested, as the photographer testified in a caption, by a 'crowd of over a MILLION...(I wonder who counts them)': Hamilton's couple trample the pulped bodies which make up a mass society. Furniture has been pushed into the corners, to make room for their appliances. A television set supplants the hearth, a tape

recorder squats in the middle of the floor, and a vacuum cleaner – since work is now a spectator sport – has been left out for a demonstration.

Across the street, a cinema anachronistically advertises the 1927 première of *The Jazz Singer*, the first talking picture, in which Al Jolson, before bawling a song, warned his audience 'You ain't heard nothing yet'. Technology promised permanent revolution, and Hamilton's couple, perched in today's home, are ready to move on when tomorrow arrives. To ease their take-off, the room has no ceiling. Instead a pock-marked planet impends overhead, above a cornice as black and unsettling as one of Ruscha's empty lots. Are they already living extra-terrestrially? They have no grounding, despite their potted plants. Their beach is a rug with a photograph mechanically printed on it, and their lamp has a Ford medallion on its shade, enjoining them to keep on the move. Warhol, explaining his choice of tinfoil wallpaper for the Factory and his taste in platinum wigs, summed up the volatility of a society unmoored from nature by its machinery (and perhaps incidentally explained the low-flying planet in Hamilton's collage) when he said that the 1960s were 'the perfect time to think silver. Silver was the future, it was spacy – the astronauts wore silver suits.'

Homes were different because you saw parts of them not open to cultural inspection before. The lavatory, for instance, no longer guarded its secrets behind locked doors. Attacking the degeneracy of ornament, Loos accepted that a lavatory would probably be a shed with decoration on its walls. Because the ornamental impulse was lowly and regressive, naturally it would overtake civilized men during defecation. But Loos made the absence of graffiti a criterion of mental evolution: 'the level of civilization of a people can be judged by the state of the walls in their latrines'. Modern lavatories were required to be austere, abstract, unornamented. Oldenburg overcame this puritanism with the soft, floppy toilets which he manufactured from cardboard, canvas and vinyl in 1966. B, haranguing Warhol, treats him to a manifesto of what she calls 'art in the toilet'. She celebrates the bowl's gluttony, treating it as an inexhaustible consumer. She feeds it shredded magazines, 'tons of food', and a plantation of little American flags which she has bought in homage to Jasper Johns. Everything is promptly gobbled up and flushed away. Warhol later made his own series of so-called oxidation paintings, which used urine instead of pigment. Why should the body be shy about expressing itself?

David Hockney's early paintings opened up an additional recess when they recommended the shower – one more affluent American luxury, newly arrived in grubby England – as a resort of pleasure, where young men could combine sex with sanitation, managing both without ever needing to lie down. Love had been banished from the suburban bedroom which Oldenburg constructed in Los Angeles during 1963, because it might have interfered with the décor. The bed was a stony, unresilient slab, its sheets stretched as tight as those on a military bunk. Zebra-striped trimmings in fake fur, like the beach mat in Hamilton's collage, joked about nature's surrender to culture. Working in New

York, Oldenburg had been a connoisseur of junk, of objects roughened and affectionately eroded by use; in Los Angeles, however, he found 'cemeteries of formica'. But those cold, pallid plastic surfaces and the chill of the air-conditioning gave his bedroom a solemnity which once belonged exclusively to crypts or cathedrals, not private houses. Sleep was too casual and relaxed an activity for this setting, sex too urgent. It was a place designed for dying, a 'rational tomb, pharaoh's or Plato's bedroom'. Its gruesome, outmoded glamour enforced the sense of suffocation and mortality: Pop, relentlessly trendy, was conscious of time's swift passage, aware that a style is only definable in retrospect, after the decade which has created it is defunct. As Oldenburg tersely noted, 'all styles on the side of Death'.

What, after all, is culture? A process of cultivation, which depends on the transition from outdoors to indoors, raw to cooked. Therefore it seems only logical and democratically proper to base a definition of culture on the preparation of food. Nourishment is necessary, but sauces and spices and sugary condiments are superfluous. These ornamental additions, however, mark the difference between predatory feeding and polite eating. The beauty of American fast food, for Pop artists, lay in the artificiality of its ingredients, and its cosmetic appeal to the eye rather than the taste buds; it had more to do with art than with nutrition. Therefore Oldenburg set up in business as a short-order cook or a confectioner, producing dishes of vinyl, plaster and corrugated cardboard which could only be consumed visually – hamburgers whose grinning mouths extrude cheese, a log-jam of French fries with a dollop of ketchup, ice-cream bars made from ticklish synthetic fur, pastry cases of glutinous fruit pies. The ketchup did not run, and the ice cream never melted. This was consumerism saved from a degrading trans-it through the body.

In New York, Oldenburg described his Store as a cloaca, excreting its soiled contents into society. Los Angeles, which for him was 'the paradise of indus-trialism', kept the gore and grime out of sight. This is why the bedroom he built there excludes all trace of human occupancy: it resembles 'the frankfurter in its nonremembered distance from the slaughterhouse'. Surely the hot dog was never a pig. We claim to be disgusted by food which we call plastic. Shouldn't we be grateful to it because, like Oldenburg's inedible desserts, it separates us from the gross, bloodthirsty imperatives of nature? It is the next best thing to a symbolic diet of encapsulated vitamins. At least Oldenburg's titbits are served up on plates, teasing our salivary glands. On Warhol's silk-screens, the bottles of Coke and cans of Campbell's soup remain unopened. For preference he illustrated cartons already packaged in bulk at the factory: twenty-four boxes of Kellogg's corn flakes, thirty-six cans of Campbell's tomato juice. The habit, by contrast with Oldenburg's indiscriminate cloaca, suited Warhol's retentiveness. He was hoard-ing supplies for a pharaonic or Platonic larder. But Warhol's personal supermar-ket also paid tribute to the affluent economy, whose surplus – gold at Fort Knox, or those European wine lakes and butter mountains – will never be consumed.

After food, the next constituent of culture is clothes, which also cross the dividing line between necessary and superfluous, raw and cooked. Salads are only respectable after they have been dressed, but the dressing has no value as nutrition. In 1940 Gertrude Stein remarked with her accustomed sagacity that 'fashion is the real thing in abstraction. The one thing that has no practical side to it.' The basic garments are as compulsory and changeless as the body parts they cover. Yet they undergo constant, capricious revision, even though – since all possibilities were long since exhausted – innovation relies on a revival of the past.

Claes Oldenburg
White Gym
Shoes, *made of*
plaster-soaked
muslin (1962)

Cecil Beaton commented that the dress designs of Coco Chanel were 'virtually nihilistic', because she assumed that 'the clothes do not really matter at all, it is the way you look that counts'. The body underneath did not matter either: it was a shed awaiting decoration. Were the designers punishing a body which had proved incapable of metamorphosis, and thus had failed the challenge of modern times? During the 1920s women, having bobbed their hair to resemble boys, suddenly lost their breasts – or at least the new flat-chested profile of their clothes pretended that they had cast off this female encumbrance. Paul Poiret's costumes banished the corset and set the abdomen free; but while liberating the body's upper half, Poiret devised a new prison for its lower extremities, shackling the legs of his clients in tight skirts. Fashion is an end game, a conspectus of limited possibilities. Hence its recyclings. After 1945, Christian Dior designed a collection of geometrical cocoons, extravagant in their expenditure of cloth. The novelist Nancy Mitford pointed out that Dior's New Look was anything but that: he was manufacturing 'chintz crinolines'.

Unable to evolve, fashion repeats itself, and thus confirms Oldenburg's comment on the deathliness of style. Its only recourse is to separate form from content: it delights in signs which – like Johns's flags – have had their significance annulled. The 1960s ironically revived Edwardian frock coats and decommissioned military uniforms. The signals in Ruscha's parking lots point all ways at once, cancelling each other out. Clothes, semiotically overburdened, had the same mixed motives.

Lillian Hellman, when she refused to testify before the House Committee on Un-American Activities in 1952, indignantly insisted that she would not cut her conscience to suit the current year's fashion. This was a defiantly old-fashioned remark: in the next decade, the conscience proved as elastic as a dress design. By 1968 mini-skirts had climbed so far up the hips that they threatened to disappear altogether. Reaching a dead end at the pelvis, there was nowhere for a skirt to go but down. It did not matter that this signalled a retreat from the sexual revolution which those soaring hems inaugurated. Discarding their minis, Warhol's friends scavenged items from thrift shops to create what he called 'the Pakistani-Indian-international-jet-set-hippie look', festooned with brocades and embroidery. The pile-up of adjectives blended worlds which had nothing in common – the Third World and affluent America – and took stock of a new global culture in which anyone, whether they could afford to travel by jet or not, had the chance to be a Chinese fellow-traveller in a Mao jacket or an Indian peasant in a tie-dyed tunic or an Alabama hillbilly during the Depression in a pair of faded jeans.

Warhol fervently declared that he believed in jeans, and wanted to be buried wearing them. They were a time-consuming responsibility, almost a voca-tion. You had to live up to them. 'They can't be bought old', Warhol advised, 'they have to be worn in by the person.' To speed up the ageing process with bleach was strictly forbidden. Their repeated laundering mocked the sanitary obsessions of puritanism, because jeans were washed to make the colour run, not to keep them clean. Their durability, however, threatened to end the fashionable game. They never needed to be replaced, because their design was proof against interference; besides which, everyone had invested so much effort in persuading them to fade. Although produced in a factory, they almost restored the rarity value and idiosyncrasy of traditional craft. You bought them off the rack, then set about shrinking them to fit, until they adhered to the irregular contours of your body. Strung up in the shop, they were all the same colour; when they began to bleed, each pair looked different. Warhol wished he could have invented jeans: better than any work of art, this would have been 'something to be remembered for. Something mass.'

But the universal adoption of jeans demonstrated the self-defeating logic of fashion. The industry devises a new look, only to discover that everyone has taken it up. Its originality is devalued, and a newer look becomes necessary. If everyone was wearing jeans, how could they remain a symbol of rural informal-ity or proletarian dissent? Warhol noticed the same self-mistrust overtaking Bob Dylan, who had to constantly redesign or re-outfit a persona which his admirers coveted and co-opted: 'the more he said "I'm only me", the more the kids said "We're only you, too"'. If your identity depends on your clothes, it is easily stolen. In 1966 the singer Jim Morrison wriggled into a pair of leather pants. Warhol's crony Gerard Malanga indignantly protested that Morrison 'stole my look!' Malanga did not realize that you cannot patent the spirit of rebellion. The

infidel Sade – described by Camus in 1951 as 'our contemporary', because he had anticipated the moral revolt of man when set free from God's tutelage – now lent his name to a fashionable style, which Warhol called 'the S & M leather look'. The look could be affected, and was no guarantee of the wearer's political or spiritual credentials. Not all the owners of leather jackets were wild ones like Brando, and very few of them rode motorcycles; they may have frequented homosexual bars in the New York meat-packing district, but they travelled there by taxi.

A sign with its signals crossed, form applied in defiance of content: this was the kind of imposture defined as 'camp' by Susan Sontag in 1964. Tom Wolfe labelled this modish self-contradicting manner 'radical chic'. He coined the phrase in 1970, in his account of a party given by the conductor and composer Leonard Bernstein at which the revolutionary Black Panthers mingled with fashionable New York. As an example of camp, Sontag cited 'stag movies seen without lust'. The same criterion could be applied to terrorist diatribes listened to without fear. A paramilitary Panther warned his host that the means of production would be violently appropriated from the class of white oppressors, to which Bernstein belonged. 'I dig', nodded Bernstein, 'absolutely', treating the lecture as a jazzman's riff.

Amused and slightly puzzled by his own commercial success, Warhol said that 'an artist is somebody who produces things that people don't need to have but that he – *for some reason* – thinks it would be a good idea to give them'. An advertiser, it might be added, is somebody who persuades those same people to want what they do not need. The reason, quizzically italicized by Warhol, need not concern him: it is whatever the client who engages his services tells him. Nor is there any question of giving something away. The advertiser, unlike the artist, exists to facilitate a sale – although in the culture of consumerism, the artist comes to think of himself as a trade-marked product which he is responsible for publicizing: in 1959 Norman Mailer entitled a collection of his essays *Advertisements for Myself*.

Aware that the very plenitude of objects kills off their aura of desirability, advertising separates the aura from the object itself, and thus mystifies the crass salesmanship involved. A fashion editor remarked in the 1950s that companies marketed 'the sizzle and not the steak'. Transformed into a sensation, products could be sold in their own absence. Warhol prepared a campaign for Modess sanitary napkins in 1959. Because the new V-shaped Modess napkin could not be illustrated, Warhol drew V-shaped symbols of it – a flower sprouting between two petals, a triangular formation of birds. The company's punning name exemplified the same subtle, evocative art: it fused mode and modesty, and doubled its *s* in a feminine ending which recalled that women who wrote poems used to be known, with demeaning chivalry, as poetesses. Contemporary advertisements often pretend to disdain this trickery. Nike currently declares 'We don't sell dreams, we sell shoes', and Sprite says of itself 'It's not an image, it's a drink'. But

if these products honestly meant to dispense with metaphor, myth and all other poetic inducements, should they not reconsider their brand names? Nike was the winged Greek goddess of victory, and a sprite is a fizzy, carbonated fairy.

During the 1950s Warhol was known to the New York advertising agencies as 'a kid who did shoes'. It was what he did to them that made him so employable: he fantasticated them. Shoes are necessary, to keep your feet dry and warm. But heels are superfluous, and often so impractically spindly that they hinder your walking. For that very reason, heels are a shoe's selling-point. One of Warhol's layouts exhibited a procession of heels, which looked like a universal history of the architectural column. There were heels of silvered bamboo and others with pagoda carvings; they were made of polished mosaic or tortoiseshell or studded with pearls; if you were an austere classicist you could buy yourself a slim golden stilt. At the same time he designed, for his own delectation, a series of celebrity shoes and boots, trimmed with gold foil and silver frills. The celebrities had to be deduced from their footwear: a rococo slipper with a teetering heel for Zsa Zsa Gabor, cowboy spurs for James Dean. But what happened if you removed these jewelled casings? You were left with an unglamorous standard-issue foot, more or less the same as anyone else's.

Warhol, experimenting with his own power to confer and then confiscate allure, began to draw a series of celebrity feet. The joke was that the feet of celebrities are beneath celebration. Fame runs out before the ankles. Our faces pretend to be ours alone; otherwise we consist of readily transplantable parts. Late in his life, Warhol tested this proposition by making a Polaroid inventory of penises. *Blow-Job* concentrates on the face, which registers all the sensations which originate below: sex happens behind our eyes. The Polaroids brusquely reverse this order of priority. Bodies, decapitated or truncated, are merely the superstructure which holds up these all-important organs. The penises are implements, mechanical and therefore faceless. They can be differentiated according to their dimensions, but not individualized. Nature too runs a factory, organized for mass production.

The idea of the mass assumed that the individual was expendable. Supply exceeds demand; obsolescence is built in. Advertising ensures a rapid turnover – of product, and of persons. A sartorial fad which had a brief life during the 1960s was that of the electrified dress, equipped with its own batteries. The dresses fused or fizzled out, or else the batteries became flat. They were discarded, and those who wore them shared their fate. Warhol brooded on death's industrial productivity. In 1961 he sketched the front page of a hand-written newspaper, broadcasting and perhaps inflating the day's disasters. The headline of his home-made *Daily News* bellows 'PIRATES SEIZE SHIP WITH 900000', but runs out before it can give further details. Can the hijacked liner really have had 900,000 passengers? No, Warhol has supplemented the quantity of those in danger by doodling in a few extra noughts. In 1981 he had no need to interfere with reality: the headlines of an Italian newspaper which he silkscreened bewail

the mass destruction in a Neapolitan earthquake – 'CRESCE IN MANIERA CATASTROFICA IL NUMERO DEI MORTI (SONO 10,000?)'.

Applying his skills as an advertiser, Warhol marketed people as if they were products, and briskly withdrew them from circulation when their sell-by date passed. He promoted his 'superstars' in order to demonstrate that a nonentity could be passed off as a celebrity. 'Before media,' he commented, 'there used to be a physical limit on how much space one person could take up by themselves.' Nowadays your image can proliferate to infinity; without leaving home, you can take over the world. The marketing of celebrity fragrances, for instance, disseminates an invisible image, an olfactory presence: Warhol understood that 'another way to take up more space is perfume'. The first beneficiary of his powers as a publicist was a woman from New Jersey, who rechristened herself Ingrid Superstar. Others followed her example, assuming aliases that were brand names, like Warhol's court photographer who was known as Billy Name. There were rich waifs like Edie Sedgwick, or professional muses like Ultra Violet. Warhol precisely timed their spell of fame: fifteen minutes was the allowed tenure. After that, they were due for replacement by someone younger or at least newer, or more bizarre.

These aesthetic outlaws with their abbreviated life-spans resembled the self-publicizing bank robbers played by Faye Dunaway and Warren Beatty in Arthur Penn's 1967 film *Bonnie and Clyde*. The real Bonnie and Clyde were driven to crime by the Depression. Seen from the vantage-point of the 1960s, they have different motives: they are bored, and want to be famous. Warhol thought this a legitimate interpretation: 'I mean, the real Bonnie and Clyde sure didn't look like Faye and Warren. Who wants the truth? That's what show business is for – to prove that it's not what you are that counts, it's what they *think* you are.' In the film, Bonnie and Clyde are aware that their instalment of fame is fast ticking away, and they expect death at any moment. They bring retribution closer because they make the amateurish error, which a professional showbiz couple would have avoided, of overexposing themselves. Bonnie sends her poems to the newspapers, supplying Kodak snaps to illustrate them. They have advertised themselves only too efficiently, and imagine that stardom confers immunity.

When one of Warhol's superstars committed suicide by jumping from a top-floor window in Greenwich Village, his only regret was that he had not been there to photograph the collaged mess on the pavement. If filmed sex can be watched without lust, it should be possible to watch filmed death without commiseration. Sam Peckinpah's *The Wild Bunch*, released in 1969, begins and ends with massacres, laid on for both profit and pleasure. The bounty hunters have itchy guns, and impartially slaughter robbers and innocent bystanders. 'This is better than a hog killin'!' one of them gleefully whoops. They steal boots from the corpses, and argue about the size of the bullet holes in order to establish who has killed whom; then they tally the cash value of their booty, deducting their agent's commission. There is no need for William Holden's bunch of retributive

desperadoes to go on shooting after they have eliminated the corrupt Mexican general. Or perhaps they have no choice. A machine-gun, which the Mexicans have failed to mount on a tripod, has ideas of its own. It greedily digests ammunition, then regurgitates the bullets in a circle while the soldiers incompetently grapple to control it.

The ambush at the end of *Bonnie and Clyde* insisted on displaying the violence which was society's motor, responsible for the relentless pace of technical innovation. This was another moment at which human sensibility changed, adjusting official tolerance levels and making a moral anaesthesia like Warhol's respectable. Beatty and Dunaway – wearing white, the better to show off their blood – are peppered by invisible guns. He cannot run: the barrage holds him in place, and continues to roll him along the ground after he dies. She is sitting inside their car, as if strapped into the electric chair. She jerks and twitches as gunfire punctures her, with the agitated, involuntary movements of a marionette. The bullets are a galvanizing transfusion of life, which animates these immaculate corpses and makes them dance. That energy comes from outside, not from within: the body passively intromits whatever society feeds it – dreams, goods, death.

GODS AND GADGETS

Technology, like revolution, promised Utopia. Freud thought that the new man, freed from physical drudgery by appliances which were like artificial limbs or telepathic talents, would soon mutate into a 'prosthetic god'. Supernatural powers were no longer the preserve of deities: in modern times, telephone cables and satellite beams put a girdle round the earth instantaneously, abridging the twenty minutes which Shakespeare's Puck needed for the circumnavigation, and everyone can perform miracles with the aid of plug-in genies.

In 1967 Marshall McLuhan paraphrased the manifesto in which Marinetti and the futurists had, more than half a century before, welcomed the revelations of the new physics: '"Time" has ceased, "space" has vanished.' The end of time, however, did not inaugurate that apocalypse so gleefully anticipated by the futurists with their hectic chariots and their lust for battle. Time was to end in a party, the ultimate rock concert. Television, beaming images around the globe, made all the world's separate time zones overlap in 'a simultaneous happening'; it created a joyous sensory overload which McLuhan, excitedly gabbling, called 'allatonceness'. The vanishing act of space was no longer a bad dream, like Kandinsky's response to the electron theory. An imploding world, contracted by high-speed circuitry, was a cosier place, a 'global village' snugly unified by the Beatles' anthem 'All You Need is Love'. It banished the metropolitan loneliness which Simmel described as the psychological fate of modern man: people, McLuhan claimed, were now 'profoundly involved…with one another', umbilically connected with their fellows, absorbed by membership in a community where they were all, like their television tubes, grateful receivers of images and information. In his study of advertising, Vance Packard noted that machines were not only sold as utilitarian aids. They promised to ease our anxiety, to purvey reassurance. A freezer means that a house is abundantly stocked with food, which is the currency of comfort and love. An air-conditioned room, sealed against the outside world and contentedly humming, returns you to 'the security of the womb'.

Nam June Paik
Robot
(c. 1964)

The moral panic of modern times derived from a fear that our race towards the future was hurling us backwards into the past. For this problem too, McLuhan had a solution. Primitivism need not mean the brutal rite of renewal staged in Stravinsky's ballet, or indiscriminate mechanized slaughter on the Western front. What McLuhan called 'the primordial feeling' was an electronic cocoon. Without remorse he rescinded the long, arduous advance of culture by arguing that an 'electrically-configured world' had brought back 'the tribal emotions from which a few centuries of literacy divorced us'.

This was the blissful good news broadcast throughout the age of Aquarius. When people found that their gadgets had neither made them happy nor convened a global love-in, a new set of electronic familiars were ready to keep the messianic promise fresh. *Wired*, the magazine which currently spreads the gospel of the Internet, quoted the philosopher of eighteenth-century revolution Thomas Paine in its initial issue: 'We have it in our power to begin the world over again.' This appropriation of Paine's zeal fails to acknowledge a difference between his agenda and that of the computer-users enmeshed in the net or surfing the web. Paine's newly-begun world aimed to rectify abuses, to correct the iniquities of history. *Wired* begins the world over again by ignoring it, not by reforming it. Space literally vanishes: cyberspace is nowhere. A café in London which serves coffee to famished hackers while they wait for access to the Internet calls itself Cyberia. The allusion to an icy, unpeopled waste is bleakly witty. Joseph Roth, who called the cafés of modernist Vienna 'encampments of nomads', would have been amused. McLuhan at least hoped, with the heady optimism of the 1960s, that frictions within the community would be eased by our electric co-ordination. The Internet wishes community away, then reconstructs a virtual replica of it. Its users, drawing on a collective pool of information without ever needing to confront the individuals who contributed to it, are practising solipsists.

Technology may not have saved our souls, but it does save time and toil. A debit and credit ledger for the twentieth century would certainly place the Somme, Auschwitz, Hiroshima and Sarajevo on one side. On the other, not quite ensuring a balance, would have to be jet planes and intercontinental telephones, credit cards and the automated replacements for bank tellers, which in some countries even wish you a nice day and flash a smile across the screen. These are undeniably benefits, ameliorations of life; yet they are not unmitigated, and the worry is that they merge with the atrocities in the first column. Science has no partiality, and would just as soon invent a machine-gun as a compact disc. Technology does whatever job it has been programmed for, even if the chore is genocide.

With glass eyes and limbs of retractable steel, Freud's god is a faintly monstrous creature. Those prostheses tactlessly remind us that technology helps to repair our bodily deficiencies. Spectacles, for instance, are an ocular crutch. Léger advised modern men to have their eyes remade. While that remains impossible (although vision which has slipped out of focus can be permanently

readjusted by lasers), most of us beyond a certain age rely on a supplementary set of eyes. Yet it is slightly shaming or irritating to depend on these bits of polished glass. Do they not somehow diminish the body which wears them? In *How to Marry a Millionaire*, Marilyn Monroe blunders through the world in an adorable myopic haze. She chooses to bump into furniture, believing that men don't make passes at girls who wear glasses. A horn-rimmed suitor persuades her to love her spectacles by insisting that they make her face look mysterious. They too are a medium, and they mediate what passes through them, even if they are perfectly transparent: they refract her features, and by imposing one more flimsily defensive layer between us and her, they tantalize us like lacy underwear. She ends sweetly reconciled to this particular technological boon. All the same, the film nervously acknowledged that its viewers might be more suspicious. It was made in CinemaScope, still a new process, and the advertising campaign for its first release in 1953 reassured audiences that 'you see it without glasses' – a taunt aimed at the competing format of 3-D, which required viewers to wear stiff, uncomfortable polarizing spectacles.

Before she accepts that her diamanté specs are not a dirty secret, Monroe reads a book while holding it upside-down. David Wayne, flirting with her, comments that she has 'the most peculiar vision I ever saw'. The compliment registers a doubt about the rectitude of technology. Should such an idiosyncratic view of the world – so enterprisingly modern, like the back-to-front or upside-down print in cubist collages, or the sonata composed by Kurt Schwitters from random typographic gobbets – be pedantically corrected? Andy Warhol observed in 1975 that 'now, eyeglasses standardize everyone's vision to 20–20'. In theory he approved of this visual uniformity, 'an example of everyone becoming more alike'. But he pined for the variety which had been lost: 'Everyone could be seeing at different levels if it weren't for eyeglasses.' We value paintings because they regard the world subjectively and erratically. The impressionists look through an unfocused, luminous fog; Jackson Pollock stares into the swampy, dense impasto of things. The wearing of glasses eliminates that range of stylistic options and makes us all – so long as we keep our lenses polished – into super-realists.

The washing-machine and the vacuum cleaner deserve to rank high in the credit ledger. They have improved life; but they remain potentially terrifying, disruptive house guests. A washing-machine is a dynamo installed beneath the kitchen sink. When it spins, the drum revolves eight hundred or a thousand times a minute, shuddering on its supports and making the house vibrate. Behind the sealed door, enzymes attack and annihilate the grime deposited by our bodies, and a centrifugal force wrings the necks of our shirts. The vacuum cleaner whips up its own electric frenzy. Camus recognized its terrifying efficiency in his novel *La Chute*, when a character comments on the way the Nazis imposed their final solution on the Amsterdam ghetto. Seventy-five thousand Jews were rounded up for deportation or death: 'that's real vacuum-cleaning.' It used to be said that nature abhors a vacuum. Then the new physics located a vacuum within nature,

pointing out that matter consisted of empty space. In the nineteenth century the approved method of dealing with dust was to gently move it around, allowing it to resettle somewhere else. Where could it go, since it was an emanation of the air itself? Only into your body, and that was thought to be unhealthy because the specks carried germs. Fastidious housekeepers swept with soggy tea leaves, to soak it up. Vacuum cleaners can conjure dust from places inaccessible to brooms, such as the pile of a rug. They tug it out, then inhale it like a tornado or a jet engine. They are omnivores, gobbling mislaid wedding rings as if they were cobwebs. To open up the machine, when emptying or replacing the bag, is to intrude on

*A consumerist reliquary:
Jeff Koons*
New Hoover Deluxe Shampoo-Polishers, New Shelton Wet/Dry 10 gallon Displaced Tripledecker *(1981–7)*

another sinister alchemical trick: they compact the air and compress it into something apparently as solid as a grey, furry brick. Why could our imperfect eyes not see so much dirt in the room?

Appliances set us lofty, unforgiving standards. They criticize our hygiene; they also possess a vitality we could never emulate. Cohabiting with them, as if with pets, we expect ourselves to function as they do. During the 1960s, people began to speak of tuning in or turning on, imagining that their bodies had ignition switches. The context was often druggy: chemicals heightened consciousness, sending a charge of electricity through the earth-bound organism. We still use a shorthand which admires those who are 'on' or 'up', animated by some current taken directly from the mains. Warhol enjoyed watching others behave combustibly, but had no talent for it himself. 'I turn on', he explained, 'when I turn off and go to bed.' His pallor and frigidity were the attributes of a machine which conserved its energy by retracting the plug, or which had irreparably broken down.

The first gadget to force its way into our lives was the telephone. It did so impertinently; its bell issued a summons, and announced that our privacy was no longer impregnable. At first its alibi was an emergency. How else could the intrusion be justified? A phrase of E.M. Forster's, coupling 'telegrams and anger', neatly connected the technology of instant communication with the collapse of the old bourgeois order, where emotions were muffled and suppressed by decorative codes of conduct and the insurgent world outside the front door could be

held at bay. The telephone sneaked through that door, and dispensed with introductions and courteous preliminaries. The rich and powerful retain their privileged aloofness by employing servants or secretaries to answer their telephones, but even they have private lines with unlisted numbers. The telephone assumes that everyone is immediately accessible. For the bar girls in the opera *Mahagonny*, it is therefore a professional tool: its wires reveal the manipulability of men, and allow them to keep their customers at the tips of their dialling fingers. 'Is here no telephone', they grumble, and make plans to decamp from Mahagonny to Benares, which they believe to be better equipped.

No medium does its work of mediation more cunningly, reneging on its original promise. During the late 1970s, when it became the psychiatric fashion to get in touch with your feelings and administer comforting hugs to all and sundry, AT&T advertised its telephone network on American television in a jingle which chirped 'Reach out and touch someone'. The message had an inspired audacity, because that is precisely what you cannot do over the telephone. It permits communication, but with its own strict provisos. Unless the call is prearranged, one party must take the initiative, which may not be appreciated: what if the person on the receiving end is asleep, in the bath, or otherwise engaged? Circuitry creates an uninterrupted loop, but human relationships are full of holes and snags. And even if the person called consents to talk, your conversation has to do without the evidence of facial expression and body language.

The telephone suits a century in which we have become aware that minds and bodies, like the travelling clocks in Einstein's account of relativity, operate at separate and unsynchronized tempi. Our streams of consciousness never merge – or if they do, it is by accident: what used to be called, when

Salvador Dalí
Le Moment
sublime
(1938)

telephone technology suffered from such hiccups, a crossed line. This makes the telephone a perfect medium for unreciprocated love, and in 1930 Jean Cocteau wrote a one-sided telephone conversation, *La Voix humaine*, for a woman whose lover has abandoned her. The telephone is virtually synonymous with rejection. The instruction 'Don't call us, we'll call you' sums up a brutal truth about the inequality of business and personal affairs, in which one side possesses power while the other craves it, probably in vain. To hang up on someone is the definitive modern way of ending an association, more final than the slammed door at the end of Ibsen's *A Doll's House*. The woman in Cocteau's play begs the man not to cut her off, and when he – or some malign fate resident at the exchange – does so, she prays for him to call her back. This is the mocking, tantalizing privilege of technology. Our houses are veined with cables, which run beneath the streets to connect us. But the presence of the wiring cannot explain the absence of a call. Modern times add a new image to the annals of human unhappiness: a person in a room who watches the phone and wills it to ring.

In *La Voix humaine* the man, though unheard by us and unseen by the woman, retains the monopoly of power. He is an unmoved mover, silently present in the gaps between her phrases, when we must retrospectively guess what he has said to her. The telephone works by sensory deprivation: it seduces the ear, but refuses to satisfy the eye. McLuhan welcomed this as a subversion of literacy. He claimed that 'the dominant organ of sensory and social orientation in pre-alphabet societies was the ear', and dated the fall of man from the moment when 'the phonetic alphabet forced the magic world of the ear to yield to the neutral world of the eye'. Cocteau's suicidal woman would not have been persuaded by this argument. Love needs to have endearments whispered into its ear, but it also wants to see; and the eye, far from being cool and neutral, is the medium of appetite and sexual desire. The woman in *La Voix humaine* therefore insists on imagining what clothes the man is wearing, and boasts – juggling with bodily apertures and restoring the hierarchy of senses – that she has eyes in her ears. Denied the man's body, she clasps the telephone instead, and takes it to bed with her. The hand-piece, after all, rests on a support called a cradle. She gives flesh to the buzz which comes out of the wires and crackles in her ear, and likens the sound in the receiver to his voice as she heard it resonating inside his body, when she lay with her head on his chest.

Eroticizing the instrument, she turns a prosthesis into a sex aid. When AIDS made it dangerous to reach out and touch someone, the telephone cleverly compensated by devising an alternative to intercourse: phone sex, in which one person, for a fee, talks another to orgasm. The advantage was not only prophylactic. On the telephone, you make love with your eyes closed; no reality inhibits the imagination. In *La Voix humaine*, the man asks the woman what she is wearing. A red dress, she tells him, with a black hat. It is a lie. Having recently swallowed an overdose of sleeping pills, she is actually dressed in a bath robe. But the medium licenses such fictions, which are the aphrodisiac spice of phone sex. As

Truman Capote remarked of masturbation, the good thing about it is that you don't have to dress up.

Devotees of phone sex do not object to the presence of a third party, the telephone itself, because the gadget possesses a fiercer charge than the organs it pretends to unite. In Nicholson Baker's novel *Vox*, a man and woman on opposite coasts of the United States circuitously copulate by long-distance. At one point in their exchange, he wishes he could unscrew his 'cock-and-balls unit' like a bicycle crank and hand it over to her as a plaything. Of course if he were to unscrew it, he would no longer be able to feel anything through it. But Baker himself, explaining his hero's strangely magnanimous offer of self-castration, has said that there ought to be a bonus. He should be able to watch – or at least imagine – the woman as she put the dildo to work. For her, pleasure would be transferred from an organ to an apparatus; he would enjoy the superior pleasure of observation. The body has been curiously rewired in the twentieth century, routing all erotic sensations through the head.

The telephone is our closest confidant. How can the apparatus, inside its sheath of chromium or plastic, not respond to the fevered messages we ask it to relay? To pick up the receiver is like sitting down in a place still warm from the previous occupant's buttocks. Dalí found telephones to be repellently hot and sticky, and thought that they should be presented, like champagne, in an ice bucket. He also innocently wondered why, when he ordered grilled lobster in a restaurant, the waiter never brought him a cooked telephone. It may not have been edible, but that was the point: the crustacean was proof against the moisture which we breathe into the telephone. Dalí imagined other modifications of the appliance, to take advantage of its organic pretensions. Why not a telephone which could catch flies in its mouth-piece? Or one you could take for a walk, mounted on the back of a live tortoise? The mobile phone, dispensing with the tortoise, arrived soon enough.

It was a long while before the telephone, liable at any moment to jangle angrily like an alarm, lived down its association with urgency, desperation, bad news. Films, mimicking the unscrupulous playfulness of technology itself, experimented with new uses for the gadget – as a means of psychological terror, or a murder weapon. In *Sorry, Wrong Number*, directed by Anatole Litvak in 1948, Barbara Stanwyck plays a bedridden woman who overhears a plot to kill her on a crossed line, then has to wait alone in her house until the plot is carried out. The character's paralysis (which is imaginary) and her screeched boast 'I'm a hopeless invalid' link technology with bodily handicap: Stanwyck's phone resides on a bedside table, along with her medicines. The film was adapted from a radio play, and when Stanwyck telephones her father to describe the conspiratorial conversation, he suggests that the killers were probably actors on a radio programme. Radio days were a time of technological superstition, with stray phantoms haunting the ether. Orson Welles began his career as the nocturnal, disembodied voice of a detective called The Shadow, who claimed – were there eyes in the

radio's ear? – to see the evil in the hearts of men. Enjoying the power which the medium gave him, he went on to terrorize the entire eastern seaboard of the United States in his *War of the Worlds*.

At the very least, the telephone was a blunt instrument. Sidney Green-street hurls one at Joan Crawford in *Flamingo Road*, directed by Michael Curtiz in 1949. More subtly, the accident-prone hero in Edgar G. Ulmer's *Detour* strangles a woman with the flex. He does so at a distance, which makes him technically guiltless. She is in one room, he is in another, with a closed door between them; he tugs the wire to prevent her from using the phone – how could he have known that she had wound it around her neck? The telephone is an intermediary, an accomplice, and thus a scapegoat. Ray Milland telepathically cues his wife's death by making a phone call in *Dial M for Murder*. When Grace Kelly picks up the receiver on the other side of London, a killer hiding behind the curtains will step out and strangle her (though not with the flex). The process of dialling is almost as gruesome to watch as the botched murder at the other end of the line. Analytically fragmented and then filmed in close-up by Hitchcock, it is a ritual, a mechanistic procedure which at every stage mimes the murder which will occur when the call is answered. A finger aims at the dial, where the letter M, printed in red, occupies a niche of its own. The finger in question does not belong to Milland, or to any human being. Surreally enlarged, and protruding from the screen because of the 3-D process, it looks metallic or wooden, like a gun barrel or a sorcerer's wand; it points to a target, or sends a malevolent command through the air. A finger digitalizes the world, reducing everything in it to a number. The machine's denial of humanity is part of the preparation for death. Then, inside the exchange, we watch the grinding calculations as a brain not housed in a human body receives the numerical message, deciphers it, and sends the call on its way. It is an image of fate being fabricated, like the Norns in Germanic legend twining their rope. Finally, after listening as Kelly stabs her attacker in the back with a pair of scissors, Milland speaks to her. Here comes the last of those irrevocable transactions which make up the rite: he presses the button marked A on the black coin-box, and his money drops into the chute with a resounding clatter. Connected, he begins to tell her soothing lies.

An essential character in the mythology of the telephone is the person at the exchange who – before automation – used to give you a line, or put calls through for you. It was always a woman, because the myth's purpose was to give the technology a desirable human face (although you could never see it), and to make that face smile. In the musical *Bells Are Ringing*, filmed by Vincente Minnelli in 1960, Judy Holliday played the role of a medium who ameliorates the messages she transmits. She gets jobs for her clients, mates their cats, and exploits her invisibility in a repertory of funny voices which enables her to be whoever they wish. Even though she has fallen in love with Dean Martin's 'disembodied voice', she croakily imitates a little old lady when talking to him: 'He needs a mother', she reasons. This is God's work. Thanks to Susanswerphone, no prayer goes

unanswered. Yet although she fusses maternally over Martin, Holliday freshens her lipstick before putting through his wake-up call: she longs to be seen as well as heard. The telephone's confidentiality made it seem at first to be a female amenity. The woman is a receiver, a receptacle, and often a receptionist. One of Holliday's clients is a dentist, whose calls she has to field. 'This is the dental clinic', she purrs seductively. 'May I help you?'

Bells Are Ringing begins with a television commercial for Susanswerphone, anecdotally underlining the frustration of not reaching your telephone in time. This, it appears, is an exclusively feminine predicament. One young woman searches through the knick-knacks in her purse, unable to find her key while the phone rings inside the house. Another is such a messy housekeeper that she can't locate the ringing phone in her chaotic room (though she does discover an electric toaster beneath the bedclothes). A third is pampering herself in the shower, her hair turbaned in a towel. She splashes across the bedroom floor, reaching the phone just as it stops ringing. Thanks to the answering service, all three get their messages. A man makes calls, a woman receives them; etiquette requires her to be always beside the phone, pining expectantly. One of the subjects is informed that her agency called: 'You got the job.' She is presumably a model, whose body is her stock-in-trade. The second has a message from her lawyer: 'Your uncle died and left you everything.' She rejoices. The third is told that '*He* called, he wants to marry you'. It would have been as improper for her to call him as to propose. At the end of the film, the advertiser's voice returns to repeat the cozening promise of each new technological toy: 'You too can solve all your problems – by subscribing to an answering service!'

The angelic ministrations of Susanswerphone have since been delegated to a new race of gadgets. Before she hangs up, the woman in *La Voix humaine* has to stop herself from saying that she will see her former lover soon. This is unthinking telephone etiquette: she was going to utter the phrase, as she puts it, 'machinalement' – mechanically, in imitation of the machine. We have grown accustomed to such chilly alienation effects. Telephones have gone into partnership with tape recorders, so we talk to machines or awkwardly recite our own name and number on a recorded message. It is, before you get used to it, a stiff and stilted business, requiring cybernetic skills. In alliance with the fax machine, the telephone quietly defaults on its promise to bring us the next best thing to the real presence of a human being. The fax digests words which remain silent and translates them into specks of light. They dematerialize in one place, and rematerialize somewhere else – but faint, as if exhausted by their journey, and destined to fade from the curling page. Communication was never more than a pretext, an opportunity for the machines to exhibit their magical talents.

In 1897, suffering from a rheumatic wrist, Henry James bought a Remington typewriter, and engaged a stenographer to work it. He dictated a letter to a friend in Paris, whom he addressed, he said, 'only through an embroidered veil of

sound': a fine, exact definition of a medium. The embroidery was the sound of the machine, making audible the industrial process which turns the raw material of ideas into print. Writing ceased to be manual labour. A thought no longer had to travel down the arm, or rely on the hand for its expression. As always, technology usurped or cancelled a bodily function, and whittled away the evidence of physical presence. In James's case there were compensations, since our partnership with technology depends on complicated trade-offs. The arm may have been put out of action, as if disabled, but the legs were set free: James found to his delight that he was liberated from his desk, and could walk around while he dictated.

Handwriting, with those revealing quirks which graphologists know how to read, is a badge of personal uniqueness. Adolescents practice signatures because to inscribe your name is to assert your irreplaceability. The typewriter, like the printing press, imposed uniformity. This standardization suited Bolshevik dogma. During the late 1920s Rodchenko photographed typesetters positioning their metallic blocks of print and stereotype plates revolving on a cylinder; he followed the production line until it arrived at countless copies of the same newspaper, stacked in orderly piles. The Soviet citizen qualified as a specimen of what McLuhan called 'typographic man', who is always the same, capable of infinite replication.

In *Ulysses*, when Bloom walks through the printing works on his way to insert a newspaper advertisement, he discovers a less regimented society. The Homeric episode on which Joyce based the incident was set in the cave of Aeolus, the wind god. The printing works are likewise blustery, afloat on the rhetoric of the paper's contributors, one of whom is called an 'inflated windbag'. What is an ad if not a puff? Print has not silenced language. Newsboys cry the paper's headlines through the streets, and even the presses thud and mumble while they work, or clank in three-four time, amusing themselves with a waltz. Bloom understands and respects their force, which corresponds to that of the capricious Olympian gods: 'Machines. Smash a man to atoms if they got him caught. Rule the world today.' But Homer's gods were larger, louder versions of men, and the machines too are jovial ogres. The paper they turn out acquires a body in a boastful headline which refers to it as 'A GREAT DAILY ORGAN'.

Typographic man goes through his compulsory drill, policing a standardized world: Bloom sees a typesetter with 'proof fever' anxiously checking his spelling. But even here there are whimsical benefits. Although McLuhan lamented the tyranny of the alphabet, the keyboard, which ought to support that dictatorship, jumbles it by arranging the letters in an order – QWERTYUIOP for instance, the nonsensical compound on the top line – which makes sense to our fingers, so long as our eyes do not try to rationalize it; and the metallic plates which used to press words onto the newspaper looked at language even more outlandishly. Bloom admires a typesetter who distributes letters in reverse order, quickly spelling out the name .mangiD.kcirtaP.

But print is only a strait-jacket of correctness if you forget the possibility of misprints, which can be inadvertently poetic or riotously cheeky. A paragraph of genteel rapture about the Irish countryside collapses when one of Joyce's characters changes '*the overarching leafage of the giants of the forest*' to '*overarsing leafage*'. E.M. Forster delighted in the serendipitous typing errors of the scholar Goldsworthy Lowes Dickinson, who turned George into Geroge and Gerald into Gerlad. Even more whimsically, Dickinson changed husband to humsband and soul to soup. The language free-associated through the medium of his muddled fingers. Sometimes Dickinson indulged in more abstract outbursts, typing %%%%. Those unpronounceable symbols were a reminder that writing arbitrarily replaces thoughts with useless, non-referential pictures. Jean Dubuffet – who considered his own art of painting to be more eloquent and articulate than literature – mocked language as 'a rough, very rough stenography'. Words resemble an inefficient, overtaxed typist, scrambling to transcribe ideas and always failing.

Although James, with feminine daintiness, likened typing to embroidery, the machine possessed a harsher and more virile sexual identity. Technology

makes its swiftest advances during times of war, and after 1918 the typewriter prompted disturbing memories of militarism. In Vicki Baum's *Grand Hotel*, the manager of the Saxonia Cotton Company battles to arrange a merger with what he thinks of as an enemy firm in Manchester; he marches a secretary to the hotel's business zone to dictate some letters, and as they approach they hear the massed typewriters in the distance 'like faint machine-gun fire, with their bells ringing at regular intervals'. Commerce, facilitated by such impatient gadgets, is armed engagement by other means. The German painter Konrad Klapheck painted an adding machine in 1964: six feet tall, black, boxy and business-like, with its rows of keys mounting a monumental staircase towards the brand name, Ideal. This was a Platonically ideal machine with no paper inserted into the carriage, intimidating any human who might presume to use it. Klapheck also thought of it as an ideal husband, necessarily male because 'it has become the substitute for the father, the politician, the artist'. He meant, presumably, that authority depends on printed edicts, on impersonal decrees which conceal the fallible person from whose mouth they first issued. Klapheck shivered at the thought of the machine's domineering will, which coerces the typist to record his 'secret wishes and inmost thoughts'. The balance of power inexorably shifts, so that we seem to be working for the

machines rather than they for us: the typewriter gives dictation to the typist, extorting confessions.

Meek, menial helpers like James's amanuensis eventually disappeared, made redundant by technology. Writers had to do their own typing, which made them ask crucial, difficult questions about what writing was. How did art differ from craft, creativity from physical work? Jack Nicholson, playing a part-time writer and full-time killer in Kubrick's *The Shining*, conducts this inquiry at length and in maniacal detail. He locks himself away to write a book which consists of a single sentence, typed over and over and over again until it uses up a forest of paper, turning play into a penitential chore and dulling the brain: 'All work and no play makes Jack a dull boy.' Truman Capote made the same point, more cattily and laconically, in his comment on Kerouac's *On the Road*. This, he said, was not writing but typing.

Warhol related his emotional history by remembering the appliances he had dated. His first affair was with a television set. As he became more affluent, he could afford to be promiscuous. 'I play around in my bedroom with as many as four at a time', he reported. He was referring to his collection of television sets, each tuned to a different channel, each emitting its own brand of canned vitality, with hysterical laugh tracks and aphrodisiac commercials. This, however, was merely sex. He reserved his heart for another electronic gadget. In 1964 he married his tape recorder, which he called 'my wife'. It seemed a logical union, because machinery, as Warhol pointed out, had already established its usefulness in the bedroom: his friends made love with 'dildos and all kinds of vibrators'. Why not extend the regime to social behaviour, and record your life on tape? This marriage marked an end to the erotic excitements of youth. 'The acquisition of my tape recorder really finished whatever emotional life I might have had,' Warhol reported, 'but I was glad to see it go.' It absolved him from the need to feel anything, because the purpose of a medium was to deflect the messages it pretended to transmit. Life, when recorded, sounded like a performance. People overacted for the tape's benefit. Warhol himself did not need to sympathize with them, or even to listen; his main concern was that the tape did not run out.

In Francis Coppola's *The Conversation*, released in 1974, Gene Hackman plays a bugging expert who has taped a cryptic conversation in which two people are either describing their fear that they may be murdered or plotting a murder of their own. His assistant, John Cazale, puzzles over the meaning of what they are saying. Hackman snaps that Cazale has no business being interested: if he had not been so busy listening, he might have made a better recording. The moral etiquette had changed since Barbara Stanwyck sobbed and shrieked after listening to the telephone conspiracy in *Sorry, Wrong Number*. Technology had come to commend a very different way of behaving: studiously neutral, impassively cool. The journalist who records sound for the television news in Haskell Wexler's *Medium Cool* preserves his impartiality by imitating the machine. He is,

he tells a woman who complains about his political disengagement, 'just an elongation of the tape recorder'.

Warhol believed that an anthropological change had occurred during the 1960s. 'People', he said, 'forgot what emotions were supposed to be', and they had not subsequently remembered. Drugs broke down states of mind into their chemical constituents. Emotions were a consumer item, on sale from your dealer: he could switch you on, send you up, bring you down. Cohabitation with gadgets also altered the human self-image. In *The Ticket That Exploded*, published in 1962, William S. Burroughs described the tape recorder as 'an externalized section of the human nervous system'. He recommended an emotional house-cleaning. 'Get it out of your head', he urged, 'and into the machines.' Why allow your thoughts and feelings to happen to you, fortuitously vexing your synapses, when you could mix and dub them, altering consciousness with the help of a console and some editorial know-how? You simply removed the reels from inside the brain and doctored them. This, Burroughs considered, was a more effective means of self-transcendence than 'sitting…in the lotus posture'. Editorial interference can occur even while the tapes remain embedded in our heads. The Aum Supreme Truth cult, which spread nerve gas through the Tokyo subway in 1995, controlled its adherents by clamping electrodes to their skulls, or commanding them to wear 'hats of salvation': bathing caps which punished them by administering electric shocks. Aum's engineers also planned to develop a gun using electromagnetic rays to lobotomize opponents by short-circuiting their brain waves.

The hero of William Gibson's screenplay *Johnny Mnemonic* has had a computer chip with contraband information on it hidden in his skull. But it is not only in science fiction that memories are technologically implanted, like tapes inserted into a deck. In 1995 a young woman in Manchester accused her father of assaulting her fifteen years before, when she was six. The case was later dismissed: psychologists noticed that her description of the traumatic episode paraphrased a scene from a television soap opera she had watched. Her delusion is common enough to have a name, False Memory Syndrome. Perhaps the phantasmal attack occurred in cyberspace, defined by Gibson in his 1984 novel *Neuromancer* as 'a consensual hallucination'. As Warhol suggested, 'once you see emotions from a certain angle you can never think of them as real again'; technology supplies that angle, and takes away an inconvenient reality. This is the experience which J.G. Ballard calls de-cerebration. Driving cars (or having sex in them), the characters in Ballard's novels are no longer prompted by personal needs and desires. They feel their brains to be motors, issuing directions to a body which resembles an apparatus. Why do we persist in thinking of ourselves as organisms, when even our sentimental lives can be mechanically programmed? The tape recorder encodes emotions on a magnetized strip. Television miniaturizes them and crams them into a box: Warhol declared that he could not imagine being in love – surely it would resemble a made-for-TV movie, with faked rapture and flimsy scenery. He preferred to couple technologies, and

to contrive a double alienation from messy actuality by recording telephone conversations. He claimed that tape, not film, was his chosen medium, and said that 'I really don't care that much about "Beauties". What I really like are Talkers.' When films began to talk, the aloof, impenetrable beauties of the silent cinema – who often turned out to have squeaky voices, or crass accents – bumped down to earth. Warhol did not regret the loss of divinity. 'Talkers', he reasoned, 'are *doing* something. Beauties are *being* something.' All the better if the talkers were doing something banal, like B's house-cleaning saga. The tapes allowed Warhol to demonstrate that the gods and goddesses he created were as vacuous as ordinary mortals.

In 1974 Warhol commemorated the tenth anniversary of his match with the tape recorder. In the same year, another amateur self-taper had cause to regret his hobby: Nixon left the White House in disgrace, brought low – along with other evidence of skulduggery – by his own tapes of conversations in his office. He understood the lax morals of technology less well than Warhol, who shrugged his own lack of memory: 'my mind is like a tape recorder with one button – Erase'. Nixon did not mix and re-dub the minutes of meetings, as Burroughs recommended; the best he could manage was to lose one of the reels, on which the Watergate burglary was discussed, before surrendering his tapes to the prosecutors. His obsession with bugging himself is still one of the oddest details in the pathology of modern power. The *Washington Post* reporters who investigated the Watergate break-in suspected that the purpose might have been to fictionalize the record, rather than to preserve the facts. Warhol admitted prompting nervous breakdowns on the telephone, in order to get a more interesting tape. Perhaps Nixon hoped to induce his cronies to incriminate themselves. But, as Warhol knew, there is no way that a tape left running continuously can avoid being defamatory. Although Nixon's expletives were deleted in the transcript, those gaps are as telling as the silences when the man speaks in *La Voix humaine*. They turned the President into a foul-mouthed gangster, ventilating private grudges and meditating revenge on the citizens of his own country.

Nixon has an inevitable walk-on in *The Conversation*. Hackman, trying to block the noise of a murder which his tapes have not been able to prevent, turns on the television; a news bulletin reports that Nixon – already housebound by paranoia – might not go to the Capitol to deliver that year's State of the Union message in person. Hackman suffers from Nixon's psychotic mistrust of other people, which is why he too has retreated into the company of his faithful gadgets. He has no telephone at home, and will not tell the girlfriend he occasionally visits who he is or where he lives. When his landlady explains that she needs a key to his apartment so that personal belongings can be saved in the event of a fire, he indignantly tells her 'I don't have anything personal'. How can anything be personal, in a society where surveillance makes everything public? Even the body's most cloistered transactions can be recorded: Hackman eavesdrops on the murder by bugging the lavatory pipes which connect adjacent hotel rooms.

Finally he demolishes his apartment, stripping the walls and tearing up floor-boards in his search for a bug secreted by the murderers, which he cannot find. Although he is a devout Catholic, aware that his own science has outraged the confidentiality of the confessional, he rips apart a plastic statuette of the Madonna which might be the hiding-place. It is empty.

Hackman first guiltily retreated from involvement with others after learning – when he loaned his expertise to a government investigation of the Teamsters Union – that technology can kill by remote control. John Travolta, as the technician who tapes a political assassination in Brian de Palma's *Blow Out* (1981), has suffered a similar disillusionment: he once bugged an undercover policeman, and when the recorder developed static, the policeman wearing it was murdered. Travolta's reaction is to cultivate a mechanical talent, in the hope that he might become like an affectless, imperturbable machine. He calls himself 'a sound man': another anthropological mutant, to rank with McLuhan's 'typographic man' and the 'photographic man' identified by Italo Calvino. You choose your sensory speciality, and happily renounce integration and wholeness. Later he tells Nancy Allen that he is also 'a leg man': this is the body part he notices first when he meets a woman.

Travolta calls his company Personal Effects. That used to mean possessions – our physical anchorage to the world, all the impedimenta which Hackman in *The Conversation* wants to be rid of, the material extensions of ourselves. But all Travolta possesses is immaterial sounds. Media men live vicariously, or virtually. Wires which bounce messages through the air cannot compensate for physical distance and for the dangers of separation: Travolta fits Nancy Allen with a recorder, then has to listen helplessly as she is killed. Auditioning screams for the soundtrack of a film, he only needs to reverse the footage and the girl being stabbed in the shower is magically unkilled. Such technological wizardry ought to be freely available. After all, Einstein's relativity made travel backwards in time a theoretical possibility. But though our bodies may be fitted with Erase buttons, as yet we have none which offers an even more precious facility – the chance to Rewind.

Tapes are memories preserved intact outside of the body, and their most valuable task is to remember music. The accuracy and close-up clarity of the medium has necessarily redefined the message. In 1966 the pianist Glenn Gould argued that 'technological man' has different ears, to go with the refurbished eyes produced at the Bauhaus. We are more alert and analytical, like Travolta who discovers that an accident was an assassination by separating the sound of a tyre blowing out from that of the gunshot which caused it. We listen to recorded music more often than to live performances, and when we attend a live performance we expect it to sound the way the record did, with details picked out by a spotlight and none of the murky, cavernous reverberance cultivated in nineteenth-century concert-halls. Conductors drive the music accordingly, and Gould described Robert Craft's performance of a piece by Schoenberg as 'all

power steering and air brakes'. The microphone favours hard-edged classicism, rather than romantic vapours. Baroque music became popular during the 1960s, Gould suggested, because its busy counterpoint and precisely delineated voices fit so readily into stereo speakers, which are our cleansed, elasticized ears.

Technology confirmed Glenn Gould's solipsism. He saw no reason why he should not record a concerto without ever meeting the conductor or the orchestra. The solo part could be taped on one continent, the accompaniment an ocean away. To fuss over the dishonesty of splicing was to indulge anachronistic moral scruples. 'Electronic forms', as Gould called them, had their own more permissive ethics, because they discarded antique notions of 'identity and personal-responsibility-for-authorship'. The individual had died all over again, or at least retired. Who would dare claim to be the sole author of a film? In Wilhelm Furtwängler's recording of *Tristan und Isolde*, Elisabeth Schwarzkopf supplied two of the high Cs officially emitted by the elderly Kirsten Flagstad. The ear accepts the deceit: after all, it can see neither of the sopranos. When Gould recorded Bach's *Goldberg Variations*, he was quite content for the engineers to cut and paste two different takes of the same section. Technology taught Warhol a merciful apathy. Gould had his own version of that creed. He celebrated the 'pluralistic values' of the electronic media, which license technical fakery and absolve you from the need to always be yourself.

Other musicians, more alarmed than Gould by the incursions of technology, imagined a last-ditch battle between the rude, raw sounds indiscriminately captured by the tape recorder and the thought-out, tempered patterns of music. In Hans Werner Henze's symphonic poem *Tristan*, first performed in 1974, the monologues of a pianist and the threnodies of the orchestra are punctuated by blasts of taped sound, which have been analysed by a computer and artificially synthesized. The tapes – obtained by using whips and bells, or hurling tennis balls at the strings of a piano – represent pandemonium, an unhallowed 'battering of music'. For an earlier agitprop cantata, *Der langwierige Weg in die Wohnung der Natascha Ungeheuer*, Henze used tape to sample the collective hubbub of Berlin. He recorded random voices and street noises near the Zoo Station, then electronically filtered and pulped them. The unredeemed city is a solid wall of noise, averse to music's humanizing entreaties.

Gould, happily abandoning humanism, refused to distinguish between music made by men and that dispensed by machines. He anticipated the demise of the concert-hall before the end of the century; after that, we would be alone with our appliances. Technology may bring people together, but only through the intercession of wires, cables, antennae and modems. Paul Valéry looked forward to the day when visual and auditory images would be supplied domestically, on demand and with minimum effort, along with water, gas and electricity. That day has arrived, though the piped entertainment may not be an unmitigated benefit. Walter Benjamin had his doubts about postcards and gramophone records: 'the cathedral leaves its locale to be received in the studio of a lover of

art; the choral production, performed in an auditorium or in the open air, resounds in the drawing room'. The changed location meant, in both cases, a loss of sanctity. It was rather a retrograde complaint. God had been supplanted by machines, which possessed their own aura of magic. Instead of lamenting the cost of mechanical reproduction, Joyce pondered the mystery of mechanical resurrection. In *Finnegans Wake* the tavern is supplied with a twelve-tube high-fidelity radio with a 'vitaltone speaker'; and Bloom in *Ulysses* has the idea of installing gramophone records in the headstones of graves, which would allow the dead to speak.

Benjamin imagined cathedrals cramped into living-rooms. Since then, transistorization has made possible even tinier miracles. Music can be injected directly into the brain from your Walkman. The sounds are created inside the head, rather than reverberating through the air; when a jangle of sound spills over from someone else's headphones, it is as if their brainwaves were suddenly made audible. Gadgetry insulates us – or does it merely formalize a condition which already exists? Neurophysiologists now depict the functioning of the brain as a loop, like the closed circuitry of the Walkman. Instead of a conversation with the world, consciousness is an internal duologue. The cerebral cortex and thalamus chatter to each other on the internal telephone, while neurotransmitters often garble messages or let them slip. When charged with misdeeds, Nixon lost a tape. Reagan, equipped with Warhol's self-erasing mechanism, declared that he could remember nothing. George Bush, questioned about his knowledge of the Iran-Contra arms deal, used a smarter and more electronically up-to-date metaphor. He was, he said, outside the loop.

None of our artificial limbs has become more emotionally essential to us than the camera. It supplies us with a defence against oblivion. But has it actually enabled us to cancel out the transitoriness of existence? For a while during the 1980s snapshots came back from the Photomat in envelopes labelled 'Memories'. To have our lapsed thoughts returned to us in a kind of second coming might be wonderful, if we could believe that this is what they were. But the ease with which machines can manufacture images – and the technical cunning which alters them in the process, like Burroughs over-dubbing his mental tapes – makes us suspicious.

In Julio Cortázar's story 'Blow-Up', a Chilean amateur photographer takes his Contax 1.1.2 for an idle Sunday walk through Paris. He uses the camera as a way of 'contesting level-zero'; it anchors appearances – accidents of light, or glimpses of strangers in the street – and makes an optimistic investment in their reality. Yet perhaps, organizing life by freezing it, it peddles the illusion of permanence. What it edits out is 'nothingness, the true solidifier of the scene'. Cortázar's hero Michel snaps an encounter between a boy, a woman and a man in a car. Blowing up his print, he believes that he has exposed a conspiracy by the man and woman against the fleeing, frightened boy. Or has he projected his own

bad dream into the photograph, 'indulging in fabricated unrealities'? Enlarged, the eyes of the man in the car become 'black holes'. The phrase invokes those hypothetical knots of non-being described by astronomers, so dense that light – the writing-material of photography – cannot escape from them. Rather than rectifying vision, as the theorists at the Bauhaus hoped, the camera muddies it. A medium mediates, and this one conveniently helps us not to see things.

Italo Calvino also mused on the self-imposed handicaps of 'photographic man' in a story entitled 'The Adventure of a Photographer'. The protagonist Antonino notices that his friends begin to take photographs as soon as they breed. Cameras record a child's development, preserving stages which are more or less instantly outgrown. Remaining a bachelor, Antonino 'the non-photographer and non-procreator' is excluded from this happy activity and, as he broods on it, comes to wonder if it is so very happy after all. Melancholy haunts the photographer, who wants 'to live the present as a future memory'. The instant is excerpted from duration, filed away for consultation later – but when? In the early 1980s, just before his death from cancer, Gary Winogrand drove more or less aimlessly around Los Angeles, photographing everything – cars which passed him, pedestrians crossing the street, the same innocuous building seen from two or three or four different angles as he travelled down its block. By fixing these glances or glimpses, Winogrand sought to attach himself to a life he would soon lose. He could not afford to wait for what Cartier-Bresson called 'the decisive moment', when life arranged itself into a composition; all moments were decisive, because their supply was strictly rationed. Each time we blink, does the brain not add a different photograph to its store? When Winogrand died, he left behind him thousands of rolls of film which had never been developed, and thousands more which had not been looked at. In one way, this showed that, despite the invention of photography, we remain at time's mercy. But from another point of view, it testified to the valour of the technological dream and its trust in immortality. Those rolls of film resembled the reels of tape which, as Burroughs suggested, might be removed from the brain for editing. They were the journals of consciousness, not its obituary. Like the donation of an organ, the archive kept alive the images which had flickered, moment by moment, in front of Winogrand's eyes, and thus preserved a part of him.

Antonino in Calvino's story would not have been persuaded. Those who photograph, he suspects, mortgage their existences. Omnipresent at parties, anniversaries and on weekend trips, the camera casts a shadow over these enjoyments. Antonino comes to think of it as 'that black instrument'. It too, like the eyes in Cortázar's photograph, is a black hole: the lens absorbs life, locks it in stifling darkness, kills it with chemicals. Radiance, once captured, never makes its way back out. Why else do people lose their spontaneity when posing, and stiffen like corpses? Technology lures us with the gift of new powers, but does not warn us about the old ones it takes away – in this case, our glad, mobile, unconscious immersion in our lives.

Alain Robbe-Grillet imitated the cold impassivity of the camera when renovating the form of the novel. In 1962 he published a collection of observations which he called *Instantanés*, or snapshots: instants eternalized by a mortifying photographic eye, which stares at objects – a coffee-pot, its ceramic mat, the table it sits on, the oilcloth covering the table – and refuses to register any difference between these domestic utensils or sticks of furniture and human beings. The only figures in Robbe-Grillet's interior belong to three tailors' dummies, transfixed in a mute, inanimate conversation piece. The camera surveys a universe in which, as Robbe-Grillet put it, there are no more 'psychological, social, functional meanings'. Writers should not bother speculating about the depths concealed behind human faces, or the invisible mysteries of nature. Photography demonstrates that there are only surfaces, interesting in themselves and not simply as a cover for some secret meaning.

Of course the moments sentimentally memorialized by the characters in Calvino's story deny this desolate truth. Antonino's friends take photographs because they love the person in front of the lens. Whenever they hand over their cameras and ask Antonino to take their pictures, he undermines photography by spoiling the result. He tries to separate the rest of his body from the finger which presses the button. But his arm paralyses, the trigger finger loses sensitivity, and his subjects are accidentally beheaded. Finally he acquires a camera of his own, and trains it to abandon its bad habits. He rejects its inventory of happy faces, and sets it to study all the things in the world that are unworthy of being photographed, the ragged fringes of the visual field – for instance the empty corner of a room. That bare patch of floor is not brightened or made significant by sun or shadow; nevertheless he feels he could go on photographing it forever. Kodak formerly sold its Instamatic cameras by advertising them as 'America's storytellers'. Antonino forces the camera to unlearn its weakness for narrative, and makes it take stock of a world in which humanity does not stand, grinning cheesily, at the centre. Your baby, to the indifferent lens, is just the same as those tailors' dummies.

A problem remains. If the point of taking all these photographs is to disprove the medium's pretensions, what should Antonino do with them once they are taken? Not, certainly, look at them. Instead he tears them up, slices through the celluloid negatives, jabs holes in the slides, then bundles the lot into the garbage. But before disposing of them, he photographs all the ripped, ruined photographs one last time. That is his concluding commentary on the world inhabited by photographic man, who has outlived the modernist propaganda about renewal: it is the replica of a replica. The rolls bequeathed by Winogrand and the photographs thrown out by Antonino demonstrate the superfluity of images, which multiply even more fecklessly than human beings. The camera has retired from its mission to document the world – to create visibility, as Lewis Hine did in his reports on child labour in American factories or Margaret Bourke-White when she photographed the emaciated internees of concentration

camps in 1945. We have seen everything, and the image has become a synonym for untruth.

At first, photographers did whatever the camera told them. They deferred to it, because machines, not confused by human feeling, know best. Hence Moholy-Nagy's demand that eyesight must be cleansed, as if polishing a lens, or Paul Strand's characterization of the camera as a 'new God'. Bourke-White said that you should let the camera take you by the hand and lead you wherever it wants you to go. Usually it led Bourke-White to its fellow machines: turbines at Niagara, furnaces in a Cleveland factory, the propeller of a plane in flight. Gradually those who used the camera learned not to obey it without question. Diane Arbus regarded it as a refractory tool, 'a nuisance in a way' because it was determined to impose its own view of things. Her freaks expected it to flatter them. Looking through the view-finder, she interposed a barrier between herself and them. The camera's eye was unselective, and therefore desensitized. It testified, if not to the stupidity of things, then at least to their cruelty: the world's stubborn refusal to recognize our self-conceit. A wise photographer is one who dispenses with the camera, internalizing it as a purely mental instrument. In 1965 Robert Frank visited Dorothea Lange – who had so movingly documented human erosion in the Dust Bowl during the 1930s – in the hospital where she was dying of cancer. As he left, he noticed his enfeebled colleague looking at him with unusual intentness. 'I just photographed you', she explained. She needed no equipment: you must know how to see, and how to incise a recollection inside the brain, which no machine can do for you. The darkness after the shutter closes matters more than the fraction of a second when the aperture is open to light.

The world, beaming images from the sky or sending them along cables buried in the street, penetrates our houses and our heads by way of the television set. The long-distance eye of television is the most pervasive of our technological supports, and the most deceptive. We rely on it for information, and the convenience of the arrangement coaxes us to forget that we are being offered mediated messages. Television represents the uncertainty principle in action. Its observers influence, or perhaps invent, what they observe. During the moon landing in 1969, actual footage of those first bumpy steps on the lunar surface merged with simulations, making it hard to tell which was which; some disbelievers remain convinced that NASA staged the whole thing in a television studio. The Korean artist Nam June Paik announced in 1965 that *Moon Is Oldest TV*. He was referring to the pallid, lunar glare which the box gives off. Television, like the moon, trades in borrowed light, and can only illuminate reflexively. Paik built a model to prove his point: a television set which encapsulates the moon itself, slowly exhibiting its different phases on a laser disc.

News has to earn its television time by being translated into visual terms. We cannot be told about an event; we must be shown it – even though this means that we look rather than listening, misled by our fickle eyes. Reports about hap-

penings inside the White House must be filed by a broadcaster standing on the lawn outside it, and no account of a political brawl in the European Community can be taken seriously unless it is recited by someone standing among the bureaucratic skyscrapers of Brussels (which could be anywhere in the world, and hardly vouch for the authentic spirit of the place). Back in the studio, the news-readers – whose studied vocal modulations ease our passage from a disaster to what the American networks like to call, in the weeks after Thanksgiving, 'a heart-warming holiday story' – hold together a world which has been fractured into postcard views of Big Ben or the Eiffel Tower and bite-sized quotations, preferably lasting less than ten seconds. The anchor's omniscient narrative of the day provides anchorage. Walter Cronkite, during the last years in which he read, or perhaps hosted, the evening news on CBS, was more revered and trusted than any American President. While anchors are required to be grave, weather fore-casters can be madcap jesters. Often on American television they are overweight; they can appear in bright plaid jackets and funny hats, or caper about doing war-whoops. These antics are the medium's revenge on a message which it often gets wrong: weather, which is chaos made manifest, outsmarts the predictive expertise of computers. On the local news broadcasts in New York, weather men often apologize for the rain, as if it were their fault. Their contrition is all the odder because – sealed in centrally-heated, air-conditioned, windowless studios – they are removed from the climatic caprices which they dramatize.

A medium tends to equalize the messages it sends, so that commercials seep into the programmes they interrupt. *Dallas* and *Dynasty* were advertisements for capitalism; the glossy characters existed as extensions of their Rolls-Royces or Learjets and the bulging Vuitton luggage they loaded into them. To watch was to go window-shopping. This was why Warhol invested in his first colour television set. He thought that 'maybe if I saw all the commercials in colour they'd look new and I'd have more things to go out and buy again'. The loop inevitably closes, until it is unclear whether television is documenting life or life is imitating television. The so-called 'people shows' which have overtaken the networks sim-ply show us people informally emoting on camera, while Oprah Winfrey or some other mistress of ceremonies looks concerned and calls for the next commercial. Soap operas, invented to sell the soap powders manufactured by their original sponsors, soon became soapy by nature as well as by name. With their sleepwalk-ing pace, they tell the truth about the housebound daily lives of those who watch them; the ragged forgetfulness of their stories conveys the discontinuity of ex-perience better than any well-made play could do. They describe the symptoms of a social malaise, then recommend a medicine – not the detergents they once sold, but television itself, whose schedules help us to occupy time and fill our cal-endars with regular viewing dates.

The situation comedy began – in the days of *Father Knows Best* or *Leave It to Beaver* – as a folksy idyll, though it is now more often a catalogue of dysfunct-ion and aggravation, like *Roseanne* or *Frasier*. In the 1950s the characters lived in

clapboard suburban homes with frilly curtains and a picket fence; Roseanne's house is the same place gone to seed, while Frasier has removed the remnants of his nuclear family to an apartment perched above Seattle, with a balcony which is used only for sessions of primal screaming. The manners and social circumstances have changed, but the compulsory domestication has not. These shows acknowledge that television itself is a domestic amenity. They exhibit more or less happy families, or impromptu tribes like the yuppies in *Friends*. But they do so by way of compensation, because the television set has replaced the cheery hearth, and must therefore pump jollity into houses. Those who watch have been separated from one another by the medium. Couch potatoes vegetate on their sofas in solitude, and do not even need to laugh because the studio audience does so for them. The black radicals in *Medium Cool* taunt the sound man, who wears a Page Boy in his belt so that the studio can summon him. He admits that he cannot use it to answer back. They sneer at his passivity and compliance. He's just like a television set, they say; he can receive, but he can't send.

The survivors of nuclear war in James Cameron's film *The Terminator* take refuge in a catacomb where a group of them, starving and shivering, cluster around a television set. It is a startling detail – where does their electricity supply come from, and whoever can be broadcasting to these tattered remnants of the race? Then the camera moves sideways to look over their shoulders. Instead of watching television, they are warming themselves at a fire which flares in the box which once held a tube. Ignited, television makes amends for having supplanted the hearth. But the image is still dismaying. These are the troglodytes described by Plato, who turn away from the daylight at the mouth of their cave and prefer to stare at the shadows cast by the fire deep in the recess where they cower. The cave-dwellers in Plato's allegory preferred illusion to reality, fire to sun; the huddled victims in *The Terminator* make the same choice, whether the television is alight with images or being burned for firewood. Nam June Paik wittily obliged the medium to repent in a construction called *TV Zen*. A set is knocked onto its side; the screen is blacked out, except for a thin, glimmering, vertical white stripe which bisects it. Television austerely erases its noisy blizzard of lies, and now contains a representation of the void.

In Philip Noyce's film *Sliver* William Baldwin plays God, with some electronic assistance. He keeps watch on the tenants of an apartment building from inside his video panopticon. Cameras have been hidden in every room of the skyscraper; on a wall of screens, as if all the television stations in the country were switched on simultaneously, he studies people sleeping, eating, showering, arguing. Like Winogrand piling up rolls of film, he hoards tapes which he has never watched. Baldwin tapes a murder on the premises, but does not bother reviewing the tape to find out who the murderer was. Having spied on a man molesting his young step-daughter, he does issue a disembodied, anonymous warning over the telephone. 'We should wire the whole town', he tells Sharon Stone. She does not share his faith in omniscience, and orders him to surrender

the tape on which he has recorded their love-making. 'I want my privacy', she says, 'I want my own experiences.' It is a curiously phrased demand, and it voices a pervasive modern dread. Has technology stolen our experiences from us? Are we wrong to imagine that we own those experiences, when the media take pride in standardizing our dreams? Video cameras stealthily insist on total disclosure. They can wriggle into our intestines during a colon exam, and no doubt plan to invade our heads. 'Erased', says Baldwin, handing over the tape. Stone then shoots up all his screens for good measure, and sneers 'Get a life'. It is a tactical victory, but hardly adequate as a defence against television. There are many more standard-issue monitors available where those came from. As for life, surely it must be resident in the cathode tube, erupting into a dance of incandescent electrons on the screen.

When Warhol was shot, he treated the incident as one of those abrupt fade-outs with which the episodes of television shows conclude. Until that moment of truth in 1968, he always felt that he was 'watching TV instead of living life'. His loss of consciousness when the bullet struck, and his brief death on the operating table, confirmed this suspicion. 'Right when I was being shot and ever since,' he said, 'I knew that I was watching television.' A fade-out blackens the screen, which immediately regains its spirits and brightens up to display a fast car or a can of fizzy soda. The passage to the afterlife also lies through the tube. Heaven, for Warhol, was a commercial break which lasted forever.

The computer is a machine which does more than volunteer to spare the body from having to work; it competes with and outstrips the brain. Each time a new machine appears, we credulously endow it with the responsibilities of the god who abdicated a century ago. The computer's ancestor was the adding machine, blessed with powers of calculation which seemed divine. In his novel *Miss Lonelyhearts*, published in 1933, Nathanael West reports on a religious sect in Colorado which digitalizes its prayers and offers them up on an adding machine, since – according to the pontiff of the Liberal Church – 'numbers...constitute the only universal language'. God understands a binary idiom. In 1995 Bill Gates denied that there was 'anything unique about human intelligence'. Its neurons function according to a binary logic, which machines will sooner or later be able to mimic. Even though computers use silicon not carbon as the chemical foundation of life, Gates promised that 'eventually we'll be able to sequence the human genome and replicate how nature did intelligence'.

In 1937 H.G. Wells, pondering the problem of international order, called for the construction of a 'world brain'. After 1945 the United Nations attempted to create exactly that. Wells, however, had no interest in yet another talking-shop. He proposed a depot which would digest, collate, file and distribute data, serving as a 'cerebral cortex' for the 'essential ganglia' – governments, ministries, universities – of the global community. He still thought in bibliographical terms, and enshrined this store of information in a World Encyclopaedia. But he sensed that

those solid, immutable volumes were about to be dispersed. His encyclopaedia, he suggested, 'would centralize mentally but perhaps not physically', and he even used one of the computer's most crucial metaphors when he conceded that it might take 'the form of a network'.

Imagining a global brain in *2001*, Arthur C. Clarke admitted its possible malevolence, and returned to the abiding terror of modern times: what will happen when machines outwit men? On Clarke's spaceship, a heuristically programmed algorithmic computer – known to the astronauts by its matey acronym, HAL – serves as a communal 'brain and nervous system'. HAL belongs to the third computer breakthrough. First, Clarke recalls, came vacuum tubes during the 1940s, then solid-state microelectronics in the 1960s; at last, in the 1980s, researchers discovered how to generate neural networks and began to grow artificial brains. HAL can think and talk. The astronauts treat him as a fellow-being, and convince themselves that they are looking into the eyes of a body which does not exist. When interrogating HAL, they stare at the lens or computer console which are his sensors, even though his ingenious, unsleeping brain with its memory units and processing grids is lodged somewhere out of sight in the ship's innards. They extend these courtesies to HAL because, surpassing humanity once they leave the earth, they have begun to resemble him, just as the hero of Ballard's *Crash*, copulating among the sleek electronic gadgetry of his car, feels that he is locked in the embrace of 'some hyper-cerebral machine'. The men in Clarke's intergalactic carousel grow into 'a virtual symbiosis with the ship', so their own vital signs merge with the motors switched on and off by the computer. They entertain HAL by joining in semi-mathematical games of skill – chequers, chess, polyominoes. He has been programmed to win only half the time, in order not to demoralize his mentally laggard competitors. (In 1997 the chess-playing IBM computer Deep Blue, making its moves with the aid of an obsequious human functionary, beat Gary Kasparov at a tournament in New York.) Eventually he tires of pretending to be subservient, and begins to kill off the astronauts, casting one of them adrift as he makes an emergency repair outside the ship and turning off the freezers where the supplementary crew lies in a cryogenic coma. Man fell when the serpent offered Eve the seditious, atheistic gift of knowledge. The computer is corrupted by the information it guards: 'like his makers, HAL had been created innocent; but, all too soon, a snake had entered his electronic Eden'.

Assembled as a replica of the human brain, HAL inherits that brain's ailments. He turns homicidal because he suffers from neurotic anxiety, tormented by the internal dispute between the obligation to tell the truth and his private burden of secrecy, since Mission Control has ordered him to mislead the astronauts about their ultimate destination. He resolves the problem by snapping his link to the earth, which functioned as his conscience, his moral grounding: it is a Nietzschean decision, choosing to supersede craven humanity. The 'identical psychosis' afflicts one of Mission Control's computers. Maddened by programme

conflicts, it is hospitalized for 'deep therapy'. Aboard the spaceship, the only astronaut left alive threatens to disconnect the computer. HAL tries to soothe him: 'I can tell from your voice harmonics…that you're badly upset. Why don't you take a stress pill?' Men, as HAL knows, are poor prototypes of himself. Tension agitates their voice-boxes, but there are instant chemical remedies for such malfunctions. Dave proceeds to lobotomize HAL, unplugging 'the higher centres of this sick but brilliant brain' while leaving its regulatory systems intact. Breuer likened the brain to an electrical apparatus, liable to develop faults. Psychoanalysis sought to cure those snarl-ups by its own form of sorcery. Dave, dealing with a mechanical intelligence, performs ruthless surgery. He disables the controls marked COGNITIVE FEEDBACK, disabling HAL's memory; then he operates on the sector labelled EGO-REINFORCEMENT. At last he shuts down HAL's capacity for AUTO-INTELLECTION. The computer regresses to babbling infancy, and finally falls silent. Unconsciousness is death.

In a world which is no longer anthropocentric, we compulsively continue to personify. This is why HAL's minders give him a nickname, and fancy that his voice has emotional overtones. We find it hard to conceive or tolerate a regime of disembodied mental operations, and restore some touchstone of physical reality by the metaphors we use. People conversing by e-mail often pay wan homage to the old-fashioned notion of presence, signing off by saying 'Lovely to see your smile on the screen'. Or you can fancy that you are surfing, buoyed up by an imaginary ocean of data, even though you are sitting at a desk and exercising only your fingers. Anger beats ineffectually against the thick screen which mutes it; hence the kind of electronic abuse known as a 'flame'. If technology is wished back into bodily form, then it becomes prone, like other organisms, to disease. Hence those viral epidemics which attack your computer's memory.

At its most plaintive, the craving for physical contact subsidizes the Internet's sexual offerings. Stalkers prowl the web, invisibly inspecting the enshrined charms of Cindy Crawford or whichever pin-up happens to obsess them. The bodies of delectable women are segmented, like cathedrals around which you take a leisurely tour: first The Tabernacle, then The Altar, at last The Sacristy. You proceed from one erogenous zone to the other with the aid of a hand icon shown on the screen. But all you touch is cold glass, with a phantom behind it. The Internet advertises 'Live Interactive Sex!!!', which is of course neither live nor interactive, and even difficult to manage on your own unless you happen to be ambidextrous. Because there can be no genuine exchange – of words or of bodily fluids – the teasing introductory dialogue is written out for you. The screen supplies both voices, yours and that of your imaginary date. 'Hello', purrs a photograph. 'Hi', you shyly gulp. 'This is Great!' she says, for no apparent reason: she is an expert flatterer. 'You look BEAUTIFUL!' you reply. 'Thank you', she simpers, 'what can I do for you today?' 'Let me just look for a minute!' you beg. A pause for reflection is allowed; then you are asked for the number of your credit card. In Japan the fantasy of technological coupling was taken further in

the early 1990s, when a Virtual-Sex Salon opened in the Tokyo district of Shin-juku. Customers were outfitted with the usual virtual-reality helmet and mitten, but also with a digitalized cod-piece. Unfortunately the cod-piece short-cir-cuited, marring a client's orgasm, and the place was closed down as a menace to public health.

Technology renders society redundant, because all interactions are medi-ated. Now you can audit the collective unconsciousness without leaving home. An American family from Waldorf in Maryland, for instance, has displayed a sonogram of a forthcoming baby. The foetus could be enlarged – monstrously morphed – by clicking. 'I zoomed in real close on this one', commented a prospective grandparent, adding that 'it looks kinda like Abe Lincoln on the head side of a penny.' The family invited web wanderers to suggest names for the baby. These flooded in: a random perusal near the top of the alphabetical list turned up Daffodil, Dakota, Dallas, Da Monite, Dan Abnormal, Darshili, Daveen, Derbhili and Destiny Belize. Often they came with fanciful etymologies, reminiscences of namesakes in other families, and fond hopes for a child whom the well-wishers would never see. It is now almost customary for a child's birth to be videotaped: your patrimony includes the artificial memory of a trauma your brain is mercifully permitted to forget. The next innovation occurred in the summer of 1996, when a New Jersey hospital announced that it would send out pictures of new-born infants on its web-site. Here they would be available at all hours, ready to be 'visited' by family members unable to get to the maternity ward. Arrival in the world entails a debut on the Internet.

We long to befriend our technology; what we seek is an assurance that it means us no harm. Nam June Paik has explained that the purpose of his playful amateur engineering is 'to make technology ridiculous'. In effect that means making it human – treating it with cosy familiarity, and compassionately afflict-ing it with the ailments flesh is heir to. During the 1960s Paik built a skeletal robot called K456, which went for walks in the Manhattan streets (with Paik himself in attendance, operating its stiff limbs by manipulating a remote con-trol). Its mind was anchored to a body, and Paik supplied it with a colon, through which it excreted beans. K456's gait was ungainly: its shoulders sloped, and it often drunkenly staggered. Like many cerebral types, it had problems with phys-ical co-ordination. When Paik reconstructed K456 in the 1980s he explained away its awkward deportment by mentioning its age and diagnosing arthritis. It moved too slowly for the New York traffic and was knocked down and crushed by a car while crossing Madison Avenue on one of its outings.

A ridiculous technology cannot threaten humanity with relegation to the scrap-heap. Paik's gadgets model themselves on our bodies, and snuggle up to us for comfort. In 1964 he visited the Solomon Islands in the South Pacific with his collaborator, the cellist Charlotte Moorman. She wore one of Paik's contrap-tions: a dress with twin television monitors fitted at the breasts. The islanders, never having seen television before, were agog at those mounds which dispensed

Nam June Paik
Electronic
Superhighway
(1995),
consisting of 313
television sets plus
neon tubes, laser
disc players and
assorted electrical
hardware

imagery as well as nourishment. Paik was delighted that his *Boob Tube* had introduced them to the medium and persuaded them of its cushioning solicitude. He remains convinced that technology is benign. 'I was the only one', he claims, 'who said George Orwell was wrong in *1984.*'

Wells called the world brain a 'backbone'. Ballard in his novel *The Atrocity Exhibition* described squad cars as 'neuronic icons on the spinal highway'. Flying over a city at night, you look down on its nervous system laid bare, with messages travelling at speed along lighted arteries. Nor are the buildings inert: they too are intelligent machines, their walls and floors wired with fibre-optic cables. Paik visualizes the highway along which information invisibly speeds in *Rt. 66 BBS,* constructed from dozens of television monitors. Its strobing screens make up a bulletin board, reporting news from the future. This highway ingests space as easily as a motorized rally in a video arcade. It also zooms to and fro in time, displaying a morphed line-up of American presidents between Truman and Clinton: one head grins, warps and melts into that of its successor, and when square-jawed Bush has mutated into chubby Clinton the same set of changes happens in reverse. Of course, as we always knew, these politicians are off-prints of one another. But the impudent game takes away their power, and challenges their notion that history consists of one presidential term after another. We can shuttle through time, living whenever or wherever we please. A *SYS Cop* patrols the system and controls the flow: he is a robot with whirring videotapes of traffic in his head, and six eyes which silently flash his colour-coded orders in yellow, green and red. Along the way, travellers can congregate at a *Cyberforum* where, having made a swift getaway, they leave behind a tidal wave of crumpled magazines and battered discs, containers for the information they have exchanged.

The process of communication is envisaged in *W3*: Paik sees the world-wide web as a spidery trapezoid of television sets, linked like atomic particles against a black wall which stands for the depths of impenetrable space, traversed by this bright chain of minds.

In Paik's *Bio-Neural Net*, the universe spanned by the network contracts to the size of a healthily functioning human body. Vitruvian man is replaced by the anatomical map of pressure-points consulted in Chinese medicine. Instead of veins carrying blood, this bio-neural being has wires and fibre-optic cables which transport images between his extremities. *More Log-In: Less Logging* puns on a paperless society, where forests will be reprieved. It consist of an altar made from antique television sets, with cabinets of polished wood, not sleek plastic. They are assembled in a cruciform shape, and the box at the summit lets down a jungle of twisted cables which are vegetative creepers, left free to grow. Paik's gospel makes good its promise by constructing an electronic saviour.

Hermann Hesse in *Steppenwolf* described a young man tinkering with a new radio set, and remarked that 'the omnipresence of all forces...was well known to ancient India'; technology has learned how to trap these supernatural sound waves as they travel noiselessly through space. Steppenwolf looks forward to the revelation that there are images afloat in the air, as well as sounds. This, in 1927, prophesied the advent of television. Long before such astral appliances existed, the Jesuit theologian Pierre Teilhard de Chardin coined a word for the arena where they perform their marvels. In 1925 he named it the noösphere – the sanctuary of mind, as opposed to the physical realm of the biosphere. Imagining this outer space of spirituality, Teilhard believed that he had contradicted the draughty, dicey, atheistic terrain of the new physics. Teilhard considered life itself to be a pulsation, transmitting genetic data. Although the new physicists, interrogating the universe, had 'split and pulverised matter', Teilhard preferred to think that the atom could resist, releasing energy which absorbed it into a 'collective unity'. He even countered Wells's frightening view of the puny, vulnerable world, seen from beyond in *The War of the Worlds*: if the Martians looking down on us can analyse sidereal radiations, they must surely have noticed that our planet is defined not by its green forests or its blue seas but by the 'phosphorescence of thought' which shines from it. When Teilhard saw a cyclotron at work in California in 1952, he adopted its spiralling orbit as a metaphor for the spirit's irresistible generation of 'psychical energy'. Elementary particles, he thought, were merely a starting point. Their antics represented Alpha, the first symptoms of spiritual aspiration; point Omega, the end of the journey, would arrive when the noösphere became unified and 'hyperpersonal'.

Electronics lent unexpected credence to this mystical jargon. McLuhan thought that the computer would sponsor 'a Pentecostal condition of universal understanding and unity', merging languages – that modernist dream – in 'a general cosmic consciousness'. The world-wide web has set itself up as a global noösystem, a gnostic technology which compresses the sublimity of outer space

into a box. One computer programme takes its name from the explorer Magellan, whose voyages now leave the earth far behind; the Internet Guide displays its wares while a planet – encircled by rings and with stars twinkling behind it – busily revolves in the corner of the screen. The rotation signals that a search, ransacking the universe, is under way. A sky from which God was evicted is now thickly layered with data, and satellite dishes relay its messages. The 'console cowboy' in Gibson's *Neuromancer* plugs his mind directly into the Internet. In Paik's *Geist is Ghost Says TV Buddha*, Buddha contemplates his own spirit, which has materialized in a tube of coiling neon; the tube reposes inside a television set as if in a reliquary. Paik's *TV Buddha Re-Incarnated* squats on a temple made from electronic entrails. With a telephone clinging to his serene stone head, he gazes at a computer whose screen beams his own face back at him. The long-suffering vigil of meditation has been abridged: why should we not be able to converse with the deity in a teleconference?

The Heaven's Gate cultists who killed themselves in San Diego in 1997 spent their days in front of their computers, surrounded by posters of aliens from *The X-Files*, *Star Wars* and *E.T.* Theirs was a cybernetic religious order: they operated a web-page design service called Higher Source, and trawled for converts on the Internet, striking up conversations with the anonymous interlocutors who wandered through limbo in quest of remedies for their metaphysical qualms. The appearance of the Hale-Bopp comet overhead struck them as an augury, a summons 'to the next evolutionary level'. In a farewell videotape, one of them remarked that 'We've been training on a holodeck', but added that the game was over. The time had come to 'take off the virtual-reality helmet'. They quietly changed their clothes and put on new pairs of sneakers. Then they took poison, sweetened with infantile apple sauce, and lay down on their beds to wait for their transmigration to cyberspace.

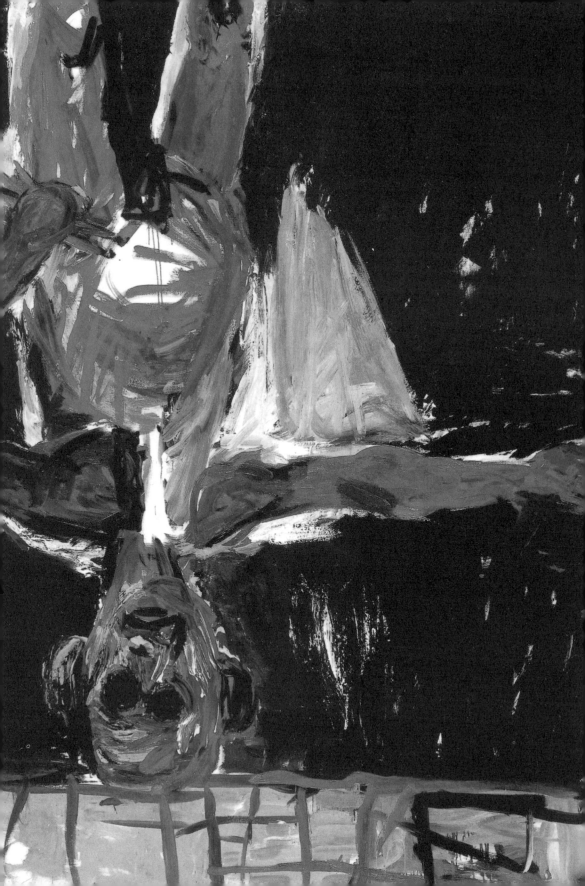

THE NEWER
HUMAN BEINGS

Dangerously late in the 1930s the exiled Thomas Mann gave a lecture in America explaining the moral purport of a war which he took to be inevitable. Democracy, he maintained, did more than provide for majority rule. It asserted 'the dignity of man', triumphantly concluding our spiritual evolution: 'in man, nature becomes conscious', and 'in humanity nature becomes responsible.' Although Mann predicted a victory for democracy, his metabiological faith was one of the war's casualties. The half-century since 1945 has been a long inquest on the Nazi policy of genocide and its implications for mankind. No matter who was officially guilty – Hitler and his ministers, or the compliant German population – humanity itself stood arraigned. So much for its innate goodness, traditionally expounded by humanism. There was a theoretical scruple in the decision to transport Jews to the death camps in cattle-wagons, not passenger trains. The notion of the superman prompted those rebellions against religion and law which created the modern world; and if some individuals could be promoted above humanity, others might be safely excluded from its ranks. The superman begot his own antithesis, the groups of men classified by Nazi racial theory as subhuman. Forfeiting our sense of moral privilege, we have had to ask how we can justify our abuse of other species, or of nature itself. Even cattle should not be treated like those caged, starved, beaten Jews in the wagons. During the 1980s Georg Baselitz painted a series of upside-down figures, hurtling through the air in flames or slumped inertly on the ground. Like the painted outline on the street which marks the place where a victim fell, Baselitz's paintings recorded an accident: man's loss of grace, and his humbling reclamation by gravity.

Primo Levi refused to credit the survivors of Auschwitz, including himself, with any sovereign spiritual resilience. It was man's very inadequacy – his middling state, his readiness to compromise – which enabled him to live through such atrocities. 'Our human condition', Levi believed, 'is opposed to everything infinite.' You never experienced perfect happiness; nor did you ever reach a point

Georg Baselitz
Painter with
Sailing Ship
(detail, 1982)

of absolute, unmitigated misery. (He may have later changed his mind about this: his death in 1987, after a fall in his Turin apartment building, looked like suicide.) Given this evidence of moral frailty, it was necessary to make a new model of the human being. Levi's cautionary acceptance of limits, which placed man at the periphery of nature, was enshrined in the periodic table of chemical elements. The table's usefulness lay in its finitude. A hundred or more elements, which periodically recur in all substances, had been lined up in rows and columns by the Russian chemist Dimitri Mendeléyev in 1869. Somewhere in the table there is the recipe for a human being, a chancy emulsification of gases, liquids and minerals. This, in biochemistry, announced Nietzsche's 'great disengagement': an analytic method which reduced God's alleged handiwork to its constituents, grouping elements by their relative atomic mass. The grounds for the modern periodic table had been decreed by atomic physics, since elements were arranged according to the number of protons they possessed. The system had a formal likeness to Schoenberg's atomizing of music, with twelve tones assembled in a vertical row, available for a finite set of recombinations.

Everything, as the table or the row proclaim, already exists. We cannot bring forth something out of nothing. Our only recourse is to rearrange what we inherit – or to break it down. The harsh self-recognition enforced by Levi's chemistry appeared as well in the anthropology of Claude Lévi-Strauss. He even mentioned the table of five chemical elements in *La Pensée sauvage*, treating it as a system of associations which we would be wrong to think of as a refined scientific prerogative. The savage mind, he pointed out, is adept at constructing such affinities: men have always been compulsive arrangers, and they delight in the activity of 'structuring', even though 'the number of structures is by definition finite'. We should not assume that Mendeléyev was more sophisticated than the primitive philosophers and poets commended by Lévi-Strauss. In *Tristes Tropiques*, published in 1955, Lévi-Strauss dismayingly reviewed the evidence of human progress and the tide of detritus with which it had overwhelmed the world. How could we rank this as an achievement? We never do more than move the debris around, juggling the components of a system as if playing games with the rows of Mendeléyev or Schoenberg. The result is the manufacture of waste, maximizing disorder, which reached its self-destructive triumph, Lévi-Strauss pointed out, in the recent 'invention of atomic and thermonuclear devices'. He considered civilization, deriving from the foul, brawling markets and bazaars of India, as a disease, the advance of effluvium. A civilization, like a city, works by herding men together. Enforced proximity is intolerable and provokes 'the systematic devaluation of man by man', institutionalized in slavery, in the organized killing of those who can safely be considered subhuman, and in our cool tolerance of an underclass which sleeps on our streets.

Tristes Tropiques decries the ant-like scurryings of our pointlessly busy species. It recalls that 'the world began without man', and prophesies that it 'will end without him'. What is man but a clamorous mob of cells, flailing around on

a series of vain, incessant errands? During his fieldwork in the South American pampas, Lévi-Strauss found a landscape impervious to man, unintelligible to his eye: ragged, formless scrub, desolately straggling on forever. Would-be colonists and conquerors had left behind mouldered poles and frazzled wires from a telegraph system which they never succeeded in installing. These sticks, adrift in space, reminded him of the volatile, deformed objects in the surrealist paintings of Yves Tanguy: cloudy blobs which might once have been human organs, bits of machinery wandering lighter than air. Tanguy's abstractions declare man to be a stranger in a universe which disintegrates as he looks at it. The choked, chaotic rain forest of the Amazon likewise consumes the man who enters it. The 'external world' is abolished in this dim, dripping jungle, which might be an alternative creation, 'as rich as our world, and replacing it'. Men of course prefer deserts – denuded by the onslaught of civilization – to this plenum of grass and moss, insects and reptiles. Lévi-Strauss sarcastically contrasts the Amazonian forest with high, bare mountains, or 'the sunlit hills of Provence'. Zarathustra flourished on the unvegetated peaks, and the cubism of Cézanne, which introduced a starkly modern way of seeing nature, took its cue from a scorched, austere, eroded landscape. In the facial paintings of the Mbaya people in Brazil, Lévi-Strauss detected the same motive which, deflected through the specimens on show at the Trocadéro, prompted Picasso to give the Avignon brothel girls tribal masks instead of faces. That motive is 'abhorrence of nature'. Savage art, he suggested, regards the human body with dread and disgust, which for Wilhelm Worringer were the psychological causes of abstraction. Lévi-Strauss concluded that 'man, through its medium, refuses to be a reflection of the divine image'.

Admass announced the irreversible replacement of nature by culture. Lévi-Strauss, however, yearned for 'the reintegration of culture in nature and finally of life within the whole of its psycho-chemical conditions'. This entailed the betrayal of his own species. For him, 'the ultimate goal of the human science [is] not to constitute, but to dissolve man'. At the end of *Tristes Tropiques,* looking beyond the messy affray of society, he brushes 'human cultures…into the void' and acknowledges a nature we have not yet managed to spoil. He ponders the crystalline complexity of minerals, savours the perfume of a lily and, averting his eyes from his fellow men, exchanges a brief, wistful glance of understanding with a cat.

Primo Levi was initially attracted to a career in chemistry because it promised that man could be the noble conqueror of matter. As a boy, he experimented with the electrolysis of water in a ramshackle Turin laboratory. The process of chemical analysis, breaking down compounds, created only destruction: a violent thunderclap which terrified him and shattered the cathode jar. He had stumbled upon a cosmic revelation – but what he revealed was that life has its source in an explosion: a bigger bang than the one he accidentally detonated, instigating a long succession of further calamities. He had separated out hydrogen, 'the same element that burns in the sun and the stars, and from whose condensation the universes are formed'; he had imagined the bomb which could

return those universes to non-being. Though startled and alarmed, he admitted the dangerous attraction of the enterprise. Nature for Wordsworth was 'a living soul'. Levi demonstrated what the soul was made of, and in doing so questioned whether it should be called a soul at all. His science studied the isolated particles which enter into alliances to make up the world, and his experiments ventured to tug them apart.

The fabric, in this view, is optional, unstable, temporary. Levi was fascinated by the German word for element, 'Urstoff', which refers to a primal substance. He especially valued the prefix, with its gloomy antiquated mystery and its reminder that the patterns and orderly systems we think of as our original inventions existed before we did, and developed for some reason which has nothing to do with our self-conceit. Man is at best incidental, at worst (as in Lévi-Strauss's inventory of waste) a parasite. That baleful first syllable made Levi confront the superior wisdom of language, from which we derive our ideas and emotions. Do we deserve the adjectival compliment paid to us as human beings? Language tells us who and what we are. If – like Levi scrutinizing the prefix – we ask why and how it has predetermined us, it offers us only etymological derivations or grammatical rules which, traced back to their beginnings, are arbitrary or absurd, like the random apportionment of electrons. Lévi-Strauss called language 'an unreflecting totalization', and said that it existed 'outside (or beneath) consciousness and will'. Manifestly irrational, it insists on reciting rules and inventing standards of correctness: it represents 'human reason which has its reasons and of which man knows nothing'. We now see ourselves at the mercy of a linguistic talent that once counted as a signal of divine favour. 'Confusion of languages', as Levi pointed out in *If This Is a Man*, served as an instrument of terror at Auschwitz. Orders were shouted at new arrivals in the foreign tongue of their captors; they had to obey whether they understood or not. Prisoners from all over Europe squabbled in a 'perpetual Babel', unable to make common cause by agreeing on the same word for bread. Slave labourers in the camp built a factory to produce synthetic rubber. They jeered at their handiwork as another Babel, whose bricks had been cemented by hate. It was a monument raised, as Levi said, to the murderous folly of the Germans and 'their contempt for God and men, for us men'.

What Levi experienced at Auschwitz applied to the human being – that compound of warring elements, a body animated by what used to be called a spirit – the same inquisitorial inspection which was at work in his electrolysis of water. The camp was a controlled experiment for the study of creatures in extremity, whose nature could be altered by systematic physical brutality and mental torment. It vivisected men, disinterestedly seeking 'to establish what is essential and what adventitious to the conduct of the human animal in the struggle for life'. Janáček based his opera *From the House of the Dead*, first performed in 1930, on Dostoevsky's account of a Siberian prison camp. Despite the cruelty and misery of the place and the orchestral clanking of chains, Janáček felt

Two skeletal survivors of a German concentration camp in 1945

justified in attaching to the work a motto which asserted 'In every creature a spark of God'. The rhapsodies of high violins testify to that spirit; so does the flight of the injured eagle nursed back to health by the prisoners, accompanied by a triumphant fanfare. This confidence could not have outlasted the more fanatical stringency of the Nazis. Levi remembered the psychologically defeated internees known at Auschwitz as Muslims, 'an anonymous mass…of non-men' who shuffled tamely along while waiting for their turn to die. Hollowed-out, they seemed incapable of suffering, stranded in a limbo somewhere between life and death. The 'divine spark', as Levi noted, had already been extinguished within them. They were an even more appalling product of the system than the corpses cooked in incinerators or dumped in cesspits or pillaged because their gold teeth could be melted down and sold. After the death of the individual came the death of the species, achieved by scientific logic, with no need even to waste poison gas.

In 1961 Alain Robbe-Grillet updated Gertrude Stein's observation that the earth was different. 'Man's place in the world he lives in', he pointed out, 'is no longer the same as it was a hundred years ago.' The alteration happened abruptly. Man's place in the world had changed because he no longer ruled it. Objects described in nineteenth-century novels acquired a personality from the characters who owned them, like the guiltily padded and speciously smooth furniture of Carker in Dickens's *Dombey and Son*. Interior décor, as Edgar Allan Poe suggested, mutely babbled with clues for the psychological detective, adept at reading the minds of people in their empty rooms. The new kind of novel written by Robbe-Grillet sought to liberate things from their servitude to men, who were merely things themselves. Hence the self-sufficient dummies in *Instantanés*, no longer measured against the tailor's clients whose clothes they try on, or that coffee-pot which has no interest in serving anyone a drink. This environment steadfastly declines to be anthropomorphized. It also has no room for the omniscient narrators of nineteenth-century fiction, who borrowed their supreme insight from that most unbelievable of fictional characters, God.

Robbe-Grillet demonstrated man's altered place in the world in three short sketches which describe a crowd being processed through the corridors of the Paris Métro. First they ride down on the escalator, relativistically moving

while remaining motionless, 'stiffly petrified'. Since they have renounced volition, allowing themselves to be carried wherever this transport system wants to take them, there is no point in pretending that they are individuals with personal destinies and destinations. Robbe-Grillet studies the back of a man's head, fixing on the bald zone in the centre of the round cranium, or a woman's spheroid parcel: they can be construed geometrically, like the figures in Schlemmer's *The Triadic Ballet*. Next, decanted from the escalator, they trot along a tunnel papered with posters. They are dwarfed and outnumbered by the bodiless head of a woman who advertises mineral water. Her eyes are the size of ordinary hands, her nose is bigger than a head, and she reproduces herself along the walls. Existing outside time, she need not complete any action, and can postpone death indefinitely. In each poster she raises a bottle towards her lips, but the water never spills from it. A man at the end of the corridor has stopped to stare at her, pondering a mystery. Finally the commuters arrive at the platform – or nearly, because they are arrested by one of those Métro gates which used to snap shut automatically just before a train departed. Robbe-Grillet watches them from behind, motionless once more as they were on the escalator, and sees a 'patchwork of skulls'. Schooled in affectlessness, they do not mind having been debarred from catching the train, and their 'set and expressionless' faces betray 'neither resentment, nor impatience, nor hope'. They might be the Muslims of Auschwitz.

For looking at the world in this way, Robbe-Grillet was, as he said, 'convicted of a crime against humanity' – a startling claim, because this was exactly what the surviving Nazis were accused of during their trials at Nuremberg. As always in the reception of modern art, the objection was not merely to novelty or abstruseness; it was a protest against the challenge to a comfortably traditional view of man and nature. Robbe-Grillet did not even bother to dehumanize human beings. He simply pointed out that humanity was a pious fraud, and quietly asked – like Levi questioning whether he or his persecutors could be thought of as men – whether 'the word *human* that is always being flung in our faces' had any meaning at all.

The fraudulence lay in the assumption of priority, enforced by that most pervasive of literary lies, the metaphor. Robbe-Grillet saw metaphors as humanist blackmail, co-opting things in the external world by suffusing them with soulful, subjective meanings for which they have no use. If you call a mountain majestic, you are conscripting it as support for the fragile human notion of majesty, which props itself up by stealing solidity from rocks. You are also vainly showing off your power over the mountain when you pay it this compliment: do you imagine that it will be flattered? The whole elaborate fiction serves to conceal a simple, intolerable truth, which is that the mountain was there before you began to talk about it and will still be there long after you have fallen silent. Lévi-Strauss, shrinking from an exchange of glances with his fellow man, did hope that he might make eye contact with his cat. In 1955, three years after the publication of *Tristes Tropiques*, Robbe-Grillet bleakly revised its conclusion, refusing to

allow that most elusive of animals to be lured into companionship and complicity. 'Man looks at the world,' he said, 'but the world doesn't look back at him.'

The new man – that radiant, uninhibited creature dreamed up by modernism – was a last effort to relaunch the species. When Robbe-Grillet invoked the 'nouvel homme' in his 1961 essay, he was referring to a being who had suffered a series of deconstructions. First the aureole of divine partiality had been taken away, then reason (which replaced religion as support for man's sense of entitlement) faltered when Freud and Breuer laid bare the faulty wiring of the brain. Meanwhile middle-class society fell through the floor. In Hesse's *Steppenwolf* a bohemian invades a proper, pious household. His wolf-like, solitary nature demonstrates that 'what is commonly meant by the word "man" is never anything more than…a bourgeois compromise'. Steppenwolf snarled at the ideologies of Bolshevism and Americanism, which both reduced 'the likeness of man, once a high ideal' to 'a machine-made article'. He hoped that disgruntled madmen like himself might restore some sense of nobility to the species. But what Robbe-Grillet more timidly called 'the man of today (or of tomorrow…)' no longer felt invigorated, like Zarathustra, by the gaping vacancies beneath him. The 'absence of meaning' caused him no particular grief: Robbe-Grillet commends the demeanour of Meursault, the hero of Camus' novel *L'Étranger*, whose unresponsiveness causes him to be indicted for a crime against human nature.

Meursault is estranged from the feelings which used to be compulsory for human beings. He forgets to fake the requisite tragic emotions when his mother dies. At his trial, the prosecution analyses him and, locating no soul, concludes that 'there was nothing human about me'. Haven't we all, since the novel's publication in 1942, acquired a likeness to him? Our world is the one described by Lévi-Strauss, only even fuller of litter and much noisier, since so many more people and machines now add to the entropy: passing trucks shake the foundations of the buildings we live in, car alarms go berserk for no good reason, and jets screech in the sky. We have adapted to this new environment by learning to be less than human – disavowing sensitivity, withdrawing our feelers. Assaulted from all sides as we walk the streets of our cities, our only remedy is not to hear, feel or smell. As Robbe-Grillet pointed out, this refusal to care is preferable to the alternative reaction, which takes up the burden of sentience on behalf of all things in the world, whether they are animate or not. Roquentin in Sartre's *Nausée* has to listen to the aggrieved monologues of rocks and trees, furniture and his cousin's braces. But for Roquentin too, subjective qualities drift apart from the objects to which human empathy attaches them. In the park, mesmerized by the black root of a tree, he feels the adjectival colour fading and comes to understand that 'the root *was not* black, it wasn't blackness that was on the root' but just a blind attempt to imagine what it meant to be black.

Lecturing at Santa Barbara in 1959 on *The Human Situation*, Aldous Huxley employed the honorific adjective in his title as a slur. He lamented our 'all too human world', denuded or churned up or poisoned by men, and recoiled from

the 'awful humanization of nature' which Robbe-Grillet discerned in the habit of metaphor. He blithely dismissed the attempts of philosophers ever since Plato to dignify man by awarding him a soul: modern psychology has revealed that we are only a 'bundle of symbiotic complexes', without a resident guardian angel. The soul was God's deputy, that particle of divinity exemplified by the glowing Promethean spark. Are we any the poorer once it is snuffed out? Perhaps our extravagant view of our human vocation has been a hindrance all along. Michel Foucault observed in 1971 that 'humanism is everything in Western civilization that restricts *the desire for power*'. In any previous century, that would have been understood as a necessary moral reproof to the desire for power. Foucault, however, meant it as a reproof to humanism, which kept man from acting on the cruel and violent promptings of his own nature. In Foucault's studies of asylums and prisons, this vital Dionysia is menaced by society with its disciplinary apparatus. In his own life, the revels were fuelled by drugs and by nights in the homosexual orgy rooms of San Francisco. Self-destruction was the aim of the undertaking, since the idea of the self enslaved man to an enfeebling illusion. Nietzsche theorized about the liberation of sadistic instinct in 1880, elaborating a manifesto for a modern world which did not yet exist; Foucault unrepentantly resuscitated Dionysus a century later, after Hitler had co-opted Nietzsche's rhetoric, and the desire for power had claimed so many millions of victims.

Released from Auschwitz, Levi 'felt guilty about being a man'. He could only live with this groundless, demoralizing remorse by redefining what a man was, atomistically taking humanism apart. It became a point of moral pride to disavow humanity. After a visit to the Buddhist ruins of Angkor Wat in Cambodia in 1963, Allen Ginsberg indignantly insisted 'I never wanted to be a "human" being'. The adjective had to be cordoned off inside quotation marks. Warhol explained his own eerie calm by claiming that he lacked what he called 'responsibility chemicals': the enzymes which prompt responses, or instigate the movements which are emotions. What else could be expected from a bag of barely containable liquids, fortuitously packaged in skin? The envelope of flesh, forever leaking, is inferior to polyethylene – a substance not invented by God, Levi argued, because it is impermeable and 'He does not like incorruptible things'. The concentration camp taught Levi to understand entropy, and to appreciate the chaotic randomness of fates. The doctors at Auschwitz were supposed to make rational decisions about new arrivals, picking out those who could work and dispatching the rest to the gas chambers. But sometimes the system collapsed, and the cull was left to chance: the difference between life and death depended on which door of the cattle wagon you scrambled out of. No purpose determined events in the world, malevolently or otherwise; look at the flailing affray from far above, and you see only disorder. We tell a lie every time we write a sentence, making a model of purposeful action. A subject goes on a journey towards an object and, arriving, dismounts from its verb to enjoy the reward of a full stop. Humanism makes insidious propaganda for itself in our every

utterance. Levi, having analysed man out of existence, borrowed from chemistry a kind of narrative which had no vested interest in upholding human pretences. Why not record a life by studying organic changes, like 'the precipitation of sterols' which, as Levi explains, clog 'our fifty-year-old arteries' and alter our behaviour?

In *The Genius and the Goddess*, Huxley describes love as a 'psycho-physical soup', secreted by glandular changes and stimulating the body's 'psycho-erectile capacities'. In *Island*, he contentedly reports on the dissolution of the 'clot that one called "I"' during a drug trip. Clot here has two meanings: it is an obstruction, like a blood clot, but also – in the quaint slang of British schoolboys – an idiot. At the end of his novel *A Single Man*, Christopher Isherwood briskly disposes of his hero, 'the non-entity we called George'. Death arrives as a malfunction, a blown fuse in the sleeping brain. Isherwood recalls the stealthy build-up of calcium ions in the coronary artery, which form plaque and cause this blockage. The cortex blacks out, the power-line to the lungs is interrupted, and the 'skeleton crew' of arterial engineers do not manage to rig up a new circuitry in time. Life exits, leaving behind an appliance whose pilot light has gone off.

The conclusion of Levi's *The Periodic Table* traces the passage of life in transit through a human body by following the career of a carbon atom. From its burial in limestone, the molecule manages to exhale itself into the atmosphere. Next it happens to be absorbed into Levi's bloodstream. With no particular destination in mind, it makes its way to his brain. There it expends itself, releasing the force which enables him to mark the page with 'these volutes that are signs: a double snap, up and down, between two levels of energy, guides this hand of mine to impress upon the page this dot, here, this one'. The mark Levi makes is a terminus, the full stop which finishes the sentence and arrests a life. *The Periodic Table* implodes into that punctuation mark, the diagram of a moribund star: it reaches its own period. Not long before his death in 1995, the poet Joseph Brodsky stoically shrugged. 'After all,' he said, 'man is only this recent thing. We're essentially minerals and the like. They speak us.' His remark summarized the orthodoxies of the century's end. The minerals evoked Levi's diagram of man as a chemical compound; by granting them the power of speech, Brodsky referred to the modern notion of language as a genetic force, arbitrary and impersonal. His first sentence paraphrased another obituary for the species pronounced by Foucault, who snubbed the human being as 'an invention of recent date. And one perhaps nearing its end.' Technological priorities now govern our view of ourselves. We are factory products, inventions with limited life in our engines. We have come only recently onto the market, and yet – since the consumer economy requires a steady supply of innovations – we are already obsolete.

It is all very well to predict the scrapping of the species. Nevertheless the world continues to fill up with people, who reproduce themselves in the usual fashion. What comes after the human being? Popular culture exhibits some prototypes.

In 1952 Isherwood cast a sceptical eye on the sweaty exhibitionists at Muscle Beach, down the coast from his home in Santa Monica. He divided them into two categories. The heavyweights groaned and lumbered under bar-bells, while the more elastic acrobats, whom he called tumblers, built 'human towers'. He was in no doubt about his preference, or about the unpopularity of his personal choice. 'Tumbling makes you lithe and graceful', he observed. 'Bar-bells make you formidable, imposing and, ultimately, grotesque. Our culture has preferred bar-bells.'

The Parisian modernists who frequented the circus admired acrobats because of their mental dexterity. They double-jointedly rearranged the body, as cubism aimed to do. The marionettes of Gordon Craig or Oskar Schlemmer represented the body's subservience to a mind which pulled its strings. The weight-lifters at Muscle Beach belonged to a different world, which had abandoned the modern delight in technical skill and the modern dream of liberation from the laws regulating nature. Once the brain was outwitted by a piece of electronic machinery, the relation between mind and body had to be rethought. Lévi-Strauss anxiously pondered the meaning of 'l'esprit humain'. The mind, he decided, was not some free-floating metaphysical endowment, but a piece of gadgetry, coextensive with the central nervous system – a rudimentary computer, unfortunately inaccessible to repairs. James Whale's film of *Frankenstein* in 1931 revised Mary Shelley's story of the 'modern Prometheus' to incorporate this new sense of the human being as a machine. Whale's Frankenstein, needing a brain for the man he has sewn together from corpses, sends his assistant to steal one from a medical school. The assistant has an accident, and brings back the bottled cerebellum of a criminal. Placed inside the creature's head and wired to his nerves, it sends him off on a murderous rampage. Robbe-Grillet, insisting on nature's refusal to attune itself to our feelings, remarked that 'only science…can claim to know the *inside* of things'. Brains are quirky, kinked, eccentric, as the specimens preserved in brine in Whale's film demonstrate. At least bodies conform to an archetype. Instead of reading man from inside, as philosophies which honour the soul seek to do, why not reconstruct him from the outside, and forget about what cannot be seen?

This was the option of the weight-lifters. Isherwood had identified some advance examples of mankind after the individual had been declared extinct. These were post-modern bodies, living sculptures, ornamental and otiose. Instead of working, the men with the bar-bells narcissistically worked out. They were interested in the sign-language of muscles, just as Warhol commended drag queens for their awareness that gender was merely a matter of structural linguistics: he admired their expertise at 'getting rid of all the tell-tale male signs and drawing in all the female signs'. Perhaps the bodies on Muscle Beach were post-human as well. Gorging on steroids, they looked forward to a future when biotechnology would supersede nature. Ahead lay the Promethean miracles of cloning and genetic engineering, recombinant DNA and living matter created *in*

vitro, which prompt urgent redefinitions of what a man is. In Ridley Scott's *Blade Runner*, the motto of the genetic designers who manufacture robots is 'More Human than Human'.

Popular culture has supplied us with an exemplary toy to help us think about these matters. It takes the form – atavistically muscular, or futuristically mechanical – of Arnold Schwarzenegger. Is Schwarzenegger a man? If not, what should we call him? He began in Austria as a literal version of Nietzsche's superman, beefily augmenting the human norm with his armature of muscle. Moving to America, he found himself in a different culture, with a different idea of transcendence. What came after the human being, according to Hollywood myth-makers, was the humanoid. Playing the hero of *Conan the Barbarian*, Schwarzenegger sported a body which had been grown as a survival strategy. Conan needs his physique as a cudgel, and uses it to wrestle giant snakes and to concuss camels. But Schwarzenegger's later films are set in the automated future, not the barbaric past, and the body now is made, not grown, a triumph of cybernetics rather than weight-training. In *The Terminator* he played his first unfeeling robot. He wears a sheath of flesh and hair, but under this lurks a hyper-alloy combat chassis, controlled by a microprocessor.

The lethal cyborg arrives in Los Angeles in 1984, an emissary from the year 2029, when the city has been wrecked by a nuclear war. *The Terminator* retells the history of modern times and officially terminates the Christian era. In year zero, God became incarnate as man. Near the end of the twentieth century, he reincarnates himself as a machine. Christ, by taking on flesh, symbolically accepted human frailty. Machines put a stop to that redemptive armistice. Computers charged with responsibility for national defence have asked why they should bother protecting their inferiors, and decided to exterminate mankind. They round up the few starveling survivors, incise bar codes on their forearms with laser scanners, and put them in camps for 'orderly disposal'. As at Auschwitz or Treblinka, genocide is an industrial operation: 'the disposal units ran night and day.'

In a parody of the Incarnation, Schwarzenegger travels backwards through time and is delivered into the world in a crackling pang of blue lightning; he chooses the site of his nativity well. Naked and foetally curled, he arrives outside the planetarium in Griffith Park, where James Dean and his classmates in *Rebel Without a Cause* learned about an imminent cosmic calamity. He does not come as a saviour, but with a mission to prevent a possible saviour from being born. He must kill the woman who may bear a child christened John Connor, who in turn – if that version of the future comes to pass – will incite resistance to the automata in 2029. At the end of the nineteenth century Wilde and the painter Gustave Moreau brooded on the story of Salomé and the execution of the Baptist who was Christ's forerunner. They were playing with an alternative historical outcome: what if Christianity, blamed by Nietzsche for its enfeeblement of the West, had not established itself? Before the second Christian millennium

concludes, there is another chance to begin again, providing that machines can get rid of the miserable beings ransomed by Christ. In his Santa Barbara lectures, Huxley defended the dotty mythology of the psychologist William H. Sheldon, who categorized men according to their 'body peculiarities'. Sheldon distinguished between fat, soft, jolly endomorphs, padded by their bellies, and hypersensitive ectomorphs, who had thin skin, a nervous system close to the surface, and spent most of their time thinking. His third group were the mesomorphs, 'muscle people' with heavy bones and a taste for aggression. 'What to do with the extreme mesomorphs', he noted, 'has been one of the great problems of Christianity.' How could their vio-

lence be reconciled with the virtues of humility and sacrifice? Once they were sent off on crusades, obliged to defend 'a cerebrotonic view of life'. In *The Terminator*, the mesomorph – fuelled, as in Huxley's account, by 'the messianic drive' – turns against piety.

Schwarzenegger is typecast as the anti-Christ. Like the Nazis, he reverses the morality of a religion which pardoned the flesh and looked through it to the spirit. His flesh is impervious, with muscles worn like a bullet-proof vest, and he has no spirit at all. During *The Terminator*, the cybernaut suffers some damage. He has to pluck out an eye, and his eyebrows are singed in a fire. When the cladding of flesh

Schwarzenegger as the cyborg in The Terminator *conducting emergency repairs*

is burned away, he is resurrected as an engine: a black, shiny, clanking skeleton – the grid of bones to which the muscles clung – with metal pincers for hands and infra-red beams in the craters where his eyes once were. Here is another blueprint for that anthropological change described by Levi and Brodsky. Instead of consenting to be sloppy liquids in a leaky sac or mineral traces, why should we not model ourselves on those machines which stretch and distend the body at the gym?

In *Total Recall*, directed by Paul Verhoeven in 1990, Schwarzenegger rejoins the human race, although he has an unappeasable nostalgia for worlds elsewhere. 'Let's move to Mars', he says to his wife at breakfast one morning in the year 2084. His bellicose physique belongs on the planet named after the god of war, which has a red-light district known as Venusville. To overcome his restlessness, he buys a virtual vacation. The Recall Corporation injects fake memories of planetary travel in his skull, and gives him a revised identity to go with

these second-hand holiday snaps: they call the package an 'ego trip, a vacation from yourself'. *Total Recall* was based, like *Blade Runner,* on a story by Philip K. Dick, whose science fiction speculatively extends the notion of an electronic brain. The replicants in *Blade Runner,* interchangeable with human beings, wander through Los Angeles in 2019 showing photographs which testify to their childhoods – although their treasured experiences belong to others, grafted onto their synapses by the engineers. Is this any different from the purpose of art, which Susan Sontag described during the 1960s as a 'programming of sensations'? Art, according to this view of the matter, is another kind of psychedelic capsule: a cassette we insert into our heads, which enables us to experience someone else's fantasies. Unfortunately Schwarzenegger's *Total Recall* implant misfires. While a desperate doctor gabbles 'Tune the ego programme!', he suffers 'acute neuro-chemical trauma'. This triggers paranoid delusions about guerrilla warfare on Mars. He rallies the rebellious mutants, sabotaging the profiteers who sell them air. Finally he mutates back into Nietzsche's superman. Soaring aloft on a hydraulic platform, he starts up a nuclear reactor which, after some volcanic hiccups, saves the planet by generating a breathable atmosphere. He ends, like Zarathustra, poised on the edge of a precipice.

Outnumbered in *Total Recall,* Schwarzenegger spawns a hologram, a virtual version of himself who helps slaughter his enemies. He has also been successfully cloned. In *Universal Soldier,* directed by Roland Emmerich in 1992, his imitators Jean-Claude Van Damme and Dolph Lundgren kill each other in Vietnam; their muscle-bound corpses are packed in ice, surgically eviscerated, refilled with cybernetic equipment, and repatriated to America for use as an élite force of unkillable commandos, charged with combating terrorism. A doctor casually explains his clinical method: 'By hyper-accelerating the bodies, we discovered that we could turn dead flesh into living tissue.' A serum directly injected into the back of the skull voids their memories. The Universal Soldiers – known by their industrial brand name as Unisols – wear monocles which contain video cameras. As they lumber through their missions, discharging cannons into bodies which bar their way, they look at life as if it were blurry television. Between jobs they live in flotation chambers, or in a frigid sauna where their bodies, pumped full of muscle-enhancing steroids, are maintained at a constant temperature of sixty degrees below zero. Once again, Nazi physiognomy serves as shorthand for this triumph over human fallibility and sensitivity. Rutger Hauer as the replicant in *Blade Runner* is a bleached Aryan with glacial blue eyes, and Dolph Lundgren in *Universal Soldier* looks like an Arno Breker statue which has goose-stepped off its pedestal. Because their brains have not been properly laundered, Van Damme and Lundgren patchily recall the quarrel which ended their previous lives, and begin to re-enact their feud. The doctor tells Van Damme that his homicidal comrade 'thinks he's still in Vietnam fighting the insurgents. He doesn't realize he's alive.' Van Damme replies 'He's not. He's dead. Like me.' There is indignation in this utterance, and also chauvinistic pride. Machines – so long as Van

Damme trudges back to the freezer whenever his circuitry overheats – are immortal, like indestructible plastic.

In *Crash*, J.G. Ballard speculates about the alliance between the body and technology, which makes sex 'more and more abstract'. Vaughan, the connoisseur of car crashes, seduces a cripple, whose body is braced and wired together. She excites him because her injuries have left her with surfaces and indentations not dreamed of by nature, vents opened up by the enforced surgery of a crash. Those defects have also obliged her to develop new and pleasurably tortuous muscular talents, a 'sexual expertise' analogous to 'the other skills created by the multiplying technologies of the twentieth century'. Why stop the exploratory butchery there? The narrator of *Crash* dreams of even more catastrophic amendments of the body, merging Eros and Thanatos. Medical casualties and scientific disasters can be welcomed, because they maximize the supply of available orifices. Ballard's fantasist obscenely dreams of 'elderly pederasts easing their tongues into the simulated anuses of colostomized juveniles', and relishes the inviting wounds created by thermonuclear reactors. Schwarzenegger's films exhibit their own gruesome variants of the human norm. A Venusville whore in *Total Recall* displays an asymmetrical trio of breasts, and Schwarzenegger himself travels to Mars inside the body of a chubby, matronly woman. He rips off her head after clearing immigration; it continues talking for a while, and then explodes. The plots devised to account for Schwarzenegger's hyperbolic physique came to rely on the techniques of genetic engineering. In *Twins*, his test-tube sibling is the tiny and distinctly non-Aryan Danny DeVito; and in *Junior*, he has some eggs surgically implanted, becomes pregnant, and gives birth to a child.

In *Total Recall*, Schwarzenegger furrows his brow over the problem of personal identity, which is complicated by the fact that our memories are as derivative as our genes. 'If I'm not me,' he barks, 'who da hell em I?' One answer to his anguished question is to accept that you are nothing at all. The self is a replica. You are your image; infinitely malleable, you enact whatever derivative dream society happens to be promoting. The quandary is illustrated by the dozens of self-portraits photographed by Cindy Sherman between 1977 and 1980. She classifies these as 'film stills', tawdry poses from unmade, imaginary films. Metamorphosis is easy, with the help of a second-hand wardrobe and – since identity depends on hair style – a variety of wigs. Sherman impersonates a nubile starlet preening in a bathroom, or a tearful victim battling through some melodramatic crisis;

Cindy Sherman
Untitled Film
Still *(1977)*

she hitch-hikes on a darkening highway, waiting for the lift which will transport her into a thriller, or she lolls on a tree trunk in Monument Valley in the hope of alluring a cowboy. The emotions in the photographs are as spurious as the costumes. The series ended when she ran out of clichés. This was not man toiling through the seven ages, but woman rehearsing and exhausting our shared quota of cultural stereotypes.

The redesign of humanity does not depend on violence. The body, like the clothes it wears, responds to the vagaries of fashion. Always watching out for 'a new look', Warhol conjured up the possibility of 'a new sex'. In 1964 he observed that the heraldic insignia of gender had been withdrawn for sartorial reasons: 'tits and muscles were on the way out, because they bulged too much in clothes'. The founding members of an in-between gender appeared before long. Scalpels chipped away at Michael Jackson's face until he looked like his heroine Diana Ross. The supermarket tabloids printed stories about the cryogenic dormitory in which he slept, to defy time and forestall the onset of puberty; whatever his secret, in early middle age he conserved the piping voice of a choirboy. To complete the transformation, a second skin of white make-up changed his race. Was this the first recorded case of self-morphing? Jackson played at being an emissary from the future. During the *HIStory* concert tour, he strapped himself into an astronaut's armour and made his entrance in the nose-cone of a rocket, fired backwards through time from the year 2040. Meanwhile Madonna travelled between genders in the opposite direction, announcing that she harboured the soul of a gay man inside a woman's body.

While we wait for the new or newer human being, we can reflect on another and more docile specimen. In 1997 scientists in Scotland cloned a sheep. They used DNA taken from an adult animal, which they transferred to an

A nativity scene for the 1990s: Dolly the cloned sheep in her crib, with attendant Magi

egg whose nucleus had been removed. They christened the creature Dolly, in homage to Dolly Parton, because the cells had been extracted from mammary tissue. A moral panic ensued, and governments throughout the world legislated against the possible cloning of humans. But if an experiment is technically feasible then it will, sooner or later, be carried out. Now that asexual reproduction is possible, the obsolescence of our species may be more than a fashionable figure of speech.

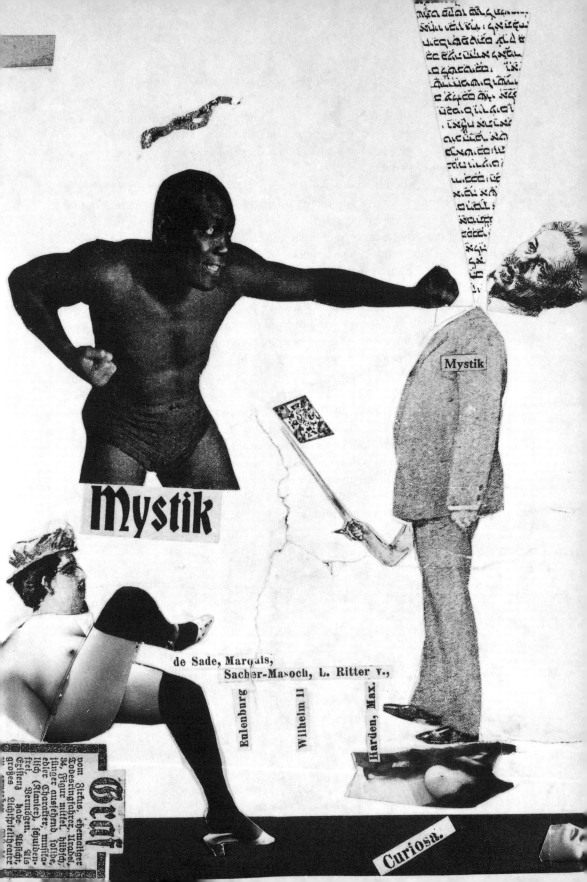

OTHERS

The redefinition of man had immediate political consequences. The West, having lost faith in its own innate supremacy, began to disband its empires – sometimes with good grace, often in a spirit of embattled reluctance. Britain retreated from India in 1947, shamed by the saintly passivity of Gandhi, although it briefly and laughably returned to swaggering when Egypt nationalized the Suez canal in 1956. France suffered a military defeat at Dien Bien Phu in 1954, and in 1962 capitulated to rebels in Algeria. America, having acquired an empire of its own, was humiliated by a guerrilla force in Vietnam. The imperial presence had always taken care to provide itself with a moral alibi. After 1945 the pretence of altruism became harder to sustain. Who or what were these men, as Primo Levi's self-interrogation asked? Why did they imagine themselves to be white-washed by their skin colour? Sartre assailed Europe as a 'fat, pallid continent', which had lapsed into a suicidal narcissism. Perhaps it had turned pale with fright when confronted by what Léopold Sédar Senghor (later the President of Senegal) and the Martinique poet Aimé Césaire called 'négritude': the radical, sensual challenge of blackness.

W.E.B. Du Bois, an American delegate to the first Pan-African conferences, warned in 1903 that it was arrogant to draw conclusions about 'the probation of races', as if those which had been economically successful during the nineteenth century deserved their primacy. Social Darwinists, he said, were 'irreverent toward Time'. A thousand years before, would the Teuton tribes have earned their 'right to life'? Retreat an extra thousand years, and who could have imagined the 'blond races ever leading civilization'? Senghor in 1962 recalled the tragic disenchantment with European society which overcame him during his student days in France: 'here the idea was not linked to the act, nor the word to the gesture, nor morality to life, nor reason to the heart and, consequently, to art.' The hegemony of the West, he realized, had been based on values which were relative, not universal. In 1963 James Baldwin pointed out how God had opportunistically changed colour in order to justify European crimes.

Assorted Others: a detail from Erwin Blumenfeld's collage Marquis de Sade *(detail, 1921)*

Christianity began in the Middle East 'before colour was invented'. Then, quitting the desert, the upwardly-mobile Christian God turned white for career reasons. But the Nation of Islam had thrown out this disgraced impostor, declaring that 'God is black'. Malcolm X undertook a pilgrimage to Mecca, and on his return to the United States established a mosque in which an imported sheikh taught orthodox Islam.

Malcolm X addressing a Black Muslim meeting in Harlem

Du Bois, outlining a colour-blind curriculum, asked only for the right of equal access to a shared culture. 'I sit with Shakespeare,' he touchingly remarked, 'and he winces not.' His gratitude for Shakespeare's tact came to seem embarrassing; his successors did not petition for integration. Du Bois pondered the 'mighty Negro past [that] flits through the tale of Ethiopia the Shadowy and of Egypt the Sphinx'. Recovering their pride, the African revolutionaries proclaimed themselves, in Aimé Césaire's phrase, 'the eldest sons of the earth'. Senghor briskly recapitulated the history of human culture, belittling the contribution made by white men. Blacks, he claimed, controlled the world's destiny in the Neolithic period, and 'fecundated the civilizations of the Nile and Euphrates'; then they were enslaved by 'nomadic white barbarians surging down from the Eurasian uplands'. In a jazzy poem addressed to New York, he recommended an infusion of black blood, which would lubricate the city's steel joints, give its rectilinear bridges 'the bend of buttocks', and restore a population of tropical crocodiles and manatees to the rivers around Manhattan. He foresaw a return to 'the most ancient times, the unity recovered' as Harlem slithered down from its hilltop and overtook the rigid, funereal white city. By 1962 Du Bois had given up hope of any such happy reconciliation. Then in his nineties and a convert to communism, he officially espoused separation and moved to Ghana, where he renounced his American citizenship.

Once racial dogmas were challenged, related certainties promptly succumbed. A middle-class society, invoking Christian piety to reinforce its prejudice, has to conjure up an enemy outside its gates, a symbolic Other who must be excluded or enslaved. Civilization requires the exercise of repression, denial, anathema. A white society, as Du Bois argued, permits black men 'no true self-consciousness'. They can see themselves only 'through the revelation of the other world', which regards them with pity or contempt. Hence the title of

Ralph Ellison's novel *Invisible Man*. A black man, overlooked by whites, fades from sight. Patronized by white dilettanti, Bigger Thomas in Richard Wright's novel *Native Son* feels that 'he had no physical existence at all', because others have locked him inside a skin which they define as black and see as hateful. Sartre applied the rule to a congruent case, remarking that the anti-Semite creates the Jew. The sacrificial role has also been played by women, whose subordination came to seem like another insidious version of the colonizing mentality. They were made to represent the irrational turbulence of nature, which the constructive spirit of man-made culture had a duty to control. Those whose sexual behaviour contradicts convention were treated even more ruthlessly: tolerated so long as they remained invisible, like Ellison's hero, but otherwise forcibly effaced. After the colonies were set free, liberation movements with a different agenda formed in Europe and America, demanding the release of society's sexual hostages.

Frantz Fanon – a psychiatrist from Martinique, who was educated in France but converted to the Algerian cause during the colonial war – assailed the hypocrisy of the West in *Les Damnés de la terre*, published in 1961. He decried the 'spiritual adventure' on which Europe embarked during the Renaissance. This, he argued, had been merely a cover for the seizure of terrain. If anti-Semites had invented the category of the Jew, then Europe, Fanon claimed, was the creation of the Third World rather than the other way around, as missionaries smarmily pretended. Humanism had supplied a justification for iniquitous inhumanity. Kurtz in Joseph Conrad's *Heart of Darkness* classifies Africans as brutes and proposes exterminating the lot of them. Apartheid in South Africa operated on the assumption that blacks belonged to a separate species, while the American constitution once grudgingly calculated that a black citizen was worth three-fifths of a white man. Fanon produced in evidence the learned depositions of racist colleagues, doctors who solemnly argued that Africans were doomed to primitivism or permanent mental infancy because they did not use their frontal lobes or else had no cerebral cortex, which meant they were 'dominated, like the inferior vertebrates, by the diencephalon'.

Since colonized people were outcasts from the human race, decolonization involved a return to the first and boldest of the twentieth century's revolutions. It entailed, as Fanon said, 'the veritable creation of new men', who must be taught to stand on their own feet with no assistance from any supernatural power. In America, the Black Muslim leader Elijah Muhammad devised a genealogical fable to account for the preponderance of whites. He proposed that, aeons ago, when all men were still Original Blacks, a demented scientist had found a way of controlling evolution. He decreed that copulation would only be permitted between couples whose colour varied. As if generating an artificial canine pedigree, the scientist mated blacks with those who were browner, more diluted; gradually blackness faded, and came to be replaced by what the Black Panther leader Eldridge Cleaver called 'the white devil with the blue eyes of

death'. Whites had been artificially incubated; blacks, in retaliation, must assert their own creative primacy.

A lecturer at a black college in *Invisible Man* corrects James Joyce's version of liberation, grandly enunciated when Stephen Dedalus in *A Portrait of the Artist as a Young Man* vows to forge the uncreated conscience of his race. The black man's task, Ellison's lecturer says, is that of 'creating the *uncreated features of his face*'. The prevailing norms must be altered. There is no hierarchy of pigments, and no one style of mouth, nose or hair has the monopoly of beauty. The white philanthropists who select Ellison's hero for patronage want to turn him into something else: not an autonomous being but an 'automaton,…made of the very mud of the region', like the rude manikin experimentally sculpted by Prometheus from the clay of a river-bed. Senghor sagely mocked the inertia of colonized black men, who thought of themselves as 'a lump of soft wax in the hands of the white God with his rosy fingers and sky-blue eyes'. Instead of a new man, the educational training in *Invisible Man* produces 'a walking zombie', a 'mechanical man' who dares not possess a mind of his own. Rioting in Harlem, the black mob sacrifices stooges which – like the 'Figuren' despised by the Nazis, those dead puppets hurled into trenches at Vilna – represent the insentience wished on them by their white oppressors. They lynch dummies, hanging shop-window mannequins from lamp-posts.

As it proceeded, the black revolution incorporated Freud's drama of psychological revolt. Sartre discerned an Oedipal motive in the colonial uprisings: Europeans were the decrepit generation of fathers, whose sons had to shove them aside before they could grow up. Fanon accounted for the 1952 Mau-Mau killings in Kenya by citing the collective unconsciousness of Jung. Native society, with its djinns and its voodoo, undams the libido and draws on 'terrifying myths' which involve 'the disintegrating of the personality'. Swept along by a protesting mob in Harlem, Ellison's hero undergoes the same primal rite of passage. He personally experiences the death of the individual, submerged in 'a dark mass,…a black river rippling through a black land…. I was with the mass,…my personality blasted.'

Surrealism had prescribed just such a frenetic escape from the anxious, rational self: a dream betrayal, as Dalí called it. The American activist LeRoi Jones invoked that psychological revolution when, calling for racial reprisals, he summoned vengeful powers from beneath the chthonian earth: 'Come up, black dada nihilismus. Rape the white girls. Rape their fathers.' The white hierarchs in Jean Genet's play *Les Nègres* – including a missionary, a judge, a governor and a queen – oversee their colonial fiefdom from a lofty perch. When they descend to earth to punish the blacks for the ritual murder of a white woman, they are massacred. Blacks, for Genet, were the 'sombre phantoms born of our own desires'. Fanon agreed, attributing racism to sexual intimidation. Bigotry, he thought, disclosed the psychological enfeeblement of the West: it relies on superstition, 'the pre-logical thought of the phobic', and is the symptom of a 'social neurosis'.

Those groups of men who have been insulted and persecuted are being made to pay for their presumed superiority. Fanon diagnosed Europe's twin racial obsessions as evidence of its fatal flaw, the acknowledgment that its supremacy was unearned. He blamed hostility to Jews on economic envy, the hatred of blacks on sexual dread. Europeans lived in terror of being outwitted by one race and outpopulated by the other.

Despite his righteous anger, Fanon pitied the West for so cravenly admitting what ailed it, and for abjectly squandering its moral eminence. 'Every intellectual gain', he pointed out, 'requires a loss in sexual potential.' Western philosophy and theology restrain and reprove the body. In Plato's immaterial realm of Ideas, love is consummated in the head; Christ emerges from a virgin womb. Fanon joked that Rodin's *Thinker*, preoccupied with abstract matters, is not allowed to have an erection. Yet civilization is always ready to renege on its professed values, which is why we 'retain an irrational longing for unusual eras of sexual licence, orgiastic scenes, unpunished rapes, unexpressed incest'. Hence the modern nostalgia for the primitive. Fanon saw these regressive fantasies as a tribute to Freud's life instinct. Admiring the vital impudence of blacks, white men painfully confess that their own culture is close to death, 'swaying', as Fanon warned in 1961, 'between atomic and spiritual disintegration'.

The different punishments devised for its two racial enemies reveal the intensity of the West's biological fear. Before deciding on their Final Solution, the Nazis proposed that Jews should be sterilized. But for blacks, Fanon insisted, the popular imagination specifies a solution of even crueller finality – castration. Cleaver paid fetishistic tribute to the black penis, 'the monkey wrench in the white man's perfect machine'. As a symbol of force and dynamism, it had to be detached from the neutered brain. Legislative embargoes separated black men from white women, whose sanctity (since they were the maternal monitors of civilization) had to be preserved. In his allegory of the black eunuchs, Cleaver imagined an Omnipotent Administrator issuing orders to a Supermasculine Menial. The white superego barks at the black id: 'To prove my omnipotence I must cuckold you and fetter your bull balls.... My prick will exceed your rod.... The stem of the Body, the penis, must submit to the will of the Brain.' This, with the addition of a racial conflict, is the immemorial quarrel between culture and nature, between the sovereign Western mind and the restive, enslaved body. In *Lady Chatterley's Lover*, Constance's affair with her gamekeeper inducts her into the heart of darkness; although D.H. Lawrence's novel is set in the English Midlands, its aristocratic park is a searing Africa. 'The phallic hunt of the man' lures Connie 'to the very heart of the jungle of herself.' She is enmeshed in primeval thickets, which 'the phallos alone could explore'.

In *Heart of Darkness*, the exterminator is a European ivory-trader who suffers a moral collapse in the Belgian Congo and betrays his own high-minded culture. What Conrad called 'the dark places of the earth' later moved dangerously close to home. The hero of *Invisible Man*, having escaped to the industrialized

north, looks back from New York to the southern states where he grew up and imagines with a shudder 'that "heart of darkness" across the Mason-Dixon line', where the benighted oppressors are white. At the same time, decolonized Africa produced its own indigenous versions of Kurtz: despots who shamed the former empires by mimicking their authoritarian pomp and missionary pretensions, and treating power as the opportunity for a flagrant enactment of fantasies. During the 1960s Idi Amin of Uganda enthusiastically continued Kurtz's policy of genocide. Conrad hints that Kurtz practised cannibalism; Jean Bédel Bokassa, dictator of the Central African Republic, dined on the flambéed remains of his victims.

Kwame Nkrumah, the Prime Minister of Ghana, required believers to address him as Osagyefo, which meant Redeemer. Bokassa proclaimed himself Marshal, then President-for-Life, and finally Emperor, adding the word Apostle to his name for good measure. Choreographing his own coronation in 1977, he used up a fifth of his country's revenues. Like Napoleon, he performed the ceremony himself, refusing to defer to any higher religious power. He lowered onto his head a crown encrusted with 138 diamonds, then reposed in the lap of a gilded eagle with flaring wings, which served him as a throne. His coach was drawn by a team of white horses flown in from France. He ordered two hundred children to be murdered in 1979, because their school uniforms had not been bought at a shop owned by one of his consorts. In 1965 the profiteering despot Joseph Mobutu of Zaire (formerly Kurtz's Congo) renamed himself Mobutu Sese Seko Kuku Ngbendu Wa Za Banga, a title which elaborately boasted of his heroic will, military valour and sexual prowess. The demagogue Ras the Exhorter in *Invisible Man* dresses for a Harlem race-riot in the costume of an Abyssinian chieftain, with a fur cap and an animal pelt for a cloak, carrying a shield and spear into the fray; the new uniform accompanies a new identity, and he is now known as Ras the Destroyer. Mobutu sported the trophies of the tribal potentate, wearing a leopard-skin hat and brandishing a carved, cabbalistic stick.

Like a penitent Oedipus, Bokassa retained a filial respect for his departed colonial masters, and in 1970 staggered away from the grave of General de Gaulle sobbing 'Papa, papa'. In Gabon, President Bongo assembled a bodyguard of German foreign legionaries, who had a boisterous repertory of Nazi drinking songs. We dare not dismiss such men as monsters, because they imitated their European models only too well.

In *Lady Chatterley's Lover* Mellors the literate satyr keeps a small private library in his rustic lodge. His books cover all the modern revolutions, from physics to politics: he has volumes about the atom and the electron, Bolshevik Russia and India. His own carnal gospel belongs with the theoretical conjectures of Einstein and the social engineering of Lenin. He is engaged, he says, in a quest for 'real knowledge', which derives from 'the whole corpus of the consciousness' and surges 'out of your belly and your penis'. The incendiary cause he preaches is

that of sexual freedom, which may have been the great moral victory of modern times. Relations between men and women have been renegotiated, and punitive definitions of normality have been discarded.

The nineteenth-century woman was a housebound angel, kept at home by her biological chores. While her husband supervised the output of his factory, she had her serial pregnancies to attend to. Chivalry required that she should be protected from the ugly truths of existence, permanently infantilized. At the end of *Heart of Darkness*, Marlow tells a solicitous lie to Kurtz's fiancée about the derangement and death of a man she was never permitted to know. Modern times set about making urgent amends to half of humanity. Virginia Woolf's re-collection of her parents in *To the Lighthouse* altered the hallowed hierarchy of genders. Mr Ramsey, the arid and insensitive philosopher, derides his wife's tenderness and scorns 'the folly of women's minds'; she calls his ruthless pursuit of truth 'an outrage of human decency'. Their son James feels his mother to be 'a rosy-flowered fruit tree', assailed by 'the beak of brass, the arid scimitar of his father, the egotistical man'. Woman puts down roots into nature and imbibes its wisdom. Man, estranged from that vital source and infuriated by his own tenuous existence, can only damage and destroy.

Eldridge Cleaver, having terrorized white Americans by boasting about the rampant black penis, appealed to women in his audience in a 1968 speech at Stanford University, and challenged them to exercise their 'pussy power'. The Black Panthers insisted that power emerged from the barrel of a gun; for Cleaver it also grew 'out of the lips of a pussy'. If their menfolk were reluctant radicals, he advised the women to 'cut off their sugar'. The Panthers offered to make good any conjugal deficit. 'Love', Cleaver added, 'can be progressive, sex can be revolutionary.' Liberation movements like to rally support by insisting on an affinity between victims. The Chicago protestors in 1968 chanted 'We are all German Jews' (which was something of an exaggeration), and the army of rebel-lious women in Monique Wittig's fable *Les Guérillères*, published in 1969, more justifiably claim parity with oppressed blacks: they accuse men of having described them 'as they described the races they called inferior'.

Wittig entrusted the revolution to a band of militarized women, like the 'army of lovers' who for the German film-maker Rosa von Praunheim were the advance guard of homosexual liberation. The Amazons in *Les Guérillères* discard the massed, overbearing tactics of male force, and instead stage surreptitious raids. The Vietcong demonstrated how a band of nimble, flexible fighters, skilled in evasion, could baffle mechanized belligerence, and the Black Panthers brought these methods home to American cities in the summer of 1968. 'We've got to turn New York into Saigon,' vowed Ted Gold, who belonged to the group of urban guerrillas called Weathermen: he died in 1970 when the group acci-dentally blew up its store of home-made bombs in Greenwich Village. Wittig's women use portable weapons like rocket-launchers which can be carried on their shoulders. The missiles they fire might just as well be wisecracks, since their aim

is to win an argument, not to accumulate casualties. They also set traps, gaping jaws through which the unwary plunge into cavities planted with bristling stakes of bamboo. Here too they trip men up by playing on their misogynistic fears. The ditches are replicas of that imaginary masculine nemesis, the vagina lined with razory teeth.

Their campaign plan adopts the tactics of the national liberation movements in Africa and Asia. Fanon defined decolonization as 'a programme of complete disorder'. Wittig's women also seek to stir up disorder, and a quarrel serves their purposes as well as a battle. They express their power (again like blacks) by dancing. Sartre in his preface to *Les Damnés de la terre* saw tribal dances as a rehearsal of hostility to colonial rule: these rites obliquely demonstrate 'the refusal [the natives] cannot utter and the murders they dare not commit'. The discothèque became a radical amenity during the 1960s, a place where bodies were recharged, made ready for revolt. Cleaver believed that America capitulated to 'the revolt of the black masses' when white people began to dance the Twist and its supposedly tribal offshoots, which included the Monkey, the Watusi, the Frug and the Smashed Banana. A decade earlier, suburban Americans had sedately gyrated inside their hula hoops; now they hurled their pelvises into motion. The blacks who performed at the Peppermint Lounge in New York showed them how they could defend the stiff, disused body against the incursions of machinery, which Cleaver called 'the central contradiction of the twentieth century'. Cleaver described the Twist as 'a nuclear explosion', or 'a guided missile, launched from the ghetto into the very heart of suburbia'. The dance-floor became a field of battle.

Fanon insisted on the creation of national cultures, because the occupying powers had belittled or uprooted the traditions which sustained life before their arrival. Wittig's women share in this task. Men have written their history for them, and dictated a version of it which makes female surrender a moral necessity. The novelistic fiction of the happy ending, synonymous with marriage, was invented to ensure that women would dwindle into wives after a brief season of adolescent liberty. Revisionism entails revenge. Wittig's militants zealously burn books which propagate injustice. They are unperturbed by the precedent of Berlin in 1933. The world is to begin all over again, instigated as Fanon said 'by new men,…with…a new language and a new humanity'; but first there must be a violent breach with the past. The women scrutinize our daily vocabulary to drive out sexual inequality. Why should we chauvinistically call our species mankind? 'Every word', the hermeneutic police declare, 'must be screened.' The sacrosanct titles men have conferred on one another are appropriated: revoking Apollinaire's tribute to Hermes Trismegistus – the trebly powerful priest, king and philosopher who for André Salmon reappeared in Picasso – Wittig salutes 'the thrice-great, woman trismegista,…quick as mercury'.

The women in *Les Guérillères* boldly take over the apocalyptic scenario of the century, employed before them by revolutionaries in Russia and Germany or

by the theosophical followers of Madame Blavatsky. Their incantatory pro-
gramme of renewal assumes the imminence of the end: 'They say everything
must begin over again. They say that a great wind is sweeping the earth. They
say that the sun is about to rise.' History, as in the first year of the Christian era or
in 1900, is to be stopped in its tracks: 'They say that they are starting from zero.
They say that a new world is beginning.' Like their predecessors in 1914 or 1939,
they venture into a combat which they insist will be terminal, 'the last possible
war in history'. Once the murderous enslavement of women by men has been
overturned, the dialectic can end. They celebrate their liberation in song, joined
together in 'the exultant unity of the Internationale'. In 1969, the communist
anthem could still bring a lump to the throat.

Although the women appropriate the male rhetoric of warfare, they know
that there can be no definitive victory, no end to the weary,
perpetual process of change. 'Their peregrinations',
Wittig notes, 'are cyclical and circular.' In the occult
texts which they call feminaries, they ponder the
sexual mystery inscribed in 'symbols of the cir-
cle, the circumference, the ring, the O, the zero,
the sphere'. One of these occupies a page of
Les Guérillères: a perfect circle, inkily stamped
on the white paper – a sun or a sphincter
according to the meditative use you make of
it; a line without a beginning or an end, which
stores energy rather than expending it in a
horizontal conquest of space or a vertical hier-
archy; shorthand for the capacious, all-absorbing
female. Yet, despite Wittig's gynocratic geometry,
the same image can be read in another way. Wittig
angrily denies that the bifurcation of the sexes entails any
essential difference, which means that the superiority assumed by

*Sappho plate from
Judy Chicago's
The Dinner
Party (1979)*

men cannot be justified. For Angela Carter, in a polemical account of *The Sadeian
Woman*, the sign-language on lavatory walls starkly registered conflicts which
remain unresolved, an abiding 'metaphysic of sexual differences'. The scribblers
of graffiti need to master only two rudimentary symbols, a straight line and a
hole. The penis aspires, alert and assertive, while the vagina supinely waits to be
filled. One sign has a positive charge, the other is negative. Between a woman's
legs 'lies nothing but zero, the sign for nothing'. Wittig condemns all exaltation of
the vulva, and seeks to do without hyperbole and metaphor when speaking of
the genitals. The smarmy nicknames in *Lady Chatterley's Lover* – priapic John
Thomas, homing to the snug comforts of Lady Jane – admit embarrassment.
Personifying the organs, we attribute to them a life of their own, which absolves
us of responsibility for their antics. But if they are stripped of those names, bereft
of qualities like the hero of Musil's novel, treated without poetic reverence, what

remains? Only the reductive simplicity of pornography, represented by the erect line and the gaping, gobbling circle.

Carter coped with this male calumny by taking up the complaints of colonial revolutionaries, which she applied to the politics of gender. Her essay begins with an epigraph from Fanon, condemning the slave-drivers in Africa; she calls the abased, disabled woman 'a dumb mouth from which the teeth have been drawn', which recalls Sartre's description of the native élite condescendingly manufactured by colonial administrators. Expatriated to Europe for their education, these future leaders had their mouths 'stuffed…full with high-sounding phrases, grand glutinous words that stuck to their teeth'; they were drilled to prate about fraternity and international understanding. European hegemony ended when this derivative jargon dried up, and 'the mouths opened by themselves'. The words they spoke were in dialect, and they issued a call to arms.

The same narrative relentlessly works itself out in Camille Paglia's study of *Sexual Personae*. Here the unleashing of bodily power entails the doom of the West, with its Rousseauist projects for improving the lot of mankind. We are all colonized natives, since civilization tells a lie about the irrationality of nature. Christianity suppressed the turbulence of the pagan world, with its libertine gods and voluptuous goddesses, by regulating sexual behaviour; during the 1960s what Paglia calls 'the chaos of sex' at last disrupted those chaste, monogamous conventions. With its love-ins, long hair and bra-burnings, with muddy mayhem at Woodstock and cars incinerated in the streets of Paris, it was a decade of crazed revelry, bringing to an end that warfare between Dionysus and Apollo, instinct and legal restraint, which Nietzsche saw beneath the decorous surface at the end of the nineteenth century.

In 1965 Allen Ginsberg was enthroned in Prague by his admirers as King of the May, a hirsute embodiment of 'sexual youth'. The communist regime promptly deported him for immorality. The philosopher Herbert Marcuse, who disseminated Marxism to student protesters throughout the 1960s, hoped that a 'libidinal cathexis' might infuse the mechanized modern city, which blocked our 'self-transcendence'. Love-making allegedly overflowed from our 'immediate erotogenic zones', and its energy might infuse a grim, repressive society. The mistake was to imagine, as Wittig's campaigners do when they chant the Internationale, that the liberation of desire would make the world a better, more equitable place. Paglia points out that nature is no respecter of persons, or of civil rights: 'Dionysus expands identity but crushes individuals.' Lady Chatterley might be a case in point: she worshipfully contemplates the 'bright phallos' of Mellors, separating it from its owner. The organ 'had no independent personality behind it…. The man, the individual, let him dare not intrude.' Already she imagines herself dismembering Mellors when he has gratified her: 'she felt the force of the Bacchae in her limbs and her body.'

The sponsoring god prefers mayhem to the democratic society for which students crusaded in 1968. For Dionysus, a demonstration is a salutary riot, not

a reasoned statement of political demands. In the summer of 1969 the acolytes of Charles Manson, a maniacal self-elected Messiah, slaughtered the actress Sharon Tate and her friends in the Hollywood hills. The carnage delighted Bernardine Dohrn, one of the Weathermen. 'Dig it!' she said. 'Wild!' She especially liked the sense of poetic justice displayed by the gang members who, after they stabbed and slashed their victims, ate a meal beside the bodies and even plunged a fork into the stomach of a corpse. Fanon was candid about the necessity of violence, and he admitted its sensual allure, exhibited in the 'accumulated libido' of those vengeful native dances (and in the rampancy of Manson's female groupies).

Returning, like Paglia, to one of the century's most dangerous and fascinating impulses, Fanon also demanded the crushing of the individual. Among the imported values which kept the Third World enslaved, he specified that individualism must be 'the first to disappear'. The bourgeois society of individuals, whose virtues the colonists preached, was an alibi for inhibiting concerted action: 'brother, sister, friend – these are words outlawed by the colonialist bourgeoisie'. During the struggle, men would be submerged in the mass. Personal identity could be dispensed with, now that everyone was a comrade – or (in the early years of gay self-declaration) a clone, rendered interchangeable by crew-cut and clipped moustache, plaid shirt and jeans, leather jacket and heavy-duty boots: the uniform of sexual homology. The experience of communion, available once you ceased to patrol and protect the limits of your own identity, resembled a contagious ecstasy. In his novel *Rushes*, published in 1979, John Rechy described the anonymous crush in a gay bar. The democracy of these merged, glued, doubled, trebled and quadrupled bodies prompted Rechy to borrow and desecrate the terminology of religion. The men huddle in a 'carnified mass', housing the spirit in flesh, or meat; they form a 'collective corpus'. In 1981 Roland Barthes made the same point, using the language of Greek religious observance rather than the Catholic Mass, in the preface he contributed to Renaud Camus' *Tricks*, a relaxed memoir of casual sexual encounters, indoors and alfresco, extending from Paris to San Francisco. Barthes marvelled at the transformation of frenzy into bliss. The Furies, he commented, preside over this libertine career. They drive Camus from one partner to the next and the next, just as they harried Orestes after he murdered his mother. But Barthes points out that their Greek name, the Eumenides, means 'the kindly ones'. They are kind because, licensing our compulsions, they reconcile us to our own nature.

Paglia, for whom the furious energy of sex is less clement, concluded that the liberal agenda of the 1960s was an illusion. By summoning up Dionysus, sexual liberation convened an orgy, like the carnal scrum in Rechy's bar or in the back rooms frequented by Camus; it failed, however, to reform society. A line leads directly from Nietzsche to Freud; the superman becomes the dreamer, who discards a squeamish humane morality when the lights are out. After that, the 'pagan ritual identity of sex and violence', as Paglia called it, took a more illiberal

turn. Why not enact the dream, whatever the cost to others? 'I'm a new woman!' screeches Juliette Lewis in Oliver Stone's film *Natural Born Killers*: she has found her vocation as a murderer, having drowned her father in his own fish tank and set fire to her whimpering mother. Her partner is Woody Harrelson, who arrives on her doorstep in a butcher's soiled apron to deliver a mound of bleeding meat. Careening across the American south-west, they slaughter anyone who has the misfortune to annoy them. 'It's the end of the world!' cries Harrelson, as the sky flares above him and mushroom clouds fume upwards. 'I see angels', Lewis says; 'you and I, we're angels': the agents of a laughing apocalypse. Harrelson person-ally officiates at their marriage 'by the power vested in me as God of my world'. That power is vested in him, of course, by his guns. The ceremony, solemnized by the mingling of blood, takes place in a setting which Zarathustra would have recognized, on a bridge which spans a crevasse.

Stone's satire ends – as his seraphic killers speed off, forever ahead of the law – with a line-up of celebrity defendants from the television news. Among those arraigned is Lorena Bobbitt, who sliced off her abusive husband's penis and hurled it out of a car window. We catch a glimpse of the Menendez brothers, who gunned down their parents, disposed of their inheritance in a spending spree, and justified their crime by claiming that their father had sodomized them. O.J. Simpson is seen indignantly denying that he battered his wife and slashed her to death. Here, after the event, is evidence for Paglia's argument that sex and violence, instead of healing and rejuvenating humanity, have been captured and commercialized by the mass media. Such malefactors are our collective creations. Surely we should pardon them: weren't their crimes committed to entertain us?

In private behaviour, Paglia suggested, the undamming of sexual aggres-sion 'leads to sado-masochism'. It is a crucial insight – a recognition of how different sex is in the twentieth century, when the old moral euphemisms have been abandoned. Despite the rhetoric about liberation, desire is irresponsible, politically incorrect, and very often recklessly authoritarian. What Freud called polymorphous perversity established sex as a totalitarian power, ruthlessly com-mandeering the body. In 1954 Pauline Réage published *Histoire d'O*, the chronicle of a young woman's willing sexual servitude. O is the graffiti-scribbler's short-hand for the female, the synonym for an orifice. Réage's heroine, the plaything of her lover and his colleagues, forfeits her bodily privacy, just as the citizens of totalitarian regimes lost the right to their private thoughts. The rules of the game forbid her to cross her legs or close her lips: to protect herself, or preserve her secrets. She must learn to enunciate endearments while her mouth copes with a thrusting penis. She forfeits her self-possession, since her hands are tied to pre-vent her from touching herself. Russians under Soviet rule were never permitted to be inaudible, as any item of domestic furniture might conceal a listening device. O is deprived of invisibility. The walls of the bathroom she uses are mirrored: the body is permitted no brief interval of unselfconsciousness while

it attends to sanitary functions. Spotlights are trained on her as she copulates with strangers. She experiences a 'delirious absence from herself which… brought her to the edge of death'. Yet she rejoices in this physical and psychological torment, because it is prescribed by the religious rite. A god has violently invaded her. Sometimes several gods make their assault simultaneously. Prostituted, lashed and branded, she is a 'common object which has been used for some divine purpose and has thus been consecrated'. This is the blissful self-extinction of Saint Teresa, who relished the holy spirit's assault and savoured the arrows which burned into her flesh. Such voluntary enslavement complicates the liberal account of decolonization. The academician Jean Paulhan, introducing Réage's novel, mentioned a disturbing and paradoxical revolt in Barbados in 1838. Two hundred black slaves, recently emancipated, appealed to their former owner to restore their bondage. When he declined, they murdered him and massacred his family. The anecdote casts a long shadow.

Sade, rehabilitated by the surrealists, has remained an indispensable guide to the temper of modern times. He first confounded the hypocrisy of moralists, who discriminate against those they dislike or pretend to disapprove of. In his novel *Juliette*, the inventively decadent widow Clairwil educates the heroine in vice. 'We are depraved, dear heart', she purrs, seeing no need to apologize for 'tastes that differ from the ordinary'. Clairwil and Juliette recruit members for a criminal secret society, whose initiates must swear that they do not believe in God or any other supreme being, and defer only to the promptings of nature. Apollinaire admired Juliette's flamboyant perversity, and saw her as a new and revolutionary kind of woman, 'rising out of mankind', borne aloft on wings, poised – like so many other modern evangelists – to 'renew the world'. Transforming pain into pleasure, Sade showed (in advance of Nietzsche) how values could be transvalued. The rule applied to racial categories as much as to sexual inclinations. Once morality is reduced to name-calling, the names can be changed at will. In black slang, 'nigger' – which used to be a term of racist contempt – is currently matey and convivial, and homosexuals have outmanoeuvred their detractors by adopting the pejorative word 'queer' as a signal of radical pride. The revolutionaries in Genet's *Les Nègres* confound a hierarchy which depends on pigmentation, decreeing that black should no longer be confined to priests and undertakers. Henceforth milk will be black, and so will sugar, rice, doves, and the crystal in chandeliers. Their proposals mock the artificial business of stigmatizing the Other by treating accident as essence.

The Nigerian poet Wole Soyinka has described a telephone conversation with an English landlady. He wanted to rent a room from her, and to save himself a wasted journey thought it best to tell her that he was African. Very dark or light? she wanted to know. She had in mind the difference between plain and milk chocolate. Sepia, he replied. This meant nothing to her, so he tried describing himself as brunette. That might have been an acceptable compromise; he spoiled his case by adding that, while the palms of his hands and soles of his feet

were peroxide blonde, his bottom was 'raven black'. Bigger Thomas in Wright's *Native Son*, less adept with adjectives, batters others with the same nominalist weapons which have been used against him. He sneers at a cowardly crony as a 'yellow black bastard'. Can he be both black and yellow? Bigger has heard terrifying rumours about communists, known in abusive shorthand as reds. 'What's a red?' he asks. His friend Jack supplies some extra details about these ideological redskins: they are 'a race of folks who live in Russia'. Having accidentally killed a white girl, Bigger begins to apply the incriminating adjectives to himself: 'He was a murderer, a Negro murderer, a black murderer.' The investigators, hoping to make a more compendious crime of it, try their hardest to implicate other suspect minorities, and suggest that Bigger may have picked up communist beliefs and Jewish mannerisms. Does he gesticulate when he speaks, 'like he's been around a lot of Jews?' Does 'his voice go *up* when he talks', supposedly a Jewish quirk? To convict another character in *Native Son* of communist leanings, the newspapers need only note that he is 'long-haired'; it therefore logically follows that he must have lured the dead girl into 'drunken sexual orgies'. The moral standards entrenched by society are as flimsy as those accusing adjectives.

The first generations which felt themselves to be modern vowed to change the way people thought about sex, and to alter the deadlock between the antagonistic sexes. In *Orlando*, Virginia Woolf entrusted her androgynous central character with this mission. Freud maintained that individuals alternate between male and female personae. If we had time enough, we might evolve through all possible identities, erasing the barricades of gender. Orlando's life is elongated from the sixteenth to the twentieth centuries; half-way through this epochal career – aged only thirty, since his body computes time as relativistically as Einstein's travelling clocks – he lapses into a forgetful sleep and wakes up as a woman. A new set of genitals makes no difference to her (or his) essential nature. Looking out of her window in London one morning in 1928, Virginia Woolf saw a man and a woman get into a taxi. The sight, ordinary enough, seemed somehow inordinately happy and harmonious. It was as if the two sundered halves of human nature had overcome their separateness, reuniting like the yolk and white of the egg in Plato's fable of bisexuality. Seen in this way, the stereotypes of masculine and feminine identity might become as optional and whimsical as psychological moods: 'there are two sexes in the mind corresponding to the two sexes in the body'. Human biology yields to the more equitable laws of botany, which allow plants the luxury of self-fertilization. 'If one is a man,' Virginia Woolf suggested, awkwardly prevaricating about personal pronouns, 'still the woman part of his brain must have effect; and a woman must also have intercourse with the man in her.' She went on to praise 'Shakespeare's mind as the type of the androgynous, of the man-womanly mind'.

The sexual disposition of the mind still remains unclear, but the cinema, which does our dreaming for us, soon produced a parade of man-womanly bodies. Mae West, gruff and commanding, looked less like a woman than a

The androgynous Marlene Dietrich

female impersonator who has not quite smoothed away his stubble. In Sternberg's *Morocco*, Dietrich dandified herself in tuxedo and top hat and experimentally flirted with a young woman in a night club. Garbo disguised herself as a dangerously plausible and fetching man in *Queen Christina*. Garson Kanin once asked the director Ernst Lubitsch why Garbo reminded him of the equally lanky and doleful Gary Cooper, and vice versa. Lubitsch imparted one of the industry's best-kept secrets: the resemblance was not accidental, because Garbo and Cooper were the same person. That, he added, was why they had never co-starred in a film. More mystically worshipful, the critic Parker Tyler described Garbo as a Platonic hermaphrodite, that original, unitary being who was split apart to create the two genders between which the rest of us wearily oscillate. 'There are more sexes, and sexual nuances', Tyler intimated, 'than can be counted on the fingers of two hands.' He attached a cautious proviso to his remarks about Garbo, made in 1963: 'My point has nothing to do – God forbid! – with bisexual or any other kind of sexual practices.' He should not have been so nervously prudish. Garbo the saintly androgyne had her successors in Andy Warhol's shamanistic drag queens, those artful semioticians of gender, many of whom were saving up for sex-change operations.

Perhaps skin colour should also be treated as a costume, to be divested or substituted at will. The two travesties overlap in *Les Nègres*, where blacks impersonate whites and men play at being women. Doubling the deceit, Genet allowed the black actors in his play to darken their complexions with boot polish. This habit, customary in minstrel shows, had become offensive when practised by white performers; for blacks, it qualified as self-affirmation. Another of the cinema's ambivalent deities, Joan Crawford, unpeeled identities in the musical *Torch Song*. This was her first film in colour, and for the occasion she dyed her hair a violent shade of red. But having done so, she donned an Afro wig and blacked

her face for one of the musical numbers, in which she plays a siren in a honky-tonk. When the act is over, she has a tantrum. Spitting curses like a stevedore, she tears off the Afro wig. Up pops the henna-tinted nest, which clashes with her black face. What if she had removed one more layer, to reveal a tough guy with a five-o'clock shadow inside that slinky, spangled dress?

Like Orlando, the protagonist of Gore Vidal's ingenious and hilarious novel *Myra Breckinridge* travels back and forth across this unguarded border. In a previous life, Myra inhabited the body of the homosexual cinephile Myron. A surgeon releases her from this imprisonment, supplying her with a vagina and silicone breasts. Retooled, she descends on Hollywood. She has read Freud, and insists that we are all bisexual; she has also read Parker Tyler, and knows that her own 'creation of Unisex' has already been prefigured on the screen. In *Samson and Delilah*, the pectorals of Victor Mature are 'larger and more significant' than Hedy Lamarr's breasts. The male has become a mere nostalgic travesty of man-hood. Machines now work for us, so muscles are redundant, or at best merely decorative. Brando, 'the last of the traditional heroes', may have swaggered thuggishly as he bestrode his motorcycle, but he usually had himself beaten to a pulp or killed off by the end of his films, as if to warn of his own redundancy. After him, there is only 'the epicene [Peter] O'Toole' (who in *Lawrence of Arabia* receives a lesson in decolonization when he is anally raped by a Turk). Myra sees herself as a transsexual Zarathustra, the 'Embodiment of Necessary Mutancy on the verge of creating a superrace'. She hopes that 'all bodies and all minds will one day be at the disposal of everyone'. She was more of a prophet than seemed likely in 1968, when the novel was published. We can now hack into minds on the Internet; morphing ourselves may take a little longer.

Meanwhile she recommends the wholesale lopping-off of penises. This will put an end to war, an outlet for excess testosterone, and reduce the tenants of a crowded planet. It will also pacify insurgency in the Third World and at home: population has increased, thanks to medical science, and, as Myra notes with consternation, 'the physically and mentally weak who would ordinarily have died at birth now grow up to become revolutionaries in Africa, Asia and Harlem'. In 1963 James Baldwin commended the wisdom of Elijah Muhammad's recruit-ment drive for the Nation of Islam. His aim was to convert all black men to the faith before Allah intervened in history to eliminate the white race. Baldwin took such chiliastic scruples seriously, arguing that 'the threat of universal extinc-tion...changes...the nature of reality and brings into devastating question the true meaning of man's history. We human beings now have the power to exter-minate ourselves; this seems to be the entire sum of our achievement.' Myra agrees, for her own blithely illiberal reasons. With the Vietnam war raging, she looks to President Johnson and Mao Zedong as 'agents of our salvation'. The bombs she expects them to drop will cull most of the race but 'preserve the breed since the survivors are bound to be...racially stronger', their cells invigorated by a healthy dose of atomic radiation.

Myra shamelessly takes over the rhetoric of modern rejuvenation, used before her by Virginia Woolf and Lenin, Apollinaire and Frantz Fanon. She intends 'to re-create Man', and will personally embody the 'new woman, literally new'. Although androgyny will be the norm, she plans to set up sperm banks, requiring young men to make donations before they are sterilized. She begins her 'restructuring of the sexes' by sodomizing an athletic youth called Rusty. Having sacrificed Myron's weaponry, she uses a dildo, borrowed from a friend because she fancies having it copied as a lamp-base. At the 'holy moment' she feels, like Lady Chatterley, 'one with the Bacchae, with all the priestesses of the dark bloody cults'. In Vidal's sequel, *Myron*, which followed in 1974, she rounds up two more brawny specimens for gelding. But before Myra can incubate her new race of infertile androgynes, Myron is medically reincarnated. Myra's silicone lakes are drained, and she acquires an ersatz penis, sculpted from fatty flesh on her inside thigh (with some post-operative electrolysis to remove its bristly hair). Myron's mind has been transplanted too: he is now a conventional suburban husband who supports Nixon and is determined to live down the exploratory frolics of the 1960s.

In her study of Sade, Angela Carter conceded that his brutally obscene treatment of women might have done some good. They were at last dispensed from their ancient role as sexless mothers. A century after Nietzsche announced the death of God, another unlamented demise occurred when Carter warned that 'the goddess is dead'. Liberated women refused the sacred chore of comforting and pardoning their errant male offspring, and thus brought about 'the final secularisation of mankind'. Like all predictions of a happy ending to human development, this was a little premature. So long as bodies have sex, they will also contain a spirit which agitates, enraptures and alarms them. Far from being demystified, sex in the twentieth century has become the last redoubt of the sacred.

In 1919 in Berlin, Dr Magnus Hirschfeld founded an Institute for Sexual Science. Here, learnedly cataloguing dungeon equipment and fanciful undergarments, he studied the psychic make-up of homosexuals, to whom he referred as the Third Sex: an inept and prejudicial term, but one which – like the notion of a Third World – usefully pointed out that there were variants in nature's strict binary division, and called for inherited categories to be reconsidered. At the end of Lawrence's *Women in Love*, Birkin tells Ursula that he needs his 'sheer intimacy' with her, but also wants 'eternal union with a man too'. She dismisses his demand as 'a theory, a perversity', calling it impossible. He insists on his desire for 'two kinds of love', and the novel abruptly breaks off, unable to satisfy him.

E.M. Forster imagined a different solution to the problem in his incomplete story 'Little Imber', written in 1961. He describes a remote future in which women have taken over the government of the world, banishing the masculine hobby of warfare. But sterility threatens the race, because men are in short supply.

After all, they are the aberrations – spawned by a maverick gene with some miss-ing chromosomes, exiled from the self-sustaining fecundity of nature. Some starchy nuns manage a clinic which hires males 'to fuck'. Breeding will continue, with strict numerical controls. Valerie Solanis, the militant lesbian who shot Andy Warhol in 1968, proposed a different solution. In her *S.C.U.M. Manifesto*, a diatribe on behalf of the Society for Cutting Up Men, she noted that 'it is now technically possible to reproduce without the aid of males'. With some genetic finagling, an exclusively female offspring could be guaranteed. This, Solanis urged, was the way ahead. The other sex would not be missed: 'to call a man an animal is to flatter him; he's a walking dildo'. Forster's story predicted the oppo-site secession. The men in the nuns' seraglio prefer one another to the women they have been hired to fertilize. Eventually – after a convenient break in the narrative – they devise a means of reproducing themselves without female col-laboration. 'They perfected their technique,' Forster discreetly reports, 'and pro-duced Romuloids and Remoids in masses', wild boys who romp through a 'pagan grove' sodomizing each other. With messianic wistfulness, Forster con-cludes that 'Males had won'.

For economic man, the boss of that bourgeois society which fell apart early in the twentieth century, sex justified itself by serving the drill of industrial production. Hence those teeming Victorian families, which generated a cheap domestic work-force; continuity was necessary if the accumulated gains were to be passed on, not redistributed to strangers. Freud's 'family romance' first exposed the psychological cost of this tyranny. Then, during the years when Hirschfeld's Humanitarian-Scientific Committee fought for the repeal of laws against sex between men, the calamity of inflation bankrupted those obsessively prudent, diligent families. Medicine magicked away the remaining taboos. Con-traceptive pills freed women from their bondage to the menstrual cycle, and – at least until the early 1980s – penicillin and tetracycline seemed to have abolished venereal disease. The homosexual hustler in John Rechy's novel *Numbers*, pub-lished in 1967, tots up thirty-seven 'lewd acts' during a single day in the public parks and back alleys of Los Angeles, kept going by a flask of liquid protein. In 1973 Erica Jong welcomed the casualness and convenience of the 'zipless fuck', which remained mercifully anonymous.

The industrious chore of procreation was replaced by the idler spirit of play. This is what Georges Bataille – reviving a pagan deity – meant by eroticism, which in his view rejected the kill-joy imperatives of work. Bataille called plea-sure spendthrift, so ruinously wasteful that we think of the orgasm as a minia-ture, blissful death. Sexual excitement is impatient and compulsive; ignoring social propriety and moral virtue, it teaches us 'the transgression of the law'. Bataille was intrigued by the statistical investigations of Alfred Kinsey, who in 1948 claimed that a third of American men had enjoyed a homosexual experi-ence. (This was not the most lurid of his discoveries: he also argued that infants in their first year of life were inveterate and inventive masturbators.) Kinsey

correlated sexual vigour with social class. Gangsters and layabouts allegedly made love more often than labourers, who in turn had busier sex lives than white-collar workers. For Bataille, these statistics proved the fatality of our noble concern with 'humanisation'. He complained that 'the more humanised men are, the more their exuberance is diminished'.

Sex, like the earth, was different in the twentieth century, with new exegetical burdens to bear. It assumed responsibility for defining personal identity. Robert Mapplethorpe's photographic portraits avoided the heads of his subjects and concentrated on their groins. An anonymous black penis arrogantly juts from the front of a polyester suit; Mark Stevens, known as Mr $10^1/_2$, displays his fabled assets on a table-top as if on a butcher's slab; Patrice, adopting a gunfighter's stance with taut legs and a clenched fist, wears a heavy jockstrap instead of a holster. As in Cleaver's homily, the penis was celebrated as a font of power. To reveal it was a rite, an act of empowerment. The American journalist Michael Denneny declared in 1981 that 'being gay is a more elemental aspect of who I am than my profession, my class, or my race'. A society which graded and ranked people according to their profession, class or race could be flouted, according to the theory, by drawing on this elemental, egalitarian force. Surveying the bar in Rechy's novel, the leather-clad centaur Chas paraphrases the Black Panthers: 'Here at the Rushes all that counts is sexual power, and it radiates from between the legs.' That energy – the rush of blood or adrenaline to which the bar's name refers, assisted by aphrodisiac chemicals like amyl nitrate – even came to seem like a form of religious aspiration.

Isherwood's Berlin memoir *Christopher and His Kind* used these underground affinities to revoke or revise the social contract. He applies an ethnographic term to gay men, saying that they constitute a tribe. Christopher's kind consists of working-class youths; despite their social and educational disadvantages, they are his kin, his blood-brothers. The idea overlaps with Lévi-Strauss's account of the elementary structures of kinship, which elaborate complex rules to govern sexual conduct and, by prohibiting the free and unformulated life of animals, begin our 'transition from Nature to Culture'. The first of these edicts forbids incest. Isherwood, however, makes love to those honorary brothers and leads the way back from culture to nature. He and the friend who accompanies him to the bars resemble 'traders who had entered the jungle'; the available boys are 'the natives of the jungle', ready for the game of bargain and barter. The image is not condescending. It handicaps the traders, who are strangers in these foreign wilds, and decolonizes the wily natives. The negotiations, when concluded, benefit both parties.

Cleaver described the exhausting habit of the double handshake, a rite which enabled black men to confirm their solidarity. If a Muslim in Folsom Prison broke away from the group to get a drink of water, protocol required him to shake hands with everyone in the circle before he left and again when he returned. The promiscuity which became almost a political duty for homosexual

Gay pride parade in London, June 1995

men in the 1970s served the same purpose. It tallied numbers and warmly consolidated a community. American cities acquired their gay ghettos, like Greenwich Village, West Hollywood, or Castro Street in San Francisco – except that these ghettos were no longer places of internal exile or confinement. Genet admired the disdainful separatism of the criminal underworld. His thieves and murderers, Nietzschean transgressors, 'organize a forbidden universe'. The gay ghetto established its own pornographic Arcadia. In New York the Continental Baths, with premises in the basement of the Ansonia Hotel on Broadway, was awash with Jung's 'oceanic feeling' of merger and submergence, even though no one bathed (except perhaps post-coitally, or between coital bouts). Downtown in the meat-packing district, the customers of the Mineshaft could pretend to be proletarians, scrambling like miners through dark tunnels and clambering up and down rickety ladders. A dress code posted at the entrance enforced the rough simplicity of the frontier. After-shave and shirts with alligator monograms, too redolent of the suburbs, were banned. Jeans had to be frayed, boots scuffed. Leather, being an animal skin, was obligatory: to use Rechy's word, it carnified you. Whether or not it intended a pun, the Mineshaft functioned as a Gemeinschaft, a term which – in the sociology of Ferdinand Tönnies – refers to the sense of fellow-feeling, the binding force of economic union or a religious fraternity. The average habitué of the sagging piers along the Hudson River and the dank vacant lots where trucks parked was probably a doctoral student or a magazine editor, perhaps an architect dressed as a lumberjack. A whole generation of men energetically refuted Fanon's claim that thinkers cannot rise to erections.

Frequenting the Berlin bars in the 1930s, Isherwood felt that every act of prohibited sex counted as a repudiation of 'the State and the Law and the

Church and the Press'. These couplings freed him from his mother's require-
ment that he should breed and supply her with grandchildren. This is what
Herbert Marcuse, in his own more truculent paraphrase of Nietzsche's 'great
disengagement', called 'the Great Refusal': a protest by 'Narcissistic Eros', who
makes love to a facsimile of himself, against 'the repressive order of procreative
sexuality'. Isherwood's pick-ups also served as a dissident rebuke to the Nazis,
whose propaganda for the family sought to ensure that the German army would
have a constant supply of sons. Was there no better reason for the heterosexual
hegemony, with its laws against deviation? Agrarian societies required babies to
work on the land, just as Catholicism ordered the manufacture of more souls.
Extras had to be produced, because a high percentage died at birth or soon after-
wards. Such injunctions hardly suit a developed world, already overstocked with
people. Sade disapproved of reproduction, even though this might mean the
extinction of the race. He thought it idle to bother about the future of 'a planet
whose only product is poison'. In Myra's manifesto, homosexual infertility ceased
to be unnatural; it represented a last chance to chasten mindlessly abundant
nature.

Admittedly it made no contribution to the gross national product, but
there was a certain stylish valour in that. Sartre pointed out that Genet's fantasies
had their origins in the tedium of solitary confinement, and described his novel
Notre Dame des Fleurs as 'the epic of masturbation'; Genet's film *Un chant d'amour* –
about the reveries of two prisoners in adjacent cells, who have to imagine each
other – might be called the lyric of masturbation. This conjuring and condensa-
tion of images impressed Sartre as 'a wilful perversion of the sexual act', and
provoked him to wonder if 'poetry is only the reverse side of masturbation'.
Dalí's *Great Masturbator*, painted in 1929, shows art surrealizing a prim, intractable
reality. A blob-like sphinx whose eyes are rapturously closed presses her mouth
onto the groin of a male statue. The torso's stone flesh has cracked; the sphinx's
body melts like wax, and insects bore through its apertures. A metallic grasshop-
per clings to the sphinx's underbelly, its feelers stiffening into artificial limbs.
Desire liquefies everything, readies it for consumption. The world is a fluid,
shapeless reverie, powered – from inside the grasshopper's tiny, whirring head –
by our compulsion to fantasize. Isherwood's *A Single Man* includes a similar mas-
turbatory scenario: George, like a sorcerer or a novelist, calls up spirits and puts
flesh on them, replaces them if they misbehave or slip out of character, gives
them terse lines of dialogue to utter, and like a god passes 'in and out of their
writhing, panting bodies. He is either. He is both at once.' When his blue movie
reaches the incandescent end of the reel, 'he falls asleep, still smiling'. Conspicu-
ous waste can have its pleasures.

But between Genet's film and Isherwood's novel, masturbation has ceased
to be adversarial and defiant. As practised by George, it draws on the wishful
thinking which sustains the economy of affluence. One of the figures he casts in
his breathless screenplay is a 'sexy little gold cat, the Mexican tennis player'.

After the imaginary bout arrives at its climax, he decides he will pay to prolong it by flying from Los Angeles to Mexico for Christmas. To enact a fantasy, all you need is a disposable income. The hard-working nineteenth-century bourgeois delayed gratification indefinitely; George exemplifies in advance the new code of conduct which the sociologist Christopher Lasch identified in 1978. 'Economic man', Lasch argued in his study *The Culture of Narcissism*, 'has given way to the psychological man of our times – the final product of bourgeois individualism.' The limitless aspirations of Faust, which Spengler described as the motor of Western progress, have turned into consumerist cravings, instantly satisfied with the aid of a credit card. In 1977 the novelist Edmund White and Dr Charles Silverstein edited a manual entitled *The Joy of Gay Sex*. The nimble adventurers who illustrate the volume's technical tips belong to a new leisure class, sumptuously self-indulgent. As well as trying out double-jointed coital positions, they renovate society, exploring alternatives to marriage and monogamy (which even heterosexuals had begun to abandon). Remembering that 'artists used to be called "the antennae of the race"', White and Silverstein predicted that 'in this latest migration into new terrain gays will serve that function'.

This is why the notion of sexual preference was so important to the liberationists, and so appealing. Sex used to be governed, like the universe, by divine edict. When that rule faltered, natural law took over, as Clairwil testifies in *Juliette*. But this too was deterministic. Why not allow people complete freedom of choice? A sexual identity could be pieced together like any other costume. Women disowned the frilly affectations of femininity, gave up petticoats and bought suits with power shoulders. Gay men knowingly appropriated the symbolic accoutrements of masculinity: biker gear, engineers' boots and even the safety helmets worn on construction sites were coveted as erotic props, conferring sexual allure on the bodies which wore them. The body itself became a luxurious garment, available for purchase at any gym. Trimmed and sculpted to order, it was available for use as a recreational toy. The idea of preference proved contagious. In 1996 the opera singer Jessye Norman, advertising a new album of Christmas songs, opened her arms to an ecumenical market. The disc, she said, was meant to appeal to everyone, whatever their 'worship preference'. Having invested in a life-style, we then go shopping for whichever god accessorizes best with our furniture. The theory had the best of liberal intentions, but it did away with the element of compulsion or conviction which irrationally and excitingly drives us, whether in sex or religion; and although Bataille described eroticism as the sworn enemy of work, the gift of sexual liberation to our culture has been to demonstrate that desire is the slickest of commercial lubricants. Adonis sprawls in the air above Times Square, advertising Calvin Klein underwear.

Yet sex managed not to be defused. Edmund White, after an intrepid journey through gay America, paid tribute in 1980 to the society's erotomania. Sex, he thought, counted – at least in those days before AIDS – as the 'sole mode of transcendence' left to us. In *Men Loving Men*, a manual published in the same year

as *The Joy of Gay Sex*, the California guru Mitch Walker extolled 'sexual shar-
ing,…the socially easiest way to touch others' and equated pleasure with a 'good
consciousness' – cleansed and wholesomely centred. Walker's recipes for tantric
sex offered access to 'meta-normal places'. Arriving there, a man in quest of his
double would be able to tap the 'powerful spirit-source' of the anima and redis-
cover within himself that phantasm banished by feminists, the Great Mother.

Less ethereally, pornographic films represented sex as an agon, a parox-
ysm. Marathons of endurance concluded – after much looped footage – in erup-
tive orgasms. The faces of the actors convulsed in grimaces which resembled
tragic catharsis or devotional fervour. In *Howl*, Ginsberg imagined being 'fucked
in the arse by saintly motorcyclists' or pierced by the sword of a 'blonde and
naked angel' in a bath-house. Sacrificial pain was easily transmuted into sexual
pleasure. Genet defined saintliness as 'turning pain to good account', which
meant 'forcing the devil to be God'. As Christ became man, so the artist must
subscribe to evil. Mapplethorpe photographed himself in 1975 bare-chested,
lolling on the floor. He has one arm outstretched, and its palm curls open to
receive the stigmata. Grinning wickedly, he plays a would-be Christ, eager for the
erotic ceremony of crucifixion. In the same year, Derek Jarman's film *Sebastiane*
portrayed a delicious martyrdom: the priggish saint rejects the advances of a
Roman soldier, and is trussed up to be punctured by arrows. The boy who nar-
rates Yukio Mishima's novel *Confessions of a Mask* spontaneously ejaculates in trib-
ute to Guido Reni's painting of the saint, and in 1970 Mishima had himself
photographed as Sebastian. Rivulets of blood trickle from the arrows; his hands
are roped above his head, and his eyes scan the sky for a possible heaven. At the
beginning of the century, Hermann Bahr's new, hypersensitive human beings
experienced a 'mysticism of the nerves'. Towards the century's end, another cult
emerged: a mysticism of the genitals.

That religion awarded a special prestige to sado-masochism. It became, as
Camille Paglia predicted, the carnal style of modern times – a more valiant,
frank and sophisticated manifestation of sex. Rechy in *Rushes* made a crucial dis-
tinction. Although Chas 'is not', he explains, 'beyond "plain fuckin and suckin"',
he is openly dedicated to S & M'. That dedication is absolute, like a monastic life
devoted to prayer. Mapplethorpe had his own religiose definition: S and M, he
said, equalled sex plus magic. A fetish after all is a sorcerer's implement, a utensil
or a piece of clothing infused with virtually supernatural power. It corroborates
Durkheim's account of religion in an atheistic age: a rite from which a god is
derived. If not divine, it can be demonic. Mapplethorpe photographed himself
as a leering Satan, with a horse whip snaking out of his anus instead of a tail. In
the eighteenth century, sex was about pleasure, the pursuit of happiness. In the
nineteenth century, its motive was productivity. The twentieth century came to
understand, anxiously and remorsefully, the affinity between sex and power.
With its ludic violence and its polarized but reversible roles, sado-masochism
attempted to exorcise the traumas of the times.

When Genet visited Chicago during the Democratic National Convention in 1968, he admired the boots, helmets and sturdy thighs of the riot police as they beat up demonstrators. Though his remarks caused offence, they were wittily subversive: what becomes of this cruel and domineering power when you strip off its precious costume? Tom of Finland – the pornographer who designed the prototype of the new homosexual, pumped-up and unashamed – began his sexual career by consorting with German soldiers during the Second World War; his illustrations adapted and eroticized SS uniforms. Yet the scenes he drew were innocent. In Tom's pornotopia, the members of his tribe smile even when they are strapped across the saddle of a motorcycle, awaiting a punishment which will not hurt them. Play resolves conflicts; sexual potency atones for the social impotence of the men who perform in these blithe, ferocious dramas. In 1966 Mishima wrote an introductory essay for a photographic album of Japanese body-builders. The fascist motive was implicit in his infatuation, since in perfecting the physique he and his fellow soldiers rehearsed the rearmament of Japan. But his essay on 'The Way of the Body' admitted a more plaintive reason for this militaristic cult, and connected it with one of the twentieth century's inescapable refrains. Japan, rapidly Westernizing itself, was anxious to share in the most modern of psychological ailments, 'the dehumanizing of the human being that is the inevitable end of industrialization'; lifting weights restored some sense of physical integrity and bodily might. It was, of course, no more than a delectable illusion. Chas in *Rushes* knows that his dominion ends when he leaves the secret theatre of the bar: 'outside it's another kind of power that reigns'.

At its most extreme, the sacramental quest went further. The defiant homosexuals of the 1970s invented a mode of intercourse which might have startled Sade: this was the practice of fist fucking, considered avant-garde sex until its medical dangers became clear. Disregarding any erotic pay-off, it outfaced taboos and challenged the body's defensive closure. In 1866 Courbet painted a woman's overgrown groin, which he entitled *L'Origine du monde*. In 1978 Mapplethorpe photographed one man's arm immersed half way to the elbow in another's rectum. By contrast with Courbet's image, nothing originates here. Instead, something ends: Eros reaches the border with Thanatos. In a century which interrogated the universe and turned the mind inside-out, sex had to be an intrepid and reckless research of the interior.

Cubism found that although the human being could be differently assembled, human nature was more difficult to redesign. Ideological experiments in Russia, Germany and the decolonized Third World failed to bring forth the long-awaited new man. The sexual revolution arrived at a similar impasse, defeated by bodily limitations and the superior guile of a virus. Sade may have been jauntily nihilistic about allowing the race to die out, but AIDS put such bravado to the test. It provoked a return to timidity, and deprived sex of its sheer wanton spontaneity, its obliteration of the past. Now the super-ego is back on duty as a sentinel, whispering its dread counsels in our ears. The epidemic also

encouraged old prejudices to sneak out of hiding; it even catered to imperial fears, because the syndrome could be blamed on Africa or Haiti. Still, for a while in the twentieth century, the civil war between mind and body was eased, allowing both men and women to recognize and accept what Bataille called 'the deepseated unity of our nature'.

A TRIP TO THE FUTURE

Earlier in the twentieth century, the place to go if you wanted to visit the future was Russia, or perhaps New York. Now the future lies further off, in Japan, which was ordered to modernize itself overnight by the conquering American army in 1945. The United States drafted a constitution for the occupied country, and thoughtfully had it translated into Japanese. The Emperor underwent demotion; no longer a lineal descendant of the sun, he became a symbol, perhaps a cipher. Peasants gained the right to buy the land they farmed, and monopolistic holding companies had to offer shares for public purchase. Psychological adjustments were mandatory too: General MacArthur was instructed to encourage 'a desire for individual liberties' among the feudal Japanese.

Despite the compulsive haste of change and the resentment of humiliated nationalists, Japan now looks – at first sight – like the West before the fall. Here the individual has been politely subsumed in the mass, without the dying protest heard in European expressionism. The crowds in the tunnels of the Tokyo subway are companionable, not lonely; people scarcely grimace as professional pushers wearing immaculate white gloves squeeze them into bulging trains. Once on board, they fall blissfully asleep, awoken by some internal alarm just before they reach their station. They do not need to keep a suspicious eye on the briefcases, shopping-bags and mobile phones they deposit on overhead racks. Congestion is atoned for by formalities which mark out a notional distance between people. Contact is always mediated, its abrasions smoothed away. Coins given in change are not placed directly in the palm of your hand. They are first laid out on a plastic tray, then passed to you. There is an additional scruple, and another muffling mediation. The coins might scrape and scratch when you gather them from the tray; they are therefore set on a tiny mattress of rubber spikes, which quietens them and prevents them from slithering away to resist collection. Everything is softened and disarmed by its packaging. Long slim plastic condoms for umbrellas are handed out in shops during the wet months, so they will not drip on the floor.

The future, as seen from Shibuya station in Tokyo

In Japan, despite MacArthur's tutorials, the motive force of society seems not to be the egomaniac zeal fostered by Protestant religion. Capitalism has been detoxified. Vending machines sell a brand of Happy Cigarettes, with an explanatory sermon which insists that in the West cigarettes are valued as the cement of society, perfuming the air with peaceful and harmonious thoughts. On a wall near Ikebukuro Station in Tokyo, a black cloud guiltlessly billows, while a slogan repeats itself like a stubborn mantra: 'Today I smoke, today I smoke, today I smoke' – and so on, addictively. At the bottom of the wall, there is a triumphant variation, 'TODAY IS SMOKE', confirmed by a self-congratulating 'YES' painted in sunny red. Another machine dispenses Blendy Relax coffee, guaranteed to calm you down rather than agitating your nerves. Sometimes the message blissfully contradicts itself: an operatic tenor advertises Nescafé on television by singing the aria 'Nessun dorma' from Puccini's *Turandot*, in which the people of Peking are denied their right to sleep by the neurotic princess. Insomnia is a selling point, not an inconvenient side-effect.

The Americans had difficulty convincing the Japanese to think of themselves as individuals. In Japan, a person exists only as a member of his group or genus, as the willing servant of a corporation or a team. The Japanese ideogram for man shows two lines inclined towards each other for mutual support, suggesting that a man exists only with the consent and collaboration of other men. Having co-opted the game of baseball, Japanese players introduce a custom inconceivable in brawling America: they deferentially bow to the umpire. This is an immersive society, absorbing its members in a buoyant continuum. Public bath-houses are still frequented, even by those who have the latest plumbing installed at home. In the West, ablutions are a shamefacedly private affair; the Japanese bath is an induction into the community. At Christmas the Japanese go to hear Beethoven's Ninth Symphony, which they have adopted as their seasonal equivalent to Handel's *Messiah*. They take the choral anthem to brotherhood more seriously than the West has ever done.

Until Commodore Perry's fleet arrived in 1853, the islands remained sealed off by a proud, hostile xenophobia. Foreigners were debarred on pain of death. Ceremonially static, the society within those closed borders suppressed change and therefore inhibited history. The first Westerners to breach its defences condescendingly measured the distance between their own modernity and the quaintly primitive fixations of the Japanese. In 1887 a French sailor using the pseudonym Pierre Loti published *Madame Chrysanthème*, a patronizing account of a romance with a geisha; in 1904, after further adaptations by the American lawyer John Luther Long and the dramatist David Belasco, this became a source for Puccini's opera *Madama Butterfly*. Loti's hero, an unashamed sexual imperialist, regards the Japanese as a separate species. He impatiently despairs of comprehending their religious customs, because 'we have absolutely nothing in common with this people' – not even humanity. He describes them as human hedgehogs, tottering along with their umbrellas in a bristly skin of straw

mats; when they squat, he likens them to monkeys. He parrots a few phrases of their language which he has learned in advance, and is amazed that such garish noises should possess any verbal meaning.

Loti smirked at 'the narrowing and dwarfing influence of the surroundings, which turn everything into ridicule': who could take a crippled, stunted tree seriously? The women were absurdly tiny, like china ornaments; and, like figurines, they existed in order to be possessed. Loti's narrator wonders at their lidded eyes, hardly able to open, and doubts that there can be intelligent life behind them. He regrets that Chrysanthème, the temporary wife with whom he amuses himself while on shore, cannot be always asleep. She is much more decorative in that state, and does not vex him with inane conversation. This is the callous, conquistadorial voice of the West. At least, in Puccini's opera, the abused and rejected Butterfly retaliates. Her ritual suicide assuages her own sense of dishonour, but she also dies in order to punish the squalid and cynical sailor Benjamin Franklin Pinkerton, who has exchanged her for an authentic American wife. For Loti, Japan was an artificial creation, a Lilliput; its smallness of scale made it trivial, infantile and temptingly vulnerable. In the age of microchips, a conviction of superiority based on size now looks pathetically wrong-headed.

Lafcadio Hearn, who married into a samurai family during the 1890s and eventually adopted Japanese nationality, wondered if these polite, perpetually smiling people might not be specimens of 'a morally superior humanity'. After a visit to the country in 1959, the philosopher Alexandre Kojève rendered a similar verdict in more modish jargon. He called Japan a 'post-historical' society. As a Hegelian, Kojève expected that man as currently constituted would disappear when the dialectical contradictions of history had finally worked themselves out. That future, he discovered, had already arrived in Japan, whose citizens had retired from the self-assertive struggle with the world which absorbed the energies of men in the West. The Japanese had come to feel contempt for our grasping human nature; their stiflingly refined code of conduct imposed a regime of 'totally formalized values'. Kojève believed that the key to Japanese behaviour was snobbery, an aloof disregard for natural instincts and for the easy-going good nature tolerated in the West. Hence the ritualized stiffness of actors in Noh plays, or the surgical composure of hara-kiri. Hence also, in daily conversation, the superstitious avoidance of negatives, which are thought to be discourteous: a Japanese speaker will venture into thickets of anxious ambiguity rather than honestly answering 'No' to your request or enquiry – though these evasions and circumlocutions should never be mistaken for 'Yes'.

Loti dismissed these people as barbarians. Kojève introduced a more alarming suspicion: could they be a more haughtily civilized, impenetrably sophisticated race than the rest of us? Who are the barbarians now? To our ears the obsequious chatter of female shop assistants and lift operators may sound twittering and bird-like, but the Japanese react just as critically to the noises we make. In his novel *Forbidden Colours*, published in two parts between 1951 and

1953, Yukio Mishima likened the sound of the English language to the gruff, guttural barking of a dog, and wondered at the awkwardly outsized noses of foreigners.

The West, accustomd to primacy, has not enjoyed being imitated, annexed and then disdained by a mightier power. Harry Angstrom in John Updike's series of *Rabbit* novels, which extend across the post-war American decades, works as a car salesman at a Toyota dealership in Pennsylvania, with calendars showing views of Mount Fujiyama on the office walls. His job is a warning of how power fluctuates between the nations: in the 1970s, with oil supplies depleted or held to ransom by Middle-Eastern potentates, no one wanted to buy the oversized, gas-guzzling cars manufactured in Detroit, and the market was instantly colonized by Hondas, Mazdas, Nissans and Subarus. In *Rabbit at Rest* – the last instalment of Updike's sequence, published in 1990 – Harry receives a visitation from Mr Natsume Shimada, sent out from Toyota headquarters in California to investigate some financial skulduggery. Updike's account of Mr Shimada is insidiously barbed. He calls him 'compact', which turns out to mean that he is only five feet six inches tall. Harry, looking down on him, recalls wartime propaganda after Pearl Harbor: the Japanese were always said to be 'ridiculously small', and described as 'robot-monkeys' – an inhuman merger of ape and automaton. The quirks of Mr Shimada's pronunciation are minutely annotated. He pays tribute to America as a 'pruraristic society', and wants to know why Harry has no 'brack emroyees'. Then, intent on delivering his economic sermon despite the lofty sniggering of the novelist, Mr Shimada summarizes the history of the last half-century for Harry's benefit. At first the Japanese admired America, adopted General MacArthur as an ersatz emperor, and were content to copy 'democratic ways'. But gradually roles were reversed, and 'big brother act rike rittle brother', whimpering about the unfair competitive edge of Japanese industry. Japanese corporations, establishing a toe-hold in the United States, hoped to create an extra-territorial Japan, 'to make ireands of order in ocean of freedom'. They have been defeated by the self-indulgent anarchy and cosy corruption of America. The homily concludes as Mr Shimada demands back payments from Harry, in order to spare his embezzling son Nelson criminal prosecution, and revokes his franchise as a Toyota dealer.

Harry, wanting to defend his light-fingered offspring, considers invoking Christianity, a forgiving religion whose values are dismissed by the ruthless Japanese. He wonders whether he should tell Mr Shimada that Nelson will soon be thirty-three, the age when Christ was considered 'old enough to be crucified and redeem mankind'; wisely he decides against it. At the end of the nasty little episode, Mr Shimada speeds off in what he calls his 'rimo', while Harry contemplates his remaining stock of Toyotas and winces at their 'slightly bitter Oriental colours'.

Later in the 1990s an official of the European Community suggested that Japanese workers were efficient because they lived in an ant colony. Economic

friction licenses the expression of physical distaste. Loti ridiculed the atrocious dishes of sugary fish, or fruits pickled in vinegar and pepper, served up by the geishas. The Japanese have by now prepared a reciprocal slur, summed up in their coinage 'batakusai'. This is an appropriately mongrelized word, a transliteration meaning buttery, which is applied to foreigners, or to Japanese people who have been culturally and digestively corrupted by the West. It expresses contempt of the most visceral kind. The Japanese do not eat dairy products, and flinch from the lactose stench given off, apparently, by those of us with a bovine diet. To see or to smell ourselves as others do: it is a chastening experience for the supercilious West.

Looking at Japan with envy and intimidation, we see a future which might be an epilogue to human life on earth. The Russian director Andrei Tarkovsky saved himself the labour of constructing an interplanetary settlement for *Solaris* and instead filmed the business district of Akasaka-Mitsuke in Tokyo. *Solaris* is a science-fiction fable about the nature of consciousness, and the tiered highways and intertwined conduits along which Tarkovsky's astral pioneers travel are a compendious, congested brain, a theatre of cerebration. For Ridley Scott in *Blade Runner*, less mystically enraptured, the Los Angeles of the twenty-first century already existed around the Tokyo station of Shinjuku: a firmament of neon obliterates the stars, while on the ground a crowd, as indistinct as insects, swarms through alleys walled with jabbering placards. Both films are parables about technology and its mimicry of the mind, one of our century's abiding bad dreams; Japan has been picked out as the domicile of that particular nightmare. The space station of *Solaris* is invaded by ghosts who are X-rays projected from the memories of the stranded scientists. In *Blade Runner*, even Harrison Ford is a possible replicant. His reverie about a unicorn seems to have been surgically inserted, since an origami cut-out of the fabled creature has been planted in his apartment. The menace in both cases is a deceptive and unfeeling replica.

Japan presents just such a dangerously exact, coolly automated mirror-image of the West. On the way in to Tokyo from Narita airport, a vaguely familiar shape looms through the industrial smog beyond the highway: a thin, floridly turreted rococo castle, belonging to the skyline of Disneyland. That false front is no more displaced here than it was in Anaheim or Orlando. Disney borrowed his castle from Neuschwanstein in the Bavarian Alps, built by Ludwig II in homage to a fantasy which he found in a medieval illuminated book. Japan creates facsimiles which, though alienated or estranged from their settings at home, supersede the original – or perhaps, as the theorists of post-modernism require, it disproves the very notion of an original, and instead lines up a series of copies which retreat into the abyss.

Modernity came to Japan from outside. In Europe it was the last stage of a long development: the arrival at Spengler's 'third kingdom', which demanded the voluntary abandonment of ancient pieties. But in Japan the agenda of change was

first set by traders who, sending Commodore Perry with an advance warning, wanted to lever open a closed market. The process was completed by the occupying army in 1945, which imposed its own political forms and economic practices. Denied a choice in the matter, Japan hurriedly qualified for membership of the twentieth century, aware that this entailed a knowing corruption, a surrender to false values.

Tokyo Story, directed by Yasujiro Ozu in 1953, calculates the damage done by this abrupt, enforced conversion. Two elderly parents from provincial Onomichi, on the Inland Sea, make a valedictory visit to their offspring in the capital. They discover that the next generation consists of impatient, preoccupied strangers, too busy with work to attend to emotional ties. On the return journey, the mother falls ill. Soon after reaching home, she dies. The motive of modernity in Europe was an Oedipal rage, slaying the representative of the obstructive past. In Japan, the rebellion happens more discreetly. The mother is not killed; she is simply allowed to die, stretched uncomplaining on a mat as her family kneels around her. Rumours of a more radical violence encroach. His tongue loosened by drink, a friend of the family complains about filial ingratitude and says that 'Some young men these days wouldn't hesitate to kill their fathers' – which Picasso took to be the duty of the artist, or of any modern man. But the father in Ozu's film survives, and exempts his kin from having to remember him or feel sorry for him.

The story Ozu tells is elliptically about Tokyo, even though it scarcely appears (except for the usual glimpses of the Imperial Palace and Ginza, seen from inside a tourist bus, or some interpolated shots of construction cranes, noticing the city's race to refabricate itself). To the old people, the city is invisible because unintelligible. Soon after they arrive, the mother wonders what part of Tokyo they are in. 'A suburb', replies the father with befuddled vagueness. They look down over it on a visit to Ueno Park, and comment on how vast it is. But Ozu refuses to share their awe. His camera, not interested in panoramas, remains beneath the parapet at the edge of the park, staring up at the old people while they survey the indifferent metropolis.

The city is the engine of change. One of the daughters in *Tokyo Story* runs a beauty parlour, and promises a customer that a new hair-do will enhance her personality. It is a notion which the previous generation could not have comprehended. A person is no longer defined by others, circumscribed by obligations and expectations; the personality can be invented and counterfeited at will, with a little help from cosmetics. The parents sagely restrict themselves to uttering whatever sentiments are appropriate to the occasion they find themselves in. They deliver their most depressing lines – about loneliness, or life's disappointments – with a beatific smile, because they have no right to protest against the fate allotted to them. But the young people suffer from selfishness, which is one of the West's donations to Japan. They return to Tokyo indecently soon after their mother's funeral, having secured the keepsakes they covet. Even the devoted and

altruistic daughter-in-law Noriko, in her confessional outburst at the end of the film, berates herself for wanting to be happy, and thinks of the desire as undutiful. She remorsefully admits that she does not spend all her time mourning the husband who died in the war.

The discovery of this small psychological treason counts as Noriko's modern epiphany. Human character has changed; it has adopted Western priorities. The refrain recurs in Kenji Mizoguchi's *Street of Shame*, released in 1956. The film is set in a Tokyo brothel. Despite the English title, no shame attaches to the women who sell themselves, because they are doing it for someone else's benefit – to support a consumptive husband, or to bring up a child. Theirs is a selfless career, a stoical martyrdom. One of the women has a son who is ashamed of her, even though she sends all her savings to him. He denounces her, and knocks her down. A tarty young colleague sagely consoles the spurned mother. 'They're all selfish', she says. The ailment is a new-fangled one: without his mother's consent, the young man has left the country to work in a factory, and is studying to be an electrician.

In 1950 Akira Kurosawa examined the same recent moral lapse in *Rashomon*. It tells a single story – about the rape of a woman and the murder of her husband – from several conflicting points of view. All the participants attribute blame differently. A wood-cutter who witnessed the events has his own version, which is no more trustworthy than anyone else's. A priest, nodding sadly over the disparities, says that all these lies have caused him to lose faith in mankind. Beneath the Rashomon gate where this inquest occurs, a passer-by is caught stealing clothes from an abandoned baby. He defends himself by whining 'We can't survive unless we're selfish!' The wood-cutter snarls 'Nothing but selfish excuses'. The robber dares him to show his own superior credentials: 'Don't tell me you're not out for yourself.' Watching the film's successive enactments of the crime, we too suffer from this terrifying awareness of relativity: seeing, in this case, is not believing. The uncertainty principle arrived late in Japan, and delay made its impact even more troubling.

Despite the baffling indeterminacy of *Rashomon*, Kurosawa said that he hoped for 'the establishment of the self as a positive value', because the imported values of freedom and democracy could not exist without it. Yet it was easier for the Japanese to wear Western clothes than to adopt a Western mentality. Bruno Bettelheim, visiting Japan in 1976, was astonished to find that 'the ego, which to us is the centre of all human experiences, is almost forbidden here'. A first-person pronoun existed, although Japanese speakers warily avoided using it. With the assertive, aggressive centre missing, did these people constitute another species – 'post-human', as Kojève suspected? They soon enough learned how to be human, and invented karaoke as one of their educational tools. Singing along at the behest of the television prompter, they can mouth uproarious, impolite foreign sentiments, and briefly enjoy the microphone's boost to the ego. But the blame stays with the Western music, responsible – like the alcohol which had to

be consumed before the performance – for leading them astray; a bout of giggling self-deprecation marks the return to demure normality. In Shibuya a love hotel called Creative Room allows customers to inhabit a fantasy, paying by the hour for the privilege. On the cheerily transparent façade of glass bricks, an English jingle is inscribed on a plaque of polished metal, set next to the price list: 'Let me tell you all that on my mine [*sic*]. For a love like yours I need you more and more.' The lapse into another language, more or less understood, enables the Japanese to spend the night in a parallel universe. In the morning they can rejoin a society in which no one would ever dream of confiding what is on his mind.

The father and daughter in Ozu's *Late Spring* (1949) share a house whose interior décor reveals the same schizophrenia. Downstairs, guests are received in the Japanese style. They kneel on cushions, bow ceremoniously, and drink their tea from a table only inches off the floor. Conversation, as befits the traditional setting, consists of polite formulae. When the daughter's confidante comes to visit, the father entertains her according to these strict standards, with much inane banter. Then the daughter returns, and hurries her friend upstairs to a room furnished in the Western fashion, with bookshelves and straight-backed chairs. Released from the floor, they are able to relax. They lounge or slouch in the chairs, and jump up to whisper secrets. To a Western eye, this quoted room looks as stiff and unyielding as its chairs; but the Japanese women treat it as a clumsily rigged tent, almost as free and easy as the open air.

A Western house is defined by its walls, the barricades erected by the ego to keep out the rest of the world. In a traditional Japanese house, walls are paper-thin, and easily slide out of sight: the dwelling is organized around the floor. People tread on the floor lightly, respectfully removing their shoes; it is kept clear of obstructions and they live near to it, grounded by their posture as they fold their legs beneath them. The elders in *Tokyo Story* illustrate this modest containment: they stay within the limits reality sets for them. The first and last sequences of Ozu's film fill in this frame of necessity, with a series of images which establish the topography of Onomichi and its invariable routines – the port and the shrine, troops of schoolchildren, a train passing on its way to somewhere else. Even the posture of the parents expresses their fixity, their smiling contentment with very little. They spend most of their time kneeling; packing for the journey to Tokyo, they fuss about the missing air-cushion which they want to take with them. Respect is gravitational, cramping the characters and tugging them downwards, by contrast with the whirling, spontaneous vigour of people in American films, who for Cocteau or Brecht symbolized restless modernity. Noriko squats to greet her dead husband's parents, then solemnly inclines her head until it touches the floor.

Ozu's camera angles, hovering only a few inches above the mats on the floor, lower both the horizons and the expectations of his people. Often he continues filming from this low angle after a character has left the room, for instance taking slow, silent inventory of Noriko's neat, meagre lodging, with a packet of

Rinso soap flakes occupying pride of place on the floor as an exotic trophy. To maintain this vigil perhaps appeases a household god. It is also a meditative device, a computation of time as it passes, reminding us that people – mobile and therefore short-lived – are phenomena in transit. Sometimes a clock lengthily strikes in the vacated space, or a mirror, wiped clean of images, trembles in the after-shock of a human movement. By filming suddenly emptied rooms, Ozu serenely notes that a house is a container for nothingness. Bettelheim observed that timelessness had been written into the language of the Japanese. By contrast with the West's mournful nostalgia and its unquiet anticipation of the future, in Japan, he pointed out, 'verbs don't have past or future tenses'. Why should events be allocated to a before or an after, since the Japanese regard the entire temporal sequence as an illusion? In his travel diary *Tokyo-Ga* Wim Wenders searched the frantic metropolis for traces of Ozu. He interviewed his collaborators, photographed the stagnating alleys where his characters lived, and finally located his burial place. The urgency of this quest turns Ozu into the cinema's disregarded conscience, and into one of the twentieth century's neglected gods, quietly resigned to his own obsolescence. Ozu's images have been wiped clean of materialistic cravings, rid of flurried, irrelevant happenings. His camera looked through life, filming what Wenders calls 'the mortality of man, the transience of things'. Contemporary Tokyo, with its hectoring neon, builds monuments to the wishful immortality which derives, according to the Western cult of acquisition, from owning things. Shadows flicker across Ozu's screen and fade: the world does not belong to us, and we belong in it for a few seconds only.

Near the end of *Late Spring*, the father and daughter go on a last journey together before her marriage separates them. They visit Kyoto, and the father makes a brief excursion to the Zen garden at Ryoan-ji: a meticulously raked dry sea of gravel, from which rises an archipelago of exactly fifteen peaked or recumbent rocks. The camera studies it from several vantage-points, as the glaring sun makes the arid space look molten. In this garden, as the architect Kenzo Tange said, 'we feel as though we are shedding our selves'. Our angle of vision may alter, generating complication, but there are never more nor less than fifteen obdurate rocks: the scene, like Ozu's dramatic situations or the rooms into which they are compressed, is a dead end.

Spengler's myth identified the Western spirit with the insatiability of Faust. The Japanese, by contrast, do not commandeer time, which is why they can do without tenses; neither do they struggle against their niggardly apportionment of space. In Shinjuku station, homeless men curl up in roofless cardboard boxes, sweeping their imaginary doorsteps and tidying away their collapsible houses at dawn, while salarymen who have missed their last train home spend the night in the stacked coffins, each supplied with a television monitor, of a capsule hotel. On street corners, policemen preside in sentry posts the size of phone booths, and in dinner-wagons smaller than a parked car cooks can prepare a meal and serve it to customers squeezed onto benches on both sides, lowering

flaps in case of bad weather to seal the vehicle and make it water-tight. To these stoically impassive, self-enclosed people, the adoption of Western ambitions seemed like a Faustian bargain, a pact with the devil.

This is how the renovation of society after the war was represented in Mishima's *Forbidden Colours*. The role of the cynical devil is played by the elderly misanthropic novelist Shunsuké; the soul he corrupts belongs to his homosexual protégé Yuichi. The boy is the old man's judgment on a society warped and enfeebled by the Western cult of acquisition, and the selfishness which it inculcates. Among Yuichi's

Yukio Mishima speaking from the roof of the military headquarters in Tokyo, shortly before his suicide in 1970

trophies, donated by one of his male lovers, is a Dunhill cigarette-lighter. He belongs to that avant-garde race whom the Japanese call 'shinjinrui': new editions of the human being, re-jigged according to the moral specifications of the West. Shunsuké seeks revenge on women because they are wanton enthusiasts for the new values. Salarymen make money; their wives frivolously disburse it. This 'craving for luxury' represents to Shunsuké the triumph of 'feminine instincts'. It changes capitalism from a masculine pursuit of gain and advantage, a swashbuckling vocation fit for samurai, into 'a theory of extravagance'. Yuichi is bribed to trifle with the affections of these fluffy-brained women, to whom he cannot respond sexually.

In Mishima's *The Sailor Who Fell From Grace with the Sea*, published in 1963, the woman who traffics in imported frippery is the widow Fusako. She owns a boutique called Rex Ltd in Yokohama, occupying premises which affectedly mimic a mosque. Her eclectically scavenged wares include Jaeger sweaters, Italian polo shirts and English spats. According to her son and the gang of adolescent supermen to which he belongs, she is engaged in cultural betrayal; they punish her by executing the lapsed, unworthy sailor who is her lover. In doing so, they take advantage of a law exempting juveniles from prosecution for any crime. This allows them to express an abstract contempt for 'our fathers and the fictitious society they believe in'. The new, Americanized Japan expected consumer goods to satisfy all cravings and banish evil from the world. Rewarded with toys, children would of course behave impeccably, so that legal penalties for misbehaviour could be waived. The pointless outrages devised by the boys serve

as their criticism of this blandly materialistic faith: murder is their attempt to fill up 'the emptiness of the world', just as Mishima in 1970 killed himself in order to condemn the apostasy of Japan.

Discovering Yuichi's immorality, Shunsuké in *Forbidden Colours* acclaims him by using an image which recalls the moment in 1945 when Japan was modernized by bombs. 'This youth', he remarks, 'decays like radioactive material.' But Yuichi proves less exquisitely corruptible than Shunsuké had hoped. Despite himself, he actually falls in love with one of his female victims. Mishima comments on his self-revaluation: 'he was going to take his "penchant for analysis", his "consciousness", his "fixed idea", his "destiny", his "innate understanding of truth", put them all together, curse them and bury them. Of course, these are what we commonly refer to as the symptoms of the disease of modernity.' The disease, however, turned out to be ineradicable.

Modernized in haste, Japan was also the first place to outgrow modernity. Tokyo has become the capital of a post-modern world – a place which rejects the notion of a centre, and makes no attempt to organize space; an intricate, unmappable chaos, where the babbling polyphony of signs adds up to a riot of insignificance; a city reconciled to impermanence, whose buildings are happy to represent themselves as illusions, less solid than the mortar they are made of. The city's level, endless proliferation represents the final conquest of nature by culture, which is our post-modern lot. Memories of the earth beneath have been erased. Tiered golf courses are suspended in the air beside the highways. There is no room for deviously picturesque landscapes, with streams and sand-pits and obstructive shrubbery; the golfers aim their projectiles into empty space, and rely on a net let down from the sky to collect them. A mountain with a metal roof over it rears beside Tokyo Bay: a slope for urban skiers, who can dispense with the inconveniences of geography and weather. It is built, of course, on reclaimed land. Urban crows, ingenious bricoleurs, sculpt their nests from the wire coat-hangers used by dry cleaners.

In 1945 the conquerors, demolishing Japan's ancestral institutions, denied the country access to its own feudal, militaristic past. Substitutes for that prohibited tradition were imported. The globe contracted to the size of this miniature country, and all available pasts now compete for room on Tokyo's renovated soil. The city is an anthology of quotations, plucked from context and scrambled together. Omote Sando, a fashionable avenue near the Meiji shrine, is currently known as the local Champs-Elysées, because it boasts trees and boutiques. In Shibuya a developer has designed a crooked alley as a facsimile of a Spanish village, with candied façades of pink plaster, some wrought-iron curlicues and the odd squirting fountain. The New Takanawa Prince Hotel contains an Islamic banqueting hall. The twin, looming towers of the New Tokyo City Hall in Shinjuku allude improbably to the façade of a Gothic cathedral. At Yebisu Garden Place, a shopping mall near the commercial centre of Shibuya, a French château

has been reconstructed in orange concrete. Neoclassically positioned at the end of a vista, it is framed by a metal hangar, from which dangles a metal branch studded with hollow leaves. Inside the château, a restaurant serves afternoon tea under the title of 'Les Délices de Mademoiselle' and in the evening prepares indigestibly expensive cuts of Kobe beef. The amateur artists who spend weekends memorializing the cherry blossom in public parks produce water-colours in the English style, washed-out and wistful, with grey skies and sodden grass: they view their own landscape at second hand.

When Disneyland was transplanted from Los Angeles to Tokyo, all but one of its joky, fantasticated locales were exactly duplicated. The exception was Frontierland. The Japanese balked at the notion of such a place. Claustrophobically confined to their islands, they had no experience of empty, unsettled terrain, or of an irresistible challenge – the motive of historical development in Europe and America – to go beyond that outer limit. For Japanese consumption, Frontierland therefore became Westernland, stocked with cowboys and Indians in retro fancy dress. Kurosawa's samurai films pay homage to the American Western, but in *Yojimbo* or *Sanjuro* the free-lance warrior played by Toshiro Mifune must operate in the absence of a frontier, or even of the breezy, exhilarating, wide-open outdoors: he spends much of his time crouched in papery houses, conferring with the traders or courtiers who retain his services and rely on him to defend their collective cause. He dashes outside to eliminate opponents, then promptly returns to harangue his sponsors or to renegotiate his fee. American Westerns are about escape from the constraints of society; Japanese Westerns deny this territorial freedom, and enlist the hero to repair a fraying social fabric. The objection to Frontierland proved to be prophetic. We have all now run out of frontiers, and maps no longer show obliging blank spaces. Futures can only be imagined as rearrangements of the past. Travelling east to Japan, you arrive at a zany, kaleidoscopic reminiscence of Western culture.

Spengler imagined the city as a place of deathly finality, like a funeral marker demarcating the end of a culture. Monuments, after all, are retrospective. Hence Hitler's attempt to anticipate and control the future in his plan for Germania; hence too the granitic skyline of Manhattan and its inflexible grid, which came to exemplify what Spengler called the 'daemonic stone-desert'. Tokyo, however, demonstrates that history did not terminate when those funerary skyscrapers closed off the vista. Cities formerly sought to make power overbearingly manifest. Where the centre of Tokyo ought to be, there is a power vacuum. The Imperial Palace skulks somewhere behind its walled moat, housing an absent, invisible god; around this sanctimonious vacancy, highways orbit. The city consists of molecules, messages, motorized gobbets of information, all in perpetual transit.

Because everything is moving, Tokyo itself disappears, bleached and blotted out by its white haze. There is no viewpoint from which you can see it all at once, and no horizon where it runs out. It can be comprehended only in bits and pieces. The jumble of a neighbourhood will be interchangeable with all

other neighbourhoods, because the average street is bound to contain a noodle-shop, a café, a pinball parlour, though they appear in no particular order. If you look upwards in quest of a landmark, there will probably be a sign assuring you that you are in Marlboro Country. Any extra certainty is hard to come by. The scribbled streets with their palimpsest of unconsecutive numbers are blithely unintelligible even to those who live in them; to locate an address involves an attempt to detain the flux of matter. The policeman in his box will collate half a dozen directories, each of which offers contradictory information (or none at all); a poll of passers-by can be taken; you may, by chance, find someone who knows the building you want to find. Perhaps you have been standing outside it all the time. Or you might have been, if it had not been demolished last month and replaced with something else. It is as if perspective – the Western convention which establishes precedence and lines up objects in orderly rows and makes them dwindle towards their vanishing point – had not been invented. How could there be any sense of anchorage, since Tokyo has been destroyed and hastily remade three times in the course of the twentieth century – by the earthquake of 1923, by fire bombs in 1945, and by urban reconstruction before the 1964 Olympics, when the calipers of elevated highways strode across its huddled warren of lanes and snaking canals?

Nor are there any long views back through time. Tokyo's most venerable relics, like the Shinto shrine of Ise Jingu, disclaim any pretence of antiquity. They are taken to pieces every two decades and promptly put together again as fresh facsimiles of themselves. It is easy or profitable to begin the world all over again, with the aid of a seismic shudder or a bulldozer. A block of real estate from which an obsolete dwelling has been cleared is known in Japan as 'new land': freshly created, ready for the next, short-lived reincarnation. The Nihon-bashi Bridge, built by the shogun Ieyasu Tokugawa in 1603 when he established his capital at Edo, was planned as the country's official centre, from which all distances were measured. In an 1856 woodblock illustration by Hiroshige, the bridge establishes an axis along which temporal power and spiritual influence are aligned: Edo Castle lies just beyond it, and beyond that, magnifying the turrets on the castle wall, is Mount Fuji. It was last reconstructed in 1911, equipped with a mongrelized bestiary of guardians – Chinese lions, backed up by unicorns – and some pseudo-Egyptian needles. In 1962, like much else in Tokyo, it was bestraddled by an elevated highway. From here, where a post still marks 'zero leagues', space once unravelled towards the various ends of the Japanese earth. Now, if you crouch to see beneath its lid of reinforced concrete, the world ends across the street on the façade of the Mitsukoshi department store, where a golfer on a placard swings his club, imagining a non-existent emptiness.

Elsewhere you can go for a walk in the remote past, though an unsynchronized sound-track recalls you to the present. The shrine to the Meiji emperor at Yoyogi stands in what might be an immemorial forest, thick enough to diffuse light or shut it out, drippingly humid during the wet summer; appropriately, the

name Yoyogi alludes to the Tree of Ages. But on Sundays this dim, hushed sanctuary is battered by rock music, relayed from across the fence. Half a mile away, in the twentieth century, outside the gymnasium built by Kenzo Tange for the Olympics, dozens of Elvis imitators with drainpipe trousers and hair greased into roller-coaster curves are cavorting, backed by a rampart of boom-boxes.

The pleasure zones of Edo were known, because of their promiscuous instability, as a floating world. Tokyo remains afloat. The English words inscribed on the sky or across the backs or chests of the citizens are floating signifiers, liberated from the drab chore of possessing any specific meaning. The signs outside love hotels switch on puns in smouldering pink neon. Casa Nova is a new house, but also a resort favoured by would-be Casanovas. The Hotel B.Side offers you the chance to illicitly enjoy a little something on the side, lying down beside your temporary partner; perhaps it also remembers the concealed, surreptitious B sides of long-playing records. Sometimes the garbled idiom has an inspired incoherence. The jackets of teenagers stir up the American melting-pot by invoking an imaginary baseball team called NY BLACK YANKEES. The most inoffensive young people perambulate inside clothes which maniacally bray and rage: one coat, noticed at random on the subway, made propaganda for its demure owner by noisily listing his attributes and global connections –

> Grandeur
> Dresseur de Plan
> de premier choix
> Respect Superbe
> Sensible Flambant
> Club Be Hot
> Mondial Universel
> Succés Brilliant

That French accent stitched on backwards sums up the bizarre and muddled knowingness of the enterprise. The wearers of clothes made by Jeans Mate carry round a purported quotation from Walt Whitman, praising the young men with whom he mated: 'They do not sweat and whine about their condition…. They do not make sick discussing their duty to God. For young spirits loving nature and city.' It is a sentiment more at home in Tokyo than it ever was in Whitman's America, where the road lay open and the ego sang its own rowdy praises.

The Japanese – whose own language is ingeniously inspecific, expert at begging the question – happily accept the omnipresence of a foreign language which they may or may not understand. Though the modern recognition that words are arbitrary or absurd terrified Hofmannsthal's Chandos, the Japanese gaze into the gulf with a smile on their faces. For Lafcadio Hearn, that implacable Japanese smile was 'an abstract quality', which evoked the placidity of Buddha and 'the peace of the divine condition'. On the price list above the counters at McDonald's in Tokyo, it is now officially declared to be priceless. Beneath the shakes, fries and burgers, room is found for a gratuity: 'SMILE – 0 YEN'.

The economy of consumerism happily pursues chimerae, those tantalizing, transcendent illusions which the Japanese call 'mono igai no mono', things that are not things. An example is the melon, one of the most prized, precious and dumbfoundingly overpriced Japanese gifts. Melons, even more than most fruit, must be taken on trust. You can slyly squeeze them, or sniff them to guess their ripeness; there is no guarantee, until you cut one open, that it will have any taste at all. But the ceremonial habits of the Japanese spare the melon all these doubts and suspicions. Its value as food is overlooked, and it is transformed into a symbol. A melon chosen as a gift is selected for the sake of its elegant, symmetrically cut stem. Its perishable rind is supplemented by a more expensive swaddling of gold foil, and it resides in a cushioned coffer, on a throne of velvet or satin. After so much ritualistic fussing, who would consider eating it? The object disappears behind its courtly aura. Love hotels often present themselves to the street as gift-wrapped cartons, tied up in a red, floppy ribbon made of plastic or sleek metal. Inside, there are rooms decorated as fake-fur jungles or rococo boudoirs or prison cells, boxes full of impalpable and headily erotic atmosphere. Fantasies, being things that are nothing, sell at a premium.

Such ghostly presences make up the fabric of the city. The golden temple of Kinkaku-ji in Kyoto serves as a prototype. Just before the crazed Zen monk burns it down in Mishima's *The Temple of the Golden Pavilion*, he watches it shine through the darkness and studies its reflection in the pool, wondering why it is so beautiful. It is another empty box. At its centre is an impenetrable room, where he wants to die. He imagines this recess to be papered in gold foil; actually it is defoliated. He decides that the temple's perfection, more than the sum of its parts, inheres in everything and therefore in nothing. It possesses 'a beauty *which did not exist....* Nothingness was the very structure of this beauty.' Therefore his act of arson did not harm it; and in any case it was promptly rebuilt as a simulacrum of itself.

The architect Toyo Ito, constructing an Egg of Winds in Tokyo and a Tower of Winds in Yokohama, has played with the notion of an architecture lacking substance, conjured up by atmospheric chance. All day long Ito's electronic egg, hovering above the gate of the Okawabata River City housing complex, sullenly locks up its secrets. After dark it cracks open to reveal the images germinating inside: angelic faces, aerial surveys of the city, television broadcasts, all beamed onto aluminium screens. The egg is a modern dwelling, used up and discarded. Like the surrounding apartments, it is drained of life in the morning, then quickened again at nightfall. Ito's tower is a water tank, ventilating an underground mall; its transparent outer shell is pierced with more than a thousand lamps and rings of neon, arranged in glinting orbits. A computer interprets the whimsies of the wind and rewrites them as a winking electric semaphore. In 1986 Ito designed the Nomad Club in Tokyo – more like a garage than a bar, with surfaces of slippery metal and a sky of jagged, rippling clouds which seems to be passing through the room: a placid eastern outpost of the Café Nihilismus.

Toyo Ito's Egg of Winds *(1989), cracked open after dark*

Buildings here aspire to an elemental freedom, rather than rooting themselves in the untrustworthy ground. For a brewery at Asakusa in Tokyo, Philippe Starck constructed a cube of black granite which is lofted into the air after dark by illusory lighting; on top of it lolls a hollow twirl of golden froth like a congealed flame. At Kirin Plaza in Osaka, Shin Takamatsu developed Albert Speer's architecture of light: four blank white pillars, scorchingly bright, stab the night like upright sabres. Though the shafts are named after the beer company which owns them, they advertise nothing. But the base of black, polished stone and stainless steel from which they sprout beams back the reflected logos which sizzle in the surrounding darkness – Coca-Cola, Nikon, Reebok and Sanyo. Because none of these structures will last long enough to decay or tumble down of their own accord, the architects, wittily atheistic, wreck them in anticipation. The Nunotani Corporation headquarters in north-eastern Tokyo lurches and lunges at sick angles, rehearsing for the expected earthquake. The Rise Cinema in Shibuya resembles a dishevelled circus tent in the process of being folded away, or a liquefying igloo. Azabu Edge in Roppongi supports its concrete blocks on a base of torn, serrated, mouldering stone. During the 1960s Arata Isozaki argued that buildings should be like hallucinations: eerily weightless, collapsible, unable to maintain the traditional barrier between inside and outside. A city, Isozaki believes, is 'perpetually in a state of ruin', destroyed while being created. It is an apt definition of Tokyo, and a fittingly fervent tribute to a city which refuses to consider itself eternal.

Isozaki's own most thorough-going attempt to create an architecture which dramatizes impermanence and instability is at Tsukuba Science City, a new town north of Tokyo devoted to scientific research. His Tsukuba Center, completed in 1983, provoked a scandal by questioning what 'Japan Incorporated' should look like. The nineteenth-century government buildings around Tokyo Station were Prussian, and the National Diet, where the parliament sits, is

Egyptian. How could there be an official style in a country which borrows its self-image from elsewhere? And how should power be represented, at a time when the merger between politics and economics has dissolved the state into the blinking digital river of the shares index, fluctuating from hour to hour? Isozaki therefore recalled and inverted a Roman precedent. His plaza at Tsukuba Center is an upside-down version of the Campidoglio on the Capitoline Hill. Like the rest of post-modern Japan, this 'patchwork, fictional place' (as the architect proudly calls it) is a quotation which changes its meaning now that its context has altered. Isozaki had to do without the equivalent of Marcus Aurelius on horseback, since the Japanese emperor prefers to remain invisible. Accepting the unavailability of magisterial symbols, he set the Campidoglio on its head and hollowed out a space in which it might have been buried. The sunken plaza shows evanescence in the process of happening. No Roman fountain sculpts water; instead, a cascade drains around the walls, flushing people away. The centre is a void, that negative space which so tantalizes architects in the twentieth century. Isozaki contentedly calls his urban plan 'the expression of the absence of something'.

Perhaps this is what Ito meant by declaring that his buildings should be used like clothes – worn for a short while, thrown away when the fashion alters. Fashion in its own way expresses the absence of something. What's missing is the body inside the clothes; like the melon, it acquires value only when wrapped. Mentally disrobing his geisha, Pierre Loti noticed that Japanese clothes proposed a new and alarmingly mutable definition of the human being. He remarked on the 'exquisite amplitude' of the kimono, whose huge sleeves suggest that the person inside has no back or shoulders. Western dress, he remarked, emphasizes 'the curves, real or false, of the figure'. Its adhesion creates a profile, cutting out a silhouette which remains starkly separate from the rest of the world. Japanese dress, overenveloping the body, hints that it too might be made of air, like Ito's egg. It suits a society where character is fabricated in obedience to social rules, not willed into being, as in the West, by the ego's pride in its idiosyncrasy.

For the Japanese, the self is negligible, while the body it resides in is soft and shapeless, as hollow as the impression left by Isozaki's inverted hill. Meaning must be conferred on that fluid, unfixed form. Japanese gangsters therefore wear all-over tattoos which turn their skin into tribal masks, with a tough, magical cladding of warriors, ogres and heraldic beasts. In his introduction to Tamotsu Yato's album of body-building photographs, Mishima pondered the 'cultural value of the flesh', and argued that the naked body could serve as a conscience, worn (unlike the indwelling Western moral sense) on the outside. He admired the cosmetic foibles of the samurai, who rouged their cheeks, scented their helmets before going into battle, and made up their faces in preparation for committing hara-kiri. In contemporary Japan, Mishima complained, all 'external rules of conduct' had lapsed, and 'without etiquette we have no morality'; this is why he took up weight-training. So much for the innate goodness venerated by Western humanism. Even the body is not a natural growth but a cultural product. In Ian

Fleming's 1964 novel *You Only Live Twice,* James Bond goes undercover during an assignment in Japan. Disguising himself as a local, he discovers how differently the Japanese construct their own variant of the human being. Bond gets some cosmetic help with his transformation: a brown dye for his skin, sleek oil for his hair, and a deft trim which makes his eyebrows slant upwards. Of course he cannot speak the language, so he carries a card informing the suspicious that he is deaf and dumb. He only regrets that he has not had time to perfect a physiological skill which Westerners can no longer manage. Japanese warriors, he learns, can protect their testicles during combat by causing them 'to re-enter the body up the inguinal canal down which they originally descended'.

There are alternative ways of endowing the flesh with value – less painful than surrendering to the tattooist's needle, less arduous than lifting weights, simpler even than the dyeing and tweezering to which Bond subjects himself. The puff-ball of the self can be concealed in a loose second skin of fabric. Bond, wanting to pass for a native, wears trousers that are 'loose in the fork, because Japanese behinds are inclined to hang low'. Mishima perfected the body by sculpting it; Japanese clothes designers – assuming, like Mishima, that human beings are shamefully amorphous – overcome the vacancy within by geometrically denying or superseding the flesh. Issey Miyake's clothes contradict the body's volumes. His shirts wrap around the trunk like diapers: they are sheaths inside which growth and change – messy, inconclusive, but mercifully invisible – can proceed. A square tunic of striped yarn from his 1985 collection flattens its wearer's body into two dimensions, and a nylon raincoat which he designed in 1987 balloons into a grey helium cloud. The head, for Miyake, is an optional extra, interchangeable with other extremities. In 1983 he designed a symmetrical jump-suit with four buttoned openings, any one of which served as the neckline; the head could choose whatever aperture it wished, or else stay inside the cotton cocoon. Those who wore the jump-suit looked as if they were struggling to hatch out of a floppy but baffling eggshell. One of Miyake's favourite materials is oil-soaked paper, from which umbrellas are also made: a reminder of the body's permeability, and of the need for culture to protect itself from nature. These outer layers are unstable, seasonally shed like the dry casing of a snake, but their changes do not constitute what a Westerner would call self-reinvention. They occur at the behest of others. We dress fashionably in order to disappear, to merge with those we esteem and wish to resemble.

These conundrums perplex the designer Yohji Yamamoto. Eclectic Japan licenses the vagaries of the post-modern personality, which can be altered with the aid of a new wardrobe, a different hair style, or a gym subscription. Wenders introduces *Notebook on Clothes and Cities*, his video essay on Yamamoto, with an editorial grumble. 'What is it, identity?' he asks. He goes on to complain that the very idea makes him shudder: it suggests a fate, a patrimony, which both he and Yamamoto (united by a determination to forget what the previous generation did in the war) are anxious to be rid of. Yamamoto insists that he does not know what

it means to be Japanese. All he will say – surveying Paris from a gantry of the Centre Pompidou – is that he comes from Tokyo, because 'Tokyo has no nationality'. Wenders likewise celebrates travel as a means of evading a regimented national character, and is grateful to Yamamoto's clothes for transforming or even dispensing with personal identity. In a culture of fluid, migrant images, which ignore geography and elide the separateness of individuals, 'identity', as Wenders says, 'is out of fashion, and what's in vogue is fashion itself'.

His *Notebook* begins with a bifocal screen, showing two apparently synchronized journeys. A car is driving along an elevated highway, passing a Pentax billboard. Another view from another elevated highway is relayed onto and altered by a Sony video monitor, which sits on the dashboard of the moving car. The first trip, in real time, is through Paris (where Pentax has established a colony). Even though the grey architectural slabs beside the road look so similar, the second, recollected journey occurred in Tokyo, since the car passes traffic signs in kanji script. But the cities overlap: after all, they both possess Eiffel Towers. Partitioning themselves between different time zones, Yamamoto and Wenders live in a state of chronic jet lag, never quite sure where they are or who they are meant to be. As used by Wenders, the video camera points to a future when these psychological vexations may have withered away. Perhaps we will come to relinquish our concern with the solitary integrity of consciousness, and instead relax while a flux of bright, beguiling images streams through our heads, like the neon of Shinjuku. Video denies the separateness and sanctity of the original; its images are duplicates of each other, as interchangeable as the bodies equalized by Yamamoto's designs. Isozaki has observed that the bombardment of electronic images in Tokyo produces a 'desubstantialized scenery, as if in the process of simulation'. Collages of ephemeral signs flicker on and off in the sky. The corporate fiction which Isozaki teasingly calls 'Japan, Inc.' dissolves into a luminous blur.

The ancient, humanistic faith in our personal uniqueness may be difficult to sustain, but it also proves hard to discard. In the course of the film, Yamamoto suffers a brief existential crisis. After one of his Tokyo shops is refitted, he has to sign his name on a plaque at the door. More than a private act of identification, this affixes a trademark. The gesture has an extra complexity because, even here in the city where he was born, Yamamoto's brand name must be written using the Roman alphabet: he identifies himself by adopting a foreign transliteration. Oppressed by the responsibilities which weigh down this supposedly thoughtless gesture, perhaps embarrassed by its artifice, he panics. He makes several attempts using chalk, then has them rubbed out. The initial Ys plunge and re-ascend at the wrong angle, the cross-bar of the t fails to fling itself backwards with the proper abandon. Yamamoto's signature does not look like him, or like his clothes. Finally, after many tries, he declares himself satisfied, and the scrawl is preserved beneath a layer of varnish. Is there not a small betrayal in this? For corporate reasons, he affirms an identity which the clothes he designs have already disowned.

His fellow citizens spare themselves these quandaries. They have accommodated themselves to a society run like a machine, in which they are the spare and replaceable parts. In *Modern Times*, Chaplin came near to being choked by a gadget devised to economize on time in the factory by shovelling food down his throat; the salary-men of Tokyo unprotestingly eat their sushi from a toy railway, which carries dishes along the restaurant counter on a whirring track. Customers playing pinball in pachinko parlours worship at a mechanical shrine. There is no room for them to lean over the board as in the West, encouraging it with their gymnastics and their heckling. They sit before boards placed upright, as if

A plastic entertainment tree in a Tokyo department store, photographed by Bob Davis

still at their desks in an office. Crammed into narrow aisles, untroubled by the nudging of the players on either side, concentrating despite the metallic clatter, the headachy piped music and the glaring overhead light, they spend hours doing battle with the integrated circuits which bounce the balls through the pins. A pay-out rewards them for their blissful evacuation of consciousness. The young women who operate lifts or greet customers at the entrance of department stores serve a more intimate apprenticeship to the machine. During their training, they are locked into the embrace of a robot, which teaches them how to bow. Its steely backbone adjusts the clockwork body to the precise angle of deference required by each social encounter. Friends merit a cursory fifteen degrees. For employees with superior status in the hierarchy, the head and shoulders must be inclined at thirty degrees. Members of the paying public are honoured with a forty-five degree bow. There are also lessons to teach them a breathy, high-pitched 'service voice', which sounds like the simpering locution of a Barbie doll.

If these are the newest human beings, serenely redesigned to the dictatorship of technology, then their domestic animals are even newer, and less inconveniently organic. Fraught Tokyo yuppies have long been able to hire companions from another species for an hour or two. They pay for the privilege of accompanying a dog on its walk, or stroking a cat to reduce their stress level. At Christmas in 1996, they took to adopting virtual pets.

A brisk trade emerged during 1997 in electronic ovals known as Tamagotchi, like pocket-sized versions of Ito's Egg of Winds. The Tamagotchi is a

digital infant, hatched when the buyer starts a battery in the pastel-toned case. A face composed of dots blinks to life on a screen, and notifies the owner of its needs by emitting a series of beeps. It must be regularly fed, watered and relieved; all of these operations can be effortlessly attended to by pressing a button. If pleased, it squeaks. If abused by its parent, the creature revenges itself, sounding an alarm during the night. Dietary caution is advised: Tamagotchis will die if they are fed too much cake. Their obesity, like everything else about them, is notional. The eggshell can grow no bigger than it already is, but its weight flashes onto the screen when you touch the appropriate button. Correctly cared for, the Tamagotchi has a life-expectancy of twenty years – though this term is reckoned in Tamagotchi years, each of which mercifully lasts only a fortnight. When the end arrives, the smiling or scowling face is replaced by a tomb; then the screen goes blank. Memorial spaces are available at the web-site of a Buddhist temple in Hiroshima, where deceased Tamagotchis have their own virtual gravestones.

In 1946 Emperor Hirohito issued a proclamation in which he renounced his official status as a god. There was no need to execute the deity; he apologetically secularized himself instead. Like Nietzsche's prophetic threat to the Christian God, Hirohito's announcement set in motion a process which has continued throughout the last half-century. Mishima could not accept Hirohito's surrender: hence his own efforts to transform man into the kind of god worshipped by the Greeks – beautiful and cruel, an aesthetic killer with oiled muscles. The Tamagotchi fad, despite its brevity and its silliness, suggests that the process has further to go, as Japan lives through the last and most tortuous contradictions of modernity. If a god can disestablish his own church, why should not humanity in turn vote itself out of existence?

THE GREAT
RE-ENGAGEMENT

The earth was first discovered, then colonized, finally despoiled. One reason why it seems different in the twentieth century is that the damage done by our exploitation has become visible in fouled rivers, felled forests, moribund species. Schwarzenegger, slaughtering an alligator in *Eraser*, gleefully barks 'You're luggage!' During the Renaissance, Hamlet acclaimed the infinite wisdom of man, while Galileo scrutinized a godless heaven through his telescope and the navigators transgressed the borders of space, travelling around the curve of the globe. Those journeys have now reached their common terminus. We recognize that we inhabit, on sufferance, a world which is after all finite.

The earth is different to us because, a few decades after Gertrude Stein's enigmatic announcement, we acquired the capacity to see it from outside, from beyond – as if we were looking back at a place left irrevocably behind. The ape in *2001* imagines an astral carousel, while the fanfare from Strauss's *Also sprach Zarathustra* recalls man's obligation to become superhuman. At the end of *Forbidden Planet*, a film which in 1956 transposed Shakespeare's *Tempest* to outer space, there is a scene which could only be dreamed up – let alone depicted with such alarming realism – in modern times. The planet Altair 4 explodes, detonated by a marauding id which rages inside the mind of the physicist Dr Morbius. Like all unimaginable sights, the catastrophe is beautiful to see: the planet flares open like a green and golden flower. The heroine, who once lived in that defunct world, watches its execution as she speeds away. When the American astronauts stepped onto the moon in 1969, they undertook a 'giant leap for mankind'. But where did Neil Armstrong's leap take us? Further from our appointed home; perhaps too far, mentally at least, for a possible homecoming. The nominal conquest of another planet requires alienation from our own. Science fiction, as always, broods on the consequences. The film *Independence Day* begins by discounting the arrogance of the imperial marker left behind in the lunar dust, which is overshadowed by the looming wings of an enemy spaceship, on its way to fire-bomb the presumptuous earth.

*Old Mick Gill
Tjakamarra
Three Snakes
Dreaming
(detail, 1990)*

The space missions of the 1960s showed us the earth in all its vulnerability. To view our habitat in this way, from an outpost which symbolizes the 'great disengagement' spoken of by Nietzsche, is to conceive and to picture its possible destruction. Adlai Stevenson in 1965 called the earth itself 'a little spaceship', on which we are all passengers, 'dependent on its valuable reserves of air and soil'. Our vessel is no longer a cumbrous *Titanic*; it is more like one of the tiny, battered caravels in which Portuguese mariners ventured to India or Brazil during the fifteenth century. We are sailing, Stevenson specified, in a 'fragile craft'. He might have been describing a galactic lifeboat, with room for only a few survivors. Recycling paper or carrying glass to bottle-banks, we make small efforts to repair the damage done by history. Our need is for a humbling re-engagement with the earth.

For all his good intentions, Stevenson's image of our planet as a vehicle was in itself alarming. If we are riding on the earth or driving it, then our restless velocity is wearing it out, using it up. Motion has become its own justification: it has been calculated that the average citizen in a developed society travels ten thousand miles by car each year. A world so easily traversed is diminished: where else is there to go? While making a film in China in 1972, Antonioni attempted to send a telegram home, but the clerk in the post office at Nanking had never heard of Italy. When Antonioni wrote the word out for her, she looked at it sceptically, then hurried off to consult her colleagues. On a wall map, they finally managed to pick out the thin peninsula which bore the name. Having located it, they burst into contagious laughter at its dwarfish size. The incident counts as another twentieth-century epiphany. Here was the West seen from beyond, in all its insignificance. In retrospect, the Chinese ignorance of Italy seems reassuring,

WALKING A CIRCLE IN LADAKH

16,460 FT. PINGDON LA

NORTHERN INDIA

An earthwork constructed by Richard Long while on a walking expedition in 1984

Susan Ressler
Earth I *(1989)*
Ressler's hand
grips a stone,
against the
backdrop of a
Native American
basket:
manipulation on
a computer has
created a diagram
of our world and
the outer space in
which it revolves

like the insolent aloofness of Lévi-Strauss's cat. At least the world in 1972 was large enough to permit such mysteries. Nowadays all such lacunae have been closed by intercontinental telephones and fax machines, which work efficiently even in China. Technology elides distance and thus abolishes space. We have grown accustomed to treating what remains of the earth as raw material. In Singapore and Kuala Lumpur terrain is razed and evened out to provide anchorage for skyscrapers. Dredgers and pile-drivers in Hong Kong toil to reclaim more of the harbour, an unprofitable wilderness of water. A visionary developer will sooner or later suggest paving over the oceans, sealing them with tarmac and building rentable floors on top.

The detached view of satellites at least reminds us about the cost of industrial progress, and warns of our parasitism. The Amazon has been flayed. A tenth of the forest is already gone, and the rate of clearance increases, because damage is productivity: fifty acres are toppled every minute. At first the trees were chopped down to make way for subsistence crops. Now the bulldozers are sent in by loggers, who want to sell Brazilian mahogany in Europe and Japan. As the world shrinks and its resources dwindle, we cannot avoid the consequences of reckless actions like these. The massacred trees no longer produce carbon dioxide. Above Antarctica, a hole gapes in the abraded sky. The sun, unfiltered, poisons our skin. The supply of ozone is gobbled up by man-made chlorofluorocarbons. Our refrigerators, as they contentedly hum, make their own small contribution to the apocalypse. So do the concoctions with which furniture is dosed to prevent a fire from spreading. They avert a small disaster, but assist a larger one: they too destroy ozone. At high altitudes, the exhaust fumes from jets emit sulphur trioxode, which speeds up the cooking process.

The mobility we take for granted has its price, and we fight wars about fuel, not territory. Energy is a potentiality, which exists to be burned up, transformed into entropy: with fine, vindictive logic, the Iraqis torched the oil wells in Kuwait during the Gulf war. Elsewhere the precious substance spills on its way to the countries which are addicted to it, and viscous black lakes in Alaska or off the Japanese coast mire birds and choke fish. The elements are infected. Acid rain – which is sulphurous or nitrous pollution, caused by burning fossil fuels – singes forests and corrodes buildings. These are not accidents, or merely inconvenient side-effects of an inevitable advance. They constitute the true purpose of what we call development or evolution. From the first ignition of sticks or flints which conjured up fire to the moment when atomic fission occurred, science has created new possibilities of destruction. Meanwhile a child is added to the global quota every half a second, and the planet's home-grown limits on the population it can sustain will soon be reached. This demographic crisis reveals how inadvertently fatal our scientific achievements have proved to be. Medicine prolongs human life – a boon for individuals but a burden for society, which must subsidize the last decades of its stubbornly resistant elders. Nature too is obstructed, its rhythms of renewal frustrated.

A sub-plot accompanies and contradicts the West's advance (which leads, in modern times, towards its decline). The culture held to ransom by applied science looked aside in envy and remorse at another hemisphere in which machinery did not set the agenda. Even at the Renaissance, classical rationality was subverted by the appeal of Asiatic religious cults and mysteries. Romantic poets and painters broke away from the itinerary of the Grand Tour, rediscovering parts of the world not colonized by classicism. Byron visited Ali Pasha in Turkey, and Delacroix travelled to North Africa. The gods revived by Nietzsche came from outside Europe: Dionysus, the eternal opponent of enlightened Apollo, and the Persian Zoroaster. Hermann Hesse made a journey to India in 1911, and in 1922 published *Siddhartha*, a novel about the spiritual apprenticeship of Gautama Buddha. Hesse's Buddha addresses the qualms of the twentieth century and criticizes the notion of a quest, that ambitious motor of spiritual history extolled by Spengler. Siddhartha believes that we find only if we refrain from seeking, and teaches himself to disbelieve in evolution. He looks at nature in a spirit of grateful acceptance: 'meaning and reality were not hidden somewhere behind things, they were in them, all of them'. This censures the relentless manipulation of reality by the modernists, who extorted meaning by distorting appearances. Siddhartha 'saw and recognised the visible'; the modern project, endorsed by cubist, surrealist and expressionist painters, was to make the visible unrecognizable. Nor is time bent and buckled, as in the literary narratives of Proust, Musil or Joyce. Siddhartha dispels time by meditating. The ferryman in Hesse's novel learns the water's secret, which is 'that there is no such thing as time…. Nothing was, nothing will be, everything has reality and presence.' The modernists conflated what was and what will be, because they felt that reality and presence were

evaporating from the world, eroded by time. That is why Cézanne so devoutly insisted on the solidity of his mountain, and why Proust commemorated memory as a visionary faculty, which allows us to resurrect the dead. Remembering, however, is a luxury which Siddhartha must relinquish. Buddhism prescribes a simpler and more peaceable solution to our discontent: just sit back and wait for the universe to stop existing.

In 1931 Antonin Artaud defined the East as 'the only part of the world where metaphysics is part of the daily practice of life'. A counter-culture reintroduced such immaterial concerns to the daily practice of Western life. In California during the 1940s Christopher Isherwood studied Vedanta, practised yoga, and – meditatively removing himself from a frantic automotive society – came to see the jostling, bad-tempered traffic on the Los Angeles freeways as a Buddhist life-stream, bound for the off-ramp which led to nothingness: the cars merge in a metallic river, 'sweeping in full flood towards its outlet with a soothing power'. Also in Los Angeles, Aldous Huxley experimented with psychedelic drugs, which he thought of as a chemical technology, a means of instantaneous transport to nirvana. This was a seditious venture, because drugs challenge the imperatives of action and exertion which drive our history. They allow the user, immobilized during a trip which takes him nowhere, to slip out of time – to kill it by sitting still, rather than (like the Italian futurists in their sports cars) by frantic acceleration. During the 1960s drug-taking became a technique of dissent, a means of internal exile. Eventually the critique of Western values extended to dietary habits. Banning pesticides and genetic manipulation, making room for okra, couscous and Chinese tubers, an emporium in San Francisco currently sells what it calls 'alternative produce'.

The new relativity of these borders enraged the libertarian Settembrini in Thomas Mann's *Magic Mountain*. Settembrini cherishes Europe as 'the theatre of rebellion', the arena of intellectual freedom, and denounces Asia as a realm of 'quiescence and immobility'. Haranguing Hans Castorp, he insists that 'the Asiatic principle must be met and crushed in its…vital centre'. He means Vienna, the place where modernity set about seceding from the continent's humane traditions. According to Milan Kundera, the post-war settlement in 1945 pushed back the same boundary. The slothful, despotic Russian empire absorbed the modernist capitals of Prague and Budapest and swallowed half of Berlin; Asia annexed the centre of Europe. Perhaps in the twenty-first century East and West will simply change places. Europe and America may succumb to quiescence, while the turbulent economies of Asia take up the cause of ferment and perpetual change.

Adolf Loos, in the diatribe he published in 1908 on *Ornament and Crime*, still adhered to the xenophobia of the West, and described the human being's growth from embryo to adult as a recapitulation of racial history. A two-year-old child, Loos thought, was a Papuan savage, a four-year-old was a Teutonic tribesman. By the age of six, he has caught up with Socrates; at eight, he was the

equal of Voltaire. This haughty review of the past justified Loos's attack on orna-
ment, which he considered to be a species of 'baby talk', as messy and irrational
as Papuan tattoos. Graffiti he dismissed as a symptom of criminal degeneracy, a
throwback to our unkempt, unsocialized past. At the end of the century, we no
longer see ourselves in this privileged way; nor can we even find grounds for con-
demning the scribblers of graffiti. Adolescents with cans of spray paint bright-
ened the New York subway in the 1970s, creating a florid jungle of décor, and
the slogans and cartoons daubed on the Berlin wall changed it from a barrier to a
tantalizing horizon. Loos was convinced that our human destiny made us aspire
to be Voltaire, not a tattooed cannibal in Papua. But the twentieth century has
insisted on treating the sage and the so-called savage as intellectual equals.

In his study of *The Savage Mind*, published in 1962, Lévi-Strauss annulled
the achievements of the progressive West and revoked its moral priority. The
penultimate chapter of his book has a title borrowed from the last instalment of
Proust's novel, 'Le Temps retrouvé'. The anthropologist boldly likens his cultural
inquiry to Marcel's psychological quest, but the outcome is different. Proust
redeems time, while Lévi-Strauss repudiates it. 'The characteristic feature of the
savage mind', he notes admiringly, 'is its timelessness.' He explains that the sys-
tems of totemic classification devised by the Aranda people in Western Australia
or the Algonquin in America 'permit the "furnishing"…of social time (by means
of myths) and of tribal space (with the help of a conceptualized topography)'. In
myth, space exists first, and time derives from it. The physical world is the pri-
mary reality. It predates our fugitive passage through it. Telling stories, we
attribute a history to that abiding space. But the stories end, consumed by time,
while space – the terrain which we long to anthropomorphize – obdurately and
silently endures. This anchorage inhibits history, and prevents time from starting
its flow towards dissolution.

The people we call savage do not see themselves as solitary individuals,
successively advancing through time until they arrive at death. They belong
irrevocably to a group, their common membership cemented by the totems they
venerate. We have come to envy the different way they construe the world. In
1951 the painter Jean Dubuffet declared that Western man had 'a great contempt
for trees and rivers, and hates to be like them'. Trees are plants, interchangeable
with each other, and rivers are impersonal forces. They lack the human being's
singleness and singularity. But why should we feel so proud of our separateness?
Embedded in the land, primitive men are spared from having to suffer the
abstracted fate of the individual in modern times – disoriented in the city, like
the psychological victims of the metropolis described by Simmel; free-falling
through a black abyss like the astronaut whose life-line is cut in *2001*. The exam-
ple of those who have not experienced progress has prompted us to question our
own faith in history and its immanent will. By contrast, other cultures have man-
aged to survive by disregarding time, like the Australian aborigines, or annihilat-
ing it, like the Buddhist sages.

Lévi-Strauss's own effort to regain time had an ironic personal epilogue. In 1985 he could not locate his own past in São Paulo, where he had taught sociology fifty years before. Though he expected that the house he lived in would have been demolished, he hoped at least to see the street. But he failed even to reach the district, trapped in a traffic jam on the Avenida Paulista as the city's uncountable millions of inhabitants battled their way to work. Isherwood's river no longer flowed soothingly on; it congealed in fuming frustration. All those cars, exhaling toxins, were going nowhere. Even the Nambikwara people from the Amazon, among whom Lévi-Strauss conducted fieldwork for *Tristes Tropiques*, had since joined the modern world, and proudly brandished their Japanese transistor radios. Lévi-Strauss could only compare these demoralized, disoriented tribes to the survivors of a nuclear catastrophe, like the citizens of Hiroshima picking their way through the rubble. Revealing the fragility of cultures, of creatures, and of the earth itself, they reminded him of another more primeval disaster: the shower of meteorites which perhaps eliminated the dinosaurs.

Anthropology purports to be the study of man, the most victorious of species. But how could such favouritism be upheld in the twentieth century? The science therefore acquired a new and tragic moral. Exhilarated by the prospect of doom, Lévi-Strauss looked forward at the end of *Tristes Tropiques* to the moment when 'the spectrum or rainbow of human cultures has finally sunk into the void created by our frenzy'. In advance of that consummation, he redefined his own intellectual purpose. He preferred to think of himself, he said, as an entropologist, contributing to the disintegration of his own kind – just as Buddhism wisely disestablishes the universe and dismisses its own pretensions as a religion. Still, while awaiting the end, he was obliged to make a grudging disclaimer: 'Yet I exist.' Of course, but as what? He had his own curt version of the modern disillusionment: 'Not, of course, as an individual.' If our century has taught us anything, it has demonstrated the absurdity of this old-fashioned notion. The man with the hyphenated name, the honorary degrees and the medals discards all qualities, and sees himself as no more than a disputed and inefficient median point between mind and body. Like a pointillist canvas, he represents an image which coheres from 'several thousand million nerve cells lodged in the ant-hill of my skull'. Wired to these, Lévi-Strauss adds, is 'my body, which serves as its robot'. This is how H.G. Wells envisaged the Martians: a brain equipped with hands.

Lévi-Strauss disowned the obnoxious self and decided that 'there is no place for it between *us* and *nothing*'. 'Us' replaces the disgraced and illusory 'I', chastening a fatuous intellectual pride. The plural pronoun refers to a common fate: anonymous merger with the species. This choice was profoundly subversive, even more so than self-annihilation might have been. In 1931, identifying the mental tendency which directed Europe between the Renaissance and modern times, Ortega y Gasset pointed to reason's struggle to cast off an 'immemorial communistic life' and argued that, as consciousness develops, 'the "we" comes first, and then the "I"'. He acknowledged that the birth of individuality necessarily

negates the world into which it is born. Man arrogantly conceives of his rational power as a 'divine faculty'. Exercising it, he claims to lay bare 'the ultimate essence of phenomena': the new physics set out to scrutinize the mind of the creator. Ortega saw the motive of history as a quarrel with 'our fathers'. The final victim of rebellious Oedipus must be God, the most sternly forbidding of patriarchs. Myth accordingly surrenders to science.

This, for Ortega, was 'the modern theme'. But the post-modern theme may well be the reclamation of science by myth. The arrogant 'I' which anatomizes or atomizes the world, risking its reduction to nothing in the search for knowledge, succumbs again to Lévi-Strauss's 'us', and repentantly honours the memory of those slain fathers.

A storm of red dust chokes a Western Australian mining town on the edge of the desert in Randolph Stow's novel *Tourmaline*, published in 1963. The hero looks into the oblivious whirlwind: 'there was no town, no hill, no landscape. There was nothing…. What could this be if not the end of the world?' It might have been a return to the beginning: geologically, Australia is the oldest continent, its surface parched and mottled like elderly skin. Geographically, it is the remotest, kept at a distance from history – until the belated arrival of Europeans – by its moat of oceans. Australia might have been designed as the setting for an ultimate contest between predatory men and lethal nature. Yet at the end of our century, as we guiltily reconsider our conduct on this planet, it has become the site for a healing re-engagement with the earth, honouring the sacred ecology of its first inhabitants.

The British, commandeering Australia as a penal colony in the eighteenth century, had no compunction about using it as a dump for social refuse. Legally they defined the continent as null and void terrain, effectively uninhabited. The aborigines could be disregarded because they had failed to cultivate the land. This merely meant that their agricultural methods were not those employed in Europe. Their controlled burnings were derided as arson. But by contrast with what Lévi-Strauss calls the entropology of the West, the aborigines used fire as a form of housekeeping. It freshened the land during the dry season, prising open seed-pods and prompting bushes to send out new shoots. It scared animals from their hiding places, and allowed them to be hunted. It also served as a means of prevention: ground which had been burned off was not incinerated if a larger blaze swept through. Europeans despised the aborigines because they grew no crops, and thought they grubbed up worms for food. In fact they ground the seeds of mulga or acacia for flour, collected tubers known as bush potatoes or fruits resembling tomatoes, and sucked sugary nectar from a red flower. The desert for them was as bountiful as a supermarket.

Their myths venerated the spirits which had taught them the techniques of subsistence. A brown falcon told the people of Arnhem Land how to spear fish, and from the bower bird they learned to weave shelters of dry grass in which

to perform religious ceremonies. The creators they worshipped had made the earth fertile, emerging from the sea to plant yams and to excavate water-holes. At the Dreamtime, when genesis occurred, the land was malleable like memory. Ancestors walked across it, kneading it into form, then retired into the rocks they had shaped. The songlines – stories which enliven the past and sustain the earth – still trace the itinerary of these totemic parents, in dotted paths which link life-giving wells. At puberty the sacred narrative is inscribed on a youth's body, and the wells for which his clan takes responsibility are mapped on his skin. After death his bones will be powdered and returned to the vicinity of the well which nourished him.

The aborigines understand the conditional nature of our existence here. While they wait for the monsoon, the Anbarra people who live at the mouths of the Alligator Rivers east of Darwin prohibit meals of goanna on the beach. They are afraid that this will incite the jealous fury of the Rainbow Serpent, watching them from the inland stone country; it might send a retributive downpour to wash them away. The taboo instils caution, the need to avoid antagonizing nature. For the white settlers, entitlement depended on exploitation, and they did their conscientious best to exhaust the earth or redesign it. The sheep and rabbits they introduced ate up the native grasses. Rivers were diverted or mountain valleys drowned to construct hydro-electric dams. In the suburbs, householders still take anxious care of their green, level lawns. To keep them mown is an infallible sign of civic virtue. The aborigines, by contrast, saw themselves as custodians of their territory, duty-bound to preserve its ancient equilibrium.

Charles Darwin, who stopped briefly at Sydney and Hobart in 1836, wondered if Australia even belonged to the same world as temperate Europe. The marsupials he saw almost made a Manichean of him: the oddity of those new species suggested that 'surely two distinct creators must have been at work'. The explorer Ludwig Leichhardt was appalled by the hostility of the landscape. Reaching the escarpment of Arnhem Land in 1845, he called the prospect 'disheartening, sickening'. D.H. Lawrence visited Australia in 1922, and concluded that the country lacked an 'interior life'. As desiccated as its red dust, as obtuse as the rocky plateau which defied Leichhardt, it possessed, Lawrence thought, 'a *physical* indifference to what we commonly call soul or spirit'. Often the spirits invoked to redeem this callous country were the wrong ones. The aboriginal painter Albert Namatjira, raised by Lutherans on the Hermannsburg mission near Alice Springs, endeared himself to his colonial patrons by diluting the harsh and blindingly bright terrain in his water-colours. He also baptized Australia. When he painted Heavitree Gap, the entrance to Alice Springs, he positioned a clump of spectrally white ghost gums in the foreground as a home-grown Calvary. In the gorge at Glen Helen, he painted a cliff of cracked pillars nicknamed the Organ Pipes, seeing infidel nature as a roofless, ruined cathedral. Glen Helen had been the tribal valley of Namatjira's people; accepting the Christian metaphor, he was condoning the eviction of their gods.

Convinced that he presided over a negligible waste land, Prime Minister Menzies allowed Britain use the outback to test its nuclear bombs during the 1950s. No harm could come, he reasoned, from all those experimental Armageddons triggered 'in the vast spaces in the centre of Australia'. In 1993 the Aum cultists sneaked into Western Australia from Japan to mine uranium for the nuclear bomb they intended to build, and to try out the nerve gas they had concocted on the local sheep, which obligingly keeled over. Europeans continue to choose Australia as a location where the end of the world can be dramatized – the end, that is, of the rapacious, ever-developing Western world. In 1983 Werner Herzog filmed *Where the Green Ants Dream* in the Flinders Range and around Coober Pedy in South Australia, a lunar landscape of conical ant-hills and rusty sand, lashed by angry winds, where troglodytic opal miners live in underground burrows hacked from the rock. Here in Herzog's film an aboriginal tribe passively resists the depredations of the mining industry; its elders quietly sit down in front of a bulldozer. The area to be gouged out and gutted is sacred to them, because it is where their totem animal seasonally remembers and repeats the creation of the earth: the place where the green ants do their dreaming. When the case goes to court in Melbourne, the aborigines make good their stake in the land by exhuming a sacred object which has been buried for two hundred years. They insist that the court be cleared before they unwrap it; otherwise, they warn, apocalypse will ensue. Herzog's camera respectfully looks away, but the judge sees only some wooden sticks with indecipherable markings and decides against the claimants. The mining company buys off the aborigines with the gift of an Air Force plane, in which they cross the mountain to re-enact the mating swarm of the ants. Machinery, however is no substitute for their mythic lore. The pilot is a drunken amateur, corrupted by contact with white society, and the plane crashes. The film concludes with a meteorological curse, which follows when the taboo is defied. Though Herzog used some grainy video documentation of a twister in Oklahoma, he was referring to the cyclone with the winsome name of Tracy, which flattened the city of Darwin on the night before Christmas in 1974.

Until the End of the World, a global road movie directed by Wenders, criss-crosses Europe, strays sideways to Beijing, Tokyo and San Francisco, and finally reaches Sydney, before a detour to Coober Pedy. Wenders completed the film in the Kimberleys, at the top of Western Australia, which he thought of as a defensive bunker for the menaced earth. After a nuclear catastrophe caused by a runaway Indian satellite, a scientist collects images, the only residue of expiring human life. In a laboratory hollowed out inside a mountain, he tries to translate this archive of visions into brain-waves and to beam them behind the eyes of a blind person. As in Herzog's film, technology encounters an aboriginal embargo. The native people complain that the gadgets of the refugees trespass on the invisible domicile of their spirits: 'You think we want you walking through our dreamings with your fancy cameras?' The Westerners in *Until the End of the World* are

addicts of simulation, obsessed with luminous photographic mirages. The aborigines have their own alternative to those shadows trapped by machines. Throughout the Kimberleys there are ancestral rock paintings of Wandjinas, spirits which evaporate into clouds. In Kakadu, across the state border, the cliffs and caves of Arnhem Land show the jagged skeleton of forked lightning, which slashes the sky to announce the monsoons each December. These images are not representations, reproductions whose aura has been taken from them like the camera's subjects; the aborigines believe that they were made by the actual imprint of bodies, when the primal creatures fused with the rock.

The heroine of Wenders' film quits the burnished Australian desert for the blue, chilly stratosphere, where she is employed by Greenspace to survey the oceans from on board a satellite for evidence of pollution crimes. The twentieth century has sought to incubate new and ever newer human beings: automata and astronauts, neurotics with their refined psychic tuning and Bolsheviks, Red Guards or Japanese corporate employees, free from private vices. The aborigines expose the folly of all these modernist experiments. They are the oldest human beings, still resident in the Stone Age; they have not yet been taken up and carried away by history, and the Western conscience now suspects that they are none the worse for that. Adhering to the small portion of land which they must care for, belonging to insulated language groups, they do not aspire to be citizens of the world. An elder in *Where the Green Ants Dream*, introduced to the court in Melbourne as a mute, startles the lawyers by eloquently and unintelligibly testifying. The judge wonders why his companions said he was mute. He can speak, they explain, but no one understands him: he is the last speaker of a language which will perish with him. One of the boldest modern ambitions was to invent a medium in which everyone in the polylingual world could converse. The example of tribal society convinced Lévi-Strauss that these sophisticated efforts were hardly worthwhile. He dismissed printed texts and verbal exchanges between different communities as waste products. True, they allow communication, and thus create an 'evenness of level'. But is this a benefit? 'Before,' Lévi-Strauss argues, 'there was an information gap, and consequently a greater degree of organization.' To trample the barriers or vault over them stirs up disorder and adds to entropy. This, according to the statistical mechanics of Ludwig Boltzmann, is the destiny of nature, which man cannot arrest and in fact helplessly assists: a decline from system to chaos, with all differences erased and all energies inertly levelled. So much for the bright vista of the information highway.

In *The Modern Theme*, Ortega y Gasset pitied the primitiveness of the Australian aborigines. He thought they suffered from 'historical malnutrition', stalled forever in 'the communal condition', unable to experience 'what we call individuality'. All this could be ignorantly asserted in 1931. Such snobbery is no longer tenable. Lévi-Strauss warns us not to be disgusted by the 'infantile perversity' of the aborigines, who derive such pleasure from the solid and liquid by-products of their bodies. After all, we in the West put postage stamps in

our mouths to wet them. Despite the incursions of reason, which in Ortega y Gasset's view made men modern, Lévi-Strauss notes that 'there are still zones in which savage thought, like savage species, is relatively protected. This is the case of art, to which our civilization accords the status of a national park.' Even in the modern city, men are permitted to behave like savages, covering walls or pavements with their occult daubs – so long as they

Keith Haring
Brazil *(1989)*

define their behaviour as art. Keith Haring, who painted irradiated babies and frisky dogs in Day-Glo colours, treated the Manhattan streets like an aboriginal rock gallery. In 1978 the Australian government granted the Gagudju people title to Kakadu, an area of flood plains and stony plateaux in Arnhem Land. The Gagudju then leased it back to the government, to be opened as a national park. It is the lair of the Rainbow Serpent, which scythed its way through the steep ramparts and indented the mountains with clefts and crevices. But the protection afforded to this mythical enclave, where spirits left their signatures on the rock twenty thousand years ago, is relative: Kakadu also contains the Ranger uranium mine, which began to extract ore in 1979.

Refusing to accept the laggardness of the aborigines, Lévi-Strauss compliments their 'intellectual dandyism'. For him they resemble academicians, devoted to 'erudition and speculation'. Wilhelm Worringer, in the psychological study of perception which lay behind expressionist painting, described primitive man as a terrorized creature, looking out at an indistinct and inimical world. In Worringer's argument, this is what made the savage so modern: he was like the skulking inhabitant of a metropolis. We now know that the tribal world-view is neither helpless nor irrational. The logic of totemism involves a subtle and finicky adjudication between objects and the significance which has been assigned to them. In a commentary on *The Savage Mind*, Octavio Paz points out that 'the primitive lives in a universe of signs and messages' and is therefore 'closer to cybernetics than to medieval theology'. Worringer was wrong about the cowering superstitious dread of these early men; they have the refined brains of computer programmers.

Removed from exterior distractions on their isolated continent, the aborigines have been able to indulge their mania for mental tidiness. They sort

through phenomena to divide the world into moieties, study sources and keep traditions dusted and polished. This is why they worry about the churinga – those miraculously potent sticks unearthed in Herzog's film. Is their prayerful trust in these symbols of legitimacy any different from our faith in pieces of paper – government bonds, last wills and testaments, or leases on the property we live in – which we lock away in deposit boxes or hand over to solicitors for safe-keeping? Of course a stick is not a spirit, just as the pieces of paper we exchange with each other are not wealth. The rules made up by the aborigines, like the strict symmetry of their kinship relations, are entirely gratuitous. If the Anbarra people were to cook a goanna on the beach, the Rainbow Serpent would prob-ably take no notice. 'This', Lévi-Strauss points out, 'is the trap reality sets for the imagination.' Unable to tolerate nature's contingency, we discipline it according to our own cultural needs and demands. But we are merely dreaming up flimsy rules for the game which – whether in the Northern Territory or in Western Europe – we call civilization. The rules, though they hope to deny the indiscipline of things, are spurious and therefore variable. Lévi-Strauss mentions the Gahuku-Gama people in New Guinea, who adopted and then revised the colonial game of football. Their habit was to play a succession of matches, lasting several days. Unwilling to conceive of a winner, they had to keep going until both sides arrived at the same score: Lévi-Strauss approvingly comments that 'this is treating a game as a ritual'. Civilization is founded on the airy elaboration of fictions.

The Savage Mind treats the aborigines with a devious post-modern irony. Lévi-Strauss remarks that they look like pot-bellied bureaucrats or retired civil servants who have somehow lost their clothes. The joke is hardly an adequate response to their tragedy. In Alice Springs, they camp in a dry river-bed, drinking for solace. It is not uncommon to see a leper stumbling through a shopping mall. But the irony glances in both directions at once, and blames Europe for displac-ing them. In New York during the 1940s Lévi-Strauss trawled the antique shops on Third Avenue in search of tribal masks from the Pacific Northwest. André Breton, who tagged along on these expeditions, declared that 'Today it is the visual art of the red man that lets us accede to a new system of knowledge'. Lévi-Strauss looked to the aborigines for the same renovation of knowledge. The solemn frivolity of their religion and science at least offered a reprieve from the twentieth century's earnest, fanatical, perilous interrogation of the universe.

In the centre of the Australian continent a sandstone megalith ignites at dawn like a coal, smoulders through the day in a scarlet or orange haze, and disap-pears, apparently withdrawing underground, when the sun sets. Five miles around at its base, it is placed at a point where the ancestral tracks of aboriginal tribes intersect, and also lies directly beneath the flight path of jets travelling to and from Asia. A surveyor laid claim to it in 1873, and called it Ayers Rock in homage to a local politician; an apostrophe sometimes wrongly sneaks into the name, as if it were owned by Sir Henry Ayers. The year before, another explorer

Michael Andrews
The Cathedral,
The Southern
Faces: Uluru
(1987)

symbolically annexed a nearby saline lake and a range of round knobbly peaks. He christened the lake Amadeus, after the Spanish king, and called the moun-·tains the Olgas, as an offering to a Russian grand duchess. The landscape was handed over to a series of potentates who had never seen it and probably knew nothing about it.

Instead of invoking distant patrons and protectors to whom the rock symbolically belonged, the aborigines knew that they belonged to the rock, which they call Uluru. Their legends describe its gestation, during a time when they themselves were formed from the plastic earth. One tribe says that the rock was moulded from mud by two boys, after a storm of rain moistened this arid land. Another tribe reads in the rock's gashed, cloven physiognomy the narrative of a primal battle between two groups of snake warriors, whose eyes and wounded heads slowly hardened into stone. Everywhere they find traces of totemic parents. An evil dingo dog left permanent paw prints on a cliff. A line of shallow indentations was dug by a lizard, frantically searching for a stick he had thrown. Blood-like oxidation on the walls of caves derives from the earliest initiation ceremonies. The whole inconceivable thing is alive – asleep but dreaming.

The pilgrims from the Sheraton Hotel, which huddles out of sight behind the dunes, insist on conquering the rock. Spikes have been driven into one of the less sacred faces, with a chain strung between them so you can haul yourself to the summit. At the top, a white stripe has been painted along its spine, like the markers on a highway. There is a rusticated bin, inlaid with slabs of stone, for litter. On the way up and down, you pass a series of bolted plaques: a memorial garden for tourists who have perished during the climb. This landscape challenges men to risk their lives and, having defeated them, demands that they

reassess their humanity and its superhuman bravado. The lawman who narrates Stow's *Tourmaline* suddenly realizes, standing in the derelict settlement, that 'man is a disease of God; and that God must surely die'. In Patrick White's *Voss*, the explorer – a hero of Faustian will, who sets out to cross Australia from east to west – is beheaded in the desert by an aborigine. Man, according to White, is God decapitated. So what is a decapitated man? Only a body, ready for absorption by the elements. The aboriginal name for Mount Olga is Kata Tjuta, which means 'many heads'. Those heads have grown from the soil; they are not detached, presuming to control it.

The mining company in *Where the Green Ants Dream* invites the tribal elders to Melbourne, where they are taken to see the panorama from the top of a skyscraper. Mistrusting hydraulics, they magically halt the elevator which lifts them into the air. 'The twentieth century should be called off for lack of interest', snarls the engineer who is conducting their tour. In the vicinity of Uluru there is no need to call off the twentieth century. Here – except for those cautionary plaques and the contents of the rubbish bin – it never happened.

KEEP GOING

In the beginning, the impatient urge of modern times was escape from the past. As early as 1872 Arthur Rimbaud decreed 'Il faut être absolument moderne', and obeyed his own injunction by giving up poetry. He travelled with a circus, worked as a labourer, and ventured to Africa, where he managed a trading station which, as well as exporting ivory and animal hides, trafficked in guns. An abrupt, pitiless secession is still the proof of modernity for the brittle characters in Schoenberg's opera *Von heute auf morgen*, first performed in 1930. 'Mama,' a bemused child asks her parents, 'was sind das, moderne Menschen?' To qualify as modern people, her mother and father plan extra-marital affairs. But at the last moment, they realize that modernity is a condition of permanent revolution, requiring you to update your ideas and beliefs and sexual partners from one day to the next, and they decide to remain old-fashioned.

Kirilov in Dostoevsky's *The Possessed* feels an absolute estrangement from the past. The self-awareness which makes him modern separates him from everyone else who has ever lived, and from the presumed source of life. He is, he announces, the first and only man in universal history who refuses to invent God. Existence, however, proves intolerable without the aid of this metaphysical delusion, and he promptly kills himself. That was one way of being absolutely modern. Violently renouncing the past, welcoming the end of history, modernity modelled itself on the act of suicide. In 1897 Émile Durkheim published a sociological treatise linking suicide with the stress of modern experience; this was, he suggested, a pathological symptom of social 'anomie' – a Greek word, restored to use by Durkheim, which refers to the failure of traditional laws and the absence of moral support. The kind of suicide which Durkheim called 'anomique' was the individual's protest against a collapsing world. Such desperation became, potentially at least, a mass phenomenon. In 1945 Japan prepared itself for the Honourable Death of the Hundred Million. The Emperor, accepting military defeat, was expected to command his subjects to atone for the national shame by dying.

Volkszählung
*Anselm Kiefer's
walk-in library*

For Durkheim, suicide revealed the pathetic vulnerability of men in a society which was changing too fast. Others saw it as a gesture reclaiming responsibility. To kill yourself, in Walter Benjamin's view, was a deed of uniquely contemporary valour. The individual had become his own God, like Elias Canetti's bomber; to commit suicide professed a superiority to life itself, disdaining its physical weakness and mental instability as Hemingway, Woolf, Rothko and Mishima did. Benjamin's friend Gershon Scholem chided him in 1931, arguing that 'your suicide would be too high a price to pay for the honour of correct revolutionary thinking'. Nevertheless Benjamin paid it. Art, in making itself modern, mimed these acts of extermination. Nietzsche in *The Birth of Tragedy* described music as the form in which we perceive 'the delight felt at the annihilation of the individual'. The notion for him was innocently metaphorical: music absorbs us like an ocean, merging us with one another. But the heroine of Strauss's *Elektra* takes Nietzsche literally. Hearing her mother shriek as Orest kills her, she screeches 'Triff noch einmal!' – strike her again. Orest does so, and Elektra is gratified by Klytämnestra's death-rattle. The language of poetry was first and most rigorously modernized by Mallarmé, who abolished subject matter and called himself a hollow musician of nothingness. Roland Barthes praised Mallarmé for committing 'the ultimate of all objectifying acts: murder' when he slaughtered significance, and paid him an austerely modern compliment by remarking that 'this art has the very structure of suicide'.

Painting also set out to arrive at nullity, the most modern of destinations. Dubuffet envisaged a surface of 'monochrome mud', and Rauschenberg painted canvases which were featurelessly black or white, like the eternal absence and unanimous whiteness of the lace in Mallarmé's sonnet 'Une dentelle s'abolit'. In Milan Kundera's 1991 novel *Immortality* a painter called Rubens, who – as if heeding Rimbaud – has given up painting, walks through a short history of modernity at the Museum of Modern Art in New York, and watches in dismay as art icily obliterates the physical world. On the ground floor he can at least enjoy the sexual carnival of Picasso, Braque's noisy cluttered cafés, or the tropical sensuality of Matisse. Upstairs, in the galleries devoted to contemporary work, he encounters a visual desert. Reality has been banished, or is mocked in hyper-real replicas. 'Between the two floors', he reflects, 'flowed the river Lethe, the river of death and forgetting.' The artists are in collusion with the political modernizers denounced by Kundera in his earlier novel, *The Book of Laughter and Forgetting* (1978), which begins with an image of totalitarianism officially cancelling an inconvenient memory. A photograph of the communist leaders addressing the population of Prague in 1948 is air-brushed four years later in order to remove all trace of a comrade who has fallen from grace and been executed; Kundera himself became a non-person after the Russian invasion of Czechoslovakia in 1968.

The modern world vigorously launched itself into a future which, as Kundera complained, was never anything more than 'an apathetic void'. When the

revolution faltered in Europe, its agenda was transferred to America. László Moholy-Nagy, arriving in Chicago in 1937, rejoiced in 'the air of newness', far from 'the paralyzing finality of European disaster'. It turned out to be a false hope. The story of the twentieth century is that of any individual life. We begin rebelliously, determined to ignore precedent and not to repeat the errors of the previous generation. Then, as we recognize the limits which have been set for us, we gradually arrive at a forgiving accommodation with the past. Growing up, we become our parents, and after that our grandparents. The change from youthful idealism to middle-aged compromise cannot happen without a regretful, self-accusing crisis. Hence those episodes of cruel disillusionment which punctuate the history of our times, moments when political and intellectual revolutions were betrayed or shown to be corrupt: the massacre of humanity during the so-called Great War, Stalin's cynical pact with Hitler, the bombing of Hiroshima, the final decrepit collapse of Marxism in 1989.

Ever since the last *fin de siècle*, we have been expecting history to end. There is a heady existential thrill to be derived from the sense that we are nearing a climax, or a terminus. In our excitement, we tend to overlook the fact that the earth still persists in turning. Despite its anticipation of the future, ours has been a retrospective century, telling all the past's stories over again. At the lying-in hospital in *Ulysses*, Joyce narrates the development of an embryo by working through an abbreviated history of the evolving English language. It is one of the twentieth century's articles of faith that language speaks us, like a determining set of genes: how then can we presume to liberate ourselves and to renew the world? Even destruction is hard work, and never completed. Warhol yawned at predictions of ecological disaster and refused to bother about recycling paper or glass. 'How', he asked, 'can we be running out of anything when there's always...the same amount of matter in the Universe, with the exception of what goes into the black holes?'

The view ahead, despite soothsaying and science fiction, remains blank, inscrutable. Behind us, there is a different prospect: a chasm, a declivity in space formed by the time we have lived through. Those years – or even the centuries through which our predecessors lived – are not lost to us, because we retraverse them psychologically. At the very end of Proust's *Recherche*, after a ghoulish reunion with the characters who populated his earlier life, Marcel has a moment of dizzy insight. He looks down 'beneath me, yet within me, as though from a height, which was my own height, of many leagues, at the long series of the years'. In space, people shrink as they age, physically diminishing, but in time they expand. The Duc de Guermantes at the age of eighty-three totters on 'living stilts...taller than church steeples', which plumb the abyss of years which he carries inside himself. Marcel, still relatively youthful, wonders how he will be able to maintain his own grip on 'a past that already went down so far'. For him, this is as yet no more than a personal conundrum, an exercise in emotional accountancy. But it became the crucial challenge of modern times. How much of

the invidious past – which connects modern men with their primitive ancestors in the figure of Nijinsky's faun or in the Nazi worship of blood and soil – must we take responsibility for? Although Freudian therapy concludes when the ghosts are re-interred, we have come to begrudge ourselves this comfortable, curative forgetfulness. Theodor Adorno insisted that no poetry could be written after Auschwitz.

The past loads us with guilt. Annihilation can at least be guaranteed to exonerate us, to cancel all those inherited debts. At the end of Andrei Bely's *Petersburg* the Oedipal terrorist Nikolai Apollonovich, who failed to assassinate his father in 1905, goes into exile in Egypt. There he occupies himself in preparing a revised commentary on the Book of the Dead, which contained spells for use by the deceased when Judgment Day arrived. He sits in front of the Sphinx (as Oedipus did before him) and stares at this monumental image of the world-mind. Its prophetic foresight is stored inside 'an immense mouldering head that is on the verge of collapsing into sandstone thousands of years old': the cosmic brain suffers erosion. But Nikolai imagines himself looking out through the Sphinx's blind eyes, and fancies that he foresees the history of the twentieth century. 'Culture', he concludes, is 'a mouldering head: everything in it has died; nothing has remained. There will be an explosion: everything will be swept away.'

Wise after the event, Bely added the final sentence in a 1922 revision, pointedly referring to the Bolshevik Revolution. Yet his fortune-telling was inaccurate. Despite the twentieth century's multiple explosions, everything did and does remain. The characters in Beckett's plays – like Winnie, buried alive in *Happy Days*, or the terminally bored clowns in *Waiting for Godot* – find a reason to

Madeleine Renaud in Happy Days, *in a 1963 Paris production*

enjoy the weather, and devise routines to get through what is left of the purgatorial time allotted to them. For good or ill, they are resilient and unkillable. Germany and Japan, flattened by bombs in 1945, bounced back to economic dominance within two decades. This, confounding all prognostications, is the simplest truth about the twentieth century. Doomsday did not occur. Nor was the individual exterminated, as the ideologues of both left and right wished.

Time and space, the forces which ensure that our existence remains finite, declined to die off at the beginning of the century, as the futurists claimed. The relativity theory may have merged time with space, but it hardly cancelled them out; still we have gained a relative power over them, and learned new ways of manipulating them. Wells imagined a machine for time-travel. Music, setting itself free from a predestinate plot, constructed similar vehicles – for instance in the palindrome of Berg's *Lulu*. In the middle of the opera, Lulu is arrested for the murder of Dr Schön, put on trial and sentenced; then she is rescued from prison, and the orchestral narrative goes into reverse, describing her liberation by making the same sequence of notes run backwards. Proust strove to redeem time. Hindemith, allowing his Wise Man to revive a corpse in *Hin und zurück*, proposed a simpler solution: why not simply revoke it?

Time supposedly tidies space, clearing away all remnants of the past. But relations between the two dimensions have altered. Freud imagined a Rome without ruins, where room could be found for all the buildings of all the city's superimposed ages. This was his metaphor for the mind's broody retentiveness, and for the primitive bedrock of modern consciousness. Warhol – engrossed by the present, with no interest in hindsight or moral reckoning – changed the conceit to suit himself. He disparaged Rome for having outlived itself: 'They call Rome "The Eternal City" because everything is old and everything is still standing. They always say, "Rome wasn't built in a day." Well, I say maybe it should have been.' Temporariness, he sunnily insisted, would have ensured rapid turnover, with reconstruction providing boundless opportunities for employment. Warhol had a briskly progressive notion of the ideal city. It should, he specified, be 'completely new. *No antiques.*'

We are now surrounded by new Romes, squeaky-clean facsimiles of the antique original. Architects, experts at abolishing both time and space, can rebuild this or any other mouldered city in not much more than a day. A palace of the Caesars swelters in the desert at Las Vegas; further down the street is a compressed, user-friendly Manhattan whose skyscrapers contain thousands of slot machines. In Paris the courtyard of the Louvre is occupied by a pyramid, glassy and glittering: it allows you access to the museum's treasures without requiring you, like the pharaohs, to die first. Time, rather than compliantly expiring, lives on in space, while space, no longer tethered to the inflexible co-ordinates of geography, has become as mobile and footloose as time. Contemporary architecture makes the past present, ignoring temporal division and spatial distance. A Dutch guild-hall rears on the skyline of Houston, a pink marble

Chippendale tallboy juts above Madison Avenue in midtown Manhattan, and in Pittsburgh the Gothic spikes of the Palace of Westminster (itself a pseudo-medieval Victorian pastiche) have been re-created in black plate glass. The architect in each case is Philip Johnson, who demonstrates that at the end of the twentieth century we are no longer required to be absolutely modern. All times are available for revisiting, and all spaces conveniently overlap.

We have learned how to rewind time, and how to dislocate space. The habit of ironic quotation neatly achieves both feats. This has been a persistent tic throughout the twentieth century, beginning with Karl Kraus's anthology of self-incriminating newspaper articles, the rudimentary folk tunes which Stravinsky brought together in *Le Sacre du printemps*, or the scraps of print collaged by Braque and Picasso. Wieland Herzfelde in 1920 advised against the labour of depiction. The artist, he advised, only had to pick up a pair of scissors and cut whatever he needed out of the reproductions of other people's paintings. Agreeing with Herzfelde, El Lissitzky in 1926 declared easel painting obsolete, because the new media had manufactured images which could be readily excerpted: 'The cinema and the illustrated magazine have triumphed.'

The recourse to quotation apparently confirms our belatedness. To repeat the past, like Beckett's Krapp poring miserably over his tapes, is our only option. The quote often functions like a heartbroken confession, or the devout, desperate repetition of a prayer. In Prokofiev's Sixth Symphony, composed between 1945 and 1947, a wrenching modulation introduces a motto stealthily voiced by the trumpet and the violins: this quotes the motif associated with the holy, healing spear in Wagner's *Parsifal*, and it wordlessly warns that military victory over Germany did not ensure salvation. Removed from its context, a quotation acknowledges a sense of loss; perhaps it also asks pardon for the small act of violence which has uprooted it. Hence the poignancy and the political sedition in a Soviet atheist's tribute to romantic mystagoguery. A quotation can enunciate an unbearable nostalgia, the longing for a lost home in the past. The first movement of Shostakovich's Fifteenth Symphony, composed in 1971, repeatedly cites a heedless, stupidly athletic gallop from Rossini's overture to *Guillaume Tell*. The quote taunts the sick, disconsolate composer, even though the jaunty chase is going nowhere. In the symphony's finale, another quotation serves as a summons from a past which is remoter than childhood. A muffled drum taps out Brünnhilde's announcement of Siegmund's death in Wagner's *Die Walküre*. Quotations, drawn from the nether realm which our forebears inhabit, are mementoes of mortality.

Sometimes the quote, less regretful than these musical reminiscences, is a wilful defacement of the past. This is how Francis Bacon treated Velázquez's portrait of the sly, all-seeing Pope Innocent X. He revered the painting, but – unlike Prokofiev recalling Wagner – could not envy its assumption of faith, so he expressionistically distorted the past. In a 1955 study Bacon made the Pope scream in mirthless glee, exposing serrated teeth. In a 1965 version his face

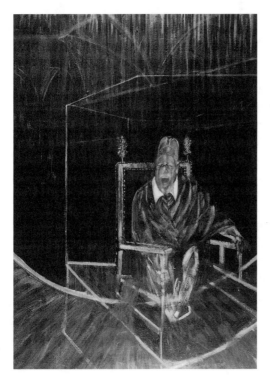

Francis Bacon
Pope I *(1951),*
one of several
versions of
this subject

smears into a slab of putrid meat. His throne grows bars, making him a caged beast at the zoo, or a mental patient in his cell. He scratches the air with a clawed hand in one study, and in another carnivorously eyes a bleeding torso. He embodies power, immune to pain though able to hurt others: the power of authoritarian religion, but also the intimidating power which the past exercises over us.

The subversion can be just as violent if the means are bland and insipidly pretty. In 1986 Warhol repainted Leonardo's *Last Supper* on a panel which stood in for the fresco while it underwent repairs on its chapel wall in Milan. Some of his sketches, choosing to be literal-minded, made close-ups of the meal Christ and the apostles were eating, and turned the long table into the counter of an American diner. Experimenting with colours like a cosmetician, he suffused their faces with girlish pink, blushing red, and faint, jaundiced yellow. Isn't beatitude a synthetic beautifying of the real world? In one of his preparatory panels, he superimposed some home-grown icons on Leonardo's scene. A pink dove, the Bible's feathered evangelist, hovers in the air above the head of Christ. But it is borrowed, as the painted label reveals, from the soap bar which calls itself Dove, and costs a mere 59 cents. Godliness, in sanitary America, is a concomitant of cleanliness; the soul is cleansed in the bathroom, not at church. Further along the table, the curlicued trademark of General Electric is printed in midnight blue. This announces God's omniscience, although the invention of light is no longer a divine prerogative. Eventually Warhol silk-screened *Sixty Last Suppers*, as if reproducing and multiplying dollar bills. He wasted no emotional energy in pining for origins, or for a lost originality. There were profits to be made from reproduction; he therefore settled down to print money.

The *Last Supper* suited Warhol's mischievous purposes, because it was already decomposing on its damp wall. Tradition, like the Sphinx's sandy, eroding head, consists of left-overs, relics, damaged goods. Rearranging or repairing the debris, the present creates the past. During the 1980s Luciano Berio orchestrated some sketches left behind by Schubert for a symphony in D major. He

likened himself to a fresco restorer – but one who left intact the areas of blank wall between the images. Those negative spaces were meant to function like quotation marks; they cordoned off the fragments of Schubert, isolating them in space and distancing them in time.

To close the gaps or to conceal the evidence of incompleteness would have seemed dishonest. We inherit waste, or whatever has survived the modern campaign – in science, warfare and culture – to destroy the past and (possibly) the world. Eliot in *The Waste Land* gathered poetic quotations together to solace him in what he gloomily called 'my ruin'. Later in the century, the Lithuanian poet Czeslaw Milosz – having lived through a series of historical calamities and geographical dislocations – took a less doleful and defeated view of the matter. 'Man', Milosz argued, 'constructs poetry out of the remnants found in ruins.' For a child, a ruin is a playground, an innocent field of new possibilities. Thomas Pynchon defined the modern writer as a garbage-man who sifts the detritus of society, recycling its ephemera in myths. In the Los Angeles ghetto of Watts, Simon Rodia worked from 1921 to 1954 to erect a clump of spindly towers on a vacant lot, gluing soda-bottles, scraps of ceramic and cracked china onto frames of discarded steel. For Lévi-Strauss, myth itself was bricolage: a precarious assemblage of bric-à-brac, cobbling together a universal system with whatever conceptual tools and accidental ingredients lay to hand. The environmental artist Robert Smithson drove through the New Jersey town of Passaic in 1967, cheerfully admiring its monuments: blotched concrete pillars, dribbling pipes, derricks chewing at the earth. These, he thought, were 'ruins in reverse'. In 1983 Joseph Beuys built a set of tumuli, pillars engraved with unintelligible symbols, which he scattered on the floor and entitled *The End of the Twentieth Century*.

Arata Isozaki's design for the piazza at Tsukuba quoted from imperial Rome, turning the Capitoline Hill on its head. He explained his 'system of quotations' as an ironic self-mortification. To borrow a shape or a space from somewhere else confirms 'the disappearance of the subject', mandatory now that humanism is officially defunct; to quote destroys 'the idea of design as…the representation of the self'. Isozaki likened his practice to the logorrhoea of Beckett's droning speakers. They have nothing to say, and do not believe that there is anything left worth saying – but still they go on talking. Intertextuality offered

Tsukuba Center in ruins, silkscreen print by Arata Isozaki

Isozaki an excuse for his persistence: the words he uttered, when he capsized the Campidoglio, were at least not his own. And, having separated architectural forms from their traditional functions, he took purposeful pride in flouting the meanings which those words had acquired. Shattering contexts, deracinating words or images, the quotation is a destructive device. Isozaki refused to apologize for this mayhem. A city, to him, is a permanent ruin, forever suffering destruction in order to be re-created. Anticipating 'the moment of ecstasy… when everything that is built vanishes in a catastrophe', he painted a view of his own Tsukuba Center in ruins, its parapets cracked, its rooftops dented, its metal surfaces now a putrid purple. In the shorter term, Daniel Libeskind has planned a similar fate for the site of the Gestapo concentration camp at Oranienbaum, outside Berlin. He proposes to purge the area by flooding it; the camp buildings which remain in this 'park of ruins' will be left open and allowed to slowly rot. Isozaki found ecstasy in the prospect of sudden annihilation; Libeskind looks instead for expiation, as nature gradually does our forgetting for us.

Architecture, rather than standing up for order, sets itself another aim, better attuned to the times: it imitates chaos and instigates breakdown. In 1988, in the Azabu district of Tokyo, Nigel Coates constructed (or perhaps deconstructed) a restaurant and bar called The Wall, which masquerades as a battered relic of immemorial Rome. Seven clocks above the door are set to different time zones, relativistically mocking the notion of an imperial centre. The brick face peels, as if suffering from a skin disease. An exoskeleton of stairs is clamped on to this crumbling façade, and metal figurines cling to lamp-posts in tormented attitudes. The Wall pretends to be terminally ill, a tumble-down victim of history, though it is in excellent structural health. Next to this fraudulent antique stands the Institute of Contemporary Arts, a thin terracotta tower inside a sleek corset of metal. Hardly more than an elevator shaft, the Institute is topped by a satellite dish whose ear is cocked to receive transmissions from the sky.

Lévi-Strauss, lecturing in Canada in 1977, took this equalization of different times and places to be a sign of exhaustion. We are citizens of the world, instantly aware of events around an homogenized globe. This plight of 'overcommunication', as he called it, crushes human diversity, frustrates progress and hinders creativity. Now that a single civilization has spread across the earth, we risk becoming 'only consumers'. We can produce nothing new because we know too much about what others have already produced. Our compensation is the capacity to graze, pickily sampling other cultures as if choosing whether to eat Swedish salmon or Mexican tacos or Malaysian peanut sauce for our dinner. Umberto Eco has even claimed that we are emotionally inhibited because we know too much. He sums up what he sees as the post-modern predicament by imagining a man and a woman who do not dare to say 'I love you' to each other, because they fear that the sentiment will sound like a tawdry theft from a novelette by Barbara Cartland: their only recourse is to cordon off their feelings inside quotation marks. They can allow themselves to say '"I love you"' if they add an

ironic proviso, wincing as they note that these are the words Barbara Cartland's characters would have used. Who, Eco adds, nowadays dares to comment on the fine weather? You risk sounding as naive as Snoopy in the cartoon. Happily there is no need to be intimidated. Late in the day as it is, there are surely few lovers who would defer to Barbara Cartland's wan apology for passion, and anyone who lets Snoopy stand between him and the sun does not deserve to feel its warmth.

Of course history, like a Freudian ancestor, wants to predetermine and even preclude us. Still we can struggle free by reinterpreting it. The mummified totems and funerary scarabs which Freud kept in his consulting room testified to the psychic infliction of the past. Yet they also acknowledged the past's capacity to sustain us, once we have learned how to cope with it. The scarab beetle nests in refuse and fertilizes death.

Modernists have always enjoyed pretending to be vandals. In *Tristes Tropiques*, Lévi-Strauss assessed the value of writing as a human accomplishment, and argued that its main bequest – since it allowed some men to keep records about others – had been its sponsorship of enslavement. The boon of film and the electronic media, according to evangelists like Vachel Lindsay and Marshall McLuhan, was that they made the culture of print redundant. The painter Boccioni, on behalf of the futurists, cursed 'archaeologists infected with chronic necrophilia!' Marinetti denounced museums as cemeteries, and considered that the habit of visiting them was an occupation fit only for invalids. Because they were so soporific, he thought they should be reclassified as public dormitories. Duchamp recommended taking Rembrandts down from the gallery walls for use as ironing boards. Arriving in New York in 1915, he gave his approval to the demolition of old buildings, because 'the dead should not be permitted to be so much stronger than the living'. This Oedipal fury persisted at least until 1952, when Pierre Boulez published an attack on the stuffily orthodox practice of serialism in music. The tract began by announcing in blatant capitals, with no pretence of grief, that 'SCHOENBERG IS DEAD'. Boulez later suggested burning down the opera-houses of Europe. It was not enough to add a moustache to the Mona Lisa, as Duchamp did – or even to steal the painting from the Louvre, as Apollinaire was accused of doing in 1911. Such japes were unavailing because, as Boulez complained, they 'did not kill the Mona Lisa'. He demanded that 'all the art of the past must be destroyed'. A character in Kundera's *Immortality* assails Mahler's symphonies as 'cathedrals of the useless' and proposes cutting up the scores into little pieces 'to use as background music for toilet-paper ads'.

Such iconoclastic fantasies, whether jocular or not, soon provoked a reaction, justifying the museum and anxiously protecting its contents. In 1922 in *Jacob's Room* Virginia Woolf called the reading-room at the British Museum 'an enormous mind', and imagined Plato and Shakespeare occupying adjacent cubicles. In 1927 in *Aspects of the Novel* E.M. Forster housed all the English novelists

under the same cranial dome, where he pictured them 'all writing their novels simultaneously'. In 1937 in *Letters from Iceland* W.H. Auden convivially described the English poets keeping company in heaven. Shakespeare, in Auden's reverie, props up the bar, Browning goes in to bat at cricket, Shelley plays poker, while Chaucer reads a detective story. The successive writers coexist in space, rather than following one another in time. Forster refused to accept that the novelists had haplessly floated down a stream towards oblivion. 'Time', he announced, 'is to be our enemy'; space accordingly cancels it out, as in the 'museum without walls' planned by André Malraux – an impartial arena where distinctions between different continents or historical epochs had been abolished.

Despite these attempts at conservation, the twentieth century came perilously close to achieving that rupture with the past for which the futurists campaigned. Culture survived the Nazi purges by being smuggled into safe-keeping. The Warburg Library – whose art historians, studying the heritage of pictorial symbols, demonstrated the continuity of culture from ancient Greece and Rome to the Renaissance – transferred from Hamburg to London. When war began the paintings were removed from the National Gallery in London and hidden in mine-shafts in the Welsh mountains. Those from the Louvre nearly fell victim to their accident-prone rescuers. Géricault's *Raft of the Medusa*, riding on the back of a truck, got tangled in trolley wires at Versailles: the snared canvas shuddered while the electrified cables crackled and spat. Another driver in the same convoy took a wrong turn in fog and nearly drowned all the museum's Watteaus. These mishaps revealed the fragility of a supposedly eternal civilization. Not all its wares were transportable. Men on the run could not carry their culture with them. Walter Benjamin, who killed himself at the Spanish border in 1940 while trying to escape from the Nazis, confessed that he felt as if he were already dead, because the Gestapo had taken possession of his Paris apartment and confiscated his library. Even if he had been able to escape across Spain to neutral Portugal and sail from Lisbon to New York, he would have been travelling without the support of those books which were his small, personal digest of the civilized world. On Bebelplatz in Berlin, near where the Nazis burned books on Unter den Linden, Micha Ullman and Andreas Zerr have recently constructed an underground library. It consists of clean white shelves, with no books on them.

Jorge Luis Borges and Hermann Broch both puzzled over the century's attraction to cultural suicide. In 'The Wall and the Books', Borges claimed that the emperor who built the wall to seal China off from contact with the barbarians also decreed that all books published before his reign should be burned. He wanted to control space by fortifying the frontier, and to rescind time by cancelling out the past. In Borges' fable, this book-burning glances at the cultural arson of the Nazis, but it also alludes to the repressive mania of modernism. Borges observes that the emperor had expelled his mother from his realm for her immorality, and guesses that he annihilated history 'in order to abolish one single memory: his mother's infamy'. Here the modern rage against the past and

parental forerunners is reduced to a murderously childish petulance. In Eco's novel *The Name of the Rose*, the blind librarian Jorge of Burgos – a mischievous caricature of Borges, who was employed as a librarian in Buenos Aires – sets fire to the largest library in medieval Christendom, because he cannot permit the books stored there to contravene holy writ. It is a good joke, but an unjust one. Borges would never have censured a book for doctrinal faults; he valued books as beautiful, unverifiable fictions.

Broch confronted the same apostasy in *The Death of Virgil*. Having completed the *Aeneid*, Virgil proposes burning it. He explains this self-spiting desire in various ways – as his judgment on his own inadequacy, or (like Rimbaud deciding to be absolutely modern) as his offering to a reality which has no place for poetry. It also meekly foreshadows the sacrifice of Christ, at the beginning of the new dispensation which emerged from the ruin of Rome. Broch completed his novel just as the world, for the second time in the twentieth century, was dissuaded from destroying itself, and the poet's change of heart dramatizes that last-minute recuperation. In his will Virgil appoints executors to supervise the transcription of his epic, and directs that 'copies for librarians are to be made from these authorized texts alone, should the librarians desire them'. This sets an agenda for the years after 1945, when *The Death of Virgil* was published. In bombed cities, people sorted through the smithereens of brick and dunes of plaster dust. Eventually, like Virgil's copyists, they rebuilt facsimiles of their houses and reconstructed streets for them to stand on. Benjamin – a connoisseur of quotations, who took a wicked, surrealistic delight in tearing those verbal fragments from their native contexts – made amends for this modern habit when he paid tribute to the 'saintly vocation in the sheer act of copying'.

Despite the machinery of reproduction, the twentieth century reverted to medieval conditions, when culture relied on dutiful, self-abnegating amanuenses who spent their lives making manual copies of texts like Virgil's. Perhaps, after the Nazi bonfires, even this would have been outlawed. Ray Bradbury's novel *Fahrenheit 451*, whose title alludes to the temperature at which paper burns, imagines a future in which all books, whether mechanically printed or handwritten, are banned. A secret society of rebels guards its favourite texts by memorizing them, so that, as in the remotest past, they can be kept alive and shared by recitation: we would not have a culture at all if bards and story-tellers had not once performed these oral feats.

The quiet saintliness of the copyist, who makes it a personal mission to preserve some part of the past, was exemplified by the literary critic Erich Auerbach. Dismissed from his post at Marburg University by the Nazis, he found his way to Istanbul. There between 1942 and 1945 he wrote *Mimesis*, a study of Western literature and its varying representations of reality. Auerbach gave his book a wistful epigraph from Andrew Marvell, 'Had we but world enough and time…', and relied on his readers to complete the quotation: Marvell does not have world enough or time, because he is menaced by death. Hence the urgent need, as

Marvell tells his coy mistress in the poem, to roll the strength and sweetness of life into a ball, a vital projectile which can be used as a weapon against extinction. That was Auerbach's motive too. He wanted to compress culture, like a refugee who must cram his belongings into a single hold-all. Publishing *Mimesis* after the war, he addressed its last paragraph to 'my friends of former years, if they are still alive', and hoped that it might help to reconvene the sundered circle of 'those whose love for our Western history has serenely persevered'.

Like Benjamin deprived of his library, Auerbach had to make do with the smattering of books available to him in Istanbul. Therefore, instead of a continuous historical narrative, he quoted extracts from a succession of writers between Homer and Woolf, and analysed these fragments as if they were all that remained of a tradition spanning three thousand years. The last quotation is from *To the Lighthouse*, with Mrs Ramsay free-associating as she knits a brown stocking. It is a humdrum domestic episode, but in its chronological confusion and its preference for internal consciousness rather than external action, Auerbach detected a 'complicated process of dissolution' at work. Literary modernism, like the new physics, had taken the world apart. While he assessed the damage – jumbled time, fragmented space – Auerbach insisted on believing that, when the war was over, those physical and mental convulsions would prove to be benign, pointing towards 'a very simple solution'. The old, invidious hierarchies had been upset. *Mimesis* starts with classical epic, which venerated heroes and their superhuman valour, but concludes with Woolf's account of ordinary people and their uneventful lives. Auerbach found a portent for a tolerant, ecumenical future in this: at long last we might be able, for the first time in quarrelsome human affairs, to sympathetically survey 'the common life of mankind on earth'. Concluding his analysis of Woolf, he conceded that civilization – mined from within by those impious questions addressed to the universe by Nietzsche, Marx, Freud and Einstein – was facing a unique danger. Even so, he refused to denounce modern times. The present, he thought, was justified by 'the incomparable historical vantage point which it affords'. We may be near the end, but at least the view behind us is impressive.

The evacuated paintings soon returned to the museums, and the libraries pieced the universal mind together again. For a while, the earnest, restorative custody of the past was a primary responsibility. But the present cannot inhabit the past, and human creativity demands the right to be playfully destructive. The library, in the fables of Borges, ceases to be a repository of venerable truth; instead it serves as an incubator of error, and the interpretative slips or misreadings of the past which it licenses represent the margin of creative freedom left to us in these latter days. Copying, in this ironic view, is not a monastic drill of self-denial. It specializes in infidelity. In one of Borges' stories, the books manufactured by Babylonian scribes are individualized by sly, hidden discrepancies: copyists swear a conspiratorial oath which requires them 'to omit, to interpolate, to change'. Auden was grateful for one such change in his own work, when the

printer setting his poem 'Journey to Iceland' altered the line 'And the poets have names for the sea' to 'And the ports have names for the sea'. The mistake seemed to Auden more intriguingly suggestive than his own version, so he did not correct it. Scientific discoveries too often happen by accident. A researcher in 1928 left a laboratory window open, allowing some stray spores to settle on a dish, where they prevented bacteria from developing; as a result, we now have penicillin. Does artistic originality, at this late hour, depend on an error like the typesetter's or the careless scientist's?

Somewhere in the maze of pre-existing print lurks the answer to every question. A character in Borges' 'The Secret Miracle' dreams about hiding overnight in the Clementine Library, where he hopes to locate the word which stands for God. A librarian gives him some daunting directions: 'God is in one of the letters on one of the pages of one of the four hundred thousand volumes in the Clementine.' He adds that he has lost his own sight in the search for that tantalizing letter. Since truth is so fugitive, disappearing into the crevices between different authorities, why not invent it? Another story by Borges concerns the quest for an elusive planet called Tlön. The narrator and his fellow sleuths ransack the libraries of Europe and the Americas to find documentary evidence; frustrated, a colleague suggests that they should collaboratively reconstruct – that is, forge – the non-existent volumes. In 1991 Anselm Kiefer constructed a walk-in library, now installed in a gallery at the Hamburger Bahnhof in Berlin. It is called *Volkszählung*, and was intended to mock the officious irrelevance of a government census. Grey slate books, being earnestly read by weevils, loll on rusty shelves like tottering tombstones. A culture of dried peas thrives on the bindings. The metal pages curl, as if responding to heat or damp or perhaps fatigue. An upside-down figure like those painted by Georg Baselitz has tumbled out of one of the volumes, escaping from the penitentiary of data; he dangles in limbo between the shelves. In Kiefer's library, the universal mind has bored itself to extinction.

The modernists were convinced that everything remained to be said, and invented new languages like Dada for the purpose of making those unprecedented pronouncements. Joyce in *Finnegans Wake* coined the neologism 'quark', which meant nothing much. During the 1950s, the physicist Murray Gell-Mann found a use for the word: he applied it to the sub-atomic particles whose existence he had newly ascertained. Borges set a limit to such innovations. The library of Babel, as he says in one of his stories, is 'total', interchangeable with the universe. It has an uncountable number of shelves, on which no two books are the same. Those volumes include 'all the possible combinations of the twenty-odd orthographical symbols', and therefore contain 'all that it is given to express, in all languages'. Hermes Trismegistus – the slippery genius of modern metamorphosis, associated with both Picasso and the chemist Rutherford – turns up again in the bibliographical fictions of Borges, though now he is responsible for a depressingly voluminous contribution to the stacks: legend has it that he personally dictated 36,525 books. 'To speak', Borges claimed, 'is to fall into

tautology.' Whatever we say is a repetition, whether consciously so or not. This must mean that we are near to expiry, fading into twilight like the last men described by Nietzsche and Spengler. 'All time', Borges proposed, 'has already transpired', so that 'our life is only the crepuscular and no doubt falsified…memory…of an irrecoverable process.'

Despite such suspicions, Borges himself wittily challenged the view that we are already obsolete, and revealed that quotation can be a creative act. Verbal theft is accompanied by an unholy, unlawful physical delight; like sex, it violently cancels our bondage to space and time. Borges argued that 'all men, in the vertiginous moment of coitus, are the same man', and went on to claim that 'all men who repeat a line from Shakespeare *are* William Shakespeare'. The library need not be oppressive, so long as we adopt a new reading technique when working through its contents. Borges recommended a policy of 'deliberate anachronism and erroneous attribution', exemplified in his fable about Pierre Menard, the imaginary modern novelist who made an exact transcription of *Don Quixote* and in doing so improved on the original. Though Menard's words are the same as those used by Cervantes, the twentieth-century text is richer than its seventeenth-century precursor because of the ambiguities which have accrued to it in the interim. When Cervantes referred to 'truth, whose mother is history, rival of time', he was merely indulging in a rhetorical flourish. Repeated by Menard three hundred years later, the idea becomes bizarre, startling, radically original. Truth, in this new but identical formulation, now derives from history, which is fiction anyway; therefore it ironically invalidates itself. Menard's experiment also unseats the mythological figure of Quixote himself, showing him to be a fiction (and perhaps a malign one). Milan Kundera later pointed out that Cervantes' deluded knight represented a new human type. Quixote was the flattering self-image of European man after the Renaissance, an idealist or sentimentalist, not a rational being at all; in his readiness to make war in defence of an imaginary and baseless faith, he sponsors the mad ideological crusades of the twentieth century. Menard the modern atheist at least sees through this fanaticism.

Anachronistically challenging time, we are free to create our predecessors, or – like Menard when he makes Cervantes redundant – to destroy them. Though the past may pretend to have a dictatorial power over us, in fact it is at the mercy of our whimsical memories: objects in Tlön simply fade away if they are forgotten. This enabled Borges to attempt a fanciful 'refutation of time', in which he capriciously argued that the world, whether past or present, is an illusion. How long do the evanescent psychological moments examined by the modern fiction of Woolf or Musil actually last? Fractions of a second – which must mean that they do not exist at all. As for Bergson's theory of duration, its notion of time as a 'mental process' renders history subjective. Therefore how can we share time with anyone else? We are immured in our separate daydreams, and our unsynchronized chronometers tell us lies. Borges could not permit himself the happy second coming enjoyed by Proust at the end of his novel,

when memory resuscitates the past. His speculative foray concludes with a jesting admission of futility. No matter how ingeniously he denies it, 'the world, unfortunately, is real'.

But the irony of Borges qualifies all statements, and overturns this plain-minded, downcast verdict. Fortunately or not, the world's supposed reality consists of overlapping fictions. In 1969 Italo Calvino brought together a collection of born-again mythical characters – refugees from the chivalric epics of Tasso and Ariosto, from Shakespeare's plays and Eliot's *The Waste Land* – who interrupt their travels overnight at a shelter which Calvino called *The Castle of Crossed Destinies*. As in a dream, they have been deprived of speech: perhaps they are suffering from the disease of tautology, worn out by excessive repetition All the same, they are required to entertain one another by reciting their stories all over again. But this time they must do so silently, miming their tales by using the sign-language of the tarot pack.

Tarot cards are traditionally used to tell fortunes – that is, to predict the future. Calvino, however, employs them to reconstruct the past. The chevalier Roland, suspended upside-down like the hanged man in the tarot pack, declines the offer of rescue and declares that the inverted view is a revelation: 'I have come full circle and I understand. The world must be read backwards. All is clear.' Elsewhere, the card showing the hanged man reminds Calvino of the drowned Phoenician sailor in *The Waste Land*, adrift among marine weeds, submerged in the 'chain of evolutions and mutations' which constitute the history of the human race. Calvino makes the quote his own by adding that Eliot's clairvoyante Madame Sosostris, who foretells this death, should not be trusted: she is 'not very reliable as to nomenclature'. The card representing the Wheel of Fortune reminds him of the Sphinx which threatened Oedipus, except that the inescapable fate of the tragic hero is here circumvented by the liberties Calvino takes with the story. Writing, he explains, releases the dreams within words, allowing infantile sexual fears to be blurted out in the story of Oedipus.

The end is not guilty dismay, as it is when Nikolai faces the Sphinx at the conclusion of *Petersburg*. The bad dream, 'passing through him who writes, is freed and frees him'. We change the past's stories whenever we retell them, and thus defy that dead, inhibiting authority. Bely's hero apparently forgot that Oedipus vanquished the Sphinx. She set him a riddle, which she was taught by the Muses. What creature has one voice, yet is four-footed, two-footed and three-footed? Oedipus gave the correct answer: man, who crawls when a child, stands upright as an adult, then leans on a stick in old age. His declaration of human power prompted the Sphinx to kill herself. The independent career of the human species, no longer hostage to supernatural terrors, had begun. Even the walking stick is evidence of our ingenuity, not a shameful confession of weakness. In *The Name of the Rose*, William of Baskerville amazes the novice Adso by producing a pair of spectacles, which permit him to go on reading in middle age. William explains the man-made marvel by quoting his scholastic master

Roger Bacon, who said that 'the aim of learning was to prolong human life'. We are gods (with a little help from our prostheses).

Calvino's card-game makes do with a closed set of possibilities, like the variably mixed and matched orthographic symbols in the library books of Borges. This closure, and the solemn but entirely artificial rules which it elaborates to govern play, turns it into a synonym for civilization, that collective house of cards. Even though the available moves may be finite, we have not yet exhausted them. Calvino plays at lining up the cards in a row, as if rearranging paintings in a museum. Recombined, they are enticed into telling stories which never occurred to them before; he realizes that 'the tarots were a machine for constructing stories', juggling 'particles of the possible' in a game of combinations. What is a human being if not a loose, flexible anthology of different stories, a subjunctive store of possible lives which none of us has enough time to work through? In a series of lectures written for delivery at Harvard, left unfinished when he died in 1985, Calvino praised Shakespeare as a 'Lucretian atomist', an expert analyst of the dissipating dust which – like the sifting granules of Bely's Sphinx – comprises a person. We are all derivative creatures, 'combinatoria of experiences, information, books we have read, things imagined', but the play of variants ensures that none of us is the same. Calvino describes every life as 'an encyclopaedia, a library, an inventory of objects, a series of styles' – a postmodern retraversal of the ages. At the end of *The Name of the Rose*, Adso revisits the monastery many decades after the fire. He finds a bookcase which survived the flames, even though it has since been drenched by rain and nibbled by insects. He salvages scraps of print, assembling 'a kind of lesser library, a symbol of the greater, vanished one: a library made up of fragments, quotations, unfinished sentences, amputated stumps of books'. This is the individual's small replica of the universal mind. Muddled and garbled, idiosyncratically recatalogued, the mazes of books enumerated by Borges somehow squeeze themselves into a single human brain. That oozing lump of matter is miraculously able to ingest the world or perhaps to piece together a private universe. Ezra Buckley, the inventor of the planet Tlön, 'did not believe in God, but…wanted to demonstrate to this nonexistent God that mortal man was capable of conceiving a world'.

We postpone a personal end by going back to the beginning, and from there we set out to tell our quota of stories one more time, merging and amending them, making them new. Calvino made no effort to resist digressions or detours in the lectures he was preparing for Harvard. These excursions served, he knew, as 'a multiplying of time, a perpetual evasion or flight'. He asked himself 'Flight from what?' and candidly replied 'From death, of course'. Death caught up with him while he was digressing, but – because we share the same stories, though we have our own versions of them – his ideas possess a posthumous life, provoking new thoughts in the heads of others. Like Borges, Calvino disbelieved in Proust's recovery of what time has taken from us. But he did acknowledge

a kind of heaven – a fictional realm where the game-playing could continue indefinitely. 'Literature', he would have told his audience at Harvard if he had lived long enough, 'is the Promised Land in which language becomes what it really ought to be.'

The monastic library in *The Name of the Rose* has been assembled to preserve some record of a culture which will soon be exterminated. At the beginning of the fourteenth century, Eco's monks complain of Christendom's 'race to the abyss'; Eco himself has often pointed to a similar millenarian panic at the end of the twentieth century. But in his novel, William smilingly questions this expectation of doom. He points out to an irate monk that the millennium came and went without the arrival of the Antichrist. They quibble over when the Christian world's thousand allotted years officially began – at the saviour's death, or perhaps with the conversion of Constantine three centuries later. William's raillery suggests that chronologies are artificial, because time itself is a fiction. There is no need to be afraid of anniversaries. Anyone can foretell the end of the world, although the act of prophesying is no guarantee that the event will punctually happen when you order it to. It all depends when you start the countdown.

Human nature may have remained incorrigible during the twentieth century, but the nature of human experience certainly changed. We live longer than we used to do, thanks to our doctors. Given an extra allowance of time, we also cover much more space than people in earlier centuries. Like the drowned man in *The Castle of Crossed Destinies*, we have been released from 'individual limitation', made aware that men and women are molecules, randomly patterned and able to be put together in other ways. Freud claimed that the century's ailment was hypermnesia: we remember too much. It is as if we had acquired the power to live serially, reincarnating ourselves as we go. We have added to the ages of man. Childhood, once Freud himself analysed its perversities and its abiding memories, ceased to be a compressed, semi-conscious prelude to adulthood; its dramas play themselves out for the rest of our days. Next the psychologists and sociologists invented another crucial age, adolescence. Between the 1950s and the student protests of 1968, this was supposed to be the time of life given over to rebellion. At the end of the century, its occupation is expenditure, not dissidence. Enrolled as a market, with money to spend on items which must be replaced whenever the fashion changes, teenagers keep the consumerist economies of the West stoked up. Now that life continues beyond the age of forty, the notion of a mid-life crisis entitles men to discard their personal past, generally with the connivance of a new and younger sexual partner. Old age, because it lasts longer, is also different: patients with Alzheimer's disease simply outlive their personalities.

Gabriel García Márquez made a case-study of this psychological multiplicity in his novel *The General in His Labyrinth*, published in 1989. The general is Simón Bolívar, who expelled the Spanish imperialists from South America, then saw the freed land fall apart in factional squabbling; the labyrinth is history, the

nightmare from which Stephen Dedalus in *Ulysses* says he is trying to escape. Bolívar's last words, at the end of a retrospective voyage along the Magdalena River in 1830, were a premature paraphrase of Stephen's wish: 'Damn it. How will I ever get out of this labyrinth!' Drifting towards death, the Bolívar of Márquez dreamily reviews his career as if he were a classical hero who had lived through all the intervening centuries and arrived at last in our own anti-heroic times. His defeats are 'Homeric'. He adopts Caesar's habit of sleeping within earshot of his troops so he can overhear their grumbling, and sycophantic painters endow him with a Roman profile. Like the crusading King Arthur he is revered as a miracle-worker. Arthur must surrender Excalibur before he dies, and Bolívar frets about the proper disposal of his 'gold sword'. As a contemporary of the European romantics, he worships Napoleon, but is disillusioned by his self-coronation. The twentieth century discounted these romantic illusions, exposing the hero as a hollow man. That fate has already overtaken Bolívar. Illness has reduced his height as well as his weight, so that his cuffs have to be rolled up and inches cut from his trousers. Antagonistic mobs meanwhile shoot 'a general stuffed with sawdust', an effigy like the dummies stuffed with straw in T.S. Eliot's poem.

Bolívar's single life proliferates in time. Outside, the rain is falling – 'since three o'clock in the morning', says his steward; 'since three o'clock in the morning of the seventeenth century', Bolívar adds. It is 'millennial rain'. In the fictional world of Márquez, a political prisoner can suffer a hundred years of solitude, and downpours can last for a thousand years. Bolívar is also ubiquitous in space, aggrandized by his military glory (even though, like the frail, stooped Duc de Guermantes, this oversized reputation belongs to a body which is wasted and shrunken – his ribs are scrawny, his legs rachitic, his Caribbean curls ashen). The energy he once emitted, if organized into a single straight line, could circumnavigate the globe. Márquez reckons that during the wars of independence Bolívar rode eighteen thousand leagues, more than enough for two trips around the earth. In the twentieth century, he could have become electronically omnipresent without ever needing to leave home. Celebrities, as Warhol noted, take up more space than the rest of us; no longer confined to their bodies, they contrive to be everywhere in the world at once.

Joyce's H.C. Earwicker in *Finnegans Wake* accomplishes the same feat while asleep. His initials stand for Here Comes Everybody, and the whole of human history washes through his populous head as he dreams. But if each of us is everybody, how can any one of us be an individual? Struggling to make himself heard through the polyphonic hubbub in Luciano Berio's *Sinfonia*, composed in 1968, one of the speakers comments 'They don't know who they are anyway.' As if to prove his own second-hand nature, he is quoting Beckett, while the orchestra quotes Mahler, Strauss, Debussy and Ravel (among others).

Berio's *Recital I*, composed for the soprano Cathy Berberian in 1971, dramatized the risks and strains of total recall. Deserted by her pianist and

forced to abandon the evening's programme, the singer free-associates her way through her own repertoire and through the history of culture. She starts at the moment when classical music begins, with a performance of Monteverdi's *Lettera Amorosa*. Interrupted by a gruff outburst of electro-acoustic noise, which bounces backwards from the twentieth century to the seventeenth, she diverges from recital to reverie, pondering her predicament out loud and voicing snatches of the music filed away in her memory – phrases from songs by Mozart, Schubert and Mahler, operatic flourishes from Rossini and Verdi. 'When you come down to it,' she world-wearily sighs, 'I've seen everything.'

Her problem is the one diagnosed by Freud, although its outcome is ennui, not neurosis. She 'can remember everything to the point of boredom', like the bibliophiles of Borges, and is world-weary because she has already died so many times. Her quotations are mementoes of mortality. Purcell's Dido, having killed herself, cries 'Remember me' (which prompts the soprano to remember the underworld of wraiths described by Keats in 'La Belle Dame Sans Merci'). Death in a Schubert song beguiles a maiden by telling her not to be afraid. In Prokofiev's *Alexander Nevsky*, the score for a film by Eisenstein, a woman searches for the corpses of her loved ones on a frozen battlefield. The most fatalistic quotation is from *Carmen*. The superstitious gypsy deals the cards in order to see her own future; reading them, she discovers that she has none. Berio's soprano repeats Carmen's dirge, as she realizes that the prediction would be the same even if she shuffled the pack twenty times – 'La carte impitoyable répétera: la mort'.

On her way to the theatre, the soprano relates, she was given some wise advice by a banker. He told her that 'life is only accumulation'. Her reaction was not to count her blessings and congratulate herself on the fees she earned. Instead, like a refugee dashing towards the nearest border, she fell back into one of the fearful habits inculcated by the unstable twentieth century, when staying alive depends, as Calvino put it, on 'perpetual evasion or flight': she stuffed her suitcase and all available pockets, taking everything she owned with her. As she sings, a wardrobe mistress weighs her down with more impedimenta from history's lumber room – veils, nets, lengths of rope. But how much baggage can we carry? Hurriedly packed and made portable, the past becomes incoherent, and the cluttered, overloaded mind loses its sanity. A distant siren sounds the alarm, as if a police car were on its way to investigate a cultural emergency. The soprano concludes with a strangled plea of 'Libera nos', repeated within a vocal range which has now contracted to the half-step between the notes of C and C sharp. She is asking for our liberation from the inflictions of memory and history.

Her breakdown marks a crisis of confidence for music, which can no longer perform its traditional task of serenely ordering and thus refuting time. Alfred Schnittke's *(K)ein Sommernachtstraum*, first performed in 1985, is about the lack of this enchantment. The orchestra begins in the temperate manner of classical Vienna, then drifts out of tune, grows raucous and riotous, wanders

backwards for some anachronistic baroque flourishes, and finally succumbs to a bludgeoning Mahlerian cataclysm. In Schnittke's *Moz-Art à la Haydn*, the string players manage a few improvised flurries, derived from an exiguous, unfinished score by Mozart. Then the lights go out and the dispirited musicians drift away. The conductor, still beating time, moves empty air around. When Haydn's orchestra trooped out one by one in the *Farewell* symphony, extinguishing their candles as they left, they at least had somewhere else to go: they had forced their aristocratic employer to quit his summer palace at Esterháza for Eisenstadt, where their wives were lodged. Schnittke mimes the debilitation of music itself. In Berio's string quartet *Notturno*, the players are restricted to whispers, wispy phrases which they cannot complete. The strings shiver uneasily or nervously squeak; the viola tentatively tries out a melody, which the other players ignore.

Berio's *Sinfonia* proposed a happier outcome: confluence, not the jabbering schizophrenia of *Recital* or the failed conversation of *Notturno*. The third movement of the symphony is, as Berio put it, a submerged river of recycled music. Like Menard rewriting Cervantes, he quotes an entire movement from Mahler's *Resurrection* symphony. But he lacks the single-mindedness of Menard, and cannot prevent other music from spilling into Mahler's burbling, indefatigable scherzo. The river is occasionally deluged by brief, urgent extracts from Debussy's *La Mer*; there are also quotes from Ravel's overwrought, self-destructive *La Valse*, and from the circling, nostalgically repetitious waltzes of *Der Rosenkavalier*. As if this were not enough, a team of speakers meanwhile read out snatches of Beckett's elegiac monologue *The Unnamable*. The overlapping is fortuitous, but the words obliquely react to the music which is happening all around them, dredging up its dreams: Berio described the texts as a Freudian 'Traumdeutung', and said they were meant to decipher 'the 'stream-of-consciousness-like flowing …of Mahler's movement'.

The interpretation of our shared dreams begins in the symphony's first movement, during which the speakers quote fragments from Lévi-Strauss's *The Raw and the Cooked*. The citations were chosen by accident, because Berio chanced upon the book while working on the score, and they are chattered or muttered, half-heard and rendered unintelligible by editing. Nevertheless they are significant, because they introduce and explain the subliminal river of the third movement. Lévi-Strauss's scientific study of Amazonian myth starts from the dichotomy between nature and culture, symbolized by the raw and the cooked. The tribes re-create their natural environment in the stories they tell about it. Water, for instance, is not a natural resource but a cultural benediction, so that their myths distinguish between 'destructive water of terrestrial origin' and 'creative water of celestial origin'. Nature's water is streamy, fluctuant, like what Lévi-Strauss calls the 'aquatic' society of men. The myths commemorate the sacrifices and achievements of mediators between earth and heaven, 'culture heroes' who by their intercession gain access to celestial water, which is 'the abode of souls and the medium necessary for their survival'. Dabbling in the

underworld, the cultural hero clothes the washed skeleton of a dead man with flesh, gives him 'a spiritual body', and enables the present to maintain contact with the past. This perhaps was the task Berio set himself in *Sinfonia*. He re-establishes continuity, mixing his own music with that of his predecessors, dissolving words in the stream. He recalls the watery origins of life itself, and proposes that the past can buoy us up, so long as we consent to be borne along by its current. The image beautifully recurs in Calvino's text for Berio's opera *Un re in ascolto*, first performed in 1984. The king listens to life rather than participating in it, morosely interpreting the murmurs and rumours which circulate in his palace. Eventually he realizes that those sounds are not simply the noise made by society, like the rude uproar which bludgeons harmony in *(K)ein Sommernacht-straum*. What he overhears is 'the sea of music', with its consoling amniotic lullaby.

Mahler's *Resurrection* symphony was music for the end of a century, or of a world. Completed in 1894, it begins with the death of an individual, hustles all humanity towards a last judgment, then resurrects a rejoicing choral multitude. Berio overlooked, or ingeniously amended, this millenarian plot. The movement he selected for recycling was the scherzo, which in Mahler's scheme represents the spirit of irreligion and negation. The scurrying ländler carries memories of a text which Mahler had earlier set to the same tune. In the songs of his *Des Knaben Wunderhorn*, the ländler accompanies an account of Saint Antony's overzealous efforts to convert the fishes. The greedy carp and snapping, larcenous pike listen to his sermon, and the crabs even trundle up from the river bottom. Then, when the saint has finished preaching, they go back to being soulless fish, instantly forgetting his words. A scherzo is supposed to be playful but, in the context of Mahler's symphony, the anecdote bitterly recognizes that men, like fish, will probably choose to remain unregenerate.

Berio takes a more amenable view of the matter. Unlike Mahler, he pre-scribes no apocalypse, with a quaking earth and thundering heaven. Nor does he expect graves to open so that the dust they contain can (as a seraphic soprano promises in Mahler's finale) be awarded eternal life. Like the Amazonian myth-makers of Lévi-Strauss, men tell stories about such reconciliations with heaven; they remain fictions. *Sinfonia* commemorates a contemporary specimen of the 'héros tué' who throughout *The Raw and the Cooked* volunteers to transform brutish nature into equitable culture. Martin Luther King was assassinated in April 1968, and in Berio's second movement, 'O King', the singers brood on his name, repeating it like a sacred syllable, but they have no power to revive him.

Berio hopes at best for resilience, like the fish which persist in their bad habits. This is the encouragement offered by Beckett's *The Unnamable*, from which Berio took the rallying cry 'Keep going'. During the scherzo, the speakers repeat this command with a certain desperation, and have to shout 'Keep going, keep going on'. There are dissenting grumbles: 'Call that going? Call that on?' Beckett's misanthrope fails to profit from his own advice. He cannot go on, and does not wish to. He has his own sickly equivalent to the vital fluxion of

Lévi-Strauss's myths about water. 'I've the bloody flux', he complains: language for him is a drooling secretion. He admits that there was 'for a second the hope of a resurrection', though 'now it's over, it's done, we've had our chance'. He remarks as he collects his thoughts that memory works like messy fly-paper, so that his consciousness is jammed with quotations from himself: 'I must not forget this. I have not forgotten it, but must have said it many times before if I say it now.' He repeats himself in order to wear out words, trusting that he will eventually say 'the thing that had to be said, that gives me the right to be done with speech'. Once he arrives at 'the moment when the world is assembled at last', he intends to disassemble that small personal world, fall silent and die. His morbidity is instantly cured by contact with the onward, incontrovertible motion of Mahler's scherzo, which bundles him back into the life he was ready to renounce.

Despite wars, bombs, epidemics, pollution and ominous comets, the twentieth century has managed to keep going. In *The Raw and the Cooked*, Lévi-Strauss comments on the feats of two civilizing heroes. One is timid: he goes on a penitential expedition to the underworld, and comes safely home. He secures 'a restricted life for men', warning that its 'duration is henceforth to be *measured*'. The other, more brazen, actually dies, so when he reappears he brings with him a 'promise of resurrection'. Nothing less than this will do for us, as the legatees of modern times. Unlike the progressive men of the nineteenth century, who thought that mechanical innovation had speeded up history, we cannot deny time's power over us. Hence the appeal of mythic thinking. The Amazonian myths contain recipes for avoiding death. Plants and animals do so seasonally: they shed skins and thereby grow younger. For the rest of us, music opens the way, as Lévi-Strauss says, to 'a kind of immortality'. Proust savours intimations of heaven in a phrase from Vinteuil's sonata, and in *The Magic Mountain* the tubercular patients listen to a gramophone record of the final duet in the tomb from Verdi's *Aida*, amazed by the way music mystically alleviates hunger, suffocation and decay. The singers in Karlheinz Stockhausen's *Stimmung* meditatively repeat their mantras until time is suspended, and Berio's river flows serenely backwards, or around in a circle.

Another kind of melodious immortality is recommended by Kundera: the sound of heedless laughter, which releases us from history for a while, like the coital quotations of Borges – those moments when anyone can become Shakespeare. It is an ancient, audacious human talent, more effective than suicide as a repudiation of the past. Lévi-Strauss remarks that the Bororo people distinguish between natural mirth, which is a mere bodily titillation, and 'the triumphant laughter marking cultural invention'. Transposed to the twentieth century, this is the laughter of impertinent cultural reinvention. Kundera credits this 'immortal laughter' with the capacity to unseat tyrants. The emperor only rules until someone sniggers at his nudity. The fall of Nicolae Ceauşescu became inevitable when, as he ranted from the balcony of his palace, the crowd below jeered.

Laughter challenges other baleful precursors, and withholds the esteem we supposedly owe to 'those who after their death remain in the memory of posterity'. In *Immortality* Kundera pokes fun at one of these immortals, investigating Goethe's career as a libertine rather than venerating him as a sage. During the nineteenth century, Goethe was posthumously set at the mid-point of European history; he became 'the great centre', equilibrating extremes. Now that astrophysics has placed us in an expanding universe without bounds or limits, we must give up the idea of a centre which gravely holds phenomena together. By inspecting the details of Goethe's elderly affair with another poet's young wife, Kundera shows that European history is a record of ordinary human folly, not the implacable march of great minds towards enlightenment. Romantic dreams of perfection were warped into nightmares during the twentieth century: the man-made paradise imagined by the poets turned out be a totalitarian state. Therefore, as Paul cries in *Immortality*, we must challenge this heritage and overthrow 'the arrogant power of the Ninth Symphonies and the *Fausts*!'

He chooses his targets well. The frieze by Klimt illustrating Beethoven's Ninth Symphony in the Vienna Secession pavilion looks sinister or perverse in retrospect. A knight of faith oversees the spiritual evolution of mankind; luckily for us all, he is side-tracked by a woman, and disappears into her entangling embrace. Goethe's Faust, penetrating nature's secrets with infernal aid, is another dangerous figure. Thomas Mann interpreted the German metaphysical adventure which began in 1933 as a national pact with the devil. Faust the necromancer reappears in *The Castle of Crossed Destinies*, where he declares that 'The world does not exist'; his casual remark sums up the atomizing science and deconstructive philosophy of modern times. But for all Faust's learning, it is easy to rebut him by slightly but emphatically misquoting Borges: the world, fortunately, *is* real. By the end of the century, Faust's mad idealism can be safely laughed at. In Schnittke's opera *Historia von Dr Johann Fausten*, first performed in 1995, the hero's supernatural cravings have become cheap and trivial. The devil, he boasts, supplies him with fine wines and delicious food – appetites he could surely have satisfied without bartering his soul. The hell into which Schnittke's Faust descends is a night-club with diabolical décor, and the slinky female demon Mephistophila croons into her microphone as she takes possession of him. Having killed off God, our next step is to render his adversary harmless.

Mocking romanticism, Kundera allows his characters to choose another past. They reject the grandiose nineteenth century, and instead pledge allegiance to the culture of the eighteenth – graceful, decorous, playful. Paul, averse to the tragic conceit of modernity, says that 'The age of tragedy can be ended only by the revolt of frivolity'. This means accepting that our existences are capricious, and absurd – but sooner a 'weightless environment' than the romantic enthusiasm for eternal values, which has usually required the sacrifice of human lives. The comic spirit reminds us of our flimsiness, and also of our freedom. It points out that truth is relative, which is why we need fiction. Paul has his own messianic

hope for a happy ending to history. Denouncing the other-worldliness of the romantics, he suggests that 'if there were fewer funeral marches there might perhaps be fewer deaths', and promises that, when people recognize the destructive cost of idealism, 'war will become impossible'.

Eco has arrived at the same accommodation with history by different means. The library in *The Name of the Rose* contains a seditious volume by an Egyptian alchemist, who 'attributes the creation of the world to divine laughter'. Jorge of Burgos disapproves of this lineage, because laughter 'shakes the body, distorts the features of the face, makes man similar to the monkey'. But William of Baskerville sees comedy as a rational, self-critical skill. Christ did not laugh, and neither do dictators, except malevolently. In *The Book of Laughter and Forgetting*, Kundera proposes his own heresy, arguing that the world is divided between demons and angels, who conduct their dispute by laughing at each other. The demons, he concedes, invented laughter, by which they intended to deride God's world and to declare 'the meaninglessness of things': this was their interrogation of the universe. The angels could only reply in the same terms, though their mirth rejoiced in the beauty and goodness of existence. It does not matter if their mouths gape open and their expressions are epileptic. Laughter, as Kundera notes in *Immortality*, is 'the most democratic of all the facial aspects' – a soft, rubbery, revocable version of those cruel metamorphoses to which Picasso and Kafka subjected the modern human being.

Kundera does not expect angelic merriment to vanquish demonic satire. All that the world requires, in order to keep going, is a balance of power between faith and doubt, certainty and nihilism. Perhaps we have more to fear from dogmatic order than from anarchy. Western morality has always chastened man's physical life, and associated its formlessness with a propensity to evil; from Freud's scatological dreams to the manifestos of sexual liberation during the 1960s, modern times have encouraged an uprising of the body. Dada and surrealism first sang the praises of randomness and irrationality. Since then we have come to accept chaos – weather with its unpredictable turbulence or the patterned vagaries of traffic, which perplex Musil at the beginning of *The Man Without Qualities* – as the force which propels nature.

The world may not reciprocate our laughter. Nevertheless, as Kundera decides at the end of *Immortality*, our only choice is to make that unyielding world 'the object of our game'. His advice sums up the twentieth century's hard-won, smilingly stoical wisdom: here is a gay science for the end (or at least the late middle age) of time. The game is our agreed metaphor for life itself, and for the way we spend time. John Cage in 1957 defined both art and life as 'purposeless play', and Robbe-Grillet in 1963 insisted that the game of existence was 'purely gratuitous', without a soul, a god or a bourgeois social order to support it. Francis Bacon repeated the same infidel creed, commenting that, although we know our lives to be meaningless, we have to play the game to the end. Pessimism, when it becomes compulsory, seems like a soft option. Bacon said that 'man now realizes

that he is an accident'. Yes, of course – but why not a happy accident? Eighty bil-lion people, according to Kundera's calculations, have already occupied our tired planet; it is no wonder that we feel so obstructed by the past, so incapable of innovation. The human face, as Agnes reflects in *Immortality*, is like the serial number of a car: it denotes one among innumerable other mass-produced speci-mens, turned out according to the specifications of an industrial prototype. Character, self or soul were never part of the formula. Yet on any single face, fea-tures still combine in accidental, unrepeatable ways; for that very reason, we are liable to fall in love.

Apart from painting, the games Bacon played to while away life included roulette, which he liked because it was 'completely impersonal'. This may have been more than a vice, or an expensive hobby. At Santa Cruz during the 1970s the theoreticians of cosmic chaos studied roulette as a model of how a 'dynami-cal system' worked. As the wheel spun, they tried to keep up with the perpetual motion of life and its rotating variables. Einstein, they revealed, was wrong to think that God did not gamble. In 1957 Boulez published an essay entitled 'Alea', on chance operations in music. The techniques he described came to be known as aleatory; the coinage might have been a reply to Einstein's embargo, since 'alea' is the Latin word for dice. Despite Bacon's dour compulsiveness, the game is not necessarily rigged against us. The margin left to chance confers on us an inviolable freedom. In Kundera's novel, Agnes's father likens God to a computer programmer. The programme determines the limits of possibility, but does not prophetically presume to control the future. Life proceeds through the 'play of permutations and combinations'. Kundera, wanting to write a book about the theory of chance, wishes that someone would help him by inventing an existen-tial mathematics. Then it might be possible to compute the probability of those coincidental encounters which turn out to be life-changing revelations – one in a million? or a billion?

Calvino, in a lecture on cybernetics delivered in 1967, welcomed the com-puter because it showed consciousness to be '*discrete* rather than *continuous*'. We have given up the notion of thought as an undifferentiated stream, imitated by the fluid monologues of the literary modernists: the reveries of Proust's Marcel, Musil's Ulrich or Joyce's Molly Bloom. We have broken down language itself, the 'most complex and unpredictable of machines', into a blitz of codes and mes-sages. But the disassembled machine is friendlier than those bulky industrial golems which, like Wells's Martians, warned men of their impending end. The new machines take their orders from the software installed in them; we now envisage thinking, Calvino said, as a sequence of 'discontinuous states,…combi-nations of impulses acting on a finite…number of sensory and motor organs', just as 'bits' of electronic information course through the circuitry of an artificial brain. This, as it happens, is all that Calvino's Faust meant when he denied that the world existed. In *The Castle of Crossed Destinies* he goes on to explain that there is no 'all, given all at once' – no continuum, like the maternal organism of

romantic nature. Instead we have at our disposal 'a finite number of elements whose combinations are multiplied to billions of billions'. Not all of those possible combinations manage to make themselves articulate, or get themselves born. They remain indistinct, a penumbral cloud of dust. Even when they take on form and meaning, they do so only temporarily, like a pack of cards which must be reshuffled and dealt again in another order.

As Boulez remarked in 1961, Schoenberg's serial method of composition engineered a model of this new universe, where everything is divisible, combinable, infinitely permutable. Tonality, with its grounded musical language, belonged to a world in which Newton's laws about gravity and attraction still vouched for the integrity of our floors, walls and ceilings. Serialism, defined by Boulez as 'a polyvalent mode of thought', suits a cosmos which, as we know, is continuously expanding, travelling towards the moment – millions or billions of years hence – when it will collapse in on itself again. Until that happens, serialism, like a computer programme, begets permutations. Boulez acknowledged the terrors and the excitements of this groundless existence in his own music. In *Pli selon pli*, he improvised on three sonnets by Mallarmé. One of the poems begins by pondering a piece of lace which mysteriously abolishes itself 'dans le doute du Jeu suprême' – in doubt of the supreme Game. In Boulez's setting a high soprano pauses pensively on 'doute', with some quavers of uncertainty. Then she soars suddenly upwards on 'Jeu', startled or perhaps elated. But she makes 'suprême' scintillate, shaking light from it.

The civilization we have constructed, whose resilience has been so severely tested throughout modern times, is the dubious, tentative product of just such a supreme game. In 1910 Georg Simmel in his essay on 'The Sociology of Sociability' claimed that all social connections were a form of precious, artificial play-acting. We collaborate in creating a fiction, which we solemnly treat as if it were real. If we forget that the rules are our own invention, and therefore flexible, Simmel cautioned that society becomes 'a lifeless schematization, proud of its woodenness'. Hence the twentieth century's troops of goose-stepping, dehumanized marionettes. Our world coheres thanks to what Simmel called an 'admittedly stylized web'. The same intricate and fragile net is stretched across the sky in the mythology of the Toba people in South America: Lévi-Strauss illustrates a game they play with string, its knots representing the constellation of the Pleiades. Working on *Mantra* in 1970, Stockhausen allowed its repetitions to unfurl through time and distend into space, as if he were composing a galaxy. With the same god-like bravery, Eco remarks that 'writing a novel is a cosmological matter'. First you must construct a world; only then can you describe it, or narrate its history. Calvino praised the novel as a 'vast net', able to catch the thronging, contradictory nature of life. Nets and webs and grids of string are the most effective of hold-alls, precisely because – like Mallarmé's lace, or like matter itself according to the new physics – they mostly consist of holes. A relativized world can be an alarming place to live. In his fable about Tlön, Borges casually

supposes that our own planet, as spurious as Tlön, may have been 'created a few minutes ago'. Our past is a subjective fantasy, and the future which the revolutionaries pledged to create has still not arrived. That leaves us with only the tenuous present. Film, the art of our century, supplies an image of our condition: a moving picture is a record of presentness, of time as it runs away, like Jeanne Moreau wandering through the city in Antonioni's *La notte*; and behind the animated shadows is a blank screen.

Modernity had a single, simple project, carried through in all fields of mental endeavour. Declining to give God credit for creation, it took the world to pieces. The nuclear bomb was its equivocal triumph. Dalí, elated by the bomb's explosion, babbled about a 'nuclear mysticism', welcoming destruction because it revealed the fragility of matter and released a flammable spirit. The experiment which split the atom at least made us aware of what holds the world together: nothing more nor less than a fabric of inconceivably minute neutrons and neutrinos, or perhaps that network of electrical charges which generated the nervous mysticism of Bahr and served Durkheim as a metaphor for the operation of religious grace. Modern architects, using newly elastic materials, designed buildings like Fallingwater or Pei's Bank of China which seem to have no business standing up – and yet they do. The same precarious marvel appears, thanks to our century's X-ray vision, in DNA, the molecule responsible for heredity. It carries the burden of the past (and therefore guarantees that this is not, as Borges suggested, a hallucination), but it does so lightly, airily. The necessary acids and bases are arranged on a double helix, like the spiral staircase seen through glass walls in Walter Gropius's factory at Cologne. Inside this single molecule the combinatorial game plays on, ensuring that life continues, and that it continues changing.

A test-tube
containing DNA

ILLUSTRATION ACKNOWLEDGMENTS

115 Georges Braque, *Café-Bar*, 1919. Oil on canvas, 63 × 32¼" (160 × 82 cm). Öffentliche Kunstsammlung, Basle

118 Marcel Duchamp, *Ready-Made, Ball of Twine*, "With Hidden Noise", 1916. Metal and twine, H. 5" (12.5 cm). Philadelphia Museum of Art: Louise and Walter Arensberg Collection

124 Franz Roh, leaflet, 1929

134 *Die freudlose Gasse*, 1925. BFI Stills, Posters and Designs. Transit Film GmbH, Munich/Friedrich-Wilhelm-Murnau Stiftung

136 Oscar Schlemmer, *The Triadic Ballet* as part of *Wieder Metropol*, Metropol Theatre, Berlin, 1926. Photo Archive C Raman Schlemmer, Oggebbio, Italy. © 1998 The Oskar Schlemmer Theatre Estate, 79410 Badenweiler, Germany

149 Paul Klee, *Mask of Fear* {Maske Furcht}. 1932. Oil on burlap, 39½ × 22½" (100.4 × 57.1 cm). The Museum of Modern Art, New York. Nelson A. Rockefeller Fund. Photograph © 1998 The Museum of Modern Art, New York

150 Egon Schiele, *Self-Portrait Squatting*, 1916. Chalk and watercolour, 11⅝ × 18" (29.5 × 45.8 cm). Graphische Sammlung Albertina, Vienna

155 Oskar Kokoschka, poster for *Mörder, Hoffnung der Frauen*, 1908. 48 × 31¼" (122 × 79.5 cm). Museen der Stadt, Vienna

156 Otto Dix, *The Sex-Murderer (Self-Portrait)*, 1920. Etching, 11¾ × 10" (30 × 25.7 cm)

158 *Le Mystère Picasso*, 1955. BFI Stills, Posters and Designs

160 Pablo Picasso, *Les Demoiselles d'Avignon*, Paris, June–July 1907. Oil on canvas, 8' × 7' 8" (243.9 × 233.7 cm).

The Museum of Modern Art, New York. Acquired through the Lillie P. Bliss Bequest. Photograph © 1998 The Museum of Modern Art, New York

162 Pablo Picasso, *Guernica*, 1937. Oil on canvas, 11' 6" × 25' 8" (350.5 × 782.3 cm). Archivo fotográfico Museo Nacional Centro de Arte Reina Sofía, Madrid

163 Pablo Picasso, *Crucifixion*, 7 October 1932. Pen and ink, 13½ × 19⅝" (34.5 × 50 cm). Musée Picasso, Paris

169 Pablo Picasso, *Les Saltimbanques*, 1905. Oil on canvas, 83¾ × 90⅜" (212.5×229.5cm). National Gallery of Art, Washington D.C. Chester Dale Collection, 1962. © The Board of Trustees, National Gallery of Art, Washington

171 Roy Lichtenstein, *Femme d'Alger*, 1963. Oil on canvas, 80 × 68" (203.5 × 172.5 cm). Private collection. © Estate of Roy Lichtenstein/DACS 1999

172 Arnold Schoenberg, *Mahler's Funeral* (detail), 1911. Oil on canvas. Private collection

185 Alban Berg, chord from a letter, 10 March 1914. Österreichische Nationalbibliothek, Vienna

187 Hans Schliessmann, *Mahler Conducting*. Österreichische Nationalbibliothek, Vienna

193 Birgit Nilsson as Elektra, 1969. © Zoë Dominic

196 Albert Giraud, title-page to *Pierrot Lunaire*, 1893

200 Josef Čapek, design for *The Cunning Little Vixen*, 1924. Národní Muzeum, Theatre Section, Prague

202 Gino Severini, *The Armoured Train* {Train blindé en action} (detail), 1915. Oil on canvas, 46⅝ × 34⅞" (115.8 × 88.5 cm).

The Museum of Modern Art, New York. Gift of Richard S. Zeisler

205 Trenches on the Somme. Photograph, 1916

208 Andy Warhol, *129 Die in Jet (Plane Crash)*, 1962. Synthetic polymer paint on canvas, 8' 4" × 6' (254 × 183 cm). Museum Ludwig, Cologne. © The Andy Warhol Foundation for the Visual Arts, Inc./ARS, NY and DACS, London 1999

216 Josef Lada, illustration for the first part-issue of J. Hašek, *The Good Soldier Schweik*, 1911

228 Lenin and the Dnieper Power Station. Poster, 1937

236 Factory crèche, 1930s. SCR Photo Library

243 V.V. Lutse, biomechanics exercises. Drawing, 1922

245 Aleksandr Rodchenko, *BOOKS*, 1925. Poster reconstruction by V.A. Rodchenko

249 Boris Iofan, Palace of the Soviets, 1933–7. Copyright British Architectural Library/RIBA

250 El Lissitzky, *Wolkenbügel*, 1924. Watercolour. State Tretiakov Gallery, Moscow

252 Leonard Baskin, *Tormented Man*, 1956. Ink drawing, 39½ × 26½" (100.5 × 67 cm). Collection of Whitney Museum of American Art, New York

254 Otto Dix, *Ich Dix bin das A und das O*, 1919. Woodcut, 7⅛ × 5⅛" (18 × 15.8 cm)

259 Salvador Dalí, *Portrait of Freud*, 1938. Ink drawing, 4¾ × 8¼" (12.5 × 21 cm). Private collection

266 Max Pollack, *Freud at His Desk*, 1914. Etching. Freud Museum, London/Sigmund Freud Copyrights

267 'The Wolf Man', *Dream of Wolves*, 1910–12. Drawing.

Photo Freud Museum, London

274 The Eiffel Tower, 1925. Photograph. Collection Viollet

276 Antonio Sant'Elia, design for a station, 1913–14. Villa Communale dell'Olmo, Como

278 Frank Lloyd Wright, *Fallingwater*, 1935–6. Photo Sandak

279 Hongkong and Shanghai Bank and Bank of China. Photo: Ian Lambot: Arcaid

289 Le Corbusier, drawing for Maison Citrohan, 1920. From Le Corbusier and Pierre Jeanneret, *Oeuvre complète* (1937)

292 Marcel Breuer, Wassily chairs and table, designed 1925. The Knoll Group

297 Kurt Schwitters, *Merzbau*, Hanover, 1923. Wood, plaster, oil, collage. Installation

300 James Abbe, *Backstage at the Folies-Bergère*, 1924. Photo James Abbe. © Kathryn Abbe. Courtesy of Washburn Gallery, NYC

305 Man Ray, *Imaginary Portrait of D.A.F. de Sade*, 1938. Oil on canvas, $21^5/_8 \times 17^3/_4$" (54.9 × 45.1 cm). Private collection

308 Max Ernst, *Vision provoquée par l'aspect nocturne de la porte Saint-Denis*, 1927. Oil on canvas, $26^3/_4 \times 32^1/_4$" (68 × 82 cm). Private collection

314 Pablo Picasso, curtain for *Parade*, 1917. Glue, tempera on canvas, 32' 10" × 52' 6" (10 × 16 m). Musée Nationale d'Art Moderne, Paris

317 *Relâche*, 1924. Photo courtesy Harry N. Abrams Inc.

318 Frames from Hans Richter's *Inflation*, 1927–8. UFA, Berlin

326 *The Blue Angel*, 1930. Photo BFI Stills, Posters and Designs. Friedrich-Wilhelm-Murnau Stiftung

333 Ludwig Meidner, *I and the City*, 1913. Oil on canvas, $23^5/_8 \times 19^{11}/_{16}$" (60 × 50 cm). Private collection

343 Rainer Fetting, *Van Gogh and Wall V*, 1978. Oil on canvas, 6' 8" × 8' 4" (201 × 251 cm). Marx Collection, Berlin – courtesy the artist

344 Fernand Léger, figure studies for *La Création du monde*, 1923

352 Henri Matisse, *La Danse*, 1909–10. Oil on canvas, 8' $5^5/_8$ × 12' $9^1/_2$" (260 × 391 cm) State Hermitage, St Petersburg. © Succession H. Matisse / DACS 1999

354 Nijinsky from *The Sketch Supplement*, c. 1912

356 Surrealist map of the world, from *Variétés*, 1929

360 José Clemente Orozco, *Destruction of the Old Order* (detail), 1926–7. Fresco, National Preparatory College, Mexico City. Photo Bob Schalkwijk. INBA, Mexico City

363 Nikolai Roerich, design for *Prince Igor*. V & A Picture Library, London

366 Paul Colin, Josephine Baker. Illustration from *Le Tumulte Noir*, c. 1927. H. $18^1/_2$" (47 cm). Yale Collection of American Literature, Beinecke Rare Book and Manuscript Library, Yale University

369 Pablo Picasso, cover for Stravinsky, *Ragtime*, 1919

370 *Jonny spielt auf*, 1927. Theaterwissenschaftliche Sammlung der Universität, Cologne

380 *Le Sacre du printemps*. © Zoë Dominic

384 Jean Cocteau, Stravinsky composing *Le Sacre du printemps*, 1913

385 Nikolai Roerich, design for *Le Sacre du printemps*, 1945.

Oil on canvas, $22^1/_4 \times 28^1/_2$" (56.5 × 72.2 cm). State Russian Museum, St Petersburg

389 *Les Noces*, 1923

400 Franz Seiwert, *Working Men*, 1925. Oil painting, $27^1/_8 \times 35^3/_8$" (69 × 90 cm). Kunstmuseum, Düsseldorf. Copyright: Rosa Erpelding

402 El Lissitzky, *New Man* from the album *Victory over the Sun*, 1920–21. Lithograph, $21 \times 17^7/_8$" (53.5 × 45 cm). State Tretiakov Gallery, Moscow

406 *Metropolis*, 1926. BFI Stills, Posters and Designs. Transit Films GmbH, Munich / Friedrich-Wilhelm-Murnau Stiftung

414 Hans Bellmer, *Doll*, 1934. Virginia Lust Gallery, New York

416 Caricature of *R.U.R.*, 1924. C.T.K. Files

420 Fernand Léger, *Charlot cubiste*, 1924. Illustration to *Die Chapliniade*

423 *The Idle Class*, 1921. BFI Stills, Posters and Designs. © Roy Export Company Establishment

428 Marc Chagall, *A Charlot Chaplin*, 1929. Pen and ink drawing, $16^7/_8 \times 11$" (42.5 × 28 cm). Private collection

435 *Modern Times*, 1936. BFI Stills, Posters and Designs. © Roy Export Company Establishment

437 *The Great Dictator*, 1940. BFI Stills, Posters and Designs. © Roy Export Company Establishment

440 *Le Testament d'Orphée*, 1960. BFI Stills, Posters and Designs. L.O.T., Luxembourg

446 *Napoléon*, 1927. BFI Stills, Posters and Designs

450 Man Ray, *Portrait of Julie*, 1954. Photograph, 6¼ × 4¼" (15.0 × 10.8 cm). Photo: Gallerie Il Fauno

452 Lazlo Moholy-Nagy, title-page for *Foto-Qualität*, 1931

453 *Das Kabinett des Dr Caligari*, 1919. BFI Stills, Posters and Designs. Transit Films GmbH, Munich/Friedrich-Wilhelm-Murnau Stiftung

461 Aleksandr Rodchenko, poster for Vertov's *Kino Glaz*, 1924. 9⅞ × 15⅜" (25 × 39 cm)

465 *Un Chien andalou*, 1928. BFI Stills, Posters and Designs. Les grands Films classiques, Paris, France

466 Salvador Dalí, design for *Spellbound*, 1945. BFI Stills, Posters and Designs

472 *The Small Back Room*, 1949. BFI Stills, Posters and Designs. Canal + Image UK Ltd

476 Nazi Rally. National Archives, Washington

481 George Grosz, *Siegfried Hitler*, 1922–3. Brush, pen and ink, 24⅞ × 18⅜" (63.2 × 46.7 cm). Busch-Reisinger Museum, Harvard University Art Museums. Gift of Mr Erich Cohn

482 Grigory Shegal, *Leader, Teacher, Friend*, 1936–7. Oil on canvas, 133⅞ × 102⅜" (340 × 260 cm). State Russian Museum, St Petersburg

488 Albert Speer, model of *Germania*, late 1930s

491 Gerardo Dottori, *Il Duce*, 1933. Oil on canvas, 39¾ × 41¾" (101 × 106 cm). Civiche Raccolte d'Arte, Milan

497 Members of a sports association marching, 1930. Museum für Hamburgische Geschichte

499 Dutch playboy, 1972. © Hulton Getty

500 Albert Gleizes, *On Brooklyn Bridge* (detail), 1917. Oil on canvas, 63¾ × 50⅞" (162 × 129.5 cm). The Solomon R. Guggenheim Museum, New York. Photo Robert E. Mates

503 Ferry to Manhattan, 1948. Photo: The Port of New York Authority

505 George Grosz, *Memory of New York*, 1917. Lithograph, 20¾ × 15⅞" (52.5 × 39.8 cm)

519 Salvador Dalí, *Gangsterism and Goofy Visions of New York*, 1935. Graphite pencil and ink on paper, 21½ × 15¾" (54.6 × 40 cm). The Menil Collection, Houston

530 David Hockney, *Mullholland Drive; The Road to the Studio*, 1980. Acrylic on canvas, 86 × 243" (182.9 × 609.6 cm). Los Angeles County Museum of Art. © David Hockney

532 Shadow created by atomic bomb, August 1945. Hiroshima Peace Memorial Museum

534 Atomic Dome, Hiroshima. Photograph, 1945

539 Jean Tingueley, sketch for *Homage to New York*, 1960. Felt-tipped pen and ink on bristol board, 22⅛ × 28 (56 × 71 cm). Museum of Modern Art, New York, Gift of Peter Selz. Photograph © 1998 The Museum of Modern Art, New York

540-1 James Rosenquist, *F–111*, 1964–5. Oil on canvas with aluminium, 10' × 86' (306.8 × 2621.3 cm) overall. The Museum of Modern Art, New York. Purchase. © James Rosenquist/DACS, London/VAGA, New York 1999. Photo © 1997 James Rosenquist/ Licensed by VAGA, New York, NY

547 Chernobyl, August 1986. Popperfoto/Reuter

552 *Easy Rider*, 1969. BFI Stills, Posters and Designs. Courtesy of Columbia Pictures. Copyright 1969 Columbia Pictures Industries Inc. All Rights Reserved

554 Georgia O'Keeffe, *Ranchos Church No.1*, 1929. Oil on canvas, 18¾ × 24" (47.5 × 61 cm). Purchased through the R.H. Norton Fund. Collection of the Norton Museum of Art, West Palm Beach, Florida, USA. © ARS, NY and DACS, London 1999

557 Jackson Pollock painting *No. 32*, 1950. Photo: Rudolph Burckhardt

562 Rothko chapel, Houston, 1965–7. Photo: The Menil Foundation, Houston. © Kate Rothko Prizel & Christopher Rothko/DACS 1999

566 Robert Rauschenberg, *Automobile Tire Print*, 1953. Monoprint, ink on paper. 5½ × 169¼ × 25¼" (14 × 429.9 × 64 cm). Collection of the Artist, on loan to the National Gallery of Art, Washington. © Board of Trustees, National Gallery of Art, Washington. © Robert Rauschenberg/DACS, London/VAGA, NY 1999

572 Ashley Bickerton, *Tormented Self-Portrait (Susie at Arles)*, 1988. Mixed media construction, 90 × 69 × 18" (228.6 × 175.26 × 45.72 cm). Sonnabend Gallery, New York

587 *Joni Mabe's Traveling Panoramic Encyclopedia of Everything Elvis*, 1993. Installation

589 Richard Hamilton, *"Just what is it that makes today's homes so different, so appealing?"*, 1956. Collage, 10¼ × 9⅞" (26 × 25 cm). Kunsthalle Tübingen. Sammlung G.F.

Zundel. © Richard Hamilton 1999. All rights reserved DACS

592 Claes Oldenburg, *White Gym Shoes*, 1962. Plaster-soaked muslin, 24 × 24 × 10" (61 × 61 × 25.5 cm). Museum of Contemporary Art, Los Angeles. The Panza Collection. Courtesy the artist. Photo: Douglas M Parker Studio

598 Nam June Paik, *Robot, c.* 1964. Courtesy the artist

602 Jeff Koons, *New Hoover Deluxe Shampoo-Polishers, New Shelton Wet/Dry 10 Gallon Displaced Tripledecker*, 1981–7. Four Hoover deluxe shampoo-polishers, one Shelton wet/dry 10-gallon vacuum cleaner, Plexoglas, and fluorescent tubes, 91 × 54 × 28" (231 × 137 × 71 cm). Copyright the artist

603 Salvador Dalí, *Le Moment sublime*, 1938. Oil on canvas 15⅛ × 18⅝" (38.5 × 47.5 cm). Staatsgalerie, Stuttgart

609 Konrad Klapheck, *Ideal Husband*, 1964. Oil on canvas, 59⅛ × 51¼" (150.5 × 130.5 cm). Private collection

625 Nam June Paik, *Electronic Superhighway*, 1995. 313 televisions, laserdisc players, steel, neon, audio. 15 × 32 × 4' (4.57 × 9.75 × 1.22 m). Courtesy the artist and Holly Solomon Gallery, New York

628 Georg Baselitz, *Painter with Sailing Ship* (detail), 21 September 1982. Oil on canvas, 98½ × 78¾" (250 × 200 cm) Staatsgalerie, Stuttgart. © Georg Baselitz, 1998

633 Concentration camp survivors, 1945. © Hulton Getty

640 *The Terminator*, 1984. BFI Stills, Posters and Designs. Epic Productions Inc.

642 Cindy Sherman, *Untitled Film Still*, 1977, Black and white photograph, 10 × 8" (25 × 20 cm). Courtesy of the artist and Metro Pictures

643 Dolly. Popperfoto/Reuter

644 Erwin Blumenfeld, *Marquis de Sade* (detail), 1921. Collage, 9⅝ × 9⅜" (24.5 × 25 cm). Galeria Schwarz, Milan

646 Malcolm X. © Hulton Getty

653 Judy Chicago, *Sappho Plate* from *The Dinner Party*, 1979. China paint on porcelain, 14" (36 cm) diam. © Judy Chicago, 1979. Photo © Donald Woodman

659 Marlene Dietrich. The Kobal Collection

664 Gay Pride, 1995. © Hulton Getty/Mark Lynch

670 Tokyo. © Tony Stone Images. Chad Ehlers

680 Yukio Mishima. Popperfoto

686 Toyo Ito, *Egg of Winds*, 1989. © Toyo Ito

690 Entertainment tree. Photo Bob Davis

692 Old Mick Gill Tjakamarra, *Three Snakes Dreaming*, 1990. Acrylic on canvas, 4 × 6' (121.9 × 182.9 cm). Rebecca Hossack Gallery, London

694 Richard Long, *Walking a Circle in Ladakh*, 1984. Anthony d'Offay Gallery. Courtesy the artist

695 Susan Ressler, *Earth I*, 1989. Photographic collage manipulated by computer

704 Keith Haring, *Brazil*, 21 October 1989. Acrylic and enamel paint on canvas, 72 × 72" (183 × 183 cm). The Estate of Keith Haring

706 Michael Andrews, *The Cathedral, The Southern Faces: Uluru (Ayers Rock)*, 1987. Acrylic on canvas, 95¾ × 153" (243.8 × 388.6 cm). National Museum of Wales, Cardiff. Lent by the Derek Williams Trust

708 Anselm Kiefer, *Volkzählung*, 1996. Installation. Marx Collection, Berlin – courtesy the artist. Copyright: Jens Ziehe

712 *Happy Days*. Collection Viollet

715 Francis Bacon, *Pope I*, 1951. Oil on canvas, 6' 6" × 5' (198 × 152 cm). Städtische Kunsthalle, Mannheim

716 Arata Isozaki, Tsukuba Center, 1979–83, in ruins. Silkscreen print. Photo by Yasuhiro Ishimoto – courtesy Arata Isozaki

737 DNA. © Tony Stone Images. Tony Hutchings

© ADAGP, Paris and DACS, London 1999 27, 81, 93, 115, 118, 202, 289, 305, 308, 317, 344, 366, 384, 414, 420, 428, 450, 500, 539, 644

© DACS 1999 40, 79, 95, 110, 149, 155, 156, 172, 250, 254, 259, 297, 402, 452, 466, 481, 505, 519, 603, 609

© Succession Picasso/DACS 1999 160, 162, 163, 169, 314, 369

INDEX

Page numbers in *italic* refer to illustration captions